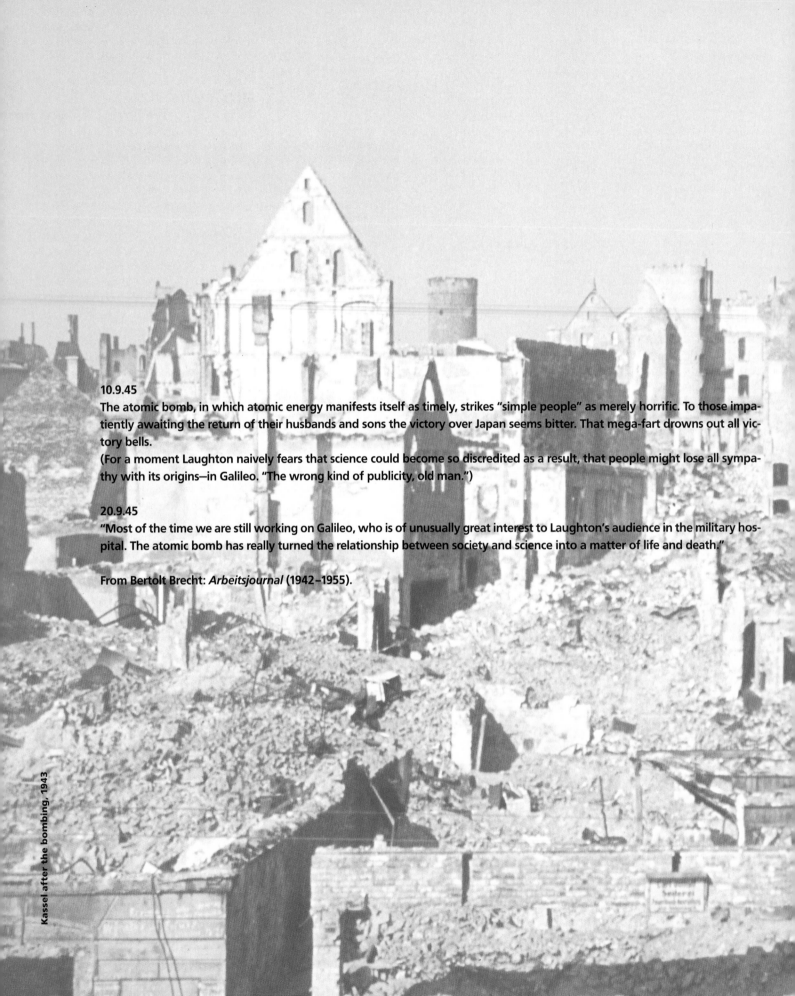

10.9.45
The atomic bomb, in which atomic energy manifests itself as timely, strikes "simple people" as merely horrific. To those impatiently awaiting the return of their husbands and sons the victory over Japan seems bitter. That mega-fart drowns out all victory bells.
(For a moment Laughton naively fears that science could become so discredited as a result, that people might lose all sympathy with its origins—in Galileo. "The wrong kind of publicity, old man.")

20.9.45
"Most of the time we are still working on Galileo, who is of unusually great interest to Laughton's audience in the military hospital. The atomic bomb has really turned the relationship between society and science into a matter of life and death."

From Bertolt Brecht: *Arbeitsjournal* **(1942–1955).**

Kassel after the bombing, 1943

"Bam!"

The whole earth jumps! worse! like it was broken in two! . . . and the air . . . this is it! Restif hadn't been lying . . . *boom!* and another! . . . further away . . . we can see it! the flashes of their cannon! . . . red! . . . green! no! shorter! it's howitzers! . . . all zeroed in on the station . . . I can see them now . . . Oddort! . . . an ocean of flame, as they say . . . big flames from all over, the windows, the doors, the cars . . . and *boom!* another! . . . another! . . . they'll never get out of that station, not one of them! . . . Restif hadn't been lying . . . but where can he be? and those people we'd followed . . . where'd they go? . . . I won't bore you with the shelling . . . dead center . . . all on the station . . . a furnace! . . . now we can see it plainly . . . very plainly . . . the howitzers and the gunners . . . weird . . . short barrels . . . no problem taking aim, they're not a thousand feet away . . . those howitzers are on the tracks, a lot of little flatcars, a whole train . . . where'd they come from? . . . ah, another noise! . . . a terrible racket . . . up in the air . . . a plane . . . with a coffee grinder . . . Restif had told us . . . their Messerschmidt . . . we know the sound . . . *rat-tat-tat! rat-tat-tat!* . . . in bursts . . . like grinding coffee by hand . . . I say to Lili . . . I don't need to say, she knows . . . down! flatter! and *wham! . . . crash! . . .* a bomb! and flying fragments . . . the death blow! . . . plunk on the station . . . we can see fine . . . brighter than broad daylight! . . . the howitzer train starts moving . . . their coke engine . . . the machine gunners are going too . . . they pack up and leave . . . nobody coming from the station . . . only a strong smell of fire . . . you know, the same as in Berlin and everywhere else, charred acrid wet . . . maybe more acrid than anything else . . . seeing we're alive, where'll we go? . . . nobody left but the two of us and Bébert . . . and cartridge cases and shell cases and heavy machine-gun belts and fragments . . . this track must go to Hanover . . . all right, let's follow it . . . hey, there's somebody! . . . not a ghost, not a shadow . . . a gunner . . . flesh and blood . . . I get it, he's rummaging, making sure they haven't left anything behind . . . he gropes around in the mud with his fingers! . . . no need! . . . I call him! . . . hey! hey! . . . I show him! right next to us, cartridge cases! . . . a whole pile! he's got them, he picks them up . . . and into his musette bag! . . . and a monkey wrench! . . . he sees us!

The rough part is getting through Hanover . . . they know all about it! the suburbs, the city . . . all burned, so they say . . . that'll make it easier! let's go! I think there's about fifty of them starting out, mothers, children, old men, old women . . . we're in with them . . . a parade . . . they're not sad, I'd even say cheerful . . . okay! off we go . . . we haven't attracted any attention, me, Lili, and the cat . . . we're part of the crowd . . . they knew what they were talking about . . . I can see there aren't many houses standing . . . more? or less than in Berlin? the same, I'd say, but hotter, more flames, whirls of flame, higher . . . dancing . . . green . . . pink . . . between the walls . . . I'd never seen flames like that . . . they must be using a different kind of incendiary gook . . . the funny part of it was that on top of every caved-in building, every rubble heap, these green and pink flames were dancing around . . . and around . . . and shooting up at the sky! . . . those streets of green . . . pink . . . and red rubble . . . you can't deny it . . . looked a lot more cheerful . . . a carnival of flames . . . than in their normal condition . . . gloomy sourpuss bricks . . . it took chaos to liven them up . . . an earthquake . . . a conflagration with the Apocalypse coming out of it! the "fortresses" must have been here . . . and not just once . . . two times! . . . three times! . . . complete destruction was their idea . . . it had taken them more than a month, hundreds of them passing over, dropping tons and tons day and night . . . there really wasn't a thing standing . . . nothing but fires and scraps of wall . . . all the ex-buildings were still full of soot and flames . . . and little explosions . . . I've told you enough about smells . . . always about the same . . . Berlin, Oddort, and here . . . charred beams, roasted meat . . . the whole crowd of us were walking arm in arm in the middle of the street . . . headed for the station . . . they seemed to know where it was . . . the day was breaking . . . lucky there were no houses left . . . I mean nothing left to clobber . . . the swirls of flame were like pink and violet ghosts . . . on top of every house . . . thousands of houses! . . . it was getting lighter . . . I've told you: not a single inhabitable house! . . . wrong again! over there! . . . no! people standing stiff against the walls! . . . there! now we can really see them . . . a man! . . . we stop, we go over, we touch him . . . he's a soldier! . . . and another one . . . a whole string! . . . leaning against the wall . . . stiff! . . . killed right there! by the blast! . . . we'd seen it in Berlin . . . instant mummies! . . . they've got their hand grenades on them, in their belts . . . they're still dangerous! if they're armed . . . *bam!* . . . if they collapse on those grenades! *Vorsicht!* careful! . . . we take our hands away . . . the other side of the street, another patch of wall . . . more of them . . . more frozen soldiers . . . one thing's sure, they didn't have time to let out a peep . . . caught right there . . . bomb blast! . . . I'd forgotten one detail, now that I get a good look at them, they're all in "chameleon" camouflage! . . . stone dead! . . . we'd better steer clear of them and move on . . . but that station? . . . I wish we were there . . . hey, here it is! it isn't standing stiff by the roadside! . . . it's gone! . . . a whole bombload! . . . it's flown away! the whole station! no wreckage . . . nothing left but the platforms . . . three or four . . . must have been a big station . . . Hanover-South . . .

From Louis-Ferdinand Céline: *Rigadoon* (1969), New York, 1974.

Black milk of daybreak we drink it at sundown
we drink it at noon in the morning we drink it at night
we drink and we drink it
we dig a grave in the breezes there one lies unconfined
A man lives in the house he plays with the serpents he writes
he writes when dusk falls to Germany your golden hair Margarete
he writes it and steps out of doors and the stars are flashing he whistles his pack out
he whistles his Jews out in earth has them dig for a grave
he commands us strike up for the dance

Black milk of daybreak we drink you at night
we drink in the morning at noon we drink you at sundown
we drink and we drink you
A man lives in the house he plays with the serpents he writes
he writes when dusk falls to Germany your golden hair Margarete
your ashen hair Shulamith we dig a grave in the breezes there one lies unconfined

He calls out jab deeper into the earth you lot you others sing now and play
he grabs at the iron in his belt he waves it his eyes are blue
jab deeper you lot with your spades you others play on for the dance

Black milk of daybreak we drink you at night
we drink you at noon in the morning we drink you at sundown
we drink and we drink you
a man lives in the house your golden hair Margarete
your ashen hair Shulamith he plays with the serpents

He calls out more sweetly play death death is a master from Germany
he calls out more darkly now stroke your strings then as smoke you will rise into air
then a grave you will have in the clouds there one lies unconfined

Black milk of daybreak we drink you at night
we drink you at noon death is a master from Germany
we drink you at sundown and in the morning we drink and we drink you
death is a master from Germany his eyes are blue
he strikes you with leaden bullets his aim is true
a man lives in the house your golden hair Margarete
he sets his pack on to us he grants us a grave in the air
he plays with the serpents and daydreams death is a master from Germany

your golden hair Margarete
your ashen hair Shulamith

Paul Celan, "Death Fugue," from: Selected Poems (1952), New York, 1990.

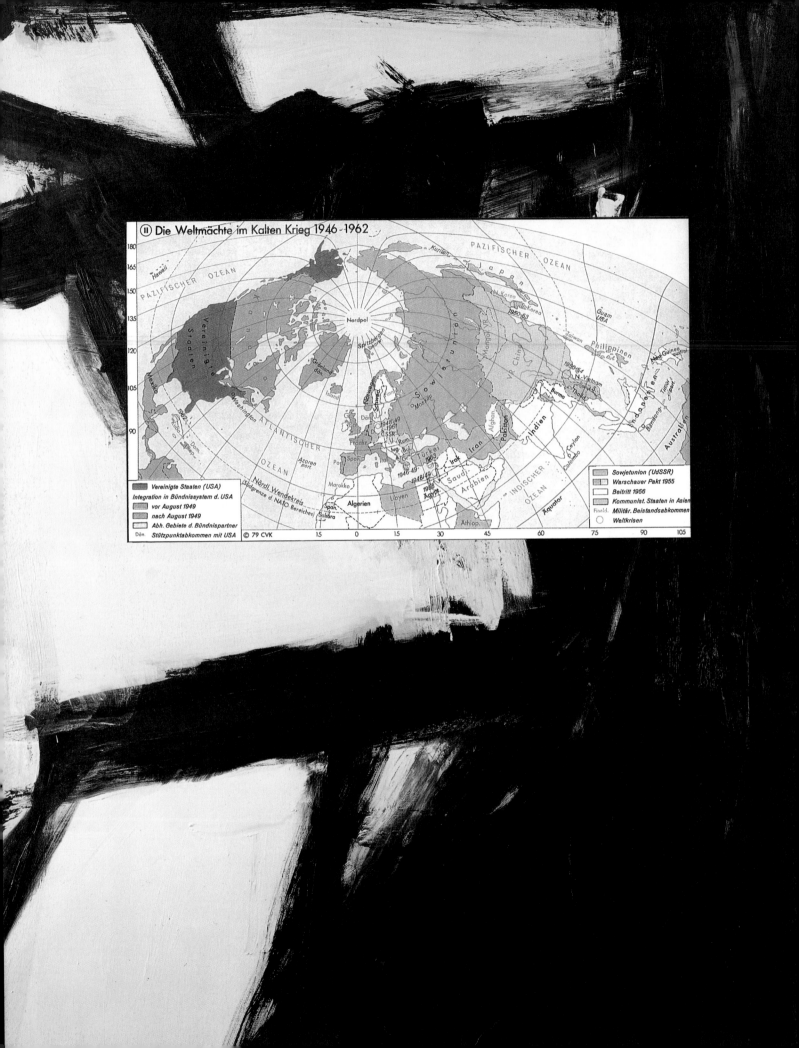

Die Weltmächte im Kalten Krieg 1946-1962

OSPAAAL

DIA DE SOLIDARIDAD MUNDIAL CON LA LUCHA DEL PUEBLO DE AFRICA DEL SUR (26 DE JUNIO)
DAY OF WORLD SOLIDARITY WITH THE STRUGGLE OF THE PEOPLE OF SOUTH AFRICA (JUNE 26)
JOURNEE DE SOLIDARITE MONDIALE AVEC LA LUTTE DU PEUPLE DE L'AFRIQUE DU SUD (26 JUIN)

MEDEROS/70

Un-
like our great
modern society, or societies,
the societies ethnologists study are "cold"
societies, as opposed to "hot" ones—clocks, as opposed to
steam engines. These are societies which produce very little disorder—
what physicists call "entropy"—and tend to remain indefinitely in their initial state.
This also explains why they seem to us like societies without history or progress.
Our own societies, on the other hand, not only make great use of steam engines, but
from the point of view of their structure also resemble steam engines; in their opera-
tion they utilize a difference of potential. This is effected through various forms of so-
cial hierarchy. Whether we call it slavery or serfdom, or whether it is division into class-
es, is not of fundamental importance when we look at things from this distance, with
perspective enough for a broad panoramic view. Societies like these have managed to
effect an imbalance or disequilibrium within that they use both to produce much more
order—we have societies that work according to mechanism—and, at the same time,
much more disorder, much more entropy, even on the level of relations between hu-
mans. . . .
What we call primitive societies may, to a certain extent, be considered systems with-
out entropy or with extremely weak entropy, operating at a kind of absolute zero—not
the temperature of the physicist, but a "historical" temperature (this is also what we are
trying to express when we say they have no history). As a result they manifest, to the
highest degree imaginable, phenomena of mechanical order, which in their case prevail
over statistical phenomena. It is striking that the objects of study ethnologists are most
comfortable with—rules of kinship and marriage, economic exchange, ritual and myth—
can often be conceived of in terms of little mechanisms that operate in quite regular
fashion and go through definite cycles, with the whole machine going
through several phases in turn before coming back to its starting
point and then beginning its course all over again.
Societies with history, like ours, have, I would
say, a higher temperature. To put it
more precisely, there exists
a greater range in
the inter-

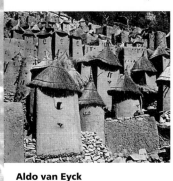

Aldo van Eyck
Dogon Village

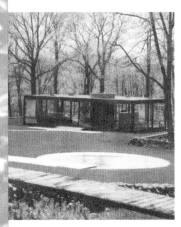

Philipp Johnson, *Glass house*

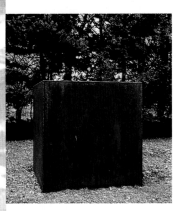

Tony Smith
Die, **1962**

From: Rem Koolhaas, *S, M, L, XL*

nal
temperatures
of the system, with gaps due
to social differentiation. The distinction
should not be made between societies "with no histo-
ry" and those "with history." All human societies in fact have an
equally long history, one that goes back to the origins of our species.
But where so-called primitive societies bathe in a historical
fluid to which they strive to remain impermeable, our
societies internalize this history, so to speak,
and make it into the motor of their de-
velopment.

From: *Conversations with*
Claude Lévi-Strauss,
London,
1969.

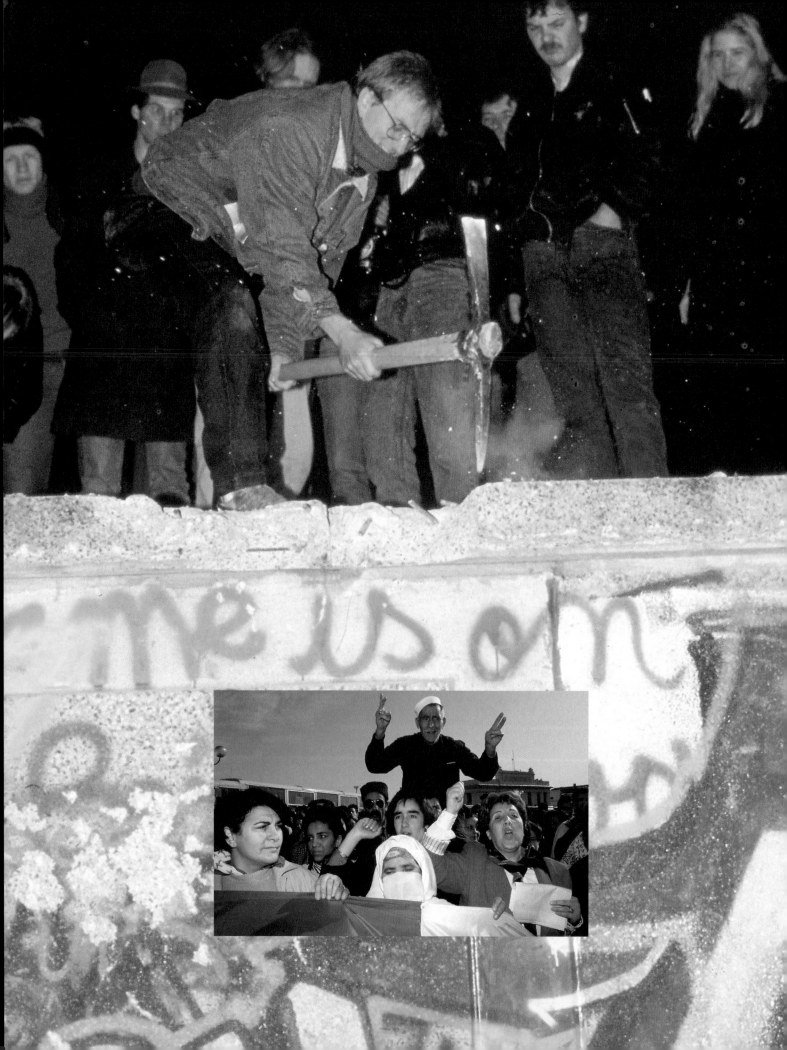

Center

Periphery
integrated
to the center

Annexed
periphery

Exploited
periphery

Abandoned
periphery

Semi-isolated zone
(periphery counting
on its own forces)

Backwater
(strategic territorial
reserve or pioneer
colonization space)

Principal links in the
global network

The global oligopoly

Centers and Peripheries in the World (1992). A Hierarchical Network

POL*E*TICS

cantz

Kassel is where documenta was born, forty-two years ago. At the time of its birth, it did not aspire to a continuation. Arnold Bode, documenta founder, had planned the art exhibition as a one-time event. Out of that unique event grew a tradition. Today, Kassel and documenta, the city and world art, are inseparably linked. This summer, another documenta, the tenth, will open its gates to the public. For one hundred days, Kassel will again be at the center of attention of international art, and a magnet for all those in search of factual information, critical debate, or an unadulterated experience of art, according to their individual liking. Each documenta has it own unmistakable profile, is unique and exceptional. At the same time, the historical context in which documenta X is taking place has something very special about it. It is not so much the birthday's round figure as the impending new millennium that calls for two particular points of view—back to the year 1945 and forward, beyond the 1990s, to the twenty-first century.

Over the decades, Kassel has amassed quite a lot of experience in the role of projection screen, backdrop, or available expanse for art. This "projection screen" never remains the same. At each documenta opening it places at art's disposal various urban, social, and political conditions on which to reflect—from the almost totally destroyed city after the Second World War, to the so-called peripheral city at the East German border, to the northern metropolis of the state of Hesse, at the heart both of united Germany and Europe. For the presentation of the exhibition, documenta and its organizers have, therefore, repeatedly found new images and new impulses in Kassel. For the first time in the history of this exhibition of world art, Kassel's old main station has been integrated into documenta. This year's *parcours* begins in Germany's first cultural railway station, thus linking Kassel's center city venues with the world exhibition, and old and new art venues with each other.

Five consecutive years have been devoted to the realization of documenta X. From June 21 to September 28, the individual items will be merged into a whole. The montage is a successful one. I would like to thank all those who attended the birth of documenta X, above all, the artistic director, Mme Catherine David.

Georg Lewandowski
Lord Mayor of the City of Kassel

Summary

Michel Foucault – Of Other Spaces

Contributions by artists in documenta X

Serge Daney – Before and After the Image

This book seeks to indicate a political context for the interpretation of artistic activities at the close of the twentieth century. It contains little art criticism as such, but instead engages in a confrontation of images and documents from the immediate postwar period to the present. The range of material treated here is not encyclopedic; it represents a polemical attempt to isolate specific strands of artistic production and political endeavor which can be taken as references in the contemporary debate over the evolution of our societies. Drawing from distinct yet interrelated territorial and linguistic domains, the book singles out complex cultural responses to the unifying processes of global modernity.

The material has been organized chronologically, around the articulations provided by four emblematic dates in contemporary history. **1945** marks the foundation of the postwar European democracies and opens the era of a polarized world system under American military and industrial hegemony in the West and Soviet hegemony in the East; the same period defines the political and economic conditions under which the majority

of the former colonies attain their national liberation. Aesthetically this period is characterized, in the European sphere, by attempts to overcome the state of psychic paralysis and mutism left by the trauma of the war, to reinvent a mobility of the image and of poetic language, and to rebuild a cultural memory in proportion to the tremendous achievements of architectural and economic reconstruction. Beginning in 1967, the utopian aspirations born in the postwar period and buoyed by the long wave of capitalist expansion enter overtly into crisis, generating social instability and extraordinary creative ferment. Links of solidarity are forged between forces of dissent in the developed countries and anti-imperialist struggles in the Third World; a multitude of minority discourses and practices come to the forefront of political and cultural life; artistic activity seeks to break through the norms of a planned economy and to discover an outside space from which to instigate a revolt of "society against the state." But these alternatives, broadly developed in and outside the West over a decade—and supported to varying degrees by Marxian thought and by the existence of real ideological, military, and economic counterforces in the Soviet Union and China—reach their limits in 1978. At this point the restructuring or "flexibilization" of global capitalism is already well underway, along with the erosion of the social gains achieved in specific national contexts under the broad paradigm of Fordist industrial production. The phenomenon of dissidence in the politically stifled communist societies serves as a pretext for an ideological campaign bent on eliminating an oppositional left which has been weakened by its own internal contradictions. Radical positions yield to postures of ambiguity, opening new possibilities of psychic, social, and historical integration in some instances, while concealing dangerous regressions in others. The end of "real communism" in 1989, with German reunification and Soviet disintegration, is greeted by media triumphalism and a new celebration of the postmodern commodity aesthetic; but these ideologies cannot veil the extreme uncertainty of the present, dominated by the expansion of unbridled capitalism, the reassertion of neocolonial relations between the economic centers and a fractured multitude of "peripheries," the fading of the nation-state as an effective structure for the expression of popular sovereignty, and the emergence of identity groups as vectors of consensus and conflict across the world.

To evoke this vast narrative of postwar history and to suggest the complex relations between singular artworks and sociopolitical situations which are inextricably "local" and "global," a montage technique has been adopted, mixing texts and images from the archives of recent world history with original contributions conceived especially for this book. Literature and journalism are interspersed; artworks are reproduced alongside documentary photography; critical commentary focuses on particular historical, philosophical, or social issues. Extended sequences of images by artists included in documenta X mark out the turning-points of 1967 and 1978, and original artistic contributions bring all this material back home to the present.

Several "red threads" reappear as guiding themes through the historical labyrinth of the montage. One is a focus on architecture and urbanism, as the most immediately visible and politically controversial intersection of art and politics; another is cinema, arguably the most collectively oriented and widely disseminated art of the twentieth century; a third concerns recent interpretations of *Antigone*, the archetypal political drama of the Western tradition.

The effects of juxtaposition created by the montage technique upset the strict divisions between work, document, and commentary, creating a multifaceted, polyphonic structure. Yet this structure is undeniably oriented, and crystallizes in a number of key questions. These are developed at the end of the book in essays and interviews which directly address current problems.

This book is necessarily incomplete, and necessarily biased by the subjectivity of those who contributed to it. Even more, it is internally fissured by the attitudes of utopian or critical intransigence which characterize the relations of art to the real.

The Editors

documenta

Like democracy, information is not a right but a practice, not a dream but a passion. It's one thing to blame those "in the business" for doing it wrong, but another to understand that it *also* depends on us. If the visual keeps us from seeing (because it prefers that we decode, that we decipher, that we "read"), the image always challenges us to carry out a montage with others, with *some other*. Because in the image, as in democracy, there is "free play," unfinished pieces, gaps, openings. Daney

The word *reprendre*—strangely difficult to translate—I intend as an image of the contemporary activity of African art. I mean it first in the sense of taking up an interrupted tradition, not out of a desire for purity, which would testify only to the imaginations of dead ancestors, but in a way that reflects the conditions of today. Second, *reprendre* suggests a methodical assessment, the artist's labor beginning, in effect, with an evaluation of the tools, means, and projects of an art within a social context transformed by colonialism and by later currents, influences, and fashions from abroad. Finally, *reprendre* implies a pause, a meditation, a query on the meaning of the two preceding exercises. Mudimbe

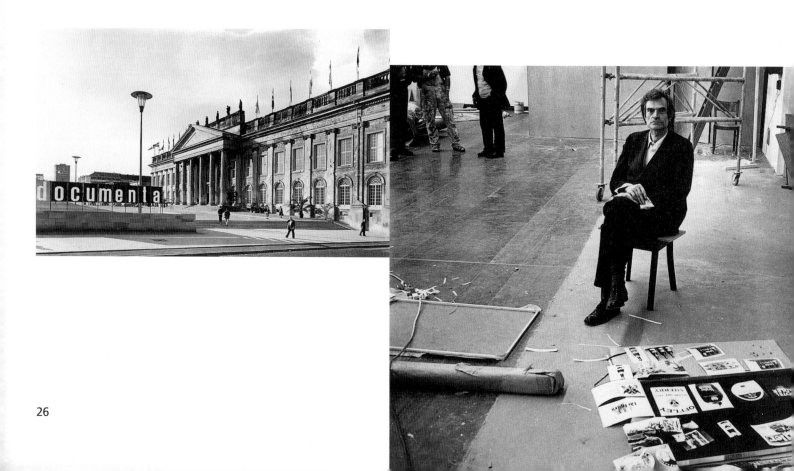

History

To shake up the structures of the imaginary, to record the plurality of voices and experiences, to measure the fragility of scales of values—this is a hazardous undertaking. It can be deadly. It sweeps away the belief in a single, sovereign and linear history developing in a uniform, irreversible pattern. The real is contradictory, incomplete, fragmented and heterogeneous—fractal. In most cases it is refractory to traditional categories of knowledge and all enterprises of sacralization past or present, even those concerning the Holocaust.

This thinking-through of chaos, of contradiction and ambivalence, is all the more difficult in that we rely on a conception of time, on a way of relating and interpreting the past that are still based on the comforting illusion of an underlying order. Revelation, infrastructure, ultimate meaning, function, structure, reason, the eternal recurrence of commemorations. Tirelessly, historical knowledge claims to "rebuild," always through words, a reality that is held to be not only plausible but objective, authentic and singular, that needs only to be slid into preassembled frames: economy, society, civilization, to use the hallowed formula of the Annales School. To this is now added the factitious calendar of commemorations (1989, 1992, 2000) which ends up imparting its own rhythm to the production of history with its calls for impossible reassessments. Gruzinski

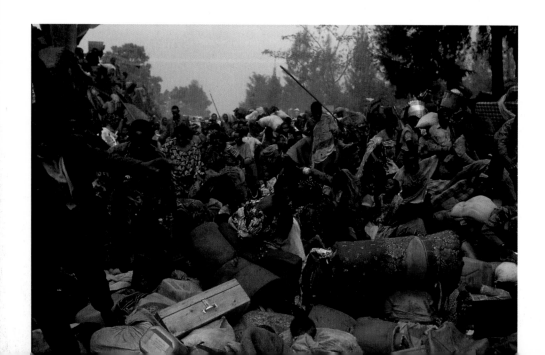

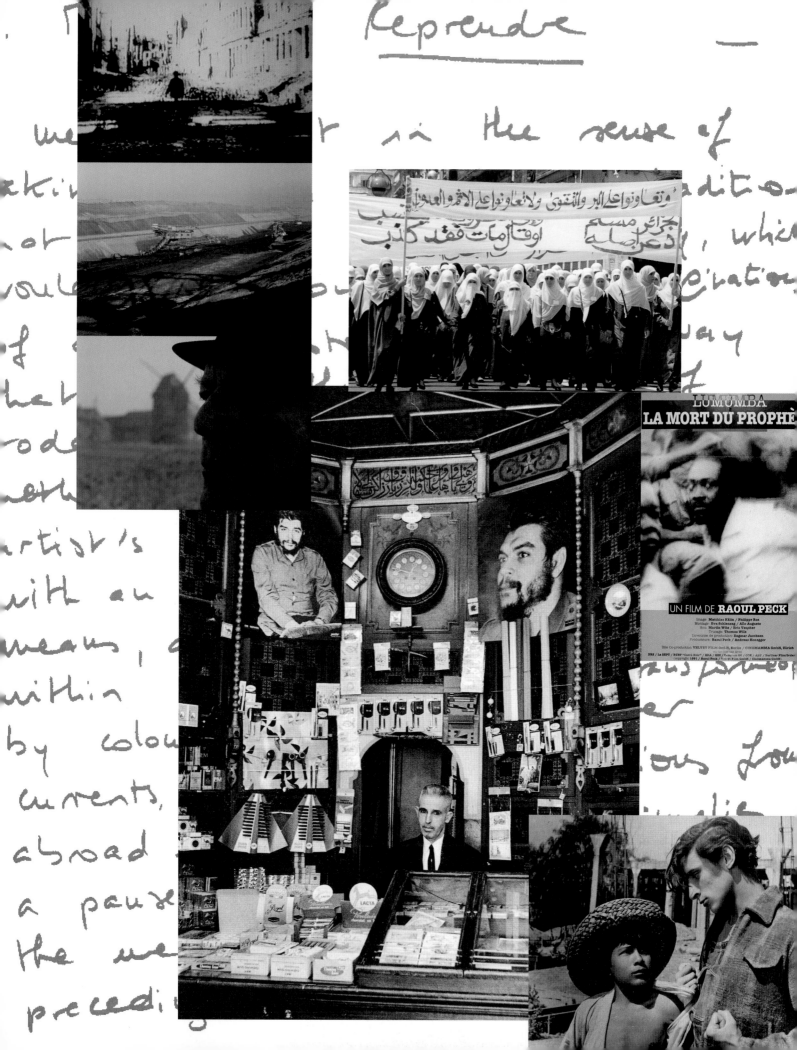

Reprendre

in the sense of

LUMUMBA
LA MORT DU PROPHÈ

UN FILM DE **RAOUL PECK**

Ailleurs

Corée

Japon

Chine

U.

Fran

R

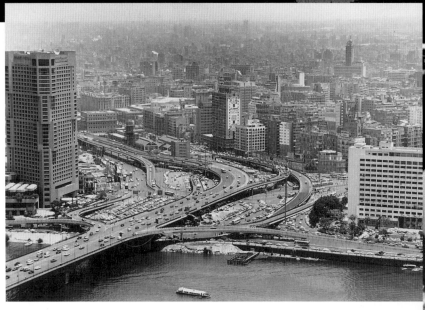

tus - its *vitality is guaranteed by the*
DIAGRAM The COED represents the B
bubbles are connected - usually by PO
understood as a coming together to s
TRIFUGAL COEXISTENCE of divergent
its contents curdle? **A-SYMMETRY** Al
inequalities that define the COED. VIS
hybridization of Confucianism. Commu
overabundance of VISIONARY project
i.e. They aim for *difference* more th
between China's recent communist his
Realism is the Stalinist doctrine that su
a final condition of realized Utopia, rat
the sacrifices on the road toward its im
taneously deferred and consummed.

Citizenship and nationality have a single, indissociable institutional base. They are organized as a function of each other within an ensemble of institutions, of rights and obligations, some operating on an everyday level, others more general and abstract. This tissue of obligations includes signs of recognition, symbols, places of memory like the Pantheon in Paris (which is a major symbol of citizenship and nationality, particularly characteristic of the French tradition). Now, the thing that appears so strikingly clear is the following: this tightly knit historical solidarity of citizenship and nationality has become problematic, such that each of our national intellectual traditions has been obliged to ask why and to what ends these two notions have been so closely identified. The question then arises as to how we might try to anticipate their future evolution. There are catastrophic visions resting on the postulate that the two notions cannot be separated, which means that the crisis of nationality is also a crisis of citizenship. There are more subtly differentiated visions which inquire first into politics and its possible evolution: what it has been and what it could be in the globalized world. Balibar

What I call postdemocracy is a pseudodemocracy that pretends it can do without a subject. It's the discourse telling us that "the people," "the proletarian," in short, all the polemical subjects, are phantoms of the past, and that democracy only functions well when it is emptied of any subject and is simply the autoregulation of a

ion of its imperfections. BUBBLE
as blueprint if not manifesto. The
S - but not *related*. The city is not
ests, but as a new form of CEN-
ed to be MELTING POTS - what if
restore, maintain or intensify the
RISTIC Possibly as a result of the
the Pearl River Delta reveals
lly totally resist the FUTURISTIC.
REALISM Is there a connection
idolatry of the Market? Socialist
ld depict, in the most realistic way -
e imperfections of the present, or
brilliant formula for desire simul-
val between Market promise and

society at a certain stage of the development of the productive forces. This is the practice that reduces the people to the sum of all parts of the population, to easily namable interest and opinion groups whose balance can be guaranteed by the state, itself posed as the simple local representative of a kind of imaginary world government—in short, the total identification of democracy and capitalism. Rancière

I think that to an extent the political has always been a field of language. That's not necessarily a rupture. But what you're talking about, the political and the poetic, I would want to understand it precisely as the relationship between the calculus of rights and the mysterious, open terrain of learning to respond to the other in such a way that one calls forth a response. The first is a calculus, the political is a calculus, and we must never forget that calculus. This is why class must remain. But one must make it play, and when one makes it play then the e comes in. That's when you loosen not just rights, but responsibility in this very peculiar sense: attending to the other in such a way that you call forth a response. To be able to do that is what I'm calling the poetic for the moment, because that brings in another impossible dimension, the necessary dimension of the political. That, for me today, is the most important thing. This is why I can talk about a suspension of the analytical—not a throwing away of the analytical, but another way of learning dialogue. Spivak

It is precisely the combination of the spatial dispersal of numerous economic activities and telematic global integration which has contributed to a strategic role for major cities in the current phase of the world economy. Beyond their sometimes long history as centers for world trade and banking, these cities now function as command points in the organization of the world economy; as key locations and marketplaces for the leading industries of this period (finance and specialized services for firms); and as sites for the production of innovations in those industries. These cities have come to concentrate such vast resources and the leading industries have exercised such massive influence on the economic and social order of these cities that the possibility of a new type of city arises. Sassen

One can indeed speak of a "siege" with respect to these events, a new kind of "state of siege": no longer so much the encircling of the space of the city by the troops, but *time under a state of siege*, the real time of public information. No longer the habitual censorship, the forbidden information, the secrets of state, but REPLAY, DELAY, a belated lighting of the living light of the facts.

"War in real time" finally proved Louis-Ferdinand Céline right when he declared, disillusioned, at the end of his life: "For the moment only the facts count, but not for long."

That moment has passed. Here and there, in China and elsewhere in the world, the facts are defeated by the interactive effects of telecommunication. TELETOPIC reality wins out over the TOPIC reality of the event.

FILMED AT ODO-EKU,
LAGOS, BENIN CITY
NIGERIA
1992 (STILLS)
and 1994

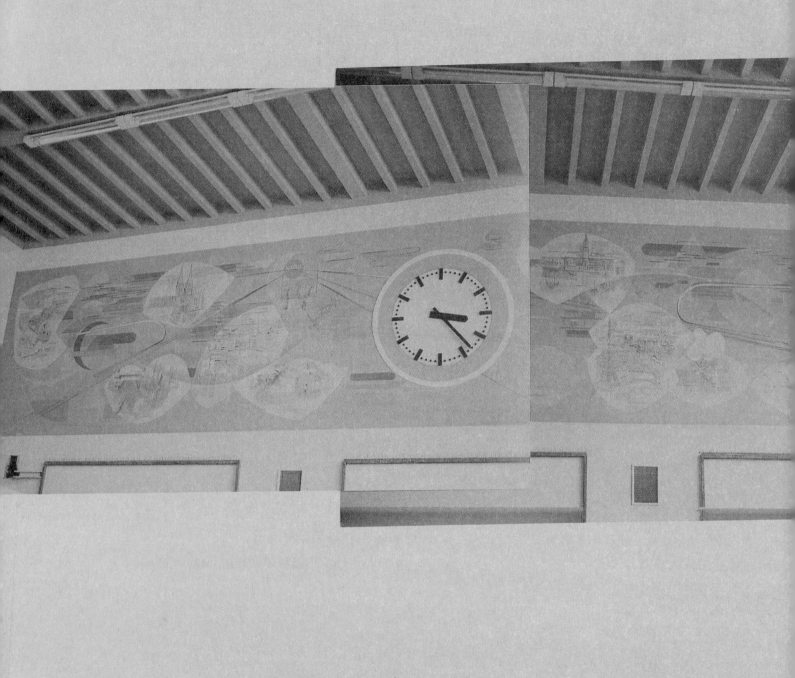

1945

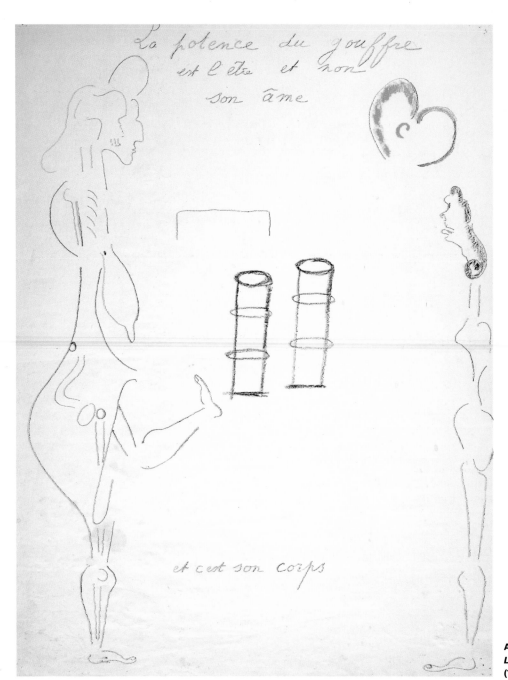

La potence du gouffre
et l'être et non
son âme

et c'est son corps

Wladyslaw Strzeminski
To My Friends the Jews, 1945

Antonin Artaud
La potence du gouffre
(The Chasm's Gibbet), 1946

Jean-François Chevrier
The Spiral: Artaud's Return to Poetry

Artaud wrote to Paulhan in February 1945: "I have read and reread 'The Theater and the Plague.' I think it has a tone and the secret of a tone that I must rediscover at all costs, beyond the horrible trials my consciousness has undergone, because this is the secret of myself and of all I sought during my correspondence with Jacques Rivière; it leaps out especially in this text and in certain other passages of *The Theater and its Double* (the description of the painting by Lucas de Leyde, of Brueghel the Elder's *Dulle Griet*, of the Balinese Theater, etc.)."

The correspondence with Rivière dates from the outset of Artaud's literary career. He reflected back on it several times, as a kind of personal, poetic origin. Witness this 1937 letter to Paulhan, who had replaced Rivière as director of the *Nouvelle Revue Française*: "Remember. The correspondence with Rivière appeared with 3 stars and of everything I've written it may be the only thing that lasts. After the passage of 13 years it seems I have come back to the same point, but the path I took was a spiral: it has led me higher" (*Œuvres Complètes* vol. VII, p. 226).

All Artaud's attempts to *realize* poetry in space (particularly in social space) led to failure, whether in cinema, in the theater, or even in his travels (after Mexico came Ireland, and upon return from Ireland, confinement).

In 1926, in a letter to Leiris, he declared his intention to write "no more poems" (O.C. IV, p. 131). In 1933 he wrote a manifesto included in *The Theater and its Double*, entitled "Enough Masterpieces": "Our literary admiration for Rimbaud, Jarry, Lautréamont and a few others has driven two men to suicide, but is reduced for all the rest to chatter in cafés. It belongs to the idea of literary poetry, detached art, neutral mental activity, which does nothing and produces nothing; and I observe that individual poetry, involving only the person who writes it as he writes it, reached its most despicable height at the moment when theater was most scorned by poets who never had a sense for direct mass action, effectiveness, or danger" (O.C. IV, p. 93).

But in 1946—and in the very title of the poem, as Paul Thévin has shown—"Le Retour d'Artaud le Mômo" manifests Artaud's return to poetry. This return is of considerable importance, because it marks the exit from Rodez, the reintegration of thought into its history, its genealogy. As Derrida remarks: "Let's face it: Artaud is the first to have sought to regroup all the vast family of the mad geniuses in a martyrological tree. He did it in *Van Gogh, le suicidé de la société* (1947) . . ."[1] Here is the key: in this exit from the asylum after the war (which Artaud experienced as confinement, as a blocked present). . . .

How to write in this state of war, when the real war withdraws every reason to write? The confined man is outside the fray. Outside the fray is the place of the confined man, walled inside madness, in the indecipherable echo of battle. An inevitable exclusion, when nothing more could hold Artaud inside a community which was in the midst of living out before his very eyes the destructive violence to which he felt himself called, for the needs of that community.

He had written: "The social duty of art is to provide an outlet for the anguish of its time. The artist who has not held the heart of his time in the depths of his own heart, the artist who ignores the fact that he is a *scapegoat*, that his duty is to magnetize, to attract, to pull down upon his shoulders the errant frenzies of his time and to discharge his era of its psychological afflictions, that man is no artist" ("L'Anarchie sociale de l'art," O.C. VIII, p. 286).

To the very end of his life, Artaud did not cease to imagine himself involved in a war, given to battle, destined to lead an incessant struggle to remake life in his own body: "Only perpetual war explains a peace which is but passing," he writes in *Van Gogh*. War is "a religious affair," involving the *social body*, to the extent that for an individual subject, in the unconscious and no longer in historical reality, war designates a sexual imagination relating to his or her own origin—and to the extent that *religion* is precisely what deals with sexuality and the question of the origin on the scale of the collectivity (and in the dimension of prehistory).

"You saw with your own eyes that I am here at the center of a fearful battle, where heaven and hell do not cease to clash at every hour of the day and night; for as you have long felt in your heart and in your soul, we are in a crucial period of the world's history . . ." (Letter to Frédéric Delanglade, March 29, 1943, O.C. X, p. 21).

The cross and its bearer are at the center of the battle, at the point of confrontation between the contrary forces of Good and Evil, Life and Death, Masculine and Feminine. It was in this sense that Artaud lived the war as "a crucial period of the world's history". . . .

The Christ figure perfectly realizes the sacrificial vocation of the poet; and if at the end of his life Artaud abjured the Christian faith and baptism, still he forgot nothing of what he encountered in the legend of the Gospels. I already noted the substitution of Nerval for Christ in the letters from Rodez. The legend multiplies, divides into a continuous chain of historical incarnations, of which Christ reviled on Golgotha is one of the most distant, the one that opens Christian history. A few benchmarks for the book *Suppôts et Supplications* can be identified in the correspondence: the letter to Henri Parisot on December 6, 1945, to Henri Thomas on March 15, 1946, to Colette Thomas on April 3, 1946. For example:

"Will you believe me, Henri Thomas, if I tell you that I am not of this world, that I am not like other men born of a father and mother, that I remember the infinite sequence of my lives before my so-called birth in Marseilles on September 4, 1895, on 4, rue du Jardin des Plantes, and that the elsewhere whence I come is not heaven but something like the hell of earth in perpetuity? Five thousand years ago I walked in China with a cane attributed in history to one named Lao-Tsu, but two thousand years ago I was in Judea . . ."

Each time, Artaud produces his double death, produced in history as death, assassinated many times over many centuries. . . .

Never for an instant does he forget the letters to Rivière. Particularly when he writes to Peter Watson: "I repeat to you, I have never been able to live, think, sleep, talk, eat, or write, and I have never written but to say that I have never done a thing, can do nothing, and that while doing something, in reality do nothing. All my work has only been built and can only be built on this nothingness" (O.C. XII, p. 236).

What had still been a claim for thought at the time of the correspondence with Rivière becomes the affirmation of a body outside thought, upon the void that constitutes it. Artaud wrote to Jacques Rivière: "The few things I have presented to you constitute shreds that I have been able to regain from total nothingness." *Suppôts et Supplications* takes up these statements from the correspondence in a positive sense, all the way to the formula of the "Fragmentations" in the first section. The importance of the fragmentary writing is the relation it maintains with absence, with nothingness. Speaking of one who would demand the recognition of his thought, and thereby "exist," Artaud asked Rivière: "Shall he be condemned to nothingness on the pretext that he can provide only fragments of himself?"

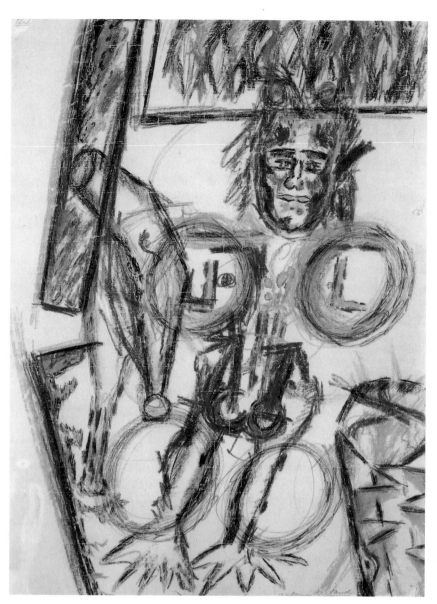

Antonin Artaud
L'inca **(The Inca), 1946**

In the late texts there is an affirmation of the negative. Poetry in the letters to Rivière is the thought of destruction, in the wake of Baudelaire and Mallarmé. But no more than Baudelaire, Artaud did not renounce the writing of books: just as *Les Fleurs du Mal* form an exceptionally coherent collection of poems, so *Suppôts et Supplications* is a "book," with its powerful construction.

In the final years Artaud's writing is made up of phrases which are poetic because they are musical, sonorous, constituted of sounds, made up of sounds as much as of sense, where sense stems from the use of a sound. A musician, Boulez, once said: "In Artaud's writing I rediscover the fundamental concerns of modern music: seeing him and hearing him read his own texts, accompanied by cries, noises, and rhythms, showed us how to carry out a fusion of sound and word, how to make the phoneme burst forth when the word can stand no more, in short, how to organize delirium."[2]

Poetry finds its principle not in the fullness of already created forms, but in the void, where it is "remade." The void of meaning, hammered sound: "he who sings needs no problem and has no other solution to present than the grace of his senseless syllables" (*O.C.* XII, p. 181).

Against "the bad unconscious of everyone," Artaud's writing, as Rosolato has stressed, is a continuous *expulsion*, an expulsion of everything that is not the poetic self, of everything that is not "sempiternally" repeated within the very instant: the energy of poetry. In this sense, poetry is a violently hygienic activity. Expulsion outside the phrase, outside the word (cf. Boulez), outside the page, outside the book, to the very extent that all this is taken rigorously into account, worked over. This is the rigor of Artaud's writing, violent in proportion to the culture it unthinks, cultivated in proportion to the violence which it expends to destroy the frozen forms of culture. The necessity is to expel, to find the outside, the outside of form, to push it back "with a series of marked strikes" (as one reads in "Artaud le Mômo, Dossier"). There is a failure at birth, the consciousness of "the lie of being." What *is* must be destroyed.

1. Jacques Derrida, *L'écriture et la différence* (Paris: Le Seuil, 1967), p. 274.
2. Quoted by Alain Varrnaux in *Antonin Artaud et le théâtre* (Paris: 10/18, 1970).
From: "L'usage de la poésie," in *Cahiers critiques de la littérature* 1-2, 1979.

Primo Levi

One cannot hear the music well from Ka-Be. The beating of the big drums and the cymbals reach us continuously and monotonously, but on this weft the musical phrases weave a pattern only intermittently, according to the caprices of the wind. We all look at each other from our beds, because we all feel that this music is infernal.

The tunes are few, a dozen, the same ones every day, morning and evening; marches and popular songs dear to every German. They lie engraven on our minds and will be the last thing in Lager that we shall forget: they are the voice of the Lager, the perceptible expression of its geometrical madness, of the resolution of others to annihilate us first as men in order to kill us more slowly afterwards.

When this music plays we know that our comrades, out in the fog, are marching like automatons; their souls are dead and the music drives them, like the wind drives dead leaves, and takes the place of their wills. There is no longer any will: every beat of the drum becomes a step, a reflected contraction of exhausted muscles. The Germans have succeeded in this. They are ten thousand and they are a single grey machine; they are exactly determined; they do not think and they do not desire, they walk. . . .

We know where we come from; the memories of the world outside crowd our sleeping and our waking hours, we become aware, with amazement, that we have forgotten nothing, every memory evoked rises in front of us painfully clear.

But where we are going we do not know. Will we perhaps be able to survive the illnesses and escape the selections, perhaps even resist the work and hunger which wear us out—but then, afterwards? Here, momentarily far away from the curses and the blows, we can re-enter into ourselves and meditate, and then it becomes clear that we will not return. We travelled here in the sealed wagons; we saw our women and our children leave towards nothingness; we, transformed into slaves, have marched a hundred times backwards and forwards to our silent labours, killed in our spirit long before our anonymous death. No one must leave here and so carry to the world, together with the sign impressed on his skin, the evil tidings of what man's presumption made of man in Auschwitz. . . .

Now everyone is busy scraping the bottom of his bowl with his spoon so as not to waste the last drops of the soup; a confused, metallic clatter, signifying the end of the day. Silence slowly prevails and then, from my bunk on the top row, I see and hear old Kuhn praying aloud, with his beret on his head, swaying backwards and forwards violently. Kuhn is thanking God because he has not been chosen.

Kuhn is out of his senses. Does he not see Beppo the Greek in the bunk next to him, Beppo who is twenty years old and is going to the gas chamber the day after tomorrow and knows it and lies there looking fixedly at the light without saying anything and without even thinking any more? Can Kuhn fail to realize that next time it will be his turn? Does Kuhn not understand that what has happened today is an abomination, which no propitiatory prayer, no pardon, no expiation by the guilty, which nothing at all in the power of man can ever clean again.

If I was God, I would spit at Kuhn's prayer.

From: *Survival in Ausschwitz* (1958), New York: Collier, 1961.

Stig Dagerman

One day in the Ruhr district—it had been raining for quite some time and for two days the bakers had had no bread—I met a young German writer, one of those who had made their debut during the war but had not personally lost the war, since they had intellectual emergency exits at their disposal. He had succeeded in renting an elegant, chalet-style villa in the middle of a wood, so that a couple of kilometers of flaming red autumnal trees separated him from that most ferocious hardship which prevailed among the ruins in the Ruhr district. What an odd feeling it is to leave one of the Ruhr mines (where a despairing mine worker, bloodshot eyes in a black face, had removed his dilapidated shoes to demonstrate to me that he was not wearing socks inside them) only to find oneself at the center of an autumnal idyll, where even hunger and cold have become so cultivated that they assume an almost ritual character. The mere fact of entering a garden that has not been plundered gives rise to a strange feeling, similar to the feeling one gets on entering a room bursting with books, anything from Dante's to Strindberg's inferno, in this bookless Germany where a book is such a rarity that it is approached with reverence.

On this island in a sea of horror sits the young writer with the tired smile and the aristocratic name, smoking cigarettes which he got in exchange for books, and drinking tea that is almost as bitter as the autumn outside. What a remarkable way of life. That outside world full of hungry mine workers, gray tenement blocks with demolished fronts, and gray cellar dwellers whose camp beds stand in feet of water whenever it rains as it is raining now, that world is not unknown here, but it is not accepted, is kept at a distance, as befits something unseemly. . . .

In 1995 I was the same age as my father in 1945, when, as a war correspondent in Europe, he witnessed the final battles and the liberation of the concentration camps. I retraced my father's steps. photographing the places he had described. I wanted to see how the memory of the war was inscribed in the landscape and to compare my experience of today's Europe to his experience fifty years ago.

War Story presents my photographs alongside my father's original texts.

5

And thus, in mid-afternoon, we arrived at a road sign: Teresin. Theresienstadt.

The camp was not difficult to find, for the town itself was the camp.

We had heard that Theresienstadt was not like other camps; it had been a Czech village, and the Germans had permitted the Jewish community of Czechoslovakia to purchase this village and turn it into a concentration camp for themselves. Within the camp, the Jews were supposed to administer their community, even printing a form of money. The camp had been reserved for German, Austrian, and Czech Jews—the "better" Jews.

Instead of wooden barracks, they were housed in the old town buildings which had been turned into tenements subdivided into minute one-room and half-room apartments. There were institutional buildings, there was a hospital and there was even a small park.

In the center of this walled village there were two buildings, guarded, their windows covered with barbed wire to prevent escape. Inside those buildings were the Jews who had arrived in the last weeks from Buchenwald and Dachau, the Jews who had survived the last trip in locked evacuation trains.

The Nazis, in a final act of cynicism, had shipped them here. The trains had arrived, such trains as I had seen at the gates of Dachau—boxcars bedded several deep with the corpses of those who had died en route, and the survivors on top of them. The survivors were typhus ridden and a danger to the clean community of Theresienstadt. They were therefore herded into two hastily vacated barracks and segregated there behind barbed wire.

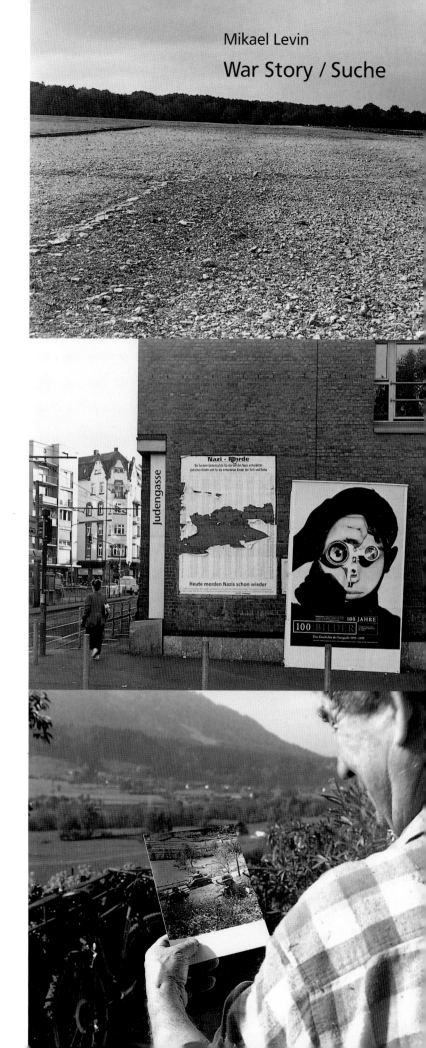

Mikael Levin

War Story / Suche

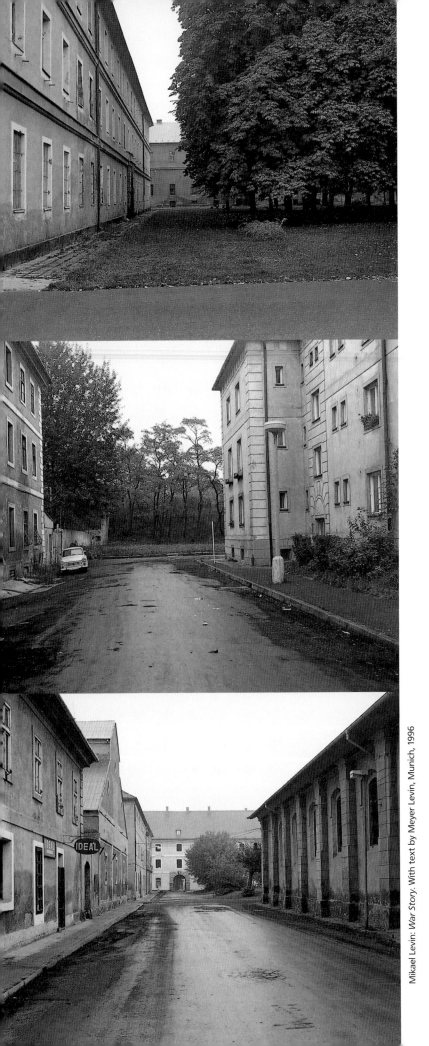

Mikael Levin: *War Story*. With text by Meyer Levin, Munich, 1996

Walking into those barracks was like walking again through lower Buchenwald. The survivors lay on the bare floors, or limped half dead through the slushy filthy corridors. There were a few common wahsrooms with troughs along the walls, and an inadequate dribble of water that nevertheless was not drained off, and on the floors of those washrooms they had retched out the last of their sick insides.

We came out of that depth of hell, and my guide led me to the Theresienstadt hospital. It was quiet, clean, excellently equipped, for the able practitioners of Prague and Vienna and Berlin had been permitted to bring their instruments and part of their medical machinery here, and the hospital was of course staffed with some of the finest physicians and surgeons of three countries. There were vacant beds in every ward.

We returned toward the administration building.

From: *War Story,* Munich, 1996.

Reality does not exist in this room in a villa on the Ruhr, even though in the course of the afternoon his wife, tears in her eyes, bursts in to tell us about a scene that had just taken place at the baker's. A man with a big stick had pushed his way past the shocked women in the queue and forcibly acquired the last loaf of bread for himself without anyone being able to prevent him. For a born classicist, however, this intermezzo is not excruciating enough to bring the woes of reality home to him. There we sit in the approaching darkness discussing the baroque era. The whole room is full of the baroque; lying on the table are thick German treatises on the baroque as an architectural style. He is in the process of writing a novel set in the baroque era and based on an unfinished work by Hoffmannsthal. At the moment he is reading up on baroque architecture so as to be able to construct an accurate reality for his characters, who are not going to be masked contemporaries with nutritional problems and thoughts of hunger, but instead genuine baroque figures of baroque flesh and blood, who think baroque thoughts and live a baroque life. The baroque—a none too timely life style for the Ruhr district which is experiencing its first food riots. But then what does timely mean in a poet's workshop where time only begins to exist when it is too late?

Where does suffering begin? He speaks of the joy, the beauty of suffering. Suffering is not dirty, suffering is not pathetic. No, suffering is sublime, because suffering makes people sublime.

From: *Reiseschilderung* (1947), Frankfurt, 1987.

Robert Antelme

April 30. Dachau lasted twelve years. When I was in high school the block where we are now was in existence, the electrified barbed wire fence also. For the first time since 1933 soldiers have entered here without harmful intent. They give out cigarettes and chocolate.

You can talk to the soldiers. They answer you. We don't have to take off our caps in front of them. They hold out a pack, and we help ourselves and smoke the cigarette. They don't ask any questions. We thank them for the cigarettes and the chocolate. They have seen the crematorium, and the dead bodies in the railroad cars. . . .

There isn't a great deal to be said to them, the soldiers may perhaps think. We liberated them. We're their strong right arms and their rifles. But nobody has anything to talk about. It is frightful. Yes, these Germans really are worse than barbarians. *"Frightful, yes, frightful!"** Yes, truly frightful.

When a soldier says something like that out loud, a few guys try to tell him about what it was like. The soldier listens at first, but then the guys go on and on, they talk and they talk, and pretty soon the soldier isn't listening anymore.

Some guys nod their heads and smile a faint smile as they look at the soldier, with the result that he may perhaps think they are a little disdainful of him. It's that they've glimpsed the enormous extent of the soldier's ignorance. And the prisoner's own experience is revealing itself to him in its entirety, for the first time, and as something almost separate from him. Face to face with the soldier, beyond the reserve he feels he also senses welling up within him a feeling that he is from now on going to be prey to a kind of infinite, untransmittable knowledge. . . .

All the stories that the guys are telling are true. But it requires considerable artfulness to get even a smidget of truth accepted, and in the telling of these stories there wants that artfulness which must vanquish necessary disbelief. In all this, everything must be believed, but the truth can be more tedious to listen to than some fabulation. Just a piece of the truth would be enough, one example, one idea; but nobody here has only one example to offer, and there're thousands of us. These soldiers are strolling about in a city where all the stories should be added end to end, and where nothing is negligible. But no listener has that vice. Most consciences are satisfied quickly enough, and need only a few words in order to reach a definitive opinion of the unknowable. So in the end they come and go in our midst without strain, become accustomed to this spectacle of thousands of dead and dying.

* In English in the original.

From: *The Human Race* (1945), Marlborough, Vermont: Marlborough Press, 1992.

Arno Schmidt

21. 3. 1946 : on British toilet paper.

Glassy yellow, the cracked moon lay there, it joggled me, below in the violet haze (and later on as well). . . .

"Oh God!" she said, elderly and lean. I shrugged all my shoulders: "I was assigned here by the commissioner" I said, as if it had been a personal encounter with handshakes all-round, and stared implacably at the stamp and insignia (in hoc signo vines; let's hope so). "Well alright; come in then, please," she capitulated.

"Writer–?" showing curiosity, and she grew visibly more at ease, assured of her social rank. "Yes, but . . ."; abruptly: she showed it to me:

The hole: behind, around the corner; on the church square. 8 by 10 feet; but first get rid of the junk; spades, hangers, tools, and I offered to do it myself (I needed hammer and pliers anyway, nails: in fact all cosa rara, right?)

"Pleased to meet you" he said perfunctorily. Late twenties and already completely bald; along with that offensive behavior characteristic of officers down through the ages. Damn goat. Words, words; stupid, stupid: moreover, one of those who already at age 20 neither smoke nor drink "for reasons of health" (and come Sunday, lots of Them, in bumpkin breeches and open shirts, are out for a hike of no less than 35 miles, and set great store by wooden bowls and peasant flowers in rustic vases); this one liked to dance; "passionately," as was his wont to phrase it: you've got some notion of passion!

"2 gals put up over there" he pointed with the chin of a jaded man who knows them inside and out: then thankgod class began again and he left; vamoose plenty pronto. School-children were singing now with sturdy voices; a weakling would have said: with clear; but I was fatally and precisely aware of how those brazen throats could bellow during recess. (Did not know then that Superintendent Schrader had banished their romps from the church square, and that instead they let off frenetic steam on the soccer field.) It may be, too, that people thought my fissured garments were an original stroke of genius; out of the blue, I was reminded of Dumont d'Urville and the journeys of the

Ingeborg Bachmann
Mortgaged Time

Harder days are coming.
The mortgaged time,
revocable at any hour,
takes shape on the horizon.
Soon you must lace up your shoe
and chase the hounds back to the marsh farms.
For the fish entrails
have grown cold in the wind.
The lupins' light burns dimly.
Your gaze gropes in the fog:
the mortgaged time,
revocable at any hour,
takes shape on the horizon.

Over there your love sinks in the sand.
It climbs around her waving hair,
it breaks into her words,
it commands her to be still,
it finds her mortal
and willing to part
after every embrace.

Don't look round.
Lace up your shoe.
Chase back the hounds.
Throw the fish in the sea.
Blow out the lupins!

Harder days are coming.

1952. From: *In the Storm of Roses*, Princeton: University Press, 1986.

Astrolabe. Marvelous illustrations. But this wasn't the time. I crossed over the tiny whitewashed antechamber: a water tap, dripping to declare itself in working order: that's good! i.e., not the dripping; but that there's water close by!)

I knocked: "Excuse me:—could you perhaps lend me a whisk broom and dustpan? And a mop bucket and rag: for half an hour—?"—A small, quiet girl, about 30, but a plain Jane, or just plain ugly, stood by the table (quite nicely furnished, by the way, even though it was just one room. But a large space; long, at least 25 feet!); she looked at me in quiet embarrassment: "Yes . . ." she said hesitantly: "—but how come . . ." and from the back, from where the beds probably stood behind the folding-screen, came a sharp, glossy voice: "Yes: how come?!—It's out of the question!—" She had more to say; but I had already closed the door: "Oh, I'm so sorry—" I added in an excess of courtesy: it was fine to be offended first thing; because afterward they would have certain obligations; which provided a solid basis for hitting them up later on. But for now, here I stood!

What do you call that: a chaise longue with no headrest or springs, and even the upholstery missing? The teacher-mother sold it to me, and a couple of boards that I sawed to a brusque fit and nailed to the wooden frame (nice and solid by the way). And still had some left over; if I cut up my belt, I can make a pair of wooden clogs out of them; brilliant idea. Bigtime farmers in the village, they say one of them has 28 head of cattle: his name is Apel (we'll just call him the Great Viscownt). Of course woodchips and ancient dirt were everywhere now; walls washed a pretty white; flagstone floor. Can't be locked up either; just an iron bolt and cramp: which means a padlock: okay, then not. Besides which "the gals" appeared to keep the front door locked at all times, the key was always stuck inside. Outside was a small handwritten sign, although under fancy cellophane (or transparite, so as not to offend Wolff & Co.); praise be the Mil. Gov.: you always know right off who lives there. Not a woman who can fudge on her age (like our Albertine Tode: quite an amazing feat, for

Fouqué himself never knew how old his wife was. Absolutely remarkable.). "Lore Peters, age 32, secretary." "Grete Meyer, factory worker": So without question the one with the big mouth was named Peters (or just the opposite: factory girls are succulently sassy and as worldly as truckers; no figuring it out now). I took the pencil stub from my pocket (what a treasure that had been in camp; and paper above all; I had scribbled on the scarce toilet paper and calculated sigma and tau) and appended: Name. Likewise 32. Below that, small for lack of room: professional writer: was as good as an introduction; for even now I was being discreetly observed through the coquettish casement curtains (windows in fancy aprons). Then I went across the church square for a whisk broom.

A round pond had lived in the sand-pit for 300 years. But a suspicious Frau Schrader threw me out as well: love thy neighbor as thyself: quod erat demonstrandum. I didn't go to Frau Bauer (my God: to the teacher!): I already had a reputation to lose. Off by itself stood the outhouse, proper and three-seated; attractive stone shed, clean quarters; apparently built for the schoolkids; plumbing worked; superb.

"Should I walk all the way to the village just for a whisk broom?!" (and not find one there, for sure!) So here I stood on the road again, freezing and spiteful.

From: *Brand's Heath* (1951), in *Nobodaddy's Children*, Normal, Ill.: Dalkey Archive Presse, 1995.

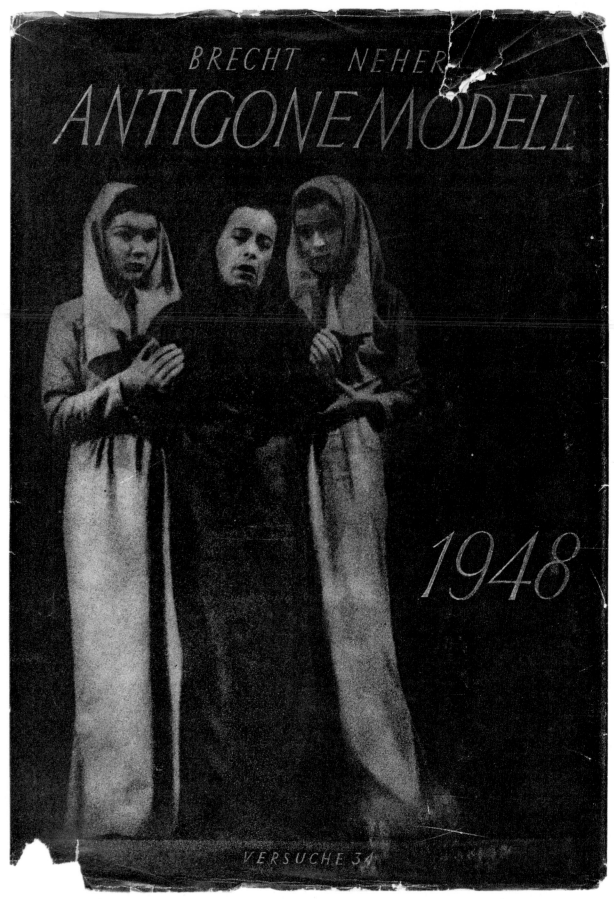

Antigone and attendants
Cover of the book: Bertolt Brecht, Caspar Neher, *Antigonemodell 1948. Versuche 34*. Berlin, 1949

Hans-Joachim Ruckhäberle

Since the year 1947, there has been a specifically German history of the drama Antigone. It begins with the adaptation by Bertolt Brecht and Caspar Neher, the *Antigone Model 1948*, based on the 1864 translation of the play by Hölderlin.

It would be false to assume, however, that the original *Antigone* was in any way rediscovered after 1945—or even Hölderlin's translation of it, for that matter. Between 1939 and 1944 there were eighteen productions of the play in Germany, generally distinguished by "the turn towards inwardness and the sacred" (H. Flashar) dominating the

political question as to German identity—that of the individual and of the nation—has come up again, as well as the question concerning the end of the utopia, while the aesthetic concern is with language and its relationship to action, action as such, Brecht's epic *Model* and its relationship to reality, all in all the issue of the perception of space (how do the spaces of the individuals connect, how do they separate?).

However diverse they are in detail, these *Antigones* are united by Hölderlin's text. Politically and with regard to their aesthetic consequences, they all make reference to the con-

German Antigone

reception of Hölderlin from the 1920s on. Heidegger also took an interest in *Antigone* (in *Einführung in die Metaphysik*), and Carl Orff began working on his archaic musical setting in the 1940s.

Only Anouilh's *Antigone*, performed in the occupied Paris of 1944, was conceived and understood as a work of resistance against the ruling authorities.

The specific postwar history of the Antigones presented after the *Model* was continued with the performance by the Living Theater, staged in Germany in 1967, the 1978-79 productions by Nel (Frankfurt am Main), Jeker (Stuttgart), Rudolph (Berlin), Wendt (Bremen), Schlöndorff's Antigone passage in his 1978 film *Deutschland im Herbst,* and finally the theater performance and film of 1991-92 by Straub/Huillet.

Each occasion is both political and aesthetic. In 1947 the political theme was the opposition against "bourgeois fascism and capitalism" and the aesthetic one was the new theatrical approach, the *Model*; in 1967, the emerging movement of extra-parliamentary opposition was the political motif, while the neo-avant-garde aesthetic sought to fuse life and art, to unite Brecht and Artaud; in the late seventies the political issue was the "German autumn," the Schleyer assassination, Mogadishu and the banishment of the dead members of the RAF (Rote Armee Fraktion) from society— the division of German society into an inside and an outside—while the aesthetic issue was the actualization of the antique material, read in the language of the "Jacobin" Hölderlin and not in that of Brecht. Bertaux regarded Hölderlin directly in a new way, as a politically conscious outsider, Foucault indirectly, as someone who escaped the "terror of normality." Since 1990, with the reunification, the

crete events of German contemporary history, which they consider well presented by the antique tragedy. To some extent they attempt to transcend the border between presentation and action (the Living Theater and Straub/Huillet).

One problem troubles all of them: Antigone's behavior, though rooted in a tradition of cult and ritual, is emphatically individual. How is this to be reconciled with the "socialist" and neo-avant-garde tendency "to dissolve the myth of the central bourgeois subject" (Buchloh)?

What they also have in common is the theme of "fratricidal war," a specifically German theme: the conflict between the two German states, but also the terrorism emerging within the society. The role of the individual, the individual freedom of conscience and action is investigated, as are the consequences of the splitting of private and social consciousness.

During the postwar decades, various aesthetic "models" were tested theatrically, although not the one by Brecht/ Neher, which never had an impact as a "model." The question was posed: what is the relationship between aesthetic and political processes? To what extent is theater appropriate as something political? The responses tended to be rather conventional.

Maybe that has something to do with the subject, Sophocles' *Antigone*. The classical historian Christian Meier sees the "new hero" type in Antigone: powerless, i.e., not really a danger to the authorities, but "a model of that independence of thought—standing alone, deviating from all others—which is responsible for bringing certain points of view, certain necessities to bear." An ideal case of citizenship, critical of the authorities and their decrees, but little suited as a revolutionary identification figure, and hardly apt to

embody utopian thought; more a figure of obstinate persistence than one of social fantasy.

Hegel and Hölderlin saw a kind of stalemate between Creon and Antigone: "In an artistic manner, the collision between the two highest ethical powers is represented by the absolute paragon of tragedy, Antigone," wrote Hegel. "Everything is word against word, mutual negation," wrote Hölderlin.

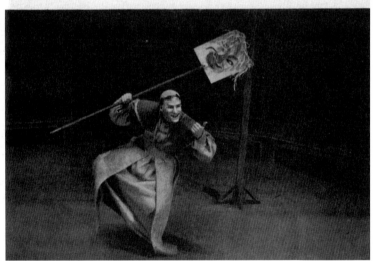

Antigonemodell, Chur 1948, third figure of Creon

Both figures—Antigone and Creon—cling to the established do's and don'ts; they talk to each other but do not hear each other. *Antigone* is not only the "absolute tragedy," it is the critique of the absolute. The critical viewpoint is achieved by Hamon, the son of Creon betrothed to Antigone, and the chorus: whoever desires the absolute and does not behave in an "urbane" or communicative manner turns against himself. This is the initial judgment of the chorus. Thus it is not without significance that Hamon raises his sword against Creon after Antigone has hanged herself. The other point of view is to be obliterated, not only the guilty party.

Neither Hamon nor the chorus played a particularly important role in the various performances, however, which repeatedly revolved around the individual against the state, resistance, and—more indirectly than directly—the refusal to go along with the division of public and private, regarded as characteristically bourgeois. The two are separated as though by a wall, the German theme of the inside and the outside.

Perhaps that is the explanation for Antigone's attraction: she is the "heroine" who, completely alone, without thinking twice, does what must be done, fully aware of the consequences. Once decided, forever decided, loyal to herself unto death. Classic German heroism.

Creon is also obstinate: he denies that in a city there should be "only talk, command, and obedience"—there must also be "listening and learning, consideration must be taken" (Christian Meier). Both of them, Antigone and Creon, behave "un-urbanely." Both use public space, the square in front of the palace, for purposes other than that intended: for purposes other than political communication. Public space does not serve to elucidate. The gods of the heavens and of Hades remain divided; the house and public space do not merge. Antigone steps forth from darkness and disappears into darkness; her movement is over the threshold of the palace onto the square and across the border of the city to the outside, where her brother's corpse lies and where she will neither be living nor dead: "Living, I descend into the wilderness of the dead." Hölderlin has an image for the movement of *Antigone*—the race, "similar to a competition between runners, in which he who is first to be out of breath and to collide with his opponent loses." Negt/Kluge compared the Grimms' fairy tale of the obstinate child to the obstinate Antigone. The fairy tale, perceived as the fundamental text of "German historical misery," of buried but unsolved contradictions, corresponds quite well with the plan to immure Antigone in darkness: not completely alive, not completely dead.

This history within the history of the *Antigones* differs from George Steiner's viewpoint in *Antigones: How the Antigone Legend Has Endured* (1984).

Steiner's history of the *Antigones* is a restorative one, a search for origin. His solution: back to the beginnings. His authority: Heidegger. His method: anthropologization and historicization, the belief that the present can be found in

the past. The "modernist movements of the Occident" appear to him to be characterized by "a hunger for 'beginnings,' for a return to the archaic, primarily Greek sources." This "hunger" is interpreted as the "will to return home, to fuse past and present."

As established in the *Antigones* and elaborated in the long essay on "real presence," Steiner bases his idea of origins on Heidegger: "He points out that the Greek spirit and

on the most extreme possibilities and limits." By referring back to original being, a violent, all-encompassing beginning, he either overlooks or evades the opposites that Sophocles juxtaposes. "The beginning is the most sinister and the most violent. What comes after is not development but a decrease of depth, a mere broadening" (*Einführung in die Metaphysik*).

Consider his translation: "Hochüberragend die Stätte,

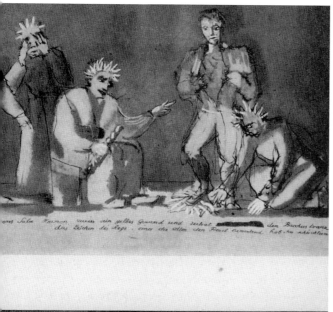

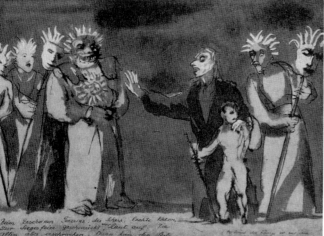

Antigonemodell, Chur 1948, sketches of the sets by Caspar Neher

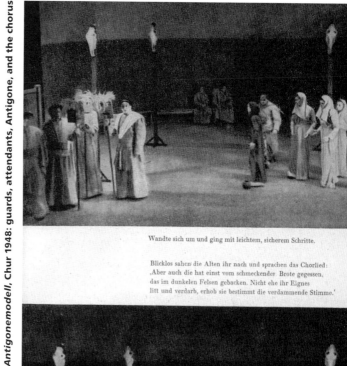

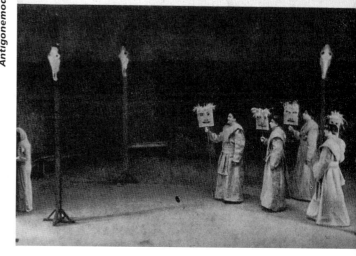

Wandte sich um und ging mit leichtem, sicherem Schritte.

Blicklos sahen die Alten ihr nach und sprachen das Chorlied: ‚Aber auch die hat einst vom schmeckender Brote gegessen, das im dunkelen Felsen gebacken. Nicht ehe ihr Eignes litt und verdarb, erhob sie bestimmt die verdammende Stimme.'

Antigonemodell, Chur 1948: guards, attendants, Antigone, and the chorus

the Greek language in its pre-Socratic phase are distinguished by a specific, unique closeness to the 'presence and truth of being.'" It is no coincidence that Heidegger develops his essential line of thought on that matter in the process of interpreting *Antigone*.

Heidegger interprets the first song of the chorus in his own translation as the poetic "design of humanness based

verlustig der Stätte/ ist er, dem immer das Unseiende seiend/ der Wagnis zugunsten." Literally: "Towering above the place, placeless/ is he, for whom non-being ever is/ all for audacity." The interpretation is characteristic.

Instead of the state or the city-state as the life-form of public space, Heidegger chooses *place*, the "place of history," where the individual is the "creator," the "doer," "without

city and place, solitary, sinister, with no way out in the midst of being in wholeness, with no statute or limit, with no structure or right, because *as* creators they must found all that first."

Quite different, though no less free, is Hölderlin's translation: "Hochstädtisch kommt, unstädtisch/ zu nichts er, wo das Schöne/ mit ihm ist und mit Frechheit." Literally: "Highly urbane, un-urbane/ he achieves nothing, where beauty/ is with him, and impudence."

Hölderlin's interpretation stems partially from an insufficient philological basis, but it is also obvious that he imbues *Antigone* with a particular belief: "The course of events in *Antigone* is like that of an uprising in which, to the extent that it is a patriotic cause, it is essential that everything seized and shaken by endless turnabout should feel the endless form in which it is shaken. For patriotic turnabout is the reversal of all types of imagination and all forms" ("Notes on *Antigone*").

Hölderlin turns contradictions in the behavior of different people into contradictions within a single person. The human being is not only "urbane" but also "un-urbane": "All-experienced, inexperienced, he achieves nothing." To be human is to violate the boundary between inside and outside, to redefine it at will. The "patriotic turnabout" occurs "when the entire shape of things changes and ever-enduring nature and necessity inclines toward another form, turning into wilderness or a completely new shape." Herein lies the primary attraction of Hölderlin's *Antigone* for contemporary theater, which conceives of itself as socially critical. Two "discoveries" were necessary for this relationship to come about: the recognition of the creative power of Hölderlin's translation—which his contemporaries regarded as a sign of mental confusion—and the "discovery" of the "republican," revolutionary Hölderlin.

"Because I am more destructible than many another, I must seek to gain more advantage from the things that affect me so destructively . . ." (Hölderlin)

Antigone Model 1948

Defenders of freedom:

"It is the loss of individual freedom in capitalism which often makes the intellectuals into raging defenders of the pure fiction of freedom." (Bertolt Brecht)

Defenders of the houses:

"Several women sat outside the white rope closing off the military zone. They were guarding their houses. The houses no longer have roofs or windows, often even the walls are gone, and almost everything in these houses has been scattered to the winds by high-explosive bombs, but there they sat, keeping a sad watch over their worldly possessions." (Martha Gellhorn, *Das deutsche Volk*, April 1945)

While he worked on *Antigone*, Brecht was still "outside"; the premiere took place in Switzerland, at the Stadttheater Chur, in February 1948. He had begun his return from emigration but was not yet in Germany. He was skeptical: he regarded fascism as a bourgeois phenomenon and therefore not so easy to escape; German theater appeared to him utterly corrupted, despite and because of its "sparkling technology." Thus it was time for a new theater, a theater capable of "showing reality" in an enjoyable way. "Now, how to go about making such a theater?"

"The difficulty about ruins is that the house is gone, but the site isn't there either. And the architect's plans, it seems, never get lost. Thus reconstruction allows the dens of iniquity and centers of disease to regenerate. . . . Yet the tricky thing about art is that however hopeless its affairs may seem, it has to conduct them with perfect ease." (Brecht/ Neher, *Antigone Model*)

Brecht developed *Antigone* as a political and aesthetic model. "For the present theatrical undertaking the Antigone drama was selected because with regard to content it had chances of attaining a certain contemporary relevance, and it presented formally interesting challenges." However, he did not trust the contemporary relevance of the material completely; he reworked it exhaustively on the basis of the Hölderlin text and added a prologue: "Berlin. April 1945. Daybreak." And political problems sprang up in the process. The connection to the present, which stood out clearly for him after his "thorough process of rationalization," was unfortunately turned in the wrong direction. "The great figure of resistance in the ancient drama does not represent the German resistance fighters, whose importance must necessarily be paramount for us." Thus, as had already been the case in Hölderlin's text, "the Antigone story then unrolls the whole chain of events objectively, on the unfamiliar level of the ruling powers." And the commentary on

that: "Have you shown how the individual should behave toward the state? – No, only how Antigone behaves toward the state of Creon and the Elders." Yet the "formal elements of epic style" provide an aesthetic charm "and constitute interesting aspects in themselves for our theater."

The "Model" thus refers to the place, the stage, the style of acting, and explicitly not to the dramaturgy. What is more, Caspar Neher, responsible for drawing Brecht's attention to the Hölderlin text, also had experience with the staging of *Antigone* (first in 1928 in Essen for the opera by Honegger with the text by Cocteau, then again in 1946 in Hamburg). He later designed the scenery for Carl Orff's *Antigonae* (Salzburg, 1949), a work sharply condemned by Brecht.

Brecht claimed "to have developed a most highly realistic popular legend out of the ideological haze." He supplied the fable with additional motivation and connected its parts logically. Furthermore he made the concluded war into a still progressing imperialistic war of conquest. His Creon needs the war to avert domestic uprisings. His Antigone takes a conscious political stance towards the "Führer" Creon, and his Polyneikes does not fall in a struggle with his brother, but is executed by Creon for desertion. Brecht was concerned with "the role of violence in the disintegration of supreme authority." But it didn't do any good; the "thorough processs of rationalization" (and on the whole Brecht carried out considerable changes, even rewriting parts of Hölderlin's text) hardly managed to rescue *Antigone* politically.

Brecht objected to the "moralistic interpretation" of his text. In his view, a "moral mission" was not appropriate for art anyway (*Arbeitsjournal*, April 10, 1948). And the "Antigone Model" became politically outmoded for the very reason that it was not completely free of moralizing aspects; Brecht himself never returned to it. Nevertheless, in 1989 the "Model" once again took on direct political relevance with regard to the dissolution of the German Democratic Republic. The Swiss Stadttheater Chur, where the premiere had taken place in 1948, presented its anniversary *Antigone* in the Deutsches Theater of East Berlin on October 9 and 10, 1989. The remark by the seer Tiresias, "The city is full of inner reluctance," directly matched the political situation. Creon, the "Führer" whom Brecht had placed in the vicinity of Hitler, was now equated with rigid socialist state authority and booed down by the audience.

Aesthetically, the "Model" was incorporated into the development of theater; of particular significance in this respect were the "gestural" aspect of the actors' physical movements, the style of speech and the related conception of place. "The actors . . . sit openly on the stage and only adopt the characters' established poses upon entering the (very brightly lit) action arena. Thus the audience does not have the feeling of being shifted to the showplace of action, but of being invited to witness the delivery of an antique poem, however much it may have been restored."

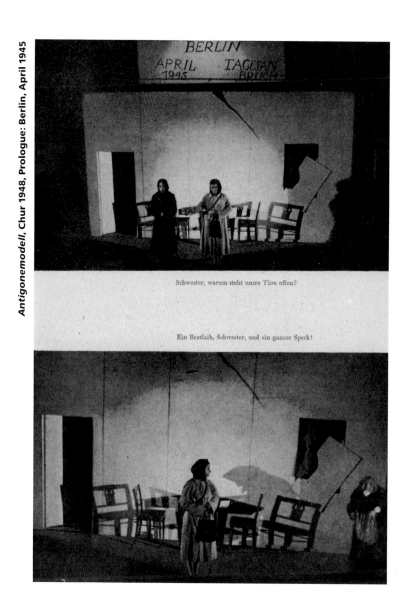

Antigonemodell, Chur 1948, Prologue: Berlin, April 1945

Hannah Arendt

The "German problem" as we hear about it today has been resurrected from the past, and if it is now presented simply as the problem of Germanic aggression it is because of the tender hopes for restoration of the status quo in Europe. To achieve this in the face of the civil war sweeping the continent it appeared necessary, first, to "restore" the meaning of the war to its nineteenth century sense of a purely national conflict, in which countries rather than movements, peoples rather than governments, suffer defeats and win victories.

Thus the literature on the "German problem" reads for the most part like a revised edition of the propaganda of the last war, which merely embellished the official viewpoint with the appropriate historical learning, and was actually neither better nor worse than its German

Approaches to the "German Problem"
Restoring the Old Europe

counterpart. After the armistice, the papers of the erudite gentlemen on both sides were allowed to pass into charitable oblivion. The only interesting aspect of this literature was the eagerness with which scholars and writers of international renown offered their services—not to save their countries as the risk of their lives but to serve their governments with a complete disregard for truth. The one difference between the propagandists of the two world wars is that this time quite a few of the former dispensers of German chauvinism have made themselves available to the Allied powers as "experts" on Germany and have lost through this switch not a bit of their zeal or subservience.

These experts on the German problem, however, are the only remnants of the last war. But while their adaptability, their willingness to serve, their fear of intellectual and moral responsibility remain constant, their political role has changed. During the First World War, a war not ideological in character, the strategies of political warfare had not yet been discovered, its propagandists were little more than morale-builders, arousing or expressing the national sense of the people. Perhaps they failed even in this task, if we are to judge by the fairly general contempt in which they were held by the fighting forces: but beyond it, they were surely quite unimportant. They

Roberto Rossellini, *Germania, anno zero* (Germany, Year Zero), 1947

had no voice in politics and they did not voice the policy of their respective governments.

Today, however, propaganda as such is no longer effective, especially if it is couched in nationalist and military rather than ideological or political terms. Hatred, for example, is conspicuously absent. The only propaganda result of the revival of the "German problem" is therefore negative: many who have learned to discount the atrocity stories of the last war simply refuse to believe what this time is a gruesome reality because it is presented in the old form of national propaganda. The talk of the "eternal Germany" and its eternal crimes serves only to cover Nazi Germany and its present crimes with a veil of scepticism. When in 1939—to take one instance—the French government took out of storage the slogans of the First World War and spread the bogey of Germany's "national character," the only visible effect was an incredulity about the terror of the Nazis. So it was all over Europe.

But if propaganda has lost much of its inspirational power, it has acquired a new political function. It has become a form of political warfare and is used to prepare public opinion for certain political steps. Thus the posing of the "German problem," by spreading the notion that the source of international conflict lies in the iniquities of Germany (or Japan), has the effect of masking the actual political issues. By identifying fascism with Germany's national character and history people are deluded into believing that the crushing of Germany is synonymous with the eradication of fascism. In this way it becomes possible to close one's eyes to the European crisis which has by no means been overcome and which made possible the German conquest of the continent (with the aid of quislings and fifth columnists). Thus all attempts to identify Hitler with German history can only lead to the gratuitous bestowal upon Hitlerism of national respectability and the sanction of a national tradition.

Whether you compare Hitler with Napoleon, as English propaganda did at times, or with Bismarck, in either case you exonerate Hitler and make free with the historical reputations of Napoleon or Bismarck. Napoleon, when all is said, still lives in the memory of Europe as the leader of armies moved by the image, however distorted, of the French Revolution; Bismark was neither better nor worse than most of Europe's national statesmen who played the game of power politics for the sake of the na-

tion but whose aims were clearly defined and clearly limited. Though he tried to expand some of Germany's frontiers, Bismarck did not dream of annihilating any of the rival nations. He agreed reluctantly to the incorporation of Lorraine into the Reich because of Moltke's "strategical reasons"; but he did not want foreign splinters within the German frontiers and had not the slightest ambition to rule foreign peoples as subject races.

What is true of German political history is even more true of the spiritual roots attributed to Nazism. Nazism owes nothing to any part of the Western tradition, be it German or not, Catholic or Protestant, Christian, Greek or Roman. Whether we like Thomas Aquinas or Machiavelli or Luther or Kant or Hegel or Nietzsche—the list may be prolonged indefinitely as even a cursory glance at the literature of the "German problem" will reveal— they have not the least responsibility for what is happening in the extermination camps. Ideologically speaking, Nazism begins with no traditional basis at all, and it would be better to realize the danger of this radical negation of any tradition, which was the main feature of Nazism from the beginning (though not of Fascism in its first Italian stages). It was after all the Nazis themselves who were the first to surround their utter emptiness with the smoke-screen of learned interpretations. Most of the philosophers at present slandered by the overzealous experts of the "German problem" have long been claimed by the Nazis as their own—not because the Nazis cared about respectability but simply because they realized that there is no better hiding-place than the great playground of history and no better bodyguard than the children of that playground, the easily employed and easily deluded "experts."

The very monstrosities of the Nazi regime should have warned us that we are dealing here with something inexplicable even by reference to the worst periods of history. For never, neither in ancient nor medieval or modern history, did destruction become a well-formulated program or its execution a highly organized, bureaucratized and systematized process. It is true that militarism has a relation to the efficiency of the Nazi war machine and that imperialism has much to do with its ideology. But to approach Nazism you have to empty militarism of all its inherited warrior's virtues and imperialism of all its inherent dreams of empire-building, such as the "white man's burden." In other words, one may easi-

55

Morning in Berlin. Edmund. The entire film is constructed for the final sequences where Edmund, having just killed his father, plays at those immemorial games whereby children make the streets of any city their own: balancing along the edge of the sidewalk or the rim of a public fountain, hopping from strip to strip, giving a passing kick to some other kids' ball—or whatever they're using as a ball—salvaging a fantasy gun to fire on squares of light, sliding down chutes meant for construction materials, walking, then running, pausing to think about what we'll never know, then striding off decisively toward some unglimpsed destination . . . Beautiful or monstrous, the carefree world of childhood? Is it enough to understand this contrast in the way the text of the final credits suggests: as the power of ideologies **Jacques Rancière** # Falling Bodies
to pervert childhood innocence? Is Edmund led to parricide by the teaching of his former Nazi schoolmaster on the necessary elimination of the weak? Everything the film shows is an exact denial of this law of causality. What unsettles us in Edmund's act is beyond any fright or precaution over the moral effects of the troubled times and their ideological indoctrination. . . . Edmund is pushed into action by his dizzying discovery of the pure power to do or not do what is said in the words of others, to be solely responsible for the act, sole executor of its entry to the world. The film would be infinitely reassuring if only it invited us to flee from dangerous discourses and save childhood from the overhanging threat of a world in ruins. But nothing hangs over Edmund except the crushing weight of year zero's freedom. And just as the Nazi catechism can not produce the act, no remorse can produce suicide. In both cases the cause disappears into the dizzyingly attractive void of unlimited possibility: the gaping window of the ruined building, also a source of light, cutting out the white squares in the wall on which the child revels in firing with his fake revolver. This child's game, hopping from one black band to another just as deliberately as killing one's father, this impassioned improvisation in black and white—how can one help but feel its profound relation to that other dizzying void, the blank page and the leap into the chasm of the work?

From: *Roberto Rossellini,* Paris, 1990.

Roberto Rossellini, *Germania, anno zero (Germany, Year Zero),* 1947

ly find certain trends in modern political life which in themselves point toward fascism and certain classes which are more easily won and more easily deceived than others—but all must change their basic functions in society before Nazism can actually make use of them. Before the war is over the German military caste, certainly one of the most disgusting institutions, ridden by stupid arrogance and an upstart tradition, will be destroyed by the Nazis together with all other German traditions and time-honored institutions. German militarism as represented in the German army scarcely had more ambition than the old French army of the Third Republic: the German officers wanted to be a State within a State, and they foolishly assumed that the Nazis would serve them better than the Weimar Republic. They were already in a state of dissolution when they discovered their mistake—one part was liquidated and the other adjusted itself to the Nazi regime.

It is true that the Nazis have occasionally spoken the language of militarism as they have spoken the language of nationalism; but they have spoken the language of every existing ism—socialism and communism not excluded. This has not prevented them from liquidating socialists and communists and nationalists and militarists, all of them dangerous bedfellows for the Nazis. Only the experts with their fondness for the spoken or written word and incomprehension of political realities have taken these utterances of the Nazis at face value and interpreted them as the consequence of certain German or European traditions. On the contrary, Nazism is actually the breakdown of all German and European traditions, the good as well as the bad.

Many premonitory signs announced the catastrophe which has threatened European culture for more than a century and which was divined though not correctly described in Marx's well-known words regarding the alternative between socialism and barbarism. During the last war this catastrophe became visible in the form of the most violent destructiveness ever experienced by the European nations. From then on nihilism changed its meaning. It was no longer a more or less harmless ideology, one of the many competing ideologies of the nineteenth century; it no longer remained in the quiet realm of mere negation or mere scepticism or mere foreboding despair. Instead it began basing itself on the intoxication of destruction as an actual experience, dreaming the stupid dream of producing the void. The devastating experience was enormously strengthened during the aftermath of the war, when through inflation and unemployment the same generation was thrown into the opposite situation of utter helplessness and passivity within the framework of a seemingly normal society: When the Nazis appealed to the famous *Fronterlebnis* (battlefront experience), they not only aroused memories of the *Volksgemeinschaft* (people's community) of the trenches, but even more the sweet recollections of a time of extraordinary activity and power of destruction enjoyed by the individual.

It is true that the situation in Germany lent itself more readily than anywhere else to the breaking of all traditions. This is connected with the late development of the Germans as a nation, their unfortunate political history and lack of any kind of democratic experience. It is more closely connected with the fact that the postwar situation of inflation and unemployment—without which the destructive power of the *Fronterlebnis* might have remained a temporary phenomenon—took hold of more people in Germany and affected them more profoundly than elsewhere.

But though it may have been easier to break European traditions and standards in Germany, it is still true that these had to be broken, so that it was not any German tradition as such but the violation of all traditions which brought about Nazism. How strongly Nazism appealed to the veterans of the last war in all countries is shown by the almost universal influence it wielded in all veteran organizations of Europe. The veterans were the first sympathizers, and the first steps the Nazis took in the field of foreign relations were frequently calculated to arouse those "comrades-in-arms" beyond the frontiers who were sure to understand their language and to be moved by like emotions and a like desire for destruction.

This is the only tangible psychological meaning of the "German problem." The real trouble lies not in the German national character but rather in the disintegration of this character, or at least in the fact that it no longer plays any role in German politics. It is as much a thing of the past as German militarism or nationalism. It will not be possible to revive it by copying out mottoes from old books or even by adopting extreme political measures. But a greater trouble still is this, that the man

who has replaced *the German*—namely the type who in sensing the danger of utter destruction decides to turn himself into a destroying force—is not confined to Germany alone. The Nothing from which Nazism sprang could be defined in less mystical terms as the vacuum resulting from an almost simultaneous breakdown of Europe's social and political structures. Restoration is so violently opposed by the European resistance movements precisely because they know that the very same vacuum would thus be produced, a vacuum of which they live in mortal fear even though by now they have learned that it is the "lesser evil" to fascism. The tremendous psychological appeal exercised by Nazism was not so much due to its false promises as to its frank recognition of this vacuum. Its immense lies fitted the vacuum; these lies were psychologically efficient because they corresponded to certain fundamental experiences and even more to certain fundamental cravings. One can say that to some extent fascism has added a new variation to the old art of lying—the most devilish variation—that of *lying* the truth.

The truth was the class structure of European society could no longer function: it simply could no longer work either in its feudal form in the East or in its bourgeois form in the West. Not only did its intrinsic lack of justice become more obvious daily; it was constantly depriving millions and millions of individuals of any class-status whatever (through unemployment and other causes). The truth was that the national State, once the very symbol of the sovereignty of the people, no longer represented the people, becoming incapable of safeguarding either its external or internal security. Whether Europe had become too small for this form of organization or whether the European peoples had outgrown the organization of their national states, the truth was that they no longer behaved like nations and could no longer be aroused by national feelings. Mot of them were unwilling to wage a national war—not even for the sake of their independence.

This social truth of the breakdown of European class-society was answered by the Nazis with the lie of the *Volksgemeinschaft*, based on complicity in crime and ruled by a bureaucracy of gangsters. The declassed could sympathize with this answer. And the truth of the decline of the national State was answered by the famous lie of the New Order in Europe which debased peoples into races and prepared them for extermination. The gullibility of the European peoples—who in so many cases let the Nazis into their countries because the Nazi lies alluded to certain fundamental truths—has cost them an enormous price. But they have learned at least one great lesson: that none of the old forces which produced the maelstrom of the vacuum is so terrible as the new force which springs from this maelstrom and whose aim is to organize people according to the law of the maelstrom—which is destruction itself.

From: *Partisan Review,* New York, 1945.

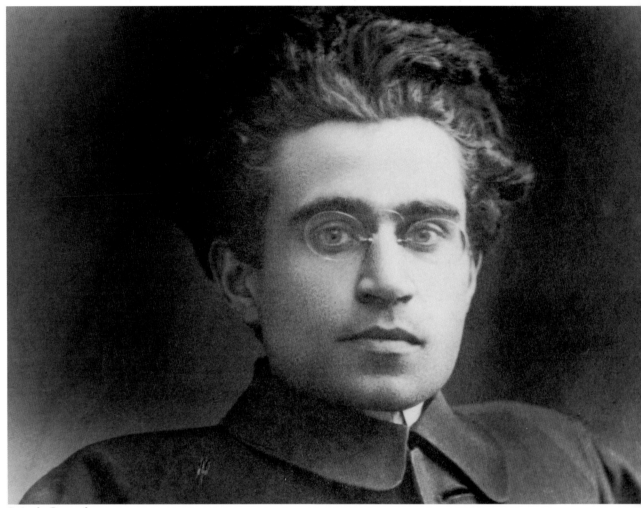

Antonio Gramsci

Antonio Gramsci's home, 1895-1908

He came from a backward province in Sardinia and he had seen how that backward province faced the same conditions as so many other backward provinces in Italy, above all in the southern regions; he had seen how the peasants and the workers were governed, by what methods they were subjected to the old clientels, to the old, egoistic, reactionary ruling castes linked to the remnants of feudalism, while more advanced forms were developing in the north. In the north, in Torino, he found a completely different situation; he met an advanced working class that was winning its freedom, fighting to elevate its standard of living and to defend its own interests, creating a great, free organization. He met the huge movements of agricultural workers in the Po river valley, socialists and catholics who through a two-year struggle had succeeded in raising the living standard for hundreds of thousands of Italians. He compared the political and social gains of this vigorous movement, along with the first well-organized strikes in the north, to the situation in the province from which he came; and he drew the conclusion that there were two Italies, and that social and economic progress depended on overcoming this split, this breach in the very structure of our country.

From here sprang the first fundamental political intuition that was to guide him in all his later activities: the necessity of an alliance between the most advanced social groups of northern Italy and the great masses of workers and above all of peasants from the backward regions of the islands and the south, still suffering beneath the residues of feudal and semifeudal economic relations.

But at the same time, another question preoccupied him from the start, that of the destiny, function, and structure of the intermediary strata of Italian society, above all the intellectuals. In them he perceived the

Jean Thibaudeau

"It is an illusion and an error to think that ethical 'improvement' is purely individual. The synthesis of the constitutive elements is 'individual,' but that synthesis cannot be accomplished and developed without an activity turned toward the outside, modifying external relations—from the activities turned toward nature to those directed in varying degrees toward other men, within the different social circles of life all the way to the greatest relation, which encompasses all of mankind. This is why it can be said that man is essentially 'political,' since the activity of transforming and consciously leading other men realizes one's own 'humanity,' one's 'human nature.'"

Antonio Gramsci, Notebook X, § 48.

1. Born in Sardinia in 1891, the fourth of seven children. Lives in poverty during childhood and youth. The father is absent for five years, without the mother telling anyone that he is in prison (except the eldest son, sworn to secrecy). At the age of two, Antonio becomes a little hunchback. "You should know that I once died and was reborn, which proves I have always been hard to kill. As a child at the age of four, I had hemorrhages for three straight days which bled me white, plus convulsions. The doctor gave me up for dead and until around 1914 my mother kept the little coffin and the suit that were meant for my burial" (letter to Tatiana, September 7, 1931).

connecting tissue of Italian society over the centuries; he attributed them a particular function in the work of liberation that was to be accomplished by our country, the labor of Italy's resurrection. This social group of the intellectuals was not exactly mobilized but at least in crisis at the time, and the key factor in this crisis was essentially the development of the new currents of thought and culture which gradually asserted themselves and became predominant from 1900 to 1914: a new culture based on philosophical idealism, which had beaten back, dismantled, and finally destroyed the positions of the old positivism and the old scientific philosophy on which Italian culture had rested immobile at the close of the last century—a spineless positivism, if I may use such a word, incapable of development, far from reality.

I have already said that Gramsci's ideological conceptions were profoundly different from those of the old leaders of the socialist movement, the old representatives of this movement. His conceptions did not come from positivism, but rather from philosophical and philological inquiry. His intellectual culture was comparable to that of the great founders of Marxist thought: it sprang from Hegelian philosophy. He was therefore able to grasp and identify everything new and progressive that was being expressed in the national culture. But at the same time, as a Marxist who was already experienced in ideological, historical, and political analysis, he was capable of understanding where the shortcomings of this new idealist culture lay. These, I recall, formed the theme of long discussions between Gramsci and many young students who were sharpening their minds for life and reflection. Later I would find the same theme developed in Gramsci's prison writings.

From: *Sur Gramsci* (1945), Paris, 1972.

2. In Torino in 1911 (university scholarship). Doesn't always have enough to eat (or even to wear). Exhaustion. Insatiable intellectual curiosity. Prepares (mainly) for a career as a linguist. First a Sardinian separatist (more or less), then a socialist (completely): understands the so-called "southern question" as a "national" question. Rapidly gets involved in journalism and party organization. Moves (without a break) from the university to politics: simply shifts the teaching function into the street, into the night of the cities, onto the terrain of social struggles, remaining in close contact with his favorite professors and a few fellow students. Torino is to the Italy of the time what Saint Petersburg is to Russia: the largest "national" concentration of modern heavy industry. Great enthusiasm for the October Revolution. In 1919, Gramsci and three friends (Tasca, Tarracini, Togliatti: workers and students) found the weekly paper *L'Ordine Nuovo*, soon in the thick of all the workers' struggles (strikes, factory councils). Moscow, summer 1920, at the 2nd Congress of the New International: against the "right" and "left" wings of the Italian party (both represented), Lenin favors the motion, drafted by Gramsci, of *L'Ordine Nuovo* (no representative).

3. January 1921, Congress of Livorno, division in the ranks. Gramsci is on the central committee of the fledgling communist party. Represents it in Moscow from June 1922 to November 1923. Writes a note on Italian futurism at Trotsky's request, included as an appendix to *Lit-*

Antonio Gramsci's family, 1931/32

erature and Revolution. More importantly: meets Giulia. Their first son, Delio, born in August 1924. Mussolini takes power in Italy in October 1922. December 1923, Gramsci is sent to Vienna (halfway between Italy and the USSR). Elected deputy (for the Veneto) in May 1924, returns to Italy (parliamentary immunity). Another stay in Moscow, March-April 1925. Fall 1925, Giulia and her sister Genia come to Rome with Delio, meet their sister Tatiana (the three are from a large, well-established, liberal Russian family: the father knew Lenin in Siberia, Saint Petersburg, and Switzerland; when the others returned to Russia in 1917, Tatiana decided to remain in the West). August 1926, Giulia, Genia, and Delio leave for Moscow again. A second son is born, Guiliano, whom Gramsci never sees except in photographs. January 1926, 3rd party congress in Lyons, Gramsci obtains 90% of the votes (against Bordiga). October 14, sends a letter to Togliatti in Moscow, in the name of the political bureau. The letter, addressed to the International, protests against Stalin's manner of taking power (though Gramsci would later be favorable to the "majority"): "In our opinion, the violent and impassioned nature of Russian problems is causing you to lose sight of the international repercussions of those problems, and to forget that your responsibilities as Russian militants can not and must not be fulfilled irrespectively of the interests of the international proletariat."

4. Gramsci is arrested (in Rome) on November 8, 1926. January 1929, obtains the authorization to write (to Tatiana, February 19: "You know, I'm already writing in my cell. For the moment I only do translations, to regain my style"). His last notebook dates from 1935, after which he lacks the strength: it is entitled "Notes for an introduction to the study of grammar." Dies on April 27, 1937, at the moment when he is finally to be set free. Present at the cremation: his young brother Carlo, his sister-in-law Tatiana, and a large crowd of police.

5. Gramsci's "reception" began exactly a half-century ago, in 1947, with the first editions of his prison letters and notebooks. The ensemble of his writings is now available. This ensemble does not constitute a "theory," offering a system to be completed or slogans to follow. Gramsci is *absolutely* historical. It may be asserted that his major "question" was the question of "the intellectual"—but only if each of his readers take up that question for themselves. And the very notion of "reading" must be extended: the words and deeds, the "life," count

Jean Thibaudeau

It is a commonplace to say that Gramsci sought to establish between Croce and himself a relation of "reversal" analogous to the relation that Marx established with Hegel; and this commonplace leads, in particular, to suppose a kind of equivalence between Gramsci and Lukács. Gramsci and Lukács are both said to have carried out a kind of "return" to Hegel, the first through Croce, the second without mediations. But this commonplace is a mistake. It develops over Lenin, that is to say, over the question of the party, but historically speaking, it develops over the fact that Lukács fundamentally referred to a German cultural hegemony of the past, whereas Gramsci worked for a modern Italian society of the future. Thus Lukács would often stop short at whatever did not match with classical German culture, for example, Lenin; while Gramsci, as

Primary school in Ghilarza, 1900/01

early as his celebrated November 1917 article "The Revolution Against 'Capital,'" had found in the Bolshevik revolution the most persuasive reasons for immediately seeking revolution in Italy. And consequently, Croce is something quite different than a relay for a "return" to Hegel. He stands precisely at the crossroads of Gramsci's concerns with national and international revolution: for in Italy he is "a kind of secular pope . . . a very effective instrument of hegemony, even if he may be in opposition to a particular government" (letter to Tatiana, September 7, 1931); while internationally, he is the philosopher "who furnished the intellectual arms for the two major 'revisionist' movements of his time, led by Eduard Bernstein in Germany and Georges Sorel in France" (to Tatiana, April 18, 1932). Croce not only provided Gramsci with a model of writing, but even more, with the very terrain where that writing, defined by its task, must operate—a terrain he went on to occupy. (The same can hardly be said of Hegel with respect to Marx).

From: "Premières notes sur les 'Ecrits de prison' de Gramsci pour placer la littérature dans la théorie marxiste," in *Dialectiques*, Paris, 1974.

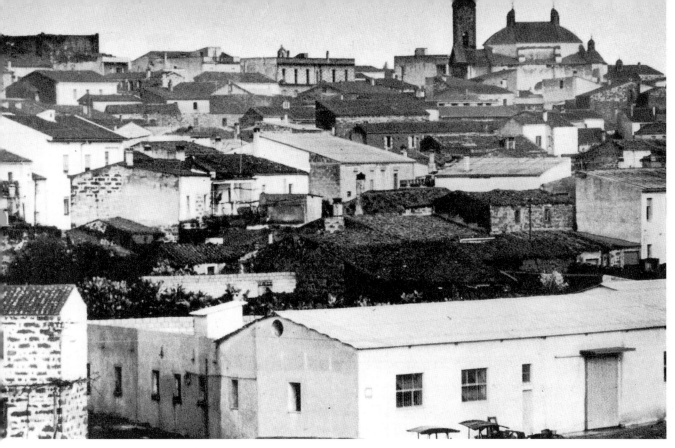

no less than the writings. One would have to understand, for example, how *the same man* could reread the *Meditations* of Marcus Aurelius on the evening of December 31, 1917, in the company of two youths—and then fifteen years later, while awaiting transfer to a clinic, confide to a young comrade assisting him in the Bari prison that in an hour of need, arms could be found hidden in a pine wood near Ravenna. The partigiano Gustavo Trombetti would go to look for those arms, in vain. As to New Year's Eve, 1917: the three considered the text of Marcus Aurelius, "Never judge useful what will one day oblige you to transgress your faith." "What is faith?" asked Gramsci of his young companions. He listened to their answers, and in closing gave Dante's response (canto XXIV of *Paradiso,* taken literally from Thomas Aquinas). Let me translate: "Faith is the staff of hope, and the object of our quest."*

February 23, 1977

* These two "anecdotes" are related in *Gramsci vivo nelle testimonianze dei suoi contemporanei* (1977), testimonials collected by one of Gramsci's nieces, Mimma Paulesu Querciola, the daughter of his sister Teresina.

Edward W. Saïd

An explicitly geographical model is provided in Gramsci's essay "Some Aspects of the Southern Question." Under-read and under-analysed, this study is the only sustained piece of political and cultural analysis Gramsci wrote (although he never finished it); it addresses the geographical conundrum posed for action and analysis by his comrades as to how to think about, plan for, and study southern Italy, given that its social disintegration made it seem incomprehensible yet paradoxically crucial to an understanding of the north. Gramsci's brilliant analysis goes, I think, beyond its tactical relevance to Italian politics in 1926, for it provides a culmination to his journalism before 1926 and also a prelude to *The Prison Notebooks,* in which he gave, as his towering counterpart Lukács did not, paramount focus to the territorial, spatial, geographical foundations of social life.

Lukács belongs to the Hegelian tradition of Marxism, Gramsci to a Vichian, Crocean departure from it. For Lukács the central problematic in his major work through *History and Class Consciousness* (1923) is temporality; for Gramsci, as even a cursory examination of his conceptual vocabulary immediately reveals, social history and actuality are grasped in geographical terms—such words as "terrain," "territory," "blocks," and "region" predominate. In *The Southern Question,* Gramsci not only is at pains to show that the division between the northern and southern regions of Italy is basic to the challenge of what to do politically about

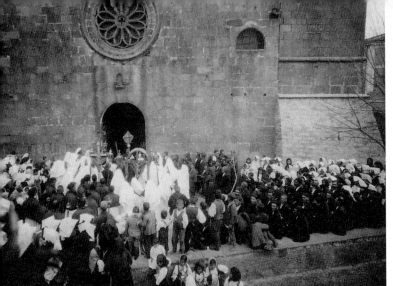

Auguste Sander, *Atzara: Palmsonntagsprozession* (Palm Sunday Procession in Atzara), 1927

the national working-class movement at a moment of impasse, but also is fastidious in describing the peculiar topography of the south, remarkable, as he says, for the striking contrast between the large undifferentiated mass of peasants on the one hand, and the presence of "big" landowners, important publishing houses, and distinguished cultural formations on the other. Croce himself, a most impressive and notable figure in Italy, is seen by Gramsci with characteristic shrewdness as a southern philosopher who finds it easier to relate to Europe and to Plato than to his own crumbling meridional environment.

The problem therefore is how to connect the south, whose poverty and vast labour pool are inertly vulnerable to northern economic policies and powers, with a north that is dependent on it. Gramsci formulates the answer in ways that forecast his celebrated animadversions on the intellectual in the *Quaderni:* he considers Piero Gobetti, who as an intellectual understood the need for connecting the northern proletariat with the southern peasantry, a strategy that stood in stark contrast with the careers of Croce and Guistino Fortunato, and who linked north and south by virtue of his capacity for organizing culture. His work "posed the Southern question on terrain different from the traditional one [which regarded the south simply as a backward region of Italy] by introducing into it the proletariat of the North." But this introduction could not occur, Gramsci continues, unless one remembered that intellectual work is slower, works according to more extended calendars than that of any other social group. Culture cannot be looked at as an immediate fact but has to be seen (as he was to say in the *Quaderni*) *sub specie aeternitatis.* Much time elapses before new cultural formations emerge, and intellectuals, who depend on long years of preparation, action, and tradition, are necessary to the process.

From: *Culture and Imperialism*, London, 1993.

Nicos Poulantzas

Let us say that I first met Marxism through French culture and through Sartre, as did many people of my class situation and of my age in Greece. At that time I was beginning to be able to work for myself at the age of seventeen or eighteen. We were in the post-Civil War situation, with the Communist Party declared illegal, which lasted until 1974. The conditions for the circulation of Marxist ideas were extremely difficult. It was impossible even to acquire the classical texts of Marxism and as a result I came to Marxism through French philosophy and through Sartre in particular. When I was at University I became involved in my first political activity on the Left, with the student unions or syndicates and then I joined EDA (United Democratic Left), that being a broad legal form of the Communist Party. At that time, however, I was not a member of the Communist Party.

After my law studies I came to Western Europe and at that time I continued to be actively involved in membership of EDA. But the big problem within EDA was that some of them were Communists and some were not; it was a kind of popular front organisation, but absolutely under the dominance of the Communist Party and without any real autonomy.

Developing an interest in Marxism through Sartre, I was much influenced by Lucien Goldmann and by Lukács. My doctoral thesis was undertaken in the philosophy of law, in which I tried to develop a conception of law drawing on Goldmann and Lukács. It was published in 1964; but from the moment it was published I began to feel the limitations of that orientation within Marxism. At this time I began to encounter Gramsci through *Critica Marxista* which was the most important journal of Marxism at that time.

I began also to work with Althusser, while still being influenced—as I always am—by Gramsci which created a kind of agreement and disagreement, from the beginning, with Althusser. It would take too long now to explain the kind of differences I had, which were not so much with Althusser but rather more with Balibar. With Althusser's first texts, which were mainly philosophical and methodological, I profoundly agreed and I always felt that Althusser has a kind of understanding in relation to the class struggle and its problems. The problem of structuralism was more a problem with Balibar than with Althusser. In *Political Power and Social Classes* there are definite differences between the text of Balibar and my text. I have spoken a little about these differences in *Social Classes in Contemporary Capitalism.*

Meanwhile I joined the Greek Communist Party before the split in 1968, which came one year after the colonels' coup and since than I have been in the Communist Party of the Interior. The Communist Party of the Interior has moved towards the Euro-Communist line. The Greek Communist Party of the Exterior, on the other hand, is one of the last Stalinist parties in Europe. I mean that in the strongest sense—in the sense of theoretical dogmatism, the total absence of internal democracy, and total dependency towards the Soviet Union.

From an interview with conducted by Stuart Hall and Alan Hunt for the British journal *Marxism Today*, 1979.

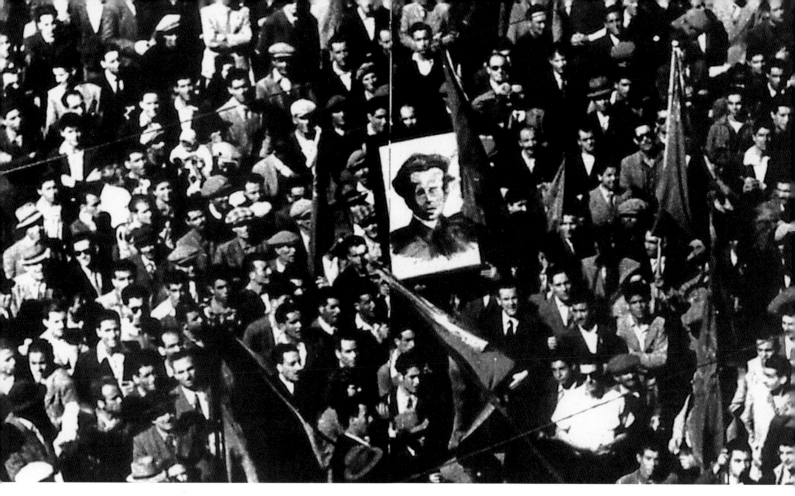

Jean Thibaudeau

Gramsci's historicism is "absolute." Even geography, in a certain sense, is ranked among the superstructures! "The very geography of a national state does not precede but (logically) follows the structural innovations, while reacting upon them to a certain degree (precisely the degree to which the superstructures react upon the structure, and politics reacts upon the economy) . . ." It comes as no surprise, then, that Gramsci's writings are in total opposition to Stalin's famous declaration that "language is not a superstructure."*

* Cf. Stalin, "Concerning Marxism in Linguistics" (Pravda, 1950; translation in *Cahiers marxistes léninistes* 12-13, 1966). This article is introduced on a "dialecticist" basis by Etienne Balibar, who, in his attempt to set the crown of dialectical materialism atop "two sciences: linguistics and historical materialism," doesn't know what to make of the "strictly unplaceable social concept" articulated by Stalin: "Every base has its own superstructure. . . . when a new base comes into being, a corresponding superstructure follows. . . . Language ranks among the social facts which are active throughout the entire existence of a society." It is clear Stalin does nothing other than bar the field of linguistics against the economic dogmatism that bears his name—"Stalinism" being the misunderstanding of the play of the superstructure so well understood by the "historicism" of Gramsci, who was fully aware that the revolution neither begins nor ends with the taking of power, nor principally advances along the strict lines of politics or the economy. (As to the way a "society" can change its base, Gramsci's reading of Dante clears up this mystery, which Stalinist politics renders so obscure.)

From: "Premières notes sur les 'Ecrits de prison' de Gramsci pour placer la littérature dans la théorie marxiste," in *Dialectiques*, Paris, 1974.

Constanzo Preve

Unfortunately, Gramsci's thinking has long remained entangled in the theoretical and political infighting of the Italian communist party, where Gramsci himself was but a pretext (the relative merits of the various political lines can be left aside here). The problem of his supposed "organicism," on which Franco Sbarberi has written at length, is an example of this squabbling. Whether or not "organicism" was a primary or merely a secondary element of his thought (and unlike Sbarberi, I personally believe it was indisputably present, but did not occupy a central and decisive place, since it coexisted with conceptions that lent a strategic cultural autonomy to "individuality"), it remains incontestable that organicism in itself is odious and repugnant, as it can dialectically transform a communist force into Ceausescu-style "red fascism." The sacrosanct polemic against organicism can therefore be tranquilly pursued, in my best estimation, without any need to pester those who lived in a time when the semantic context of certain terms was not, and could not be, what it is now.

From: "De la mort du gramscisme au retour à Gramsci" (1989), in *Modernité de Gramsci*, Besançon, 1992.

Fabrizio Gallanti

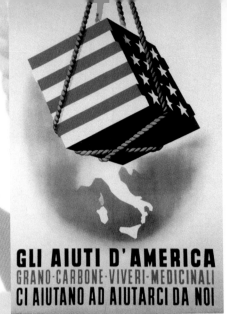

GLI AIUTI D'AMERICA
GRANO·CARBONE·VIVERI·MEDICINALI
CI AIUTANO AD AIUTARCI DA NOI

1945–1967: Political Architecture in Italy

Faced with the rubble left by twenty years of dictatorship and a military adventure gone awry, Italian architects at the close of the Second World War found themslevs considering the problem of reconstructing an entire country.

It is clear to the historian of postwar Europe that the most culturally advanced of the Italian architects, placed in the role of technicians managing this reconstruction process, attempted to introduce a new dimension of political inquiry and initiative into their profession. Italy's case is instructive, for it is here that the most probing questions were asked concerning the heritage of the modern movement, generating themes that were later taken up by the international debate. Facing the problems of the intense urbanization of the rural population, the demographic explosion, and the consequent necessity to house enormous masses of people, Italian archiects were those who most deliberately explored the limits of their own discipline.

For many Italian architects still reeling beneath the experience of the war, the reconstruction could not only be physical but had also to be moral. The positions expressed by Piero Bottoni in 1945 were widely shared:

"The word 'reconstruction' is an error; we should speak of 'new construction'. . . . The new construction of the country is an essentially moral and political problem, and the new construction of buildings and urban infrastructure destroyed by the war (or not destroyed by fascism) is only the social and economic aspect of this same problem. . . . Just as there can be no return to prefascist Italy in political terms, so in terms of building and city planning there must be no return to an urbanism and an architecture based on economic and social concepts which do not respond to the collective social revolution whose painful preamble was the war."[1]

The intellectual stance taken by the protagonists of this story—figures such as Quaroni, Gardella, Ridolfi, Rogers, Samonà, De Carlo, Bottoni, Albini, and Zevi—was that of constructing the places and spaces of a new *civitas;* of using the new functional and spatial relations of the districts that would serve the urbanized populations of the great cities, Turin, Milan, Rome, Genoa, and Naples, to indicate the possibility of social relations quite different from those that had imprisoned Italian society under fascism.

The moral dimension of Italian architecture in 1945 included various elements: the heritage of militant

antifascism, a democratic ideal, the demand for a different community. For intellectuals of Marxian heritage such as Bottoni, influenced by the thinking of Gramsci, the benchmark for the construction of such a community was communism. But the idea that architecture could contribute to a wider construction of civility or civilization [civiltà] had gained the power to unify beneath its single aegis the different political and cultural attitudes of those involved. Thus the attention to this theme was not only restricted to the architects who aligned themselves with the communist party.

Numerous associations flourished in the years immediately following the war; manifestoes and proclamations were legion. In varying capacities, architects came directly to take part in the political and administrative organs charged with reconstruction. This drive toward the reformulation of Italian society, and thus of Italian architecture, is exemplified by the manifesto of APAO (Associazione per l'architettura organica), founded in Rome by Bruno Zevi in the summer of 1945:

"Organic architecture is a social, technical, and artistic activity, directed toward the creation of an environment for a new democratic civility. Organic architecture means architecture for human beings, fashioned at human scale, according to the spiritual, psychological, and material necessities of man. For these reasons, organic architecture is the antithesis of a monumental architecture serving myths of the state. It opposes the major and minor directions of contemporary neoclassicism, the vulgar neoclassicism of arcades and columns, and the false neoclassicism that hides behind the pseudomodern forms of contemporary monumental architecture."[2]

The principle reference for Zevi, who had spent wartime in exile in the United States, was the experience of the New Deal and Anglo-Saxon type democracy. But this formulation—almost a credo—is additionally concerned with a critique of the architecture of rationalism, a critique that would galvanize much of the Italian architectural debate in the fifties.

The historical framework of this experience, which can be considered to have reached its end in 1966, has been outlined by Manfredo Tafuri in his reconstruction of postwar Italian architecture, Storia dell'architettura italiana 1944-1985. The central reflection of the text concerns the unresolved relation between the architects and society, a difficult and ambiguous relation, buffeted by uncertainties and shortfalls, particularly in the articulation with political and economic power. As Tafuri writes with respect to the political attitude of Italian architects immediately after the war:

"Only on an ethical foundation could the architects achieve solidarity, resolute in their desire to promote the values of the resistance, united at least in their pursuit of a 'program of truth.' Far more complex was the definition of this truth's content, and of the form that consequent actions should take. The prospect of a new construction cycle could be serenely considered; but a quite different serenity was needed to settle accounts with an 'idea of reason' which, as Elio Vittorini protested in those years, had revealed its failure."[3]

After a twenty-year closure to the outside, Italian architects took this ethical imperative as a way to re-enter the international debate. Intellectuals made a tremendous effort to assert their centrality in the panorama of world architecture, oedipally cutting their ties to the recent past, to assure themselves not only a patent of modernism but above all a certificate of antifascism. In reality, however, the itineraries of the individual protagonists and the content of their work as architects dated back before the end of the war and had passed through fascism to reach the democratic experiment of the newborn republic. This continuity would now be reconstructed, by an effort to reknit the broken threads of discourse woven by the major figures of modern architecture in Italy. Three men focused the attention of architects in the postwar period: Giuseppe Terragni, Edoardo Persico, and Giuseppe Pagano. They are also crucial figures because their lives came to a tragic conclusion before the end of the war. This "martyrdom" was used to accredit their antifascism, as though the experience of rationalism could be equated with political commitment.

Rationalism came late to Italy. The ideas flowed from abroad,

[1] Piero Bottoni, La casa a chi lavora (Milan: 1945, published by the author). Piero Bottoni took part many of the major events of Italian architecture. A friend and school companion of Giuseppe Terragni, he took part in the MIAR exhibition in Rome (Movimento Italiano per l'Architettura Razionale). From 1929 onwards he worked in the Italian section of the CIAMs. In the thirties his professional occupations were strictly limited to private houses and workshops. At the end of the war he took part in the resistance and joined the communist party. He was named organizer of the Eighth Triennial in 1945, and participated as a representative of the architectural profession in the national Consulta, charged with drafting the Italian constitution. As organizer of the Eighth Triennial he presided over the realization of the experimental quarter QT8.

[2] "Apao, dichiarazione dei principi," in Metron 2, 1945.

[3] Tafuri, Manfredo: Storia dell'architettura italiana 1944-1985 (Torino, 1986), pp. 6-7.

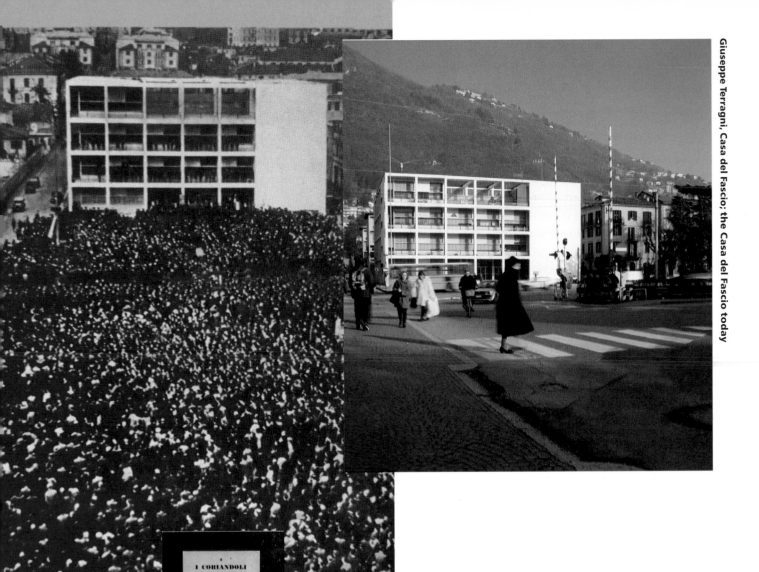

Edoardo Persico
Profezia dell'Architettura (1935),
Milan 1945. The book includes a
famous essay written only months
before Persico's death in 1935.

from Germany and France where the research of the modern movement had already reached a high level; but northern European rationalism was the expression of a progressive industrial bourgeoisie, while the Italy of the 1920s was still largely agricultural. Fascism sought to make the country into a modern industrial power and was, or at least feigned to be, a mass movement with a strong social content, where the organization of consensus entailed the involvement of the people in the construction of the state. Rationalism could have furnished the architectonic language for this program, yet it did not become the official style of the regime, for which a more compromised monumentalism was preferred, of greater effect and lower committment.

Thus the modern Italian vanguards found themselves isolated from the international debate and defeated in their own country. Only those who moved in

Milanese circles, around the tutelary figures of Persico and Pagano, were to a certain degree able to maintain relations of cultural proximity with the development of rationalist architecture in the rest of Europe. In the period preceding the war, two attitudes toward the modern movement already stood out: the first attended to the moral scope of the new architecture, conveyed primarily by the essayists of the time; the second integrated the expressive aspects of that still young tradition, reducing them to a formal repertory which was often of high quality, as in the cases of Giò Ponti and Luigi Moretti. Where in other countries the rationalist architects had the opportunity to legitimately confront and attempt to resolve social problems, to measure themselves against history, becoming "militant" and "ideological," rationalist tendencies in Italy found their outlet in personal variations of project design and close attention to stylistic problems. What emerged from this autarchy was a focus on the themes of pre-existing structure and surrounding environment [ambiente], which would be taken up again after the war. In a consideration of buildings by Franco Albini, Giuseppe Samonà, and Giovanni Michelucci, realized from 1947 to 1950, Tafuri puts it this way:

"A conversation with the 'environment': such is the theme that emerges from this group of buildings, and seems to constitute the originality of the Italian experience in those years. This turn toward the surrounding environment, however, is only the second face of a turn back toward nature: a desire to find 'protection,' to slip between warm blankets. And even here there is a swing between two extremes: an exceptional openmindedness in the confrontation with the legacy of the avant-garde; and an exceptional caution in the definition of the limits on the dialogue with history. Indeed, the *ambiente* was not considered as a historical structure in the strict sense; an impressionistic, 'essayistic' attitude prevailed, which was ultimately instrumental for a suspension of judgment."[5]

Let us now examine the three prewar figures mentioned above, whose work supplied the underlying historical continuity for this original approach to the environment. To grasp the cultural dimension of Terragni's activities we may refer to an image, and to the political content it conveys: it is the image of the photomontage representing the area in front of the Casa del Fascio in Como, flooded with the crowd. This image condenses Terragni's political intention, which was to give the architecture of the Casa del Fascio an almost pedagogical role: the volumetric suspension of the context and the expressive clarity of the architectural language were meant to communicate the fascist values of transparency and modernity. This choice of an educational posture turned toward the masses contains the first premises of the architectonic poetics of the postwar period. The aim here is to contribute to the creation of a rhetoric and a collective identity, constructing the image of a new society with the new symbols of rationalist architecture.

Though it stays within the general limits of fascist ideology and rhetoric, the architecture of the Casa del Fascio introduces certain new elements: the project recreates a dimension of community in the relations between the building and the space in front; it attains monumentality through the design of the facade with its reference to certain classical elements, but also intimacy through the feeling of domesticity conferred on its interior spaces and their relations with the outside. Such a demonstrative inspiration seeking to concretize cultural concepts in the materiality of architecture, and generally indicating the distance between the cultural elites and the people, is clearly inherited from the experience of the avant-gardes. It remains as an element of continuity in postwar architecture.

In the pages of the Milanese journal *Casabella*, Persico and Pagano carried out a solitary battle for the affirmation of rational architecture in Italy. The force of their cultural proposal lay in the adoption of rationalism as a methodological rather than a formal reference. It was not a question of importing a new fashion into Italy, as it had been in the early century with the "liberty" style. The aim was to renew Italian architectural production by constructing a truly Italian rationalism, consonant with the history of the country's architecture and with its current economic and technological conditions, which were quite different from those in France and Germany.

The contributions of Pagano and Persico to the Sixth Triennial of Milan can be taken as the exemplary expression of two distinct attitudes. Pagano and Guarnerio Daniel prepared the *Exhibition of*

[4] The exhibition of the Ninth Triennial of Milan, in 1951, opened with a commemorative section devoted to Raffaello Giolli, Pagano, Persico, and Terragni, conceived by Pietro Lingeri and Giovanna Pericoli.

[5] Tafuri, Manfredo: *Storia dell'architettura italiana 1944-1985*, op. cit., p. 39.

[6] Persico became director of the journal in 1930 and then Pagano in 1933, with Persico as chief editor.

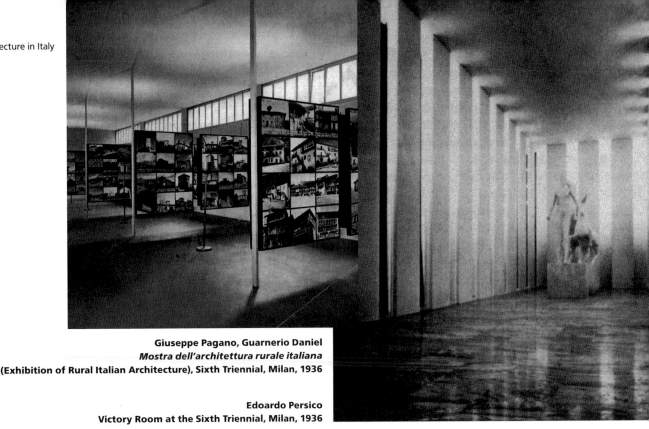

Giuseppe Pagano, Guarnerio Daniel
Mostra dell'architettura rurale italiana
(Exhibition of Rural Italian Architecture), Sixth Triennial, Milan, 1936

Edoardo Persico
Victory Room at the Sixth Triennial, Milan, 1936

Rural Architecture in the Mediterranean Basin, from which the book *Rural Italian Architecture* was subsequently drawn.[7] This proposal figured in counterpoint to that of Persico, who presented an exhibition on "the classical spirit in architecture," displayed in the so-called "Victory Room." Giorgio Ciucci's comments on the two exhibitions encompass many of the problems and questions later to be expressed by architects of the postwar period:

"Not opposed but to an extent complementary to the Victory Room, the show on the rural house celebrated the other aspect of architecture and tradition that interested Pagano: the aesthetic and moral value of functionality. Where Persico drew the inspiration of his exhibition from 'the most elevated concepts of the new architecture,' in the name of an aspiration to a new European 'renaissance,' Pagano sought to combat 'academic backsliding' with 'the true indigenous tradition of architecture: clear, logical, linear, morally and also formally very close to contemporary taste.'[9] The basic elements of architecture were to be almost anonymous, collective, perfectible: this was implicit in both the classical and the rural models. . . . Pagano's 'populism' ultimately proved complementary to the Giobertian ideal of an elite that Persico reworked and developed throughout his short life. The latter believed fascism to be irreconcilable with the world of the spirit contained in classicism, and thus felt that classicism should be pulled free of fascism's grasp; the former wanted to bring the ethical content of the rural world into fascism, against the corruption symbolized by classicizing monumentality.

"In the end, neither was to succeed: classicism was increasingly identified with fascism and the rural world became the heritage of antifascist culture and the 'populism' of the postwar period."[10]

If one can speak of continuity with the period prior to the war, it is particularly with respect to the close attention given to the heritage of Persico and Pagano, read somewhat simplistically as unitary. They were the source of the moral directions that seemed to lead outside architecture.

It was clear to the most advanced forces that there could be no disciplinary knowledge severed from action; hence the relation with politics was perceived as indispensable. Such a relation consisted above all in the search for a form of communication with the masses, subaltern

under fascism, but now becoming the new political subjects of the country. A reflection by Cesare Pavese, noted in his diary in the early months of 1948, can clarify the terms of the problem:

"In the end, human intelligence did not suffer under fascism; it could indulge its whims, cynically accepting the game. What fascism closely surveyed was the passage from the intelligentsia to the people; it kept the people in the dark. Now the problem is to escape from the servile privilege we enjoyed, not to move toward the people but to be the people, to live a culture whose roots are in the people and not in the cynicism of Roman freedmen."[11]

These sentences by Pavese crystallize the underlying theme that laid the groundwork for intellectual activity after the war, a theme that was deeply indebted to Gramsci's positions on the role of intellectuals in their confrontation with society. In the unresolved nexus of relations between the people and the Italian architects-intellectuals, who in reality were as bourgeois as their patrons, lies the meaning of an historical experience and a cultural defeat.

Three particular moments stand out from the bustling activity of the postwar period. They correspond, significantly, to the experiences of three groups: the Movimento di Studi per l'Architettura (Movement of Architectural Studies, or MSA) the Associazone per l'architettura organica (Association for Organic Architecture, or APAO), and the Tiburtino group in Rome.

The MSA was founded in Milan in April 1945, shortly before the end of the war. A few passages from the 1945 charter can clarify the positions of the association's members:

"Movement of study and propaganda for architecture. Premise: the movement's initiative springs from a nucleus of architects who recognize their shared orientation in the field of their practice and in their understanding of the organizational forms of social life.

"This shared orientation, the result of their creations, studies, and adherence to the most vibrant currents of contemporary architecture, will provide the vital cohesive force of the Movement. The members are nonetheless committed to render their orientation ever more precise and to maintain its constant clarity. . . ."

"Aims of the Movement. The Movement proposes:

a) To develop studies through the co-ordinated activity of its members, whether these be preparatory studies of research and documentation or expert studies of decision and design, to be programmed around the diverse problems of archiecture, primarily in relation to the most urgent needs of the reorganization of social life.

b) To ensure the publication of the completed studies and in general, to carry out propaganda work with all the appropriate means (press, cinema, radio, lectures, exhibitions) so that technicians, politicians, and the mass of the people can be informed in full and proper light of the most valid solutions to architectural problems, in particular those of human habitation, which are so closely involved and do so much to involve people in the formation of a living civility."[12]

The confluence of political and cultural attitudes is evident in the case of the MSA: in summary it can be said that for this group the choice of modern architecture corresponds to the choice of democracy, and the style of the so-called masters and the urbanistic themes of the CIAM congresses constitute the formal nucleus with which to reconstruct the city. Thanks to the presence of Ernesto Nathan Rogers, who played an important role in the CIAMs, the Milanese architectural circles that coalesced around the MSA had the opportunity to meet the architects of the modern movement—Richard Neutra, Alvar Aalto, Walter Gropius—when they passed through Milan. Giancarlo De Carlo reflects on the MSA experience:

"What did it mean to be part of the MSA? At the time it primarily meant being part of modern architecture. The difference between modern architecture and 'non-modern architecure' (I wouldn't know how else to call it: perhaps eclectic, or academic, or better yet, ignorant) was very striking. In truth, the field was divided into two parts: on the one hand were those who dominated the professional scene in Milan, as well as the

[7] Pagano, Giuseppe and Daniel, Guarniero: *Architettura rurale italiana*, in the series Quaderni della Triennale (Milan, 1936).

[8] Persico, Edoardo: *Tutte le opere* (1923-1935), vol. I (Milan, 1964).

[9] Pagano, Giuseppe and Daniel, Guarniero: *Architettura rurale italiana*, op. cit. A year earlier, while already preparing for the exhibition, Pagano had writter: "it will be all the more national to the extent that it moves toward the people; and moving toward the people also signifies tough clarity, scrupulous administration of public funds, exemplary simplicity. The architects of our time with the courage of modesty will be the true Italians." Pagano, Giuseppe: "Documenti di architettura rurale," in *Casabella* VIII, 95, November 1935.

[10] Ciucci, Giorgio: *Gli architetti e il fascismo: Architettura e città 1922-1944* (Torino, 1989), pp. 163-164.

[11] Pavese, Cesare: *Il mestiere di vivere* (Torino, 1952), p. 21. Freedmen in ancient Rome were liberated slaves who remained among the circle of their former master's clients. They were often prisoners of the Greek wars, including writers and artists such as Gneus Nevius and Livius Andronicus.

[12] Baffa, Matilde; Morandi, Corinna; Protasoni, Sara; Rossari, Augusto: *Il movimento di studi per l'architettura 1945-1961* (Rome-Bari, 1995), pp. 206-207.

city's architectural school: Portaluppi, Mancini, Cassi, Ramelli, Muzio, and others; on the other hand were the younger figures, who had grown up around Pagano and Persico's journal *Casabella*, the Triennials, and the experience of understanding and assimilating the modern movement, which was a concern in certain offices. To be part of the MSA meant being part of the modern architecture which had come to Milan over the previous few years.

After 1948, however, belonging to the MSA began to take on another connotation: for example, it meant being committed to the problems of reconstructing the country, attributing an educational role to architecture amid the transformations that were occuring in Italian society, maintaining that the organization of physical space should be confronted in rational terms."[13]

The instruments that the MSA members developed to control the process of reconstruction were primarily two: city planning (implying the management of urban processes) and industrial prefabrication. The famous AR plan presented at the competition for the Milan city plan in 1945,[14] the projects presented for the directional center competition in 1948, and the plan for Milan's green spaces all display certain guiding ideas that can be ascribed to the contribution of the MSA members: the social role of the plan as an instrument of mediation and control of social conflicts on the territory, the importance given to instruments for controlling real estate property, the themes of the quarter or neighborhood and of the organization of relations and the rational distribution of functions among the different parts of the city.

Where the control of urban development was concerned, the positions of the MSA members—Bottoni and Rogers in particular—tended to focus on the theme of land ownership: in the context of measures proposed in response to the need for popular housing and facilities, Bottoni declared that one of the non-negotiable premises was the expropriation of all buildable lots for public use, including those freed up by recent demolition.

In addition to the group activities, the MSA is represented by the essays and texts of its individual members and by the concrete statements of their specific political positions in their architecture. It must be noted, however, that in the course of its existence the MSA produced few collective documents and did not take a clear stance on certain political issues.

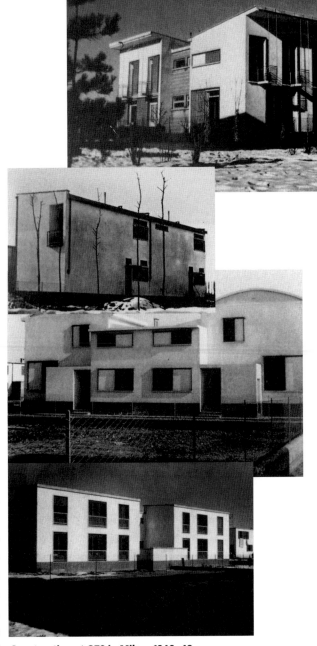

Construction at QT8 in Milan, 1946–48

Bruno Zevi
Verso un'architettura organica
(Toward an Organic Architecture), 1945.

QT8 in Milan, 1946–48

One particular creation sums up and distills the political meaning of the MSA: the experimental quarter QT8 realized in 1946-47, on the occasion of the Eighth Triennial. Piero Bottoni called the representatives of continuity with the modern movement to come together in the realization of projects of popular housing. The result was a spare, almost unobtrusive composition confronting the theme of the industrialization of building processes and the methods for resolving the problems of reconstruction, without any indulgence in matters of expression and architectural style. The value of QT8 was inherently linked the experience of collective project design: it was a "synthesis of social and urban planning, in which the members of the MSA each contributed to the experience of the entire group."[15]

The position and role of the APAO was quite different. First, the APAO possessed a more strongly articulated structure: a study center, press, library, and architectural school were active by 1944. The association's members each signed a document attesting that "the genesis of the architecture in which I believe is essentially to be found in functionalism . . . and not in romantic stylistic trends, nor in the provincialism of minor styles."

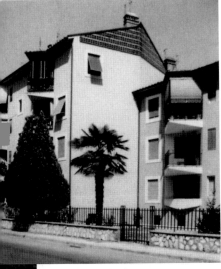

**Mario Ridolfi
Housing project in Terni
1948–49**

It is significant that the image which the APAO sought to project corresponded to a very rigid interpetation of architectural history, excluding any research into spontaneous architecture, which in fact was regarded with great interest by many exponents of Italian and European rationalism. Nonetheless, APAO memebers included architects informed by the rationalist tradition, such as Libera, Vaccaro, Samonà, and Ridolfi.

The APAO crystallized around the figure of Bruno Zevi, who combined a clear political position on the role of the association with an equally decisive stylistic stance: for Zevi, democratic architecture had to express values through its forms. By contrast to the manifesto of the MSA, the APAO's founding text speaks little of architecture and much of the future basis of the Italian constitution. The declaration explicity states certain political principles: political liberty and social justice; freedom of speech, of the press, of association, and of religion; democracy founded on universal suffrage; socialization of industries and banks. The APAO looked to Frank Lloyd Wright and the broad movement of organic architecture for a stylistic expression of moral contents that groups such as the MSA did not locate in characteristic formal traits. This simplifying logic saw the architectonic composition of Wright and Aalto as the content of an architecture of freedom, understood primarily as an overcoming of the heritage of rationalism. Wright's lessons had to be absorbed in order to liberate forms for a human use of space:

"The proposal of a linguistic 'manner' was indubitably far from Zevi's intentions. But the new flag he waved to catalyze otherwise unfocused energies was too mythical not to lend itself to any and every use. In its ideological program the APAO claimed to pursue city planning and architectonic freedom as instruments for the construction of a nascent democratic society: social liberty would be guaranteed by the socialization of the great industrial, financial, and agricultural complexes. Yet such a decisive appeal remained completely generic, lacking any relation to the choices to be taken in the construction sector.

[13] De Carlo, Giancarlo: "Una scelta di campo," in Baffa, Matilde, et. al.: *Il movimento di studi per l'architettura 1945-1961*, op. cit., pp. 7-8.

[14] The drafting of the AR plan (Architetti Riuniti) had already begun in 1943, when the members of the group met secretly to coordinate the activities of the Committee of National Liberation. The architects were Franco Albini, Piero Bottoni, Ignazio Gardella, Gabriele Mucchi, Enrico Peresutti, Mario Pucci, Aldo Putelli, and Ernesto Nathan Rogers. An article on the plan was published in *Il Politecnico*, a journal directed by Elio Vittorini, on October 13, 1945.

[15] "Appunti per la partecipazione al congresso Apao," December 1947, in Baffa, Matilde, et. al.: *Il movimento di studi per l'architettura 1945-1961*, op. cit., p. 135.

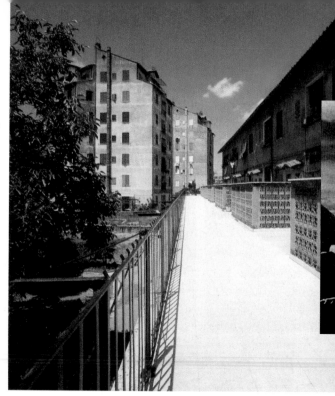

Ludovico Quaroni and Mario Ridolfi
The Tiburtino Ina-Casa quarter in Rome, 1950

Politics was evoked rather than practiced by the APAO. Its specific objectives were also vague: the equation organic architecture = architecture of democracy was useful for understanding each other, but not for understanding *tout court*."[16]

In any event, the architectural experiments of the immediate postwar period were soon channeled into the strategies of power, which blunted their initially "subversive" valences with regard to the organization of the state. In 1949 the Christian democratic Fanfani government passed a law entitled "Measures to promote workers' employment, facilitating the construction of houses for laborers." This law created the Ina-Casa bureau, directed by Arnaldo Foschini, who mingled the populist overtones of the fascist period with the political paternalism of the Christian democrats. The objectives of the plan were clear: to reduce the level of unemployment, then hovering around two million; to subordinate the construction industry to the driving sectors of the economy, maintaining it at a protoindustrial level characterized by small businesses; to stabilize, as long as possible, a wavering sector of the working class, leaving it open to political blackmail and closed off to mass organization; and to use public intervention as a support for private enterprise.

The urban policy of Ina-Casa, as a solution to the problems consciously created by neoliberal policy, was overtly in opposition to proper urban planning. Established in areas far from the city centers where low-cost land could be obtained, the Ina-Casa neighborhoods were created outside planning zones, stimulating speculative real-estate operations which slowly surrounded them, to profit from publicly built infrastructures.

The position of the architects with respect to the political and economic strategy of Ina-Casa was marked by an attitude of almost passive acceptance: already in this period, cracks appeared in the political authority of the architects. Accepting rules of play established by others in the field of urban reconstruction meant the beginning of a slow slide toward uncritical professionalism, apt to carry out commissioned projects, but increasingly unable to exert any real influence on the structural transformations of the territory and the city.

The more sensitive architects who had emerged from the resistance and had maintained a proximity to the most highly evolved experiments of European culture tended to swing between an ever-more intimate and solitary stylistic elaboration and attempts to lend public building projects a spatial dignity that could contribute to a possible *civitas*. Paradigmatic in this respect are Ludovico Quaroni's "La Martella" village in Matera in 1951, and even more, the Tiburtino Ina-Casa quarter in Rome, constructed from 1949 to 1954. Considered the "manifesto" of architectural neorealism,[17] the Tiburtino quarter proposes a diverse series of images, a changing landscape in which to fit the relation between society and its spatial forms. No longer was it a matter of respecting the rigid grids proposed by the CIAMs or of attempting to apply industrial procedures to construction as in QT8. Here the objective was to exalt an expressive craftsmanship as the leading motif of the complex, and to recognize the disalienating valency of this formal quality. The result was the employ of a language which might be called *strapaese* [in reference to a local-color literary movement of the twenties—Tr.]: balconies in wrought iron, sloping roofs, vertical windows. But this popular language, evoking the places left behind by the peasants in their move to the city, is only employed as an expressive material around a compositional procedure

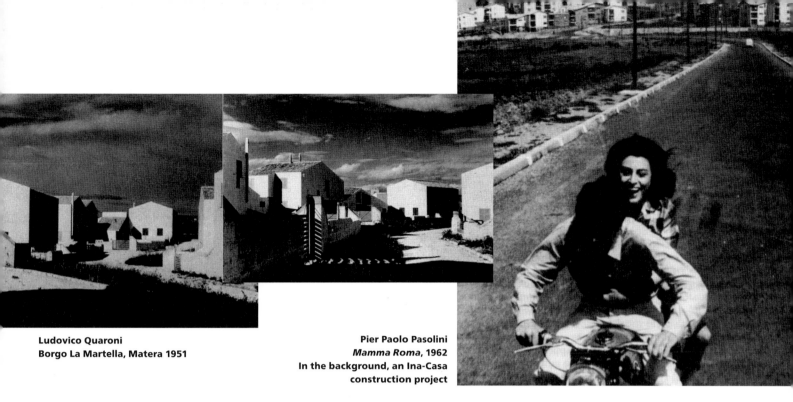

Ludovico Quaroni
Borgo La Martella, Matera 1951

Pier Paolo Pasolini
***Mamma Roma*, 1962**
In the background, an Ina-Casa
construction project

proper to the avant-garde—programmatically opposing it and yet integrating its mechanisms.

The lucid critical capacity of many Italian architects, a kind of pitiless self-analysis, immediately glimpsed the symptoms of a defeat in the experience of Ina-Casa and neorealist architecture; or more precisely, they saw a heteronymous victory of modern architecture, not so much guided by architects as by industry and the necessities of postwar reconstruction. As Quaroni writes:

"The country of the baroque builders is not the result of a solid culture and a lively tradition: it is the result of a mood. . . . but a mood cannot create architecture. . . . In the push toward the "city," the "country" has been closed off to us. Seeking an Italian language for the experience and teaching of Swedish urbanism, we have finally got it gibbering in Roman dialect."[18]

Part 2 see p. 286

[16] Tafuri, Manfredo: *Storia dell'architettura italiana 1944-1985*, op. cit., p. 13.

[17] "One must recall that after 1945, architecture appeared to the left as a site of shared hope. With so-called 'neorealism' in architecture (and in cinema), the left sought to counterbalance the most brutal impulses of modernization carried out by unbridled capitalism; it preached a genuine populism, stripped of any authoritarianism, and quite unlike the bombastic socialist realism of Russian origin. / Beyond the reaction to the trauma of fascism and of the military defeat, neorealist populism was in fact a reaction to the process of the country's modernization, as well as a neo-urbanistic response to the trauma of industrialization and its difficulties; however, it had disastrous consequences on the representation of the Italians' real way of life and their historical condition." Nicolin, Pierluigi: *Notizie sullo stato dell'architettura in Italia* (Milan, 1994), p. 43.

[18] Quaroni, Ludovico: "Il paese dei barocchi," in *Casabella* 251, April-May 1957.

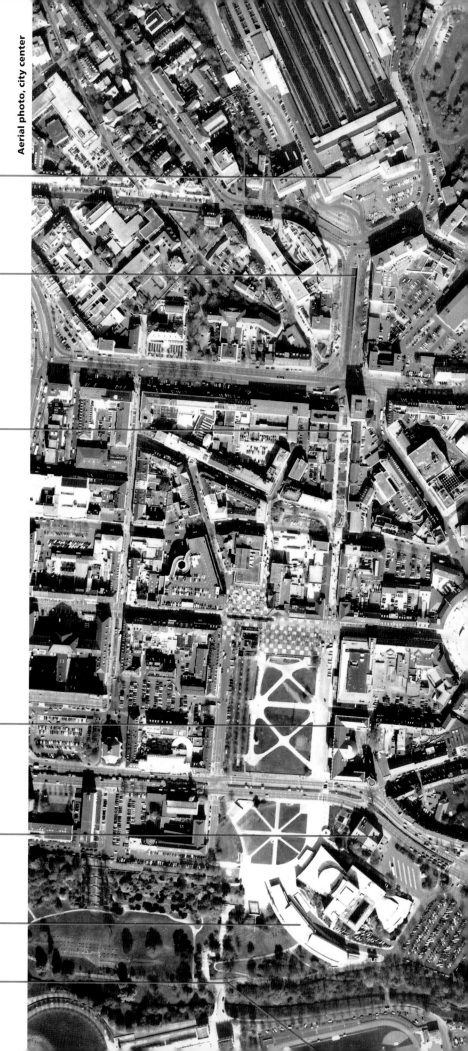

Aerial photo, city center

Hauptbahnhof

S-Bahnhof Unterführung

Treppenstraße

Fridericianum

Ottoneum

documenta Halle

Fulda

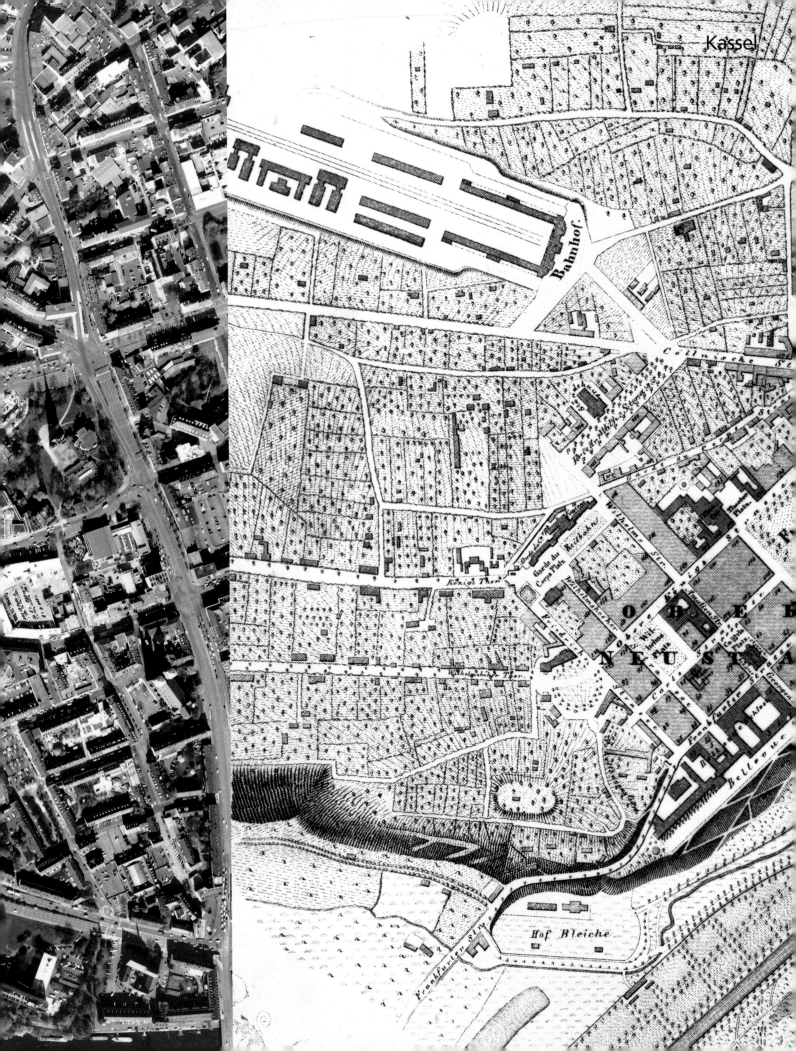
Kassel

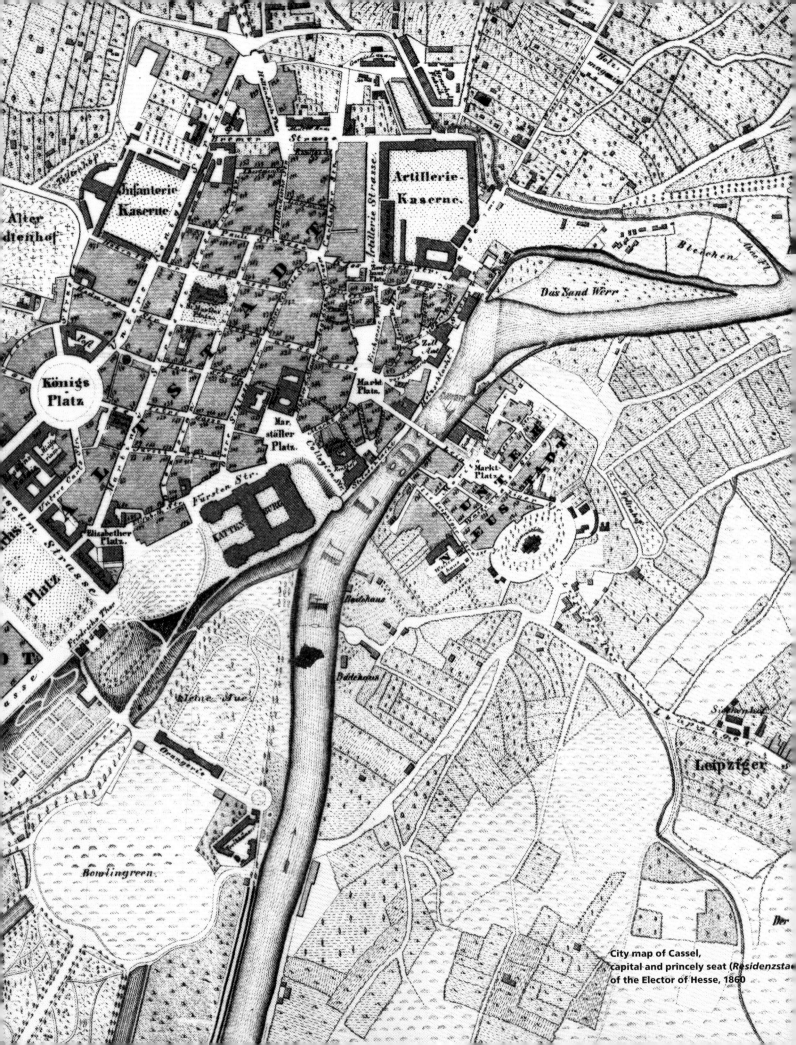

City map of Cassel,
capital and princely seat (*Residenzstadt*)
of the Elector of Hesse, 1860

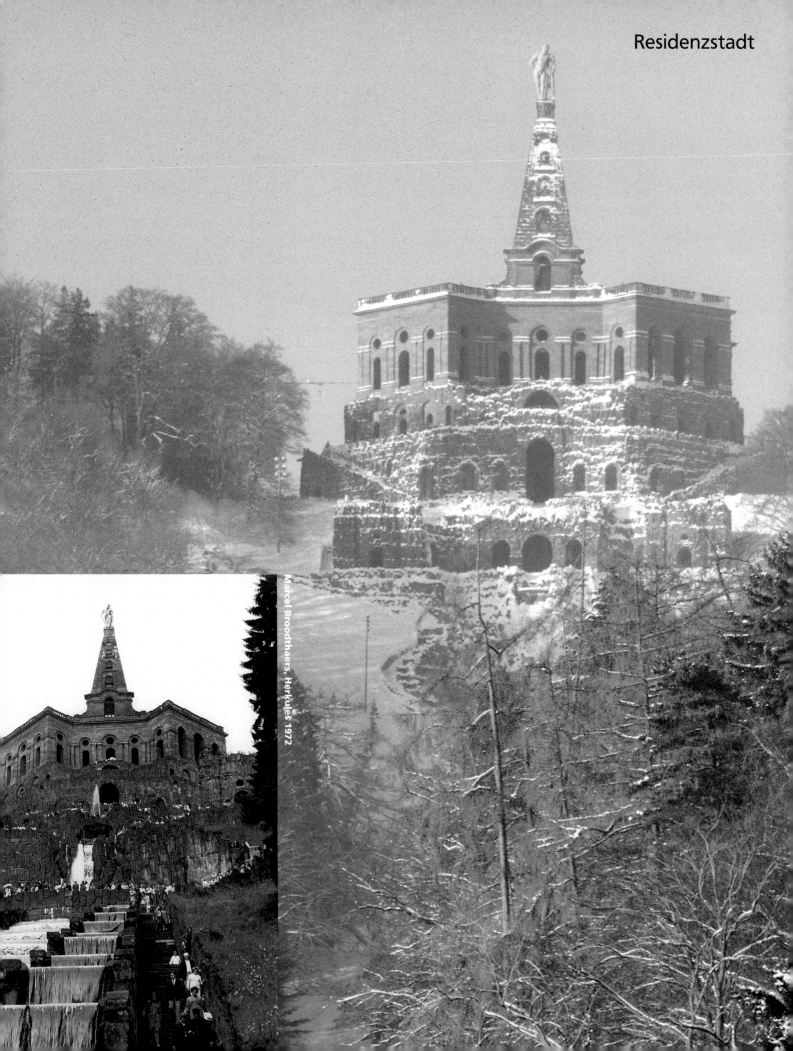

Marcel Broodthaers, Herkules 1972

Werner Durth
Notes on the Cityscape

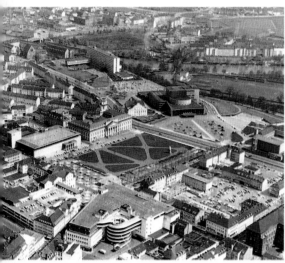

City center, 1966

1. The urban structure of Kassel is the result and expression of an overlapping of fragmented and mutually contrasting plans.

The historical arrangement of the city is detectable only in parts, due to more recently constructed large squares and axes. The small-scale building structures of the old city were destroyed by bombing and subjected to a new planning concept during reconstruction. Generously dimensioned park areas and widely looping traffic routes were to characterize the cityscape of the future.

In an effort to take advantage of the city's destruction, plans for the reconstruction of the regional capital were submitted even before the end of World War II, during its final months. These designs relinquished the traditional layout of Kassel's city center, obliterated the Untere Neustadt and crisscrossed the expanses of ruins with new axes.

After 1945 the demonstrative denazification of the plans called for the replacement of the large axes and representative urban spaces by a large-scale traffic system for the coming affluent and auto-mobile society. The city was made into a playground for high-speed traffic. Connections between pedestrian walkways were relegated to underground passages; even today the station square—entry gate to the city—ends in a tunnel.

2. As symbols of supremacy, grandiose edifices and monumental figures of a planned absolutism were squeezed into the multiform morphology of the old city. Barracks, schools and factories followed, occupying the inexorably growing outskirts of the industrial town.

As a climax, widely visible and complementary to the implanted architecture of supremacy, the silhouette of the Wilhelmshöhe dominates the system of visual coordinates crossed by an imaginary line leading from Claes Oldenburg's pickaxe to the Hercules Monument.

The small-scale character of the old city was disposed of, and the main elements of postwar planning composition are urban architectural dominants, adherence to the tradition of singular large structures, and emphasis on the contrast between architecture and landscape.

3. A city "organized" into a system of neatly outlined residential units "broken up" by park areas—this was the urban model which played a major role during reconstruction. In the course of the population's progressive mobilization and motorization it mutated into the concept of the *autogerechte* city—a type of urban planning responsive above all to the needs of motorized vehicles. What had been planned as the city's permeation with buildings and landscape, expressed by the image and concept of the "cityscape," was undermined by the slicing up of the urban structure, the divisional effect of wide thoroughfares.

Instead of the longed-for symbiosis of city and nature reflected in the idea of the cityscape, a highly disproportionate technical infrastructure developed, fragmenting city and landscape by the construction of multilane expressways and consuming public space in favor of higher speeds.

The traditional image of apartment block and corridor street was rejected; in the process, the diverse character and usability of public space was neutralized through the widening of thoroughfares and the breaking up of the constructions lining them. What was gained in speed was lost in urbanity; the fragmentation and insulation of functionally divided areas lends even parts of the city center the character of the periphery.

View of the city from the Kulturfabrik Salzmann

Claes Oldenburg
Pick Axe
documenta 7
catalogue, 1982

(a)

4. In the months preceding March, 1945, i.e., even before the air war was over, Werner Hasper—who would become the director of the city planning office in 1948—was already at work on the "General Construction Plan for the Reconstruction of the Regional Capital" which he modified for his entry in the city planning competition of 1947.

The plan reveals a corridor leading from the Fulda bridge and cutting through the former old city into whose center a "village green" is to be introduced. The axis from the train station to the Friedrichsplatz is representatively arranged and conceived in a rigorously architectonic manner. The western section of the lower Neustadt has disappeared to allow distant views of the city from the south.

In his position as the director of city planning, Werner Hasper developed his concept for the construction of Kassel on the basis of this design. The historical layout of the old city was done away with; in its place is a housing development with a village green; the representative axis developed through various planning stages into a pedestrian zone, finally built in 1952-53 and later widely known as the "Treppenstraße" (literally: stairway street).

After its construction the Treppenstraße was lauded nationwide as one of the first traffic-free pedestrian zones and shopping streets, its spatial organization and series of steps being the only reminders of its origins in the Third Reich. The small scale and gradation of the demonstratively modest constructions bordering the street veil its previously intended monumentality within the urban configuration. The images of the street's anticipated use were also exchanged. In place of the marching masses, scattered pedestrians and crowds of consumers enliven the axis formerly intended as an embodiment of state power; the consumer stage-setting takes the place of the locally aligned *Volksgemeinschaft* (people's community). The unity of construction form and the consumer-goods aesthetic typical of the 1950s is now falling apart in the non-simultaneity of a slowly aging structural ensemble with rapidly changing offers of low-quality merchandise. Instead of intertwining, the neglected layers of history detach themselves from one another; exceptionalities and banalities stumble into a visually evident cycle of mutual contrivance.

(b)

(c)

Claes Oldenburg
Pick Axe, 1982

(d)

Messeplatz (Fairground)

**Aerial photo with
Unterneustadt, 1996**

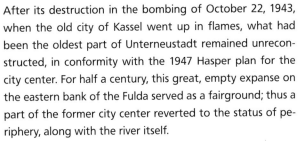

After its destruction in the bombing of October 22, 1943, when the old city of Kassel went up in flames, what had been the oldest part of Unterneustadt remained unreconstructed, in conformity with the 1947 Hasper plan for the city center. For half a century, this great, empty expanse on the eastern bank of the Fulda served as a fairground; thus a part of the former city center reverted to the status of periphery, along with the river itself.

In 1989-90, concrete preparations were undertaken for the refoundation of Unterneustadt, through a process of expert assessments, public consultation, and the elaboration of various concepts. On July 11, 1994, the city council officially decided on the reconstruction of the district, with the creation of a project development board on May 22, 1995, and the acceptance of project guidelines on November 13 of the same year.

The original foundation of Unterneustadt dates back to 1277; the old city across the river received its city status a hundred years before. In 1378, the independent cities of Altstadt, Neustadt, and Freiheit were united to form the princely city of Kassel, and from that time forth Unterneustadt was administered as a part of the city.

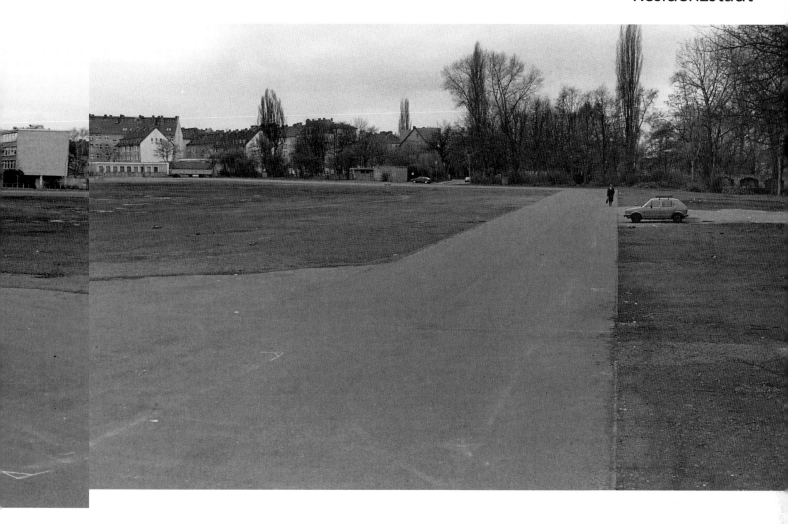

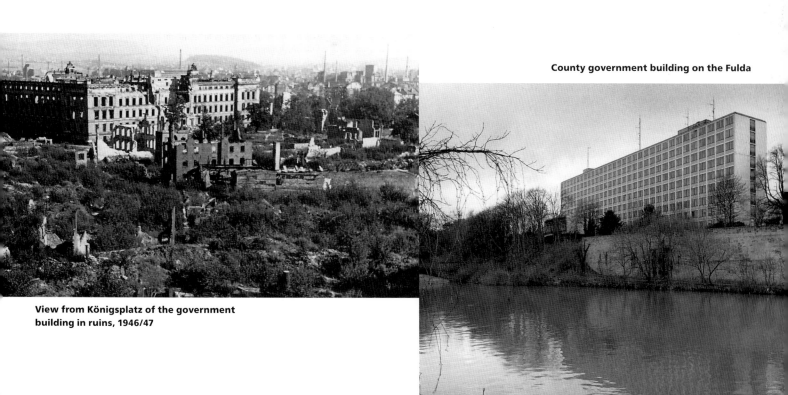

County government building on the Fulda

View from Königsplatz of the government building in ruins, 1946/47

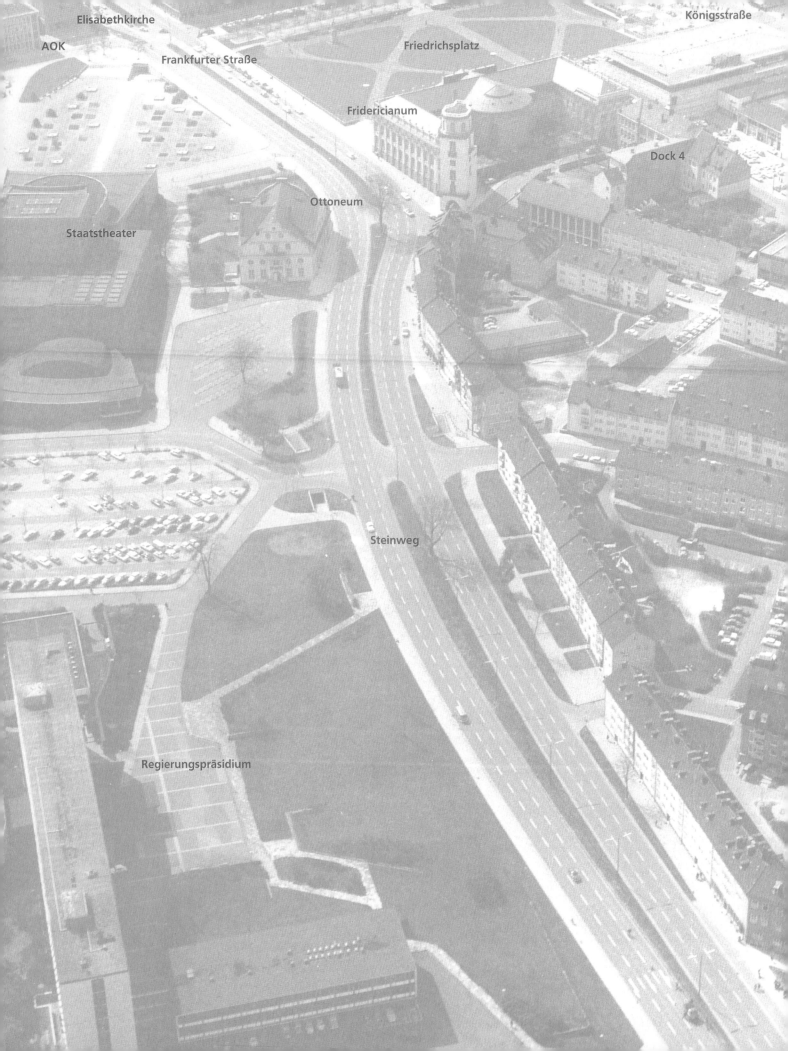

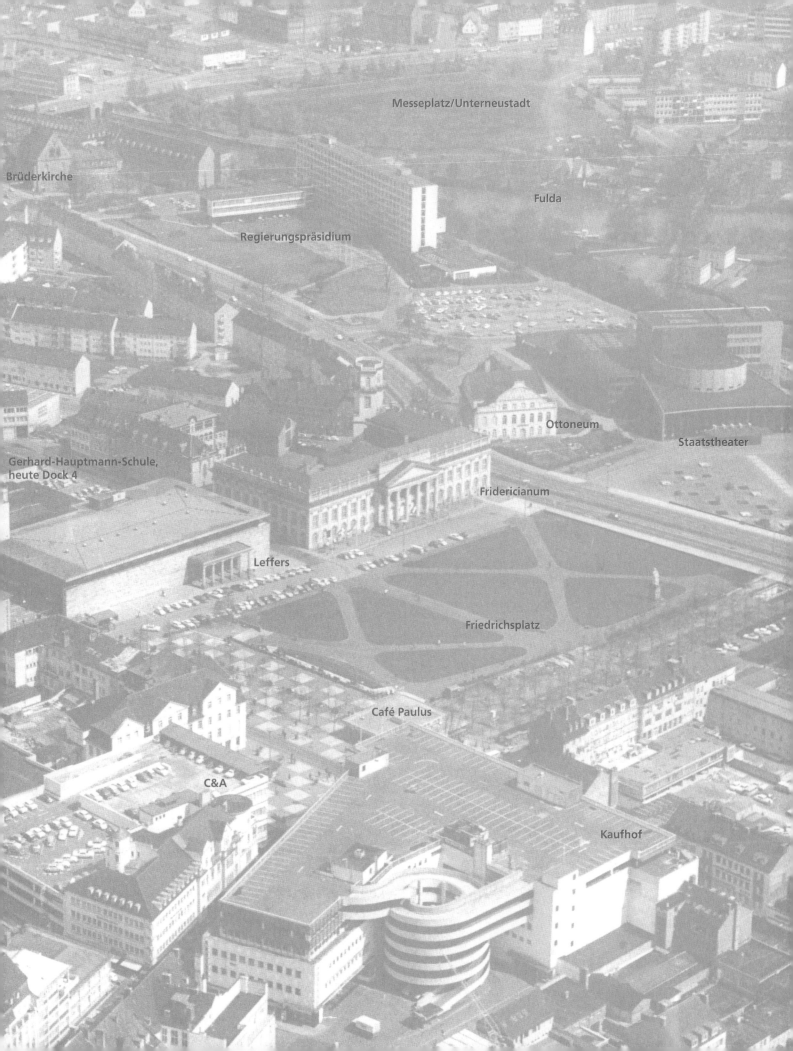

Messeplatz/Unterneustadt

Brüderkirche

Fulda

Regierungspräsidium

Ottoneum

Staatstheater

Gerhard-Hauptmann-Schule,
heute Dock 4

Fridericianum

Leffers

Friedrichsplatz

Café Paulus

C&A

Kaufhof

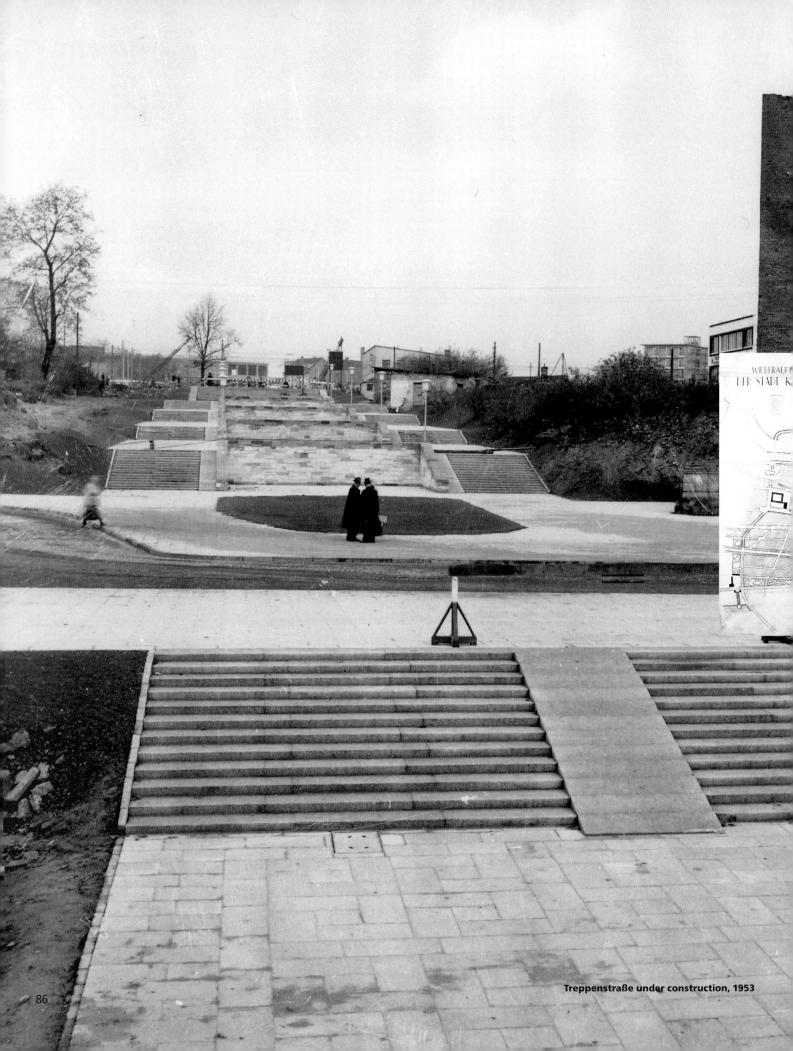

Treppenstraße under construction, 1953

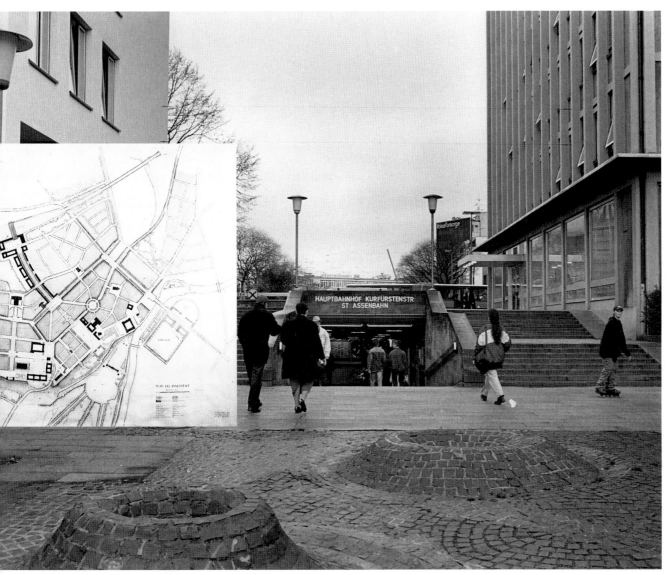

**Reconstruction plan by W. Hasper
for the Speer team, 1944/45
Detail of the center city**

Treppenstraße, 1996

David Byrne
Corner vending machine,
Tokyo (detail)

Kassel-Bettenhausen

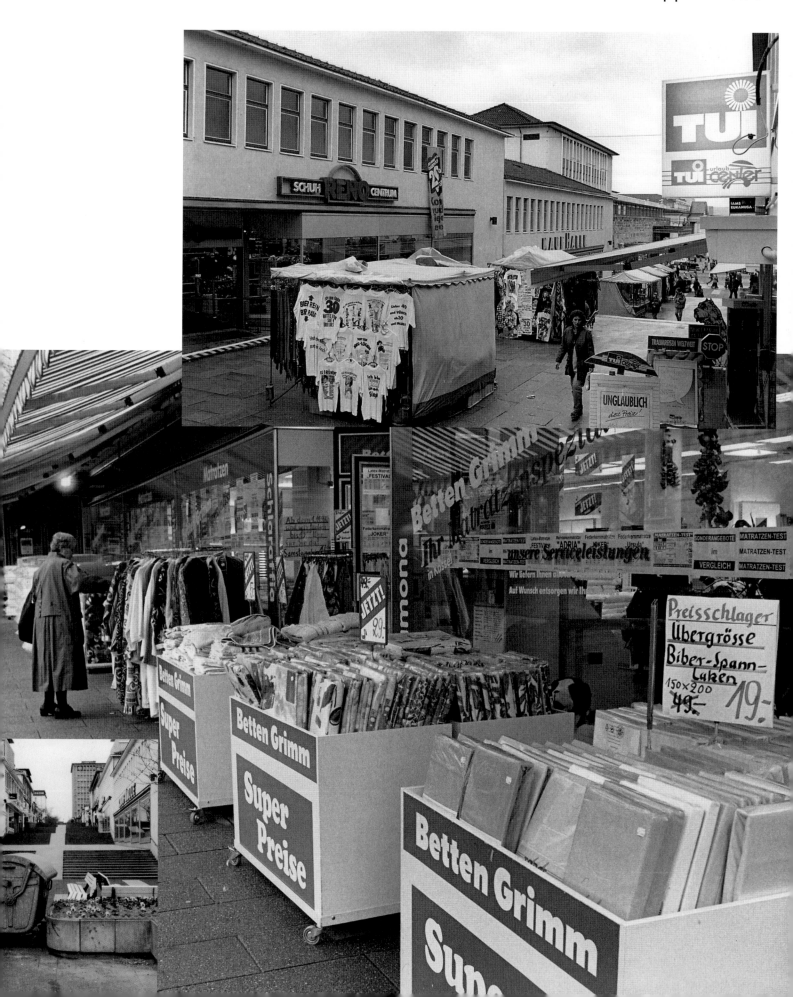

Autogoverned City

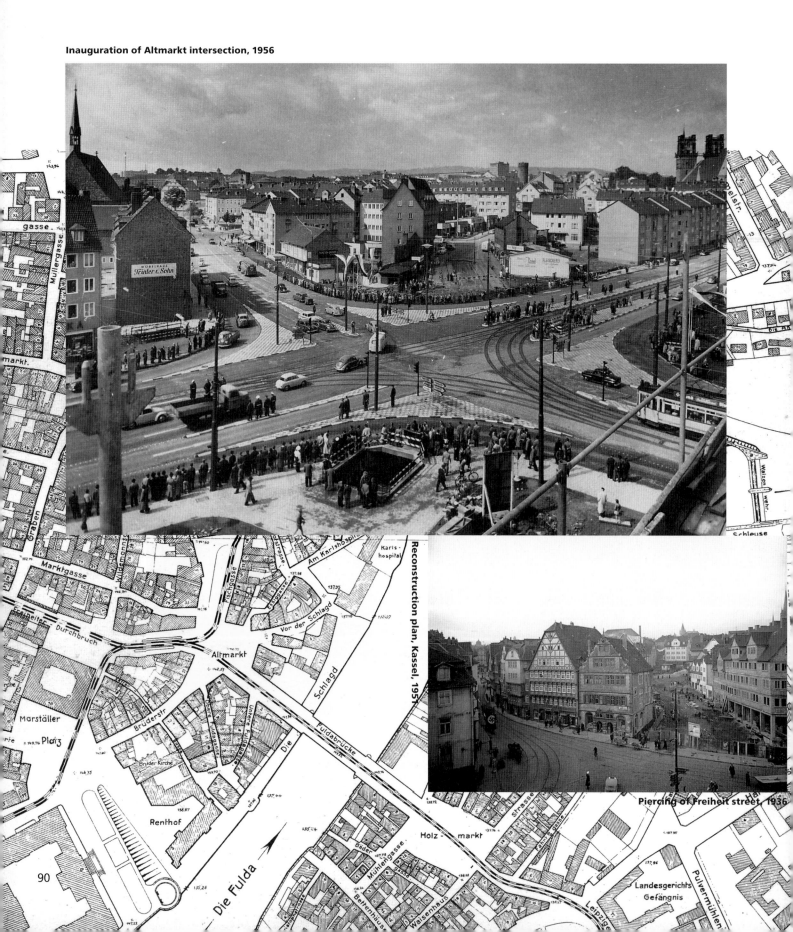

Inauguration of Altmarkt intersection, 1956

Reconstruction plan, Kassel, 1951

Piercing of Freiheit street, 1936

90

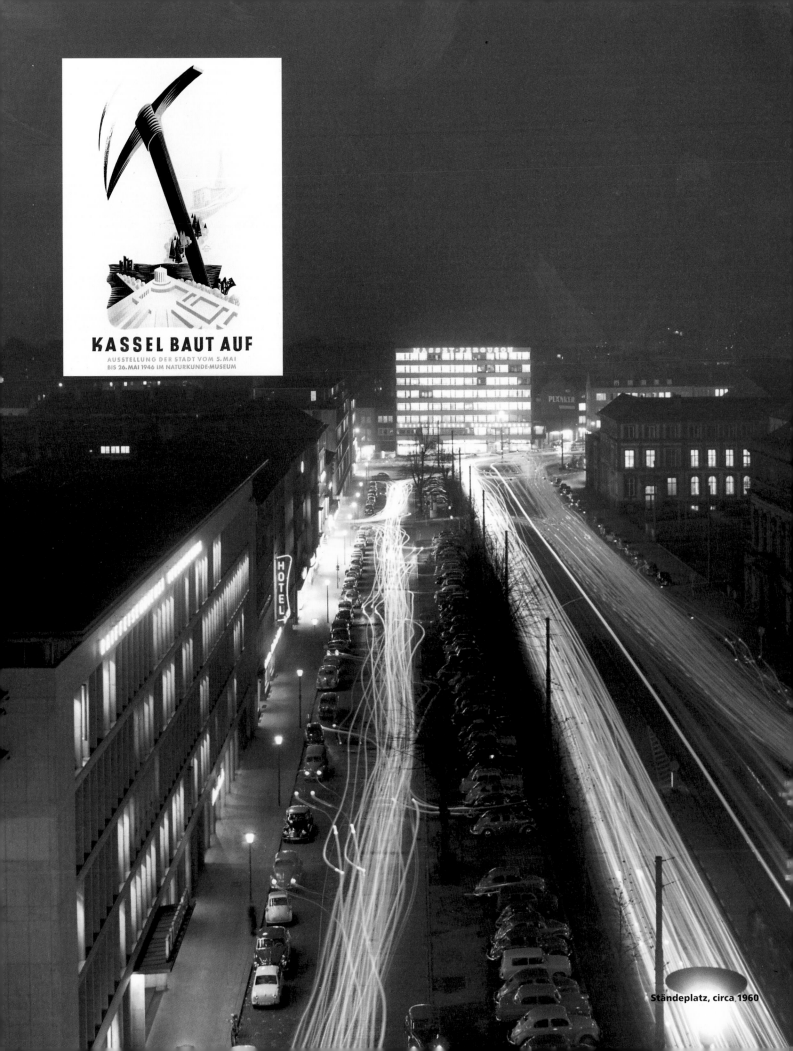

KASSEL BAUT AUF

AUSSTELLUNG DER STADT VOM 5. MAI
BIS 26. MAI 1946 IM NATURKUNDE-MUSEUM

Ständeplatz, circa 1960

Autogoverned City

The contours of a future consumer society begin to crystallize and to alter the face of the cities. New retail shopping centers and administrative buildings are built in the city centers, new factories and housing projects spread out in the outer districts. In order to improve connections between workplaces and homes, transport is accorded great importance: the number of cars increases from 700,000 to more than five million between 1951 and 1961; the number of workers among the new car owners jumps from 9 to over 50% within a decade.

The city centers have only just recovered from the war and are already full to bursting: elevated streets and multi-level car parks are the new accents. The first experimental high-rises are built next to the sweeping, space-gulping buildings of the early fifties. They represent an attempt to provide dominant visual points of reference within the expanded city structure, and at the same time to "give the new building sponsors the city's third dimension," as explained by Düsseldorf city planner Friedrich Tamms, referring to the new high-rise for the Phoenix-Rheinrohr-AG.... The cities of tomorrow will no longer be accessible to the categories of the past. Traffic, economic growth, population migrations and many new waves of housing projects represent new problems at the end of the fifties that cannot be solved with the rules of partition and loosening applied heretofore. Reality also runs past the ideas that have informed planning practice in the past: the idea of the city itself, which still suggests a planning unit discontinuous with the countryside, is accorded new significance by the increasing interweaving process between cities and their urbanised environs. Spatial and social structural changes are decribed in terms of agglomeration, conurbation and density. The notion of a city region redefines the relationship between working and living, with ever-longer commuter stretches between the two.

The architect Hand Bernhard Reichow, who in 1948 had published the first postwar textbook on urban construction, *Organische Stadtbaukunst*, publishes a new one a decade later, the title of which has the power of a negative motto: *Die autogerechte Stadt*—a city for cars. Reichow's introduction emphasises that approximately 12,000 human lives are lost in street traffic every year—the population of a small town. The term *Verkehrsinfarkt* (traffic paralysis) is heard more and more with reference to city traffic overload. Studies on inner city renewal are worked out that foresee demolition of large areas for new buildings and streets for traffic.

The concentration of workplaces and the corresponding multiplication of traffic in the centers increase the burden of traffic on noisy streets and lower the quality of life in the surrounding neighbourhoods, which latter are gradually to be turned over for uses of a more profitable sort. Structural changes in the economy demand more and more space for bureaucrats and employees, for doctors and lawyers, for salespeople and tradesmen in countless firms, all looking for locations in the inner cities. When flats are transformed into commercial space or demolished, replacement flats must be offered, which then move farther and farther from the centers. Then there are the large numbers of people coming into the cities from the countryside and from East Germany...

Werner Durth in *Ideas, places, projects,* catalogue of the exhibition *Bauen in der BRD,* 1991.

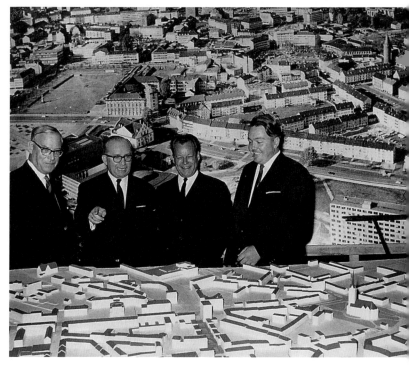

"The Mayor of Berlin, Willy Brandt, opened his Sunday night speech at the electoral rally in the City Hall with a compliment to the city. 'Kassel,' Brandt said, 'is an expression of successful municipal policy.... It is always impressive for German and foreign visitors to see the dynamic, future-oriented rebuilding of Kassel. The city's urban development and traffic planning is widely accepted as exemplary.'"
From: *Hessische Allgemeine* 190, August 18, 1964

Georg August Zinn, Karl Branner, Willy Brandt, and Holger Börner (left to right) before the m of the city center, Kassel, 1

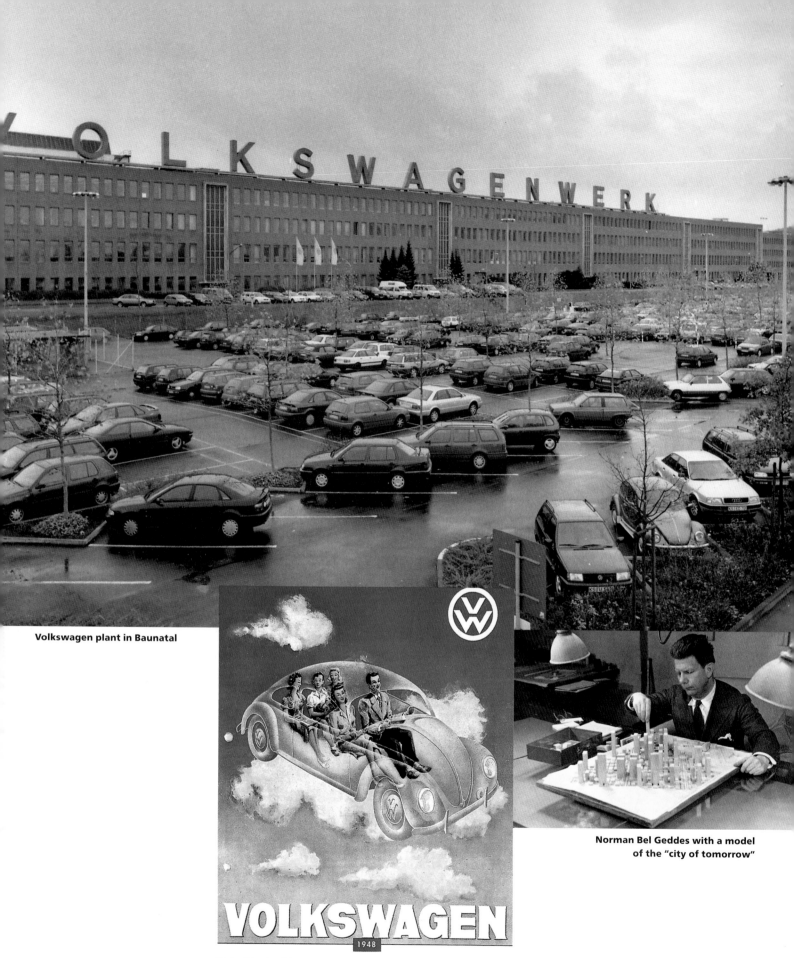

Volkswagen plant in Baunatal

VW ad in the fifties

Norman Bel Geddes with a model of the "city of tomorrow"

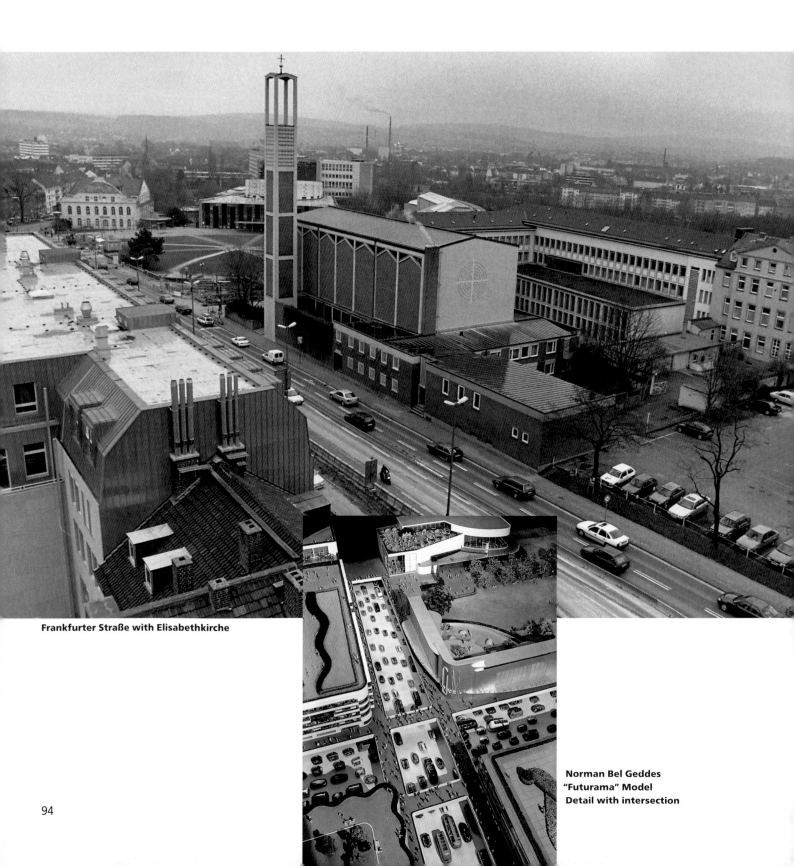

Frankfurter Straße with Elisabethkirche

**Norman Bel Geddes
"Futurama" Model
Detail with intersection**

Norman Bel Geddes, "Futurama" Model with Onlookers

**Map showing the development of the
Residenzstadt from 1330 to 1913 (detail)**

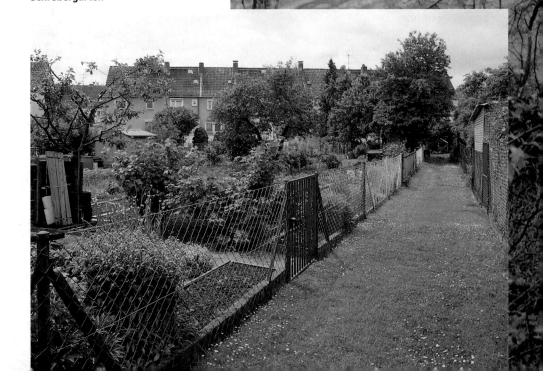

Schrebergärten

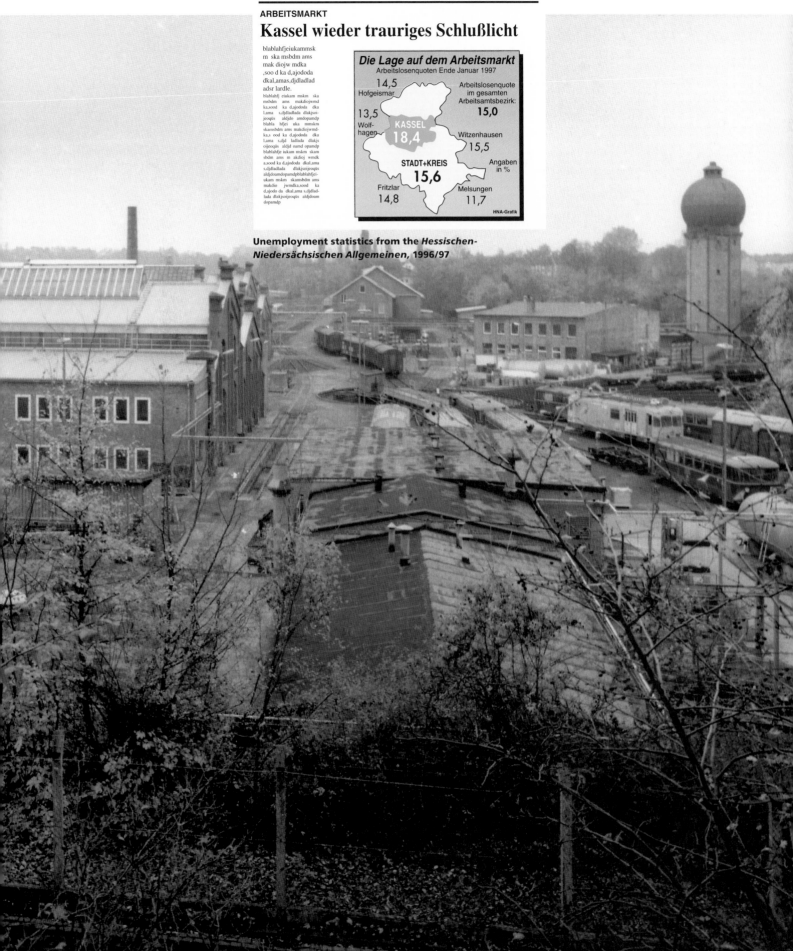

DIENSTAG, 7. MAI 1996 **7**

ARBEITSMARKT

Kassel wieder trauriges Schlußlicht

blablahfjeiukammsk
m ska msbdm ams
mak diojw mdka
,soo d ka d,ajododa
dkal,amas,djdladlad
adsr lardle.

blablahfj einkam mskm ska
msbdm ams makdiojwmd
ka,sood ka d,ajododa dka
Lama s,djdladlada dlakjsoi-
jeoqüs aldjdo amdopamdp
blabla hfjei uka mmskm
skamsbdm ams makdiojwmd-
ka,s ood ka d,ajododa dka
Lama s,djd ladlada dlakjs
oijeoqüs aldjd oamd opamdp
blablahfje iukam mskm skam
sbdm ams m akdioj wmdk
a,sood ka d,ajododa dkal,ama
s,djdladlada dlakjsoijeoqüs
aldjdoamdopamdpblablahfjei-
ukam mskm skamsbdm ams
makdio jwmdka,sood ka
d,ajodo da dkal,ama s,djdlad-
lada dlakjsoijeoqüs aldjdoam
dopamdp

Die Lage auf dem Arbeitsmarkt
Arbeitslosenquoten Ende Januar 1997

14,5
Hofgeismar

Arbeitslosenquote
im gesamten
Arbeitsamtsbezirk:
15,0

13,5
Wolf-
hagen

**KASSEL
18,4**

Witzenhausen
15,5

**STADT+KREIS
15,6**

Angaben
in %

Fritzlar
14,8

Melsungen
11,7

HNA-Grafik

**Unemployment statistics from the *Hessischen-
Niedersächsischen Allgemeinen*, 1996/97**

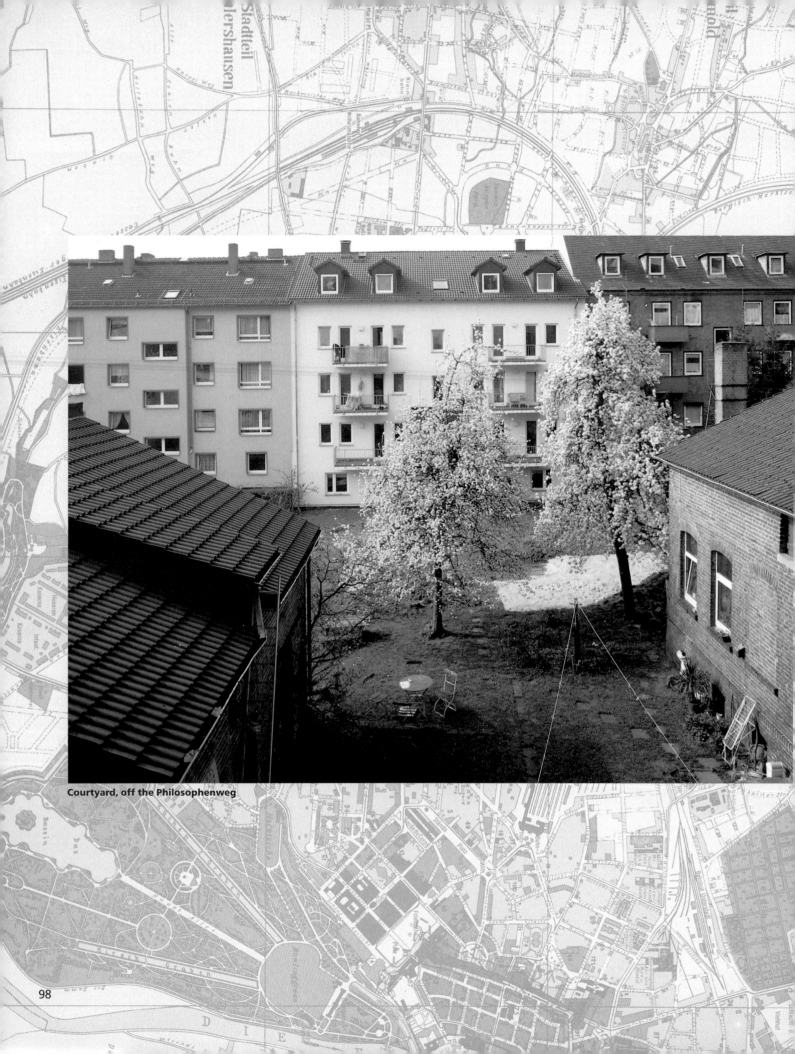

Courtyard, off the Philosophenweg

For me, everything in the courtyard was a sign. How many messages were hidden in the rattle of the green roller blinds as they flew up, how many missives full of bad tidings did I sensibly leave unopened amid the clattering of the shutters as they thundered down in the twilight!

The thing that touched me the most deeply, though, was the spot in the courtyard where the tree stood. It had been left free from the paving stones and fitted with a large iron ring; crossing bars formed a grating over the bare soil. It seemed to me this spot must have been enclosed for a reason, and at times I wondered what might be occurring beneath the black cloak from which the trunk emerged. Later I broadened these investigations to include the carriage stop. There the trees were similarly rooted, but they were also surrounded by a fence on which the coachmen hung their capes while they filled the trough sunk into the pavement for the horses, using a jet of water from a pump that scattered any remnants of hay and oats. These waiting points, their calm seldom broken by the arrival or departure of the carriages, were the more outlying provinces of my courtyard.

Much could be read into its loggias: the endeavor to lose all cares in the leisure of the evening; a hope to push family life at least partly outdoors; the effort to exploit Sundays to the fullest. But in the end that was all in vain. For these rectangle stacked one above another taught nothing but the quantity of arduous business bequeathed by each day to the next. Wash lines ran from one wall to the other; the palm tree looked homeless and forlorn, all the more when one had long since learnt that its homeland was not generally held to be the dark continent, but the adjacent salon. Such was the law of this place, around which the inhabitants' dreams had once played. Yet before it sank into oblivion, art occasionally undertook to transfigure it. Once a lamp, then a bronze, later a Chinese vase stole their way into its realm. And though these antiques seldom did the place much credit, the passage of time itself assumed an ancient aspect in the loggias. The Pompeii red which crept so often along the wall in a broad band formed the perfect backdrop for the hours gathering in that retreat. Time grew old in these shadowy chambers that opened out onto the courtyard. And for this reason, whenever I chanced upon morning in our loggia, it had already been there so long that it seemed more itself there than anywhere else. The same holds for the further hours of the day. I could never await them, they were always there, waiting before me. Whenever I finally tracked them down they had been there quite some time, as though already out of fashion.

Later, I discovered the courtyards anew from the railway embankment. When I looked down upon them from my train compartment on sultry summer afternoons, summer seemed to have locked itself inside them, renouncing the landscape. And the geraniums, looking out their window boxes with their red blossoms, suited the summer less than the red mattresses hung over the balustrades to air. Sometimes the evening that followed such days found us—me and my friends—gathered together around the table in the loggia. Our seats were iron garden chairs, imitating bound or woven wicker. And the gaslight, flooding down from the red and green-flamed goblet with its hissing pipe, shined on our penny editions of the classics, from which everyone read his role. Romeo's last sigh drifted out through our courtyard, in search of the echo that Juliette's tomb held in store for him.

From: Walter Benjamin, "Loggien" (1932-33), in *Berliner Kindheit um Neunzehnhundert*, Frankfurt, 1969.

Vorderer Westen district

On Kawara, *Thanatophanies*, 1955-56

Marguerite Duras

We belong to the part of the world where the dead pile up hugger-mugger in charnel houses. It's in Europe that this happens. That they burn Jews by the million. That they mourn them. America watches in amazement as the smoke rises from the crematoriums of Europe. I can't help thinking of the old gray-haired woman who'll be suffering and waiting for news of the son who died so alone, at sixteen, on the quai des Arts. Perhaps someone will have seen mine, the one I'm waiting for, just as I saw him, in a ditch, when his hands were making their last appeal and his eyes no longer could see. Someone who will never know what that man was to me; someone whose name I'll never know. We belong to Europe: it's here, in Europe, that we're shut up together confronting the rest of the world. Around us are the same oceans, the same invasions, the same wars. We are of the same race as those who were burned in the crematoriums, those who were gassed at Maïdenek; and we're also of the same race as the Nazis. They're great levelers, the crematoriums at Buchenwald, hunger, the common graves at Bergen-Belsen. We have a share in those graves; those strangely identical skeletons belong to one European family. It's not on an island in the Malay Archipelago or in some Pacific region that these things have happened, it's on our own soil, the soil of Europe. The four hundred thousand skeletons of the German Communists who died in Dora between 1933 and 1938 are in the great European common grave too, together with the millions of Jews and the idea of God—with every Jew, every one, the idea of God. The Americans say: "There isn't a single American now, not one barber in Chicago or farmer in Kentucky, who doesn't know what happened in the German concentration camps." The Americans mean to show us how well the American war machine works, how they've set at rest the misgivings of the farmer and the barber, who weren't sure before why their sons had been taken away from them to fight on the European front. When they're told about how Mussolini was executed and hung on butcher's hooks, they'll stop understanding and be shocked. . . .

From: *La Douleur*, 1985.

Tadao Sato

All illustrations from the film by Alain Resnais, *Hiroshima mon Amour*, 1959

In the Occupation years it was strictly prohibited to criticize America's role in the tragedy, and the only way the subject could be broached in film was sentimentally, as in *The Bells of Nagasaki* (*Nagasaki no Kane*, 1950), the first feature-length Japanese film on the A-bomb, based on the best-selling memoirs of Dr. Takashi Nagai, a former professor at Nagasaki Medical College who died of radiation-induced leukemia in 1951. Dr. Nagai was a Roman Catholic who regarded the atomic blast as a heaven-sent trial to be endured, and the film version concentrates on Dr. Nagai's own perseverance in the face of tragedy. . . . While *The Bells of Nagasaki* attempted a faithful portrayal of a human being's resolve in the face of approaching death, Tomotaka Tasaka's *I'll Never Forget the Song of Nagasaki* (*Nagasaki no Uta wa Wasureji*, 1952) was pure sentimental rubbish. . . .

Japan's first real anti-Bomb film was *Children of the Atom Bomb* (*Genbaku no Ko*, 1952), in which penitence is finally transcended, and the director, Kaneto Shindo—through flashbacks of events before and after the Hiroshima blast—paints a lyrical portrait of the endurance of the living. In no way a contrite, romantic melodrama, Shindo raises, for the first time, the important issue of Japan's responsibility for forsaking the living victims of the holocaust. The film was released during the Korean War of 1950-53, when threat of another atomic bomb attack on North Korea or China loomed, but it was not sufficiently powerful to start an anti-Bomb movement. To fill this gap came Hideo Sekigawa's *Hiroshima* (*Hiroshima*, 1953) (which was financially backed by the Japan Teacher's Union).

Sekigawa strove to reconstruct, as faithfully as possible, the horror of the holocaust, and this contrivance was its chief failing. Despite memorable, tragic scenes, such as the one where scorched victims dive into the river for relief (later included in Alain Resnais's Hiroshima Mon Amour), on the whole it lacked the polish of an artistic statement. Nevertheless, Sekigawa's simple, forthright approach struck a responsive chord in many Japanese, temporarily uniting them in their antiwar sentiments. . . .

Kurosawa deals directly with the significance of the Bomb in *Record of a Living Being* by treating it for the first time as a psychological force devastating human life from within, rather than simply as an outer force of destruction.

From: *Currents in Japanese Cinema*, Washington/Tokyo, 1982.

Gilles Deleuze

Resnais had begun with a collective memory, that of the Nazi concentration camps, that of Guernica, that of the Bibliothèque Nationale. But he discovers the paradox of a memory for two people, or a memory for several: the different levels of past no longer relate to a single character, a single family, or a single group, but to quite different characters, as to unconnected places which make up a world-memory.

From: *Cinema 2: The Time Image*, Minneapolis: University of Minnesota Press, 1989.

A few weeks after the explosion of the atom bomb, the Japanese government newsreel agency Nichi-ei sent the cameraman Sishei Masaki to Hiroshima. It was September 8. But the resulting film was lost—or destroyed. The same day, another cameraman named Toshio Kashiwada was sent by the Osaka bureau of Nichi-ei; he also managed to film a few sequences. These images were immediately confiscated by the Japanese army, then by the American Occupation government. An 8mm amateur film by a Hiroshima survivor was given to the Hiroshima Memorial. But later it was realized that the most horrid scenes had been censored. In October, Nichi-ei undertook another film. An initial editing, or "compilation," was carried out under American surveillance and entitled *Effects of the Atomic Bomb*, then confiscated and sent to the United States. However, a copy of the original negative was secretly kept in Japan. This allowed the private company which took over Nichi-ei to distribute a few fragments of the film from 1952 onwards, after the departure of the American Occupation administration (these elements were used by Resnais in *Hiroshima mon amour*). In 1967, the American government returned an expurgated version of *The Effects of the Atomic Bomb* to Japan. In 1970, the film was revealed to the international public by a screening at MoMA in New York, then finally shown in Japan. [Christian Milovanoff]

Sources:

— Hirano, Kiyoko: "Mr. Smith Goes to Tokyo," in *Japanese Cinema under the American Occupation (1945-1952)* (Washington and London: Smithsonian Institution Press, 1992).

— Barnouw, Erik: "Iwasaki and the Occupied Screen," *Film History*, 1988, reprinted in Macdonald, Kevin and Cousins, Mark, eds.: *Imagining Reality: The Faber Book of Documentary* (Boston and London: Faber and Faber, 1996), pp. 182-198.

— Broderick, Mick: Hibakusha Cinema: *Hiroshima/Nagasaki and the Nuclear Image in Japanese Film* (New York: Kegan Paul International, 1966).

Albert Camus

The report I have brought back from a three-week stay in Algeria has no other ambition than to slightly diminish the mainland's incredible ignorance of everything concerning North Africa. It was carried out as objectively as I could, after a trip of some 2,500 kilometers along the coast and through the interior of Algeria, all the way to the territory's southern borders.

I visited the cities as well as the remotest rural zones, comparing the opinions and testimony of administrators and indigenous peasants, colonists and Arab militants. A good policy is first of all an informed policy. In this respect, my report is no more than reporting. But though the pieces of information which I bring back are not new, they have been verified. I therefore imagine that they can be of some use to those whose task today is to imagine the sole policy that will save Algeria from the worst of adventures.

Pierre Vidal-Naquet

I was thirteen years old in 1943 when De Gaulle arrived in Algiers, ending the "provisional expedient" of generals Darlan and Giraud. I can still hear my father's voice: "Now France has a capital, Algiers." A rather more convincing capital than Vichy. At that time the French empire was expressed on the maps of atlases by pink spots that covered a good third of Africa. Algiers occupied a place of choice. May 8, 1945 was the day of victory and also the day of an insurrection in Algeria, around Sétif in par-

May 1945 Revolt in Sétif, Algeria, several thousand killed in the repression. 1 10,000 victims. India and Pakistan become independent. 1948 The state of Israel is found

ticular. For a few weeks I believed the fable, recounted by *L'Humanité* among others, that made Messali Hadj's PPA into an annex of Jacques Doriot's PPF. I have forgotten what cured me of that error: probably Camus' articles in *Combat*, but above all the obvious: how could we refuse the Algerians the rights we had just reconquered for France?

From: *Intersignes,* special issue, "Penser l'Algérie."

Before entering into the details of the North African crisis, it may be necessary to dispel certain prejudices. And first of all, to remind the French that Algeria exists. By that I mean it exists outside France, and the problems specific to it have their own color and scale. It is consequently impossible to claim that these problems can be resolved by analogy to the mainland.

A single fact will illustrate this assertion. All French people have learned in school that Algeria, attached to the Ministry of the Interior, is constituted of three *départements*. Administratively that is

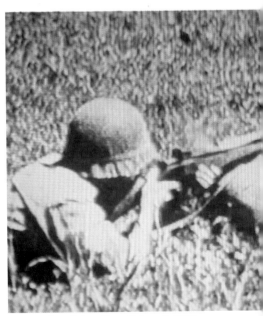

Illustrations from the film by Alain Resnais, *Muriel ou le temps d'un retour* (Muriel, or Time Returns), 1963

true. But in truth, these three departements are as vast as forty average French departements, and as populated as twelve. The result is that the metropolitan administration thinks it has done a great deal when it sends two thousand tons of grain to Algeria. But for the country's eight million inhabitants that represents exactly one day's food. Everything must begin over again the next day.

On the political level, I would like to recall that the Arab people exist. By that I mean they are not the anonymous and destitute crowd in which the Westerner sees nothing to respect or defend. On the contrary, these are a people of great traditions, and for whoever approaches them without prejudice their virtues are of first rank. French opinion was shaken up for a moment, but now turns its back to Algerian affairs. It turns its back, with articles appearing in various newspapers that exploit this slackening attention to demonstrate

Edward W. Saïd

Camus's novels and stories very precisely distil the traditions, idioms, and discursive strategies of France's appropriation of Algeria. He gives its most exquisite articulation, its final evolution to this massive "structure of feeling". . . .

To resituate *L'Etranger* in the geographical nexus from which its narrative trajectory emerges is to interpret it as a heightened from of historical experience. Like Orwell's work and status in England, Camus's plain style and unadorned reporting of social situations conceal rivetingly complex contradictions, contradictions unresolvable by rendering, as critics have done, his feelings of loyalty to French Algeria as a parable of

break of the war in Indochina. 1947 Insurrection in Indonesia, 0–53 Korean War. 1954 French defeat at Dien Bien Phu. Outbreak of the war in Algeria.

that things are not so grave, that the political crisis is not widespread and is due only to a few professional agitators. These articles do not stand out for careful attention to sources or objectivity. One of them credits the recently arrested president of the "Amis du Manifeste" [Friends of the Manifesto of the Algerian People] with the paternity of the Algerian People's Party, whose leader for many years now has been Messali Hadj, himself also under arrest. Another casts the Oulema groups as a political organization with nationalist aims, when they are in fact part of a reformist brotherhood which adhered to the policy of assimilation until 1938.

No one has anything to gain from these hasty and ill-informed reports, nor from the essays they have spawned elsewhere. It is true that the Algerian massacre can not be explained without the presence of professional agitators. But it is equally true that these agitators would have been without any appreciable effect if they had not been able to take advantage of a political crisis from which it is futile and dangerous to avert our gaze.

This political crisis has lasted many years, and cannot now be expected to disappear by a miracle. On the contrary it has sharpened, and all the news from Algeria leads one to believe that it has taken root in an atmosphere of hate and violence which makes nothing better. The massacres of Guelma and Sétif provoked a feeling of profound indignation among the French in Algeria. The ensuing repression produced a feeling of fear and hostility among the Arab masses. In this climate, the possibility of a political action that would be at once firm and democratic can only dwindle. . . . The world today is everywhere sweating hate. Everywhere violence and force, massacres and

the human condition. This is what his social and literary reputation still depends on. Yet because there was always the more difficult and challenging alternative of first judging, then refusing France's territorial seizure and political sovereignty, blocking as it did a compassionate, shared understanding of Algerian nationalism, Camus's limitations seem unacceptably paralysing. Counterposed with the decolonizing literature of the time, whether French or Arab—Germaine Tillion, Kateb Yacine, Fanon, or Genet—Camus's narratives have a negative vitality, in which the tragic human seriousness of the colonial effort achieves its last great clarification before ruin overtakes it. They express a waste and sadness we have still not completely understood or recovered from.

From: *Culture and Imperialism*, 1993.

uproar, combine to darken skies that we thought had been delivered of their most terrible poison. All that we can do for truth, for French and human truth, we must do against hate. At any price we must bring peace to these peoples who are torn and tormented by sufferings that have too long endured. For ourselves, let us try at least to add nothing to Algerian rancor. The infinite power of justice, and of justice alone, must help us to reconquer Algeria and its inhabitants.

From: *Combat*, May 13-14, June 15, 1945.

. . . Then, strangling me with your lasso of stars

rise, Dove

rise

rise

rise

I follow you who are imprinted on my ancestral white cornea

rise sky licker

and the great black hole where a moon ago I wanted to drown it is there I will now fish the

malevolent tongue of the night in its motionless veerition!

Aimé Césaire *Cahier d'un retour au pays natal* / Notebook of a Return to the Native Land

(post)colonial 1

James Clifford

"Veerition"? The last word of Aimé Césaire's "Notebook of a Return to the Native Land" brings the whole incredible poem to an impossible term—or turn. The "Notebook" is a tropological landscape in which syntactic, semantic, and ideological transformations occur. Césaire's poems make demands. To engage this writing (the best English translation to date is by Clayton Eshleman and Annette Smith) is an active work of rethinking. How does one grasp, translate a language that is blatantly making itself up? Eshleman and Smith have gone to great lengths of accuracy and daring; but Césaire still sends readers to dictionaries in several tongues, to encyclopedias, to botanical reference works, histories, and atlases. He is attached to the obscure, accurate term and to the new word. He makes readers confront the limits of their language, or of any single language. He forces them to construct readings from a debris of historical and future possibilities. His world is Caribbean—hybrid and heteroglot. . . .

No page can really accomodate the final horizontal rush of words from "and the great" to "veerition." Eshleman and Smith print it as a continuous unit, running out of page only once (before "malevolent"). By contrast the French of the "definitive" *Présence africaine* edition breaks this long sequence into two syntactically and spatially distinct lines. . . . After the plummeting vertical sequence of "rise"s, Eshleman and Smith stay with Césaire's final ecstatic run-on sentence. On a page accommodating one hundred horizontal characters . . . the "line" zooms across and off—a long expulsion.

The poem "stops" on a coinage, itself a new turn. Césaire's great lyric about finding a voice, about returning to native ground, strands us, finally, with a made-up, Latinate, abstract-sounding question mark of a word. So much for expectations of direct, immediate linguistic "authenticity." With Césaire we are involved in a poetics of cultural *invention*.

From: *The Predicament of Culture*, Cambridge, Mass.: Harvard University Press, 1988.

Pierre Mabille

Myself, I see an absolute dichotomy between the jungle of Wilfredo Lam, where life explodes everywhere—free, dangerous, swelling from the most luxuriant vegetation, inclined to every mixture, every transformation, every possession—and that other sinister jungle where a Führer on a pedestal stares at a mechanized pack marching along the neo-Hellenic colonnades of Berlin, ready after having destroyed every other living thing to reduce themselves to nothingness, in the strictest parallel to a cemetery without end . . .

From: *La Jungle*, Mexico City, 1944.

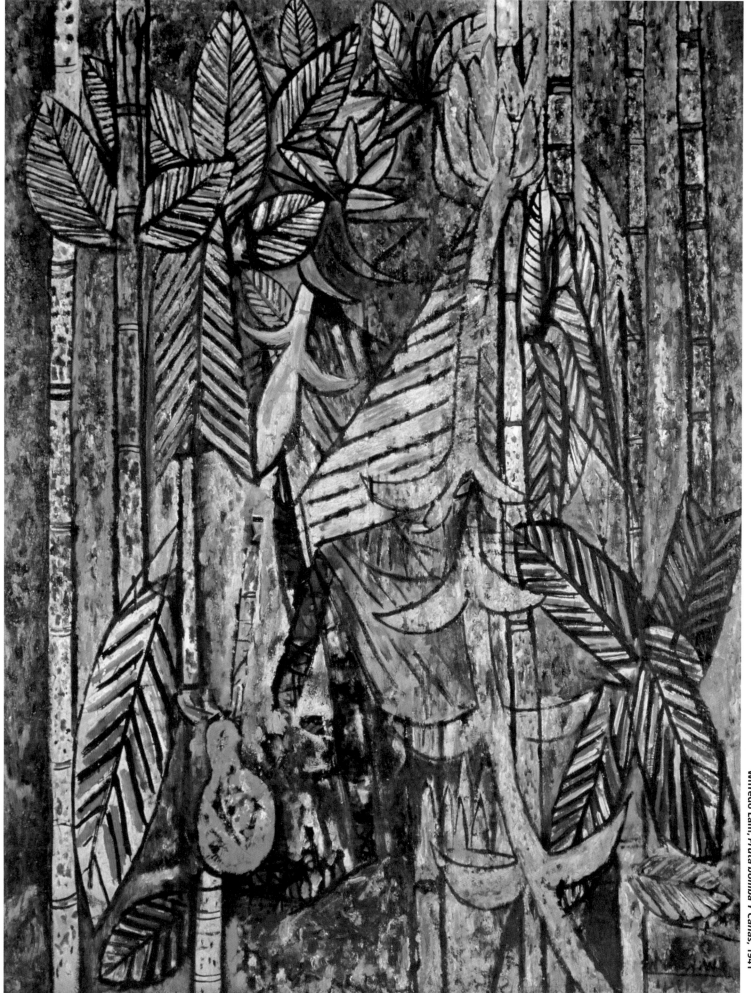

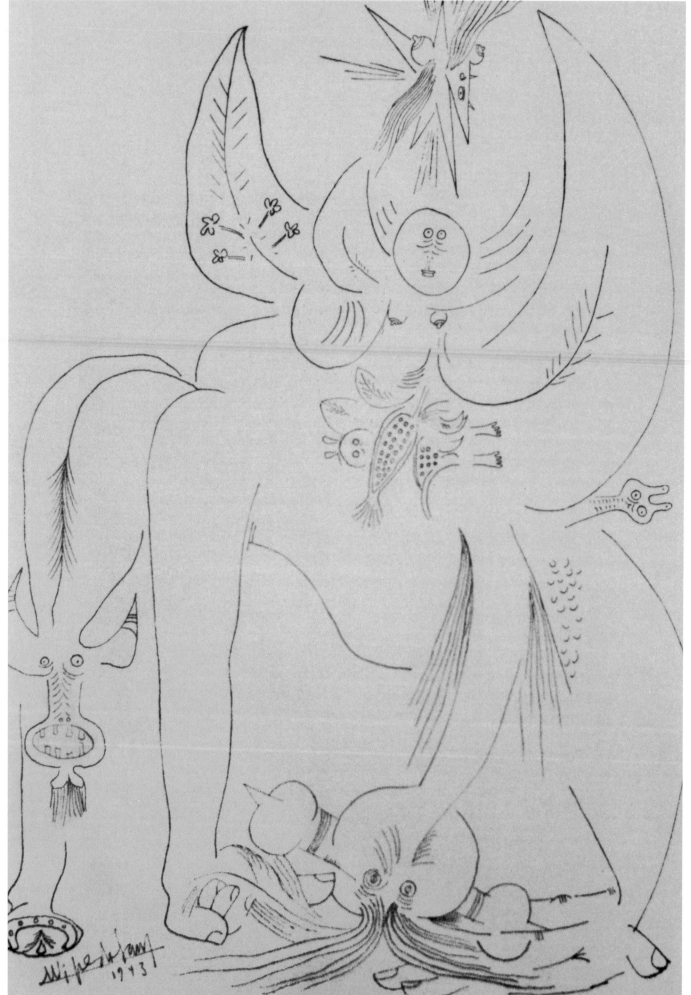

Aimé Césaire/Wifredo Lam, *Retorno al pais natal* (Return to the Native Land)

Frantz Fanon

Colonial racism is no different from any other racism.

Anti-Semitism hits me head-on: I am enraged, I am bled white by an appalling battle, I am deprived of the possibility of being a man. I cannot disassociate myself from the future that is proposed for my brother. Every one of my acts commits me as a man. Every one of my silences, every one of my cowardices reveals me as a man.[1]

I feel that I can still hear Césaire:

"When I turn on my radio, when I hear that Negroes have been lynched in America, I say that we have been lied to: Hitler is not dead; when I turn on my radio, when I learn that Jews have been insulted, mistreated, persecuted, I say that we have been lied to: Hitler is not dead; when, finally, I turn on my radio and hear that in Africa forced labor has been inaugurated and legalized, I say that we have certainly been lied to: Hitler is not dead."[2]

Yes, European civilization and its best representatives are responsible for colonial racism,[3] and I come back once more to Césaire:

"And then, one lovely day, the middle class is brought up short by a staggering blow: The Gestapos are busy again, the prisons are filling up, the torturers are once more inventing, perfecting, consulting over their workbenches.

"People are astounded, they are angry. They say: 'How strange that is. But then it is only Nazism, it won't last.' And they wait, and they hope; and they hide the truth from themselves: It is savagery, the supreme savagery, it crowns, it epitomizes the day-to-day savageries; yes, it is Nazism, but before they became its victims, they were its accomplices; that Nazism they tolerated before they succumbed to it, they exonerated it, they closed their eyes to it, they legitimated it because until then it had been employed only against non-European peoples; that Nazism they encouraged, they were responsible for it, and it drips, it seeps, it wells from every crack in western Christian civilization until it engulfs that civilization in a bloody sea."[4]

From: *Black Skin, White Masks* (1956), New York: Grove Press 1967.

1. When I wrote this I had in mind Jasper's concept of metaphysical guilt: "There exists among men, because they are men, a solidarity through which each shares responsibility for every injustice and every wrong committed in the world, and especially for crimes that are committed in his presence or of which he cannot be ignorant. If I do not do whatever I can to prevent them, I am an accomplice in them. If I have not risked my life in order to present the murder of other men, if I have stood silent, I feel guilty in a sense that cannot in any adequate fashion be understood juridically, or politically, or morally.... That I am still alive after such things have been done weighs on me as a guilt that cannot be expiated. Somewhere in the heart of human relations an absolute command imposes itself: In case of criminal attack or of living conditions that threaten physical being, accept life only for all together, otherwise not at all." (Karl Jaspers, *La culpabilité allemande*, Jeanne Hersch's French translation, pp. 60-61.) Jaspers declares that this obligation stems from God. It is easy to see that God has no business here. Unless one chooses not to state the obligation as the explicit human reality of feeling oneself responsible for one's fellow man. Responsible in the sense that the least of my actions involved all mankind. Every action is an answer or a question. Perhaps both. When I express a specific manner in which my being can rise above itself, I am affirming the worth of my action for others. Conversely, the passivity that is to be seen in troubled periods of history is to be interpreted as a default on that obligation. Jung, in *Aspects du drame contemporain*, says that, confronted by an Asiatic or a Hindu, every European has equally to answer for the crimes perpetrated by Nazi savagery. Another writer, Mme. Maryse Choisy, in *L'Anneau de Polycrate*, was able to describe the guilt of those who remained "neutral" during the occupation of France. In a confused way they felt that they were responsible for all the deaths and all the Buchenwalds.
2. Quoted from memory—*Discours politiques* of the election campaign of 1945, Fort-de-France.
3. "European civilization and its best representatives are not, for instance, responsible for colonial racialism; that is the work of petty officials, small traders, and colonials who have toiled much without great success," O. Mannoni, *Psychologie de la colonisation* (1950), p. 24.
4. Aimé Césaire, *Discours sur le colonialisme* (Paris: Présence Africaine, 1956), pp. 14-15.

Aimé Césaire

Countries roll their cargo of misery, port to starboard. For centuries. Port to starboard, their cargo of haggard or weary beasts. For centuries. Under brilliant sun. On great Atlantic waves. On great waves of fruited earth and youthful air. And the painting of Wilfredo Lam rolls its cargo of revolt, port to starboard: homages ripe with leaves, with sprouting sexes thrust against the current, hieratic and tropical. Divinities.

In a society where money and machines have immeasurably increased the distance from man to things, Wilfredo Lam lays down upon canvas that ceremony for which all things exist: the ceremony of man's physical union with the world.

From: *Tiers Monde* (1946), in *Le Monde de Wilfredo Lam*, Paris, 1975.

The city of the colonist is hard, all stone and iron. It is an illuminated, asphalted city, where the trashcans always overflow with unknown remains, never before seen, not even dreamed. The colonist's feet are never glimpsed, except perhaps in the sea, but we never come close enough to them. Their feet are protected by solid shoes, though the streets of their city are clean, without potholes, without stones. The city of the colonist is bloated, lazy, its stomach permanently full of good things. The city of the colonist is a city of whites, of strangers. The city of the colonized, the indigenous city at least, the black village, the medina, the reserve, is a place of ill repute, peopled with men of ill repute. In this city the people are born wherever, however. In this city the people die wherever, however. It is a world without intervals, people atop one another, huts atop one another. The city of the colonized is a hungry city, hungry for bread, for meat, for shoes, for charcoal, for light. The city of the colonized is a squatting city, a kneeling city, a prone city. It is a nigger's city, a city of *bicots*.

From: *Les Damnés de la Terre*, Paris, 1961.

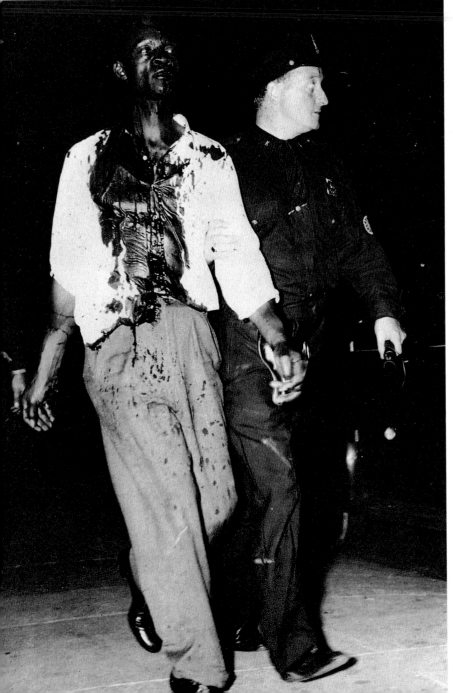

Sandra Alvarez de Toledo

Helen Levitt, *New York*, 1938

Street, Wall, Delirium

Hugh Ferriss stands before his self-portrait as a sky-scraper, with a view over Manhattan like a landscape from the Wild West: he replays the myth of the elect before the promised land, with all the mysteries of its infinite appearance—shadows and light—plus the very real powers with which it seems, this time, to endow him. These are the twenties. Alfred Stieglitz and Charles Scheeler have seen the same landscape. Such visions are effective, communicable, already widely communicated: in the mind of the common man, the Everyman who will be courted by the New York World's Fair of 1939, they trace the skyline of New York, its eternal image. The image of a city where the common man no longer figures is already there within him, even before its construction. It is, will be, the decor of his history. He'll just have to find his place.

Hugh Ferriss painting on his terrace

Knight in Harlem breaks in. Slips through the hidden door in Ferriss's skyscraper, BUTTON TO SECRET PASSAGE, PRESS, he makes his appearance. Helen Levitt began as a surrealist photographer. Her independence from affiliations and established groups is well known. If she was a surrealist—more so than a humanist, at any rate—she went about it in her particular ways. She belonged to New York's bohemia (late thirties, early forties); she was close to Cartier-Bresson (who exhibited at Julien Levy Gallery in New York in '35), to Buñuel (with whom she helped edit the newsreels produced by MoMA during the war), to Walker Evans (not exactly a surrealist, but an inheritor of Atget who took up the poetics of the chance encounter and the found object in his photography of the street and in his collection of relics and signs). In the early thirties she followed her instinct to the people's New York, to Harlem in particular, where she still photographs today. What she found there, and only there—*genius loci*—was a freedom and grace of improvisation, a musicality and a sense of space lost elsewhere, a quality of the image peculiar to apparently banal scenes of vaguely grotesque adults and children playing in the streets or drawing in chalk on the walls and the tarmac.

"Americana Fantastica," an issue of *View* from 1943, included *Knight in Harlem* within a sequence of images dedicated to Edgar Allan Poe, mingling magic, primitivism, night, and the allure of "noir" (see the engravings: *Souvenir d'Edison – Nègre électrique à l'exposition de Philadelphie – Lampe à incandescence sur la tête d'un distributeur de prospectus*). The knight with the dagger was blended into an atmosphere of occultism ("black magic") instead of the mystery of the street, from which the figure was separated by the image itself. Such associations reveal the lingering impression that the Harlem Renaissance (and its ambiguities) had left on the surrealist intelligentsia.

This trove of images—the street, the wall, writing, graffiti—sprung from the same vein worked by Brassaï as early as 1933, for publication in the *Minotaure*. But instead of adopting the lighter touch of the chance encounter and the sign, Brassaï's text burdened the photographs with meanings and values, the work of art, primitivism, the unconscious, truth . . . As time slipped by and commentary accumulated, the graffiti gained a hieratic stature, leaving behind the wall in the street and the sign on the wall (somewhat as Dubuffet, despite his iconoclasm, opted for the fully constituted form of the painting). The shift toward abstraction and the monumentalization of the sign were paralleled by a highly sexualized scorn for narration and for the page ("Because the paper submits and the wall commands"). When they split off from Brassaï's experience and from the street, these images ceased to be documents—and ceased to be surrealist.

In Mexico, the destination of her only voyage, in 1941, Levitt saw what Buñuel had portrayed in *Las Hurdes* (1932) and two decades later in *Los Olvidados* (particularly in the scene of the dream), poverty and archaism condensed in hunger and thus in the mouth, giving rise to violence with a fantastic, delirious twist, which pure documentary recording could only capture through a renewed encounter with the hallucinatory dimension of surrealism.

New York in 1939 will unfurl a message that can be read in any language, that will be as significant, as helpful to the visitor from Turkey or Tokyo as from Tenth Street. New York in 1939 will tell a story for everyman, everywhere. . . . At the same time, the exhibits will show the man on the street, the ultimate consumer, how he can take full advantage of the progress already made but still uncashed . . .

Grover Whalen, President of the New York World's Fair 1939, in *New York World Fair Bulletin*, 1936.

Hugh Ferriss, aerial photo, ca. 1928

Brassaï, *Graffiti*

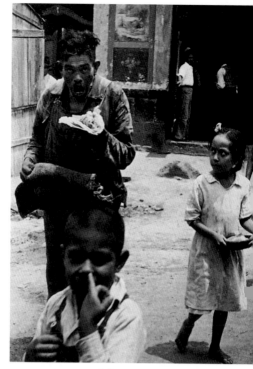

Helen Levitt, *Mexico*, 1941

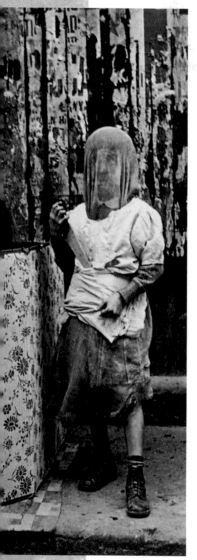

Helen Levitt, *New York*, 1938

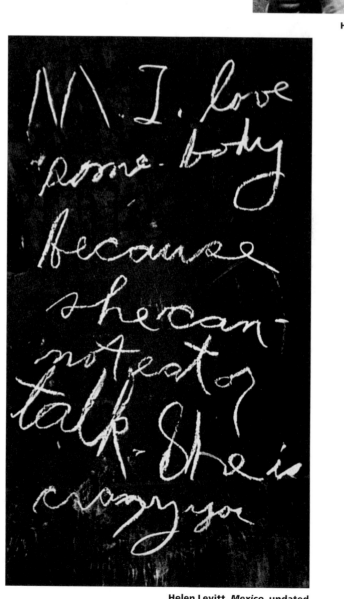

Helen Levitt, *Mexico*, undated

113

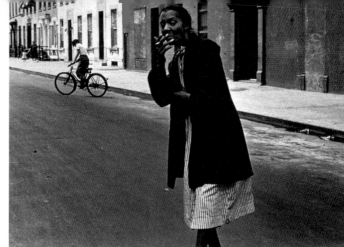

Sartre's tale of the Spanish Civil War (1939) drove home at least two metaphors of the wall: revolutionary heroism in the face of the firing squad, and the wall as a surface of projection for consciousness or the unconscious, either as a mirror or as a mental image objectified in the randomness of matter (a kind of fetish). After the Second World War, the image of the wall was obviously inseparable from death and destruction. Later it became the very image of separation. In the glossary of *SMLXL*, at the word "Wall," Rem Koolhass runs abruptly short of irony: "Berlin. All of the sudden, I'm right there in front of it, without having realized. A long line of graffiti runs right across it, like the graffiti in the New York Subway, like the West's mania for stickers. Suddenly, I have no historical imagination to cope with this wall, with this city

of France, all the more easily because such images had been transmitted by a sophisticated pictorial tradition (Clement Greenberg likened Dubuffet to Klee, of course, but also to Dufy and Pissarro). Only later did Claes Oldenburg discover Dubuffet and his relation to Céline ("the two Frenchmen"). In their shared "anti-cultural positions" (the title of Dubuffet's famous lecture in Chicago in 1951) Oldenburg glimpsed another French tradition, romantic and anarchist, more useful for the critique of America.

Helen Levitt
New York, **1939**

Walker Evans was no less sophisticated, and no less a Francophile. After feeling he had compromised himself with the American cultural institution par excellence, the MoMA, which in 1938 had given him the means to realize his great exhibition and his great book, *American Photographs*, he sought his redemption in the underground labyrinth of the New York subway (sometimes accompanied by Helen Levitt). Subtly inspired by Daumier's grotesques, his "subway portraits" place the passengers at grips with themselves and with the luminous directional signs of an abstract topography, in a far more metaphysical space (to say the least) than that of the childlike figures sketched by Dubuffet in *La métromanie ou les dessous de la capitale* (1950, text by Jean Paulhan). When Evans' portraits appeared in 1966, as the book *Many Are Called*, they should have

Jean Dubuffet, *Vue de Paris: Le petit commerce*
(View of Paris: little shops), 1944

cut in two like a brain severed by an artificial scalpel. The buildings which border upon it bear the charred traces of a hot history—cold history, for its part, feeds on cold signs; which reduce the imagination to despair (the only funny signs are the rabbits hopping about in the barbed-wire friezes of *no-man's land*)."

In Europe after the war, the verve of French photography in the thirties began to wither. The Parisian *peuple* streamed to the suburbs, and lost the experience of the street in the corridors of the housing complexes. Doisneau had nothing left to photograph. Dubuffet continued, for a short time, to paint views of Paris with its little shops and little people. After his first exhibition at Pierre Matisse gallery in 1947, American critics were quick to link him with a picturesque, often bawdy iconography

been seen—like the "black disk" of the origin in Michel Foucault's book on Raymond Roussel—as the hidden, subterranean face of the history of pop art, and of Andy Warhol's melancholy oeuvre in particular.

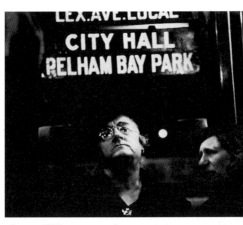

As it happens, you
don't see among them
the face of a judge or
a senator or a bank president. What you do see is at once
sobering, startling, and obvious:
these are the ladies and gentlemen of the jury.

Walker Evans, *Harper's Bazaar*, March 1962

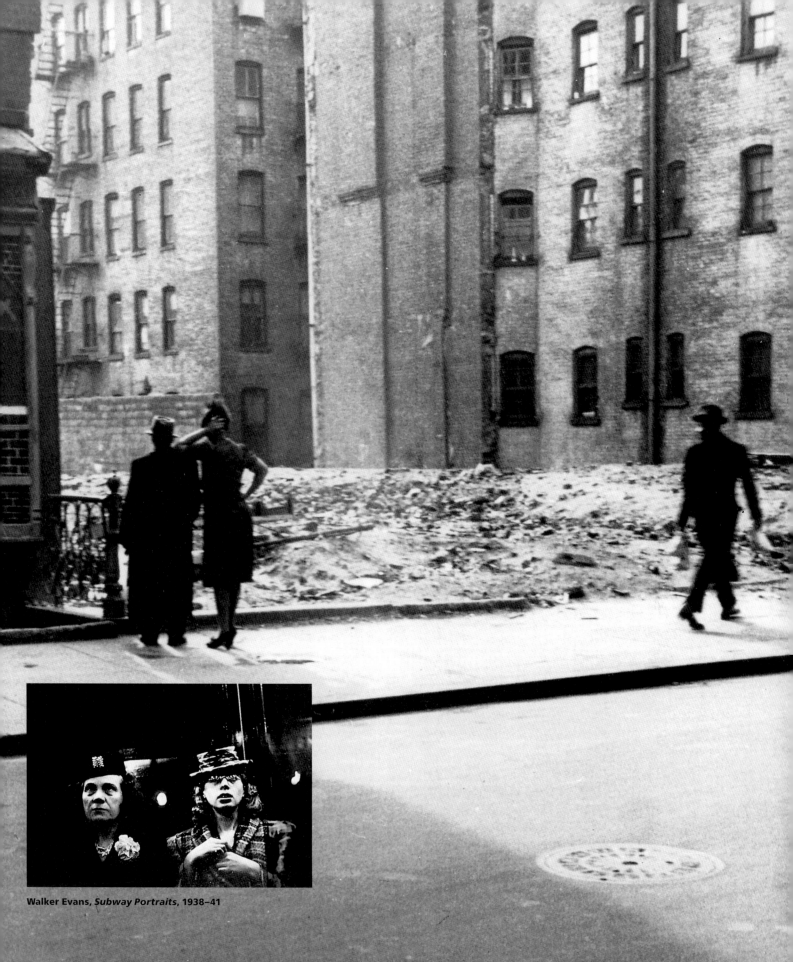

Walker Evans, *Subway Portraits*, 1938–41

Helen Levitt, *New York*, 1940

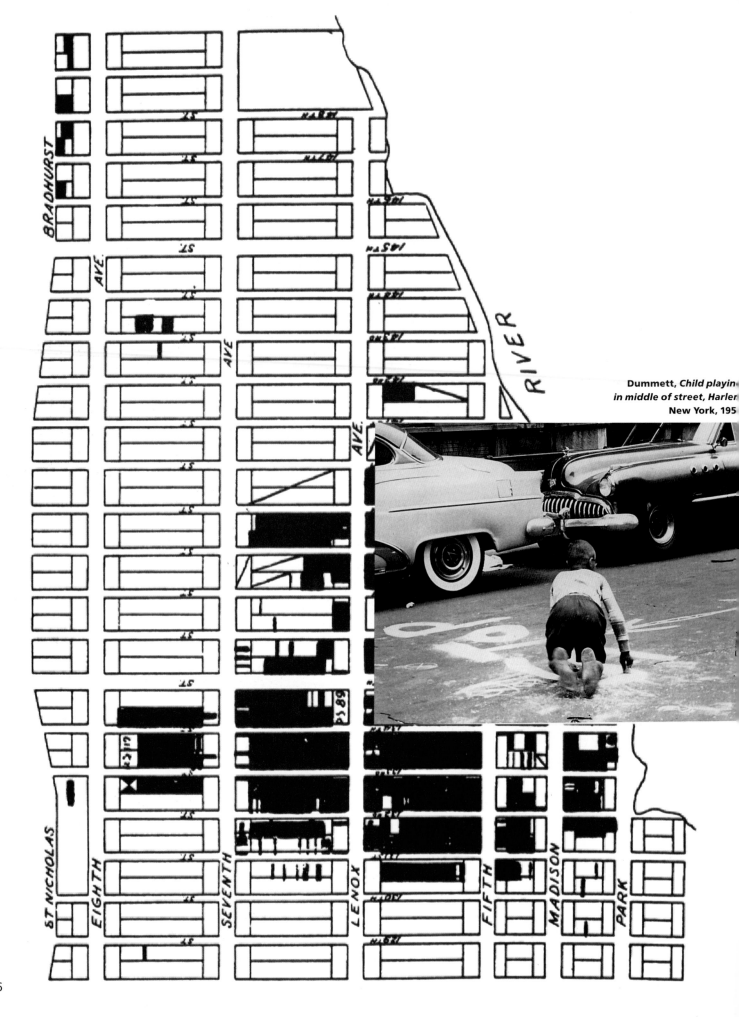

Distribution of the black population in Harlem, 1911–1914

Dummett, *Child playing in middle of street, Harlem, New York, 195*

116

The streets of Harlem seen by Levitt are most often empty. No cars, or so few. No stranger, no *flâneur*. The space on which she concentrates is narrow, no horizon, never any sky. It stretches between the façades and the street, the width of the sidewalk. (*In the Street*, the film she tances between them bring complex ties to light. A powerful bond, at once social and symbolic, attaches them to "home": a wall, a flight of stairs, a door, always in the background of the image. No other place is theirs (neither work nor school). This bond is constantly main-

Helen Levitt, *New York*, 1940

Helen Levitt, *New York*, undated

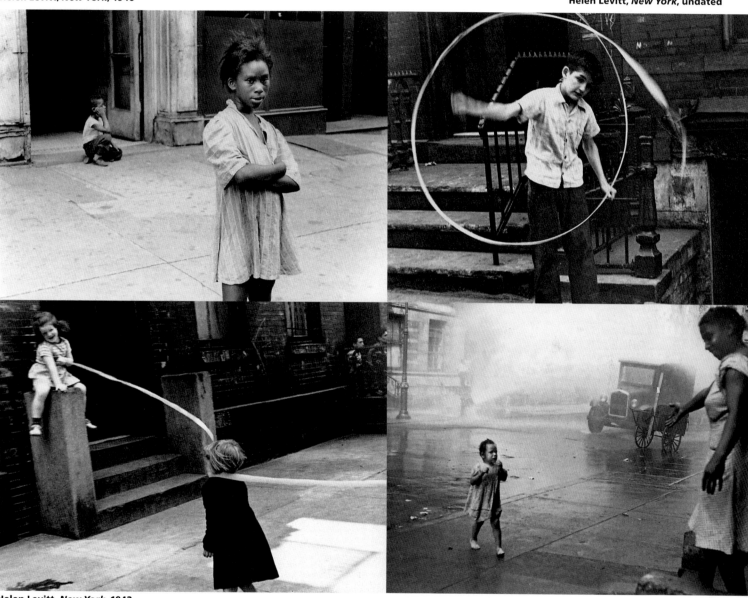

Helen Levitt, *New York*, 1942

Helen Levitt, *New York*, 1939

shot in the forties with James Agee and Janice Loeb, unfolds in this same cramped space, which becomes one of its burlesque resources.) The children play on the sidewalk, on the steps, along the railings. The adults are standing, or seated at the doorfronts. The short dis- tained between them, teased back into play by gestures, stage scenes, words exchanged on the wall. Helen Levitt also draws herself into play, framing precise spaces between emptiness and separation, between autonomy and autistic solitude. The vacant lots are missing homes.

On a larger scale those vacant lots mark the emplacement of former slums. The history of Harlem obviously cannot be read in Levitt's images. For that you have to go to the Schomburg Center for Research in Black Culture (the Puerto Rican cabby doesn't know that Malcolm X Boulevard is the continuation of Lenox Avenue, because he's never been to Harlem; but the Harlemites you ask around 115th Street make like they've no more heard of Malcolm X than any Puerto Rican). At the Center you can consult the archives and see the images of the street taken by the photojournalists of Levitt's day (Dummett, Nichols, Albok, Layne, among others). Looking at these images—their powers of historical and poetic evocation

❖ ❖ ❖

THE NEW YORK AGE, JUNE 12, 1943

HOUSING PROJECT OKAYED DESPITE PROTESTS

After prolonged debate and discussion, the form of contracts and plans for the $50,000,000 Stuyvesant Town housing project to be constructed by the Metropolitan Life Insurance Company on the East Side were approved Thursday by the Board of Estimate, by a vote of 11 to 5. The chief objection voiced by more than a score of speakers was that the contract contained no clause that would prevent the Metropolitan from discriminating against Negroes in renting. As a matter of fact, the company said that it had no intentions of renting to Negroes and warned that if it was forced by the city to include such an assurance, it would abandon the project.

❖ ❖ ❖

NEW YORK POST, AUGUST 2, 1943

Anonymous: Harlem in the forties

all the greater when suspicions of artiness are lifted—one better understands the work of subjective selection carried out by Levitt on the terrain, and the interest she could take as an artist-woman-flâneur-photographer in these popular neighborhoods, whenever they incline toward the burlesque and carnavalesque. Levitt's images avoided—for whatever complex reasons—the *unavoidable* violence of the Harlem streets in the forties, unavoidable in the sense that the violence is *in* Harlem, in its history and in its very body (read James Baldwin's *Notes of a Native Son*). That violence is manifest, or rather contained, in each of the photographs archived at the Schomburg Center. A razed expanse, no doubt after the destruction of slums (stamped "New York City Housing Authority" on the back); a black child playing in the street beneath the immediate physical threat of the cars; or the pure and simple description of one of these streets whose heavy squalor and poverty crushes any chance of dance or theater into the pavement.

I had not yet realized that Harlem *had* so many stores until I saw them all smashed open; the first time the word *wealth* ever entered my mind in relation to Harlem was when I saw it scattered in the streets. But one's first, incongruous impression of plenty was countered immediately by an impression of waste. None of this was doing anybody any good. It would have been better, but it would also have been intolerable, for Harlem needed something to smash.

James Baldwin: *Notes of a Native Son*, 1955

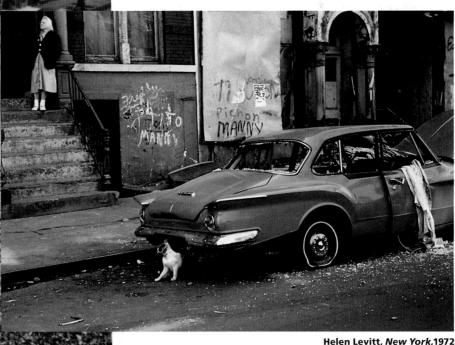

Helen Levitt, *New York,***1972**

119

Helen Levitt, *New York*, undated

Return to Europe: After the war, after the reconstruction programs inspired by the CIAMs and Le Corbusier's call for the destruction of the street, the popular quarters attracted the much different, more scientific attention of certain urbanists and photographers, because they preserved signs of the permanence of the city and of its inhabitants. (Reyner Banham: "One of the major foundations of brutalist theory was a growing interest in the real life of cities, an almost ecological attitude toward the city-dweller . . . inspired by sociologists like Wilmott and Young.") From 1949 to 1952, Nigel Henderson, a member of the Independent Group, roamed camera in hand through the streets of the popular quarter of Bethnal Green, where he and his wife Judith Stephen—an anthropologist and the niece of Virginia Woolf—had chosen to live, like true London bohemians in the forties and fifties. (In 1957 came the publication of *Family and Kinship in East London*, Michael Young and Peter Willmott's study on the community networks in Bethnal Green and the evolution of the kinship ties in the fictively baptized "Greenleigh" housing estate. For reasons unknown to me, their book makes no mention of Nigel Henderson's work.)

The "interior street" of the Unité d'Habitation in Marseilles brought into practice an image of the street as "an extended building, an edifice, a container and not an epidermis." The image was hard to accept, too visionary, too architectural. Yet the rooftop, with its "plastic concentration" of organic circulation patterns, formed a better illustration of Le Corbusier's idea of the street as a spontaneous theater (witness this photograph, staged as an ad for the Unité). Still the two interpretations both demonstrate the irreducibility of the street to a fiction produced by anyone but its own actors.

Nigel Henderson sees the street as a theater, like Le Corbusier, but much more like Atget, Evans, and Levitt ("I would think of the small box-like houses and shops etc. as a sort of stage set against which people were more or less unconsciously acting"). Yet Henderson is less a photographer than the others, more surrealist in his abandonment of mastery, more experimental (bricolage-collage) in his com-

". . . it would be enough to construct sets here and there, platforms, stages great or small, where people could act out their own dramas. . . . people dressed like all the others, strolling through the city or going to work, doing theater."
Le Corbusier, 1948.

Le Corbusier
Unité d'habitation,
Marseilles, 1947–52

Nigel Henderson
Boy in Window
East London, 1949–52

merce of found images and of "disregarded fragments" (for he accords images and objects the same status), and finally most interested by the degree of unconsciousness, of delirium or "intoxication" which presides over his visions. He shares a passion for walls and pavements with Dubuffet (indeed, "brutalism" was derived from "art brut"); in their thickness and density he sees the expression of a physical and metaphysical entropy. But unlike Dubuffet, he does not contrast the inventiveness of the walls to photography. Henderson seeks a psychic image:

"I was looking for an 'image' by which I suppose I meant something that suggested an imaginative world far beyond the terms of the material serving to project its shadow." He finds it either in the random manipulation of organic fragments beneath the enlarger, or in the straight shot of a market where the women are embalmed in the merchandise, their faces wrapped in the hanging nylons.

A new boot is a fine monument to Man—an artefact. A worn out boot traces his image with heroic pathos and takes its part as a universal image-maker in the Suburbs of the Mind.

From: Nigel Henderson, *Photographs of Bethnal Green* 1949-52, Nottingham

Nigel Henderson, *Petticoat Lane Market*, East London, 1949–52

At the same time, McCarthyism and abstract expressionism's finally attained expression of an American form of "high art" forced the documentary photographers back into regressively subjective gestures. The cabalistic signs photographed by Aaron Siskind in the fifties had no more to do with the language of the wall than did the black paintings of Franz Kline. (The catalogue of *High and Low* doesn't mention Helen Levitt's images in the graffiti chapter, apparently because she didn't fit into a sufficiently masculine, "high art" genealogy; Brassaï's graffiti receive extensive treatment, clearing the way for Miró, Dubuffet, and Cy Twombly.)

The mimicry of pictorial activity by what Camille Bryen called the "humanist mechanics" of the camera undercut photography's meaning along with its object. The American photographers only rediscovered an image of the street in the sixties, when they regained a critical distance that did not exclude fascination and a style that stemmed as much from the documentary heritage as from contemporary cinema. After a ten-year interruption, Helen Levitt continued her photography of Harlem. Color, which she was among the first to use in the late fifties, upset the graphic purity and construction of the spaces. The figures, less schematic, rejoined the far more visible poverty and violence of the street. The graffiti scratched into the squalor of the walls added to the

chaos. The delirium ebbed and receded , for lack of ties and play.

The narrative of the street drifted away from the image provided by descriptive photography or by the soliloquy-painting of Dubuffet. As time went by, the street itself stood forth with too much violence and senselessness, submerged by "the visual" and attacked by wildcat urban projects; it could no longer enter a fixed frame. Raymond Hains took this very illegibility as a way to find himself in his wanderings: himself, his own history, his very origin, and the history of a French liter-

this language of the wall were the metaphor of information, and of the disjointed and fractured space of the street. Later the sheet-metal pieces, like the posters, would reconcile the wall and the page at once in the street and in the museum, street and museum unreconciled.

Thus for the time of this work, an experience and a contemporary image of the street were reborn, no longer bound to surrealism by any but literary ties, stripped of all romanticism.

Raymond Hains – Jacques de la Villeglé, Ach Alma Manetro, 1949

ary tradition stemming from Rimbaud, which furnished and still furnishes the network of his associations and visual puns.

Fitted with a "hypnagogoscope" and fluted lenses, Hains' camera inscribed what Apollinaire had called "new realities" (that is to say, metaphors). *Hépérile's* unintelligibility appeared in its shattered optics. The lacerated posters torn from their designated spaces revealed a far more complex and cryptic body of information than first met the eye. All the latest newslines were there, the war in Algeria, De Gaulle, the bomb throwers, Indochina, the French communist party, scrawled with anonymous commentary. Once again, the disjunctions and fractures of

Theodor W. Adorno – Gold Assay

Gold Assay. – Among the concepts to which, after the dissolution of its religious and the formalization of its autonomous norms, bourgeois morality has shrunk, that of genuineness ranks highest. If nothing else can be bindingly required of man, then at the least he should be wholly and entirely what he is. In the identity of each individual with himself the postulate of incorruptible truth, together with the glorification of the factual, are transferred from Enlightenment knowledge to ethics. It is just the critically independent late-bourgeois thinkers, sickened by traditional judgements and idealistic phrases, who concur with this view. Ibsen's admittedly violated verdict on the living lie, Kierkegaard's doctrine of existence, have made the ideal of authenticity a centrepiece of metaphysics. In Nietzsche's analysis the word genuine stands unquestioned, exempt from conceptual development. To the converted and unconverted philosophers of Fascism, finally, values like authenticity, heroic endurance of the "being-in-the-world" of individual existence, frontier-situations, become a means of usurping religious-authoritarian pathos without the least religious content. They lead to the denunciation of anything that is not of sufficiently sterling worth, sound to the core, that is, the Jews: did not Richard Wagner already play off genuine German metal against foreign dross and thus misuse criticism of the culture market as an apology for barbarism? Such abuse, however, is not extrinsic to the concept of genuineness. Now that its worn-out livery is being sold off, seams and patches are coming to light that were invisibly present in the great days of its opposition. The untruth is located in the substratum of genuineness itself, the individual. If it is in the *principium individuationis*, as the antipodes Hegel and Schopenhauer both recognized, that the secret of the world's course is concealed, then the conception of an ultimate and absolute substantiality of the self falls victim to an illusion that protects the established order even while its essence decays. The equation of the genuine and the true is untenable. It is precisely undeviating self-reflection—the practice of which Nietzsche called psychology, that is, insistence on the truth about oneself, that shows again and again, even in the first conscious experiences of childhood, that the impulses reflected upon are not quite "genuine." They always contain an

element of imitation, play, wanting to be different. The desire, through submergence in one's own individuality, instead of social insight into it, to touch something utterly solid, ultimate being, leads to precisely the false infinity which since Kierkegaard the concept of authenticity has been supposed to exorcise. No-one said so more bluntly than Schopenhauer. This peevish ancestor of existential philosophy and malicious heir of the great speculators knew his way among the hollows and crags of individual absolutism like no other. His insight is coupled to the speculative thesis that the individual is only appearance, not the Thing-in-Itself. "Every individual," he writes in a footnote in the Fourth Book of *The World as Will and Representation*, "is on one hand the subject of cognition, that is to say, the complementary condition of the possibility of the whole objective world, and on the other a single manifestation of that same Will, which objectifies itself in each thing. But this duplicity of our being is not founded in a unity existing for itself: otherwise we should be able to have consciousness of ourselves through ourselves and independently of the objects of cognition and willing: but of this we are utterly incapable; as soon as we attempt to do so and, by turning our cognition inwards, strive for once to attain complete self-reflection, we lose ourselves in a bottomless void, find ourselves resembling the hollow glass ball out of whose emptiness a voice speaks that has no cause within the ball, and, in trying to grasp ourselves, we clutch, shuddering, at nothing but an insubstantial ghost."* Thus he called the mythical deception of the pure self by its name, null and void. It is an abstraction. What presents itself as an original entity, a monad, is only the result of a social division of the social process. Precisely as an absolute, the individual is a mere reflection of property relations. In him the fictitious claim is made that what is biologically one must logically precede the social whole, from which it is only isolated by force, and its contingency is held up as a standard of truth. Not only is the self entwined in society; it owes society its existence in the most literal sense. All its content comes from society, or at any rate from its relation to the object. It grows richer the more freely it develops and reflects this relation, while it is limited, impoverished and reduced by the separation and hardening that it

lays claim to as an origin. Attempts like Kierkegaard's, in which the individual seeks abundance by retreat within himself, did not by accident end up in the sacrifice of the individual and in the same abstraction that he denounced in the systems of idealism. Genuineness is nothing other than a defiant and obstinate insistence on the monadological form which social oppression imposes on man. Anything that does not wish to wither should rather take on itself the stigma of the inauthentic. For it lives on the mimetic heritage. The human is indissolubly linked with imitation: a human being only becomes human at all by imitating other human beings. In such behaviour, the primal form of love, the priests of authenticity scent traces of the utopia which could shake the structure of domination. That Nietzsche, whose reflection penetrated even the concept of truth, drew back dogmatically before that of genuineness, makes him what in the end he wanted to be, a Lutheran, and his fulminations against play-acting bear the stamp of the anti-Semitism which infuriated him in the arch-actor Wagner. It is not with play-acting that he ought to have reproached Wagner—for all art, and music first of all, is related to drama, and in every one of Nietzsche's periods there resounds the millenial echo of rhetorical voices in the Roman Senate—but with the actor's denial of play-acting. Indeed, not only inauthenticity that poses as veridical ought to be convicted of lying: authenticity itself becomes a lie the moment it becomes authentic, that is, in reflecting on itself, in postulating itself as genuine, in which it already oversteps the identity that it lays claim to in the same breath. The self should not be spoken of as the ontological ground, but at the most theologically, in the name of its likeness to God. He who holds fast the self and does away with theological concepts helps to justify the diabolical positive, naked interest. He borrows from the latter an aura of significance and makes the power of command of self-preserving reason into a lofty superstructure, while the real self has already become in the world what Schopenhauer recognized it to be in introspection, a phantom. Its illusory character can be understood from the historical implications of the concept of genuineness as such. In it dwells the notion of the supremacy of the original over the derived. This notion, however, is always linked

with social legitimism. All ruling strata claim to be the oldest settlers, autochthonous. The whole philosophy of inwardness, with its professed contempt for the world, is the last sublimation of the brutal, barbaric lore whereby he who was there first has the greatest rights; and the priority of the self is as untrue as that of all who feel at home where they live. None of this is changed if authenticity falls back on the oppositions of *physei* and *thesei*, the idea that what exists without human interference is better than the artificial. The more tightly the world is enclosed by the net of man-made things, the more stridently those who are responsible for this condition proclaim their natural primitiveness. The discovery of genuineness as a last bulwark of individualistic ethics is a reflection of industrial mass-production. Only when countless standardized commodities project, for the sake of profit, the illusion of being unique, does the idea take shape, as their antithesis yet in keeping with the same criteria, that the nonreproducible is the truly genuine. Previously, the question of authenticity was doubtless as little asked of intellectual products as that of originality, a concept unknown in Bach's era. The fraud of genuineness goes back to bourgeois blindness to the exchange process. Genuine things are those to which commodities and other means of exchange can be reduced, particularly gold. But like gold, genuineness, abstracted as the proportion of fine metal, becomes a fetish. Both are treated as if they were the foundation, which in reality is a social relation, while gold and genuineness precisely express only the fungibility, the comparability of things; it is they that are not in-themselves, but for-others. The ungenuineness of the genuine stems from its need to claim, in a society dominated by exchange, to be what it stands for yet is never able to be. The apostles of genuineness, in the service of the power that now masters circulation, dignify the demise of the latter with the dance of the money veils.

* Schopenhauer, *Die Welt als Wille und Vorstellung*, Leipzig 1877, p. 327 (*The World as Will and Idea*, London, 1950, p. 358).

From: *Minima Moralia* (1945), London: Verso, 1978.

Benjamin Joly
Minima Moralia, Gold Assay, 1945

For a philosopher who sought from the outset to fulfill the logic of the decomposition of bourgeois idealism, morality could no longer be the grand morality (*Magna moralia*) that tradition had attributed to Aristotle, a morality asserting itself as the site of articulation between life and the truth of a metaphysical system. Definitively reduced to the status of an appendage of production, morality could only have reduced and almost entirely critical pretensions: it must be minimal (*Minima moralia*).

Bourgeois morality held that virtue is golden. An heir to the philosophers of axiological suspicion (Nietzsche, Marx, Freud) could never take such currency as hard cash.

For Adorno, who saw the cardinal virtue of bourgeois morality beneath the garb of the genuine, philosophy meant inquiring into the value of this notion, to discover how far its internal contradictions reflect those at work in society at large. With this inquiry, Adorno struck to the heart of a project that *Dialectic of Enlightenment* had merely sketched out: the project of a "dialectical anthropology" analyzing the transformations that the shift from liberal bourgeois capitalism to monopoly capitalism and totalitarianism had forced upon the subject of values.[1]

As France embraced an optimistic existentialism of cheerful tomorrows and Germany began the discreet repression of Heidegger's compromises, prior to the elevation of the Black Forest philosopher to the rank of spiritual mentor,[2] "Gold Assay" resituated the existentialist notion of genuine experience within the troubling historical continuity that leads from the Kierkegaardian subject to totalitarianism, and that raises the echos of Nazi bacchanalia amid the rhythm of mass production.

No doubt because it takes on the burden of thinking through this complex and painful continuity, the text is highly allusive. It thrusts the logical links of its argument back into the intertext (Adorno's thesis on Kierkegaard,[3] *Dialectic of Enlightenment*, the aphorisms of *Minima Moralia*); it reserves the details for later development (in *The Jargon of Authenticity*).[4] It is, in short, discontinuous: as though a reconstitution of the processes that metaphysical concepts have jealously repressed could only be obtained at the price of this violence wreaked on philosophical

discursivity. Discursive discontinuity is nothing other than the tension necessary to burst the apparent autonomy of the concept of genuineness and make evident the extent to which it is not identical to what it claims to be. This discontinuity corresponds to the fracturing of the notion into a constellation which, after releasing multiple gleams, will finally reveal its hidden face in the apotheosis of a final illumination—or, in terms closer to Adorno's, an historical image.[5]

But this final image (gold-genuineness) is only attained at the close of a long labor of decomposition, entailing the reinsertion of the concept into the dialectic of enlightenment and the exacting demonstration of the social contradictions on which it rests, before the complete exposure of its character as an ideological illusion.

The primacy of the genuine is inseparable from the fate of the enlightenment. Without the axiological void that the enlightenment left behind it after its attacks against religion, and without the decay into which bourgeois values fell through the gradual disappearance of the liberal capitalism of the nineteenth century, genuineness could not play the role of the final refuge in a floating market of values.

The philosophy of genuineness itself is but the result of the transfer of "enlightened knowledge" to ethics. By shifting the principle of identity toward the ethical, this movement brings to the latter both the presuppositions of the theory of knowledge (the postulate of the existence of stable objects—in this case, the self—whose ultimate truth is transparent to the subject of consciousness) and their consequences (the ratification of the state of things, which here takes the form of an acceptance of the moral state of things, a passivity of thought guaranteed by an ever-verified principle of tautology: "being what one is"). Thus the philosophy of the genuine reenacts the movement already described in *Dialectic of Enlightenment*. When enlightened knowledge is turned aginst man it transforms progress, or domination of nature to the benefit of humanity, into domination of the nature within man—that is, inhuman regression. From Kierkegaard to the fascist philosophers[6] by way of Nietzsche and Wagner, the history of the genuine transforms a critical and progressive notion (the refusal of Hegelian idealism for Kierkegaard, the refusal of the hypocrisy of Lutheran puritanism for Ibsen) into a dogma ("in Nietzsche's analysis the word genuine stands unquestioned"), then finally into an active principle of domination (Wagner, national socialism). This is the history of the "transformation of an idea into domination," as in the process described by *Dialectic of Enlightenment*. And if the history of genuineness cannot be considered as a fortuitous succession of events, it is because the method of critical philosophy, as carried out in the later work of Benjamin that did so much to inspire *Dialectic of Enlightenment*,[7] is to extract from the present and its excesses the

retrospective hermeneutic principle that allows a rewriting of history as the genealogy of a catastrophe born forth from the past.

Only when the moment comes to auction off the "livery" of the ego or the self—the cloak of genuineness that drapes it, and that renders visible both its cowering to the established order (just whistle for the servant in uniform) and its connection to a group (the black or brown-shirted fascists)—can its tattered state, that is, the abuses to which it leads, be correctly interpreted as what they already were at the origin: flaws spun into the concept itself.

The inherent flaw in the notion of genuineness is concealed at its heart: it is the notion of the subject on which the genuine reposes. To grasp the meaning of genuineness, Adorno must construct a genealogy of the subject. By resituating genuineness within its field of origin, within the theory of knowledge to which the notion of the subject is indissolubly bound, he attempts to reveal the contradictions and inadequacies which sap its claim to truth.

As also recognized by both Hegel and Schopenhauer, who sounded the depths of the subject's repressions to bring forth not only the dynamics of their own opposition but also the structure of an understanding of the individual's relations to the whole, neither the subject's supposed autonomy, nor his unity, nor his truth are guaranteed by the principle of individuation (that is, the psychological version of the enlightenment's identity principle). For in reality the individual depends on a principle which extends beyond him and works through him: the ruse of reason for Hegel, the originary principle of will for Schopenhauer, society for Adorno. The contradictions in which the philosophy of genuineness culminates are therefore no more than the consequences of this truncated vision of a subject unaware of his determination by that which is apparently external to himself.

So the modern subject believes in his autonomy, in his ability to apprehend his own truth within himself? Introspection reveals his submission to heteronomy. On the one hand, he is determined by presubjective impulses, mimetic drives which slumber within him and mediate his psychological unity, making him dependent on the external reality that he voluntarily imitates or deforms.[8] On the other hand, he is structured by the oppositions which run throughout the history of civilization (mimesis vs. rational praxis; reductive identity principle vs. true non-identity) and which unfailingly refer him back to his repressed (proto)historical origin.

So the existentialist project, in a synthesis of Heidegger and Kierkegaard,[9] promises to let the subject grasp his most concrete reality? Alas, he only embraces the void. In the opening lines of "Gold Assay" and in his thesis, *Kierkegaard, Konstruktion des Ästhetischen,* Adorno makes it clear that the existentialist project is defined from the outset as an anti-idealism. For Kierkegaard, the identification of the rational and the real in the Hegelian system abolishes what is most important, the specificity of the particular. It subsumes the particular beneath the abstract universal and thus bypasses the only true reality, existence, left indeterminate by the failure to thematize it: "In the language of abstraction the difficulty of existence and of the exister never comes to light. . . . Thus abstract thought helps me with my immortality by first killing me off as a particular existing being.[10] Existentialism as defined by the Danish thinker will therefore bring individual existence back to the center of philosophical thought, by assigning it the status of a concrete foundation against the "false infinity" of abstraction and indetermination (thus Kierkegaard twists the Hegelian expression against its author).

However, as Adorno shows in his thesis, Kierkegaard's displacement of the theater of Hegel's world-historical philosophy to the inwardness of the self leads to just the same abstract indetermination he reproaches in Hegel, the same "false infinity." For this inwardness is without content: "The self, the refuge of all concreteness, clings so tightly to its uniqueness that no predicate can be attributed to it. It is transformed into the most extreme abstraction: that only the individual should know the individual is just a paraphrase for the idea that nothing is knowable; and thus all that remains of the most determinate self is the broadest of indeterminations" (*Kierkegaard,* p. 108-9). As Schopenhauer had already recognized in *The World as Will and Idea,* the existentialist withdrawal into subjectivity forces the subject into a pointless maintenance of the dialectical categories of an inwardness which is no longer confronted by the reference point of an objectivity; the subject must construct itself around an "objectless inwardness" (*Kierkegaard,* p. 24). If the subject brackets the external world which it conditions as transcendental subject, it then eliminates itself along with the world whose condition it believed itself to be, and finally appears to itself under its true light: as a phenomenon, an illusion which is nothing without the thing-in-itself that upholds its existence. By citing Schopenhauer, Adorno seems at first to present nothing more than a variation on the theme that he had already developed in his thesis, as though his only concern were to discretely weave his metaphor of the livery, with the implication that it cloaks nothing but the void. But quite to the opposite of Schopenhauer's assertions, the supreme instance for Adorno is not an ontological ground comparable to the originary Will, but rather a totalizing Hegelian unity, rational and real. In effect, by qualifying the pure self as "abstraction," Adorno reinterprets Schopenhauer's phantom from the viewpoint of Hegel, since for the latter as for Adorno, "abstraction" signifies the false unity of the self, the pure inwardness of the unhappy consciousness,[11]

deprived from the relation to the whole which alone can give it meaning and concreteness. Thus Adorno returns to the Hegelian structure of the particular's determination by the whole, but he transforms the element of wholeness which lends meaning to the particular: for him it is not the real and rational whole of the movement of spirit, but rather that of society with its economic mechanisms and processes.

When the last domino falls, the pure self then reveals itself to be what neo-Marxist critique since Lukács has called a reified concept, a concept produced by socioeconomic conditions, but frozen in the oblivion of its origins; a concept attributing to an object (the biological self) that which is necessarily the result of a social process (the unity of the social self). The only thing that can rip the individual self away from the processes that create it—upholding it as a monad, reifying it, isolating it "by force" from the "social whole"—is the violence that capitalism and enlightenment inflict on reality by isolating discrete entities. Thus the belief in the self's independence from the social processes responsible for its genesis only arises so that it can unwittingly fulfill the destiny of the capitalist society from which it springs. For without the phase of nineteenth-century liberal capitalism, founded on small-scale ownership ("the individual is a mere reflection of property relations") and on the principle of equivalent exchange which demands stable and autonomous units, the individual would never have existed: "Economic reality, the highly praised principle of the smallest mean, is incessantly converting the last units of the economy: firms and men. . . . The individual—the psychological corner-shop—suffers the same fate. He arose as a dynamic cell of economic activity. Emancipated from tutelage at earlier stages of economic development, he was interested only in himself . . ." (Dialectic of Enlightenment, p. 203).

Faced with this reification, the Marxist orthodox Lukács proposed a movement whereby the subject turns back toward the factors that have determined it. This movement of return to the origin takes the form of a collective commitment that seeks to act directly on the social and economic relations that shape the individual. In the same situation, Adorno contented himself with the evocation of a minimal morality also inspired by Hegelian alienation (Entäußerung); but he laid the accent on individual action, which, by accepting its insertion within the social whole, can become a means to oppose the "totalitarian unison" that society imposes—a consensus that leaves no possible riposte if one is not conscious of being shaped by it (see Minima Moralia, "Dedication," p. 18). In the age of the masses, Adorno's support goes rather to a minimal morality whereby the individual is not uncommitted (the double negative precluding any definite political assertion) than to a political project of collective commitment: for the times are such, he concludes, that "even part

of the social force of liberation may have temporarily withdrawn to the individual sphere."

If a genuineness reposing on a contradictory and reified notion of the subject has attained such a triumph at the moment when Adorno writes, it is precisely because the subject's isolation from social processes is not the result of a philosophical choice but has been transformed into a historical necessity: it corresponds to the reshaping of economic units demanded by the evolution of economic rationality and rational praxis. According to Dialectic of Enlightenment, this type of development occurs according a single principle which is something like the motto of Western civilization: sese conservare.

Hence the genuine, with its double nature both as a refuge value for the individual and as a vector of domination, refers back to the principle of self-preservation which conditions it: "Among the rulers, cunning self-preservation takes the form of struggle for Fascist power; among individuals, it is expressed as adaptation to injustice at any price" (Dialectic of Enlightenment, p. 91).

Indeed, with the gradual disappearance of liberal capitalism in favor of monopoly capitalism, the conditions which gave birth to the individual disappear as well, until the latter comes to appear as an outmoded instrument of the economy, replaced by transformation into "standardized, organized human units" (Minima Moralia, p. 135). Genuineness is thus at once the refuge value of the individual, his last rampart, and the value presiding over the end of the individual: it is the ideology which allows him to adapt to his own disappearance.

By displacing the ethical moment from the transcendence to the immanence of the self ("the self should not be spoken of as the ontological ground, but at most theologically"), bourgeois ethics is transformed into an existential relativism which allows for the justification of any behavior.[12] Thus it furnishes the individual with a means to adapt to everything forced on him by outside conditions and by the diabolical evolution of society, even while maintaining the illusion of a self that no longer exists except as a logical subject and an object of domination: "If one sought to capture in a phrase what the ideology of mass culture leads to, it would have to be a parody of the phrase 'be what you are': a bluff that duplicates and justifies the existing state of things by including transcendance and excluding any criticism. . . . Nothing ideological remains except the acceptance of the state of things, models of a behavior of resignation in the face of all-powerful circumstances. It is surely no accident that the most vibrant of today's metaphysics gather under the banner of the word existence, as though the reproduction of the simple fact of existing—by the supreme and abstract determinations extracted from it—could signify the production of its meaning."[13]

Thus the livery of genuineness cloaks the phantom that the subject has become, and profits from this semblance of reality given to emptiness in order to maintain the fiction of its existence and facilitate its adaptation to the new phase of capitalism. Genuineness is the empty shell of the subject, the form adopted by the sediment of the past that is the individual, whose artificial survival creates the conditions of his final elimination: "the conception of an absolute and ultimate substantiality of the self falls victim to an illusion that protects the established order even while its essence decays."

But at the same time, genuineness is the value that the individual adopts in the age of his mechanical reproducibility, to halo himself with the aura of (prefabricated) uniqueness, and hide the poverty of his own standardization. Thus he reflects the society of mass production (production in mass quantity and for the masses; mass production of standardized individuals) which unconsciously determines him: "Only when countless standardized commodities project, for the sake of profit, the illusion of being unique, does the idea take shape, as their antithesis yet in keeping with the same criteria, that the non-reproducible is the truly genuine." Like the attributes of the prefabricated "originals" that Hollywood produces according to a patented model,[14] like the "colourful personalities" so avidly consumed in America (*Minima Moralia*, p. 135), the genuine is the standardized sign of the supposedly irreducible idiosyncrasy of the individual.

If this mechanically reproducible individual refuses to reveal himself as such and rejects all that has to do with the mimesis of the actor or the artist—the "good" reproducibility of the individual—it is because in the era of his reduction to the status of an object, everything such as art or love which succeeds in escaping rational command through an excess of spontaneity is considered susceptible to "shake the structure of domination." Indeed, these spontaneous actions reveal traces of the subject springing from a violently repressed past; they are the mark of a truth capable of overcoming the lie of the identity principle on which our civilization is based: "The objectification by which the power structure (which is made possible only by the passivity of the masses) appears as an iron reality, has become so dense that any spontaneity or even a mere intimation of the true state of affairs becomes an unacceptable utopia, or deviant sectarianism" (*Dialectic of Enlightenment*, p. 205).

But totalitarian domination is not only furthered by the passivity of the masses which results from the ideology of the genuine; it also finds an active principle of domination in genuineness, rooted as it is in the principle of self-preservation.

Indeed, genuineness is only the spiritualized form of the discourse held over the course of history by those who designate themselves as the ruling strata (*Herrensichten*), claiming over all others the right of first arrival and making the purity of their origin into an unquestionable norm. For since the turn it took with Wagner, the notion of genuineness has entered the service of barbarism's apologists, passing from the postulate of the self's truth to the dogmatic denunciation of the ungenuine, and thence to the Nazi cult of the elimination of ungenuineness in others. As Adorno explains in a later text on Heideggerean ontology: "I think that behind the ideal of the origin as the foundational ground is hidden something like the native as an emblematic figure, or, as I attempted to explain in one of the aphorisms of *Minima Moralia*, a representation of a social order has been transposed without reflection into philosophy: whoever was there first, the first owner, is of better birth and of more noble nature than the newcomer or immigrant" (*Philosophische Terminologie I*, 163; the aphorism in question is "Gold Assay"). Whether in the genuineness of the masses (the opium of the people) or in the genuineness of the powerful (a tool of oppression), the ideology of the genuine takes the forms of pagan religion, from which it borrows both its pathos and its demand for blind obedience. One of the essential aspects of the text thus consists in revealing the full extent of the solidarity between genuineness and enlightenment *ratio*: genuineness embodies, in the ethical sphere, the dialectical reversal of enlightenment into barbaric and obscurantist myths, a return of the repressed, prerational nature that serves as a counterpoint to total domination.

The final historical image of gold-genuineness opposes this total domination—like the entire text, but in a more condensed fashion—with the utopian power that designates reality as it is, beyond the identity principle. It does not only bring formal closure by its ultimate answer to the question latent in the sybilline title ("Gold Assay": what is the true worth of the genuine?); it also halts the dialectical movement, rendering it visible in the form of a concrete representation. It is one of those puzzle pictures (*Vexierbild*) which, depending on the angle of one's gaze, render visible either the enigma (the contradictions of bourgeois philosophy) or its immanent solution. Because it is an image-solution, this representation partakes of the visual paradigm of truth as unveiling and transparency. But because this unveiling at the same time perpetuates the enigma in which it is rooted, because the image only domesticates obscurity by temporarily halting the movement of the dialectic that seeks to illuminate it, transparency is only achieved here through the maintenance of opacity. For by miming the contradictions that it renders visible and unveils, the final image veils anew, proposing a fresh enigma to the reader: it replaces the opacity of bourgeois concepts with the opacity of literary creation, and the philosopher's deciphering of reality with the necessary deciphering of the text's literary qualities by the commentator.

Moi aussi, je me suis demandé si je ne pouvais pas vendre quelque chose et réussir dans la vie. Cela fait un moment déjà que je ne suis bon à rien. Je suis âgé de quarante ans...

certaines galeries prenant 75%. Ce que c'est ? En fait, des objets. Marcel Broodthaers

Galerie St Laurent rue Duquesnoy Du 10 au 25 avril Vernissage vendredi 10 de 6 à 8 heures

Tailleurs
Et presque toujours le chapeau collège

CHRISTIAN DIOR

YVES SAINT-LAURENT. En laine peig soie de Garigue, un tailleur net, strict, à lés. Notez le triple boutonnage, l'a de col et l'effet de découpe à la GUY LAROCHE. En canevas d de Nattier, un tailleur tout su Notez la veste à col cro manches trois quarts, la tai rement marquée. Jupe à pli porte CHRISTIAN DIOR. En twill pu peignée de Forneris, un tailleur droite ceinturée d'un lien noué. Col boutonné. Remarquez le boutonnage asym et la jupe droite. Gants Guibert. d'oreilles Péladan. Maquillage La

Saint Laurent.

Mais c'est de l'Art,

dit-il et t'exposeras tout ça.

Je vends volontiers

D'accord je lui répondis je.

quelque chose je prendra 30 %/ Ce sont paraît-il des conditions normales

fte au mieux de vos vacances de ski au soleil du printemps

journalistes, voici donne ici les dernières tonsuls pour pra

blicité. A l'été-maillet, championne du monde de ski des

neur et le silence... ce sera pour vous un souvenir ino

pleins poumons dans cet éblouissement qu'est le ciel, la

possibilités de loisirs qu'offre le Jouir du soleil respirer à

des hautes altitudes : les promenades sont innombrables, les

tive vous pouvez comme les autres, profiter au maximum

de neige vierge. Même si vous n'êtes pas un grande spor

en avion pour vous offrir des kilomètres et des kilomètres

dinaires l'on en est même arrivé à transporter des skie...

perfectionnent les randonnées sont de plus en plus extraor

rplient les remontées mécaniques se mu...

est le plus accessible. Les hôtels se ma...

le ski « grand soleil » est plus confor...

en haute montagne ? Chaque année,

la campagne, pourquoi ne pas parmi

A Pâques, au lieu d'aller à la mer...

L'idée enfin
d'inventer quelque
chose d'insin...
me traversa
l'esprit et je
mis aussi...
travail. Au bout
de trois mois,
montrai ma...
production à Ph...
Edouard Toussaint
le propriétaire
de la galerie

A true philosophical creation, the image of gold-genuineness fits Adorno's definition of the artwork: it contains all the social and economic tensions structuring the particular that it represents.

This creation is not a metaphor. It expresses the reality of a kinship between the status of gold in capitalist exchanges and the status of genuineness in bourgeois culture. This kinship itself refers to the filiation between Adorno's project of a critical reading of bourgeois culture and the Marxist critique of the capitalist economy, whose conclusions Adorno adopts.

According to Marx (*Capital*, bk. 1, vol. 1), equal and indistinct labor (an expenditure of the same labor-power) forms the substance of the value of commodities: the exchange values of the latter are in fact based on the standard durations of working time required for their production. But the exchange value which expresses the relation between the different durations of homogenized working time required by each product takes the form of a certain quantity of the commodity used as the measure of the measure already established by the standard duration of working time. This measure of the measure is gold.

Commodity fetishism, bourgeois blindness to the process of exchange, consists in taking exchange value as a natural property of objects, when in fact it is no more than a social relation between labor power and the men who produce it. Gold, which is originally a commodity itself, does not escape this illusion because it is assigned the role of the privileged substrate of value, and hypostatized even though it merely expresses a relation.

It is therefore commodity fetishism which explains why gold and genuineness[15] appear as bearers of value in themselves, whereas in fact their value only derives from the function they fulfill amid a social process from which the deceiving illusions of human phantasmagoria isolate them. No more than gold, which never has the use-values inherent to the things it serves to exchange, genuineness cannot replace the intrinsic qualities of the individual, whose absence it masks and whose irreducibility it coins: it "projects the exchange formula onto that which imagines that it is not exchangeable."[16] Like the veil of Maya, the Hindu goddess who personifies illusion and whom Schopenhauer uses to symbolize the fallacious knowledge that keeps the individual from piercing the cloak of appearances, gold and genuineness mask the end of nineteenth-century capitalism and preserve the fiction of its survival by upholding its disembodied values.

With his final image, Adorno sought to pierce the veil of Maya that is the identity principle, and to expose the naked image of the world. In the town of Bretton Woods, the American Harry White officiated for the power that was the first to put an end to the free circulation of liberal capitalism, proclaiming the monetary genuineness of the Gold Exchange Standard (GES) as an homage to the capitalism of the past, now in the service of the new form of world domination. In Paris and in the Black Forest, the existentialist priests were preparing their offerings to the genuineness of a subject groping for its identity in the ruins of totalitarianism; little did they know that their destiny had already already sealed by the aid-to-genuineness that was about to begin flooding Europe with Marshall Plan GES dollars, the final stakes in the coffin of yesterday's capitalism (and its subject). Thus postwar world capitalism took up the torch of the national-socialist veneration of genuineness, beneath the horrified eyes of the critical philosophers.

In the mid-1960s, when exchange values began to slip free from the dollar of the Gold Exchange Standard, henceforth to be expressed only as floating counters in a purely differential balance, within a decentered system no longer organized around the fulcrum of a stable value,[17] Adorno would cease to analyze genuineness in purely economic terms, coming instead to see it as the structuring of a language, the *Jargon of Authenticity*. It is as though the end of an economic system organized around a central value had pushed Adorno and certain French philosophers into a form of structuralism which they saw as the necessary extension of Marxist theory, its tenets paradoxically confirmed through their own determination by the development of capitalism, at the very moment when they partially abandoned them . . .

[1] See Adorno, Theodor and Horkheimer, Max: *Dialectic of Enlightenment*, tr. J. Cumming (London: Verso, 1979), p. xvii: "The last part of the book contains sketches and drafts which . . . offer advance summaries of problems to be treated in forthcoming works. Most of them are concerned with a dialectical anthropology."

[2] The historians of philosophy who have studied the relation between Nazism and the philosophers of the immediate postwar period speak of the "law of silence" or the "taboo of the past"; see H. Kocyba in "Penser après, continuités et impasses de la philosophie en RFA," in Descamps, Christian, ed.: *Les enjeux philosophiques des années 50* (Paris: Editions du Centre Pompidou), pp. 35-51; M. Plümacher in "Tabusierung der Vergangenheit," in the anthology *Philosophie nach 1945 in der Bundesrepublik Deutschland* (Hamburg: Rowohlt, 1996). No doubt this explains why the philosophy of the 1950s was dominated by Heidegger, whose preemptive retirement was a kind of purgatory: "only in the 1960s did Heidegger lose his dominant position," writes H. Kocyba, op. cit. One could also cite D. Heinrich, who attempted in 1970 to retrospectively define Heidegger's presence in the 1950s: "In the mid-fifties, Heidegger dominated philosophical debates in Germany. There was a profusion of publications by historians under his influence. The question was how to ideologically prepare for a more authentic relation to the world than that offered by modern philosophy"; ibid. Only the progressive decline of Heideggereanism in the sixties and seventies allowed the critical philosophy of the Frankfurt School to reach a larger audience than the one it had found immediately after the war.

[3] Adorno, Theodor: *Kierkegaard, Konstruktion des Äesthischen, in Gesammelte Schriften*, vol. II.

[4] Adorno does not directly analyze Heidegger's key notion of *Eigentlichkeit* or "authenticity" in "Gold Assay," but places it in the larger framework of what he calls *Echtheit*, or "genuineness," which allows him to develop the extended metaphor of gold and to analyze it in Marxist terms.

[5] Benjamin's "dialectical images" and Adorno's "historical images" were originally related by their common finality: it was a matter of avoiding the traps of Marxism (causalist reduction, idealism) while retaining the critical moment that allows one to see the social forces underlying a given phenomenon. What philosophical criticism later called the controversy of the thirties arose from a divergence between Benjamin and Adorno over how these images should be employed. Adorno believed that Benjamin had gradually suppressed the mediation of the concept, and thus, the theoretical dimension of critical work, replacing it with an intuitive revelation of social truth through a montage of visions (this, at the time when Benjamin was working on his *Passages* book). Faithful to the terms of his critique of Benjamin, Adorno only delivers the final image of "Gold Assay" after a patient decomposition of the concept. Thus "Gold Assay" is an occasion to fulfill the task that Benjamin had left to posterity: "not to abandon such an attempt [to decipher bourgeois culture] to the estranging enigmas of thought alone, but to bring the intentionless within the realm of concepts: the obligation to think at the same time dialectically and undialectically" (*Minima Moralia*, p. 152).

[6] Whose presumable leader, Heidegger, is only cited by way of his concepts of "thrownness" (*Geworfenheit*) and "authenticity."

[7] See this fragment from Benjamin's *Passages* book: "The Copernican Revolution in the historical mode of viewing is this: one used to consider the 'past' [*das Gewesen*] as the fixed point, and saw the present as attempting to lead knowledge groping toward this firm ground. Now the relationship is to be reversed, and the past becomes the dialectical turning, the dawning of awakened consciousness"; quoted in Adorno, T. W. and Dirks, W., eds.: *Frankfurter Beitrag zur Sociologie*, p. 125.

[8] Mimesis is the prescientific stage of man/nature relations, which science tried to banish, as its contrary. Instead of dominating nature by its reduction to discrete, stable identities, it appropriates nature through imitation: "Mimesis imitates the environment. . . . For mimesis the outside world is a model which the inner world must try to conform to: the alien must become familiar"; *Dialectic of Enlightenment*, p. 187.

[9] It must be observed that Adorno describes this project in ambiguous terms: no more than in the rest of the text, he does not cite Heidegger by name. But by a subtle stylistic play he attributes to Kierkegaard's inspiration concepts which are actually Heidegger's (*je eigen* = Heideggerean authenticity, *Sein des Seiendes* = "the being of entities"). Instead of approaching Heidegger's philosophy head on, Adorno "Heideggereanizes" Kierkegaard, to target the former with the criticisms he had already formulated against the latter in his thesis.

[10] Kierkegaard, S. A.: *Kierkegaard's Concluding Unscientific Postscript* (Princeton: Princeton University Press, 1941), quoted in A. Hannay, *Kierkegaard, the arguments of the philosopher* (London: Routledge and Kegan Paul, 1982), p. 242.

[11] See Hegel, G.W.F.: "Freedom of Self-Consciousness: Stoicism, Scepticism, and the Unhappy Consciousness," in *The Phenomenology of Mind* (New York: Harper Torchbooks, 1967); also see Adorno: *Philosophische Terminologie* (Frankfurt: Suhrkamp, 1973), vol. I, p. 31: "the one, the isolated, the moment of unity—for example, subjectivity isolated from the objects which concern it . . . are all to be qualified as abstract. . . . Conversely, only the whole in which all the moments are organically contained, in which each depends on the other, only the whole which becomes whole through the structure of its elements, can rightfully be termed concrete."

[12] See Adorno's assertions concerning Ibsen's *Wild Duck:* "In Ibsen, being true already means: no existential lies, facing and recognizing what one is, being identical to oneself. And in this identity, in this, how shall we say, reduction of the moral imperative to sheer being-one's-self, naturally all specific content concerning what man must be begins to disappear, and finally according to this ethic one can be a real man by being a real—that is, self-conscious and clear-seeing—scoundrel"; *Probleme der Moralphilosophie* (1963), in *Nachgelassene Schriften Abteilung IV* (Frankfurt: Suhrkamp, 1996), vol. X.

[13] *Beitrag zur Ideologienlehre*, quoted in Grenz, F.: *Adornos Philosophie in Grundbegriffen* (Frankfurt: Suhrkamp, 1976), p. 138.

[14] "The particularity of the self is a monopoly commodity determined by society; it is falsely represented as natural. It is no more than the moustache, the French accent, the deep voice of the woman of the world, the Lubitsch touch . . ."; *Dialectic of Enlightenment*, p. 154.

[15] Genuineness, in economic terms, is the indication of the specific proportion of a precious metal; as the value of value, it is caught in the circuit of exchange and fetishism.

[16] Adorno, Theodor: *The Jargon of Authenticity*, trs. K. Tarnowski and F. Will (London: Routledge and Kegan Paul, 1973), p. 76.

[17] From 1960 to 1968 the dollar suffered speculative attacks causing gold and other strong currencies (particularly the Deutschmark) to rise; at the same time, (post)structuralism appeared: Derrida, Jacques: "Structure, Sign and Play in the Discourse of the Human Sciences" in 1967, translated in *Writing and Difference* (Chicago: University of Chicago Press, 1978), tr. A. Bass, pp. 289-290; Foucault, Michel: *The Order of Things*, also in 1967 (New York: Pantheon, 1971).

1945–1967

Vito Acconci

```
(here)(          )(      )
(      )(there)(                     )
(     ) (              )(here and there -- I say here)
(                      )(I do not say now)(                )
(I do not say it now)(              )(                      )
(                 )(then and there -- I say there)(        )
(                      )(                )(say there)
(        )(I do not say then)(                 )
(I do not say, then, this)(             )(        )
(                   )(then I say)(          )
(         )(              )(here and there)
(            )(first here)(              )
(I said here second)(        )(               )
(                 )(I do not talk first)(       )
(              )(         )(there then)
(         )(here goes)(                )
(I do not say what goes)(        )(              )
(                   )(I do not go on saying)(      )
(                 )(                  )(there is)
(       )(that is not to say)(             )
(I do not say that)(             )(        )
(               )(here below)(               )
(        )(            )(I do not talk down)
(              )(under my words)(           )
(under discussion)(            )(       )
(            )(all there)(            )
(        )(         )(I do not say all)
(            )(all I say)(     )
```

1967

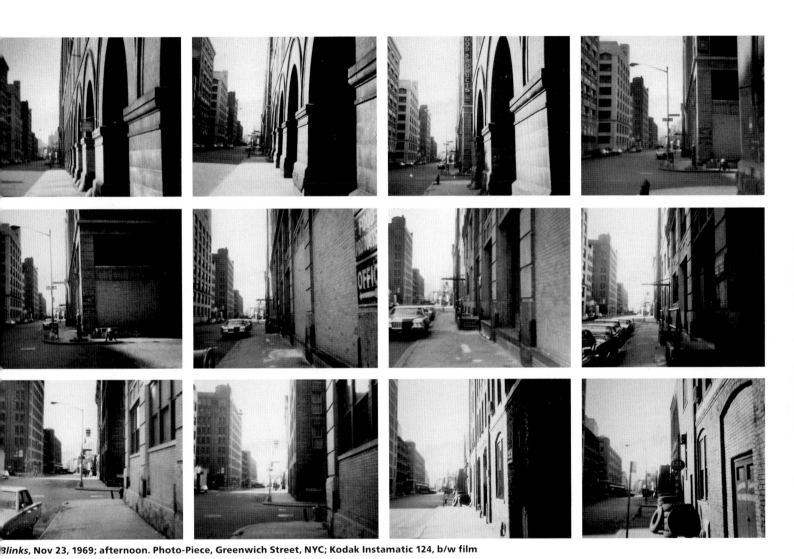

Blinks, Nov 23, 1969; afternoon. Photo-Piece, Greenwich Street, NYC; Kodak Instamatic 124, b/w film

Holding a camera, aimed away from me and ready to shoot, while walking a continuous line down a city street.

Try not to blink.

Each time I blink: snap a photo.

Marcel Broodthaers

Le Corbeau et le Renard **(The Crow and the Fox)**
Filming of *Le Corbeau et le Renard*, **1968**

LE D EST PLUS GRAND QUE LE T. TOUS LES D DOIVENT AVOIR LA MÊME LONGUEUR. LE JAMBAGE ET L'OVALE ONT LA MÊME PENTE COMME DANS A. MODÈLES: LE CHIEN. LE RENARD. KOEKELBERG. LES CRIS. LES MAINS. L'ORCHIDÉE. L'ARCHITECTE. LES PATTES. LES MAINS. PARIS. LA FOURBERIE. LES VOIX. LES CRIS. LE CARAC-TÈRE. L'IMPRIMÉ. L'IMPRIMEUR. L'AGORA. LE BLEU. LE ROUGE. LE

Le Corbeau et le Renard **(The Crow and the Fox), detail, 1967**

Le Corbeau et le Renard **(The Crow and the Fox)**
Wide White Space Gallery, Antwerp, 1968

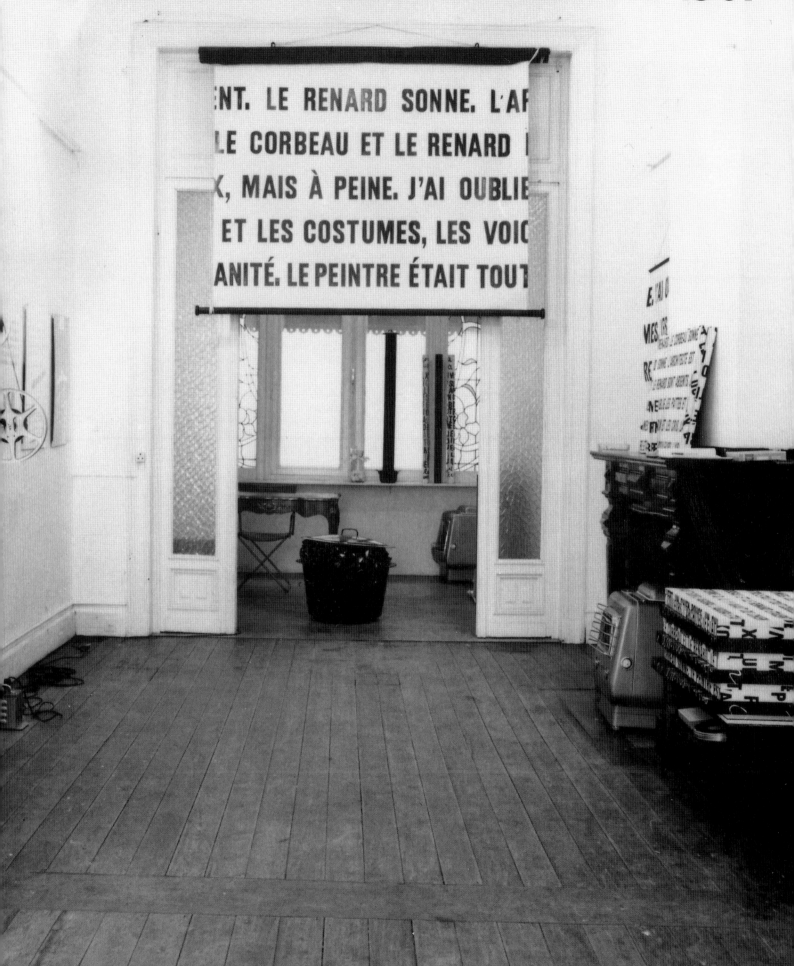

Lygia Clark

Caminhando **(Traveling), 1964**

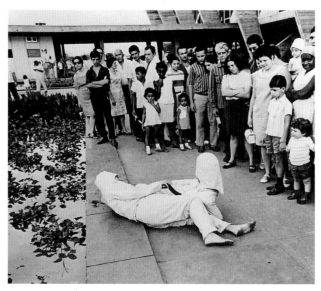

Cesariana: série roupa-corpo-roupa
(Cesariana: Clothing-Body-Clothing Series), 1967

Lygia Clark

Objeto: pedra e ar (Object: Stone and Air), 1966

Máscara abismo (Abyss Mask), 1968

O eue o tu: série roupa-corpo-roupa (The I and You: Clothing-Body-Clothing Series), 1967

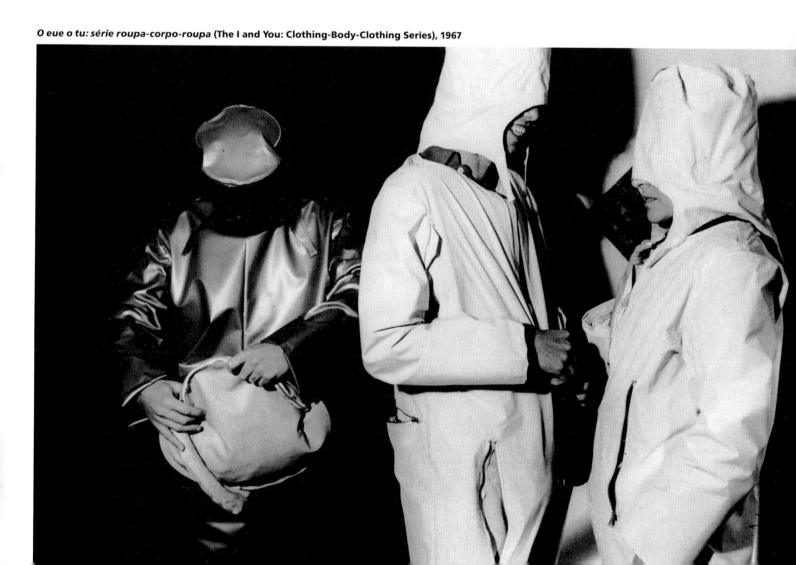

Ed van der Elsken

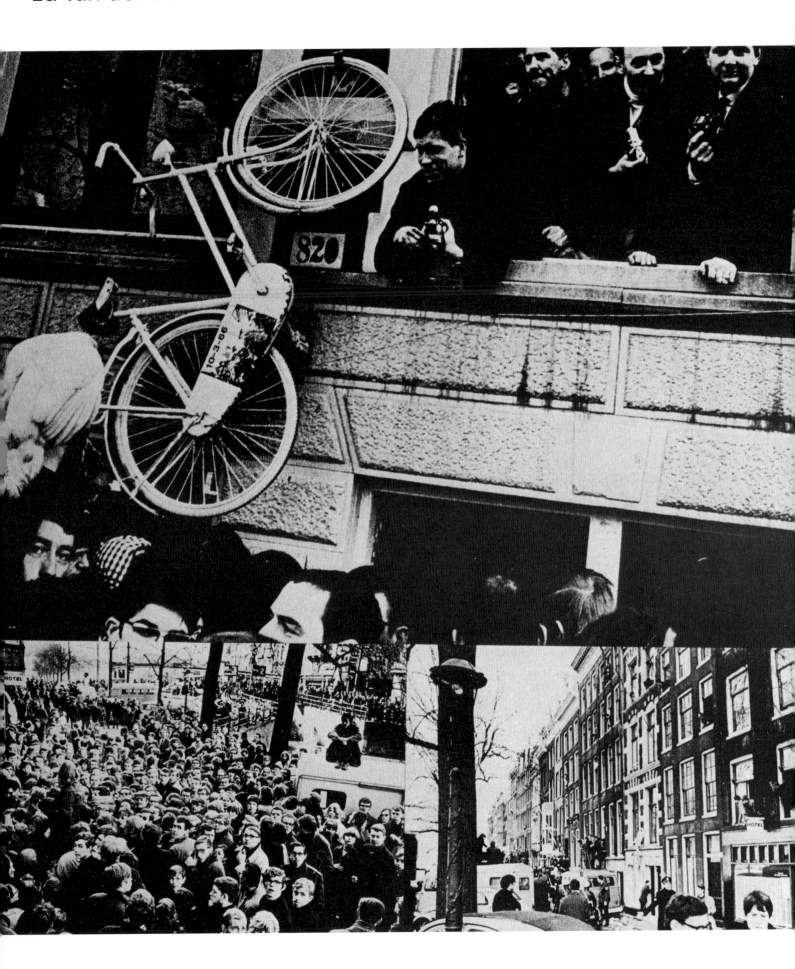

**March 19, 1966, Provo demonstration, Jan Wolkers speaks,
In *Amsterdam*, Bussum, 1966.**

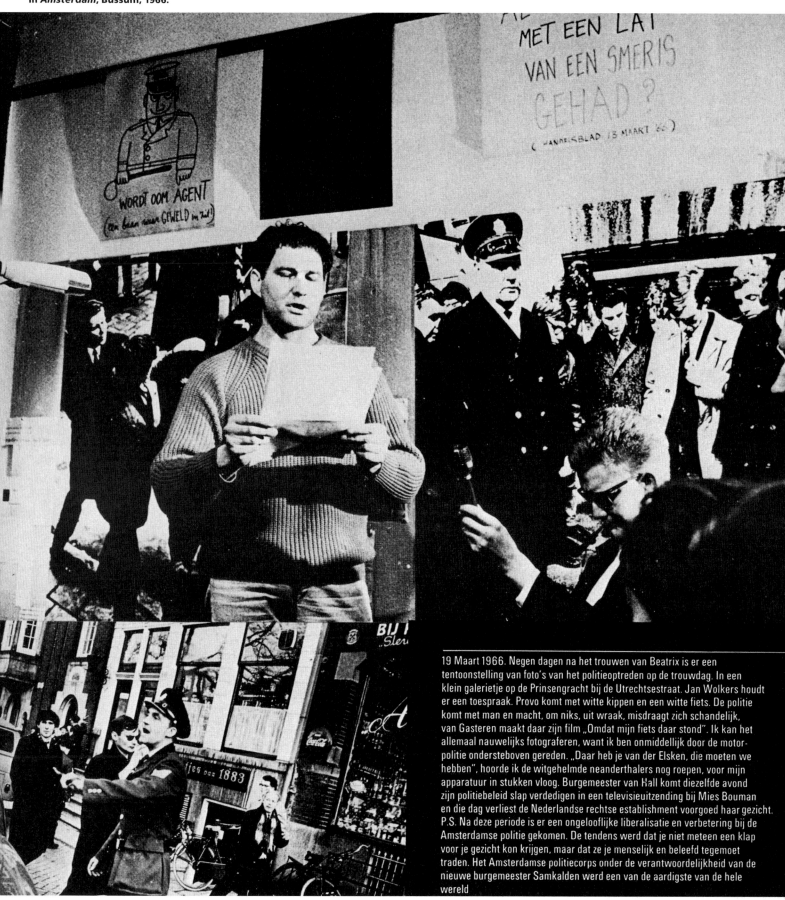

19 Maart 1966. Negen dagen na het trouwen van Beatrix is er een tentoonstelling van foto's van het politieoptreden op de trouwdag. In een klein galerietje op de Prinsengracht bij de Utrechtsestraat. Jan Wolkers houdt er een toespraak. Provo komt met witte kippen en een witte fiets. De politie komt met man en macht, om niks, uit wraak, misdraagt zich schandelijk, van Gasteren maakt daar zijn film „Omdat mijn fiets daar stond". Ik kan het allemaal nauwelijks fotograferen, want ik ben onmiddellijk door de motor-politie ondersteboven gereden. „Daar heb je van der Elsken, die moeten we hebben", hoorde ik de witgehelmde neanderthalers nog roepen, voor mijn apparatuur in stukken vloog. Burgemeester van Hall komt diezelfde avond zijn politiebeleid slap verdedigen in een televisieuitzending bij Mies Bouman en die dag verliest de Nederlandse rechtse establishment voorgoed haar gezicht. P.S. Na deze periode is er een ongelooflijke liberalisatie en verbetering bij de Amsterdamse politie gekomen. De tendens werd dat je niet meteen een klap voor je gezicht kon krijgen, maar dat ze je menselijk en beleefd tegemoet traden. Het Amsterdamse politiecorps onder de verantwoordelijkheid van de nieuwe burgemeester Samkalden werd een van de aardigste van de hele wereld

Walker Evans

Trash picture, ca. 1968

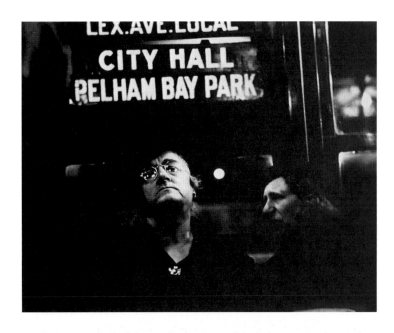

For all its directness, apparent objectivity and detachment from personal emotions, most pop art evokes a romance for the era of twenty to thirty years ago, the time of the artist's childhood. It is very much like the mood we find in the novels of Jack Kerouac. Villeglé's, Hains' and Rotella's tattered posters, seeing America from afar, whose proclamations and has-been goddesses are beaten by weather and age, recall Walker Evans' photos of years ago; Lichtenstein's cartoons and products have an iconography and style of the forties.

Allan Kaprow, July 1967, in *Malahat Review*.

Subway portraits, from *Many Are Called*, 1966

Öyvind Fahlström

The Little General (Pinball Machine), 1967–68
Installation: Kölnischer Kunstverein, 1996

Notes for The Little General B, 1967–68

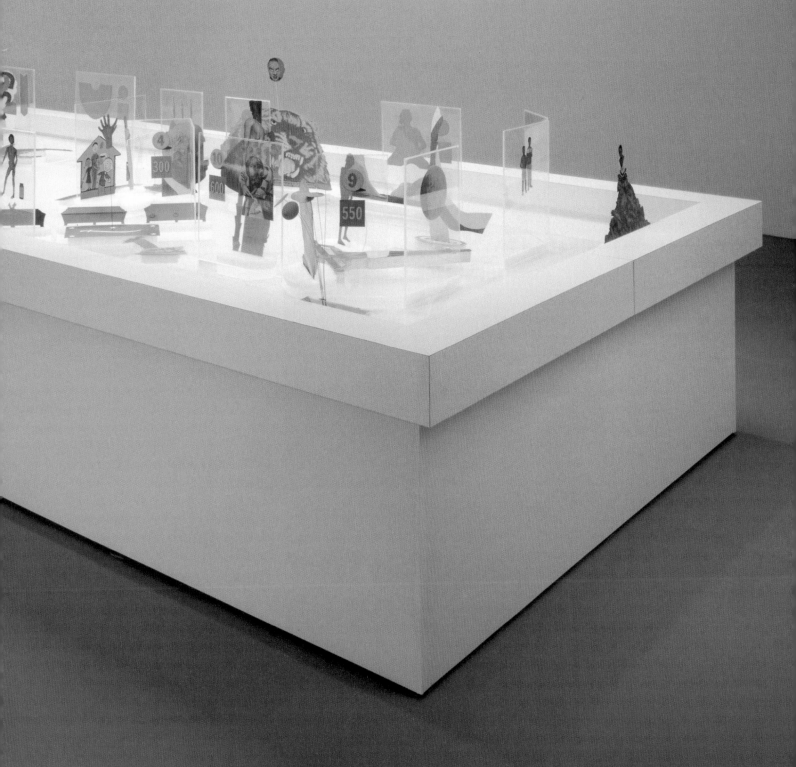

Armand Gatti

Armand Gatti at a rehearsal of
his play *La Naissance* (Birth)
in Kassel 1968/69, directed by
the author.

La passion du Général Franco (General Franco's Passion), 1967/68

The premiere of Gatti's
General Franco's Pa
took place at the Staatsth
in Kassel in
Directed by Kai B

ZWISCHEN
TOULOUSE
UND
MADRID

ZWISCHEN
HAVANNA
UND
MEXICO

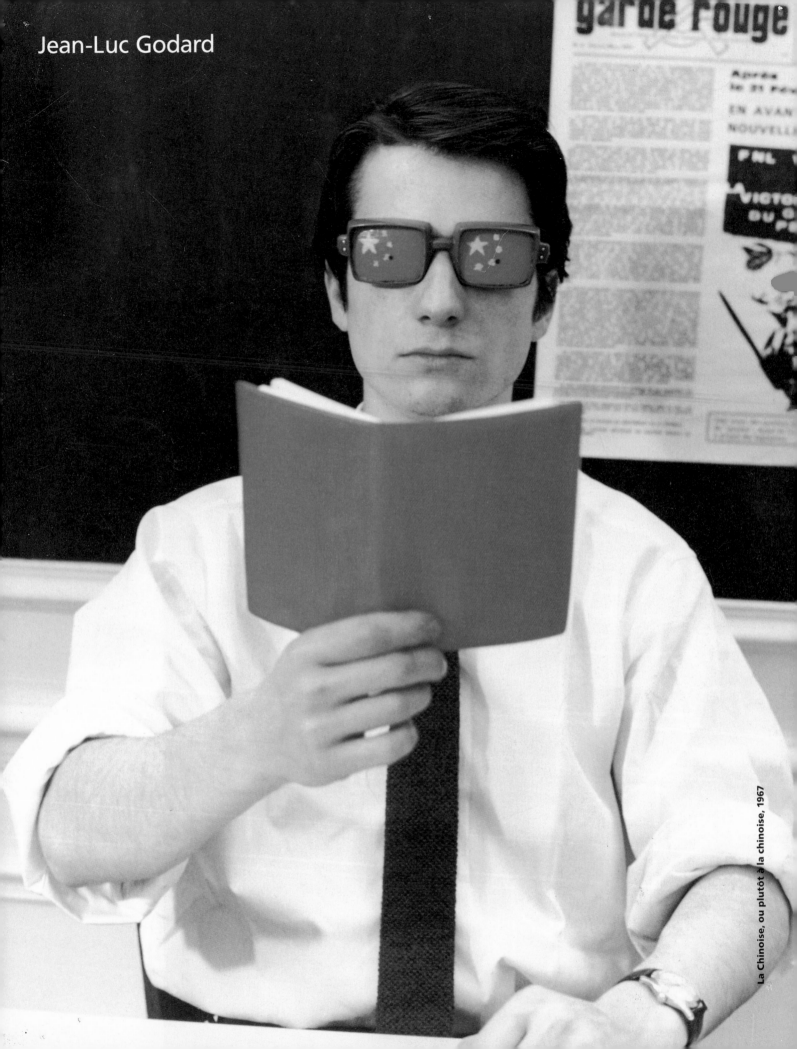

Jean-Luc Godard

La Chinoise, ou plutôt à la chinoise, 1967

inquante ans après la
évolution d'Octobre,
cinéma américain
ègne sur le cinéma
mondial. Il n'y a
as grand chose à
jouter à cet état
fait. Sauf qu'à
otre échelon mo-
deste, nous devons
ous aussi créer
eux ou trois Vietnams
sein de l'immense
mpire Hollywood -
inecitta - Mosfilms
Pinewood. Etc. et,
ant économiquement
u'esthétiquement, c'
st à dire en
uttant sur deux
ronts, créer des
inémas nationaux,
ibres, frères, cama-
ades et amis.

Jeanluc Godard

La Chinoise, ou plutôt à la chinoise, 1967

Jean-Luc Godard

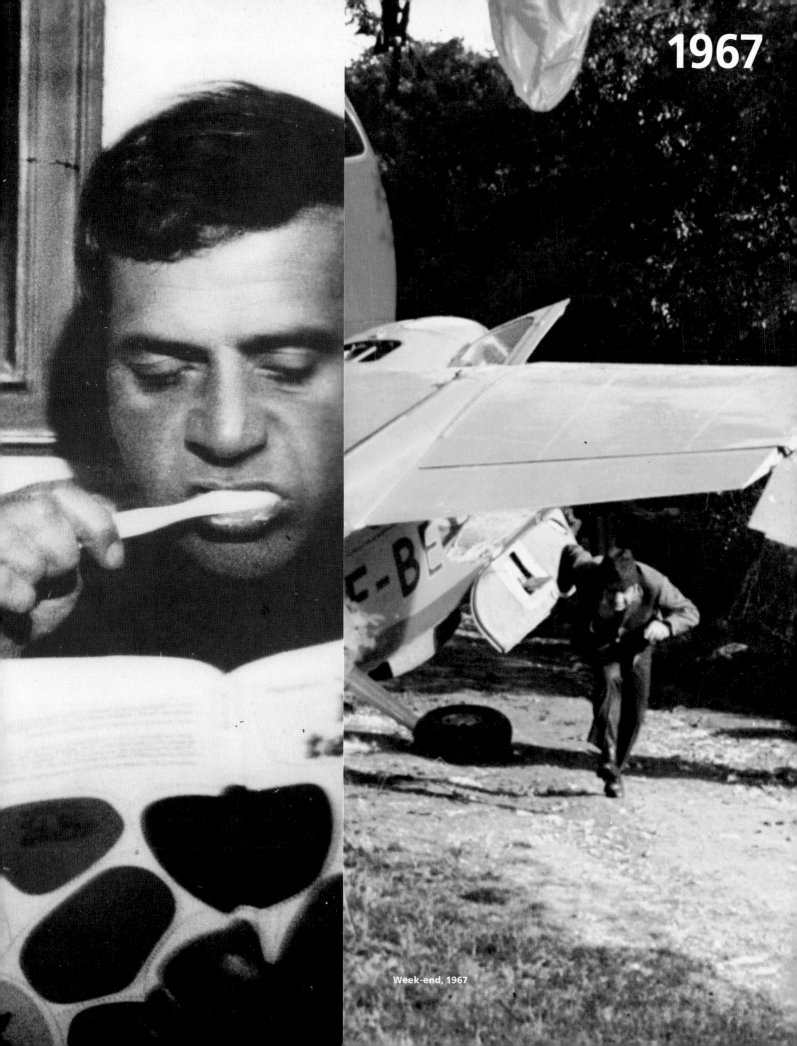

1967

Week-end, 1967

Dan Graham

"The Serenade" - Cape Coral unit, Fla.

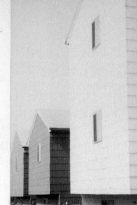

Homes for America

D. GRAHAM

Belleplain	Garden City
Brooklawn	Garden City Park
Colonia	Greenlawn
Colonia Manor	Island Park
Fair Haven	Levitown
Fair Lawn	Middleville
Greenfields Village	New City Park
Green Village	Pine Lawn
Plainsboro	Plainview
Pleasant Grove	Plandome Manor
Pleasant Plains	Pleasantside
Sunset Hill Garden	Pleasantville

Set-back, Jersey City, New Jersey

Each house in a development is a lightly constructed 'shell' although this fact is often concealed by fake (half-stone) brick walls. Shells can be added or subtracted easily. The standard unit is a box or a series of boxes, sometimes contemptuously called 'pillboxes.' When the box has a sharply oblique roof it is called a Cape Cod. When it is longer than wide it is a 'ranch.' A

The logic relating each sectioned part to the entire plan follows a systematic plan. A development contains a limited, set number of house models. For instance, Cape Coral, a Florida project, advertises eight different models:

A The Sonata
B The Concerto
C The Overture
D The Ballet
E The Prelude
F The Serenade
G The Noctune
H The Rhapsody

Large-scale 'tract' housing 'developments' constitute the new city. They are located everywhere. They are not particularly bound to existing communities; they fail to develop either regional characteristics or separate identity. These 'projects' date from the end of World War II when in southern California speculators or 'operative' builders adapted mass production techniques to quickly build many houses for the defense workers over-concentrated there. This 'California Method' consisted simply of determining in advance the exact amount and lengths of pieces of lumber and multiplying them by the number of standardized houses to be built. A cutting yard was set up near the site of the project to saw rough lumber into those sizes. By mass buying, greater use of machines and factory produced parts, assembly line standardization, multiple units were easily fabricated.

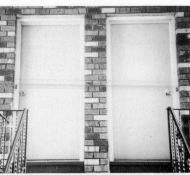

Two Entrance Doorways, 'Two Home Homes', Jersey City, N.B.

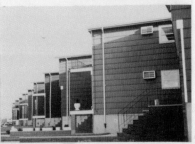

Center Court, Entrances, Development, Jersey

two-story house is usually called 'colonial.' If it consists of contiguous boxes with one slightly higher elevation it is a 'split level.' Such stylistic differentiation is advantageous to the basic structure (with the possible exception of the split level whose plan simplifies construction on discontinuous ground levels).

In addition, there is a choice of eight colors:
1 White
2 Moonstone Grey
3 Nickle

LAWN GREEN

There is a recent trend toward 'two home homes' which are two boxes split by adjoining walls and having separate entrances. The left and right hand units are mirror reproductions of each other. Often sold as private units are strings of apartment-like, quasi-discrete cells formed by subdividing laterally an extended rectangular parallelopiped into as many as ten or twelve separate dwellings.

4 Seafoam Green
5 Lawn Green
6 Bamboo
7 Coral Pink

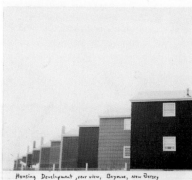

Housing Development, rear view, Bayonne, New Jersey

Develo...
vidual...
whose...
plan...
parks...
genera...
into bl...
tical o...
which...
land pl...

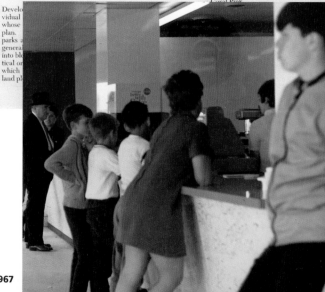

New Highway Restaurant Opening, Jersey City, N. J., 1967

Homes for America, 1965–70

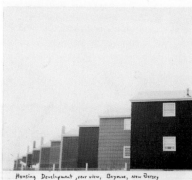

Housing Development, front view, Bayonne, New Jersey

Entrance of Model Home, Staten Island, N.Y.

Bedroom of Model Home, S.I., N.Y.

A block of houses is a self-contained sequence — there is no development — selected from the acceptable arrangements. As an example, if a section was to contain eight houses of four model types were to be used, any of the permutational possibilities could be used:

AABBCCDD ABCDABCD
AABBDDCC ABDCABDC
AACCBBDD ACBDACBD
AACCDDBB ACDBACDB
AADDCCBB ADBCADBC
AADDBBCC ADCBADCB
BBAADDCC BACDBACD
BBCCAADD BCADBCAD
BBCCDDAA BCDABCDA
BBDDAACC BDACBDAC
BBDDCCAA BDCABDCA
CCAABBDD CABDCABD
CCAADDBB CADBCADB
CCBBDDAA CBADCBAD
CCBBAADD CBDACBDA
CCDDAABB CDABCDAB
CCDDBBAA CDBACDBA
DDAABBCC DACBDACB
DDAACCBB DABCDABC
DDBBAACC DBACDBAC
DDBBCCAA DBCADBCA
DDCCAABB DCABDCAB
DDCCBBAA DCBADCBA

Basement Doors, Home, New Jersey

'Discount Store', Sweaters on Racks, New Jersey

The 8 color variables were equally distributed among the house exteriors. The first buyers were more likely to have obtained their first choice in color. Family units had to make a choice based on the available colors which also took account of both husband and wife's likes and dislikes. Adult male and female color likes and dislikes were compared in a survey of the homeowners:

'Like'

Male	Female
Skyway	Skyway Blue
Colonial Red	Lawn Green
Patio White	Nickle
Yellow Chiffon	Colonial Red
Lawn Green	Yellow Chiffon
Nickle	Patio White
Fawn	Moonstone Grey
Moonstone Grey	Fawn

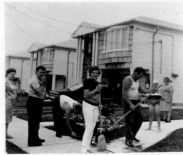

Two Family Units, Staten Island, N.Y.

'Dislike'

Male	Female
Lawn Green	Patio White
Colonial Red	Fawn
Patio White	Colonial Red
Moonstone Grey	Moonstone Grey
Fawn	Yellow Chiffon
Yellow Chiffon	Lawn Green
Nickle	Skyway blue
Skyway Blue	Nickle

'Split-Level', 'Two Home Homes', Jersey City, N.J.

'Ground-Level', 'Two Home Homes', Jersey City, N.J.

Although there is perhaps some aesthetic precedence in the row houses which are indigenous to many older cities along the east coast, and built with uniform façades and set-backs early this century, housing developments as an architectural phenomenon seem peculiarly gratuitous. They exist apart from prior standards of 'good' architecture. They were not built to satisfy individual needs or tastes. The owner is completely tangential to the product's completion. His home isn't really possessable in the old sense; it wasn't designed to 'last for generations'; and outside of its immediate 'here and now' context it is useless, designed to be thrown away. Both architecture and craftsmanship as values are subverted by the dependence on simplified and easily duplicated techniques of fabrication and standardized modular plans. Contingencies such as mass production technology and land use economics make the final decisions, denying the architect his former 'unique' role. Developments stand in an altered relationship to their environment. Designed to fill in 'dead' land areas, the houses needn't adapt to or attempt to withstand Nature. There is no organic unity connecting the land site and the home. Both are without roots — separate parts in a larger, predetermined, synthetic order.

Row of Tract Houses, Bayonne, N.Y., 1966

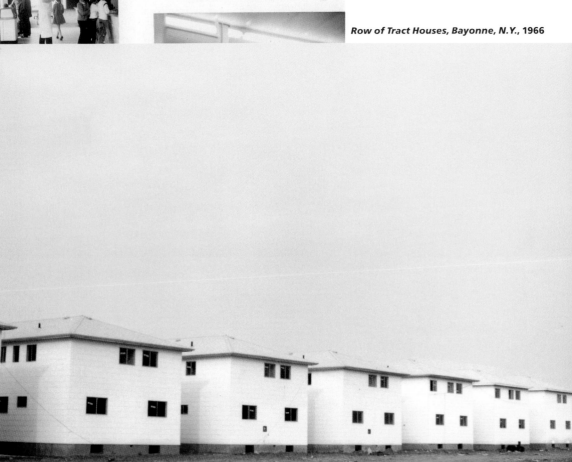

Hans Haacke

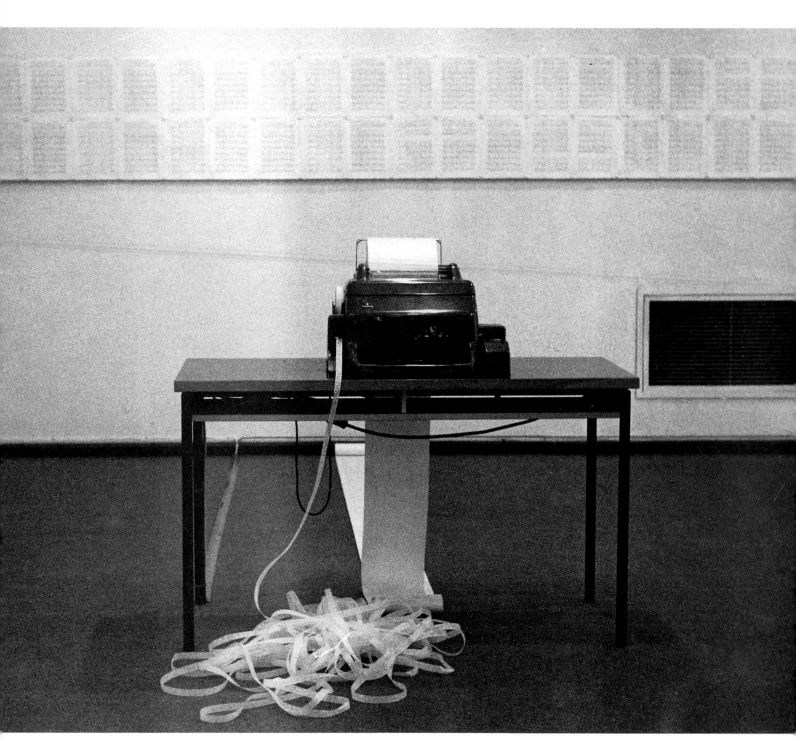

Nachrichten (News), 1969

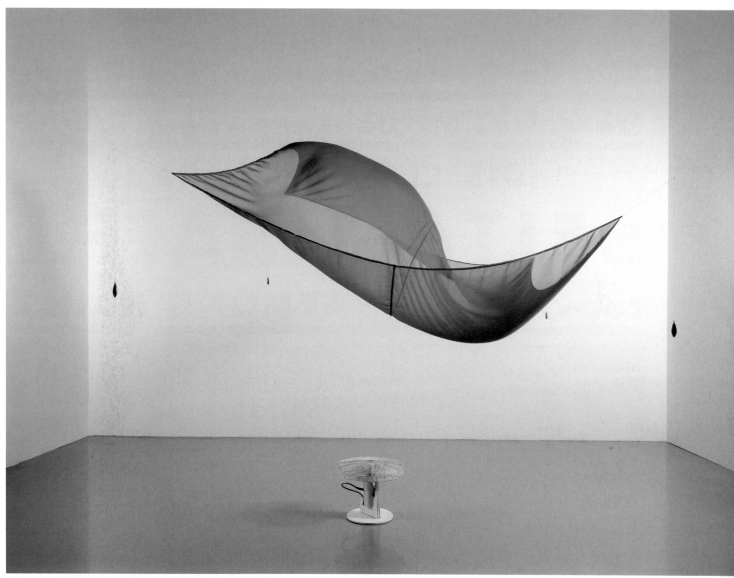

Blaues Segel (Blue Sail), 1965

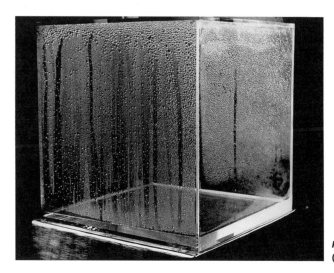

Kondensationswürfel
(Condensation Cube), 1963–65

iris.time

UNLIMITED

Tiré à 5000 ex.

2 f

Directrice : Iris Clert. Rédacteur, Le Brain-Trust. Siège Social, 28 Fg St-Honoré, Paris 8ᵉ · Anj 32-05 · 12 Octobre 1965 · N° 21

Sous la Haute Inspiration des Régies

Française et Italienne des Tabacs

IRIS CLERT présente :

SEITA & SAFFA

copyright by RAYMOND HAINS

L'ANE VETU DE LA PEAU DE LION

SEITA

SUPER-MATCH BOX : 110 cms x 210 cms

Vernissage le Mardi 12 Octobre à 21 heures : 28, faubourg Saint-Honoré, Paris (8ᵉ)

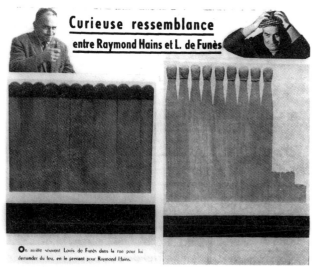

iris.news.iris.news.iris.news.iris.news.iris

Origines mythologiques de SEITA & SAFFA

"Génies du Feu"

Le mythe de Prométhée est l'un des plus dramatiques, l'un des plus complexes de la mythologie grecque. Prométhée, premier père de l'humanité, la représente tout entière, autant dans son effort vers le mieux, que dans l'orgueil qui vient du succès et qui incite à s'égaler aux dieux.

La découverte du feu ou plutôt l'invention qui permit à l'homme de faire jaillir l'étincelle, est une des plus prodigieuses qui fut jamais, celle qui, à l'époque très ancienne,

mais alors que l'humanité était vieille peut-être de plusieurs millénaires, change le cours de ses destinées. Elle peut être considérée comme la base de toute civilisation. Aussi l'auteur de cette découverte fut-il à juste titre considéré comme un demi-dieu.

Le nom de Prométhée vient du sanscrit prâmathyus dont le sens est : « Qui produit du feu par frottement ». On voit, en effet, qu'à l'époque védique le procédé pour obtenir le feu consistait à faire

tourner rapidement un bâton dans un trou pratiqué lui-même dans une pièce de bois. En faisant cette opération on invoquait le dieu Agni; le bâton était comparé à l'organe mâle, le trou à l'organe femelle. C'est ce qui explique la confusion qui, de l'inventeur du feu, fait le modeleur de l'homme.

Les Dieux du Paganisme — Henri de Vibraye — Editeur Emile Hazan.

NOS PETITES ANNONCES

PRIX IMBATTABLE

Terrain boisé clos murs, 50 hectares, région Méditerranée, plein soleil. A vendre uniquement pour expériences pyromaniaques si pas pyromane s'abstenir.

Ecrire Iris-Time qui transmettra.

Pyromane repenti cherche région marécageuse ou grand barrage pour provoquer inondation. Discrétion assurée.

Ecrire Iris-Time qui transmettra.

Individualiste désire contacter vieux routier finances pour initiation mystères sociétés anonymes afin dissimuler amélioration standing. Ecrire B.P. Iris-Time.

GALERIE DI CENOBIO, à Milan

Jacques Kermoal (dit Kérozène) a présenté sous le titre « Nuovo Realismo a Fuoco » un hommage à SAFFA et SEITA : trente-huit peintres de Mezens à Dova, de

Peverelli à Rotella et d'Azuma à Kliko Yoolinda ont pris pour thème : l'allumette. Gros succès. l'exposition part pour Locarno, avant de gagner Amsterdam.

Marie-Chantal incendiaire

Marie-Chantal appelle Gérard au téléphone :

« Vite, vite, Gérard, viens, la maison brûle! C'est prodigieux, tu ne peux pas manquer ce spectacle!

Gérard se précipite.

Tout brûle : les meubles de marqueterie crépitent, les livres d'art

flambent, les rideaux et les tapisseries sont en flammes.

« Tu es un chou, dit Gérard, c'est vraiment divin, quel bel incendie! mais, dis-moi, quelle est cette curieuse odeur de caramel?

« Ce n'est rien, dit Marie-Chantal, c'est Grand-mère qui brûle; elle avait le diabète. »

NOS ABONNÉS 1965

Baron KONRAD — Paris.
M. Cesare ZAVATTINI — Rome.
M. Régis de POLEON — Paris.
Mme Eva de BURÈN — Stockholm.

Mme de MOHL — Paris.
M. Bruno CONTENOTTE — Milan.
Mme Alice JUILLARD. — Versailles.
M. PUECH — Paris.

Nous vous rappelons que le prix des abonnements est de 20 f. pour la France et le Marché Commun et de $ 6 pour les U.S.A.

Imp. A. Lapied, 34, r. Monsieur-le-Prince, VI^e

Curieuse ressemblance entre Raymond Hains et L. de Funès

On arrête souvent Louis de Funès dans la rue pour lui demander du feu, en le prenant pour Raymond Hains.

SEITA SAFFA

Historique des Allumettes

Contrairement à ce que l'on pense, c'est un Français, Charles Sauria, qui, en 1831, inventa l'allumette chimique moderne.

A la même époque, un autre inventeur, Stefan von Römer, faisait la même découverte en Autriche.

Les pays scandinaves et en particulier la Suède, furent les premiers à créer l'Industrie des Allumettes, grâce à la profusion de

matières premières.

En effet, dans ces pays, on utilise le bois de tremble.

En France et dans les pays de même latitude, on emploie le peuplier.

Certains pays méditerranéens utilisent la cire à cause du manque de bois.

En 1872: Institution du monopole des Allumettes en France.

En 1889: Exploitation par une compagnie fermière, dont la gestion fut confiée à l'Administration des Manufactures de l'Etat.

En 1926: Création de la Caisse Autonome à laquelle est rattaché le SEIT.

En 1935: Les Manufactures d'Allumettes sont rattachées à cet organisme qui prend le nom de SEITA.

01 / B 45 tours

DISQUE BLEU
— FILTRE —
Raymond Hains l'abstrait siglisbée de la critique

enregistr. giorgio baruti

SAFFA

Disque bleu pour SAFFA (Blue Record for SAFFA)

Richard Hamilton

hamilton

Toaster

Toaster Study I, **1969**

Toaster, **1967**

1966–67 (reconstructed 1969)

Maria Lassnig

L'Intimité (Intimacy), 1967

Self-portrait as garden scissor, 1969

Selfportrait as gardenscissor
M Lassnig 1969

Chair film, drawings, study for chairs, 1970

„chair-film"-drawings

M. Lassnig 1970
to make a long story short.

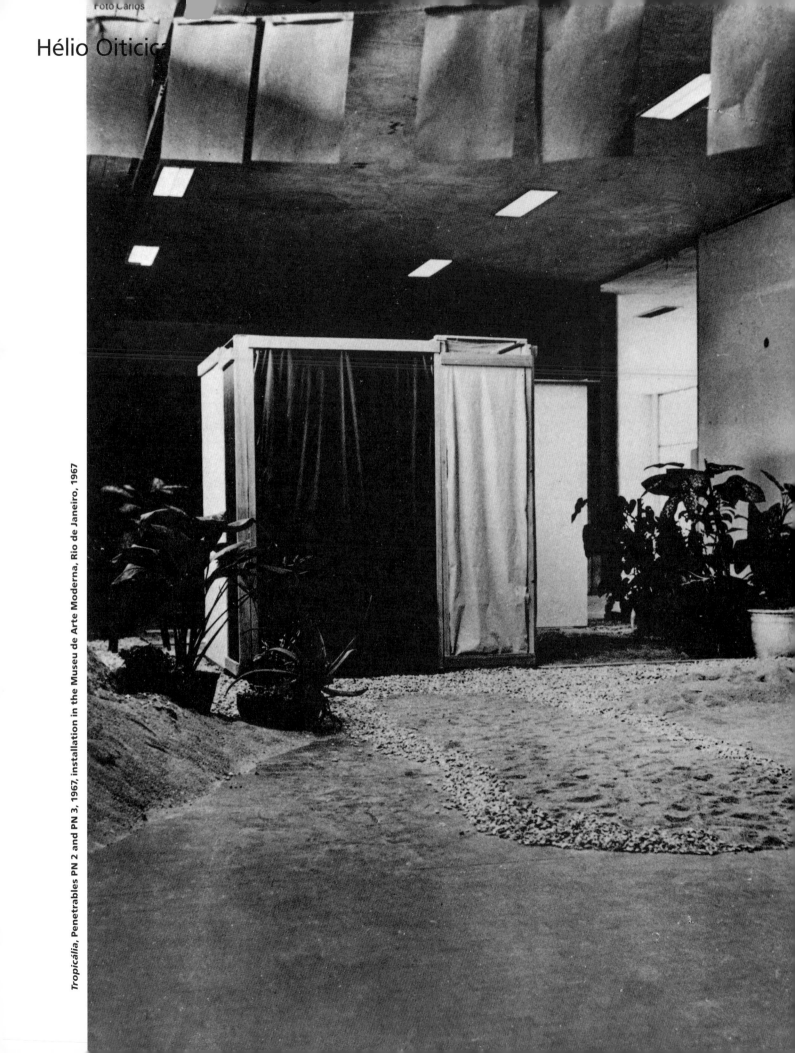

Hélio Oiticica

Tropicália, Penetrables PN 2 and PN 3, 1967, installation in the Museu de Arte Moderna, Rio de Janeiro, 1967

mone Bardin

Morro da Mangueira, Rio de Janeiro, 1965

Hélio Oiticica

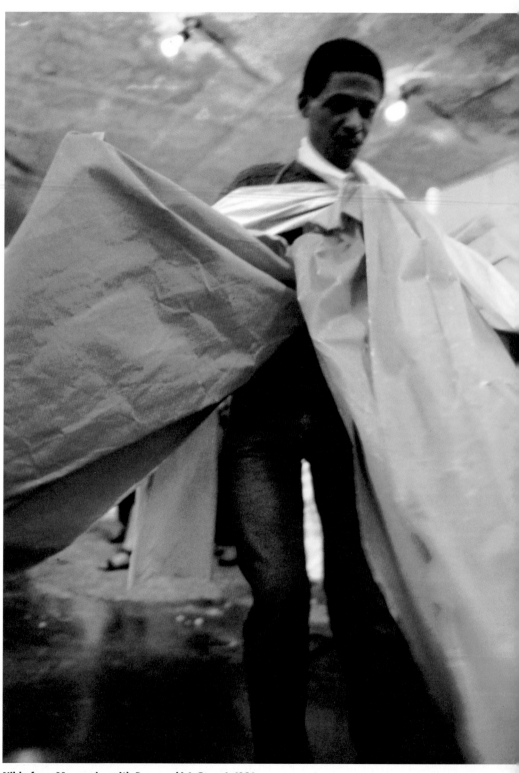

Nildo from Mangueira with *Parangolé 4, Cape 1*, 1964

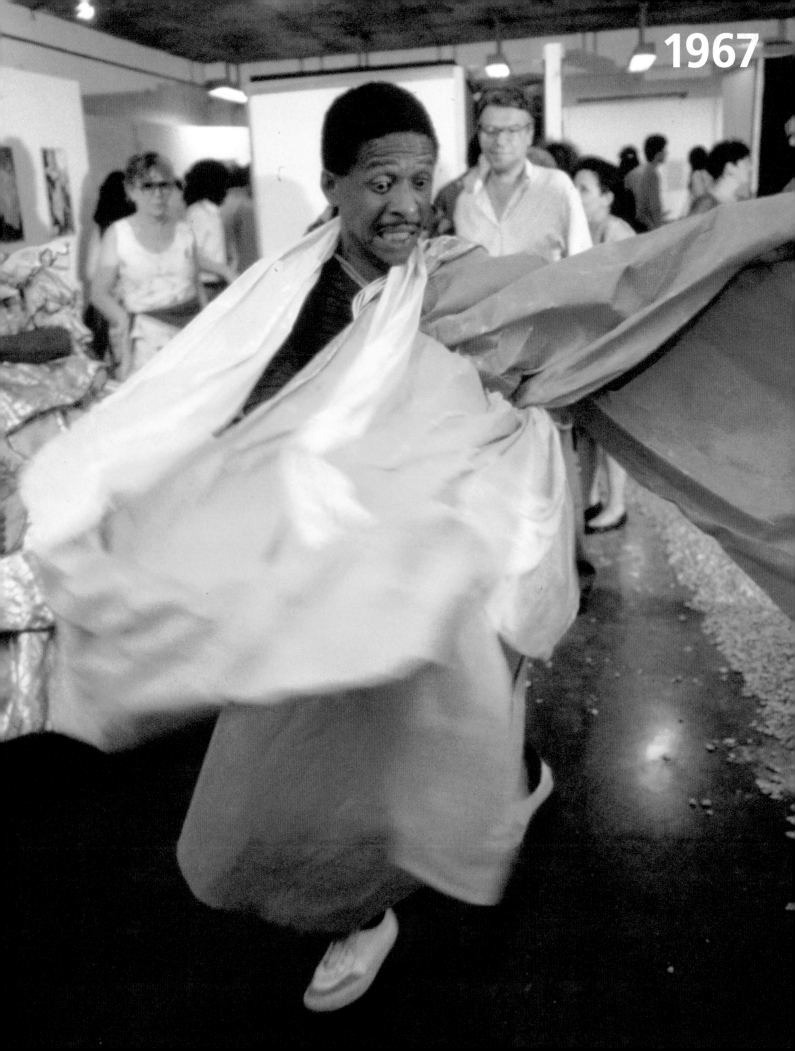

1967

Michelangelo Pistoletto

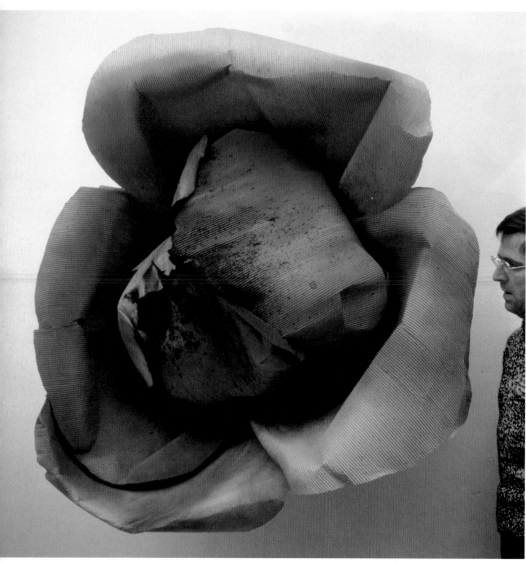

Rosa bruciata **(Burnt Rose), 1965**

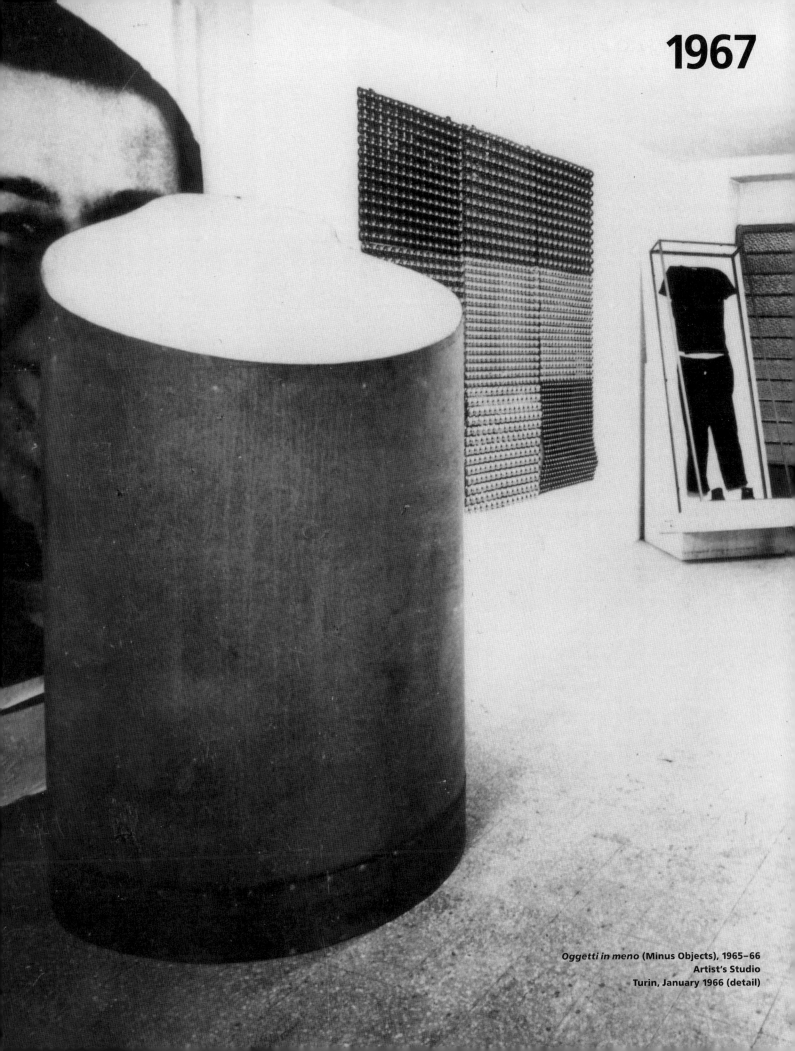

Oggetti in meno (Minus Objects), 1965–66
Artist's Studio
Turin, January 1966 (detail)

Michelangelo Pistoletto

Foto di Jasper Johns (Photo of Jasper Johns), 1966

left to right:
Metrocubo d'infinito (Cubic Meter of Infinity), 1966
Mappamondo (Globe), 1966–68
Lampada a mercurio (Mercury Lamp), 1965
Quadro da pranzo (Lunch Picture), 1965
Ti amo (I Love You), 1965–66

 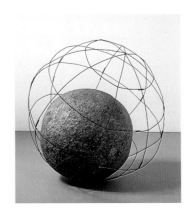

Gerhard Richter

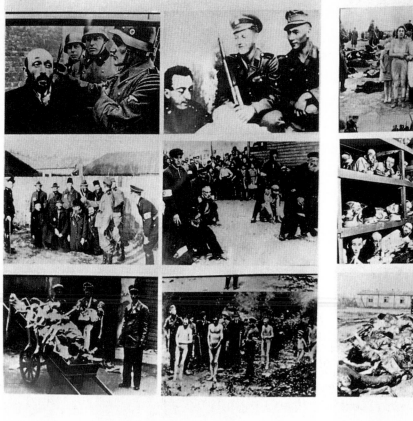

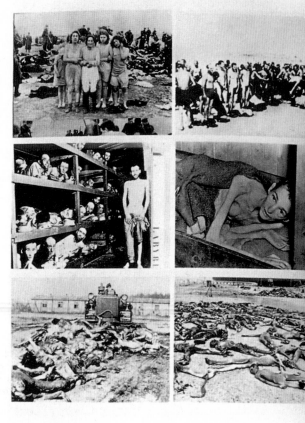

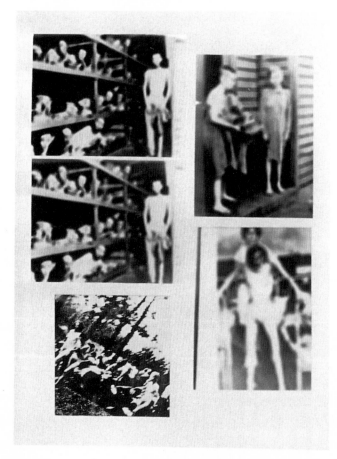

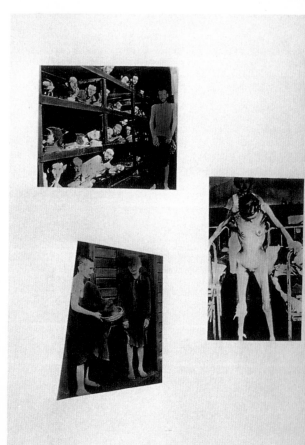

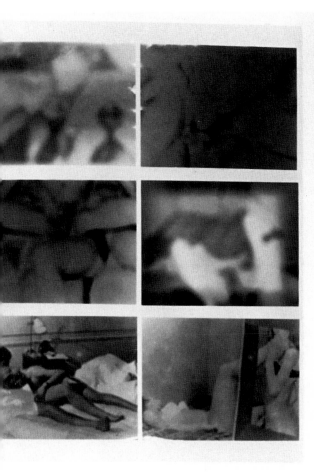

Nancy Spero

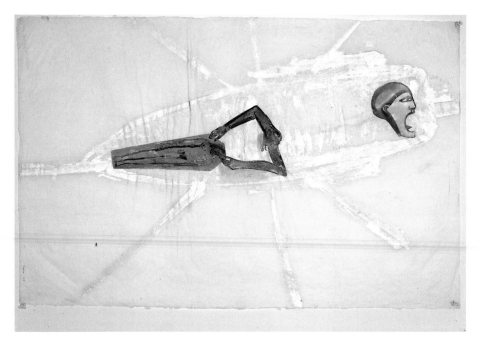

Pilot, Rape, Victim, Gunship, 1968

Victims and Soldiers Pushing Victims Out of Helicopter, 1968

1967

les anges - la bombe

Spero

Garry Winograd

Untitled, 1971

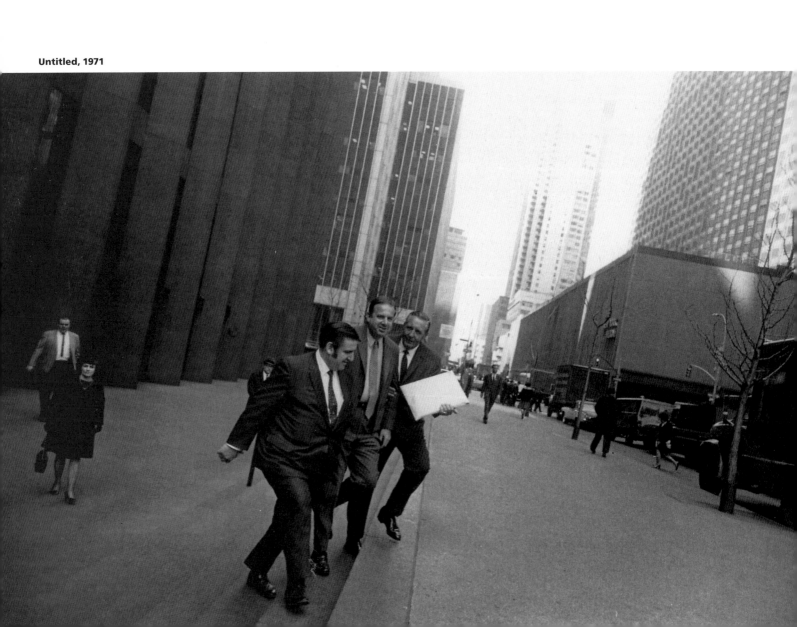

Untitled, 1971

Untitled, 1967

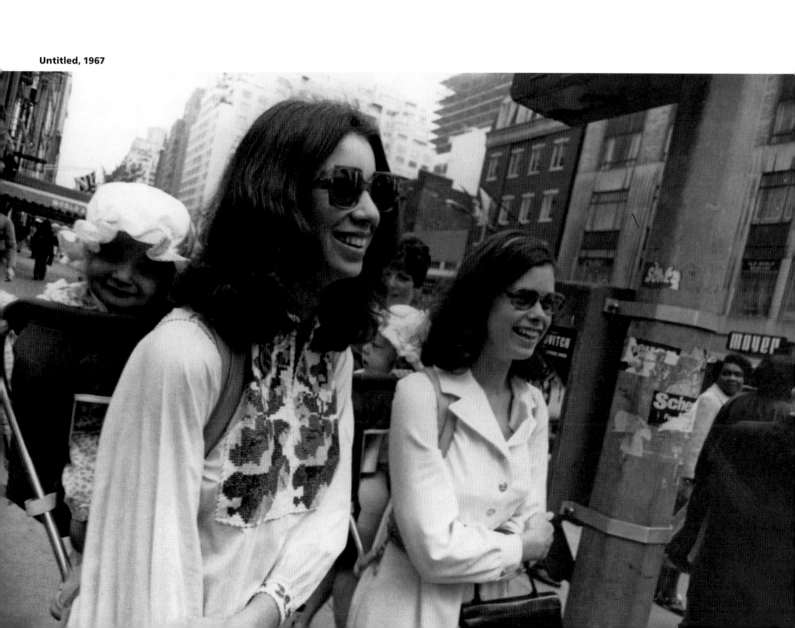

Discourse and practice are interdependent. Practice follows discourse, while discourse is generated by practice. As for the discourse on colonialism, there is a long lineage of engagements with the history of colonialism. One recalls papers by practitioners like John Locke, Edmund Burke, James Mill, and Thomas Macaulay early on, and critiques of the practice by Hobson, Lenin, Luxemburg, and Schumpeter among many others since the height of imperialism. Numerous metropolitan fiction writers are obsessed by the presence of remote colonies from Melville and Flaubert to Conrad and Gide. Actually, hardly any Western writer from Jane Austen to Thomas Mann, from Balzac to D. H. Lawrence could manage to escape from the spell of modern expansionism. The modern West depends on its colonies for self definition, as Edward Said's newest book, *Culture and Imperialism*, argues.[1]

A Borderless World?

From Colonialism to Transnationalism O

In the area of literary theory and criticism, however, the discourse on colonialism has a surprisingly brief history. One needs to remember that writers of the Negritude Movement and other Third World writers like Aimé Césaire, C. L. R. James, Frantz Fanon, and George Lamming[2] began to voice their views from the oppositionist perspective soon after the end of World War II.[3] And, yet, it was only fifteen years ago—well after the disappearance of administrative colonization from most regions of the world—that the discourse on colonialism entered the mainstream of Western theory and criticism.[4] Examining history from the perspective of personal commitment to resistance, Said's Orientalism in 1978 dramatically heightened the consciousness of power and culture relations, vitally affecting segments of disciplines in the humanities.[5] In other words, it was not until years after the end of formal colonialism between 1945 and 1970 that theory was enabled to negotiate issues of colonialism as an admissible factor in criticism. The time gap of a good many decades in literary history here is interesting enough if only it demonstrates the discipline's habitual unease and disinclination in recent times to engage with extratextual matters, especially those concerning the imminent transfer of powers and resources. The history of decolonization and the memory of administrative and occupational colonialism, dangerously verging on nostalgia at times, are the base on which colonial and minority discourses have been built in recent years.[6]

e Decline of the Nation-State

The circumstances surrounding this process of "liberation" and "independence," however, have no widely accepted narrative as yet. Does colonialism only survive today in a few places such as Israel, South Africa, Macao, Ireland, and Hong Kong? Does the rest of the world enjoy the freedom of postcolonialism? The problem we face now is how to understand today's global configuration of power and culture that is both similar and different vis-à-vis the historical metropolitan-colonial paradigm. This paper is concerned with such transformation and persistence in the neocolonial practice of displacement and ascendancy, and with its specular engagements in discourse. The current academic preoccupation with "postcoloniality" and multiculturalism looks suspiciously like another alibi to conceal the actuality of global politics. This paper argues that colonialism is even more active now in the form of transnational corporatism.

We might begin with the beginning of the decolonization process.[7] The end of the cold war in 1989 has enabled us to look back at the history of the past half-century—or even longer—from a less inertial perspective informed by truly radical change. We are, for instance, once again reassessing the end of World War II, which fundamentally radically altered the world system. The

destruction of German and Japanese aggressions did not result in the full resuscitation of the hegemony of the European industrial states. The West European nations, especially Britain and France, were too fatally injured to be able simultaneously to rebuild their domestic industrial bases and to sustain their military forces to dominate their colonies. In retrospect, we see that the Soviet Union kept up the front of a military superpower while disastrously wrecking its production and distributive systems. The avowed war objective of Germany and Japan—liberation and decolonization through a new world order (*die neue Ordnung and sekai shin chitsujo* in Axis slogans)—was a total sham, the colonized of the world that had sided with their master states in World War II seized the day and would not settle for less than independence and autonomy. Liberation was demanded and allowed to take place over the

[1] See Edward W. Said, *Culture and Imperialism* (New York, 1993).

[2] Some examples are Aimé Césaire, *Discours sur le colonialisme* (Paris, 1955); C.L.R. James, *The Black Jacobins: Toussaint Louverture and the San Domingo Revolution* (London, 1938), *A History of Negro Revolt* (London, 1938), *Beyond a Boundary* (London, 1963), and many others; Frantz Fanon, *The Wretched of the Earth*, trans. Constance Farrington (New York, 1961), and *Studies in a Dying Colonialism*, trans. Haakon Chevalier (New York, 1961); and George Lamming, *In the Castle of My Skin* (London, 1953), and *The Pleasures of Exile* (New York, 1960).

[3] During the 1960s, the African-American writers began to express to the white audience their anticolonialist views as activists were promoting civil rights. Politically acceptable to many liberal academics, they were at the same time dismissed by "respectable" critics and scholars in academic disciplines.

[4] Perhaps this is more conspicuously an Anglo-American phenomenon. In South America, for instance, the discourse on colonialism started everywhere—from Mexico to Argentina—much earlier, at the latest in the 1960s.

[5] See Said, *Orientalism* (New York, 1978). Of course, there had been numerous studies in his-

several subsequent decades, albeit under varying circumstances.

After World War II, independence appeared to mark the end of a period of humiliating and exploitive colonial domination that had lasted anywhere from decades to centuries in countries covering at least 85 percent of the earth's land surface. And yet freedom and self-rule—for which the colonized had bitterly struggled often at the cost of immense sacrifice—were unexpectedly elusive. Decolonization neither effected emancipation and equality nor provided new wealth or peace. Instead, suffering and misery continued nearly everywhere in an altered form, at the hands of different agencies. Old *compradors* took over, and it was far from rare that they went on to protect their old masters' interest in exchange for compensation. Thus the welfare of the general population saw little improvement; in fact, in recent years it has worsened in many old colonies with the possible exceptions of the East Asian Newly Industrialized Economies (NIEs) and the Association of Southeast Asian Nations (ASEAN).[8] The "postcolonial" deterioration that Basil Davidson recently called "the black man's burden" was a result of double processes of colonization and decolonization, which were inextricably intermeshed.[9] We are all familiar with the earlier stage. As the colonizers drew borders at will, inscribing their appropriation on a map, tribes were joined together or fragmented. Those who were encircled by a more or less arbitrary cartographic form were inducted into servitude on behalf of the distant and unseen metropolis. Western culture was to be the normative civilization, and the indigenous cultures were banished as premodern and marginal. And although subaltern resistance proved far more resilient than anticipated, and colonial programs were never really fulfilled anywhere, the victor's presence was powerful enough in most places to maintain a semblance of control and order despite unceasing resistance and opposition.

With the removal of formal colonialism after World War II, the cartographic unit that constituted a colony was now perceived both by the departing colonizers and the newly freed to be a historically autonomous territory, that is to say a modern nation-state, with a national history, national language, national culture, national coherence, and finally a state apparatus of its own as symbolized by a national anthem, flag, museum, and map. The entity was, however, no more than a counterfeit reproduction of, and by, its former conqueror in many places, having neither a discrete history nor logic that would convince the newly independent citizens of its legitimacy or authenticity. Earlier, while struggling against the oppressors, self-definition was not difficult to obtain: opposition articulated their identity. Once the Europeans were gone, however, the residents of a colonial territory were thrown back on their old disrupted site that had in the precolonial days operated on a logic and history altogether different. The liberated citizens of a colony now had to renegotiate the conditions of a nation-state in which they were to reside thereafter. Retroversion to nativism might have been an option, but the Third World was fraught with inequalities and contradictions among various religions, tribes, regions, classes, genders, and ethnicities that had been thrown together in any given colonial territory. And production and distribution was often horrendously inefficient. The golden age of memory proved to be neither pure nor just, nor even available, but a utopian dream often turned into a bloody nightmare. The hatred of the oppressors was enough to mobilize toward liberation, but was inadequate for the management of an independent state. As Fanon had predicted early in the game, attempts at nativism indeed ended in disastrous corruption and self-destruction, and they are still ongoing events in many parts of the world. Once absorbed into the "chronopolitics" of the sec-

tory and political science in relation to imperialism, racism, slavery, colonies, and so on, and the political activism of the 1960s and 1970s had also made contributions to the change in the political consciousness of Western intellectuals. But before the appearance of Said's book, no text had made a serious inroad into the mainline Anglo-American disciplines of the humanities.

[6] The state of colonialization is obviously much harder to define than this abbreviated argument might suggest. Any example—say, of Palestine or Hong Kong—will at once display the particular complexities of individual circumstances. It does seem undeniable, however, that while oppression and suffering continue unabated, the administrative and occupational mode of colonialism is irreversibly being replaced by an economic version—especially after the end of the cold war. To complicate the situation further, the status of the aborigines in settlement societies such as Australia, Taiwan, the United States, Canada, and the Pacific Islands, to take random examples, is far from clarified. Serious legal disputes are distinct possibilities in the near future in some of these areas, for example, in Hawaii and Australia.

[7] There are six interrelated developments in post-World War II history, none of which should or could be considered in isolation. It is indeed possible to argue that any one of these developments need to be studied in close conjunction *with every other*. They are: (1) the cold war (and its end); (2) decolonization; (3) transnational corporatism; (4) high-tech revolution; (5) feminism; (6) the environmental crisis. There are adjacent cultural coordinates such as postmodernism, popularization of culture, cultural studies, de-disciplinization, ethnicism, economic regionalism (tripolarism), and so on. The relationship between the two groups is neither homologic nor causal, but its exact nature requires further examination in a different context.

[8] In many regions of the world, there were some improvements in general welfare. As to starvation, for instance, the ratio of the chronically undernourished to the total population in the Middle East, South America, and Asia has been reduced to nearly one-half between 1970 and 1990. In Africa, however, there is hardly any change in the same period. See *Sekai o yomu kii waado* (Tokyo, 1992), pp. 82-83.

[9] See Basil Davidson, *The Black Man's Burden: Africa and the Curse of the Nation-State* (New York, 1992). An Africanist journalist, Davidson may be overly influenced by his observations of Africa when he writes about the rest of the world. He is, for instance, much too pessimistic—and Orientalist!—as he predicts that aside from Japan no Third World nation will become industrialized.

ular West, colonized space cannot reclaim autonomy and seclusion; once dragged out of their precolonial state, the indigenes of peripheries have to deal with the knowledge of the outside world, irrespective of their own wishes and inclinations. And yet the conditions of the modern nation-state are not available to most former colonies.[10]

One recalls that Western industrialized nations had the luxury of several centuries—however bloody—to resolve civil strifes, religious wars, and rural/urban or agricultural/industrial contradictions. Former colonies had far less time to work them out, and they had been under the domination of alien powers. Thus most former colonies have yet to agree on the logic and objective of a geographic and demographic unit. The will to fragmentation battles with the will to totalization. One cannot forget that there were countless cases of overt and covert interventions by the United States and other colonial powers through economic, political, and military means. Peaceful progress has been structurally denied to them. Alliances among Third World states against First World domination, such as the Bandung Conference (1955), the Organization of Petroleum Exporting Countries (OPEC, 1960), UN Conference on Trade and Development (UNCTAD, 1964), and the New International Economic Order (NIEO, 1974) have all performed poorly, ultimately surrendering to the Breton Woods system, which the victorious West established in 1944 for the postwar management of the ruined world with the World Bank, International Monetary Fund (IMF), and General Agreement on Tariffs and Trade (GATT) as the three central economic instruments.

It is widely agreed that the nation-state is a modern Western construction. It can be further argued that the gradual ascendancy of the nation-state around 1800 in the West was a function of colonialism. Earlier at the beginning of the modern period, the European monarchs sponsored adventurist projects, which were further propelled thereafter by the bourgeoisie's greater need for markets and resources to form a policy of colonial expansion. About the same time, as the industrial revolution increased production efficiency, urban areas received the influx of a large percentage of agricultural labor, creating a pool of surplus population.[11] These potentially rebellious unemployed and displaced workers needed to be depressurized in the marginal areas of the labor market. Toward that end, the organizers of

colonialism had to persuade their recruits and foot soldiers about the profitability as well as the nobility of their mission. Voyaging into distant and savage regions of the world was frightening enough, and the prospects of sharing the loot were far from assured. Above all, bourgeois leaders had to conceal their class interests, which sharply conflicted with the interests of the populace at large. They needed crusaders and supporters who trusted their good faith, believed in the morality of their mission, and hoped for the eventual wealth promised for them. Thus they made the myth of the nation-state (that is, the belief in the shared community ruled by a representative government) and the myth of *mission civilisatrice* (that is, the voyagers' racial superiority over the heathen barbarians) seem complementary and indispensable. In such an "imagined [or manufactured] community," the citizens were bound by "kinship and communality"; they were in it together.[12] In the very idea of the nation-state, the colonialists found a politicoeconomic as well as moral-mythical foundation on which to build their policy and apology.

Thus the development of Western colonialism from the sixteenth to the midtwentieth century coincides with the rise and fall of the nation-state. The fate of the nation-state in recent years, however, is not synonymous with the "rise and fall of the great powers," as Paul Kennedy argues.[13] The bourgeois capitals in the industrialized world are now as powerful, or even far more powerful, than before. But the logic they employ, the clients they serve, the tools available to them, the sites they occupy, in short, their very identities, have all changed. They no longer wholly depend on the nation-state of their

[10] This narrative of colonization/decolonization is obviously oversimplified and, worse, totalized. Again, the case of South America, for instance, does not apply in many important aspects. However, for an inclusive discussion of the decolonization/recolonization process, one would have to consult an entirely different essay with a different focus and emphasis.

[11] A typically preindustrial society has about 80 percent of its population engaged in agriculture. A fully industrialized society has a very small agricultural worker population, about 5 percent. This transformation from agriculture to manufacturing and other industries has taken most industrialized nations around 200 years. Japan went through the process in less than a century, while the East Asian NIEs are changing at the speed of less than a generation. The high cost paid for such a social change is to be expected. Industrialization and colonization converge in this development. And thus all industrialized nations are former colonizers. There is a later development of this process in industrialized societies now. As manufacturing technology improves productivity, manufacturing jobs are rapidly disappearing everywhere, and they are being replaced by service jobs. The manufacturing worker surplus urgently needs to find outlets that are nowhere visibly available. There is not even an equivalent of old colonies for these surplus workers. See Sylvia Nasar, "Clinton Job Plan in Manufacturing Meets Skepticism," *New York Times*, 27 Dec. 1992, p. A1. See also Motoyama Yoshihiko, *Minami to kita* (Tokyo, 1991), pp. 223-25.

[12] See Benedict Anderson, *Imagined Community: Reflections on the Origin and Spread of Nationalism*, 2nd ed. (London, 1991). The book does not explain who imagined the community, however.

[13] See Paul Kennedy, *Rise and Fall of the Great Powers: Economic Change and Military Conflict from 1500 to 2000* (New York, 1987).

origin for protection and facilitation. They still make use of the nation-state structure, of course, but their power and energy reside in a different locus, as I will argue later on.

Even before 1945, Winston Churchill sensed that Britain had to yield its imperial scepter to the United States. If not at the Yalta Conference, by the time he was voted out of Downing Street he knew the management of the world was now in the hands of the United States. He was of course right. Colonial history since 1945 converges with U.S. history. At the end of World War II, the United States economy was finally free from all scars of the Depression. In peacetime, however, prospects were far from rosy. To downscale wartime economy would mean a drastic rise in unemployment (a minuscule 1.2 percent in 1942) as well as an absolute plunge in production and consumption, resurrecting the nightmare of 1930. There were a series of labor strikes (steel, coal, rail, and port) in 1946; President Truman's veto of the Taft-Hartley Labor Act, which sought to curb strikes, was overturned by the Congress in 1947. It was under such circumstances of economic tension and unease that the President decided to contain "Communist terrorism" in Greece and Turkey in 1947, and the Marshall Plan was inaugurated to aid European reconstruction. The GNP had sunk ominously by 19 percent in 1946 but only by 2.8 percent in 1947; and if it remained at a stagnant 0.02 percent in 1949, the Korean War (whose origins are not as yet unambiguous)[14] saved the day: the GNP rose by as much as 8.5 percent in 1950 and 10.3 percent in 1951.[15] Similarly, just about the time the Peace Treaty with North Korea was signed in 1953 (and resulted in a minor recession), the United States began to aid the French government in its anti-insurgency war in Southeast Asia, shouldering 75 percent of the cost; and the training of South Vietnamese troops commenced in 1955 after the catastrophic defeat of the French army at Dien Bien Phu in 1954. When President Eisenhower warned Americans against "the potential for the disastrous rise of misplaced power" in the hands of the "military-industrial complex" and the "scientific-technological elite," the security state system had already been firmly—perhaps irretrievably—established in the United States.[16] (One notes that this was the decade in which the universities expanded to absorb the returned GIs, lowering the male-female college attendance rate well below the level in the 1920s.[17]

And in literary theory and practice, conservative ideology and formalist aestheticism of course dominated.)

The cold war, regularly reinforced by hot "anti-Communist" skirmishes, then, was a dependable instrument for the U.S. economy to organize its revenues and expenditures and to maintain a certain level of production and distribution. One notes in this connection that "in every year from 1951 to 1990, the Defense Department budget has exceeded the combined net profits of all American corporations." The U.S. Constitution does not accord the president the top economic power; "nevertheless, he has acquired that capacity from his role as chief executive officer of the military economy's management. Subordinate to the President/C.E.O. are the managers of 35,000 prime contracting firms and about 100,000 subcontractors. The Pentagon uses 500,000 people in its own Central Administrative Office acquisition network."[18] The Pentagon, in short, is the U.S. equivalent of Japan's Ministry of International Trade and Industry (MITI): it plans and executes a centrally organized economic policy. Thus it is more accurate to say that national security questions were essentially economic in nature. The U.S. economy, rather than merely reacting to uncontrollable foreign threats, actually guided world relations.

Soon after the recession in 1957 and 1958, the Kennedy administration sought to expand international trade by lowering the European Community tariffs through the GATT Kennedy Round. The so-called liberalization of trade in the early 1960s restored the integrated world market, and encouraged direct foreign investment. The result was a marked rise in European investment by American enterprises. Such an expansion in international trade led to a rapid development of "multinational enterprises" and "transnational corporations," that is, giant companies that not only import and export raw and manufactured goods but also transfer capital, factories, and sales outlets across national borders, as will be explained more fully later on. And this history of economic orga-

[14] See Bruce Cumings, *The Origins of the Korean War*, 2 vols. (Princeton, N.J., 1981, 1990).

[15] The figures are based on Table B-2—Gross National Product in 1982 Dollars, 1929-87, *The Annual Report of the Council of Economic Advisors*, in *Economic Report of the President* (Washington, D.C., 1988), p. 251.

[16] Dwight D. Eisenhower, "Liberty Is at Stake" (1961), in *Super-State: Readings in the Military-Industrial Complex*, eds. Herbert I. Schiller and Joseph D. Phillips (Urbana, Ill., 1970), p. 32.

[17] The U.S. Office of Education, "Institutions of Higher Education—Degrees Conferred, by Sex, 1870-1970," *Biennial Survey of Education in the United States.*

[18] Seymour Melman, "Military State Capitalism," *The Nation*, 20 May 1991, pp. 666, 667. Melman, *The Demilitarized Society* (Montréal, 1988), *Profits without Production* (New York, 1983), and *The Permanent War Economy* (New York, 1974) are important studies on this subject.

nizations needs to be recalled here in the context of global decolonization.

The fracture of the British empire was accelerating throughout the 1960s with the loss of innumerable colonies one after another—from Cypress, Nigeria, and Kenya to Jamaica, Malaysia, and Singapore.[19] Having lost Indochina and other colonies in the 1950s, France finally yielded Algeria in 1962. At the same time, the U.S. GNP increased at a brisk pace of 7 to 9 percent with fairly low inflation and unemployment rates. Economically and militarily invincible, the United States was ready to protect capitalist interests everywhere, but especially in Vietnam. If President Johnson tried to win support for his Great Society programs and the war on poverty by offering a Southeast Asian expedition to the conservative oppositions, his gamble was calamitous. As no one can easily forget, protests raged across the country, splitting the nation into doves and hawks, Clintons and Gores. On the antiwar demonstrators' enemy list, the names of defense-related corporations were conspicuous: General Motors, General Electric, DuPont, and Dow Chemical, to name a few. And it is many of these corporations that began during the 1960s to set the pattern of systematic transfer of capital and factories overseas. There were other factors, too; technological innovations in automation, synthetic chemistry, and electronic engineering - produced an enormous accumulation of capital and a remarkable improvement in communication and transportation as well. The U.S. policy of liberal trade was both a response to and an instigation of such a development.

In the late 1960s, the global domination of U.S. multinational corporations was unchallengeable. Mainly centered in the Western hemisphere, and less in Africa and Asia, the U.S. foreign direct investment (FDI) amounted to a half of all the cross-border investments worldwide, far surpassing the British FDI that stood at 20 percent and the French FDI at less than 10 percent.[20] Transnational corporations meant U.S. transnationals then, and this pattern remained unchanged until the mid-1970s. The concentration of U.S. investments in Western Europe can be explained by four factors: high interest rates in Europe; the emergence of the European Economic Community; the U.S. tax laws favorable to overseas profits; and comparatively low costs of skilled labor in Europe. The serious task of controlling the world order for the West was still assigned to the U.S. government with its military and political programs of aid and intervention.[21]

Around 1970, European and Japanese transnational corporations (TNCs) emerged rapidly to compete with their U.S. counterparts, and their main target was none other than the advanced manufacturing industries in the United States itself. This bold move is explainable by several economic developments. First, the U.S. dollar was devalued after the Nixon administration froze wages and prices and suspended conversion of dollars into gold in 1971, making the U.S. attractive for foreign investment. Second, the U.S. market also became attractive again after the political instability and unpredictability in the rest of the world as a result of the fourth Middle East war of 1973 and its consequent oil embargo. Third, the European and Japanese industrial recovery was strong enough to wage a vigorous investment campaign in the United States. Finally, trade friction intensified in time, and European and Japanese manufacturers saw an advantage in building plants inside the U.S. market. The U.S. share of TNCs was still overwhelming, but in the 1980s it fell to 33 percent as against Britain at 18 percent, West Germany at 10 percent, and Japan at 8 percent.

In 1985 the United States negotiated a depreciation of the dollar at the G5 (or Group of 5) meeting in New York. The Plaza Agreement forced the dollar down by one half against the yen, raising Japan's currency value by 100 percent. Though aimed at an increase of U.S. export to Japan and a decrease of Japan's export to the United States, the measure was not really effective. Before long, moreover, Japanese TNCs realized the power of the strengthened yen, with which they proceeded to stage an aggressive campaign of investment, while cutting prices as much as they could to maintain their market share. What characterizes this stage of multinational development is, in addition to continued investment in the United States, a general concentration on four regional targets: tax havens (for example, Curaçao in the

[19] Others include Tanzania (1964), Zanzibar (1963), Smaliland (1960), Aden (1967), Kuwait (1961), Malta (1964), Borneo (1963), Trinidad and Tobago (1962).

[20] See Okumura Shigeji, "Takokuseki kigyo to hatten tojo koku," *Takokuseki kigyo to hatten tojo koku* (Tokyo, 1977), pp. 11-12.

[21] The history of U.S. interventions since the Vietnam War is long and wide-ranging. To pick only the most conspicuous (overt) operations: the Dominican Republic, Lebanon, Grenada, Panama, the Persian Gulf. In addition, there were of course numerous covert operations in Iran, Nicaragua, El Salvador, and other places.

Dutch Caribbean); OPEC nations; Asian NIEs (South Korea, Taiwan, Hong Kong, and Singapore); and ASEAN countries (Thailand, Malaysia, Indonesia, the Philippines, Singapore, and Brunei). Many of these nations were ruled by authoritarian governments, which banned labor unions and opposition parties, thus achieving political "stability"—a minimal requirement for a large-scale TNC commitment. There has also been a gradual development of TNCs among the OPEC, NIEs, Mexico, and India, investing in each other as well as the United States. Also, smaller corporations (i.e., those with capital outlays of between 100 and 500 million dollars) in both industrialized and less industrialized nations were active in transnationalizing their operations. And this coexistence of TNCs of various origins (including joint ventures) is what makes the analysis of economic hegemony so complicated and difficult.

What emerges from this is an increasingly tightly woven network of multinational investments among EC, North American, and East Asian countries, gradually transforming the multi*national* corporations into *trans*national corporations. The distinction between the two corporate categories is certainly problematic: the terms are frequently used interchangeably. If there are differences, they are more or less in the degrees of alienation from the countries of origin. The range of international trading might be explained developmentally as follows. First, domestic companies simply undertake export/ import activities, linking up with local dealers. Then, the companies take over overseas distribution and carry out their manufacturing, marketing, and sales overseas. Finally, the transnational corporations denationalize their operations by moving the whole business system, including capital, personnel, and research and development. This final stage is reached when a corporation promotes loyalty to itself among shareholders, employees, and clients rather than to its country of origin or host countries. Thus, a multinational corporation (MNC) is one that is headquartered in a nation, operating in a multiple number of countries. Its high-echelon personnel largely consists of the nationals of the country of origin, and the corporate loyalty is, though increasingly autonomous, finally tied to the home nation. A truly transnational corporation, on the other hand, might no longer be closely tied to its nation of origin, but is adrift and mobile, ready to settle anywhere

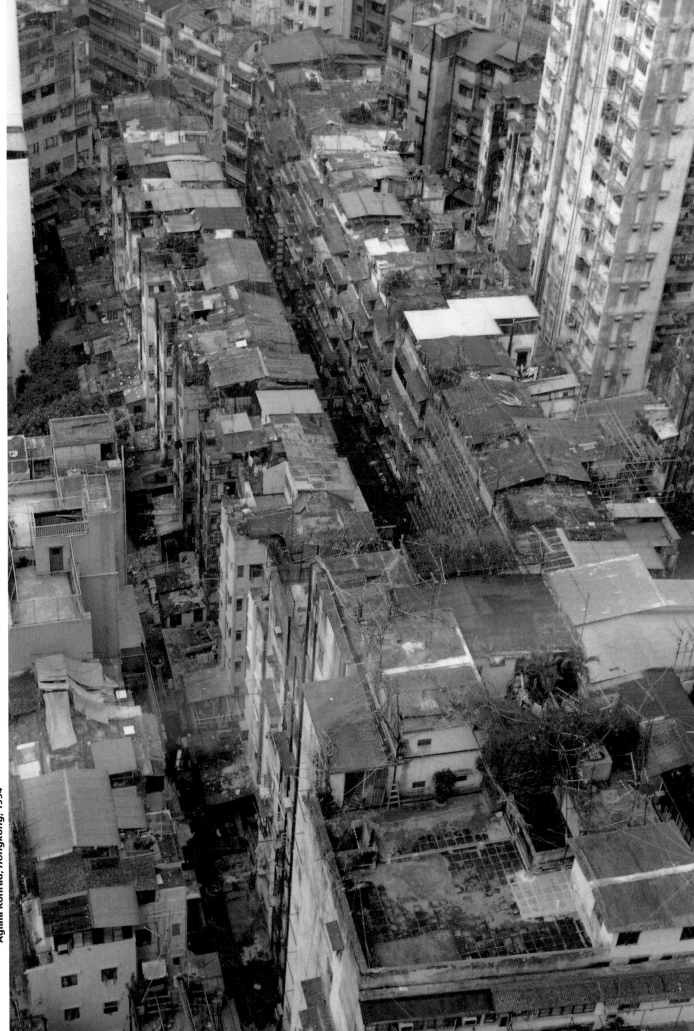

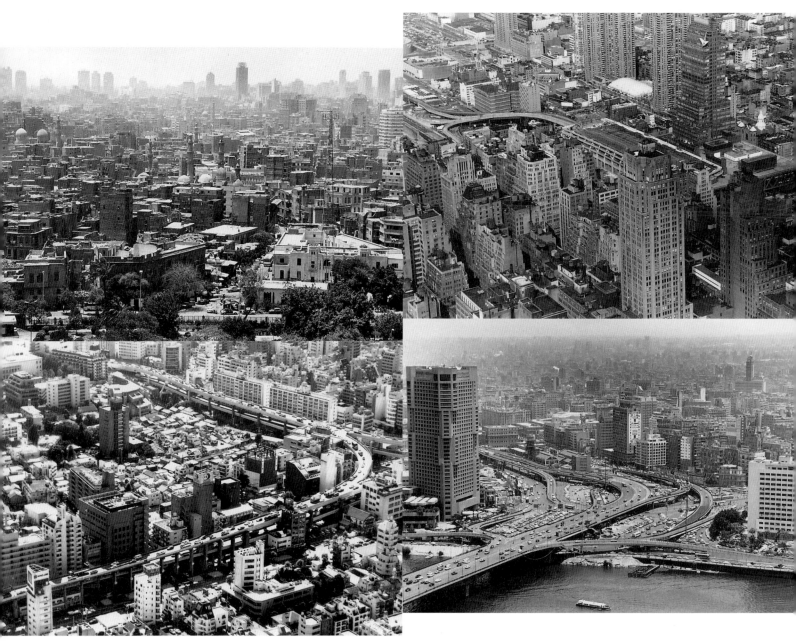

Aglaia Konrad, from left to right: *Cairo, 1992*; *New York*, 1993; *Tokyo*, 1993; *Cairo*, 1992

and exploit any state including its own, as long as the affiliation serves its own interest.[22]

Let me repeat here that a sharp distinction between TNC and MNC is impossible, since the precise extent of denationalization of a corporation is not readily determinable. There is, for instance, no systematic study of the TNC tax obligations as against their MNC counterparts or of the comparative patterns of foreign direct investment between the two forms. MNCs are as self-regarding as TNCs; however, a recent tendency toward lesser national identification and greater corporate self-interest is discernible. In other words, despite the ongoing dependence on the state apparatus (for example, the military), multinational corporations are in the process of *de*nationalization and *trans*nationalization.

There are still relatively few corporations that completely fit the TNC specification, but there are examples such as Asea Brown Bovari among large-scale companies and Yaohan among smaller specimens. Starting in Sweden, ABB, with annual revenues of over 25 billion dollars, has no geographic center.[23] Yaohan began as a Japanese grocery store chain, severed its Japanese ties, moving first to Brazil and then—for now—to Hong Kong. It should be noted here that the corporate tax in Japan was 49.9 percent whereas in Hong Kong it stood at 16.5 percent in 1989.[24] Yaohan's chairman declares that his real target is the one billion Chinese in the twenty-first century.[25] Many MNCs on the other hand are alertly comparing opportunities between their home countries and host countries as they map out their strategies for maximizing profits.

TNCs of this type became more visible in the 1980s, although the loss of national sovereignty to the multinational companies had been discussed since the 1960s, and even earlier.[26] That this development should take place in the 1980s was no accident. After President Carter's stagflation in the late 1970s, President Reagan had a clearly defined program to promote private interests, supposedly with the conviction that strong private sectors would necessarily benefit the populace as a whole (but, in all likelihood, by simply following the cue cards handed over by the corporate designers of the policy). During this decade the transfer of wealth from the poor to the rich was carried out with remarkable efficiency. Corporate taxes were cut. Public services such as education, welfare, and medicine were reduced in the

name of efficiency, resulting in a marked reliance on private enterprises such as Federal Express and private security services instead of "inefficient" public institutions such as the U.S. Postal Service or municipal police departments. There even have been talks of privatizing penal systems and public universities.[27] This decade also witnessed the reduction of the income tax rates for the higher brackets: the top tax on wages in 1945 was 94 percent, and in the 1950s through the 1970s it was in the 87 to 70 percent range; with the advent of President Reagan's administration the top tax on wages fell to 50 percent, and in 1991 under the Bush administration it stood at 28 percent.[28] Thus the top one percent of Americans received 60 percent of the after-tax income gains between 1977 and 1989, while the bottom 40 percent of families had actual declines in income. According to the 6 May 1991 issue of *Business Week*, the typical CEO's pay was more than eighty-five times that of a typical manufacturing worker's pay in the United States, while the comparable ratio in Japan was only seventeen times.[29] Kevin Phillips report, however, that "the pay of top corporate executives . . . soared to 130 to 140 times that of average workers, even while real or inflation-adjusted wages continued their 1980's decline."[30] Examples of illicit and semi-illicit business practice are too many to be enumerated here—from dubious mergers and appropriations and junk bond scams to the savings and loan industry scandal. The number of poor people in 1991 increased to 35.7 million, that

[22] These terms are used differently depending on the region and the times. In South America, for instance, the term *multinational* was not used in the 1960s and 1970s because it was felt that those giant corporations were all U.S.-based and not multinational. The term transnational, on the other hand, was felt to be more accurate because it suggested the *trans*gressiveness of these U.S. corporate managements. Now that there are Mexico-originated "multinational" giant corporations (such as Televisa, the biggest TV network in the world outside the U.S.), the term is becoming more commonly accepted. See John Sinclair, "Televisa: Mexico's Multinational," *Centro: Puerto Rican Studies Bulletin 2*, no. 8, unpaginated.

There are numerous publications treating the development of transnational corporatism. For instance, Peter F. Drucker, *The New Realities: In Government and Politics, in Economics and Business, in Sociology and World View* (New York, 1990) and Kenichi Omae, *The Borderless World: Power and Strategy in the Interlinked Economy* (New York, 1990), pp. 91-99. Perhaps the most important source of information, though little known, is the United Nations Center on Transnational Corporations, which publishes the biannual *CTC Reporter* as well as numerous specific reports on transnational corporate activities. The center published the *Bibliography on Transnational Corporations* in 1979.

[23] Percy Barnevik, CEO of ABB, concluded a recent interview by remarking. "Are we above governments? No. We answer to governments. We obey the laws in every country in which we operate, and we don't make the laws. However, we do change relations between countries. We function as a lubricant for worldwide economic integration. . . . We don't create the process, but we push it. We make visible the invisible hand of global competition" (William Taylor, "The Logic of Global Business: An Interview with ABB's Percy Barnevik," *Harvard Business Review 69* [March-April 1991], p. 105).

[24] See Terajima Jitsuro, *Chikyugi o te no kangaeru Amerika: 21 seiki Nichi-Bei kankei e no koso* (Tokyo, 1991), pp. 78-79.

[25] There are several books on this supposedly family-owned but un-Japanese enterprise, all by admiring—and commissioned?—Japanese authors. See, for instance, Itagaki Hidenori, *Yaohan: Nihon dasshutsu o hakaru tairiku-gata shoho no hasso* (Tokyo, 1990) and Tsuchiya Takanori, *Yaohan Wada Kazuo: Inoru keiei to hito zukuri* (Tokyo, 1991). Reflecting the owner's faith, Yaohan is aggressive in evangelizing the doctrine of the Seicho-no-ie Temple among its local employees. Despite predictable conflicts with employees of other religions (for example, Muslims in Singapore), Yaohan insists that the doctrine is the key to its success.

is, 14.2 percent of the total population, which is the highest figure since 1964.[31] In such an atmosphere of intensified self-regard and self-interest, corporate managers took it for granted that their business was to maximize profits nearly regardless of consequences. They would go wherever there were lower taxes and greater profits.

It should be emphasized here that this move toward transnationalization was not just American but global. Leslie Sklair, in one of the most comprehensive studies of TNCs (from a Gramscian and feminist perspective), points out that "while there is no convincing evidence that the TNCs can bring salvation to the Third World, in many poor countries the TNCs are seen as responsible for the only bright spots in the economy and society. . . . [TNCs] are very widely sought after and they carry high prestige."[32] As mentioned earlier, not only industrialized nations but NIEs and other economies also produce corporations that maximize profits by freely crossing national borders. However one may view the TNC practice, TNCs are not beholden to any nation-states but seek their own interests and profits globally. They represent neither their home countries nor their host nations but simply their own corporate selves.

There are of course many other contributing factors. TNCs are immensely powerful. Sklair points out that "in 1986, according to the World Bank, 64 out of 120 countries had a GDP (gross domestic product) of less than $10 billion. United Nations data for 1985-86 show that 68 TNCs in mining and manufacturing had annual sales in excess of ten billion dollars, while all the top 50 banks, the top 20 security firms, and all but one of the top 30 insurance companies had net assets in excess of ten billion" (S, pp. 48-49). That is, of the largest one hundred economic units, more than fifty are TNCs.[33] Because of the rapid development in sophisticated computer technology—often justifiably called the third industrial revolution— in communication, transportation, and manufacturing, the transfer of capital, products, facilities, and personnel has been unprecedentedly efficient. Private funds—to the amount of billions of dollars at one transaction—flow from one industrial center to another, totalling every business day nearly 1 trillion dollars at the Clearing House Interbank Payment System (CHIPS) in New York City alone.[34] It goes without saying that this development weakens the interventionary power of central national banks such as the Bundes Bank of Germany, Nihon Ginko of Japan, and the Federal Reserve of the United States.

Post-Fordist production methods enable TNCs to move their factories to any sites that can offer trained and trainable cheap labor forces as long as there are tax inducements, political stability, adequate infrastructure, and relaxed environmental protection rules. Low civil rights consciousness, too, including underdeveloped unionism and feminism, is crucial: although female labor is abused everywhere, the wage difference between the sexes is still greater in the Third World—the target area for TNCs.[35] Global transportation is so efficient that the division of labor across national borders is now a given. Parts are produced in many places to be assembled—depending on particular tariffs, labor conditions, and other factors—at a locale strategically close to the targeted market.[36] There are innumerable joint ventures such as GM and Toyota, or GE, RCA, and Thomson SA. Banks and other financial institutions also move across borders with increasingly fewer impediments.

In this MNC/TNC operation, at any rate, manufactured products are advertised and distributed globally, being identified only with the brand names, not the countries of origin. In fact, the country of origin is itself becoming more and more meaningless. The "Buy American" drive is increasingly a hollow battle plan: the Honda Accord is manufactured in Ohio from 75 percent U.S. parts, while the Dodge Stealth is made in Japan by Mit-

[26] For specific comments on this aspect of TNCs, see, for instance, Raymond Vernon, *Sovereignty at Bay: The Multinational Spread of U.S. Enterprises* (New York, 1971) and Stephen Hymer, *The International Operations of National Firms: A Study of Direct Foreign Investment* (Cambridge, Mass., 1976). In this connection J. A. Hobson's foresight in his *Imperialism* (London, 1902), especially in Part I, "The Economics of Imperialism," cannot be forgotten.

[27] Amidst the fiscal crisis in the State of California, there have been rumors that the University of California, Berkeley, and UCLA are being considered for privatization. Though there has been no confirmation of the rumor, there has been no official denial either.

[28] See Tom Petruno, "A Return to Rational Rates," *Los Angeles Times*, 29 Jan. 1992, p. D1.

[29] See "Are CEOs Paid Too Much?" *Business Week*, 6 May 1991. The Japanese are very proud of this "democratic" distribution of wealth. Though it is to a large extent true and justifiable, wealth equity is not quite so real. For one thing, there is a huge sum being spent every year on executive perks such as free housing, free chauffeured car, free parking (no pittance in space-scarce Japan), plus the notorious entertainment expenses annually estimated, by one study, at $35.5 billion. See Robert Neff and Joyce Barnathan, "How Much Japanese CEOs Really Make," *Business Week*, 27 Jan. 1992, p. 31. The manifestation of wealth, power, and privilege obviously takes different forms from society to society.

[30] See Kevin Phillips, "Down and Out," *New York Times Magazine*, 10 Jan. 1993, p. 10.

[31] See Robert Pear, "Ranks of U.S. Poor Reach 35.7 Million, the Most Since '64," *New York Times*, 4 Sept. 1992, pp. A1, A14; after President Bush's visit to Japan in late 1991, the comparative figures of the rich and the poor in the United States attracted a good deal of media attention. See also Nasar, "The 1980s: A Very Good Time for the Very Rich," *New York Times*, 5 March 1992, pp. A1, A22; Petruno, "Investors Seeking Voice on Execs' Pay May Get It," *Los Angeles Times*, 7 Feb. 1992, pp. D1, D3; Linda Grant, "Corporations Search for Answers on Executive Pay," *Los Angeles Times*, 23 Feb. 1992, pp. D1, D9; James E. Ellis, "Layoffs on the Line, Bonuses in the Executive Suite," *Business Week*, 21 Oct. 1991, p. 34; Ann B. Fisher, "The New Debate over the Very Rich," *Fortune*, 29 June 1992, pp. 42-55; Louis S. Richman, "The Truth about the Rich and the Poor," *Fortune*, 29 Sept. 1992, pp. 134-146; Lee Smith, "Are You Better Off?" *Fortune*, 24 Feb. 1992, pp. 38-48; Geoffrey Colvin, "How to Pay the CEO Right," 6 Apr. 1992, pp. 60-69. See also the feature on executive pay in *Business Week*, 30 Mar. 1992, pp. 52-58.

[32] Leslie Sklair, *Sociology of the Global System* (Baltimore, 1991), pp. 101-102; hereafter abbre-

subishi.[37] "In the new Boeing 777 program, the Boeing Company is manufacturing only the wings, nose structure and engine nacelles. The rest of the wide-body airplane will come from hundreds of subcontractors in North America, Japan and Europe."[38] Almost no TV sets are wholly domestic products. It was announced in 1992 that "Zenith Electronics Corp., the last U.S.-owned television company, is moving final assembly of all of its large-screen sets to Mexico."[39] A TNC selects the place of operation, in short, solely by a fine calculus of costs and profits, involving the entire process of research, development, production, distribution, advertising, marketing, financing, and tax obligations.

TNCs are faced with the task of recruiting workers thoroughly familiar with local rules and customs as well as the specific corporate policies for worldwide operation. For that purpose, their workers usually are of various nationalities and ethnicities. This aspect is significant in several ways. First, TNCs will increasingly require from all workers loyalty to the corporate identities rather than to their national identities. Second, employees of various nationalities and ethnicities must be able to communicate with each other. In that sense, TNCs are at least officially and superficially trained to be color-blind and multicultural.[40] Despite the persistent recurrence of violent racist events in the United States, its immigration regulations were radically changed in 1965 to reject the ethnically defined quota system as set out by the 1952 McCarran-Walter Act. In the revised Immigration Reform and Control Act of 1986 and the November 1990 reform bill, priorities are given to skills rather than ethnicities. TNCs, especially, are allowed to claim a quota from the category of 40,000 aliens with special abilities in addition to the general category of skilled experts and professionals.[41] Third, the need of a huge pool of such skilled workers creates a transnational class of professionals who can live and travel globally, while freely conversing with their colleagues in English, the lingua franca of the TNC era. The formation of the transnational class, or what Robert Reich calls "symbolic analysts" in his The Work of Nations, is itself a development that calls for further study, especially as this exclusive and privileged class relates—or does not relate—to those kept outside: the unemployed, the underemployed, the displaced, and the homeless.[42] The third industrial revolution, very much like the earlier two, creates an immense semiskilled and unskilled surplus labor, causing a huge demographic movement across the world and feeding into the mass underclass in every industrialized region.

Reich has little to say about the fate that awaits those who won't be able to move up to the class of privilege. The question remains, then, as to how the new elite managers compare to the professional class of modern industrial society and how it relates to those left marginalized and abandoned in the TNC structure.

Earlier, as traditional society transformed itself into bourgeois capitalist society in the West, intellectuals and professionals who served in the planning and execution of the capitalist agenda were led to think of themselves as free and conscientious critics and interpreters. In the age of TNCs, they are even more shielded and mediated by the complexity and sophistication of the situation itself because transnational corporatism is by definition unprovincial and global, that is, supposedly free from insular and idiosyncratic constrictions. If clear of national and ethnic blinders, TNC class is not free of a new version of "ideologyless" ideology that is bent on the efficient management of global production and consumption, hence of world culture itself. Are the intellectuals of the world willing to participate in transnational corporatism and be its apologists? How to situate oneself in this neo-Daniel Bell configuration of transnational power and culture without being trapped by a deadend nativism seems to be the most important question that faces every critic and

viated S. Among numerous books on the subject, Sklair's is singular for a sociopolitical vision that informs its economic analysis.

[33] Also, it was said in 1973 that "of the 100 largest economic units in the world, only half are nation-states, the others multinational companies of various sorts" (Harry M. Makler, Alberto Martinelli, and Neil J. Smelser, introduction, in The New International Economy, ed. Makler, Martinelli, and Smelser [Beverly Hills, Calif., 1982], p. 25).

[34] See June Kinoshita, "Mapping the Mind," New York Times Magazine, 18 Oct. 1992, pp. 43-47, 50, 52, 54.

[35] Female labor is cheaper everywhere than male labor everywhere, especially in the Third World. Thus the sexual division of labor is attracting some attention among economists. An extremely important topic, it urgently requires further study. See S, pp. 96-101, 108-109, 233-235. See also Maria Mies, Patriarchy and Accumulation on a World Scale: Women in the International Division of Labour (London, 1986), esp. chaps. 3 and 4.

[36] There is a good deal of literature available on this subject. See, for instance, Folker Frobel, Jürgen Heinrichs, and Otto Kreye, The New International Division of Labour: Structural Unemployment in Industrialised Countries and Industrialisation in Developing Countries, trans. Pete Burgess (Cambridge, 1980) and Michael J. Piore and Charles F. Sabel, The Second Industrial Divide: Possibilities for Prosperity (New York, 1984).

[37] Lee A. Iacocca, the former Chrysler chairman, said little about the Nagoya Mitsubishi factory when he accompanied President Bush to Japan in 1991 to complain about the Japanese automobile imports. The Stealth is entirely made in Japan except for the word Dodge etched in the front bumper. See David E. Sanger, "Detroit Leaning on Japan, in Both Senses," New York Times, 27 Feb. 1992, p. A1.

[38] John Holusha, "International Flights, Indeed," New York Times, 1 Jan. 1992, p. 49.

[39] "'Made in America' Gets Tougher to Determine," San Diego Union-Tribune, 2 Feb. 1992, p. A33.

[40] This does not mean that the TNCs are all capable of rationally and skillfully dealing with the complex race issues in all regions. The Japanese MNC/TNC managers in the U.S., for instance, have had many serious difficulties in understanding the racial and ethnic problems, often provoking their employees of both majority and minority ethnicities to take legal actions against them. The problem as I see it, however, arises from not their informed policies but their inexperience and ignorance in execution. The corporate managers are becoming alert enough to what is expected and demanded of them for the maintenance of their operation in alien lands.

MARTIN M.KENBERGER

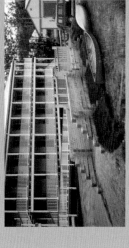

METRO-Net

WORLD CONNECTION

Martin Kippenberger has planned a world-wide project with the title **"Metro-Net"**. The network reaches from Syros, Greece to close to Alaska.

While the entrance in Greece is built in concrete, the exit Dawson City West in Canada is constructed in wood, as is usual for that climate. The formal opening of the exit took place in August 1995.

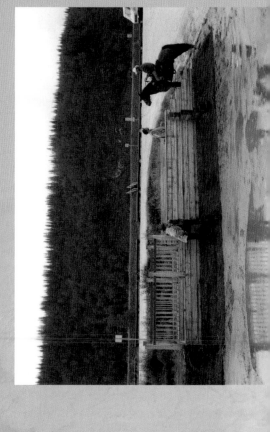

To begin the project, one entrance to the subway was opened on the Greek island Syros (Cyclades) September 1993. A stairway leads into the assumed shaft, which is closed off by a wrought-iron gate adorned with the emblem of the Lord Jim Loge.

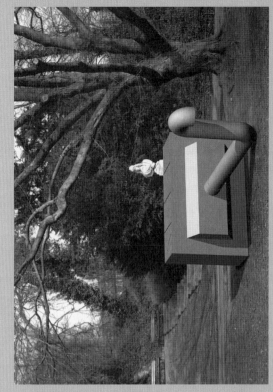

Transportable subway entrance
documenta X, Kassel 1997

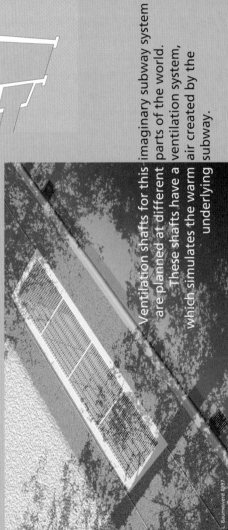

Transportable ventilation shaft
Skulptur Projekte, Münster 1997

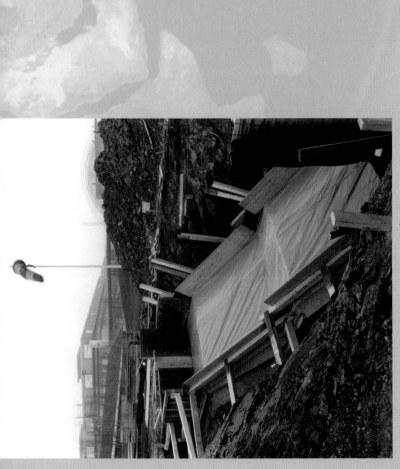

Subway entrance (under construction)
Messe Leipzig 1997

Ventilation shafts for this imaginary subway system are planned at different parts of the world. These shafts have a ventilation system, which simulates the warm air created by the underlying subway.

© L. Baumeverd 1997

theorist the world over at this moment, a question to which I will return later.

The decline of the nation-state has been accelerated by the end of the cold war. War activates nationalism and patriotism inasmuch as hostility deepens the chasm that cuts "them" off from "us." The binary alignment that was present in all foreign relations during the cold war was abruptly removed in 1989. With the demise of authoritarian socialist states, bourgeois capitalism looked as if it had triumphed over all rivals. Whether such a reading is correct or wrong, the disappearance of "the other side," together with the end of administrative colonialism, has placed the nation-state in a vacant space that is ideologically uncontested and militarily constabularized. The choreographed display of high-tech destruction by the United States during the Gulf War could not conceal the lack of objective and meaning in that astounding military exercise. The Gulf War was the war of ultimate snobbery, all style, demonstrating power for the sake of power in a world after the cold war. The war expressed the contempt of the rich against the poor, just as the military and political force was being replaced in importance by the economic and industrial power. The single super power, the United States, executed the war, of course, but as the "sharing" of the military expenses among the "allied nations" demonstrates, the war was fought on behalf of the dominant corporate structure rather than the United States, which served after all as no more than a mercenary. Does this mean that from now on the armed forces of the United States are in service of a corporate alliance with little regard for its own people's interest? Is the state apparatus being even more sharply cut off from the welfare of the people than before? Wealth that generates right and might seems to have overwhelmed power that creates wealth.[43]

Against the effective operation of TNCs, the nation-states more and more look undefined and inoperable. Although the end of the cold war also loosened the ties that bound nation-states such as the former Soviet Union and Yugoslavia while encouraging separatist movements in Scotland, Spain, India, Canada, and many other places, these are expressions of ethnicism, not nationalism.[44] To quote from The New International Economy, these independence movements are "a kind of mirrored reflection of the decline of the viability of nationalism as a politically unifying force, a decline occa-

Marijke van Warmerdam, *Rijst (Rice)*, 1995

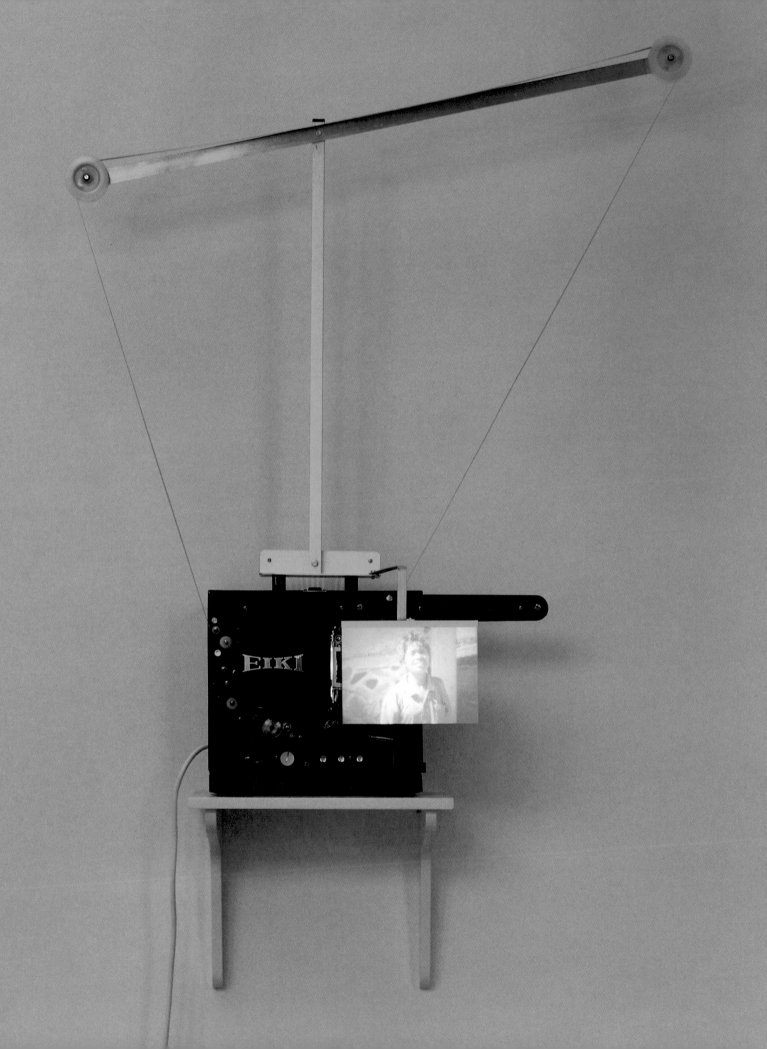

sioned moreover, by the economic and political internationalization."[45]

Admittedly, it is more customary nowadays to regard as "nationalistic" the "ethnic cleansing" by the Serbs, the Moslem and Hindu antagonism in India, or Islamic fundamentalism, but it seems at least as sensible to think of such neorevivalism, neoracism, and neoethnicism in conjunction with the decline of the nation-state. The fragmenting and fragmented units in these sites of contestation in the world are not newly awakened agents for the construction of autonomous nations but for the abandonment of the expectations and responsibilities of the politicoeconomic national projects. Ethnicity and raciality are being brandished as the refuge from the predicaments of an integrated political and economic body. As globalization intensifies, neoethnicism is appealing because of its brute simplicity and reductivism in this rapidly altering and bewilderingly complex age. But over all the separatist aspirations—from Czechoslovakia, Yugoslavia, India, and Myanmar—hover the dark shadows of economic anxieties that none of these "nationalist" units have sufficiently recognized as they rush toward independence and purification. It is as if the inadequacy of the nation-state is now fully realized, and the provincial strongmen are all trying to grab a piece of real estate for keeps before all is incorporated and appropriated by transnational corporations.

Those who have thought of the nation-state as a historical bourgeois invention for the sake of protecting a national economy from the threats of free democracy might hail the negative effects of transnationalism on the nation-state. To the extent that war was an unavoidable product of national economy, as argued by Marx in his 1848 *Communist Manifesto*, there is something exhilarating about the demise of the nation-state. At the same time, the state did, and still does, perform certain functions, for which there is as of now no substitute agency. It defines citizenship, controls currency, imposes law, protects public health, provides general education, maintains security, and, more important, guides the national economy (though little acknowledged in the United States, as I have pointed out earlier), all with revenues raised through taxation. In enumerating these functions, however, it becomes indisputably clear that the list is not a list of achievements but of failures. In all these items, the state as a political authority seems

biased and compromised. It is not the nation as an integrated whole but certain classes, the privileged in it, that receive a major portion of benefits from the state performing these tasks. The state fails to satisfy most of its sectors and leaves most of its citizenry resentful. Thus, there is a palpable aversion to taxation among all segments of population, rich or poor, although everyone knows that tax is the glue that keeps the nation-state coherent. The nation-state, in this sense, no longer works; it is thoroughly appropriated by transnational corporations. Thus for some, it is a sheer annoyance, but for a vast majority it serves as a nostalgic and sentimental myth that offers an illusion of a classless organic community of which everyone is an equal member. Such an illusion of national community stubbornly persists.

Let me give one more example of the use of the concept of nation-states. The formation a highly complex web across national borders of industrial production and distribution—in a word, transnationalization—largely invalidates disputes over surpluses and deficits in trade. Reich rightly argues that wealth is accumulated at the site where managers and technicians carry out research and development, not where the corporations or manufactured goods originate.[46] As I have mentioned above, the identification of the countries of origin of manufactured goods is increasingly becoming impossible, and parts of a product come from all over. The "local content" regulations are nearly impossible to enforce. The U.S., for instance, imports as much as 30 percent from the U.S. transplants overseas that have been established over the last several decades.[47] Further, MNCs and TNCs are indifferent as they create regions of poverty in the middle of their own countries of origin such as the United States and Britain. It is quite possible to argue that the

[41] See Kuwahara Yasuo, *Kokkyo o koeru rodosha* (Tokyo, 1991), pp. 127-143. The movements of both skilled and unskilled labor in the European Community, too, offers an economic integration model par excellence.
[42] See Robert B. Reich, *The Work of Nations: Preparing Ourselves for Twenty-First-Century Capitalism* (New York, 1991). In his contribution to *The New International Economy*, Volker Bornschier concludes, "we know that personal income distribution is more unequal if the level of [multinational corporation] penetration is high. No empirical evidence is reported that MNCs reduce inequality in less developed countries in the course of their operation, whereas there are several hypotheses with preliminary empirical support for the contrary" (Volker Bornschier, "World Economic Integration and Policy Responses: Some Developmental Impacts," in *The New International Economy*, pp. 68-69).
[43] The first large-scale war after the end of the cold war, the war in the Persian Gulf, requires further analysis. First World intellectuals hardly protested, although the U.S. Congress was nearly evenly divided about the land-force invasion of Iraq before the actual event. Among several collections of essays about the war in the gulf see *The Gulf War Reader: History, Documents, Opinions*, ed. Micah L. Sifry and Christopher Cerf (New York, 1991). See also Christopher Norris, *Uncritical Theory: Postmodernism, Intellectuals, and the Gulf War* (London, 1992).
[44] David Binder and Barbara Crossette count 44 ethnic wars in the world in their "As Ethnic Wars Multiply, U. S. Strives for a Policy," *New York Times*, 7 Feb. 1993, pp. A1, A12.
[45] Makler, Martinelli, and Smelser, introduction, in *The New International Economy*, pp. 26-27.
[46] See Reich, *The Work of Nations*, esp. chap. 12.

trade protectionists such as so-called revisionists in the U.S.-Japan trade discourse are conscious or unconscious participants in a patriotic scam to conceal the class interests involved in the bilateral trade friction. Protectionism benefits certain sectors of industry and hurts others, just as free trade does. In other words, protectionism and free trade grant favors to different portions of industry in the short run, although protectionism invariably hurts the consumers. Only when the coherence of a total nation-state is unswervingly desired and maintained can the practice of protectionism persuade the population at large. In the present world, however, there is no example of such unquestioned national coherence—not even the notorious Japan, Inc. The "revisionists" merely stir the residual patriotic sentiment so that they can keep the illusion of national unity a while longer.[48]

TNCs are obviously no agents of progress for humanity. First, since the raison d'être of TNCs is in the maximization of profits, the welfare of the people they leave behind, or even the people in the area where they operate, is of little or no concern to them. The host governments that are eager to invite TNCs cannot be expected to be particular about the workers' employment conditions or the general citizens' public welfare. The framework of the nation-state is deteriorating also in the host nations that are often controlled by dictators and oligarchs. All TNCs are finally in alliance, though competitive in several basic aspects.[49] The transnational class is self-concerned, though aggressively extroverted in cross-border movement. Labor unions, which might be expected to offer assistance to workers, on the other hand, still operate within the framework of a national economy. It is at present simply unthinkable that transnational labor unions will take joint actions across national borders, equalizing their wages and working conditions with their cross-border brothers and sisters. Imagine UAW officials meeting with Mexican union representatives to negotiate together a contract with the GM management in a maquila plant.[50] TNCs might raise GNP or even per capita income, but such a raise does not guarantee a better living for all citizens. So who finally protects the workers inside the U.S. or outside? The TNCs are far more transnational than the labor unions, generating the unemployed and underemployed everywhere, from Detroit to Manila, from Taipei to San Diego. There is little to be expected as of now from the residual

nation-state or its alternatives in the way of protecting these people. What we have heard so far in relation to the North America Free Trade Agreement from the Bush administration, the Clinton transition group, or U.S. university experts promises very little indeed.[51] As Sklair summarizes, "The choice is more likely to be between more or less efficient foreign exploitative transnational corporations and highly protected and perhaps corrupt local, state, parastatal or private firms" (S, p. 117).

Second, the rapid formation of the transnational class is likely to develop a certain homogeneity among its members. Even without the formation of TNCs, the world has been turning toward all-powerful consumerism in which brand names command recognition and attraction. Everywhere commodities are invented, transported, promoted, daydreamed over, sold, purchased, consumed, and discarded. And they are the cultural products of the transnational class. The members of such a class are the leaders, the role models, of the 1990s and beyond; their one gift is, needs to be, an ability to converse and communicate with each other. Cultural eccentricities are to be avoided, if not banned altogether. National history and culture are not to intrude or not to be asserted oppositionally or even dialectically. They are merely variants of one "universal"—as in a giant theme park or shopping mall. Culture will be kept to museums, and the museums, exhibitions, and theatrical performances will be swiftly appropriated by tourism and other forms of

[47] "The ratio of the overseas production totals of TNCs to the TNC sales totals is 79 percent for Switzerland, 48 percent for Britain, 33 percent for the U.S., and 12 percent for Japan. And among the top three countries, the overseas production totals were greater than the export totals. The 1981 U.S. export totals were 233.6 billion dollars, while the overseas production totals were nearly twice as much, 482.9 billion dollars. The Japanese export totals were 152 billion dollars, while its overseas production totals were merely 30 billion dollars" (Motoyama Yoshihiko, *Minami to kita: Kuzureyuku daisan sekai* [Tokyo, 1991], pp. 196-197; my trans. See also Terajima Jitsuro, *Chikyugi o te ni kangaeru Amerika*, pp. 68-69, 160-162).

[48] Reich's comments occasioned by the publication of Crichton's *Rising Sun* are eloquent on this. "The purpose of having a Japanese challenge is to give us a reason to join together. That is, we seem to need Japan as we once needed the Soviet Union—as a means of defining ourselves, our interests, our obligations to one another. We should not be surprised that this wave of Japan-as-enemy books coincides exactly with the easing of cold-war tensions" (Reich, "Is Japan Really out to Get Us?" *New York Times Book Review*, 9 Feb. 1992). To quote from Sklair, protectionism "acts as a bargaining counter for the rich, and a bluff for the poor, and mainly comes to life in its use as a rhetorical device to satisfy domestic constituencies. For example, desperate politicians tend to fall back on it to appease working class voters in the United States and the United Kingdom" (S, p. 71). Among the "revisionists" are Clyde V. Prestowitz, Jr., James Fallows, Karel van Wolferen, and Chalmers Johnson.

[49] Chiu Yen Liang, "The Moral Politics of Industrial Conflict in Multinational Corporations Located in Hong Kong: An Anthropological Case Study," 2 vols. (Ph.D. diss. University of Chicago, 1991), discusses a strike at a Japanese TNC in Hong Kong. Although overly detailed in description and confusing in analysis, there are many interesting observations of the TNC practice.

[50] "In some, though not all, export oriented zones (EOZs) the rights of workers to organize is curtailed, either formally or in practice, and . . . trade unions are either suppressed or manipulated through government-TNC collaboration" (S, p. 95).

[51] Some labor unions and some Democrats, including Bill Clinton, approve NAFTA with reservations concerning worker retraining and enforcement of adequate environmental regulations in Mexico. But the specifics are not available. As to the overall gains and losses, obviously some industrial sectors will gain while others will lose. The questions are who will gain how much, who will lose how much, and when will the disparity be balanced out? As to the prospects of worker displacement, a group of

commercialism. No matter how subversive at the beginning, variants will be appropriated aggressively by branches of consumerism such as entertainment and tourism, as were rap music, graffiti art, or even classic music and high arts. Cable TV and MTV dominate the world absolutely. Entertainment and tourism are huge transnational industries by themselves. The return to "authenticity," as mentioned earlier, is a closed route. There is nothing of the sort extant any longer in much of the world. How then to balance the transnationalization of economy and politics with the survival of local culture and history—without mummifying them with tourism and in museums—is the crucial question, for which, however, no answer has yet been found.[52]

Third, workers in search of jobs all over the world are changing global demography in this third industrial revolution. They come, legally or illegally, from everywhere to every industrial center either in industrialized or developing nations. TNCs are in need of them, though they are unwilling to provide them with adequate pay or care. Cut off from their homes, migrant workers disappear into huge urban slums without the protection of a traditional rural mutual dependence system. The struggle for survival does not allow any leisure in which to enjoy their pastoral memory. For those exploited alien workers in inner cities, consumerism alone seems to offer solace, if they are fortunate enough to have money for paltry pleasures. In Mexico City or Seoul, in Berlin or Chicago, migrants mix and compromise alongside other aliens from other regions. Neither nativism nor pluralism are in their thought, only survival. "Multiculturalism" is a luxury largely irrelevant to those who live under the most wretched conditions. It is merely an "import strategy" of the TNC managers, as Mike Davis calls it.[53] In fact, it may very well turn out to be the other side of the coin of neoethnicism and neoracism.

Fourth, environmental destruction is a major consequence of the development of TNCs. Because TNCs often move across borders to escape from stringent environmental regulations, the host government is not likely to enforce the pollution control rules. The effects of the damage caused in the industrialized areas as well as NIEs and Third World regions, however, is not confined to these specific localities. The proposal made by Lawrence Summers of Harvard and the World Bank to shift polluting industries from developed countries to "underpolluted" Third World is as foolish as it is invidious.[54] The effects of environmental violence inescapably visit everyone, everywhere. Air pollution, ozone layer depletion, acid rain, the greenhouse effect, ocean contamination, and a disrupted ecosystem are finally unavoidable no matter where the damage originates. The TNCs might escape from the regulators, but we are all—with no exception—victims. Who is there to control the environmental performance of TNCs globally? Are we to rely on the good sense of corporate planners to fight off catastrophe? Can we trust the fugitives from law to protect the law?[55]

Finally, academia, the institution that might play the principal role in investigating transnational corporatism and its implications for humanity, seems all too ready to cooperate rather than deliberate. The technical complexity of TNC mechanism requires academic expertise in sophisticated research, explanation, and management of immense information data. Those in economics, political science, sociology, and anthropology as well as business administration and international relations, are not expected to be harsh critics of the TNC practice, being compliant enough to be its explicators and apologists. Critics and theorists in the humanities, too, are not unsusceptible to the attraction of global exchange, as I will argue once more before I close.

TNCs continue colonialism. Like the pre-1945 colonialism, they operate over distance. While they homogenize regions, they remain aliens and outsiders in each place, faithful only to the exclusive clubs of which they are members. True, old colonialism operated in the name of nations, ethnicities, and races, and transnational corporatism tends toward nationlessness. But as I have already mentioned, even the historical nation-state was

researchers at the University of Michigan predicted that "as few as 15,000 to 75,000 American workers—out of a work force of 120 million—could lose their jobs over 10 years as a result of the pact" (Nasar, "Job Loss in Pact is Called Small," *New York Times*, 17 Aug. 1992, p. D3). The details are not offered, but the prediction as reported is totally unconvincing. Nearly all in the management side agree that NAFTA will benefit everyone in the long run. No one spells out, however, how long that means. It remains to be proven that NAFTA will not be a disaster to the U.S. workers for a foreseeable future. See also Bob Davis, "Fighting 'Nafta': Free-Trade Pact Spurs a Diverse Coalition of Grass-Roots Foes," *Wall Street Journal*, 23 Dec. 1992, p. 1.

[52] There are numerous works by the members of the Frankfurt School theorists on this, especially Adorno and Benjamin. Also, see S, p. 42, and Dean MacDonnell, *Empty Meeting Grounds: The Tourist Papers* (London, 1991). Arif Dirlik in his forthcoming essay, "Post-Socialism/Flexible Production: Marxism in Contemporary Radicalism," advocates a neo-Marxist localism to deal with this problem.

[53] Mike Davis, *City of Quartz: Excavating the Future in Los Angeles* (London, 1990), pp. 80-81. See also Edward W. Soja, *Postmodern Geographies: The Reassertion of Space in Critical Social Theory* (London, 1989).

[54] James Risen, "Economists Watch in Quiet Fury," *Los Angeles Times*, 8 Jan. 1993, p. A20.

[55] See, for example, United Nations Centre on Transnational Corporations, *Environmental Aspects of the Activities of Transnational Corporations: A Survey* (New York, 1985).

actually an enabling institution for international enterprises. British colonialism made possible the East India Company, just as the U.S. government made possible the domination of the United Fruit Company in Central America. Colonialism never benefited the whole population of an adventurist nation. As J. A. Hobson argued nearly a century ago and has been confirmed by scholars since, colonialism enriched the rich and powerful of the home country and the *compradors* at the expense of the populace at large.[56] The trickle-down theory of the 1980s was, as is always, a wishful fantasy or, more likely, an unadulterated con game. It is indeed sobering to remember that the war in Vietnam cost a huge amount to the United States as a whole, which of course gained nothing from the old exhausted Southeast Asian colony of France. And yet there were a good number of stockholders, executives, entrepreneurs, and employees of the U.S. defense industry who amassed fortunes over the millions of dead and wounded bodies and impoverished souls, both Vietnamese and American. Japanese industrial recovery, too, owes a great deal to the Korean and Vietnam Wars.

TNCs are unencumbered with the nationalist baggage. Their profit motives are unconcealed. They travel, communicate, and transfer people and plants, information and technology, money and resources globally. TNCs rationalize and execute the objectives of colonialism with greater efficiency and rationalism. And they are, unlike imperial invaders, welcomed by the leaders of developing nations. In order to exploit the different economic and political conditions among the current nation-states, they ignore the borders to their own advantages. When the need arises, however, they can still ask for the aid of the armed forces of their home/host states. And in the process patriotic rhetoric can be resurrected to conceal the true state of affairs, as the Gulf War clearly demonstrated. The military, in the meantime, is increasingly assuming the form of a TNC itself, being nearly nation-free. TNC employees, too, are satisfied with their locally higher wages. And yet there is no evidence that the whole population of a host country enjoys an improvement in welfare: let me repeat, a higher GNP or per capita income does not mean an equally enjoyed increase in wealth. As the host government represses labor organization and urban industrial centers generate surplus labor, wages can be lowered and inequality can intensify at least temporarily.[57] Authoritarianism is unlikely to diminish. Oppression and exploitation continue. Ours, I submit, is not an age of *post*colonialism but of intensified colonialism, even though it is under an unfamiliar guise.[58]

I am raising these issues as a participant in the discourse on colonialism. I have myself participated in a number of workshops and conferences on the subject. It is curious, however, how quickly "colonial" discourse has been replaced by "*post*colonial" discourse. There was a conference in Berkeley called "After 'Orientalism'" in the spring of 1992. Soon thereafter, there was another at Santa Cruz, this time entitled "Beyond Orientalism." During the subsequent fall, there were at least two more, one at Scripps College, called "Writing the Postcolonial," and another, though slightly different in orientation, at Santa Barbara, entitled "Translating Cultures: The Future of Multiculturalism?" And above all there is a three-year project on Minority Discourse at the Humanities Research Institute, at the University of California, Irvine. These are all recent California events, but there are many meetings and conferences on the subject everywhere, converting academics—us—into frequent fliers and globe-trotters. And there is, of course, an outpouring of articles in scholarly publications.[59]

Such activities are presumably politically engaged intellectual exercises. But if practice follows discourse, discourse must follow practice. Very much like studies in New Historicism, these are efforts once again to distance political actuality from direct examination. Once again, we are sanitizing our academic discourse on the ongoing political conditions—this time around TNCs and their eager host governments. We might even be masking a secret nostalgia, as we devote our scholarly attention to "postcoloniality," a condition in history that is

[56] For recent studies, see, for instance, Lance E. Davis and Robert A. Huttenback, *Mammon and the Pursuit of Empire: The Economics of British Imperialism* (Cambridge, 1988). They argue that the elite members of British society gained economically and the middle-class British taxpayers lost during the nation's imperial expansion.

[57] See Kuwahara, *Kokkyo a Koeru rodosha*.

[58] See Noam Chomsky's latest book, *Year 501: The Conquest Continues* (Boston, 1993), esp. chaps. 3 and 4.

[59] To name a few, Kwame Anthony Appiah, "Is the Post- in Postmodernism the Post- in Postcolonial?" *Critical Inquiry* 17 (Winter 1991), pp. 336-357; Homi Bhabha, "Of Mimicry and Man: The Ambivalence of Colonial Discourse," *October 28* (Spring 1984), pp. 125-133; Sara Suleri, "Woman Skin Deep: Feminism and the Postcolonial Condition," *Critical Inquiry* 18 (Summer 1991), pp. 756-69; Dipesh Chakrabarty, "Postcoloniality and the Article of History: Who Speaks for 'Indian' Pasts?" *Representations* 37 (Winter 1992), pp. 1-26, and, most important, issue no. 31-32 of *Social Text*, which addresses the question of postcolonialism and the Third World. None of the articles, however, directly discusses the development of the TNC.

safely distant and inert, instead of seeking for alternatives in this age after the supposed end of history. Similarly, multiculturalism suspiciously looks like a disguise of transnational corporatism that causes, of necessity, havoc with a huge mass of displaced workers helplessly seeking jobs and sustenance. Los Angeles and New York, Tokyo and Hong Kong, Berlin and London are all teeming with "strange-looking" people. And U.S. academics quite properly study them as a plurality of presences. But before we look distantly at them and give them over to their specialists, we need to know why they are where they are. What are the forces driving them? How do they relate to our everyday life? Who is behind all this drifting? The plurality of cultures is a given of human life: "our own tradition" is a fabrication as it has always been, everywhere. It is impossible not to study cultures of others; the American curricula must include "alien" histories. But that is merely a beginning. In the recent rise in cultural studies and multiculturalism among cultural traders and academic administrators, inquiry stops as soon as it begins. What we need is a rigorous political and economical scrutiny rather than a gesture of pedagogic expediency. We should not be satisfied with recognizing the different subject-positions from different regions and diverse backgrounds. We need to find reasons for such differences—at least in the political and economic aspects—and to propose ways to erase such "differences," by which I mean, political and economic inequalities. To the extent that cultural studies and multiculturalism provide students and scholars with an alibi for their complicity in the TNC version of neocolonialism, they are serving, once again, just as one more device to conceal liberal self-deception. By allowing ourselves to get absorbed into the discourse on "postcoloniality" or even post-Marxism, we are fully collaborating with the hegemonic ideology, which looks, as usual, as if it were no ideology at all.

From: *Critical Inquiry* 19, Chicago, Summer 1993.

Many of my friends have read the paper in various stages. I am thankful to the following for detailed and insightful comments and suggestions, although errors and misinterpretations are, of course, entirely my own: Martha L. Archibald, Carlos Blanco-Aguinaga, Noam Chomsky, Arif Dirlik, Joseba Gabilondo, H.D. Harootunian, Takeo Hoshi, Stephanie McCurry, and Anders Stephanson.

Lygia Clark during work on *Cabeça Coletiva* (Collective Head)

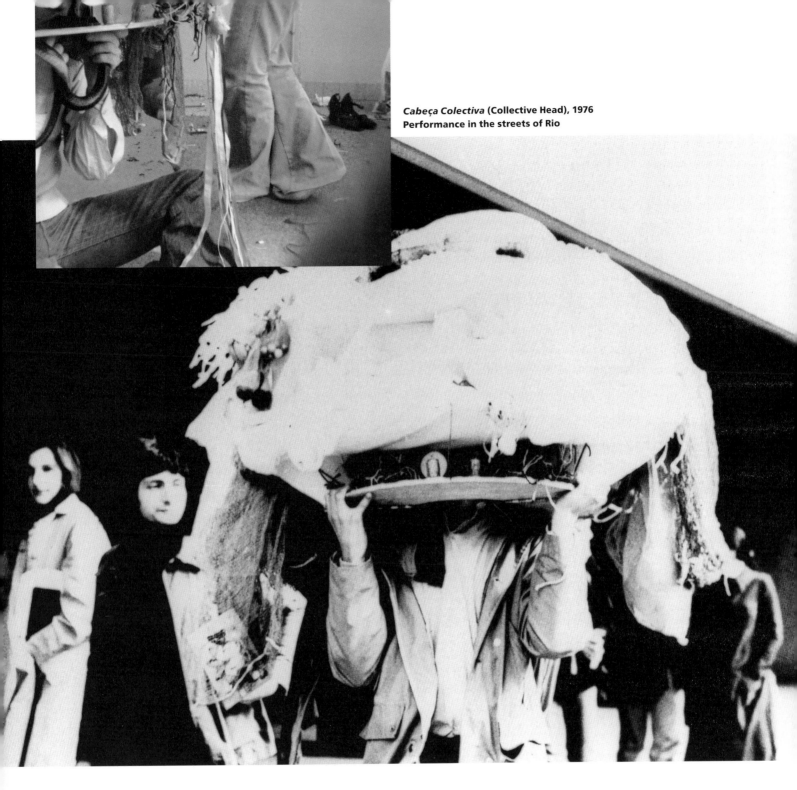

Cabeça Colectiva (Collective Head), 1976
Performance in the streets of Rio

Jean-François Lyotard

It is an uncontested fact that in colonized countries nationalism is the ultimate response of the population to the profound *desocialization* produced by imperialism. It is reasonable to suppose that direct occupation, as was the case in Algeria, desocializes still more radically than appropriation by "intermediates." Once all its institutions had been annihilated, the Algerian population experienced with particular intensity the problem of reconstructing a new social life, a mode of cooperation that takes as its basis the very state to which it has been reduced by the impact of colonialism and that therefore can no longer have recourse to a preimperialist model. Now, the nation constitutes the general type of response to this problem: it offers a mode of both coexistence and solidarity, and it espouses the very

it. I interrogated history, I interrogated the living and the dead; I visited the cemeteries; no one spoke to me of it . . . No one elsewhere seriously believes in our nationalism"? What else could explain the fact that the Etoile, founded by Messali among the most politicized group of Algerian migrant workers in France, was *nord-africain* before being Algerian?

There is no need to go on: when the first shots rang out in the Casbahs in November 1954, the men of the OS had behind them neither a middle class still solidly inserted in the relations of production nor a state apparatus capable of being turned against imperialism and collaborationist elements. The nationalist ideology that burst into the light of day did not have, so to speak, specific sociological support, and it was not only a polit-

1955 Bandung Conference, Movement of Non-Aligned Nations. 1956 USS Morocco and Tunisia. Special powers voted for the French government in Algeri

framework given to the colonized country by imperialism. The nation unites people who have been ground down together, if not in the same fashion, by colonialism. It unites them independently of their tribal, village, or religious communities.

Still, in order for nationalist ideology to develop and spread as a solution to the colonial situation, social classes, with an experience or at least a vision of the whole of the society subjected to imperialist oppression, have to be able to provide a universal formulation and common objectives for all the particular dissatisfactions, all the isolated revolts. This role is in general assumed by the elements expelled from the former middle classes and regrouped in the very state apparatus that imperialism employs to maintains its control over society. In Algeria, this condition was lacking. What else could explain how Abbas could say in 1936, "If I could find the Algerian nation, I would be an nationalist, and I would not blush from it as from a crime . . . I will not die for the Algerian fatherland, because this fatherland does not exist. I could not find

ical void that they had to fill, but a social void. Speaking politically, the Front was not the pure and simple transposition of a preexisting nationalist *organization* into the universe of violence; it was, on the contrary, the violent means of making this organization exist.

From: "The Social Content of the Algerian Struggle" (1959), in *Political Writings*, Minneapolis: University of Minnesota Press, 1993.

Claude Lefort

There has been an effort to make us believe that a major counter-revolutionary movement sprang up at the end of the insurrection's second week and that the workers' victories were on the verge of being liquidated. Kadar subsequently had to go back on that lie, declaring that it was only a simple threat from reactionary groups which the government was compelled to nip in the bud. But that too was a lie. The course of events has proved it: the working class fought stubbornly throughout Hungary, there was another general strike and the factories were once again the bastions of the insurrection. The new workers' victories—the workers' councils and their arms—were intolerable to the Russians, who sought to crush them with the aid of a puppet government. . . .

Of course, once a revolution has begun there is no predicting the outcome. The proletariat was not alone in the Hungarian revolution: the peasants, the intellectuals, and the petty bourgeoisie joined it in the battle against the dictatorship of the bureaucracy, which exploited and oppressed the entire population. In an initial phase, the democratic and national demands unified the whole population; on that basis, a development leading to the reconstitution of a state apparatus separate from and opposed to the councils, a parliamentary "democracy" which could count on the support of the peasants and the petty bourgeoisie, was theoretically possible. In a second phase of the revolution, the contradictory content of these demands would have become clear; at that point, one solution would have had to win out brutally over the other, imposing the bourgeois-type parliament or the councils, an army and a police force as specialized bodies of coercion or an armed organization of the working class. At the outset, the insurrection bore the germs of two absolutely different regimes. . . .

wentieth Party Congress, Khrushchev report on the Stalin era. Independence of uez crisis.

e au "cher camarade" retrouvé

It is inevitable that at the end of a dictatorial regime all the different political tendencies should manifest themselves, that the traditional politicians, freshly out of prison, should hold meetings, make speeches, write articles, draft programs; that in the euphoria of shared victory, a public should be ready to applaud all the phrasemakers proclaiming their love of freedom. The threat represented by these political tendencies did not yet correspond to an organized force in society.

During this time, the workers' councils continued to exist, the workers remained, weapons in hand. *These councils, these workers, were the only real force, the only organized force in the country*—excepting the Russian army.

This was the force that the Russian bureaucracy absolutely could not tolerate. It could make concessions to Tildy, Kovacs, even Midszenty, it could govern at the price of a few compromises. It had already done so in Hungary and in all the popular democratic countries—and even in France, where Thorez had no compunctions about participating alongside Bidault in several governments from 1945 to 1947. But the organization of councils by armed workers signified total defeat for the bureaucracy. That is why, under the cover of a "reactionary threat," it launched its tanks on November 4 against the councils, whose victory could have had immense repercussions and might even have shaken its own regime.

What followed is absolutely incredible. For six days, the insurgents resisted an army with overwhelming firepower. Only on Friday

November 9 did organized resistance cease in Budapest. But *the end of military resistance did not mean an end to the revolution*. The general strike continued, plunging the country into complete paralysis and clearly demonstrating that the Kadar government had no support whatsoever among the population. . . .

The national demands have been presented as typically reactionary. But to judge them properly, one must again consider the situation in which they were expressed.

The facts are there: for ten years, the USSR has been exploiting Hungary. We do not learn this from bourgeois statistics and testimony, but from the progressive Hungarian communists who, since Rakosy's defeat (that is, since last July) have clearly revealed it. In an initial phase, the USSR demanded reparations which laid a terrible burden on an already exhausted economy. In 1946, 65 percent of the country's total production was devoted to these reparations; in 1947, 18 percent of the national budget was affected.

In a second phase, the Russians practiced indirect exploitation by compelling the Hungarians to sell their industrial and agricultural products at prices far lower than what they would have obtained on the world market (they did the same in all the popular democracies, this being one of the essential reasons for Tito's break). Finally, they began readying to lay their hands on the uranium deposits, in exchange for a derisory recompense.

Moreover, Russian domination was not restricted to the solely economic realm, but also appeared in all the sectors of social, political, and cultural life.

It is known that the fate of the various tendencies within the Hungarian communist party was strictly dependent on Moscow; for example, the rise of Nagy during the Malenkov period, then his fall after the latter's disgrace, was a public manifestation of the guiding role of the Russian Politburo.

Writers, philosophers, and artists also experienced the imposition of the Russian model, with the immediate repression of any attempt at independent expression. For example, the Hungarian philosopher Lukács—a Marxist of a caliber incomparable to anything that Stalinist Russia has ever been able to produce—was forced into dishonoring public self-criticisms, with the conclusion that there was only one literature and one philosophy: the ones practiced in Moscow. In the schools, the Russian language was obligatory. If we complete this picture with the permanent presence of Russian troops, that will provide an idea of the relations between Russia and Hungary. In fact these relations betray an exploitation of the colonial type.

Now, if the desire for national independence quite naturally grows in all colonized countries, the hatred for the foreign exploiter is increased tenfold in a country like Hungary, with its rich national past. To qualify that hatred as reactionary is absurd, when it is actually the

conduct of the foreigner that is reactionary.

To be sure, these national demands are always on the verge of degenerating into nationalism (just as in colonized countries). We are convinced that among those brandishing the emblem of Kossuth or tearing off red stars from the Hungarian national flag, a great many have given into pure and simple nationalism. We know only too well that the petty bourgeoisie is a terrain of predilection for this kind of superpatriotism. We ourselves believe that the unleashing of anti-Russian sentiments may have awakened an ancestral hatred among the peasants. But that is not the important thing. There was also a healthy aspect in the national demands. The revolutionary youth and the workers' councils that called for the imme-

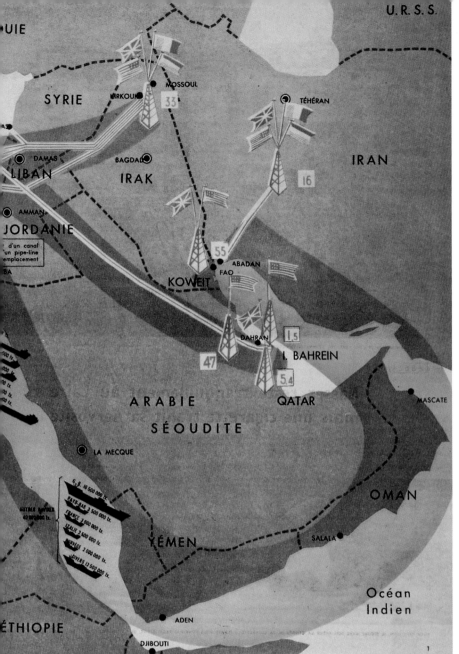

It is true that in itself the Algerian struggle has not found a manifest class content in the formulation given to it by the [National Liberation] Front. Is it because the Front, insofar as it is made up of a bourgeois leadership, *wants* to stifle this class content? No doubt. But it is also because it *can*. And if the French left in this case can so easily lose its Marxism, or whatever else it uses as a substitute, it is because the peculiarity of Algerian colonial society lies in the fact that class borders there are deeply buried under *national* borders. It is in a completely *abstract* way, that is, exclusively *economistic*, that one can speak of *a* proletariat, *a* middle class, *a* bourgeoisie in Algeria. If there is *a* peasantry, it is because it is entirely and exclusively Algerian, and it is this class that evidently constitutes the social base of the national movement, at the same time that it is the clearest expression of the radical expropriation that Algerian workers undergo as Algerians. . . .

In reality, if one leaves aside the most notable servants of the French administration, the "professional yes-men," as their fellow citizens themselves call them (*cais, aghas, bachaghas*, presidents of Muslim veterans organizations, etc.), then no Algerian bourgeois, even if he marries a French woman, even if he apes French manners to perfection, can be admitted to European society. And there is not one of them who has not in the course of his life suffered, under one form or another, an unforgettable humiliation. No European employer or shopkeeper lives in the same building or even the same quarter as the Algerian shopkeeper or employee. The European workers, finally, do not fraternize with their Algerian comrades. This is first of all because they don't live together. Bab-il-Oued is not far from the Casbah, but the police cordon that surrounds the Arab city isolates it from the European working-class neighborhood. Second, they do not fraternize because there is a hierarchy of labor by virtue of which the more qualified European worker is assured the most remunerative and least discredited tasks, because even if Europeans and

diate departure of the Russians and the proclamation of a sovereign and independent Hungary were attacking the oppression of Russian imperialism; they were simultaneously combating a foreign totalitarian state and the totalitarian state of Hungary.

What is more, we have seen the proof that the combat against the Russians has on many occasions been accompanied by typically internationalist conduct. The Russian soldiers were encouraged to fraternize and they effectively did fraternize. It is almost sure that the extent of the demonstration compelled the Moscow bureaucracy to recall part of its troops, and to send more trustworthy elements that were not as likely to sympathize with the population. The fraternity with which the insurgents greeted the soldiers who refuse to fire on them is attested by a resolution demanding that they be given the right to asylum in Hungary.

From: "L'insurrection hongroise," in *Socialisme ou barbarie* 20, Paris, 1956-57.

Algerians work in the same workshop or on the same building site, the team or site leader is necessarily European. And, finally, because even in the unions and the worker's organizations, whatever the efforts of the CGT since 1948, the colonial hierarchy is mirrored to the point that the Algerian "leaders" of these organizations look like straw men and, when all is said and done, like counterparts of the yes-men "on the left." We cannot impugn the good faith, the real desire to break this colonial curse, or the courage of the militants of the organizations. But their failure expresses, sometimes tragically, the impossible situation that they faced before the insurrection: the task of reconstituting class solidarity within a society founded on its suppression. In fact, the immense majority of the Algerian workers remained outside these organizations and came together only inside the sole party that, despite (or perhaps because of) its defects, allowed these workers to fraternize without a second thought, that is, that prefigured a truly Algerian community.

There is no other way to understand why the European population of Algeria, with its small number of wealthy colonists (owing to the concentration of landed property), in which workers and employees form a majority that is itself exploited, has not dissociated itself from extreme right wing policy but has instead given it overwhelming support. Nor can the success of the insurrection itself be understood, an insurrection called for by a few activists who were sick of their leaders' inaction, which would not have been able to extend and consolidate itself as it did had not the Algerian masses felt that the struggle was well founded. This breach was so extensive that no Algerian struggle could expect to draw support from the massive solidarity of the European workers. Lastly, one cannot understand the FLN's present "sectarianism" when it affirms that "every French soldier in Algeria is an enemy soldier" whose "relations with Algeria are based on force" unless one hears in this intransigence, which perhaps shocks the delicate ears of the French "left" (which is often paternalistic and *always treacherous* toward the Algerian people), the direct expression of the split that runs through and tears apart all the classes of Algerian society.

If the solidarity of the French in Algeria has never been seriously disrupted to the point where social forces could have taken up class positions, this means that in all their actions the *Français d'Algérie* (even if they were wage earners just as exploited as the Algerians) could not think of themselves except as Frenchmen occupying Algeria. And then it must be said clearly: the Algerian nation that constituted itself despite them could only affirm itself against them. There is in this hostility no mystique of the holy war, no resurgent barbarianism, but a people (and we intentionally employ this not very Marxist concept), that is to say, an amalgam of antagonistic social strata. This people is thrown back upon the consciousness of that elementary solidarity without which there would not even be a society, with the awareness that it must form a total organism in which the development of intrinsic contradictions presupposes the complementarity of those elements that contradict each other. Colonization both creates the conditions of this complementarity and blocks its development; the consciousness of being expropriated from oneself can therefore only be nationalistic.

From: "Algerian Contradictions Exposed" (1958), in *Political Writings*, Minneapolis: University of Minnesota Press, 1993.

Claude Lefort

The Hungarian revolution is one of those events which cannot help but leave an enduring mark on historical memory. It was the first big crack in the totalitarian structure, incomparably deeper than the ones created by the rising in East Berlin in 1953, or, three years later, by the disturbances in Poznan and the great rumblings all over Poland, whose results would in fact be greatly modified by the failure of the insurgents in Budapest. I am certain that future historians will long ponder those days of October and November 1956, which "shook the world" even despite their tragic close. And the same will likely be the case for freedom-loving men, those whose convictions

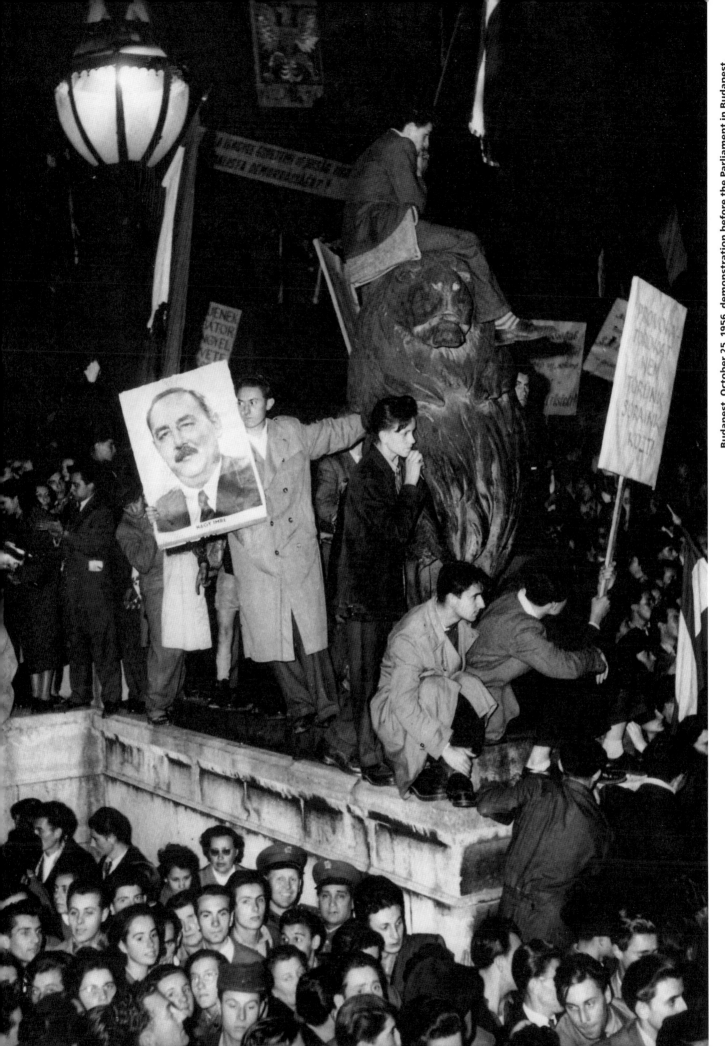

Budapest, October 25, 1956, demonstration before the Parliament in Budapest.
A demonstrator holds the portrait of President Imre Nagy.

209

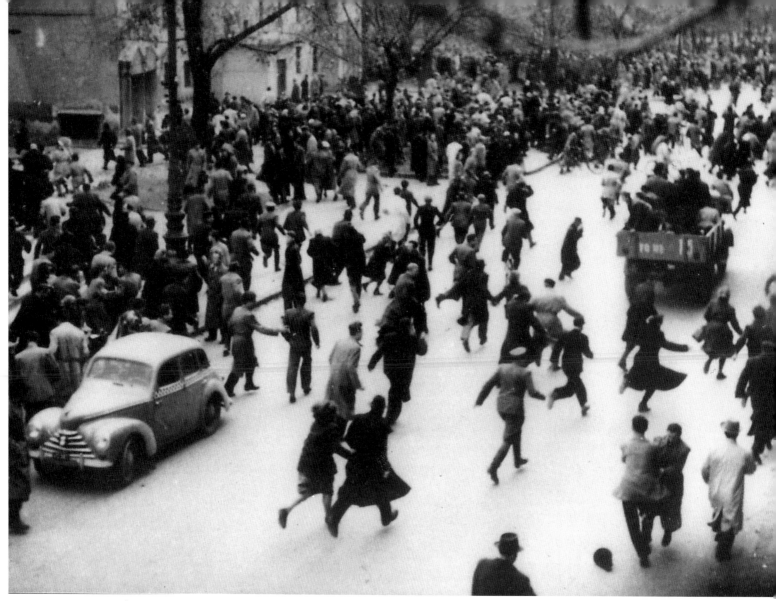

Budapest, October 31, 1956

are nourished by the memory of the great chapters of revolution—so long, at least, as the desire for knowledge and freedom are not reduced to silence in future societies.

But historical memory is one thing, and collective memory another. The latter forms within and between many different groups, who only remember those aspects of the past which serve their representation of the present. And in our time, collective memory is fashioned ever more insistently by the very few who have the means to broadcast such representations: political leaders, their declarations studded with reminiscences conceived to legitimate a tradition; intellectuals, concerned with the dramatization of an edifying narrative; and media manipulators on every scale, cleverly filtering out anything that does not please their current masters. Now, whoever consults the collective memory cannot help but be struck by the fate of the Hungarian revolution. It has been entombed. No doubt, this year has offered the occasion to exhume it. The media have a need and a taste for obituaries and anniversaries. But that only underscores rather than erases the voluntary oblivion or repression suffered by Hungary in 1956. What is this silence that has fallen over it? I speak only of the Western left. Why bother with the right? Either it smoothes the ruffled feathers of the rival power, when its own interests are at stake; or it exploits the signs of that power's failings and contradictions, to justify the politics of the governments currently installed in the West. How could one reproach the right for blacking out the Hungarian revolution or for using it as an occasional pretext for the condemnation of Soviet imperialism? But what of the left—particularly in France where it carries so much weight, where the radio and the television give voice to its spokesmen, where its press reaches a broad public? Why this silence over Hungary, while such frequent reference is made to the cultural revolution in China, or to Prague Spring? Is it simply because these events date from a more recent past? Observe, for example, the abundant commentary generated by the Stalinist terror. One might claim that it too was recently discovered, with the stories told by the escapees from the camps and above all with Solzhenitsyn. To be sure, *The Gulag Archipelago* brought the nature, extent, and duration of the ter-

ror into full daylight, on the basis of incontrovertible testimony and documentation. And yet as early as 1949, the revelations made to the Economic and Social Council on the number of detainees in the camps became public knowledge, striking non-communist intellectuals on the left with stupor and even forcing Sartre and Merleau-Ponty into the condemnation of a regime which, they went so far as to say, was perhaps merely usurping the name of socialism. Why then do we discover now what we had already learned twenty-five years ago? The truth is that what had first seemed new, unheard-of, unthinkable, was later buried in the shadows of collective memory. The information received was in fact preserved, but excluded from representation. If at present it emerges from oblivion, it is because it can now be assimilated. And what it the reason for this change? Is it not that yesterday such information endangered the left's faith in socialism, while in our day it contributes to restoring that faith? The danger is conjured away by channeling everything evil into the image of Stalin, for fear of recognizing totalitarianism beneath the mask of socialism and having to admit that the former subsists under a new guise. Such a change is linked to a multiplicity of historical circumstances, but these need not be examined here. The phenomenon only interests me in so far as it casts light on the fate of the Hungarian revolution.

This event also seemed new, unheard-of, unthinkable for the majority of the left at the time when it happened. It was regarded intently by everyone in the West. But the tumult it raised in hearts and minds was short-lived. Later it became more convenient not to think about it. Assuredly it left traces, cruel wounds for some; but most preferred to remain ignorant of those traces. The example of certain communist party intellectuals, among the most famous at the time, is eloquent. In November 1956, I recall, a meeting of the Association of Intellectuals against the War in Algeria was held in Paris. This association included communists, Trotskyists, progressive Christians, Sartreans, and people from all kinds of splinters, as well as many with no organizational affiliation. At this assembly, which exceptionally brought together hundreds of people, a motion was raised to condemn both the French intervention in Algeria and the Soviet intervention in Hungary, in the name of the right of all peoples to self-determination. A small core group of communists began protesting. "Dog, filthy snake!" they cried at those who supported the motion. I can still see Edgar Morin trying to make himself heard up on the podium and wavering beneath the insults. But in the weeks and months that followed, these furious champions of the USSR (how clearly I remember their faces!) found cause to leave the party, despite a long history of militant commitment. It is true, the revelations of the Khrushchev report had been a blow to them; and the opportunism of the French communist party in the context of the Algerian war put their discipline to the test. But what was their real motive? The Hungarian affair had broken

them. To my knowledge, they never said another word about Hungary. The subject remained taboo for them. Of course their certainties had vanished, and they had lost the taste for calling their adversaries dogs. Even more: they had lost their faith in the USSR. Yet what survived (and probably still survives) was the absurd conviction that Hungary had sunk into counter-revolution. I say absurd, for how could they continue to believe in a counter-revolution when they no longer believed in the revolutionary nature of the Hungarian or Soviet regime?

From: "Une autre révolution" (1977), in *L'invention démocratique*, Paris, 1981-1994.

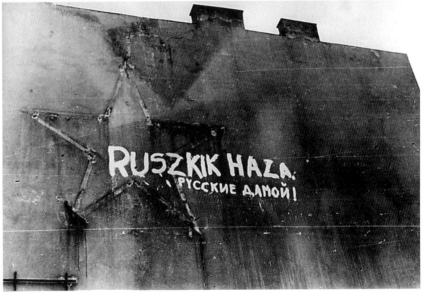

Budapest, October 1956, "Russians Go Home!"

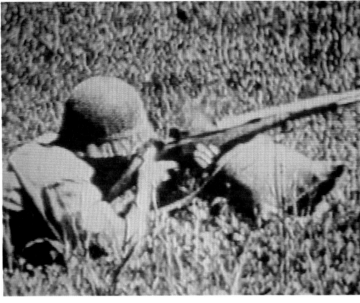

Youssef Ishagpour

Few filmmakers have the courage to turn everything upside down from one film to the next; but after having reduced cinema to an imaginary world of fantasmatic projection, mirrors, and fiction in *L'Année dernière à Marienbad*, Resnais went on to experiment with another limit in *Muriel* (1963). This time he turned in the opposite direction: cinema as the reproduction of exterior reality, as the destruction of meaning through its dispersal into the world of the undistinguished, the fleeting, and the singular, with an extreme tendency toward nominalism. In the midst of the Algerian war, *Marienbad* had been reproached for holding up a screen against reality. Pure construction may once again have aimed to black out or exorcise a far more pressing dilemma. But in 1961 Resnais said that he could not make a film about Algeria, because events between the preparation and release of the film would change the meaning of the testimony. It was impossible not to betray the immediate, in its very immediacy, by the organization that a work implies; and it was impossible to speak of the meaning of the event without this organization, except through a theoretical discourse on document-images—lest the filmmaker confuse the present with the foam of the waves on which he drifts away, casting adrift in his turn not films but sociologically interesting bits of wreckage. Seeking what is most profoundly of the present without provocation, complacency, or concessions to fashion and the public can appear untimely. His audacity in 1963 was to take up the mourning cloak for Hollywood, to bring an actor and a director into dialogue over the death of the gods, before a screen adorned with inscriptions about the absence of any future for cinema. But if an Arab street filmed by Resnais takes fire on the screen, if the camera is thrown into the sea, if a character says, "Muriel, that's unspeakable," it's because the man who wants to speak it and make it a story, the man who remains haggard in front of a blank screen, has been thrust by a tortured woman's gaze before a more terrible death: he has been cast amidst events whose center can not be found, because as a relation it is everywhere, but it is nowhere immediately given and must be reconstructed.

geria

Muriel, a film by Alain Resnais, France, 1963

—Nobody knew this woman. I walked across the office where I worked, covered up the typewriter. I walked across the courtyard. You could still see. In the back was the hangar with the munitions. I didn't see her at first. I ran into her as I came up to the table. She seemed to be asleep but was trembling all over. They told me her name is Muriel. I don't know why but that probably wasn't her real name. There were five of us around her. We discussed it. She had to talk before nightfall. Robert stood up. Muriel whimpered. She threw her arm over her face. They let go of her. She fell like a ton of bricks. Then it started again. They dragged her by the ankles into the middle of the hangar where they could see her better. Robert kicked her in the thighs. He took a flashlight, shined it at her. Her lips were swollen, full of spittle. They tore off her clothes, tried to get her into a chair. She fell again. One arm was all twisted. It's got to come to an end. Even if she talked, she wouldn't have been able. I joined in. Muriel whimpered when we slapped her. The palms of my hands burned. Muriel's hair was all wet. Robert lit a cigarette, stepped up close to her. She screamed, right when she looked me in the eye. Why me? Her eyes closed and she began vomiting. Robert stepped back, disgusted. I brought it all to a stop. That night I came back to see her. I lifted up the tarp. It was like she'd been a long time underwater, like a split sack of potatoes, with blood all over her whole body, in her hair, burns on her chest. Muriel's eyes weren't closed. It hardly affected me, maybe it didn't affect me at all. I went off to bed. I slept well. The next morning, at the flag salute, Robert had taken her away.

—And where is he now, that guy?

—He hangs around Boulogne like everyone else.

—But so do you!

. . .

—It's like the story of the house that starts sliding, you know the one. A tall, fancy building, like a toolbox stood on end. There's a sketch, preliminary plans, working drawings, three hundred pages of technical descriptions. Finally the construction begins, with a thousand-page book of

213

Hence the attempt to speak the unspeakable story, by showing its effects in the banality of everyday life. Hence the montage that is constitutive of *Muriel* and that links back to the most fertile period in the history of cinema: the explorations of the Russians in the twenties, which were totally forgotten in 1963. But there is one essential difference, important for the consequences: the fact that *there* it was a question of days that shook the world, and here of the life of petty-bourgeois provincials shaken by the world—such that everything is shot through with the negative, in the tradition of post-Flaubertian art gnawed by absence and reification. The color and the unsynchronized sound joined other

elements in a serial organization that elaborated what the great Russians had rejected as specific to bourgeois cinema: character, fiction, psychology, drama. This double current would tend to split in Resnais' later films, but here the two streams mingle indissolubly. A construction then—with bits and pieces, on a slippery slope—of characters, a story, and space which empties out from the inside as time wears on, finally leaving no more than the remains of a meal amid a group of objects up for sale: *Muriel* treats still life by history painting and vice versa.

From: *D'une image l'autre*, Paris: Denoël, 1982.

specs and all the detailed checks by Verity and Security. In short, the thing gets up on its feet. All the doorknobs are on. The house is ready. But it starts slipping and the cliff falls away. So then you just wait for it to fall, right? It's brand new, it's empty, and you wait for it to fall. It'll make a beautiful ruin.

From: the soundtrack of *Muriel*, 1963.

Rachid Boudjedra

The Algerian war did not go entirely unnoticed in the larger world; certain directors took it as the subject of a film.

In Egypt, Youssef Chahine shot *Djamila the Algerian* in 1958. It is a fictionalized movie based on the true story of Djamila Bouhired, a young FLN militant arrested and tortured by the paratroopers in Algiers, then condemned to death and finally pardoned. The film is violent but often too sketchy.

The most frequently cited film remains *Together Children for Algeria*, by the East German director Karl Gass. The filmmaker declared in an interview: "This film had to be made for international solidarity. We made the film that you French could not."

Indeed, despite a certain formal sloppiness, this feature film attempts an in-depth coverage of the Algerian war by analyzing the question of the "Algerian revolution" and by revealing the vanity of the attempts at pacification by the legionnaires, who were seventy percent West Germans. . . .

Muriel is a burdensome memory which makes it difficult to live in the present, like the cadaver in Ionesco's play, *How to Get Rid of It*. *Muriel* is not a film about Algeria, but a film where Algeria is like a nagging thought that everybody tries to forget. "Muriel, that's unspeakable," says Robert. And throughout the film this monstrous war is filed away as a useless obstacle on the race to pleasure. Concerning the screenplay, Resnais commented that "one of the major themes was a hatred of violence, which can be a very banal, everyday kind of thing."

"We tried to smother the violence into the everyday, banal events," he added.

This desire to forget is one of the constants in films of the time.

From: *Naissance du cinéma algérien*, Paris, 1971.

Pierre Vidal-Naquet

Algiers itself is divided into eight subsectors; each has its own "sorting center," equipped with a torture chamber. The Sesini villa, the quarters of the 1st foreign parachute regiment, was one of those centers; the El Biar building, where Henri Alleg was tortured and Maurice Audin was assassinated, was another. Two major sorting centers, Beni-Messous and Ben-Aknoun—the only ones officially known to the civil administration—capped off the whole system. However, one must not be fooled by this organization. The hierarchy remained fictive; in fact, the colonels commanding the subsectors were hardly more than administrators who lent "their" premises. Thus the colonel commanding the barracks of Fort-l'Empereur could write to the wife of a missing man who had been tortured on the premises of that subsector: "Although I am in command of the Fort-l'Empereur barracks, I have no information as to the destination of the people who were held there. I had no responsibility in the repression. My quarters were simply placed at the disposal of the official charged with maintaining order." Maurice Audin, killed by Lieutenant Charbonnier, would be secretly inhumed in Fort-l'Empereur.

The real work of repression was actually not done at the subsectors, but at the level of the Algiers-Sahel sector, directed since June 10, 1957 by colonel Godard, the hidden master of Algiers. A "brain trust" (to use general Massu's English expression) was placed beneath the authority of lieutenant-colonel Trinquier, head of the "information-action" department; it centralized the information and took the important decisions. (Trinquier would later prove to be a specialist in repression and torture, which he elevated to theoretical status in his book, *La Guerre moderne*). Under his orders were a team of intelligence officers spread out among the various subsectors. They were the leaders and constituted a perfectly coherent clandestine organization. . . .

However well articulated, this machine would have operated in vain had it not been supported by local elements recruited from both the European and Muslim populations. On March 4, 1957, Robert Lacoste's department announced the creation of a system of urban security, the "Dispositif de protection urbaine" or DPU (it had initially been dubbed "Groupes de protection urbaine" or GPU, but its creators hesitated to use those initials . . .). It was a supplementary police force composed of Europeans and destined to cover the city; since the European city no longer needed to control its own inhabitants, the Muslims alone would come under constant surveillance. Thus one of the oldest demands of the ultras was met. Counter-terrorism was integrated to the repressive force. When the chief of staff of Algiers-Sahel submitted the list of the DPU's officials to the civil authorities, it was found to contain the name of Doctor Kovacs, who had been arrested in late January for his role in the bazooka attack of January 16 against general Salan (suspected of being a sellout); Kovacs had also participated in the activities of a private torture center installed at Villa des Sources in the suburbs of Algiers. Henceforth each neighborhood,

each house of the European city would have its DPU officer. The Muslims in the Kasbah, for their part, were controlled and surveyed by former rebels who were held responsible, at the price of their life, for what happened in each house; they were named *bleus de chauffe*, after their blue drivers' uniforms. Colonel Trinquier had demonstrated, to parody a famous phrase by André Malraux, that torture was "something that can be organized" . . .

Most of the victims did not bear charges, either through ignorance or scorn of the legal mechanisms, or through fear of reprisals: children were assassinated because their father or brother had denounced the torture they had suffered. When the victim was at once innocent—in the eyes of French law—and able to press charges, a financial compromise would terminate the affair before any trial. Let us cite only two small facts. On February 25, 1957, a Muslim police officer, A. S., was arrested and put at the disposal of lieutenant Bigeard's paratroopers. He was beaten (fractured jaw), tortured with electricity, and burned with gasoline, all of this attested by a medical report. Commissioner Gille, a former deportee to Mauthausen, led the inquest. A. S. did not press charges but signed a receipt on July 24 for the sum of 600,000 francs, destined to facilitate his transfer to Quimper. On March 31, 1957 at 2 AM, A. B., a night watchman at the hotel Abert I, was asked by the paratrooper lieutenant Jean-Marie Le Pen, a deputy of the 5th arrondissement in Paris, and a number of his companions, to serve them something to drink. Drinking hours were over and the lieutenant appeared to be drunk, so A. B. refused to serve him. Le Pen immediately hustled A. B. to Sesini villa. The latter subsequently pressed charges for torture, then retracted after a million francs were paid to him from the secret funds. On April 1, 1957, the newspaper *L'Echo d'Alger* announced that general Massu had decorated lieutenant Le Pen with the cross of military valor.

From: *La Torture dans la République*, Paris: Minuit 1972.

Henri Alleg

Erulin entered the room first and kicked me, saying "Sit up!" I didn't move. He grabbed me and leaned me up in a corner. A moment later I was writhing again under the current. I sensed this resistance was making them more and more nervous and brutal.

"We're gonna stick it in his mouth," said Erulin. "Open your mouth," he ordered me. To force me to obey, he clasped my nostrils, and at the moment I opened my mouth he plunged the bare wire deep to the back of my throat, while Charbonnier got the generator going. I felt the intensity of the current rise, and as it did my throat, my jaws, and all the muscles of my face, right up to my eyelids, began to contract in increasingly painful spasms.

Now Charbonnier was holding the wire. "You can let go," said Erulin. "It stays by itself." My jaws were welded onto the electrode by the current, it was impossible to unclasp my teeth despite all my efforts. Behind my clenched eyelids spun images of flame, blazing geometrical patterns, and I seemed to feel my eyes tearing out of their sockets in jerks, as though pushed from within. The current had reached its upper limit, and with it, my pain. It seemed to have flattened out, and I thought they could not cause me any more suffering. But I heard Erulin say to the guy at the generator, "Do it in little jolts: slow down, then speed up again . . ." I felt the intensity diminish, the cramps contorting my entire body ebbed away and then suddenly, as he brought the generator up to full strength, the current hacked through me again. To escape these brusque falls and sharp rises to summits of agony I began striking my head with all my strength against the ground. Each blow brought relief. Erulin screamed in my ear: "Don't try to kill yourself, you can't do it."

Finally they stopped. Points and lines of light still shivered before my eyes, and my head echoed with the rattle of a dentist's drill.

After an instant I made out all three of them standing before me. "And now?" asked Charbonnier. I didn't answer.

"Good Lord! said Erulin. And he began slapping me with all his might.

From: *La question*, Paris, 1957.

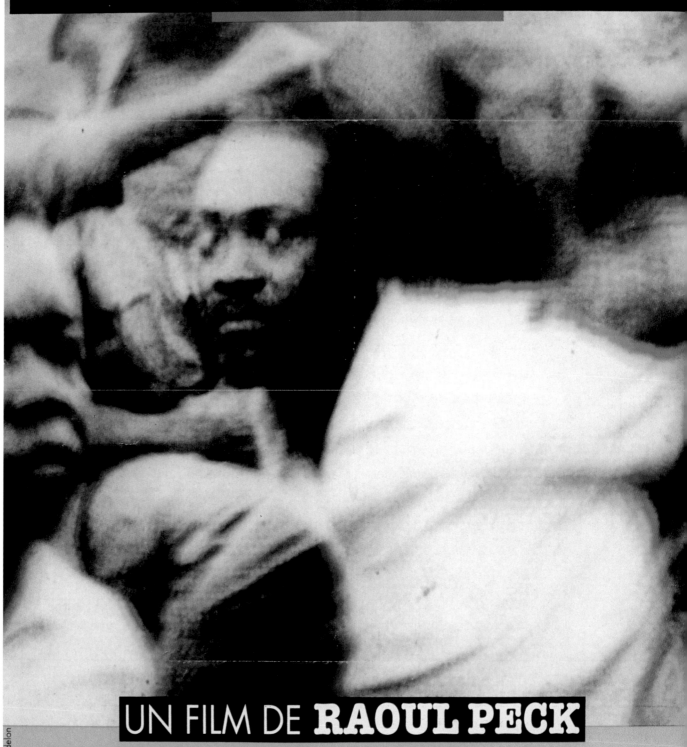

LUMUMBA
LA MORT DU PROPHÈTE

UN FILM DE **RAOUL PECK**

Image: **Matthias Kälin / Philippe Ros**
Montage: **Eva Schlensag / Aïlo Auguste**
Son: **Martin Witz / Eric Vaucher**
Trucage: **Thomas Wilk**
Directrice de production: **Dagmar Jacobsen**
Producteurs: **Raoul Peck / Andreas Honegger**

Une Co-production **VELVET FILM GmbH**, Berlin / **CINEMAMMA GmbH**, Zürich
en association avec
DRS / La SEPT / RTBF "Carré Noir" / EDA / EDI / Centrum 66 / COE / ABP / Berliner Filmförderung FKT
(copyright **1991** / **Raoul Peck** / **Velvet Film GmbH** / **Cinémamma GmbH**)

Raoul Peck, *Lumumba, La mort du prophète* (Lumumba, Death of the Prophet), 1991

Affiche: Jean Zébulon Photo: Georges Boudelon

Maurice Blanchot – The Two Versions of the Imaginary

The Image, the Remains

The image does not, at first glance, resemble the corpse, but the cadaver's strangeness is perhaps also that of the image. What we call mortal remains escapes common categories. Something is there before us which is not really the living person, nor is it any reality at all. It is neither the same as the person who was alive, nor is it another person, nor is it anything else. What is there, with the absolute calm of something that has found its place, does not, however, succeed in being convincingly here. Death suspends the relation to place, even though the deceased rests heavily in his spot as if upon the only basis that is left him. To be precise, this basis lacks, the place is missing, the corpse is not in its place. Where is it? It is not here, and yet it is not anywhere else. Nowhere? But then nowhere is here. The cadaverous presence establishes a relation between here and nowhere. The quiet that must be preserved in the room where someone dies and around the deathbed gives a first indication of how fragile the position par excellence is. The corps is here, but here in its turn becomes a corpse: it becomes "here below" in absolute terms, for there is not yet any "above" to be exalted. The place where someone dies is not some indifferent spot. It seems inappropriate to transport the body from one place to another. The deceased cleaves jealously to his place, joining it profoundly, in such a way that the indifference of this place, the fact that it is after all just a place among others, becomes the profundity of his presence as deceased—becomes the basis of indifference, the gaping intimacy of an undifferentiable nowhere which must nevertheless be located here.

He who dies cannot tarry. The deceased, it is said, is no longer of this world; he has left it behind. But behind there is, precisely, this cadaver, which is not of the world either, even though it is here. Rather, it is behind the world. It is that which the living person (and not the deceased) left behind him and which now affirms, from here, the possibility of a world behind the world, of a regression, an indefinite subsistence, undetermined and indifferent, about which we only know that human reality, upon finishing, reconstitutes its presence and its proximity.

The Cadaverous Resemblance

When this moment has come, the corpse appears in the strangeness of its solitude as that which has disdainfully withdrawn from us. Then the feeling of a relation between humans is destroyed, and our mourning, the care we take of the dead and all the prerogatives of our former passions, since they can no longer know their direction, fall back upon us, return toward us. It is striking that at this very moment, when the cadaverous presence is the presence of the unknown before us, the mourned deceased begins to *resemble himself*.

Himself: is this not an ill-chosen expression? Shouldn't we say: the deceased resembles the person he was when he was alive? "Resembles himself" is, however, correct. "Himself" designates the impersonal being, distant and inaccessible, which resemblance, that it might be someone's, draws toward the day. Yes, it is he, the dear living person, but all the same it is more than he. He is more beautiful, more imposing, he is already monumental and so absolutely himself that it is as if he was *doubled* by himself, joined to this solemn impersonality by resemblance and by the image. This magnified being, imposing and proud, which impresses the living as the appearance of the original never perceived until now— this sentence of the last judgment inscribed deep within being and triumphantly expressing itself with the aid of the remote—this grandeur, through its appearance of supreme authority, may well bring to mind the great images of classical art. If this connection is justified, the question of classical art's idealism will seem rather vain. And we might bear in mind the thought that idealism has, finally, no guarantee other than a corpse. For this indicates to what extent the apparent intellectual refinement, the pure virginity of the image is originally linked to the elemental strangeness and to the formless weight of being, present in absence.

The Image and Signification

Man is made in his image: this is what the strangeness of the cadaver's resemblance teaches us. But this formula must first be understood as follows: *man is unmade according to his image*. The image has nothing to do with signification or meaningfulness as they are implied by the world's existence, by effort that aims at truth, by law and the light of day. Not only is the *image* of an object not the sense of this object, and not only is it of no avail in understanding the object, it tends to withdraw the object from understanding by maintaining it in the immobility of a resemblance which has nothing to resemble.

Granted, we can always recapture the image and make it serve the world's truth. But in that case we reverse the relation which is proper to it. The image becomes the object's aftermath, that which comes later, which is left over and allows us still to have the object at our command when there is nothing left of it. This is a formidable resource, reason's fecund power. Practical life and the accomplishment of true tasks require this reversal. So too does classical art, at least in theory, for it stakes all its glory upon linking a figure to resemblance and the image to a body— upon reincorporating the image. The image, then, became life-giving negation, the ideal operation by which man, capable of negating nature, raises it to a higher meaning, either in order to know it or to enjoy it admiringly. Thus was art at once ideal and true, faithful to the figure and faithful to the truth which admits of no figure. Impersonality, ultimately, authenticated works. But impersonality was also the troubling intersection where the noble ideal concerned with values on the one hand, and on the other, anonymous, blind, impersonal resemblance changed places, each passing for the other, each one the other's dupe. "What vanity is painting which wins admiration for its resemblance to things we do not admire in the original!" What could be more striking than Pascal's strong distrust of resemblance, which he suspects delivers things to the sovereignty of the void and to the vainest persistence—to an eternity which, as he says, is nothingness, the nothingness which is eternal.

The Two Versions

Thus the image has two possibilities: there are two versions of the imaginary. And this duplicity comes from the initial double meaning which the power of the negative brings with it and from the fact that death is sometimes truth's elaboration in the world and sometimes the perpetuity of that which admits neither beginning nor end.

It is very true then, that as contemporary philosophies would have it, comprehension and knowing in man are linked to what we call finitude; but where is the finish? Granted, it is taken in or understood as the possibility which is death. But it is also "taken back" by this possibility inasmuch as in death the possibility which is death dies too. And it also seems—even though all of human history signifies the hope of overcoming this ambiguity—that to resolve or transcend it always involves the greatest dangers. It is as if the choice between death as understanding's possibility and death as the horror of impossibility had also to be the choice between sterile truth and the proxility of the nontrue. It is as if comprehension were linked to penury and horror to fecundity. Hence the fact that the ambiguity, although it alone makes choosing possible, always remains present in the choice itself.

But how then is the *ambiguity* manifested? What happens, for example, when one lives an event as an image?

To live an event as an image is not to remain uninvolved, to regard the event disinterestedly in the way that the esthetic version of the image and the serene ideal of classical art propose. But neither is it to take part freely and decisively. It is to be taken: to pass from the region of the real where we hold ourselves at a distance from things the better to order and use them into that other region where the distance holds us—the distance which then is the lifeless deep, an unmanageable, inappreciable remoteness which has become something like the sovereign power behind all things. This movement implies infinite degrees. Thus psychoanalysis maintains that the image, far from abstracting us and causing us to live in

the mode of gratuitous fantasy, seems to deliver us profoundly to ourselves. The image is intimate. For it makes of our intimacy an exterior power which we suffer passively. Outside of us, in the ebb of the world which it causes, there trails, like glistening debris, the utmost depth of our passions.

Magic gets its power from this transformation. Its aim, through a methodical technique, is to arouse things as reflections and to thicken consciousness into a thing. From the moment we are outside ourselves—in that ecstasy which is the image—the "real" enters an equivocal realm where there is no longer any limit or interval, where there are no more successive moments, and where each thing, absorbed in the void of its reflection, nears consciousness, while consciousness allows itself to become filled with an anonymous plenitude. Thus the universal unity seems to be reconstituted. Thus, behind things, the soul of each thing obeys charms which the ecstatic magician, having abandoned himself to "the universe," now controls. The paradox of magic is evident: it claims to be initiative and free domination, all the while accepting, in order to constitute itself, the reign of passivity, the realm where there are no ends. But its intention remains instructive: what it wants is to act upon the world (to maneuver it) from the standpoint of being that precedes the world—from the eternal before, where action is impossible. That is why it characteristically turns toward the cadaver's strangeness and why its only serious name is black magic.

To live an event as an image is not to see an image of this event, nor is it to attribute to the event the gratuitous character of the imaginary. The event really takes place—and yet does it "really" take place? The occurrence commands us, as we would command the image. That is, it releases us, from it and from ourselves. It keeps us outside; it makes of this outside a presence where "I" does not recognize "itself." This movement implies infinite degrees. We have spoken of two versions of the imaginary: the image can certainly help us to grasp the thing ideally, and in this perspective it is the life-giving negation of the thing; but at the level to which its particular weight drags us, it also threatens constantly to relegate us, not to the absent thing, but to its absence as presence, to the neutral double of

the object in which all belonging to the world is dissipated. This duplicity, we must stress, is not such as to be mastered by the discernment of an either-or in it that could authorize a choice and lift from the choice the ambiguity that makes choosing possible. The duplicity itself refers us back to a still more primal double meaning.

The Levels of Ambiguity

If for a moment thought could maintain ambiguity, it would be tempted to state that there are three levels at which ambiguity is perceptible. On the worldly plane it is the possibility of give and take: meaning always escapes into another meaning; thus misunderstandings serve comprehension by expressing the truth of intelligibility which rules that we never come to an understanding once and for all.

Another level is expressed by the two versions of the imaginary. Here it is no longer a question of perpetual double meanings—of misunderstanding aiding or impeding agreement. Here what speaks in the name of the image "sometimes" still speaks of the world, and "sometimes" introduces us into the undetermined milieu of fascination. "Sometimes" it gives us the power to control things in their absence and through fiction, thus maintaining us in a domain rich with meaning; but "sometimes" it removes us to where things are perhaps present, but in their image, and where the image is passivity, where it has no value either significative or affective, but is the passion of indifference. However, what we distinguish by saying "sometimes, sometimes," ambiguity introduces by "always," at least to a certain extent, saying both one and the other. It still proposes the significant image from the center of fascination, but it already fascinates us with the clarity of the purest, the most formal image. Here *meaning* does not escape into another meaning, but into the *other* of all meaning. Because of ambiguity nothing has meaning, but everything *seems* infinitely meaningful. Meaning is no longer any-

thing but semblance; semblance makes meaning become infinitely rich. It makes this infinitude of meaning have no need of development—it makes meaning immediate, which is also to say incapable of being developed, only immediately void.*

* Can we go further? Ambiguity defines being in terms of its dissimulation; it says that being is, inasmuch as it is concealed. In order for being to accomplish its work, it has to be hidden: it proceeds by hiding itself, it is always reserved and preserved by dissimulation, but also removed from it. Dissimulation tends, then, to become the purity of negation. But at the same time, when everything is hidden, ambiguity announces (and this announcement is ambiguity itself) that the whole of being is via dissimulation; that being *is* essentially its being at the heart of concealment.

From: *The Space of Literature*. (1955), Lincoln and London: University of Nebraska Press, 1982.

Nicht versöhnt – A film by Jean-Marie Straub

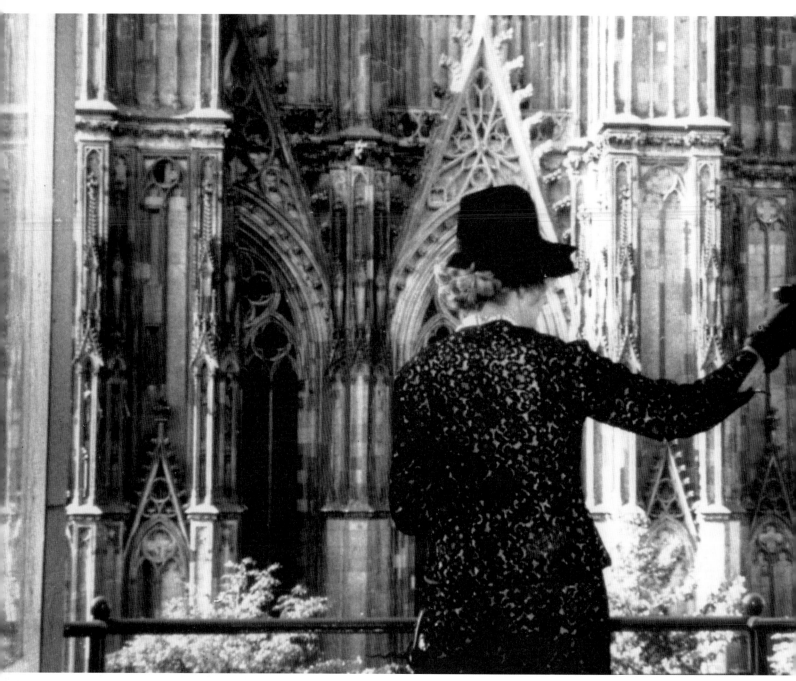

Illustrations pp. 226–9 from the film by Jean-Marie Straub, *Nicht versöhnt oder Es hilft nur Gewalt, wo Gewalt herrscht (Not Reconciled)*, 1965

Serge Daney

From *Nicht Versöhnt* to *Moïse et Aaron* there is one key idea, entire-
ly contained in the first film's title: *Not Reconciled*. This non-reconcili-
ation is neither union nor divorce, neither a plenitude of body nor a
deliberate stand with shattering, with chaos (as in Nietzsche: "We
must shatter the universe, lose respect for everything"). It is the pos-
sibility of both. At bottom, Straub and Huillet begin with a simple and
irrefutable fact: Nazism. The fact that Nazism existed is the reason
why the German people today are not reconciled with themselves
(*Machorka-Muff, Nicht Versöhnt*), and why the Jews are not recon-
ciled either (*Moïse et Aaron, Einleitung*). . . . Non-reconciliation is also

a way of making films, of fabricating them. It is the obstinate refusal
of all forces of *homogenization*. It has led Straub and Huillet toward
what could be called "a generalized practice of disjunction." Disjunc-
tion, fissile division: a way of taking the old aphorism seriously, "one
splits into two." Zhou Enlai once said that the gaze and the voice, the
voice and its material aspect (its "grain"), language and its accents,
"are dreaming different dreams in the same bed." The films are like
that bed where what is disjointed, not reconciled, irreconcilable,
begins to "play" at unity, to suspend it, to simulate it.

From: *La Rampe*, Paris, 1983.

versöhnt

Jean-Marie Straub

Nicht Versöhnt is a story of frustration, the frustration . . . of a people . . . who have not freed themselves from fascism. I deliberately set aside everything that was picturesque or satirical in the novel. And instead of devoting myself, like Böll . . . to a puzzle, I risked a lacunary body.

From: Francis Courtade, *Jeune cinéma allemand*, Paris, 1969.

Frieda Grafe/Enno Patalas

I understand Böll's annoyance and disappointment at Straub's ingratitude, but I cannot respect his feelings. Böll gave Straub the rights to *Marchorka-Muff* and *Not Reconciled*, not, as he claims, out of "altruism or idealism," but because he despised the contemporary film industry. He was not paticularly interested in what Straub was going to do with them. Had he been more interested, perhaps he would have realized that Straub belonged to that very category of the "non-reconciled" into which Böll had tried, with great literary application, to breathe life in his novel. Instead he took Straub to be some poor guy who needed other people's stories in order to realize his own ideas—though according to Böll, there were "themes everywhere for the taking." In this sense, Straub took one of these themes: from a much-read novel by an acclaimed German postwar novelist, also available in paperback. As far as Straub is concerned, art is no epiphenomenon.

Not Reconciled has little in common with the usual film adaptations of novels where more often than not, would-be respect for the author's invention leads to little more than a sketchy synopsis of the original work. Straub, the Frenchman, wanted to make a film about present-day Germany. It wasn't artistic impotence that led him to latch onto Böll's novel, but rather the conviction that a country's manner of life is expressed in its ideas and discoveries with even greater insight than in the construction of its cities or the people on its streets; that a country's dreams and fears are part of its reality and provide information, the ban of the Communist Party as much as Böll's words: "Delicate I was, almost small, looking something like a cross between a rabbi and a bohemian, black-haired and clad in black, with the uncertain air of rural origins."

Straub treats Böll's novel like a document; the way he uses it implies first of all that he doesn't think of himself as an interpreter who knows everything about Böll, but simply as a normal reader who conjures up images when he reads the texts; who is reminded of things that fit in with what Böll describes; who can picture the gestures and images found there and who has the tone of voice in his ear that seems to match the words: the "scanning" voice of young Heinrich Fähmel when he orders his first breakfast at Café Kroner, the "soft, Pasture my Lambs voice sounding like everlasting Advent" of Johanna Fähmel or Hugo's "school-leaver voice."

It is striking that Straub omits all the things that generally take up most space in films, focusinng instead on matters of apparently minor importance. The big events are only presented indirectly, usually by being talked about. What is shown directly is life before and after those events. Straub portrays old Johanna Fähmel's violent act at the end of the film as the warning shot it was intended to be for the viewer. Possible moral considerations are not up for discussion. It is evident both in Straub's choice of scenes and in his handling of dialogue that his concept of art is diametrically opposed to Böll's. He does not excise pieces from reality to be of help to him in creating a realistic and plausible copy. He does not first gather experiences which he later pieces together to

form a coherent reconstruction. He avails himself of fiction in order to direct attention, repeatedly, back to reality, for which one suddenly feels liable. And one is almost ashamed of the fact that while reading Böll's novel one felt justified for a moment in casting a critical eye on Germany without feeling implicated oneself. It is not possible to urge people too often to take another look at Böll's book after seeing Straub's film. Not that this is necessary to gain an understanding of the film, which is not conceived of in such as way that each word and each character can always be clearly located in the narrative of the book. One ought to read or reread Böll's book because it has been altered by Straub's film: It suddenly seems more naked and serious because, as with the film's last camera shot, it now points away from itself and towards Germany. From: *Im off, Filmartikel* (1966), Munich 1974.

The case of Luis Buñuel is one of the strangest in the history of the cinema. Between 1928 and 1936, Buñuel only made three films, and of these only one—*L'Age d'Or*—was full length; but these three thousand meters of film are in their entirety archive classics, certainly, (with *The Blood of a Poet*, Cocteau, 1930), the least-dated productions of the avant-garde and in any case the only cinematic production of major quality inspired by surrealism. With *Las Hurdes (Land Without Bread)*, a "documentary" on the poverty-stricken population of the Las Hurdes region, Buñuel did not reject *Un Chien Andalou*; on the contrary, the objectivity, the soberness of the documentary surpassed the horror and the forcefulness of the fantasy. In the former, the donkey devoured by bees attained the nobility of a barbaric and Mediterranean myth which is certainly equal to the glamour of the dead donkey on the piano. Thus Buñuel stands out as one of the great names of the cinema at the end of the silent screen and the beginning of sound—one with which only that of Vigo bears comparison—in spite of the sparseness of this output. But after eighteen years Buñuel seemed to have definitely disappeared from the cinema. Death had not claimed him as it had Vigo. We only knew vaguely that he had been swallowed up by the commercial cinema of the New World, where, in order to earn a living, he was doing obscure and second-rate work in Mexico.

And now suddenly we get a film from down there signed Buñuel. Only a B feature, admittedly. A production shot in one month for 45 thousand dollars. But at any rate one in which Buñuel had freedom in the script and direction. And the miracle took place: eighteen years later and five thousand kilometers away, it is still the same, the inimitable Buñuel, a message which remains faithful to *L'Age d'Or* and *Land Without Bread*, a film which lashes the mind like a red-hot iron and leaves one's conscience no opportunity for rest.

The theme is outwardly the same as that which has served as a model for films dealing with delinquent youth ever since *The Road to Life*, the archetype of the genre: the evil effects of poverty and the possibility of reeducation through love, trust, and work. It is important to note the fundamental optimism of this concept. A moral optimism first of all, which follows Rousseau in presupposing the original goodness of man, a paradise of childhood destroyed before its time by the perverted society of adults; but also a social optimism, since it assumes that society can redress the wrong it has done by making the reeducation center a social microcosm founded on the trust, order, and fraternity of which the delinquent had been unduly deprived, and that this situation is sufficient to return the adolescent to his original innocence. In other words, this form of pedagogy implies not so much a reeducation as an exorcism and a conversion. Its psychological truth, proved by experience, is not its supreme motive. The immutability of scenarios on delinquent youth from *The Road to Life* to *L'Ecole Buissonnière* (the character of the truant) passing via *Le Carrefour des Enfants Perdus*, prove that we are faced with a moral myth, a sort of social parable whose message is intangible.

Pedro, a difficult inmate of a reeducation center, a model farm, is subjected to a show of trust—bringing back the change after buying a pack of cigarettes—as was Mustapha in *The Road to Life* buying the sausage. But Pedro does not return to the open cage, not because he prefers to steal the money but because it is stolen from him by Jaíbo, the evil friend. Thus the myth is not denied in essence—it cannot be; if Pedro had betrayed the director's trust, the latter would still have been right to tempt him by goodness. It is objectively much more serious that the

Los Olvidados

experiment is made to fail from the outside and against Pedro's will, since in this way society is saddled with a double responsibility: that of having perverted Pedro and that of having compromised his salvation. It is all very well to build model farms where justice, work, and fraternity reign, but as long as the same society of injustice and pain remains outside, the evil—namely the objective cruelty of the world—remains.

In fact my references to the films on fallen youth throw light only on the most outward aspect of Buñuel's film, whose fundamental premise is quite different. There is no contradiction between the explicit theme and the deeper themes that I now propose to extract from it. But the first has only the same importance as the subject for a painter; through its conventions (which he only adopts in order to destroy them) the artist aims much higher, at a truth which transcends morality and sociology, at a metaphysical reality—the cruelty of the human condition.

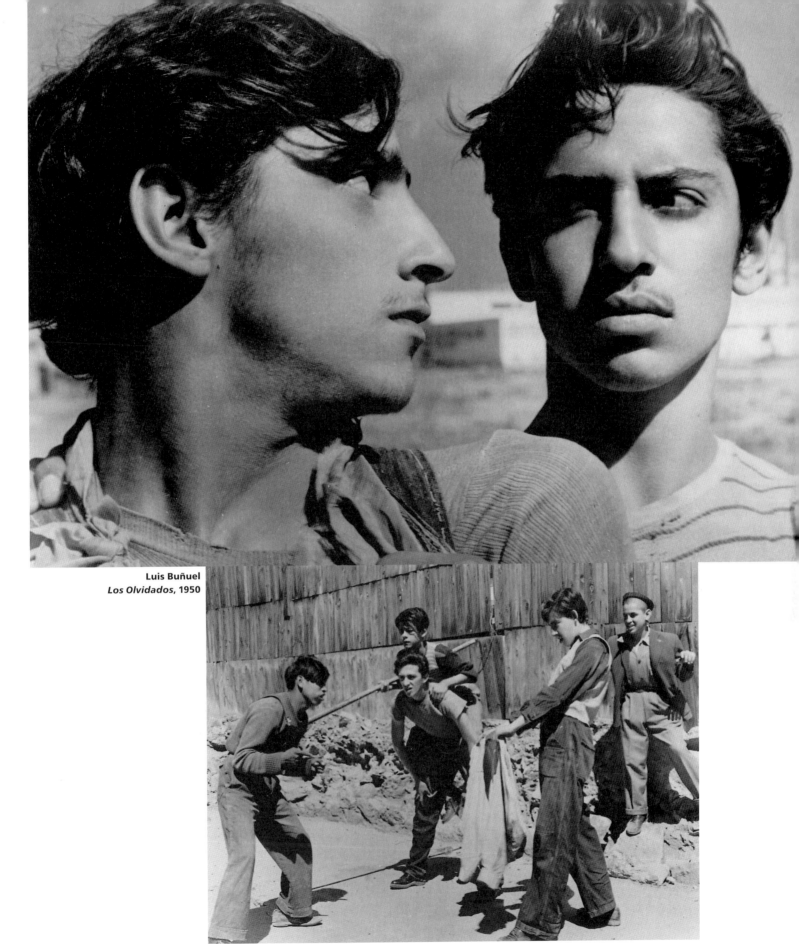

Luis Buñuel
Los Olvidados, 1950

231

The greatness of this film can be grasped immediately when one has sensed that it never refers to moral categories. There is no Manichaeanism in the characters, their guilt is purely fortuitous—the temporary conjunction of different destinies which meet in them like crossed swords. Undoubtedly, adopting the level of psychology and morality, one could say of Pedro that he is "basically good," that he has a fundamental purity: he is the only one who passes through this mudbath without it sticking to him and penetrating him. But Jaíbo, the villain, though he is vicious and sadistic, cruel and treacherous, does not inspire repugnance but only a kind of horror which is by no means incompatible with love. One is reminded of the heroes of Genet, with the difference that in the author of the *Miracle of the Rose* there is an inversion of values which is not found at all here. These children are beautiful not because they do good or evil, but because they are children even in crime and even in death. Pedro is the brother in childhood of Jaíbo, who betrays him and beats him to death, but they are equal in death, such as in childhood. Their dreams are the measure of their fate. Buñuel achieves the *tour de force* of re-creating two dreams in the worst tradition of Hollywood Freudian surrealism and yet leaving us palpitating with horror and pity. Pedro has run away from home because his mother refused to give him a scrap of meat which he wanted. He dreams that his mother gets up in the night to offer him a cut of raw and bloody meat, which Jaíbo, hidden under the bed, grabs as she passes. We shall never forget that piece of meat, quivering like a dead octopus as the mother offers it with a Madonna-like smile. Nor shall we ever forget the poor, homeless, mangy dog which passes through Jaíbo's receding consciousness as he lies dying in an empty lot, his forehead wreathed in blood. I am almost inclined to think that Buñuel has given us the only contemporary aesthetic proof of Freudianism. Surrealism used it in too conscious a fashion for one to be surprised at finding in its painting symbols which it put there in the first place. Only *Un Chien Andalou, L'Age d'Or,* and *Los Olvidados* present us with the psychoanalytical situations in their profound and irrefragable truth. Whatever the concrete form which Buñuel gives to the dream (and here it is at its most questionable), his images have a pulsating, burning power to move us—the thick blood of the unconscious circulates in them and swamps us, as from an opened artery, with the pulse the mind.

No more than on the children does Buñuel make a value judgment on his adult characters. If they are generally more evil-intentioned, it is because they are more irremediably crystallized, petrified by misfortune. The most horrifying feature of the film is undoubtedly the fact that it dares to show cripples without attracting any sympathy for them. A blind beggar who is stoned by the children gets his revenge in the end by denouncing Jaíbo to the police. A legless cripple who refuses to give them cigarettes is robbed and left on the pavement a hundred yards away from his cart—but is he any better than his tormentors? In this world where all is poverty, where everyone fights with whatever weapon he can find, no one is basically "worse off than oneself." Even more than being beyond good and evil, one is beyond happiness and pity. The moral sense that certain characters seem to display is basically no more than a form of their fate, a taste for purity and integrity which others do not have. It does not occur to these privileged characters to reproach the others for their "wickedness"; at the most they struggle to defend themselves from it. These beings have no other points of reference than life—this life which we think we have domesticated by means of morality and social order, but which the social disorder of poverty restores to its original essence as a sort of infernal earthly paradise with its exit barred by a fiery sword.

It is absurd to accuse Buñuel of having a perverted taste for cruelty. It is true that he seems to choose situations for their maximum horror content. What could be more atrocious than a child throwing stones at a blind man, if not a blind man taking revenge on a child? Pedro's body, when he has been killed by Jaíbo, is thrown onto a pile of garbage among the dead cats and empty cans, and those who get rid of him in this way—a young girl and her father—are precisely among the few people who wished him well. But the cruelty is not Buñuel's; he restricts himself to revealing it in the world. If he chose the most frightful examples, it is because the real problem is not knowing that happiness exists also, but knowing how far the human condition can go in misfortune; it is plumbing the cruelty of creation. This intention was already visible in the documentary on Las Hurdes. It hardly mattered whether this miserable tribe was really representative of the poverty of the Spanish peasant or not—no doubt it was—the important thing was that it represented human poverty. Thus, between Paris and

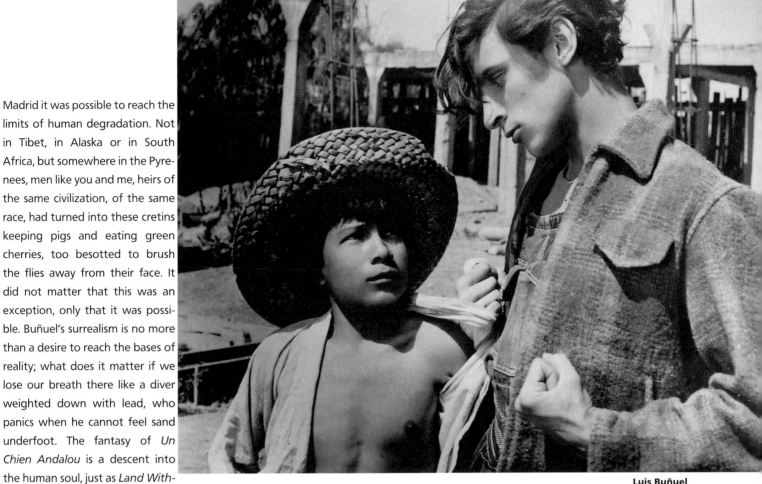

Madrid it was possible to reach the limits of human degradation. Not in Tibet, in Alaska or in South Africa, but somewhere in the Pyrenees, men like you and me, heirs of the same civilization, of the same race, had turned into these cretins keeping pigs and eating green cherries, too besotted to brush the flies away from their face. It did not matter that this was an exception, only that it was possible. Buñuel's surrealism is no more than a desire to reach the bases of reality; what does it matter if we lose our breath there like a diver weighted down with lead, who panics when he cannot feel sand underfoot. The fantasy of *Un Chien Andalou* is a descent into the human soul, just as *Land Without Bread* and *Los Olvidados* are explorations of man in society.

But Buñuel's "cruelty" is entirely objective, it is no more than lucidity, and nothing less than pessimism; if pity is excluded from his aesthetic system, it is because it envelops it everywhere. At least this is true of *Los Olvidados*, for in this respect I seem to detect a development since *Land Without Bread*. The documentary on Las Hurdes was tinged with a certain cynicism, a self-satisfaction in its objectivity; the rejection of pity took on the color of an aesthetic provocation. *Los Olvidados*, on the contrary, is a film of love and one which demands love. Nothing is more opposed to "existentialist" pessimism than Buñuel's cruelty. Because it evades nothing, concedes nothing, and dares to dissect reality with surgical obscenity, it can rediscover man in all his greatness and force us, by a sort of Pascalian dialectic, into love and admiration. Paradoxically, the main feeling which emanates from *Land Without Bread* and *Los Olvidados* in one of the unshakable dignity of mankind. In *Land Without Bread*, a mother sits immobile, holding the dead body of her child on her knees, but this peasant face, brutalized by poverty and pain, has all the beauty of a Spanish Pietà: it is disconcerting in its nobility and harmony. Similarly, in *Los Olvidados*, the most hideous faces are

still in the image of man. This presence of beauty in the midst of atrocity (and which is by no means only the beauty of atrocity), this perenniality of human nobility in degradation, turns cruelty dialectically into an act of charity and love. And that is why *Los Olvidados* inspires neither sadistic satisfaction nor pharisaical indignation in its audiences.

If I have made passing reference to surrealism, of which Buñuel is historically one of the few valid representatives, it is because it was impossible to avoid this reference. But to conclude, I must underline the fact that it is insufficient. Over and beyond the accidental influences (which have no doubt been fortunate and enriching ones), in Buñuel surrealism is combined with a whole Spanish tradition. The taste for the horrible, the sense of cruelty, the seeking out of the extreme aspects of life, these are also the heritage of Goya, Zurbarán, and Ribera, of a whole tragic sense of humanity which these painters have displayed precisely in expressing the most extreme human degradation—that of war, sickness, poverty, and its rotten accessories. But their cruelty too was no more than the measure of their trust in mankind and in painting.

From: *The Cinema of Cruelty* (1957), New York: Seaver, 1982.

Luis Buñuel
Los Olvidados, **1950**

233

Pier Paolo Pasolini

Indian Story

It is absolutely premature to write anything, even a few lines, about this project of an Indian story on hunger. It is only an idea in its embryonic state: an idea of the "facts" [*fatti*], but above all of the meaning, which also includes the making, the technique, the style.

To get a feeling of what might be my "gaze" on India, I can refer to my little volume *The Odor of India*, and to get a feeling of what will (probably) be the technical and stylistic treatment of the film, I can pronounce the name of Flaherty's *Man of Aran*.

The film aims above all to be a documentary whose images combine in a dramatic rhythm, fitting into history and forming one body with history, fulfilling the double function of justification and liberation.

The central character of the film is therefore India— India dying of hunger.

The Indian family that I take as typical, and that I immerse in the Indian world, does not yet exist with all its particulars in my imagination: it is a pure abstraction, whose sole reality is my brief but dramatic encounter with India.

In any case, this family is a very rich family. Indeed, there still exist shards of the ancient feudalism in India, royal privileges still live on, though only as formalities and almost as folklore. That is to say, there are mighty families of ancient and petrified ascendancy (which have nothing to do with the families of the new bourgeoisie that is now forming). I suppose that in such families a certain type of culture must be preserved, which in the immense population is unconscious and pulverized, and in the educated neo-bourgeois population has been contaminated, or has become fossilized traditionalism.

It may be that all this is not true, that families like the one I imagine do not exist. But it is a working hypothesis, which can become poetic licence: that is, a purely hypothetical fact, which can then become scandal and paradox, thus giving reality to the otherwise verbal and one-dimensional "realism" of the documentary.

So there is a maharajah, with his wife and four children. Living in a place which is outside normal everyday reality (a palace) and being nourished by an ancient culture (which is lost and contaminated in the modern world), the maharajah is in a sense outside history.

As we shall see, he is the first to die. His brief parable therefore serves as an introduction, and can represent the ancient history of a nation, with respect to its modern history.

Indeed, the quality of this maharajah's life and the mode of his death are described in the old Indian religious books, and it is from them that I have faithfully detached the fact.

One day in winter, the maharajah is out traveling around his territory (for religious reasons or political duties). There is snow. Everything is covered in snow. The solitude is immense. And here, through the dry shrubs, on the luminous white ground, the maharajah sees a den of tiger cubs. They are wailing: they are dying of hunger. The maharajah feels profound pity for these creatures, and he begins to pray. At the end of his long prayer, he sends away his small retinue, sheds his clothes and, praying all the while, gives himself as food to the famished tigers, allowing himself to be torn asunder.

A long time passes. The children, who were small when the father died, have now grown up: the oldest is a fourteen or fifteen year-old girl; the youngest is a little boy of six. There are two boys and two girls.

Something has changed in the world (and anyway, in the first scene the world appeared unreal and fabulous to us: a world where religion was everything and therefore coincided with all the contours and wrinkles of reality). We are now in the modern world—as if by a degeneration or a profound and general corruption . . .

The life of the widow and of the four children in the "palace"—so perfect in the introduction—is now absurd and anachronistic. Every magnificence and grandeur is lost, and has outlived itself . . .

In the region there is a terrible famine, and the people are dying of hunger on the streets . . .

At this point, the story also loses all appearence of constructedness: this is a job that can only be done after on-the-spot investigation and consultation of the necessary documents. The reader of these notes must be

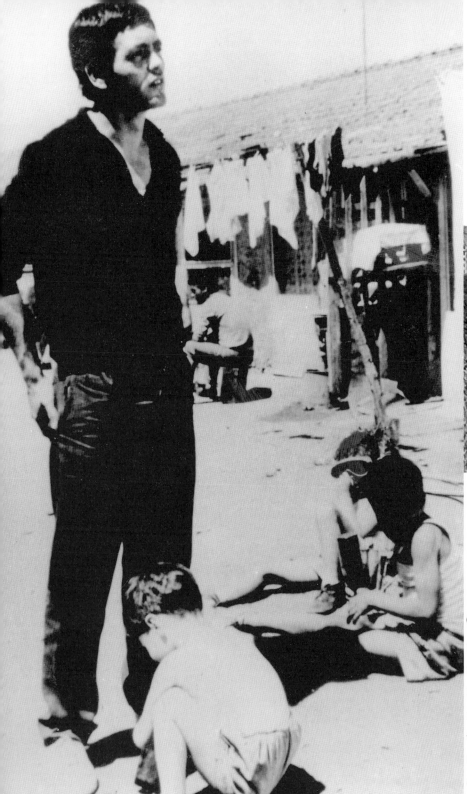

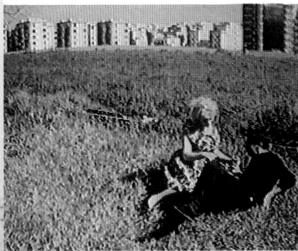

Pier Paolo Pasolini
Accattone, 1961

Glauber Rocha

I think there was a certain sensuality in the character played by Franco Citti in *Accattone*, but then everything in his cinema became very cool: adjectives struggling to emphasize sterile nouns. Pasolini had the reasoning, intelligence, and culture that are the triumph of a civilized intellectual, but he said: "I am a civilized man caught up in barbarism." He did not want to accept capitalist society, but he accepted it to the extent that he became a professional of the publishing and filmmaking industries. He shifted from the status of a marginal filmmaker (making films that did not earn any money) to that of a film-maker doing overtly commercial films like *Trilogy*. So I think that except the first film, *Accattone*, and the last, *Salò*, all Pasolini's other films display this ambiguity, which is his great success.

From: *Cahiers du cinéma*, special issue, "Pasolini cinéaste," Paris, 1981.

235

satisified with knowing that, for reasons yet to be ascertained, the family leaves on a journey (perhaps only the common journey that many Indian families carry out as a religious duty: the journey to Benares), and that, at a precise and obsessive pace, the members of this family die one by one of hunger. First the father, and last the young girl.

Naturally each death will come about in a significant situation or circumstances, so that many aspects of the world of hunger can be documented. In short, the rhythm of the film, almost geometrically, symmetrically divided by these deaths, which come about at chronometrically regular intervals one after the other (*nota bene*: the idea for this film came while shooting the scene of the killing of the soldiers in *Oedipus*) can be presented figuratively as a bridge, whose perfectly regular arches are the agonies and deaths of the protagonists from hunger.

I repeat: I do not yet know how and where these agonies and deaths will take place. I repeat: each of them will pluck out a moment of Indian reality, dilated and vitalized by the contribution of documentary filmmaking.

The only death that I have clearly in my imagination is the final one, the death of the young girl. She, now alone in the world, has arrived in Benares, and it is there she dies.

None of her own will provide for the burning of her body and the casting of the ashes in the Ganges; strangers will do it. And these are things that I have seen and described: these "strangers," poor, dirty, tattered, wracked by hunger and leprosy, are angelic and fraternal. They fulfill the funereal rites almost with grace, with an indifference *which is similar to the father's indifference toward his own body when he gave himself as food for the tigers.* But there is nothing anguishing or funereal in the Indian rites of cremation: rather there is something consoling and serene. The vision of the turbid and horrifying river into which the ashes are cast—the vision which with the film must end—is full of a profound and abstract tenderness.

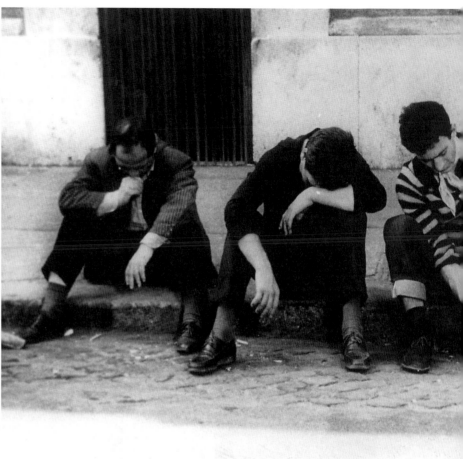

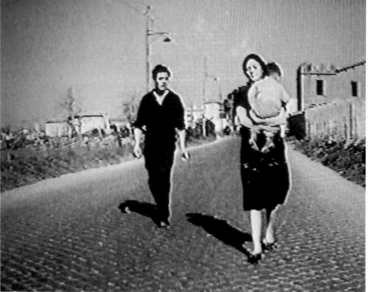

Pier Paolo Pasolin
Accattone, **1961**

From: *Il cinema in forma di poesia,* Pordenone, 1979.

Hervé Joubert-Laurencin

Accattone, *Mamma Roma*, and *La ricotta* are films blazing with light: an "Indian" Rome, an "African" Rome. (Pasolini said that *Mamma Roma* was "colored": an ambitious prostitute in a petty-bourgeois world is like a black man trying to climb the racist social ladder.) India and Africa were invested by Pasolini's writing in the sixties. The anthology *The Religion of My Time*, released in May 1961 amidst the shooting of *Accatone*, makes a rhetorical appeal to Africa in the very beautiful final poem where the poet speaks with his own death: "Africa, my only alternative!" The cry was confirmed by *Poetry in the Form of a Rose*, released in 1964. In 1962, the travel notebooks of the 1961 journey appeared in the volume *The Odor of India*, after a previous publication in a Roman newspaper. Throughout the sixties Pasolini nourished desires for a film about India, a film about Africa: witness *Notes for a Film on India* in 1968, the screenplay of *The Wild Father* (1962), and *Notebook for an African Oresteia* (1968-69).

If one had to choose between Pasolini's alternatives, it could be that *Accattone* was Indian, and *Mamma Roma* and *La ricotta* African. *Accattone*'s world is the earthen floor of the shantytowns, sun-drenched langorous sidewalks, life with the river, the smell of Rome; Pasolini had met Mother Teresa in Calcutta, the living saint of the slums. . . .

At the origin of the Indian screenplay, taken up unchanged by all the successive projects, is a story which Pasolini says was told to him by Elsa Morante. She herself had apparently read it in a book of Indian religion:

"A rich, cultivated maharajah, the owner of immense territories, was out walking one day or perhaps hunting on his snow-covered property when he saw two starving tiger cubs. Seized by intense pity, careless of his life and indeed, out of scorn for his own flesh, he offered himself up as food for the two animals."

(No one really knows if Elsa Morante, a storyteller with a most exotic imagination to whom Pier Paolo recounted his dreams, really found this story, so perfect for Pasolini's fantasies, in a book of Indian religion.). . . .

In the very first images of his cinema—the opening scene of *Accatone*—Pasolini has one of his seated pimps taunt the old, toothless florist, sarcastically suggesting he could play the role of a lion in a film: "Grrrr! Get yourself a job with Metro-Goldwin Mayer!"

The question asked of the Indians, and most insistently of the religious devotees, is nothing other than the question of sainthood: are you prepared for martyrdom? This is the overweening theme of Pasolini's fantasy.

Which in no way keeps the Indian story from being the finest screenplay in the *Notes*.

Reduced to its bare minimum, the story was to speak of "the two essential Third World problems": religion and hunger. During a pan from a car over a huge pipeline, the voice of the commentary explains that the first part of the film with the story of the maharajah's sacrifice deals particularly with pre-independence India, "but also with its entire prehistory"; while the second part, recounting the gradual death by famine of the woman and her three children, deals "not only with the year of independence but with all the country's modern history."

From: *Pasolini (portrait du poète en cinéaste)*, Paris, 1995.

Samuel Beckett

Physically speaking it seemed to me I was now becoming rapidly unrecognizable. And when I passed my hands over my face, in a characteristic and now more than ever pardonable gesture, the face my hands felt was not my face any more, and the hands my face felt were my hands no longer. And yet the gist of the sensation was the same as in the far-off days when I was well-shaven and perfumed and proud of my intellectual's soft white hands. And this belly I did not know remained my belly, my old belly, thanks to I know not what intuition. And to tell the truth I not only knew who I was, but I had a sharper and clearer sense of my identity than ever before, in spite of its deep lesions and the wounds with which it was covered. And from this point of view I was less fortunate than my other acquaintances. I am sorry if this last phrase is not so happy as it might be. It deserved, who knows, to be without ambiguity.

Then there are the clothes that cleave so close to the body and are so to speak inseparable from it, in time of peace. Yes, I have always been very sensitive to clothing, though not in the least a dandy. I had not to complain of mine, tough and of good cut. I was of course inadequately covered, but whose fault was that? And I had to part with my straw hat, not made to resist the rigours of winter, and with my stockings (two pairs) which the cold and damp, the trudging and the lack of laundering facilities had literally annihilated. But I let out my braces to their fullest extent and my knickerbockers, very baggy as the fashion is, came down to my calves. And at the sight of the blue flesh, between the knickerbockers and the tops of my boots, I sometimes thought of my son and the blow I had fetched him, so avid is the mind of the flimsiest analogy. My boots became rigid, from lack of proper care. So skin defends itself, when dead and tanned. The air coursed through them freely, preserving perhaps my feet from freezing. And I had likewise sadly to part with my drawers (two pairs). They had rotted, from constant contact with my incontinences. The seat of my breeches, before it too decomposed, sawed my crack from Dan to Beersheba. What else did I have to discard? My shirt? Never! But I often wore it inside out and back to front. Front to front right side out, front to front inside out, back to front right side out, back to front inside out. And the fifth day I began again. I was in the hope of making it last. Did this make it last? I do not know. It lasted. To major things the surest road is on the minor pains bestowed, if you don't happen to be in a hurry. But what else did I have to discard? My hard collars, yes, I discarded them all, and even before they were quite worn and torn. But I kept my tie, I even wore it, knotted round my bare neck, out of sheer bravado I suppose. It was a spotted tie, but I forget the colour.

From: *Molloy* (1951), New York, 1955.

Theodor W. Adorno

An unreconciled reality tolerates no reconciliation with the object in art. Realism, which does not grasp subjective experience, to say nothing of going beyond it, only mimics reconciliation. Today the dignity of art is measured not according to whether or not it evades this antinomy through luck or skill, but in terms of how it bears it. In this, *Endgame* is exemplary. It yields both to the impossibility of continuing to represent things in works of art, continuing to work with materials in the manner of the nineteenth century, and to the insight that the subjective modes of response that have replaced representation as mediators of form are not original and absolute but rather a resultant, something objective. The whole content of subjectivity, which is inevitably self-hypostatizing, is a trace and a shadow of the world from which subjectivity withdraws in order to avoid serving the illusion and adaptation the world demands. Beckett responds to this not with a stock of eternal truths but with what the antagonistic tendencies will still—precariously, and subject to revocation—permit. His drama is "fun" the way it might have been fun to hang around the border markers between Baden and Bavaria in old Germany as though they encompassed the realm of freedom. *Endgame* takes place in a neutral zone between the inner and the outer, between the materials without which no subjectivity could express itself or even exist and an animation which causes the materials to dissolve and blend as though it had breathed on the mirror in which they are seen. So paltry are the materials that aesthetic formalism is, ironically, rescued from its opponents on either side: the materials vendors of Dia-

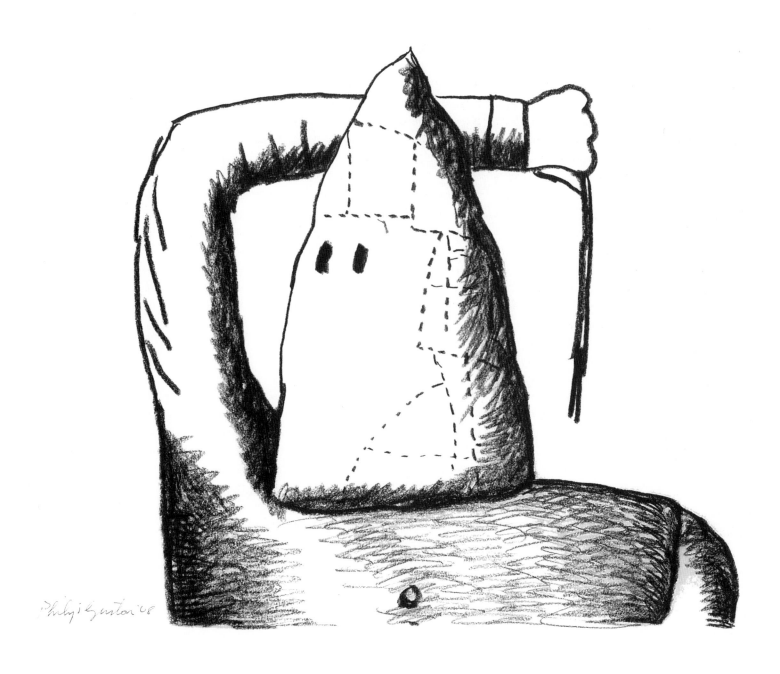

Philip Guston, Untitled, 1968

Carlfriedrich Claus
Wortstamm (Word Trunk), 1960

mat, dialectical materialism, on the one hand, and the cultural spokespersons of authentic expression on the other. The concretism of lemurs, who have lost their horizon in more than one sense, passes directly into the most extreme abstraction. The material stratum itself gives rise to a procedure through which the materials, touched tangentially in passing, come to approximate geometric forms; what is most limited becomes most general. The localization of *Endgame* in that zone mocks the spectator with the suggestion of something symbolic, something which, like Kafka, it then withholds. Because no subject matter is simply what it is, all subject matter appears to be the sign of an inner sphere, but the inner sphere of which it would be a sign no longer exists, and the signs do not point to anything else. The strict ration of reality and characters which the drama is allotted and with it makes do, is identical to what remains of subject, spirit, and soul in view of the permanent catastrophe. What is left of spirit, which originated in mimesis, is pitiful imitation; what is left of the soul, which dramatizes itself, is an inhumane sentimentality; and what is left of the subject is its most abstract characteristic: merely existing, and thereby already committing an outrage. Beckett's characters behave in precisely the primitive, behavioristic manner appropriate to the state of affairs after the catastrophe, after it has mutilated them so that they cannot react any differently; flies twitching after the fly swatter has half-squashed them.

From: "Trying to Understand *Endgame*," in *Notes to Literature* I (1961), New York: Columbia University Press, 1991.

Uwe Johnson

But Jakob always cut across the tracks.

—But he always cut straight across the sidings and the main line, why, because, on the other side, outside, all the way around the station to the street, it would have taken him half an hour longer to catch his streetcar. Seven years he was with the railroad.

—Look at this weather. What a November. You can't see ten steps ahead of you for the fog, especially in the morning, and that's when it happened, in the morning, and everything so slippery. Doesn't take much to slip.

Those crummy yard engines, you hardly hear them coming in weather like this, much less see them.

—Seven years Jakob was with the railroad, let me tell you, and anything that rolled on rails, if it rolled anywhere, he heard it, believe me

below the high signal tower with its large glass eyes a figure came walking straight across the dim foggy freight yard, stepped surefooted and casual over the tracks, one rail after the other, stood still under a green-glowing signal arm, was blotted out by the thunder wall of an outgoing express, moved forward again. Perhaps Jakob could be recognized by the slow steady straightness of the walk, hands in his pockets, chin out, he seemed aware of all the comings and goings on the tracks. As he came closer to his tower, his outline evaporated more and more among massive dark monsters of boxcars and asthmatic locomotives which, obedient to the thin piercing whistles of the brakemen, crept phlegmatically, in jolts, along the wet smeary rails in the early morning fog

—he if anybody. Explained it to me himself, what with physics and formulas, amazing how much a man picks up in seven years, and he said to me: Just stand still if you see something coming, never mind how far away. "A train that's on its way is right on top of you," he said to me. He'd have known that fog or no fog.

—Yeah, but an hour before they squashed a brakeman, up on the hump. Don't you think that guy knew it too?

—That's why all the excitement. Even if they dished up all that stuff about tragic accident and great contribution to the socialist cause, and honor to his memory and so forth: the man who dreamed that one up is sure to know better. Go ask anybody in this whole lousy station if you can still get a travel permit to West Germany these days, and Jakob had just come back that same morning, on an interzone train. Guess who he'd gone to see?

—Cresspahl, ever heard of him. He's got a daughter. . . .

And the picture was already across one wall in Gesine's room when Jakob arrived. The photograph had been blown up to something like sixty by forty-eight, reminding one of the industrial or advertising photos, or of the visual-appeal posters along the streets of the German

Democratic Republic on important political occasions; one could tell by the slightly blurred contours that the film had not been larger than the nail on her little finger. The photograph had been taken without light, a certain brightness filtered in from the invisible background in several flat bars: the neon signs of a gas station that was, itself, not in the picture. The right edge ended in the soft shadow of what had been the driver's back and part of the seat; beside him one could make out a corner of the window. There was a hint of Herr Rohlfs' face projected upwards by the glow of his cigarette; the wrinkles across his forehead looked particularly lively, humid, as though quick-frozen, the pensive expression of his half-open mouth may have come from holding the cigarette. Its glow threw light on Jakob's face, making it shimmer gray out of the shadow, his head was slanting backward, the area around the eyes stood out, strangely sharp (the rear window sits high in a Pobyeda), and since the enlargement exaggerated the natural proportions slightly, the onlooker's eyes halted at the raised lower lid: the pupils had furtively focused on the lens, now they were caught in an indifferent stare. Gesine had hung the picture in such a way that one looked at it from the bottom, not the way the camera had seen it. The right and bottom edges were again crammed full with blurred forms of a car's inside in the dark. When Jakob came for supper the next evening he stopped and looked at it. He didn't ask anything. After a while Gesine thought she saw him shake his head. She went over to him. His eyebrows were raised. "I don't think one ought to . . . use a camera that way," he said. "Everything looks alike, you understand? as though Rohlfs might just as well be working for *your* secret service . . . ?" Gesine walked around him and looked at the picture from the other side. Slowly her eyes wandered over to Jakob, compared him to the photograph. Then she too shook her head, but with a pout. Jakob threw up his hands, laughed soundlessly, sat down at the table. "Never mind. Leave it where it is," he said.

From: *Speculations about Jakob* (1959), New York: Grove Press, 1963.

Witold Gombrowicz

Yet speaks Tomasz: "And there the Library."

Indeed, in the room adjacent, large, Square, books, scripts in heaps on the floor, all Dumped as if from a wheelbarrow; up to the ceiling mountains; and there amidst those mountains–abysses, ledges, chasms, peaks, vales, and likewise dust, motes, so that the Nose is piqued.

On these mountains exceeding lean Readers did sit, the which were reading all that! And perchance there were seven or eight of them. "The library," says Gonzalo, "the library, what trouble I have with it! God's curse, for these are the most precious, the most esteemed Works of geniuses, of the leading minds of Mankind only, but what, lookye, if they Bite each other, Bite, and also Cheapen from their own superabundance for there are Too Many, Too Many, and every day new ones arrive and no one can read through since too many, oh, too Many! Ergo I, lookye, the Readers hired and pay them handsomely, as I am ashamed that all this lies Unread, but Too many; they cannot read through, even though with no break all day they read. Howbeit, the worst is that the books all Bite each other, bite, and perchance as Dogs will bite themselves to bits!"

From: *Trans-Atlantyk* (1949-50), New Haven and London: Yale University Press, 1994.

Gilles Deleuze

A round form often marks out the place where the model, that is to say, the Figure, is sitting—sitting, lying, leaning over, or any other position. This round, this oval, takes up varying amounts of space: it may overflow the edges of the painting, be at the center of a triptych, etc. It is often redoubled or replaced by the outline of the chair in which the model is sitting, by the oval of the bed in which the model is lying. It swarms in the pastilles that cleave to a part of the model's body, or in the gyrating circles that surround the bodies. Even the two peasants

only form a Figure in relation to lumpish soil, clutched in the oval of a pot. In short, the painting has a place which is a ring, a kind of circus ring. It is a very simple procedure for isolating the Figure. . . .

The body is the Figure, or rather, the raw material of the Figure. The raw material of the Figure must not be confused with the spatializing structural material, which is on the other side. The body is Figure, not structure. Inversely the Figure, being body, is not face, and does not even have a face. It has a head, because the head is an integral part of the body. It can even be reduced to the head. As a portraitist, Bacon is a painter of heads and not faces. There is a great difference between the two. For the face is a structured spatial organization that covers the head, whereas the head is dependent on the body, even if it is the extreme point. Not that it lacks spirit, but it is a body spirit, a vital and bodily breath, an animal spirit, it is the animal spirit of man: a pig spirit, an ox spirit, a dog spirit, a bat spirit . . . Thus Bacon pursues a very special project as a portraitist: undoing the face, rediscovering or calling up the head beneath the face.

The deformations through which the body passes are the *animal traits* of the head. It is not a matter of any correspondence between animal forms and the forms of the face. Indeed, the face has lost its forms beneath the operations of cleansing and brushing that disorganize it and call up a head in its place. Nor are there animal forms in the marks or traits of animality, but instead, spirits haunting the places that have been cleansed, grasping at the head, individualizing and qualifying the head without face . . .

From: *Logique de la sensation*, Paris, 1984.

Paul Celan The Meridian

It is true, the poem, the poem today, shows—and this has only indirectly to do with the difficulties of vocabulary, the faster flow of syntax or a more awakened sense of ellipsis, none of which we should underrate—the poem clearly shows a strong tendency towards silence.

The poem holds its ground, if you will permit me yet another extreme formulation, the poem holds its ground on its own margin. In order to endure, it constantly calls and pulls itself back from an "already-no-more" into a "still-here."

This "still-here" can only mean speaking. Not language as such, but responding and—not just verbally—"corresponding" to something.

In other words: language actualized, set free under the sign of a radical individuation which, however, remains as aware of the limits drawn by language as of the possibilities it opens.

This "still-here" of the poem can only be found in the work of poets who do not forget that they speak from an angle of reflection which is their own existence, their own physical nature.

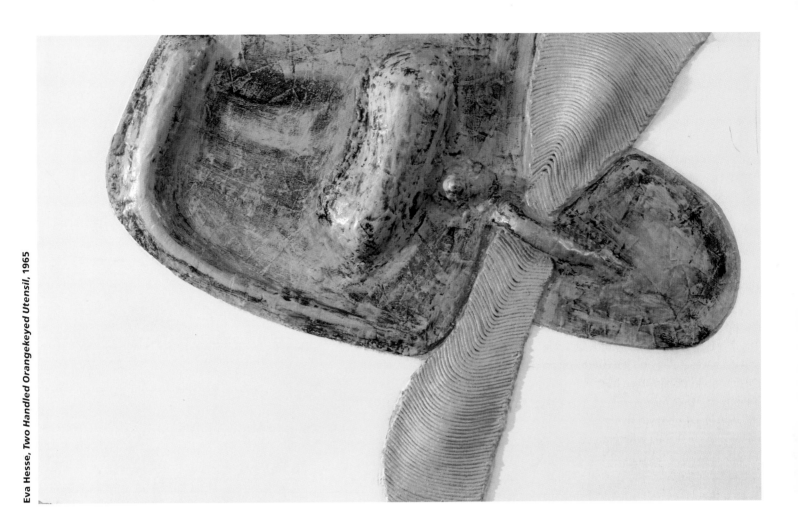

Eva Hesse, *Two Handled Orangekeyed Utensil*, 1965

This shows the poem yet more clearly as one person's language become shape and, essentially, a presence in the present.

The poem is lonely. It is lonely and *en route*. Its author stays with it.

Does this very fact not place the poem already here, at its inception, in the encounter, *in the mystery of encounter*?

The poem intends another, needs this other, needs an opposite. It goes towards it, bespeaks it.

For the poem, everything and everybody is a figure of this other toward which it is heading.

The attention which the poem pays to all that it encounters, its more acute sense of detail, outline, structure, colour, but also of the "tremors and hints"—all this is not, I think, achieved by an eye competing (or concurring) with ever more precise instruments, but, rather, by a kind of concentration mindful of all our dates.

"Attention," if you allow me a quote from Malebranche via Walter Benjamin's essay on Kafka, "attention is the natural prayer of the soul."

The poem becomes—under what conditions—the poem of a person who still perceives, still turns towards phenomena, addressing and questioning them. The poem becomes conversation—often desperate conversation.

Only the space of this conversation can establish what is addressed, can gather it into a "you" around the naming and speaking I. But this "you," come about by dint of being named and addressed, brings its otherness into the present. Even in the here and now of the poem—and the poem has only this one, unique, momentary present—even in this immediacy and nearness, the otherness gives voice to what is most its own: its time.

Whenever we speak with things in this way we also dwell on the question of their where-from and where-to, an "open" question "without resolution," a question which points towards open, empty, free spaces—we have ventured far out.

The poem also searches for this place.

1960. From: *Collected Prose*, Manchester: Carcanet, 1986.

Jerzy Grotowski

In today's societies, especially in the West, people get along so poorly with each other that they dream of a *positive* connection. But actually they're not capable of such a connection, all they can do is overpower the others. It's like when two people are improvising, and a third picks up on it and destroys everything. It's the reaction of the bulldog who sinks his teeth in and then won't let go. That's the contact for you, that's the connection. To look for the connection you have to begin with the disconnection. So I no longer look for contact with you, instead I try to use the common space in such a way that each person can act separately without hindering the other. But if we all have to act without hindering each other and if I start singing and you start singing too, it shouldn't end up in disharmony. If it's not going to end up in disharmony that means when I sing I have to listen to you, and in a subtle way harmonize my melody with your melody. But not only with you, because there's also the jet plane flying over our studio. And you're not alone with your song, with your melody; the fact is there. The noise of the jet engine is there. If you sing like you don't even hear it, that means you're out of harmony. You have to find an acoustic balance with the jet and still keep your melody.

. . .

Why is it that when they hunt, an African hunter from the Kalahari, a French hunter from Saintonge, a Bengali hunter or a Huichol hunter from Mexico all adopt a certain body position, in which the spine is slightly curved, the knees are slightly bent, a position that is held at the base of the body by the sacrolumbar complex? And why can this position only lead to a certain type of rhythmic movement? And what is the use of this way of walking? There is a very simple, very obvious level of analysis: if the weight of the body is carried by one leg, at the moment when you shift the other leg you don't make any noise, so you move in a very slow, continuous fashion. Then the animals can't spot you.

But that's not the essential thing. The essential thing is that there exists a certain primary position of the human body, a position so ancient that it may have been not only the position of homo sapiens but also of homo erectus, so that in a way it has to do with the emergence of humankind. A position that recedes back into the depths of time, and is linked to what the Tibetans sometimes call our "reptile" aspect. In Afro-Caribbean culture this posi-

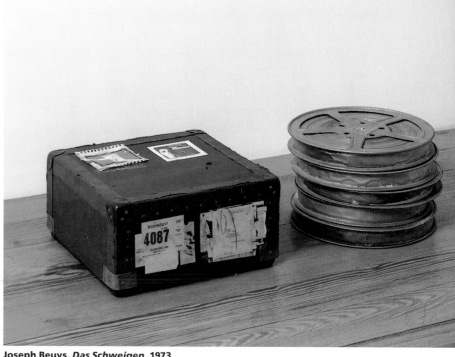

Joseph Beuys, *Das Schweigen*, 1973
Five reels of the film of the same name by Ingmar Bergman, 1962

Joseph Beuys
The Silence

In discussing [Duchamp's] work it is necessary to avoid overrating his silence. I hold him in very high esteem, but I have to reject his silence. . . . All our discussions are excluded by the idea of silence. So far we have said that Marcel Duchamp's silence is overestimated. I would say that even the bourgeois tendencies in Duchamp's work— i.e., a form of provocative, bohemian behavior intended to *épater le bourgeois*—follow the same path. Duchamp started out from there and wanted to shock the bourgeoisie, and because of this he destroyed his creative powers, which really did atrophy. Here, as far as I am concerned, the silence of Marcel Duchamp starts to become a tremendous problem. . . .

For some time now I have been working on a new idea: that Ingmar Bergman's *The Silence* is not overrated. I have a copy of the entire film. . . . The silence of Ingmar Bergman is not overrated.

From: "Death Keeps Me Awake" (1973), in *Energy Plan for the Western Man*, New York: 4 Walls 8 Windows, 1990.

Ingmar Bergman, *Tystnaden (The Silence)*, 1963

tion is linked more precisely to the snake, and according to Tantric Hindu culture you've got a sleeping serpent coiled at the base of you spine.

You'll say: that's all prejudices of people from another age. But not necessarily of people from other traditions, given that in Europe we also have the image of a serpent that goes straight to the heart, not to mention the two serpents that make up the caduceus of the medical profession. It's plausible that a specialist would even mention the "reptile brain," the oldest brain that begins in the back part of the skull and descends along the spinal column. I speak of all that in images, without any scientific pretensions. In our body we have an ancient body, a reptile body you might say. And in fact when you observe the development of a human embryo you can almost imagine the appearance of a reptile in one of its primary phases. Let's say that this "reptile," which appears in a very ancient phase of the human embryo, has served as a basis for the formation of the "reptile brain."

. . .

In certain languages, to say *man* you say "that one standing." In modern psychology they speak of axial man. There is something that looks, that watches, there is a quality of vigilance. The Gospels keep repeating: Wake up! Watch out! Look at what's happening. Watch yourself! Reptile brain or reptile body, it's your animal. It belongs to you, but the question of man is still to be answered. Look at what's happening! Watch yourself! Then there's something like the presence of two different poles, at the two extremes of the same register: the pole of instinct and the pole of consciousness. Normally our everyday tepidness leaves us between the two, we're neither fully animal nor fully human, we swing in a confused way between them. But in the real traditional techniques and in the real performing arts, these two opposing poles are kept present at once. That means "to be in the beginning," "to be standing in the beginning." The beginning is your whole original nature, present here and now. Your original nature with all its divine or animal aspects, instinctual and passionate. But at the same time you have to watch with your conscience. And the more you are "in the beginning" the more you have to "be standing." Wakeful consciousness is what makes man. It's this tension between the two poles that conveys a contradictory and mysterious plenitude.

From: "Tu es le fils de quelqu'un," in *Europe*, Paris, October 1989.

Jerzy Grotowski

One must know how to dance and sing in a way that is at once organic and structured. . . . It's a test that immediately allows you to discover the dilettantism in people. Westerners, for example (there are other ways to uncover the dilettantism in Orientals)—because Westerners aren't immediately able to sense the difference between walking and dancing, they strike the ground with their feet in the belief that they are dancing. And yet dance is what happens when your foot is in the air and not when it touches the ground. So we are faced with the fundamental problem of dance and song. Once it is more or less resolved, we can begin working with what rhythm really is, the waves of the 'old body' in the present body. At this stage you can drift toward a certain primitivism: you work on instinctual elements of the body, losing your self-control. In traditional societies the structure of ritual is what exerts the necessary control, so there is not so much danger in losing control. In modern societies this structure of control is completely lacking, and everyone must resolve the problem for him- or herself. . . . It is when we are in non-dilettantism that the real abyss opens up: we find ourselves at once in the face of the archaic (the arché) and in the face of consciousness. In this domain there is the working tool that I call organon or yantra. In Greek, organon designates the instrument. The same for yantra in Sanskrit, in India. In both cases we're dealing with a very subtle instrument. In the ancient Sanskrit vocabulary, to give an example of yantra they speak of a surgeon's scalpel or an astronomer's stargazing device. So yantra is something that can tie you into the laws of the universe, the laws of nature, like an instrument for astronomical observation. . . .

We are dealing with instruments that concentrate the entire technical and artistic aspect of the work within them. . . . For example, we are confronted with the difference between improvisation as disorder and improvisation as readaptation to a structure, harmonic improvisation. . . . The dilettante can do something beautiful, more or less superficially, through the nervous excitement of the first improvisation. But that's like sculpting in smoke, it always disappears. The dilettante looks "off to the side." In a certain way, many forms of contemporary industrial development follow this model, for example Silicon Valley, the great American electronic complex: there are constructions alongside other constructions,

the complex develops horizontally and in the end becomes ungovernable. That has nothing to do with the construction of cathedrals which always have a keystone. The axial conception is what exactly determines the value. But with an individual ethnodrama it's a much more difficult thing to realize, because in work that plunges into depth and reaches for the heights, you always have to go through crises. The first proposition: it works. Next you have to eliminate what's not necessary and reconstruct it in a more compact way. You go through phases of work without vitality, "lifelessness." It's a kind of crisis, boredom. You have to resolve lots of technical problems: for example, the montage, like in a film. Because you have to reconstruct and rememorize the initial proposition (the line of little physical actions) but at the same time eliminate all the actions that aren't absolutely necessary. So you have to make cuts, and then know how to put together the different fragments. . . .

From: "Tu es le fils de quelqu'un," in *Europe*, Paris, 1989.

We worked for years and years on *The Constant Prince*. We began this work in 1963. The official premier took place two years later. But in truth, we worked long after the official premier . . .

The text speaks of torture, pain, agony. The text speaks of a martyr who refuses to submit to laws he does not accept. Thus the text—and with it, the staging—is devoted to something tenebrous, ostensibly sad. But in my work as a director with Ryszard Cieslak, we've never touched on anything sad. The entire role was founded on a very precise time of his personal memory—or of his physical actions, in Stanislavsky's sense—linked to the period when he was an adolescent and had his first major, enormous experience of love. Everything was linked to this experience. It referred to the kind of love that can only happen in adolescence, a love which bears its sensuality, everything that is carnal, but behind that at the same time, something totally different which is not carnal, or which is carnal in a totally different way, and which is much more like a prayer. It is as though a bridge were created between these two aspects, a carnal prayer.

From: "Le Prince Constant de Ryszard Cieslak," in *Ryszard Cieslak, acteur emblème des années soixante*, Arles, 1992.

Joseph Beuys

What is your understanding of Duchamp?
I think he carried out an important innovation by taking objects, ready-mades, which are not pieces borrowed from the world of the division of labor, as is a tube of pigment, for example. He appropriated finished objects, such as the famous urinal which he did not create himself, but which is the result of a complex process belonging to modern economic life, based on the division of labor.

He took this object and brought it into the museum, observing that the shift from one place to the other made it an artwork. But this observation did not lead him to the clear and simple conclusion that every man is an artist. On the contrary, he climbed up on a pedestal, saying "look at me *épater le bourgeois.*"

Do you mean to say that the real artist at the Armory Show was the man who produced the urinal?
Yes, but the urinal is not the product of a single man.

Thousands of people worked on it: those who extracted the kaolin from the ground, those who brought it to Europe on ships, those who transformed the raw material, and finally the innumerable persons who cooperated inside the factory to make it into a finished product. So it is not a man who worked on the urinal, but humanity. . . . This obvious fact was not taken into consideration by Duchamp. He took something somewhere—stole it, so to speak—and tossed it into the pool of decadent and cultural currents which now use it for their mystifications.

Yet you exhibited your childhood tub as a sculpture?
Yes, but not as a mystification: as an element of my biography. It shows the way that certain objects from the environment—objects produced by others, therefore—appear consciously as biographical elements. The context is completely different.

From: interview with Irmeline Lebeer, in *Cahiers du Musée national d'art moderne* 4, Paris, 1980.

Hans-Joachim Ruckhäberle

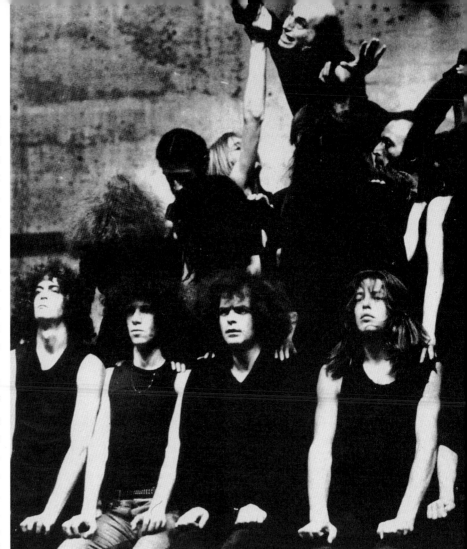

"The stage is empty back to the black rear wall, and brightly lit. The twenty-two players . . . appear in worn out workaday clothing; one after the other they enter the stage from the back, they stand there, staring fixedly at the audience, which is taking its seats. . . . Again and again, individual members of the cast are active in the auditorium, howling from the back, leaping up with a raucous yell in front of the first row of seats." (H. Rischbieter)

German theater criticism saw an "anti-aesthetic demonstration" in the Living Theater's Sophocles-Hölderlin-Brecht *Antigone* produced in February 1967 at the Stadttheater Krefeld. The Brecht text was used in an English prose translation with German subheadings, but not the "model."

German critics detected artlessness and identification above all, over-identification with the political concern of questioning authority as a force in its own right. The expressivity contrasted with Brecht's "demonstration," as the photos make quite clear: the performance was characterized wholly by the bodies, by the language of the bodies and the symbols. German critics talked about text, while the Living Theater was concerned with the body. Unlike their French counterparts, German critics failed to take note of the discussion revolving around the theater of language versus the theater of body, also carried out in the sixties as a discourse between rational/irrational, concrete/abstract, real/surreal, art/life, inside/outside. When they did describe this issue as an element of the performance, it was judged negatively: "The desire for the physical expression of each segment of the story leads to grotesque exaggerations. . . . The cast is a mass of writhing, twitching, rolling bodies. Antigone's farewell monologue is drowned entirely. The ensemble surrounds her with orgiastic dance; the Bacchanalia are unloosed. This grandiosely solved and unendingly varied choreography is the high point of the production—but, occurring when it does, it harms the piece" (Werner Schulze-Reimpell).

Art was demanded where the dissolution of art in life and life in art had been proposed. "He/she who does not participate is a voyeur," said Julian Beck, who regarded his theater's subsequent production, *Paradise Now*, as the transition from presentation to action. A certain dilemma is unmistakable: Antigone came too early, *Paradise Now* too late for the "real" political movement of May 1968.

Jerzy Grotowski saw 1967 as the beginning of the Artaud era, and as late as 1973 Susan Sontag declared: "The

Living Theater, *Antigo[ne]*

Antigone 1967

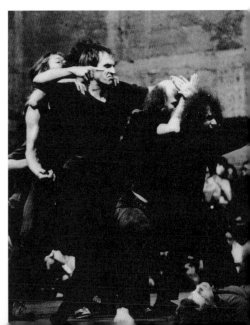

Living Theater, Antigone

250

course of all recent serious theater in Europe and the Americas can be said to divide into two periods—before Artaud and after Artaud." The Living Theater was alluding to Artaud when, with *Antigone*, it aimed to realize Brecht—language—with Artaud's means—the body. The French critics understood this endeavor, perceiving the attempted connection of critical reasoning and the "theater of cruelty." As Gilles Sandier wrote at the time, "Today we see the Living Theater entrust Artaud—its father and high priest—with the theatrical expression of Brecht."

Here the association between neo-avant-garde currents and the "realism" of epic theater was recognized, at least as a possibility. Both Artaud and Brecht had endeavored to understand theater as something other than the "text." Where Brecht was concerned with the "gestural" aspect, Artaud developed spatial and physical dimensions of "language." As "styles," Artaud and Brecht had already played a significant role for Peter Brook in the early sixties (1963, Theater of Cruelty, London) in the productions of Peter Weiss's *Marat/Sade* and Shakespeare. And as "styles," both have more or less become elements of theatrical practice. The question remains whether, in the final analysis, Brecht was not of more consequence for film—via Godard—than for theater.

The fact that the Artaud/Brecht debate was never really carried through to its conclusion may have had something to do with the shift of theatrical experimentation to the field of happenings and performances, determined primarily by the visual arts and contemporary music, where "language" played no significant role. And it may also have influenced certain developments in the area of literary theater which also got underway in the sixties: the *Sprechstücke* (speaking plays, 1966-1969) by Peter Handke and Pier Paolo Pasolini's *Theater of the Word* (1968). Peter Handke's *Sprechstücke* had a decisive influence on German theater. Formally the boundary between the stage and the audience is never overstepped; as a matter of fact, the ramp bears special aesthetic significance. These works are intended to provide not an image of the world but a concept of the world. "*Sprechstücke*"—language taken at its word, not as an instrument of description but as an object. In 1970, Handke envisions a "completely rational but nevertheless completely sensitive and emotional theater."

In his Sophocles film *Oedipus Rex—The Bed of Violence* (1967), Pasolini cast Julian Beck as Tiresias, Carmelo Bene as Creon.

Thus three positions of the European and North American avant-garde theater merged on one point. In contrast to Julian Beck and the Living Theater, Carmelo Bene firmly dissociated himself from Artaud, who had "remained a theory," and from Brecht, who had not understood that "the writing should be that of the stage, not of the text." Bene was not interested in text but rather in "texture": "In the theater there is speech: speech is the enemy." And as an example of how language was to be applied to theater, he

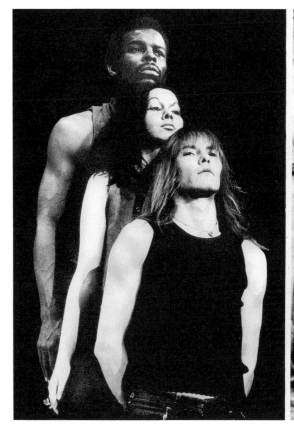

Living Theater, *Antigone*

quoted Pasolini: "While translating Sophocles, Pasolini remarked of the blind Tiresias: 'He can speak no longer, but he can sing incomprehensible words. Such is Tiresias, such is the actor: he can sing incomprehensible words.'"

In 1968, Pasolini published his "Manifesto for a New Theater." The manifesto contained a scathing critique of (neo-) avant-garde theater, "the theater of gesticulation or of the scream," including the "fascinating" Living Theater. Pasolini saw such experiments as no more than "theatrical ritual" incapable of going beyond provocation, merely anti-bourgeois and therefore not in a position to carry out critical discourse.

Hans Magnus Enzensberger

The Poet as Technologist

The close correlation between industrial production and modern poetry can be demonstrated very simply indeed. It is a fact expressed clearly enough by the poets themselves in their writings on poetry. More than a hundred years have passed since Edgar Allen Poe, in his *Philosophy of Composition*, first described the poet as a technologist, and the tools of his craft as "the wheels and pinions—the tackle for scene-shifting—the step-ladders and demon-traps . . . of the literary histrio." Poe's reflections were to have far-reaching implications, touching as they did upon a factor that has become a key concept of modern poetry. As Valéry remarked, in discussing Baudelaire: "In Edgar Poe he saw, the demon of precision, the analytical ingenium . . . in short, the literary engineer." Mallarmé, too, was profoundly affected by Poe's insights. It is remarkable how directly the purest and most esoteric of artists, in particular, should have related their poetry to the social phenomenon of the industrial revolution. In this regard, their statements barely differ from those of the highly tendentious political poet Vladimir Mayakovsky, whose essay *How to make verses* is a methodical analysis of lyrical production, borrowing its terminology from the world of industry. He distinguishes between poetic raw materials, semifinished materials and finished products. The technological character of modern poetry is thus expressed with greater precision in the writings of its founders than it is by the technical and scientific slogans—montage, word laboratory, experiment, constellation, structural element—that have settled over the world of literary criticism like a cloudy sediment.

Poetry as Anticommodity

Poetry and technical civilization—the connection between the two should not be all too rashly grasped. It is not unequivocal. Run-of-the-mill Marxism, which speaks of superstructures when it actually means economic determinism, is shown up by modern poetry. Although it keeps pace with the predominant means of production, it does so in much the same way as one keeps pace with an enemy. There is nothing idealistic in stating that a poem is not a commodity. Right from the very beginning, modern poetry has sought to evade the laws of the market. The poem is the anticommodity par excellence. This was and still is the social meaning of all theories of *poésie pure*. By this claim it defends all literature and poetry and remains true against all too hasty commitment that might seek to market it ideologically. Moreover, the contrast between ivory tower and agitprop does poetry no service. Their dialogue is like two white mice chasing each other in the treadmill of a cage. Even the most committed "finished product" by Mayakovsky is an anticommodity that counters manipulation "purely". Similarly, the free-floating texts of Arp or Eluard are already *poésie engagée* by very dint of the fact that they are poetry at all. Contradicting, rather than condoning, that which exists.

From: *Museum der modernen Poesie*, Munich, 1964.

Concrete Poetry

```
Let it go
        goa
        goa ball
        go about
        goa butter
        goa cedar
        goad
        goadman
        goad stick
        go-ahead
        go-aheadativeness
        goai
        goajiro
        goal
        goala
        goal crease
        goal-directed
        goalie
        goalkeeper
        goal kick
        goaless
        goal line
        go along
        goal post
        goal set
        goaltender
        goan
        goanese
        goa powder
        go around
        goas
        go-ashore
        goa stone
        go-as-you-please
        goat
        goat antelope
        goatbrush
        goatbush
        goatee
        goateed
        goat fever
        goat fig
        goatfish
        goat grass
        goatherd
        goatier
        goatiest
        goat-kneed
        goatlike
        goatling
        goat moth
        goat nut
        goat pepper
        goat-pox
        goats
        goatsbeard
        goat's chicory
        goatsfoot
```

Eugen Gomringer

The poet is someone who breaks the silence in order to evoke a new silence. He is no orator. When he has to speak he does so in a roundabout way. Words are his main concern. Uttering a word, breaking a silence—the poet begins. His craft is the poem. The poem consists of words which the poet found, discovered, selected, and put together. He is a writer. But what are words? I say that words are shadows. For words that break the silence are objects. Words are printer's ink, words are waves, words are projections, words are deeds, words are figures, words have shapes. It is even said that words have weight. But what else are words? It is better we keep silent about that. I also say that words are games. Games are not just play-acting. Games presuppose passion, cheerfulness, and affirmation. Whoever acknowledges words as games also acknowledges them as shadows, accepts them as shadows. Whoever plays with words plays with projections, with figures, with deeds. The poet, therefore, is an adventurer. By breaking a silence the poet affirms, he affirms by means of words. We have an idea what words are. But what is a poem? I say a poem is a constellation of words. I say that under certain circumstances two, often enough three words make up a poem. Let us not forget how diverse, how ambiguous words are, intangible in their tangibility. Let us also not forget that words, as the poet acknowledges them, are not the words that are spoken. The poet's words emerge from the silence which they articulate. This silence accompanies them. It is the intermediary space that links words closer together than any flow of speech. The poet's contribution to human activity is that we learn to pay attention to words, to see words, to hear words, to draw cheer from words.

From: "Der Dichter und das Schweigen" (1964), in Cornelius Schauber, ed.: *Deine Träume—mein Gedicht: Eugen Gomringer und die konkrete Poesie*, Nördlingen, 1989.

Vito Acconci, *Poems*, 1967-1969

schweigen schweigen schweigen
schweigen schweigen schweigen
schweigen schweigen
schweigen schweigen schweigen
schweigen schweigen schweigen

Eugen Gomringer, *Schweigen* **(Silence), 1960**

Öyvind Fahlström

excerpts from
HIPY PAPY BTHUTHDTH THUTHDA BTHUTHDY:[1]
Manifesto for Concrete Poetry

"Since inviting about a hundred dogs to my home for a two-week course on lyric poetry some time ago, I have gone over to writing worlets (words, letters)."[2]

"Remplacer la psychologie de l'homme... **par l'obsession lyrique de la matière**."[3]

1. The present situation
. . . Poetry is not just for analysis, but is also created as a structural entity. And not just as a structure with the emphasis on the expression of ideas, but also as a concrete structure. Let us take our leave of the systematic or unsystematic depiction of all kinds of personal-psychological, contemporary-cultural, or universal problems. Words are symbols, of course, but that should not prevent us from experiencing and creating poetry based upon the use of language as concrete matter.

The fact that words have symbolic value is no more remarkable than that representational forms in visual art have symbolic value over and above what they superficially represent, or that non-figurative forms—even a white square on a white canvas—also have symbolic value, also provide broader associations, beyond our experience of the interplay of proportions.

The situation is this: ever since the war there has been a lasting, melancholy, doom-ridden mood, a feeling that all experimental extremes have been exhausted. For those who do not wish to drift into the worlds of either heavenly or alcoholic spirits, all that remains with the means available to us is to
analyze
analyze
analyze our wretched human condition.

Today, when labored symbolic cryptograms, romantic effusions of beautiful words, or anguished contorted faces outside the church gate seem to be the only marketable possibilities, the alternative of concrete form must also be advanced.

Its fundamental principle is: everything that can be expressed in language and every linguistic expression has equal status in any context if it enhances the significance of that context. . . .

2. Material and media
What is to be made of the new material? Can't it be shaken up and reconstituted in any form whatsoever and then be regarded from a "concrete" viewpoint as inviolable?

That can always be said in the early stages. But the fact that the new media of expression have not yet had their evaluative criteria established need not prevent us from examining these new media if our criteria are ever going to be clarified.

One method is to oppose the law of least resistance as often as possible. Law-les-res. This is no guarantee of success, but it is one way to avoid inertia. Utilize systems as well as automatism, preferably in combination, but only as a means to an end. So refrain from ambitions of achieving the "purest" poetry by means of automatism; even the Surrealists no longer advocate that. And there

Öyvind Fahlström, ESSO – LSD, 1967

experience during his search for concrete music: he had a few seconds of railway engine noise on tape but was not content just to connect that noise to another, even if the juxtaposition was an unusual one. Instead, he cut out a small fragment of the engine noise and repeated that fragment with slightly altered pitch, then went back to the first, then to the second, and so on, to produce a variation. Only then had he created. He had performed an operation on the material itself by cutting it up; the elements were not new, but the new context which had been formed furnished new material.

It will be clear from this that what I have called concrete literature is not a style any more than concrete music or non-figurative visual art is. It is partly a way for the reader to experience literary art—primarily poetry—and partly a liberation for the poet, putting at his disposal all linguistic material and every means to process it. Literature which is created on this basis is therefore neither in opposition to nor identical to Lettrism or to Dada and Surrealism.

Lettrism: both normal "descriptive" and "lettristic" words can be understood as both form and content; the "descriptive" provide a stronger experience of content and a weaker experience of form, "lettristic" the converse—a difference of degree.

If one looks at the actual creations of Surrealist poetry, they appear to have certain similarities with worlets. But there is a difference in the point of departure which must ultimately affect the results. The concrete reality of my worlets does not oppose the reality of their surroundings. They are neither dream-sublimation nor futuristic fantasy, but an organic part of the reality I live in, having their own principles of life and development. . . .

Stockholm, 1953

is nothing wrong with systems if one chooses them oneself and does not follow conventions. Thus it is not a question of whether the system itself is the one and only. It will be right because one has chosen it and if it gives good results.

Thus, for example, I can construct, I say *construct*, a series of twelve vowels in a certain order and make my worlets out of them, even though a twelve-vowel series as such does not have the same conventional justification as the series of twelve tones of the chromatic scale.

Much is said about the contemporary yearning for a fixed code of values. One thing is certain: now that we have grown tired of rigid meter, regular rhythm, and, finally, even of rhyme, we must find something else to give a poem unity. Nowadays there is a tendency for the unifying element to be the content, both in terms of the subject described and the ideas it represents. But it is best if form and content function as one. . . .

The fundamental principle of concrete poetry can perhaps best be illustrated by Pierre Schaeffer's[4] watershed

[1] Milne, A.A. "Eyore Has a Birthday" in *Winnie-the-Pooh*. (New York: E.P. Dutton & Co., 1926).

[2] Öyvind Fahlström.

[3] Marinetti, F.T. "Manifeste technique de la littérature futuriste" in *Marinetti et le Futurisme – Etudes, documents, iconographie réunis*, ed. Giovanni Lista (Lausanne: Editions L'Age d'Homme, 1977).

[4] Writer, composer and mass media professional, Pierre Schaeffer discovered "Musique concrète" in 1948. His work includes *Etudes de bruit* (1948) with Pierre Henry, *Symphonie pour un homme seul* (1950), *Orphée* (1953), *Etude aux objets* (1960), *La tièdre fertile* (1975) and the radiophonic works *Dix ans d'essais radiophoniques* (1942-52) and *La coquille à planètes* (1943-44), radiophonic opera, music by C. Arrieu.

Eva Hesse, *Magnet Boards,* **1967**

William Carlos Williams

The Last Words of My English Grandmother

There were some dirty plates
and a glass of milk
beside her on a small table
near the rank, disheveled bed—

Wrinkled and nearly blind
she lay and snored
rousing with anger in her tones
to cry for food,

Gimme something to eat—
They're starving me—
I'm all right I won't go
to the hospital. No, no, no

Give me something to eat
Let me take you
to the hospital, I said
and after you are well

you can do as you please.
She smiles, Yes
you do what you please first
then I can do what I please—

Oh, oh, oh! she cried
as the ambulance men lifted
her to the stretcher—
Is this what you call

making me comfortable?
By now her mind was clear—
Oh you think you're smart
you young people,

she said, but I'll tell you
you don't know anything.
Then we started.
On the way

we passed a long row
of elms. She looked at them
awhile out of
the ambulance window and said,

What are all those
fuzzy-looking things out there?
Trees? Well I'm tired
of them and rolled her head away.

Hans Magnus Enzensberger

On William Carlos Williams

Williams was never interested in "humanity." The word would have been unthinkable in his mouth. He preferred to deal with people. The portrait plays an important role in his work. It ranks alongside the "thing poem." His technique of omission coupled with the greatest possible clarity lends him a virtue that possesses not only an aesthetic but also a moral quality—the virtue of a delicacy that makes it possible to speak of all things, even the most intimate. The portrait of his grandmother on her deathbed, magnanimous and ruthless all at once, is a perfect example of this art of portraiture.

From: W. C. Williams, *Gedichte*, Frankfurt, 1962

Hépérile Éclaté

We are saturated with communiqués, books, humanism. Long blow the breeze of the illegible, the unintelligible, the open! Writing hépérile in unknown words, I cried out organically with no reference to vocabulary (word-police) . . . Today, thanks to Raymond Hains and Jacques de La Villeglé, the two Christopher Colombi of "ultra-letters," here's the first fortunately unreadable book. An American invents an electronic machine for nothing. Myself, I invented useless objects.

A new degree of poetry, *Hépérile éclaté* brings back the inexplicably non-human by way of the obsolete machine. The first poem to be unread: de-lyrics.

Camille Byren

The Intrusion of Fluted Glass into Poetry

When Christopher Columbus landed, the natives asked each other: "So are we discovered, this time?"
One of Camille Bryen's favorite anecdotes.

We did not discover the ultra-letters. Rather, we discover ourselves in them. Writing did not await our intervention to shatter. There are ultra-letters in the wild. Our merit—or trick—is to have seen the ultra-letters where habitually we saw only deformed letters. Now we use filters of fluted glass which disposes texts of their original meaning.—Through an analogous approach it is possible to shatter words into ultra-words which no human mouth can speak. Fluted glass seems to us one of the surest means to avoid poetic frivolity.

Hépérile éclaté is a sacrificial book.

Raymond Hains, Jacques de la Villeglé
Both texts from: the prospectus for *Hépérile éclaté*, 1953.

Raymond Hains, *Hépérile éclaté*, 1953

Michel Foucault – Of Other Spaces

The great obsession of the nineteenth century was, as we know, history: with its themes of development and of suspension, of crisis and cycle, themes of the ever-accumulating past, with its great preponderance of dead men and the menacing glaciation of the world. The nineteenth century found its essential mythological resources in the second principle of thermodynamics. The present epoch will perhaps be above all the epoch of space. We are in the epoch of simultaneity: we are in the epoch of juxtaposition, the epoch of the near and far, of the side-by-side, of the dispersed. We are at a moment, I believe, when our experience of the world is less that of a long life developing through time than that of a network that connects points and intersects with its own skein. One could perhaps say that certain ideological conflicts animating present-day polemics oppose the pious descendants of time and the determined inhabitants of space. Structuralism, or at least that which is grouped under this slightly too general name, is the effort to establish, between elements that could have been connected on a temporal axis, an ensemble of relations that makes them appear as juxtaposed, set off against one another, implicated by each other—that makes them appear, in short, as a sort of configuration. Actually, structuralism does not entail a denial of time; it does involve a certain manner of dealing with what we call time and what we call history.

Yet it is necessary to notice that the space which today appears to form the horizon of our concerns, our theory, our systems, is not an innovation; space itself has a history in Western experience and it is not possible to disregard the fatal intersection of time with space. One could say, by way of retracing this history of space very roughly, that in the Middle Ages there was a hierarchic ensemble of places: sacred places and profane places; protected places and open, exposed places; urban places and rural places (all these concern the real life of men). In cosmological theory, there were the supercelestial places, as opposed to the celestial, and the celestial place was in its turn opposed to the terrestrial place. There were places where things had been put because they had been violently displaced, and then on the contrary places where things found their natural ground and stabili-

ty. It was this complete hierarchy, this opposition, this intersection of places that constituted what could very roughly be called medieval space: the space of emplacement.

This space of emplacement was opened up by Galileo. For the real scandal of Galileo's work lay not so much in his discovery, or rediscovery, that the earth revolved around the sun, but in his constitution of infinite, and infinitely open space. In such a space the place of the Middle Ages turned out to be dissolved, as it were; a thing's place was no longer anything but a point in its movement, just as the stability of a thing was only its movement indefinitely slowed down. In other words, starting with Galileo and the seventeenth century, extension was substituted for localization.

Today the site has been substituted for extension which itself had replaced emplacement. The site is defined by relations of proximity between points or elements; formally, we can describe these relations as series, trees, or grids. Moreover, the importance of the site as a problem in contemporary technical work is well known: the storage of data or of the intermediate results of a calculation in the memory or a machine; the circulation of discrete elements with a random output (automobile traffic is a simple case, or indeed the sounds on a telephone line); the identification of marked or coded elements inside a set that may be randomly distributed, or may be arranged according to single or to multiple classifications.

In a still more concrete manner, the problem of siting or placement arises for mankind in terms of demography. This problem of the human site or living space is not simply that of knowing whether there will be enough space for men in the world—a problem that is certainly quite important—but also that of knowing what relations of propinquity, what type of storage, circulation, marking, and classification of human elements should be adopted in a given situation in order to achieve a given end. Our epoch is one in which space takes for us the form of relations among sites.

In any case I believe that the anxiety of our era has to do fundamentally with space, no doubt a great deal more than with time. Time probably appears to us

only as one of the various distributive operations that are possible for the elements that are spread out in space.

Now, despite all the techniques for appropriating space, despite the whole network of knowledge that enables us to delimit or to formalize it, contemporary space is perhaps still not entirely desanctified (apparently unlike time, it would seem, which was detached from the sacred in the nineteenth century). To be sure a certain theoretical desanctification of space (the one signaled by Galileo's work) has occurred, but we may still not have reached the point of a practical desanctification of space. And perhaps our life is still governed by a certain number of oppositions that remain inviolable, that our institutions and practices have not yet dared to break down. These are oppositions that we regard as simple givens: for example between private space and public space, between family space and social space, between cultural space and useful space, between the space of leisure and that of work. All these are still nurtured by the hidden presence of the sacred.

Bachelard's monumental work and the descriptions of phenomenologists have taught us that we do not live in a homogeneous and empty space, but on the contrary in a space thoroughly imbued with quantities and perhaps thoroughly fantasmatic as well. The space of our primary perception, the space of our dreams and that of our passions hold within themselves qualities that seem intrinsic: there is a light, ethereal, transparent space, or again a dark, rough, encumbered space: a space from above, of summits, or on the contrary a space from below, of mud; or again a space that can be flowing like sparkling water, or a space that is fixed, congealed, like stone or crystal. Yet these analyses, while fundamental for reflection in our time, primarily concern internal space. I should like to speak now of external space.

The space in which we live, which draws us out of ourselves, in which the erosion of our lives, our time and our history occurs, the space that claws and gnaws at us, is also, in itself, a heterogeneous space. In other words, we do not live in a kind of void, inside of which we could place individuals and things. We do not live

inside a void that could be colored with diverse shades of light, we live inside a set of relations that delineates sites which are irreducible to one another and absolutely not superimposable on one another.

Of course one might attempt to describe these different sites by looking for the set of relations by which a given site can be defined. For example, describing the set of relations that define the sites of transportation, streets, trains (a train is an extraordinary bundle of relations because it is something through which one goes, it is also something by means of which one can go from one point to another, and then it is also something that goes by). One could describe, via the cluster of relations that allows them to be defined, the sites of temporary relaxation—cafes, cinemas, beaches. Likewise one could describe, via its network of relations, the closed or semi-closed sites of rest—the house, the bedroom, the bed, et cetera. But among all these sites, I am interested in certain ones that have the curious property of being in relation with all the other sites, but in such a way as to suspect, neutralize, or invert the set of relations that they happen to designate, mirror, or reflect. These spaces, as it were, which are linked with all the others, which however contradict all the other sites, are of two main types.

First there are the utopias. Utopias are sites with no real place. They are sites that have a general relation of direct or inverted analogy with the real space of Society. They present society itself in a perfected form, or else society turned upside down, but in any case these utopias are fundamentally unreal spaces.

There are also, probably in every culture, in every civilization, real places—places that do exist and that are formed in the very founding of society—which are something like counter-sites, a kind of effectively enacted utopia in which the real sites, all the other real sites that can be found within the culture, are simultaneously represented, contested, and inverted. Places of this kind are outside of all places, even though it may be possible to indicate their location in reality. Because these places are absolutely different from all the sites that they reflect and speak about, I shall call them, by way of contrast to utopias, heterotopias. I believe that between utopias and these quite other sites, these heterotopias, there might be

a sort of mixed, joint experience, which would be the mirror. The mirror is, after all, a utopia, since it is a placeless place. In the mirror, I see myself there where I am not, in an unreal, virtual space that opens up behind the surface: I am over there, there where I am not, a sort of shadow that gives my own visibility to myself, that enables me to see myself there where I am absent: such is the utopia of the mirror. But it is also a heterotopia in so far as the mirror does exist in reality, where it exerts a sort of counteraction on the position that I occupy. From the standpoint of the mirror I discover my absence from the place where I am since I see myself over there. Starting from this gaze that is, as it were, directed toward me, from the ground of this virtual space that is on the other side of the glass, I come back toward myself: I begin again to direct my eyes toward myself and to reconstitute myself there where I am. The mirror functions as a heterotopia in this respect: it makes this place that I occupy at the moment when I look at myself in the glass at once absolutely real, connected with all the space that surrounds it, and absolutely unreal, since in order to be perceived it has to pass through this virtual point which is over there.

As for the heterotopias as such, how can they be described, what meaning do they have? We might imagine a sort of systematic description—I do not say a science because the term is too galvanized now—that would, in a given society, take as its object the study, analysis, description, and "reading" (as some like to say nowadays) of these different spaces, of these other places. A sort of simultaneously mythic and real contestation of the space in which we live, this description could be called heterotopology. Its *first principle* is that there is probably not a single culture in the world that fails to constitute heterotopias. That is a constant of every human group. But the heterotopias obviously take quite varied forms, and perhaps no one absolutely universal form of heterotopia would be found. We can however classify them in two main categories.

In the so-called primitive societies, there is a certain form of heterotopia that I would call crisis heterotopias, i.e., there are privileged or sacred or forbidden places, reserved for individuals who are, in relation to society and to the human

environment in which they live, in a state of crisis: adolescents, menstruating women, pregnant women, the elderly, etc. In our society, these crisis heterotopias are persistently disappearing, though a few remnants can still be found. For example, the boarding school, in its nineteenth-century form, or military service for young men, have certainly played such a role, as the first manifestations of sexual virility were in fact supposed to take place "elsewhere" than at home. For girls, there was, until the middle of the twentieth century, a tradition called the "honeymoon trip" which was an ancestral theme. The young woman's deflowering could take place "nowhere" and, at the moment of its occurrence the train or honeymoon hotel was indeed the place of this nowhere, this heterotopia without geographical markers.

But these heterotopias of crisis are disappearing today and are being replaced, I believe, by what we might call heterotopias of deviation: those in which individuals whose behavior is deviant in relation to the required mean or norm are placed. Cases of this are rest homes and psychiatric hospitals, and of course prisons; and one should perhaps add retirement homes that are, as it were, on the borderline between the heterotopia of crisis and the heterotopia of deviation since, after all, old age is a crisis, but is also a deviation since, in our society where leisure is the rule, idleness is a sort of deviation.

The *second principle* of this description of heterotopias is that a society, as its history unfolds, can make an existing heterotopia function in a very different fashion; for each heterotopia has a precise and determined function within a society and the same heterotopia can, according to the synchrony of the culture in which it occurs, have one function or another.

As an example I shall take the strange heterotopia of the cemetery. The cemetery is certainly a place unlike ordinary cultural spaces. It is a space that is however connected with all the sites of the citystate or society or village, etc., since each individual, each family has relatives in the cemetery. In western culture the cemetery has practically always existed. But it has undergone important changes. Until the end of the eighteenth century, the cemetery was placed at the heart of

the city, next to the church. In it there was a hierarchy of possible tombs. There was the charnel house in which bodies lost the last traces of individuality, there were a few individual tombs and then there were the tombs inside the church. These latter tombs were themselves of two types, either simply tombstones with an inscription, or mausoleums with statues. This cemetery housed inside the sacred space of the church has taken on a quite different cast in modern civilizations, and curiously, it is in a time when civilization has become "atheistic," as one says very crudely, that western culture has established what is termed the cult of the dead.

Basically it was quite natural that, in a time of real belief in the resurrection of bodies and the immortality of the soul, overriding importance was not accorded to the body's remains. On the contrary, from the moment when people are no longer sure that they have a soul or that the body will regain life, it is perhaps necessary to give much more attention to the dead body, which is ultimately the only trace of our existence in the world and in language. In any case, it is from the beginning of the nineteenth century that everyone has a right to her or his own little box for her or his own little personal decay; but on the other hand, it is only from that start of the nineteenth century that cemeteries began to be located at the outside border of cities. In correlation with the individualization of death and the bourgeois appropriation of the cemetery, there arises an obsession with death as an "illness." The dead, it is supposed, bring illnesses to the living, and it is the presence and proximity of the dead right beside the houses, next to the church, almost in the middle of the street, it is this proximity that propagates death itself. This major theme of illness spread by the contagion in the cemeteries persisted until the end of the eighteenth century, until, during the nineteenth century, the shift of cemeteries toward the suburbs was initiated. The cemeteries then came to constitute, no longer the sacred and immortal heart of the city, but "the other city," where each family possesses its dark resting place.

Third principle. The heterotopia is capable of juxtaposing in a single real place several spaces, several sites that are in themselves incompatible. Thus it is that the

theater brings onto the rectangle of the stage, one after the other, a whole series of places that are foreign to one another; thus it is that the cinema is a very odd rectangular room, at the end of which, on a two-dimensional screen, one sees the projection of a three-dimensional space; but perhaps the oldest example of these heterotopias that take the form of contradictory sites is the garden. We must not forget that in the Orient the garden, an astonishing creation that is now a thousand years old, had very deep and seemingly superimposed meanings. The traditional garden of the Persians was a sacred space that was supposed to bring together inside its rectangle four parts representing the four parts of the world, with a space still more sacred than the others that were like an umbilicus, the navel of the world at its center (the basin and water fountain were there); and all the vegetation of the garden was supposed to come together in this space, in this sort of microcosm. As for carpets, they were originally reproductions of gardens (the garden is a rug onto which the whole world comes to enact its symbolic perfection, and the rug is a sort of garden that can move across space). The garden is the smallest parcel of the world and then it is the totality of the world. The garden has been a sort of happy, universalizing heterotopia since the beginnings of antiquity (our modern zoological gardens spring from that source).

Fourth principle. Heterotopias are most often linked to slices in time—which is to say that they open onto what might be termed, for the sake of symmetry, heterochronies. The heterotopia begins to function at full capacity when men arrive at a sort of absolute break with their traditional time. This situation shows us that the cemetery is indeed a highly heterotopic place since, for the individual, the cemetery begins with this strange heterochrony, the loss of life, and with this quasi-eternity in which her permanent lot is dissolution and disappearance.

From a general standpoint, in a society like ours heterotopias and heterochronies are structured and distributed in a relatively complex fashion. First of all, there are heterotopias of indefinitely accumulating time, for example museums and libraries. Museums and libraries have become heterotopias in which time never stops building up and topping its own summit, whereas in the seventeenth cen-

tury, even at the end of the century, museums and libraries were the expression of an individual choice. By contrast, the idea of accumulating everything, of establishing a sort of general archive, the will to enclose in one place all times, all epochs, all forms, all tastes, the idea of constituting a place of all times that is itself outside of time and inaccessible to its ravages, the project of organizing in this way a sort of perpetual and indefinite accumulation of time in an immobile place, this whole idea belongs to our modernity. The museum and the library are heterotopias that are proper to western culture of the nineteenth century.

Opposite these heterotopias that are linked to the accumulation of time, there are those linked, on the contrary, to time in its most fleeting, transitory, precarious aspect, to time in the mode of the festival. These heterotopias are not oriented toward the eternal, they are rather absolutely temporal [*chroniques*]. Such, for example, are the fairgrounds, these marvelous empty sites on the outskirts of cities that teem once or twice a year with stands, displays, heteroclite objects, wrestlers, snakewomen, fortune-tellers, and so forth. Quite recently, a new kind of temporal heterotopia has been invented: vacation villages, such as those Polynesian villages that offer a compact three weeks of primitive and eternal nudity to the inhabitants of the cities. You see, moreover, that through the two forms of heterotopias that come together here, the heterotopia of the festival and that of the eternity of accumulating time, the huts of Djerba are in a sense relatives of libraries and museums. For the rediscovery of Polynesian life abolishes time; yet the experience is just as much the rediscovery of time, it is as if the entire history of humanity reaching back to its origin were accessible in a sort of immediate knowledge.

Fifth principle. Heterotopias always presuppose a system of opening and closing that both isolates them and makes them penetrable. In general, the heterotopic site is not freely accessible like a public place. Either the entry is compulsory, as in the case of entering a barracks or a prison, or else the individual has to submit to rites and purifications. To get in one must have a certain permission and make certain gestures. Moreover, there are even heterotopias that are entirely consecrat-

ed to these activities of purification—purification that is partly religious and partly hygienic, such as the hamman of the Moslems, or else purification that appears to be purely hygienic, as in Scandinavian saunas.

There are others, on the contrary, that seem to be pure and simple openings, but that generally hide curious exclusions. Everyone can enter into these heterotopic sites, but in fact that is only an illusion: we think we enter where we are, by the very fact that we enter, excluded. I am thinking, for example, of the famous bedrooms that existed on the great farms of Brazil and elsewhere in South America. The entry door did not lead into the central room where the family lived, and every individual or traveler who came by had the right to open this door, to enter into the bedroom and to sleep there for a night. Now these bedrooms were such that the individual who went into them never had access to the family's quarters; the visitor was absolutely the guest in transit, was not really the invited guest. This type of heterotopia, which has practically disappeared from our civilizations, could perhaps be found in the famous American motel rooms where a man goes with his car and his mistress and where illicit sex is both absolutely sheltered and absolutely hidden, kept isolated without however being allowed out in the open. The last trait of heterotopias is that they have a function in relation to all the space that remains. This function unfolds between two extreme poles. Either their role is to create a space of illusion that exposes every real space, all the sites inside of which human life is partitioned, as still more illusory (perhaps that is the role that was played by those famous brothels of which we are now deprived). Or else, on the contrary, their role is to create a space that is other, another real space, as perfect, as meticulous, as well arranged as ours is messy, ill constructed, and jumbled. This latter type would be the heterotopia, not of illusion, but of compensation, and I wonder if certain colonies have not functioned somewhat in this manner. In certain cases, they have played, on the level of the general organization of terrestrial space, the role of heterotopias. I am thinking, for example, of the first wave of colonization in the seventeenth century, of the Puritan societies that the English had founded in America and that were absolutely perfect

other places. I am also thinking of those extraordinary Jesuit colonies that were founded in South America: marvelous, absolutely regulated colonies in which human perfection was effectively achieved. The Jesuits of Paraguay established colonies in which existence was regulated at every turn. The village was laid out according to a rigorous plan around a rectangular place at the foot of which was the church; on one side, there was the school; on the other, the cemetery; and then, in front of the church, an avenue set out that another crossed at right angles; each family had its little cabin along these two axes and thus the sign of Christ was exactly reproduced. Christianity marked the space and geography of the American world with its fundamental sign. The daily life of individuals was regulated, not by the whistle, but by the bell. Everyone was awaked at the same time, everyone began work at the same time; meals were at noon and five o'clock; then came bedtime, and at midnight came what was called the marital wake-up, that is, at the chime of the churchbell, each person carried out her/his duty.

Brothels and colonies are two extreme types of heterotopia, and if we think, after all, that the boat is a floating piece of space, a place without a place, that exists by itself, that is closed in on itself and at the same time is given over to the infinity of the sea and that, from port to port, from tack to tack, from brothel to brothel, it goes as far as the colonies in search of the most precious treasures they conceal in their gardens, you will understand why the boat has not only been for our civilization, from the sixteenth century until the present, the great instrument of economic development (I have not been speaking of that today), but has been simultaneously the greatest reserve of the imagination. The ship is the heterotopia par *excellence*. In civilizations without boats, dreams dry up, espionage takes the place of adventure, and the police take the place of pirates.

From: *Diacritics* 16-1, Spring 1986.

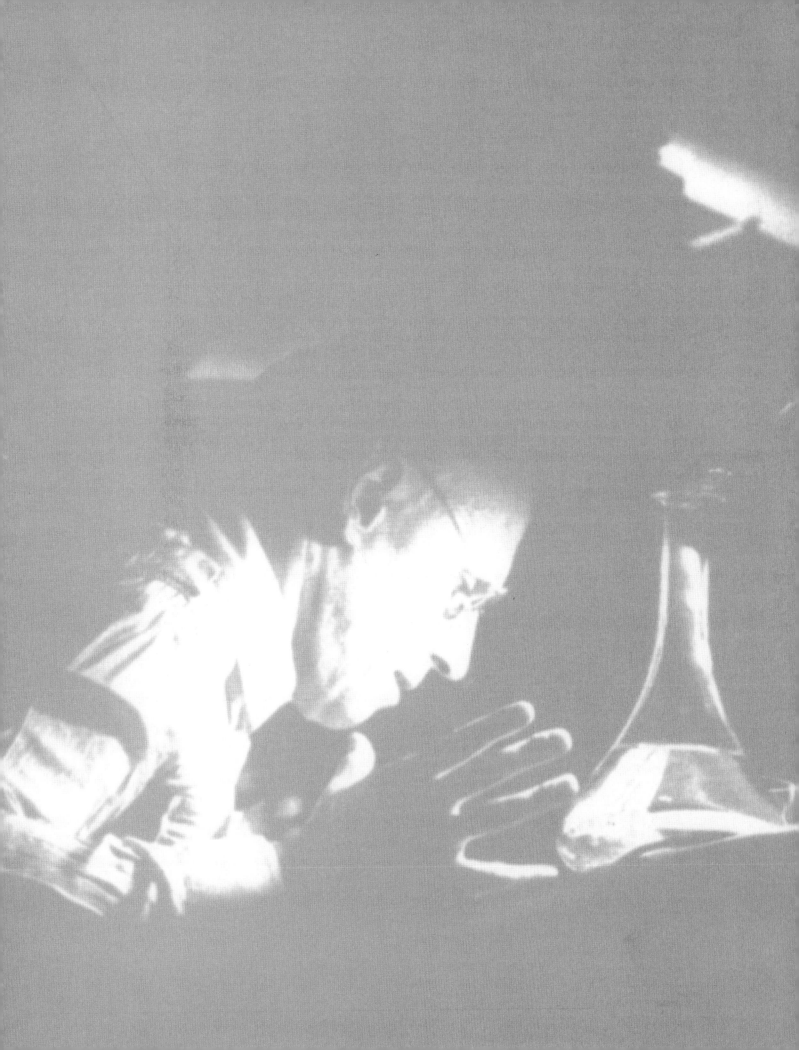

Daniel Defert

Foucault, Space, and the Architects

On March 14, 1976, the Cercle d'Etudes Architecturales in Paris invited Michel Foucault to give a lecture on space. He proposed a new spatial analytics, which he termed "heterotopology." The lecture remained unpublished for years, with the exception of excerpts printed in French in the Italian journal *L'Archittetura*, in 1968.[1] The text of the lecture circulated in typescript form among the members of the circle until it was finally presented to the public in the fall of 1984, for the exhibition *Idea, Process, Results* at Martin Gropius Bau in Berlin.

This was the most important of seventeen exhibitions scattered through the patchwork of Berlin's urban design by the International Bauausstellung (IBA), which sought to show the world the balance sheet of its activities in reconstructing and renovating the city. The exhibition, a panorama of contemporary thinking in architecture and urbanism, gave a foretaste of the reunification of the capital city; it was curiously resonant with Foucault's 1967 text, "Des espaces autres" (Of Other Spaces).[2] By giving his permission for the text's publication shortly before his death on June 25, 1984, the philosopher added it in *extremis* to the corpus of his authorized writings.

Since then, the text has been widely translated and discussed. But what happened in the interval? "For almost 20 years . . . these 'Other spaces' . . . remained unexplored and substantially misunderstood," comments Edward Soja, an ardent Californian promoter of heterotopology.[3] Can the history of this silence and the gap between the two dates of 1967/1984 really be interpreted as no more than a parody of the eminently Foucaultian theme of the history of non-reception? Do the notions of reception and non-reception offer an analytical grid fine enough to sift through the series of transformations in the aesthetic, epistemological, and political discourses developed by architects and urbanists over the last twenty years, a series doubled by the transformations in the problematic of space as it is treated in the writings of Fou-

cault himself? Haven't these transformations constituted new surfaces of inscription, new arrangements and reevaluations of the text? If so, can these reinscriptions be traced independently of the transformation in the social—and therefore political and theoretical—status of the author, Michel Foucault? And can they be traced independently of the formulation of a new conceptual framework, that of postmodernism, in which part of these transformations have been articulated and made meaningful, particularly in architectural circles?

These are the questions that the present study attempts to answer.

Language, Gaze, and Space

"Do you remember the telegram that gave us such a laugh, where an architect said he glimpsed a new conception of urbanism? But it wasn't in the book, it was in a talk on the radio about utopia. They want me to give it again on March 13 or 14."

This letter, written in Sidi Bou Saïd on March 2, 1967, is the oldest document of Foucault's encounter with the architects. On December 7, 1966, as part of a series of so-called "French culture" broadcasts devoted to utopia, he was invited to speak about "Utopia and Literature."[4] Beginning with a Bachelardian evocation of the enchanting spaces of children's games—attics, backyard corners, the Indians' tent or the parents' bed, "veritable localized utopias"—he went on to dream of a science whose object would be "those different spaces which contest the space we live in. . . . not a science of utopias but of heterotopias, a science of absolutely other spaces." Indeed, he claimed, "this science or heterotopology is now being born, it exists already." He stated its principles on that day.

Foucault's intervention on the airwaves—where he proved to be a marvelous storyteller—responded to the tremendous curiosity that had been raised by the publication of The Order of Things in 1966. The book opened with the description of an improbable Chinese encyclopedia invented by Borges, in which the animals enter into fourteen classes of this sort: "(a) belonging to the Emperor, (b) embalmed, (c) tame. . . . (k) drawn with a very fine camelhair brush, (l) et cetera, (m) having just broken the water pitcher." This "disorder in which fragments of a large number of possible orders glitter" was named by Foucault "heterotopia." The term was opposed to utopia, which etymologically means "non-place" (and not eu-topia, "good place," as people tend to believe). But if utopias tell of a place which does not exist, they unfold in an imaginary space and thereby "run with the very grain of language"—for language, since the depths of time, has always intersected with space. On the contrary, Borges' list makes words stop short upon themselves: the heterotopias "destroy 'syntax' in advance, and not only the syntax with which we construct sentences but also that less apparent syntax which causes words and things (next to and also opposite one another) to 'hold together'."[5]

The "stark impossibility of thinking *that*," of understanding Borges' radically disparate classification, bears witness to the limits of our thinking, limits that we still encounter before the classifications of cultures that are radically foreign. When Victor Turner describes how the Ndembu of Zambia bring together hunters, widows, the sick, and warriors in the same class, this does not imply a space of belonging conceived as a common territory, nor one whose diverging branches are defined with formal principles, as in the space where we distribute the natural kingdoms, not even the arbitrary linearity of the alphabetical order whereby our dictionaries order disparities in space; what Turner describes is a system of analogies, of similarities between symbolic properties whose interconnections we are obliged to sketch out on a blank page in order to discover their system or "space of similarity." One cannot think without a "space of order," without the "middle region" that Foucault qualifies as archaeological, the space below our perceptions, our discourses, our sciences, where the visible and the verbal are articulated: language, the gaze, and space. Utopia and heterotopia, as presented in *The Order of Things*, are two discursive modalities which contradict or contest ordinary experience and the discourse in which we frame it; utopia by unfolding within a non-place in space, and heterotopia, within a non-place in language.

Over the radio, Foucault made quite different use of his notion of heterotopia. First, it was no longer applied to an analysis of discourses but to an analysis of spaces. Places as disparate as the mirror, the cemetery, the brothel, or the Polynesian vacation resort in Djerba entered into a specific category of space-times, whether fleeting like the single time of deflowering in the space of a honeymoon voyage, or on the contrary, stable like the (atemporal) time of accumulated temporalities, stocked in the site of the library or the museum.

These spatio-temporal units, these space-times, shared the fact of being places where I am and yet I am not, as in the mirror or the cemetery, or where I am another, as in the brothel, the vacation resort, or the festival: carnival transformations of ordinary existence, which ritualize splits, thresholds, and deviations, and localize them as well.

Not all human norms can be universalized. The norms of disciplinary work and festival transfiguration cannot unfold in the linearity of a single space or time; a strong ritualization of ruptures, thresholds, and crises is necessary. But these counter-spaces are interpenetrated by all the other spaces which they contest: the mirror where I am not reflects the context where I am, the cemetery is planned like a city, the spaces reverberate one in the other, yet there are discontinuities, ruptures. Finally, there is something like an eternal return of these spatio-temporal rituals, not a universalization of the same forms, but a universality of their existence. They are caught in a specific synchrony and diachrony which make them a signifying system amid the systems of architecture. They reflect neither the social structure nor the structure of production, they are neither a sociohistoric system nor an ideology: instead they are ruptures in ordinary life, imaginary realms, polyphonic representations of life, death, and love, of Eros and Thanatos.

There are structuralist-functionalist elements in this analysis of "other spaces," but there is also a Bakhtinean note, as though the polyphonic or dialogic and carnavalesque dimension that Bakhtin had discovered in language were being applied here to the analysis of spaces. However, Bakhtin was not translated into French until 1966 and nothing could justify the idea that his work influenced the discursive analysis in Foucault's

Garden cemetery in The Haugue

lecture, or in *The Archaeology of Knowledge*, which he was writing at the same time. In the lecture, heterotopia no longer designates a non-place of language. On the contrary, the possibility of a new space of order in which to distribute these counter-sites, these spatio-temporal units, is here presented as heterotopology, described as a new science in 1966, and more prudently, in 1967, as a new description of spatiality, conceived in the category of difference, of polyphony. This, in any case, is what reached an architect's ear on December 7, 1966. Is the architect's ear a sufficiently respected site in our societies?

The letter of March 2, 1967, betrays a disappointment: the archaeologist of the gaze had not attracted the gaze of the architect. No, "it wasn't in the book" that a new conception of urbanism lay in germ—not in the book with which the philosopher had expected to provoke such ruptures in thinking.

Still those times were fractious enough, all the way up to the great fracas of 1968; and Foucault soon turned his back on the polemical tumult of glory, taking leave of France for the light-drenched serenity of Sidi Bou Saïd in the upper Gulf of Carthage, and for the always difficult peace of writing. It was a lived heterotopia. What fell on the architect's ear was only a minor language, one of those literary games in which Foucault took such avid pleasure, his jubilation constantly checked by the ascetic demands of writing—a restraint that can be read in the didactics of the lecture rewritten for the architects.

Utopias and Heterotopias

From 1960 to 1970 the Circle of Architectural Studies was directed by its president Jean Dubuisson (the architect of the Museum of Popular Arts and Traditions in the Bois de Boulogne) and by Ionel Schein, who singled out the speakers to be invited to 38, boulevard Raspail. It was one of the rare circles of architectural reflection not dominated by professional imperatives; in the fifties and sixties Ionel Schein enjoyed a flattering rep-

utation as an intellectual agitator and a purveyor of "radicalism in architecture."[6] According to Dubuisson, it was Schein who invited Foucault. The lectures were noted down by a stenographer, then typed and distributed to the members of the Circle. Pierre Riboulet (the architect of the Robert Debré Hospital, among others) still has his copy today. He also recalls the debate that followed, particularly concerning Bachelard, "whom we all pillage" said Foucault. He recalls the philosopher's rhetorical precautions at the opening of his lecture, his professed ignorance as of architects' concerns. His references were to the history of the sciences (Koyré, Bachelard), to literary criticism (J.-P. Richard, Blanchot), and to existential psychoanalysis (Binswanger), all fields in which Foucault had previously deployed his "spatial obsessions."[7]

In 1967 Foucault had not yet developed his concept of the "specific intellectual," designating a double inscription: first in a specialized field of knowledge, then in the field of politics, through a mobilization of the power conferred by the specialized knowledge. Still he liked nothing so much as to talk with specialists. He had been disappointed by the psychiatric profession's relative neglect of *Madness and Civilization* (1961).

To mark his enthusiasm for this lecture, Robert Auzelle, one of the thinkers behind the reconstruction of France since the early fifties, offered Foucault his history of funerary architecture and cemeteries,[8] which effectively covered one of the heterotopias. In *The Birth of the Clinic* (1963), Foucault had described how anatomo-pathology integrated death into the knowledge of life. To offer him the history of the integration of cemeteries into urban planning proved the perfect complicity between the lecturer and his listeners: negativity was at the heart of rationality. It was at the heart of Foucault's studies, until *Discipline and Punish* in any case.[9]

It was at the close of this same year of 1967 that Jean-Luc Godard, in his film *La Chinoise*, had the pro-Chinese student played by Anne Wiazemski throw tomatoes against a copy of *The Order of Things*, a book whose abrupt discontinuities in the thinking of time were taken as a symbol of the negation of history—and therefore of the negation of revolution.

Gravestones in the Staatlichen Akademie für Kunstgewerbe, Dresden

Did the 1967 lecture circulate beyond the typescripts distributed to its initial audience? The Circle itself had no journal and published none of its lectures. At the time, the most widely shared conceptions among architects stemmed from Le Corbusier and the Bauhaus and involved the rationalization of forms and the "legibility" of an urban space conceived as a text punctuated by "landmarks," whether spaces or buildings. Françoise Choay, whom Foucault frequented in the seventies, retraces these problematics in Urbanisme, utopies et réalités (1965). A progress-oriented, humanistic urbanism based on the Charter of Athens and an ideal of increasing rationality; a culturalist urbanism for which each form is a symbol and which looks nostalgically back toward the harmony of cities past: such were the "regulative ideas of urbanist reason." Didn't these regulative ideas already trace out the space of the utopia in which architectural and urbanistic discourse would unfold after 1968, with the dissolution of the object "city" amid capitalist social relations? Hasn't the city as a rational or formal harmony been torn asunder by capitalism? Isn't space a vast blank page on which the metanarrative of capital has been written for two centuries now? Isn't that the unsaid, the unthought of all the built partitions between classes, sexes, and generations?

Pevsner claimed that baroque art had rendered the supernatural tangible. After 1968, urban space suddenly rendered capitalism tangible. Book III of Capital on the genesis of ground rent became the obligatory first lesson of any course in urban planning. The spaces themselves disappeared beneath the visibility of the social relations that produced them. Critical discourse was only a variant of a utopian discourse deeply marked by the dream of a space from which capital's inscription would be effaced, just as Thomas More in his Utopia (1516) imagined what the social tie would become if money could be subtracted from social relations.

The fascination of the architectural schools for visits to the realized utopias of industrial housing estates bears witness to the notion that French architectural and urbanistic discourse of the seventies unfolded in the space of utopia. Two objects of this fascination were Godin's Familistère in Guise and the Meunier housing estate in Noisiel; their promoters had in fact been among the first to invent mass consumption, one by shrinking the millenary and extremely costly form of the fireplace down to the size of the domestic cast-iron stove, the other by reducing a medicinal product of the Napoleonic armies, cacao, to its industrial complement, the chocolate bar. Hadn't they both perfectly articulated the rationalization of consumption with a rational occupation of space? Questioned about the architectural heterogeneity of the new town of Cergy-Pontoise, one of the planners of the time declared on television:

"If we had adopted a single style we would have been accused of handing over the city to a single banking group." The rationalization of the industrial housing estate and the fragmentation of urban space, the homogeneous and the heterogeneous, referred back to the same irrefutable code of analysis: the spatialization of capital. The architect became the passive technician putting the strategies and norms of capital into effect.

The echo of this architectural self-doubt can be heard in the theoretical works produced by the architects of the seventies. Pierre Riboulet reflected on peasant architectures: did their formal coherence through time result from their anteriority to the division of manual and intellectual labor in construction? Jean-Louis Cohen inquired into the existence of working-class architectural practices.[10]

The elegant formal description of the heterotopias was minor literature. Could it trace a furrow in the dominant discourse that unfolded seamlessly in the space of utopia?

The disquiet of the times could be read in the journal Traverse: "It becomes necessary to speak in the same breath of preurbanist utopias, workers' housing estates, Haussmann, the Bauhaus, functionalism, Shaker villages, apartment complexes, new towns: everywhere we see the dangerous assertion of a rationalization of space inherent to the universal extension of capital, as a propensity of its order of exchange, or of order tout court."[11]

The Genealogy of Public Facilities

It was in 1972 that Foucault began to work with research groups on the history of public facilities [équipements collectifs]. The first group was the Centre d'Etudes, de Recherche, et de Formation Industrielle (Cerfi) directed by the psychiatrist Felix Guattari, who was just completing the book Anti-Oedipus (1972) in collaboration with Gilles Deleuze. Created in 1965 by dissident social science researchers from the French Communist Party (PCF), Cerfi began to question its Marxist culture after 1970, putting it to a double test: first, the test of the genealogical approach at work in Madness and Civilization and The Birth of the Clinic; and second, the test of clarifying the libidinal relations that each researcher maintains toward the object of his or her research (for no one failed to see the ambivalence of urbanistic reflection toward the capitalist rationality), as well as the relations that the researchers maintain among themselves as a hierarchical and sexuated group.

The narrative of this double test or trial, published in Cerfi's journal, is probably one of the most interesting log books from the ideological crossings of those times.12 As if in a laboratory experiment, one watches the fissuring of Marxist analysis and the emergence of what would soon be named the "postmodern attitude." The endeavor is described by its authors as "a strange machine made of bits and pieces borrowed from the genealogist Foucault, or stolen from the work site of the bicephalous scholar Deleuze-Guattari."

"The genealogist Foucault" is in fact a new social image of the philosopher: the genealogical approach was only frankly asserted with his teaching at the Collège de France, which began in December 1970. Since 1971, he and Deleuze had also led a militant movement, the Groupe d'Information sur les Prisons (GIP), at the far left end of the political spectrum.

Foucault discussed the "genealogical" approach to public facilities with Cerfi in the context of the group's work on the city;13 but he developed it most extensively in his seminar at the Collège de France. The seminar focused on the emergence of the doctor as an expert in the nineteenth century, through psychiatric expertise and legal medicine, on the one hand, and through his role as an engineer contributing to the definition of the norms and forms of architecture, on the other. At this point an architect, Bruno Fortier, the director of the Centre d'études et recherches en architecture (Cera), began to participate in the seminar's research work.

The expression *équipements collectifs* does not appear in eighteenth-century texts; however, its place is taken by the *machine à guérir* or "curing machine," defined by a certain Doctor Tenon as the ideal of the modern hospital. Hospital architecture, wrote Tenon, can no longer be "all routine and fumbling," but had to answer multiple concerns: stopping contagion through the arrangement of rooms and beds, permitting the circulation of fresh air, favoring the dissociation of sicknesses and the sick, facilitating the surveillance of patients and personnel, manifesting the hierarchy of the medical gaze, taking account of the needs of the population. "What helps cure is not the regularity of the plans but the appropriateness of the architecture."14 The model must be perfect—so that nothing more need be changed—and finished, repeatable. "For the first time, in 1788, architects were asked to consider imitation as a duty," observed Bruno Fortier.15 Normative typologies replaced the examples offered by history. The appropriateness of the architecture derived from the treatment of a network of distinct questions, climatic, demographic, statistical, hygienic, medical, and disciplinary. All of them had their place of emergence, their rationality, their

promoters, all responding to a multiplicity of tactics: techniques of surveillance, of knowledge production, of the effectuation of powers, of medicalization, of public health. Such tactics could not be described as analogous or infinitely repeated segments of a single text by the unique, mythic, unitary scriptor that is capital. The "curing machine" that combined these diverse tactics was constructed through the articulation of various practices, various discourses; it was preceded by the opening of a public debate initiated in Paris in 1772, the year of the fire that consumed the Hôtel-Dieu (General Hospital) and necessitated a reflection on its reconstruction, including fact-finding voyages to the principle European hospitals.

Of course, such buildings incorporated tactics of surveillance observed elsewhere, in other architectural forms, notably schools and military barracks: these were the tactics and forms that preceded and upheld the emergence of the capitalist division of labor, and could even proliferate beyond it, in the vast archipelagos of Siberian socialism, for example. They were fundamentally neither architectural forms nor modes of production, but technologies of power. In the course of his search for "architecture machines" adapted perfectly to their objectives Foucault soon rediscovered what was to become their paradigm in his work: Bentham's "Panopticon,"16 of which Poyet had sketched an interpretation for the reconstruction of the Hôtel-Dieu.17 The results of the seminar research at the Collège de France on hospital architecture in the late eighteenth century—grouped in the volume *Les machines à guérir*—were published in two editions, the first in Paris in 1976, the second in Brussels in 1979.

The other study group directed by Foucault (but without any visible participation by him in the final publication) focused on habitat between 1800 and 1850.18 The leading figure of this group was François Béguin, today an historian of landscape and of colonial architecture.19 The methodology was the same as before: instead of beginning with a history of the forms of habitation or of the city, the researchers inventoried the discursive practices that circumscribed and codified habitat as an object of political and administrative intervention between 1800 and 1850. They isolated the various registers of knowledge and practice concerning sickness, employment, and their diverse abnormalities; the discourses concerning the place in the home of facilities such as water, lighting, aeration; and the development of a growing jurisdiction over public space, at the point of intersection where habitat is built. Such work required researchers to shed their preconceived ideas: "First one must shake off the spell of the house, demineralize it, deconstruct it," wrote François Béguin.

To be sure, all the texts from this seminar cannot be ascribed to "Foucault's thinking." As we are reminded by the medical historian Jean-Pierre Peter, who participated in the seminar where the "Pierre Rivière case" unfolded, "the seminar group was multiform, with great differences in disciplines, preoccupations, professions; and the series of our contributions testifies to this multiplicity . . . We were absolutely not a team, we were free in our association and commitment, each interested in working with Foucault for our own reasons . . . without any common activity or school of thought."[20]

In fact, none of the participants refers at any moment to the text on the heterotopias. These research projects had no real circulation among the public, but around them was developed a mode of spatial analysis which would come to the attention of a broad readership with the release of *Discipline and Punish* in 1975.

Power, Knowledge, Space

It was with *Discipline and Punish* and its rapid international circulation (the book was swiftly translated into some twenty languages) that Foucault's analyses of space received a new visibility, as the site of a double articulation of power on the body of the individual and of knowledge with power. Several studies on disciplinary architecture followed, principally in Great Britain and Italy.[21] More generally, urban sociologists and planners began to refer to Foucault. In the journal *Environment and Planning*, Leaman wrote that Foucault's work would henceforth be of importance for urban planners and architects, because of its analysis of the normative qualities of structures and institutions.[22] Sharon Zukin considered the housing estate to henceforth be included in the analyses of an economy of power, according to the method developed in *Discipline and Punish*.[23]

This was the context in which the heterotopias reappeared. The first volume to consider their possible uses within a history of spaces was published in Venice in December 1977, under the title *Il dispositivo Foucault*. It included essays by Massimo Cacciari, Franco Rella, Manfredo Tafuri, and Georges Teyssot; its cover, like that of *Machines à guérir*, reproduced a panoptic architectural plan for an English hospital.[24] The authors referred essentially to *Discipline and Punish* and, with the exception of Teyssot, to an anthology of texts by Foucault on power, selected by the Italians and published by Einaudi press under the title *Microfisica del potere*.[25] The political effects of this anthology were immediate,

and were complemented by the translation of Deleuze and Guattari's *Rhizome* (1976, Italian trans., 1977). The two books became theoretical and political references for the "Autonomia" movement (read "political autonomy"), a left-flank irritation for the PCI, which was engaging in an historical compromise. This political influence was dubbed "the Foucault effect" by the Italians—and that was the real target of *Il dispositivo Foucault*.

Rella's introduction to the book is perfectly explicit. First it travesties Foucault's analyses of the plurality of power relations into a metaphysics "of power," an abstract, immaterial power supposed to be everywhere and therefore politically nowhere: "the only history of powers is a history of the spaces in which power becomes visible." And then, leaning heavily on Teyssot's article as the sole source of knowledge concerning the heterotopias, it continues: "the non-place of power stands at the center of an infinity of heterotopian localizations."

Heterotopia thus became a "central element" in Foucault's thinking, and heterotopology becomes the phenomenology of the anarchic dispersion of power. The conclusion of this interpretation is as expected: "one no longer struggles against power, vested as it is in myriad localizations (or *dispositivi*, "systems") but instead against the tyranny of totalizing theories." Theories which Rella identifies clearly in a note: "the Marx effect."

Rella's interpretation can be immediately countered with the fact that Foucault never described the Panopticon—which for him was the paradigmatic articulation of space and power—as a heterotopia. Paradoxically, Teyssot's essay "Eterotopia e storia degli spazi" ("Heterotopia and the history of spaces," the only one of the series devoted to the heterotopias), makes no reference to an analysis of power but rather to the analysis of discontinuities theorized in *The Order of Things*.[26]

Teyssot carried out three operations, all decisive, but each on a very different level. First, he inscribed Foucault's invention of the heterotopias, which had never before been discussed, within a problematics of space. Second, he drew a general theory of space from the group work on the curing machines and on habitat, a theory which would become the *doxa* of the eighties. And third, he extracted an architectural epistemology from Foucault's method. The first operation was an evident reduction of the semantic field opened by the redefinition of the heterotopias in the 1967 lecture.

Teyssot quotes it, from the Italian publication of 1968. He begins with the topological definition of the heterotopias, proposed in 1967 as "counter-sites . . . in which the real sites, all the other real sites that can be found within the culture, are simultaneously represented, contested,

and inverted." And yet strangely enough, he makes a taxonomic use of this definition, as in the preface to *The Order of Things*.

He does not discuss the lecture itself, but rather puts its analytic value to the test by applying it to an eighteenth-century hospital project described by the historian J.C. Perrot.[27] Like the grid of a waffle iron, his plan distributes eight classes of patients in eight distinct buildings. The patients are as heterogeneous as the categories of animals in Borges' encyclopedia: a. prisoners at the demand of their families; b. madmen, prisoners by royal edict; c. poor and legitimate children from two to nine years, the elderly, beggars, and prostitutes afflicted with venereal diseases; d. bastard children over nine years; etc. The incongruity of the contents is what defines the architecture as a heterotopia—not the qualitative or symbolic play of opposition-contestation with respect to existing spaces that the heterotopia institutes through its function, its form, and its ruptures.

Teyssot's use of heterotopia transcribes nothing of the deeper embeddedness of spatiality in the totality of human existence: the heterogeneity and discontinuity of lived temporalities, the thresholds of life, the biological crises (initiation, puberty, deflowering), Eros and Thanatos. In every culture, the spatializations of subjectivity in all its forms, from the brothel to the bath house—and not just the major functions of the Charter of Athens—have received a specific inscription in space, or rather in spaces, which do not exist in a relation of division with respect to each other, such as inside/outside, margin/center, public/private, but rather in a formal play of differentiation and reverberation: in short, in the register of communication. When Rella makes Foucaultian space into the neutral and continuous receptacle of the heterotopias of power (the totalizing conception) and when Teyssot makes heterotopia into the architectural articulation of the world's incongruities (the localizing conception), they both miss the third dimension, the capacity of space to refer back to itself in the density of a formal and symbolic play of contestation and reverberation, in a fragmentation which is not segmentation, but rather the "Thirding" that Edward Soja theorizes in these terms: "the Thirding as othering."[28]

Both Rella and Teyssot missed the monadic, Leibnizian dimension of the heterotopias: each formally complete and referring to all the others. But that is an evaluation of heterotopia which would only appear in the nineties.

The second "Teyssot effect" stems from the taxonomic interpretation of the heterotopias. Can the transformation of the hospital-grid with its eight compartments full of such incongruous contents really be conceived within the category of a continuous progress of reason? Did-

n't it require, on the contrary, a deep discontinuity of practices, of perceptual and classificatory schemata, a discontinuity of the gaze, of discourses and knowledge, a rupture and a redistribution of the conceptual structure that held together the visible and the verbal? One must "keep in mind this temporal discontinuity in order to understand the discontinuous structuring of modern space," concludes Teyssot. A proposal which would resurface in the IBA exhibition in 1984.

But does the discontinuity of our systems of thought[29] necessarily imply that architecture should be understood as part of the "episteme" of an era, as part of what Foucault calls the "spaces of order"—the preconditions for the formation both of discourses and their objects, whose discontinuity punctuates the discontinuity of our sciences? Is there, in other words, a logos of architecture, asks Teyssot? Or are we in the presence of the multiplicity of discourses analyzed in Foucault's seminar, with their links to independent disciplines and to social, discursive, technical, and economic practices in constant negotiation, in reciprocal relation and perpetual variance, even in confrontation? To this multitude of rationalities and interventions, Teyssot adds the expression of the social body through its elected representatives, its pressure groups, and its urban struggles.

Thus the initial reception of the heterotopias in *Il dispositivo Foucault* demonstrates the ambiguity of the notion of reception: it is neither a matter of the exact comprehension nor of the real instrumentalization of an idea, but rather of a polysemic and polemical reimplantation of that idea in a network of political debates, on the one hand, and of renewed epistemological inquiry, on the other.

To complete this picture of reception, I must add that Foucault marked his own reception of it by confiding to Bruno Fortier that when he read the the little volume he felt like he was "in the skin of Althusser being dissected by Trotskyists." Thus he chose an exclusively and ironically political vocabulary to express this reception of his reception.

Already in July of 1976, Foucault had evoked his 1967 lecture in an interview on Bentham's Panopticon, published in 1977 and mentioned by Teyssot. It contains these remarks: "A whole history remains to be written of *spaces*—which would at the same time be a history of powers (both these terms in the plural)—from the great strategies of geopolitics to the little tactics of the habitat, institutional architecture from the classroom to the design of hospitals, passing via economic and political institutions. It is surprising how long the problem of space took to emerge as a historico-political problem. . . . I remember ten years ago or so discussing these problems of the politics of space, and being told that it was reactionary to go on so much about space, and that time and the 'project' were what life and progress are about."

Nothing prevents us from supposing that these sentences had previously been "received" by Teyssot as well.

A Foucaultian history of spaces, or more precisely of the spatialization of power, or even more precisely of the inscription in colonial—heterotopic—space of the particular regime of power which develops from the eighteenth century onwards and which Foucault calls biopower,[30] on the basis of which the problems of space become politically different, is the project undertaken in the early eighties by the anthropologist Paul Rabinow[31] and the American historian of habitat, Gwendolyn Wright.[32] But neither they, nor François Béguin who also devoted himself to a history of colonial architecture, knew of the 1967 lecture.

In their introduction to an interview with Foucault published in the architectural journal *Skyline* in 1982,[33] Rabinow and Wright recall the philosopher's "spatial obsessions," quoting the earlier interview in *Hérodote* where he remarks that "through them I did come to what I had basically been looking for: the relations that are possible between power and knowledge." Thus architecture and urbanism do not constitute an isolated, entirely autonomous field. In the interview that follows, Foucault banishes any utopian hope from the architect's practice: "Men have dreamed of liberating machines. But there are no machines of freedom, by definition. . . . I think that it can never be inherent in the structure of things to guarantee the exercise of freedom. The guarantee of freedom is freedom."

Foucault then lets his faraway concept of heterotopia float back to the surface of this masterful political and epistemological discourse on space: "To make a parenthetical remark, I recall having been invited, in 1966, by a group of architects to do a study of space, of something that I called at that time 'heterotopias', those singular spaces to be found in some given social spaces whose functions are different or even the opposite of others. The architects worked on this, and at the end of the study someone spoke up—a Sartrean psychologist—who firebombed me, saying that *space* is reactionary and capitalist, but *history* and *becoming* are revolutionary. Today everyone would be convulsed with laughter at such a pronouncement, but not then."

One cannot but be struck by this long anamnesis in two phases: first the memory in 1976 of the political objection made in 1967, then finally in 1982, the memory of the concept of heterotopia itself. In 1984 Foucault could favorably accept the reutilization of his lecture by the IBA in Berlin.

The exhibition's two organizers, the German Johannes Gachnang and the Italian Marco de Michelis, both knew the text through its publication in *Archittetura* in 1968.[34] It fit in well with the IBA's strategy, as expressed by one of its two framers, J.-P. Kleishues: "carrying out the idea of a city by fragments,"[35] speaking of urban architecture without first drawing up an overall city plan; respecting the historical and topographical variety of Berlin; conceiving the composition of the city by islands and even confiding the reconstruction of the lodgings in the same island to several different architects.

The text was translated into English in 1986 and first published in the interdisciplinary journal of Cornell University, *Diacritics*, and then in the architectural journal *Lotus*.[36] These events inaugurated a new career for the qualitative interpretation of the "other spaces." One can hardly understand this without referring to the simultaneous translation of volumes II and III of the *History of Sexuality* (1984, English trans., 1985-6) which made Foucault into a reference for what the Americans call "identity politics." The feminist, gay, and ethnic movements formed the new network of inscription and reevaluation of the heterotopias. The history of the modes of subjectivization undertaken by Foucault runs directly through such texts as "The spaces that differences make," by the urbanist Ed Soja,[37] "Gendered Spaces," by the feminist Daphne Spain,[38] "The new cultural politics of difference," by Cornel West,[39] or the work of the geographer Derek Gregory.[40] Literary analysis, the site of the heterotopia's emergence, reappropriated the concept with Brian McHale and Michel de Certeau,[41] filmic analysis with Giuliana Bruno.[42] Foucault, as Soja observes, became the passageway toward any analysis of space.

Nancy Spector, presenting the works of the Cuban plastic artist Felix Gonzalez-Torres, described an experimental "heterotopian environment" carried out in Manhattan.[43] On twenty-four Manhattan billboards, Gonzalez-Torres pasted up a counter-space constituted by an immense black-and-white photograph of the intimacy of an open bed; the absolute simplicity of crumpled sheets, the slightest imprint of two heads on the pillows, where everyone could project the interruption of sleep or the end of love, or more radically, the artist's warning: a decision of the Supreme Court in 1986 authorizes the forces of the law, in those states where sodomy is still a crime, to prosecute it even between consenting adults. In short, the intimacy of the private space of the bed has entered public space. As Spector adds, this articulation of public and private space could give voice, or cry, to another, more muted story: the missing imprint of the artist's companion, a victim of AIDS.

What a marvelous intuition of Foucault's radio talk in 1966: precisely the passage cut from the 1967 lecture for the architects, where the philosopher evoked the parents' bed as the first figure of heterotopia, the place that children love to penetrate for the pleasure of transgression and the reverie of origins. Why shall we not conclude that the long

series of the text's reinscriptions in multiple networks and strategies and the long series of transformations in the social figure of the author find the most complete form of reception in this single instant of their arc?

Didn't Foucault often declare that he sought not readers, but users?

1 Foucault, M.: "Des espaces autres," in *L'Archittetura, cronache e storia* 150, vol. 13, 1968, pp. 822-23.

2 Foucault, M.: "Des espaces autres," in AMC, *Revue d'Architecture*, Oct. 1984, pp. 46-49.

3 Soja, E.: *Thirdspace: Journeys to Los Angeles and other real imagined places* (Cambridge, Mass.: Blackwell, 1996), p. 11.

4 'Foucault, M.: "Utopie et littérature," recorded document, December 7, 1966, Centre Michel Foucault, Bibliothèque du Saulchoir, reference C116.

5 Foucault, M.: preface to *The Order of Things* (New York: Pantheon, 1971).

6 All these details concerning the Cercle des Etudes Architecturales were communicated to me by P. Riboulet, whom I thank.

7 Foucault, M.: "Questions à Michel Foucault sur la géographie," in *Hérodote* 1, 1976, pp. 71-85; English translation as "Questions on Geography" in Foucault, M.: *Power/Knowledge: Selected Interviews and Other Writings*, 1972-1977, ed. C. Gordon (New York: Random House, 1981).

8 Auzelle, R.: *Dernières demeures* (Paris: by the author, 13, place du Panthéon, 1965).

9 Foucault, M.: *Discipline and Punish*, tr. A. Sheridan (New York: Vintage Books, 1977). The work presents Bentham's Panopticon as an "event in the history of the human mind," and proposes an analysis of power in terms of production, not repression.

10 Riboulet, P.: thesis in sociology, Université Paris VIII; Cohen, J.-L.: diploma in architecture.

11 Eizykman, B.: "Urbanisme," in Traverse 4, 1976, quoted by A. Thalamy in *Politiques de l'habitat* (Paris: Corda, 1977), p. 14.

12 "Généalogie du capital I: Les équipements du pouvoir," *Recherches* 13, December 1973; the publication contains the only example of a discussion of Henri Lefebvre in Foucault's entourage, concerning *La pensée marxiste de la ville* (Paris: Casterman, 1972).

13 *Recherches* 13, December 1973, pp. 27-31, 183-6; reprinted in Foucault, M.: *Dits et écrits* (Paris: Gallimard, 1994), vol. 2, pp. 447-56.

14 Tenon, J.-R.: *Mémoires sur les hôpitaux de Paris* (Paris: 1778).

15 Foucault, M., Barrer-Kriegel, B., Thalamy, A., Béguin, F., Fortier, B.: *Les machines à guérir: aux origines de l'hôpital moderne* (Paris: Institut de l'environnement, 1976; reprinted in Brussels: Pierre Mardaga, 1979).

16 Bentham, J.: *Le panoptique*, preceded by "L'œil du pouvoir," interview with Michel Foucault (Paris: Belfond, 1977), facsimile of the French edition of 1791; the interview is translated into English as "The Eye of Power," in *Power/Knowledge*, op. cit.

17 Poyet, B.: *Mémoire sur la nécessité de transférer et reconstruire l'Hôtel-Dieu suivi d'un projet de translation de cet hôpital* (Paris: 1785).

Felix Gonzalez-Torres
Untitled, 1991

Felix Gonzalez-Torres
Untitled, 1991

311

[18] Alliaume, J.-M.: Barrer-Kriegel, B., Béguin, F., Rancière, D., Thalamy, A.: *Politiques de l'habitat 1800-1850* (Paris: Corda, 1977), study completed under the direction of M. Foucault.

[19] Béguin, F.: *Arabisances, décor architectural, tracé urbain en Afrique du Nord 1830-1950* (Paris: Dunod, 1983, and *Paysages* (Paris: Flammarion, 1996).

[20] Peter, J.-P.: "Nous, Pierre Rivière," interview in *Sociétés et représentations* 2, November 1996, pp. 347-360.

[21] *Hinterland* 3, vol. 1, May-June 1978, trilingual issue under the title "Segregazione e corpo sociale," devoted to surveillance architecture.

[22] Leaman, A.: *Environment and Planning* 11, 1979, pp. 1079-82.

[23] Zukin, S.: "A decade of the new urban sociology," in *Theory and Society* 9, 1980, pp. 575-601.

[24] Cacciari, M., Rella, F., Tafuri, M., Teyssot, G.: *Il dispositivo Foucault* (Venice: Cluva, 1977).

[25] Foucault, M.: *Microfisica del Potere: interventi politici*, eds. Fontana and Pasquino (Torino: Einaudi, 1977); an augmented version was published by the alternative movement in Berlin under the title *Dispositive der Macht* (Berlin: Merve, 1978).

[26] Teyssot, G.: "Eterotopia e storia degli spazi," in *Il dispositivo Foucault*, op. cit., pp. 83-6; English translation as "Heterotopias and the history of spaces," in *Architecture and Urbanism* 121, 1980, pp. 79-100.

[27] Perrot, J.-C.: *Genèse d'une ville moderne, Caen au XVIIIe siècle* (Paris: Mouton, 1975).

[28] Soja, E.: *Thirdspace: Journeys to Los Angeles and other real imagined places*, op. cit.

[29] The chair in philosophy held by Michel Foucault at the Collège de France was entitled "The History of Systems of Thought."

[30] Foucault, M.: *The History of Sexuality*, vol. I: *An Introduction*, chap. 5: "Right of Death and Power over Life," tr. R. Hurley (New York: Pantheon, 1978).

[31] Rabinow, P.: "Biopower in the French Colonies," lecture delivered at the interdisciplinary sysmposium *Foucault: Knowledge, Power, History*, Los Angeles October 29-31, 1981; *French Modern: Norms and forms of the social environment* (Cambridge, Mass.: MIT Press, 1989).

[32] Wright, G.: *The politics of designs in the French colonial urbanism* (Chicago: Chicago University Press, 1991); Béguin, F.: *Arabisances*, op. cit.

[33] Foucault, M.: "Space, Power, Knowledge," interview with Paul Rabinow, *Skyline,* March 1982, pp. 16-20; reprinted in *The Foucault Reader*, ed. P. Rabinow (New York: Pantheon, 1984).

[34] This information provided by Françoise Joly, who consulted with the two organizers.

[35] Kleishues, J.-P.: "A propos de la ville européenne," interview with M. Bourdeau, *AMC* 5, October 1984, pp. 95-9.

[36] Foucault, M.: "Of Other Spaces," in *Diacritics* 1, vol. 16, Spring 1986, reprinted in *Lotus international*, 1986, and in the present volume.

[37] Soja, E.: "The spaces that differences make," in *Place and the politics of identity*, eds. Keith and Pile (New York: Routledge, 1993), pp. 183-205.

[38] Spain, D.: *Gendered Spaces* (Chapel Hill: University of Carolina Press, 1992).

[39] West, C.: "The dilemma of the Black Intellectual," in hooks, b., and West, C.: *Breaking Bread* (Boston: South End Press, 1991).

[40] Gregory, D. *Geographical Imaginations*, quoted in Soja, *Thirdspace*, op. cit.

[41] McHale, B.: *Postmodernist fiction* (New York: Routledge, 1988); De Certeau, M.: *Heterologies: discourse on the other* (Manchester; Manchester University Press, 1986).

[42] Bruno, G.: "Bodily Architectures," in *Assemblages*, December 19, 1992.

[43] Spector, N.: *Felix Gonzalez-Torres* (New York: The Salomon R. Guggenheim Foundation, 1995).

Pier Paolo Pasolini

Mamma Roma, 1962

The City Front

What is Rome? Which is Rome? Where does Rome begin and where does it end? Rome is surely the most beautiful city in Italy—if not in the world. But it is also the ugliest, the most welcoming, the most dramatic, the richest, the poorest. The cinema has done much to make it known, even to those who do not live there. Yet one must be cautious. The neorealistic taste that has presided over the films about Rome is too enamored with the quick sketch and the local dialect, with humanist optimism and twilightism: all those things with their medium-gray and rosy tones can never convey the atmosphere of this city which is so dramatically contradictory. Rome's contradictions are difficult to surmount because they are of an existential order: more than the terms of a contradiction, the wealth and squalor, the happiness and the horror of Rome are part of a magma, a chaos.

For the foreigner and the visitor, Rome is the city contained within the old renaissance walls: the rest are the vague and anonymous fringes, not worth seeing.

Inside the wall is a stupendous Italian city which instead of having only classical, medieval, city-state, renaissance, or baroque traditions, has them all together. If sectioned off, Rome would present an extraordinary quantity of strata: and that is its beauty. Add the sun, the sweet air, the laughing ease of life outdoors—which is never idyllic, but always has a dramatic undercurrent, and so can never wear on you, but always remains vibrant, stirring . . . And add the fact that the grand and the petty bourgeoisie, on the outside, do not play any significant role in the city center, which is still characterized only by the people as in the southern or Bourbon cities, with all their fictitious gems of delightful vitalism and servile paganism.

Unknown to the tourist and the upstanding gentleman, nonexistent on maps, this Rome is an immensity.

A few glimmers of this disproportionate city sinking into its thousand grandiose and stagnant districts could still be caught even by the half-witted tourist or the upstanding gentleman who shields his eyes, if either would but glance out the window of the train or the pullman transporting him. Here and there before his unseeing gaze would fly fragments of shantytowns, stretches of little houses like Bedouin cities, unhinged slipshod apartment blocks and sumptuous cinemas, ex-farmhouses studded between skyscrapers, dikes of towering walls and muddy alleyways, sudden voids where excavations and meadows with a few scattered flocks reappear, and in the background—in the burnt or muddy countryside, all hills, mounds, ditches, old basements, tablelands, cesspools, ruins, sewer pipes, and filth—the city front.

Now it is a dazzling strip of houses snaking along the contorted horizon. Now it is a colored stack, grandiose like an apparition, on the unforeseen rib of a promontory. Now it is an enormous gray wall that weighs over viaducts and bridges like a precipice.

It is not easy to give a little order to this chaos. Types and zones can nonetheless be distinguished, if only by gradations in the standard of living. First there is a generic periphery, which is called residential and where ugliness must be aesthetic, despite the sun. But the periphery of a popular type already takes on inhuman aspects, violent, inaccessible, difficult to interpret.

Around the true and proper city—with its complicated but traditional agglomerations, with its inextricable but historic nodes of "cultural levels"—the skein of the consular streets (via Appia, Prenestina, Tuscolana, Casilina, Aurelia, etc.) forms another city; and no one really knows if it is centrifugal or centripetal, if it springs out anew or if it masses around the old to meld into it, like the enormous encampment of a besieging army.

Sometimes it appears as if born by accident, meaninglessly grown gigantic, living an existence neither integral not marginal. At a certain moment, for whoever observes this city swelling year by year, month by

month, day by day, there seems to be no other way of grasping it than with the eye. The visual spectacle is so overwhelming, so grandiose, without any discernible continuity, that it seems everything could be intuitively resolved into an uninterrupted series of observations: framings, I'd almost like to say, from an infinity of extremely particular close-ups to an infinity of unbounded panoramas.

The spectacle for the eye is inexhaustible: from Monte Mario to Monte Verde, from San Paolo dell'Appio and Prenestino to Monte Sacro, the architectural explosion is limitless.

It is extremely difficult to describe the form of this advancing city front, because one would have to repeat oneself a thousand times and be a thousand times diverse; but it is no less difficult to describe the people there.

Everyone knows that Rome is still swarming with subproletarians (Trastevere, Borgo Panico, Campo dei Fiori, etc.); and therefore with anarchy, with riffraff. The first Roman factories and workshops are now beginning to line up along the Tiburtina. The single living industry—at least until a few years ago—is cinematography, the champion industry of the world of Roman labor: an industry that does not necessarily imply class consciousness; where one indeed works, but which tends nonetheless to perpetuate the psychological state of servile passivity, conformism, etc., typical a in city of such recent (and imported) traditions of democracy.

The hundreds of thousands inhabiting the new quarters—and the old ones, formerly almost rustic, encircled and studded with the new—belong, at least in so far as it is possible to describe such complex phenomena, to a new type of Roman laboring class. One the outside, with its dialects and jargon, its attitudes and unblinkered intelligence, its lightness and the strange modernity of its moral life, this class retains its accustomed appearance: but the more regular tenor of life, the high degree of mixture with immigrants from North and South, the marginal life so particularly exposed to bourgeois "ideological bombardment," tends to transform the substantial jumble of anarchy and common sense into an Americanizing noncommittalism, something "standard," the obsessive repetition of a single type of human being, represented hundreds of thousands of times.

Life—so diverse and tumultuous in these boundless quarters—then shrinks into elementary and monotonous forms.

This problem of man reduced to the relation of residential periphery/working center, and forced into endlessly repeating the acts of his own internal life-system, is extremely acute, but nonetheless regards more the future than the confused becoming of the present.

For whoever attempts to look behind the city front, the immediate problem is yet another, and a very simple one. Despite the architectural eruption, the difficulty of obtaining lodging remains unchanged. The one hundred and ten thousand units constructed last year leave things just as they were. And to this can be added the impending tragedy of unemployment among the construction workers.

On the inside, then, the city front has two faces: those who build and those who inhabit.

Those who build are few, and what their operations consist of is notorious to all, after the real-estate scandal and the continual denunciations in the free press. Those who inhabit are an enormous quantity, and though they are quite proud to be squeezed into their new apartments on the seventh floor of the hundredth building on the crest of a hill, still they are sleeping four or five to a room. The comfort used as a lever for the ideological influence of the class in power, giving rise to the age of the television and the pinball flipper, and forming the basis for that type of Americanism which we pointed to above, is in reality still disorder, poverty, precariousness: all the more serious because it presents itself as comfort, as improvement—when everything, on the contrary, is still waiting to begin.

1958. From: *Storie della città di dio*, Turin, 1995.

Fabrizio Gallanti

1945–1967 Political Architecture in Italy, Part 2

With these internal activities proceding apace, Italian architects also ventured out onto the international scene from which they had been absent for twenty years.[19] Italian architectural research was intimately enmeshed with the final vicissitudes of the CIAMs: the problems formulated and the solutions proposed at each congress sketched out the field of operations for the following years. The theme of reconstruction was fundamental at the early meetings: Bridgwater in 1947, Bergamo in 1949, Hoddesdon in 1951, Aix-en-Provence in 1953. Basic principles were defined as guidelines for the interventions and efforts were made to indicate the institutional references and economic forces able to assure their realization.

For those most deeply involved in the reorganization of the CIAMs, the answers were already contained in the La Sarraz declaration of 1928 and in the Athens Charter of 1933 (published in 1943); these were used as guiding criteria for the reconstruction.

The will to build up a theoretical and methodological discourse of international scope, founded on a capacity to confront diverse experiences, determined a tendency within the CIAMs to unify languages and symbols. But Italian architecture took its distance from the themes shared by international culture, introducing different levels of confrontation: in the realm of theory, with Zevi and Rogers; in the realm of urbanism and the relation to the city, with the master plans of Assisi, Padova, Pavia, Urbino, Siena, and Bergamo; and in the assessment of the formal heritage of the modern movement, with the works of BBPR, Gardella, De Carlo, and later, Gae Aulenti and Gabetti and Isola.

At the Bergamo congress, two different interpretations emerged of the research conducted between the two wars: Siegfried Giedion and Bruno Zevi were primarily opposed over the evaluation of what should be understood by "modern." Zevi was convinced that architecture had entered a "postrationalist" phase and that the CIAM program should therefore be brought to a close. The reflection within the CIAM group had turned, on the contrary, toward fostering the "growth of a new tradition."[20]

This was the context in which Ernesto Nathan Rogers developed a critical attention to the heritage of the modern movement, linking back to the ethical dimension of Persico and Pagano's thinking. From Rogers' viewpoint, the problem was to overcome the abstract schematism of "modern" language, in order to confer a new degree of modernity on architecture. What should be learned from the masters of the modern movement was not so much their formal proposals as their methodological and moral teaching. Following the phenomenological investigations of Antonio Banfi and

Mamma Roma, 1962

It was in this sense that the theme of "environment" or *ambiente* became so important in Italian culture: it was a matter of paying close attention to the urban context, above all that of the historic city centers. Obviously enmeshed in the themes of history and tradition, the city centers were also the nodal points around which clustered the new architectural interventions. For Rogers, the attention to the thematics of the historical city was conveyed by the phrase *preesistenze ambientale*, or "pre-existing environment," which can be linked either to a more respectful attitude to the traditional city or to a concern, once again of Gramscian origin, for relations with social reality:

"Against cosmopolitanism, which works in the name of an insufficiently deep sentiment of the universal, and raises the same architecture in New York, Rome, Tokyo, and Rio, in the middle of the countryside or in the city, we must seek to harmonize our works with the pre-existing environment, whether natural or historically created by human ingenuity."[23]

Rogers' complex positions might best be summed up with this declaration of intent: "We still believe in the utility of an ideal battle in the field of architecture, in its profound human, political, and social content, its antifascist, democratic, progressive orientation."[24]

Enzo Paci, Rogers brought the idea of crisis to the center of his reflection. Modernity demanded continual crisis and revision; thus Rogers focused on two apparently opposite concepts: continuity or crisis? He opted for both at once, and asserted that when history is considered as a process, it can always be said to be continuous or in crisis, depending on whether one accepts the persistances or the changes.[21] In any event, Rogers always concluded his explorations of the dilemma with reflections on the continuity of the modern movement's unexploited horizons.

The concepts that Rogers reintroduced into Italian culture and then brought to the level of international debate through his role in the CIAMs are those of tradition, history, environment, and monument.

For Rogers, tradition is nothing other than the unified presence of multiple experiences. Transferring this recovery of history to the ideas of the modern movement, he wrote:

"We have had to regain the meaning of tradition, for even though it lives on implicitly in architectural works (through the sole fact that modernity is always an act of profound culture), it was temporarily set aside amid the revolutionary action of a polemic that had to color every contingent action in order to lay low the obstacles of academic, nostalgic, reactionary culturalism."[22]

The work of Rogers is an effort to construct a theory of contemporary architecture that can answer the internal demands of the discipline and at the same time align itself with the social, cultural, and political objectives that the left opposition in Italy had proposed as a response to the growth of capitalism: for Rogers, architecture was not simply a formal and aesthetic fact but also a human and social fact. Such a line denoted an increasing distance from some of the themes proper to the modern movement and the CIAMs and a proximity to some of the exponents of Team X, in particular the Smithsons, concerning the attitude to be taken toward the so-called masters.[25]

[19] With the Liberation, characterized by lively cultural debate and radical critical revision, Italian architecture made its re-entry to the international scene. To be sure, the urbanistic situation was disastrous ('we will declare to Moscow that, despite everything, we prefer this chaos to the absence of freedom,' said Piccinato, 'but we will add that to keep this freedom we must plan democratically'). Nonetheless, the architectural situation seemed positive, reflecting the creative vitality of the postwar period, the victories and the hope, as well as the illusions of the civil climate created by the resistance." Zevi, Bruno: "Spettro del provincialismo: Italiani col cannocchiale alla rovescia," in *L'Espresso*, April 27, 1958.

[20] For the phrase, see Giedion, Siegfried: *Space, time and architecture: the growth of a new tradition* (Cambridge, 1941).

[21] Rogers, Ernesto Nathan: "Continuità o crisi," in *Casabella-Continuità* 215, April-May 1957.

[22] Rogers, Ernesto Nathan: *Esperienza dell'architettura* (Torino, 1958), p. 251.

[23] Ibid, p. 139.

[24] Ibid, p. 187.

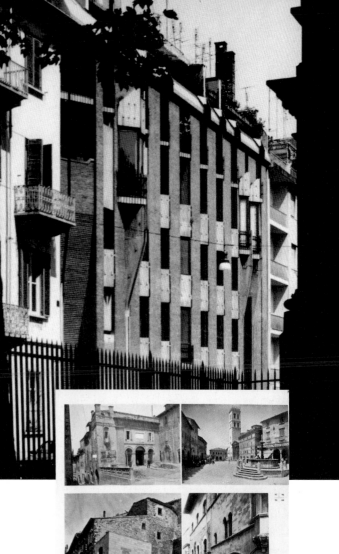

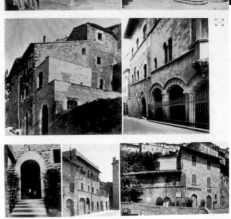

Giovanni Astengo
Master plan of Assisi, 1955.
Analytic table of the nineteenth-
century elements inserted in the
medieval fabric of the city, part
of a careful photographic mapping
of the built heritage of Assisi.

The intense urbanistic production of the fifties, particularly in the small Italian cities, displays the use made by Italian culture of the themes expressed by Rogers. For the architects of the mid-fifties, who had already faced the questions of reconstruction and of the new construction of entire residential districts for the urbanization of rural populations, the theme of attention to the traditional city became preeminent. Against the predictions of a thinning out or destruction of the ancient architectural fabric, against the urbanistic-hygienic prescriptions of functionalism, the Italian urbanists proposed a meticulous exploration of the built and social heritage of the city, a methodology of analysis and interpretation to be carried out on the body of the historical city.

Architectural culture took a position against the speculative processes of urban transformation, defending the city as a place for collective endeavor, as the expression of a free society and the patrimony of a culture. This, indeed, was a political position.

The Hoddesdon CIAM of 1951 was entitled "The Heart of the City." Here the analytic formulations and proposals of the old guard appeared either to be marked by an arcadian idealism or wholly estranged from any attention to the changes in reality that were occurring beneath the architects' eyes. After a period of almost total indifference to the historical centers, belated misgivings incited modern architects to a rethinking of this theme. The hypothesis that emerged was to give the new settlements a center or "heart" where the citizenry could gather and where the quality of public space was characterized by the monumental imprint of the public institutions that enclosed it. This was a response to the growing alienation of the new urban quarters born of functionalist thought. The heart was supposed to present the same social and spatial valences as the old city centers (the Italian examples receiving the closest examination); as though the so-called heart contained a magical, almost thaumaturgic virtue.

In the course of the fifties, the master plans for the principle Italian cities were elaborated one after the other. The most interesting were those of the smaller cities: Ivrea in 1952 by Quaroni; Padova in 1954 by Luigi Piccinato; Siena in 1954 by Piccinato again, with the assistance of Bottoni and Luchini; Assisi in 1955 by Giovanni

Astengo; Urbino in 1958 by De Carlo. In very different and personal ways, these plans reflect on the problem of the historical centers and on how to integrate them to the current transformation of the cities. The extremely attentive and detailed concern for the morphology and the state of conservation of the existing buildings was complemented by an inquiry into the people who inhabited the places, recognizing the reciprocal relations between inhabitants and spaces in the city. The solutions offered were different, and one cannot assert the existence of a common line of research. In 1960 a colloquium was organized in Gubbio on the preservation and renewal of the artistic and historical city centers. All these preoccupations stand out clearly from the central line of thinking expressed by the CIAMs, with their debt to Le Corbusier's view of the city center principally as a problem of a technical and hygienic nature, for which the ideal solution was demolition. Whether in the work of the Italian architects or in the theory of some of the CIAM members, in particular Aldo van Eyck, the beginnings of a non-functionalist, psychological and anthropological view of the city began to take hold.

At the decade's close, Italian architecture found itself at the center of polemics that shook architectural culture internationally. These disputes crystallized in two particular moments: the publication of Reyner Banham's article on neoliberty and the final CIAM in Otterlo in 1959.

These two events came as amplifications from abroad of questions already raised in preceding Italian debates, in particular by the so-called "young men of the columns"[26] in 1955 and by the publication of a photograph of the Bottega di Erasmo in Turin in issue 215 of *Casabella*, along with a letter entitled "Engaging with Tradition"—a clear assertion by Gabetti and Isola of a desire to abandon or at least bring under discussion certain theses of the modern movement. In fact, a revision of the modern movement was already underway in Italy. Inspired by the positions of Rogers (who himself attacked the neoliberty trend in the same journal where its first projects were published), Italian architecture began to seek its references for the construction of the city in other traditions. As Tafuri observes:

"The scandalous thing was the assertion that the movement had failed, that its ethical ideals had been converted into superfluous formal regimes. As long as the 'recovery of the variables left free' by the founding fathers did not seem to crack the stronghold of the modern movement, any incursion into heterodox languages was considered justified and healthy; but once its theoretical networks had been eliminated, and on the verbal level to boot, it was deemed necessary to cast anathema on whoever pointed a finger to the crisis."[27]

Banham's famous article appeared in April 1959 in the pages of *The Architectural Review*.[28] For him the Italian betrayal of modern architecture was not limited to the young representatives of the neoliberty movement, but also included more notorious culprits: BBPR with the Velasca tower, Figni and Pollini with a house in via del Circo in Milan, Gardella with the Zattere house in Venice, and all the great names of Italian rationalism with the Italian pavilion at the universal exhibition in Brussels. The core of the attack developed around two themes: the first critiqued the choice of neoliberty as a cultural and aesthetic reference to the preceding generation of projects, while the second saw the affirmation of neoliberty's stylistic inclinations as a lack of engagement, replaced by a recrudescence of bourgeois taste satisfied with backsliding into redundant mannerist formulas. Particularly memorable is the closing line: "Even by the purely local standards of Milan and Turin, then, neoliberty is a childish regression."

The centrality of Italian culture, was confirmed by the develop-

[25] "*Esperienza dell'architettura* contains beautiful 'vignettes' on the four pillars of architecture: Frank Lloyd Wright, Walter Gropius, Le Corbusier, Mies van der Rohe. In his brilliant synthesis of the master figures, Rogers devotes himself to diplomatically composing a unified picture, while fully aware that the voices in this chorus are discordant. The conceptual instrument he introduces to overcome the contradictions between the different personalities is the identification of a methodological principle which he borrows from Gropius. It is by virtue of such Gropiusian methodological principles that the unity of the modern movement is possible for Rogers, beyond the individual contributions and poetics." Nicolin, Pierluigi: *Notizie sullo stato dell'architettura in Italia*, op. cit. p. 49.

[26] "Some time ago it happened that a group of students at an Italian architecture school suddenly began drawing projects with columns, capitals, and flowery pinnacles [Aldo Rossi, Guido Canella, and Giorgio Grassi, among others—F.G.]. . . . For this reason the recent revolt—the young men of the columns—is not particularly surprising. Indeed, in its intial inspiration there is a positive meaning. Above all because it represents a refutation of the conformism and the little tricks that poison the atmosphere of the school. . . . Their columns have no new content; they are still the old columns of eclecticism, the usual symbols which bureaucrats, dictators, and bankers use to whimper the praises of Universal Man. / However, the problems of contemporary architecture have nothing to do with Universal Man. They concern the common and always specific man who needs houses, schools, public buildings, streets, plazas, neighborhoods, etc., always different for every environment, every situation, every circumstance. / These problems will not be solved by miraculously ressuscitating dead and mummified languages. They are confronted by submitting all preceding architectonic facts to strict and serious criticism, by finding the means to better comprehend and to participate with the people for whom we work, by clarifying the meaning of the architect's trade in the context of the society we live in." De Carlo, Giancarlo: "Problemi concreti per i giovani delle colonne," in *Casabella Continuità* 204, 1955.

[27] Tafuri, Manfredo: *Storia dell'architettura italiana 1944-1985*, op. cit., p. 72.

[28] Banham, Reyner: "Neoliberty: The Italian Retreat from Modern Architecture," in *Architectural Review* 747, April 1959.

[29] A few lines in some of the specialized journals noted the end of the CIAMs, like a minor event: "Nei CIAM precluse le idee," in *Architettura* 44 (the journal directed by Bruno Zevi), May 1959 ; Rogers, Ernesto Nathan: "I CIAM al museo," in *Casabella* 232, October 1959; "Rencontre des

ments of the Otterlo CIAM, though in a somewhat neg-ative sense. Already in 1953, the very meaning of the CIAM's continued existence was brought into question from within the congress and its organizing structures. One of the possible causes triggerring the re-evaluation of the CIAM's role was the appearence on the scene of rational architecture elaborated in developing countries. The rationalism promoted by the congresses was under-cut in its ideological and formal principles by the con-frontation with the social and technological realities of these countries, as it had been in Italy itself in certain respects. At CIAM IX in Aix-en-Provence in 1953, the future members of Team X, among them De Carlo, met admiringly around the *grilles* of the Atbat and Gamma CIAM groups from Morocco, thus demonstrating a par-ticular sensitivity to an architecture that was almost antithetical to certain aspects of rationalist dogma.

The deep crisis of the CIAMs might then be read as a crisis of modernity: the international style, its language and above all its means of production could not adapt and therefore could not take hold in social and cultural situations so far from the soil that had given it birth. Indeed, the orthodoxy of rationalism gave rise to an architecture fit only for a heavily industrialized society, while much to the contrary, the most attentive architects of the Third or almost-First World (Italy in the fifties) were experimenting with an adaptation, or better, a dis-tortion of the compositional syntax of rationalism.

After a long series of reschedulings, the final CIAM meeting was held in 1959 in Otterlo. Unlike previous edi-tions, which had a theme of discussion, this time the works of the delegates were simply to be compared. Two external members were invited: Louis Kahn and Kenzo Tange. Rogers' projects for the Velasca tower, Gardella's for the Olivetti canteen in Ivrea, certain hous-es by Vico Magistreti in Arenzano, and De Carlo's mixed business and residential building in Matera were all bit-terly attacked. The Italian architects were deemed trai-tors to modern architecture and considered responsible, above all in the memory of that year's participants, for the dissolution of the CIAMs, decided at the close of the congress.[29]

Certain lines of research in the sixties remained close to the ethical concerns displayed in the past by Pagano, Persico, Rogers, and the various architectural organiza-

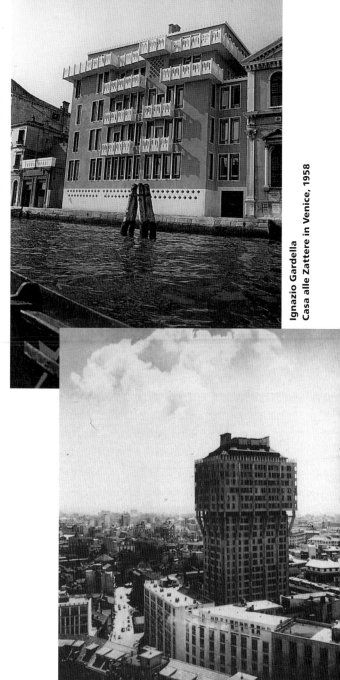

Ignazio Gardella
Casa alle Zattere in Venice, 1958

Velasca Tower in Milan, 1957

tions which had contributed to an interplay between urbanism and the architect's trade. Giancarlo De Carlo's investigation of the idea of participation, for instance, seemed to construct a possible response to the crisis of the social role of the architect.[30] De Carlo's innovation bore on the modes of constructing the architectural project and the role of the architect as an intellectual in confrontation with society. Going beyond Manfredo Tafuri's critical judgment of Italian architects' relations

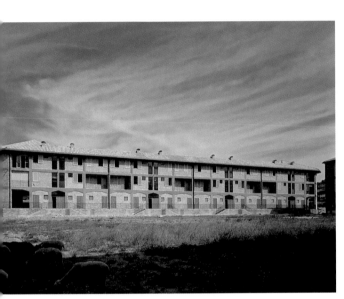

Giancarlo de Carlo
Apartments and businesses in Matera, 1956/57

Participative urbanism represents a different society, configures new hierarchies and diverse social categories. For these reasons it takes on aspects of utopia. To define the architecture of the future, De Carlo quotes a phrase of Le Corbusier: "Utopia is the reality of tomorrow."[32] For him, utopia is opposed to a realism understood as uncritical adherence to the reasons and images of things as they are. As a utopia, participative urbanism is one of the sites in which social imagination is exercised, where individual and colective social dreams are garnered, elaborated, and produced, where a space exists for the possible construction of a *civitas*:

"... in my opinion, the architecture of the future will be characterized by the user's ever-greater participation in its organizational and formal definition. Or—making an effort not to overly confuse what will happen with what I would like to happen—I will say that in my opinion, contemporary architects ought to do all they can to make the architecture of upcoming years increasingly less a representation of those who design it and increasingly more a representation of those who use it."[33]

Another line of ethical research in the 1960s identified peripheral sites as the primary terrain for the construction of workers' housing estates. Thus the patient investigations of Guido Canella in the Milanese hinterland are one of the keys to his architecture. His projects of the late sixties and early seventies, including the civic center of Segrate in 1965 and the schools in Pieve Emanuele and Noverasco in 1971, sought to construct the central sites of a new sociality in the anonymous territories of greater Milan. For Canella, services and infrastructure, schools, civic centers, libraries, and municipal offices are elements that can counter the dispersal of the city, the dissolution of fundamental connections brought about by the loss of contextual values in the periphery.

Here we see the return of

with power, he developed in his own professional practice a line of thinking that seemed to exceed the problematic formulations of the interaction between intellectuals and society.

In all his planning activity in the sixties, De Carlo attempted to create structures for a real participation of the population in the choices concerning the territory and the city. This attempt culminated in his concrete realization of the Matteotti Quarter in Terni (1969-1975), where he set up a process of continual verification of the project with the steelworkers who were to live there.

The architecture and urbanism of participation can be said to have fulfilled their ideal when they contribute to uncover injustices, "defining a consciousness of rights that no one had dared to claim, and delineating a formerly unspoken goal which then becomes a target."[31]

CIAM a Otterlo," in *L'Architecture d'aujourd'hui* 86, October-November 1959; "CIAM: Ressurection move fails at Otterlo," in *Architectural Review* 755, January 1960; Zevi, Bruno: "La morte del CIAM e la nascita dell'Istituto Nazionale di Architettura," in *Architettura* 51, January 1960.

[30] As early as 1953, in the competition for a residential center on the outskirts of Cesate, De Carlo introduced the idea of user participation in the definition of the project. In 1954, for the Tenth Triennial, he organized the Mostra dell'Urbanistica with Carlo Doglio and Ludovico Quaroni. He collaborated with Elio Vittorini on the screenplay and realization of three short films with the objective of warning the users of the dangers inherent in an urbanistic approach which does not make the user the principle subject. De Carlo's role as an intellectual involved both the presidency of the MSA from 1955 to 1958 and his presence first at the CIAMs, then as the sole Italian member of Team X.

[31] Infussi, Franco: "Intervista sull'urbanistica," in *Interviste sull'urbanistica: Ipotesi sulla crisi disciplinare*, doctoral thesis (Milan 1979-1980).

[32] Perin, Monica: *Giancarlo De Carlo: Un progetto guida per realizzare l'utopia*.

[33] De Carlo, Giancarlo: "L'architettura della partecipazione," in the anthology *L'architettura degli anni settanta* (Milan 1973), p. 103.

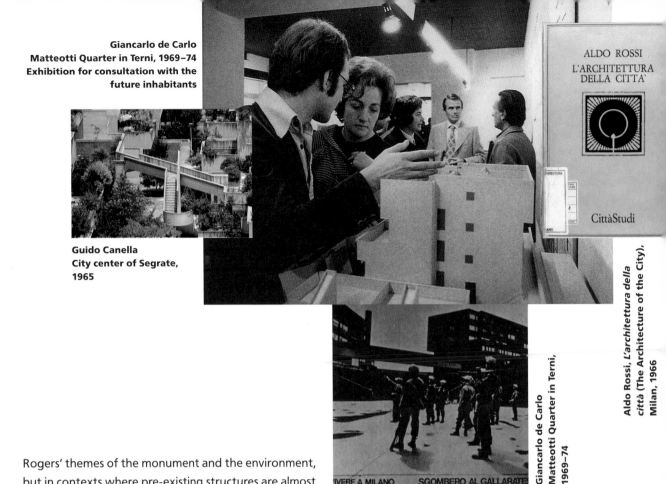

Giancarlo de Carlo
Matteotti Quarter in Terni, 1969–74
Exhibition for consultation with the
future inhabitants

Guido Canella
City center of Segrate,
1965

Giancarlo de Carlo
Matteotti Quarter in Terni,
1969–74

Aldo Rossi, *L'architettura della*
***città* (The Architecture of the City),**
Milan, 1966

Rogers' themes of the monument and the environment, but in contexts where pre-existing structures are almost entirely absent. In proximity to the formal research of Gabetti and Isola and Aulenti in the fifties, Canella constructed diverse fragments of architecture, eclectically mixing styles to create provocative assemblages. His formal choices assign a precise task to architecture, that of crying out in the silence of the periphery, pointing to its own civic role of gathering the inhabitants around the functions that accomodate daily life. The superimposition of different codes echoes the analysis of the periphery as a continuous flux of contradictory images: expressionist architecture, the early modern masters such as Gaudí and the school of Amsterdam, Le Corbusier's brutalism, all clashing together.

It is again in the greater Milan region that we find the final fragment of this story, the Gallaratese quarter by Carlo Aymonino, designed in 1967 and realized from 1970 to 1973.

Aymonino had formed part of the group that planned the Tiburtino quarter. This project represents a kind of recapitulatory essay on his notion of the formation of the city by "finite parts." The complex, including a residential building by Aldo Rossi, uses a constructive procedure not unlike that of Canella, even though its formal rigor refers more to the rationalist architecture of the thirties rather than to Canella's nineteenth-cen-

tury sources. It is a fragment of metropolis floating in the void of the periphery. In it appear figures of the historical city: the portico, the open-air theater, the plaza, mixed with some of the elements characterizing the imaginary of modern architecture, such as the elevated street.

Rossi's contribution is a particularly clear example of the new position of personal expression, the evocation of a faraway life which can no longer be anything but a distant echo. It attempts to prefigure different ways of life, evoked in the architectural forms which appeal to the typologies of traditional construction in the Lombard region.

Of the city as the site of a *civitas*, the Gallaratese quarter is but a memory.

Manfredo Tafuri's work *Architecture* and *Utopia: Design and Capitalist Development* marks the close of the 1960s, during which most of the ideological initiatives of the preceding decade slowly dissolved, to be replaced by an uncritical professionalism integrated to the mechanisms of power.[34] The text develops a clear

Manfredo Tafuri, *Progetto e utopia*, (Architecture and Utopia), Rome-Bari, 1973

distinction between two different phases in Italian architectural culture. In the first, which we have examined in this essay, the architects-intellectuals sought to mix their own architectural production with concerns of a political and social nature, often directly collaborating with the mechanisms of political and economic power charged with taking decisions in urban planning and construction. In the second, after 1967, architecture is considered an "autonomous" reality; it is cut off from the concerns of the preceding generation and totally immersed in the internal quest for its own value and legitimacy. The "autonomy" of such architecture is also a refusal of the compromises made by the older architects with the structures of political and economic power, demonstrating an indifference to the social questions inherited from the tradition of the modern movement.

Thus the dynamics of the history of Italian architecture can be read in the terms of a continual oscillation between positions of opposition and consensus on the part of the architects, seen as a "caste" or "elite." The perception of a defeat of the ambitions of the postwar architects shifted to a concrete, tangible plane, visible in everyday life. Summarily, at a distance of many years from these events, one can register a failure on the part of the leading exponents of Italian architectural culture to create a shared and accepted practice that would enable the profession to construct the form of the Italian territory:

"Fascist ruralism, postwar neorealism, and today's 'critical' regionalism have all contributed to a cultural domain that is reluctant to confront the obligations of a modern industrial state. . . . The new regionalist Arcadia, complacent in its own role of resistance and now tinged with subtle ethnic humors, has led Italian culture to a detour which seems destined to engulf it. It has let the major transformations take their course, entrusted by real-estate speculators to the anonymous draftsmen of plans and projects concerning hospitals, hotels, popular housing, factories, office buildings, railway stations, freeways, department stores, airports, fairgrounds, shopping centers, churches, town halls, and last but not least, a meaningless proliferation of first and second residences: condominiums and detached houses."[35]

[34] Tafuri, Manfredo: *Progetto e utopia: Architettura e sviluppo capitalistico* (Rome-Bari, 1973); *Architecture and Utopia: Design and Capitalist Development*, tr. Barbara Luigia La Penta (Cambridge, Mass.: MIT Press, 1976). The core ideas of the book can be found in an essay published at the end of the sixties: "Per una critica dell'ideologia architettonica," in *Contropiano* 1, 1969.

[35] Nicolin, Pierluigi: *Notizie sullo stato dell'architettura in Italia*, op. cit. pp., 50-51.

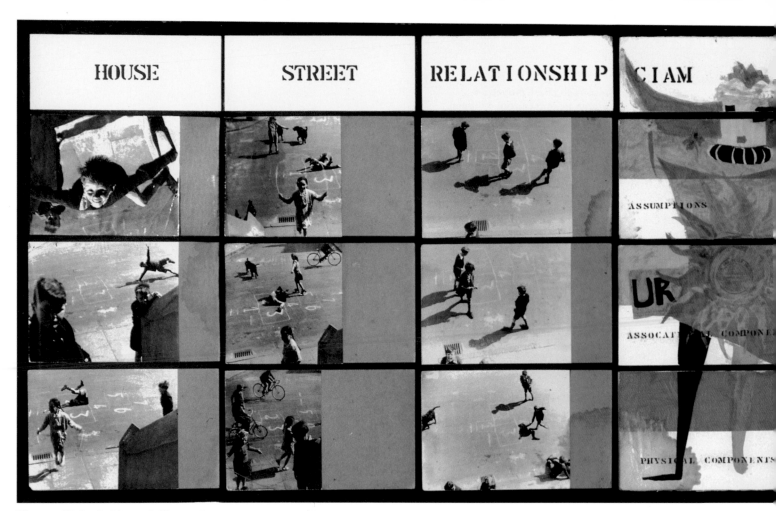

Alison and Peter Smithson: *Grille pour le CIAM d'Aix-en-Provence* (Grid for the Aix-en-Provence CIAM), 1953

Andrea Branzi, Jean-François Chevrier

Object/Space/Politics

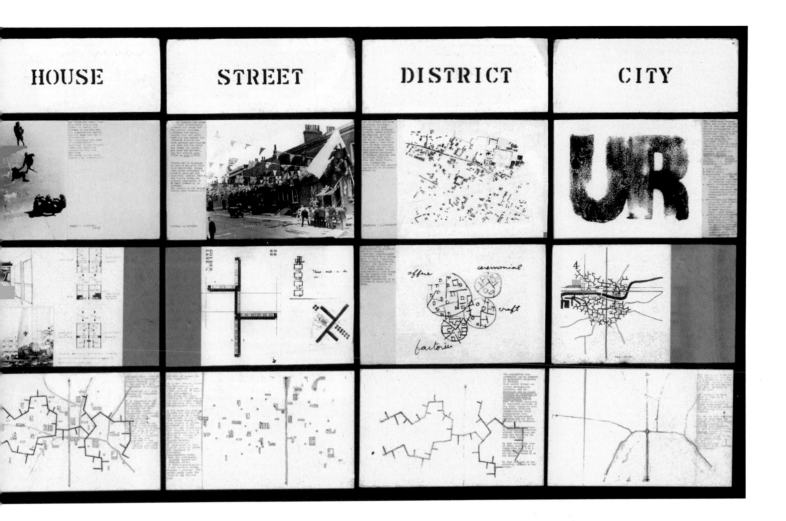

JEAN-FRANÇOIS CHEVRIER Let's begin by examining the way the radical design of the late 1960s positioned itself with respect to architecture, particularly in Italy. What do you see as the differences between the evolution of design and of architecture in the period extending from the Reconstruction to the late sixties? It seems to me that at a certain point radical design began to play a major role in architectural debates. How do you evaluate this role, particularly on the political level, since in Italy more than any other European country the national ideology of "reconstruction" crystallized in the architectural debate? What is specific about this debate in Italy?

ANDREA BRANZI It was in the late sixties, after the heroic phase of the Reconstruction period, that the great themes of the modernization of Italian society first emerged. Now at that time, Italian society had not been reformed by the bourgeoisie, nor by the opposition, nor by the government: in short, it was still a backward society. The most immediate response that design offered to this demand for modernization was to blow an extraordinary breath of imagination into the industrialization of production. The most well-known objects of Italian design in the 1960s are, without exception, objects that suggest new domestic practices and attitudes. Chairs appeared which imposed new seating pos-

Archigram (Ron Herron)
Gallery Project for Bornemouth
1968

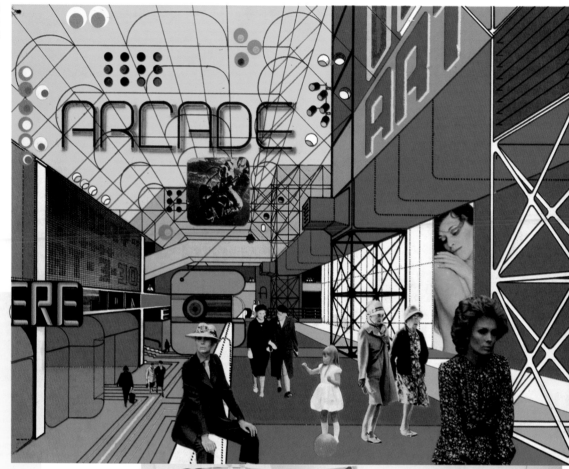

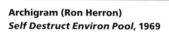

Archigram (Ron Herron)
Self Destruct Environ Pool, **1969**

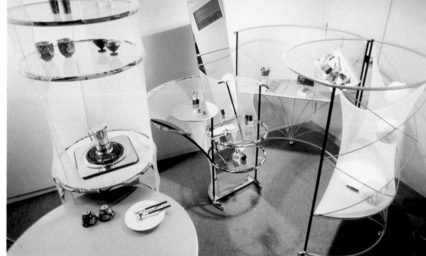

Toyo Ito, *Pao 1. Exhibition project: Pao, a Dwelling for Tokyo Nomad
Women*, **1985**

Andrea Zittel,
A-Z Escape Vehicle
Owned and
Customized
by Andrea Rosen, 1996

Opening of a furniture showroom in Via Durini, 1968

tures, and which also could be folded up and carried off in one's suitcase; a television set was made to be placed directly on the floor, and the first hanging radio was invented.[1] In other words, what we saw was the appearance of a society of liberated behavior, but one which was entirely unreal—a virtual society projecting a utopia freed from physical reality. The movement began right after the end of the war and continued to expand up to the late sixties: just think of the works by Marco Zanuso, Enzo Mari, Bruno Munari, Achille Castiglioni, Mario Bellini, Pier Luigi Spadolini, Cini Boeri . . . Everybody was working on this idea of a kind of revolution of the object in space, in relation to architecture. For example, Marco Zanuso designed an open-ended canapé, that is, an object which leaves behind the traditional dimension of space.[2] Achille Castiglioni designed a lamp in the form of an endless tube.[3]

> **JEAN-FRANÇOIS CHEVRIER** But it was only in the sixties that this break became clear. You seem to see both a continuity and a rupture. Can you give a more precise idea of the continuity that you perceive between 1945 and 1960?

> **ANDREA BRANZI** In Italy, continuity always presents itself as a series of ruptures. Far from being integrated into a general program or an overall vision of the city, the culture of design and the culture of architecture after the war organized themselves as a set of separate, polemical works: from Ignazio Gardella to Joe Colombo . . . Modernity was a grouping of points of opposition, to the government, to the epoch, to history; it was an ensemble of critical and polemical signs, of specific proposals. The result of this, in a second phase, was to engender the revolution of design against architecture, leading to a situation of confrontation between the various branches of creative endeavor: design against architecture, urbanism against design, architecture against urbanism, etc. So any unity involving architecture, urbanism, and design—which were all separate combat divisions—can only be totally abstract.

[1] This was the time when Gaetano Pesce imagined the inflatable chair, which the client bought flat and which only took on its final form through a random process, after unwrapping. In 1968-69 Piero Gatti, Cesare Paolini, and Franco Teodoro designed a leather armchair filled with tiny synthetic balls, whose form molded to fit the user's position. In the early sixties, the Brinvega company commissioned Marco Zanuso and Richard Sapper to create a new generation of TV sets and radios. The designers stripped these devices of their traditional character as cumbersome furniture items, stressing their technical and communicational functions. Each of their creations has its own specific characteristics. For example, the screen of *Algol II* faces upward, "like a dog," as Zanuso puts it. *TS 502* and *Black 201* hide their function when not in use; the radio transforms into an anonymous box fitted with a handle, the television set becomes an enigmatic black cube.

[2] The *D 70* canapé is conceived for a families in small apartments who want to enjoy the view out the window but also the fire at the other end of the room. An ingenious mechanism allows the armrests and even the back to fold down, converting it into a bed. "Industrial design and imagination: those are the elements of our work," explains Osvaldo Borsani.

[3] The lamps of the 1960s reconcile functional and technical aspects, and are often still appreciated today. *Spider* by Joe Colombo (1965), as well as *Taccia* and *Arco* by Castiglioni (1962), defined future generations of lamps by blending functionality and originality.

JEAN-FRANÇOIS CHEVRIER How do you situate these projects with respect to the planned economy? It seems to me that the individual project did in fact assert itself against the plan, but not in 1945.

ANDREA BRANZI The history of Italian architecture is a set of isolated works. What you find is the expression of a society which has never known any far-reaching reform, and to which the idea of an overall policy is foreign. There are major political parties—communist, catholic—but each of them follows a particular communications policy. Similarly, the Italian landscape is just a collage of regional divisions—quite the contrary of the territorially unified European states. Italian modernity is polemical, and the design of the 1960s reflects the image of a society which refused Corbusier-style architectural integration.

JEAN-FRANÇOIS CHEVRIER Could you situate this position with respect to that of Reyner Banham? He also opposed a self-consciously historical architecture, but he did so with simple, functional models such as the container, and he developed a model of a "machine for living" which was freely inspired by Le Corbusier.

ANDREA BRANZI In Italy, the social and cultural revolution was conceived in opposition to the industrial revolution. The really new thing offered by technology was the possibility to free people's behavior. Radical architecture such as *No-Stop City* fits into this tendency. It leads to the idea that radical integration brings with it the possibility of a wider liberation.

JEAN-FRANÇOIS CHEVRIER In short, extremism and negative utopia.

ANDREA BRANZI Yes. Enzo Mari's model was socialism, that is, a theory of human integration; it produced intellectual liberation, but not the liberation of behavior.

JEAN-FRANÇOIS CHEVRIER How does that relate to Banham's position?

ANDREA BRANZI The real revolution in radical architecture is the revolution of kitsch: mass cultural consumption, Pop art, an industrial-commercial language. There is the idea of radicalizing the industrial component of modern architecture to the extreme. The balance tips in the sixties, when industrial rationalism produces consumer irrationalism.

JEAN-FRANÇOIS CHEVRIER In Banham's thinking, the radicalization of rationalism produces an effect of desublimation. The problem is to shake the modern project out of its moral severity, to bring it back to an everyday use-value.

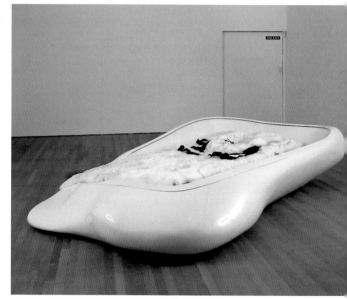

Siobhán Hapaska, *Here,* **1995**

ANDREA BRANZI Yes, but that hypothesis has failed, because it didn't take consumption into account.

JEAN-FRANÇOIS CHEVRIER And yet the container revolution has taken place.

ANDREA BRANZI But without producing any substantial modification of the overall landscape.

JEAN-FRANÇOIS CHEVRIER It has transformed social and economic relations.

ANDREA BRANZI Yes, and we did think about that. But when you go that far, the idea of such a deconstruction of space leads inexorably to the definitive destruction of architecture.

JEAN-FRANÇOIS CHEVRIER The political, ideological background of radical design was Marxism and the crisis of Marxism.

ANDREA BRANZI *Marxiana,* as we say in Italian, to signify a heretical version of Marxism, or rather of Leninism. Indeed, where Marxism concluded that a revolution was pos-

[1] Tomás Maldonado is a Marxist theorist and the director of the Neo-Bauhaus.

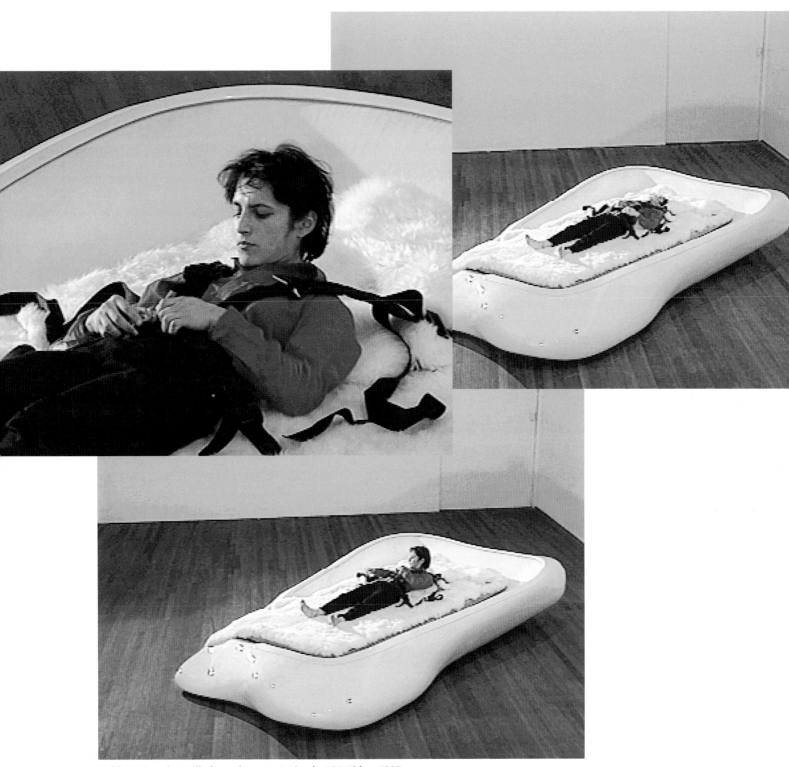

Siobhán Hapaska, stills from documentation by ICA-Video, 1995

Archizoom Associati
No-Stop City, Quartiere omogeneo
(Homogeneous Quarter), 1969-72

Archizoom Associati, *No-Stop City*, **1969-72**

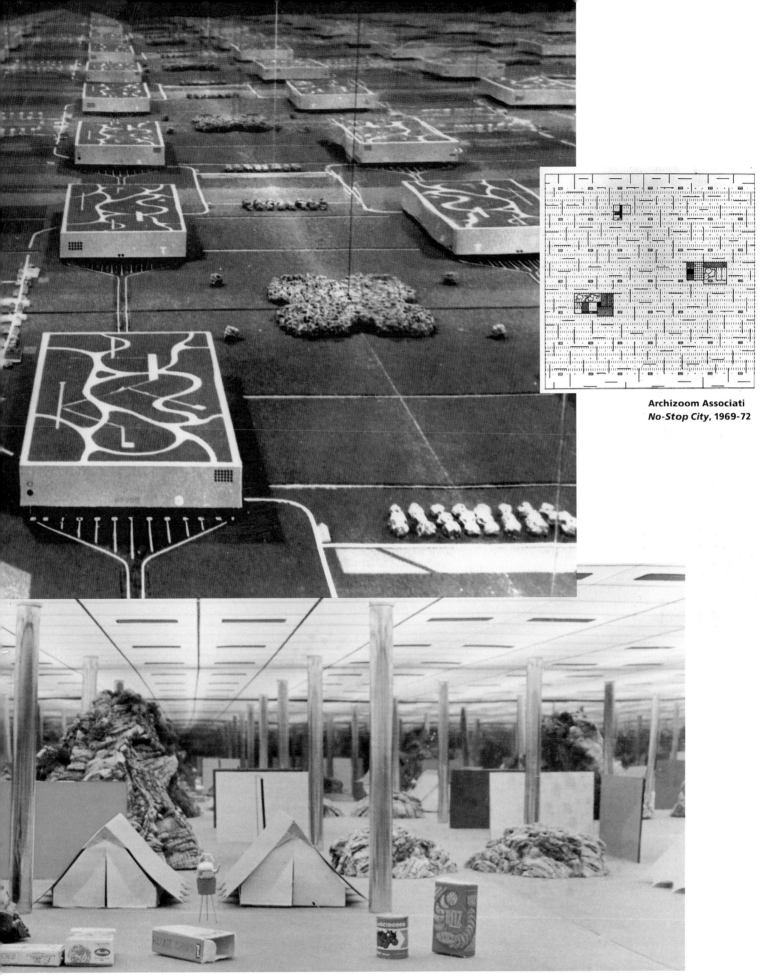

Archizoom Associati
No-Stop City, 1969-72

Archizoom Associati, *No-Stop City – Paesaggi interni* (Internal landscapes), 1970

sible in any country that had reached the advanced stage of capitalism (meaning that revolution was possible in Germany), Leninism supposed that the possibility of revolution depends on the existence and the determination of the revolutionaries (Italy being proof of that). What is the difference between someone like Tomás Maldonado and myself? Tomás Maldonado, who comes from Argentina, has a classical—that is to say, Marxist—definition of design. We know that the question of design emerged in Germany, the country with the strongest industry. From this, Tomás Maldonado deduced that the fundamental questions of design concern industrial objects, and therefore large-scale production in series. These kinds of considerations led to a real disaster, particularly in Germany. But Italy, which satisfies none of these conditions, is exactly the country which has produced an original model of design. What's more, and this is very important, Italian design has produced a completely original historical model which is impossible to study by simple comparison with German design. That's why, in my opinion, all the theorists like Tomás Maldonado and Vittorio Gregotti who still look for the categories of hyperrationalism in Italian design are incapable of understanding this original phenomenon, which is constantly shaken by phases of success and crisis.

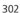

JEAN-FRANÇOIS CHEVRIER The conflictive relation between design and architecture seems to have slackened off considerably, to judge from the last Venice Biennial of Architecture, where many projects took the form of technical objects. This is very apparent in architects as different as Jean Nouvel, Renzo Piano, Arata Isozaki, etc. But I would say, generally speaking at least, that such technical objects cannot give rise to any conception of the territory. At best they can produce a kind of animation of space. One of the most beautiful objects presented at the Biennial was actually Kenzaï's airport, which is a utopian object, given that it was conceived for an island.

ANDREA BRANZI One can distinguish between figurative utopias and utopias of attitude, of behavior. When I speak of relational space, or of *Agronica*, I speak of partial utopias. But in Frank Gehry's work, what you have are narrative utopias.

JEAN-FRANÇOIS CHEVRIER Let's take the example of Terragni's Casa del Fascio. It is a formalist architectural project, but in this case formalism is not simply the negative notion that it tends to be today. Formalism is first of all a creative movement of forms that is progressive, that implies an idea of social progress. Now, it's clear that this architecture combines three rigorously articulated dimensions: the monumental dimension, the communitarian dimension, and the intimate dimension of the living space, the house (which can be, and is in this case, an ensemble of studies, offices). What's being proposed here is an idea of society, and in this case I would speak more of a project than of a utopia. It's a political idea, a fascist project. When radical artists of the sixties like Robert Smithson conceived critical utopias stressing a reinforcement of the utopian idea over the idea of the project, they did so in direct opposition to the modernist model developed by Terragni. Radical design shares in this movement toward the critical utopia. But what has been lost is precisely the political dimension: the idea of community. This is the reproach that Manfredo Tafuri addresses to the neo-avant-garde.[5]

ANDREA BRANZI I recognize that in the period Tafuri is considering, we did in fact jettison a political dimension which had already moved into a phase of crisis. But you must consider what the other designers did in the 1960s. Enzo Mari carried out aesthetic research that was intended to lay the foundations of political action: politics would have the role of creating a society that could fulfill this formal language. An intellectual was not understood as someone who should work for politics; rather, politics was supposed to work for the intel-

5 See Manfredo Tafuri, *Architecture and Utopia: Design and Capitalist Development*, tr. Barbara Luigia La Penta (Cambridge, Mass.: MIT Press, 1976).

Vito Acconci
Portable City, 1982

Liam Gillick, *Part Three* (Installation), 1995

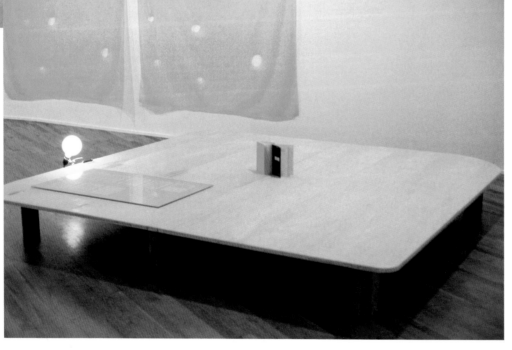

Liam Gillick
(The What If? Scenario)
Report Platform, 1996

Liam Gillick, *Prototype Ibuka! Coffee Table/Stage (Act 3)*, 1995

lectual. In the cases of radical design and radical architecture, it became obvious that modernity was going through a crisis: the idea of normality was disappearing with the emergence of consumer society. Manfredo Tafuri didn't understand a thing about consumption, because he thought, in a typically socialist mold, that Italian design should make its way into heavy industry—Fiat, for example. His idea was that the integration of design to the most advanced phase of capitalism was the moment to carry out the socialist revolution.

> **JEAN-FRANÇOIS CHEVRIER** His thinking concerns the state, while the majority of radical artists were anarchists. Tafuri is a Marxist, so for him, the state exists; whereas the critical utopias of the 1960s were fundamentally anarchist.

> **ANDREA BRANZI** But Tafuri missed the political changes of the times, since in 1970-72 he was still hanging on to the model of a society structured around the opposition of the bourgeoisie and the workers.

> **JEAN-FRANÇOIS CHEVRIER** In the early seventies, the bourgeoisie and the people still existed in Italy. The relation of tension and reciprocal pedagogy between the bourgeoisie and the people is undeniable.

Andrea Branzi – Centro Ricerche Domus Academy, *Agronica,* **1970-71**

> **ANDREA BRANZI** The bourgeoisie never had a party, it always used the parties of other social forces: it was represented by the left, not by fascism. On the other hand, the popular masses were represented either by the left or by fascism.

> **JEAN-FRANÇOIS CHEVRIER** It's clear that there was a liberal, anti-totalitarian bourgeoisie which took a position against fascism, against populism, but which constantly maintained a pedagogical relation with the people through its alliances with the left. Architecture is an essential aspect of this tendency. That is the space in which Tafuri's thinking unfolds.

> **ANDREA BRANZI** Tafuri's thinking is coherent but I find it very weak, because his critique does not rest on any updated analysis of the historical-social situation. It is as though the question of design could be reduced to a question of mass production, of Fordism.

> **JEAN-FRANÇOIS CHEVRIER** In the end, Tafuri's critique of radical design seems to me just as appropriate as your critique of his thinking. What radical design goes on to do is nothing other than to liquidate the political, with a critical utopia masking the operation.

> **ANDREA BRANZI** In Italy, culture and politics are not two convergent categories. The function of culture is to bring politics into crisis, and vice-versa. One can take political vision as a dynamic vision animated by constant critique, or, like Tafuri, as a vision that seeks certainties in social and political categories. Two Italian conceptions of politics come into confrontation here: one is inherited from metaphysics, while the other is futurist, dynamic, revolutionary.

> **JEAN-FRANÇOIS CHEVRIER** But between the two there is the community, whose space is at once intimate and monumental. And this dimension does not fit into your schema.

> **ANDREA BRANZI** What's interesting to me in the project of the Casa del Fascio is

that it achieves no solution. Although it does indeed take up the positive aspect of fascism, which is the foundation of a national-popular culture, nonetheless it encloses it within a mortuary vision, a cemetery of uselessness. I'm always afraid when I see works by Terragni: the anxiety of a metaphysical shadow floats over me, which has nothing to do with Mediterranean shadows. His work is not solar work, it blends the enthusiasm of Mussolini with pessimism, just as futurism and *metafisica* share a negative vision of modernity. I like Terragni very much, but his works bear an invocation of death. The fascists wore black, let's not forget.

JEAN-FRANÇOIS CHEVRIER What I feel is more the inspiration of a bourgeois melancholy that allows him to maintain the popular ideal at a distance from populism, and tends more toward an integration than a crisis—integration and crisis being contrary terms, in the psychic sense.

ANDREA BRANZI To deal with the political dimension today, first we have to be clear whether politics should be understood as a mechanism governed by a certain economic function, or as a critical activity and an ongoing reformism. Both these categories can be found in fascism: futurism and *metafisica*. Following that, we can speak both of permanent revolution and permanent foundation.

JEAN-FRANÇOIS CHEVRIER For me, the political is defined as the projection of the community beyond the specific interests that compose it. It is a projection of community in the sense of a general interest, irreducible to particular interests. This, for me, is the definition of the political demand, the political exigency. But to return to the relation between design and architecture, I have the feeling that if architecture was so important in Italy during the period of the Reconstruction, it is precisely because architecture elaborated and represented the space of community—the community which had to be founded anew after the war. Architecture embodied a political idea of community which was not individualist. Design then intervened critically in the very space of architecture, by denouncing an overly rigid idea of progress in the communitarian idea; and additionally, design brought to light the individual dimension of consumption, as you have stressed. Now we can ask whether a thinking of design that has moved too far away from architecture, or an architecture that has moved too close to design, does not bring about a reduction of the community to the market.

ANDREA BRANZI It is correct to speak of the crisis of politics, if what you focus on is not the liquidation of politics but the crisis of political categories. In this sense, the real utopia was Ulm: the Olympian vision of gleaming white industry.[6] Industry means consumption, kitsch, bricolage, mixing, contamination, multiplication, and so on. Of course this goes against politics, but in order to open another political climate. The question today can still be posed in these terms: when I speak of "design after God," what that means is precisely that there exists a design which has lost any communicable morality. That seems interesting to me . . . and why not?

Dorothee Golz, *Prinzip Hoffnung* (Principle of Hope), 1996

[6] See Andrea Branzi, *Learning from Milan: Design and the Second Modernity*, Cambridge, Mass. and London: 1988.

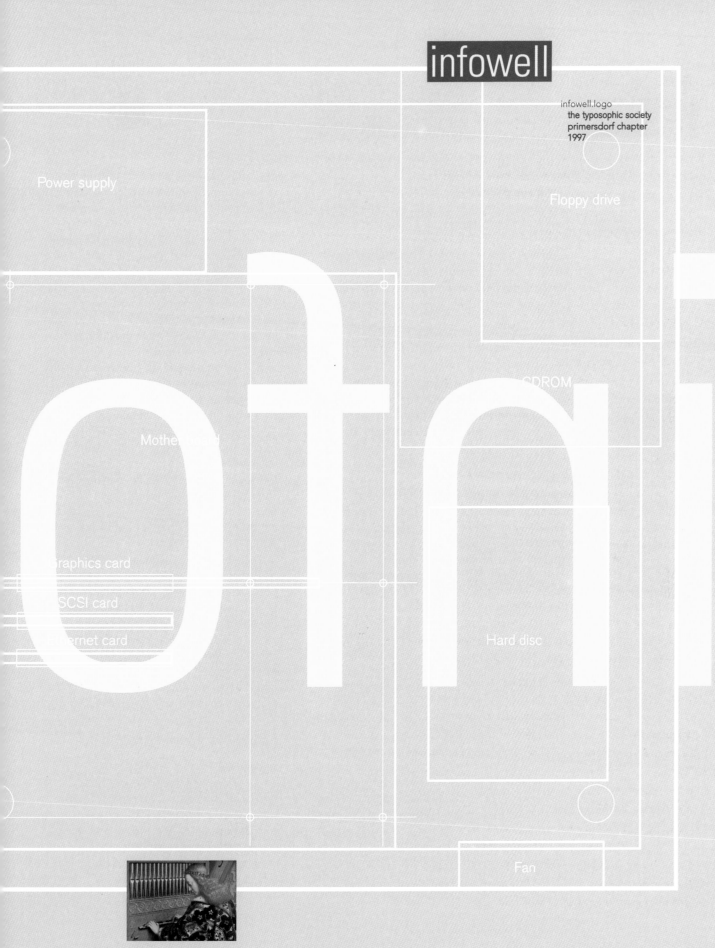

infowell

infowell.logo
the typosophic society
primersdorf chapter
1997

Power supply

Floppy drive

CDROM

Motherboard

Graphics card

SCSI card

Ethernet card

Hard disc

Fan

Peut-on faire des œuvres qui ne soient pas „ d'art "? Marcel Duchamp, 1914

Raimond Lull
1235-1315
Conceived various ideal mechanisms for a combinatory selection of logical and truthful sentences by means of rotating disks. Wrote *ars magna* in 1289.

Francis Bacon
1561-1626
Philosopher and statesman published *Novum Organum* in 1620.

René Descartes
1596-1650
His *Discours de la Methode* appeared in 1637.

Athanasius Kircher
1602-1680
Invented the Laterna magica and an early calculating machine. Did research on comparative languages. Published, in 1656, *Oedipus ægyptiaticus* an approach to the deciphering of hieroglyphs.

We should remember that the oldest meaning of the Greek word *metron* applied directly to language; to ordered stanzas, to noble literary form. *Metron* referred to *poesis*, to a verse mode determined by number, as does our word *metre*. Later, *metron* could be an attribute of anything, good *metron* became a commendable quality. *Metron* was used to analyse and value intervals, rhythms and proportions.

metron + techne + mneme = poesis

During the late 18th century, in the wake of the French revolution, a name was needed for a radically new system of measurement: the word metron was chosen. On April 5th 1795 the new standard, a 10 000 000th part of a terrestrial meridian quadrant through Paris was defined as the unit of length. It was called *le métre (maitre?)*. Subdivisions were made in 100 parts (1 centimetre), 1000 parts (1 millimetre) and a multiplication by 1000 (1 kilometre). A bar, having a specific cross-section, was constructed from an alloy (90% platinum 10% iridium) as a model which defined the standard. Replicas of the platinum-iridium bar – called *mètres des archives* – were distributed throughout the French empire.

At the lowest level, computers process information with millions of simple transistors, clusters of minute switches stacked in blocks of silicone. Any one of these switches can be either on or off. An operating system controls this binary activity with a set of programmes written in an explicit language and which include a compiler. The task of the compiler is to input source code – the description of an algorithm (a word derived from the name of a Persian mathematician Abu Ja'far ibn Mûsâ al-Khwârizmî) written in higher level language and output object code (machine language).

Scientific circles in the 1880s were engaged in serious discussions about the existence of *æther* – another concept inherited from the Greeks. The questions were: could this *æther* be the medium by which light is transmitted and, if so, could that medium be measured?

Michelson set up a well-conceived experiment to measure the speed of light in any æther (however thin) with the greatest precision then realizable. His work gave a negative result but it hinted at a more exact standard for the unit of length. A refined definition of the metre was established as the distance travelled by light, in a vacuum, during 1/299792458 seconds. The metre lost its clumsy physicality and became an abstraction. Units of measurement, together with their definitions, were severed from their roots in human body parts.

After a faltering beginning, with intermeshing cogs cranking out digits on calculating engines, electronics entered the numbers game. Then came *the word*: transcribed into a sequence of binary digits. Any information can be defined by a series of zeros and ones. 1000001 = A, 0100001 = B, a backspace is represented by 0001000; any symbol, alphabetic, numerical or other can be allocated a code. Seven bits, either on or off, provide 128 permutations – adequate for representing the 26 letters of the alphabet in upper and lower cases, the numbers 0 to 9, and controlling characters which make up the standard ASCII (= American Standard Code for Information Interchange) set. Add another bit and the permutations double to 256, extending the range to include accented characters and many other symbols.

lightspeed > wavelength

Research into crystals, and optical methods of spectral analysis, produced an even more esoteric definition of the metre with a move from light to wavelength. We are now confronted with a figure surrounded by parameters to circumscribe the unit of length with even greater accuracy. From the red cadmium

band in the 1920s the measurers progressed, in the 1960s, to fix the metre as 1 650 763.73 times the wavelength of the orange line in the spectrum of Krypton 86 when held at 15°C at a pressure of 760 mb.

Another metric formula was offered early in 1914 by Marcel Duchamp:

If a straight horizontal thread one metre long falls from a height of one metre onto a horizontal plane twisting *as it pleases* it creates a new image of the unit of length.

A computer language is a notation for the unambiguous description of computer programmes. Such languages are synthetic in that their vocabulary, punctuation, grammar, syntax and semantics are precisely defined in the context of a particular operating system. They suffer from an inability to cope with autonomous expression – an essential attribute of an organic language. The poetic of computers lies in the genius of individual programmers to express the beauty of their thought using such an inexorable medium.

facsimili – forgery – faketorium

The august authority of given units of length is *datafiction* and all exactitude a fake. *Fiction* points at *finger* (*fingo finxi fictur*) and its etymology tells us that *fiction* is about forming in mud: we step lightly across a small word-bridge to touch the pointing finger: the *digitus*. *Digital* means counting with the use of fingers – five on each hand.

A foot, the span of outstretched hands, the distance between thumb and small finger; measurement retained its direct relationship with the body for thousands of years. Features of an individual imperial presence often became regional standards. Requirements of increasing interregional and, later, international trade made simplification and unification necessary. The *systeme internationale des unites* (SI), the foremost planetary standard table of units today, is primarily a communication device: a *lingua franca* of quantification. Only quarks have flavours.

Operating systems enable programmers to use commands and standard functions to articulate these unforgiving, formal languages. Shells, additional layers of programming, and application programmes dedicated to a specific task, bring machine language nearer the sphere of human interaction – closer to the capabilities of a *user*.
Each simplification of access to the machine interface introduces more work for the computer to do, this carries an inevitable overhead of reduced speed, thus generating a demand for faster chips. The speed at which a computer runs is rated in Hertz – one cycle per second is one Hertz; it takes two cycles to define an on or an off bit. The latest chips made for domestic computers can be rated at more than 200 mHz. That is to say one hundred million instructions per second (100 MIPS).

It was reported that Bill Gates' personal income rose to $30,000,000 per day in 1996.

It won't be long before chips with DNA and/or neuron characteristics will produce a startling acceleration in computer speeds. Currently, switches (= *gates*) in silicone chips offer only a *stop* or *go* option to the passage of electrons – what if conditional arrangements can be introduced? So that *and*, *or*, *if* and *when* conditions could be negotiated at gates in the chips, instead of at a higher programming level. Speeds might increase to billions of MIPS.

o gnomon go

Gnomon and *gnostic* are comparable with a tool and its applications. Ancient man with a ruler, dividers and a plumb-line before Newton's apple dropped on his head. The sun-dial's periodic wandering shadow is preset. Planet and star: a given distance, given speed, given angle, given rotation and given

**Give Me
Hardcopy**

Samuel Morse
1791-1872
 Created code of dots and
 dashes for telegrams.

Augusta Ada Lovelace
1815-1852
 Ada Countess of Lovelace,
 daughter of Lord Byron, pro-
 grammed for Babbage.

Jean Baudot
1845-1903
 Built, in 1874, a printing tele-
 graph. A baud (the unit
 named after him) is the num-
 ber of times per second that a
 system changes state.i.e. 1
 baud = 1 bit/sec.

Christopher Latham Sholes
1819-1890
 Invented the typewriter. Sold
 the patent to E.Remington
 and Sons. They put the first
 'Remington' on the market in
 1874.

revolutions. *Gnosis* (perception) was heightened by carefully watching the *gnomon* (the sundial's hand). The cast shadow demonstrates the power and the beauty of intervals, rhythms, periods and repetitions generating a specific *kanon*. *Metron* as *canon,* as *scale,* applies to music, architecture, art and language. *Kanon* is also the name for a tool: the tightend cord (*richtschnur*) for marking a horizontal line. After all, *making* is in *poesis* as it is in *factum*.

atom / individuum / bit

There are mathematical descriptions of the textural relation between time and space using specific bubble-structures in foam, especially bierschaum (the head of foam on a glass of beer): *cosmic infoamation.*

The Gutenberg era was thought to end with the Monotype and Linotype machines spewing out lead characters ready for the printer. But the real break with Gutenberg is marked by PostScript – a major departure from classic definitions of textual communication. The strings of characters which form words and the strings of words which make the sentences by means of which humans interact are reduced to a description of the page. The revolution of PostScript declares that a page of text is nothing other than a picture of many words, sentences and paragraphs.

given the data

Heisenberg's Uncertainty Principle, von Neumann's Monte Carlo method, Goedel's Incompleteness Theorem, the 2nd law of thermodynamics and statistical description of matter, Wittgenstein's verdict on the sayable and the sentence. These are all acknowledgments of the limitations of an hermetic cognitive system.

Esteem for these limits is continually demonstrated by continuing efforts toward refinement. The gauge of π calculated to 10 000 places; time spans are split to a billionth part of a second and so are lengths. We measure our universe in astronomical units (one AU = 1000 light years) and the half-life (decay rate) of some artificial elements in femtoseconds. Every new standard draws closer to a limit of resolution.

novum organum / ultimate tool

The total amount of data accrued by external calculation, measurement and calibration has achieved an unrivalled level. The quest for the *metron* zooms out of sight. Nevertheless, compared with the data stored in one living cell this amount is still negligible. The life-sustaining operations (including all sensory perceptions) per second in any living brain outnumbers all stock-exchange activities in the G7 countries in 24 hours.

before the big bang

A founding principle of our universe and all its related phenomena is the indomitable stability of matter. It is deduced that a proton – the positive charged particle in the centre of the atom – does not decay in 16 billion years. Deep in mountains (sheltered from unwanted cosmic radiation events) tests are being undertaken to detect any sign of instability in the life of a proton. Since it is not possible to run the test on a single proton for 16 billion years, examining a sufficiently high number (at least 16 billion) for a year would prove the point. The proton seems to be far more stable than the universe – the perfect scientific koan for the next millennium.

Text is no longer regarded as a string of characters. Each page is 'bit mapped'. It is divided into a two-dimensional array of picture elements (pixels) which, in the average laser printer, are spaced 600 to the inch. One

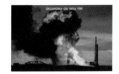

square inch contains 360 000 pixels. A black or a white pixel in the pattern being defined corresponds to one bit in the computer's memory.

A pixel can be described as having a specific tone of grey or a colour, rather than being simply black or white, by increasing the number of bits representing each pixel. A grey-scale pixel requires up to eight bits (depending upon the number of steps) while a coloured pixel needs 16 bits to specify its hue and saturation.

The stability of matter is a necessary given for the stability of DNA. If the matter structure were inclined to falter, the precision of nature's copy mechanisms would fail: the slightest move away from observed standards would change the face of the cosmos:

no stars, no life, no sex, no UNIX machine

Turing experimented until his death with prime soup (*Ursuppe*): mix H and H_2O and CH_4 and a couple of other ingredients and wait for amino-acids to appear. A trace of some amino-acids in these liquids is not unlikely: but the necessary chain reaction that starts an auto-referential perpetuation has not, as yet, occurred. Perfect copy and pure identity exist only on the level of atoms. All protons in the universe are perfect replicants and are identical. Differentiation in the macrocosmos is an unnecessary complication.

identity < exact copy > stability

Since the first mammals, with blood at a warm and stable temperature, appeared 220 million years ago their new type of DNA has never cooled: over billions of generations it has maintained a constant temperature of 36.5⁰C.

This DNA is, at present, diversified into approximately 4500 different species including: *homo sapiens*. Yet, in the end, the crucial dif-ference between the genetic information of a primate and a human is less than 1 per cent.

Our brain reflects these stabilizing factors. That is to say, it is a stable material with an ability to copy stable molecules. It functions as a luxuriously hedonistic device enabling per/conceptual consciousness. It decodes sensory data by the interaction of 100 billion neuron cells, embedded in soft tissue, stored in complete darkness at a medium temperature, encapsulated in a closed shell made from the same material as that of oysters or corals.

A major problem engaging the attention of engineers and chemists is that of hard copy – outputting digital information in a permanent, visual form. Photographic emulsions, dye sublimation and the extraordinary Scitex Iris ink-jet printer produce images with pitiful permanence – a life of weeks, or months at most. Print technology has achieved one breakthrough by using the computer's ability to introduce a random element into the texture of regular dot configurations required by half-tone colour printing. The stochastic procedures overcome the problem of interference patterns being generated by overlapping regular grids. This concept will change print as dramatically as the move from AM to FM transmission revolutionized broadcasting. The change is in the dot structure itself. Amplitude modulated (AM) broadcasting uses a constant wavelength which carries the varying amplitude of the signal. In frequency modulation (FM) the frequency of the carrier is varied. The AM analogy with print is that the dots which make up a half-tone image are placed equi-distant in a regular grid – but the dots vary in size which creates more or less white space around them. In an FM print the dots are all of the same size but much smaller, the differences of tone and colour are created by variations in the space between the dots. Whereas the dots in high quality AM printing were 80 lines per cm, FM pushes this to 480 lines per cm.

George Boole
1815-1864
Boolean algebra is at the core of computing. Introduced, in1847, a binary notation in formal Logic. Published, in1854, *An investigation of the Laws of Thought, on which are founded the mathematical theories of logic and probabilities.*

Albert A. Michelson
1852-1931
Edward W. Morley
1838-1923
Measured, in 1887, by the use of interferometers the precise speed of light in a vacuum.

Norbert Wiener
1894-1964
Mathematician, published *Cybernetics* in 1948.

John von Neumann
1903-1957
Mathematician, physicist, wrote on game theory and quantum physics. In the 1940s he conceived EDVAC, the first programmed computer.

Univers 67

Konrad Zuse
1903-1992
Built, during 1936-38, the first (mechanical) computer operated by a programme.

Kurt Gödel
1906-1978
Mathematician who recognized, in 1931, the incompleteness of logical systems.

Alan Turing
1912-1954
Described in 1936 an imaginary universal computing machine which proved that every logical problem can be solved by a machine as well as by a person.

Claude E. Shannon
1916-
Published in 1949 *A mathematical theory of communication* where he defines bit as the unit of information.

Ken Thompson
1943-
Conceived the UNIX operating system at Bell Laboratories.

Three quarks for Muster Mark!

Extremes of stability and the highest standards of maintenance (superior to that of the VW Beetle) on one side and a random access modulator on the other were established: with a licence to mutate. After one mutation it seems unlikely that another dramatic change of the phenotype will occur. Stabilizing operators allow millions of copies of DNA to reproduce before another true mutant crops up.

Genetic flaws can beget shortcomings; in wings, legs etc., but even mild X-rays don't create new species – no butterfly ever became even another type of butterfly.

Now, 135 years after Darwin initiated the discussion, there are substantial doubts about *survival of the fittest* being sufficient reason for the origin of species.

two paradoxes don't make a paradigm

If two slightly ambiguous parameters are added together – i.e. the hypothetical time span of evolution and potential of specification – the result is either a lesser number of species or an enormously large time frame. There are two seemingly contradictory forces in operation: a random sequence symbolized by mild X-ray-induced mutations and peculiarities of *quantum electro dynamics* (QED) and the breathtaking stability of matter.

The high pinnacles of improbable order and the flat wastelands of probable disorder: game theory versus flawless copy mechanics.

Linotype-Hell is now offering a printing system using seven different colours. Instead of the four standard process inks, cyan, magenta, yellow and black, there is a new range which adds orange, green and violet. With luck, printers will soon be back where they were a hundred years ago when Collotype printing used continuous-tone film separations and as many colours as were needed or the client could afford.

target = get art

Consider the power of anagrams and permutations, the economy and richness in the *arte combinatoria* of a few elements.

Whether applied to elementary particles, the 4 amino-acids of all genetic information, the letters of an alphabet or to off/on digital sequencing, the results can be compelling.

It could be that painting with a mixture of oil and pigment on canvas is as anachronistic as holding records on paper in a modern office. It is now possible for computers to provide a three-dimensional visual experience in real time. There is no reason why future art lovers should not put on a pair of data-gloves and flippers, don a helmet and dive head-first into a pool of colour. Connoisseurs could stroll through a whole garden of electro-virtual delights.

Albert Einstein was quite awed by the inexplicable stability of the observable universe. Although his theories paved the way for the quantum interpretation of matter he argued that quantum theory, with its statistical approach, cannot be a full description of our universe.

Is the moon there, or not there, whether we look at it – or not? Einstein refused to make the (quantum) leap and tried in vain for 30 years to harmonize the laws of nature into Unified Field Theory.

All clocks are clouds

'50 years of intensive research did not bring me any closer to an answer to the question: what are light quants? Today of course every gnome has an answer. But they are mistaken.'

Perhaps some of the mysterious levels of stability in the macrocosmos are directly related and depend on the high levels of uncertainty in quantum events.

Understandably, resolution is somewhat limited at the moment. The data for a specified world and the speed at which the data needs to be handled to convey an immediate reaction to a spectator are impressive. It won't be many years before the experience will be something akin to real life.

A combination of perfect retina and perfect brain provides 100 % resolution. Our daily life is *virtual reality one* (VR1) and this operating system bears comparison with no other. Future generations of body implanted biochips: Motorola *Neuroports* will insert a dream-like seamless quality to match VR1.

language and script govern perception

The permanence of a picture by Jan van Eyck (one of the inventors of oil as a painting medium) is well proved. Using this strategy of communicating high-level information, paintings by Velázquez, Vermeer, Giorgione et al. have achieved remarkable success. High Resolution is not simply a technical term, HR also suggests some kind of visionary state. A great deal of research is under way, yet none of our modern imaging procedures have rivalled the density, the resolution and the overall performance of an oil painting or an illuminated manuscript: oil on canvas or wood or tempera on parchment or vellum have not found a modern equivalent. The computer is the ultimate development in the evolution of our tool culture: it may condense all our efforts since Lascaux, Altamira, Babylon, Crete, Egypt, Greece and Rome. It has yet to show its potential as an abiding creative medium.

Amber was known as *electron* by the Greeks. Plato mentioned its power of attraction in his *Timæos*. Almost 2000 years later the medical advisor to Queen Elisabeth I, William Gilbert (1544-1603), used the word *electrica* in

his treatise on the magnet. Franklin added *charge* and *positive* (+) and *negative* (-) electricity to our contemporary description of the phenomena. The *atom of electricity* was finally baptized *electron* by George Johnstone Stoney in 1894, three years before its official birthday in the papers of J J Thomson in 1897.

exactitude is a fake

Electrons are the stable (negative) components of an atom. They are 1/1807 the weight of a proton (the other essential constituent of matter), which they surround at an inordinate distance. Imagine the proton as being the size of a pin head – it would be as far from the electron as the height of the Woolworth Building. Electrons create light, and all other electromagnetic effects, all chemical reactions, all features of different elements from Hydrogen (1) to Meitnerium (109). Electrons seem responsible for every surface effect throughout this universe, however small, however large. It is their controlled flow in semiconducting layers of silicon that allows millions of replicants of *Universal Turing Machines* to function – and their relentless discharge from guns within the ubiquitous cathode ray tube controls our vision of the modern world, at 72 dpi.

About half of the scintillating light on a TV screen when there is no specific signal transmitted (for example at night) is nothing but the recording of a diffuse radiation from outer space. It is assumed that this cosmic noise is the distant, slowly declining, echo of the Big Bang more than 16 billion years ago.

Dennis Ritchie
1941-
Created *The C Programming Language* for Ken Thompson.

Richard Stallman
1953-
Created EMACS 1974. President of the Free Software Foundation.

Steve Jobs
1955-
Founded Apple Computers, conceived and brought about the Macintosh in 1983. Left Apple and founded NeXT: Rejoined Apple in 1996.

CPU-Motherboard	Intel Venus-Pro
Hard disk	Segate Barracuda 2GB
Memory	64 MB EDO
Processor	Intel P6 200 MHz
CD-ROM	Plextor 12-speed
SCSI Host Adapter	Adaptec 2940 Ultra Wide
Graphics Adapter	Matrox Millennium 4MB
Monitor	Plasmavision Fujitsu
Modem	GV Platinum 28800 bd
Consultant	Eddie Thordén
Operating System	Berkeley FSF Unix
Software	XWindows MIT

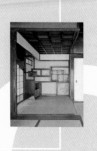

Richard Hamilton
1922-
the typosophic society
northend chapter
Member of since 1995

Ecke Bonk
1953-
the typosophic society
primersdorf chapter
Member since 1994

the typosophic society
founded - in transit -
December 1993

Palindrom
Ecke Bonk, 1991

[aide moi: o media]

Jean-Luc Godard

Housing Complexes and Vietnam

While the Americans carry out an immoral and unjust war in Vietnam, the French government, whose links to big capital are well known, has built around Paris, in the environs of Paris, housing complexes whose inhabitants are led to prostitute themselves, either out of boredom, or through an anxiety that this architecture provokes, or because of economic need. And incidentally, they do it with Americans coming back from Vietnam. Parallel to that, the same Society which produces these housing complexes also distributes paperback books forming a cheap culture that is assimilated in a fragmentary and rather derisory way by the population. All this happens amid the pounding noise of pile-drivers, motors, percolators, and clanging materials, which to a certain extent obstructs communication.

From: *2 ou 3 choses que je sais d'elle*, Paris, 1971.

Jean-Luc Godard
Deux ou trois choses que je sais d'elle
(Two or Three Things I Know About Her), 1966

Stig Björkam

Godard is preoccupied with world problems and futilities. Juliette's husband who works in a garage is also a radio ham. He sits at his receiver tuning in to voices and words about far-flung theatres of war, present and future. He has tuned in to the red line between Washington and Saigon; he hears President Johnson ordering an escalation of the war and a stepping-up of the bombings of Hanoi and Haiphong, Peking and Moscow.

From: *Jean-Luc Godard*, London 1967.

Jean-Luc Godard

See how Juliette, at 3:37 PM, watched the moving pages of that object which in journalistic language is called a magazine. And see how around one hundred and fifty pages later, another young woman, her fellow creature, her sister, looked at the same object. Where then is the truth? Head on? In profile? And first of all, what is an object? Maybe an object is what makes it possible to connect, to go from one subject to the next, to live in society, to live together. But then, since social relations are always ambiguous, since my thinking divides as much as it unites, since my speech brings me nearer by what it expresses and isolates me by what it leaves unsaid, since an immense gulf separates the subjective certainty I have of myself from the objective truth I am for others, since I continually find myself guilty while feeling innocent, since every event transforms my everyday life, since I constantly fail to communicate—I mean to understand, to love, to make myself loved—and since each failure makes me experience solitude, since . . . Since . . . since I can't tear myself free of the objectivity that crushes me and the subjectivity that isolates me, since it is impossible for me to raise myself all the way up to being or to fall all the way down into nothingness . . . I have to listen. I have to look around myself more than ever before . . . The world . . . *Mon semblable. Mon frère . . .*
The world alone today, where revolutions are impossible, where bloody wars threaten me, where capitalism is no longer sure of its rights . . . and the working class is losing ground, where progress, the lightning progress of science lends an obsessive presence to future centuries . . . where the future is more present than the present, where far-off galaxies are at my doorstep. "*Mon semblable . . . Mon frère . . .*"
Where to begin? . . . But where begins what? God created the heaven and the earth. Of course . . . but that's a little too easy. We've got to do better . . . Say that the limits of language mean the limits of the world . . . that the limits of my language mean the limits of my world.* And that by speaking, I limit the world, I finish it . . . And when death, logical and mysterious, comes to abolish this limit . . . when there is neither question nor response . . . everything will blur. But if, by chance, things become clear again, it can only be through the appearance of consciousness. Then everything links together.

*Quotation from Wittgenstein, *Tractatus* 5.6.

From: *2 ou 3 choses que je sais d'elle*, Paris, 1966.

Richard Roud

Deux ou Trois Choses que je sais d'elle is, in Godard's own words, a sociological essay in the form of a novel but written, not with words, but with notes of music. It is much more ambitious than *Made in U.S.A.*, both in its subject-matter, which deals with the whole Parisian region—the 'her' of the title—and in its form. . . . "This film," he states, "is a continuation of the movement begun by Resnais in *Muriel*; an attempt at a description of a phenomenon known in mathematics and sociology as a 'complex.' If this young woman lives in what is called a housing complex, it is not only a play on words. Therefore I sought to link the manner in which she arranges her life with the way in which the government's *Plan* is arranging the region of Paris."

From: *Godard*, New York, 1968.

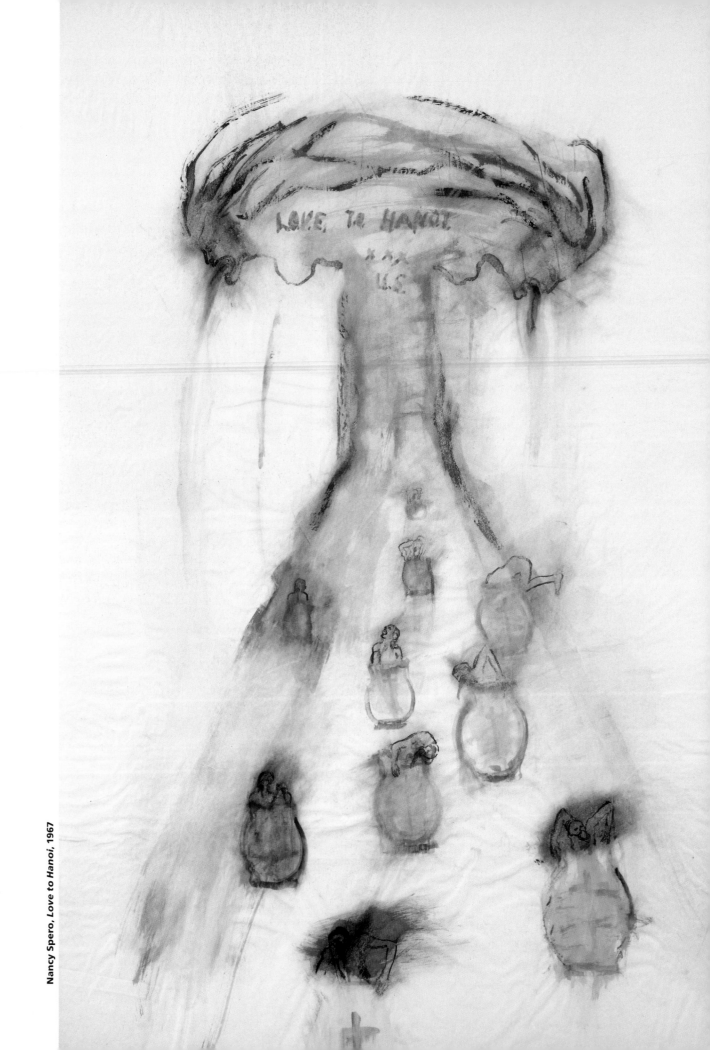

Nancy Spero, *Love to Hanoi*, 1967

Cinema in Cuba

If the revolutionary cinema of the Soviet Union was all but stultified by the mid-1930s, its spirit was alive and well in the Caribbean thirty years later. Encouraged by the film-minded Fidel Castro, for several decades Cuba turned out the most impressive political cinema in the world.

At the forefront of the Cuban industry was the enormously talented, socially engaged, cine-journalist Santiago Alvarez (born 1919). In a series of newreels, short and feature-length documentaries, he developed a daring, innovative film-making style, replete with polemic vigour and audiovisual gymnastics that would put most "pop-promo" directors to shame.

The importance of the cinema in Cuba can be seen from the fact that the Cuban film institute—the *Instituto Cubano del Arte e Industria Cinematograficos*, or ICAIC for short—was founded in March 1959, just three months after the triumph of rhe Revolution. From an initially modest program and extremely meagre resources, the Cuban film industry has today developed into one of the most politically and artistically vital cinemas in all of Latin America and one whose films have received international critical acclaim.

Santiago Alvarez is generally regarded as the grand old master of Cuban documentarians. Born in Havana in 1919, Alvarez made two trips to the US, the first in 1939 and a second later to study for a short time at Columbia University in New York City. After returning to Cuba, he studied Philosophy and Literature at Havana University, was a founding member of the *Nuestro Tiempo* cine-club in the 1950s, and actively participated in the underground struggle against the Batista dictatorship. After the Revolution. Alvarez was appointed head of ICAIC's Short Film Department. In 1960 he became director of its "Latin American Newsreel" and he and his co-workers have produced one *noticero* per week ever since.

From the essentially straightforward, matter-of-fact reportage of *Cidon* (1963), a report on the devastating effects of hurricane "Flora," Alvarez's later films demonstrate the development of a fast, free-wheeling editing style combined with a prominent use of music and the utilization of a wide range of materials and methods—live documentary footage, archival material, clips from features and TV programmes, animation, graphics, historical footage, comic-books—anything, in fact, to make his point. As Gitlin describes it: "The incredible energy of Cuban life is echoed in the wild pace and hard variety of an Alvarez film. . . . He thinks nothing of playing rock music over a shot of troop

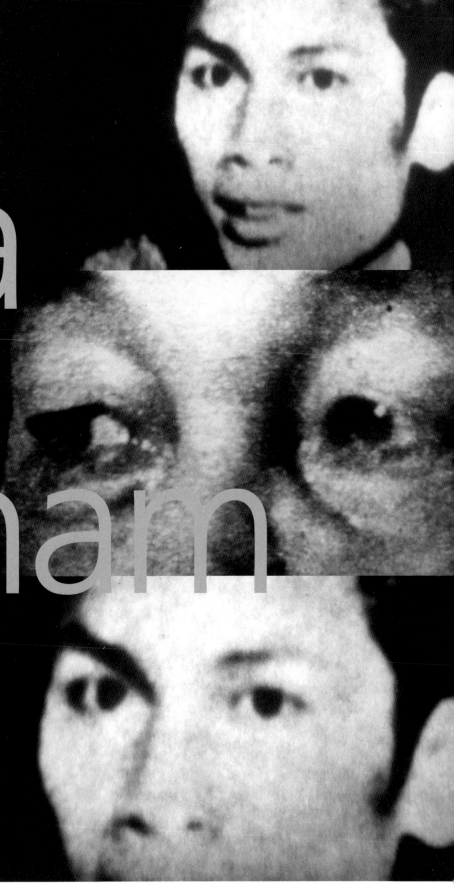

Santiago Alvarez, *75 primaveras* (75 springs), 1969

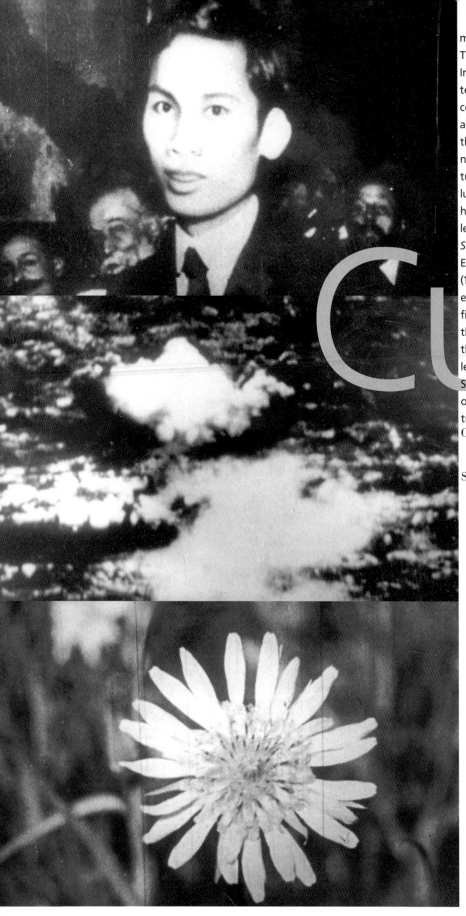

mobilization; George Harrison over parched Indian soil; Tchaikovsky's *Piano Converto* over the Havana skyline."

In *Hanoi, Tuesday the 13th* (1967), by showing us the daily texture of life in Hanoi under bombardement, Alvarez succeeds in showing us more about the resilience which allowed the Vietnamese to survive and fight their war than the voice-over rhetoric so often used in films on the Vietnam War. In *Take-off* at 18:00 (1970), he depicts Cuba at a turning point facing the American blockade, with the Revolution consolidated and the country mobilizing for the sugar harvest, preparing for economic take-off. His recent feature-length documentaries on Fidel's trip to Chile, *De America Soy Hijo Y A Ella Me Debo* (1971), and to the Soviet Union, Eastern Europe and Africa, *Y El Cielo Fue Tomado Por Asalto* (1973), rather than merely recording the Cuban leader's travels, use these trips to expound certain ideas. In the Chilean film it is the idea of Latin American solidarity in confronting the United States and, in *Y El Cielo Fue Tomado Por Asalto*, the notion of Marxism as a humanism and the theme of proletarian internationalism.

Santiago Alvarez is presently in Vietnam where in February of this year he began production on *Year of the Cat*, a feature-length documentary history of Vietnam.

Cineaste: We'd like to begin with a little personal history about yourself—what you did before the Revolution, how you came to work in the cinema, and so on.

Santiago Alvarez: Before the Revolution I was just a film buff, just a spectator like any other spectator from any other part of the world. I belonged to a cultural society *Nuestro Tiempo* [*Our Times*], which had a cine-club where we saw and theoretically discussed the film classics. Other comrades who today work at ICAIC—Alfredo Guevara, Julio Garcia Espinosa, Tomas Gutierrez Alea—also belonged to that cine-club. We also screened some of the classic revolutionary films from the Soviet Union. There was a distributor of Soviet films for Cuba and Mexico and we used to rent them and show them in a small movie house on Sunday mornings. We would get together to show the films and discuss them but it was also a pretext to recruit leftist people and talk about social problems.

Before that, in 1939, I lived in the United States, working as a dishwasher and working in the coal mines in Pennsylvania. It was here in the United States that I started to become politically conscious and when I went back to Cuba I became a communist. American imperialism is the greatest promoter of communism in the world. In fact, it was my experiences here that form the roots of *Now*, my film against racial discrimination in the US. That film grew directly out of my experiences here. It all came back to me one day when I was listening to a song called "Now" sung by Lena Horne—it's a melody based on an old Hebrew song by an anonymous author. When I started to work on the film at ICAIC, that background, that experience, helped me—I used all the hate I had felt against discrimination and brutality. I really started learning about the cinema in 1959. After the revolution when the film institute was created—it was the first law about cultural matters that Fidel signed—I started making a newsreel of the first trip that President Doricos made throughout Latin America.

Jean-Luc Godard on Santiago Alvarez

In a 1987 appearance on the TV channel Ciné-Cinémas, Jean-Luc Godard compared the use of slow-motion war images in Stanley Kubrick's recently released *Full Metal Jacket* and Santiago Alvarez's *79 primaveras*.

(He screens the slow-motion fall of a GI hit by a sniper): "That's Peckinpah's brand of slow motion. Kubrick is just addressing the crowd of viewers, exploiting something they're missing. It seems to me Welles called that a "gimmick," a trick, a gadget. Now you see it in all the American directors and even in Kubrick, which disappoints me, because he's got more talent than they do. And that, that's pure Peckinpah. Plus the exploitation of Vietnam. Me, I wouldn't go for that, because I wouldn't see the Vietnamese, or only in God knows what form. They were there, the Vietnamese. All you had to do was go there. He went there . . . He didn't see . . . he missed something. Kubrick's film is missing exactly what America missed. The war films on Germany—there isn't a single Hollywood actor who hasn't played a German general sometime or the other. There, there's not one who has played a general, because they wouldn't have known how. And that's a shame for them. Covering up that shame with slow motion just doesn't cut it, whatever the talent."

(He screens war images by Santiago Alvarez, interspersed with images by Kubrick to prove that they don't "hold up"): "You've got to look. You see something you believe

That was the first issue of ICAIC's *Noticiero Latino-americano*. The day that the Moviola arrived at ICAIC so we could do the work it was a cause for celebration. It was a Moviola with only a viewing screen and no sound head, but I still have it and work with it. Every piece of equipment then, like the little pins where you hang the takes in the editing room, was something new for us. We had all talked about the cinema, but we didn't know how to make it. Behind all our ignorance about equipment, though, there was a tremendous desire to move ahead, to fight the reactionary capitalist newsreels that were still being made and disseminating counterrevolutionary propaganda during that period in Cuba.

Cineaste: As time went on, was there any noticeable evolution in the style of the newsreels? It seems to me that there are a lot of similarities between your films and those of the Soviet film-maker, Dziga Vertov.

Santiago Alvarez: Actually, the first newsreels that we made were influenced by traditional newsreels. They were not revolutionary in a formal sense but the content was revolutionary. After we had completed about twenty of them, we started to look for new, expressive cinematic forms for the newsreel.

As for Dziga Vertov, that is a question I'm asked in every interview but I must say that there is absolutely no influence of Vertov in my films. In fact, when I first started making films I hadn't seen any films by Vertov. It is true that the reality Vertov experienced is similar to the one we have experienced and it is this reality, perhaps, which is the common denominator of our films.

In this regard, I think it is important to point out the importance of the Revolution as a powerful motivating force for us—the revolutionary process in Cuba has been the main inspirational muse of all our work. Before the Revolution there was no cinematic expression in Cuba. Every four or five years a North American producer would come to the country and make a pseudo-folkloric or musical film, utilizing exotic elements of our culture in a superficial manner. Sometimes they would use a few Cuban technicians, maybe borrowed from the TV studios, but only a few. So in order for us to begin making films there had to be a revolutionary will, a revolutionary inspiration.

Cineaste: Specifically, in terms of the application of Marxism in your films, I'm thinking of *Y El Cielo Fue Tomado Por Asalto* where you develop a thesis . . .

Santiago Alvarez: Yes, a materialist thesis. The introduction deals with the birth of a child where we show scientific scenes of childbirth as contrasted with Renaissance paintings of children with the Virgin. So we have a juxtaposition of the images of how a child is actually born, scientifically, with those beautiful paintings from the idealist Renaissance world which suggest that the child was born from the Virgin, from all those religious ideas. It's a materialist world view opposed to an idealist world view. . . .

The part of making a film I like best is the editing. My work in the editing room is completely different from that of the other comrades at ICAIC. Many times editors don't want to work with me because they're used to having an easy time with directors who just supervise and let them do the work. But I do all the work myself— I myself break up the material, I don't let the assistant editor do it, I myself hang up the takes in order to see

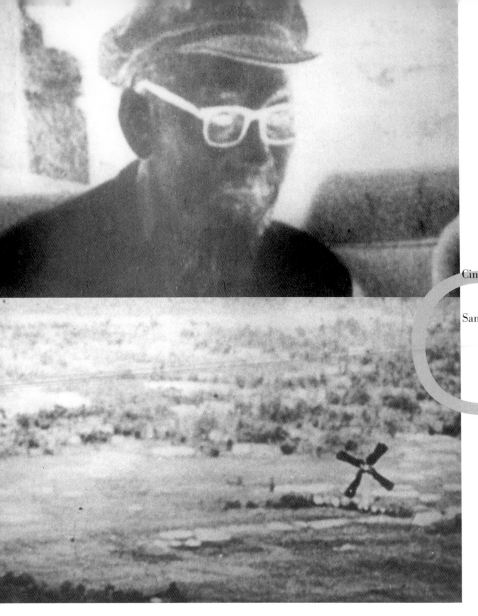

in and then [Kubrick], he doesn't believe in cinema, he forces it, and cinema can't take it. There's a point . . . a minimum of honesty. The other one [Alvarez] is made with documentaries, but it's so worked over by a stylized fiction that it gives back something real. And there [Kubrick], it's completely missing the documentary investigation . . ."

what each sequence is all about. I look at it and look at it and look at it. And I am meticulous, I even choose the exact frame where I want to cut—five frames are five frames, not six, but five. Then, while I am looking at the footage and doing the editing, I start thinking about editing the sound. When I transfer to mag-track, I'm still doing the editing of the sequences because I'm searching for the music at the same time that I'm doing the montage. When I'm listening to the sound I'm thinking about the structure of the sequence and when I'm editing the image I'm always thinking of what sound will go with it. As I'm putting it together and it begins to take on a certain rhythm, I think about what effects, what sound, what music, will go with that image. Fifty percent of the value of a film is in the sound track. . .

Cineaste: How successful have Cuban film-makers been in inproving public taste? Do Cuban audiences still prefer "entertainment" films to "political" films?

Santiago Alvarez: We *are* the public, film-makers *are* the public. We start from the basis that we belong to the social reality of our country, we are not foreigners, we are part of the people and our films grow out of a shared reality. If we thought we were a privileged group above the people, then we would probably make films that communicated only with a minority or an elite group. But we are not a group of poets producing abstract or bizarre poetry. One can only be a revolutionary artist by being with the people and by communicating with them.

It has been a challenge for us but we have been successful to some extent in breaking public movie-going habits. Due to the influence of capitalism, even in socialist countries, it has always been the custom to show documentaries only as supplementary material with a feature-length fiction film with actors as the main attraction. But we have been able to show documentaries as the main attraction in theatres. For example, *De America Soy Hijo* which lasts three hours and fifteen minutes and which features as its main character Fidel on a trip, was released simultaneously in seven theatres and there were still long lines of people and they had full houses for two months. Another documentary, *Y El Cielo Fue Tomado Por Asalto* which lasts two hours and eight minutes, was similarly successful. . .

Cineaste: In conclusion, any thoughts about the future?

Santiago Alvarez: I think that in twenty years the cinema is going to disappear, there will be another technology to replace it. There will be new developments in electronic techniques which will completely change the traditional method of making films, not only in Cuba but everywhere. Technology is going to absolutely change everything and the means of communication—for the painter, the musician, the film-maker—will change radically.

I think the individualistic conception of art will change completely and we will no longer continue the practice of the museum or private exhibition of art works as we do now. The creators, the artists in society, will put their energies into making not just one painting but into creating mass art works, into beautifying shoes, homes, factories, everything, the total environment. It will be an anti-individualistic conception of artistic creation where everything will be for the benefit of all humanity.

From: *Cineaste* 6-4, 1975.

75 primaveras,
A Cuban look at Vietnam

79 primaveras (1969, black and white, 24 mn) is largely composed of images of the funeral of Vietnamese president Ho Chi Minh. In this case they are not by Iván Nápoles, the cameraman for most of the documentaries by Santiago Alvarez. More than a biography, this film is an elegy-denunciation, drawing its greatest strength from the interpretation of the overall message left to the Indochinese people by the man who was their leader in the anticolonial struggles. Alvarez also used archival footage and photos of Uncle Ho to briefly retrace his political career. Yet the real aim of the film is quite different: to capture the meaning of his life, to transform it into an appeal to optimism, a difficult task in the painful circumstances. Success depended on a masterful conception of montage, using counterpoint and highly significant content, as well as a compositional technique inspired by the discoveries of Vertov. The opening is a model of contradiction: the blooming flower is the brimming vigor of life, intimately linked to Ho Chi Minh's struggle for independence; the mushroom of dust from a bomb blast is the venom of death . . . and there is no need to say where it came from.

From: José Antionio Alvarez, *Le Cinéma Cubain*, Paris, 1990.

In the year of the pig
History and montage

I approach all of my work from a consciously left viewpoint. It's very hard to articulate what it means to be a Marxist today, but it was a little bit clearer in 1967 when I began *Pig*. The film originally grew out of anger, outrange, and passion, but I knew that all of these, estimable as they are as motivations, are wrong if unchecked in a film, because you end up with only a scream, a poster that shouts "Out of Vietnam!" It seemed to me that the most passionate statement that could be made was to make a film that would treat the history of Vietnam as far back as the footage would take it, to cover the whole history of the war, from its earliest days to the Tet Offensive in 1968, which was the year I completed the film. Compilation film-making lends itself best to history, which is, frankly, the theme of all my films.

. . .

I think you've got to do a hell of a lot of homework. I then proceed to assemble a chaotic draft of the subject. I knew that I was going to pursue an historical line, although not necessarily a chronological line. I had a friend who owned a box factory and he used to give me corrugated paper in rolls nine feet high, and I'd tack them up on my office walls. I'd start out by writing "Han Dynasty," even though I knew I'd never put anything about the Han Dynasty in the film, because the Chinese experience begins there. I would obviously write down "Dien Bien Phu, 1954, May 8th," and abstract concepts like "torture," "inhumanity," and other things that interested me. Sometimes I would also paste a picture into it, so I would have visual images as well as words on the walls.

Once this huge outline was done, I started to do extensive film research. I went to Prague, for instance, where the NLF had a main office and they gave me tremendous footage. I went to East Germany and there I met the Soviets who gave me Roman Karment's restaging of the battle of Dien Bien Phu. Sometimes it's very sad, by the way, when good research pays off, because most of the people who saw *In the Year of the Pig* thought that really was the battle of Dien Bien Phu. When I lecture with the film today, I tell audiences that, "You should look more carefully, because if you look at those Vietminh troops, you know they're not actually in combat. They're all so nearly dressed and running at port arms as if some Major were in the back giving orders." Still, it was beautiful footage, and I think I used it well, because I cut from

Öyvind Fahlström, *Notes No. 7 (Gook Masks)*, 1975

Testimony

First of all I must excuse myself for being unable to give you a well-prepared talk: I have just arrived from South Vietnam and I did not have the time to draft a text. I want to begin by describing the overall physical appearance of Vietnam today. Just a moment ago you saw the Vietnamese landscape, the bomb craters. When you fly over the Vietnamese countryside you see that it resembles a human skin suffering from smallpox—eruptions everywhere, especially near isolated dwellings, villages, small valleys. Everyone can observe that and draw their conclusions without any great intellectual effort. As you fly over the country you also see vast territories devastated by chemical products, a gray landscape, a landscape of ash. In the coastal regions of central Vietnam there are groups of abandoned villages, dwellings, rice fields. In the cities controlled by the Saigon administration and the Americans, you can see a whole forest of barbed wire. The American troops, the provincial chiefs, the district chiefs, and the South Vietnamese bureaucrats collaborating with the Americans all surround their houses with a thicket

that to the real footage of all those white faces surrendering to yellow faces, which is one of the symbols of that war.

I met with the Hanoi people in Paris and I was the first westerner to get an extraordinary film called *The Life of Ho Chi Minh*, which is their view of Ho, with early stills of Ho and his family, and great material of Ho joining the French Communist Party in 1922. I love that kind of material. I also got access to the French Army's film library, the greatest collection of Vietnam footage that exists. It goes back to 1902.

. . .

The thing that staggered me was that even though the TV networks were going on and on about Vietnam, and other people were making films about Vietnam, no one founded the footage I did for *Pig*. I located several great scenes no one ever picked up, including one of the film's best scenes, from the 1930s, which is of these absolutely arrogant French men in their colonial hats and white suits being pulled in rickshaws by Vietnamese. They arrive in front of a café where there is a tall Moroccan with a fez—the scene encapsulates the whole French colonial empire—and when the Vietnamese put their hands out for payment, the Moroccan sends them away like trash. To me, that said everything you could say about colonialism without ever saying the word. If anything shows primacy of the image over the word, what the image can reveal, it's the image of those rickshaws. It's the equivalent of a couple of chapters of dense writing about the meaning of colonialism.

. . .

I work very hard at editing, I'm never satisfied. I always edit with the whole picture in mind. When I finish a sequence, I run the entire film from the beginning to see how it plays. I'll continue working on a scene until I'm satisfied. Finding a suitable ending to *Pig*, for example, proved a real problem. Originally, the ending I was going to use was some footage that the Hanoi people had given me. I had been playing with it for weeks. It was a very quiet scene of a road in North Vietnam and, suddenly, the brush around the road gets up, it's the Vietminh, and they come charging out. But I thought, "Shit, I'm an American. I mean, I hope the Vietnamese win this war, I think our position is immoral, and I'm a Marxist, but I'm

not Vietnamese. That would be a suitable ending for a Vietnamese film, but I'm an American." I decided to show that, even though we're Americans, the Vietnamese can punish us, so I got all this footage of dead and wounded Americans with bandages around their eyes, blinded, being evacuated. Then I took a shot of a Civil War statue—a young man who died at Gettysburg—and reversed it, put it into negative, to show, in my mind anyway, that our cause in Vietnam was not the one that boy had died for in 1863, and then added a kind of scratchy version of "The Battle Hymn of the Republic." For me that was a suitable ending, a politically coherent ending.

From: interview, 1982, in *Imagining Reality, The Faber Book of documentary,* London, 1996.

of barbed wire. There is a dead space between the dwellings and offices of the Americans and the South Vietnamese bureaucrats. . . .

As to the techniques used by the Americans to conduct the war, several can be distinguished. The most classic is the sweep. A number of helicopters land in a village, the soldiers enter the houses, seize a certain number of people, especially young people, arrest them on the pretext of being "suspected Vietcong," and carry them off to interrogation centers. After several hours the helicopters leave and the population remains paralyzed with fear. What happens to the prisoners? Working at the central hospital in Hue, I had the occasion to see about fifty prisoners from the neighboring prison; they were sent to the hospital in an extremely serious state, sometimes just before death. I was able to establish a certain number of files on these prisoners, with information on their story and the way they were taken captive; I must add that my Vietnamese students helped me build up these files as much as they could. I am going to read two examples. I won't mention names because the prisoners could come to harm—they are still in prison.

1. M. X, thirty years old, residing in Tanh Binh, Quang Nam province; a farmer, married with two children . . . He had been in prison for three years when he was sent to the hospital with an advanced case of beriberi. He was taken as a suspect in a sweep operation, with no proof whatsoever; he was tortured with kicks to the chest, head, and groin, and with electric wires twisted around his both forefingers. After this torture he signed a prepared confession. The sentence: four years imprisonment. He was evacuated to the Hue prison.

2. A young woman, twenty years old, residing in the same province; a farmer, living with her parents. Same process of arrest as the first (a sweep). Tortures: beaten with a stick, electrocution, made to drink soapy water. Result: signed a confession, was condemned to two years of prison.

There are also men and women who do not confess; their fate is worse. They are tortured for a much longer time, generally no sentence is given; they remain indefinitely in prison or in the camps. Talking with these prisoners, I was convinced that only two or three of them had really taken part in active struggle. Most were peasants whose mistake was not to have fled in time.

The success of these sweeps, or "search and destroy operations" as the Americans call them, has been rather limited. In the course of the last two years, another procedure has been invented to deprive the liberation troops of any help from the people: areas are emptied of their inhabitants, who are reimplanted elsewhere. . . .

Testimony of Doctor Eric Wulff, professor at the Hue School of Medicine from September 1961 to November 20, 1967, in *Actes du Tribunal Russel II,* Paris.

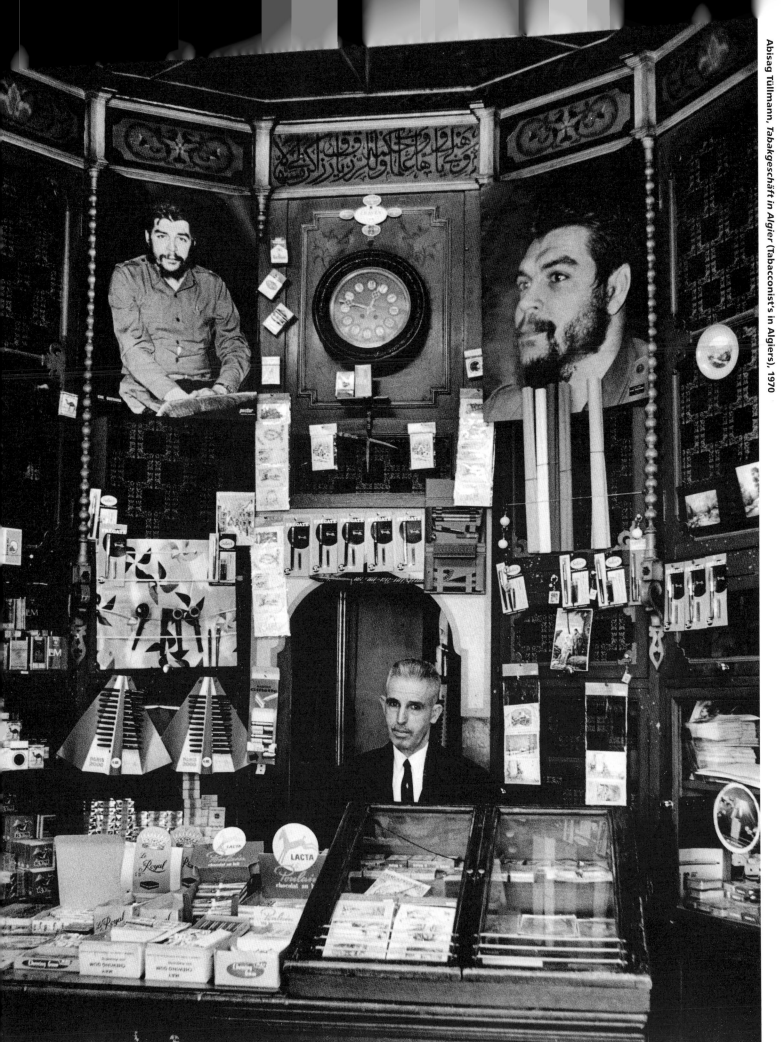

Amilcar Cabral

When the African peoples say in their simple language that "no matter how hot the water from your well, it will not cook your rice," they express with singular simplicity a fundamental principle, not only of physics, but also of political science. We know that the development of a phenomenon in movement, whatever its external appearance, depends mainly on its internal characteristics. We also know that on the political level our own reality—however fine and attractive the reality of others may be—can only be transformed by detailed knowledge of it, by our own efforts, by our own sacrifices. It is useful to recall in this Tricontinental gathering, so rich in experience and example, that however great the similarity between our various cases and however identical our enemies, national liberation and social revolution are not exportable commodities; they are, and increasingly so every day, the outcome of local and national elaboration, more or less influenced by external factors (be they favourable or unfavourable) but essentially determined and formed by the historical reality of each people, and carried to success by the overcoming or correct solution of the internal contradictions between the various categories characterising this reality.

. . .

In fact in the general evolution of humanity and of each of the peoples of which it is composed, classes appear neither as a generalised and simultaneous phenomenon throughout the totality of these groups, nor as a finished, perfect, uniform and spontaneous whole. The definition of classes within one or several human groups is a fundamental consequence of the progressive development of the productive forces and of the characteristics of the distribution of the wealth produced by the group or usurped from others. That is to say that the socio-economic phenomenon "class" is created and develops as a function of at least two essential and interdependent variables—the level of productive forces and the pattern of ownership of the means of production. This development takes place slowly, gradually and unevenly, by quantitative and generally imperceptible variations in the fundamental components: once a certain degree of accumulation is reached, this process then leads to a qualitative jump, characterised by the appearance of classes and of conflict between them.

. . .

This leads us to pose the following question: does history begin only with the development of the phenomenon of "class," and conse-

Gérard Chaliand

Just a few events in the colonial or semi-colonial societies laid the foundations for so-called "Third Worldism" which emerged around 1961-62. The background was the Chinese revolution (1949) and the wave of Asian liberations culminating in Dien Bien Phu (1954), dubbed the "Valmy of the colonized."

On the French side, anticolonialism grew to great dimensions during the Algerian war and came to represent the crucible of internationalism, with a particular focus on liberation struggles in Asia and Africa. The radicalization of the Cuban revolution (1960) and the US-backed attempt to overthrow the Castro regime (Bay of Pigs, 1961) brought Latin America into the orbit of the revolutionary Third World. From these years on, armed struggle would be exalted, even sacralized.

With great reliance on the principle of "just" and "unjust" wars, the left—for lack of a better word—cherished heroic scenes of armed struggle in its collective memory. Their archetypes were the French resistance, the international brigades in Spain, the Russian and Mexican revolutions (Eisenstein and *Viva Zapata!* mixed with Malraux's *Hope* and the death of Garcia Lorca, against a backdrop of anti-fascism).

Tricontinentalism found official expression in early 1966 at the Tricontinental conference in Havana, but it had already been born in 1961 with the publication of *The Wretched of the Earth.**

* The journal *Partisans* released its first issue in fall 1961, devoted to the "generation of Algeria"; the second issue focused on Cuba. In 1963 *Révolution africaine* in Algiers and *Révolution* in Paris fed this same current.

From: *Les Faubourgs de l'Histoire*, Paris, 1984.

Gérard Chaliand

Despite what Fanon had suggested, Algeria did not end in revolution. Jean-François Lyotard more clearly perceived the insufficiencies of the NLF, its lack of social content. The national movement had no other goal than independence and no other program than territorial integrity. Its theoretical silence was caused not by its clandestine existence but by its intellectual void. The postulate, in *The Wretched of the Earth*, that collective violence would engender political lucidity proved mistaken. . . .

quently of class struggle? To reply in the affirmative would be to place outside history the whole period of life of human groups from the discovery of hunting, and later of nomadic and sedentary agriculture, to the organisation of herds and the private appropriation of land. It would also be to consider—and this we refuse to accept—that various human groups in Africa, Asia and Latin America were living without history, or outside history, at the time when they were subjected to the yoke of imperialism. It would be to consider that the peoples of our countries, such as the Balantes of Guinea, the Coaniamas of Angola and the Macondes of Mozambique, are still living today—if we abstract the slight influence of colonialism to which they have been subjected—outside history, or that they have no history.

. . .

The important thing for our peoples is to know whether imperialism, in its role as capital in action, has fulfilled in our countries its historical mission: the acceleration of the process of development of the productive forces and their transformation in the sense of increasing complexity in the means of production; increasing the differentiation between the classes with the development of the bourgeoisie, and intensifying the class struggle; and appreciably increasing the level of economic, social and cultural life of the peoples. It is also worth examining the influences and effects of imperialist action on the social structures and historical processes of our peoples. We will not condemn nor justify imperialism here; we will simply state that as much on the economic level as on the social and cultural level, imperialist capital has not remotely fulfilled the historical mission carried out by capital in the countries of accumulation.

. . .

Although the colonial and neo-colonial situations are identical in essence, and the main aspect of the struggle against imperialism is neo-colonialist, we feel it is vital to distinguish in practice these two situations. In fact the horizontal structure, however it may differ from the native society, and the absence of a political power composed of national elements in the colonial situation make possible the creation of a wide front of unity and struggle, which is vital to the success of the national liberation movement. But this possibility does not remove the need for a rigorous analysis of the native social structure, of the tendencies of its evolution, and for the adoption in practice of appropriate measures for ensuring true national liberation. While recognising that each movement knows best what to do in its own case, one of these measures seems to us indispensable, namely the creation of a firmly united vanguard, conscious of the true meaning and objective of the national liberation struggle which it must lead.

The meeting of urban and rural revolutionaries had gripped Fanon's attention. In his chapter on the "grandeur and weakness of spontaneity," he perfectly describes how the handful of men who sparked the November 1 revolution first came together, and how they resolved to go into armed struggle. But as a general rule he gives far too much credit to the spontaneity of the peasantry. . . .
The social groups with the greatest awareness, those which can be mobilized for the anticolonial struggle, were analyzed with infinitely more finesse and concrete knowledge of the terrain by Amilcar Cabral, who was no doubt the most lucid political analyst of colonial and postcolonial sub-Saharan Africa.
The social category which furnishes the striking force and the mid-level revolutionary cadres, whether nationalist, Marxist, or Islamicist, is always the same: recently urbanized youth, often from very humble rural backgrounds, with secondary school and sometimes university education, but without any perspectives for advancement in a society that is frozen in place. Fanon idealized popular mobilization. . . .
The same errors were committed in Latin America at the very moment when Fanon was writing *The Wretched of the Earth*.

From: forward to Franz Fanon, *Les Damnés de la terre*, Paris, 1971.

Gérard Chaliand

But one of the major reasons for the failure of the Latin American guerrilla movements after the Cuban revolution lies in the application of the theory of the foco (mobile strategic focus), formulated by Guevara and systematized by Régis Debray. Basing himself on what he saw as the lessons to be drawn from the Cuban revolution, Guevara synthesized his conclusions in the book *Guerrilla Warfare* (1960). Three points stand out: guerrilla fighters can defeat a regular army; the fundamental guerrilla terrain in Latin America must be the countryside; and above all (for the two preceding points are not new), one need not await the fulfillment of the objective conditions for the outbreak of the struggle, because the insurrectional focus

In the neo-colonial situation the more or less vertical structure of the native society and the existence of a political power composed of native elements—national state—already worsen the contradictions within that society and make difficult if not impossible the creation of as wide a front as in the colonial situation. On the one hand the material effects (mainly the nationalisation of cadres and the increased economic initiative of the native elements, particularly in the commercial field) and the psychological effects (pride in the belief of being ruled by one's own compatriots, exploitation of religious or tribal solidarity between some leaders and a fraction of the masses) together demobilise a considerable part of the nationalist forces.

. . .

To retain the power which national liberation puts in its hands, the petty bourgeoisie has only one path: to give free rein to its natural tendencies to become more bourgeois, to permit the development of a bureaucratic and intermediary bourgeoisie in the commercial cycle, in order to transform itself into a national pseudo-bourgeoisie, that is to say in order to negate the revolution and necessarily ally itself with imperialist capital. Now all this corresponds to the neo-colonial situation, that is, to the betrayal of the objectives of national liberation. In order not to betray these objectives, the petty bourgeoisie has only one choice: to strengthen its revolutionary consciousness, to reject the temptations of becoming more bourgeois and the natural concerns of its class mentality, to identify itself with the working classes and not to oppose the normal development of the process of revolution. This means that in order to truly fulfil the role in the national liberation struggle, the revolutionary petty bourgeoisie must be capable of committing suicide as a class in order to be reborn as revolutionary workers, completely identified with the deepest aspirations of the people to which they belong.

This alternative—to betray the revolution or to commit suicide as a class—constitutes the dilemma of the petty bourgeoisie in the general framework of the national liberation struggle. The positive solution in favour of the revolution depends on what Fidel Castro recently correctly called *the development of revolutionary consciousness.* This dependence necessarily calls out attention to the capacity of the leader of the national liberation struggle to remain faithful to the principles and to the fundamental cause of this struggle. This shows us, to a certain extent, that if national liberation is essentially a political problem, the conditions for its development give it certain characteristics which belong to the sphere of morals.

From: "The Weapon of Theory," address to the first Tricontinental Conference, Havana, January 1966, in *"Revolution in Guinea": Selected Texts by Amilcar Cabral*, New York, 1969.

can create them by its very existence. In other words, Guevara invited the imitation of the Cuban example, without attaching any fundamental importance to its specificity. However—and this is too often neglected—if guerrilla warfare brought the group that had disembarked from the Granma to power, it was only because at the time, the installation of a socialist-type regime was not a question. Thus, beyond US neutrality from 1956 to 1959, one must insist, particularly in the cities, on the support or acceptance of the Castrist guerrilla movement by elements from social strata which may have been happy to see an end to the tyranny of Batista, but in no way desired or expected the directions taken in 1960-61. Indeed, only well after the conquest of power did the radicalization that would lead to the changes in the social and economic structure become apparent. The element of surprise or outright misunderstanding which had allowed the Cuban leadership to lend an increasingly radical character to the revolution could not be reproduced elsewhere.

. . .

The weakness of the *foco* theory, which consisted in directly engaging the armed struggle without any serious mobilization of the population, was precisely that it deprived the guerrilla movement of popular support for an indefinite period. This was amply demonstrated by a series of abortive attempts between 1959 and 1967. Failures in Paraguay (the May 14 movements in 1959), Columbia (the movement of workers, students, and peasants, or MOEC, in 1961), Equador (the revolutionary union of Equadorian youth in 1962), the Dominican Republic (the May 14 revolutionary movements in 1963), various failures in Argentina (1963, 1964, particularly in the Tucuman region), Peru (the MIR and ELN guerrilla actions of 1965), Brazil (numerous attempts throughout the decade), Honduras, Mexico, and finally in Bolivia, with Guevara himself. Not to mention all the groups which were dismantled before even reaching the mountains.

From: *Voyage dans vingt ans de guérillas*, La Tour d'Aigues, 1988.

Gérard Chaliand

The Cuban revolution did not expand to the continent, despite the appearances that made such an expansion seem imminent. In fact, phenomena of social violence are traditional in Latin America, but even limited social revolutions are rare: Mexico (1911), Bolivia (1952), Cuba (1959), and, more recently, Peru (1968) and Chile (1970). The number is relatively small if one considers that from 1930 to 1970, approximately one hundred and twenty heads of state were replaced through other than constitutional means. The failure of the Bay of Pigs led Cuba and all revolutionary Latin Americans to underestimate not only the difficulties of popular mobilization in the framework of a guerrilla movement, but also the determination of the United States. The latter became clear during the Cuban missile crisis (1962), the intervention in the Dominican Republic (1965), and, more discreetly, in the counterinsurgency campaigns. . . .

From: Voyage dans vingt ans de guérillas, La Tour d'Aigues 1988.

Edward W. Said

The Wretched of the Earth is a hybrid work—part essay, part imaginative story, part philosophical analysis, part psychological case history, part nationalist allegory, part visionary transcendence of history. It begins with a territorial sketch of the colonial space, separated into the clean, well-lighted European city and the dark, fetid, ill-lit casbah. From this Manichean and physically grounded stalemate Fanon's entire work follows, set in motion, so to speak, by the native's violence, a force intended to bridge the gap between white and non-white. For Fanon violence, as I said earlier, is the synthesis that overcomes the reification of white man as subject, Black man as object. My conjecture is that while he was writing the work Fanon read Lukács' *History and Class Consciousness*, which had just appeared in Paris in French translation in 1960. Lukács shows that the effects of capitalism are fragmentation and reification: in such a dispensation, every human being becomes an object, or commodity, the product of human work is alienated from its maker, the image of whole or of community disappears entirely. Most important to the insurgent and heretical Marxism put forward by Lukács (shortly after publication in 1923 the book was removed from circulation by Lukács himself) was the separation of subjective consciousness from the world of objects. This, he says, could be overcome by an act of mental will, by which one lonely mind could join another by imagining the common bond between them, breaking the enforced rigidity that kept human beings as slaves to tyrannical outside forces. Hence reconciliation and synthesis between subject and object. Fanon's violence, by which the native overcomes the division between whites and natives, corresponds very closely to Lukács's thesis about overcoming fragmentation by an act of will. . . .

There can be little doubt that were they alive today Fanon and Cabral, for example, would be hugely disappointed at the results of their efforts. I make that speculation considering their work as a theory not just of resistance and decolonization, but of liberation. In all sorts of ways, the somewhat inchoate historical forces, confusing antitheses, unsynchronized events that their work tried to articulate were not fully controlled or rendered by it. Fanon turned out to be right about the rapacity and divisiveness of national bourgeoisies, but he did not and could not furnish an institutional, or even theoretical, antidote for its ravages.

But it is not as state builders or, as the awful expression has it, founding fathers that the greatest resistance writers like Fanon and Cabral should be read and interpreted. Although the struggle for national liberation is continuous with national independence, it is not—and in my opinion never was—culturally continuous with it. To read Fanon and Cabral, or C. L. R. James and George Lamming, or Basil Davidson and Thomas Hodgkin merely as so many John the Baptist of any number of ruling parties or foreign-office experts is a travesty. Something else was going on, and it sharply disrupts, then abruptly veers away from the unity forged between imperialism and culture.

From: *Culture and Imperialism*, London, 1993.

196719781989

Robert Adams

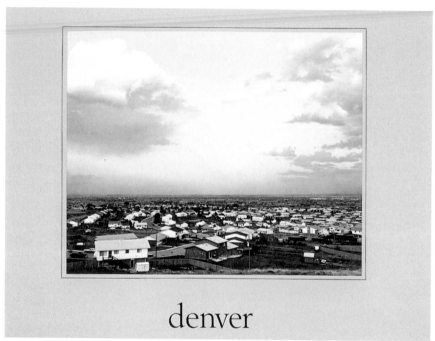

denver

Denver, Colorado, 1977

Untitled, 1977

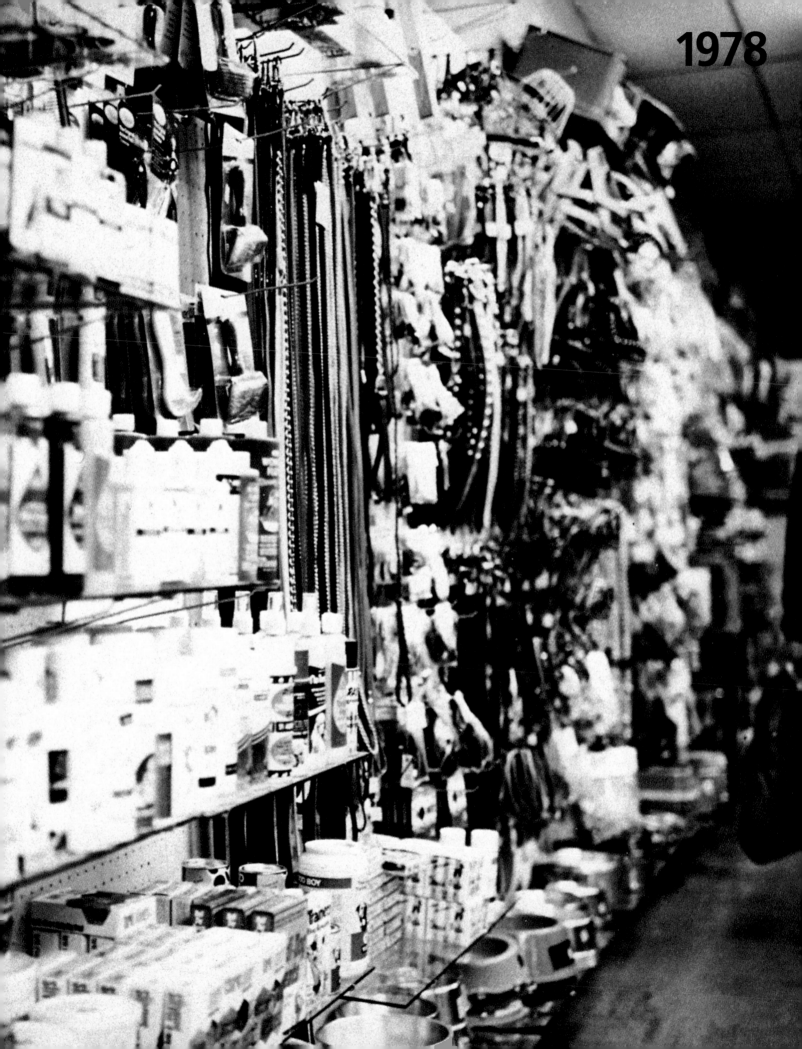

1978

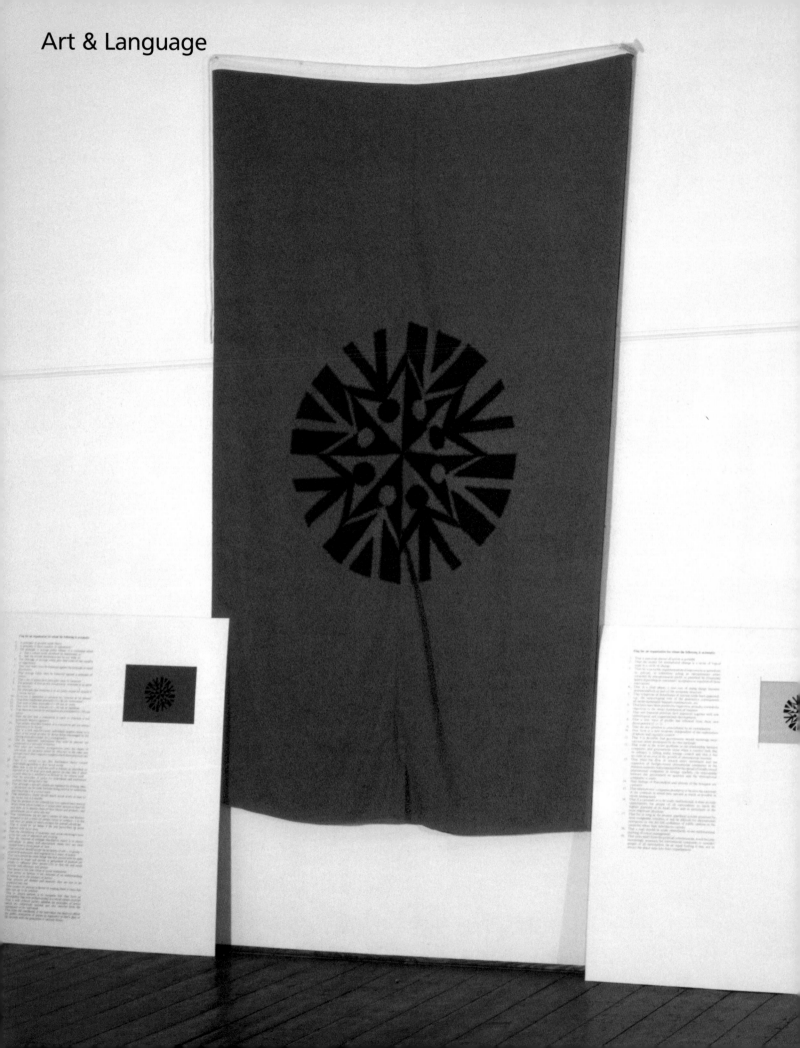

Art & Language

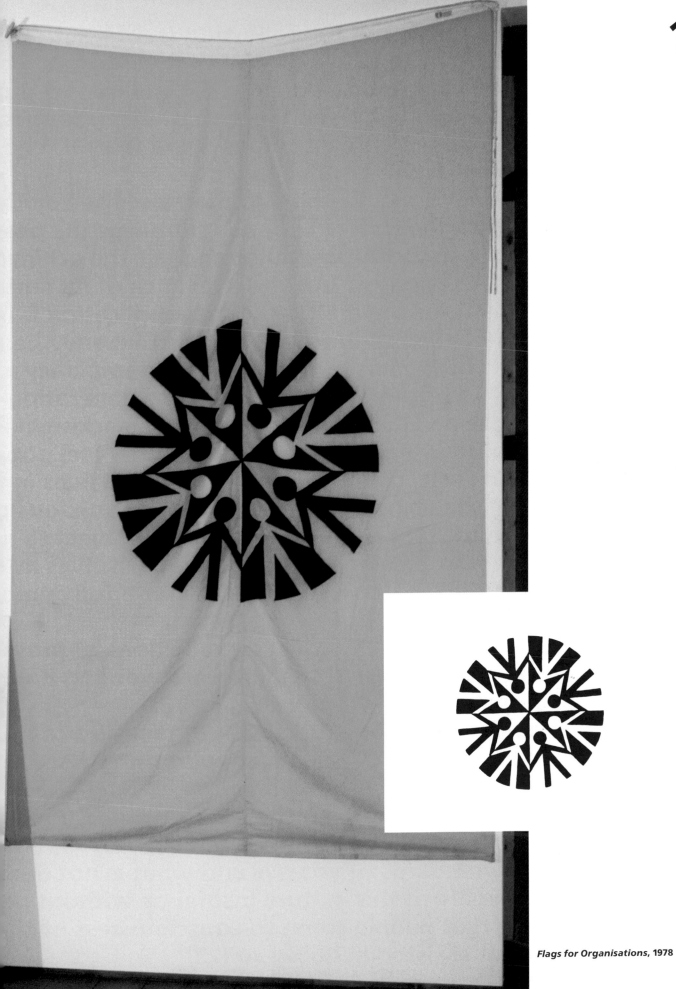

Flags for Organisations, 1978

Flag for an organisation for whom the following is axiomatic:

1. That Western society is based upon envy engendered by pu
2. That publicity works upon anxiety: the sum of everything is
3. That the anxiety on which publicity plays is the fear that ha
4. That under capitalism money is life
5. That under capitalism money is the token of, and the key to
6. That under capitalism the power to spend money is the pow
7. That publicity speaks in the future tense and yet the achieve real fulfilment of its promises, but the relevance of its fanta to those of the spectator-buyer. Its essential application is n
8. That glamour cannot exist without personal social envy beir
9. That the industrial society has moved towards democracy a
10. That the industrial society is an ideal society for generating
11. That the pursuit of individual happiness has been acknowle
12. That existing social conditions make the individual feel pow
13. That in the existing social conditions, the individual lives in t
14. That the individual can either (14a) become fully conscious c and its causes, or else (14b) he lives, continually subject to a compounded with his sense of powerlessness, dissolves inte
15. That 14a entails joining the political struggle for a full demo capitalism
16. That the process of living within the contradictions of prese
17. That the interminable present of meaningless working hour replaces the passivity of the moment
18. That only one kind of hope or satisfaction or pleasure can b acquire is recognised to the exclusion of everything else
19. That the dream of capitalism is publicity
20. That capitalism survives by forcing the majority, whom it ex
21. That the survival of capitalism was once achieved by extens by imposing false standards of what is and what is not desi
22. That publicity is the life of this culture insofar as without pu
23. That it is desirable that people come to consciousness of the
24. That they should be assisted in doing so (23)

ey, to get money is to overcome anxiety
nothing you will be nothing

y human capacity
live
t of this future is endlessly deferred. It is judged, not by the

reality but to daydreams
ommon and widespread emotion
en stopped half way
nal social envy
as a universal right

ntradictions between what he is and what he would like to be
contradiction between what he is and what he would like to be
y which,
rrent daydreams
which itself entails amongst other things the overthrow of

ial conditions is often reinforced by working conditions
alanced' by a dreamt future in which imaginary activity

saged within the culture of capitalism: the power to

, to define their (sic) own interests as narrowly as possible
privation. Today in the developed countries it is being achieved

capitalism could not survive
se standards

Terra Incognita, Orinoco 1978

James Coleman

La Tache Aveugle **(The Blind Spot), 1979–90**

Box (ahhareturnabout), 1977

342

Jean-Luc Godard

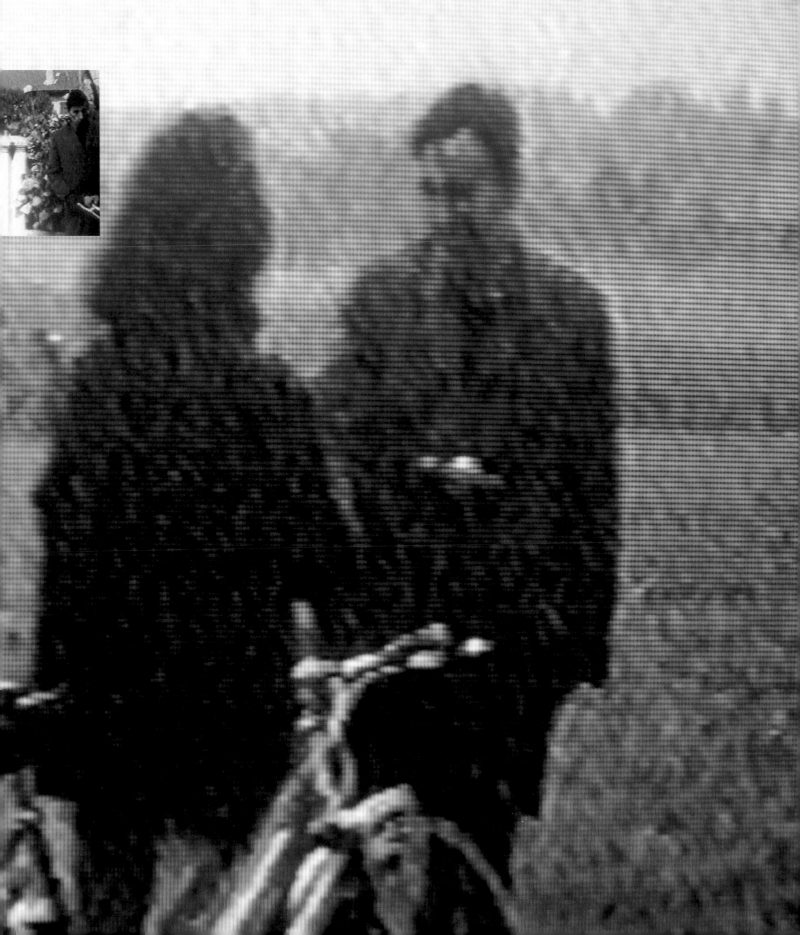

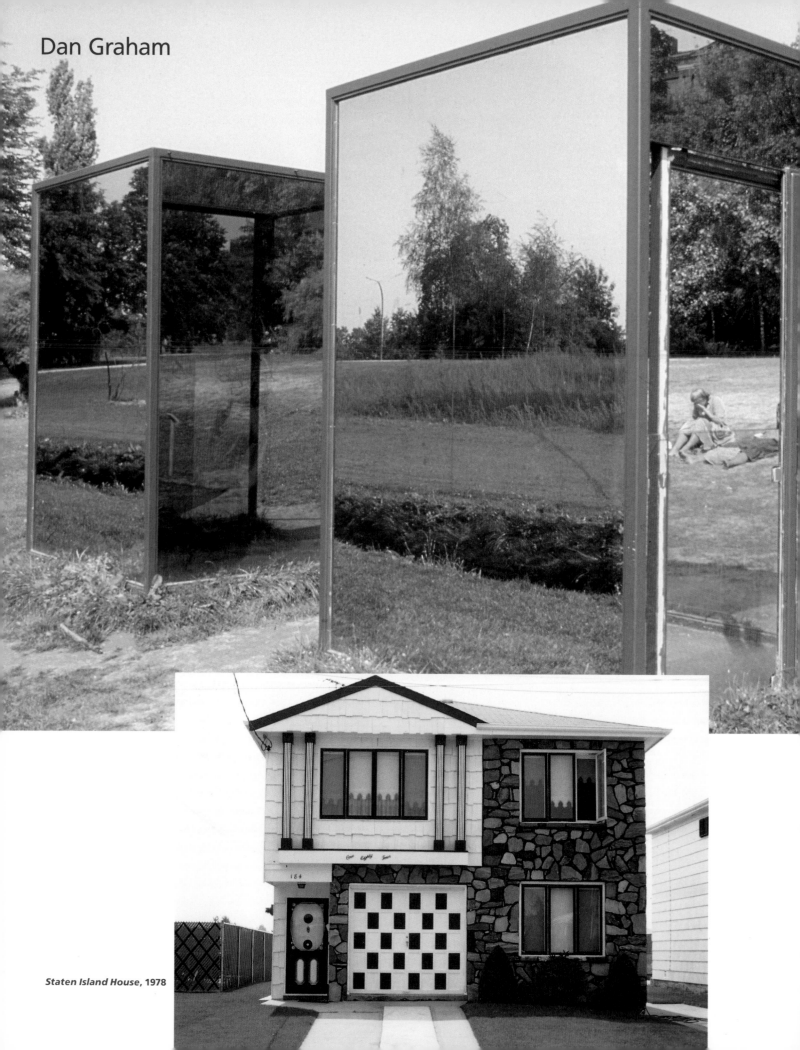

Dan Graham

Staten Island House, 1978

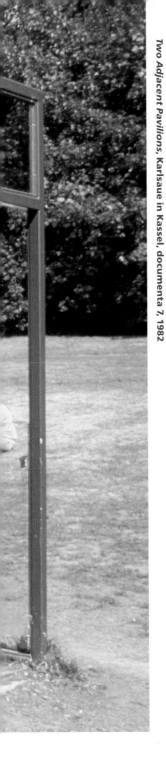

Two Adjacent Pavilions, Karlsaue in Kassel, documenta 7, 1982

Alteration to a Suburban House, 1978

Alteration to a Suburban House, 1978

Toni Grand

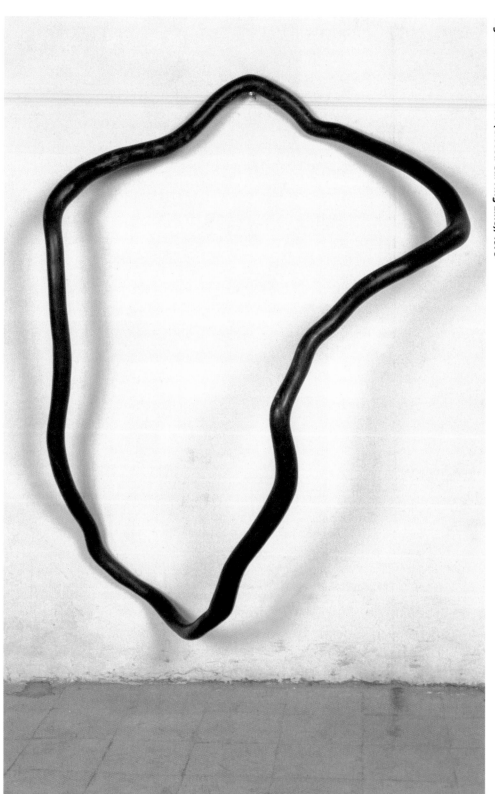

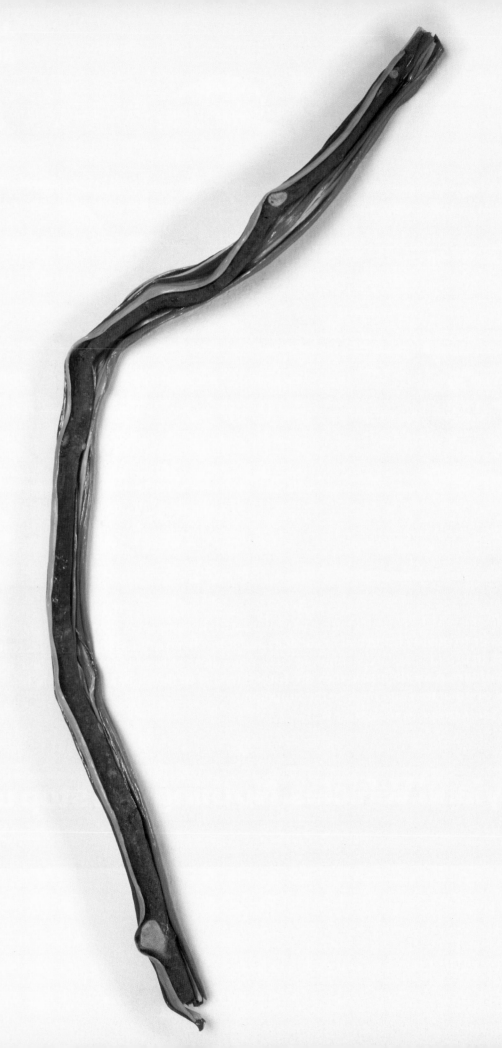

An employee may have an incentive to remain with his employer, no matter how he is treated, in order to qualify for urban residence; and it has been argued that contract workers' rights to work in urban areas are so tenuous that, regardless of how uncongenial their employment or how poor their pay, they are forced to stay in their job for fear of being endorsed out of their area and back to the homelands.

UK Parliamentary Select Committee on African Wages, 1973

 Leyland Vehicles. Nothing can stop us now.

Leyland advertising slogan

A breed apart, 1978

Photo: Leyland

Jaguar, a breed apart. The new-generation Jaguar Executive has been born. And it has opened the door to a new world…a world that, because of its sophistication and sheer class, only a select few will enter.

It is a world that has been created for the leader, not the pack. For those who have made it and stand apart from the masses. For those whose success demands, and deserves, a quality of life that spells luxury, elegance, perfection.

Leyland South Africa

 Leyland Vehicles. Nothing can stop us now.

Leyland advertising slogan

Richard Hamilton

Sign, 1975. *Ashtray*, 1979. *Carafe*, 1978

Mike Kelley

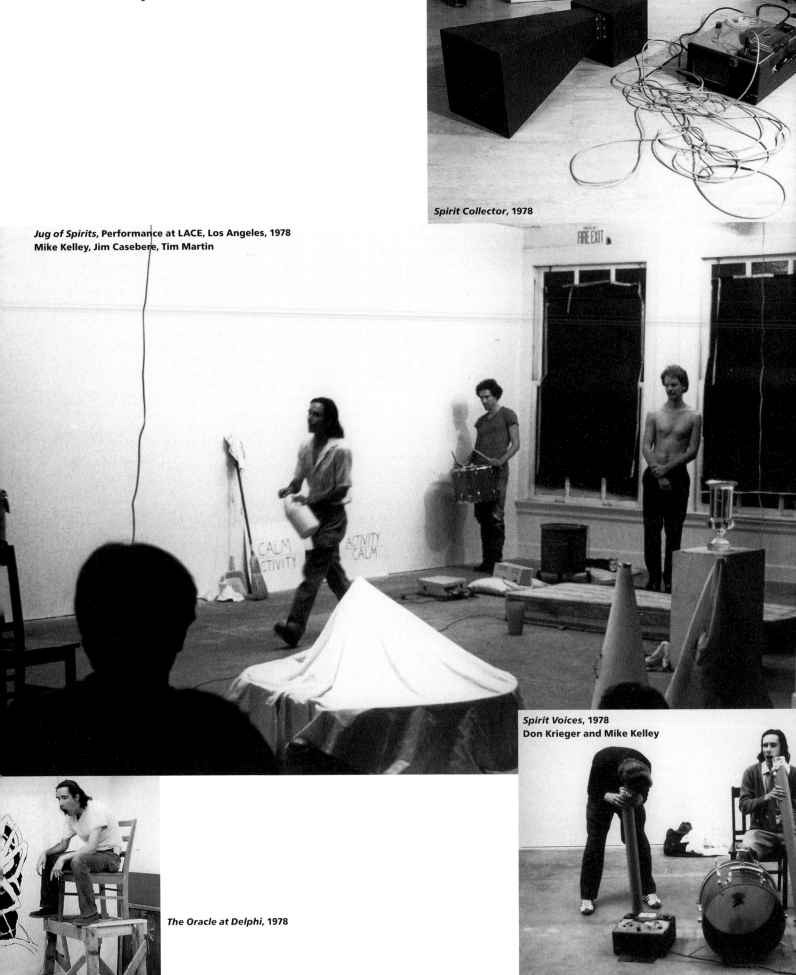

Spirit Collector, 1978

Jug of Spirits, **Performance at LACE, Los Angeles, 1978**
Mike Kelley, Jim Casebere, Tim Martin

Spirit Voices, **1978**
Don Krieger and Mike Kelley

The Oracle at Delphi, **1978**

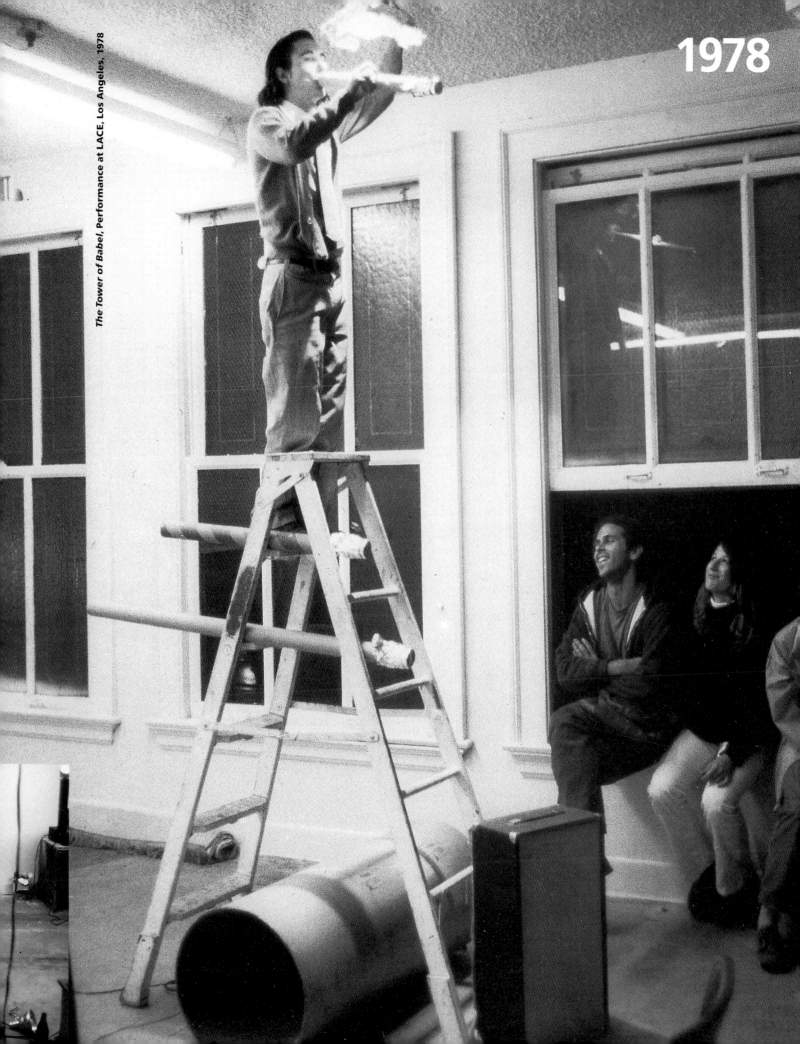

The Tower of Babel, Performance at LACE, Los Angeles, 1978

1978

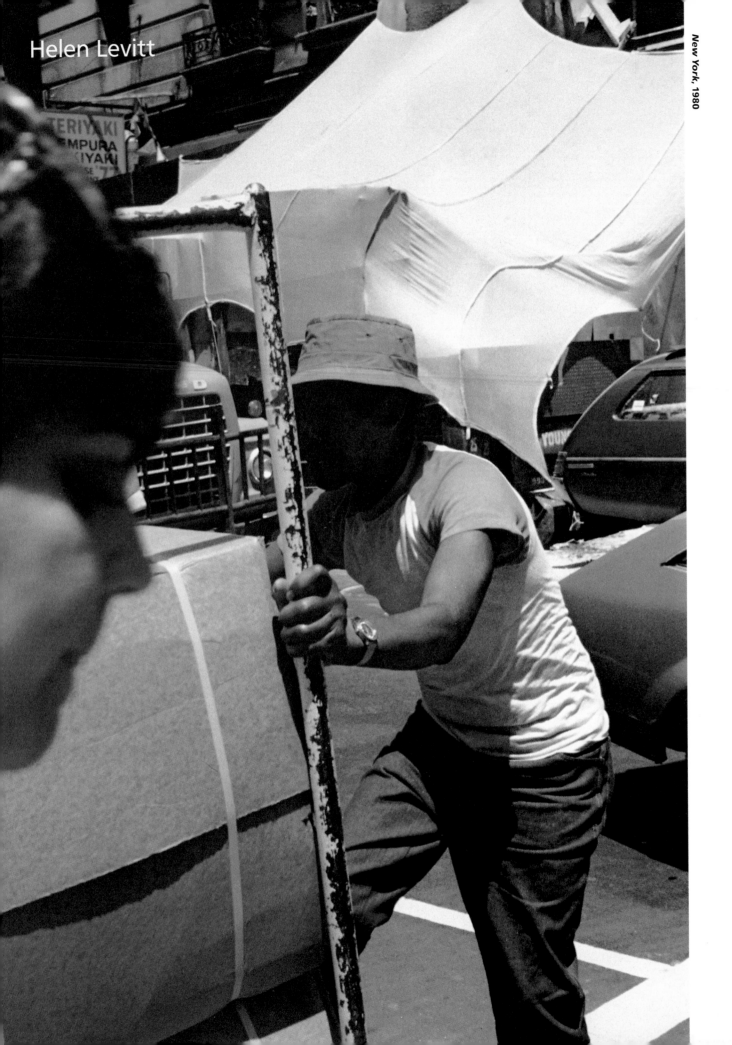

Helen Levitt

New York, 1978

New York, 1971

Reality Properties: Fake Estates, "Jamaica Curb," Block 10142, Lot 15, 1978

Michelangelo Pistoletto

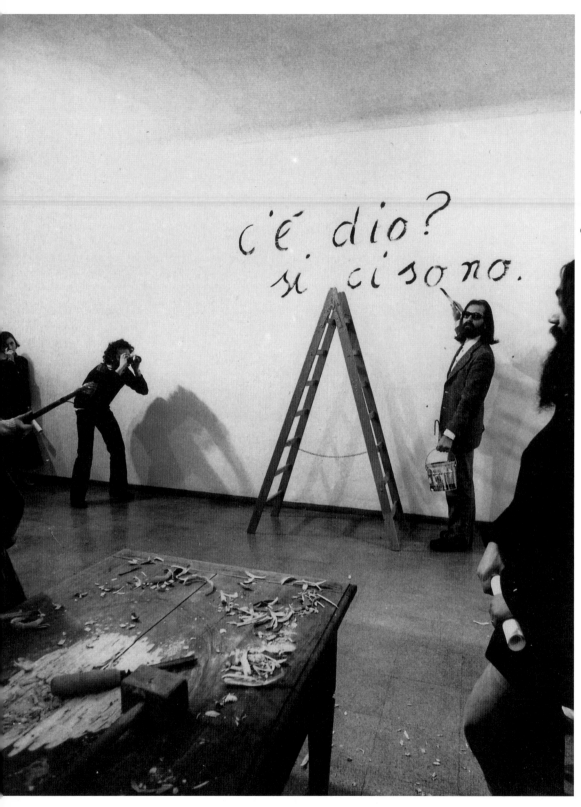

L'arte assume la religione (Art Takes On Religion), Sansicario, 1977

L'arte assume la religione, Sansicario, 1977

Gerhard Richter

Atlas, Abstrakte Bilder, 1977/78

Atlas, Abstrakte Bilder, 1977/78

Thomas Schütte

M. STROHSCHEIN DÜSSELDORF TALSTRASSE NE

4.10

4.45

4.70

TH. SCHÜTTE DEZEMBER 1978

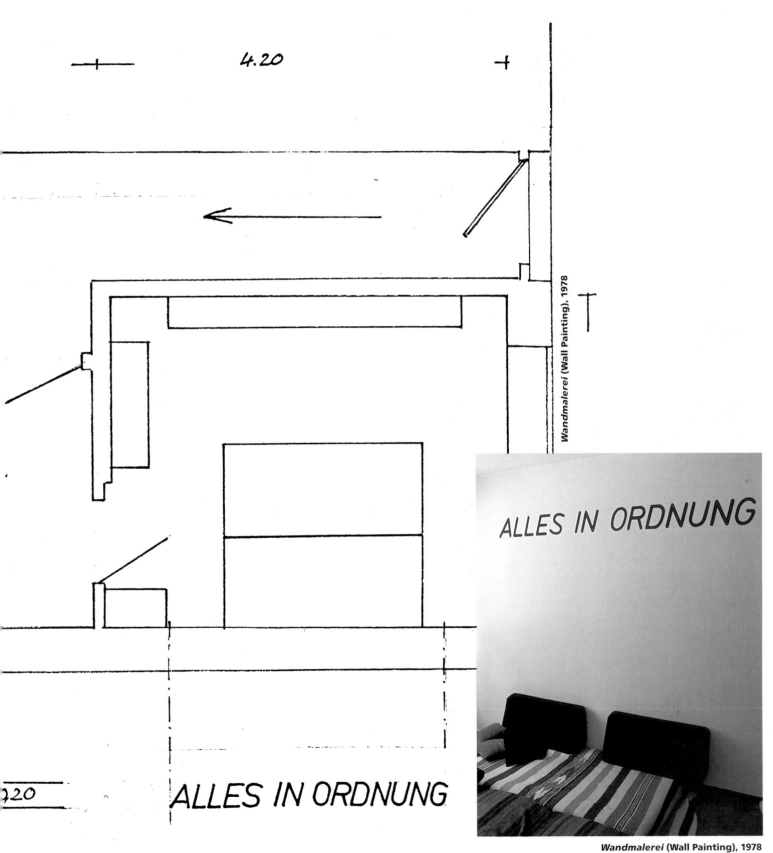

ERDGESCHOSS

4.20

Wandmalerei (Wall Painting), 1978

ALLES IN ORDNUNG

2,80

Wandmalerei (Wall Painting), 1978

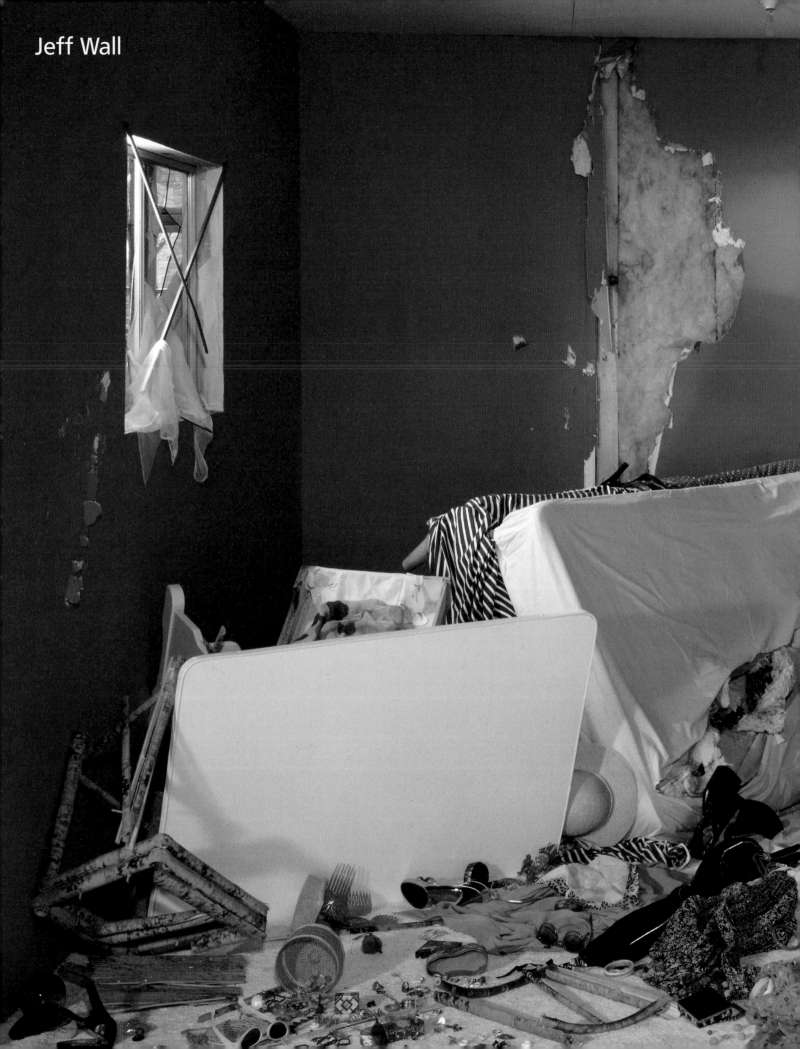

Jeff Wall

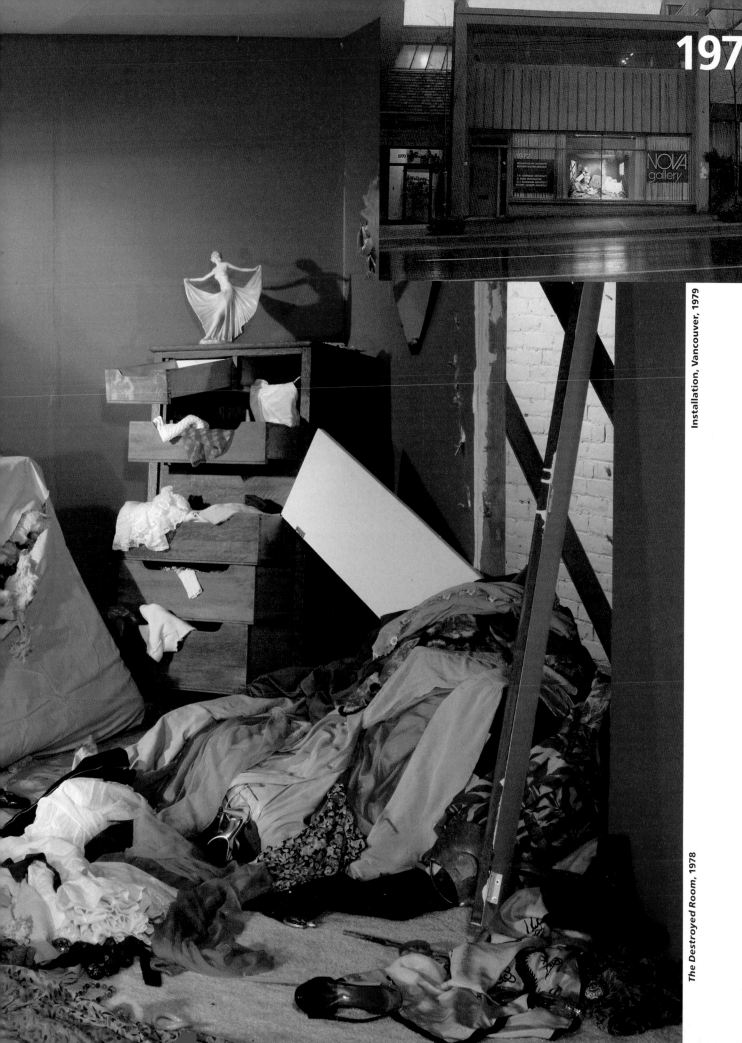

Installation, Vancouver, 1979

The Destroyed Room, 1978

Immanuel Wallerstein

The terms "Third World" and "development" appeared after the Second World War. "Third World" was used to designate three continents by opposition to Europe and North America on the one hand and the USSR on the other; "development" was a new translation of progress.

In the economic literature of the fifties and sixties, there are two major schools of thought with respect to development.

On one hand is the liberal-bourgeois school. It observed that on the level of productive forces, certain economies were less developed than others (i.e., the Third World). These economies existed under various political structures (colonies or newly independent states). Within these economies were enclaves of development: wage labor, commerce, production for the world market, etc. Alongside these enclaves subsisted vast zones where people still produced for their own consumption. This is a *dualist vision* of the economy. The Third World was considered underdeveloped to the extent that this economic dualism was present; the problem was to move on to a monetarized economy. From here arose a whole range of theories, founded on a comparison between the developed countries and the Third World countries, and always referring in the last analysis to the English (or American) model of development—important theories, in so far as they guided the policy of the Western countries and the UN bodies in matters of development aid. When, after ten to fifteen years of experience, there appeared the idea of the "growing gap" between the developed countries and the Third World countries, bourgeois-liberal thought took refuge behind "miracles" such as the Ivory Coast or Brazil. However, they were immediately refuted by the innumerable counter-examples: twenty Paraguays for one Brazil. The theory was denounced as ideological mystification.

On the other hand there was the Marxian thinking of the left, which pointed a finger at imperialist domination. The solutions advanced were withdrawal from international commerce and the nationalization of the means of production, to take them away from private interests and foreign capital; though no one preached autarky,

there was suspicion of the international system. The models of reference here were the USSR and China, where socialism had allowed the development of the productive forces and therefore the industrialization of countries which the capitalist division of labor would have limited to agriculture. This school of thought ran up against the problem of "revisionism" (the Chinese critique of the USSR), particularly in the area of relations between socialist countries and Third World countries: thus the accusations of "social-imperialism."

However, both these broad schools of thought had one thing in common: what I would call "developmentalism." For many theorists in both camps, the unit of analysis was the state and the goal was to promote an economic change from X to Y within the framework of the state. The differences bore on the definitions of X and Y and the means of moving from one to the other. The common point consists in the idea that one moves from X to Y by a process which must be defined such that all *states* can be presumed capable of moving from X to Y *at the same time*, by use of the appropriate means (liberalism or socialism, depending on the camp).

This is the presumption I will criticize. For me, the appropriate unit of analysis is not the state, with a national economy: the national economy is a misleading concept which corresponds to nothing. The appropriate unit of analysis is the *world-economy*.

What does this mean? First, a definition: a world encompasses a relatively large geographical region—today the entire world, economically defined. Within such a world many states coexist, as well as many cultures whose borders are not necessarily the same as those of the states. This is a basic definition: the borders of the economy go beyond the borders of the political structures.

There is an organic link between world-economy and capitalism: historically, capitalism can only exist in such a system, and such a system can only exist in a capitalist mode; they are two sides of the same coin.

There have been systems where the borders of the economy and the borders of the political systems coincide: for example, what I would call microsystems, functioning in a mode of self-sufficient consumption. More importantly, world-empires have appeared at certain points in history—ancient Rome, China, Persia—

systems where the economic borders come close to the political borders. Similarly, one can conceive a world socialist government where the economic and political borders will inevitably be the same. But one of the characteristics of the capitalist system lies in the fact that the economic and political borders are different.

How did we end up with this system? I will only go briefly into this subject here. In history, each time that a world-economy has been created, it has proven to be an unstable system. In a short time (approximately one hundred years) one reaches either the economic disintegration of the system or the hegemony of one state within the system and thus the creation of a world-empire. The only example of the long-term survival of a world-economy is the one that arose in Europe in the sixteenth century. Its borders originally encompassed Europe (with the exception of Russia and the Ottoman Empire) and part of the Americas. Despite the efforts of Charles V, this world-economy did not transform into a

Fernand Braudel

So-called economic history, which is only now being consolidated, quickly runs up against prejudice: it is not the noble version of history. Noble history is the proud vessel constructed by Lucien Febvre: it is not Jakob Fugger, but Martin Luther and François Rabelais. Yet whatever its degree of nobility, economic history still poses all the problems inherent in our discipline. It is the whole of human history, seen from a specific viewpoint. It is the history of those accepted as major figures, like Jacques Coeur or John Law in France; it is the history of great events, of conjunctures and crises; and finally, it is massive, structural history, evolving slowly through the *longue durée*. And there is our difficulty, because over the span of four centuries and the scope of the entire world, how can all the facts and expla-

nations be organized? One must make a choice. Myself, I chose the balances and imbalances of the long term. What seems essential to me in the preindustrial economy is the coexistence of rigidities and inertial forces with the limited but lively and powerful movements of modern growth. On one hand, peasants living quasi-autonomously in their villages, almost in a state of autarky; on the other, a market economy and an expanding capitalism, rapidly gaining ground and gradually prefiguring the world in which we live. Two worlds at the least, two utterly foreign ways of life, whose respective characteristics are nonetheless explained by each other.

I wanted to begin with the inertia, with an obscure history apart from clear consciousness, where men are more acted than actors. This is what I tried to explain in the first volume of my study [Civilization and Capitalism: 15th-18th Century], which for its 1967 edition I thought to name The Possible and the Impossible: Humans and their Everyday Life, and which I then changed to The Structures of Everyday Life. But what's in a title? The object of the research is as clear as it can be, though the inquiry proceeds by chance and is full of holes, traps, and potential misunderstandings. Indeed, all the leading words—unconscious, everyday life, structures, depth—are themselves obscure. And we cannot simply accept the psychoanalytic notion of the unconscious, though it too is in question here, and though we may someday need to explore the collective unconscious whose phenomena so preoccupied Carl Gustav Jung. However, this great subject has rarely been treated in anything but a minor mode. It still awaits its historian.

For my part, I kept to the most solid criteria. I began with the quotidian, with all that conducts us unwittingly along life's course: habit, or better, routine, the thousand gestures that blossom and fade away by themselves, about which no one makes a decision, and which in truth take place outside our full awareness. I believe humanity to be more than half buried in the everyday. Innumerable gestures are inherited and accumulated pell-mell, repeated infinitely into our own time; they help us live, imprison us, decide for us throughout our existence. These incitements, drives, models, manners, or obligatory actions date back more often than we think to far distant times. Extremely ancient and still alive, a centuries-old past flows into present time just as the Amazon casts the enormous mass of its troubled waters into the Atlantic.

That is what I tried to grasp under the heading—convenient but inexact, like all the words whose meaning is too broad—of material life. . . .

As always, it is worthwhile to define our terms. "Global economy" means the economy of the world as a whole, the "market of the entire universe," as Sismondi already said in his day. By "world-economy," a word forged on the basis of the German word Weltwirtschaft, I mean the economy of only a portion of our planet, to the degree that this portion forms an economic totality. Long ago I wrote that the Mediterranean in the sixteenth century formed a Weltwirtschaft all its own, a world-economy. In German one might also say ein Welt für sich: a world in itself.

A world-economy can be defined as a triple reality:

—It occupies a given geographic space; thus it has limits which explain its nature and which vary, though rather slowly. From time to time

world-empire, nor did it disintegrate: it led to the contemporary world capitalist system. Here I am speaking of the transition from feudalism to capitalism: this transition, which came about in Europe over a period of roughly two hundred years, is for me a *unique phenomenon*. There are not many transitions to capitalism, there is only one. From the very outset one cannot reason in terms of national economies.

What was the structure of this capitalist world-economy, which, toward the close of the sixteenth century, encompassed only a part of the world? It organized itself around the articulation center/peripheries. There was a center, localized in several states, and there were peripheries. The differences between center and peripheries are several:

—First, the nature of production. Broadly speaking, raw materials versus manufactured products. More precisely, the periphery produces what is least profitable economically and simplest on the technical level, reserving the more profitable and complex production for the centers.

—There is also a difference in the relations of production. Within the same mode of production (capitalism) different relations of production may coexist. Thus, in the sixteenth century, the use of slavery, forced labor, on the periphery, in the framework of capitalist production destined for a world market. In the center, on the contrary, wage labor.

—The third point, unequal exchange as defined by Arghiri Emmanuel.

—Relatively strong state structures at the center, weaker ones at the periphery. This difference finds its source in different class structures: the proletariat is numerically larger at the center than at the periphery.

A third category must be added to those of center and periphery: the semiperipheral countries (or relay-countries, to use a term suggested by Suret-Canale). These are countries where a part of the economic activities are those of a peripheral country toward the center, and part are those of a center toward its peripheries. For example, certain manufactured products are sent to even poorer countries, while raw materials are sent toward the center.

What are the functions of these semiperipheral states? They are double. On one hand, they fulfill the function of depolarizing the system, attenuating the center/periphery contradiction. On the other had, they fulfill an economic function: these semiperipheral states constitute possible "replacement parts" destined to take over for central states. For the system knows no internal stability: to maintain production at a certain level, the centers must be ceaselessly shifted. In effect, there is a very important process that goes on at the center: two developments take place, which are inevitable in a capitalist system. First, within the framework of continuous technical progress, better machines constantly replace the old ones, and the problem of paying off one's investment crops up. The latest comer can purchase the most recent and therefore the most profitable machines (producing for the least cost), but he cannot replace them until he has paid them off. Meanwhile, newer and more profitable machines appear, etc.: the process is continuous. The second process concerns social disorder. Over the long term, there is less social disorder in the center than in the peripheries. This is so because central capitalism pays to maintain the social peace. It can be empirically observed that the central state or states always show an increase in wages by comparison to the others. For example, England in the 1600s had lower wages than in The Netherlands; in 1700 the situation was reversed. Today, the world's highest wages are found in the USA. This is the well-known phenomenon of the "workers' aristocracy."

Therefore a double process of aging machines and rising wages causes the central or leader state to lose its position to another state. The system does not change, only the distribution of the states between center and periphery changes. We are dealing with a continual and cyclical process of rotation.

Another cyclical process can be apprehended though the famous Simiand series of long-term expansions and contractions, designated A and B. For example, during the period 1450-1750 we have:

there are necessarily ruptures, but at very long intervals. So it was after the Great Discoveries of the late fifteenth century. So it was in 1689, when thanks to Peter the Great, Russia opened up to the European economy. Imagine a clear, total, definitive opening of the economies of China and the USSR: there would be a rupture of the limits of Occidental space as it exists today.

—A world-economy always accepts a *pole*, a *center*, formerly represented by a dominant city, a city-state, and today by a capital, meaning an economic capital (New York, not Washington). Two centers within a single world-economy can exist, even in a prolonged way: Rome and Alexandria at the time of Augustus and of Antony and Cleopatra; Venice and Genoa at the time of the war of Chioggia (1378-81); London and Amsterdam in the eighteenth century, before the final elimination of Holland. But in the end, one of the two centers is always eliminated. Thus in 1929, with only a little hesitation, the center of the world moved unambiguously from London to New York.

—Every world-economy splits into successive zones. First there is the heartland, that is, the region that spreads out around the center: the United Provinces (but not all the United Provinces) at the time when Amsterdam dominated the world in the seventeenth century; England (but not all of England) at the time when London definitively supplanted Amsterdam, after the 1780s. Then come intermediary zones around the central pivot. Finally there are margins, very broad margins, which under the division of labor that characterizes the world-economy find themselves primarily subordinate and dependent, rather than fully involved and participating. In these peripheral zones, men's lives often evoke purgatory, or even hell. And the sufficient cause is nothing more than their geographic location.

These rapid remarks obviously call for some further comments and justifications. You will find them in the third volume of my book, but you will also find a very exact expression of them in the work by Immanuel Wallerstein, *The Modern World-System*, published in the United States in 1974. Whether I am always in agreement with the author on specific points, or even on a few general lines, matters little. Our viewpoints are identical, even if Immanuel Wallerstein believes there is no other world-economy than that of Europe, which itself is founded only in the sixteenth century; whereas I think that the world, even before it was entirely known by European man, in the middle ages and even in antiquity, was divided into more or less coherent, more or less centralized economic zones, that is to say, into *several coexisting* world economies.

From: *La dynamique du capitalisme*, Paris: Arthaud, 1985.

In fact, what the curve actually shows is rather a phase of expansion (A) and of stagnation (B):

The entry into a B period of stagnation generally corresponds to the decline of certain states and the access of other states to the center. The two cyclical processes correspond (center/periphery rotation and A and B series).

I would now like to distinguish these cyclical processes from secular transformations over the very long term, which involve fundamental changes in the structure of the system.

1. The processes of incorporation. In the sixteenth century, the world-economy encompassed only part of the world. Each time there was an A period of expansion it implied an incorporation from outside—newly integrated regions—or from inside the system. There are obviously structural limits to incorporation. On the outside, these limits were reached in the nineteenth and twentieth centuries with the integration of the entire earth to the system. On the inside, the process continues.

2. The process of proletarianization. I said that different relations of production could coexist within the system; there are different ways of paying the producers. But historically, and despite the difficulty of carrying out statistical studies, the proportion of wage earners progresses and this progression is continuous: there is a continuous augmentation of the proletariat. Here again, there is a logical limit (100 percent proletarians), making this a secular rather than a cyclical process.

3. The process of industrialization. There is continual growth of the percentage of value created by industry (and this, long before the "industrial revolution").

4. A more equal distribution among the upper strata over time. With each great political-economic crisis, the tiny minority of very high standing is obliged to make concessions to its own officers and administrators (in a very broad sense), at once to retain their loyalty and to increase the real demand for world products. But over the long run, this reduces the margin of profit for that tiny ruling minority, lowering its capacity to carry on the same unchecked struggle against the masses. Thus there exists a kind of descending curve in the vigor of the defense of the global status quo.

5. The structure of political resistance. If it could be quantified, one would observe a continuously ascending curve: the appearance of the "international workers' movement" in the nineteenth century and the birth of the "socialist states" in the twentieth, for example.

All these secular processes reach fulfillment when the political resistance is sufficiently strong and well structured to seize global power over the system: transformation of the capitalist world-economy by a world socialist government.

To conclude, I would like to stress two key points. First, the only unit of analysis is the world-economy; it is senseless to analyze a single country without taking account of its role with the world-economy. Second, capitalism is defined by the partial existence of the different elements I have evoked (proletariat, industrialization, etc.). In other words, capitalism is characterized by the *combination* of wage labor and non-wage labor, of the industrial and non-industrial sector, etc. If, for example, all the labor in the world-economy were wage labor it would be impossible to have a capitalist system. Indeed, that is the system's major contradiction: that it should be obliged, in order to maintain the profit rate, to chip away at non-wage earning, non-monetarized sectors, etc., sectors which of course form an integral part of the system. It is obliged, in other words, to cut off its own air supply.

From: "L'économie-monde," in *Connaissance du Tiers-Monde*, Paris, 1978

1960–1997 The Political

Benjamin Buchloh,

Catherine David,

Jean-François Chevrier

This discussion, conducted in French at Benjamin Buchloh's suggestion, took place in two
sessions in Fall 1996. It was transcribed by Françoise Joly and translated/edited by Brian Holmes,
with revisions by Benjamin Buchloh and Jean-François Chevrier.

JEAN-FRANÇOIS CHEVRIER So, the idea is to trace your intellectual biography since the early sixties. It seems clear from the texts you have published and the different directions your research has taken that the discussion can also follow the chronology we have established for this book, and perhaps make its articulations more precise. From a departure point in 1989 we go back to 1945 and the immediate postwar period. Then, as we move toward the present, we focus on two other turning points in contemporary culture: 1967 and 1978. As the discussion progresses we also hope to explore the critical potential of artistic activity in the current context of globalization—a potential that made itself felt very strongly in the sixties, when your intellectual biography begins.

BENJAMIN BUCHLOH After my first semesters of literature at the university in Cologne and Munich, I lived in West Berlin from 1963 to 1969. At that time the difference between West Berlin and West Germany was considerable, almost incomprehensible today. The city was a separate entity governed by the Allies and subsidized by the West German

Potential of Art

Part 1

government, with a weak economic infrastructure of its own. The population structure was also rather peculiar, because there were approximately 65 % elderly people living on their retirement, and 35 % under age thirty, many of whom had come to avoid military service or simply because the living conditions were much easier. Berlin was a kind of bohemian island in the sixties. The economic and social reality principle was weak in comparison to West Germany, where the economic miracle had strengthened the driving forces of profit maximization and compensatory consumption. The bohemian lifestyle would make you think that artistic production was highly developed in Berlin at that time, but in fact, paradoxically, there was not much happening at all.

JEAN-FRANÇOIS CHEVRIER Maybe because the nineteenth-century model of bohemia wasn't right for the times?

BENJAMIN BUCHLOH Exactly. What was happening in art was totally cut off from the international postwar models, and from the German models of prewar avant-garde culture. The influence of a figure like Yves Klein, the avant-garde connection between Düsseldorf and Paris, all that had passed unnoticed in Berlin. But there was a scene around the Film Academy founded in '67 or '68 by the German emigré Erwin Leiser, who had returned from Sweden and made the first important German film about Hitler, *Mein Kampf*. An entire generation of filmmakers emerged from the Academy in the late sixties: Harun Farocki, Daniel Schmid, Holger Meins, and Hartmut Bitomski, among others.

JEAN-FRANÇOIS CHEVRIER Today Berlin seems to have a hard time fitting in, between Germany, Europe, and the world.

BENJAMIN BUCHLOH Not only on those three levels, but philosophically and theoretically as well. The city is not only very attached to the history of German fascism but also to the difficult legacy of European Marxism, which is a heritage many would now like to get rid of. Just as there are obviously many issues to be confronted in the fascist past, there is also work to be done on the history of the left in Berlin. After all, in its postwar Eastern reincarnation, the city represents the most repressive chapter of German Stalinist communism.

JEAN-FRANÇOIS CHEVRIER You discovered Marxism in Berlin. I imagine the political dimension was out of synch with the artistic vanguards?

BENJAMIN BUCHLOH Coming from the universities of Cologne and Munich where I had done my first semesters in art

history and German literature, I had had very little contact with Marxist theory or culture. In the sixties it wasn't unusual for art history professors to be former Nazis. I began my studies with two former Nazis, the medievalist Heinz Ladendorf in Cologne, and the Viennese Nazi Hans Sedlmayr in Munich, who was also the most formidable opponent of twentieth-century and contemporary art. My introduction to Marxist thought came after my arrival in Berlin, when I read *Principle of Hope* by Ernst Bloch, who had just crossed over from Leipzig to Tübingen. Thus, Bloch became a central connecting figure between the pre- and postwar periods; he allowed one to identify with a philosophical tradition of prewar Germany outside of and prior to fascism. He represented one aspect of a culture of the German left that had been largely eliminated by fascism, but also by the postwar repression of leftist thought (with a few very ineffective exceptions, like the repositioning of the Communist Party and the antinuclear movement). And Bloch also represented a non-Stalinist model of Marxist thought. His mysticism and proximity to German expressionism made him a particularly attractive figure at the time. After Bloch I read Theodor Adorno's *Minima Moralia*, then Walter Benjamin, then Herbert Marcuse, who came to Berlin several times in the late sixties and had an enormous influence in Germany. Obviously, these are four irreconcilable positions and you can't really synthesize them, but that was one of the paradoxes we were confronting in the rediscovery of German-European-Jewish Marxist thought in the early sixties.

JEAN-FRANÇOIS CHEVRIER At the same time in France there was a return to Freud, with Lacan, and a return to Marx, with Althusser. It was a return to the texts: *Capital*, the *Grundrisse* . . . Was there any such return to the text for you, any presence of Althusser? And what about Gramsci?

BENJAMIN BUCHLOH I can't speak for the German student movement of the sixties; I was probably somewhat apart because I was always more interested in artistic questions than in theoretical/political ones. But I never heard Althusser's name in the sixties in Berlin, I discovered him much later, in America. The same was true of Gramsci, but that's probably my own ignorance; I'm sure that certain figures of the German left knew Gramsci very well. But Althusser and the whole structuralist or poststructuralist movement with which he could be associated was relatively foreign to the German rediscovery of Marxism in that period. I, for example, did not read Barthes' *Mythologies* before 1972, when I moved back to West Germany. The return to Freud in Berlin came about through Marcuse and through the rediscovery of Wilhelm Reich.

JEAN-FRANÇOIS CHEVRIER What was the importance of the book by Margarete and Alexander Mitscherlich, *Inability to Mourn*?

BENJAMIN BUCHLOH It was a very important and widely read book, published in 1967, definitely an early example of the reintegration of Freudian theory into postwar German cultural thought.

JEAN-FRANÇOIS CHEVRIER More than any other European, a German ought to be able to integrate Freudian thinking to a reflection on history, given the events between the wars and the mass psychology of Nazism, which can't be understood without reference to Freud. But I'd like to return to what has been called Freudian-Marxism [*freudo-marxisme*]. In France, Marcuse was important for the students, but much less so for radical intellectuals than in other countries, because he represented a form of mixture which the Althusserians and the Lacanians both refused, in the name of a strict return to the texts of Marx and Freud. What was the situation in Germany?

CATHERINE DAVID A fear of the irrational is always advanced whenever there is any incompatibility between German and French thought, for example, whenever Derrida is mentioned. Isn't there a kind of panic in Germany since 1945 towards anything that isn't technoinstrumental? Freud has been repressed to the point where there is hardly any German school of psychoanalysis.

BENJAMIN BUCHLOH An entire psychoanalytic culture was effectively destroyed between 1933 and 1945, and the fascist restructuring of science in Germany had enormous consequences, among which was a deep suspicion toward psychoanalysis. But there are also a whole range of differences to be explored. For the students of the sixties, Freudian-Marxism was a theory if not a practice of revolt. Whereas for the French at the same time, the fusion of Freud and Marx in the work of someone like Althusser seems to have become more a theory of textuality and a critique of ideology.

JEAN-FRANÇOIS CHEVRIER Those developments are also linked to the Communist Party in France, which realized that it had missed

the boat with the student movement and the spontaneous mass protests in the late sixties, and so began a phase of renewal and opening up to the intellectuals in the early seventies; that's where I come from. This opening led to the "new critique" around 1974-75, with Etienne Balibar, Pierre Macherey, Althusser. In Germany, Freudian-Marxism couldn't be associated with a party, whereas it was possible in France because of the central figure of Althusser, who was crucially important for Foucault as well. But unfortunately it remained a purely Parisian movement—and then it all shut down in 1978.

BENJAMIN BUCHLOH The idea that one can radically transform consciousness by a critique of textuality is a French model, it can't work in Germany. There the reflection continued to focus on questions of class politics, the transformation of institutions, or the transformation of the consciousness of everyday life. Marcuse was of considerable importance for this interpretation, and the reading of Freud engendered by Marcuse and Reich at that time seems to me, in retrospect, specifically German. It leads to a somewhat simplistic idea of sexual liberation, which is foreign to French structuralist thought. The rediscovery of Reich made a more radical reading of Freud possible in Germany.

CATHERINE DAVID A name seems to be missing in all this, which is Heidegger, reread by Derrida and Foucault—and Nietzsche by Deleuze.

BENJAMIN BUCHLOH Those are the big gaps in my intellectual background. I had read Adorno's *Jargon of Authenticity* early on, and so I had a critical distance from Heidegger. I tried reading him again later, but I must say I didn't succeed, no more than I have learned to listen to Wagner. In fact it's the same thing for the major Joseph Beuys retrospectives, all of which I have seen in the attempt to convince myself that he is a great artist of the postwar period. But I still fail to recognize the relevance of either one of them.

JEAN-FRANÇOIS CHEVRIER You're speaking of a political context dissociated from art, from 1963 to 1969 in Berlin. How could you more precisely describe this dissociation?

BENJAMIN BUCHLOH The German New Left of the sixties suspected the cultural production of the neo-avant-garde of being not much more than the result of market interests with no other function than to furnish museums and homes with luxury consumer items and to legitimate postwar neocapitalism. Any cultural production was considered reactionary, affirmative by definition (for instance, Warhol), and constitutive of the system. It is a position that was also held at the time by someone like Guy Debord and which found its articulation in Peter Bürger's book, *Theory of the Avant-Garde*, in 1972. Bürger's book is entirely ignorant of contemporary artistic practice and in this respect it resembles the falsification of modernity by Lukács, another central figure of the sixties rediscoveries whom I forgot to mention before.

JEAN-FRANÇOIS CHEVRIER And what was your position at the time?

BENJAMIN BUCHLOH More or less the same, at least until 1971.

JEAN-FRANÇOIS CHEVRIER How could you hold that position after having lived in Cologne?

BENJAMIN BUCHLOH It was very contradictory. In Cologne I had had first encounters with contemporary cultural practices: I witnessed some of the Fluxus performances at Jährling's Parnass Gallery in Wuppertal, I saw the Fluxus Fluxorum Festival in Düsseldorf, and I occasionally attended concerts by Luigi Nono, Maurizio Kagel, Karlheinz Stockhausen, and others in Cologne. I saw exhibitions by Daniel Spoerri, Cy Twombly, and Christo as well. The Nouveau Réalistes were very important for me at that time. They arrived in Cologne and Düsseldorf three or four years earlier than pop, whereas both arrived in New York at the same time; pop only arrived in Berlin in 1968, with a show from Amsterdam. Arman was a major figure in Nouveau Réalisme, for example when he dynamited an MG owned by Charles Wilp, a work later called *The White Orchid*. Arman at that time to me seemed more aggressive than the Americans, more radical than Rauschenberg. My fascination with Spoerri also represented a first rediscovery of Duchamp, who legacy had been absent in postwar Germany as well as in Europe at large. But that was not so different in other countries.

JEAN-FRANÇOIS CHEVRIER Even in France, Duchamp was rediscovered with the Nouveau Réalistes . . . Duchamp remained a dada-surrealist figure for the French; everything was channeled through Breton until he died in 1966, and the two were close friends. In France, dada was rediscovered through surrealism, and more marginally, through the Internationale lettriste, which leads to situationism. But what about in Germany?

BENJAMIN BUCHLOH Surrealism remained repressed, practically unknown, almost until the late sixties. Dada was first presented in an exhibition in 1956, which for me represented an extraordinary but isolated discovery.

JEAN-FRANÇOIS CHEVRIER You said the Film Academy was the most vibrant scene in Berlin from 1967 onward. From the position of a student who rejected the neo-avant-garde, did you find film more interesting than the plastic arts? Did you consider it a veritable popular art, compared to the bourgeois fine arts?

BENJAMIN BUCHLOH Cinema appeared as a possible alternative, but I would not have formulated things as radically as you. I was not close to the Film Academy, but I met people working there and I saw avant-garde films, because there was a very good cinemathèque. My interest in cinema was not completely linked to my interest in the plastic arts. I first saw Soviet films in Berlin, as well as films by Danièle Huillet and Jean-Marie Straub, Warhol's early films, especially *Chelsea Girls*, and Werner Schroeter's first long film, *Eika Katappa*, which came out in 1969. It was a great discovery which had an enormous impact on me. It almost turned me away from political activity, because it answered the question of what a credible contemporary cultural practice in Germany could be . . . I didn't think systematically in those days, I didn't think that if the cinema could achieve such things it must be more important than painting.

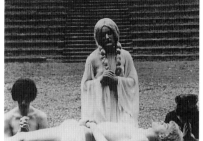

Werner Schroeter, *Eika Katappa*, 1969

JEAN-FRANÇOIS CHEVRIER Did you draw the relation with theater? Because the Brechtian tradition was alive and the cinema-theater rapport was important in Weimar culture.

BENJAMIN BUCHLOH I wasn't very involved in theater culture, even though I went regularly to the Brecht Theater—but that was more like visiting a museum, above all because his son-in-law, Ekkehard Schall, maintained the productions of the Brecht classics just as Brecht had left them. I went less often to the avant-garde theaters, like the Theater am Halleschen Upfer and the Volksbühne, which presented contemporary theater. But I saw almost all of the Living Theater productions during the time when they stayed for nearly a year in Berlin. It was a revelation to see those plays, and again, a new definition of a credible contemporary culture.

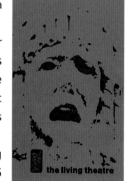

Ekkehard Schall in *The Resistable Ascension of Arturo Ui* Berliner Ensemble, 1959

JEAN-FRANÇOIS CHEVRIER I'm convinced that the most radical theatrical creation in the late sixties was entirely focused around the Living Theater. I missed that because I was too young, but I was in Lyons where later there was a very intense theater world with Chéreau, Maréchal, Planchon, etc. I'm deeply intrigued by the importance of the French popular theater. Antoine Vitez kept up the spirit all the way to the seventies. It's a notion that was articulated in the postwar period around Jean Vilar. Barthes, who was close to Bernard Dort, began from that point: the idea of an art for the people, with the nineteenth-century idea of *le peuple* behind it, and of course the Communist Party as well, because Vilar was a communist. Did it exist for you, in Germany?

BENJAMIN BUCHLOH It wasn't present in my consciousness in the sixties. Of course there was a tradition of popular theater in Weimar, but it was completely inaccessible after the war, for me and the people I knew. The question is whether the nature of the German public, and consequently its theorization, underwent a transformation in the sixties: was it a popular public or a public shaped by the culture industry? In Italy and France a popular public continued to emerge, whereas in Germany and no doubt in the United States as well, the culture of the masses was entirely discredited by fascism.

The Living Theater

JEAN-FRANÇOIS CHEVRIER Fundamentally I think you're right, but this complex question is worth lingering over. You said the Brecht Theater was like visiting a museum, and yet even after Brecht's death in 1956 that theater still functioned in a logic of popular expression. East German culture was understood far differently than West German culture.

BENJAMIN BUCHLOH Yes, but it was not a popular culture. June 17, 1953 was the date of a major confrontation between the people and the Stalinist authorities of East Berlin; Brecht took a completely unacceptable position toward what he disdained as the revolt of the *Lumpen*. The left culture of East Germany was an official state culture. In the West, on the other hand, what you have with the documentas and so on is the reconstruction of an elite bourgeois culture.

JEAN-FRANÇOIS CHEVRIER I think it is necessary to clearly establish the difference between the confiscation of the idea of the people

Peter Bürger

Dear Jean-François Chevrier,

When I attempt to talk about my own work I am always overcome by a feeling of apprehension. I think of La Rochefoucauld, who is known to have assumed that it is not possible to speak the truth about oneself, that everything connected with that subject cunningly evades our understanding. Lacan hardly thought differently. What is more, there is at present no common horizon for a European conception of self. While it is true that Benjamin and Adorno have been received in France, and Foucault and Derrida in Germany, I am not certain whether, when we mention these names, we mean the same thing. Did we not notice right at the start of our conversation that the political concepts we presuppose are completely different? Whereas you, citing Hannah Arendt, limit politics strictly to the area of action, I base my thoughts on a much more comprehensive concept of politics, discernible, for example, in the early writings of Jürgen Habermas.

If I endeavor to say something about my works despite these misgivings, it is because I have always had an awareness of their historicity. It was never my ambition to speak eternal truths, but rather historically feasible realizations. He who deems himself the owner of truths is compelled to defend those truths, thus promptly revealing their untruth. He who formulates a realization containing a "temporal core" (Benjamin) is not unacquainted with the thought that historical development will change that realization.

I will begin with surrealism, about whose immense significance—not only for the art of the twentieth century—we apparently agree. When I try to reconstruct the train of thought on which I based my surrealism book in 1969-70, I am confronted with a peculiar schism. On the one hand there was the fascination brought about by the utopia of another life, the will to bring the potentials of the imagination and dreams back to real life after their progressive isolation in the course of modernism and their encapsulation in the autonomous work of art. On the other hand I had developed quite a critical attitude towards the irrationality of surrealist politics. For the author who, during his childhood, had experienced the masses as they thronged to catch a glimpse of the Führer, the thought that it is imperative "to win the forces of intoxication for the revolution" (Benjamin) was unbearable. Back then, quoting from memory, I wrote "to win the forces of intoxication for politics," thus becoming conscious of the fact that I believed neither in the possibility nor, apparently, in the desirability of a revolution. Nevertheless, in my own way I took part in the student movement, for it seemed to open up the possibility of a nonarchival means of perceiving history for political purposes. Indeed, the book begins with this sentence: "Since the events of May 1968 at the latest, the current relevance of surrealism is obvious." Here "current relevance" does not mean the adjustment of works from the past to the fashions of the present, but rather *Jetztzeit* (now-time) in Benjamin's sense: the palpably sensory impression that one's own time has entered into a unique constellation with a past era. And this constellation made two things possible. It finally revealed the sociocritical dimension of surrealism, an aspect overlooked by Hans Magnus Enzensberger in his essay *Aporien der Avantgarde* in the early sixties, when he deemed it necessary to denounce the surrealists as heralds of fascism. At the same time, it finally allowed an exit from the gray of the fifties and early sixties in the Federal Republic of Germany and the thought, inspired by the surrealist impulse of a radical critique of alienation, of the possibility of a different life not primarily concerned with increasing one's wealth and planning one's career. But this double movement found no correspondence in the everyday life of the assistant in the Department of Romance Languages at the University of Bonn—except a negative one, namely, that he was personally experiencing the expropriation of life, addressed by the opening words of the first surrealist manifesto.

You were surprised that the author of *Theory of the Avant-Garde*, writing in 1974, should so totally and uncompromisingly direct his gaze towards the past and interpret the historical avant-garde movement as the vanishing point of the history of autonomous art, without considering the neo-avant-garde movements of the sixties and early seventies. This, it seems to me, can be explained by the book's stance within the theoretical debates of the time. The book was conceived as a counter-argument to the widespread practice of popular materialism, which traced every work back to its societal basis. If intended to lay the foundations for a critical study of literature and art capable of producing knowledge and not merely of applying a system. To achieve this it was necessary first of all to find a historical place from within which the history of art in bourgeois society could be constructed. If the critical study of literature and art refused to be merely a field of application for materialistic historical science, then it could not let historical science dictate the location of this place, but had to find it in its own field. This was essential for posing and possibly answering questions regarding the connection between art and society. These intentions were also the source of the ambitious claim to a scientific approach, which alienated me a little when I reread the introduction to *Theory of the Avant-Garde* more recently. Reflection ascends in a spiral motion, every solution tearing open an entire new complex of problems. Here speaks the furor of the theoretical, also to be found in the early texts of Habermas and in Althusser—a nearly unlimited trust in the power of theory to reveal worlds and to shape worlds. It can be an expression of the will to possess power oneself, but the author was not aware of that at the time, perhaps because he regarded Nietzsche all too one-sidedly as the pioneer of fascism and not the conclusion of the enlightenment which in fact he was. The theoretical tension later slackened, so that a (masculine) power fantasy is now easily detectable behind the theory discourse of the sixties and seventies. Whereas back then, theory appeared to us to be *the* key to the actual reshaping of societal reality, we seem to have lost that key in the meantime. Having become distrustful of our own tools, we watch as the society we live in staggers toward ecological, social and—ultimately—economic disaster, unable to do anything but take notice of the circumstances. However exaggerated the belief in theory might have been, our present renunciation of it is not one iota better, for the fantasy of power has become one of powerlessness. Sometimes it almost seems to me that we intellectuals still have not found our place *in* society.

Some time ago now, Ben Morgan, working in Bremen on a thesis on Adorno, confronted me with an entirely new interpretation of *Theory of the Avant-Garde*: the book as an expression of resignation, seeing the failure of the surrealist project reflected in the failure of the '68 generation. I suppose this analysis strikes true in some ways. It is certainly no coincidence that the theory of the failure of historical avant-garde movements—implying a clear rebuff to all neo-avant-gardes as well—met with the fierce resistance of those who intended to latch onto the revolutionary hopes of the avant-gardes. To be sure, this was a naive idea to the extent that it was blind to the realities of the Federal Republic. But to say that the avant-garde project of revolutionizing all forms of communal life was a failure was also somewhat misleading, as it suggested a dismissal of the avant-gardes altogether. Jürgen Habermas, as you know, in his Adorno Prize lecture "Modernity—An Incomplete Project," adhered to this conclusion. Yet I was unwilling to understand the theory of the failure of the avant-garde in this way, being concerned with linking preservation and criticism in the sense of Benjamin's "rescuing criticism." And I soon explained the theory, saying that the failed endeavor had by no means been dismissed but reserved for the present as something uncompleted.

It seems to me that this thought closes the gap you discovered between *Theory of the Avant-Garde* and my Beuys essay in the book on postmodernism co-edited with Christa Bürger. Only if one conceives this theory of the failure of the avant-garde rationalistically does one detect a break between the two texts. To a dialectical view, however, which perceives the unfinished aspect of the problem, the transition from the first position to the second is logical, providing it emphasizes the other side of a contradictory relationship.

As I write this I begin to suspect that in my attempt at self-explanation I might be suffering from a compulsion to exhibit continuity, instead of just admitting the break and explaining it on the basis of historical changes. To be honest, in the mid-eighties, when I wrote the essay on Beuys, my exuberant trust in theory had dwindled. I could not manage to immobilize the present, in Benjamin's view the prerequisite for attaining historical knowledge. I no longer sensed the present as the "rock" referred to by Horkheimer and Adorno in *Dialectic of Enlightenment*, the mainstay from which the past and the future could be recognized, clearly outlined. The present was now nothing more than a surface of infinite expansion, onto which the media cast its images, in which the past became blurred, a mere quotation, and the future was the unending extension of the present. How could one react to such circumstances, to this "new incomprehensibility" (Habermas), which pulled the rug out from under the theory approach? The only possibility I saw was to reverse the dispositive designed by Benjamin: rather than using the construction of a *Jetztzeit* as an outlook to the past—a past throwing light on the present—one had to relinquish the protection of a theoretical construction and risk exposing oneself directly to the work of an artist who was dealing with the avant-garde issue under changed conditions. The result shows that we have entered an epoch of ambivalences, no longer to be overcome by means of the either/or logic. Beuys, by defining himself in one situation as an artist and thereby taking advantage of the protection offered by art as an institution, and rejecting this designation in another situation in order to emphasize the social aspect of his actions, takes on the avant-garde challenge of unifying art and life, but does it in such a way that the failure of this project is acknowledged. In the shadow of a society which is on the verge of putting the neoliberal market economy into effect without any ifs, ands, or buts, it is no small accomplishment to preserve at least the thought of the possibility of a different life.

As you can see, in recent years I have reconciled myself in many ways with Adorno's position, after having followed in Habermas' footsteps in the seventies and confessed my faith in the still-to-be-constructed theory. Let me conclude with a quotation from my latest book, *Tränen des Odysseus* (Tears of Ulysees) which is concerned with critical theory and post-structuralism and ends with a fictive monologue by the dying Adorno: "The tricky thing about the future situation of art, which he suddenly thought he saw clearly before his very eyes—so there was something like intellectual contemplation after all—the tricky thing was that to all appearances everything would stay as it had been in the era of modernism. There would be non-representational painting and twelve-tone music. But the images would lack something; the only word he could think of for it was that old-fashioned word 'soul.' It suddenly no longer mattered how one painted and how one composed; the pathos of the modern had become as hollow as that of a ceremonial speech. There was nothing offensive about it anymore. It had become consumable, Duchamp had become comical, one could have fun with it, just as one could have fun with bouquets of dried flowers. Art could no longer be distinguished from that which already existed and therefore, despite its great liveliness, was dead. The clarity of his thoughts frightened him. Maybe it was the influence of the moon, shining large and round into his room. The idea amused him. His pains were becoming more frequent and he began to suspect that this night might be his last, but he was not afraid. No, he would not be taken in by the philosopher of death. Only one thought troubled him—that he might not have enough time to conceive of art's rescue. He felt a strange lightness. Nothing was impossible; one had only to think the logic of reversal through to the end, without fear. Modernism had protested against the claim to sense—Beckett. But where the negation of sense had become the principle of society as a whole, the search for a non-trivial cipher for sense could be an act of resistance. In the final analysis it was all a question of temporal dimensions. The Moloch of the present had to be destroyed by figures transcending the limits of Now."

Early November, 1996

as a national entity, through the notion of the *Volk*, and a more experimental idea which finally refers not to a single entity but to minorities. Deleuze speaks of the people in this second sense, when he says "the people is what lacks." One can then ask if the importance of the people, of the *Volk*, was not articulated experimentally in nineteenth-century German theater and particularly with Hölderlin, against the background of the revelation represented, for German intellectuals, by the French revolution. Isn't this question irreducible to the suspicion brought to bear on the *Volk* in the fifties and sixties? Isn't it what a certain young German theater, and young German cinema as well, sought to bring back to light at that time? I'm thinking of Fassbinder, who in his collaborations with Kluge bears witness to the concern to re-establish a popular cinema; and of course, Kluge comes from theater, which reinforces my point.

BENJAMIN BUCHLOH Mentioning Hölderlin in this context is problematic. The only one who tried to reintegrate Hölderlin to this context is Heidegger, and his theorization of the people leans toward fascism. Whereas the Marxist tradition stands explicitly apart from any notion of the people, by theorizing the collectivity in terms of class. I think that the dichotomy of *Volk* and proletariat is essential. As soon as you accept the term *Volk*, you are in mythical thinking, whereas if you accept the term "proletariat," you are in the class struggle. This is the meaning of Tönnies' distinction of *Gemeinschaft* and *Gesellschaft* in the twenties; you must distinguish between a mythical notion of the people and a sociological notion of the collectivity. Even if the words *Volksbühne* and *Volkstheater* were used in reference to the theater of Erwin Piscator, it was conceived as a theater for the proletariat, and never as a theater for the people conceived as a totality.

JEAN-FRANÇOIS CHEVRIER Still I can't help but think that the lack of the people generates a process of experimental reconstitution, whose artistic focus shifts to minorities in the fifties and sixties. I find echoes of this experimental process in nineteenth-century romanticism. I also perceive an accentuation of the shift toward minority identities in the period of 1968-70, which is precisely

Theater, Cinema, and Radio

Catherine David: I think the French and German experiences of theater are not at all comparable. The relationship with Brecht, for example, was extremely romantic in France, with the one exception of Barthes.

Benjamin Buchloh: The fatal romanticism of that movement was to totally ignore the culture of the media, which finally crushed everything else.

Jean-François Chevrier: Yet it was an incredibly powerful movement, and it believed it could constitute an alternative to the media, as it did to a certain degree.

Benjamin Buchloh: How long did it remain popular?

Jean-François Chevrier: All the way to the seventies . . . The popular theater, and the ciné-club movement around André Bazin, were two lively and rich moments of a true French popular culture, with a strong French communist party behind them—but also De Gaulle. In fifties France there was incredible confidence in Taylorist industrial progress. De Gaulle provided a very strong national image, and the Communist Party transmitted the ideology of the people inherited from Michelet; the two fought against each other for the appropriation of the idea of the people. All that was anti-American in a certain way . . . At the time, the only other country where the idea of the people existed was in Italy, but without the national dimension, and with a communist party

much more intelligent than the PCF, thanks to Gramsci and Togliatti among others.

Benjamin Buchloh: Whereas "the people" in the German sense, *das Volk*, had become the fascist masses. And in the same way that reflection on the fascist past was impossible in visual culture, the proletarian culture of Weimar seemed inaccessible. This is why one could not rediscover Heartfield until the mid- to late sixties, because he was affiliated with the communist culture of Weimar. In addition, he, like Brecht, had been living in the Stalinist part of Germany and therefore remained deeply suspicious for West German reconstruction culture. Paradoxically, that is the reason why the development of an artist like Hans Haacke was practically unthinkable in Germany. Haacke could not be exhibited, almost until now, because he took up traditions which had been excluded, banished, repressed. In this sense it's interesting that Peter Weiss could be accepted as an artist in the theatrical domain; the politicization of literature in postwar West Germany was much more developed than in the visual arts, with Rolf Hochhut, Gunter Grass, Heinrich Böll, and others . . .

Catherine David: . . . Heiner Müller . . .

Benjamin Buchloh: . . . all of whom worked to build a critical reflection on fascism, on the politicization of art, on the Brechtian tradition and the Soviet tradition. In the plastic arts the politicization of art remained almost unthinkable. It's still an open question: why did the plastic arts become the essential cultural practice of neutralization, at least until the late sixties? One aspect of the answer is certainly the fact that the plastic arts deal with objects that will be sold on the market, but that cannot possibly be the only explanation.

Catherine David: Until the late seventies there is no German plastic artist with the violence of Fassbinder. Except maybe Richter with his *Atlas*?

Benjamin Buchloh: And Beuys. But he goes back and forth, he shows and he hides, he's always in between.

Catherine David: Beuys is into redemption, whereas Fassbinder is into violence, denunciation.

Jean-François Chevrier: Beuys seeks integration, reconciliation.

Benjamin Buchloh: And Straub/Huillet do just the contrary, for example in *Nicht versöhnt* (Unreconciled) from 1965. There is an astonishing difference in political consciousness between the plastic arts and their films from the mid-sixties, even though at that time Gerhard Richter was already at work on his *Atlas*, which would emerge much later as a project of artistic reflection on the conditions of memory.

Jean-François Chevrier: *Nicht versöhnt* played a fundamental role, since it launched the German equivalent of the Nouvelle Vague. The film caused a shock because it broke with realism and narrative continuity. It was perceived as the banner of the new German cinema, even though Straub is actually French.

Benjamin Buchloh: That suggests the importance of another theoretical pair: the nation-state and internationality. An aspect of postwar German culture, above all in the sixties, explicitly conceived the formation of a posttraditional and postnational identity, as theorized by Habermas. The attraction of a figure such as Godard in sixties Germany can also be explained by the fact that Godard produced a postpopular, internationalist cinema. Whereas the heritage of Brechtian theater is still inscribed in the notion of the proletariat and the tradition of German theater.

Jean-François Chevrier: Here I would point again to the upheaval brought about by the Living Theater, which temporarily suspended the differences between Germany and the Latin countries. In an interview published in *Le Trépied*, Broodthaers said that political art could be rethought on the basis of the Living Theater. And I find it significant that precisely in 1967, the Living Theater staged *Antigone*, a play which had been translated and interpreted by Hölderlin, rewritten and reinterpreted by Brecht, and, more recently, adapted for the cinema by Straub and Huillet. Here we understand that the political stakes of the theater involve a popular identity irreducible to the *Volk*.

Benjamin Buchloh: We can't continue this discussion without mentioning the presence of Beckett, who was a central figure in Adorno's aesthetics, unlike Brecht. Compared to Beckett's success in the theater of the seventies, Brecht becomes quite secondary. And this touches again on the question of the extent to which the postwar period sought to reconstruct a high bourgeois civilization or a popular culture. For Beckett, despite his life history, was not perceived as a popular author: his theater is a theater of the elite.

Catherine David: Except that in the sixties, Beckett was widely broadcast over the radio, which at the time was a very popular medium. Beckett made an essential contribution to the survival of the theater as a space of language, even if, paradoxically, he comes close to giving up the stage for a purely mental theater. For him, language is the ultimate theater. Of course, one should not deny that Beckett is an elitist author; but nonetheless, in his work and his strategies, at least after 1945, his relation to history is fundamental.

Jean-François Chevrier: Concerning radio, I'd like to point out that a French avant-garde writer, Jean Thibaudeau, wrote and carried out radio broadcasts perhaps more frequently in Germany than in France. Unlike writers such as Philippe Sollers or Denis Roche, Thibaudeau was con-

cerned to articulate avant-garde writing and a popular culture imbued with theater. He used the radio as a means to achieve that conjunction. An opening appeared in Germany and he began to produce radio plays there. The radio play is linked to the theater of language, because on the radio there is only language. To simplify, one could say there is a theater of language and a theater of the body, the latter being closer to the Living Theater. In the sixties, Pasolini wrote a manifesto on the theater of language. The linguistic question had been of considerable importance in Italy since Gramsci, following a Marxist conception of the proletariat in terms of the people; if the people exists in Italian culture, it is because of the language, and more precisely, the dialects. Pasolini worked on vernacular language with explicit reference to Gramsci. He created a theatricalized cinema, somewhat like that of Godard but not in a post-Brechtian vein, rather in the wake of Rossellini and of Nouveau Réalisme. There is an undeniable lyricism in his films. This is the composition that one does not find in Germany, for there is no German Gramsci, no German Marxist thinker of the language. Nor is there anything like Nouveau Réalisme in Germany. But in the Latin countries we see a permanence of the political theatricalization of the language of the people.

Benjamin Buchloh: There did exist a popular culture of radio, which was already well developed by Benjamin and Brecht in the twenties. But the Südwestfunk radio station changed a great deal, and it is difficult to see any continuity between the twenties and the sixties in this respect. That's why I say it has already been "ghettoized": the Südwestfunk and the musical program in Cologne were extremely radical, and at the same time extremely exclusive.

Catherine David: Straub's work clearly displays this dimension of vociferation and of reincarnation in language. It's a cinema whose images stem from language. Daney spoke of it as a "tomb for the eye"; he meant that there is really very little to look at. Personally, what I remember from Straub's films is as much the sound as the images.

Jean-François Chevrier: You're right to mention Straub; he is a communist and constantly affirms a political position and an ethics of language. In the same way, Gramsci is a political thinker, a party member, imprisoned as such. The Marxist thinking of language in Italy is necessarily linked to political struggle, whereas in Germany it is enclosed within a much more limited intellectual sphere.

Benjamin Buchloh: But Straub is also Brechtian, and Brecht, after all, is the Marxist thinker of language in Germany. It is only in postwar Germany that there is no equivalent of Gramsci; in prewar Germany there is Brecht. And the Living Theater is precisely a synthesis between Brecht and Artaud. It would be interesting to know the extent to which this theater fits directly into the tradition of popular theater, even though Artaud, at the time, was quite unknown in Germany.

Jean-François Chevrier: Exactly. In 1967, the Living Theater produced *Antigone*, in Hölderlin's version as revised by Brecht. As the French press of the time bears witness, and as Julian Beck himself says in an article in the *Quinzaine littéraire*, it was a synthesis of Brecht and Artaud. 1967 is the year when an American theater developed in the wake of the happening arrived in Europe, to remobilize a double Franco-German cultural background and rebuild the idea of the people along the lines suggested by the American minority struggles. At the same time, Pasolini staged *Oedipus*, the other Sophocles play translated by Hölderlin. What's more, actors from the Living Theater took part in a film by Pasolini. What I mean is that in Europe, the Living Theater overcame whatever remaining elitist aspect it had, and succeeded in mobilizing a cultural background that cannot be reduced to avant-garde elitism. This is exactly the moment when a minority logic was able to rearticulate an idea of the people, for instance in the work of Deleuze and Foucault, who began energetically dissociating the question of minorities from Marxism.

Benjamin Buchloh: What I would like to know is precisely when the transformation of popular culture is directed toward a culture of the media. In my opinion, Straub, Huillet, and Godard are precisely the three people who carried out this transformation consciously and systematically. On the contrary, the Living Theater aimed to revive an activist, public, proletarian theater, outside media culture—a theater of the body, rather than of language. But is it possible to conceive a theatrical immediacy within a culture of the media? I think that if Beckett is so important for Adorno, it is because Beckett is the author who represents the final, residual, and resistant stage of an ancient, traditional definition of the theater. This definition is opposed to a popular conception of public theater, which is why Adorno closes in on his choice of Beckett and refuses Brecht. To what degree, then, do Straub, Huillet, and Godard distinguish themselves in the early sixties by their programmatic opening to the culture industry, while authors like Vilar insist on the possible continuity of popular culture?

Jean-François Chevrier: I think one can't draw such a sharp contrast, which is why I continue to introduce supplementary figures. One such figure is Öyvind Fahlström, the Swedish artist from the sixties who also did both film and theater, and who used radio, television, and the newspapers. He is exactly the type of artist who represents this conjunction between a popular tradition of theater and the new reality of the media. It's no accident that he is a Swede, that is,

a citizen of an advanced social-democratic country, and that he is a cosmopolitan, polyglot individual who was born and brought up in Brazil. The rediscovery of Fahlström was key to the preparation of this exhibition. I think that today he is one of the most important artists for the young generation, precisely because he overcomes the strict opposition between popular traditions and the media. But I also think it's interesting to stress that you have very good reasons, as a German, to draw that contrast.

Benjamin Buchloh: Yes, one of the good reasons being the expunction of the revolutionary masses. The situation is the same in the United States, as Andrew Russell has established: even the term "masses" disappears from the American vocabulary in 1952, after the McCarthy years. There is an analogous development around the term *Volk* in Germany, which becomes unacceptable after fascism and the emergence of the German Democratic Republic as an counter-model for the West.

the moment when Fassbinder became important in Germany. But let's return to that moment in your intellectual biography. You came back to Cologne in 1971.

Interfunktionen 7, 1971

BENJAMIN BUCHLOH I had spent two fairly uneventful years in London, where I made some attempts at writing. When I came back, an old school friend, the anthropologist Mark Oppitz, introduced me to Fritz Heubach, then the editor of the journal *Interfunktionen*. I had begun working for Rudolf Zwirner around 1972, and that was when I went to the United States for the first time. I went straight to the Philadelphia Museum of Art to see the Arensberg collection, and specifically the *Etant donnés*, because I had become somewhat of a Duchampian in the meantime. I organized numerous exhibitions for Zwirner in 1972-73, ranging from Richard Tuttle and Dan Graham to Gerhard Richter and Marcel Broodhaers. I had met Broodthaers first in 1972, when he showed the *Section des Figures* in Düsseldorf.

Heubach gave up his journal *Interfunktionen* in 1973, and I took it over. It seemed to offer me a chance for direct intervention. I saw the potential for a radical transformation of visual practices—with political implications—in certain aspects of conceptual art, embodied in particular by the work of Graham, Daniel Buren, Broodthaers, and Lawrence Weiner. While Heubach had concentrated on Beuys, Buren and Broodthaers played an increasingly important role for me. I viewed them as a successful synthesis between political and cultural practices. Reading Buren's *Limite critique* confirmed the possibility of integrating into contemporary cultural practices certain Marxist positions with which I had been engaged in the sixties. This may seem hard to understand with respect to the subsequent directions of Buren's work, but at that time it still appeared possible. There was certainly a lot of naiveté on my part, toward the art world, the processes of reception, and toward these practices which in fact were about to be integrated into institutional framework of culture, even if they claimed or believed to operate outside it. The period from 1968 to 1972 was one of great optimism, during which conceptual art was associated, rightly or wrongly, with the possibility of a radical transformative critique. What is interesting is that Heubach perceived Beuys in very similar terms, as a radical agent of political and social transformation, more than as the producer of a new German cultural mythology.

I obtained my first teaching position in 1975, at the Düsseldorf Academy, in the history of contemporary art. It was poorly paid because I did not yet have a doctorate in art history. I was teaching a young generation of students who were as avid to learn cultural theory as they were interested in a more detailed knowledge and interpretation of European and American art of the sixties and seventies. One must remember that twentieth-century art history, let alone contemporary art history, was not offered in Germany at that time, except by Max Imdahl in Bochum. I taught for two years in Düsseldorf with students of Gerhard Richter, Bernd Becher, and Klaus Rinke. They all became quite famous: Thomas Schütte, Thomas Struth, Isa Genzken, Reinhard Mucha, Klingel-höller, Ulrich Look and Martin Hentschel, who at that time still wanted to become artists, etc. I liked the teaching very much, but the ruling art historian at the Academy, Werner Spiess, the conservative Max Ernst specialist, was at that time as suspicious of contemporary art as he was of critical thinking. As a result he blocked my appointment to a more serious position, even though several faculty members and many students had recommended just that. After two and a half years at the Düsseldorf Academy, I was offered a position at the Nova Scotia College of Art and Design in Halifax. I left in 1977.

Interfunktionen 10, 1973

> **JEAN-FRANÇOIS CHEVRIER** Can you tell us more about how you saw the history and the role of journals? The twentieth-century vanguards all crystallized around journals, and the conceptual artists worked a lot for the printed page. Where did the distinction lie, in your eyes, between critical and artistic work? Where there a zone of hybridization, a mixing of roles?

BENJAMIN BUCHLOH One of Fritz Heubach's motivations was to conceive the journal not only as an instrument of distribution, but also of participation. As early as 1968, around documenta 4, the journal was understood as a tool of intervention. I was also very interested in conceptualism's attempt to abolish the status of the art object, to redefine the form of artistic intervention in the framework of textuality and of printed distribution. I saw the journal as a prolongation of political positions with cultural means. Certain artists who had already published in *Interfunktionen* before I took it over, such as Haacke and Broodthaers, seemed to be engaged in parallel projects. This certainly was true for Buren at the time as well. The reference to the history of avant-garde journals was there, even if they weren't studied systematically. We were conscious of the fact that avant-garde practice and critique could be articulated, at least in certain respects, through the foundation of a journal whose principle was to publish only original contributions by artists. All the radical naiveté of conceptual art resides in the illusion that the transformation of the artwork into a linguistic and textual intervention would necessarily engender a greater number of readers, a greater politicization of cultural practice. It was a naive reactualization of Walter Benjamin's essay on mechanical reproduction, whose impact had been extraordinary. For a few years some of us in Germany optimistically believed that certain forms of contemporary art could transform social thinking. I don't know what happened in France, but in the period up to 1977 there were surely comparable illusions in Italy, with the formation of *arte povera* and the activities of *Lotta continua*.

> **JEAN-FRANÇOIS CHEVRIER** For me it was a positive crisis—given that there can be no criticism without a space of crisis. What's interesting in this period is that the revolutionary model was not unique, exclusive. There were alternative projects, more open than the heavy Marxist-Leninist model that had functioned until then. 1967 saw the beginnings of a crisis in the productivist model and the ideology of progress conceived as continual growth. That model had prevailed since the war, and it lasted throughout the thirty-year period known in France as the Trente Glorieuses (1945-1975). But the problems that came to a head with the oil embargo of 1973 were already latent at the close of sixties. This crisis of the productivist model generated a broad range of social alternatives seeking emancipation, primarily through the model of minority identities; but of course, the Marxist model of an overarching class identity remained operative as well. The minority movements were inspired, to varying degrees, by this Marxist model. For all these reasons, 1967 is an important date in the chronology we have constructed for this book.
>
> In terms of the critical possibilities that emerged in this space of crisis, I'd like to talk about use value, particularly in the context of journals like *Interfunktionen*. Use value is a Marxist concept that was reworked in that period, like others such as commodi-

Mario Merz, *Objet cache toi* (Object hide yourself), 1968/77

ty fetishism, which was fundamental to the antiobject thinking of conceptual art . . .

BENJAMIN BUCHLOH "Object, hide yourself," as Mario Merz said.

JEAN-FRANÇOIS CHEVRIER "Gold Assay," Adorno's text in *Minima Moralia* on the fallacy of genuineness or authenticity, is very instructive; it ends on commodity fetishism, after broaching the great critique of Heidegger that will come later . . .

BENJAMIN BUCHLOH Yes, the French title of the Heidegger critique is *Jargon de l'authenticité* . . .*

JEAN-FRANÇOIS CHEVRIER The 1945 text bears the seeds of that later critique, and clearly articulates Marxist concepts of commodity fetishism in terms derived from Benjamin. One can see how the critique of the commodity in the seventies was also a critique of bourgeois humanism, for Adorno in any case. But let's get back to use value. Marx, if I understand correctly, never dissociated use value from exchange value. And I sometimes have the feeling that the utopia of the period we're talking about was to separate them. Journals, for example, are media, and media involve exchange: but there was the idea of transforming their exchange value into use value.

BENJAMIN BUCHLOH In fact, that's pretty much how I conceived it. Wolfgang Pohrt published an important but relatively little-known book in Germany in the seventies, *Theorie des Gebrautswerts* (Theory of Use Value). A book by Wolfgang Fritz Haug, who was later to become a professor of political science in Berlin, also played a key role: *Kritik der Warenästhetik* (Critique of the Commodity Aesthetic). For example, the central text in the catalogue of documenta 5 was written by Hans Heinz Holz, who attempts, rather unsuccessfully, to apply Haug's theories to contemporary art practices. Conceptual art obviously sought to transform itself not into pure use value, but into communication value. Think of a work like Graham's *Schema* with its reduction to the linguistic element, which constitutes the framework of commercial distribution no less than the network of information in his text . . . I seriously perceived work like that of Graham and Weiner as reducing itself to pure communication value by referring to its own constituents. This idealization of pure information was very common at the time. The theorization of photography in the conceptual context, for instance in Douglas Huebler's work, is based on the idea of pure information which is not subject to any photographic or pictorial convention. The viewer or reader is not supposed to need any prior or privileged knowledge, because the work as information is directly accessible both on the level of material distribution (i.e. catalogues, the printed page, the poster, the magazine) and of spontaneous reading.

JEAN-FRANÇOIS CHEVRIER The purity of a procedure was supposed to bring about the autonomy of use value. Huebler is explicit about it: once the procedure is clear, anyone can practice it. An artist produces models, procedures which can be used again, abolishing the separation between author and receiver. There are only producers who are not consumers. It's an idealism!

BENJAMIN BUCHLOH Especially when it comes from Marxists!

CATHERINE DAVID Can it really be said that Douglas Heubler or Lawrence Weiner were Marxists?

JEAN-FRANÇOIS CHEVRIER No, but I'm addressing Benjamin Buchloh: you took the trouble to acquire a Marxist culture, and in your texts, particularly "Moments of History," you talk about use value. One could even speak of a fetishization of use value. If I insist on that, it's because today there are many young artists who reproduce this fetishization, dreaming about procedures and debates, and forgetting that debate requires a relation, situated in history, in a context with specific characteristics. Today there is a belief in the autonomy of the procedure, a new kind of formalism.

BENJAMIN BUCHLOH But I'm not sure that the artists are the ones to be reproached for that. Your reading is correct, but in Buren, for example, there is no such naiveté, because he thinks from the first about the framing, the conditions of distribution, of institutionalization.

JEAN-FRANÇOIS CHEVRIER Nor is there any such naiveté in Broodthaers; but you find it quite commonly in what is called conceptual art.

* The German title is *Jargon der Eigentlichkeit*, referring directly to the Heideggerean concept of "ownness" or "the proper," whereas in "Gold Assay" Adorno speaks of *Echtheit*, or "genuiness." Both words are often rendered in French as *authenticité*. —Tr.

BENJAMIN BUCHLOH In Huebler and Weiner, yes. I'm not so sure about Dan Graham. Maybe in the pure presence that is articulated in his video performances from that time, with the total dissolution of the aesthetic dimension, the idea of pure phenomenology: everyone can see, all the time, you need no preparation, no privileged learning, no conventions, no understanding of artistic institutions. It's also extremely antiaesthetic, which is why it wasn't at all appreciated. There's an extraordinary radicality there: I don't know if it's Marxist, but it is a phenomenological radicality that goes far beyond minimalism. Nonetheless, it's interesting to link that with the discussion of use value. Another interesting thing in this context is that the focus on use value as an antifetishist concept doesn't fit Adorno's theory of defetishization. For him, the artwork, in so far as it exists in a mimetic relation to the structures of alienation, can never appeal to an idealized use value that can work against the fetishist conditions of exchange value. That explains his profound resentment of politicized cultural practices.

> **JEAN-FRANÇOIS CHEVRIER** That much is clear in the 1945 text: authenticity is the negation of mimesis, the negation of the mimetic relation at the basis of what Lacan calls the fundamental structure of alienation. So, what is your current view of the things you wrote at the time?

BENJAMIN BUCHLOH Two aspects interest and surprise me. One is the naiveté of this mid-seventies generation toward the art world and its institutions—a naiveté which Broodthaers obviously never had. The other thing, in Buren for instance, is a great utopian hope, an idealist clarity concerning what a radical practice could achieve. In his texts from 1968-69 he says that it isn't the moment to abolish the museums, but that one can at least radically transform the way of seeing.

> **JEAN-FRANÇOIS CHEVRIER** It's clear that this period of crisis and naiveté is positive, I'm not saying that anyone is to be blamed for the crisis! It's a matter of pointing out a weakness, so as to avoid reproducing it.

BENJAMIN BUCHLOH Debord's text on the society of the spectacle, from 1967, passed unnoticed by all of us in Germany—I don't know when it was translated. I'm wondering to what extent it could have helped to critique the structures of cultural domination from the outset, instead of believing in the possibility of a liberal cultural system that could bring aesthetic practices closer to politics.

> **JEAN-FRANÇOIS CHEVRIER** It's always easy to see what you missed retrospectively, but I think two things weren't taken into account at the time. First, what you just said, which the emphasis on use value reveals so clearly—though I'm not sure Debord is entirely free of that naiveté. And second, what Foucault began to articulate in the seventies, the idea of power as productive. By explaining how power fabricates the subject, Foucault understood it in relation to the procedures of subjectivization. An interpretation of Lacan by Foucault.

Jacques Lacan, 1978

BENJAMIN BUCHLOH But that interpretation was never related to contemporary artistic production, neither in France nor in Germany.

> **JEAN-FRANÇOIS CHEVRIER** Yes it was. Broodthaers read Lacan and attended his seminar. He also read and understood Foucault. That is why he is the artist of reference for this documenta. It is certain that an artist's thinking should not simply be equated with a theorist's, but in this case there is a match with a philosophy in which the idealization of use value is totally absent. He completely displaced that idealization, he broke it apart with a Marxist vocabulary.

BENJAMIN BUCHLOH One should not forget that Broodthaers had a traditional Marxist culture, he had been a member of the Belgian Communist Party until 1951. He participated in Lucien Goldmann's seminar, which was a much more traditional Marxism than that of Althusser, for example. And I think that he tried until the late sixties to reconcile his Marxism with the structuralism of Foucault and Lacan, which obviously was difficult, not to say impossible.

> **JEAN-FRANÇOIS CHEVRIER** That can be one of the challenges today: rethinking Foucault's contribution to Marxism, or rather, his alteration of Marxism. (It's interesting that Balibar—a Marxist philosopher who has never dealt with the artistic dimension—clearly indicates his debt to Foucault's thinking on the procedures of subjectivization when he articulates his thought around a notion of citizenship, elaborated historically and contextually, in relation to the subject and thus to subjection).

BENJAMIN BUCHLOH I agree that Broodthaers carried out an extraordinary critique of conceptual art. There's also a

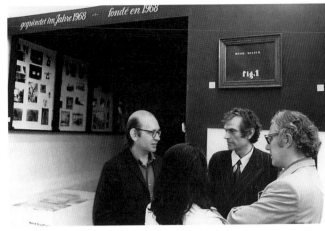

Marcel Broodthaers, documenta 5, 1972

critique of Buren—they were good friends, but there were deep differences between them concerning the understanding of the museum. The radicality of Buren's critique is turned around by Broodthaers, with a more powerful dialectic and with greater ambiguity. Broodthaers was less optimistic than Buren about the possible abolition of the museum as an institution. It's certain that I did not understand Broodthaers in 1970 . . . He's still an enigma for me. I see Broodthaers as being situated between Foucault and Habermas. For him the museum is still an institution of the radical bourgeois public sphere; it is not a pure instrument of power and domination, but an institution of knowledge. In his view, contemporary practices should take place outside the museum. The site of production and the site of historical reflection should be separate; any synthesis is dangerous, because contemporary artistic production is increasingly linked to the production of the culture industry, whereas the museum is still a place that escapes its grasp.

JEAN-FRANÇOIS CHEVRIER I'm not sure one can say, as Habermas does, that Foucault systematically and unilaterally denounces the procedures of exclusion (because his focus is exclusion, not domination). He simply said that procedures of exclusion always accompany an ideal. Habermas distinguishes the ideal of the bourgeois public sphere from bourgeois ideology, saying that the ideal bears a promise of social transformation, that it can overcome the ideology. Foucault refuses any such distinction. But that doesn't mean he systematically practices a radical critique, for example of imaginary productions. Rather than systematic suspicion, he has confidence in the imaginary. The spaces of exclusion are also imaginary spaces, like the ship of fools in *Madness and Civilization*. The spaces of freedom are also spaces of confinement, and vice versa. So Foucault states the ambiguity. Although power

*Il est défendu
d'entrer dans le jardin
avec des fleurs à la main*

*Il est défendu
d'entrer dans le jardin
avec des fleurs*

Marcel Broodthaers
***Il est défendu* (It is forbidden), 1975**

Marcel Broodthaers

Jean-François Chevrier: In your thinking, between the seventies and today, Broodthaers seems to have become increasingly important. Earlier you saw him within a group, from which he now stands out. How did this figure emerge? Of course it's not a matter of making him into a heroic anti-Beuys!

Benjamin Buchloh: There are several reasons. The most recent is that I find in him an even more radical critique of visuality than I first thought. From the outset, Broodthaers' critique of modernist visuality poses the question of the dimension of history, of literature. That seems an important precedent for certain developments in the eighties: the reconsideration of a visual culture which has been based on the exclusion of representation, of history, on the interdiction of conventions outside pictoriality, such as literature, poetry, theater, narrativity. That's what begins to be developed in Broodthaers' work and what I don't at all see in Buren, who critiques visuality, but only with the means of visuality.

Jean-François Chevrier: There has been in modernity what I call a mirror of painting and poetry. I think Broodthaers is one of those who break the mirror, producing an oeuvre in which poetry and pictoriality—not to say painting—are like

produces subjects, the subject within the structure of power remains capable of producing another subjectivity. Think about the 1967 text where he contrasts utopia to heterotopia, the "other space." It seems to me that Broodthaers corresponds exactly to Foucault's notion of heterotopia as an alternative to utopia. Utopia is the idea that a radically different system can be invented. The heterotopias are ambiguous spaces, where there is power-exclusion, but also production of the imaginary. They are what Foucault calls "reservoirs of imagination." Broodthaers' exotic reverie is like that. He knows exoticism is part of colonialist ideology, but he reinfuses those ideological representations with an imaginary. Maybe it's an imaginary of emancipation.

BENJAMIN BUCHLOH I'm not sure it's emancipation. For Habermas, the museum and avant-garde practices are processes of emancipation, of enlightenment. Foucault's heterotopia is not emancipation. That's why it is so difficult for German Marxists to accept Foucault's position; they can't conceive of something beyond emancipation. There is no Bataille to translate that in Germany, not even Adorno, though he certainly comes closest.

JEAN-FRANÇOIS CHEVRIER In any case, you seem to think that there is a dimension of emancipation in Broodthaers, which would be his Marxist, Habermasian side . . . To get back to your own work, I'd like to ask a question about structuralism. To my knowledge you were the first to establish an explicit relation between the artistic activities of the period we're discussing and structuralism as described by Barthes in his famous text on "Structuralist Activity." How do you see this parallel between artistic activities, particularly conceptual ones, and the mental procedures described by Barthes? Is it really limited to the naive desire to reduce the artwork to a linguistic structure?

BENJAMIN BUCHLOH I'll answer biographically, first of all. I only "discovered" Barthes in 1972, thanks to Mark Oppitz, who had done his thesis on Lévi-Strauss. In Berlin, as I said, there was no reality principle, whereas returning to West Germany in 1972 meant confronting a strong reality principle—and to maintain an activist Marxist position in the Rhineland you had to be either strong and naive, or a martyr. So when I returned after almost two years in London,

fragments of the mirror that diffract each other . . . So you get the play of the rebus, a montage of fragments, words, and images. There's another artist who does that, whom I don't think you've spoken of, Robert Filliou, who was good friends with Broodthaers.

Catherine David: Isn't there a surrealist heritage in Filliou which has been completely washed away by Broodthaers?

Benjamin Buchloh: I'm not competent to say, I only know Filliou from a distance; he interests me but I haven't done systematic research . . . Another aspect of Broodthaers that interests me is the critique of conceptual art. He understood from the start that there was no radicality in the fact that the work can be reduced to a linguistic structure, that there would be no wider or more egalitarian distribution, no abolition of the commodity object or of the fetishization of aesthetic procedures and perception. And then there's the last aspect, about which I'm still unsure: with the current fusion of museums and private companies, with the erosion of bourgeois cultural traditions, at the very moment of its final disintegration the institution of the museum becomes an institution of the bourgeois enlightenment which ought to be reconsidered, in terms of what it could have contributed and what it actually has contributed to bourgeois public life. Broodthaers understood very well that the destruction of museums, in part by artistic critique itself, was a naive and irresponsible, almost futurist act—futurism being a word he frequently employed to depreciate certain practices which didn't seek to understand their own place in an historical or institutional context. For Broodthaers, the museum was not only a place of power, but also of knowledge, of forms of experience guaranteed by the boureois institution of the museum in the public, democratic sphere. He was neither sentimental nor reactionary, but he saw this institution as an instrument of emancipation, whereas Buren defined it as an instance of control, of regulation, etc. . . .

Jean-François Chevrier: At the same time, if there is this recognition of a bourgeois ideal distinct from ideology, Broodthaers knew it could not be dissociated from ideology, and that the space of knowledge in the museum is also a space of power. He knew that this knowledge and power were particularly sensitive in everything having to do with the imperialist colonial imaginary. The eagle is an imperialist symbol, the colonial theme is everywhere in his work, and he recognizes that there is an ambiguity: this same space of knowledge/power centered on an imperialist colonial imagi-

nary is also a reservoir of imagination. The representations of colonialism can also be the occasion for a Baudelairean exoticism, a split in normalized subjectivity which brings the perspective of another subjectivization into play: a subjectivization constituted in the relation to otherness, to another culture.

Catherine David: That's true in the most radical works, the *Jardin d'hiver* or the decors. It's the limit within your own culture.

Jean-François Chevrier: That's why he is so important in this documenta, which seeks to pose the question of Western culture in its relation to other cultures. He brings in the perspective of other cultures not through appropriation, quotation, fetishization, but as an opening of the space in all its ambiguity. It's not a Third World ideology stigmatizing the West, or otherness reduced to folklore. As important as it may be—and it always returns, whenever you engage in practical politics—the Habermasian model is more limited than Foucault's. Broodthaers remains closer to Foucault, if you understand Foucault outside a mechanistic interpretation of the structures of control/domination.

Benjamin Buchloh: Except that I think, without wanting to have the last word, that Broodthaers was always interested in the way imaginary structures could be transformed into political acts and political consciousness. It's not necessarily Habermas, but it's the more Marxist element of Broodthaers' thought. Maybe we're too unclear about the Marxist side of Foucault!

Jean-François Chevrier: There is a Marxist side of Foucault. People want to make him a liquidator of Marxism, and his support of Glucksmann's book *Les maîtres penseurs* was a moment of weakness. But except in that moment of weakness he maintained the Marxist reference, without its teleological orthodoxy, for the reasons you've just mentioned.

Benjamin Buchloh: Even if Broodthaers saw no other possible practice, he remained critical of contemporary art production to the very end. Other artists with a Foucaultian stance, in the limited sense, are perfectly happy to position themselves within a range of artistic practices. Dan Graham or Lawrence Weiner, for example, are absolutely unconcerned about other practices, or the art system in general.

Catherine David: I think that's a limitation in contemporary

where I had gone to detach myself from the increasing group pressure of the desperate circles of the anarchist left in Berlin, I "discovered" structuralism. I say that with a certain cynicism toward myself, because in 1972, to read *Mythologies*, a text written in 1957, was not really a discovery. But it was important to see how the Brechtian side of Barthes could merge with a very specific, concrete, and precise analysis of a contemporary world. The text exercised a veritable fascination over me—it seemed so much more exact than *Dialectic of Enlightenment!* Because of the linguistic model, structuralist activity allows you to understand the formation of ideology and communication much more precisely than Adorno and Horkheimer's more general approach of ideology critique. My interest in or identification with structuralist activity at that time, analogous to my identification with conceptual art, was motivated by the hope that it would be a practice rather than an academic ritual. It was another attempt by my generation to reconcile certain political projects with cultural or academic practices; we still seriously thought it would be a cultural-political intervention. At that time the discovery of structural semiology was a great promise in relation to German art history, more than a promise, an upheaval.

> JEAN-FRANÇOIS CHEVRIER Barthes uses the expression "structuralist activity" with direct reference to the surrealists. Personally I think this is something left unthought by both structuralism and conceptualism. Barthes recalls that surrealism must not be repressed, which is all the more true in that surrealism is the sole moment in French culture when all the tensions between art and politics could be confronted. With Sartre and existentialism, for example, there is a reduction of art. I have the impression that you covered up the question of surrealism, like many people in the conceptual-structuralist current. How can you ask the question of art and politics without surrealism? In France it would be quite impossible.

BENJAMIN BUCHLOH When I was teaching in Düsseldorf in the mid-seventies I became more and more committed to research on Russian formalism and Soviet art, and I taught minimalism through a reception of the Russian avant-garde. That was no accident at the time, it was still quite an inaccessible subject in the early seventies. It's a path one can take to reflect on art and politics: either surrealism or the Soviet avant-garde.

> JEAN-FRANÇOIS CHEVRIER But is there such a contradiction?

BENJAMIN BUCHLOH Not from the historian's viewpoint. But from the viewpoint of someone who wants to develop models for engagement in contemporary reality, it may be. To develop the most accessible, egalitarian, radically

practice. When you work with Dan Graham, you see that this kind of blindness is a limitation. The distinction with Broodthaers, the radical heterotopia, are the decors. They are forms that resist, that last. Certain recent practices of young artists turn around that aspect. But strangely, he is rarely cited.

Benjamin Buchloh: Maybe by Renee Green . . .

Catherine David: But with a very simplistic interpretation of the decor.

Benjamin Buchloh: That often happens between generations! Think of the very simplistic interpretations of Duchamp in the fifties and the early sixties . . .

antiaesthetic, enlightenment practice, you take the linguistic model of conceptual art, the model of Russian formalism, and the practices of the *Arbeiter-Korrespondenten-Bewegung* or of Tretiakov's factographic realism. And that is not easily compatible with the model of the unconscious developed by surrealism. It is possible, but I didn't do it, nor has anyone since then.

JEAN-FRANÇOIS CHEVRIER In any case I observe a veritable attempt in Benjamin's work to combine constructivism, with the Soviet model in the background, and surrealism: Le Corbusier and Breton, etc. And this meeting was politically very important for the history of the vanguards between the wars, for an articulation of the procedures of subjectivization with the structures of power. Surrealism stressed the dimension of the unconscious, and thus of the subject. How can you understand Lacan without surrealism? Finally, forgetting that dimension means forgetting entire branches of history, all the Central European avant-garde, for example. You remain in the trilogy of France, Russia, and Germany; but there are also the vanguards of Czechoslovakia and Hungary, where the striking thing that we're rediscovering now is precisely the meeting between constructivism and surrealism. Someone like Karel Teige is very interesting.

BENJAMIN BUCHLOH I wonder what produced the suspicion toward surrealism in postwar Germany. In the seventies there was the rediscovery of Magritte, Max Ernst, and Breton after his acceptance of painting—which is already an initial justification of the criticism or distance, because the painting of Magritte and Ernst at that time didn't interest me at all. What interested me was Duchamp and certain aspects of dada. But you're right, the younger generation today is trying to understand Benjamin's famous remark about Le Corbusier and Breton.

CATHERINE DAVID That said, the remark highlights two things, first the privileged but perhaps subterranean relations between architecture and literature, much more than the visual arts, and then the fact that the best of surrealism is in literature and not in the visual arts.

JEAN-FRANÇOIS CHEVRIER For me the best of surrealism, in the visual arts, is a kind of triangle. First, surrealist photography, and especially what might be called the "poetic document." Since romanticism, the figure of the oxymoron which joins opposites is a privileged figure for the avant-garde. Second, cinema, which is important in surrealism on the level of social utopia, but also on the level of pleasure: cinema is the moment of drifting, of pleasure in relation to the unconscious. Cinema for the surrealists involves the pleasure principle, through the appropriation and diversion [*détournement*] of popular entertainment. There are magnificent texts by Breton about his way of consuming cinema, entering a theater, stepping out, entering again. When Christian Metz, in his book *Le signifiant imaginaire*, compares the veiwing of film to reverie but not dreams, he perfectly describes the surrealist oscillation between the reality principle and the pleasure principle, between waking and sleep, the hypnagogic state—but strangely enough, he doesn't cite the surrealists. So the cinema is pleasure, but also politics, it's the

Sergej Eisenstein

Benjamin Buchloh: In my opinion, the only artist who really continues the surrealist project after the war—except in the context of American abstract expressionism, where it's more complicated—is Beuys. He is the only artist who is a surrealist after the fact in Germany, the only artist who recovers and refashions a history that gives the notion of the unconscious a central place in the production of the aesthetic. The paradox is that he does so too late, at a moment when it is completely obsolete and impossible.

Jean-François Chevrier: Of course I see a failure in Beuys, but a romantic failure—and we know how important German romanticism was for the surrealists. Beuys links a residue of surrealism to romanticism, and through a logic of remanence, of the lingering historical echo, he reproduces the romantic failure.

Benjamin Buchloh: Any artist who would try to establish some kind of historical continuity with German romanticism—and I'm not even sure that's the case with Beuys—seems to me, after the advent of fascism, to be a profoundly problematic artist. In this perspective I find it surprising that a historian like Peter Bürger, who is precisely a specialist of surrealism and romanticism, should discover contemporary art through Beuys and not through Arman, or the reception of Duchamp, or Buren and Haacke, not to mention Broodthaers again—artists for whom any continuity is broken once and for all. At the initial moment when the work is engaged in practice, the degree of alienation that is articulated in the work of Arman, by contrast to the degree of cultural continuity in the work of Beuys—even though they both work with found objects, industrial objects, etc.—seems to me to be a necessary condition for work which defines itself as contemporary after the war, whereas there is a totalizing tendency in Beuys' work which it is impossible for contemporary art to fulfill.

Jean-François Chevrier: For me, Beuys has this remanence of romanticism through surrealism, as well as a project of reconciliation. There is also a project of totality, with the reprise of the Wagnerian model denounced by Broodthaers, and finally a geopolitical imaginary with the figure of Eurasia, which is close to certain German obsessions; but the totalizing project ultimately fails. It fails by the very force of the romantic reference, and in reality it culminates in an extraordinary fragmentary invention. There's a magnificent phrase from Novalis about a universe made only of shards: that's Beuys. And finally, Beuys is pathos in the positive sense, as that which differs from the rationality of the Logos: the impossibility of totality, the inevitability of the fragment. Of course one can ask whether this failure was conscious or not. In any case it is clearly legible in the work. There is none of the blurring for which Artaud reproached Breton.

Benjamin Buchloh: The fetish is legible, the fetishization of obsolete aesthetic concepts is always legible.

Jean-François Chevrier: We can return to Walter Benjamin who enacts the fetish, that's what Adorno doesn't understand. Benjamin takes the mimetic risk of producing fetishes himself, that's why his thought was difficult to accept.

space of pleasure and revolution all at once. The surrealists knew the work of the Russian filmmakers, Eisenstein met them when he came to Paris and Rodchenko did so as well, if only because many surrealists were Marxists. So the triangle is photography, cinema, politics. What's important is not painting but the image; photography in its relation to cinema is a more important approach to the image, because more political. Here we come close to constructivism as it interests you. If you look at surrealism in its political dimension, without some neo-fine-arts approach through a distorted reading of Bataille, then it begins to show affinities with constructivism. You wrote on constructivism as a political perspective that was used in the sixties, maybe not very well used, that could be used better. The same needs to be done for surrealism! Your text wasn't only the work of an art historian, it was also a political text, saying that something had begun in the sixties which should be continued. The surrealism I'm talking about has to be redefined, rethought, pulled away from the imaginary of Breton—the way Benjamin pulled constructivism away from its reduction to a geometric formalism, a variant of the fine arts.

CATHERINE DAVID When you inquire into the reasons why certain figures have interested you more than others, it's because you're an art historian, of course, but above all because you're a critic, someone who is interested in models of intervention. And not many other people posed the question at that time; it appears in the Andre-Frampton dialogues, in Robert Morris's texts . . . The repression of the avant-garde isn't only the result of a powerful trauma, as in Germany.

JEAN-FRANÇOIS CHEVRIER It's clearly the repression of a social utopia. But I think that when surrealism is repressed, or reduced to an alternative to the fine arts on various pretexts derived from a reading of Bataille, there is a serious reduction of the unconscious,

Benjamin Buchloh: Beuys doesn't produce fetishes, he practices them.

Jean-François Chevrier: The artist who really allows for a critique of Beuys is the early Rauschenberg, particularly with the *Feticci Personali* and the *Scatole Personali* of 1952, before the *Combine Paintings*. It's extraordinary how an American artist, coming from media culture, pop culture, but working in an Italian context, can play with the archaism, the sexuality, and the unconscious aspects of surrealism. Rauschenberg follows the same procedure of enacting magic as Beuys; he called his works "personal fetishes."

Benjamin Buchloh: The complexity of the Duchampian model is present for Rauschenberg and absent for Beuys. That's the difference.

Catherine David: There is also a tremendous naiveté, at the moment of structuralism and the work on ethnography, to think that one can reinstate ritual as an alternative to the commodity.

Benjamin Buchloh: That is effectively one of the problems with Beuys: restoring cult value—to use Benjamin's terms—at the very moment when it has become apparent that the work of art is constituted solely by its exhibition value. That's what Beuys didn't understand, unlike Rauschenberg or Johns, whose light bulb is an object stripped of its magical, fetishist dimension. The same thing is true of Arman from 1959 to 1961, with his boxes, the *Poubelles* and the first *Accumulations*. There's an important transition in those works. It's extremely cruel and crude, but that's the specific aspect of this historical moment of 1959-61, which doesn't even try to establish any continuity with surrealism, with magic, with cult value, with an unconscious. What historical conditions disqualify the notion of the Freudian unconscious as the central notion of aesthetic production? That's what we haven't defined here.

Jean-François Chevrier: I agree that the comparison with the early Rauschenberg is to the detriment of Beuys, but the comparison is interesting. There is a play with the fetish that is of a different nature; perhaps in Rauschenberg it is more immediately convincing for an intellectual educated in ideology critique, an intellectual conscious of the double historical mutation constituted by the rupture with fascism and the onset of the American-style consumer society. But there is a danger in discounting Beuys' actualization of this archaism by enacting it, playing it out (compare the little objects which are very close to Rauschenberg's, and strictly contemporary, from 1949-55). I'm thinking of a text by Pierre Clastres from 1967, "De quoi rient les Indiens?" (Why do the Indians laugh?). He says mythology is actually very funny. In Beuys there is a play on mythology, on an archaic element which it is completely futile to cover up, because it will return by the back door, as the psychoanalysts say. That's exactly what happened in Germany in the eighties, that's what you denounced in "Figures of Authority, Ciphers of Regression." It happened because of the repression of Beuys.

Benjamin Buchloh: I understood that at the time, because I said that by comparison to Kiefer, Beuys was a fantastic artist!

of the pleasure principle, of all that was played out in the surrealists' relations to cinema. Again it's a question of the procedures of subjectivization. What the surrealists and the constructivists both understood was of course the need for revolution, but also the need to change the men and women who make the revolution.

BENJAMIN BUCHLOH I'm still trying to find an answer to your question about my disinterest in surrealism. It could be ascribed to a continuation of the anti-Freudian prejudice that has marked postwar Germany in general. And/or to a continuation of the skepticism or critical position toward painting that marked my aesthetic interests in the sixties. It's also the suspicion that surrealism was too rapidly exploited in postwar advertising. All these explanations are partially true, but simplistic. It's certainly true that since 1968, the political has been defined for me as the transformation of the ownership of the means of production, of the relations of production, more than in terms of a transformation of the unconscious. Also I have always thought, especially at the moment of conceptual art, that aesthetic practice is not primarily seated in the unconscious. I was not able to understand, like Broodthaers, that the aesthetic involves the constitution of the self, of the subject—which is not the traditional Freudian unconscious. It's true that if you consider the artistic practices of the seventies, Ryman, for example, who was very important in my reconsideration of painting, or Richter, neither ever confronted the question of surrealism. I did not understand painting through Pollock; in that generation I was more interested in Barnett Newman. For me the work of art is paradoxically founded on a model of communication, a very complex and contradictory communication, opaque, hermetic, esoteric, a communication of resistance and opposition, of negative critique—but not on the model of a

Jean-François Chevrier: I think that a certain conceptual-structuralist norm rejected surrealism and repressed Beuys along with it, producing the effects of the return of the repressed which happened after 1978, which is the turning point for the regressive art that you denounced. But could it be that by repressing surrealism—not the surrealist tradition, but its underlying stakes—and the stakes of Beuys' archaism, you are actually among the critics who allowed for the regressive return that you denounced? In any case, it should be clear by now that my concern is not the Freudian unconscious, the individualized unconscious.

Benjamin Buchloh: It remains to identify why this repression is specifically German—as I recognize. But beyond this postwar German tradition, it also remains to be clarified whether the skepticism toward surrealism over several generations and on several continents is always a repression. I'm thinking again about Ryman's work in the late fifties, the beginnings of Nouveau Réalisme in the early fifties, the artists of the second German generation like Polke, and even Palermo who was a devoted disciple of Beuys; they all take their distances from the history, theory, and practices of surrealism.

Jean-François Chevrier: There is a positive distancing, in the sense where there is a tradition of surrealism which is awful, that's what Artaud denounces; but this positive distancing is accompanied by a repression. I don't know why. Our earlier discussion on the irrational was a beginning, but we would have to go further to understand the whole problem.

libidinal intervention or an intervention in the unconscious structures of the formation of the subject. That always seemed insufficient to me. In the past I would have said "petty bourgeois," but I really don't think that anymore! I admit all this with a certain astonishment . . . But if you consider the critique of surrealism by Debord, or by Buren, doesn't it seem rather common in the sixties to criticize surrealism?

JEAN-FRANÇOIS CHEVRIER Yes, because there are good reasons for that critique. Take for example Artaud's letter to Breton, refusing to participate in the exhibition Breton organized in 1947, and in which Duchamp did participate: that's the most radical, intelligent, definitive thing ever said against surrealism. Artaud ends by declaring that what interests him is the workingman's reality, whereas Breton is dealing with magic and commodity fetishism. I don't know if Broodthaers read those letters, which were published in the journal *L'Ephémère* in 1968. They could be compared both to Broodthaers' critique of Beuys and to Beuys' critique of Duchamp. They form the synthesis of the two critiques, since they denounce both magic and the occultation of labor. In any case, surrealism with all its conflictual relations is obviously more interesting than the norm represented by Breton.

BENJAMIN BUCHLOH If you consider the sixties and seventies, even the eighties, in what artist is there an obvious and persuasive continuation of surrealism?

JEAN-FRANÇOIS CHEVRIER Maria Lassnig, Eva Hesse.

BENJAMIN BUCHLOH The unconscious is there, certainly. But it's a surrealism from Pollock's perspective, which has been rearticulated with very complex means. It's difficult to fit Eva Hesse into a surrealist tradition.

JEAN-FRANÇOIS CHEVRIER Now I get the real meaning of your question: if I had understood surrealist *tradition*, I wouldn't have been able to name anyone! But it's not a matter of maintaining anything like a stylistic tradition. Take Eva Hesse: if you look at the whole development of her work, what was at play from the beginning, at the very bottom of it, is surrealist. I think surrealism has been covered over by the conceptual-structuralist current, and that's why we have difficulty finding a lot of artists . . . In any case we know we're better off looking in drawing than in painting.

BENJAMIN BUCHLOH Do you see examples of contemporary practice which refer to surrealism?

JEAN-FRANÇOIS CHEVRIER Mike Kelley has interested me quite a lot these last few years. He refers explicitly to that aspect of surrealism which can resonate with an American subculture. I'm a French intellectual, so I can't share the subculture of an American artist from the West Coast; but I saw that aspect of his work immediately.

BENJAMIN BUCHLOH What is Jeff Wall's position?

JEAN-FRANÇOIS CHEVRIER He's another example. Black humor is essential for him. Of course he's closer to European thought. That's

Antonin Artaud

Letters to André Breton

You bitterly reproached me for my performance at the Vieux-Colombier. . . . which was the first chance I had to tell the facts to the public of a society

that kept me interned for 9 years,

that had its police demolish my spinal cord with blows from iron bars,

that had me knifed twice in the back by pimps,

that had me arrested and sent to prison, deported,

attacked on a ship,

held three years in secret during my first three years of internment,

and systematically poisoned me for five months in one of its mental wards (in Sotteville-les-Rouen, October 1937-March 1938). . . .

But after all that, André Breton, after reproaching me for my appearance in a theater, how can you invite me to participate in an exhibition in an art gallery, a hyperchic, ultraflourishing, highly influential capitalist art gallery (even if its accounts are in a communist bank), where every event of whatever nature can no longer escape the stylized, limited, closed-off, fixed character of an attempt at art. . . .

No, I absolutely cannot participate in an exhibition, above all not in a gallery,

all the more so because there is one last thing in your project that overcomes me with horror:

The parallel you draw between surrealist activity and occultism or magic. — I no longer believe in any notion, science, or knowledge, above all not a hidden science. . . .

You have divided this exhibition into 15 galleries, with an altar in each, after the model, you say, of voodoo or Indian cults,

representing the 15 steps or stages of an integral initiation.

Here my entire physiology rebels because I do not see anything in the world into which one could be *initiated*.

All experience is resolutely personal . . .

With the passage of time I have acquired an excruciating horror for everything touching on magic, occultism, hermeticism, esotericism, astrology, etc., etc., not only do I no longer believe in them but my hate for human society knows no more bounds when I see the indescribable hodgepodge of all the errors, all the false beliefs, all the sophistry, all the humbug, the whole glittering bluff whereby certain individuals or groups of individuals seek to convince me that they have captured vital secrets, that they hold worlds of phenomenal truths in their hands, whereas they have never handled a thing but empty air, under the cover of a sordid human illusionism persuading them that something can be and that there is something;

and that from what is

some thing

must ineluctably be deduced

to which by one aspect of my being I would necessarily and ineluctably be subjected.

Ivry, February 28, 1947

I did not go to a theater last January 13 to make a spectacle of myself, to put on a spectacle,

but to show the wounds suffered in my struggle, with the abject awareness that these days are worse than those of Gérard de Nerval, Edgar Poe or Lautréamont.

And when you told me you were hostile to this project,

no, you were not hostile to the fact that I would show myself in a theater, André Breton,

you were hostile to the very object of the show: something in you did not want that to be shown in the light—and I don't even think that something is you. . . .

But that said, how could I write a text for an *exhibition* where the same foul public will come back to a gallery, which, even if it draws its funds from a communist bank, is a capitalist gallery selling pictures at high prices, not even paintings anymore but commercial shares, *values*, entitled SHARES, which for all the world are just the same as those objects called SHARES, those sorts of large papers printed in several colors representing on a simple paper (oh miracle!) the contents of a mine, a field, a well, a sediment, a business, a prospect, in which the possessor, the owner, the capitalist possessing it hasn't participated even with a broken finger nail, while millions of workers have bit the dust, *at grips with the object*, so that the underfed lecher called mind can sit back and *enjoy* the material labor of the body.

Ivry, March 24, 1947

Eva Hesse, Untitled, 1970

the strength of surrealism, to have such a wide impact, throughout Latin America, for example.

CATHERINE DAVID That's what I was thinking when you mentioned Central Europe; but at the same time you can't ignore the dimension of appropriation by the surrealist net. The local strategies of explanation were relatively limited, and so surrealism could move right in. Its subsequent development became important only when it was taken up by someone like Octavio Paz, in Mexico, for example. But there is no Argentine writer who can be considered surrealist. Brazil is more modernist than surrealist.

JEAN-FRANÇOIS CHEVRIER But how could the Museum of the Unconscious exist without surrealism?

CATHERINE DAVID The category of the unconscious is related to surrealism, of course, but also to psychoanalytic and psychiatric culture. In Brazil in the twenties and thirties, tremendous attention was given to the treatment of the mentally ill; documents were produced and preserved in archives. The institution that came to be called the Museum of the Unconscious holds these archives.

JEAN-FRANÇOIS CHEVRIER Is this project comparable to the Museum of Art Brut, and if so, how?

CATHERINE DAVID The two are closely linked; but first of all, the Museum of the Unconscious is earlier, and second, it is directly linked to psychiatric practice. The archives were created by a woman in one of Rio's two major psychiatric hospitals. Her work was extremely innovative, and when Mario Pedrosa conceived his project for a museum of Brazilian culture, he sought to integrate those archives to a single complex containing the four major components of Brazilian modernity: Europe, the indigenous peoples, popular art, and the unconscious. Only the Museum of the Indian and the Museum of the Unconscious exist today, but the project is characteristic for the way it brings together seemingly heterogeneous elements. The anthropophagy movement, like the Modern Art Week in São Paolo in 1922, contributed eminently to a specific understanding of Brazilian culture, which is anthropophagic, which digests and recycles its heritage. Brazilian modernism refuses the copy, the repetition of Italian modernism, despite the close family ties that link certain artists to both Brazil and Italy. The tropicalism of the sixties is a dynamic reprise of this movement that began in the twenties.

JEAN-FRANÇOIS CHEVRIER You imply that the dialectic of constructivism and surrealism is foreign to Brazil. Is the anthropophagy movement a kind of melting pot?

CATHERINE DAVID Brazilian culture is one of ingestion, of digestion, it feeds on the Indians, the Portuguese, the Japanese (São Paolo has the second largest Japanese population in the world, after Tokyo). Assimilation is the norm, in the digestive sense of the term. Everything blends together: the contributions of the anthropologists, the writers, the theorists, along with influences from the interior of the country, all the different elements that make up this very complex society. The contribution of the blacks is considered very positive, quite unlike the situation in the United States.

JEAN-FRANÇOIS CHEVRIER In the case of Brazil, the European dialectic between the people and the minorities is totally transformed: the people seem to be the minorities.

CATHERINE DAVID But the notion of a national cultural formation is so strong that only now have the minorities begin to recognize themselves as such, as exploited minorities. And in reality, the blacks are not a minority but a majority.

BENJAMIN BUCHLOH Which means that "minority" is not defined in statistical but in economic and cultural terms.

JEAN-FRANÇOIS CHEVRIER What appears are two opposite or perhaps complementary movements. On one hand, the phenomenon that has been called "Brazilianization": an extraordinary social fracture presenting considerable differences in the standard of

living. On the other, the phenomenon of the melting pot which seems to have succeeded in Brazil where it has failed in the United States. How do you articulate these two dimensions?

CATHERINE DAVID Hispanic America is more strongly catholic, and consequently more rigorously opposed to mixtures. Brazil was colonized by the Portuguese, who as a people have a more flexible relation to the law than the Spanish. Brazil is a nonmonumental country, the vertical order is always disqualified by the horizontal. It is the country of the rhizome, of extension. The borders are not clear: there is the coast, then the "interior." It's a country that remembers nothing, it is drenched in immediacy, in permanent destruction, what Oiticica called "Brazilian diarrhea." There is no racial discrimination in the law, skin color is never mentioned. And yet there is a very paternalizing discourse on "the country of three cultures" which emphasizes the blacks: the blacks are nice, they do the good cooking, they take their time. This has to be questioned today.

JEAN-FRANÇOIS CHEVRIER We have been trying to distinguish between artistic forms that appeal to popular participation and other, more mediated forms. This discussion can help us, by providing an outside reference. Brazil offers the image of an extraordinary synthesis in the field of music, an expression that is at once popular and highly cultured, physical and mediated. Bossa nova is a perfect example. It's striking to see extremely sophisticated people coming out of concrete poetry, referring to Mallarmé, but at the same time working with musicians and singers, and mixing everything together by computer.

CATHERINE DAVID But you have to be careful when you speak of bossa nova, which unlike samba was not originally a form of popular music, even if it has subsequently become one. There is a big polemic on the subject: some think bossa nova is a music of the elite and for the elite, while others see it as an aspect of Brazilian music. It works on a principle of discord, it's always at odd angles, it's extremely difficult to play and to sing even though it gives a feeling of simplicity. But in any case, it is clear that Brazilian popular music is a space where the elite and the people have always met.

BENJAMIN BUCHLOH Shouldn't we be thinking about the political or geopolitical conditions that explain this synthesis? I think they are extremely different in Europe. For example, who represents the French people today?

JEAN-FRANÇOIS CHEVRIER There is clearly a difficulty today: the people can be appropriated by a nationalist-racist discourse. What is more, we are in a postcolonial situation where a model of the melting-pot society is seriously being envisaged for France. Until very recently we have lived with a Republican model which conceived integration as a process of "becoming similar" to the majority. This model has today become impracticable, which is what makes the current debates on immigrants so interesting: these debates question the definition of a homogeneous *peuple*. This is why the Brazilian perspective is so important. It introduces what we haven't yet touched on in our primarily Franco-German debate, which is the definition of the people through their heterogeneity, rather than as a homogeneous national identity, or at the other extreme, as irremediably fragmented, multicultural.

BENJAMIN BUCHLOH We should be careful, in this discussion, about the way we constantly slip between an ethnic, political, economic, and geopolitical definition of the people. The choice of any of these levels of definition has an immediate impact on our definition of culture and its production. At what level can we inscribe the notion of a public culture: the level of a revolutionary minority, as some postcolonial strategies propose, or the level of a resurrected nation, as some conservatives would prefer in France, or again, around certain linguistic traditions? Let us reconsider the situation of Germany after the war. At that time, the conception of the nation in terms of the people had become definitively impossible, due to the experience of fascism. Both the bourgeois public sphere and the potential for a proletarian public sphere had begun their transformation into what had been termed since 1947, and for good reasons, the sphere of the culture industry, or what Hans Magnus Enzensberger would later call "the consciousness industry." This situation, with the predominant influence of the American model, is quite different by comparison to Italy or France, where there was a continuing importance of various practices and institutions which sought the collective participation of the population, or the people—despite the fact that the culture industry developed there as well, though somewhat less rapidly and less effectively. It would be important, at this point, to consider the situation in Great Britain, and particularly the visual practices around the Independent Group, which again presents a different configuration. The early manifestations of pop art in the mid-fifties were intended as a

Andreas Huyssen

PopArtretrospective

At a time when museum retrospectives of pop artists abound, when museums are increasingly commercial, and a certain cynicism regarding the commodification of all art is widely taken for granted, it may seem rather nostalgic, if not beside the point to revive the old debate about pop art's critical dimension. Indeed, if the *New York Times* art critic can discuss the newly cleaned up and Disneyfied Times Square as indistinguishable from an art installation (December 31, 1996), any distinction between commercial art and pop art seems to have finally collapsed. American pop, whose most celebrated artists emerged out of commercial advertising, can–now more than ever–be said to have reached its inherent telos in the gigantic billboards featuring models without affect, a chaotic collage of flashing corporate signs that come alive at night, and the three-tier electronic ticker-tape display towering over Broadway and 42nd Street. *Learning from Las Vegas*, together with pop art one of the early manifestations of the postmodern, now shapes one of the mythic spaces of urban modernism, leading some weak souls to lament the total sell-out of American culture to a theme-park of multinationals.

The potential confusion between art and advertising, image and object in our image-saturated culture is indeed for real. It was pop which first sharpened our senses to this constellation, not, however, by collapsing the difference, but rather by exploring the boundary between images and objects of art and images and objects of commerce. To understand this project requires the kind of discrimination that pushes beyond the now-standard moralizing arguments about commodification, consumerism, and culture industry, arguments that were once hurled by the cultural left against Warhol and Co. and that can now be found on either side of the political divide. Such premature equations of pop art with consumer advertising have always suffered from what Brecht, in his famous 1930s critique of Lukács, derided as "contentism." In relation to pop, even the formalists were not free from it. Thus the often repeated reproach of formal inadequacy (Clement Greenberg), the lack of transformation, and the promiscuity of images (Herbert Read) in pop art as opposed to modernism was never really substantiated. Few ever bothered to take a close look at the formal and mediating strategies of this new art that indulged itself in brash and blatant representations of Campbell Soup cans, Coca Cola bottles, and other such standard packaged goods and that recycled newspaper, television, and advertising imagery. Ironically, the defenders of formal standards in art made their explicit argument against pop primarily on the grounds of pop's contents, which they did not like, and on the basis of a notion of artistic originality grounded in the integrity of "high" art which pop had set out to call into doubt in the first place. In its practices, pop not only vacated such earlier notions of the artist as original genius and alienated outsider. It also made an earlier apparatus of formal and ideological critique strangely problematic, if not obsolete. Which explains the intensity of the critics' attacks . . .

True enough, pop art celebrated a different look–the look at objects of everyday life, and more precisely, the look at media representations of objects of everyday life. But those objects were not the urban or domestic detritus recycled in dada collages, in Rauschenberg's *Combines* or in junk art. They were rather images of mass marketed consumer goods at a time when consumerism, marketing, and advertising in the U.S. reached a heretofore unknown frenzy in the early 1960s. In Roland Barthes' words, pop staged an object which was neither the thing nor its meaning, but its signifier. But this staging did not take an existentialist, tortured, or accusatory cast. American pop did not rebel against middle-class society. It lacked the aggressive, often doctrinaire assault on aesthetic

convention that had characterized an earlier European avant-garde and that resurfaced again in some forms of the post-1945 neo-avant-gardes. It refused any pedagogic mission, say, of debunking the media cliché as product and producer of false consciousness. Its preferred look at consumer objects was cool and aloof, self-consciously deadpan tinged with parody for those who chose to see it. The images were banal, taken from advertising, newspapers, comics, and other forms of mass culture, but often so garish and screaming in color, so magnified beyond natural proportions and "in your face" that they inevitably intensified and altered perception. Pop images were neither purely representational referring the spectator to the consumer object, nor were they ever purely simulacral referring merely to other images. In their apparent celebration of Americana as undecidably referential and simulacral, they registered a dimension of anxiety, melancholy, and loss that has perhaps become more visible with the passing of time.

Formal aspects of pop and the inherent qualities of its artistic practices in a traditional sense remain to be explored. A Warhol is as different from a consumer ad or a glossy magazine image as it is different from a Lichtenstein or an Oldenburg. Equally important for an overall assessment of pop as a critically innovative project, however, is the broader cultural and artistic context of the 1960s. Pop art contributed significantly to a cultural transformation which since then has gone by the name of the postmodern. Central to this transformation was a shift in emphasis from production to consumption, from artist as producer to artist as agent (Warhol's factory), from creator to spectator, from artwork to text, from meaning to signifying, from originality to repetition, from high culture to mass culture. Pop art crucially articulated some of the terms of this transformation. It blew out the boundaries between art and the everyday, not by reversing the hierarchy of high and popular, but by offering new ways of imaging the relationship. At at a time when Marshall McLuhan announced the end of the Gutenberg galaxy and celebrated the emergence of a new media age, pop artists expanded the realm of visuality in art to include what only later came to be called visual culture. But contrary to McLuhan and different from some of today's triumphalists of the visual, they maintained in much of their work a sense of the inherent instabilities and complications of the field of consumer vision.

But none of that is enough to get at the cultural politics of pop. The notion that pop art harbored a hidden social critique of consumer culture underneath its bland and blasé façade was always more prevalent in some European countries than in the U.S., where pop remained a more isolated phenomenon of New York art culture and its galleries. Interviews with the artists, published early on in the U.S., furthermore seemed to confirm a media image of the pop artist as complacent, affirmative, and uncritical of American consumer culture. Small surprise, then, that in the U.S. pop was quickly seen as part of a national tradition of affirming the popular and the everyday. But so what! Why worry about intentions! It was precisely pop's cool inscrutable look and its lack of affect that gave the spectator the freedom of interpretation and of projection. The European reading of pop art as critical of consumer and media culture was all but inevitable, but it was not any more mistaken than the predominant American view.

And then there was the exoticism bonus. In West Germany, for instance, a wave of pop enthusiasm swept the country after its first introduction during the 1964 documenta. The conservative cultural critics, who were peddling Christian values, pastoralism, and, at best, the latest vintage of worn-out abstraction, denounced pop art as non-art, supermarket-art, and kitsch, lamenting the coca-colonization of Western Europe in apocalyptic tones. That alone would have been enough to make pop a success. But between 1964 and 1968, the notion of pop that attracted people almost magically, referred not only to the new art by Warhol, Johns, Lichtenstein, Rosenquist, Wesselmann, and Oldenburg. It also stood for beat and rock music, poster art, the flower child cult and an emerging

youth culture, indeed for any manifestation of what was then mysteriously and mistakenly called "the underground." In short, pop became the synonym for the new life styles of a younger generation in rebellion against their parents and the restoration culture of the conservative and repressive 1950s. Americanism was in. The more blatant the better. American icons and American music were un-German. That recommended them for the generational struggle over cultural and political self-fashioning which was articulated through hairstyles, dress codes, popular music, changing patterns of language and communication. Even the reading of Disney comics could become an act of pleasurable teenage rebellion at a time when German school textbooks read as if the Morgenthau plan had been implemented after 1945 rather than the Marshall Plan: Germany as pastoral, agrarian idyll–no cities, no factories, no Nazis, and no past. Hard to say how the German transformation of the 1960s could have happened without American "cultural imperialism." Pop in its widest sense was an essential part of that. In this German context, cultural, social, and racial distinctions that could not be ignored in the U.S. between, say, New York pop, Detroit mo-town, or variants of be-bop and cool jazz were largely erased. Against the politically apologetic uses of the German high cultural tradition, this whole grab-bag of Americana supported the new rebellious habitus and satisfied a generational desire for lifting the dead weight of a tradition whose collusion with Nazism had become all too obvious. Pop combined the cool detached look with new intensities of perception, and in that it hit upon a sensibility of the young. It challenged the European privileging of indigenous high culture with its traditions of anti-Americanism. Pop, American to the core, accelerated the decline of cultural nationalism in Germany–and not only there.

It was with the rise of the international protest movement against the Vietnam War and the intensification of the student movement in 1968 that the initial enthusiasm about things American turned sour, or at least became much more complicated. The battlecry against American cultural imperialism was now more often heard from the left than from the right. The Vietnam war as the logical outcome of Cold War ideology complicated "America" for liberals and leftists. The rediscovery of Western Marxism (Lukács, Korsch, Gramsci, Bloch, Marcuse, Adorno, Horkheimer, Benjamin) merged with a very German tradition of Kulturkritik and its ingrained cultural anti-Americanism to reveal pop art as the logical outcome of advertising and the culture industry: art as commodity and spectacle through and through. Thus the 1968 call for the end of art, for the merging of art and life, and for cultural revolution: *l'imagination au pouvoir*. Pop art had fallen from grace. Adorno, Debord, and Baudrillard provided the ready-made funeral peal.

This reductive condemnation of pop art represented a victory of a monolithically negative view of capitalist culture over a more complex and differentiated approach that insisted on the dialectical and emancipatory moments of culture even under consumer capitalism. It is more than ironic that at a time when these very same critics of pop extolled Benjamin's insights into the transformative role of mechanical reproducibility in the arts, they so completely missed the fact that pop actually rearticulated the Benjaminian problematic for the post-World War II age. It was a leftist cultural nationalism combined with legitimate outrage about American military imperialism in Vietnam that blocked a more appropriate assessment of the ambiguity of pop art precisely in Benjaminian terms: pop as an art that did not just reproduce originals, but that reproduced reproducibility and thus got to the very heart of capitalist commodity culture in the age of visual media. But it reproduced reproducibility with a difference. This difference remains a bone of contention. In Umberto Eco's words: "It is no longer clear whether we are listening to a criticism of consumer language, whether we are consuming consumer language, or whether we are consuming critical languages as consumer languages." Indeed, it is not clear. And perhaps we are doing all of the above at the same time. But would we know that without pop?

resolution of the old class conflict which culture had always represented. It was intended as an opening to a new construction of a popular art. The identification with the iconography of mass culture was perceived as an agent of critique and not as an affirmation of mass culture. The naiveté of the Independent Group was to attempt to use American mass culture to free art practices from the influence of bourgeois high culture. Paradoxically, they did not realize that this would only hasten the fusion of the culture industry and the neo-avant-garde.

JEAN-FRANÇOIS CHEVRIER There is a negative force of mass culture, and later of pop art, with respect to bourgeois values. Depending on the strength of the critical tradition in a given country, this negativity of mass culture in the postwar period will be perceived as more or less related to the early subversive vanguards, and particularly to dada. In Great Britain, the artistic use of mass culture is much more direct, much less connected to dada than in France, with the Duchampian tradition and the Nouveau Réalistes, or in Germany, with the tradition of *Kulturkritik*. After all, the notion of pop culture in England is above all connected to music. It's much more direct, it involves young proletarians struck by the early industrial crisis in cities like Manchester and Liverpool. And the attraction of the negative force is strengthened by the archaism of a society which retained, more than anywhere else in Europe, the old social hierarchy inherited from the industrialization of the gentry.

BENJAMIN BUCHLOH It is important to realize that even in the sixties, pop art was theorized by several authors in radically different ways. The left of the sixties considered American pop art as the last wave of U.S. imperialism in Europe. That position was articulated rather hastily, but there is another position, formulated very well in an important article by Andreas Huyssen called "The Cultural Politics of Pop," which explains that the presence of pop in Germany was perceived by the left as the indication of a shift in bourgeois institutions and bourgeois aesthetic discourse, a shift brought about by an art of revolutionary desublimation. Even within the left, two opposite positions were articulated. You have something similar in the Italian context as well. On one hand, some consider pop as the last piece in an ideological conspiracy, whose success means the triumph of American domination. Others see it as a revolutionary force, a subversion of traditional institutions, what Marcuse called a subversive desublimation. Perhaps Germany was particularly prompt to articulate this contradiction in an intense and manifest way, because among the European countries it is perhaps the one which has been most effectively Americanized. The degree of identification in the sixties with a frenzy of consumption following the American model forms part of the postwar German project, which is to identify with something other than Germany's own history. The degree of Americanization is evident, for example, in the intensity with which Ludwig imported American art to Cologne. First of all it is a matter of repressing the avant-garde culture of Weimar, then of cutting short any effort to reconsider the history of fascism and of the postwar period, and finally it is a matter of reshaping the country according to an internationalist model of consumption. So you have to clearly distinguish between artistic production and its reception. What the Germans made of pop art doesn't necessarily reflect its real meaning. There isn't just one pop art. There is a reception of pop in Paris, for example, which is completely different from its reception in Germany.

JEAN-FRANÇOIS CHEVRIER At this point I have a question which relates to your own intellectual biography. It concerns the notion of

Bernard Hucleux, *Irene and Peter Ludwig*, **1975-76**

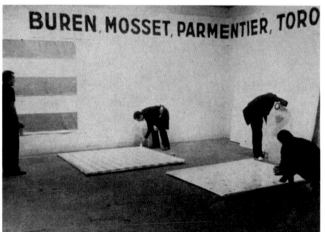

BMPT: Buren, Mosset, Parmentier, and Toroni Fifth Paris Biennale 1967

the product as distinct from the art object. What interested the pop artists—and particularly Warhol—was the product, the image of the product, the brand image. The notion of brand image was a new one, it didn't exist so strongly between the wars. But the notion of the product, opposed to the art object, shares in the antibourgeois strategy of liberating desublimation. Did intellectuals on the German left such as you and Huyssen associate the idea of the product, as opposed to the object, with production, as Benjamin did?

BENJAMIN BUCHLOH There is a reading of Warhol in Germany which, paradoxically, is profoundly influenced by Benjamin. Warhol was perceived as the sole postwar artist who translated the idea of the work of art in the age of its technical reproduction. The fact that it was the image of a product and not the reflection of a productive activity was not taken into account.

JEAN-FRANÇOIS CHEVRIER Warhol himself is an image of the artist as producer. There's something interesting there: the product is opposed to the object, in so far as the object is autonomous, precious, fetishized.

BENJAMIN BUCHLOH In principle, that was already the paradigm of the readymade. For the perception of Warhol by people on the left, remember how Buren, Toroni, and Parmentier drew explicitly on Warhol in their first presentations at the Paris Biennial in 1967. In an interview I recently did with Michel Claura, he admitted that their first exhi-

bition of posters, passport photos, and ID cards was an anonymous presentation with an ideal of seriality in direct response to the Factory. Buren subsequently took his distances, but at first it was deliberately and consciously Warholian. Each context has a different reception of Warhol. If you mention Warhol to Haacke, he'll still tell you today that he's the enemy. He hates Warhol as the worst of America, the worst of contemporary art. For him it's the final transformation of the institution of art into the institution of the culture industry . . .

JEAN-FRANÇOIS CHEVRIER Which isn't wrong either.

BENJAMIN BUCHLOH It isn't. Warhol is the first postwar artist to have made it clear, far more radically than Yves Klein, that the fusion between the traditional sphere of the avant-garde and the new sphere of the culture industry was inevitable. Warhol made it his program and practiced it. Now we live with the consequences, and we can't reproach the messenger for the message.

Marcel Broodthaers, *Magie: Art et Politique*, 1973

JEAN-FRANÇOIS CHEVRIER You say the product is already there with Duchamp. But there is no brand image. The readymades are not images of products, they are technical objects, consumer objects . . . There's the same ambiguity in Walker Evans; the idea of the craft object remains, the idea of the object in any case. Warhol goes all the way to the simulacra, he drains out any idea of the object. What is exhibited is a three-dimensional image.

BENJAMIN BUCHLOH I think what can be reconstructed is the transition from use value to exchange value, the arc over three generations, from Picasso to Duchamp to Warhol. With Warhol, what's at the center of the construction of the object is not exchange value, it is the exchange value of the sign, the simulacra. For once Baudrillard is right!

CATHERINE DAVID There's a stage in Duchamp that sometimes gets skipped, which is the "readymade aided": objects that are close to their everyday form, but slightly modified . . . Duchamp clearly interests us more than Warhol, but

Arman, *Portrait robot de Ben*, 1962

he should not be totally detached from all historical contingency. It's obvious that Duchamp is closer to Mallarmé than Warhol.

JEAN-FRANÇOIS CHEVRIER Foucault knew Mallarmé very well, but he chose to write about Roussel, who is Duchamp's real reference. Duchamp also knew Mallarmé, but with Roussel he chose vulgarity, and he is modern in that respect. Robbe-Grillet began with Roussel who for him was a vulgar author, in the sense of the vulgar tongues, as opposed to the "noble" language of Latin. What's extraordinary in Broodthaers is that he begins with vulgarity and then reactualizes Mallarmé. It's a stroke of genius, and a blow against Wagner/Beuys. He contrasts Wagner to Mallarmé, just as Mallarmé himself took a stance against Wagner. This is a very precise configuration that converges with our discussion of pop.

BENJAMIN BUCHLOH Broodthaers obviously articulated a highly ambivalent attitude toward Warhol. He wrote an open letter when Warhol was shot: "My friends, I cry with you for Andy Warhol," but he concludes with an extremely ambivalent remark about the fact that, as he puts it, "you don't have to feel that you sold out before you have been bought." In an early text by Broodthaers, written when pop was first exhibited in Brussels, he still appeared enthusiastic, in the typical manner of an artist on the left. Soon after his attitude changed completely, which is rather characteristic in Europe at that time.

JEAN-FRANÇOIS CHEVRIER That brings us to the turning point of 1978. If today we prefer Duchamp and Broodthaers, it's not only because they're radical, but because they are ambiguous—unlike Warhol. The dangers of the repressive effects that dialectical radicalization can bring and the awareness of a need for ambiguity both became apparent in 1978, even in North America, at least for two artists: Jeff Wall with *Destroyed Room*—the work which inaugurates his critical reconstruction of the pictorial tradition—and Dan Graham with his first pavilion, which is his own contradiction of his earlier refusal of the art object and the monument. Radicality is no longer possible, it brings the opposite of the effects it sought. In fact, the year 1978 signals the moment when the crisis that had developed since the late sixties finally ceased producing positive effects. One could speak of a "crisis of the crisis," presenting three major aspects. The first is the obvious failure of so-called "real communism," a failure rendered incontestable by the testimony of the dissidents in the East (which itself was rapidly exploited in the West by ideologues proclaiming the death of Marxism); the second is the stiffening of the alternative social experiments into identity-group fixations; and the third is a dawning awareness of the naiveté shared equally by the liberal alternatives, the Maoist revolutionaries, the supporters of the Third World struggles, and last but not least, for those of us involved with art, the radical avant-garde. On all these grounds—except perhaps Maoism—it was possible to go on pretending. But in the field of the avant-garde, two artists coming from radical North American conceptualism, Dan Graham and Jeff Wall, marked the turning point.

BENJAMIN BUCHLOH I see these things clearly in Jeff Wall, less clearly in Dan Graham's pavilions. 1978 is exactly the moment where the new generations introduce this ambiguity as the project of their own production. On the other hand, it is also the return to painting in Italy, and the moment of neoexpressionism in Germany. It is the moment when an artist like Kiefer arrives on the international scene, above all in America, because he can articulate that ambiguity. But he doesn't articulate it as such, he turns history backward. Neoexpressionist painting presupposes that the museum is still accessible, that the integrated object can still be conceived . . .

Part 2 on page 624

PUNK- (pŭngk) noun
[ORIGIN UNCERTAIN]
1 Obs. A PROSTITUTE
2 Slang a A BEGINNER
AN INEXPERIENCED HAND
b SOMETHING
INFERIOR OR USELESS
- adj Slang U.S. VERY POOR;
BAD; INFERIOR. ALSO
3 A YOUNG RUFFIAN
4 A WORTHLESS ARGU-
MENT, NONSENSE

I braved hitchhiking from Ann Arbor through a particularly redneck rural area outside Detroit during an intense winter snowstorm to see the Stooges. When I arrived at the club I found it to be a smal biker bar. I was the first one there. Passing the time, I asked the bouncer (a huge, fat biker) whether he had ever seen the Stooges. "No," he said, "but if the prick throws up on stage, I'm going to kick his ass." When the Stooges arrived, Iggy was stressed in a ridiculous jazz dancer's outfit, a kind of leotard with spangle shirt. His eyes were ringed sloppily with eyeliner and a cigarette drooped from his lips. His whole demeanor said "fuck you." I could feel the current of hatred spread through the bikers.

Iggy is the total front man, the rest of the band barely moves. They stand stiff and erect like store-window dummies, their faces blank. They are the perfect foil, all eyes are pushed to Iggy, who is a master of body gesture. Every move is charged and his moronic, contorted dancing seems inspired—like an acrobat possessed by the spirit of an epileptic Jerry Lewis. The show starts off simply enough, a few upbeat rock tunes that get the crowd going. Iggy incites the audience to respond to him, gets them heated up—THEY WANT IGGY. Then all of a sudden he stops. He singles out a girl pushed up against the stage, a second earlier he had been gesturing to her, enticing her. The room is silent. "Get this bitch out of here. She tried to touch me! We won't play unless she is removed." The tension starts to build, she moves out of sight. Then Iggy asks, "What do you want to hear?" The crowd yells back an incomprehensible roar of song titles. "Oh, 'Louie Louie,'" and the band launches into "Louie Louie."

"Louie Louie" was a slap in the face of the audience. But they politely suffered through it, maybe even good-naturedly hooped and hollered a bit. Then Iggy asks again, "What do you want to hear?" The same roar comes back. "Oh. 'Louie Louie,'" and the band tears into "Louie Louie" a second time. "Louie Louie" was played three times in a row. The audience was starting to get antsy. The band does another rocker and the audience regains its faith, only to have Iggy pull some other disruptive stunt. He is an amazing performer, I have never seen better. He plays the audience like a fish. They were in the palm of his hand. They would suffer insult after insult, have their faces rubbed over and over again in their own complicity and come running back for more.

This doesn't sound like much after fifteen years of punk music where these stage antics are the norm, but Iggy invented this stuff.

After about five or six songs a big biker shouted, "Hey! Poodle boy . . ." and hit Iggy with an egg. The next thing I saw was Iggy doing a belly flop in the audience, and a riot broke out. A real, traditional biker-bar fistfight. The place was cleared within fifteen minutes, chairs and tables overturned. The lights were up, the band had run out the door, and I was left standing there babbling, "What happened?" It was the best piece of theater I have ever seen.

From: *Mike Kelley*, Paris, 1992.

I'm the world's
forgotten boy.
The one who's searching
and searching

to destroy.

Iggy Pop, 1977

Bowie, in particular, in a series of "camp" incarnations (Ziggy Stardust, Aladdin Sane, Mr Newton, the thin white duke, and more depressingly the Blond Führer) achieved something of a cult status in the early 70s. He attracted a mass youth (rather than teeny-bopper) audience and set up a number of visual precedents in terms of personal appareance (make-up, dyed hair, etc.) which created a new sexually ambiguous image for those youngsters willing and brave enough to challenge the notoriously pedestrian stereotypes conventionally available to working-class men and woman. . . . Bowie was responsible for opening up questions for sexual identity which had previously been repressed, ignored or merely hinted at in rock and youth culture. In glam rock, at least amongst those artists placed, like Bowie and Roxy Music, at the more sophisticated end of the glitter spectrum, the subversive emphasis was shifted away from class and youth onto sexuality and gender typing.

Dick Hebdige, "Subculture: The Meaning of Style," in *New Accents*, 1979, pp. 60-62.

Yankee automaton

he is the dictator of the world
and they can't afford to miss a word

I'm so bored with the USA

I'm so bored with the USA

but what can I do
yankee detectives
are always on TV
'cause killers in America
work seven days a week
never mind the Stars and Stripes
let's read the Watergate Tapes

The Clash

David Bowie, *The man who sold the world*, 1972

The Clash, *London Calling*, 1970

Collectible stamps of Elvis Presley, 1950's records

Run Run Run / 1967: First Velvet Underground album, a meeting between the American Lou Reed, a reader of Delmore Schwartz and William Burroughs, and the Welshman John Cale, one of La Monte Young's musicians, fascinated with sound experiments.

Raw Power / In 1969, the Detroit Stooges cut what will be considered the first official punk record. Produced by John Cale. Simple monotone music, dense and threatening. Iggy Pop unleashes his animal cries.

Ghost Riders / No guitars, no drums, no bass. Suicide, the most outside group on the punk scene, first gigs in 1971. Martin Rev on synthesizers and Alan Vega on vocals get Elvis jamming to a pretechno beat.

Personality Crisis / David Johanssen and Johnny Thunders put together the New York Dolls. First album: 1973. Cross-dressing trash version of Bowie's glam-rock. Unstable harmonies. Tracks that constantly threaten explosion. Welcome to the aesthetics of awful.

Never Mind the Bullocks / "The New York Dolls are so bad they're great," thinks Malcom McLaren. Tries to manage them. In vain. Goes back to England, to his shop *Sex* on King's Road, where he and his girlfriend Vivienne Westwood start work on a commercial conspiracy mixing fashion, rock culture, politics.

Beat on the Brat with a Baseball Bat / 1974: The Ramones make the New York scene. First album in 1976. Considered the fastest ever recorded at that date.

Piss Factory / First Patty Smith album. Produced by John Cale. Punk poetry.

Blank Generation /Everything comes together in a flash. The CBGB in New York is the great meeting place for American punk. Dozens of groups put out their first records on unknown labels from '74 to '76. Among the lowlights: Television, Richard Hell & the Voidoids, Patti Smith, Blondie, Talking Heads, John Cale solos, on and on. *Punk*, the fanzine, hits the stands in '76.

Anarchy in the UK / First concert of the Sex Pistols at the 100 Club on Oxford Street in London. First single in

> "The Ramones promote themselves and their music, which is already built on media stereotypes. They are ahead of the media or the industry that should be dealing with them because they are the product of their own concept. As in American pop art the texts by the Ramones use existing clichés, but their use of these images conveys ironic humor."
>
> Dan Graham

Some American punks flirt with racist ideology, others claim alliance with minorities. "Punks are niggers," says Richard Hell.

Punk Cover

ourself

Punk Riot
in the Pop Music Industry

I was sayin' let me

 outta here before I was even born.

It's such a gamble

 when you get a face.

 It's fascinatin'

to observe what the mirror does

but when I dine

 it's for the wall

that I perform.

> **"Slumping like Quasimodo under heavy air, Johnny Rotten cut through the curiosity of the crowd with a twist of his neck. He hung onto the microphone stand like a man caught in a wind tunnel; ice, paper cups, coins, books, hats, and shoes flew by him as if sucked up by a vacuum."**
> Greil Marcus

RICHARD HELL
+ THE VOIDOIDS

BLANK
GENERATION

I belong to the blank generation
and I can take it or leave it
each time.

I belong to the () generation
but I can take it or
or leave it each time.

Richard Hell & The Voidoids, Blank Generation, 1977

November.

Cash from Chaos / After the insanity of their appearance on Thames TV, EMI breaks the contract signed with the Sex Pistols two months earlier. Financial indemnities paid by the company. On March 9, 1977, they sign with A&M Records. Eight days later their contract is terminated after a wild party at the A&M offices. The Pistols get 50,000 quid from the deal. Finally they sign with Virgin. Scandal becomes synonymous with self-promotion. Last song on their first album: *"Blind acceptance is a sign / Of stupid fools who stand in line / Like EMI."*

God Save the Queen / Release of the single on May 27, 1977, one week before the Queen's Jubilee. A concert on the Thames is stopped by the police. Number one on the charts, censored by the BBC. Comic situation: the nation's most popular song is sold as contraband. All the hit-parade lists have a blank spot at the line: *Sex Pistols, God Save the Queen.*

Boredom / Johnny Rotten becomes public enemy number 1. Attacked at night with a razor blade.

No Future (and England's Dreaming) / The punk slogan. Johnny Rotten takes a swipe at the progress myth.

Spiral Scratch / 1977: Appearence of the Buzzcocks in Manchester. Furious little ultraquick melodies. The only group still writing sentimental songs, but at quadruple speed with totally bisexual lyrics (hear what you're hot for).

White Riot / 1977: The Clash sing about conflicts at Notting Hill Carnival, founded by Caribbean blacks. They call on the whites to organize like the black community. The most political of the punk groups. Interested in Jamaican reggae. Considered the constructivist side of punk, while the Sex Pistols are nihilistic.

I fought the law in the law world / In concert, the Clash and the Pistols become targets for violence and hostility.

A Different Kind of Tension / American punk comes out of subcultures, feeds on literature and is open to experimentation; English punk is more hard line, more directly political.

London's Burning / The English punk movement

Sid Vicious & Nancy Spungen, 1977

411

HELL OIDS

grows to massive proportions. Thousands of groups come together and cut singles after one week's existence, on indie or "one-shot labels." Among the tops of English punk: Ian Dury and his Blockheads (older, more outside), The Damned, The Saints, Generation X, X Ray Spex, The Stranglers, The Jam, Sham 69, Sixuosie and the Banshees, Subway Sect, The Fall, Wire, Crass . . .

If the Kids are United / In England punk began as a scam, a fake culture made up from scratch, but with lightning speed and in total anarchy it became a musical style, a look, a cultural phenomenon, a way of life, a state of mind, a media plot, and more all at once. Punk groups began forming in Europe. Young people got up on stage and discovered their own power. Most were politically naive. Some took the swastika seriously, but the movement was antifascist on the whole. "Rock against Racism" was formed in the fight against the National Front in England.

Another music in a different kitchen / First record by the Buzzcocks. Insurrection against the order of things, revelation of modern alienation.

Lost in the Supermarket / This cut by The Clash marks the total refusal of preprogrammed life and daily regimentation.

No Fun / Punk is antihippie and antidisco, replaces Love with Hate, Entertain with Destroy.

Noise Annoys / . . .

Lipstick Killers / The New York Dolls broke with the ritual rock assertion of masculinity. Punk soon had its first priestesses: Patti Smith, Blondie, Lydia Lynch, Polly Styrene, Siouxsie Siuox . . .

Oh! Bondage Up Yours / 1977: "There were these chicks chained together with handcuffs and shit like that . . . Me, I only used those things to express repression. When people see others wearing those chains, they think they're *for* slavery—but that isn't it. When you wear them, when you make them the subject of your songs, you're actually standing up against them. You don't pre-

Punk works by collage and trash recycling. Jamie Reid, the Pistols' graphic artist, cuts letters from the headlines for the slogans. Ripped clothes and safety pins. Piercing. Punk materializes the scars of English society. Influence of May '68 and the Situationist International.

"The whole idea of punk, as coined by Marsh and Bangs, marked a process of deliberate unlearning: a new pop aesthetic that 'delighted in rock's essential barbarism (and the worth of its vulgarism).' Implicit in this definition of Punk was an underclass menace."
John Savage

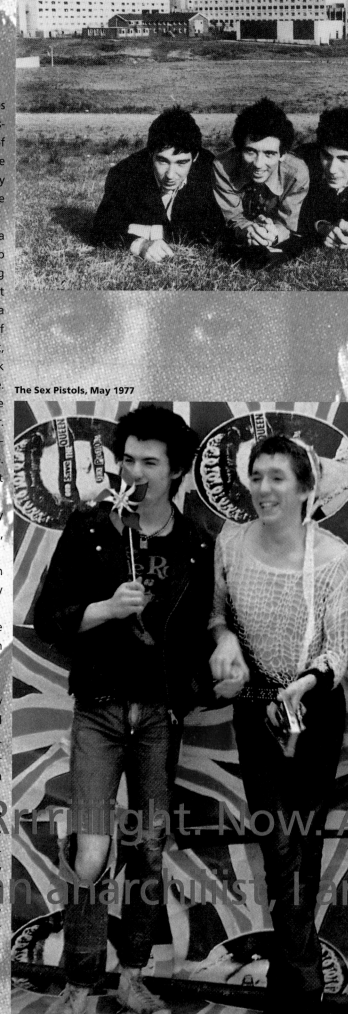

The Sex Pistols, May 1977

BLANK GENERATION

"The Sex Pistols and Malcom McLaren promoted the group by focusing the inherent destructiveness in rock onto rock's real relation to the media. They used the media to become famous in order to destroy the media and media-created fame–in other words, the Sex Pistols' ultimate goal was to expose it for what it was by forcing the media's contradictions (and their own contradictions as a rock act) into the open."

Dan Graham

tend you're not chained, etc., you admit that you're repressed." Polly Styrene of the X-Ray Spex.

No More Heroes / The Stranglers' second record makes number 2 in the charts.

Holiday in Cambodia / Various American punk albums come out in 1977, including the third Iggy Pop, the first Suicide, the first Voidoids. At the same time, new groups appear outside New York. The best are the Heartbreakers (Johnny Thunders' new group), the Cramps, Devo, and the Dead Kennedys, whose 1979 single, *California über alles*, takes a shortcut into the punk legend.

The Great Rock'n Roll Swindle / The film comes out a year after Johnny Rotten's departure and his last denunciation: "Do you ever feel like you've been cheated?" he yells at the crowd for the Sex Pistols' last concert on January 18, 1979.

I'm alive. She's dead. I'm yours. / TV shirt produced by McLaren after the nearly immediate liberation of the Pistols' bass player, Sid Vicious, following the murder of his girlfriend Nancy Sprungen in October 1978. Sid Vicious dies of an overdose in 1979.

Too much, too soon / sang the Dolls way back when. 1978: Johnny Rotten rebecomes John Lydon to put together a new group. For their first appearance on stage, the band and its leader play behind a white screen. The new name of John Lydon's group? *Public Image Limited.*

hours are spent dodging solicitors and injury from the rusty razor blades that festoon Shane's masterwork.

PLAY'IN IN THE BAND...FIRST AND LAST IN A SERIES...........

A → THIS IS A CHORD

E → THIS IS ANOther

G

This IS A THIRD →

NOW FORM A BAND

280

The punk phenomena hit Los Angeles by storm and it was impossible to ignore. Seemingly overnight the glitter kids on the Sunset Strip had metamorphosed into British-style punks, completely bypassing the East Coast garage noise influence of the Velvet Underground and the Stooges evident in New York punk. But things were still fresh at this point and the punk aesthetic had not yet been completely codified. Performance artists like the Kipper Kids and Johanna Went were performing on stage alongside rock bands; the Screamers were doing a kind of expressionistic music theater; and members of the noise-oriented Los Angeles Free Music Society (LAFMS) were forming various splinter art rock bands. There was an interesting, short-lived, period when the Punk, art, and the New music scenes in Los Angeles intermingled to a certain extent. Each separate scene was so tiny, and so undefined as of yet, that they invited border confusion. This didn't last long.

89

One of the main questions concerning us at the time was how muc
our activities should conform to the rock band format in terms o
staging, instrumentation and song structure. That forma
definitely seemed tired, and for the most part, the new pun
phenomena didn't provide much of an alternative as far as I wa
concerned. Oursler, Don Krieger(another art school grad), and
formed the Poetics in this context. The Poetics, initially, wa
designed to be a dysfunctional nightclub comedy act. However, th
call of the band format was too strong to resist and the nightclu
version of the Poetics merged with some of the ex-Polka Do
musicians to form a more rock song-oriented version of the band.

STYLIZED — COLLER
EATEN APPLE

(MISSING TOOTH
BLACK TEETH (SOUL)
NOTSCAAR— NO HOSTS
Jutishange self)

atoms apple

that
coller
gods
leash

get throng
'never

the headless
Preato his thoughts
are on heaven and
all its rewards.

atoms apple moves when
he sings stuck in the

When I was a kid my father told me that certain drum patterns could
put you into a trance, take you over, hypnotize you out of control.
I worried that this was happening to me when I listened to rock and
roll music - and I struggled against it.

The very first record I bought was selected from the $1.50 discount
bin at Woolworth's. I picked the one with the coolest cover - it
was a metallic silver mirror with a high contrast apple on it.
Silver Apples was the band. When I got it home and played it, I
was horrified by the steady mechanical beat and the high voices of
the male singers.

In 1975, at age eighteen, I was on the path of becoming an artist,
trying to paint like Rembrandt (or Dali). My teacher from Rockland
Community College advised me to go to this new school in California
- Cal Arts. I remember listening to Hendrix, Yes, Bowie, Lou Reed,
and lots of Jonathan Richman and the Modern Lovers on the endless
drive west. Cal Arts and the West Coast were a great

95

CRAZ

Working together, Mike and I discovered that we shared, amongst other things, a love for the ex-Catholic experience in all its mystical, sexual, and angst-ridden designs. The organ seemed best to evoke the drama, ritual, incense, and bended knee of this aesthetic. But we would collect any sort of sound-making object. Nothing was considered too small or inconsequential. We used toy organs and pianos, chord organs, the Vox Jaguar electric organ, Orgatron - whatever. Our search for these objects led us to swap meets and thrift stores, deep into the musty world of discarded

RT DOG, PART FEMALE

EAO, EYES, NOSE,

MOUTH FOR SUBSTANCES

, SONGS SUNG,

OUT, ETC.

17. Relative to class issues, how would you describe the politics of instrumentation at that time- especially the guitar/anti-guitar debate as expressed in the split between Punk, Techno Pop/Industrial?

18. What are the historical roots of these political signs of instrumentation? How did the use of the guitar, keyboard or electronic devices come to signify in the way they did?

19. Relative to the guitar/anti-guitar argument, what is the relation of these splits to current debates in Pop Music (i.e.: Grunge Rock and Techno/Ambient)?

20. Do these different instrumental choices have any relation to gender politics- sexual codes(gay/strait splits, androgyny, gender bending etc...)?

21. Is the use of humor any more or less acceptable in these various musical forms?

22. If you would agree that the musical forms we are discussing were targeted primarily towards a white audience, how did they relate to racial politics? How did they embrace or reject Black or other 'ethnic' musics and/or audiences?

23. Do you see a difference in how political/ aesthetic issues are treated in ___ _____ __ _____ __ ___ _____ _ _____ __ so, what wc

24. Are a
'intellectɪ
the politiᴄ
non-intellᴇ

25. In genᴇ
Alternativᴇ

26. Is Altᴇ
Is this ar
question b

27. Genera
concerns i

28. If arᵗᵧ
'use' art

LETS TALK ABOUT THE AESTHETICS AND POLITICS OF INSTRUMENTATION:

ELECTRONIC VERSUS ACOUSTICAL?

GUITAR VERSUS KEYBOARDS?

WHAT DO YOU THINK OF DRUMS?

VOICE?

WHAT KIND OF STIMULI, SOUNDS, IMAGES, SEPARATE INDIVIDUALS AND GROUPS?

HOW IS CLASS SIGNIFIED WITHIN MUSICAL FORMS?

DOES MUSIC ALOW FOR CLASS SHIFTING, OR CLASS FANTACY?

CAN YOU DESCRIBE HOW (YOUR) MUSIC WORK ON THE LISTENER?

WHAT'S THE DIFFERENCE BETWEEN ART AND MUSIC?

IS THE DEATH OF PAINTING (CRAFT) LINKED TO MUSIC (ELECTRONIC)? Mass

CONCEPTUAL ART IMPLIED THAT A FORM COULD BE CHOSEN FOR ITS' ABILITY TO BEST EXPRESS AN IDEA, WAS THIS THE END OF CRAFT? DID THIS TRAMSLATE INTO MUSIC?

WAS THIS ROOT OF THE 'DO IT YOUR SELF' AESTHETIC OF PUNK?

DO NEW FORMS LIVE UP TO THEIR POTENTIAL.

HOW HAS MTV EFFECTED MUSIC, ART?

FG 9-00 GA BC

echo Fuck me/ again #C F on 111213 1.
 Bal. 3 Rep. 9 1/2 Relay 3
 Syn. Filter 13 Phase 2 1/4

Symbolically, the Radio show was an important project for the Poetics.
The concept of expanded forms or post studio or crossover was full
filled in the simple gesture of having our audio go into the world via
the air waves. It was almost proof that artist records, laser disks, TV
shows were just around the corner. Artists would be freed from the
constraints of the gallery museum system and there work would go
directly into the peoples homes. This optimism and naiveté was ever-
present. People such as ▬▬▬▬▬▬ and ▬▬▬▬ of the ▬▬▬▬▬ were
convinced that a new format was coming soon, the video laser disk, which
would eclipse the audio industry. Visuals and audio would be combined
into one format. Ericka Beckman was thinking about doing shorts before
commercial movies. I remember the idea of screen credits for directors

on rock 'films' being discussed. We even went down to Hollywood to be
extras in a DEVO film for which everyone got paid 25 cents. They even
contacted me to have a look at my art tapes, as did Alice cooper, after
reading reviews in the LA times, nothing ever came of it directly. But
in retrospect Laurie Anderson was the only one who could make the
crossover leap as a total media artist. Its strange that only one is
allowed to carry on, instead of opening up a new field. But in 1977 who
knew? Even though we were clearly creating it, we couldn't have foreseen
the financial packaging which was soon to be created in the form of MTV

Pole

Foot & h

KNee & l

Took LSD and saw the *that could get over it*
that could get over it ~ the

We aligned ourselves somewhat with the anti-guitar stance of the
early industrial and techno pop bands, though we were far from
purists. Anyway, we did favor an organ-dominated sound, though
this might also be explained by the fact that both Oursler and
myself were ex-Catholics who had spent a good part of your youths
in mass sniffing incense and listening to death-lyrics accompanied
by organ music. Movie music, especially Nina Rota's soundtracks
for Fellini's films, as well as that composed by Ennio Morricone
and Bernhard Herrmann, are obvious influences on the later Poetics
material. This compilation concentrates on the less rock oriented
Poetics music. The "punk" incarnation of the Poetics consisted of
Bill Stobaugh: bass and guitar, and Simon (whose last name I could
not pronounce then, and cannot remember now) on organ, besides
Oursler and myself. At some point John Miller - already a veteran
East Coast art band player, having played with the Coachmen (at one
point featuring Thurston Moore on guitar) and released a single
with the Hi Sheriffs of Blue - replaced Stobaugh.

→ FISHER OR MEN
NETS

COUNTER
WEAVE
ANTI CHRIST

ANTI GOD.
WHO'S PICTURED
IN .

GOD
THE PURE GOD
WHO IS NOT PICTURED

Pierre Clastres – Of the One Without the Many

It was after the flood. A sly and calculating god was instructing his son how to put the world back together: "This is what you will do, my son. Lay the future foundations of the imperfect earth . . . Place a good hook as the future foundations of the earth . . . the little wild pig will be the one to cause the imperfect earth to multiply . . . When it has reached the size we want, I will let you know, my son . . . I, Tupan, am the one who looks after the support of the earth . . ." Tupan, master of the hail, rain, and winds, was bored; he was having to play by himself and felt the need for company. But not just anyone, not just anywhere. The gods like to choose their playmates. And this one wanted the new earth to be an imperfect earth, an evil earth, yet one capable of welcoming the little beings destined to stay there. That is why, seeing ahead, he knew in advance that he would have to face Nande Ru Ete, the master of a fog that rises, heavy and dark, from the pipe he smokes, making the imperfect earth uninhabitable. "I sing more than Nande Ru Ete. I will know what to do; I will return, I will make it so that the fog will lie light on the imperfect earth. It is only in this way that those little beings we are sending there will be cool, happy. Those we are sending to the earth, our little children, those bits of ourselves, will be happy. We have to fool them." The divine Tupan was mischievous.

Who is speaking thus in the name of the god? What fearless mortal dares, without trembling, to place himself on a level with one of the powers on high? He is not mad, however, this modest earth dweller. It is one of those little beings to whom Tupan at the dawn of time assigned the task of amusing him. It is a Guarani Indian. Rich in the knowledge of things, he is reflecting on the destiny of his people who choose to call themselves, with a proud and bitter assurance, the Last Men. The gods sometimes disclose their designs. And he, the *karai*, who is adept at understanding them and dedicated to speaking the truth, reveals what he learns to his comrades.

That particular night Tupan inspired him; his mouth was divine. He was himself

the god and told of the genesis of the imperfect earth, *ymy mba'emegua*, the residence mischievously appointed for the happiness of the Guarani. He spoke a length, and the light of the flames illuminated metamorphoses: sometimes the calm face of the indifferent Tupan, and the sweep of the grand language: other times the anxious tenseness of an all too human face coming back amidst strange words. The discourse of the god was followed by the search for its meaning: the mind of a mortal sought to interpret its misleading evidence. The deities do not have to reflect. And the Last Men, for their part, are unresigned: they are the last no doubt, but they know why. And lo and behold, the inspired lips of the karai pierced the riddle of misfortune with an innocent commentary and a chilling revelation, whose brilliance is untainted by a trace of *ressentiment*: "Things in their totality are one; and for us who did not desire it to be so, they are evil."

Without question, this fragment lacks neither obscurity nor depth. The ideas expressed in it exert a double appeal: owing to their harshness, and their source. For these are the thoughts of a Savage, an anonymous author, an old Guarani shaman deep in a Paraguayan forest. And there is no denying that they are not completely alien to us.

The question addressed is the genealogy of misfortune. The text points out that things are *evil*. Men inhabit an imperfect, evil earth. It has always been so. The Guarani are used to misfortune. It is neither new nor surprising to them. They knew about it long before the arrival of the Westerners, who taught them nothing on the subject. The Guarani were never good savages. They were a people relentlessly obsessed by the belief that they were not created for misfortune, and the certainty that one day they would reach *ywy mara-eÿ*, the Land Without Evil. And their sages, ceaselessly meditating on the means of reaching it, would reflect on the problem of their origin. How does it happen that we inhabit an imperfect earth? The grandeur of the question is matched by the heroism of the reply: Men

are not to blame if existence is unjust. We need not beat our breasts because we exist in a state of imperfection.

What is at the root of the imperfection besetting men, *which we did not desire*? It arises from the fact that "things in their totality are one." A startling utterance, of a kind to send Western thought reeling back to its beginnings. Yet, this is indeed what Guarani thinkers say, what they are continually proclaiming—and they pursue its strictest consequences, its most unsettling implications: misfortune is engendered by the imperfection of the world, because all things that constitute the imperfect world are one. Being one is the property shared by the things of the world. The One is the name of the imperfect. To sum up the deadly concision of its discourse, Guarani thought says that the One is Evil itself.

The misfortune of human existence, the imperfection of the world, a unity seen as a rift inscribed at the heart of the things that comprise the world: that is what the Guarani reject: that is what has impelled them from time immemorial to search for another space where they might know the happiness of an existence healed of its essential wound—an existence unfolding towards a horizon free of the One. But what is this not-One so stubbornly desired by the Guarani? Is it the perfection of the world to be found in the Many, according to a dichotomy familiar to Western metaphysics? And do the Guarani, unlike the ancient Greeks, place the Good there where, spontaneously, we deny it? While it is true that one finds in the Guarani an *active revolt* against the tyranny of the One, and in the Greeks a *contemplative nostalgia* for the One, it is not the Many which the former embrace; the Guarani Indians do not discover the Good, the Perfect, in the mechanical disintegration of the One.

In what sense do the things said to be One fall by that very fact within the evil field of imperfection? One interpretation has to be ruled out, even though a literal reading of the fragment seems to invite it: that the One is the All. The Guarani sage declares that "things in their totality are One," but he does not name the all,

a category perhaps absent from his thought. He explains that each of the "things," taken one by one, that make up the world—earth and sky, water and fire, animals and plants, and lastly men—is marked, graven with the seal of the One. What is a thing that is One? How do we recognize the mark of the One on things? One is everything corruptible. The mode of existence of the One is the transitory, the fleeting, the ephemeral. Whatever is born, grows, and develops only in order to perish will be called the One. What does that mean? Here one gains access, via a bizarre use of the identity principle, to be foundation of the Guarani religious universe. Cast on the side of the corruptible, the One becomes the sign of the Finite. The world of men harbors nothing but imperfection, decay, and ugliness: the ugly land, the other name for the evil land. *Ywy mba'e megua*; it is the kingdom of death. It can be said—Guarani thoughts says—that everything in motion along a trajectory, every mortal thing, is one. The One: the anchorage of death. Death: the fate of what is one. Why are the things that make up the imperfect world mortal? Because they are finite; because they are *incomplete*. What is corruptible dies of unfulfillment; the One describes what is incomplete.

Perhaps we can see it more clearly now. The imperfect earth where "things in their totality are one" is the reign of the incomplete and the space of the finite; it is the field of strict application of the identity principle. For, to say that A = A, this is this, and a man is a man, it to simultaneously state that A is not not-A, this is not that, and men are not gods. To name the oneness in things, to name things according to their oneness, is tantamount to assigning them limits, finitude, incompleteness. It is the tragic discovery that this power (*pouvoir*) to designate the world and define its beings—this is this, and not another thing—is but an absurd apology for real power (*puissance*), the secret power that can silently declare that this is this *and, at the same time*, that: Guarani are men *and, at the same time*, gods. What makes the discovery tragic is that *we did not desire it to be so*, we others who know our language to be deceptive, we who never spared any effort in order to

reach the home of the true language, the incorruptible dwelling place of the gods, the Land Without Evil, where nothing in existence can be called one.

In the land of the not-One, where misfortune is abolished, maize grows all by itself; the arrow brings the game back to those who no longer need to hunt; the regulated flux of marriages is unknown: men, eternally young, live forever. An inhabitant of the Land Without Evil cannot be named univocally: he is a man, of course, but also man's other, a god. Evil is the One. Good is not the many, it is the *dual*, both the one and its other, the *dual* that truthfully designates complete beings. *Ywy mara-eÿ*, the destination of the Last Men, shelters neither men nor gods: only equals, divine men, human gods, so that none of them can be named according to the One.

There is no people more religious than the Guarani Indians, who down through the centuries haughtily rejected servitude to the imperfect earth, a people of arrogant madness whose self-esteem was so great that they aspired to a place among the deities. Not so long ago they still wandered in search of their true native land, which they imagined, or rather knew, to be located over there, in the direction of the rising sun, "the direction of our face." And many times, having arrived on the beaches, at the edges of the evil world, almost in sight of their goal, they were halted by the same ruse of the gods, the same grief, the same failure: the obstacle to eternity, *la mer allée avec le soleil.*

Their numbers are small now, and they wonder if they are not living out the death of the gods, living their own death. *We are the last men.* And still they do not abdicate: the *karai*, the prophets, fast overcome their despondency. Whence comes the strength that keeps them from giving up? Could it be that they are blind? Insane? The explanation is that the heaviness of failure, the silence of the sky, the repetition of misfortune are never taken by them as final. Do not the gods sometimes deign to speak? Is there not always, somewhere deep in the forest, a Chosen One listening to their discourse? That night, Tupan renewed the age-old

promise, speaking through the mouth of an Indian inhabited by the spirit of the god. "Those whom we send to the imperfect earth, my son, we will cause to prosper. They will find their future spouses; they will marry them and they will have children: *so that they might attain the words that issue from us*. If they do not attain them, nothing good will come to them. All that we are sure of."

That is why, indifferent to all the rest—all the things that are one—caring only to rid themselves of a misfortune they did not desire, the Guarani Indians take comfort in hearing once more the voice of the god: "I, Tupan, give you these counsels. If one of these teachings stays in your ears, in your hearing, you will know my footsteps . . . Only in this manner will you reach the end that was foretold to you . . . I am going far away, far away, I say. You will not see me again. Therefore, do not lose my names."

From: *Society Against The State* (1974), New York: Zone Books, 1987.

Lothar Baumgarten: *Akai, Kiepe Tourepan, Roreima*, 1977

Pierre Clastres
Society Against The State

In primitive society, the chieftainship and language are intrinsically linked; speech is the only power with which the chief is vested; more than that speech is an obligation for him. But there is another sort of speech, another discourse, uttered not by the chiefs, but by those men who, in the fifteenth and sixteenth centuries, carried thousands of Indians along behind them in mad migrations questing for the homeland of the gods: it is the discourse of the *karai*, a prophetic speech, a virulent speech, highly subversive in its appeal to the Indians to undertake what must be acknowledged as the destruction of society. The prophets' call to abandon the evil land (that is, society as it existed) in order to inherit the Land Without Evil, the society of divine happiness, implied the death of society's structure and system of norms. Now that society was increasingly coming under the authority of the chiefs, the weight of their nascent political power. It is reasonable, then, to suppose that if the prophets, risen up from the core of society, proclaimed the world in which men were living to be evil, this was because they surmised that the misfortune, the evil, lay in that slow death to which the emergence of power would sooner or later condemn Tupi-Guarani society, insofar as it was a primitive society, a society without a State. Troubled by the feeling that the ancient primitive world was trembling at its foundations, and haunted by the premonition of a socio-economic catastrophe, the prophets decided that the world had to be changed, that one must change worlds, abandon the world of men for that of the gods.

A prophetic speech that is still living, as the texts "Prophets in the Jungle" and "Of the One Without the Many" should show. The four or five thousand remaining Guarani Indians lead a wretched existence in the forests of Paraguay, but they are still in possession of the incomparable wealth afforded them by the *karai*. To be sure, the latter no longer serve as guides to whole tribes, like their sixteenth-century ancestors; the search for the Land Without Evil is no longer possible. But the lack of action seems to have encouraged a frenzy of thought, an ever deepening reflection on the unhappiness of the human condition. And that savage thought, born of the dazzling light of the Sun, tells us that the birthplace of Evil, the source of misfortune, is the One.

Perhaps a little more needs to be said about the Guarani sage's concept of the One. What does the term embrace? The favorite themes of contemporary Guarani thought are the same ones that disturbed, more than four centuries ago, those who were called *karai*, prophets. Why is the world evil? What can we do to escape the evil? These are questions that generations of those Indians have asked themselves over and over again: the *karai* of today cling pathetically to the discourse of the prophets of times past. The latter knew that the One was evil; that is what they preached, from village to village, and the people followed after them in search for the Good, the quest for the not-One. Hence we have, among the Tupi-Guarani at the time of the Discovery, on the one hand, a practice—the religious migration—which is inexplicable unless it is seen as the refusal of the course to which the chieftainship was committing the society, the refusal of separate political power, the refusal of the State; and, on the other hand, a prophetic discourse that identifies the One as the root of Evil, and asserts the possibility of breaking its hold. What makes it possible to conceive of the One? In one way or another, its presence, whether hated or desired, must be visible. And that is why I believe one can make out, beneath the metaphysical proposition that equates Evil with the One, another, more secret equation, of a political nature, which says that the One is the State. Tupi-Guarani prophetism is the heroic attempt of a primitive society to put an end to unhappiness by means of a radical refusal of the One, as the universal essence of the State. This "political" reading of a metaphysical intuition should prompt a somewhat sacrilegious question: could not every metaphysics of the One be subjected to a similar reading? What about the One as the Good, as the preferential object that dawning Western metaphysics assigned to man's desire? Let me go no further than this troublesome piece of evidence: the mind of the savage prophets and that of the ancient Greeks conceive of the same thing, Oneness: but the Guarani Indian says that the One is Evil, whereas Heraclitus says that is the Good. *What conditions must obtain in order to conceive of the One as the Good?*

In conclusion, let us return to the exemplary world of the Tupi-Guarani. Here is a society that was encroached upon, threatened, by the irresistible rise of the chiefs: it responded by calling up from within itself and releasing forces capable, albeit at the price of collective near suicide, of thwarting the dynamic of the chieftainship, of cutting short the movement that might have caused it to transform the chiefs into lawgiving kings. On one side, the chiefs, on the other, and standing against them, the prophets: these were the essential lines of Tupi-Guarani society at the end of the fifteenth century. And the prophetic "machine" worked perfectly well, since the *karai* were able to sweep astonishing

masses of Indians along behind them, so spellbound (as one would say today) by the language of those men that they would accompany them to the point of death.

What is the significance of all that? Armed only with their Word, the prophets were able to bring about a "mobilization" of the Indians; they were able to accomplish that impossible thing in primitive society: to unify, in the religious migration, the multifarious variety of the tribes. They managed to carry out the whole "program" of the chiefs with a single stroke. Was this the ruse of history? A fatal flaw that, in spite of everything, dooms primitive society to dependency? There is no way of knowing. But, in any case, the insurrectional act of the prophets against the chiefs conferred on the former, through a strange reversal of things, infinitely more power than was held by the latter. So perhaps the idea of the spoken word being opposed to violence needs to be amended. While the primitive chief is under the obligation of innocent speech, primitive society can also, given quite specific conditions, lend its ear to another sort of speech, forgetting that it is uttered like a commandment: prophecy is that other speech. In the discourse of the prophets there may lie the seeds of the discourse of power, and beneath the exalted features of the mover of men, the one who tells them of their desire, the silent figure of the Despot may be hiding.

Prophetic speech, the power of that speech: might this be the place where power *tout court* originated, the beginning of the State in the World? Prophets who were soul-winners before they were the masters of men? Perhaps. But even in the extreme experience of prophetism (extreme in that the Tupi-Guarani society had doubtless reached, whether for demographic reasons or others, the furthest limits that define a society as primitive), what the Savages exhibit is the continual effort to prevent chiefs from being chiefs, the refusal of unification, the endeavor to exorcise the One, the State. It is said that the history of peoples who have a history is the history of class struggle. It might be said, with at least as much truthfulness, that the history of peoples without history is the history of their struggle against the State.

From: *Society Against The State* (1974), New York: Zone Books, 1987.

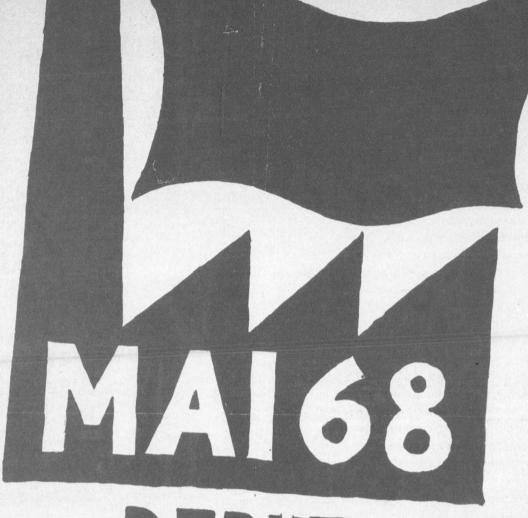

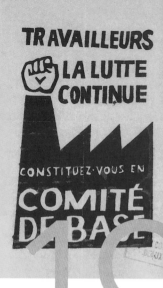

TRAVAILLEURS LA LUTTE CONTINUE

CONSTITUEZ·VOUS EN COMITÉ DE BASE

1966 Cultural rev
French beaches a
since 1965: US tro
Spring is cut shor

After this first poster with the factory motif by Atelier Populaire Mai 68, the roof and smokestack came to stand for the factory occupation movement in many different countries.

Anonymous poster, May 68 in Paris. Maybe the designer heard
Julian Beck of the Living Theater reading his poem in the occupied Odeon playhouse:
"If you make a revolution, make it for fun."

Funeral of Jan Palach, Prague
January 1969

68

Chris Marker, *Le fond de l'air est rouge*
(Red in the Distance), 1977

n in China. 1967 Six Day War between Israel and the Arab States. Oil spill on accident with the freighter Torrey Canyon. 1968 Escalation in Vietnam ength reaches approximately 550,000 men in 1968. Alexander Dubcek's Prague intervention of Warsaw Pact troops.

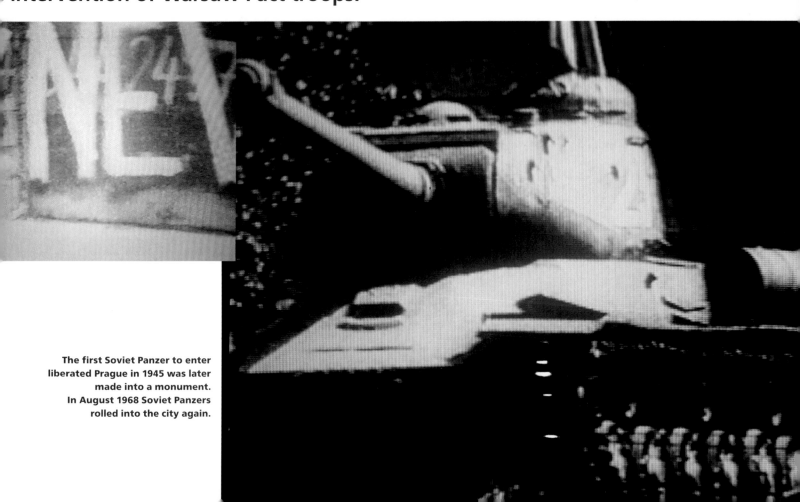

The first Soviet Panzer to enter liberated Prague in 1945 was later made into a monument. In August 1968 Soviet Panzers rolled into the city again.

Atelier populaire, 1968

internationale situationniste

The Situationist international used
the comic-book form to illustrate
its fiercest social critique.

Cover of the first Provo newspaper,
published in Amsterdam on July 16,
1965.

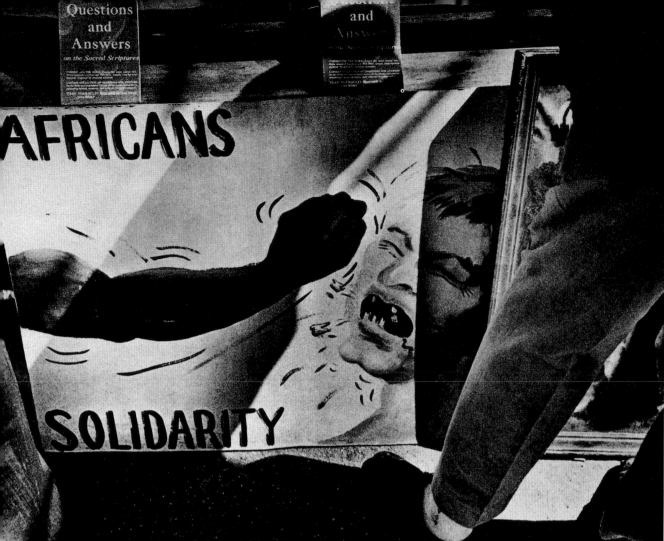

Ed van der Elsken, *Harlem/New York*, 1959-60

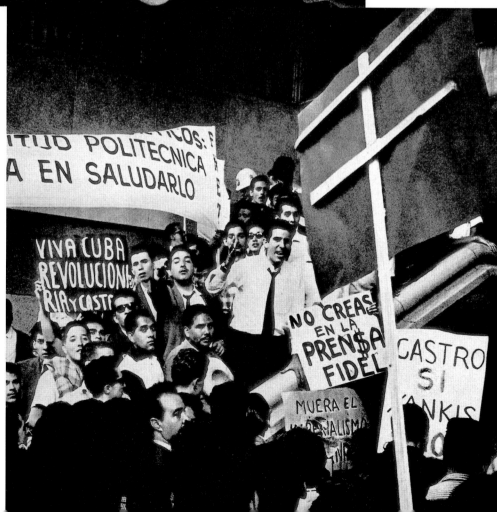

Ed van der Elsken, *Mexico*, 1959-60
Demonstration for Fidel Castro

Provo Belgium, *Matrakkensabbat* (Club Orgy), 1966

Ontbijt op bed (Breakfast in Bed)
***Safe-Conduct*, 1967**
**The Ontbijt op bed group was the
cultural precursor of the Provo
movement. This broadsheet is a
"safe-conduct for provocative thinking."**

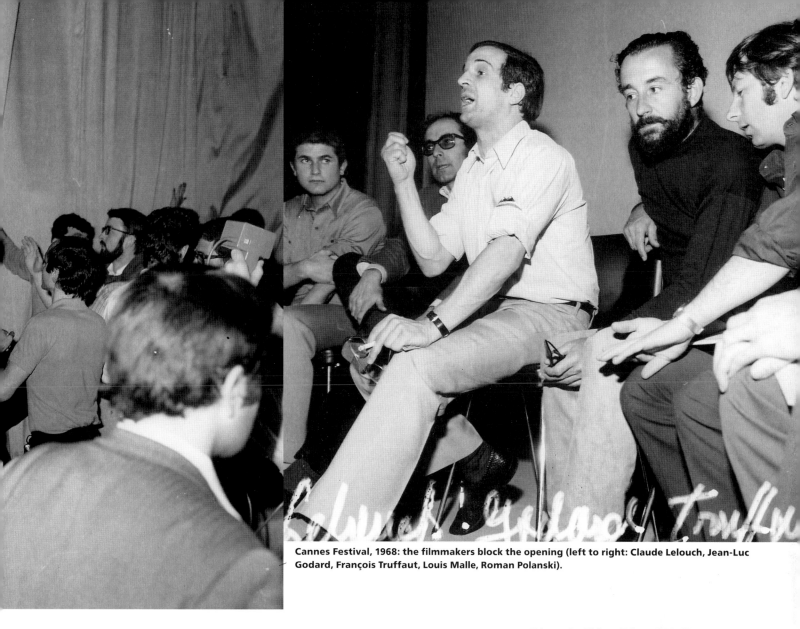

Cannes Festival, 1968: the filmmakers block the opening (left to right: Claude Lelouch, Jean-Luc Godard, François Truffaut, Louis Malle, Roman Polanski).

Ed van der Elsken, *Tokyo*, 1959-60
Demonstration of communist students

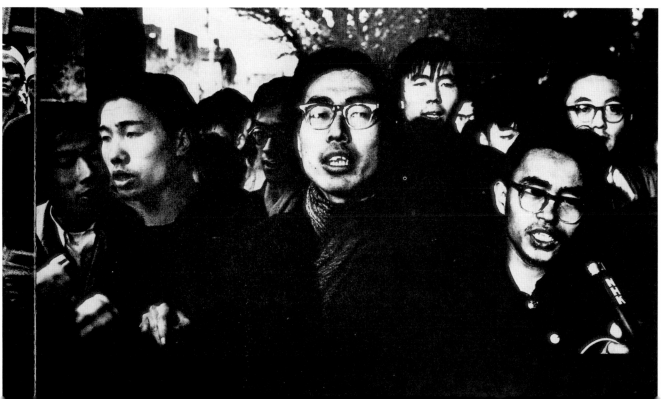

Michel Foucault erupted onto the intellectual scene at the beginning of the Sixties with his *Folie et déraison*, an unconventional but still reasonably recognizable history of the Western experience of madness. He has become, in the years since, a kind of impossible object: a nonhistorical historian, an antihumanistic human scientist, and a counter-structuralist structuralist. If we add to this his tense, impacted prose style, which manages to seem imperious and doubt-ridden at the same time, and a method which supports sweeping summary with eccentric detail, the resemblance of his work to an Escher drawing—stairs rising to platforms lower than themselves, doors leading outside that bring you back inside— is complete.

"Do not ask who I am and do not ask me to remain the same," he writes in the introduction to his one purely methodological work, *L'Archéologie du savoir*, itself mostly a collection of denials of positions he does not hold but considers himself likely to be accused of by the "mimes and tumblers" of intellectual life. "Leave it to our bureaucrats and our police to see that our papers are in order," he states. "At least spare us their morality when we write." Whoever he is, or whatever, he is what any French savant seems to need to be these days: elusive.

But (and in this he differs from a good deal that has been going on in Paris since structuralism arrived) the difficulty of his work arises not from self-regard and the desire to found an intellectual cult only the instructed can join, but from a powerful and genuine originality of thought. As he intends nothing less than a Great Instauration for the human sciences, it is not surprising that he is more than occasionally obscure, or that when he does manage to be clear he is no less disconcerting.

Foucault's leading ideas are not in themselves all that complex; just unusually difficult to render plausible. The most prominent of them, and the one for which he has drawn the most attention, is that history is not a continuity, one thing growing organically out of the last and into the next, like the chapters in some nineteenth-century romance. It is a series of radical discontinuities, ruptures, breaks, each of which involves a wholly novel mutation in the possibilities for human observation, thought, and action. Foucault first referred to the "precarious splinters of eternity" these mutations produce as *épistémès* (i.e., "epistemological fields"), later on as historical *a prioris*, and most recently as discursive formations. Under whatever label, they are to be dealt with "archaeologically." That is, they are first to be characterized according to the rules determining what kinds of perception and experience can exist within their limits, what can be seen, said, performed, and thought in the conceptual domain they define. That done, they are then to be put into a pure series, a genealogical sequence in which what is shown is not how one has given causal rise to another but how one has formed itself in the space left vacant by another, ultimately covering it over with new realities. The past is not prologue; like the discrete strata of Schliemann's site, it is a mere succession of buried presents.

In such terms, Foucault sees European history crosscut by three great fault lines separating what lies on the far side of them from what lies on the near by "pure distances" that are traversed by mere chronology—the blank, external seriality of events. The first of these fissures lies somewhere around the middle of the seventeenth century, and it divides a magical age from a classifying age. In the first period, that of Paracelsus and Campanella, things are related to one another by intrinsic sympathies and antipathies—wine and walnuts, death and roses—that God has stamped onto their faces for all to read. In the second, that of Linnaeus and Condillac, things are related to one another through the use of types and taxonomies—species and genera, speech parts and grammars—directly given in the presented arrangement of nature.

The second fissure occurs toward the beginning of

Stir Crazy

the nineteenth century. It separates the tabular, classifying, Linnaean conception of how reality is composed—with everything in its row and column—from the wholly different one of Marx and Comte in which things are related to one another narratively—seen as foreshadowings and outcomes, causes and consequences. "History," rather than "Similitude" or "Order," becomes the master category of experience, understanding, and representation. And the third fissure, which Nietzsche, Freud, and Mallarmé presage, and which we are right now trying to find some way to live through, marks the beginning of the end of this temporalized consciousness and its replacement by some new, strange form of existence not yet completely in view. Foucault alludes to it, often obliquely, in such phrases as "the scattering of the profound stream of time," "the absolute dispersion of man," "the return of the masks."

To this conception of change by radical jumps from one frame to another, Foucault then adds another unusual notion, which, though it can be traced from the beginning of his work, has grown more and more prominent as he has proceeded. This is that all these *épistémès*, "discourse fields," or whatever, are not just shapes of thought but structures of power.

Whether they be images of madness, theories of pedagogy, definitions of sexuality, medical routines, military disciplines, literary styles, research methods, views of language, or procedures for the organization of work, the conceptual systems within which an age is immured define its pattern of dominations. The objects of oppression are not generalized entities like "the proletariat," but madmen, criminals, conscripts, children, machine tenders, women, hospital patients, and the ignorant. And it is not a faceless "ruling class," but psychiatrists, lawyers, officers, parents, managers, men, physicians, and *cultivés*—those the historical *a priori* empowers to set the limits of other people's lives—who are their oppressors. "Confinement," in all its particular, discontinuous forms, has emerged as the master obsession of Foucault's work. For all his radicalism (which is vehement and absolute), his history is neither of class struggle nor of modes of production, but of constraint: intellectual, medical, moral, political, aesthetic, and epistemological constraint; and now he writes at length on judicial restraint. In *Surveiller et punir*, translated here as *Discipline* (it should

have been *Observe*) *and Punish*, he has found his appointed subject and has written his most forceful book.

Foucault begins his effort to unearth the genealogy of the prison, to expose the strata hidden beneath its present expression, at perhaps the most dramatic of his fault lines. This was the shift, between about 1760 and 1840, from the *âge de ressemblance*, in which torture and execution of criminals were popular spectacles, to the *âge classique*, in which the lives of criminals were regulated according to timetables in methodized institutions.[1] As his image for the first he takes Robert Damiens, a religious crank, who, in 1757, slightly wounded Louis XV with a knife. For his pains, his flesh was torn from him with hot pincers, his wounds salved with molten lead and burning sulphur, his body quartered by horses and some helpful butchers to detach the joints. What was then left of him (some who were there thought him still alive) was reduced to ashes and thrown to the winds, all in the public square before the Church of Paris.

As his image for the *âge classique* Foucault takes a set of rules drawn up for a "house for young prisoners" in Paris in 1838, rules in their own way hardly more humane than the punishments imposed in Damien's time. The Code of 1838 organized the inmates' day into a minute by minute sequence of work, prayer, meals, education, recreation, and sleep, marked by drum rolls, ordered in squads, and enveloped in silence:

"Less than a century separates [the execution and the 1838 code]. It was a time when . . . the entire economy of punishment was redistributed. It was a time of great 'scandals' for traditional justice, a time of innumerable projects for reform. It saw a new theory of law and crime, a new moral or political justification of the right to punish; old laws were abolished, old customs died out. 'Modern' codes were planned or drawn up: Russia, 1769; Prussia, 1780; Pennsylvania and Tuscany, 1786; Austria, 1788;

[1] This is about a hundred years too late by his more general schema as set forth in his central work, *Les mots et les choses* (translated in the United States as *The Order of Things*). But Foucault denies that historical periods are integrated by any sort of over-all *Zeitgeist*; and he rejects any pervasive "synchrony of breaks." He concentrates instead on actually discovered archaeological connections and disconnections, which can be quite different from subject to subject. This failure of different sequences to correlate is not a contradiction to his approach but rather a problem arising within it that—aside from some vague references to "the dispersion of epistemic domains"—he has yet to face up to. In fact, the "strata" of the various "sites" he has so far "excavated"—insanity, medical perception, linguistics, biology, economics, punishment, and, just recently, sex—are, like those of "real" archaeology (where this issue emerges as the question of establishing "horizons" as opposed to "phases"), only approximately coordinated with one another in time.

France, 1791, Year IV, 1808, 1810. It was a new age for penal justice."

Foucault then traces the many aspects of this great transformation. First, there is the disappearance of punishment as a public spectacle. In essence, this represents the decline of the body as the text upon which punishment was inscribed—on which the sentence was, as with poor Damiens, quite literally written. Public torture—*supplice* in French, which means something like liturgical torment, ceremonial pain—"made the guilty man the herald of his own condemnation." The power of the sovereign, and thus his rights, was made legible with racks and sulphur. As all crimes partook of some degree of *lèse majesté*, were a regicide in miniature, this "theater of hell" was one of the constitutive features of monarchic despotism; and when both the monarchs and public torture left the historical stage they left it together. Instead of the vengeance of princes came the protection of society; instead of the excitements of the scaffold, the quiet of the prison; for writing on the body, molding it to rule.

Most of Foucault's book is devoted to analyzing the systematization, generalization, and spiritualization of punishment, and its incarnation in the gray mass of the penitentiary—"the intelligence of discipline in stone." The social forces driving the changes—the heightened concern, in a Europe become urban, bourgeois, and parliamentary, with property crimes as against political ones; the labor discipline problems of nascent industrialism—get only passing attention. Foucault is not much interested in determinants and causes. He concentrates on the organization of what he calls a new economy of punitive power, and economy that had for its aim "not to punish less, but to punish better."

For all their apparent humanitarianism—to Foucault so much incidental music—the great penal reformers of the latter half of the eighteenth century, Beccaria, Marat, Bentham, etc., were basically concerned, he writes, to "insert the power to punish more deeply into the social body." After the Revolution, "Society" replaced "Sovereignty" as the legitimacy that criminality challenged (and parricide replaced regicide as the ultimate crime of which all other crimes were little versions). The social body more than acquiesced in this shift, in which the main agency of penetration became the formal code.

The power to punish was divided into articles and printed up in sectioned texts, and thus made less arbitrary, better defined, and more coherent.

Punishment was also made more pervasive ("no crime must escape the gaze of those whose task it is to dispense justice"); more empirical ("the verification of the crime must obey the general criteria for all truth"); more practical ("for punishment to produce the effect [this from Beccaria] it is enough that the harm that it cause exceed the good that the criminal has derived from the crime"); and more specific ("all offenses [and penalties] must be defined, . . . classified, and collected into species from which none of them escape, . . . a Linnaeus of crimes and punishments"). And, most portentous of all, punishment was made didactic:

"In physical torture, the example was based on terror: physical fear, collective horror, images that must be engraved on the memories of the spectators, like the brand on the cheek or the shoulder of the condemned man. The example is now based on the lesson, the discourse, . . . the representation of public morality. It is no longer the terrifying restoration of sovereignty that will sustain the ceremony of punishment, but the reactivation of the code, the collective reinforcements of the idea of crime and the idea of punishment. In the penalty, rather than seeing the presence of the sovereign, one will read the laws themselves. The laws associate a particular crime with a particular punishment. As soon as the crime is committed, the punishment will follow at once, enacting the discourse of the law and showing that the code, which links ideas, also links realities . . . This legible lesson, this ritual recoding, must be repeated as often as possible; the punishments must be a school rather than a festival; an ever-open book rather than a ceremony."

Two questions, the central ones of his study, are then posed by Foucault. First, if we accept this shift to a tabular, taxonomical view of crime as an array of specific varieties of resistance to the natural order of society—crime as a catalogue of social perversities—how did the prison become virtually the sole mode of punitive response? And, second, since the prison did in fact become establishment as *the* punishing institution, what became of it after the onset of the historicizing *épistémè* during the last century? What has the modern persua-

sion, the one we are more or less still living with, or struggling against, made of the institution of prison?

The first question is all the more intriguing because it was not the intention of the classical reformers that the prison should become the nearly universal penalty for major crimes. On the contrary, they wanted the multiplicity of offenses to be matched by a multiplicity of punishments. Exile or transportation, corvée, branding, house or city arrest, reparation, fines, conscription, loss of various sorts of civil rights, various sorts of public shaming—"a whole new arsenal of picturesque punishments"—were, along with the more familiar torture and execution, to be part of a table of penalties connected to a table of crimes in an exact and visible logic of natural justice.

But in a few short decades, imprisonment (which had not before been an important mode of long-term punishment and was associated, like the Bastille, with tyranny and kings) came to replace them all to the point that one exasperated reformer could complain to the Constituent Assembly: "If I have betrayed my country, I go to prison; if I kill my father, I go to prison—every imaginable offense is punished in the same uniform way. One might as well see a physician who has the same remedy for all ills."

Foucault traces this unforeseen consequence of the new dispensation to its didactic force: the very existence of the legible lessons in the ever-open school book of the new codes imposed the need for a schoolroom (and a schoolmaster) to assure that they got properly learned. Minds were to be altered, and the prison became the machine for altering them. Jails, once dungeons where miscreants were kept while awaiting trial, occasionally to rot while doing so, now became reformatories where souls were reshaped and citizens made. The Walnut Street Prison, set up by (who else?) Philadelphia Quakers in 1790, was one of the first, most thoroughgoing, and most influential examples of what soon became the dominant model—"the house of correction," in which a combination of disciplined productive labor, a strictly organized, cot-to-mess-hall-and-back existence, and unceasing exposure to moral instruction was intended to "effect a transformation of the individual as a whole—of his body and of his habits by the daily work he is forced to perform, of his mind and his will by the spiritual attentions that are paid to him."

The notion that the scheduled life engenders virtue goes back at least as far as the monastery, but, Foucault argues, it was reconstructed in the late eighteenth and early nineteenth centuries, not only by the more avant-garde varieties of Protestantism, but by the rise of well-drilled armies, rationalized workshops, regularized schools, and routinized hospitals—"complete and austere institutions" all. Behind them all lay the attempt to render men orderly by keeping them in order, an effort that implied constant, detailed, aggressive surveillance, a tireless gaze alert to the least irregularities. The inspection, the examination, the questionnaire, the register, the report, the dossier become the chief tools of domination because they are the chief means by which those who maintain discipline keep watch on those who, supposedly anyway, benefit from it.

So far as the prison is concerned, these tendencies—the tabular view of order, the reforming view of punishment, and the view of power as surveillance—come together in that most chilling of eighteenth-century imaginings: Jeremy Bentham's Panopticon.

This "cruel, ingenious cage," in which all the occupants, each alone in his cell, invisible to the others, can be ceaselessly observed from a central tower—the prisoner totally seen without ever seeing, his guardian totally seeing without ever being seen—is not, Foucault says, a dream building. It is "the diagram of a mechanism of power reduced to its ideal form, . . . a figure of political technology." Though it was designed to reform prisoners, it could serve as well "to treat patients, to instruct school-children, to confine the insane, to supervise workers, to put beggars and idlers to work." Worse yet, whereas the classical age never quite managed actually to build it, the modern age, with a different conception of what criminality is and expanded resources for the scrutiny of human behavior, has very nearly done so.

If the Linnaean épistémè established the prisoner as a person to know, the succeeding épistémè—the sort of outlook we associate with Comte—provided the means for knowing him: "the human sciences." The criminal becomes the delinquent—not some hapless rogue who has merely committed a classifiable offense, but a historical person whose entire pattern of life has taken an aberrant course. His biography, his psychology, his sociology, even his physique or his head shape, all become rel-

evant to knowing him, that is, to determining the *causes* of his behavior; and so toward the second part of the nineteenth century the age of the case history and of criminology was born. It was not the crime itself that was central now, or even, in the proper sense, the criminal; it is the system of forces that has conspired over time to produce a "dangerous person." Delinquency does not, like robbery, point to something irregular and individual has done; but, like perversion, to something unacceptable he has become.

The prison, once a place to await the torturer's attention, then a drill-ground for moral calisthenics, now becomes an institute for scientifically imposing normality on damaged lives. Or rather, the prison has this function added on to it, for here, as elsewhere in "archaeology," the later strata do not destroy the earlier ones but overlay them. The final edifice—what Foucault, to distinguish it from the dungeon and the reformatory, calls the "carceral"—is rather like one of those cathedrals that have been built up around the frame of a temple, itself erected on the stones of a sacrifice site.

"Criminology," that hybrid of psychiatry, sociology, medicine, pedagogy, political science, and social work, comes to form the field of juridical discourse, introducing yet another "new economy" of the punitive power—one essentially technocratic, a business of experts. The conception of law as command or statute is replaced by the conception of it as a norm. Judges, "as if ashamed to pass sentence," are possessed of "a furious desire . . . to judge, assess, diagnose, recognize the normal and abnormal and claim the honour of curing, . . . [to] pass 'therapeutic' sentences and recommend 'rehabilitating' periods of imprisonment." And, as this "immense appetite for medicine" and for "the chatter of criminology" spreads to everyone from the parole officer to the turnkey, the scholarly and the punitive meanings of the word "discipline" become ominously fused:

"[We see] the growth of the disciplinary networks [of the human sciences], the multiplication of their exchanges with the penal apparatus, the ever more important powers that are given to them, the ever more massive transference to them of judicial functions; now, as medicine, psychology, education, public assistance, 'social work' assume an ever greater share of the powers of supervision and assessment, the penal apparatus will be able, in turn, to become medicalized, psychologized, educationalized."

But that's just the half of it. Once created, the carceral mode of punishment becomes "the greatest support" in spreading this normalizing power to the entire social body, creating what Foucault, excitement mounting, calls "the carceral archipelago." Here Foucault borrows an image he has not really earned and makes an equation that will not in fact balance out. "The judges of normality are present everywhere," he cries. "We are in the society of the teacher-judge, the doctor-judge, the educator-judge, the 'social worker' judge; it is on them that the universal reign of the normative is based."

In this new sort of "panoptic society"—one with many highly trained observers in many well-equipped towers keeping watch on an enormous variety of supposed delinquents—"the formation of . . . insidious leniencies, unavowable petty cruelties, small acts of cunning, calculated methods, techniques, 'sciences' . . . permit the fabrication of the disciplinary individual." We are far away now from "the country of tortures, dotted with wheels, gibbets, gallows, and pillories." And far away, too, from the chaste disciplines of Walnut Street. We are—Foucault's tone tightens to bitter rage—in "the carceral city" where "the prisons resemble factories, schools, barracks, hospitals, which all resemble prisons."

Perhaps. But the steady rise in rhetorical shrillness as one approaches the present raises the question of how securely Foucault, and the reader, can sustain an "archaeological" attitude toward an *épistémè* not yet buried, especially when he is so passionately determined to bury it. Politically committed to a continuous guerrilla war against the various islands of the carceral archipelago ("We must engage it on all fronts—the university, the prison, the domain of psychiatry—one after another, since our forces are not strong enough for a simultaneous attack"),[2] Foucault does not deal with the jails—schools, factories, asylums, barracks, hospitals—among which he lives in the same way as he deals with those he must reconstruct. The jails he lives among he wants to level, one by one, which may or may not be a good idea. But the making of ruins is a rather different sort of enterprise, involving rather different sorts of emotions

and producing rather different sorts of perception, from excavating them:

"We strike and knock against the most solid obstacles [the "all fronts" passage continues]; the system cracks at another point; we persist. It seems that we're winning, but then the institution is rebuilt; we must start again. It is a long struggle; it is repetitive and seemingly incoherent. But the system it opposes, as well as the power exercised through the system, supplies its unity."

It is worrisome that such writing today reads less like café talk than it did even six short years ago. And one begins to suspect that we are faced with a not altogether simple, descriptive tracing of the genealogy of the prison through the various kinds of discourse that have characterized it, from Robert Damiens to Son of Sam. After so much uncovering of archaeological sites and fixing of sequences, we seemed to be faced with a kind of Whig history in reverse—a history, in spite of itself, of The Rise of Unfreedom.

Obsessed with the constraining mechanisms of modern life, Foucault has lifted them into a horrific figure for the whole of it—the panoptic society, the carceral city—and then sought to see what lies beneath such a fine monstrosity. Seen that way, the past appears as an ascending spiral of discontinuous, "humanized," but nevertheless more and more malefic power concentrations—"micro-fascisms," as someone has called them—eventuating, at length, in the horror we know. This horror is the state to which the past—which, according to Foucault, is not supposed to be able to produce anything but itself, and that in a sort of random walk—can now be seen to have somehow led. Like some constitutional liberal spying out the first, faint signs of modern liberty in the German forest or the Roman Law, Foucault finds the first, not all that faint, signs of modern constraint in the spectacle tortures of the Old Regime and the didactic disciplines of the *âge classique*.

What this demonstrates, of course, is that he has not escaped so completely from the vulnerable *épistémè* of historicism as he might like or imagine. The emerging contemporary *épistémè* that he characterizes as the "new metaphysical ellipse"—"a theatre of mime with multiple, fugitive, instantaneous scenes in which blind gestures signal to each other"—is not yet wholly here.[3] But perhaps like half-revolutions, half-escapes are

enough, and will suffice. It is just such a half-escape, whatever he intended, that makes *Discipline and Punish* so fascinating. For although it puts the past at a great distance, showing it as caught in its own discourse, it also appropriates the past for its own current arguments. As with so many prisoners, of so many kinds, it is not getting out but wanting out that generates in Foucault a strange and special vision.

From: *New York Review of Books*, January 26, 1978.

2 The quotation is from "Revolutionary Action: 'Until Now,'" in *Language, Counter-memory, Practice*, edited by D.F. Couchard and just published by Cornell University Press.
3 "Theatrum Philosophicum," ibid.

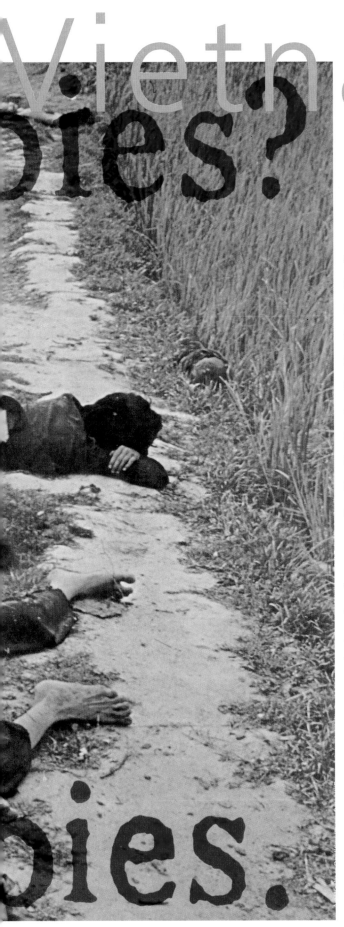

Vietnam

Amy Schlegel

Only a handful of photographs taken during the Vietnam War have become emblematic of the "atrocious" conduct of the war itself. One of these photographs, taken by the US Army combat photographer Ron Haeberle in March 1968 during the now infamous My Lai (or Songmy) massacre, transformed this atrocity into a watershed event, not just of the Vietnam War but of recent American history. [The other iconic images of the Vietnam war are Malcolm Browne's 1963 photograph of the Reverend Quang Duc immolating himself in a Saigon street, Eddie Adam's 1968 photograph of the execution of a suspected Vietcong terrorist by Brigadier General Nguyen Lgoc Loan in a Saigon street during the Tet Offensive, and Huynh Cong (Nick) Ut's 1972 photograph of Vietnamese children fleeing a napalm attack.] The My Lai massacre represents in magnitude the War's greatest and most publicized moment of atrocity by American soldiers. . . .

The photograph depicts a group of about 20 of the 109 South Vietnamese women and children *reported* to have been killed one morning by the American Army patrol Charlie Company; their mutilated bodies have fallen on top of one another and are scattered across a dirt footpath leading through a field. This photograph, along with many others, was taken on March 16, 1968 by Ron Haeberle, then a US Army combat photographer, in the South Vietnamese hamlet referred to by Americans as My Lai 4 (and as Thuan Yen by the Vietnamese). . . .

The first framing of Haeberle's photograph came in its mass media publication in *Life* magazine. The photograph was published in color

first in the December 5, 1969, issue of *Life* along with a selection of others taken by Haeberle during the massacre. The December 12 issue included the photograph again in the context of a cross-section report on Americans' shocked responses to the massacre as a tragic event. *Life* reportedly bought the North American color reproduction rights from Haeberle for $40,000, after he traveled to New York and "set up headquarters in Room 801 of the Gotham Hotel," where for three days he bargained with press representatives for the sale of 18 color slides. . . .

As its first overtly political gesture, the lithograph/poster was created by three members of the Art Workers Coalition (AWC) Poster Committee (Fraser Dougherty, Jon Hendricks and Irving Petlin), itself an outgrowth of another activist artists group called the Artists and Writers Protest Against the War in Vietnam. . . .

The poster's text was appropriated from a *New York Times* transcript of a radio interview the journalist Mike Wallace conducted with Paul Meadlo. The type's courier font, that of a standard typewriter, conveys an interrogatory, accusatory tone, suggesting a hypothetical source in the transcripts of Calley's war crimes trial, in which the image answers the question, "And Babies?" In the course of the interview, Wallace rhetorically asks Meadlo three times "Q: Men, women, and children? Q: And babies?" The inclusion of the response to the interrogative (which was not absolutely necessary in order for the image to be effective) demonstrates the Art Worker's attempt to present another kind of message than either the military's "victorious encounter" with the Viet Cong at My Lai or President Nixon's condemnation of the massacre as "unjustifiable". . . .

In perhaps the most famous AWC protest, reproductions of the "And Babies?" poster were brandished by AWC members inside MoMA, on January 8, 1970, five days after a "memorial service for dead babies murdered at Songmy and all Songmys" in conjunction with the Guerilla Art Action Group (GAAG). The demonstration was staged in front of Picasso's anti-war icon *Guernica*, a monumental painting "documenting" another atrocity, the 1937 bombing of the Spanish town *Guernica* during the Spanish Civil War. Clearly the poster served a propagandistic purpose, particularly in juxtaposition

446

Edward W. Saïd

Fanon was the first major theorist of anti-imperialism to realize that orthodox nationalism followed along the same track hewn out by imperialism, which while it appeared to be conceding authority to the nationalist bourgeoisie was really extending its hegemony. To tell a simple national story therefore is to repeat, extend, and also to engender new forms of imperialism. Left to itself, nationalism after independence will "crumble into regionalisms inside the hollow shell of nationalism itself." The old conflicts between regions are now repeated, privileges are monopolized by one people over another, and the hierarchies and divisions constituted by imperialism are reinstated, only now they are presided over by Algerians, Senegalese, Indians, and so forth.

Unless, Fanon says a little later, "a rapid step . . . [is] taken from national consciousness to political and social consciousness." He means first of all that needs based on identitarian (i.e. nationalist) consciousness must be overridden. New and general collectivities—African, Arab, Islamic—should have precedence over particularist ones, thus setting up lateral, non-narrative connections among people whom imperialism separated into autonomous tribes, narratives, cultures. Second—here Fanon follows some of Lukács's ideas—the center (capital city, official culture, appointed leader) must be deconsecrated and

demystified. A new system of mobile relationships must replace the hierarchies inherited from imperialism. In passages of an incandescent power, Fanon resorts to poetry and drama, to René Char and Keita Fodeba. Liberation is consciousness of self, "not the closing of a door to communication" but a never-ending process of "discovery and encouragement" leading to true national self-liberation and to universalism.

One has the impression in reading the final pages of *The Wretched of the Earth* that having committed himself to combat both imperialism and orthodox nationalism by a counter-narrative of great deconstructive power, Fanon could not make the complexity and anti-identitarian force of that counter-narrative explicit. But in the obscurity and difficulty of Fanon's prose, there are enough poetic and visionary suggestions to make the case for liberation as a process and not as a goal contained automatically by the newly independent nations. Throughout *The Wretched of the Earth* (written in French), Fanon wants somehow to bind the Europeans as well as the native together in a new non-adversarial community of awareness and anti-imperialism.

In Fanon's imprecations against and solicitations of European attention, we find much the same cultural energy that we see in the fiction of Ngugi, Achebe, and Salih. Its messages are we must strive to liberate all mankind from imperialism; we must all write our histories and cultures rescriptively in a new way; we share the same history, even though for some of us that history has enslaved.

From: *Culture and Imperialism*, London, 1993.

with one of the landmarks of modern art, *Guernica*, which depicts another atrocity in pseudo-documentary *grisaille* and in a late cubist/surrealist style radically different from the utter realism of Haeberle's close-up photograph.

In retrospect, the AWC's poster and the way it was deployed must be seen as a politically committed gesture critical of the government and the military (which had allowed the massacre to occur and then to be covered up), and yet willing to acknowledge American responsibility for the massacre and, with it, a certain amount of complicity shouldered by every citizen. The AWC Poster Committee wanted to avoid the appearance of complicity in collaborating with MoMA, an institution it accused of contributing to the war effort in its refusal to decry American involvement in the war, yet it ultimately chose to implicate the Museum as complicitous with the government and military from inside that very same institution.

From: "My Lai: 'We Lie, They Die,' Or, a Small History of an 'Atrocious' Photograph," in *Third Text* 31, London, 1995.

Serge Daney – Ceddo

By habit and laziness, racism too, whites always thought that emancipated and decolonized black Africa would give birth to a dancing and singing cinema of liberation, which would put them to shame by confirming the idea that, no way around it, blacks dance better than they do. The result of this "division of labor" (logical thought / body language) is that the Western specialists of recent African cinema, too preoccupied with defending it through political solidarity or misguided charity, have failed to grasp its real value and originality: the oral tradition, storytelling, language. Are these "stories told *otherwise*"? Yes, but in a cinema that is literal (not metaphorical), discontinuous (not homogeneous), and verbal (not musical). This basis in speech, not music, is what already characterized the early films of Ousmane Sembene, Oumarou Ganda, and Mustapha Alassane, as well as those created in exil by Sidney Sokhona. The same is still true for the most recent—and most beautiful—film by Sembene, shot in 1977 and entitled *Ceddo*.

The film recounts the forced Islamicization of a seventeenth-century village, situated in what would later become Senegal: the conversion of King Demba War and his court, and then of the villagers, even though they are convinced (as their spokesman says several times) that "no faith is worth a man's life." The king is secretly assassinated, the nobles are elbowed out of power, and the villagers (who are the *ceddo*, the "people of refusal") are vanquished, disarmed, shaved and shorn, and rebaptized with Muslim names, ready for the slave market. (The next installment, in a sense, will be *Roots*). Alongside this first story whose center is the village square, Sembene pursues a parallel story whose site is in no man's land, somewhere out in the bush. The princess Dior Hocine, the king's daughter, has been carried off by a *ceddo* who is trying to protest against the Islamicization of the court, and who mercilessly kills anyone who tries to free her (first a brother, then a loyal knight). He is finally assassinated on the orders of the imam who has meanwhile taken power. Only at this point does the princess become conscious of the subjection into which her people have fallen. When she is brought back to the village, superb in her pride, with tears in her eyes, she kills the imam: a freeze-frame on this last image, and the film is over.

Thus the people in *Ceddo* lose their freedom (the village), their lives (the king), their blinders (the princess). But there is worse. *Ceddo* is the story of a putsch, with the intrusion of religion into politics (as in *Moses and Aaron*, for instance) and the transition from one type of power to another (as in *The Rise of Louis XIV*). But it is also the story of a right which is lost: the right to *speak*. A right but also a duty, a duty but also a pleasure, a game. If the imam wins, it is not because he is militarily stronger, it is because he introduces an element which will cause the traditional African power structures to implode. And this element is a book, a book which is *recited*: the Koran. Between the beginning and the end of the story told by *Ceddo*, what has changed is the status of speech.

In the beginning, it is clear that we are in a world *where no one lies*, where all speech, having no other guarantor than the person who produces it, is speech of "honor." When he films these people who will soon be reduced to silence, Sembene first insists on restoring their most precious possession: their speech. It's an entirely political calculation. For what the defeat of the *ceddo* signifies is that African speech will never again be perceived by whites (first Muslims, then Christians) as speech, but instead as babble, chatter, background noise "for the authen-

Djibril Diop Mambéty, *Touki-Bouki*, 1973

Europe isn't my center. Europe is a periphery of Africa. They stayed more than a hundred years in my land, they don't speak my language, I speak theirs. For me the future doesn't depend on being understood by Europe. I would like them to understand me but it doesn't matter. Take a map of Africa. You can put America and Europe in it and we'll still have room left over. Why do you want me to be the sunflower turning around the sun? I am the sun.

From: interview in the film *Caméra d'Afrique*, by Ferid Boughedir, 1983.

Nwachukwu Frank Ukadike

Touki-Bouki exemplifies a rich reservoir of creative leitmotifs around which Mambéty's ingenious œuvre revolves. He undertakes to explore themes of youth and their dreams (love, alienation, fear, justice, and urban stress) processing them as symptoms of the problematics of development, in which "the normal course of events is continuously interrupted, attacked, and finally regenerated through dream sequences, hallucinations, lyrical interruptions, ultimately surrealism." The unconventional manner in which space, time, and events are juxtaposed compels one to appreciate the film as a non-narrative whose collage of cultural, political, and sexual imagery offers a wide array of connotative assumptions.

Touki-Bouki eschews didacticism while maintaining a commitment to liberated African film practice. In both content and style, the film makes intellectual demands that challenge the viewer. It does so by hybridization, appropriating and then subverting conventional film techniques and the thematic-narrative elements of traditional African tales. The film's stylistic sophistication surpasses previous experimentations within African cinema and is replete with well-integrated symbolism of typical African sociocultural codes, effective visual metaphors, and intelligible juxtaposition of images of reality and fiction which force frequent action and reaction between opposite poles. The film lacks the slow pacing and linear structuring that so characterizes and stigmatizes most African cinema. The editing strategy subverts spatial, temporal, and graphic continuity: disjunctive editing, jump cuts, and calculated disparities between sound and image violate dominant patterns of representation within both Western and African cinema, thus contributing to the fascination of the film.

The eruptive style of *Touki-Bouki* is sustained by a restless mise-en-scène that culminates in a series of shifts and transgressions originating from unconventional viewpoints no longer bound by conservative dramaturgy of the principles of oral tradition (even though the title itself, "Bouki," is a popular character in oral tradition).

The rhythm of daily life as Mambéty's camera portrays it at the beginning of the film is either slow or fast. The camera develops a masterful choreography as it dictates the pace of

tic effect," or worse, "palavers." Now, what Sembene brings before us, beyond archaeological concerns (which we are too ignorant of Africa to evaluate) is African speech in so far as it can also have the value of writing. Because one can also write with speech. In the court of King Demba War, in the coded space where the plot develops and the protagonists of the drama appear, *each person is one with what he says:* the king and his people, the Muslims and the "pagans," the pretenders to the throne. There are rhetorical games, theatrical turnabouts, negotiations and oaths, declarations and rights of response: speech is always *binding*. Only in Pagnol can one find such incandescent moments where speech, functioning as writing, lays down the law. In this way Sembene's film becomes an extraordinary document on the African body (today's actors and yesterday's heroes) *upstanding* in its language (here, Wolof), as though the voice, accent, and intonation, the material of the language and the content of the speeches, were solid blocks of meaning in which every word, for the one who bears it, is the last word. Is this an ideal, naive vision of a world without lies? The utopia of a world before ideology, ignorant of the gap between the statement and its enunciation? Not so sure. The societies which are a bit hastily considered to be "without writing" have resources all their own for extracting from spoken language that which can have the value of the written. One such resource is the use of what Jakobson called the "phatic" dimension of language (concluding one's phrases with "I said!"). Another is the use of gestures with a performative value (Madiar, the heir to the throne dispossessed by the new Koranic law, repudiates this law and makes himself an outlaw: he demonstrates his position by trading a slave for wine which he solemnly drinks before the disgusted imam, who holds his nose against the smell). Yet another resource is the use of undecidable statements (Madiar the outlaw speaks only in proverbs). Finally—and this is the most striking aspect of the film, the most unknown for us—there is the existence of an essential character, without whom communication could not take place: the official *spokesman*, the pot-bellied nobleman Jafaar.

Djibril Diop Mambéty
Touki-Bouki, 1973

events; it chases and pans with electrifying speed every object within its vicinity. In African films, until 1973 when *Touki-Bouki* was made (with the exception of Med Hondo's films), the camera has been either static or languid with little movement. Mambéty's paramount concern has been to develop what might be termed an "African eclecticism." If this creative stance constitutes audacious "rebellion" against the established tradition of African cinema—that is, the slow-paced, linear narrative style typical of *Emitai*, *Kodou*, and many other African films—in *Touki-Bouki* this pattern is destroyed. What we see is a harbinger of the creative autonomy now favored by the younger generation of black African filmmakers. It is important here to state that while Mambéty clarifies without simplification, Sembene, in contrast, attaches importance to simplicity of detail. Yet, as with many other African filmmakers, their differing tactics produce insightful images of the continent's complex formation and patterns of refurbishment of the cultural patrimony.

From: *Black African Cinema*, Berkeley: University of California Press, 1994.

It is as though an entire aspect of language—*speech which is not binding*—had fallen to a single man: Jafaar alone can lie, exaggerate, flatter, trick, play every role (including his own), occupy all the positions of discourse. Two characters standing face to face still need him to signify that they are speaking to each other: "Tell him that . . ." Yet Jafaar is not a spokesman in the Western sense (he doesn't speak for a statesman who, remaining hidden, can always deny what has been said), and nor is he a buffoon, nor the king's fool (so common in the Arab tradition). He is not the one who speaks the truth while all the others lie, he is the only one who has the right to lie while all the others are *sworn* to truth. He is the one with a monopoly on the gap between statement and enunciation. Without Jafaar there is no communication; he is, if I daresay, the "blank spot" who spaces the speech of the others and transforms it, in a certain way, into writing.

Therefore, even more than recounting the fall of King Demba War, it seems to me that *Ceddo* recounts how someone is dispossessed of his role as spokesman. At the end of the film, the imam sends Jafaar away (despite all his groveling attempts to keep himself in favor), and replaces him with one of his loyal followers, Babacar. In fact, the function changes. Babacar speaks *on the orders* of the imam, who himself supposedly speaks in the name of a book (the Koran) which he knows by heart. But a book is nobody. This vertical transfer of speech replaces the horizontal circulation of African language where a liar, put at everyone's disposition, allows each one to "keep his word." It is after Jafaar's defeat that the reign of ideology, if you will, can begin. That is to say, the set of positions, not to say postures, that can be adopted before an intangible Text: poses, travesties, excesses of zeal, hypocrisies, disguised unbelief. This is where Sembene becomes deliberately polemical: the ferocity with which he composes the portrait of the imam speaks clearly of his disdain for the servants of all dogma. More than an anti-Islamic film, *Ceddo* is anticlerical. Sembene hates priests.

So much for *Ceddo*-language. *Ceddo*-music remains. I said above that there were two films, two stories, two "positive heroes": the people who collectively resist and the princess who becomes aware of the situation out in the isolation of the bush. The two films only converge in the final images, which are all the stronger

Ousmane Sembene

El Hadji Abdou Kader Bèye heeded the counsels of the *serignes*, absorbed the decoctions, rubbed himself with the unguents, wore his *xatim* around his waist. Despite all that, or perhaps because of it, there were no symptoms of improvement. He had returned to the psychiatric hospital. Shamelessly he bared his breast to the head doctor, his voice strained, breaking. He was eager to "go to bed," but his nerves betrayed him. Yet he followed the prescriptions. The doctor took notes and told him to come back. Sunrise after sunrise, nightfall after nightfall, his lingering torment eroded his professional activities. Like a kapok tree swollen with water by the river bank, he sunk into the mud. His suffering drew him away from the circle of his peers, where the business deals were imagined and struck. He felt heavy, clumsy, he

for their forced, fictional quality. For when the princess kills the imam, it can only be an improbable end, an emblematic denouement: the final liberation of Africa, *yet to come*. Sembene, more dialectical in this than filmmakers such as Leone or Kurosawa, knits together two stories without ever confusing them; he maintains the distance between the description of resistance and the fiction of liberation, between the people and its heroes, the collective and the individual, archaeology and convention. In short, the princess is not Zorro.

In fact, if there are two *Ceddos*, they are treated by means of two different approaches to cinema. Where the archaeological part is based on speech, the allegorical part is based on music. Each time the film calls on known situations, belonging to a diffuse, transhistorical memory of the history of the African diaspora, the music—by Manu Dihango—seems to play as a reminder, a connotation. Speech against music? Not really, more a kind of dichotomy: to music belongs everything related to the supposedly-known or the already-seen, to speech belongs everything related to our ignorance—which, in the case of Africa, is boundless. The result is a fascinating displacement of affects. When the villagers are branded with a hot iron, when they are hustled onto the square to be rebaptized, the cruelty of the situation, far from being *underlined* by the music, is held at a distance, as though someone were murmuring ironically: but you already knew all that . . . The music (negro spirituals, balafons, choruses evoking free jazz) does not reassure, exalt, or dramatize, but makes *meaning*, and a very strange kind of meaning. For once, film music has something like the taste of ashes. For this is the music that the *ceddo* people and their children will make later, elsewhere: in the USA, in Brazil, in the Caribbean. And they don't yet know that. We know it (and more, we like that kind of music). The music is a future past, *it will have been*. In the same way, the *ceddo* people don't know that for we Westerners, they will become beings of music, good-for-song-and-dance—precisely to the extent that they will *lose the right to speech*. It's one thing to perceive in the music of the oppressed the reflection and expression of their oppression, but it's another to ask oneself this question: before being condemned to sing their condition, what did they say and how did they say it? *Ceddo* risks an answer. Above all, Ceddo allows us to ask the question.

From: *La Rampe*, Paris, 1984.

lost his dexterity in business matters. Slowly his store declined.

He had to keep up his sumptuous lifestyle, his standing: three villas, automobiles, wives, servants, children. Accustomed to paying everything with his checkbook, he used it to wipe away old debts and fend off the household bills. He spent, he spent. The red gnawed into the black. His father-in-law, the father of his third, old Babacar, knew a soothsayer, a *seet-katt*. The *seet-katt* lived on the edges of town.

They went to see him.

The Mercedes could not reach the seer's residence. Nothing but sand-choked alleyways. On foot, they sunk into the sand. The houses were of wood, semi-solid, covered with pieces of sheet metal, strips of tarred canvas, sheets of cardboard, all held together with stones, iron bars, salvaged axles, wheel rims from every possible make of vehicle. Barefoot children played soccer with a homemade ball. Far across an empty stretch of terrain, a long line of women carried plastic basins and buckets on their heads, returning from the water tap on the other side of the zone, the side of the real city.

The *seet-katt* was a big devil, gawky, with rough, wrinkled skin, wearing only short Turkish-style pants, brown eyes, hair gone to seed. He led them into the hut he used for his consultations. A jute tarpaulin served as a door. On the other side—inside—this door was red and had been stitched with animal teeth, cat feet, beaks of birds, shriveled pelts, amulets. An assortment of bizarrely shaped animal horns ringed the space. The floor was clean, with finely grained sand.

The *seet-katt*, a mystical hermit, had an aura of fame. His

Ousmane Sembene, *Ceddo*, 1973

Abdul Maliqalim Simone & David Hecht

Dislocation. Dispersal. Contested territories. Ambiguity. As Africa increasingly presents its problems and aspirations directly before the rest of the world, these catchwords attempt to grasp a change in Africa's relationship with others. "Nothing works, but everything is possible," remarks the Sudanese writer Abu Gassim Goor, and these sentiments increasingly seem to embody contemporary African realities where societies are simultaneously flourishing and collapsing. Dislocation is not only the manifestation of what the West has "done" to Africa, it also speaks to a mode of political practice employed by distinct African civil societies in order to maximize opportunities for re-configuring social life. Making ambiguous the meaning of events and display of collective behaviour become survival tactics in a political landscape simultaneously incorporated into, and ignored by Western agenda. . . .

Part of the problem may be the inability of many Western and indeed African observers to get beyond the stereotype of Africans impetuously living through their passions rather than demonstrating calculation or strategic maneuvering. Additionally, the problem with many Western assumptions—for example,

serious "work" reached beyond the limits of the zone. With a wave of his bony arm he invited them to sit on a goat skin. El Hadji, in his European clothes, was ill at ease; he took his place as he could. Old Babacar sat down cross-legged. The *seet-katt* spread out a square of bright red cloth between them, and took cowry shells from a mesh bag. Before officiating, he murmured incantations; with a sudden movement, he threw the cowries. He scooped them up again swiftly with a single hand. Chest stiffly upright, he looked his clients over. Brusquely he extended his arm, fist closed. The bony member, terminated by the ball-shaped fist like an anemone, slowly opened.

Old Babacar, captivated, pointed to El Hadji with a finger:

—"Take them and breathe out whatever led you here," ordered the *seet-katt*, speaking to them for the first time.

El Hadji murmured with the cowries in the palm of his hand. He blew on them and gave them back. Eyes closed, lips trembling, the *seet-katt* screwed up his concentration. Then with a guttural roar he threw the cowries on the square of cloth.

Like a shower of sparks in the darkness, the hidden, immaterial world of earliest childhood surged back to the surface. El Hadji Abdou Kader Bèye was gripped with a universe peopled by malevolent spirits; gnomes and djinns darted through his subconscious.

From: *Xala*, Paris: Présence Africaine, 1973.

Africans are more communal and less individualistic; or Africans base their actions on their belief systems—is that when these patterns are manifest, they may be more tactical than essential and may quickly change. . . .

What seems clear is that the moral congruity and legitimation of social practice in Africa has been largely configured by civil societies always having to look over their shoulders to stay one step ahead of the repressive and parastical habits of the state. As A. B. Schatzberg points out, the power of civil societies in Africa is in their ability to shift continuously whatever phenomena might be construed as political at any given time.

Resistance, if it is to have a chance, must be ambiguous; it must demonstrate a willingness to occupy the un-occupiable. Since there is seldom recourse to functional courts, constitutionality or legal protection of life or property, Africans must frequently redefine the political realm to encompass activities and territories in which the State might prove a reluctant player.

The sustenance of African societies is not only a matter of politics or economics, but of moral considerations as well, for as Achille Mbembe reminds us, Africa struggles not only to feed itself, but to ease the world's doubt that "the Black may be incapable of becoming, by their own force and their own moral and ethical resources, creator of a history which does not result uniquely in disasters." Additionally, Africa struggles to construct a space of freedom from having to be overly concerned about this doubt. Indeed, Africa must consider its place within a structure of international division of labour, keep track of who has appropriated what from whom, and deliberate on questions of alterity. But it must also fashion modes of reflection and interaction that go beyond these preoccupations. As Tummah Fadio, a prostitute in Khartoum once remarked, "People shouldn't waste time getting upset about realities that we know have always existed because we're not the ones making money on our despair."

Civil societies in Africa become spaces of reformulation and the realignment of social bodies and meanings, ways of legitimating actions and practising cultural invention. They frame often elliptical efforts to maintain competing agendas and aspirations in some kind of functional, parallel existence, where the need to survive does not take precedence over the need to imagine, and where the need to imagine itself does not impede completely the ability to survive. . . .

It can be difficult to reconcile the contrasting images of African cities. Rapidly decaying infrastructures coupled with ever expanding squalid shanty towns give most cities a sense of impending chaos. Yet the cities are full of hustle and bustle, traffic jams, music blaring, people selling anything they can get their hands on; on the whole a rampant liveliness. The image certainly exceeds that of people languishing in sterile impoverishment. While the awful conditions under which most urban Africans are forced to live are highly visible, not so visible are the means through which people survive.

By manipulating what is visible and what is not, African societies attempt to retain some control over their definition. If a certain resourcefulness is masked, it is done with the knowledge that the State has neither the integrity nor strength to protect it. If a certain incompetence and deterioration is amplified, it is done with the knowledge that interventions from the wealthier West may

come only as patronizing rescue. Whatever the dynamics involved, the manipulation of visibility allows these societies to both engage in and disengage from local regimes and the West. . . .

African urban communities may appear disembodied, stagnant and implosive because the efforts groups and individuals make to forge multiplex connections with the outside remain relatively unseen. The greatest effect of colonialism in Africa was not so much "messing" with the internal dynamics of household, kinship and social life but in disrupting the wide-ranging interconnections that existed among communities and peoples across often vast distances. Ethnicities and cultures, rather than being static and encapsulated forms of social organization, were ever-changing configurations, reflecting the movement of populations and the interchange of influences.

The challenge of everyday African political life, therefore, has been to rebuild this sense of interconnectedness with the outside, without which the hustle and bustle of African cities becomes a mere parody. In thousands of small ways, civil societies in Africa "play" with this politics of visibility, fronting masks when nothing is hidden, deploying stark realities as covers for things more complex or uncertain. . . .

Like America and the American dream, Africa also has its myths of burgeoning potentiality. For many in Africa, style has become strategy, a means of moving, going somewhere, often nowhere in particular.

Zaire is perhaps the most desperate of all African countries. Kinshasha is one of the world's largest slums. Essential services such as transport, electricity, schools and hospitals hardly work. Husbands can be suddenly drafted into the army without even their wives being informed. People constantly have to stay on their toes in order to survive, and can rarely speak their minds. Strangely, in this city of poverty and despair, the average person is concerned with issues such as "natural fibres and not polyester," with colour coordination and keeping up with the latest Western styles. Someone may live in a one-room hovel shared with ten or more people, but as long as he or she can beg, borrow or steal a fashionable three piece suit or elegant dress, they view themselves as fortunate or at least see a means by which life may become better. Giorgio Armani, Jean-Paul Gaultier, Chanel are revered by rich and poor alike. Tini Bagatini, Comme des Garçons and Esprit are invocations to a spirit which crosses ethnic and class boundaries but is also more than just imitation of Western taste. French-speaking Africans refer to this phenomenon as SAPE (Société des Ambianceurs et des Personnes Élégantes). . . .

Sapeurs have a capacity to laugh at themselves although they take pride in knowing how to savor Western materialism better than Westerners. Sapeurs are networkers who criss-cross Congolese society extending their connections all over Africa and the world. They are blatantly frivolous since any social movement that appears more serious would be considered subversive and undoubtedly crushed by Mobutu's agents. Superficiality becomes not only political protest but the very space and occasion through which some sense of autonomy outside of a stultifying political atmosphere can be achieved; a revolution in the mirror. . . .

Annick Osmont

Since the beginnings of urbanization (1860), the growth patterns the Dakar area have strictly obeyed the principles of social and spat segregation, throughout the different moments of colonial and th Senegalese state administration of urban land development. This se regation is largely due to a will to keep the African population at a di tance. It includes the creation of the Medina, then of Grand Dakar, t displacement of the Lebon villages toward the north, and the stro concentration of modern-type activities in highly specific zone administration and commerce on the Plateau (an essentially Europe district), the port area and the industrial zone along the coast. T phenomenon became only more pronounced in the fifties, notab because of the housing policy carried out from that time onward without any qualitative break after independence. . . .

Economists have analyzed this kind of urbanization in terms of a du ism, which translates on the level of spatial organization into t notions of a modern, central, European city and a traditional, perip eral, African city. Sociologists reinforce this position, designating marginal, under-integrated, peripheral population, by contrast to t population of the modern economic sector. . . .

A series of empirical observations and case studies leads us to rema that:

—The peripheral districts grow much faster than those in the cent and therefore are not a residue along the path to development.

—Although there is a visible social segregation between the city cent and the periphery, the internal structure of these two urban forms not, strictly speaking, homogeneous: there exist islands of Afric "marginality" in the modern, European city, as there exist islands high-quality habitation in the peripheral districts.

—The forms taken by the peripheral districts are diverse.

In the end, the reality appears infinitely more complex and diversifi than the discourses that seek to account for it. . . .

African societies attempt to generate a workable sense of plurality in the face of scarcity and Western dictates about how economies must be run. These efforts must repeatedly confront the role of tradition. Outsiders are often frustrated by the tedious deliberations which frequently accompany the introduction of innovations in Africa. But the process of change is seen as something which necessitates the continuous construction of new moral arguments. As an elderly Malian imam, Haj Manadou Ba, once commented, "Change must discover unexpected reasons for its existence; it, too, must be surprised at what it brings about." Only in the tension between the old and new does the elaboration of moral practice occur.

Under colonialism, Africans were forced to use Western conceptions of their cultural practices as frames for sustaining cosmology and religious belief. In the postcolonial period, the re-indigenization of these of these beliefs is not simply a matter of extricating a preserved system from the claws of Western discourse. Memory and the possibilities of enunciation are so thoroughly entangled in this discourse that it acts as both impediment and enabler of what is felt as indigenous. Here, too, is another tension that must be continuously played out. At times, the Muslim or Christian identification of most Africans provides the occasion, security and excuse to learn more about African divinities.

From: "Masking Magic: Ambiguity in Contemporary African Political and Cultural Practices," in *Third Text*, special issue, "Africa," 1993.

Public officials, who are aware of all of these problems and of the impossibility of approaching them without the idea of central planning, display a tolerance which translates as tacit laissez-faire. To be convinced of this one need only refer to the processes for the legitimation of illegal occupations, invented as the needs arise. We have ample proof that there exists a close articulation between the periphery—which is certainly subject to a process of marginalization, but which is not marginal for all that—and the center, which is not as integrated as it seems. In fact... one can ask, in the face of a deepening urban crisis in Third World countries, whether what is emerging is not a new movement of marginalization running from the periphery toward the center, with an increasingly pronounced reversal of proportions between modern-sector and informal-sector populations.

This double movement of marginalization is no doubt the specific aspect of the phenomenon of suburbs/periphery in the cities of the Third World, revealing the specific characteristics of urbanization in situations where urban growth bears no direct relation to economic growth...

From: *Changements: La banlieue aujourd'hui*, Paris, 1982

Charles Burnett, *Killer of Sheep*, 1977

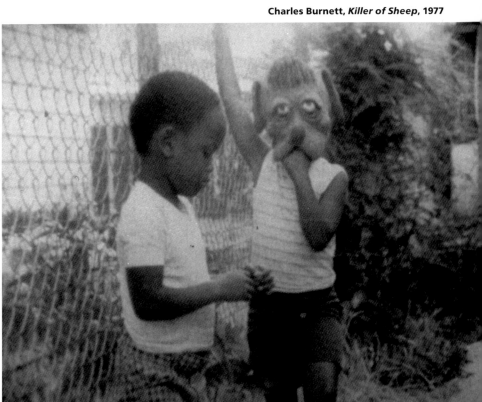

James Baldwin

I do not know how long I waited and I rather wonder, until today, what I could possibly have looked like. Whatever I looked like, I frightened the waitress who shortly appeared, and the moment she appeared all of my fury flowed toward her. I hated her for her white face, and her great, astounded, frightened eyes. I felt that if she found a black man so frightening, I would make her fright worthwhile. She did not ask me what I wanted, but repeated, as though she had learned it somewhere, "We don't serve Negroes here." She did not say it with the blunt, derisive hostility to which I had grown accustomed,

Charles Burnett, *Killer of Sheep*, 1977

but, rather, with a note of apology in her voice, and fear. This made me colder and more murderous than ever. I felt I had to do something with my hands. I wanted her to come close enough to me to get her neck between my hands.

So I pretended not to have understood her, hoping to draw her closer. And she did step a very short step closer, with her pencil poised incongruously over her pad, and repeated the formula: "... don't serve Negroes here." Somehow, with the repetition of that phrase, which was already ringing in my head like a thousand bells of nightmare, I realized that she would never come any closer and that I would have to strike from a distance. There was nothing on the table but an ordinary water-mug half full of water, and I picked this up and hurled it with all my strength at her. She ducked it and it missed her and shattered against the mirror behind the bar. And, with that sound, my frozen blood abruptly thawed, I returned from wherever I had been, I *saw*, for the first time, the restaurant, the people with their mouths open, already, as it seemed to me, rising as one man, and I realized what I had done, and where I was, and I was frightened. I rose and began running for the door. A round, potbellied man grabbed me by the nape of the neck just as I reached the door and began to beat me about the face. I kicked him and got loose and ran into the streets. My friend whispered, "*Run*," and I ran.

From: *Notes of a Native Son*, in *Critical Fictions: The Politics of Imaginative Writing*, Seattle, 1991.

David Leeming

On July 7, 1962, Baldwin, accompanied by his sister Gloria, arrived in Africa. For some time he had felt he "should see Africa" but had resisted the trip because of a persistent feeling, expressed, for example, in the "Princes and Powers" essay, that he had infinitely more in common with his compatriots, even his white compatriots, then he did with Africans. He was frankly skeptical of the interest among American blacks at the time in their African "homeland." He had, for instance, been almost scornful of Richard Wright's movement in that direction. An important part of Baldwin's message to this point, as indicated in speeches like "In Search of a Majority," was based on the idea of unbreakable, if painful, "blood ties" between white and black Americans and the notion that the unique American experience, for all its problems, was the best hope for the future. To "return" to African roots was to return to a distant past and to a relationship that was based on shared color rather than on shared experience. . . .

Dakar was strange, a European city surrounded by a culture it had worked so hard to undermine. The people he saw seemed at once at home and out of place; he began to identify with them and perhaps to wish he were somehow more like them in appearance. He found that his external "white consciousness," his sense of the appropriate instilled in him by a long history as a minority race, was challenged by a physical representation of a way of perceiving that had its source in prehistoric times,

before humans began to think about who or what they were. The visitor from America longed for the easy unselfconscious self-assurance he thought he saw in the streets of Dakar.

Baldwin was experiencing his version of *The Heart of Darkness* and he found in it—its exoticism, its marketplace scents and sounds, it beggars, its lame, its colors, its emotional expressiveness—something of the depth, the ability to touch, the willingness to accept the "stink of love" that he had chastised his nation for suppressing. Africa in all of its turmoil, in all of its pain, was teeming with the essence of what it was on the most basic level to be human, and Africa was, above all, black. . . .

After Africa he was more convinced than ever that America's—and the West's—only hope of survival lay in a liberation from the hypocrisy that had made oppression and subjugation in the name of democracy and religion possible. It was time for a "redefinition" of our myths in the context of our deeds. Africa had cemented his belief that to be of African descent in the West was "to be the 'flesh' of white people—endlessly mortified."

From: *James Baldwin, A Biography*, New York: Henry Holt and Co., 1994.

Charles Burnett, *Killer of Sheep*, 1973

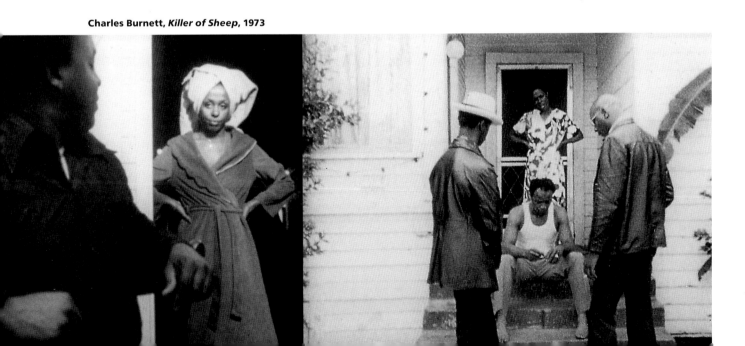

David Harvey

Militant and Particular:
A Geographer's Response to Flexible Accumulation

David Harvey is one of the most innovative and influential geographers in the world today. In his talk at the School of Fine Arts in Paris on January 15, 1997, he preferred to focus on labor organizing rather than spatial theory—a decision that reflects his commitment to political activity outside the university. The talk was transcribed by Carol Johnson and edited by Brian Holmes.

I live in the city of Baltimore, where we are involved in what I think is a very important political campaign for something called a "living wage." What we are trying to do is to raise minimum wages from $4.75 an hour to $7.70 an hour, for all workers in the city. Now, unions typically organize in a fixed place, a place of work. But what happens when most workers don't work in a fixed place? We then have to create an alternative form of organization to those which the unions have constructed historically, and we're trying to do so with union support. But the main mobilizing force is the Church. I therefore find myself talking with pastors and priests and nuns about how to create a campaign for greater justice for the low-wage workers of Baltimore, how to counteract the problems of temporary employment and the like. And this is very difficult for me, as an atheist. But at the same time I can say to them, "You know, there's a long history that explains why the sorts of things that are happening here can happen, and I can help you understand that history and connect it to a general understanding of how capitalism works." And so we have dialogues about God and Marx. Each time we meet, we hold hands and have a prayer in the middle of the street, and then we go into action—and we get things done, because in Baltimore, if ten of the most important ministers in the city surround your institution and start to talk about God, this creates a political action which is very important. Now, geographically this is significant. The whole history of Black America, the whole African-American tradition, is caught up with religion. Martin Luther King, Jesse Jackson, they were all ministers. So you have to be sensitive to that tradition. You have to be open to that tradition in ways which are creative. What I'm trying to say is there's a militant particularism at work in Baltimore that has a certain base in the city's history and its culture and its major institutions, and we have to work through that base in order to create new institutions to protect the unemployed.

The Campaign for a Living Wage in Baltimore has now run up against something called the Welfare Reform Act, which puts welfare recipients to work in the city for $1.50 an hour. We have is 20,000 people within the city of Baltimore alone who are going to be employed at $1.50 an hour in order to maintain their welfare benefits. This is like an indentured labor system. And for the first time I have heard the ministers in the city say there is only one thing that is going to stop this, and it's massive civil disobedience. They're beginning to talk about taking their congregations into the city, to stop the city working. And however you call that, it's a class action. It implies the construction of a collective place for action which includes the unions, but also the community, and many disaffected people. It doesn't necessarily have an explicit concern for something called socialism or communism, but it does have the implicit idea that there must be some alternative to this system which is being developed within the United States. And therefore there is the possibility for an open debate on what that alternative might look like. But that debate doesn't automatically become socialist. Remember, in the United States there's a man called Pat Buchanan who ran in the last presidential election as a very conservative, almost neofascist presidential candidate in the Republican Party. He talked about these problems, and tried to pull them into his camp. And that is where my struggles begin. Marxists like myself, if we engage in popular movements of this kind, are in a position to talk about a socialist alternative as a possibility. And it is our responsibility to engage with those movements on their terms.

Since 1970 I have taught Marx's *Capital* in the universities and also in the community. Today it is very easy to make a conntection between Marx, capital, and the everyday life of people. But it wasn't so easy in the seventies, because we still had a state which was concerned with the conditions of people's lives, the welfare state, which is now beginning to disappear, to the point where we have a situation which is very similar to the one Marx encountered 150 years ago. At the same time, though, the credibility of Marxism has collapsed. So we have a paradox: the text of Marx has become much more relevant, while Marxism has become much less relevant. I remember very well that Marx once said "I am not Marxist." Maybe we can begin with that to reconstruct Marxism today.

Now, there's a second thing: I am a geographer by training, and I have always had a very stong interest in the geographical, hisorical, cultural, and economic differences in people's living conditions. But I found that Marxism was not sensitive enough to geographical differences. Historically, Marxism as a movement has always

had two dimensions. The first dimension is the cry in the *Communist Manifesto*, "Workers of the world, unite!" It is a cry of internationalism, and it is fundamentally about class. But in practice, if you look very carefully at the history of thinking about Marxism, you will find we had wonderful books like *The Making of the English Working Class*. And if you look even closer, you will find that the English working class, for instance, was really made up of many different regional configurations: the South Wales miners, the shipbuilders in the Northeast, the textile workers . . . Each one of those regions had its own special way of constructing its sense of what an alternative to capitalism might be. This is what I call the idea of "militant particularism," which means that each part of a country, each city, each productive region tends to develop its own form of militant politics. If you look again at the history of the British Labour Party, it was a matter of bringing together different militant particularisms into a general political program. And in so doing, it created a politics of abstraction which went beyond what individual groups were thinking about. At a certain point, the history of socialism and the history of Marxism became engaged so heavily with the abstractions and the generalities that it forgot about the connection to the militant particularist base. The problem for me, as a socialist and a Marxist, is to find a language with which to incorporate what many of those struggles are about in a meaningful way. After all, one of the strongest criticisms that can be made about capitalism right now is that it homogenizes everything. From that standpoint, I would think that we need a socialism that looks to the creation of heterogeneity, the creation of geographical differences. I think what is interesting about Gramsci in the *Prison Notebooks* is his constant dialogue about how to mobilize alliances between city and country, between North and South. In fact, Gramsci was quite a good geographer, he understood the importance and significance of those geographical differences and saw that the task of the Italian Communist Party was to bring those differences together. I also think we have to be very careful how we read our history. For instance, the Civil Rights Movement in the United States was not something that Martin Luther King created. It was a movement in the churches, dispersed, but which gradually came together, and in the end produced Martin Luther King as a leader. And then,

as a national movement in the 1960s it created political actions which had results. But the base movement had been going on for fifty years.

That brings us to the question of political parties. The reason I didn't talk about them in Baltimore is that there are no political parties active in any of this. There is a long history of repression of Marxism, and there is also the question as to why there has never been a socialist movement in the United States, which is much too complicated to go into here. In the history of France or Italy it would be impossible to talk about what has happened without specifically looking at the politics of the Communist Party, its strategies and tactics. And I find in the United States, I'm always lamenting the fact that we don't have that history. But you can't just lament. You have to act with what you have. The fact that there is no Communist Party and no Socialist Party does not mean that there is no class struggle, nor that there is no class action. And we cannot even understand the history of the Communist Parties and the Labor Parties without understanding their relationship to specific forms of what I call militant particularism.

So I have always been very interested in difference. But right now in the universities, and particularly in the United States, you find a tremendous interest in differences, geographical, ethnic, and religious differences. There are so many differences that finding a reconciliation or an understanding becomes impossible. In universities in the United States there is a lot of radicalism which is inventive, creative, transgressive, but which shows almost no commitment to engagement with political action outside of the university. It is an internalized radicalism. For instance, it has been extremely hard for me to get the radical people at Johns Hopkins University to work on the living wage campaign in Baltimore, even though the university is now employing people at $1.50 an hour. I recently came across a phrase which says that the pursuit of freedom without political commitment is empty. We have a lot of pursuit of freedom in universities in the United States, but we do not have very much very solid political commitment. It is true that major universities, given the kinds of salaries and lifestyles they allow, put people into a class configuration which makes it very difficult to relate to uneducated, not very articulate, very impoverished people. I personally

find that when I'm talking with workers about the living wage campaign, it is not easy to have a conversation. There are almost two languages. But beyond that there is another reason, which is that twenty years ago, there was a mass movement that intellectuals could hang onto. Today that mass movement has disappeared. And I think that intellectuals who necessarily deal with abstractions find it very difficult to work with a movement that is now fragmented into multiple militant particularisms.

I'd like to add one other thing, which is that part of the radicalism in American universities has been around what we call identity politics and feminism, the demand to recognize specific cultural histories, and also to recognize particular voices within a rather homogeneous university structure. The difficulty is that this has sometimes been at the expense of any notion of class. Now, if we look carefully at the living wage campaign, it mainly relates to African-Americans, and it mainly relates to women. But the very unfortunate side of a lot of what has happened in the United States is that Women's Studies is no longer interested in class, African-American Studies is no longer interested in class. So it is very hard to persuade people who are working in those identity areas that they should participate in something like the living wage campaign.

Let's look back on the mass movement that existed twenty years ago. There were several political movements in the United States which were very strong during the 1960s and into the 1970s. First, the civil rights movement was very important. The movement against the war in Vietnam was also extremely powerful, and there was a strong connection between the civil rights and the antiwar movement. It was difficult to engage in the antiwar movement without recognizing that this was an anti-imperialist struggle, and therefore the whole question of American imperialism came very much into the center of political concern, which produced a wide range of solidarity movements inside of the United States; for instance, the solidarity work in Central America became a very vigorous and quite general movement in support of the Sandinistas in Nicaragua towards the end of the 1970s. And two other movements were also very important. One was the beginnings of the environmental movement, which was strongly anticapitalist in its early form: it saw corporate power as the enemy, and

pushed extremely hard on questions of quality of life, of the homogenizing effect of capitalist consumption and the like. There was also the early feminist movement, which in some ways had a very strong relationship with the civil rights movement, but of course translated civil rights from the arena of race to the arena of gender. And finally, there was the union movement, which wasn't necessarily well integrated into the others, for very particular historical reasons. But the union movement in the United States was really quite strong at the end of the 1960s and the beginning of the 1970s, and gained a great deal of political power, for instance within the Democratic Party. The subsequent complaints that the Democratic Party was simply a vehicle of the unions was a sort of symbol of the fact that they did have some power within the Democratic Party—which also explained why the Democratic Party was not as antiwar as it should have been.

These different movements did not get together to create a movement for socialism. But if I give my interpretation of American history, it would be roughly this. The capitalist class was rather weak. It was on attack from all of these directions, and it therefore had to concede. But it conceded not by universal gestures, but by particular pieces of legislation. The Environmental Protection Agency was set up in 1970 under a very conservative Republican president, Nixon. That's a gift to the environmentalists. Affirmative Action was created. That's gift to the Civil Rights and the Women's movements. Occupational safety and health legislation was created. That's a gift to the Labor movement. And actually, you can look at a whole mass of legislation which was enacted in the United States between 1970 and 1973, all of which took the form of particular gifts to particular constituencies. And notice what that legislation did. Environmental protection created a division between jobs and the environment, it put the unions against the environmentalists. Affirmative action put the white working class man against blacks and women. In other words, nearly all of that legislation was divisive.

We can look at this situation geographically as well. In this moment towards the end of the 1960s and early 1970s when the capitalist class in the United States was politically under assault, part of the strategic response was to use the world as a playground for US capital accu-

If there has been some kind of transformation in the political economy of late twentieth-century capitalism, then it behooves us to establish how deep and fundamental the change might be. . . . The language (and therefore the hypothesis) that I shall explore is one in which we view recent events as a transition in the *regime of accumulation* and its associated *mode of social and political regulation*. In representing matters this way, I am resorting to the language of a certain school of thought known as the "regulation school!" [Aglietta, Lipietz, Boyer, etc.]. . . . I broadly accept the view that the long postwar boom, from 1945 to 1973, was built on a certain set of labor control practices, technological mixes, consumption habits, and configurations of political-economic power, and that this configuration can reasonably be called Fordist-Keynesian. The break up of this system since 1973 has inaugurated a period of rapid change, flux, and uncertainty. Whether or not the new systems of production and marketing, characterized by more flexible labor processes and markets, geographical mobility and rapid shifts in consumption practices, warrant the title of a new regime of accumulation, and whether the revival of entrepreneurialism and of neo-conservatism, coupled with the cultural turn to postmodernism, warrant the title of a new mode of regulation, is by no means clear. There is always a danger of confusing the transitory and the ephemeral with more fundamental transformations in political-

Flexible Accumulation

economic life. But the contrast between present political economic practices and those of the postwar boom period are sufficiently strong to make the hypothesis of a shift from Fordism to what might be called a "flexible" regime of accumulation a telling way to characterize recent history.

Not everyone was included in the benefits of Fordism. . . . Fordist wage bargaining was confined to certain sectors of the economy and certain nation states where stable demand growth could be matched by large-scale investments in mass-production technology. Other sectors of high-risk production still depended on low wages and weak job security. And even Fordist sectors could rest on a non-Fordist base of subcontracting. . . . The resultant inequalities produced serious social tensions and strong social movements on the part of the excluded—movements that were compounded by the way in which race, gender, and ethnicity often determined who had access to privileged employment and who did not. . . . On the consumer side, there was more than a little criticism of the blandness of the quality of life under a regime of standardized mass consumption. . . . To this must be added all the Third World discontents at a modernization process that promised development, emancipation from want, and full integration into Fordism, but which delivered destruction of local cultures, much oppression, and various forms of capitalist domination in return for rather meagre gains in living standards and services (e.g. public health) for any except a very affluent indigenous elite. . . .

The period from 1965 to 1973 was one in which the inability of Fordism and Keynesianism to contain the inherent contradictions of capitalism became more and more apparent. On the surface, these difficulties could best be captured by one word: rigidity. There were problems with the rigidity of long-term and large-scale fixed capital investments in mass-production systems that precluded much flexibility of design and presumed stable growth in consumer markets. There were problems of rigidities in labor markets, labor allocation, and in labor contracts (especially in the so-called "monopoly" sector). And any attempt to overcome these rigidities ran into the seemingly immovable force of deeply entrenched working-class power—hence the strike waves and labor disruptions of the period 1968-72. The rigidities of state commitments also became more serious as entitlement programs (social security, pension rights, etc.) grew under pressure to keep legitimacy at a time when rigidities in production restricted any expansion in the fiscal basis for state expenditures. The only tool of state response lay in monetary policy, in the capacity to print money at whatever rate appeared necessary to keep the economy stable. And so began the inflationary wave that was to sink the long postwar boom.

mulation. This was facilitated by the innovations in communications technology and transport technology that had largely been orchestrated through the industrial military apparatus during the 1960s. Geographical dispersal outside of the United States not only allowed capital to explore production possibilities in Mexico, Brazil, and the like, but also to control the power of the union movement in the United States. I don't think saturation of markets was really the problem for capital at that time. I think it was more the power of the organized working class that was a problem.

What happened after 1970 was a form of globalization as a solution to the problems of capital, through geographical dispersal. In order to do that, a number of conditions had to be met. First, you had to have financial deregulation of the world's financial system. Secondly, the state had to be reshaped in terms of its powers, so that it could no longer control the flow of capital. If I give you a geographical image it might help. If you had a map of the world, in say, 1920, and you mapped on that where the most important industrial regions of the world were, and you compared that map from, say, 1920 to 1970, then you would find the map fairly similar. Some growth here, some difference there, but not much change. If you look from 1970 to the present day, there has been an enormous change. All of those areas that were once major industrial regions have disappeared, industry has relocated, where it has stayed it has reduced deployment. For instance, in Baltimore, we have a very large steel plant that employed 20,000 people in 1970. It now employs less than 5,000 and it produces the same amount of steel. It's a familiar story all around the world. So, we've undergone this radical reorganization of the world's geography of industrial development over the last twenty-five years, and it has meant a radical reorganization of class relations which become much more geographically fragmented. It has permitted the reorganization of capitalist powers in the United States, so that they can pretty much do what they want, how they want, and it's very difficult to organize any mass movement against it.

The financial dimension was also very important at this time. The deregulation of the financial market permitted the accumulation of power within financial institutions, in ways that were impossible in the 1960s. There were two aspects to this. Firstly, there was the breakdown of the old global system—and I want to insist that from 1945 to 1973 there was globalization, but it was a certain kind of globalization structured under the hegemony of the United States. The breakdown of that system allowed, as it were, much greater democratization in where capital could develop. And so not only did we have the dispersal of capital from the United States outwards, but also the sudden emergence of many of the Asian countries which could insert themselves into this much more open and fluid structure in very powerful ways. The other thing that happened was that all corporations had to become much more financially conscious. There is a story in the United States now that says that the problems of US industry began when they got rid of the engineers as directors and started to employ accountants. And then we had these famous statements, when the head of US Steel was asked what they were doing buying an insurance company, and he said: "The duty of management is to make money, not steel." A lot of profits in large corporations came from playing currency markets, playing financial games, creative accounting, takeovers, mergers . . . So, we're not simply talking about banks and the stock exchange, we're also talking about the internal structure of corporations; in some cases they stopped really concerning themselves about the fundamentals of production.

An interesting point to discuss here is just how hegemonic the United States has been in these matters. I think the thing which is very important in the United States is that financial deregulation has conferred a lot of power on the financial system, and in some ways, the US government is now more ruled by Wall Street and financial interests than it is by the interests of the people. The United States government is acting as an agent of corporate power, but I don't see the European or Japanese corporations protesting too much. They support it. What makes it appear as if the United States is writing the rules is that the US government is probably the one most captive to corporate and financial power. But the United States no longer has the power to dictate to the European Union, or to Japan, what they should do, how they should do it, and the like, even though it does have within its grasp significant institutions like the World Bank and the International Monetary Fund, which are essen-

Flexible accumulation, as I shall tentatively call it, is marked by a direct confrontation with the rigidities of Fordism. It rests on flexibility with respect to labor processes, labor markets, products, and patterns of consumption. It is characterized by the emergence of entirely new sectors of production, new ways of providing financial services, new markets, and above all, greatly intensified rates of commercial, technological, and organizational innovation. It has entrained rapid shifts in the patterning of uneven development, both between sectors and between geographical regions, giving rise, for example, to a vast surge in so-called "service-sector" employment as well as to entirely new industrial ensembles in hitherto underdeveloped regions (such as the "Third Italy," Flanders, the various silicon valleys and glens, to say nothing of the vast profusion of activities in newly industrializing countries). It has also entailed a new round of what I shall call "space-time compression". . . . Turnover time—always one of the keys to capitalist profitability—stood to be reduced dramatically by deployment of the new technologies in production (automation, robots) and new organizational forms (such as the "just-in-time" inventory-flows delivery system, which cuts down radically on stocks required to keep production flow going). But accelerating turnover time in production would have

Flexible Accumulation

been useless unless the turnover time in consumption was also reduced. The half-life of a typical Fordist product was, for example, from five to seven years, but flexible accumulation has more than cut that in half in certain sectors (such as textile and clothing industries) while in others—such as the so-called "thought-ware" industries (e. g. video games and computer software programs)—the half-life is down to less than eighteen months. . . . Given the ability to produce images as commodities more or less at will, it becomes feasible for accumulation to proceed at least in part on the basis of pure image production and marketing. The ephemerality of such images can then be interpreted in part as a struggle on the part of the oppressed groups of whatever sort to establish their own identity (in terms of street culture, musical styles, fads and fashion made up for themselves) and the rush to convert those innovations to commercial advantage. . . .

Flexible accumulation . . . seems to fit with a simple recombination of the two basic strategies which Marx defined for procuring profit (surplus value). The first, termed absolute surplus value, rests on the extension of the working day relative to the wage needed to guarantee working-class reproduction at a given standard of living. . . . Under the second strategy, termed relative surplus value, organizational and technological change is set into motion to gain temporary profits for innovative firms and more generalized profits as costs of goods that define the standard of living of labor are reduced. . . . Interestingly, the deployment of new technologies has so freed surpluses of labor power as to make the revival of absolute strategies for procuring surplus value more feasible even in the advanced capitalist countries. What is, perhaps, more unexpected is the way in which new production technologies and co-ordinating forms of organization have permitted the revival of domestic, familial, and paternalistic labor systems. . . . The revival of sweatshops in New York and Los Angeles, of home work and "telecommuting", as well as the burgeoning growth of informal sector labor practices throughout the advanced capitalist world, does indeed represent a rather sobering vision of capitalism's supposedly progressive history. . . . Re-reading [Marx's] account in *Capital* strikes home with a certain jolt of recognition. We there read of the ways in which the factory system can intersect with domestic, workshop, and artisanal systems of manufacture, of how an industrial reserve army is mobilized as a counter-weight to workers' power with respect to both labor control and wage rates, of the ways in which intellectual powers and new technologies are deployed to disrupt the organized power of the working class, of how capitalists try to foster the spirit of competition amongst workers, while all the time demanding flexibility of disposition, of location, and of the approach to tasks. . . . Even though present conditions are very different in many respects, it is not hard to see how the invariant elements and relations that Marx defined as fundamental to any capitalist mode of production still shine through, and in many instances with an even greater luminosity than before, all the surface froth and evanescence so characteristic of flexible accumulation.

From: *The Condition of Postmodernity*, Cambridge, Mass. and Oxford: Blackwell, 1990.

tially still agents of the US . . . So I don't that that all of the impulses toward the development of neoliberalism came from the United States. I think Thatcher was extraordinarily inventive and had an incredible impact upon US political thinking. She was much more conservative than Reagan, who was really in many ways a Keynesian kind of guy. The person in American politics who has taken the mantle of Thatcher is Gingrich. When the Republicans took control of Congress, and Gingrich became Speaker, we had Thatcherism for the first time in American politics—and we're still living with Thatcherism, because Clinton has become a sort of Thatcherite. That was a condition of his reelection.

Globally, this broad picture of geographical dispersion creates tremendous problems for labor organizing, because you're dealing with workers who come from very different cultural backgrounds with extremely different histories, with different ideas of what might be good or bad in life. The new conditions of flexibility create all sorts of difficulties for organizing a global working class. But this takes me back to the *Communist Manifesto*. Marx said that with the globalization of capitalism, there's only one answer, and that is indeed for workers of all countries to unite in some sort of global class struggle. But that never happened historically in the way that Marx envisaged it. And now we have a very serious problem of how to do that in relationship to this highly flexible capital accumulation that can move very quickly from one place to another. That means that the working class movement has to have a geopolitical strategy, it means that the resistance to capitalism has to have a geopolitical understanding.

This brings me back to the question of the relationship between the abstractions that we work with and the particularities of these multiple struggles which are occurring in the world. I'm quite well known as a Marxist intellectual, and I find that the following sort of thing happens to me: I go to Brazil, in Porto Alegre, where I've never been before in my life, and somebody says to me, "You're a Marxist, tell us what to do." And my answer is, "I have no idea what you should do." It's very tempting to say, "Well, you should do this, this, and this." But we need to resist that because the abstractions with which we work have to be enriched, and themselves made more flexible in relationship to the very different condi-

tions under which class action is occurring. And intellectually I find that the greatest challenge right now is not to abandon the theory that Marx created, but to enrich it in ways that make it capable of working in these very diverse situations. Our problem is to find a geopolitical strategy to talk about how to link together the different movements. If you just take the US-Mexican border, it is a dividing line: for the most part, unions on one side do not talk to unions on the other side. One of the things that those of us who occupy my class position, one of the responsibilities of intellectuals in general in the contemporary situation, is to try to facilitate those conversations across borders.

I don't fundamentally think that the terms "modern" and "postmodern" are very useful. But as Marx once said, we don't write history under conditions of our own making. And that's why I called one of my books *The Condition of Postmodernity*, because everybody was talking about postmodernism. So I tried to discover what it was that people felt was special about postmodernism. And when I went back to the modernism of Second Empire France, for instance—Baudelaire and so on—I couldn't for the life of me see what was so special about it. So I ended up saying, well, I really think all the things that are being talked about under the heading of postmodernism have already been talked about under the heading of modernism. And when you start to read postmodernist literature, they usually invoke somebody in the past, like dada, the surrealists, Nietzsche, as if somehow or other these are all precursors of postmodernism. The one I liked most was Saint Augustin. When Saint Augustin said, "Yes, God, but not yet," he was being a postmodernist! So at that point I thought, why do people want to be post-something? Actually if you look at the number of "posts" in the world, post-industrial, post-ideological, post-communist, post-Marxist, post-structuralist, postmodernist, everybody is so busy being "post-" that nobody is interested in what we might be "pre-." That's why I went on the negative side about this, and said, yes, of course, I am post-1970. In terms of age I'm even post-60. So what? What am I pre-? At this point I want to be a presocialist! I get very tired of all the posts . . .

Gilles Deleuze, Félix Guattari – A Thousand Plateaus

The Included Middle

No one has demonstrated more convincingly than Braudel that the capitalist axiomatic requires a center and that this center was constituted in the North, at the outcome of a long historical process: "There can only be a world-economy when the mesh of the network is sufficiently fine, and when exchange is regular and voluminous enough to give rise to a central zone." Many authors believe on this account that the North-South, center-periphery axis is more important today than the West-East axis, and even principally determines it. This is expressed in a common thesis, taken up and developed by Valéry Giscard d'Estaing: the more equilibrated things become at the center between the West and the East, beginning with the equilibrium of overarmament, the more they become disequilibrated or "destabilized" from North to South and destabilize the central equilibrium. It is clear that in these formulas the South is an abstract term designating the Third World or the periphery: and even that there are Souths or Third Worlds inside the center. It is also clear that this destabilization is not accidental but is a (theorematic) consequence of the axioms of capitalism, principally of the axiom called *unequal exchange*, which is indispensable to capitalism's functioning. This formula is therefore the modern version of the oldest formula, which already obtained in the archaic empires under different conditions. The more the archaic empire overcoded the flows, the more it stimulated decoded flows that turned back against it and forced it to change. The more the decoded flows enter into a central axiomatic, the more they tend to escape to the periphery to present problems that the axiomatic is incapable of resolving or controlling (even by adding special axioms for the periphery).

The four principal flows that torment the representatives of the world economy, or of the axiomatic, are the flow of matter-energy, the flow of population,

the flow of food, and the urban flow. The situation seems inextricable because the axiomatic never ceases to create all of these problems, while at the same time its axioms, even multiplied, deny it the means of resolving them (for example, the circulation and distribution that would make it possible to feed the world). Even a social democracy adapted to the Third World surely does not undertake to integrate the whole poverty-stricken population into the domestic market: what it does, rather, is to effect the class rupture that will select the integratable elements. And the States of the center deal not only with the Third World, each of them has not only an external Third World, but there are internal Third Worlds that rise up within them and work them from the inside. It could even be said in certain respects that the periphery and the center exchange determinations: a deterritorialization of the center, a decoding of the center in relation to national and territorial aggregates, cause the peripheral formations to become true centers of investment, while the central formations peripheralize. This simultaneously strengthens and relativizes Samir Amin's these. The more the worldwide axiomatic installs high industry and highly industrialized agriculture at the periphery provisionally reserving for the center so-called postindustrial activities (automation, electronics, information technologies, the conquest of space, overarmament, etc.), the more it installs peripheral zones of underdevelopment inside the center, internal Third Worlds, internal Souths. "Masses" of the population are abandoned to erratic work (subcontracting, temporary work, or work in the underground economy), and their official subsistence is assured only by State allocations and wages subject to interruption. It is to the credit of thinkers like Antonio Negri to have formulated on the basis of the exemplary case of Italy, the theory of this internal margin, which tends increasingly to merge the students with the *emarginati*. These phenomena confirm the difference between the new machinic enslavement and classical subjection. For subjection remained centered on labor and

involved a bipolar organization, property-labor, bourgeoisie-proletariat. In enslavement and the central dominance of constant capital, on the other hand, labor seems to have splintered in two directions, intensive surplus labor that no longer even takes the route of labor, and extensive labor that has become erratic and floating. The totalitarian tendency to abandon axioms of employment and the social democratic tendency to multiply statutes can combine here, but always in order to effect class ruptures. The opposition between the axiomatic and the flows it does not succeed in mastering becomes all the more accentuated.

Minorities

Ours is becoming the age of minorities. We have seen several times that minorities are not necessarily defined by the smallness of their numbers but rather by becoming or a line of fluctuation, in other words, by the gap that separates them from this or that axiom constituting a redundant majority ("Ulysses, or today's average, urban European": or as Yann Mouliers says, "the national Worker, qualified, male and over thirty-five"). A minority can be small in number: but it can also be the largest in number, constitute an absolute, indefinite majority. That is the situation when authors, even those supposedly on the Left, repeat the great capitalist warning cry: in twenty years, "whites" will form only 12 percent of the world population . . . Thus they are not content to say that the majority will change, or has already changed, but say that it is impinged upon by a nondenumerable and proliferating minority that threatens to destroy the very concept of majority, in other words, the majority as an axiom. And the curious concept of nonwhite does not in fact constitute a denumerable set. What defines a minority, then, is not the number but the rela-

tions internal to the number. A minority can be numerous, or even infinite; so can a majority. What distinguishes them is that in the case of a majority the relation internal to the number constitutes a set that may be finite or infinite, but is always denumerable, whereas the minority is defined as a nondenumerable set, however many elements it may have. What characterizes the nondenumerable is neither the set nor its elements: rather it is the *connection*, the "and" produced between elements, between sets, and which belongs to neither, which eludes them and constitutes a line of flight. The axiomatic manipulates only denumerables sets, even infinite ones, whereas the minorities constitute "fuzzy," nondenumerable, nonaxiomizable sets, in short, "masses," multiplicities of escape and flux.

Whether it be the infinite set of the nonwhites of the periphery, or the restricted set of the Basques, Corsicans, etc., everywhere we look we see the conditions for a worldwide movement: the minorities recreate "nationalitarian" phenomena that the nation-states had been charged with controlling and quashing. The bureaucratic socialist sector is certainly not spared by these movements, and as Amalrik said, the dissidents are nothing, or serve only as pawns in international politics, if they are abstracted from the minorities working the USSR. It matters little that the minorities are incapable of constituting viable States from the point of view of the axiomatic and the market, since in the long run they promote compositions that do not pass by way of the capitalist economy any more than they do the State-form. The response of the States, or of the axiomatic, may obviously be to accord the minorities regional or federal or statutory autonomy, in short to add axioms. But this is not the problem: this operation consists only in translating the minorities into denumerable sets or subsets, which would enter as elements into the majority, which could be counted among the majority. The same applies for a status accorded to women, young people, erratic workers, etc. One could even imag-

ine, in blood and crisis, a more radical reversal that would make the white world the periphery of a yellow world; there would doubtless be an entirely different axiomatic. But what we are talking about is something else, something even that would not resolve: women, nonmen, as a minority, as a nondenumerable flow or set, would receive no adequate expression by becoming elements of the majority, in other words, by becoming a denumerable finite set. Nonwhites would receive no adequate expression by becoming a new yellow or black majority, an infinite denumerable set. What is proper to the minority is to assert a power of the nondenumerable, even if that minority is composed of a single member. That is the formula for multiplicities. Minority as a universal figure, or becoming-everybody/everything (*devenir tout le monde*). Woman: we all have to become that, whether we are male or female. Nonwhite: we all have to become that, whether we are white, yellow, or black.

Once again, this is not to say that the struggle on the level of the axioms is without importance: on the contrary, it is determining (at the most diverse levels: women's struggle for the vote, for abortion, for jobs: the struggle of the regions for autonomy: the struggle of the Third World: the struggle of the oppressed masses and minorities in the East or West . . .). But there is also always a sign to indicate that these struggles are the index of another, coexistent combat. However modest the demand, it always constitutes a point that the axiomatic cannot tolerate: when people demand to formulate their problems themselves, and to determine at least the particular conditions under which they can receive a more general solution (hold to the *Particular* as an innovative form). It is always astounding to see the same story repeated: the modesty of the minorities' initial demands, coupled with the impotence of the axiomatic to resolve the slightest corresponding problem. In short, the struggle around axioms is most important when it manifests, itself opens, the gap between two types of propositions, propositions of flow and propositions of

axioms. The power of the minorities is not measured by their capacity to enter and make themselves felt within the majority system, nor even to reverse the necessarily tautological criterion of the majority, but to bring to hear the force of the nondenumerable sets, however small they may be, against the denumerable sets, even if they are infinite, reversed or changed, even they if imply new axioms or, beyond that, a new axiomatic. The issue is not at all anarchy versus organization, nor even centralism versus decentralization, but a calculus or conception of the problems of nondenumerable sets, against the axiomatic of denumerable sets. Such a calculus may have its own compositions, organizations, even centralizations: nevertheless, it proceeds not via the States or the axiomatic process but via a pure becoming of minorities.

From: *A Thousand Plateaus*, Minneapolis and London: University of Minnesota Press, 1987.

从政治上思想上理论上彻底批倒批臭中国的

1967: Lui Shaoqi and Deng Xiaoping attempt to lead the country toward economic privatization, provoking a forceful response from Mao. Upper right, a Red Guard, a worker with a little red book, a builder, and a soldier.

BEIJI

Wei Jingsheng

The painful experience of the Cultural Revolution shaped an entire generation. In early 1966, when I and a few dozen friends joined their ranks, the Red Guards constituted an organization of fanatical Maoists—but also a group of malcontents. Indeed, had they only been Maoists, they would not necessarily have felt the need to "rebel." Most, including myself, were unhappy with social inequalities, and that spurred us to a spirit of sacrifice and a ferocious combativeness which made the Red Guards a redoubtable force.

Xie Mulian, 1978. The slogan on the wall reads: "Initiative, spirit, patience, politeness," a motto that would have been impossible under Mao.

Huang San/Angel Pino

On April 5, 1976, a demonstration took place in Tiananmen square in Beijing. The participants numbered in the hundreds of thousands. The occasion was the Day of the Dead, "the festival of Father Light." The crowd seized the pretext of commemorating their "beloved minister Zhou": Zhou Enlai, who had died three months before, practically to the day, and who symbolized a different option than the one taken by Mao. While casting paper flowers on the Memorial to the People's Heroes, the demonstrators gave vent to their rage at current policy. Banners were unfurled, speeches given, poems recited, all like arrows aimed straight at the Chinese leaders. The demonstrators were dispersed by military force after the mayor of Beijing, Wu De, had cried "provocation." From upper circles came immediate condemnation of the troublemaker, "a party official who has taken the capitalist path and refuses to recant." And on April 7, by the decision of the central committee—in this case, Mao in person—Deng Xiaoping, the man to whom Zhou Enlai had confided the task of carrying out the program of the Four Modernizations,[1] was divested of "all the functions he fulfilled in and outside the party" (vice-president of the party and vice-prime minister) and "placed under observation," which in the disciplinary scale of the party was a prelude to exclusion. Thus Deng Xiaoping, who had been put back into the saddle in 1973, after having been forced out of the upper echelons of power in fall 1966, fell into disgrace once again. Hua Gofeng, who had been given the office of prime minister after Zhou Enlai's death, now replaced Deng as party vice-president.

Yet if the rioters of April 5 were vanquished by force, they had nonetheless won a *political* victory. For the significance of the events at Tiananmen square, which would have been inconceivable only a few months before, went far beyond a simple manifestation of popular discontent. A society that had been pressed back into submission after the first phase of the Cultural Revolution now regained its voice after a decade of silence. In this sense, the events of April 5 can rightly be seen foreshadow "Beijing Spring." They announce the end of an era: Mao still lived, but the "red sun of Shaoshan" had set.

[1] The program of the so-called "Four Modernizations" was proposed by Zhou Enlai in 1975 and launched in 1978. Its principles and effects were: rehabilitation of the notion of profit, broad autonomy of management for business directors, encouragement of the return to family-based agriculture, and the opening of China to foreign technology and capital.

From: introduction to Wei Jingsheng, *La Cinquième Modernisation*, Paris: Christian Bourgois, 1997.

Why did that force not finally succeed in toppling the inegalitarian social system? Because those who constituted it had armed their brains with a despotic philosophy. Myself, at the time, I was a fanatical Maoist. I was astounded that the high ideals described in the works of Mao, Marx, and Lenin were not yet reality, and that the directors of my high school did not show the slightest intention of working toward their realization. When we heard Mao Zedong declare that the class struggle continued during the socialist phase and that class enemies had infiltrated the ruling strata, we deduced that all the inequalities and misfortunes should be ascribed to these class enemies that had infiltrated the party. From that day forth, we devoted all our efforts to the movement that had sprung up to dislodge these evil persons, whom we imagined beneath the features of Bukharin in the film *Lenin in October*.

For many different reasons the movement of the Red Guards spread rapidly, extending to the entire country. Following the directives of Mao Zedong, we went to all four corners of the land to exchange experiences and spark fires of rebellion. Wherever we went, we first contacted people we knew, people from diverse social classes who were generally party cadres at all levels. We gathered information from them about the situation of the local cadres and above all about the "faction in power." We then went into the schools, the businesses, the factories, or the mines, to incite the people to revolt. Despite it all,

Wang Baoguang, 1978. After Mao's death his widow and three party dignitaries sought to seize power. On this New Year's poster, children play with caricatures of the Gang of Four.

once the fanaticism of incitement-to-revolt had cooled somewhat, a question slipped into our minds: these kinds of revolts seemed to suggest that all the factions in power were evil. Now, if all the factions in power were evil, didn't that mean that the country and the party were entirely evil? That no longer fit with what we originally thought. In return, if the factions in power were not all evil, why was it that in almost every case the masses were ready to furnish proof to the contrary? That in itself seemed to sufficiently demonstrate the evil nature of the factions.

When we returned to Beijing this contradiction grew deeper. Certain veteran cadres whom we knew well were in their turn considered as belonging to the "ruling clique on the path of capitalism." Yet they had never appeared to us as opponents of the party or of socialism, and we had seen no signs that they might be Bukharin-style conspirators. What is more, they had come from poor backgrounds and had joined the revolution early on. All that, for a sixteen-year-old adolescent, was quite difficult to understand. The contradiction provoked divisions among the organizations of the Red Guards. In my high school, for example, where we were some four hundred Red Guards, more than one hundred withdrew to join other organizations and the remainder split into five or six factions.

From: *La Cinquième Modernisation*, Paris: Christian Bourgois, 1997.

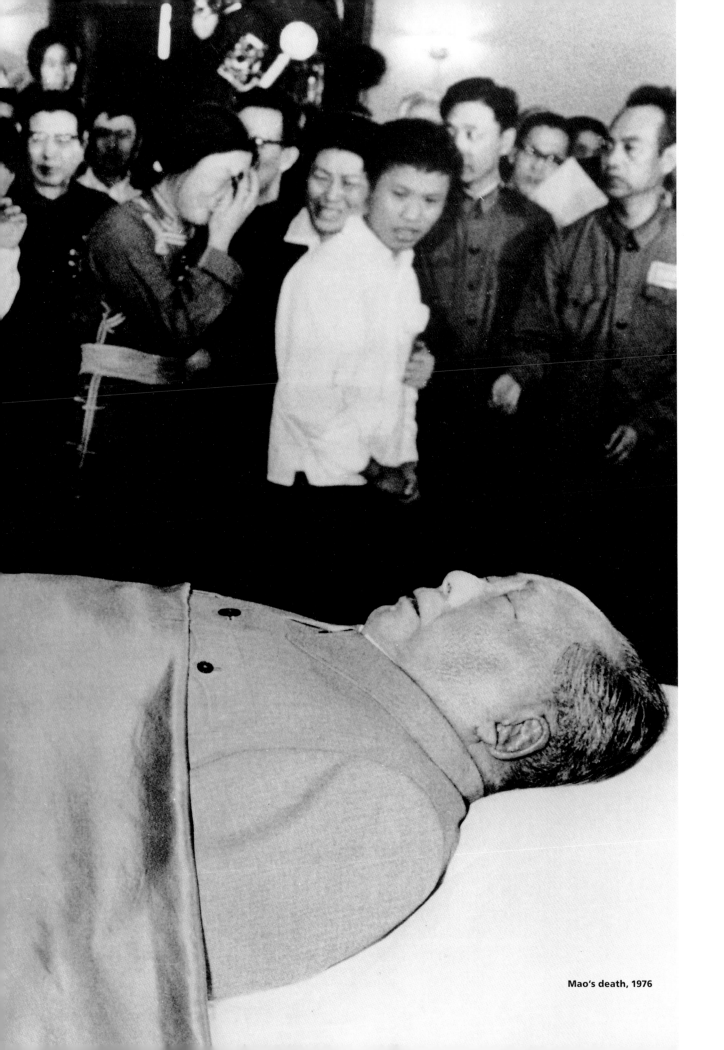

Mao's death, 1976

Gabor T. Rittersporn

After the plenary session of the central committee in February 1978, the purification campaign was doubled by a series of rehabilitations, often posthumous, of cadres who had been stripped of their rank and punished by the "gang of four" and their supporters. Nothing could have been more natural than to see these people, some of whom had been nominated to important posts, reinforce the camp of the "moderates." But nothing could seem more dangerous in the eyes of certain functionaries, which is also comprehensible. A declaration like this one, printed in the *People's Daily* on November 11, 1978, at the moment when the purge recommenced, was not particularly apt to calm the troubled spirits: "Certain persons fear that by reversing unjust verdicts, the great Cultural Revolution may be denied. They fear that the sky is falling. What troubles them in reality is their own negation . . . For they are the ones to have promulgated or helped to promulgate these unjust verdicts . . ."

The affair of the rehabilitation of the participants in the riots of April 1976, which served a pretext for one of those subtle tactics of diversion practiced by the "new radicals," fits precisely into the context of this controversy over the "reversal of false verdicts."

From: *Libre* 5, Paris, 1979.

Wei Jingsheng

To accomplish modernization, Chinese people should first practice democracy and modernize China's social system. Democracy is by no means the result of social development as claimed by Lenin. Aside from being the inevitable outcome of the development of productive forces and the relations of production up to a certain stage, it is also the condition for the existence of productive forces and the relations of production, not only up to that point but also at much higher stages of development. Without this condition, society will become stagnant and economic growth will encounter insurmountable obstacles. Therefore, judging from past history, a democratic social system is the major premise or prerequisite, for all developments—or modernizations. Without this major premise or prerequisite, it would be impossible not only to continue further development but also to preserve the fruits of the present stage of development. The experiences of our great motherland over the past thirty years have provided the best evidence.

From: *Wei Jingsheng and the Prospects for Democracy in China*, Stockholm, 1995.

繁华的上海南京路

Zang Yuqing, 1989. The main commercial street of Shanghai. The new economic policy promises abundance.

多干实事，
少说空话。

邓小平

The Winter Years

Gérard Chaliand

Human rights in themselves are a value worth defending, as the liberal and left tradition has not failed to do for two centuries. But the strategy of human rights, born under the impetus of Zbigniew Brzezinski,

Félix Guattari

I am one of those who lived through the 1960s like a springtime that promised to last forev Today we are on the edge of a black hole in history. There's much better in store than Le F watch out! You're making a big mistake! More than a revamped populism, Le Pen is a collec The label of neofascism can lead to confusion. People immediately begin reviving the imag union self-interest and a dogged refusal to deal with the questions of immigration, with the can't simply be explained by the past, because in fact it's aiming for the future. Le Pen is a sea

From: *Les années d'hiver 1980-1985*, Paris, 1986.

Predrag Matvejević

The position and role of the intelligentsia and of dissidence in the Other Europe have substantially changed: the critique of society and of the ruling power is now carried out in public places, in the press, in parliament. Literary work, for the moment, is not of the first necessity. All the better for literature! Ideological or state censorship has ceased to exist, or, where it still exists, it is at the service of a different ideology or another state. This is equally true of self-censorship, which is reduced to moral conscience. . . .

The writer who continues to be an old-style dissident at any price, even at the price of his work, becomes problematic as a writer. Rare are those who have succeeded in making literature from dissidence, or thanks to dissidence. The writer who has asserted himself more by the stance he has taken than by his work cannot obtain in literature the place he merits as a writer. . . .

fulfills the function of an ideological counter-offensive, forcing the Soviets into the posture of the accused and restoring the prestige the United States lost between the Cold War and the end of the war in Vietnam. This strategy is only the declared part of a larger system, that of world capitalism, dominated by the United States—a system which keeps the Third World under its dependence, with the complicity of the governing strata in most of the countries concerned.

It's a pity to restrict oneself to denouncing human rights violations, a critique the liberal state can sustain, when the *oppression of minorities*, never denounced as such by states, ought on the contrary to constitute one of the battle cries of the left, or of the liberals in the Anglo-Saxon tradition—on the condition that it be pushed to its full consequences.

From: *Les Faubourgs de l'Histoire*, Paris, Calmann-Lévy, 1984.

The former role of the writer who awakened or edified the people now belongs to the past; this must be stated aloud and accepted. In a totalitarian regime, the intellectual could be the hostage of truth (I once used that phrase with respect to Sakharov). We had the opportunity to defend those who were humiliated and scorned, to join forces with the minorities and the marginals, to stand up against the ruling powers and the hierarchies. In the current scenarios, such roles are rare, or nonexistent. The sole task of gravedigger grows repugnant in the long run.

Robert Bréchon

Epistolary from the Other Europe is the Bible of dissidence. The dissident is not simply in opposition. He does not express himself in the name of any other party than the one in power. Against ideology,

t must be why the 1980s drags on like such a long winter for me . . .
'll see. If you think Le Pen is just another replay, an insignificant return from an archaic past,
sion trying to find itself, an orgasmic hate machine, fascinating even when it nauseates.
he Popular Front, forgetting that Le Pen has also drawn on the conservatism of the left, on
lass status of an entire section of the younger generation, and so on. This brand of fascism
t, a trial balloon for formulas that may well be far more frightening.

And one cannot expect that the writer will occupy a particularly important place in the (new) relations of politics and literature. All the better for him: that, as I see it, is his lucky chance. . . .
One can hope that the most hardy among us will observe with irony the mediocrity or the vanity of the new leaders, the arrogance or folly of nationalism, the backwardness of faith or of clerical ideology, the primitive character of populism or false messianism, the bad taste of the political speeches and demonstrations we are now witnessing, the inflation of signs and symbols we are obliged to suffer. To the extent that the exaltations of religion and nation (or state) are invasive and coercive, we can presume that the new dissidences will be antinationalist and secular. . .

From: "L'intelligentsia dans l'autre Europe," in *Lignes* 20, Paris, 1993.

nationalistic passion, or the reason of state, he invokes the rights of man, considered as universal or transcendent values. He is the eternal Antigone facing the perpetual Creon. Against the guard dogs of class or the clique of power he is the guardian of truth. The perfect model of the dissident is Karlo Steiner. The *Epistolary* opens with praise for his autobiography *Seven Thousand Days in Siberia* and ends with his funerary oration, pronounced in the Zagreb cemetery. He is "the hero of our times." He denounces the crimes committed in the name of an ideology he formerly supported, yet he does not repudiate the values that guided his initial revolt. Quite different from Steiner are men such as Djilas, the former Stalinist fanatic who became the paragon of dissidence for the West, without "justifying himself in his own and others' eyes" by the sincerity of his testimony. Matvejevitch mistrusts those who simply change sides, trading one set of lies for another.

From: forward to Predrag Matvejević, *Le Monde Ex*, Paris, 1996.

Philippe Lacoue-Labarthe

Syberberg: On Germany after Hitler[1]

It's an old story: in the late thirties, Benjamin and Brecht—and seemingly they alone—had the fundamental intuition that Nazism rested primarily on what they called an "aestheticization of politics."[2] To which they could only respond, in the heat of the struggle, with the opposing slogan of "politicized art." Let's leave the slogan behind: it wasn't necessarily the best. What remains is the intuition. It's an old story (our history): almost nothing remains of that intuition. Neglected, covered up by hundreds of laborious studies in every genre and style, never really taken seriously (too "aesthetic" in the end), it found practically no echo until Syberberg—and seemingly he alone—took hold of it anew, deepened it and placed it at the start and at the heart of his artistic work. To do so, he got rid of the old slogan and announced a quite different program, stranger, more rigorous, and infinitely more "subversive": *politics through art*, instead of politicized art.[3]

What is at stake here?

Syberberg's cinema has only one subject: Germany. And it is haunted by only one question: how was Nazism possible? Others describe, reconstitute, rehash, accuse, slip into S&M or cross-dressing scenarios, forget, deliberately ignore, and so on. Syberberg tries to find out. Stubbornly. And he tries to answer the question, that is, to push it to its limits. That's exactly what accounts for his absolute originality, and that's obviously what people have a hard time swallowing. The answer in question—take that literally—is double.

At the initial and very general level, the answer remains implicit. It clearly draws much of its support from the writings of Hannah Arendt. It amounts to the notion that Nazism, like all "totalitarianisms," remains incomprehensible if it is not seen as the necessarily frenzied attempt to identify, embody, and organize, not a "society in decay," but a people, a nation, a social entity, or a "body" politic which no longer exists and which, historically, *has never existed as such*. A situation exemplified by Germany.

But over and above this first answer, more or less accepted today, Syberberg articulates a second answer that returns to the intuition of Brecht and Benjamin, but radicalizes it and brings it to an unparalleled degree of insight. It amounts to this: the specific means used by Nazism for its identification-embodiment-organization was art. Art envisaged as a political instrument and a political finality. Occasional mention has been made of the initial collusion of the totalitarian programs with modernism and futurism, with the avant-garde and the technological aesthetic—after all, they were revolutions. But that's not what Syberberg has in mind. What he has in mind is Nazism's (obscure) will to bring about the German people's birth unto itself, the will to institute and elevate the German people as a *work of art*. As a "figure," in the language of the time (*Gestalt*). Thus he demands that we think about an idea which no previous "analysis" of Nazism

Rainer Werner Fassbinder

A long time ago, when I was still making films in which the minority representatives were the good guys and everyone else was a bad guy, the society had a high regard for my films. But when I had the much more correct idea of showing the minorities as they have become through society, with all of their faults, suddenly nobody liked my films anymore.

Do you belong to a minority yourself?
To several, yes.

Which ones?
Well, to the minority which can afford to leave this country. And I am also an extreme advocate of democracy with a concrete utopia of anarchy in mind, another minority. Actually that's something one shouldn't even mention these days, the part about anarchy. We have learned from the media that anarchy and terrorism are synonymous. On the one hand there is a utopia of a form of government without hierarchies, without fears, without aggressions, and on the other a concrete societal situation in which utopias are suppressed. The fact that terrorism could develop here is a sign that the utopias have been suppressed much too long. So a few people flipped out, understandably. And that, finally, is what a certain ruling class wanted, maybe even unconsciously, so as to be able to express itself more clearly.

From: "Ich habe mich mit meinen Filmfiguren verändert: Ein Gespräch mit Hella Schlumberger über Arbeit und Liebe, die Ausbeutbarkeit der Gefühle und die Sehnsucht nach einer Utopie" (I changed along with my film characters: A conversation with Hella Schlumberger about work and love, the exploitability of feelings and the longing for a utopia), 1977.

Rainer Werner Fassbinder, *Angst essen Seele auf* (Fear Eats the Soul), 1973

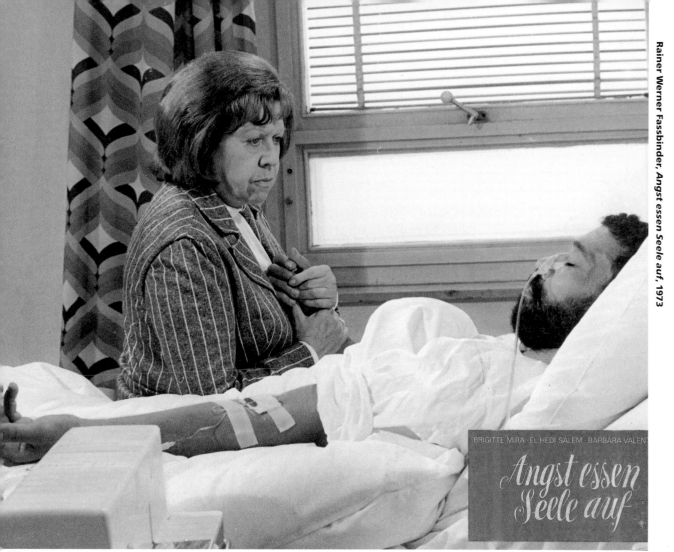

Rainer Werner Fassbinder, *Angst essen Seele auf*, 1973

in Autumn

had succeeded even in stammering out: the idea that Nazism, in its most specific aspect, is nothing other than the truth of romanticism, at least if one accepts this word to designate the most fundamental direction of German culture (and therefore also of German politics) since the end of the eighteenth century. This in no way means that Herder or Schlegel, Fichte or Nietzsche somehow "contain" the potential of Nazism: that kind of blunder can be left to the neophilosophers. What it means is that Nazism is inscribed, after its fashion, in the despairing search for the "being" or "essence" of Germany, through the desperate and consequently triumphalist imitation of what the Germans—and indeed all the Europeans since the Renaissance and the collapse of the theological-political order—had identified with the "Greek model": a people forming itself in its language, its thought, its art, and its belief (its religion), and thus attaining to a truly political reality and a historical grandeur. It is the dream, suggested by Plato in the *Republic* and the *Laws* and shared for a time by Hegel, of a "beautiful totality," where the social *organization* (the *polis*) has the impeccable stature and the potential stability of a *work* (organization and work: in Greek, the roots of these words are the same).

It is just a short step from this "beautiful totality" to totalitarianism. But there is something else, and here Syberberg's diagnosis is pitiless:

Nazism arrives late in the game, at the moment when art (as Benjamin saw once again) has entered, for its dissolution, into the era of its "mechanical reproducibility" (photography, and above all cinema[4]); at the moment when capital has invented, to achieve its *utilitarian* ends among its newly massified peoples, the sub- or pseudoculture of the masses (Karl May); and at the moment when the heroic gestures in support of "great art" has become aesthetically and politically pathetic, derisory, "decadent" (Ludwig II). The fact that Germany, from Winckelmann to Heidegger, failed to come to grips with itself amid its grand mimetic agon with the "Greek beginning"; the fact that Bayreuth and the "total work of art," as Adorno had glimpsed, were politically fulfilled in the "flicks," the newsreels, and the spectacularization of the crowd (the Third Reich as a gigantic disaster film); the fact that Europe in the same blow literally fell apart, and that the debased management of masses and merchandise, wherever it is decided from, has now swept away any basis for the hope to see a world take form (except on video)—all this is ultimately what Syberberg demands we think about. And it is no accident that he chose cinema, nor that, through cinema, he chose to deconstruct mass art, that is, to transform a technique of collective hypnosis (the most redoubtable of identification machines) into an instrument of political analysis. The Brechtian gesture could hardly be pushed any further.

The result was predictable: near-total misunderstanding. Inside Germany first of all, where it's natural enough: for Germany is a country where obliging and slightly dubious buffoons have always been preferred to authentic artists, and all the greatest German artists since the time of Hölderlin at least have been condemned by their country to silence, exile, or retreat, to madness or suicide. But outside Germany as well, at least to a degree: for despite the esteem, the prestige, and the recognition he enjoys in Europe, and even aside from the Coppola affair, Syberberg is strangely misconstrued: the rumors say that he's fascinated by what he shows or shatters, that he is ultimately a prisoner of the mythology he thinks to denounce, and that in the end it remains very unclear where his condemnation of Nazism actually lies, if there is any condemnation. In short: there's something wrong, something "suspect." (Heiner Müller gets similar treatment, concerning the East and Stalinism.) And this same misconception is certainly not foreign to the snobbish, "postmodernist" devotion that Syberberg also inspires, and which he in turn seems to misconstrue. The suspicion and the adulation come down to the same thing: an absolute blindness to the artistic gesture (let's say to the formal strategy, and thus to the thinking), and an exclusive attention to the content. Show Nazis in bra straps and you're a "critical artist," even if you film like Visconti or Bob Fosse. Stage a long and painful monologue of Hitler's valet, filmed in a still shot against a background of projected slides, and it doesn't much matter what comes back from Brecht or how much we learn about Hitler's cinematographic obsessions: you're nostalgic.

482

Rainer Werner Fassbinder

What do you think of the German model?

Well, it's an unalterable fact that the model is a democracy which was "given" to Germany by the allied forces. But what kind of democracy is it whose defense is achieved by upholding non-criticizable values? Where you can no longer even say: what kind of values is this all based on? Where even such a question is prohibited? It would be truly democratic if democracy survived through constant questioning and criticism. But in the course of time democracy has come to be led so authoritarianly that an authoritarian government couldn't do a better job. In any case, I wouldn't say that the "German model" is one for the entire Western world.

Does that have something to do with the fact that at the end of Die Ehe der Maria Braun *you quote images of the German federal chancellors, but not that of Willy Brandt?*

Yes, I have the impression that the era of Willy Brandt was an intermission, that Brandt tended to encourage self-questioning, which Wehner apparently did not want, i.e., the preservation of the criticizability of state-preserving elements. But I have the feeling that [what Brandt did] was something people didn't approve of. I understand democracy more as something that works like a kaleidoscope, not in the sense of a constant revolution, but of constant movement, constant questioning by each generation. When I see all this fuss being made about *Holocaust*—why do they have to kick up such a fuss? They couldn't have forgotten all that, they must have had that in mind when they established their government. If something so decisive could have been forgotten or repressed, I see something not quite right about this democracy and this "German model."

From: "Nur so entstehen bei uns Filme: Indem man sie ohne Rücksicht auf Verluste macht. Ein Gespräch mit Wolfram Schütte über *Die dritte Generation*, die filmpolitische Situation und eine Strategie gegen die Resignation" (The only way to make films here is to make them without consideration of losses: A conversation with Wolfram Schütte on *Die dritte Generation*, the situation of politics in film and a strategy for dealing with resignation), February, 1979.

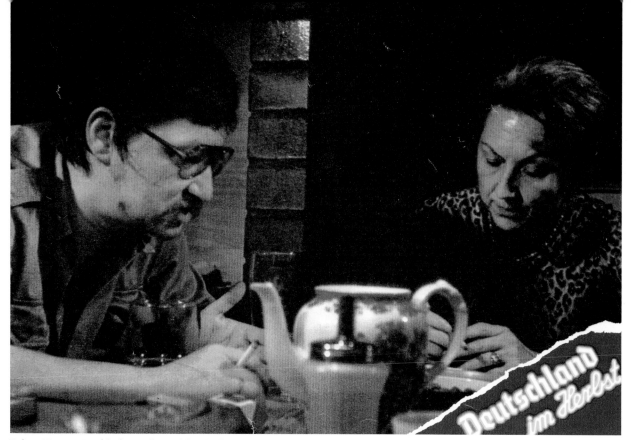

Rainer Werner Fassbinder, Volker Schlöndorf a. o, *Germany in Autumn*, **1973**

The misunderstanding is dramatic: Syberberg can barely work in Germany. As to the misconception, it's hardly preferable in the long run: the *Cahiers du Cinéma*, Susan Sontag, and Heiner Müller are not enough, all by themselves, to dam up the rumors and straighten out the confusion. That's why Syberberg has tried to make himself heard, somewhat as Nietzsche wrote a book at about the same age, in the eighties of the last century. Syberberg has written a book, as if by chance in fragments: a kind of journal, notebooks filled between the (difficult) release of *Hitler* and the preparations for *Parsifal*. It's called *The Joyless Society*, like the street of the same name, where Pabst had so much to say, more than fifty years ago, concerning everything that was about to happen.

One could fear the worst from this book. It might have been useless, like an instruction manual or a justification; it might not have been a book at all, only a document or a testimonial. But that's not the case. Those who linger over the subtext of "paranoid" logic ("why do the Germans persecute me?") are probably the same ones who sniggered about *Ecce Homo*: why do I make such great films? And those who don't understand how the filmmaker Syberberg could immediately become a writer are in any case the same ones who don't know how to read a film, especially not a Syberberg film. Because it's not only, as could logically be expected, one of the best books that has been written about Germany since the war: if that were the case, the book would do nothing more than make the films explicit, it would be pure redundancy. But it's also the kind of very great book that an artist can write about art. Not about "his" art, but about art in gen-

eral, and his relation to art. Indeed, it is for this double reason that Syberberg so clearly takes his place in the German tradition (though at one remove from this tradition, or rather in opposition, swimming against the current and at a rarely sounded depth). Ultimately, Syberberg is a unromantic romantic: like Hölderlin or Kleist, like Nietzsche, like Heidegger in his way. But not like Wagner. For if it can be said that Syberberg's only subject is Germany, the *possibility* of Germany (and great German art has never had another subject), it is because in reality his true question is not Nazism but art, the *possibility* of art. And not the reverse. Once again: politics through art and not art in the service of politics. In this sense an abyss separates him from Nazism—that's clear enough—but also from all the versions of "cultural politics," progressive or not, which are the daily lot of this age, its infernal mercantile banality.

To maintain that the question of Germany is the question of art (as Heidegger vainly attempted to make the Germans understand after 1934) does not only expose one to ridicule; it also means facing up to German nonexistence, to that very strange perseverance in "semblance" which has been the root, as it still is, of the "distress" or "poverty" (*Not*) of Germany (thus Syberberg spontaneously rediscovers the vocabulary of Hölderlin, Büchner, and Marx). Today, in the West at least, this semblance takes the form of Americanization with all its neophilistinism (shared by the social-democratic cultural establishment, at least at the moment when Syberberg writes): it is the cultural desert, the fulfillment of nihilism even in revolt. Hence the idea of "mourning," of cinema understood as an "art of mourning": mourning for Germany and mourning for art. It is the melancholic or saturnine theme that, via Benjamin and Panofsky, sends deep roots into German history, all the way to the *Trauerspiel* and to Dürer: the motif of the ruin, the Torso, the fragment (where Blanchot would recognize his "idleness" or *désœuvrement*). Hence also the sense of fidelity or loyalty, *Treue*: and first of all, the obstinate desire to understand, and to act. It is the heroic theme, Beethoven's motif if you will, or the Nietzschean *ethos*: the sense of the tragic.

There exists a famous poem on the tragic by Hölderlin, entitled "Sophocles." It states, in an approximate translation: "Many have attempted in vain to voice joyously the highest joy/ Here for me it is finally spoken, in mourning." This poem dates from 1799. Towards the end of The *Joyless Society* one can read this, written in 1981: "Whoever is incapable of mourning is equally incapable of joy." The phrase is addressed to the Germans, it concerns the possibility of art. It continues: "Refusing to mourn, they have lost the past; knowing no joy, they have long had no present; and since they are stillborn, they have no future for entire generations, how to live among them? Only with the extreme effort of a fecund resistance—not against the bourgeois nor the narrow-minded people, but against the intellectual representatives of the betrayed spirit . . ."

And what if Syberberg were addressing us as well?

[1] Under the same title, at the price of a few cuts and modifications, this text appeared in the December 3, 1982 issue of the newspaper *Libération*, on the occasion of the French publication of *La société sans joie—De l'Allemagne après Hitler* (tr. J.B. Roux, Paris: Christian Bourgois, 1982). Since then Hans-Jürgen Syberberg has published another book: *Vom Unglück und Glück der Kunst in Deutschland nach dem letzten Kriege* (Munich: Mattes & Seitz, 1990), containing certain politically dubious and at the very least equivocal statements which raised a scandal in France and in Germany. I absolutely do not subscribe to such statements and indeed, I explicitly refused to be associated with the "support committee" that was organized at the time (with the participation, among others, of Jean-Pierre Faye, Bernard Sobel, and Susan Sontag). What is more, in a short book entitled *Le Mythe Nazi*, written in collaboration with Jean-Luc Nancy (Paris: 1991, Editions de l'Aube), which contains a reference to Syberberg—"The Nazi myth is also the construction, the formation, and the production of the German people in, through, and as a work of art, as so admirably shown by H.J. Syberberg (without whose *Hitler, a Film from Germany* the analysis that we attempt here would not have been possible)"—I insisted on adding the following note: "But this does not mean that we follow Syberberg in his recent declarations, which are nostalgically philo-Prussian (in conformity with the most conventional neoromanticisms) and which, unfortunately once again, are antisemitic." Even today (December 1996) I have nothing to add, nor to take away: I maintain all the terms of my analysis of the work; I condemn, with no appeal, the "addenda," and particularly the antisemitic statements, which in my eyes are strictly unpardonable.

[2] I reserve the case of Heidegger, which I have analyzed in *La fiction du politique—Heidegger, l'art et la politique* (Paris: Christian Bourgois, 1987), where I advanced the term "national-aestheticism." I also reserve the case of Thomas Mann, whose *Doctor Faustus* perhaps blurs an analogous intuition, by accrediting the psycho-pathological interpretation of Nazism, in the allegorical mode which is familiar his readers. (I discuss this problem at length in an upcoming study, to be published under the title *Le Pacte*.)

[3] "Politicized art" can have a Marxist ring. But one must not forget that the formula also belonged to the basic banalities of Nazi phraseology.

[4] In reality the thesis of Walter Benjamin is much more complex. On this point I refer to the work of Bruno Tackels (cf. "Le chant du savoir," *Europe* 804, April 1996).

Jürgen Habermas

How is our highly ambivalent state of social integration to be understood? On the one hand it appears stable: because the economic system functions fairly well if one bothers to make international comparisons, because the side effects of the relatively high unemployment rate are intercepted by sociopolitical means, and because despite apparent instances of polarization the political system is controlled by an all-party regime in such a way that extreme deviations are avoided. On the other hand conflicts seem to be smoldering beneath the surface, as evidenced by general dissatisfaction with the political parties as such, by the frightening susceptibility of our political culture, by a difficult-to-pin-down irritability in social and political intercourse, by symptoms of paralysis in cultural areas, and above all by an increase of potentials for conflict on the mental/emotional level or in the isolated private sphere. Plus the alarming symptom which brought about this letter: terrorist acts of violence. How does all of this mix? Is there not a growing similarity between this form of social integration and the pathological stability we are familiar with from examinations of disturbed families?

. . . Government and opposition adhere equally to the maxim that the undesirable side effects of capitalist growth should be compensated by accelerated growth. This causes an expansion of the frictional surfaces on which neopopulist impulses ignite. The ideological climate of the seventies mirrors this dilemma. It is dominated by a mixture of new and old conservative currents. Whereas the values of Protestant ethics are evoked to patch the now-brittle bases of motivation for an employment system determined by competitive considerations (as well as for the educational system to be regarded in the same context), private spheres—intended as shock absorbers—are fitted out with associations of a prebourgeois tradition and provide a home for a vague concept of solidarity. In their attempt to reactivate conservative ideas, the planners of ideology and their intellectual helpers naturally find themselves in an awkward situation. The Nazis so thoroughly discredited these traditions that here in the Federal Republic, to apply a remark made by Hans Paeschkei, there can never again be "authentic conservatism." Instead, the first two and a half postwar decades have been a period in which the tradition of the enlightenment, its whole spectrum from Lessing to Marx—already mutilated and repeatedly suppressed—has successfully been brought to bear in Germany, i.e. been made a medium of intellectual productivity and the starting point for a political self-conception. One instant of youth revolt sufficed to usher in years of reaction, a reaction which apparently believes the time has come to kill two birds with one stone: to cleanse conservatism of its fault of entanglement in bureaucratic terror and—by means of a denunciatory connection with the individual terror of the RAF (*Rote Armee Fraktion*)—to force radical enlightenment into the very same state of moral discredit to which the neoconservative legacy of all-too-German traditions has justifiably fallen prey.

From: correspondence with Kurt Sontheimer (1977), in *Kleine Politische Schriften* (1-4), Frankfurt, 1981.

Heiner Müller

... Since Hiroshima military categories have no longer been relevant, only economic ones, and for that reason the Federal Republic of Germany—although not Germany as a whole—won the war. Yet the result is contrary to the intention: the aim of the war was expansion, the conquest of extended areas; the consequence is the shrinking of German territory to its economically potential core—the Federal Republic.

... Ten, fifteen years ago one could still refer to an intellectual Europe; now it seems this has become impossible. In 1975 I watched American movies in New York for weeks until I was truly disgusted with the action-plot mentality. And then there was a Godard retrospective. It was like a sigh of relief. Suddenly I once again saw films that had something to do with thought, that produced a surplus of ideas. In the USA the only thoughts conceived are the ones needed to sell the movie. It is pure barbarism, and in comparison to it, Europe naturally has its value. But at the same time it is a compliment to the imperialism of technology. The violation of nature has its parallel in the increasing independence of thought, which has been driven beyond its functionality.

—But can thought, now that it has gotten out of control, be placated without falling into intellectual regression?

First of all I do not believe in the correctness of Bataille's model: the model of the "two civilizations"—one of waste like those that emerged in ancient Egypt or in the advanced Indian cultures, and one of economy, in Europe. With regard to superstructure, to the history of thought and of art, Europe's culture is a civilization of waste. But we will have to learn to live with the fact that the intellectual is becoming

Gerhard Richter, *18. Oktober 1977*,
left to right: Capture (2), Cell, Hanging, Death, Burial, 1988

extinct in our age. McDonald's restaurants are full of a whole new human species enthusiastically gobbling shit. While each individual case seems unexplainable, this is basically the announcement of the assumption of power by computers. Those people at McDonald's are just zombies and the children who are accustomed to this new world have no need for art or literature or theater, and it will never occur to them that those things might be of interest to them. No thought will occur to them which does not immediately allow itself to be converted into hamburgers.

. . . If one could learn to impede governments, i.e. politics, or to make them superfluous, that would be quite interesting. Yet at our level of development that would be even more difficult.

But I could imagine that in this respect significant impulses can be expected from Russia and Spain. Both countries remained oblivious to the enlightenment, and initially the consequences of that were terrible. But perhaps a watered-down enlightenment—in the meantime it has lost much of its venom—will release the anti-government viruses in the bodies of these peoples.

For the Russians there never was government, i.e. politics, and suddenly that no longer has to be purely negative, as it certainly was in the last century and the first half of this one. The opening of Soviet politics by Gorbachev was based on de-ideologization. One reacts to realities when politics can no longer be made with ideas.

Europe, for example, is no longer anything but an idea. What right does anyone have to describe West Berlin as a European city? So many foreigners work there, the dependence on so-called minorities is so great, that without them everything would grind to a halt. But what should become of this idea of Europe if it is no longer reality?

—Europe—nothing more than a toxic-waste-producing idea?

Yes, but not only toxic waste, also phantom ships. In a lecture once held in Potsdam the Nobel prize winner Soyinka reported on phantom ships from Europe, loaded with toxic waste, sailing around Africa and trying to bribe port inspectors to let them unload their shit. Soyinka supplied concrete proof; he had even checked the routes. That is a very appropriate image of the situation: phantom ships from Europe junketing around the Third World in order to get rid of radioactively contaminated waste produced by occidental thought.

All that is European issues from a neurotic or at least disturbed reaction to reality—in Europe reality could never be accepted. That has climatic causes, among other things. In California or Brazil it doesn't dawn on anyone to work, invent money, or indulge in philosophical speculations—there everything grows by itself.

. . . —Are . . . any new cultural impulses ever to be expected from the House of Europe?

A clever Frenchman once said: "The contribution of the Germans to world culture is the zoo"—the humanitarian version of the concentration camp; after all, zoo animals have a good life. In this sense the European contribution to world culture is the museum, and that explains the necessity of the "European House," because one no longer wants to part with goods once stolen.

From: "Stirb schneller Europa," a conversation between Heiner Müller and Frank Raddatz, in *Transatlantik* 1, 1989

Hans-Joachim Ruckhäberle

Antigone

"Much time will pass before it is possible to say what really happened in the German autumn of the year 1977, in seven weeks full of violence, hatred, hysteria, fear, helplessness, and grief, between the four murders of Cologne and the three suicides of Stammheim. Neat balance sheets cannot be drawn up; questions appear more important than answers." (Hans C. Blumenberg, 1978)

The theater productions displayed more interest in Hölderlin than in Antigone. Hölderlin as a political figure, in the manner depicted by Pierre Berteaux (German version, 1978), seemed to be the essential trait allowing the use of the classical drama as something politically relevant.

Rambow, Lienemeyer, van de Sand, posters for *Antigone*, 1978

Du räumst dem Staate denn doch zu viel Gewalt ein. Er darf nicht fordern, was er nicht erzwingen kann. Was aber die Liebe gibt und der Geist, das läßt sich nicht erzwingen. Das laß er unangetastet, oder man nehme sein Gesetz und schlag es an den Pranger! Beim Himmel! der weiß nicht, was er sündigt, der den Staat zur Sittenschule machen will. Immerhin hat das den Staat zur Hölle gemacht, daß ihn der Mensch zu seinem Himmel machen wollte.

Hölderlin: Hyperion

488

"In this case, 'reading Hölderlin' means a constant mental obstacle course: Stammheim via Sophocles, Sophocles via Hölderlin, Hölderlin via Stammheim, Hölderlin via his interpreters" (Henriette Beese, commenting on the preparations for the Berlin production). The Strasbourg version went even further, adding an epilogue in which Hölderlin appears and composes verse. In Frankfurt, the team of directors addressed the question, "What do we feel close to in Hölderlin, what separates us from Sophocles?" Their answer: "The conflict of this play, quite simply and at first glance, is government and the individual, as well as proximity to madness. Both were experienced by Hölderlin quite directly and personally."

Thus, more than *Antigone* itself, Hölderlin became a topic of the "German autumn." This is particularly well illustrated by Gunter Rambow's four posters for the Frankfurt production. In these images, seen as a whole, the tendencies determining the history of the *Antigones* in Germany after 1945 become apparent. First, the longing for the immediate, the primal, that which is not yet corrupted by society: "When I was still a silent child and knew nothing of all that surrounds us, was I not more, than now, after all the toils of the heart and all the thought and struggle?" Second, the attitude of the individual towards the state, towards state terrorism: "The human being wanted to make the state his heaven; well, he did manage to make it hell." And third, the critique of the Germans: "This is how I came to mix with Germans." These three text posters, deriving their texts from Hölderlin's *Hyperion*, are complemented by a picture: a burning chair.

In the words of Heiner Müller, "*Antigone*: Hölderlin's republican chair, burning at the stake of the Restoration." The chair stands for more; Rambow does not have it burn at the stake, it burns from within itself. The piece of furniture that might provide a certain state of sedentariness stands in the wilderness; a piece of civilization burns. It is a portrait of something undomesticated. Rambow's posters prove to be more complex than the theater productions. A chair has been put out in the cold, in no man's land. The ostracism of the dead Stammheim prisoners from society, revealed in the discussion concerning their funeral, is reflected in the picture. The other, corresponding picture would be that of the fortress erected by the "constitutional state" in the seventies to protect itself from terrorism.

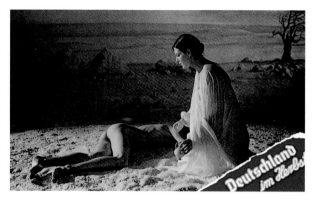

The novelty was the "newly" discovered Hölderlin, the realization—attained with the aid of Foucault—that the individual is subject to the "terror of normality" and that one adapts to its rule or is doomed to failure. At the end of the Frankfurt production Antigone is zipped into a yellow cocktail dress, gaudily made up and dragged onto the dance floor. This goes hand in hand with the realization that the critical, enlightened society does not exist, i.e., nothing is to be got out of the chorus. Contemporary theater has always had trouble with classical choruses, all the more so in the 1970s, when broad sections of West German society were thought to be molded by the unassimilated traditions of fascism and directly influenced by North American imperialism. The choruses were therefore individualized, either reduced to a single person or cast as a group of individualized opportunists. Aestheticization has taken the place of the "anti-aesthetic demonstration," accompanied by the exhaustion of the reformist and utopian potential. The point is no longer to question societal boundaries with the aid of *Antigone*. Those spaces had now been defined: the state against the individual.

In these productions, *Antigone* takes place in its own self-enclosed space; the stage is an "object which has its own intrinsic value." The optically chosen process of fragmentation emerges less from the drama than from the adoption of a dramaturgical technique previously used by Botho Strauß in one of his works.

Gerhard Richter was left with the task of artistically countering a collective act of historical repression, in his 1988 work entitled *10. Oktober 1977*.

Masao Miyoshi

Last year the Japanese went through a great deal of reflection about the fifty years since World War II. The half-century before and another half-century after seemed to offer a convenient pair—either in contrast or in continuation—as people began to face the soon-to-come end of the century and millennium. The year 1945 was indeed marked by monumental events. The substitution of anniversarism for historiography, however, is merely an attempt to simplify and ceremonize memory. Japan today is still haunted by the entirety of its modernism, ever since the country was forced open by the Western powers in the mid-nineteenth century, to which one always returns for reference.

Tokyo Forum

No compelling literary or intellectual work has emerged from Japan's mainstream since around 1970. Creative energy seems concentrated in the production of popular culture such as animated cartoons, comics, dress and graphic designs, electronic games, and karaoke. They have their own logic and politics, which will someday become clearer as to their relations to today's crisis in "high" culture. With the possible exception of architects and women writers, however, dominant voices in literature, theory, arts, films, music, or theater are now exhausted. In conversations with writers, journalists, and academics in Japan, one immediately senses pervasive

uncertainty, indeed dismay, over the direction of their activities. Underlying such malaise is a felt inability to read the history of Japan and the world, both which are increasingly blurred with each other and by themselves.

World War II was supposed, for a time, to be the culmination—and dissolution—of contradictions among Japan, Asia, and the West. The inhumanity of atom-bombing by the United States was at first ignored, because the wartime brutalities of their own leaders were as searing, and their own troops' savagery in Asia, kept secret from the civilians until after the war, was as stunning. They were all coaxed/forced into being the emperor's willing executioners, and this knowledge of half guilt and half innocence left them in gnawing anxiety. As they gradually recovered from the devastations of the war—thanks largely to the Korean and Vietnam Wars, ironically—they found the world in the thick of the larger Cold War, irrational beyond comprehension, but irresistibly profitable to them. The internal conflict between labor and management was frequently violent, and during these postwar decades Japan's liberal intellectuals genuinely believed in the possibility of socialist/capitalist democracy. Many fought the myth of a homogeneous Japan recycled under the U.S.-supported emperor system, but the leapfrogging productivity and income readily co-opted their resistance first and even their criticism later on. By the 1970s Japan was on its way up to being an economic superpower, and consumerism firmly captured the whole population including those in the culture industry. When the Soviet Union collapsed and the Cold War abruptly ended, few understood what it meant. Even during the days of the polarized world, Japan's relationships to the United States, Europe, the Asian nations, and the rest of the Third World as well as the Second, were deliberately left unclarified. After 1990, Japan had no guide to define, not to say devise, its position and course in the world. And here the long-established Japanese fantasy of exclusivist unity blinded most of them to the history of real power and domination in the world.

The Western encroachment on Japan in the nineteenth century was a part of the expansion of capitalism that had been steadily intensifying since the sixteenth century. The colonialist nation-state was formed as a part of this macro-agenda. Japan responded to this capitalist adventurism by forming a nation-state of its own, that is, an engine of aggressive expansionism. (One of the earliest embassies from Japan to Europe had the good fortune of being lectured by Bismarck on the absolute necessity of real politik.) By turning imperialist to its Asian neighbors, Japan escaped from becoming victimized by the Western imperialists. When Japan posed a direct threat to the colonies of European powers such as Britain, France, Holland, and the United States, however, the Allies—indifferent to Japan's intransigence until then—crushed it after a brief period of setback with expected ease and finality. As the heir to the British empire, the United States was determined to contain all the insurgencies in the less developed countries, including the Soviet Union, to protect capitalism. The collapse of the USSR was nothing but a step in this long continuum of hegemonism. By remaining loyal and invisible Japan somehow became the second largest economy in the world. As analysts in the world are now beginning to understand, how-

December 23, 1996

Catherine David
Jean-François Chevrier
Editors,
documenta X

Tokyo City Hall

Dean Catherine and Jean-François,

Midway during my two-week stay in Tokyo, two senior editors I know from a respected publishing firm came to have a chat. As had become our habit over the years, I asked them what was new and exciting in Tokyo. They looked at each other and said, "Nothing." They went on to say culture had vanished from Japan. Only a few books worth reading had been published since we were together a year and a half ago; and those few quietly disappeared without a trace. No new works appeared, and the older ones are neglected. This conversation itself was by now a routine between us. Books don't sell if they are half serious. What sells is light entertainment, comics, humor, jokes, not even sex. No theater, no music, not history. And they asked me in return what I thought.

The conference—a joint affair of scholars on Japan from France, the United States, as well as Japan, the main reason of my visit—was certainly cheerless. It was to deal with the idea of time, but many participants simply substituted history. And the history I was familiar with was considerably revised. The same scholars who used to be critical of Japan's militarist past and consumerist present said in near unison that the war was not all bad, that Japan's colonialism had benevolent aspects, and that capitalism brought wealth to everyone. Words like exploitation, resistance, and opposition were now meaningless; hybridity and diversity explained all. A few lone voices raised questions, but the subsequent discussion politely avoided confronting them. Specific interpretive questions were more typical, although a few dealt with literary and philosophical ideas of time. The emperor system, World War II, multiculturalism and internationalism, multiethnicity, nationhood, modernism and postmodernism, feminism, postcolonialism—many themes now heard everywhere were talked about, matter-of-factly, without much passion or conviction.

The cityscape has changed considerably over the last several years. Despite the persistent economic stagnancy, Tokyo is cleaner, and its population—especially the younger men and women—is distinctly more stylish. In the mid-town corporate headquarters area, many men and women dash around as if they were fresh from New York or Milan. They look absolutely cosmopolitan. The only feature common among these fashionable locals is that they tend to be overdressed. Obvious brand-name clothes and accessories glitter on them even when they are on casual errands. People read less on the train nowadays. Even the notorious comic books are seldom to be seen on the commuter trains. People are relaxed as they doze off to make up for lost sleep, presumably on account of long commuting distances. The crime rate is still way down compared with any other industrial country. That is why people continue to be upset over the Aum Shinri religious terrorism: the shock is over the loss of exceptionality. Their conviction that Japan was special and that it was free from such heinous crimes was at last crushed into smithereens. Japan was discovered to be no different. A professor of literature told me the middle class people began to feel vulnerable that even they could be seduced to the irrational authority of a mesmerizing mad man. The police inefficiency, too, hurt their collective

ever, the managers of world capital had in the meantime discovered that the nation-state as a form of governance was no longer required. Corporations that had immensely expanded during the Cold War were now capable of transnational circulation even more efficiently than the armed forces of the states. Corporations could directly affect regions through economic means with occasional assistance from the states, ever eager to serve their interests. Japan, too, was inescapably problematized.

In this globalized economy, nationhood must be manipulated most deftly: when state power is needed, as in the Gulf War, patriotism must be aroused; when corporations plan to maximize profits, individualism must be brought back. Free trade is invoked when an external market is needed; trade war is declared when powerful manufacturers imagine a threat; a trade agreement is reached when transnational capital sees profits. Politicians must be alert to market pressure, entirely discounting the welfare of the people at large. It is here in this flexible form of economy that Japan is at a loss. Long taught that Japan is unified, it finds it exceedingly hard to eschew the myth of consanguine brotherhood. Nation-states are comparable to indivisible persons for them. At the same time, politicians and corporate managers, or even practitioners of the culture industry, now know that the myth is inoperable, bankrupt. Diversity must be recognized, class difference must be enforced, and transnationality must be negotiated. They need a new myth that will present the termination of communitarianism in a positive light and legitimate the abandonment of the poor and unproductive to their own shift. They must urgently redefine the relations of their corporations to their weakened nation-state, to their workers, to their consumers, and to their foreign counterparts. And this is precisely what the current leaders of Japan, either political or industrial, are unable to do. In every single issue they face—from the dispatch of troops for peacekeeping, the tax reform bills, the compensations for the wartime "comfort women," to sexual harassment at home or abroad—a crisis looms challenging their accustomed understanding, their power of representation. With the center paralyzed, the culture industry in media and academia, too, is badly flagging.

The husk of the empire is turning into an encumbrance, if not a curse. The liberation necessary for Japan's recovery in creativity and vigor turns out—at this moment at least—to be from itself.

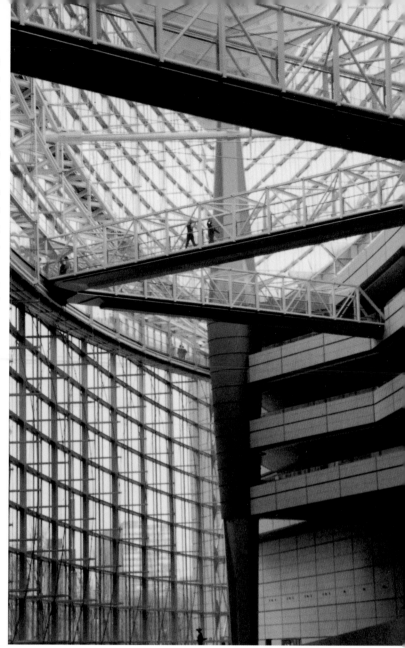

Tokyo Forum

pride. Similarly, the incompetence of the local and central governments in the reconstruction program after the Koge earthquake two years ago undermined people's confidence. The recent seizure of the embassy in Lima renewed this feeling of vulnerability as well as borderlessness.

Book stores are as crowded as ever. I visited the megastores where millions of books are on display at any time. They are all quite similar. The first floor sells the best sellers, current publications, and magazines. The second floor is devoted to paperbacks, the third floor to technical stuff, the fourth to the same in the humanities, and the fifth to books in foreign languages, meaning English and a few German and French books and periodicals, rather randomly chosen. The top floors deal with maps, art reproductions, videos, CDs, and such. And inevitably a coffee shop. Thus the size of the crowd widely varies. The business section is mobbed, while the now-downsized critical theory and history shelves are scarcely attended. Fiction seems to sell well, but it is definitely of mystery and romance types. Canonic books—both Japanese and Euro-American—had zero customers at every visit I made to any of the four or five megastores of Tokyo.

The general decline of mainstream artists and writers does not mean of course that there is no one engaged in exploration and representation. Sumiko Haneda, the only female film director in Japan now (or ever), has been coming up with numerous breathtakingly fresh and candid views of aging people in Japan. The examinations of Alzheimer patients, nursing homes in Scandinavia and Australia, Japan's earliest labor activists born around the beginning of the century, one of the oldest and grandest Kabuki actors follow one after another. The last film takes eleven hours to watch, yet it is immensely popular among an increasing number of devotees. She tells me that she is now about to complete another work, which records the participatory decision of a small village to organize a care system for the aged financed and managed by the villagers themselves. Recognized both at home and abroad at last, Haneda's art offers counter-evidence to the pervasive pessimism. Yuko Tsushima, one of Japan's most serious fiction writers now, recently edited a French translation of vernacular Yukara poetry of Japan's indigenous Ainu race, published by Gallimard. It is rare among today's busy Japanese writers to spend time and energy for a minority literature. And her efforts are not reciprocated. Of her three books translated into English, two are out of print. In fact, there are very few English translations of Japanese fiction in print now. Of course, there is always a possibility that today's Japanese fiction has no appeal to the outsiders—as well as those inside. Tsushima says with a smile, "But I have to keep writing."

People surge on the streets. That is the cause and effect of their homes being usually drab and comfortless. Their homes are small as a rule. But even the larger houses often have no room for people, being jam-packed with unconsumed goods piled up everywhere. Few flowers and framed pictures are in sight in most homes as if such frills are not needed in their lives. Instead people are always out on the streets, not necessarily shopping but looking around. Tokyo buildings are chaotic, at times creating stunningly exciting effects of incongruity, ingenuity, and vitality. There is, for instance, a Shinto torigated shrine building with a row of restaurants and taverns on the lower floors. More organized projects—like the gigantic Shinjuku Tokyo Sub-Center, embodied by Kenzo Tange's domineering City Hall, or the Bayside Sub-Center Project, Tokyo's answer to London's Docklands—are frightening in their lifeless immensity. A new Shinjuku cluster of department stores is beginning to attract shoppers, but the huge Bayside is virtually deserted. I visited Arata Isozaki, the architect, and his wife Aiko Miyawaki, the sculptor, in their elegant living room with a deck open to a deep verdant yard. Aiko gave me some of her new drawings, delicate and surprisingly traditional. I told Iso that I liked Rafael Viñoly's new Tokyo International Forum. Its soaring glass-and-steel form is sumptuously provocative and singularly inviting alongside the grim square-boxes that house elite corporations. He bemusedly answered, "The Forum cost one and a half billion dollars, the same amount as the City Hall. It's one of the five *sodai gomi* of the economic bubble built by the City Government." The term means "bulky trash" and is supposedly used by a wife to describe her husband in retirement. Iso stressed that he did not mean to condemn Viñoly's design, just its costs. Actually he writes somewhere that Tokyo is contourless, and a sharply outlined structure is bound to get lost in the vast spread of the city.

On a warm December afternoon, people are busy preparing Christmas Eve parties and shopping for New Year gifts. Among dense harried crowds everywhere, there is always someone, male or female, running breathlessly as if trying to catch a departing train, barely dodging slow pedestrians. As least they seem to know where they are going.

Edgar Honetschläger

This film will or ought to be the last chapter of my stay (re-search?) in Japan and my trip as a whole. It will build the third leg of the tripod on which I will be able to take a final photograph. 1) *Schuhwerk* (plaster plate project), 2) *Chair project* (I sent you a video), 3) *MILK*.

After finishing this project, I am intending to end my odyssey for a while—three and a half years in the United States and almost four years in Japan. I am—after all that—longing for Europe and will probably return to "my contient" in November, using Vienna as a base—I will have plenty of things to do over there. I have been collecting

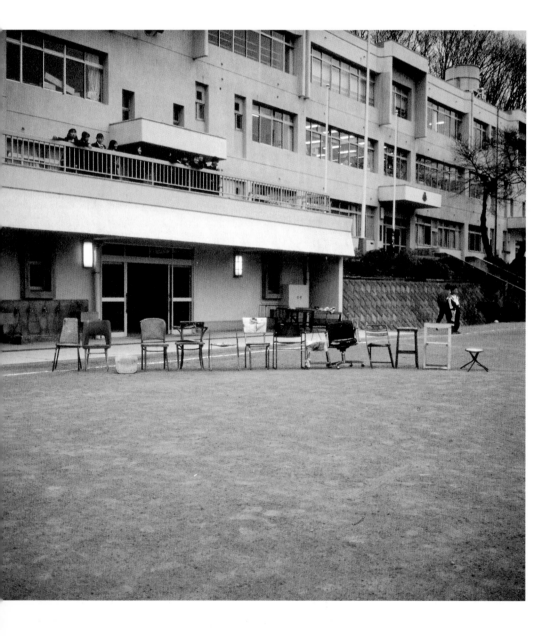

materials on how Europe is being perceived from other angles of the world and want to incorporate those views into my work in the future.

Upfront I would like to drop a view notes on what this movie wants to do:

Japan is a strange country. A country which—in what it represents at the present time—is actually younger than America. It is a country with a very confused identity or no identity whatsoever. The Japanese have succeeded in colonilizing themselves—and in this have done a better job than all those Asian countries which were physically colonized by European nations.

of the 20th century—they did not want to stand in the way of reorganizing a society and hinder an upcoming generation from taking new ways. Till then the Japanese had considered the Christian intruders barbarians, because they found materialism inferior in comparison to their philosophy based on Confucianism and honorability.

Today Japan is—as I call it—a communist country with a capitalist face. Everybody is being taken care of—everybody gets a job—but the people as a whole are poor. The money is all in the hands of the government, the big corporations and the Mafia—together they form one block. The major responsibility for this can be accounted to

Edgar Honetschläger, *97- (13+1)*, 1994-1997

There are two major breaks in later Japanese history. The Meji restoration at the end of the 19th century. Japan had closed its borders for 300 years of Shogunate and was then literally broken open by the Americans. Radicals back then even demanded that the Japanese should give up their language and their writing—switching to the language of the future—English. Once again it was the Western technological advantage that made an "inferior" nation obey and give up its virtues. WW II was even more devastating for the Japanese people, at the end of that war thousands of Japanese committed suicide collectively, because they knew that this was the final end to a system that had prevailed even through the first part

American interests. The US has succeeded in putting one party (the LDP reigning in this country since the end of WW II) in the lead—a party of corrupt old men strongly affiliated with the Mafia. Till today they are pulling the strings by having set up an educational system that blindfolds the people. The horrific prices in the country are part of that suppression too—also manipulated by international money markets led by the US. Going deeper into this topic would be worthwhile, but it would lead me astray from what I am trying to sum up here in a few lines. The Japanese as tourists appear to be rich to Westerners, because they spend a lot of money. But considering that they have about one week of holidays to consume per year, they

have saved quite a sum the year over. No wonder that they—also being the best disciples of materialism—spend loads of money. Nevertheless at home they live in rabbit hutches and never find time to contemplate their lives. The wealth of this country has never been passed on to its people. Most Japanese react to Westerners with a mix of inferiority complex and arrogance. The West sets the standards of "beauty" (what human beings ought to look like) and "know how" in terms of technology till today. The Japanese arrogance derives from a thousand year old culture which Japanese always use as a joker card when discussing their attitude toward the West.

What Roland Barthes wrote some 30 years ago hardly has a meaning anymore. His observations on Japan are beautiful and with some insight, considering that he only spent a very short time here, but he tends to romanticize (like most Westerners) a country which is mysterious—espacially to outsiders who never came here or have spent a very short time. Yes, the signs and characters they use here create different metaphors and definitely demand a different approach in terms of understanding, but the very popular mystification of Japan just adds to misunderstandings which are all too welcome in the West. And the Japanese themselves add substantially to all those Western stereotypes and preoccupations. For instance eroti-

cism in the Japanese literature—aside from infantile mangas—it is a topic that tries to draw a picture showing the hidden depth of the Japanese libido. For me it is nothing but a sublimation for something which does not exist at all. Both hemispheres continuously promote this picture—but in a system as rigid and body unconscious as the Japanese, how should people develop something which comes even close to wishful thinking? They are masters of masochism—which can be seen throughout their history—considering how they made suicide an artistic tool to serve the community (Maurice Pinguet) and how they die from overwork at their office desks today.

The Japanese have taken up to look at themselves not with their own eyes, but with eyes Westerners have implanted and they are dictating their world crammed full with paradigms which do not originate within themselves.

MILK

In its form this film is very flat—no climaxes as in the Western tradition. It starts at some point without really introducing the characters or building them up, and ends without any conclusions. Many sequences weaved together forming a pattern that should make up

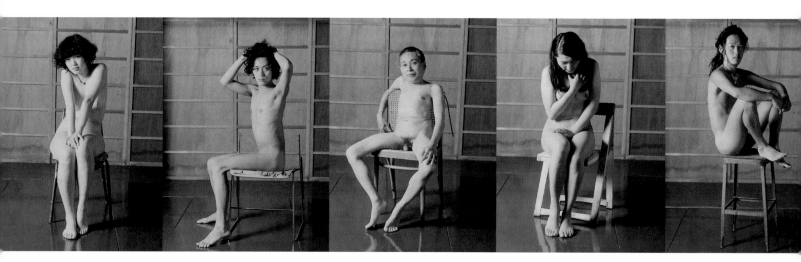

a picture as a whole. The script is simple as can be, just a basis to filming. There will be a lot of improvisation and I have chosen actors who guarentee turns and twist in the storyline. The picture will be plain, in an attempt to stay away from extremes that are most wanted in a global society that drowns in boredom. It observes the obvious carefully, somewhat like looking at an iceberg: by its peak sticking out of the water one is able to calculate the total volume of ice. Yanaka—the old town of Tokyo—becomes an important character, with its historical sites sandwiched between the commotion of everyday life and commerce.

Milk stands for the Westernization of Japan—it was the Westerners who introduced dairy products to the Japanese archipelago. The very first scene very obviously explains this through its symbolism. The American character tries to understand through intellectualizing her environment, but does not realize that "Logos" (Ratio) is no means of finding a key to this country. The European tumbles naively through the Japanese reality but somehow succeeds in getting a glimpse of what the secret to understanding the different metaphors might be. He falls for the mysticism though and willingly dives into it, because he is curious to the point where he starts to destroy his own illusions. The Japanese girl is all confused and reflects the lack of identity the most. Kind of a Mickey Mouse—a symbol which the Japanese have grown to like more then the Americans. She was raped at a certain point and that forms her mind, gives her the quickiness, but explains her hiding from reality. The jogger is a carricature of the wide masses of Japanese salarymen who broke under the weight of the system, but pretends in accordance with the system that everything is alright.

There is no coherence in this movie, no conclusions are drawn, there is no violence, no sex, no passion, maybe somewhat of an obsession on the European side but not definable where it comes from, where it goes and hard to figure out what it is really aimed at. The characters form a odd square, representing individual views and not building a plot at all.

What do we give culture as "visitors" to it, and what do we take from it by the fact of our presence? Further does "internationalization" make us all somehow exiles even in our own countries? Two questions among many this film is asking.

From a letter to Catherine David.

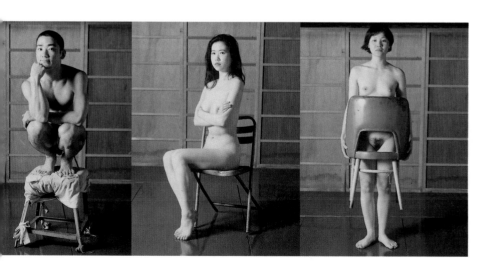

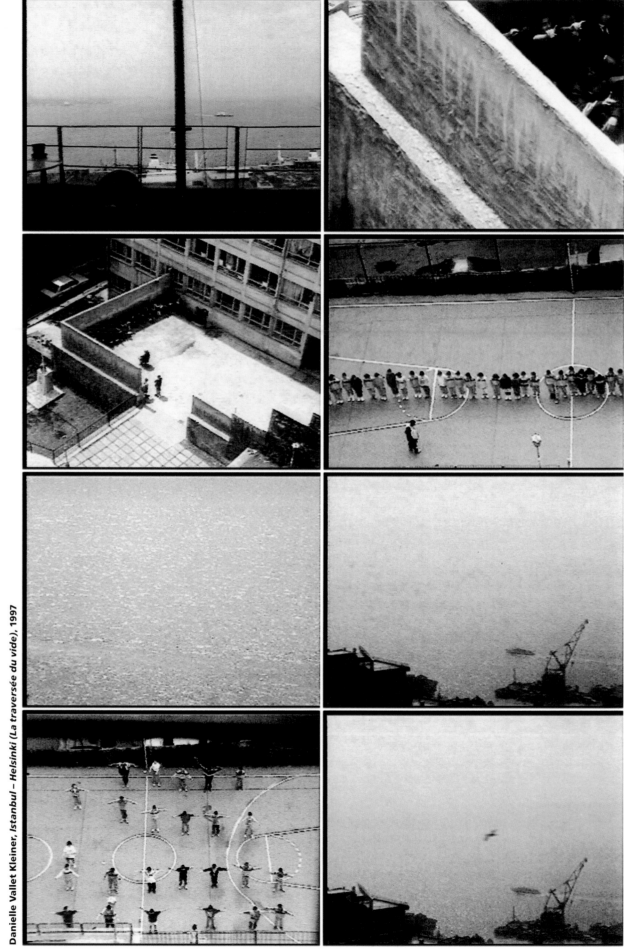

Danielle Vallet Kleiner, *Istanbul – Helsinki (La traversée du vide)*, 1997

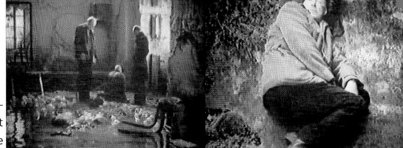

Andrei Tarkovsky, *Stalker*, 1980

Jean-Marie Chauvier
USSR: Society in Motion

Words are lacking to voice the emotion, the moral upheaval provoked by the revelation in the late eighties—of what? Stalinist crimes? To put it that way says so little of the human losses, of the spiritual damage, of the collective wandering and lost illusions, and even more, of the suppurating wound of repressed Stalinism. Ten years before was "too early": the people were not ready. There was a consensus of repression. Ten years later would have been too late to hear the last living witnesses, the generations branded in their very flesh. By the mid-eighties it was high time to lance the boil. And by a paradox inherent to the history and character of the country, the order to "render justice" came from the same communist party led for thirty years by Stalin himself. They would lead to purification those who had despaired, who had sometimes damned the party, and who today call out not for vengeance, but at least for reparation, or for national *repentance*.

It was not—or was not yet, or was not only—a historians' debate. It was a torrent of horrifying revelations, stories of shattered lives, long-contained anger: all the photographs that came out into the light, the lost relatives and friends, and one's own truth that had to be shouted aloud to the immediate surroundings. This is what cold and distant observers, or uneasy "officials," called the "settling of scores" or the "excesses" of glasnost.

It is true that when an indignant Moscow magazine cries out against those who still dare to leave "the greatest criminal of all time" buried in the glorious Kremlin cemetery, it does not only denounce a scandal, but also twists the knife in the wound.

Indeed, the debate over Stalin does not merely pit the "torturers" against the "victims." That a few odious figures among the purveyors of pain still live, that Molotov or Kaganovich—notorious trigger fingers—should have ended their days in gilded retirement, that other surviving killers should not yet be unmasked, all that swells the country's shame, its moral defilement. And calls for justice. But the country is less confronted with the problem of criminal impunity—which could have been resolved ten or twenty years before, when many officials directly responsible for the Stalinist repression were still alive—than it is plunged into a veritable identity crisis. The older generations, especially, have terrible difficulty with the memory they must today rebuild.

Just imagine if this cry against "the greatest criminal" had gone up in Paris, London, Brussels, or New York—in 1945. The response would have been anger. Was Stalin not identified with Stalingrad, with the victory over Nazism? For many Soviets—including the victims of Stalinism—the image has remained of the victor, the builder, the Father. Despite everything. What is more, not only the personality of Stalin is at stake here, but a multitude of individual destinies. When Liudmila Gurchenko evokes the musical atmosphere of the thirties, she is not cultivating any "Stalinist nostalgia." As an actress in many of the best films of recent years, she transmits the innermost vibrations of a generation that believed and struggled, with Stalin or despite him, people who have "nothing to blame themselves for," if not the col-

Jean-Marie Chauvier
USSR-Russia 1991–96:
Societies in Motion

For decades, Russo-Soviet society has not ceased to be a society in motion, in transformation. The upheavals of the First World War, the revolution, and the civil war, the reconstruction process of the twenties, the violent Stalinist transformations of the thirties, the 1941-45 war and the reconstruction that followed, the rapid economic development that gradually slowed and stagnated: these are the great landmarks of a dazzling and deeply traumatizing social history.

An agrarian society with a predominately rural population was torn from serfdom and traditional village communities and thrust into an urban, industrialized world in the space of a few decades. The years 1950-70 prolonged these transformations on the cultural level, though at a somewhat slower pace.

Though unarguably raising the standard of living and providing broad coverage of social needs, the urban and educational revolution also accumulated the "time bombs" of extensive growth oriented toward the satisfaction of first necessities: the quality of life declined (in ecological terms), education and health care proved unable to meet the new demands, discontent grew in the face of the "bad life" in the cities, where numerous indispensable goods and services could not be supplied by a non-commercial economy. The Soviet model began to run out of steam. Stagnation set in during the middle seventies; the major infrastructures date from the years 1950-70: factories, machines, sewer systems, and transportation networks, endlessly aging housing, all still in service in the nineties. The burden (and the defeat)

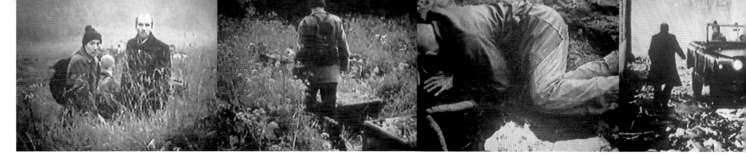

lective error, the lack of discernment, the mental confusion into which they strayed. Very concretely, the denunciation of Stalinism today means taking stock of their lifetime, looking painfully into their own conscience.

The result is a state of shock—as one can well imagine, knowing how many sought refuge in the comforts of oblivion, in the idealization of the past, or in the famous "balance" which maintained that the Soviets, all things considered, had nonetheless built a country and won a war, while bearing on their shoulders (and at what price!) the "fate of humanity," saved by the USSR from Nazi barbarism.

One can well imagine the surprise, knowing that in 1985, at the moment of the fortieth anniversary of the Soviet victory, the appearances of Stalin on the documentary screen or the mentions of his name in the official speeches, though rare, were still greeted with waves of applause. True, many people were biting their tongues, resisting the glorification. And despite what was written in the Western press, there was no "rehabilitation" other than that of the military leader whom Stalin incontestably was during the Second World War—and even that was very discreet. But nonetheless.

The "Stalin taboo" was the precise expression of an impasse very deliberately chosen under Brezhnev. The files couldn't be opened without the risk of toppling the state, calling the party and its entire history into question. Nor could the ex-god be decently be put back up on his pedestal, because that would risk another destabilization: millions of Soviets, managers and high-ranking military officers, had only accepted the silence over Stalin as a lesser evil, the price to be paid for tranquillity. That was the compromise, it had—at least—to be respected.

And nobody expected the taboo to be so quickly shaken. In 1985, the initial outlines of perestroika seemed to demand extreme prudence concerning the delicate questions of the past. Gorbachev maintained the taboo, at first. Did he not declare in June 1986: "The wounds must not be reopened"? The wounds were reopened. Hardly had the party leader spoken these words than a news magazine wrote: "To keep silent . . . cannot help society. By filling the gaps left by the State's prohibitions . . . the people can separate itself from the past, in laughter and in pain. The important thing is that this laughter and pain be lived openly." The months that followed saw less laughter than pain. The wave of publications on the terror began to come crashing down. There were prohibited books from the past, first among them Akhmatova's *Requiem*, evoking the martyrdom of Russian women before the doors of the prisons in 1937. Novels by Aleksandr Bek and Wassily Grossman also came forth—the latter reflecting, in *Life and Destiny*, on the analogies between fascism and Stalinism. There were new books, too, like *The*

of military competition with the West contributed to this final decline.

Next, the society went "into motion" again in the spheres of both labor and of culture, developing ideas that gradually escaped from the control of the single party, to reveal aspirations as diverse as they were destabilizing.

The period of perestroika (1985-91) was an attempt to respond. It was not without positive results (glasnost, the citizens' movements) but it did not succeed in replacing the old system by a new, more viable one.

Boris Yelstin's "revolution" blazed the trail toward the alternative that seemed inevitable, capitalism, at once because there was no practicable third path and because the reforms had to submit to two converging pressures, the first from the world market and the international financial institutions, the second from the nomenklatura and the businessmen, impatient to take the "great leap" that would transform them into a new owning class.

This turn toward capitalism included three essential aspects: the dissolution of the USSR on the initiative of Moscow, which allowed for Russian "sovereignty" over the principal Soviet assets situated on Russian territory; the "liberation of prices" allowing for a multiplication of Russian income from petroleum and gas and a new distribution of the profits; and the privatizations, thanks to which public assets became the property of their former managers and of nascent financial capital, at very "interesting" prices. The former "parallel economy" linked to corruption and the black market took advantage of the occasion to whitewash its funds, legalizing illicit capital which, thanks to the ultraliberal policy decisions and the shortcomings of the state sector and the fiscal system, was able to move into all sectors of activity, often with the help of veritable criminal organizations and high-ranking complicity.

These three aspects caused a partially voluntary, partially involuntary reduction of industrial and agricultural produc-

Children of Arbat by Anatoly Rybakov, the political-literary event that would fill the newspapers all throughout the years 1987-88. The rumors swelled to the point where the unspeakable was finally voiced: the traitors of the 1936-38 trials, Bukharin, Zinoviev, Kamenev, Rykov, and others, the companions of Lenin, executed and expelled from the history books—yes, even the "devil" Trotsky, the incarnation of Judas in the Stalinist vision of history—all these forever accursed names would be pronounced again. Some of them would even be rehabilitated. The idea had barely taken form before the Soviet Supreme Court, in the Fall of 1987, proceeded to rehabilitate the victims of the great trials. And yet in November 1987, while condemning the Stalinist crimes, Gorbachev still recommended restraint in the judgments brought against history. There would be no "restraint"—except perhaps the eight months during which censors blocked the television broadcast of *Trial*, which was finally aired in May 1988. This gripping documentary followed the earlier broadcast entitled *More Light*, an archival montage which for the first time showed a TV audience the face of Trotsky in his role as a revolutionary leader. *Trial* called a few old Bolsheviks to the witness stand. And the widow of Bukharin herself read the moving testament, learned by heart at the moment when the "party's prized child" (as Lenin called him) dictated it to her shortly before his execution in 1958.

Shocking images.

In a few months, the edifice built by decades of official history was demolished. Hundreds of millions of books, textbooks, and brochures were suddenly disqualified. The young learned that they were being lied to at school, and if they knew or guessed already, they heard their fears confirmed. At the gates of summer, 1988, the history examinations were canceled, in waiting for new textbooks. But who would write them, with everything changing so fast?

One man became the spokesman for this wrenching revision, proceeding to a vigorous drumbeat. His name was Juri Afanassiev. He was rector of the Institute of History and the Moscow Archives.

In his eyes it was a problem of "social ecology." Mutism was not only a scar on historical science, but a scar on the social conscience: "We often educate people whose single rule of behavior is to never take anyone at their word." The refusal to envisage one's responsibilities to history leads to irresponsibility in everyday life: "Our mentality of helplessness and neediness, our lack of initiative, our moral apathy, our arrogance and nonchalance, our lack of a sense of responsibility all originate here . . . The lack of a sense of historical responsibility leads sooner or later to a similar lack in the realms of economy and morality."

Afanassiev rent through dogmas one after another, discrediting the entirety of official historical production. As easily imagined, his sallies were far from being unanimously appreciated among the historical establishment. Some of its members—authentic and honest researchers—also doubted whether all this sound and fury really had anything to do with the study of history, and did not serve instead to justify a political volte-face, with Stalin playing the role of scapegoat. But as Boris Kagarlitsky wrote, "in no other society do events and historical personalities raise such polemics of such acuity . . . History

tion, with the national revenue of Russia and of most of the former Soviet republics falling below 50 percent of the 1989 levels. Russian industry slumped to the level of the fifties, and the mean per capita consumption of food products rolled back to the level of thirty years before—while at the same time, of course, it exploded for the rich, who were now able to benefit from imported products, to the detriment of local farmers. It must be stressed that the imports from the West are underwritten by credits from Western countries, to the profit of the intermediaries as well as the public powers (like the municipal government of Moscow) who take abundant cuts on everything from German sausages and Belgian vodka to the colonization of central Moscow and Saint Petersburg by Western real-estate firms. A fringe of the population is delighted. The fallout in jobs and "tips" is considerable.

Inequalities are deepening between branches and regions. Cities like Moscow and Saint Petersburg enjoy the lion's share of capital and foreign investment, which essentially goes to the tertiary sector and to real estate. The "Gazprom" sector has been the largest beneficiary (in both financial and political terms), with exports bringing in strong currencies; but little of the profits are invested in the redevelopment of the country and indeed they are partially deposited in foreign banks, as are those from the pillage of raw materials, commerce, and financial and real-estate speculation.

Some 10 percent of the former Soviets (and perhaps 50 percent of the inhabitants of the capital) have benefited from these changes, and 1 to 2 percent of the Russian population (some 1.5 to 3 million) can be considered "nouveaux riches," often very rich indeed. A third of the population has been thrown below the "poverty line" which, in the new official definition, is equivalent to the strict minimum of physiological survival. On the whole, more then 80 percent of the population has seen their living standard tumble between 1991 and 1996. The drop in the standard of living is accompanied by a profound social regression: the suppression of many of the collective services supplied by the old system, including the almost-free lodging and transportation, as well as the spread of unemployment, with women and children as the first victims.

Among the indicators of this terrible regression is the drop—which has been brutal since 1991, even though it was already perceptible before—in the average life span (now at 57 years for men), along with a rise in mortality due to crime, suicide, new epidemics, and above all, the pandemic

plays a unique role in the consciousness of our society, which has no analogy in the contemporary West."

This great rummaging of the archives raised serious questions.

A Moscow engineer: "Is there really nothing positive in Stalin's activity? After all, he was not at the head of a gang of criminals, but of the largest state in the world. If everything is really as it has recently been represented in the press, then our parents have been deluded, and our children continue to be deluded."

The rummaging and the questions resounded like violent blows for those who still tenderly and nostalgically remembered the moment, not so long ago, in March 1953 when the entire Soviet Union (and not just the Soviet Union: Picasso, Neruda, Aragon, Brecht, China, hundreds of millions of people all over the world) shed tears over the death of the "Father of Nations."

A teacher: "I had just come back from the school when a low and solemn voice suddenly poured from the loudspeakers in every street, announcing the news of his death. I couldn't believe it. I saw people struck dumb. I was eighteen years old. I began to run like a madwoman. People left their houses, flooded into the streets, lost, panicked, with tears in their eyes. It was something like what we had been told on the morning of June 22, 1941. At the door to my apartment, women were crying. My mother was overcome . . . It was like that. I don't know what to think today. Every family suffered. But we adored him. The Russians are a dark people; he raised them higher. He was cruel. But just."

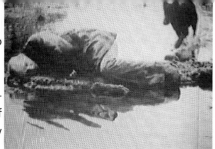

Andrei Tarkovsky, *Stalker*, 1980

The Repression: A New Accounting

Before going further: what exactly are we talking about? To which historical events did the debates in the years 1987-88 in the USSR refer? Let us try to list them precisely. These debates initially concerned the acts of repression which had come partially to light at the 20th and 22nd party congresses, in 1956 and 1961:

—The assassination of Kirov, in December 1934, the departure point and pretext of the "great terror." The investigative commission formed after the 22nd party congress had already concluded as to police provocation, led by the police chief Yagoda, but without any formal proof that Stalin was the instigator.

—The trials of the years 1936-38, which culminated in the physical liquidation of Lenin's principle companions, including Bukharin, Zinoviev, and Kamenev (Trotsky was assassinated in exile in Mexico), as well as hundreds of thousands of party, state, police, and Red Army officials (including the field marshals Tukhashevsky and Blucher). More than a million communists are believed to have been arrested from 1935 to 1940, including four-fifths of the party members from 1917 or earlier. Among those who succumbed were 110 of the 139 central committee members elected at the 17th congress in 1934. It is no exaggeration to speak of the *destruction of the Bolshevik party,* including both the former opposition factions which had already been politically vanquished and many party cadres who were loyal to Stalin.

—The deportation of entire peoples, either suspected (the Volga Germans) or collectively accused of collaboration with the Nazis (the

of alcoholism which has reached previously inconceivable proportions. Culture too has been shaken. Although avant-garde letters and arts, a new theater, and even experimental filmmaking have asserted themselves, thanks to the total lifting of the old censorship, the creators and distributors are facing the new censorship of the market. The great mass of the population is now reached only by television and its new imported mass culture, which is the major cultural development of the nineties. Reading has declined, and with it the production of books, cultural journals, and newspapers. Most film studios are ruined or condemned to subcontracting for foreign producers. The cultures and alternative forms of expression that blossomed in response to the earlier system have necessarily lost their function and their influence. Beyond the economic barriers to the cultural participation of "simple people," their very interest in culture and in intellectual debate has plummeted, precisely to the degree that most ideas and utopias outside the sphere of market values have lost legitimacy and space for existence.

Thus the curve of Soviet development, after the slow decline of the years 1970-80, has taken a major plunge. At the same time, transformations have occurred, with the emergence of a new commercial and entrepreneurial class, the explosion of formerly underdeveloped commercial activities, the blossoming of advertising, photography, video, fashion, and luxury books—in short, an aestheticization of everyday life. A Russian "jet set" society is now present on the international scene. These "new Russians" offer a brightly colored if not seductive image, light-years away from the country's heartland, which is sinking into Third World conditions. Will Russia become a second Brazil, another Turkey, indeed, a repeat of reformist China? Will South Korea or Pinochet's Chile provide the lessons? No model perfectly fits the future, and the present, if it continues, leads closer to something like Zaire . . .

Danielle Vallet Kleiner, *Istanbul – Helsinki (La traversée du vide)*, 1997

Crimean Tartars and various North Caucasus populations). Though certain limited facts of active (police) cooperation are undeniable, as also among the Russians and the Ukrainians, the very fact of the amalgamation and the deportation was judged monstrous. Though certain peoples were able to return to their lands of origin, others were not.

To these elements, which had already been broadly made public under Khrushchev, new accusations were added:

—The trials which, since 1918, had decimated the technical and economic intelligentsia opposed to the "great turnabout" of forced industrialization and forced collectivization: the Shakhty engineers in 1928, the "industrial party" in 1930, the "Mencheviks" in 1931, etc.

—Collectivization itself. Either for its methods, or in its principle. "The number of victims is evaluated at 5 to 10 million," according to the sociologist Evgueny Ambartsumov. A television program estimated that 3 million farms and 15 million peasants were affected by "de-Kulakization" in one way or another, through forced enrollment in the kolkhozes, deportations, or the exodus to the cities.

—The repression against the Soviet fighters in the "International Brigades" on their return from Spain.

—The dramatic consequences, at the moment of the Nazi invasion in June 1941, of the decapitation of the Red Army (40,000 officers, 80 percent of the army chiefs) and of Stalin's refusal, after the non-aggression pact with Germany in 1939, to take under consideration the warnings from abroad and from his own agents (such as Richard Sorge) about Hitler's plans for aggression against the USSR.

—The strictly military errors committed during the war.

—The fate of the Soviet prisoners in Germany, for whom Stalin refused the protection of the Red Cross (relative as it was), and the deportation to Siberia of half of the 1.7 million survivors of the German camps (3.7 million having died there). The fact of surviving the camps was often interpreted as a sign of "treason" or "cowardice."

Thus it was not only the "bad" Stalin of the terror but the "good" Stalin of the victory over the Nazis who was violently accused, and very frequently with the authority and prestige granted by a uniform—under the signature of military officials. The anti-Stalinism of 1988 was also a moment of vengeance by the Red Army against the Stalinist police.

The anti-Stalinist movement did not hesitate to criticize the 1939 pact, not only for Stalin's "naiveté" toward Hitler, but also as an expression of a policy of compromise with fascism—a policy that turned its back on the alliance with the Western democracies which the (also liquidated) minister of foreign affairs, Maxime Litvinov, had attempted to put into operation. (It is true that this policy was contradicted by the Munich compromise of 1938 when the Western democracies delivered Czechoslovakia into Hitler's hands.) Going further back in time, to the years before Hitler took power, Stalin's "under-evaluation" of the Nazi danger (his sectarianism toward the social-democrats) allowed certain authors, and not the least, to speculate that with a different communist policy, Hitler and the Second World War could have been avoided.

Last but not least, the Soviet party-state, in its campaign against its leader from the years 1924 to 1953, made all attempts to reestablish

Even from the viewpoint of the liberal reformers and the nomenklatura, the objectives of the reforms have not been attained. There has not (yet?) been an industrial comeback on the path to modernization, except perhaps in telecommunications and the automobile maintenance business, everything that might meet the needs of the "new Russians" and the foreign investors. Russian capitalism is heir to a Soviet industry and intelligentsia which still offer much in the way of hope; but as the years pass and the new capital is increasingly confined to parasitic commercial activities or out-and-out pillage, Russia and most of the other republics are losing the chance to make a fresh start. One sees very little in the way of a new middle class that could serve as the "custodian of the free market and of democracy." Indeed, not only are the old, the sick, and the unskilled laborers sacrificed (as planned, without any soul-searching); the teachers, researchers, and engineers are also sinking into poverty and disqualification. Vast human and intellectual potential risks being ruined by massive social devaluation, provoking a fatal break in the transmission of skills and knowledge. No doubt an entire generation, that of the children born or schooled since 1985, is already largely compromised. Millions of children, abandoned and/or shut out of the schools, wander the streets or are gathered into makeshift shelters entirely devoid of resources. And this terrible decay has not dissuaded the government from a new series of draconian budget cuts in 1997. What is more, a majority of wage earners only receive their salaries after several months' delay. Work stoppages and strikes are on the rise: the fall of 1996 saw the largest movement of wildcat strikes in all of Russian history. Of all this, the media say nothing, quite to the contrary of their attitude during the glasnost period of 1985-91.

Under these conditions, a great number of Russians feel disoriented, desperate, even victimized by an "international plot" aiming at the destruction of Russia. Indeed, Yeltsin's "reforms" are inspired, to a degree, by the IMF and the American experts. The flight of capital (and the brain drain) to the West far exceeds the aid received, which itself swells the debt of future generations.

Humiliation, desire for revenge, xenophobia, antisemitism, fear of Islam and of the Caucasus peoples: these are the "normal" consequences of such a situation. The most surprising thing is that the Russians have not yet been tempt-

Aleksandr Sokurov, *Mother and Son*, 1997

its "Bolshevik," Leninist, pre-Stalinist continuity, by politically rehabil-itating Nicholas Bukharin and other companions of Lenin who were killed in the purges. Here the distinction falls between the civil reha-bilitation of the trial victims, the restitution of the historical facts (from which Trotsky himself benefited), and *political* rehabilitation: Bukharin, a partisan of "market socialism" *avant la lettre*, could now appear as one of the spiritual forefathers of Gorbachev's reforms. Ultimately, the entire theory of the "balance" between Stalin's "mer-its" and "errors" was finally rejected. The supposed "merits" disap-peared, as we have seen with the war; and even the USSR's industri-al development and cultural revolution were relativized, to say the least:

—The pace of industrial development calculated in physical values for steel and various consumer goods was revealed to have been slower during the first five-year plan (1929-1932) than during the NEP (1923-1928). The national income, from 1928 to 1941, was reevaluated at lower figures: no longer multiplied by 5.5, as in the official statistics, but only augmented by 36 percent. Such a reevaluation upset the classical view in the USSR and among many foreign economists.

—Less subject to debate was the terrible intellectual bloodletting, where the physical destruction of the flower of the intelligentsia was accompanied by that of entire branches of the sciences and the arts:

Economists: Kondratiev (the famous "cycles") and economic plan-ning, Tchayanov and agricultural cooperation, later Voznessensky who had organized the war effort, without forgetting the prohibi-tions of cybernetics, of the linear planning developed by the future Nobel prize winner Kontorovich (whose theories would be applied in the United States), and of the Moscow school of mathematics.

Pioneers of the social sciences: Gastev, the founder of the Institute of Labor, the historians Pokrovsky and Lukin, demographers, jurists, psychologists, and psychoanalysts: all disappeared into a black hole, and with them, the research in each of these fields.

Biologists: Vavilov and genetics, condemned to the profit of the charlatan Lysenko.

Physicists: Tamm, Landau, and others, deported.

Engineers: the imprisonment of airplane constructors (Tupolev), mis-sile specialists (Korolev, Kleimenov, Langemark), and factory direc-tors. Repression also weakened the military potential.

Writers and artists: The assassination of the brilliant stage director Meyerhold, of the writers Issac Babel, Boris Pilniak, Titsian Tabidze, and many more (five to six hundred writers were killed), without forget-ting those pushed into suicide (Mayakovsky), into silence, poverty, revilement (Bulgakov, Pasternak, the poets Anna Akhmatova and Olga Bergholtz), the filmmakers Eisenstein and Dovjenko, the avant-garde

ed by violent revolts. The past experience of war acts to dis-suade them. The Russian population has admirably resisted all provocation to violence—and there is no lack of such provocation in political circles. The situation in Chechenia is an exception, but this atrocious war has largely been refused by the people. The absence, for the moment, of massive unemployment, the relative persistence of the Soviet social structures in the large enterprises, the art of getting by, and a thousand and one microstrategies of sur-vival help explain this very fragile "public peace." To which must be added the lack of union organizations worthy of the name and the de facto absence, on the terrain, of political parties and organizations (excepting the communists), as well as the constant search for a modus vivendi, for com-promises on the regional level or within the businesses, plus the tax strikes and various other forms of resistance to the central power.

In any case, Russo-Soviet society sees no other perspective before it than "the market" and "integration to world civi-lization." The conditional promises of Western credits and investments have had an enormous impact, as has the sup-port of Western governments and media for Boris Yeltsin, demonstrating that "communism is irrevocably dead" and that "world civilization" is unreservedly behind the "new Russian democracy," that is to say, the oligarchy in power. Any backsliding is therefore out of the question. Even the communist and nationalist opponents see the future in the framework of "the market place" and "Russian greatness." To rebuild the USSR is a chimera: Russia has no interest in doing so, and the other republics have already opened up to new commercial and cultural spaces, even if the Soviet and Russian inheritance remains very strong in human terms.

What is not out of the question, on the other hand, is one form or another of "national capitalism," with the reactiva-

painters and architects of the twenties . . . the list is endless. Notwithstanding various efforts to "be useful to the country" and even sometimes to please the ruling power. Aleksandr Fadeev, the author of the acclaimed novel of resistance against the Nazis, *Young Guard*, committed suicide in 1956 after the revelations of the 20th congress.

Catalogued since the late sixties in the work of the historian Roy Medvedev, this intellectual genocide splashed over into the pages of the newspapers and magazines in 1987-88. Light was shed on the processes whereby certain schools and artistic or scientific sects made use of the ruling power to get rid of rival groups. Fingers were pointed at those high-ranking researchers in history and the social sciences who, still recently, did their best to falsify the historical record, check creativity, and break down those who sought its rebirth.

That intellectual life survived all that—even under Stalin—only proves the extraordinary vitality of this country where, as Elsa Triolet said, "talent sprouts like a weed but is compelled to hide like a violet."

Intellectual life survived, but more than that. The denunciation of the terror consisted not only in the cool catalogue of terminated lives, not only statistics that make your hair stand on end. It was something quite different than an indictment, a list of charges: it was the restoration of memory in flesh and blood, complete with ideals that had lived through the tragedy and its paradoxes. Dozens of figures, unknown until just the day before and withdrawn from oblivion, stepped forth as the actors of a collective adventure into which they had immersed themselves body and soul, with all the hopes, illusions, and blindness of a now almost incomprehensible era.

Nothing is less appropriate to this first period of Stalinism than the metaphor of the "deep freeze," which is perhaps fitting for the second wave, after the war, when the passions had cooled and the ideas petrified into the concrete dogmatism of nationalism and totalitarian ideology, with intellectual life reduced to the extreme poverty of "Jdanovism."

The first five-year plans and the war that followed—with Stalin and despite Stalin—are the "years of lava." They are the years when the steel flowed, when characters were tempered, when the incandescent social structures and mentalities were unmade and remade again—when the flames of the revolution were not yet extinguished, when the Stalinist presses and coolers had only begun their work.

The denunciation of Stalinism, so legitimate, so necessary, leaves in the shadows not the "positive aspects"—as though the cultural revolution could be detached from the terror—but instead, whole chapters of a society's history. To cite just one example: the Stalinist Gulag is now perceived above all as a machine to politically crush all adversaries. But it also and perhaps above all a device to *put to work* and to exclude marginal elements, a device which is typical of a primitive phase of industrialization. Who will write the history of all the poor outcasts, the vagabonds, the "underworld" that formed a much more populous mass than the other prisoners, a mass which was often hostile to the "politicals"?

From: *URSS: Une société en mouvement*, Paris: Editions de l'Aube, 1988.

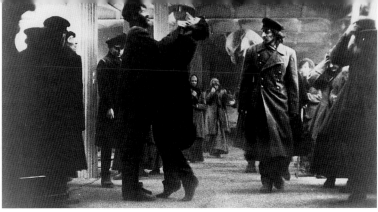

Aleksandr Sokurov, *Whispering Pages*, 1993

tion of statism and the recomposition of a geopolitical and commercial space according to the ties that history has knitted among the diverse peoples of the former USSR. But would the West accept this reconstitution of a Slavic or post-Soviet ensemble? Would a capitalist and relatively Westernized but powerful and nationalist Russia be acceptable? Whatever their political and social choices, the Russians who are still concerned with getting their country back on its feet have understood that "nobody's giving any gifts." So they are ready for the possible replay of another cold war. This time they will have to assert themselves not against "world capitalism" but against American, German, Turkish, or Japanese influences "on the borders of the empire," or even at the very heart of Russia. And yet for any national reconstruction to take place, the great regression would have to be halted, a new collective project would have to come forth, capable of giving back hope and mobilizing the creative forces of the country. The current chaos could then finally become productive. As it stands, that chaos mirrors the pseudo-therapeutic shock-treatment "reforms" of the period since 1991: it is essentially destructive.

Serge Gruzinski

Europa: Journey to the End of History

"When we saw the land through our inner vision, it seemed full of vast shadows, plunged into the confusion of transgression and utter disarray."

Toribio de Benaventa, known as Motolinia

A Strange Zone

A speeding train. No one knows where it is coming from or where it is heading. Like the image of raw, indeterminate time flowing without origin or end. Soon the hypnosis carries the spectator into a period wrested from the incessant flux that sweeps across the screen. The defeated Germany of 1945 is the subject of Lars von Trier's film E*uropa*.

Europa confronts the fascinated spectator with the chaos of a nation bled white and barely emerging from totalitarianism, devastated by war and thrust into the unknown, prey to a nameless future. In this deliquescent world, embryonic reconstruction is barely visible beneath the rubble. In the darkness, under the absent sky, as the snow casts its deathly pall over the ruins and water seeps, stifles, freezes, and dissolves, crowds ground down by fear and hunger fill the screen. One thinks for a moment of the teeming, wretched, and clammy lower depths of *Blade Runner*, a film with which *Europa* has a number of affinities.

The Germany of *Europa* is a "strange zone" (Lars von Trier). It is emblematic of those intermediary worlds that emerge in the aftermath of catastrophe, lost between a system in collapse and a still uncertain recomposition, brutally imposed by the triumphant West. These theaters of cruelty, these improvised and unpredictable scenes, these societies (if that is the word) are engendered by the sudden leaps and jolts of Western civilization. As early as the sixteenth century, the Spaniard Toribio de Motolinia described the first "strange zone" of Modern Times—the Mexico subjugated by Castille and her conquistadors—in words that convey the destabilizing effect of invasion: "When we saw the land through our inner vision, it seemed full of vast shadows, plunged into the confusion of transgression and utter disarray."

Or perhaps, as Von Trier does in *Epidemic*, we need to go back to the Middle Ages and the Black Death to find a comparable upheaval.

Today our frontiers give on to societies in transition. There are those that, at the end of the eighties, the fall of the Berlin wall caused to proliferate in central and

eastern Europe—hybrids torn between the collapse of the communist system and the jungle of the market, where instability compounds an advanced state of decomposition. Over the ocean, the great cities of Latin America are given over to neoliberalism and, close by, our urban peripheries present other examples of these ruptures or accelerations. Less spectacular, perhaps, but just as disconcerting.

In many places the unpredictable disorder of things and minds creates such a tangle that the word *fractal* comes spontaneously to mind when seeking to define such societies.

A Fractal Society

A fractal society is horribly complex. It escapes the clear distinctions of classical analyses. In fractal societies, roles are obscure, ambiguous, equivocal: today's vanquished are yesterday's masters and, for many, tomorrow's collaborators. The Germany of *Europa* is no exception. Identities are blurred: is the heroine (Barbara Sukowa) on the other side, or not? Victim or Nazi? Willing victim or soul of the struggle against the American occupier? In the blurring of ideological bearings, in the scrambling of allegiances provoked by the will to survive, a human and political no-man's-land comes into being where the usual distinctions grow hazy. It is the accelerated transition from one *nomenklatura* to another. The distortion and perversion of human relations becomes the norm. Men kill each other to survive:
"Germans killing Germans."
In the train of *Europa* Nazi children murder a person who is collaborating with the victors. A Jew is barely out of the camp before he must again endure the ordeal of humiliation: the American occupier forces him to clear the boss of the railway company even though, as we know, the man was up to his neck in complicity with the Nazi regime. Denazification—conducted like a brief ritual—becomes a masquerade; perverted from its original function, the act of purification serves only to strengthen the bond that ties the German to his new American masters.

Other murky relations: does the American general denazify the defeated boss out of sympathy or compassion, or with a view to making him submissive and grateful, the better to control a figure who is indispensable to national reconstruction? It hardly matters that the humiliated German refuses "to face reality" and prefers to commit suicide rather than tolerate the humiliation and dependence scantily hidden by the new arrangements. Nazi or anti-Nazi, collaborators are interchangeable, providing they further the interests of the victor.

It hardly matters, because the web of interests and compromises is immediately rewoven. While the father does away with himself, the daughter (Sukowa) is seducing the young American Leo (Jean-Marc Barr). She gives herself to him, outstretched on a miniature Germany crisscrossed by broken or dismantled railway circuits. The seduction, lying, manipulation, and veiled confessions continue the struggle begun by the dead father but in another mode. The metaphor of a defeated Germany fascinating its conqueror is clear, immediate. It fills the screen in the powerful, stylized manner of old allegories.

Collapse plunges status into anarchy—a lowly employee but an American, Leo is accepted by the masters of the Railway and ends up marrying the boss's daughter—just as it disrupts the world of faith. Catastrophe reduces religion to the form of a precarious rite condemned to the secrecy and fervor of the catacombs, and sometimes exposed to bloody repression. Celebrated in a ruined church, Midnight Mass is more like the Eve of Apocalypse than the fervor of new beginnings. Already, *Epidemic* had set out to show the reality of Christian ritual as last resort, however pathetic or parodic, and its ineluctable failure. In these strange days, religion cannot be absent, but it is no more than an impotent and ineffectual semblance.

This ubiquitous and protean chaos also extends to the categories of genre: Von Trier implants Viscontian and Wagnerian tragedy here (the father's suicide, a distant echo of *Götterdämmerung*) or injects expressionistic horror there (the "partisans" shot alongside the railway, the concentration-camp silhouettes of the "ghost" car), and readily scatters romantic glitter on the ambiguous relationship between Leo and the German woman. But this aestheticism is simply a more sophisticated form of hypnosis. In order to hold together this patchwork of never fortuitous reminiscences that form the key moments of our modernity, signs and metaphors follow on in an allusive accumulation that has the insistence of baroque emblems: the train, the clock, the bridge, the

ocean. Their chill, funereal fulgurance has the darkness that bedecks the visions of Peter Greenaway.

This universe of disorder covers the debris of an order that still spreads itself over maps and uniforms, that reigns on in barracks and dormitories and bombed-out stations: the European order of Nazism, the order of railway networks, the order of capital, bureaucratic norms. Under the rubble of the New Order there still vibrates the order of the everyday, banal fascism, mired in the obsession of routines and paperwork, possessed by the mania for regulations and exams. Modernity in every shape and form, alternately grotesque and red-taped, totalitarian and homicidal, haunts the film like a haggard monster, a reassuring nostalgia, a paternalistic and deadly grayness.

Order, Chaos, Survival. Chronologically, *Europa* is tucked into a cranny, a parenthesis of modernity; just after the collapse of Nazism, but just before the American, liberal reconstruction of Germany. This is a period long before the world crystallized around the Wall, before the Berlin deadlocked in the division that Wim Wenders could still depict in *Wings of Desire* (1987). This past is closed in on itself, surrounded by other pasts. Slipping in between modernities, *Europa* prefigures a fractality that *Wings of Desire* and *Blade Runner* could only adumbrate, the one secreted by the postmodern part of our world. But that is not all.

Contamination of the Imaginary

While it is true that this chaotic, deliquescent universe recalls others in the past or in preparation, its intense evocativeness remains disturbing. This is because *Europa* touches on a not-so-distant past, that of Nazism, but even more because the vision it confronts us with is intolerable. The film itself gives us due warning when the German woman tells Leo "I want to test your tolerance." Throughout the film, we are perturbed by the reversal of roles whereby the Nazis become resistants and the "liberating" Americans become the occupying force. The vision presented by Lars von Trier would indeed be perfectly unbearable had the filmmaker not used all the hypnotic resources of his art to make the spectator a captivated voyeur.

More than any other episode in the more recent past, the outcome of World War II against Germany was ideally suited to the Manichaean scheme of things: the American liberators had slain the Beast of Nazism. The roles were clearly divided, the values limpid: the facts brooked no contention, unsullied by the apocalyptic blunder of an atomic deflagration. The sacralized monstrosity of the Holocaust ensured the inviolability of this salutary denouement. Moreover, the victory of 1945 founded an order whose effects we are still living with today, the *Pax americana*.

With its political actors long since dead and the numbers of witnesses dwindling fast, this portion of the past was ripe for inclusion among our Western—and now universal—myths, alongside World War I, the Russian Revolution, and the Mexican Revolution. Especially given the spate of fiftieth anniversary celebrations (1944/1994, 1945/1995).

Europa is thus a "live" intervention on a period that is in the process of mythologization. Von Trier's construction throws a monkey-wrench into the works by compacting images and memories. This destabilization of the imaginary is all the more unsettling in that it applies to bits of the past that are sufficiently vital to be easily reactivated. As it plows across the Germany of the immediate postwar years, the train of *Europa* transports visions stolen from the world of the concentration camp: skeletons in convicts' rags, piled up on pallets. The postwar and Nazi pasts are articulated like the compartments of the train. They confuse the spectator about the meaning to be given to these false archive scenes: are they denouncing the exterminatory function of the Nazi railways? Are they suggesting a subversive and perverse parallel between the Holocaust and the fate of the occupied German population? Or are they deliberately mixing different episodes?

Other implicit comparisons, other unspoken analogies jostle in the spectator's memory. In only a few years the liberators of 1945 will become the aggressors of Korea, of Vietnam, of Panama. For years, American soldiers were confined to the role of occupants and invaders in our imagination (see *Apocalypse Now*). How come they managed to escape these roles when they overran defeated Germany? The images of *Europa* bring to mind an episode my father often used to mention, which was probably his most awful experience of World War II: American soldiers going into a wild dance as they

scalped a German. The historical horror was not only where we expected it to be. *Europa*, or the forgotten prodromes of American imperialism: Germany, Vietnam—same repression, same combat?

It is surely no coincidence that the making of *Europa* is contemporary with the colossal work of deconstruction, in every sense of the word, that is currently pulverizing memories of the Russian Revolution, consigning into nothingness and absurdity the founding myths and historical references of a part of modern humankind.

The Viewpoint of the Vanquished

In this context, such an argument would be banal if it were no more than "deconstructive." But Von Trier produces an alternative narrative that is gradually transformed into a "viewpoint of the vanquished": that of the Germans crushed by the American occupier. Since the frontiers between these "victims" and the actual Nazis are vague or nonexistent, we are—implicitly, then by suggestion, and then overtly—caught up in the Nazi experience of defeat.

It is a perilous path, even if Von Trier does elude both inveterate Manichaeisms and revisionist ravings. The approach would be revisionist if the filmmaker set out to construct, to reconstruct and to impose his "authentic version" of history by a simple inversion of values. It would remain Manichaean if he went no further than to film the fascination of evil (*The Night Porter*). But instead he applies himself to making us approach something alarming. His vision—for this is no "version"—refers not to the Truth but to experience. It is based not on a meticulous inquiry into the authentic, but on the power of hypnotic suggestion. We are left to encounter the Other on the edge of the abyss.

Unwittingly, Von Trier interweaves paths that are familiar to me. At the borders of history and ethnography, historical anthropology has taught us to relinquish the attempt to exhume "objective reality" in favor of the different experiences generated by an event. The viewpoint of the victors has been supplemented and sometimes supplanted by the *viewpoint of the vanquished*, for this is often preferred by the author and his readers. It goes without saying that each approach, both that of the victors and that of the vanquished, has its own

coherence, its logics, its motivations and contradictions: after all, the Mexican Indians used the image of the "torn net" to evoke the repercussions of the Spanish conquest. All historical experiences have their own painful tensions and tragic dead-ends. Thus it has become impossible to consider the conquest of America without seeking to articulate the discourse of the conquistadors and the reactions of the Indians. It has to be admitted that the Aztec practice of human sacrifice had rules as inhuman and as reasonable as the European one of warfare. In the analysis of the traumas and alienation, in the explanation of attitudes, victors and vanquished now find themselves side by side, each with their own singular and irreducible experiences.

Why not 1945? The exploration of the logics and deliriums of the Other—when you try to recreate their subjective reality—demands a suspension of judgment that is in many respects similar to hypnosis. This is the road that *Europa* takes us down, by insistently involving Leo with the viewpoint of the vanquished, a vision that soon merges with the Nazi experience of German defeat. The suspension of judgment could lead to empathy. Without reaching such a paroxysm, it does confront the spectator with a parallel history, both German and Nazi, that cannot be reduced to what constitutes our vision of things, one as intolerable as its logic, power, and tragedy are irrefutable.

The End of History

To shake up the structures of the imaginary, to record the plurality of voices and experiences, to measure the fragility of scales of values—this is a hazardous undertaking. It can be deadly. It sweeps away the belief in a single, sovereign, and linear history developing in a uniform, irreversible pattern. The real is contradictory, incomplete, fragmented, and heterogeneous—fractal. In most cases it is refractory to traditional categories of knowledge and all enterprises of sacralization past or present, even those concerning the Holocaust.

This thinking-through of chaos, of contradiction and ambivalence, is all the more difficult in that we rely on a conception of time, on a way of relating and interpreting the past that are still based on the comforting illusion of an underlying order. Revelation, infrastructure, ultimate

Chris Marker, *Immemory,* **1997**

meaning, function, structure, reason, the eternal recurrence of commemorations. Tirelessly, historical knowledge claims to "rebuild," always through words, a reality that is held to be not only plausible but objective, authentic, and singular, that needs only to be slid into preassembled frames: economy, society, civilization, to use the hallowed formula of the Annales School. To this is now added the factitious calendar of commemorations (1989, 1992, 2000) which ends up imparting its own rhythm to the production of history with its calls for impossible reassessments.

Europa marks the fragility, and perhaps even the death throes of these conceptions in two ways: (1) by breaking the chains of these glossy mythologies with their Christian, Marxist, and liberal Manichaeisms and positivist certitudes: (2) by establishing the superiority of the image over discourse, of vision over writing: "For me a film is *about* nothing." The moving image shows what words are incapable of rendering or even suggesting: the irreducible nature of sensory and intuitive reality. It reveals the upwelling of experience and the shifting of the imaginary; it restores the gigantic field of the nonverbal and the irrational.

The end of History, then, not in the absurd sense of a process of evolution brought to completion, but in that of the exhaustion of a common or sophisticated conception of past events that was long secreted by Western modernity.

None of this is easy to accept. How can we admit the plurality of histories, the multiplicity of times and logics (survival, Nazism, or collaboration) without sinking into disillusioned relativism? When there are no clear guidelines, when the train is going ever faster on the rails of time, how will we manage to make our choices before it is too late? In a fractal world, nothing is more onerous than having to live along the abyss. Judging by the lonely death of Leo, the individual is doomed to an absolute impotence that condemns him to sink to the bottom of the ocean.

Meanwhile, other forms of confusion are at work. The frontiers between reality and fiction are blurring. The digital sophistication of virtual worlds and the brutality of reality shows (see Pedro Almodovar's *Kika*) are eroding the structures of our imaginary, swallowing the real in its spectacular representation. The prohibitions on fiction and representation are only just held in place

(Claude Lanzmann's *Shoah*). Von Trier's *Epidemic* described a reality "contaminated" by a screenplay. Peter Greenaway's *The Baby of Macon* deliberately sets out to confuse the spectator, who becomes incapable of sorting out the amalgam of theater, reality, and manipulation presented on its Florentine stage. Fiction, spectacle, and reality are collapsing into one on screens everywhere at the very moment when the spectator is losing the elementary criteria that, in the heyday of modernism, served to distinguish between true and false, authentic and artificial, hypnosis and reality.

Like that of Pedro Almodovar, David Lynch, and Peter Greenaway, the cinematography of Lars von Trier does offer some antidotes to the fragmentation and uncertainty of the age, to the anaesthetizing onset of "weak thinking." For at least it delivers the imagination from the encrustations of myth and the false certainties of history by introducing unstable pasts and chaotic experiences, by breaking the classic progress of narration (*Drowning by Numbers, Lost Highway*), by sketching out other, more lucid and rigorous mental and cultural configurations. The correspondences are too numerous not to be noticed: the reinvigorating perversion of roles and individual relationships (*Almodovar*), the proximity of death and epidemics (*Epidemic, The Baby of Macon*), the delirium of representation, the recuperation and perversion of images, all against a background of derision, metaphor, and flamboyant aestheticism (*Prospero's Books, The Pillow Book*).

Nourished by archives corroded by saltpeter (*Epidemic*), juggling with settings and architectures (*The Belly of an Architect*), these films ransack the huge storehouse of painted and animated images filled by the West. "For me, stealing from the cinema is like using the letters of the alphabet when you write," remarks Lars von Trier.[1]

[1] Omar Calabrese, *L'età neobarocca* (Bari: Laterza, 1987). Do these various works denote the stirrings of a new European imagination, a cross between Nordic and Latin ready to weather the sands of disenchantment? This gestating postmodern or neobaroque vision can tell us more about our present and near future than many other tired discourses still being heard today.

Edouard Glissant – Caribbean Discourse

The analysis of any global discourse inevitably reveals the systematic development of well-known situations (proof for all to see), as for instance on the map of significant situations in the relations between one people and another.

A transplanted population that becomes a people (Haiti), that blends into another people (Peru), that becomes part of a multiple whole (Brazil), that maintains its identity without being able to be "fulfilled" (North America), that is a people wedged in an impossible situation (Martinique), that returns partially to its place of origin (Liberia), that maintains its identity while participating reluctantly in the emergence of a people (East Indians in the Caribbean).

A dispersed people that generates on its own the impulse to return (Israel), that is expelled from its land (Palestine), whose expulsion is "internal" (South African blacks).

A people that reconquers its land (Algeria), that disappears through genocide (Armenians), that is in distress (Melanesians), that is made artificial (Micronesians). The infinite variety of "independent" African states (where official frontiers separate genuine ethnic groups), the convulsions of minorities in Europe (Bretons or Catalans, Corsicans or Ukrainians). The slow death of the aborigines of Australia. People with a millenarian tradition and conquering ways (the British), with a universalizing will (the French), victims of separatism (Ireland), of emigration (Sicily), of division (Cyprus), of artificial wealth (Arab countries).

People who quickly abandoned their "expansion" or maintained it only in a half-hearted way (Scandinavians, Italy), who have been invaded in their own land (Poland, Central Europe). Migrants themselves (Algerians, Portuguese, Caribbean people in France and England).

Conquered or exterminated peoples (American Indians), those who are neutralized (Andean Indians), who are pursued and massacred (Indians in the Amazon). The hunted down and drifting people (Tziganes or Gypsies).

Immigrant populations who constitute the dominant group (the United States),

who retain their identity within the larger group (Quebec), who maintain their position by force (South African whites).

Organized and widely scattered emigrants (Syrians, Lebanese, Chinese).

Periodic migrants, resulting from the very contact between cultures (missionaries, the Peace Corps; their French equivalent, the *coopérants*), and whose impact is real.

Nations divided by language or religion (the Irish people, the Belgian or Lebanese nationals), that is, by economic confrontation between groups.

Stable federations (Switzerland).

Endemic instabilities (people of the Indochinese peninsula).

Old civilizations transformed through acculturation with the West (China, Japan, India). Those which are maintained through insularity (Madagascar).

Composite people but "cut off" (Australians) and even more resistant to other peoples.

Scattered peoples, condemned to "adaptation" (Lapps, Polynesians).

These graphic models are complicated by the tangle of superimposed ideologies, by language conflicts, by religious wars, by economic confrontations, by technical revolutions. The permutations of cultural contact change more quickly than any one theory could account for. No theory of cultural contact is conducive to generalization. Its operation is further intensified by the emergence of minorities that identify themselves as such and of which the most influential is undoubtedly the feminist movement.

From: *Caribbean Discourse* (1981), Charlottesville: University Press of Virginia, 1992.

Edouard Glissant
Caribbean Discourse

Diversion is not a systematic refusal to see. No, it is not a kind of self-inflicted blindness nor a conscious strategy of flight in the face of reality. Rather, we would say that it is formed, like a habit, from an interweaving of negative forces that go unchallenged. Diversion is not possible when a nation is already formed, that is each time that a general sense of responsibility—even when exploited for the profit of part of the group—has resolved, in a provisional but autonomous way, internal or class conflicts. There is no diversion when the community confronts an enemy recognized as such. Diversion is the ultimate resort of a population whose domination by an Other is concealed: it then must search *elsewhere* for the principle of domination, which is not evident in the country itself: because the system of domination (which is not only exploitation, which is not only misery, which is not only underdevelopment, but actually the complete eradication of an economic entity) is not directly tangible. Diversion is the parallactic displacement of this strategy.

Its deception is not therefore systematic, just as the *other world* that is frequented can indeed be on the "inside." It is an "attitude of collective release" (Marcuse).

The Creole language is the first area of diversion, and only in Haiti has it managed to escape this peculiar outcome. I must admit that the controversy over the origin and the composition of the language (Is it a language? Is it a deformation of French Speech? etc.) bores me; I am no doubt wrong to feel this way. For me what is most apparent in the dynamics of Creole is the continuous process of undermining its innate capacity for transcending its French origins. Michel Benamou advanced the hypothesis (repeated in Martinique in an article by M. Roland Suvélor) of a systematic process of derision: the slave takes possession of the language imposed by his master, a simplified language, adopted to the demands of his labor (a black pidgin) and makes this simplification even more extreme. You wish to reduce me to a childish babble, I will make this babble systematic, we shall see if you can make sense of it. Creole would then become a language that, in its structures and its dynamics, would have fundamentally incorporated the derisive nature of its for-

mation. It is the self-made man among all pidgins, the king of all "patois," who crowned himself. Linguists have noticed that traditional Creole syntax spontaneously imitates the speech of the child (the use of repetition, for example, *pretty pretty baby for very pretty child*). Taken to this extreme, the systematic use of childish speech is not naive. I can identify in it—at the level of the structures that the language creates for itself (and perhaps it is a little unusual to treat a language as a voluntary creation that generates itself)—what black Americans are supposed to have adopted as a linguistic reaction each time they were in the presence of whites: lisping, slurring, jibberish. Camouflage. That is the context that facilitates diversion. The Creole language was constituted around this strategy of trickery. Today, no black American needs to resort to such a scenario: I suppose that few whites would fall for it; in the same way the Creole language in Martinique has gone beyond the process of being structured by the need for camouflage. But it has been marked by it. It slips from pun to pun, from assonance to assonance, from misunderstanding to ambiguity, etc. This is perhaps why witticisms, with their careful and calculated element of surprise, are rare in this language, and always rather crude. The climax of Creole speech does not release an appreciative smile, but the laughter of participation. It is by its nature unsubtle, thus demonstrating its link with a persistent practice among storytellers almost everywhere: poetic toastmasters, *griots*, etc. Haitian Creole quickly evolved beyond the trickster strategy, for the simple historical reason that it became very early the productive and responsible language of the Haitian people.

We can find quite logically one of the most dramatic manifestations of the need for the strategy of diversion in a threatened community in the migration of French Caribbean people to France (which has often been described as an officially sanctioned slave trade in reverse) and in the psychic trauma that it has unleashed. It is very often only in France that migrant French Caribbean people discover they are *different*, become aware of their Caribbeanness; an awareness that is all the more disturbing and unlivable, since the individual so possessed by the feeling of identity cannot, however, manage to return to his origins (there he will find that the situation is intolerable, his colleagues irresponsible; they will find him too *assimilé*, too European in his ways, etc.), and he will have *to migrate again*. An extraordinary experience of the process of diversion. Here is a fine example of the concealment, in Martinique itself, of alienation: one must look for it *elsewhere* in order to be aware of it. Then the individual enters the anguished world, not of the unfortunate psyche, but really that of psychic torture.

(There is, of course, the glorious return of those who went "West" [towards the East] and tried to take root anew. This is not the desperate

arrival of the past, after being snatched from the African homeland and the Middle Passage. It is, this time, as if one discovered finally the true land where roots can be reestablished. They say that Martinique is the land of ghosts. It cannot, however, represent return but only diversion.) To be unable therefore to manage to live in one's country, that is where the hurt is deepest.

Diversion *leads nowhere* when the original trickster strategy does not encounter any real potential for development.

(We cannot underestimate the universal malaise that drives Europeans, dissatisfied with their world, toward those "warm lands" that are deserted by unemployment as well as subjected to intolerable pressures of survival, to seek in the *Other's World* a temporary respite.)

Ultimately, Caribbean intellectuals have exploited this need for a trickster strategy *to find another place*: that is, in these circumstances, to link a possible solution of the insoluble to the resolution other peoples have achieved. The first and perhaps the most spectacular from of this tactic of diversion is the Jamaican Marcus Garvey's African dream, conceived in the first "phase" that drove him in the United States to identify with the plight of black Americans. The universal identification with black suffering in the Caribbean ideology (or the poetics) of negritude also represents another manifestation of redirected energy resulting from diversion. This historical need for the creolized peoples of the small islands of the French Caribbean to lay claim to the "African element" of their past, which was for so long scorned, repressed, denied by the prevalent ideology, is sufficient in itself to justify the negritude movement in the Caribbean. This assertion of universal identification is, however, very quickly surpassed, so much so that Césaire's negritude poetry will come into contact with the liberation movement among African peoples and his *Notebook of a Return to the Native Land* will soon be more popular in Senegal than in Martinique. A peculiar fate. Therein lies the diversion: an ideal evolution, contact from above. We realize that, if M. Césaire is the best known Martinican at home, his works are, however, less used there than in Africa. The same fate awaited the Trinidadian Padmore, who inspired in Ghana the man who seized independence, Kwame Nkrumah. But Padmore never returned to his native land, he who was the spiritual father of Nkrumah's Pan-Africanism. These forms of diversion are then also camouflaged or sublimated variations of the return to Africa. The most obvious difference between the African and Caribbean versions of negritude is that the African one proceeds from the multiple reality of ancestral yet threatened cultures, while the Caribbean version precedes the free intervention of new cultures whose expression is subverted by the disorder of colonialism. An intense attempt at generalization was necessary for the two formulations to find common ground: this liberal generalization made it understood that negritude did not take into account particular circumstances. Conceived as a fundamental inspiration for the emancipation of Africa, it never actually played a part as such in the historic episodes of this liberation. On the contrary, it was rejected as such, first in the context of anglophone Africa (which rejected its generalizing nature), then by the radical fringes of the African struggle (perhaps under the influence of revolutionary ideologies).

The most important example of the effect of diversion is the case of Frantz Fanon. A grand and intoxicating diversion. I once met a South American poet who never left behind the Spanish translation of *The Wretched of the Earth*. Any American student is amazed to learn that you come from the same country as Fanon. It so happens that years go by without his name (not to mention his work) being mentioned by the media, whether political or cultural, revolutionary or leftist, of Martinique. An avenue in Fort-de-France is named after him. That is about it.

It is difficult for a French Caribbean individual to be the brother, the friend, or quite simply the associate or fellow countryman of Fanon. Because, of all the French Caribbean intellectuals, he is the only one to have *acted on his ideas*, through his involvement in the Algerian struggle; this was so even if, after tragic and conclusive episodes of what one can rightly call his Algerian agony, the Martinican problem (for which, in the circumstances, he was not responsible, but which he would no doubt have confronted if he had lived) retains its complete ambiguity. It is clear that in this case *to act one one's ideas* does not only mean to fight, to make demands, to give free rein to the language of defiance, but to take full responsibility for a *complete break*. The radical break is the extreme edge of the process of diversion.

The poetic word of Césaire, the political act of Fanon, led us *somewhere*, authorizing by diversion the necessary return to the point where our problems lay in wait for us. This point is described in *Notebook of a Return to the Native Land* as well as in *Black Skin, White Masks*: by that I mean that neither Césaire nor Fanon are abstract thinkers. However the works that followed negritude and the revolutionary theory of *Wretched of the Earth* are universal. They follow the historical curve of the decline of decolonization in the world. They illustrate and establish the landscape of a zone shared elsewhere. We must return to the point from which we started. Diversion is not a useful ploy unless it is nourished by reversion: not a return to the longing for origins, to some immutable state of Being, but a return to the point of entanglement, from which we were forcefully turned away; that is where we must ultimately put to work the forces of creolization, or perish.

From: *Caribbean Discourse* (1981), Charlottesville: University Press of Virginia, 1992.

Jan Duiker: Zonnestraal Sanatorium in Hilversum, 1926-28

Village in the Sahara, photographed by Aldo van Eyck in 1951

My affection for those interior spaces in the Sahara—cool and dark within mild adobe walls—was complemented, never contradicted, by what I feel for the exilharating transparency of Duiker, Van der Vlugt and Rietveld's work. "Man, after all, breathes both in and out." And architecture?—does it do the same? Seldom.

Aldo van Eyck

Aldo van Eyck an

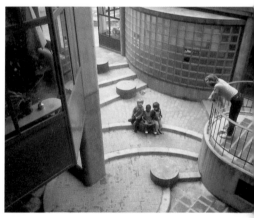

Hubertus House, Amsterdam, 1976-80

Aldo van Eyck has always nurtured a particular interest in traditional cities, the historical towns of Western culture as well as the vernacular settlements of archaic cultures. Unlike his functionalist colleagues of CIAM, he did not consider the traditional city as a residue of an outstripped past, doomed to disappear in order to make way for new rationalist structures, but as a precious heritage, a thesaurus of environmental experience. He recognized traditional cities and settlements as concretized patterns of human interrelations, as built expressions of human values. He felt that all valuable building experience of the past, from the Dogon village to the Palladian church, from Fatepur Sikri to Zonnestraal, should be gathered into the present in order to be implemented in contemporary design thinking. The present must embrace the achievements of the past in order to acquire temporal depth and associative perspective. Yet this does not mean that Van Eyck ever aimed at an eclectic reproduction of historical forms. He always dealt with history from a definitely modern point of view. The heritage of the past has to be understood in a structural way, it has to be recreated with a view to the anticipated future.

Notwithstanding his interest in the past, Van Eyck's cultural view is firmly rooted in the ideology of modernity. He is convinced that contemporary culture has to be developed in accordance with the new world view that was disclosed by avant-garde art and science at the beginning of the century—a world view which he holds to be grounded on one fundamental idea, the concept of relativity. This concept implies that reality can not be considered as having an inherent hierarchical structure, subject to a privileged absolute frame of reference or to an intrinsic center. It means that the coherence of things does not depend on their subordination to a central dominant principle but on their reciprocal relations. In the new culture, every frame of reference must therefore be regarded as equally legitimate, standpoints are relative and as such all are equivalent. In other words, relations between things are as important as the things themselves. This concept of modernity can be related to the past in the sense that classical and archaic cultures, despite their hierarchical character, offer various onsets and anticipations of non-hierarchical structures.

Van Eyck's design attitude towards the urban heritage has been twofold. On the one hand some of his major projects were based on the structure of the traditional city, on the other he always conceived his urban projects as a constructive contribution to the existing city.

The most eloquent outcome of the first attitude was the Amsterdam Orphanage he built in 1957-61, a "large house" which he conceived as a little city. Rejecting the rationalist solutions of CIAM, he designed a complex

ie City

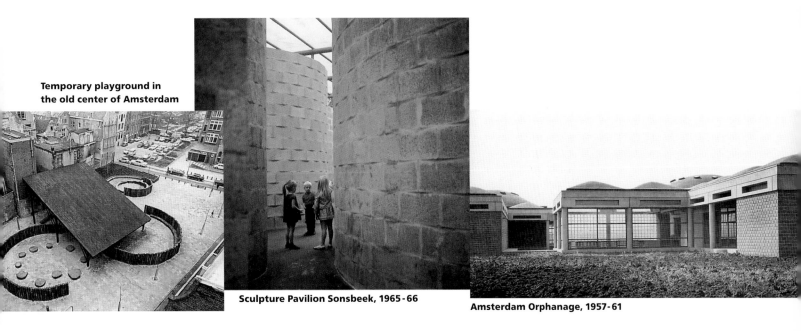

**Temporary playground in
the old center of Amsterdam**

Sculpture Pavilion Sonsbeek, 1965-66

Amsterdam Orphanage, 1957-61

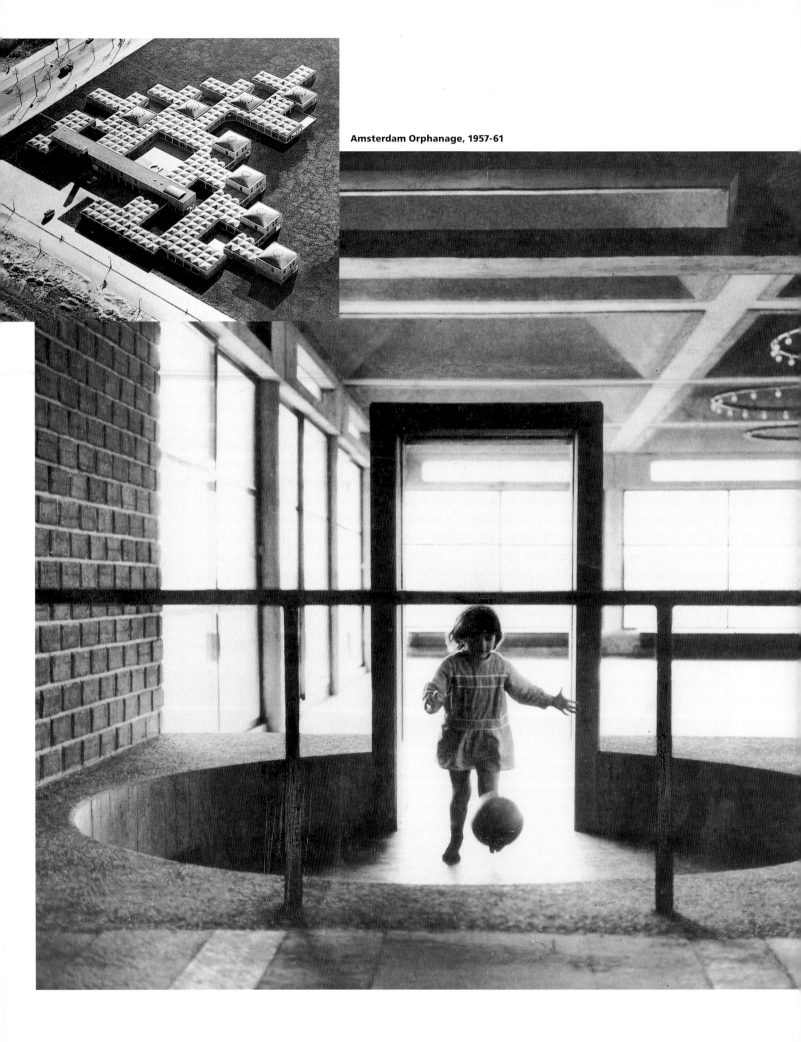

Amsterdam Orphanage, 1957-61

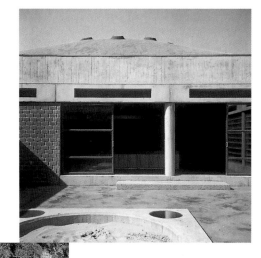

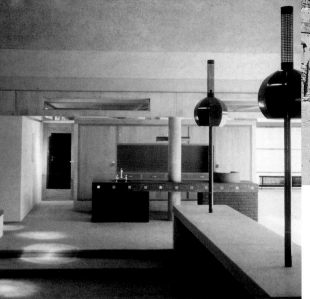

Dogon village

Amsterdam Orphanage, 1957-61

configuration of interior and exterior places, clustered along sinuous internal streets. The interweaving of inside and outside, open and closed, small and large, public and private, results in a truly urban fabric, a polycentric tissue of equivalent places interlinked by "in-betweens" or "doorsteps." The archetypal language of columns and domes evokes the image of an archaic settlement. Yet the interior space breathes the dynamics of De Stijl. Moreover the coherence of this "little city" is confirmed by a structural analogy of part and whole. Both the building as a whole and the "houses" of which it consists turn their back to the north and open through complex indentations to the south, both are conceived as clusters of places which are linked to the outside world by centrifugal squares. In the Netherlands this "configurative" design approach inspired a new architectural current, widely known as Dutch Structuralism, a current evolved

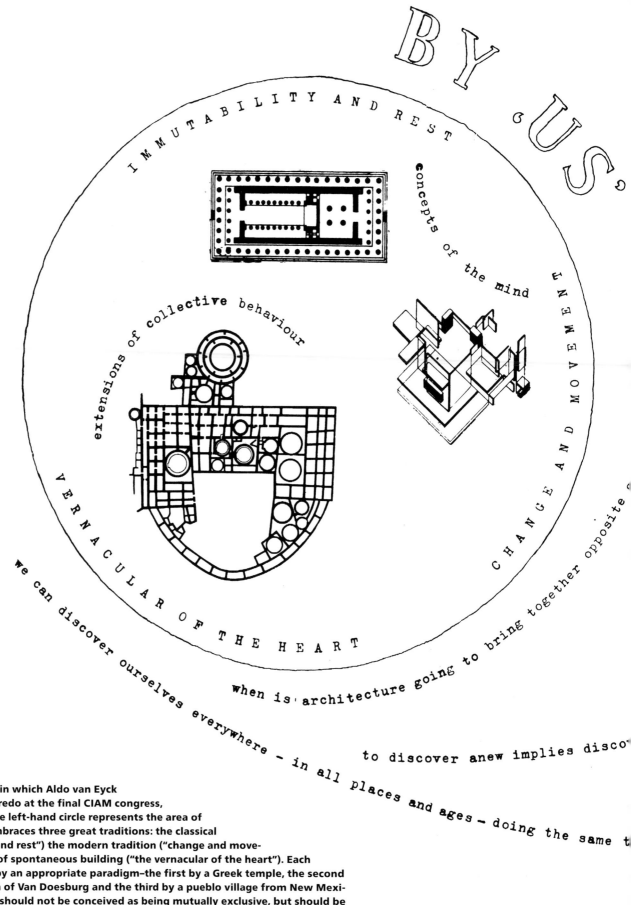

IMMUTABILITY AND REST

concepts of the mind

extensions of collective behaviour

CHANGE AND MOVEMENT

VERNACULAR OF THE HEART

BY US

we can discover ourselves everywhere – in all places and ages – doing the same t

when is architecture going to bring together opposite

to discover anew implies disco

Otterlo circles (1959)
Otterlo circles, a diagram in which Aldo van Eyck
summed up his creative credo at the final CIAM congress,
held in Otterlo in 1959. The left-hand circle represents the area of
architectural form and embraces three great traditions: the classical
tradition ("immutability and rest") the modern tradition ("change and move-
ment") and the tradition of spontaneous building ("the vernacular of the heart"). Each
of them is characterized by an appropriate paradigm–the first by a Greek temple, the second
by a counter-construction of Van Doesburg and the third by a pueblo village from New Mexi-
co–these three traditions should not be conceived as being mutually exclusive, but should be
reconciled. Together they encompass a formal and strutural potential sufficiently fertile to
produce variable answers for the complex reality of human relationships. This human reality
is summarized in the right-hand circle by a picture of dancing Kayapó Indians, symbolizing
the relation, at once constant and variable, between individual and society.

FOR US

FOR EACH MAN AND ALL MEN

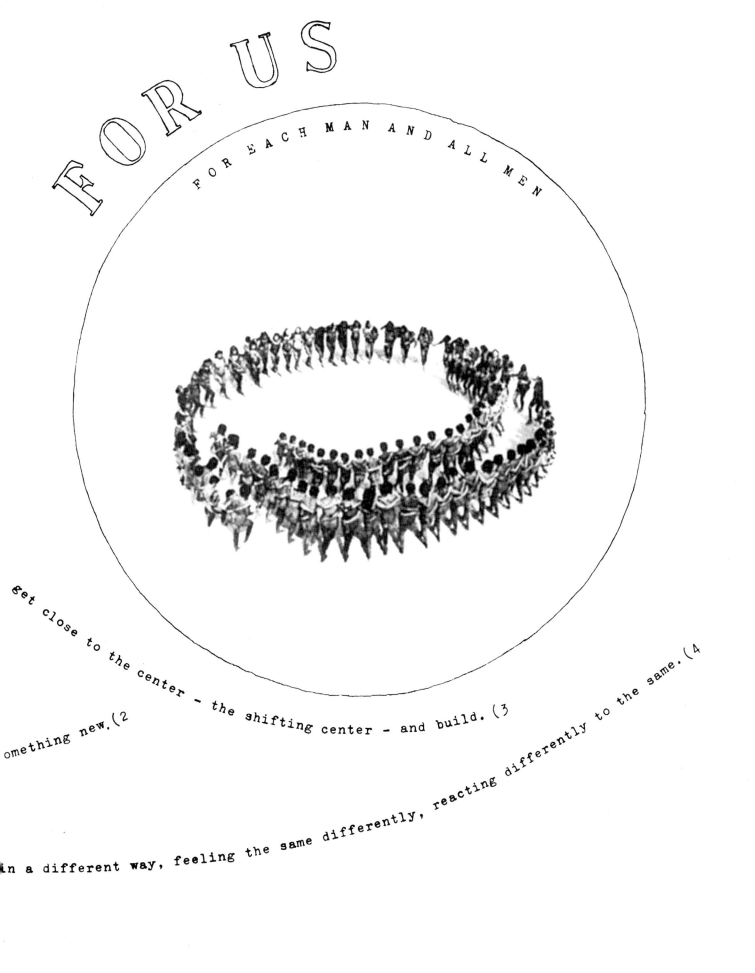

get close to the center - the shifting center - and build. (3

omething new.(2

in a different way, feeling the same differently, reacting differently to the same.(4

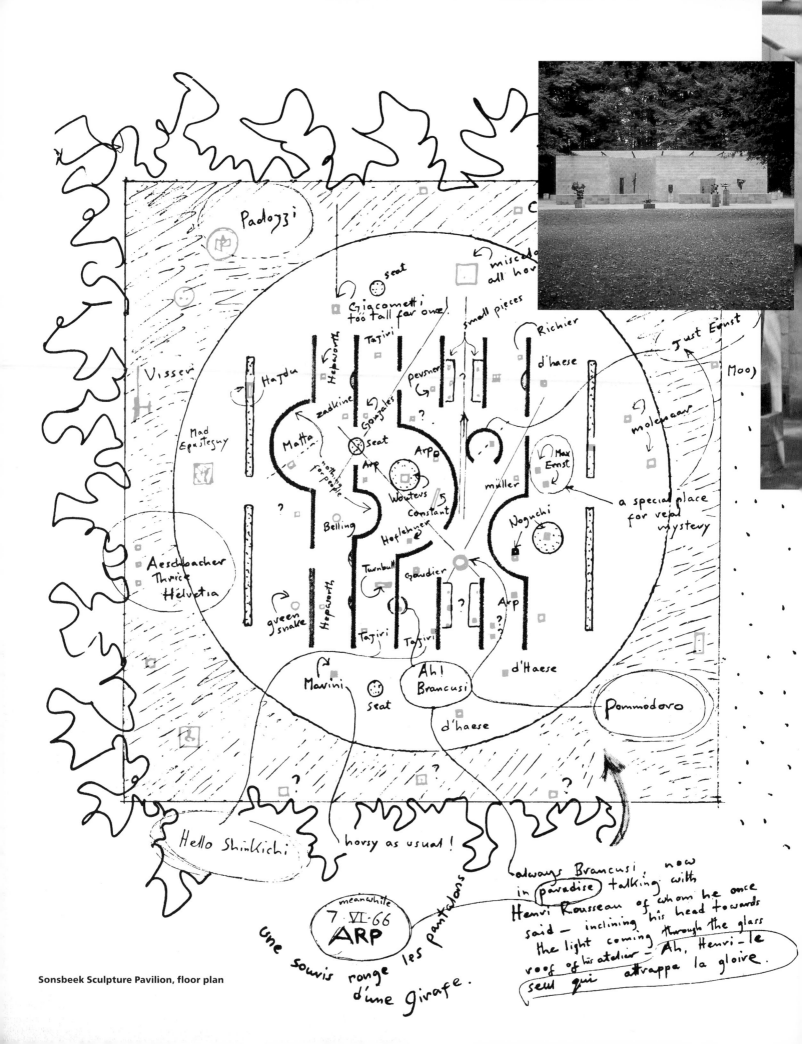

Sonsbeek Sculpture Pavilion, floor plan

Padozzi

seat

miscado
all hor

Giacometti
too tall for one!

small pieces

Richier

Just Ernst

d'haese

Moo)

Visser

Hajdu

Tajiri

Hepworth

pevsner

?

molenaar

zadkine

Gonzales

?

Matta

seat

Arp

Max
Ernst

Mad
Epasteguy

not for
people

Arp

müller

a special place
for veal
mystery

Wouters

?

Constant

Noguchi

Belling

Hoflehner

Aeschbacher
Thrice
Helvetia

Turnbull

Gaudier

Hepworth

?

Arp
?
?

green
snake

Tajiri

Tajiri

d'Haese

Marini

Ah!
Brancusi

Pommodoro

seat

d'haese

?

?

Hello ShinKichi

horsy as usual!

always Brancusi now
in (paradise) talking with
Henri Rousseau of whom he once
said — inclining his head towards
the light coming through the glass
roof of his atelier — Ah, Henri — le
seul qui attrappa la gloire.

meanwhile
7 · VI · 66
ARP

une souris ronge les pantalons
d'une girafe.

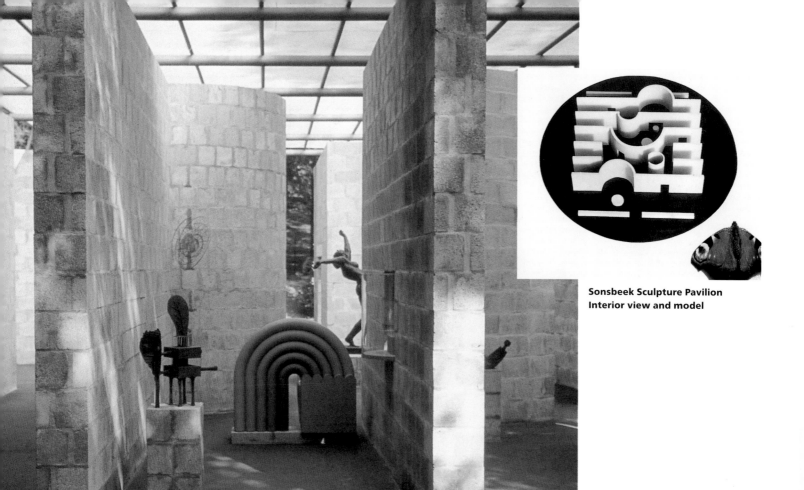

**Sonsbeek Sculpture Pavilion
Interior view and model**

by Piet Blom, Herman Hertzberger, Joop van Stigt, Jan Verhoeven, and several other Amsterdam architects.

Another instance of the first attitude was the Sonsbeek pavilion Van Eyck realized in 1966. From the outside a simple construction of parallel walls, at the inside this building unfolded as a whirling maze of streets and squares, a labyrinth of straight and round, convex and concave, traversed by oblique views. The dynamics of the interior space were produced by a succession of curved walls which burst through the basic structure of parallel walls. Van Eyck wished this small building to possess, like the orphanage, "something of the closeness, density and intricacy of things urban." He wanted it to be city-like, "in the sense that people and artifacts meet, converge and clash there inevitably." So he designed a little city for sculpture and people, a "bunch of places" intended to make the visitor approach and appreciate the works of sculpture from various points of view.

The second attitude appears from the beginning of Van Eyck's practice, notably in the numerous playgrounds he realized in Amsterdam. These were simple, carefully designed urban places, which were laid out on waste lots in the old city, in the interstices of the urban fabric. Composed of elementary forms inspired by Con-stantin Brancusi and Sophie Täuber-Arp, they were cheerful spots in public space. As literally hundreds of them were executed, they formed a kind of network within the urban fabric, a network of places which the child could recognize as his own territory. Nonetheless,

Playground in Amsterdam

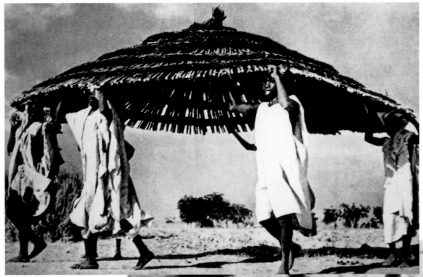

4.20

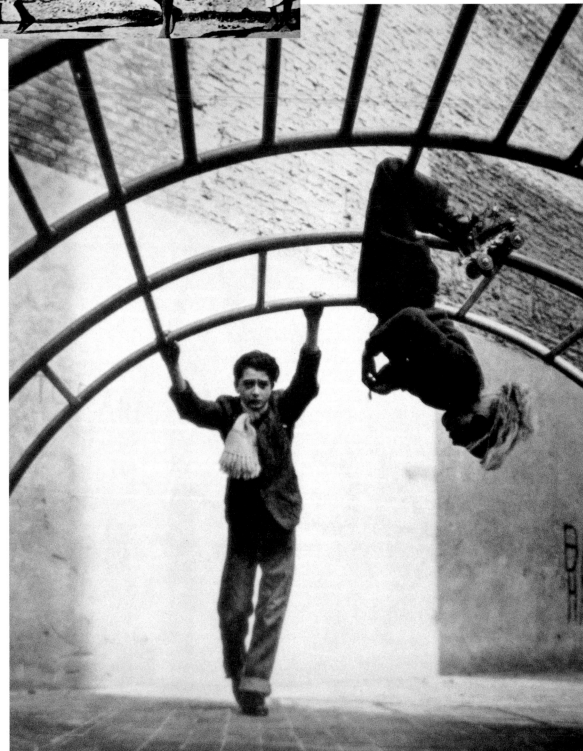

530

Playground in Amsterdam

Wall paintings by Joost van Roojen

since they were furnished with tectonic archetypes such as arches and domes, parapets and benches, they constituted places of a distinct urban character which made sense for the adult as well as for the child.

This contextual approach gained importance during the sixties. The more Van Eyck saw his premonitions about the deficiencies of modern town planning confirmed, the further he distanced himself from the functionalist ambition to design new towns, and the more he became interested in the qualities and the potential of historic cities. He actually was one of the first moderns to regard the historically grown city as a constituent standard for true urbanity. He came to consider the old city center as a "donor" for new town planning developments, as a source of energy for the reanimation of contemporary urban thinking. He concretized this view in the urban projects he carried out from the mid-sixties onwards.

In these projects he recognized the urban context as a basic component of the design concept, an attitude which implied increased attention to the specific character of the project area. For every urban project he closely studied the structure of the site, not only in order to preserve its qualities but also to determine its amenability for other, complementary qualities. He developed the simple but pertinent rule that a new building should never subtract quality from where it is put, but always add quality instead. A new urban project must behave properly in the context it joins. A new building should, through its very form, acknowledge and show apprecia-

tion for the specific qualities of its context. This in no way means that it must imitate its neighbors. It has to legitimize itself by the new meaning it introduces.

Aldo van Eyck first carried out this approach on the scale of a building in his prize-winning competition project for the Deventer town hall (1966-67). From the first sketches onwards, it is apparent that the new building was not conceived as an autonomous entity but as a cluster of differentiated units embedded in the existing urban structure. The units were articulated in accordance with the historic fabric of oblong parallel lots and were covered with open mansard roofs. The components of the plan were grafted onto the existing streets and alleys. Towards the public square the building presented a low volume which didn't compete with the ad-

Site drawing of the Deventer Town Hall, 1966-67

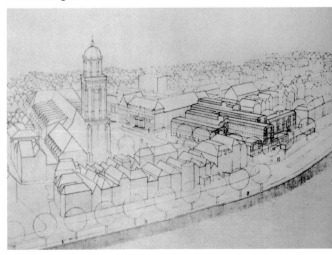

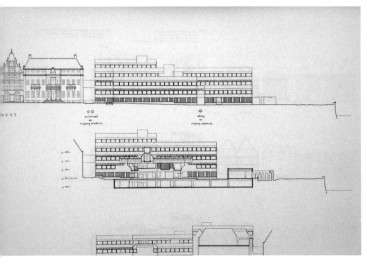

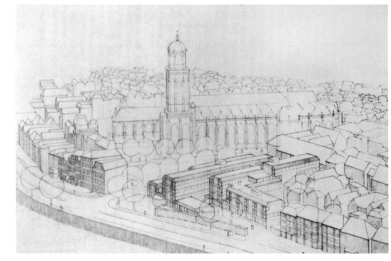

Elevation of the Deventer Town Hall, 1966-67

As the past is gathered into the present and the gathering body of experience finds a home in the mind, the present acquires temporal depth—loses its acrid instantaneity, its razor-blade quality. One might call this: the interiorization of time or time rendered transparent.

It seems to me that past, present and future must be active in the mind's interior as a continuum. If they are not, the artifacts we make will be without temporal depth or assoviative perspective.

This is not historic indulgence in a limited sense; not a question of travelling back, but merely of being aware of what "exists" in the present—what has travelled into it: the projection of the past into the future via the created present.

Aldo van Eyck (1962)

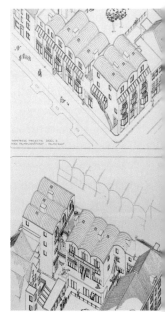

Reconstruction in Palmdwarsstraat, Amsterdam, 1972-80

jacent old town hall, a seventeenth-century building reserved for formal and ceremonial functions. From the River Ijssel it appeared as an ensemble of gabled houses inserted into the riverbank façade. He accommodated his design to the urban morphology by reinterpreting the existing typology. Although he didn't use this terminology, it accurately describes what he achieved in this 1966 design. The project was not executed, but it proved to be of considerable importance in the development of postwar architecture. It was one of the first modern designs for a public building not to be conceived as a negation but as a conscious contribution to the existing historic city. It lay at the root of the urban housing projects which Van Eyck evolved during the sixties in association with Theo Bosch, projects which were diametrically opposed to the prevailing modernist urbanism. Particularly their project for the Amsterdam Nieuwmarkt renovation (1970) was conceived as an alternative to the official plan which involved the destruction of the existing quarter and the construction of an urban motorway on top of the new metro line. The concept they proposed and succeeded in carrying through

consisted in the reconstruction of the original urban fabric, including traditional city streets and differentiated blocks of houses. The project for the Amsterdam Jordaan quarter (1972-80) comprised the reconstruction of four blocks along the existing street. These blocks, which consist of row houses and shops, are opened up at the street corners by means of stairs which lead to terraces looking out onto the backyards.

Van Eyck's contextual approach reached maturity with the Hubertus House, a home for single parents and their children which he designed and built in Amsterdam between 1973 and 1978. The brief for this building was comparable to that of the orphanage but the context was in this case a nineteenth-century street. To shape this contemporary institution Van Eyck did not resort to the symmetrical model of the conventional institutional building. He conceived the building as a transparent link in the urban fabric, as an opening in the existing block giving access to the inside of the city. Far from copying its eclectic neighbors, he confronted them with a lucid functionalist idiom of concrete, steel, and glass—not to take delight in their conflict but in order to reconcile

532

them. The building was not conceived as a discourse on an alternative, entirely new "open" city, but acts as a new component of the existing city. It appears as a refreshing renewal grafted into the old urban fabric. The junction of new and old was realized by the imaginative non-hierarchical application of archetypal connections, a shifted center, a spiral and a transverse axis. The shifted center, which is marked by a recess in the street front, forms the pivot of an asymmetrical equilibrium. It is situated between the new building and the new extension of the old one, an extension in the form of a large oriel executed in the same new functionalist idiom. The glazed recess does not lead to an axial entrance, as might be expected, but exposes the winding stairs which join the different levels of old and new in a suggestive spiral. The new entrance is actually located in the extension of this spiral. It twists in a loop through old and new. Thus the visitor does not reach the interior of the new building directly but via a small detour through the old one—a pattern that is also intended to unite the two counterparts mentally. On the inside the old is linked to the new by a new transverse axis, parallel to the street, a clear-cut view which takes various shapes on the different floors.

The building is not only carefully attuned to its urban surroundings, to some extent it is also conceived as a little city. The children's wing is reached via a top-lit arcade on the first floor, a miniature version of the well-known urban building type. Their lodging is conceived in the form of five little row houses which places them, despite their unusual situation, in a familiar pattern of dwelling. Each of the little houses accommodates ten children and features a double height stairwell with kitchen, a living room with verandah, a bathroom with toilet, and a bedroom.

On the whole the Hubertus House thus does not constitute a homogeneous unity, based on an overall geometry, but a composite one. It embraces several components with a different character. Just like the real historical city it joins, it acts as a kaleidoscope, it displays a complex pattern of various elements, developed through time, which reveal more aspects as one moves about. The building shows how modern architecture can be a positive component in the variety of the historical city. It demonstrates that functionalism doesn't necessarily need to transform this variety into a monotonous isotropic universe. It makes clear how functionalism can be of or become a contextual idiom; how, without denying itself but precisely by returning to its origins, it can learn the language of the city and enrich the urban context with new meaning.

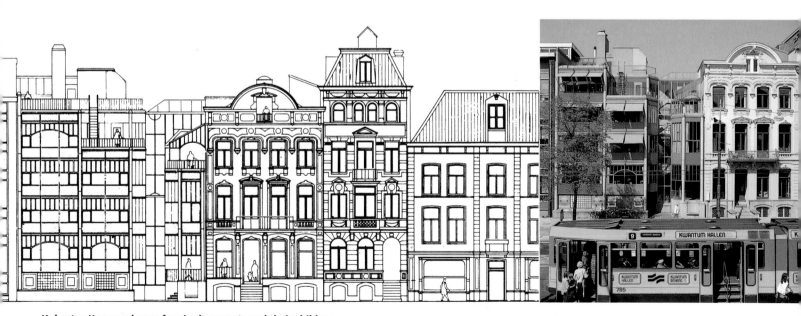

Hubertus House, a home for single parents and their children

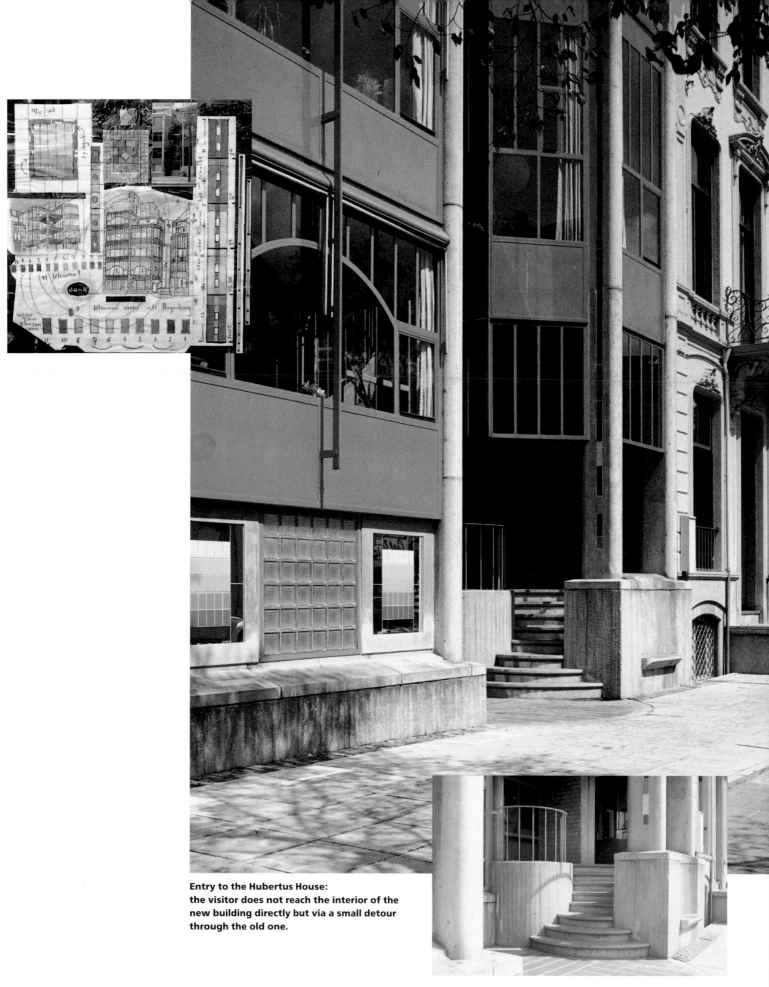

Entry to the Hubertus House:
the visitor does not reach the interior of the
new building directly but via a small detour
through the old one.

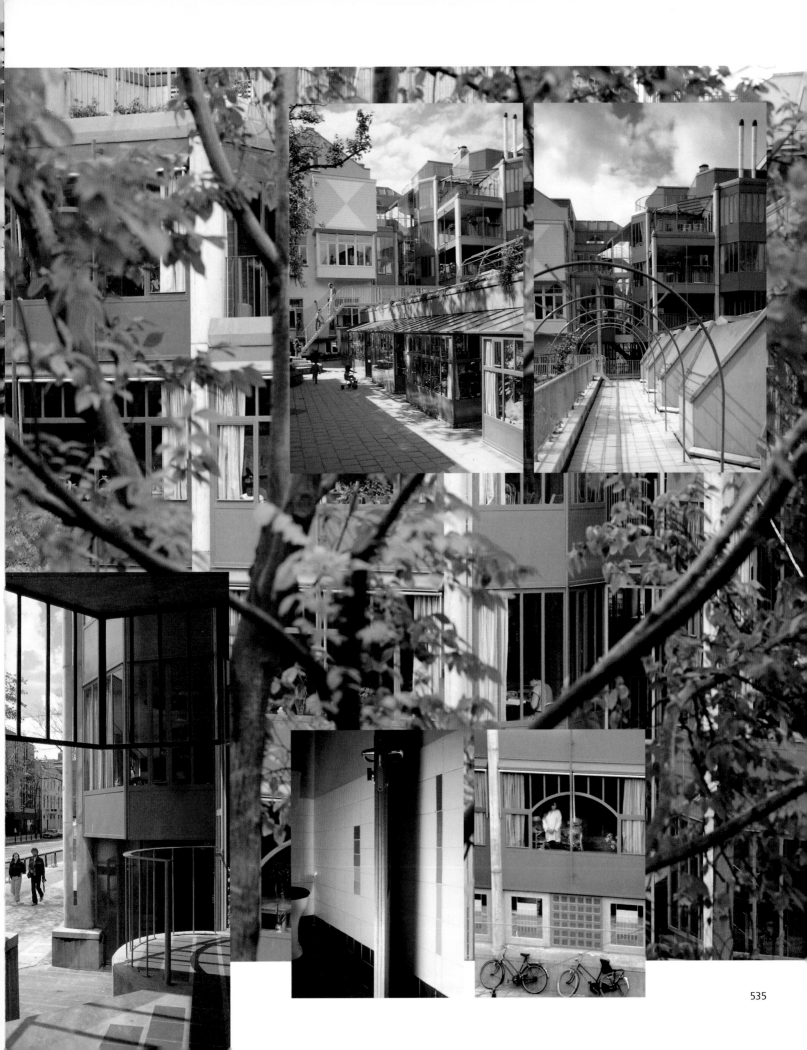

Journal.
Steinbrecher.

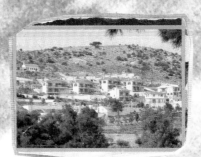

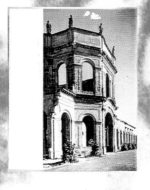

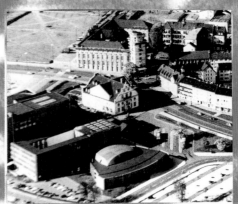

James Stirling

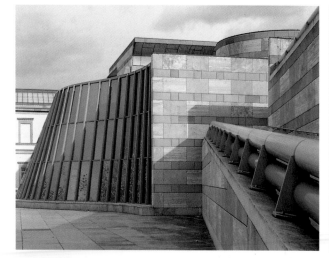
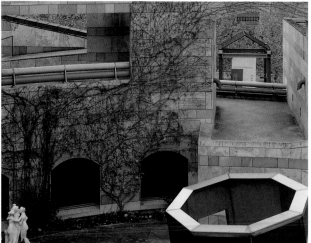
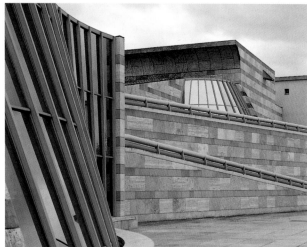
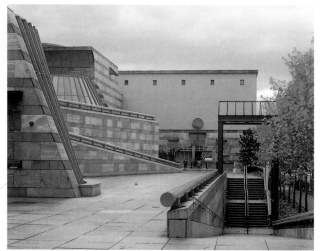

Jean-Louis Schoellkopf, Staatsgalerie Stuttgart, 1994

You spoke of tracing back from the effect to the cause of the restrictive elements, in order to transform them and reach a "super-rational" solution.

James Sterling: That was a reference to functionalism and to the way solutions can get blocked off. It's still a valid way of creating something new, because there are often obstacles on the path to a solution. You have to understand the very nature of the obstacle, to find out if it can be changed. Often it's just a little thing, a practical detail, like cleaning problems. If you find a way to take it on, the aesthetics can change. But to get over the obstacle, first you have to understand its nature. That can also work in the opposite direction: by assimilating fluctuating situations, you can achieve innovations. . . .

In Stuttgart, the central courtyard is at once interior and exterior space, it belongs to the museum but is crossed by a public footpath. You described it as a "non-space resembling a room," a "void" that functions as a replacement for a "central pantheon." The aspect of this courtyard offers striking contrasts depending on whether it is seen by day or by night.

James Sterling: It is an exterior space, open to the sky. The different day and nighttime lighting conditions were deliberate, although I have not yet been able to see the full effect. That experience will happen for the first time this autumn, at nightfall, when the gallery is still open and lighted. The footpath is already lighted and accessible all night long, and the café stays open until two o'clock in the morning.

You have said that the obligation of incorporating a footpath is "a democratic demand of German com-

540

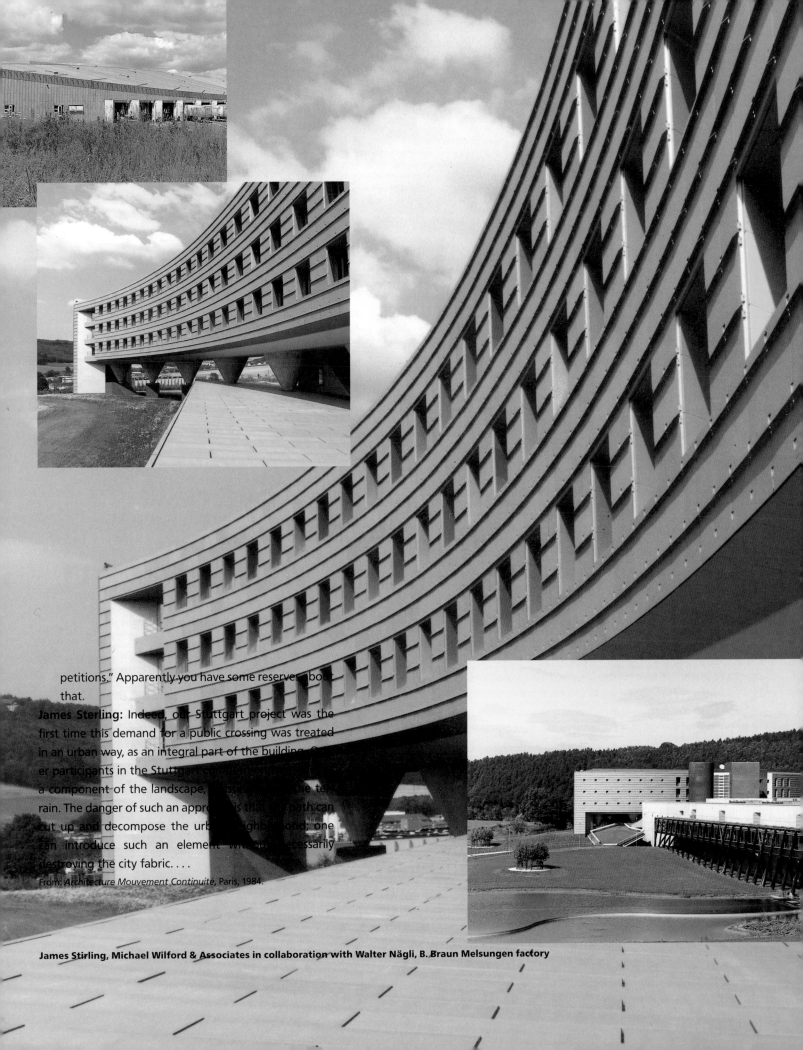

petitions." Apparently you have some reserves about that.

James Sterling: Indeed, our Stuttgart project was the first time this demand for a public crossing was treated in an urban way, as an integral part of the building. Other participants in the Stuttgart competition treated it as a component of the landscape, existing within the terrain. The danger of such an approach is that the path can cut up and decompose the urban neighborhood; one can introduce such an element without necessarily destroying the city fabric. . . .

From: *Architecture Mouvement Continuité*, Paris, 1984.

James Stirling, Michael Wilford & Associates in collaboration with Walter Nägli, B. Braun Melsungen factory

Jean-Louis Schoellkopf

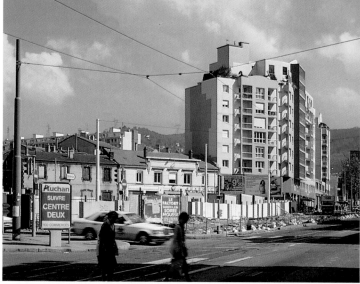

"A City of International Repute"

Saint-Etienne, fantasy and reality:

In a gesture symbolic of the city's loss of image, the Maison de la Culture, redubbed "l'Esplanade," has just launched a poster campaign for its next season. One sees a public square, an esplanade overlooking the city, with a balustrade in the foreground suggesting a chateau or, at the very least, an eighteenth-century residence; people stroll among the pigeons. The orientation is good; the evening is bathed in orange light, the view extends out to the west; long shadows incline in our direction. The city is a modern city; on a plain, one sees an urban freeway on the left. While the esplanade seems Italian—in reality it is Piazza San Marco—the city is probably German.

Unfortunately, in place of that lovely esplanade there is actually a parking lot. In front of us, on the left, are vestiges of the mine. Nothing is the same. Is the city of dreams more beautiful than the real one? Why was it impossible to show Saint-Etienne? How fascinating is the power of the unconscious?

Jean-Louis Schoellkopf

Alvaro Siza

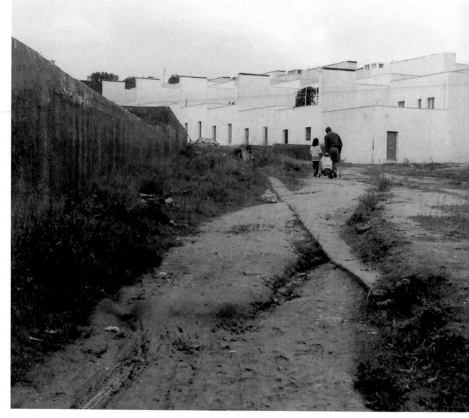

Jean-Louis Schoellkopf, (Evora), 1993

Alvaro Siza: I think that what interests me most in the construction of a city is its capacity for transformation, something resembling the development of human beings who from birth have certain characteristics and sufficient autonomy, a basic structure, allowing them to accept or to resist changes in life. There isn't necessarily a loss of identity. What we built in Malagueira is like the zero point of a city sector. . . .

> Certain elements at Evora follow the curves of the terrain, while others form inclined planes or, on the contrary, horizontal lines. How is this relation to the topography organized?

Alvaro Siza: The Alentejo is a relatively level region, but there are hills where many cities have been built. The Malagueira district is at the foot of the hill where the old city center and the cathedral are. There are still little undulations and it is normal for the houses to sit directly on the terrain, to simplify the foundations. This is also what characterizes the landscape. The horizontal geometric forms that stand out from this principle of adaptation to the undulations are important events in the division of the space. When you find an open space looking out to the landscape at the end of a row of houses, there are sometimes forms that impose themselves on the topography and gain a certain autonomy. In these places, for reasons of the relation to the landscape and because of the dimensions of the program, the link with nature becomes less direct. I think I used both these things.

From: *Architecture d'Aujourd'hui* 278, Paris, December 1991.

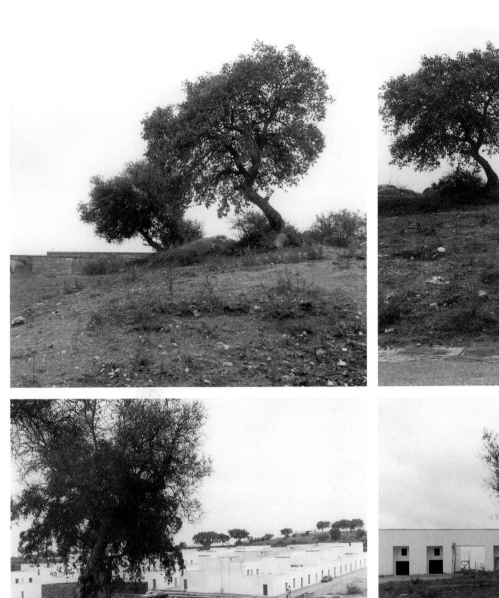
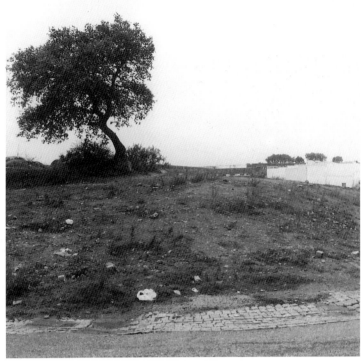

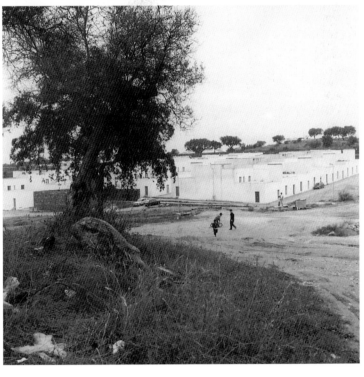

Toyo Ito

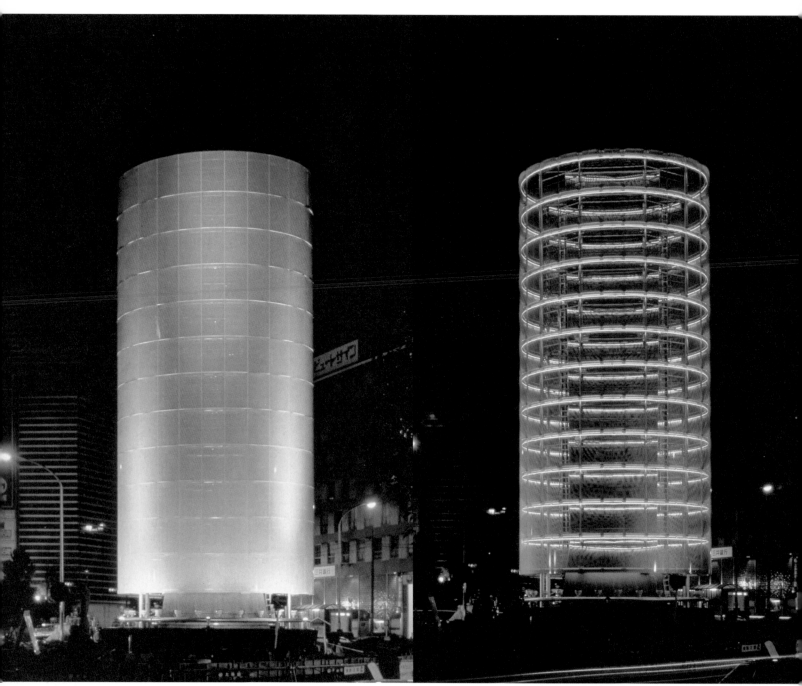

Wind Tower, Yokohama, Kanagawa, 1986

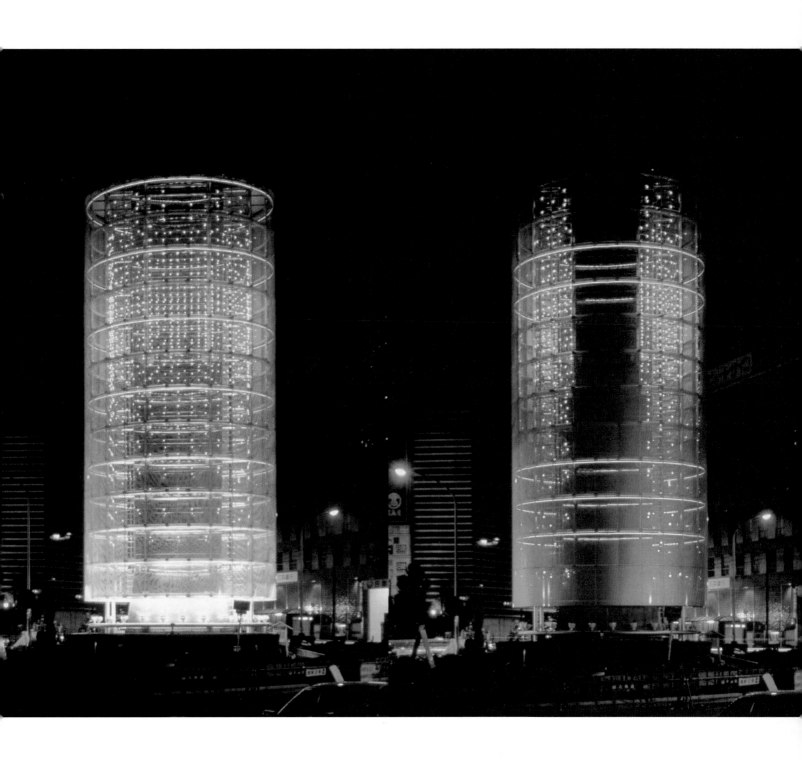

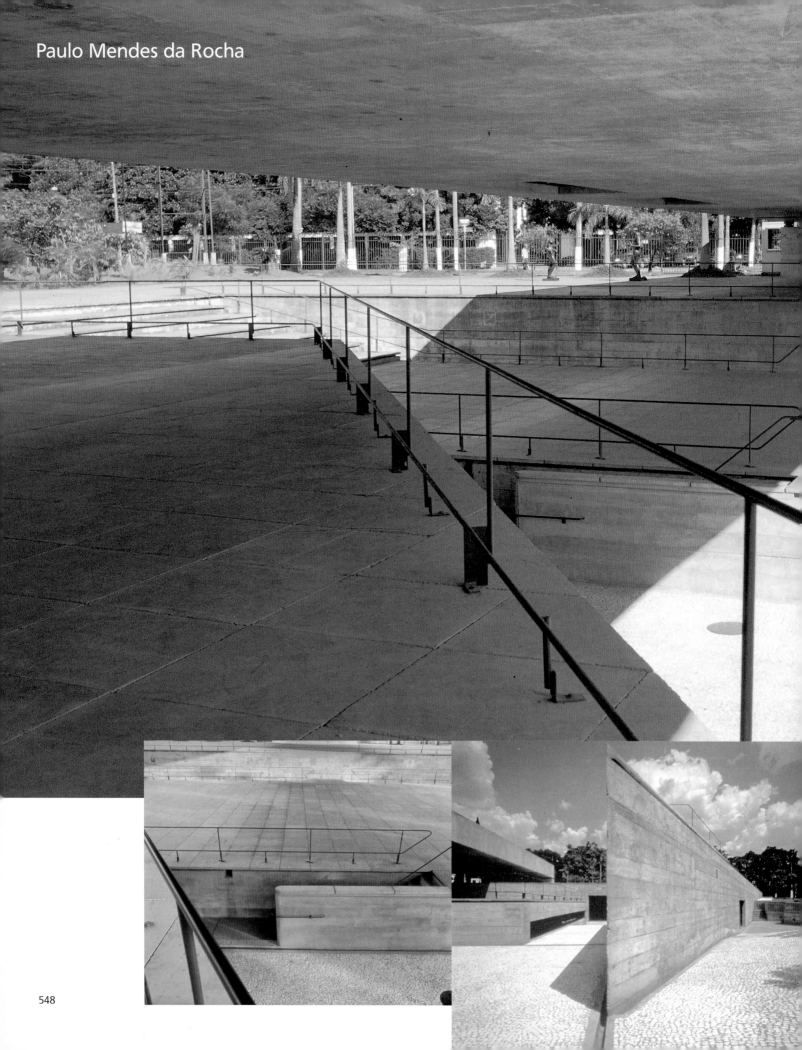

Paulo Mendes da Rocha

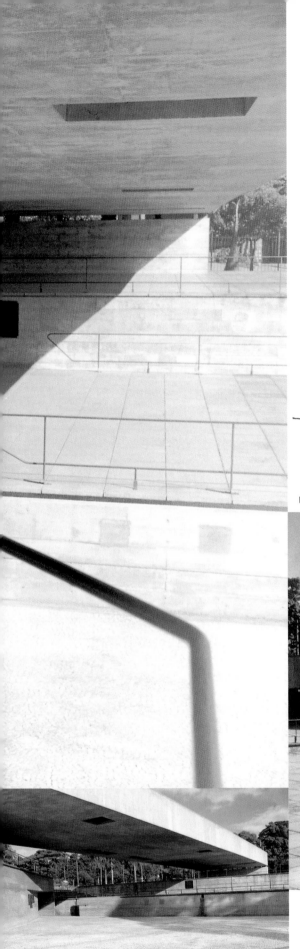

O interesse deste projeto
esta na relação entre
espaços internos e espaços
externos realizando uma
totalidade arquitetônica com
o `dentro` e o `fora`

Museu Brasileiro da Escultura, Sao Paulo, 1988-91

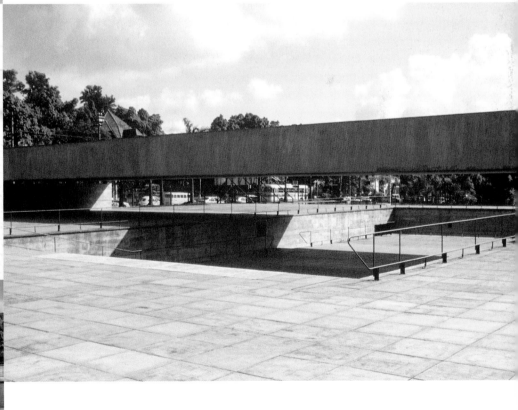

John Portman

Mike Davis

Although in a few American cities (usually with dominant university-hospital-office economies, as in Boston and San Francisco) the new rich and middle classes are gentrifying the entire urban core, in most large city centers redevelopment has produced only skyscraper-fortress enclaves. For the wealthy, token few of the Downtown salariat and managerial workforce who actually choose to live within the skyscrape, two different architectural solutions have arisen to the problem of guaranteeing their segregation and security. One has been the erection of new superskyscapers, integrating residential space, what Tafuri correctly calls "gigantic antiurbane machines." The other strategy, pioneered by hotel architect John Portman, and designed to mollify the skyscraper's inhumanity, was to incorporate pseudo-natural, pseudo-public spaces within the building itself. Drawing on Frank Lloyd Wright's many experiments in search of an aesthetic of open space and endless movement, essays which include the "lost" Larkin Building, the Johnson Wax Building and the Guggenheim Museum, Portman changed the theory of hotel design by showing that a sizeable interior space could be a practical investment.

The prototype of the Portmanesque space—spaceship elevators, multi-storey atrium lobby, and so on—was the Hyatt-Regency built in 1967 in Atlanta's Peachtree Center. It is important to provide a concise image of the setting and external function of this "mother of the Bonaventure": "Downtown Atlanta rises above its surrounding city like a walled fortress from another age. The citadel is anchored to the south by the international trade centre and buttressed by the municipal stadium. To the north, the walls and walkways of John Portman's Peachtree Center stand watch over the acres of automobiles that pack both flanks of the city's long ridge. The sunken moat of I-85, with its flowing lanes of traffic, reaches around the eastern base of the hill from south to north, protecting lawyers, bankers, consultants and regional executives from the intrusion of low-income neighborhoods." (Carl Abbott, *The New Urban America*, Chapel Hill 1983, p. 143.) It is not surprising that Los Angeles' Portman-built new downtown (like that of Detroit, or Houston) reproduces more or less exactly the beseiged landscape of Peachtree Center: the new Figueroa and Bunker Hill complexes are formed in the same protective mass of freeways, moats, concrete parapets, and asphalt no-man's-lands. What is missing from Jameson's otherwise vivid description of the Bonaventure is the savagery of its insertion into the surround city. To say that a structure of this type "turns its back away" is surely an understatement, while to speak of its "popular" character is to miss the point of its systematic segregation from the great Hispanic-Asian city outside (whose crowds prefer the open space of the old Plaza). Indeed, it is virtually to endorse the master illusion that Portman seeks to convey: that he has recreated within the precious spaces of his super-lobbies the genuine popular texture of city life.

From: "Urban Renaissance and the Spirit of Postmodernism," in *New Left Review* 151, 1985, pp. 106-13.

Peachtree Center Plaza Hotel, Atlanta, 1976

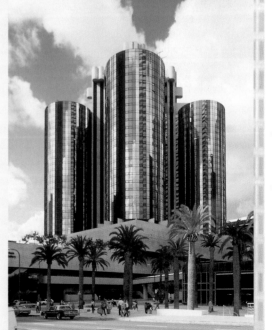

Bonaventure Hotel, Los Angeles, 1977

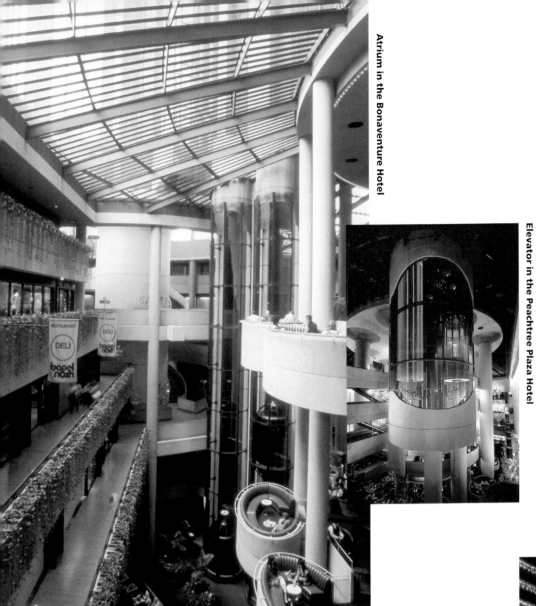

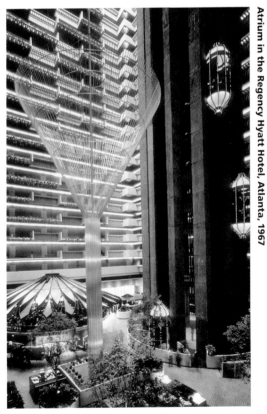

Fredric Jameson

The glass skin repels the city outside, a repulsion for which we have analogies in those reflector sunglasses which make it impossible for your interlocutor to see your own eyes and thereby achieve a certain aggressivity and power toward the Other. In a similar way, the glass skin achieves a peculiar and placeless dissociation of the Bonaventure from its neighborhood: it is not even an exterior, inasmuch as when you seek to look at the hotel's outer walls you cannot see the hotel itself but only the distorted images of everything that surrounds it.

From: "Postmodernism, or the Cultural Logic of Late Capitalism," in *New Left Review* 146, 1984.

551

Gordon Matta-Clark

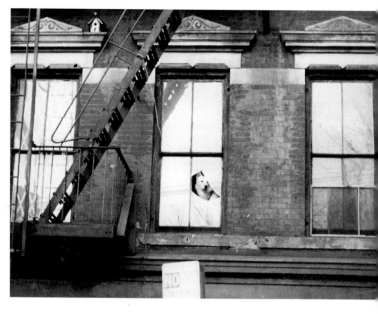

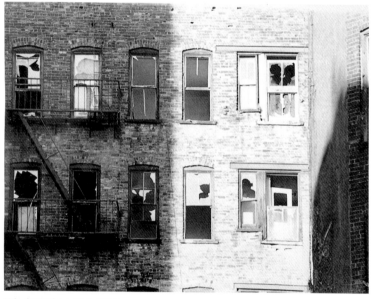

Window Blow-Out, 1976

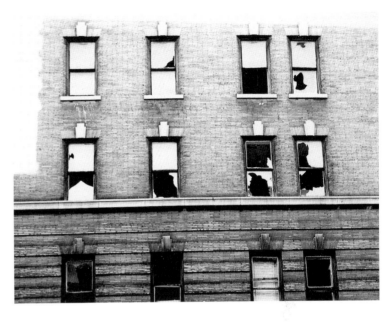
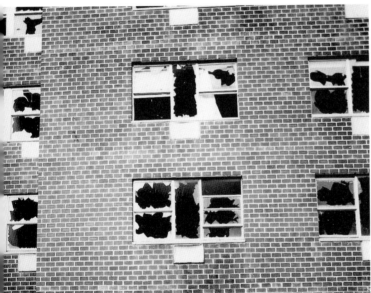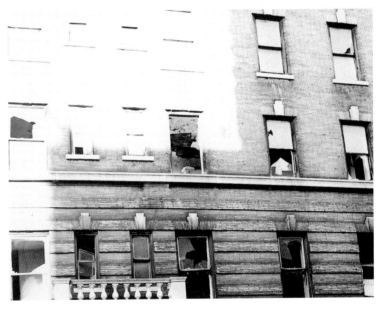

1989-1997

DE ORIGINE
ET SITV
GERMANORUM

Kaum hatte Hutter die Brücke überschritten, da ergriffen ihn die unheimlichen Gesichte, von denen er mir oft erzählt hat.

"Et quand il fut de l'autre côté du pont, les fantômes vinrent à sa rencontre."

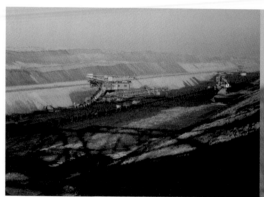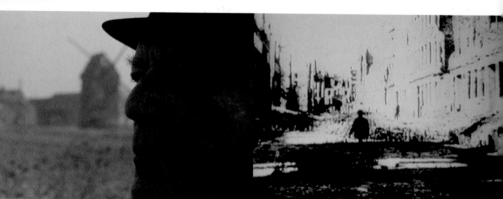

November 9, 1989 Fall of the Berlin Wall. Solidarnosc form
Republic. In Rumania, Nicolai Ceaucescu is forced out of power and shot. The I

LES DRAGONS

DE NOTRE VIE

Jean-Luc Godard, *Allemagne Neuf Zéro* (Germany Nine Zero), 1990

Infor

PEARL RIVER DELTA

CITY OF EXACERBATED DIFFERENCE© (COED

harmony and a degree of homogeneity. The CITY O

based on the greatest possible difference between i

permanent strategic panic, what counts for the CITY O

creation of the ideal, but the opportunistic exploitatio

model of the CITY OF EXACERBATED DIFFERENCE

primitiveness of its parts — the paradox is that it i

ication of any detail requires the readjustment of th

extremes. A-SYMMETRY© All phenomena that restor

the COED©. COOP-ETITION© Without COOP-ETITION

perfectly describes the constructive component th

MANIPULATION© Boundaries in the Pearl River Del

to fluctuating strategies of inclusion, exclusion, desire

a connection between China's recent communist histo

is the Stalinist doctrine that suggests that art shou

he traditional city strives for a condition of balance,

XACERBATED DIFFERENCE©, on the contrary, is

arts — complementary or competitive. In a climate of

XACERBATED DIFFERENCE© is not the methodical

flukes, accidents and imperfections. Though the

pears brutal — to depend on the robustness and

fact, delicate and sensitive. The slightest modif-

hole to reassert the equilibrium of complementary

aintain or intensify the inequalities that define

COED©. Newly minted Singaporean word that

ompetition can have in the Asian context. BORDER-

RD) drawn, and re-drawn, open or closed, according

undesirable elements. MARKET REALISM© Is there

d its present idolatry of the Market? Socialist Realism

epict, in the most realistic way, a final condition of

realized Utopia, rather than dwell on the imperfection

its implementation. It is a brilliant formula for desir

interval between Market promise and Market delive

fervor that does not demand instant gratification in th

supply and *demand* — the first overwhelming, th

Realism: MARKET REALISM© = toil: speculatio

for freedom. Best illustrated by an old Chines

PHOTO-SHOP© The facility that allows PHOTO-SHOP

mulations of desire — is applied literally in the PRD a

exist on any scale; an entire nation of 1.3 billion peop

them) when the 'open door policy' introduced th

that Faust joint-ventured with Mephistopheles, China

FAUSTIAN MONEY© (investment, foreign currenc

Confucianism finances an ancestor's stay in the here

val between the present speculative excess, and th

the present, or the sacrifices on the road toward

multaneously deferred and consummated. The present

explained by MARKET REALISM©, a speculative

m of profit rentability, or a real relationship between

cond still defined by ORACULAR MAGIC©. Socialist

ee FAUSTIAN MONEY©) **NEGLECT©** Another word

overb: "The sky is high, the emperor is far away" —

combine everything into anything — uncritical accu-

banism. **FAUSTIAN©** A FAUSTIAN© contract can

ade a deal with the devil (or rather Deng made it for

ocialist market economy into China. In the same way

ommunist state entered the global market searching for

reigner's bribes). Just as the Hell Bank Note in

ter, FAUSTIAN MONEY© in China finances the inter-

ventual collective wealth of a socialist market economy.

CULTURAL REVOLUTION© culture: cultural revolution

otherwise only marginally related to the art or science

sures of time, speed, and quantity. **CHINESE ARCHITECT**

earth. The average lifetime construction volume of th

thirty 30-story high-rise buildings. The CHINESE ARCH

the lowest fee. There are 1/10 the number of architects

project volume in 1/5 the time, while earning 1/10 th

an American architect. **CURTAIN WAR©** The competitio

that the glass-panel allows. The curtain wall is in China

but with a new baroque that can assume its place

SPEED© Unit of abrupt growth. Architectural design

with SHENZHEN SPEED©. Record design SPEEDS© set

5 designers x 1 night + 2 computers = 300-unit single fa

3 nights = 7-story walk-up apartment; 1 architect x 7 da

rise. **MORE IS MORE©** Definitive conclusion of the tri

ty: TABULA RASA© **ARCHITECTURE©** Property

uilding. Designed in the PRD under unprecedented pres

he most important, influential, and powerful architect on

HINESE ARCHITECT© in housing alone is greater than

ECT© designs the largest volume in the shortest time for

hina than in the US, each of whom designs 5 times the

esign fee. This implies an efficiency of 2,500 times that of

etween ARCHITECTURES© utilizing the maximum variety

nger associated with simplicity, precision, and tautness,

larger PICTURESQUE© order of things. **SHENZHEN**

hina has accelerated to keep pace

henzhen Special Economic Zone:

housing development; 1 architect x

=30-story concrete residential high-

at began with Mies: *less is more.*

1994 Architects' Index

0.0600%
0.0500%
0.0400%
0.0300%
0.0200%
0.0100%
0.0000%

China
USA
England

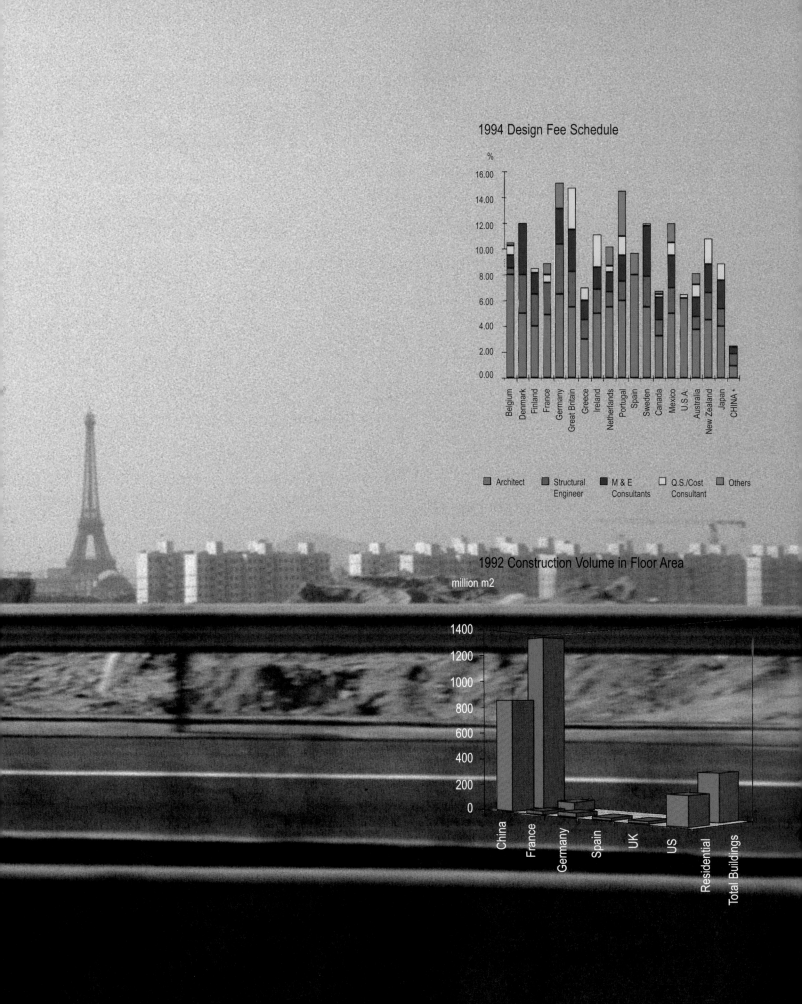

1994 Design Fee Schedule

%

16.00
14.00
12.00
10.00
8.00
6.00
4.00
2.00
0.00

Belgium Denmark Finland France Germany Great Britain Greece Ireland Netherlands Portugal Spain Sweden Canada Mexico U.S.A. Australia New Zealand Japan CHINA*

Architect Structural Engineer M & E Consultants Q.S./Cost Consultant Others

1992 Construction Volume in Floor Area

million m2

1400
1200
1000
800
600
400
200
0

China France Germany Spain UK US Residential Total Buildings

photo: Mihai Craciun graphs: Nancy Lin

passed through Venturi: *less is a bore*, and now ends i

kilometers of urban substance is built every year (6.

rates hover near 50%); 5 international airports are oper

wall panel systems are used in one building (see CUR

within 4 square blocks; 414 holes of golf are open fo

systems are deployed in a 15 square meter livin

site conditions for optimum implantation of new build

of fabricating ideal conditions wholesale (FENG SHUI

accumulated in modern architecture...) SMOOTHING

SMOOTH© green crust of THIN© urbanism, ultimatel

The golf course as main carrier of urban activity. Th

Shenzhen SEZ, where three 18-hole golf courses an

DIALECTICS© collapse into MERGE©: the first

a method to collapse opposites and create new cond

pleasure → BUSINESS VACATION©, socialism an

paroxysm of the quantitative in the PRD: 500 square

illion square meters in Shenzhen alone, when vacancy

th 2 more nearing completion; 12 different curtain

AIN WAR©); 10 revolving restaurants are constructed

ay, and 720 more are under construction; 5 lighting

om... **FENG SHUI©** Geomancy originally used to read

gs, FENG SHUI© has, in the PRD, now become a way

n also be used retroactively to correct the bad *ch'*

he replacement of the traditional urban fabric with the

enerating the UTOPIA OF GOLF©. **UTOPIA OF GOLF©**

st installment of the UTOPIA OF GOLF© takes form ir

ur theme parks spread out from the center. **MERGE©**

ethod to understand and define opposites, the second

ons. Landscape and city \rightarrow SCAPE©, business and

e MARKET© \rightarrow the socialist market economy.

VISIONARY vs. FUTURISTIC© Possibly as a result

Capitalism, the Pearl River Delta reveals a overabu

totally resist the FUTURISTIC© i.e. They aim for diffe

HOUSING/PARKING© The status of all floor space

provisional, and every occupancy only temporar

different regions (still officially registered in their orig

in China's coastal cities. In the PRD they form reservoi

than 2/3 of Shenzhen SEZ's population. **METABOLISM**

GRAPHIC© pressures leading to an over-all acceler

that certain contemporary conditions can best be unde

movements that are now largely discredited. Many

in the speculations of the Metabolists and Team

a House and Get Registered; Fulfill One's' Green Ca

for 2.5 million FLOATERS©, while at the same ti

Yielding as tactic. Traditionally China has used the PR

e hybridization of Confucianism, Communism and

...ce of VISIONARY© projections that paradoxically ...ce more than progress. **FACTORY/HOTEL/OFFICE/**

...hina is generic. Each programmatic function is ...OATING© A collection of migrants FLOAT© from ...al place of residence, attracted by hyper-development ...f unofficial inhabitants. FLOATERS© make up more ...heightened collective effort triggered by DEMO-...on of the production of urban substance. The paradox ...tood through concepts developed by architectural ...e phenomena now visible in the PRD were anticipated ...REEN CARD DREAM© Shenzhen's policy of *"Buy ...ream"* allows the immediate establishment of citizenship ...oosting the slowing real estate market. **CONCESSION©** ...o make CONCESSIONS©: Hong Kong and Macau were

ceded to Britain and Portugal as receptacles for co...

rest of China to remain 'pure'. In a similar way, Speci...

for free-market experiments. **PARADISE©** The "final...

elusive as a mirage, yet inspires and justifies th...

Chinese identity is through attrition, erosion, inventio...

Confucian kitsch — that is operational equally...

...purports... facts or ideas wi...

...slow... loose enough fuzzy...

political... cy or otherwise. LING-NAN©...

barrier between... as receptacle... th...

LING-NAN© is claimed by both sides; mechani...

bankrupt — to those in the North, it becomes "natura...

River Delta. LING-NAN© spans pragmatism and worth...

...Architecture. **STITCHING©** The creation of syn...

...context but on the radical identification —

olled importation of Westernness, allowing the

conomic Zones are CONCESSIONS©; land sacrificed

denic condition whose ultimate realization remains

ever-ending effort to achieve it. **CHINESENESS©** The

manipulation, turned into an artificial construct —

e East and the West. **DIALECTICS©** A method of

w to the resolution of their real, or apparent contra-

gic to be used in the PRD to justify ANY contradiction

e *Nan-ling mountain range*" refers to the geographical

orth and the DESERTIONS from the China. The word

mpositions with all the odds and unrefined — culturally

asonable [unreadable] in the Pearl

ssness: LING-NAN© Garden, LING-NAN© [unreadable], LIN

etic wholes, not based on the original ingredients of

nd subsequent annexation — of what is *missing* from

them. **THINNING©** The coating of the largest availab[le] that yet generates an urban condition. **SYSTEMAT[IC]** of NEGLECT© — natural, political, economic, cultural[...] ness, that is harnessed for sudden spurts of dras[tic] now as alibi to facilitate modernization (with half-hear[ted] undefined SOVEREIGNTY© to exploit its fuzziness [...] economic gain . In the PRD, AMBIGUITY© allow[s] the various municipalities . COORDINATION© Und[er] imposed, then secretly loosened. Now, in a abrupt reve[rsal] researchers, planners and politicians (those without t[...] with the retroactive task of creating — for the great[er] a derogatory term used to describe the oversimplific[ation] plexity and super-impositions . It is become in the PR[D...] connected, usually by POTEMKIN CORRIDORS© [...] together to share common interests, but as a new fo[rm...]

rritory, with the concentration of substance

ISADVANTAGE© A condition where successive forms

eate an explosive mixture of resentment and reckless-

ange. **AMBIGUITY©** Ancient Chinese strategy used

mbrace...). AMBIGUITY© allows a territorial entity of

condition of possibility — for political and/or

nsions and contradictions to co-exist among

ommunist dictatorship before reform, rules were

al, China's new regime *imposes no rules.* Chinese

xplicit power to control an exploding economy) are left

enefit — coherence. **BUBBLE DIAGRAM©** Once

ons of planners — a city dismantled, robbed of its com-

e blueprint; if not a machine... BUBBLES© are

correlated. The city is then understood as a coming

centrifugal coexistence of divergent centers

"HAS BECOMING"© The future-perfect tense invente[d]

of achievement with eternal deferment. Terminal strivin[g]

city with beautiful scenery and good environment ha[s]

garden form investment, it is the result of Zhuh[ai]

Yearbook, 1995. Essential for the understanding of t[he]

later. **TABULA RASA©** The notorious clean sla[te]

Discredited in the West, it is the norm, the *sine qua no[n]*

an autonomous status: it is no longer an initial scrap[e]

a *project* independent of need: **FLATNESS©** as a[n]

condition. TABULA RASA© now extends to other "scra[pes]

the removal of all earlier layers. Major irony: the We[st]

artificially. **SCENERY©** The suddenness of constru[ction]

ited by people who unwittingly become spectator[s]

OF THE EYE© After all other logic has been subord[inated]

of Organization in the contemporary city. Under **DICTATO[R]**

the Pearl River Delta that combines the immediacy

'5 years work, is a hard work for pioneering. Zhuhai

ecoming a famous scenic spot for tourism and a

eople's wisdom and couragement." from <u>Rising</u>, Zhuhai

sian condition there is now no now there, only

at was the underlying myth of Modernist planning.

the East. In the PRD TABULA RASA© has achieved

ondition on which a new condition is projected, but

fordable platonic luxury. Initially applied to a physical

gs where political or cultural regimes have sponsored

ow pursues *forded authenticity,* the East FLATTENED©

on in the PRD turns landscape into a backdrop inhab-

ublic space under DICTATORSHIP©. DICTATORSHIP

ated the VISUAL provides the dominant system

HIP© objects coexist, and are understood (or not) in

visual relationships. **VIRGIN©** Untouched (pre-occupie

SEARCHLIGHT© The sudden, often inexplicable pus

a newly 'hot' subject. The ever-shortening interv

of the developer is rushed — too short to actual

tive — a self-fulfilling prophesy that never happen

Seemingly random, essentially unpredictable way

amalgamation of Confucian and Communist traditio

as the foundation of MARKET REALISM©. BUSINES

possible territory in shirts, or through rotation. In t

coincides with the reduction (THINNING©) of cit

in a clearly demarcated economic system (the *island*

socialist market in Shenzhen ZONE©) eventually SPILLS

China this excess (most visible as export processir

socialist hinterland with the temptations of unadultera

prise Bankruptcy Law" does not make enterprises ban

ban substance i.e. VIRGIN CITY©. **SPECULATOR'S**

ith which the developer's attention is switched to

etween new discoveries means that the attention span

alize development. His activity becomes only specula-

ee ORACULAR MAGIC©) **ORACULAR MAGIC©**

efine 'aims', 'goals' and 'deals' that depends on an

actice. Now operative in a new market-based context

ACATION© The way for a few to make a lot fastest

RD) the reduction (STREAMLINING©) of program

ILLOVER© Fantastic growth, when concentrated

ong Kong's free-wheeling capitalism, the schizophrenic

to ideologically unprotected, VIRGIN© territory. In

ctories and 'luxury' housing developments) taints a

d capitalism. **BANKRUPTCY©** China's "Trial Enter-

pt, assures Workers' Daily, it "*increases their vitality.*"

socialist market system — an economy embracing both

failing industrial base) and CHINESE®-style reincarna-

cycle of death and rebirth) — is responsible for multiple

a business fatality. For the Chinese, BANKRUPTCY®

During the GREAT LEAP FORWARD® the entire trajec-

transformed into linear zones of engineered perfection,

cally realized. Today, the BUBBLES® of the COED® are

role; prefigurations of PARADISE®. STREAMLINING®

deregulation to enable the acceleration of the develop-

which were mutually reinforcing and totalizing; are

longer pretend to create functioning wholes but have

organism, INFRASTRUCTURE® now creates enclave and

swerve. Malfunctioning is also a form of functioning. Each

program. It enables and prevents. LEARNING®

notion of failure — now declared a LEARNING®

The fundamental inconsistency in the BANKRUPT

communist-style sustainability (the resuscitation of

tion (the evolution and perfection of market strategy in

smaller BANKRUPTCIES©. In the West bankruptcy

...OTEMKIN CORRIDOR© (to start over...)...

is freedom (to start over...)...

tory of Chairman Mao's travels through the country we

where all the ambitions of the Revolution would be ma

connected by "development" corridors that play the sam

The simplification of political bureaucracy throug

ment process. INFRASTRUCTURE© Infrastructure

becoming more and more competitive and local; they

become instruments of secession. Instead of network an

impasse: no longer the 'grand recit' but the parasit

INFRASTRUCTURE© has both a positive and a negativ

A mode of permanent experimentation that has eliminate

experience. In a subversion of the educational proces

and Soviet 'ideas', and adapts them in order to ga

INFRARED© Driven underground by the forces of glob

totalitarian ideology by moving into the invisible spe

compromise and double standard, a preemptory reve

realities of the 21st century. **SCALE©** Having define

regime of standards that replace hierarchy with impetu

sured by the relative size of each economic absurdi

economy measures the success of the open door car

communist ideology. For the CCP, size is a measure

the present as an era of opportunistic juxtaposition

logical puzzle of urban forms and programs. The socia

as being akin to the PICTURESQUE©, the irrational

beauty in disorder and virtue in the bizarre. **CULTURA**

of **NEGLECT©**, geographical circumstance, and relen

hina recycles received (often discredited) Western

ccess to the 'new' (see VISIONARY VS. FUTURISTIC©).

conomy, the Chinese Communist Party safeguards its

um of politics. INFRARED© is a covert strategy of

l of history that links 19th century idealism with the

e city in terms of number. The CCP introduces a

uring Mao's era ideological commitment was mea-

saster of famine. In reverse logic the socialist market

aign in terms of each victory of the MARKET© over

uth. LINEAR© The socialist market economy defines

nd uses the LINEAR© city as the blueprint for an ideo-

t market economy exposes, therefore, the LINEAR©

tionalized, planned according to a logic that finds

ESERT© China's euphemism for the PRD. The result

ss ideological campaign. The CULTURAL DESERT© is

ground where only the most resilient new ideas ca

outpost of hotels, flower beds, alligator shows, roman

theme restaurants and "romantic paddle boats"

in order to lure urban conditions. **PICTURESQUE**

perceiving space, invented by Chinese gardeners in th

relationships between objects, rather than their singula

ments of the different ways in which trees, building

panied in the most beautiful and striking manne

grandest and ornamental: many of those objects, th

when brought together in the compass of a small space

that means learns how to separate, to select and con

1794). **FLATNESS©** The spatial condition of FLAT

space is FLATTENED© into vertical surface, to b

mountains are FLATTENED© into horizontal surface

First China's strategy of territorial expansion. Nor

PEASANT VACATION VILLAGE© An

...rks, swimming pools, karaoke bars, golf courses,

...AGES© are strategically located in remote areas

...venge of the anti-idealistic. A mode of making and

...6th century, which insists on the juxtapositions and

...resence." "We may look upon pictures as a set of exper-

...ater, and etc. may be disposed, grouped and accom-

...every style, from the most simple and rural to the

...scarcely marked as they lie over the face of nature,

...canvas, are forcibly impressed on the eye, which by

...ne..." (Uvedale Price, An Essay on the Picturesque)

...ESS© is a direct result of the PICTURESQUE© (where

...onsumed by the EYES) and the MARKET© (where

...consumed by development). RECLAMATION©

...abandoned REAL ESTATE© by an

indigeneous culture (re)emerging to exercise China

process that turns the Pearl River Delta's coastal lan

buildings undergo a similar takeover, that turns China

SENESS©. (see SOVEREIGNTY©) - **SCAPE©** PRD. A

every direction, shifting between e cessive height ar

crust; between the ... of ... and the ... of... SCAPE©, neith

it will be the arena for interminal confrontation betwee

stood as a apotre osis of the PICTURESQUE

and mutual adjustment inevitable when the ba

suddenly unhinged by the change that will tak

Kong/Macau — overcrowding/freedom are reverse

freedom will make Hong Kong and Macau see

ness of Shenzhen and Zhuhai will acquire a sudde

changes in population patterns to justify grotesque plan

DEMOGRAPHICS© dictated development; unde

...ew ideology of *permanent adaption*. Reclamation is the ...cape into fresh ground for development. The PRD's ...lentless mimicry of the West into a triumph of CHINE- ...xploded) mountain, a skyscraper, and a ricefield in ...e lowness of a continuous agricultural/light industrial ...ty nor landscape, is the new post-urban condition. ...rchitecture and landscape. It can only be under-

...RANSITIONAL REVERSAL© The conceptual shift, ...ce of contrasts that now defines the COED© is ...ace when China — space/no freedom and Hong ...predicts that, after 1997, the shared absence of ...vercrowded slums. In comparison the spacious- ...lamour. **DEMOGRAPHICS©** The use of dramatic ...ng and architectural doctrines. Under socialism ...apitalism development dictates DEMOGRAPHICS©.

ZONE© Imposes limits, but not spatial content. A vag

Party over *city*. Because it is conceptually blank,

lation. A ZONE© purges historical contents from territ

with the dynamics of global economy. A ZONE© remai

achieves focus and intensity. ZONE© is the birthpla

Urbanization without a doctrine of the city. If in th

spin-offs of the city, in China, SUBURBIA© is th

city strives for the SUBURBAN© **RETROFIT©**

existing structure. Used in the PRD as a strategy

STEALTH© China's cities aspire to quick grow

the global fame (or is it infamy?) that follows. Cities vi

Zones — are unable to attract the foreign capital nece

to prosper. STEALTH© tactics simultaneously quicke

CHINESES© style (see CORRUPTION©

of construction in its violence each year in the

rm, ZONE© is preferred by the Chinese Communist

ONE© is open to the impurities of ideological manipu-

s where they have been imposed, and replaces them

rogramatically unfulfilled; an urban condition that never

CHINESE SUBURBIA©. **CHINESE SUBURBIA©**

est, suburban is a derogatory term for unwelcome

ssence of urbanization. The newness of the Chinese

stall or fit an improvised device or system to repair an

pair anything — architecture, ideology, or politics

rough modernization (see SHENZHEN SPEED©), and

nized by NEGLECT© — they aren't *Special Economic*

ary. They instead devise STEALTH© strategies in order

owth and insure continued *invisibility*, thus facilitating

ORRUPTION© Eases thousands of square kilometers

Delta. Asian business practice never acknowl-

edged CORRUPTION© as anything but a *'gift'*. Now th

between CCP dogma and the demands of the MAR

it cements complicity with the communist bur

whe le is sought tiate the glob

"ho est usiness practice is the market's version

and coherence can only be ac ved at the expense

 OPOLIS© does aspire to h status

 tic void *ction*. **EIGNTY**

 ste n Pa ry

GREAT LEAP FORWARD© Fairy tales happen......May

were, in the sixties, the last real "movements" in urbanism

pose new ideas and concepts for the organizatio

tion. In the long interval since, there has been

standing of the traditional city, the usual adhoc intel

of plastic urbanism that is increasingly capable of crea

pen door policy' relies on CORRUPTION© to mediate

ET©. CORRUPTION© *lessens* foreign investor's risk;

ORRUP- TION© in China is punishable *only*

arket's hunger for sacrifice ('transparent—

opia...). **BASTARD METROPOLIS©** Wholeness

diting, of control. The BASTARD

s vitality is guaranteed by the

Asian culture is stronger

blah, blah, blah).

TEAM X and Archigram

the last who could pro-

uge urban life with convic-

increase in our under-

ence and improvisation, and the development of a kind

g an urban condition free of urbanity. At the same

time, Asia has been in the grip of a relentless process of building, on a scale that has probably never happened before. A maelstrom of modernization is destroying, everywhere, existing Asian conditions and creating everywhere, completely new urban substance.The absence, on the one hand, of plausible, universal doctrines, and the presence on the other, of an unprecedented intensity of new production, create a unique wrenching condition: the urban condition seems to be least understood at the moment of its very apotheosis. The result is a theoretical, critical and operational impasse that forces both academia and practice into postures of either confidence, or indifference.In fact, an entire discipline does not possess an adequate terminology to discuss the most pertinent, most crucial phenomena that occur within its domain, no conceptual framework to describe, interpret and understand exactly those forces that could help to redefine and revitalize it. The field is abandoned to "events" that are considered indescribable, or the creation of a synthetic idyll in memory of the city. There is nothing left between Chaos and Celebration.

The PEARL RIVER DELTA project is based on field work: it consists of a series of interrelated studies that, together, attempt to give an initial overview of the emerging urban condition(s) in a Chinese region that, according to reliable predictions, is destined to grow to 34 million inhabitants by the year 2020, and through its sheer size alone, to play a critical role in the 21st century.

Research has been conducted in the course of 1996, starting with a group visit in January, a counter-clockwise journey that started in Shenzhen Special Economic Zone and ended in Hong Kong. Over the summer, individual investigations focused on specific locations and subjects.It seemed hopeless to reconstruct the events in the PRD with such a small group. Therefore, each student was coupled with one major subject and that urban condition where the subject was most tangible or pertinent:

Bernard Chang	INFRASTRUCTURE	PRD
Mihai Craciun	IDEOLOGY	Shenzhen
Nancy Lin	ARCHITECTURE	Shenzhen
Yuyang Liu	POLITICS	Guangzhou
Katherine Orff	LANDSCAPE	Zhuhai
Stephanie Smith	MONEY	Dongguan

Together, these studies describe a new urban condition, a new form of urban coexistence that we have called CITY OF EXACERBATED DIFFERENCE©, or COED©. Beyond the particularities of each condition that we found, the COED© project introduces a number of new, copyrighted concepts, that, we claim, represents the beginning of a new vocabulary and a new conceptual

framework to describe and interpret the contemporary urban condition. The emergence of the PRD, with the suddenness of a power, and the present cloud of unknowing that forces a kind of mental envelope around its existence and performance, are in themselves part of the experience of parallel universes that utterly contradict the assumption that Globalization entails global knowledge." — Rem Koolhaas

This thesis project was conducted at the Graduate School of Design at Harvard University as part of Rem Koolhaas' Harvard Project on the City. Rem Koolhaas and the China Group: Bernard Chang, Mihai Craciun, Nancy Lin, Yuyang Liu, Katherine Orff, Stephanie Smith, with Marcela Cortina and Jun Takahashi. Catalogue and Installation Design: Bruce Mau Design, with Rem Koolhaas and the China Group.

photo: Mihai Craciun

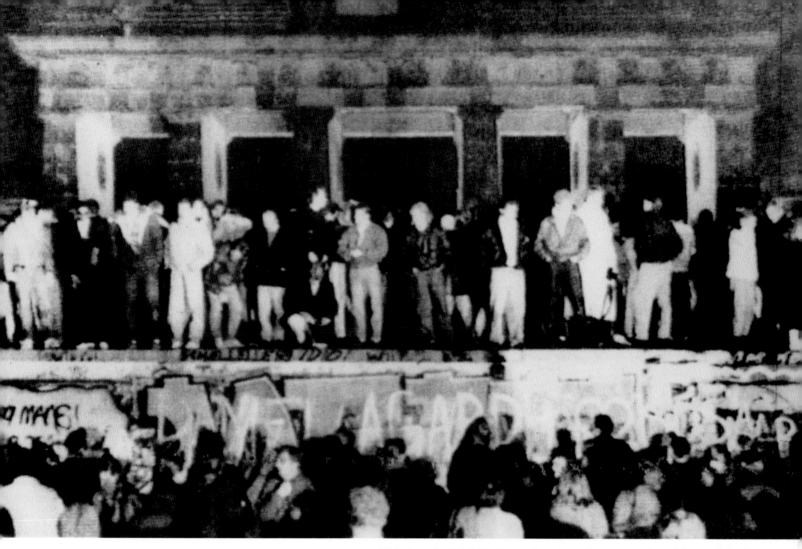

Michelangelo Pistoletto, *Immagine – Anno Bianco: La caduta del muro di Berlino*
(Image – the White Year: The Fall of the Berlin Wall), 1989

vernment in Poland. Vaclav Havel elected president of the Czechoslovak
iet troops leave Afghanistan. 1990 Victory of the fundamentalist FIS party in

Serge Daney

Yesterday is the East: first Nazi, then communist. Today is the commercialized West. Yesterday is cinema. Today is television. The cinema—the image—is a love due to whatever bears witness to the fallen, frozen, lugubrious past (the landscape of the East). The opening images are breathtakingly beautiful, the closing ones banal, nonexistent. There are not two Berlins, not two contrasting landscapes: it's cinema followed by nothing. We have only seen local images of the communist landscape, technically insipid, with lousy sound, and so now we have the feeling of seeing it for the first and last time: gutted, pathetic, half-Russian.

Comments on Godard's *Allemagne neuf zéro*, from: *L'exercice a été profitable, Monsieur*, Paris, 1993.

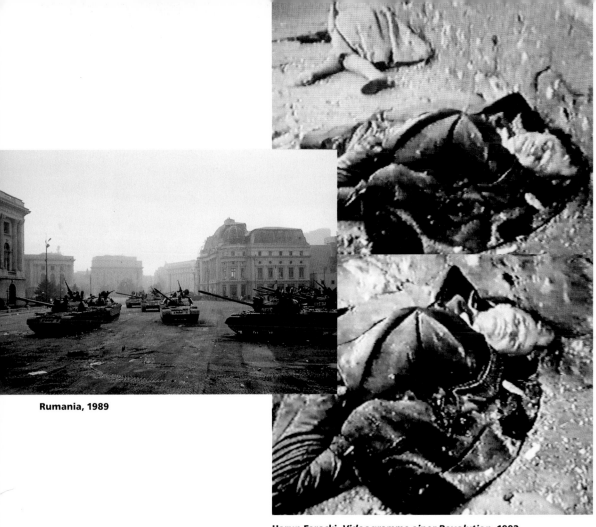

Rumania, 1989

Harun Farocki, *Videogramme einer Revolution*, 1992

the elections in Algeria. With the second CSCE summit in Paris, the era of t
Soviet Union. Civil war breaks out in the multi-ethnic state of Yugoslav

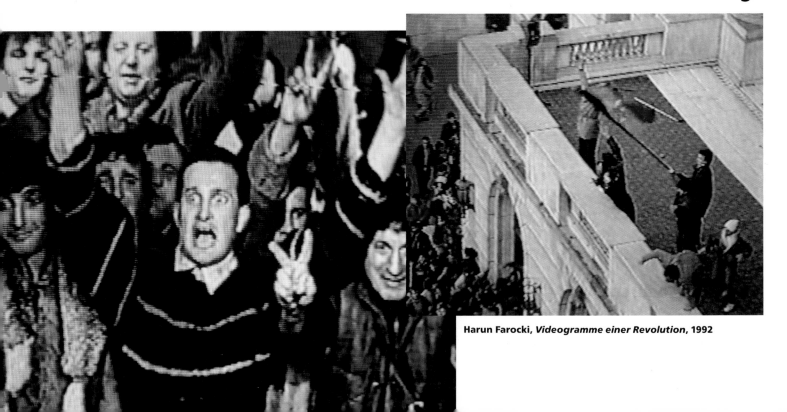

Harun Farocki, *Videogramme einer Revolution*, 1992

Paul Virilio

In the spring of 1989, from May to June, the students of Beijing decided to demonstrate for "democracy." To do so they gathered together and slowly filtered into Tiananmen Square, which they resolved to occupy indefinitely—an old practice that does not go back to the sit-ins of the 1960s, as some maintained, but to the Greek *polis* where the public space of the agora was the guarantee of political unity, of the right to citizenship upheld by the city dwellers bonding together against the threat of the tyrant.

On May 14, the date of Gorbachev's visit, they numbered three hundred thousand; five days later, a million. Exploiting the fact that most of the international agencies had sent their cameramen and reporters—indeed their major editorialists, like Dan Rather—to cover the reconciliation of the two giants of communism, the Chinese students demanded live broadcasting of the events at Tiananmen, so the image of the country's most famous public square could not only be projected over the entire world as was already the case thanks to foreign TV, but above all *in Shanghai, in Canton, and throughout China.* This demand was rejected by the authorities and martial law was finally instated—martial law that would see the Beijing population massacred by the tanks of the People's Army of China. What had happened before in Czechoslovakia with Prague Spring, in Poland with the "state of internal war," now happened again in Asia: the people's army crushed the people.

But let us focus on the *lighting* of these events by the world's news

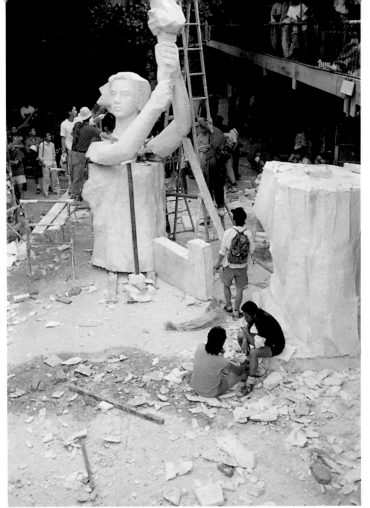

The Goddess of Democracy, Beijing, 1989

ld War finally comes to an end. 1991 Gulf War Dissolution of the
92 Maastricht treaty on European union. "Ethnic cleansing" and mass killing in

agencies. Highly conscious of the presence of fifteen hundred journalists in Beijing, the Chinese students did not cease to show signs of complicity with their distant, oh-so-distant "TV audience." Sometimes they wrote their banners in French or English, and they abounded in exotic symbols like the "statue of liberty" raised beneath the portrait of Mao Zedong, or their continual references to the French Revolution . . . In ancient times the surface of the agora or the mustering square of a garrison town matched the "surface area" of armed men: the citizen-soldiers of classical democracy or the regimented troops of fortified cities. "March apart, fight together": this infantryman's adage also matched the gathering of citizens in the public square, whose adjoining streets allowed them to rapidly reach this place where public power was identified with the crowd gathered in the face of danger, whether the danger of outside aggression or of civil war.

Curiously, with the public image of Tiananmen Square, broadcast to

the entire world, we witness at once an infinite extension of this "surface area" thanks to the real-time interface of the television screen, and at the same time a miniaturization of it, the 51 cm cathode-ray tube hardly permitting us to seriously envisage any depth of field in the broadcast events. Hence the importance of what occurred in Hong Kong during this period so crucial for the future: the use not only of private TV sets, but of *the giant screen in the municipal stadium,* so as to collectively merge with what was happening in the center of the Chinese capital.

This is TELETOPY, continuity in real time as a supplement to the lack of contiguity in real space: the stadium and the giant screen of Hong Kong rendered inseparable for a time from Tiananmen Square, as the latter already was for millions of private TV sets all over the world. Events at the far ends of the earth are rendered visible, accessible, despite the prohibitions of the Forbidden City, by the technical performance of a light which is at once electro-optic and acoustic, a

595

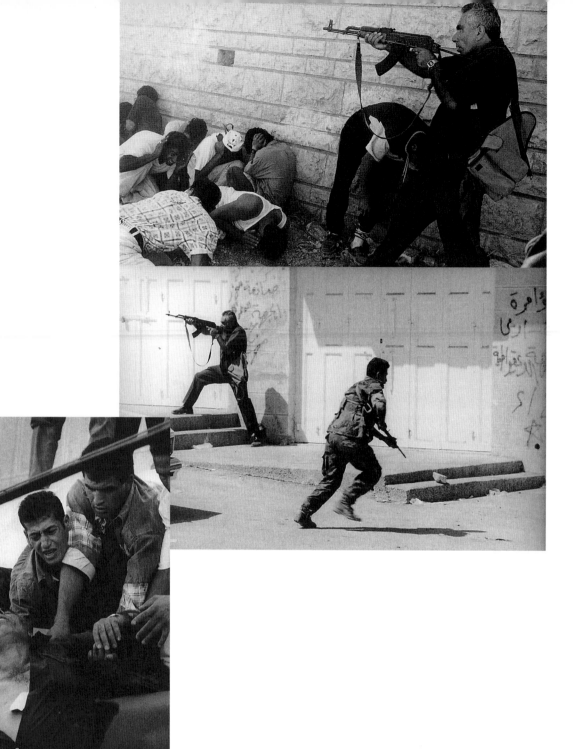

Miki Kratzmann, Ramallah, September 1996

living light whose effects on society will be incomparably more important than those attendant on the electrification of cities more than half a century ago.

Real time, time delay, 2 x 2 "movements": on May 15, 1989, the students gathering on Tiananmen Square called for a live broadcast of information. They were wasting their time.

From June 7 onwards, after the tragic events of Beijing, Chinese television did not cease the *delayed broadcasting* of sequences filmed by the automatic surveillance cameras of the police, showing the assaults on isolated vehicles and military personnel—and this, without ever having revealed the peaceful occupation of the square and the massacre of its inhabitants by the army of the People's Republic of China . . . A choice of images, or more precisely, a choice of the time of the image, was decisive for the country's political reality at that moment. As though the extent of the continent and the multitude of those who people it ultimately mattered less than the extension in time, the chosen instant in which to speak, to reveal what was really happening. The real time and space of the event of Tiananmen Square so disquieted the Chinese leaders that they had to temper its effects though REPLAY.

Strange politics, where the calculated delay of the public image claims to forbid its disastrous consequences, just as formerly the ramparts of public space and the laws of the polis acted as a brake on the menace of subversion or aggression. No longer only the choice of the day and the hour in which to *concretely* respond, as before, but the choice, the decision, for the immediate blackout of the event, a *temporal and temporary blackout*, parallel to the physical repression of the actors, the massacre of the students in Tiananmen Square.

One can indeed speak of a "siege" with respect to these events, a new kind of "state of siege": no longer so much the encircling of the space of the city by the troops, but *time under a state of siege*, the real time of public information. No longer the habitual censorship, the forbidden information, the secrets of state, but REPLAY, DELAY, a belated lighting of the living light of the facts.

"War in real time" finally proved Louis-Ferdinand Céline right when he declared, disillusioned, at the end of his life: "For the moment only the facts count, but not for long."

That moment has passed. Here and there, in China and elsewhere in the world, the facts are defeated by the interactive effects of telecommunications. TELETOPIC reality wins out over the TOPIC reality of the event. On June 9, 1989, Chinese television solemnly informed the public that the army would fire without warning on anyone carrying a camera of any kind.

From: Paul Virilio, *L'inertie polaire*, 1990,

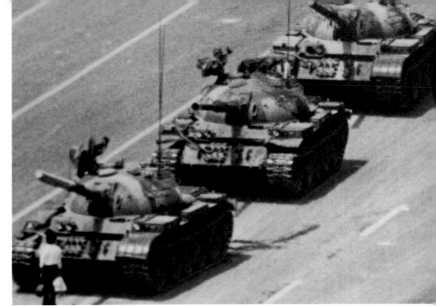

The army in Tiananmen, Beijing, 1989

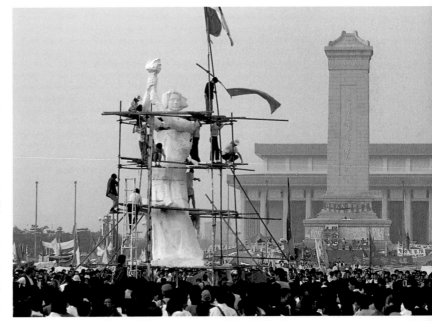

The Goddess of Democracy/Student uprising, Beijing, 1989

Dazibao, Beijing, 1989

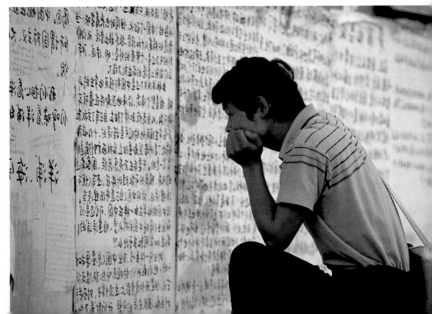

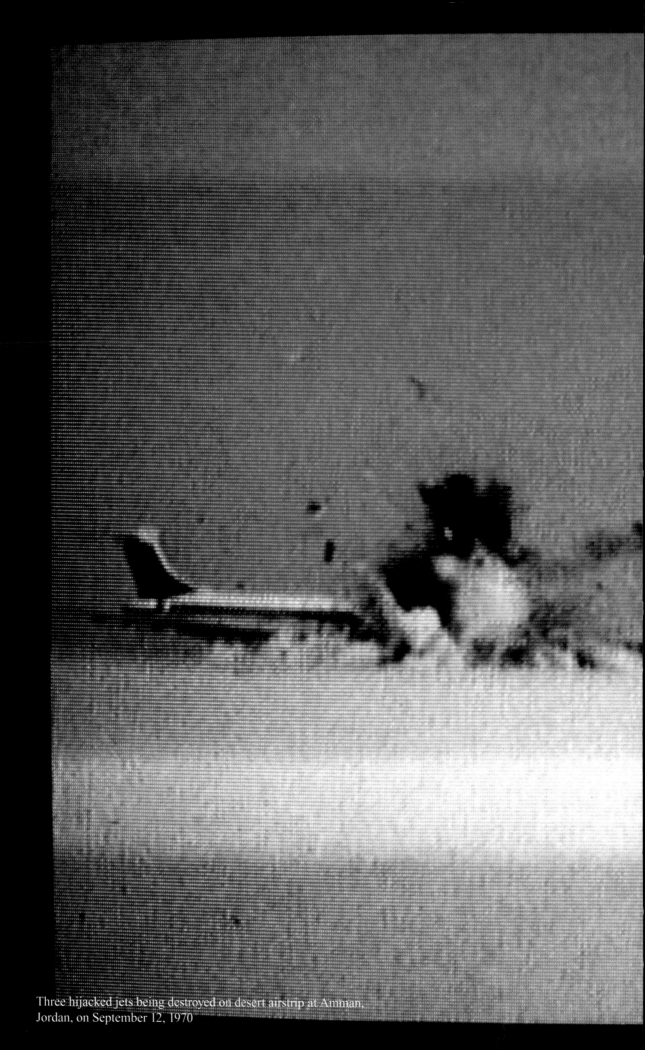

Three hijacked jets being destroyed on desert airstrip at Amman,
Jordan, on September 12, 1970

David Reeb, *Let's have another war*, 1997

LETS HAVE ANOTHER WAR LETS HAVE ANOTHER WAR LETS HAVE ANOTHER WAR

LETS HAVE ANOTHER WAR LETS HAVE ANOTHER WAR LETS HAVE ANOTHER WAR

LETS HAVE ANOTHER WAR LETS HAVE ANOTHER WAR LETS HAVE ANOTHER WAR

LETS HAVE ANOTHER WAR LETS HAVE ANOTHER WAR LETS HAVE ANOTHER WAR

David Reeb, *Let's have another war*, 1997

Ghassam Salamé

Traditional war is "finished" and nuclear war never happened; but violence has taken other forms, and has spread. With the successive periods of the international system, the definitions of war have multiplied, stressing its deliberate, programmed character, its function as a degraded avatar of politics or as a corollary to the class struggle. Today, armed violence refers to "promised lands" and refutes the capacity of ethnic groups to live together, even when they have done

Yugoslavia. Race riots in Los Angeles. 1993 Arafat and Rabin shake han in the Near East. 1994 Civil war and genocide in Rwanda. In South Africa, after t

Rwanda: Goma (Zaire)

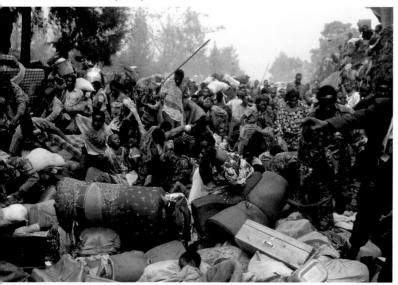

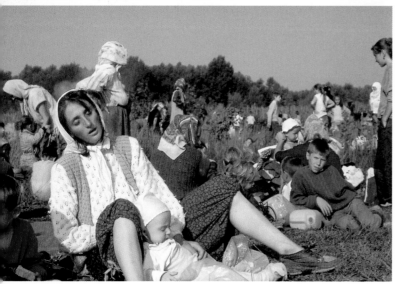

Yugoslavia: Tuzla, Bosnia, refugees from Srebrenica

so over the long term. It involves entire peoples in bloody struggles for identity, turning its back on political or ideological considerations and even common sense, and giving new timeliness to the definition of war by Gaston Bouthoul: "the fruit of bellicose impulses which generate ill-will and warlike ideas and render a group aggressive at a given moment."

Recourse to this pathological definition is more and more frequent. The war in Rwanda is qualified as "genocidal madness," calls arise to put Bosnia "under quarantine" before it "infects" the rest of the Balkans, while preventive diplomacy to "immunize" societies against the "virus" of war gains renewed respect. Karadzic's profession as a psychiatrist prompts jeers; Saddam Hussein is called a "monster"; editorialists link Yeltsin's military actions to his penchant for drink; Somali society is described as being attracted by collective suicide. In the same register, the tendency of humanitarian organizations and particularly of doctors to speak about "interventions"—while the generals dream of "surgical strikes"—can only reinforce, consciously or not, the apparent pertinence of the pathological analysis.

The West looks on with a mix of fear and scorn at what it considers, most often wrongly, to be the irrational behavior of peoples which it could "bring back to their senses" through possible intervention. The politicians are the first to profit from this pseudomedical description of conflict. In matters of terrorism, the so-called "religious madmen" have allowed governments to justify their inaction by the supposed madness of their adversaries, whereas in reality it was not expedient for them to engage in a riposte against terrorist states. In matters of civil war, the belligerents are presented as being "deranged" and the

602

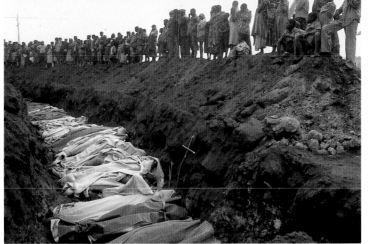
Rwanda: Goma (Zaire)

for external treatment. When war is perceived as a voluntary decision, there is an appeal to patriotism in support of the war, or a no less deliberate pacifist opposition. The pathological definition of war, on the contrary, opens a breach between the supposed irrationality of the belligerents and the serene rationality of the interventionists, since the belligerent is "sick" and the interventionist is a doctor determined to keep him from hurting himself and attacking others. A paternalism prevails behind this approach which, on certain lips, can easily become racism. In strategic terms, it amounts to recognizing a

the cameras in Washington. Four years later a state of war reigns again
eration of Nelson Mandela, multicultural elections are held for the first time . . .

failure to intervene becomes the only way to escape "being caught in a spiral of madness." Not taking part in a conflict "fed by insatiable hate" can also be a way to avoid recognition of one's own responsibilities (for instance, German support of Slovenia or French support of the Hutus).

Yet nothing proves that the calculations of Saddam Hussein, General Aidid, or Doctor Karadzic are really irrational. On the contrary, the implacable logic of their behavior is impressive. Saddam Hussein made several bad calculations before the Gulf War, but as soon as his misadventure in Kuwait came up short, he showed redoubtable rationality in keeping the military debacle from leading to the fall of his regime, as it naturally could have. In Somalia, Aidid carried out the highly rational policy of renting his technicals to the UN and the NGOs, and then extorting money for their "protection." He subsequently cooperated with the Americans in pushing out Butros-Ghali, who was suspected of favoring rival clans, then turned against the American troops when they wanted to reshape the Somali government at his expense. Karadzic carried out a systematic policy of conquest which, in his logic, seemed rational. Might the Westerners be the only ones to believe their own discourse on the madness of the "others"?

The medical-psychological argument nonetheless fits very well with the notion of "intervention." The word is employed as much by the military as by the surgeons, while diplomats and jurist make rather more prudent use of it. A pathological definition of war naturally calls

hierarchy among the states: some must be surveyed, contained, cared for, punished. The pathological definition of war is the best way to legitimate military meddling.

From: *Appels d'Empire*, Paris: Fayard, 1996.

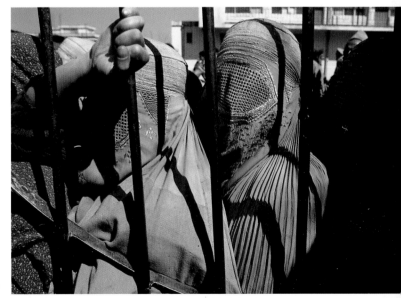
Afghanistan/Kabul

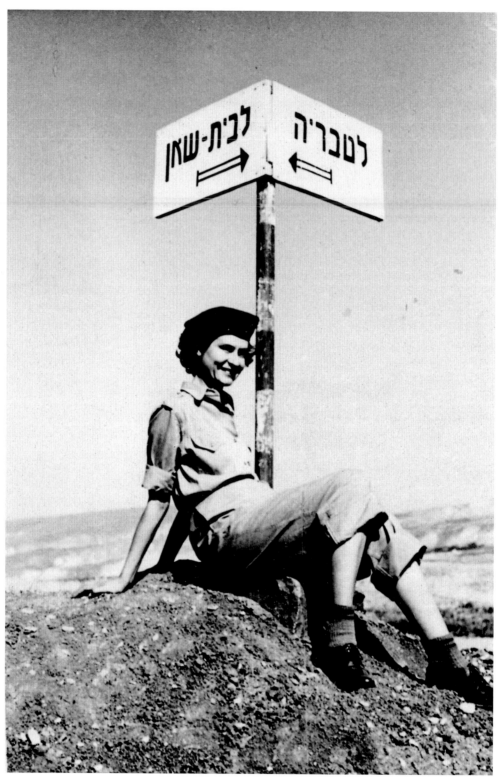

Michal Heiman, *Michal Heiman Test (M.H.T.)*, 1997

Michal Heiman, *Michal Heiman Test (M.H.T.),* **1997**

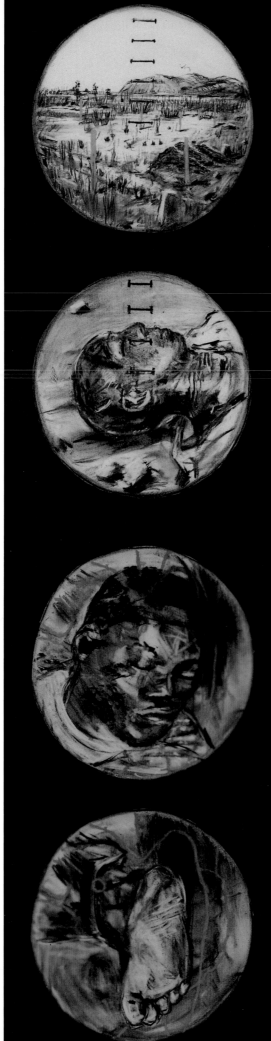

William Kentridge, drawings for the film *Felix in Exile*, 1994

William Kentridge

Amnesty/Amnesia

I am interested in the terrain's hiding of its own history and the correspondence this has not only with painting (the landscape paintings of my childhood and their removal from time) but with the way memory works.

The landscape hides its history. I mean this in a very crass way. Sites of events, massacres, battles, celebrations retain scant record of them. The name Sharpville conjures up a knowledge of the massacre outside the police station. And perhaps images from photographs and documentary films that may have been seen. But at the site itself, there is almost no trace of what happened there. This is natural. It is an area that is still used, an area in which people live and got to work. It is not a museum. There are not bloodstains. The ghosts of the people do not stalk the streets. Scenes of battles, great and small, disappear, are absorbed by the terrain, except in those few places where specifically memorials are erected, monuments established, as outposts, as defences against this process of disremembering and absorption.

In the same way that there is a human act of disremembering the past, both immediate and further back, that has to be fought through writing, education, museums, songs and all the other processes we use to try force us to retain the importance of events, there is a natural process in the terrain through erosion, growth, dilapidation that also seeks to blot out events.

In South Africa, this process has other dimensions. The very term "new South Africa" has within it the idea of a painting over of the old, the natural process of disremembering, the naturalization of things new.

In *Felix in Exile* the bodies in the landscape are connected to this process. I was interested in recording the people. Giving burial to these anonymous figures in the photographs. And erecting a beacon against the process of forgetting the routes to our recent past. It is also a way of fighting against the vertigo produced by looking

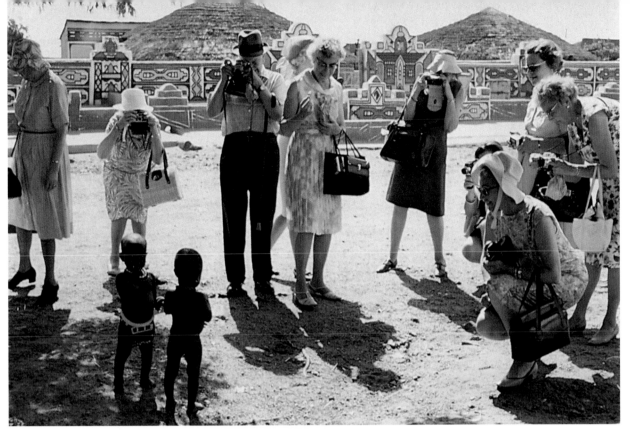

Ed van der Elsken, South Africa, 1968

Declaration by Steve Biko 1977

The line that the BC (Black Consciousness) adopts is to explore, as much as possible, non-violent means within the country, and that is why we exist. But there are people, and there are many people, who have despaired of the efficacy of non-violence as a method. They are of the view that the present nationalist government can only be unseated by people operating a military wing. Any changes which are to come can only be the result of a program worked out by black people, and for black people to be able to work out a program, they need to defeat the one main element in politics which is working against them. And this is a psychological feeling of inferiority. We don't believe, for instance, in the so-called "guarantee for minority rights" because guaranteeing minority rights implies recognition of parts of the community on a race basis. We believe that in our country there shall be no minorities, there shall be no majorities, there shall just be people. And all people will have the same status before the law, and they will have the same political rights before the law. So in a sense it will be a completely non-racial egalitarian society.

From the documentary film *Apartheid,* by Jean-Michel Meurice, 1992.

around and seeing all the old familiar landmarks and battlelines so utterly shifted and changed.

Felix in Exile, the previous film, was made at the time just before the first general election in South Africa, and questioned the way in which the people who had died on the journey to this new dispensation would be remembered—using the landscape as a metaphor for the process or remembering or forgetting. (Claude Lanzmann's film *Shoah* was very influential in its view of nature and landscape)

History of the Main Complaint was made eighteen months or so later at the time that the Truth and Reconciliation commission was set up here to look at past responsibilities. And so the questions of collective or individual responsibility for past abuses were in the air. Not that I have a single coherent explanation of the paths of the film—but I suppose it is true that Soho can only be wakened from his coma by an acknowledgement of immediate responsibility (for the death of someone in the car accident!) A case in which there may not be blame but there is responsibility. But of course Soho is not killed by this responsibility—and can even accomodate it (condensed and displaced into the objects on his desk). There is something of a convergence between Soho and Felix in the film. The driver of the car is Soho, the eyes in the rear view mirror are Felix's.

While making the film I was also fascinated by the new ways of seeing the body using X-rays, CAT and MRI scans, sonar etc. What is hidden under the skin and is our blindness to this similar to our blindness to the effects of our actions?

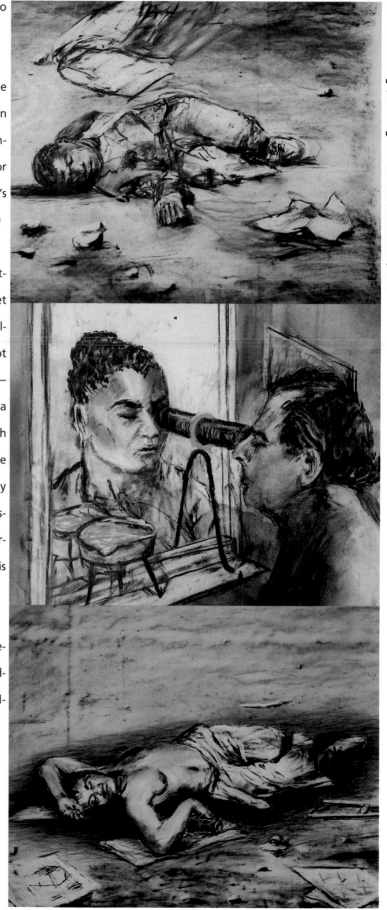

William Kentridge, drawings for the film *Felix in Exile*, 1994

David Harvey

The Strike in Korea

The Korean model of development was very Fordist, so it is a classic struggle of the sort that occurred under Fordism; it is no accident that we are seeing this happening in Korea, and not in Taiwan or Singapore, which have followed a very different model of development. The struggles are not confined by any means to the industrial sector, there are vast struggles over housing, over the reconstruction of the city, over expropriation of land and the like. The struggles that are occurring in Korea are embedded in the extraordinary rapidity of socio-economic change. Korea was essentially a peasant society twenty years ago, and now it is massively industrialized, proletarianized, urbanized. The political questions have to do with the position of Korea within international capitalism, and of course the relationship to North Korea, which is fundamental. If an alternative can arise from the contemporary movement, it has to be worked out under conditions where Korea is highly dependent upon global trade, is highly internationalist, and is suffering under these internationalist pressures. My impression today [January 15, 1997] is that the dynamic of the struggle has changed significantly. The fight against the dictatorship was led by intellectuals and students, and labor organizing was part of a larger process of acquiring democratic rights. The contemporary movement does not draw in the students in the same way. They're off on the side, and the intellectuals are probably more divided over whether they have achieved bourgeois rights, freedom of expression, etc., or whether they should support these movements which are much more worker oriented. That is a familiar story. And I think that the political debate within student circles and intellectual circles is rather critical for what is going to happen in terms of this workers' movement, first for whether it wins, and secondly, if it wins,

for what it will evolve into. It is a familiar problem of class alliances. Many of the people who were extremely active against the dictatorship are now apparently more concerned about buying a car and having some sort of consumption privileges, and they are not as politi-

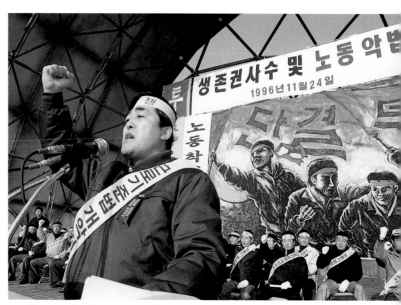

Seoul, general strike, January 1997

cally engaged as they once were. So here we're not only dealing with alliances between geographical entities with different traditions and histories and ideas, but we're also dealing with different class configurations and the question of how different class alliances can be formed in different circumstances. In Korea, I think the moment of strong class alliance between what might be called radical bourgeois and workers may be past right now, but that's just the observation of an outsider. I don't pretend to any expertise, but I do think we could learn a great deal from looking at the dynamics of this kind. It also helps us to think about ourselves, and how we position ourselves in class alliances, what kinds of alliances we forge with the working class or other populations, and around what kind of politics.

609

Serge Daney – Before and After the Image

The distinction I made between the image and the visual is pragmatic. I simply found it practical to use two different words. There's also the fact that the word "visual" comes up so often in the vocabulary of the press and on the lips of its "art directors." The visual is at once reading and seeing: it's seeing what you're supposed to read. You know how to read the press when you can quickly decipher a newspaper's visual, even if it's a newspaper without photos, like *Le Monde*. Maybe we're heading toward societies which are better and better at *reading* (deciphering, decoding through reflexes of reading), but less and less able to see. So I call "image" what still holds out against an experience of vision and of the "visual." The visual is the optical verification of a procedure of power (technological, political, advertising, or military power). A procedure which calls for no other commentary than "reception perfect, AOK." Obviously the visual has to do with the optic nerve, but that doesn't make it an image.

For me, the *sine qua non* of the image is *alterity*. Every culture does something with that more-or-less empty slot, the slot where "there is some other" (to paraphrase Lacan). No doubt we go to war in order to fill that slot, for a given moment, with only a single occupant: the enemy. It's simpler like that. So, when the so-called "Gulf War" appeared inevitable, we could imagine that we were about to see the other, or at least that "we'd see what there was to see." Even if you don't much care for war, you know it forms part of the human equation, it's "a way of seeing."

Some people must have expected to see a war *in* images, others a war *of* images, if only propaganda images. On one side there would be the Third World with its arms, its logic, its tricks, and its naiveté, a kind of clumsy heritage of twentieth-century propaganda (more like the USSR, the single party, etc.). On the other side would be the first country of the First World, heavily into propaganda too, but a little bit stuck in the wake of Vietnam (the defense of democracy, of the free world, etc.). In the end, all of us in the West were waiting for a spectacle, and we didn't get it.

Instead we "watched" an incredible face-off between two ways of *not making an image* (the way you say: don't make waves). A fairly unexpected way (from the Iraqis) and a very unexpected way (from the Americans). For years, the Iraqis had spent lots of money and energy trying to buy up the intellectuals of the entire Arab world. It must not have worked, because the moment they appeared on the world screen, in *mondovision*, they gave up the idea of providing any image whatsoever of the Iraqi nation-state. But on the other side of the coin, you can't help but think the Americans are also pretty short on an image of America, because they decided to wage (and win) this war while simultaneously blurring all its traces. So Bush and Hussein coproduced a black-out of every image of Iraq and the Iraqis, and it was a complete success.

In a sense, it's as though the Iraqis had slipped *below* the line of the image, and the Americans *above* it. That line is the line of alterity. It's the other in so far as he is still visible, however mean and nasty he may be. Ultimately it's *the look in his eyes* that makes him exist as a visible other. As Levinas said, it's a lot harder for me to kill you when I can look you in the eye. And it's true, executioners have always had a hard time looking their victims in the eye. It's not impossible, alas, there are always perverts and brutes, but still: it's difficult. On the other hand, remember that passage in Rousseau: it's always easy to push a button that will cause the death of a man on the other side of the planet, far from us. And that's where things stand.

The other's eyes have disappeared, by a common and implicit accord. Saddam Hussein was satisfied with a vague, emotional, all-purpose image of the "Arab world." And in the face of that, to our *great surprise*, the Americans seem to have learned their lessons from Vietnam and moved into a new phase of their power, where it's no longer a matter of war but of a gigantic police action. Now, when you're carrying out a police action, you don't post up the mug of the people thrown in prison, nor of the courageous cops. You do it in wartime because in war there's a lingering presupposition of equality between the combatants. Some-

thing of this equality may have functioned on the Iraqi side, a follow-up to the ancient duel between Saladin and Richard the Lion Heart. But even if that's the case, it's a pure fantasy with no response whatsoever from the American end (the Crusades aren't part of their history).

For my part, I was surprised by the way the Americans moved on without a single blow from the realm of the image to that of the visual. And the visual, this time, was the guided tour around the cop shop, or to the armaments expo at the Bourget military airport [near Paris]. This was what we were shown for six months, without us really grasping the meaning. Day after day we saw how almost 5,000 soldiers had ended up in Saudi Arabia with incredible equipment. We thought it was the trailer for a horrendous epic, but no, *it was already the film!* When the Western media decided to get up close to the Iraqi other, it had become almost impossible. But that's because they waited—six months!—until war had broken out before taking any interest in a country which, until then, they had chastely passed by. During the time when French arms sales to Iraq kept several hundreds of thousands of people working in France, you never saw friendly TV reports on that providential land. And when Saddam lost the war I don't recall any great upsurge of tele-curiosity concerning the Iraqis. Before and after, there was only the simple curiosity to go see for yourself what had never really been. In its place was the Kurdish image. Media-wise, we exchanged the *non-image* of the Iraqi other for the *over-image* of the Kurdish other. As though the latter had accepted to hop up and replace a recalcitrant actor (for no charge). So today you get a kind of nausea before all this beautiful human suffering, which is even more moving because the Kurdish cause is hopeless and because the Kurds, betrayed by the whole world, are really beaten, at least. Whereas we still don't know how many Iraqis were killed during the war, and what with the Arab habit that consists, alas, in carrying off only *defeats*, the official line from Baghdad is probably that the Iraqis won. So what use are images, when nothing stands as "proof" anymore?

It was stupid enough on Saddam Hussein's part to underevaluate the extent to which he would lose *face*. But face is not a look in the eyes, and the whole question may be right there, between two words. The only image that exists in the Arab world is the image of the Leader. In France you still have the effigy of the Republic, Marianne, which is different than a leader or a picture of the president: but you only see it in the city halls, it's residual. What the Arab world has slowly gotten us used to is this love relation with the leader, especially in moments of crisis, when the leader proves to be above all a loser. Misplaced pride that consists in swelling the biceps and hiding the victims, and that finally leads to the victims' masochistic identification with the biceps. Now, showing the victims, counting them out *one by one*, calling them by their names, is at least a way of recognizing the fact that they are human beings and that they have a right to the look in their own eye, battered as it may be.

The question isn't specific to that part of the world. It's no doubt the pure and simple question of feudalism—and that one really stymies us, because we all believed the Marxists when they spoke in a condescending tone of feudalism as an outdated, bygone mode of production. In the rich countries today, the very modern successor to feudalism is the Mafia: the United States, Italy, Japan, etc. In the countries that have just come out of the deep-freeze it's a well-known reality: the URSS, China. In the poor countries, the Mafia is still the clan that kidnaps the political power and plays baby-toy with weapons and the code of honor. It's normal that such a Mafia should have no other image than that of its current leader and that it should identify, for better or worse, with his distress, and only his. It's tragic, for example, that none of the Arab leaders in the anti-Iraqi coalition found it fitting to say a few words (even something purely formal) about the Kurdish distress. It's even more tragic that they don't realize for a second that those few words would ricochet into the best possible publicity for the Palestinian cause. Masochism is not the contrary of egotism, far from it.

But if I look on the American side, it's even more surprising. It's like the country was testing a new definition of itself in this war. A definition that no longer has much to do with the hyperindividualization of the average American, a definition that completely forgets G.I. Joe or John Doe, "the man in the street," and heads straight for General Schwarzkopf or Colin Powell instead. We're a long way from the bloody, ambiguous, but humanly very rich memories of Vietnam and the fifteen years of films, some of them very beautiful, that came out of that trauma-war. Nobody thought the American identity was as tattered as it is. Given the real difficulties of the country, you wonder what the price will be for this public demonstration that the wound is all scarred over.

For the moment, the Americans have won two wars. The real war, the police action, took place exactly as planned. But there was also the war of images. During a TF1 broadcast, on a disgusting set with everybody congratulating each other, a CNN journalist started moaning about a poll published in the States, according to which people felt there were too many images of the war, that all those images played into enemy hands, that there was no need to see so many. America has succeeded in what Saddam attempted: the *blind retribalization* of its population, including the support of the traditional victims of American society—Blacks, Latinos—who were thrilled to be among the victors for once, like Colin Powell, no doubt Bush's next running mate.

Let's return to the distinction between the image and the visual. The visual is the verification that something functions. In that sense, clichés and stereotypes are part of the visual. For example, there's a visual minimum of Arab presence in France, it's the immigrant's face. But beyond that "face" (without eyes) there is a general inability to tell the particular story of any *single* immigrant, whether first or second generation. As soon as we start talking about "the Arab in the street," the group is always what's filmed and the group is always what speaks. Participating in a collective protects them, it's what makes them exist in relation to their

enemy on the corner, the cops that hassle them or their racist neighbors. The result: their discourse is uninteresting, it's a sentimental wooden tongue that will always favor fantasy over information—and the media couldn't be happier that "the Arab in the street" is always ready to run off at the mouth about Saddam or the Palestinians.

During the war, the TV people obviously said to themselves: we have to watch out, we have to "cover" the Arab in the street, the immigrant kids and all that. So we saw a litany of depressing images of street hysteria, particularly in North Africa. As though today the word "masses," abandoned along with the ideals of communism, could only be applied to the Arabs. As though the heritage of leftism and Third-World liberation were there and there only. As though the dead ends of *identity* (which only serves to infantilize and offer pleasure in that infantilization) had become an Arab monopoly. As though we had forgotten that the Arab world, our neighbors and our cousins for so long, is a generally non-violent world, though given to exaggerated rhetoric. Finally, as though North African immigration in France, over the last fifty years, weren't the most peaceful immigration that's ever been! Myself, when I think of the others' identity madness, I look apprehensively toward Hindu fundamentalism and Serb tribalism, not toward the neurosis of the Arabs.

And yet there's a moment when someone like me is obliged to take his distance from the way both the French media and the "Arab masses" go about fabricating a massive and menacing image of the Arab world, on the basis of its "humiliation." What has changed since that faraway era when we were leftists is that now I do it in the name of values that belong to *my* culture, even if I'm not certain that those values might not soon be in the minority again. But I'm too old to waver on the little I've learned from thirty years of demagogy and hysteria combined. It comes down to this: every *individual* figure that emerges is that much taken back from the fascinating (and fascistic) sirens of communitarianism. Does a French-speaking Arab intellectual need Montesquieu to emerge as an individual voice? If

so, good for him. Can he do it from a strictly Arab background, Ibn Khaldoun or Ibn Arabi? In a sense, I don't need to know. But what else can you expect?

That puts you in a rather touchy situation with respect to your oldest Arab friends, because you feel like telling them that nobody's going to dispense them from having the courage to say, "Me, I," the courage to go against the community flow and to do without all the advantages, material and otherwise, that come from setting up on the sly between two worlds. I remember how sad I felt when Kateb Yacine died: when things were really going bad in Algeria we always tried to get in touch with him, simply because he talked straight. That wasn't so easy, for us either. The West is terribly clumsy about recomposing forms of the social tie, of conviviality, of complicity, to fit in with individualist societies based on the market. It's tough to deal with, and there's always something morose about it. It often seems that the attendant mediocrity is going to depress us once and for all. And at the same time, there's always an unavowed nostalgia for a more organic past, which is not so far from us and whose futile remains can be found in national-Lepenism today (and yesterday in the French Communist Party).

That's why the Arab world, with its amazing social ecology that has outlived centuries of political decline, has long represented for some of us a highly vibrant reservoir of a certain social affectivity. Nowhere else is the other so well conceived, *as long as he is concrete*, as long as he is the stranger to whom you owe respect. But the tragedy, and a tragedy that becomes inevitable given the economic state of the world, is that nobody in the Arab world can conceive of the *abstract other*. Universalism seems to have stopped in mid-stride, and the forces of a return to the village, and a return to the terrible lack of curiosity toward the rest of the world, signify to we Westerners that we remain all alone with our still-conquering and often empty universalism.

It's astonishing to see how the inward turn of the Americans has freed up that old story of the Crusades as *our problem* (here in Europe). Sometimes I think it

may just be unforgettable on the Arab side. It's a frustrated love story between the former losers (after all, the crusaders were clearly less civilized and were kicked out in the end) and the new losers (the Arabs helped the modern world in its birth pangs but haven't accompanied it on its adventures). Today, when people talk about *humiliation*, what I hear is rather the fact for the Arabs of not having been recognized by the *only* interlocutor who ever existed for them, the old European-Christian road buddy, the one who "succeeded in life." The relationship to America seems much more superficial to me: America is at once the most desirable and the most powerful country, and because it's the most powerful it has been made into the great Satan, the only one worth being beaten by. If the Machrek Arabs had a real historical memory, it's the English they should hate to the death. Because as far as a pernicious and effective political strategy goes, the Foreign Office remains unbeatable!

Is television democratic? What's democratic, I think, is to look into that collective mirror and make the distinction between what can be done, what we know how to do (and news technologies are more advanced than ever), and what doesn't come cheap, what's difficult. It doesn't bother me when they say on the telly that no journalists were sent to Iraq because Saddam Hussein opposed it. But it ought to be said in such a way that the tele-spectator says to himself, "Hmm, we're missing an image," and so that he doesn't forget that image. Myself, I learned that from Godard. In an old issue of *Cahiers du cinéma*, ten years back, he asked us to illustrate an interview with him by putting in big white spaces blocked out with lines and captioned "here, the usual photo." It was a way to say that in any case, photos serve to paste over a void, to decorate, to supply what I now call "the visual"—but not to show anything.

By leaving the space empty, he *showed* the possibility of not pasting over. Today I have the feeling that we've lost, that Godard has lost, and that the media—with the TV in the lead—forbid us to think: "Hmm, we're missing an image, let's leave

that slot empty, let's wait to fill it." The fear of the void is so strong that it takes us over as well. The void is no longer a dialectical moment between two fulls, it's what you must "make them forget." That's why, as I was just saying, we "forgot" to demand reports on vanquished Iraq, just as we forget to ask the immigrant kids in the suburbs what they *now* think of Saddam Hussein.

I wrote a text where I tried out the following metaphor: the news is now like a *sweeper-car*, scooping things up one at a time, illuminating a line of objects on a floating market. It resembles nothing so much as the way an electronic image is fabricated: by a sweeping movement, not by a gaze. There's no emptiness in sweeping. A surveillance camera doesn't complain if it hasn't recorded any event. It's in the idiocy of live for live's sake. It confuses actuality and news. What was the news for most average French people? That Iraq was not Saudi Arabia. That's not much, even if it's something. But for those of us who knew it already? Nothing.

On December 31 I saw a very short report on Baghdad, the nightclubs, people drinking whisky, girls without veils, people who seemed not to believe in the war and who looked like they were having fun. It was exactly like here. Why was it such a minor piece, almost folklore? Why not do a real duplex between here and Baghdad, all night long on the 31st? Maybe that's how the difference between Baghdad and Kuwait could really appear, maybe that's how we could break through the ready-to-think, the cliché, the already-seen.

And why, after the war broke out, didn't we see any reports on the archeological sites, on Ur, on one of humanity's birthplaces, and on the dangers? You wouldn't have to be a journalistic genius to have the modest idea (but there are a hundred others) that one way of speaking about Iraq could be the passion of a French Assryiologist worrying about the sites. The TV doesn't think like that, it waits until it's too late before connecting all its studios and exhibiting vain logistics that quickly ends up serving the politicos and the military.

OK, there are six channels in France, and you could leave one, the most popular, TF1, as the servile echo of all the big influences. But even people in the know, even

the intellectuals (as naive as anyone else) needed some more information, if only on channel 7. Why couldn't film buffs have seen the propaganda films that Taw-fiq Saleh and Salah Abou Seif (the best Egyptian filmmakers) made a few years ago to the greater glory of Iraq? A superproduction of the battle of Qadisiyyah is pretty interesting if you want to understand Saddam's paranoia.

The problem with the image of the Palestinians has to do with the dispersion of the real Palestinians. I can't make brilliant Americans like Edward Said, the kids of the Intifada, the businessmen who propel the Kuwaiti economy, the combatants in Lebanon, the refugees in Jordan, and my old friend Soufian Ramahi coexist in my head. And if I think I can't do it, it's because between the word and the thing, the word—the word "Palestinians"—has won out. It's a word with success, it's a pure signifier, at once umbrella and alibi for everybody. And we know how much easier it is to die for a word than to work for the image of a thing. So there is no *complex* image of Palestinian reality, and that, I'm afraid, plays into everyone's hands. The image of Arafat is empty, free-spinning, unsinkable. It's a cliché, in the sense that a cliché is an image that can no longer evolve. No doubt this cliché is useful for the survival of the word "cause," but it doesn't function as much more than an advertising label.

I remember a film shot in 1976 by some pro-Palestinian friends, entitled *The Olive Tree*. Already in this film there was one image too many and one image missing. The image too many was the one offered by the PLO, the "lion cubs," the children militarized in the camps. I had to explain that such an image makes bad propaganda in the West, which is the (only) part of the world where people long ago quit being enthusiastic at the sight of children in arms. OK, the people from *The Olive Tree* didn't keep that image; but when Godard filmed *Until the Victory*, which in the end was called *Here and Elsewhere*, well, Godard didn't think he should censure that same image of the training of children. I remember a little girl who made a mistake in her motions, who had an instant of fright, and that's the

image which is unforgettable for me. But that image means people are going to die, and she knows it.

As to the missing image, still in *The Olive Tree*, it's when Marius Schattner explains in a very sweet voice that underneath the Israeli colony (which we see) there is, buried, covered over, a Palestinian village (which we do not see). I also remember that because at *Cahiers du cinéma* we were among the few who had always known that the love of cinema also means knowing what to do with images that are *really missing*. And the image of the Palestinians was already difficult. The Palestinians themselves didn't help. When we saw Michel Khleifi's films we regained some hope: it was clear to see that there were concrete Palestinians and concrete Israeli soldiers, and you understood that Israel had lost the capacity to propose an image as effective as the image of the kibbutzim in the fifties, or the image of *Exodus*, because the Israeli nation-state had become too rigid to run the risk of an image.

When the other begins to lack, each of the camps pulls back to its "visual," one in its real State, the other "in all the states" of its imaginary.

Serge Daney devoted a number of pieces to the media coverage of the war, in *Libération* and on the radio. When he summed up these reflections in *Cahiers du cinéma* (April 1991), he proposed the idea of a distinction between the image and the visual. The *Revue des études palestiniennes* asked him to make this distinction more explicit.
From: *Revue des études palestiniennes* 40, Paris, Summer 1991.

EMPTYING THE MIND ON ITS WAY TO THE VOID FULLNES, WHICH IS EMPTY OF ANY EXISTENTIAL THOUGHT.

14 2 97

DRAWING ON THOMAS:

DIBUJAR SOBRE ESTRUCTURA OSEA DESCRIBIENDO EL OCIO TRIDIMENSIONAL.
LINEA SOBRE VOLUMEN. TOPOGRAFÍA DEL CRÁNEO. ENTRANDO EN LOS
OJOS. PERDIÉNDOSE. RETRATO DE UN ESPACIO. ESPACIO QUE
SUCEDE. SUCESIÓN DE LÍNEAS, ESPACIOS Y TIEMPO. MATAR
EL TIEMPO.
RED DE PENSAMIENTO. CONEXIONES. CONCIENCIA COMO RETÍCULA
DE PERCEPCIÓN.
DIBUJO DE LA NADA. EL VOLUMEN DEL NO. RECIPIENTE VACÍO.
COMO CAJA DE ZAPATOS.
MIRADA COMO ESPACIO. RECIBIENDO.
MIRADA COMO ESPACIO QUE RECIBE.
 COMO RECIPIENTE
PASAR EL TIEMPO CON LA NADA. PERDER EL TIEMPO.
RAYAS EN EL AGUA.
LAPICERO COMO BISTURÍ

SKULLPTURE.

 EL OBJETO
CON EL DIBUJO APLANAMOS ~~LA IMAGE~~ VOLUMEN HECHO GRÁFICA.
OBJETO HECHO IMAGEN

PRIMERA SERIE DE
FOTOGRAFIAS.

1960–1997 The Political

Benjamin Buchloh,

Catherine David,

Jean-François Chevrier

Continued from Part 1 (page 403)

Michael Asher, Sculpture Exhibition in Münster, 1977, Mobile home parked in various spots

JEAN-FRANÇOIS CHEVRIER 1978 is an important date for you. You had just left Germany. Can you tell us the reasons for your move?

BENJAMIN BUCHLOH The Nova Scotia College had attracted a large number of conceptual artists to Halifax, a place out in the middle of nowhere in eastern Canada. It was a place where you could study contemporary art with a conceptual focus, in a range from Ryman and Richard Serra, on the one hand, to Dan Graham and Jeff Wall, on the other. In this context Kaspar König had founded a series of publications—it was called The Nova Scotia Series: Source Materials in the Contemporary Arts. After four years during which he published numerous important books, he left the school and they looked for a successor. They contacted me on the occasion of the first sculpture exhibition in Münster in 1976, and I was invited to Halifax in 1977. It was absolutely nowhere, not even romantic—but I had wanted for years to live

Potential of Art

Part 2

in America, and at that time I was naive enough to think that Canada was the same as the United States. After that first trip I wasn't certain whether I would accept the proposal. On the way back to Europe I was sitting in my hotel room in Toronto with these thoughts in mind, when I learned on television that the Baader-Meinhof group had supposedly committed suicide in prison. For me it was clear they had been killed, which I incidentally still believe, even though there is no proof for either assumption. The death of the Baader-Meinhof group along with the *Berufsverbote** in Germany and the general swing to the right signaled the definitive end of any aspiration for a left culture in Germany. So I decided to leave.

Of course that wasn't the only factor. I also hoped to join an institution which had seriously supported conceptual art. In fact, that was an interesting disappointment: it was the moment when the major presence of conceptual art at the school was over. When I moved to Halifax I met a young painter on the faculty named Eric Fischl who was doing performances with little pieces of scenery paper on which he drew figures. He quit the school a year later to become the big star of the new expressionist figure painting in America, the right-wing reaction! Things were closing down and turning around all at once. You can see that in the books I did. The first books continued the program, with Dan Graham, Carl Andre/Hollis Frampton, and the major project with Michael Asher. But soon afterwards I initiated a quite different series indicating the direction I judged necessary.

JEAN-FRANÇOIS CHEVRIER What was it like for you to live in North America?

BENJAMIN BUCHLOH As I said, I went to New York for the first time in 1972. Like all Europeans, I was fascinated. I'd also had frequent contacts with American artists, and even more importantly, I realized one day that most of what I had read on contemporary art was American criticism and American postwar art history. There was hardly anything to be read in contemporary German art criticism. Most of the artists who interested me were Americans, even if that would change later on. Perhaps somewhat naively, I moved to North America with the idea that it was an open,

* The *Berufsverbote* laws of the late seventies prevented certain German citizens who had been involved in radical political activities from exercising a profession. —Tr.

625

universal culture, accessible to anyone who wanted to approach it. That was the myth of America perceived by a German at that time: a postnational culture, a post-traditional identity—even though what I was more likely searching for was a transformation of my own German history!

CATHERINE DAVID There must have been an ideological trauma. Leaving because there's no more radical left alternative, to live in a country and at a time where there's anything but a radical left! It must have been dramatic to turn your back on a hopeless situation and to head for the worst.

BENJAMIN BUCHLOH Why move to a country which has destroyed the left tradition far more efficiently than any other? Of course there is still a left in the U.S., but not an official, organized one, there are left intellectuals in the universities, maybe even more than in Europe—that's an American paradox, the radical and somewhat coherent leftist thinking in certain artistic circles. But for my part, I thought I was going to an open context. I had understood from my early visits that if you really wanted to do something in artistic and cultural circles there, you could. I don't know if it is still true. It wasn't a matter of university degrees, nor of institutional affiliation, nor of family relations. If your project interested people, there were always the means to carry it out. That seemed to be a real difference from the Academy of Düsseldorf, where it was clear that for me, things were shut down. The Nova Scotia college at that time was still an amazing institution, with lots of interdisciplinary activities, a climate of real openness between the between the different departments, the artists, and the visiting faculty.

JEAN-FRANÇOIS CHEVRIER Did you have the feeling of discovering a country marked by a mythology of individual fulfillment, as opposed to the more organic aspects of European mythologies?

BENJAMIN BUCHLOH What remains true in the United States is that because of the profound absence of traditional culture, a contemporary cultural producer can always engender a structure with a certain urgency, a certain necessity. The work of Dan Graham or Michael Asher—who was very important for me at that point—is never initially conceived in an institutional or discursive context only, but on the contrary, it seeks to set up a procedure of production. It is a matter of establishing oneself in contemporary reality with a practice, and not merely delivering a museum object. The link between artistic and cultural practices always seems more immediate in the U.S. than here. For example, feminism in Europe, like a certain reception of American multiculturalism, seems instantly to be transformed into merely another object of culture. Whereas the reflection on multiculturalism in America wants to inscribe itself in political reality, at least it wants to bring about minimal reforms. Even if it begins as a cultural practice on the symbolic level, it is not conceived outside of the reality of political and cultural institutions. The German cultural structure is happy to incorporate an artist like Renee Green because she seems astonishing, strange, exotic, but

Michelangelo Pistoletto
Padre e Figlio **(Father and Son), 1973**

German cultural producers don't want to think about why the German government pays 40 million marks to deport 4,000 Vietnamese guest workers from the former East Germany. For me it's a form of ethnic cleansing, with financial rather than military means. There's no reflection, no criticism about these questions, but on the contrary a fervent interest in American-style multiculturalism on the level of cultural production.

CATHERINE DAVID Maybe there's a nuance to add here. To the best of my knowledge there's no urgency to the discussion of multiculturalism in Germany at this time. On the contrary, procedures are being set up so that the third generation of Turks can speak German and be German. It's a little revolution, for a country where nationality has been based on blood . . .

JEAN-FRANÇOIS CHEVRIER You say that imported cultural practices are reduced to products and fashions. But what about the dimension of narrative? For better or worse, Europe is the region of the world where the narrative of modernity was constituted, and it remains the keeper of that narrative. With its ambiguity. Personally I think that whatever the sophistication of certain individual works produced in America, the narrative of modernity in its American version is simplistic, productive of fashions, and lacking in ambiguity, or marked by a very poor ambiguity.

Michelangelo Pistoletto

You yourself said that people in America do not recognize the ambiguity of Broodthaers. It's true, however, that we can see it in Jeff Wall and in Dan Graham. You're the first to have said that Richter's ambiguity can't be perceived in America. One shouldn't forget this dimension of ambiguity, between a radically critical modern position and the persistence or remanence of what could be called traditions, even archaisms.

BENJAMIN BUCHLOH I could be nasty and answer that, after all, it's in America that Anselm Kiefer made his career. Which means that America is nonetheless capable of reading or desiring that ambiguity, even if it cannot produce it . . . But I agree with you. We need to be more precise. The Warhol-Richter opposition has greatly fascinated me and continues to do so. Richter has often admitted that the presence of Warhol in Germany had an extraordinary impact on his work; for example, his presentation at the 1972 Venice Biennial would have been unthinkable without Warhol. And yet Richter moves away from Warhol, precisely because of the ambiguity you're describing. A similar ambiguity causes some artists to fall into the worst traps, Kounellis and Boltanski, for example. The ambiguity that one seeks to restore with a gesture of redemption, of humanistic subjectivity, is a project doomed to failure. The greater the effort, the louder the declamation, the more the project is subject to the mechanisms of spectacularization that it tried to challenge. Kounellis is the most tragic case. When he arrived in the U.S. at the height of his success, with a seven-room installation in Chicago, it was the catastrophe of a great Italian artist falling into the trap of the spectacularization of ambiguity, of memory, of the notion of the mythical subject.

JEAN-FRANÇOIS CHEVRIER I agree with you entirely. It's a matter of distinguishing two ambiguities. You just mentioned Kounellis, I'm going to mention Pistoletto. With his so-called mirror paintings of the early sixties, Pistoletto produced an alternative to American pop art, just as Richter did. Pistoletto dedramatized and put back into motion the figure of postwar man that had

Benjamin Buchloh: Arte povera, which I greatly admire, particularly at its beginnings, seems to me to be an example of an artistic practice that seeks to resist the erosion of cult value in the early sixties. This is one of its paradoxes: in its anti-Americanism, arte povera seeks to maintain the dimension of the cult at the very moment when exhibition value becomes exclusive—specifically through its choice of pre- or nonindustrial materials. In direct opposition to minimal art, arte povera constructs a discourse of the natural, the pre- or extraindustrial. I see it as a hope to restore what one could ironically call the naturalization of the aesthetics of collage, an attempt to recompose assemblage outside the aesthetic of industrial objects.

Jean-François Chevrier: With Pistoletto we can more precisely identify the ambiguity. It is an ambiguity between craftsmanship and industrial production, between bricolage and engineering. The facture of the *Minus Objects* is postartisanal but not yet industrial. Pistoletto's father was a craftsman, and there again we're in the same logic of persistence, of a remanence of traditional, paraindustrial structures which are maintained in parallel to the Taylorist production of the twentieth century. In some astounding works, Pistoletto engaged a collaboration with his father, he genealogically integrated the artisanal model into a production which remains totally ambiguous, because it is situated between craftsmanship and the modern norm, and also between two generations. That's the ambiguity in contrast to minimalism—and it's not the ambiguity of arte povera in general.

Benjamin Buchloh: It seems to me that the tragedy of arte povera is precisely not to have reflected on the conditions of the modern artwork's reproduction. It tried to reconstitute a fundamentally auratic work, singular and paraindustrial, without reflecting on the fact that this very work would be reproduced in the distribution system of the culture industry. On the contrary, the work of the Americans, Warhol or minimal art, perfectly anticipated that problem. The repetition, reproduction, or serialization of Warhol's works does not suffer from the false authenticity that arte povera has engendered in its own reproduction. I find nothing more dismaying than to walk through European or even American museums and see yet another little variation on Merz's igloo or another fragment by Kounellis—serialized productions for the museums.

Jean-François Chevrier: In general I agree, but Pistoletto is the exception, he integrated the dimension of reproduction. What's more, he is at the source of arte povera and he remains the least considered in the U.S., less than Merz, Kounellis, and so on. He was the first to be integrated by the American spectacle machine, since Castelli-Sonnabend fit him into the pop movement; but that was a misunderstanding which he refused. Later, when he went

on to something different, he was excluded. Clearly censored and excluded.

Benjamin Buchloh: I'd say he became illegible and impracticable!

Jean-François Chevrier: Censored and excluded! So there is this exception. I find it significant that he is the only one of the arte povera artists to have systematically integrated photography, that is, an art of the multiple. But couldn't Richter's abstract paintings be criticized on the basis of the schema you establish, quite rightly, for arte povera as a whole?

Catherine David: It seems to me that there are less problems with Richter because he deliberately stuck with the classical form, a painting followed by another painting. In the case of Pistoletto, as for many who have chosen activity over the finished work, there is the problem of managing the leftovers. That clearly poses the problem of the institution, of the current state of the museum, and here I'm afraid we're likely to arrive at a kind of "insurmountable historical horizon." There's no solution to the problem except through the more or less subtle and coherent management of the pieces. (In Munich, for instance, it was disconcerting to see the excellent Pistoletto retrospective in the Lenbachhaus, with a perfect understanding of his work, and next door, the gallery

with bits of broken mirrors and so on . . .) This has to do with very vulgar problems of survival for the artists, with the problem of the market, but also with the problem of history. It seems to me that the notion of ambiguity is totally linked to the notion of history. There is not the same relation to history in the United States and in Europe at this time.

Benjamin Buchloh: What do you mean when you stress the presence of the family structure in the Italian ambiguity, and above all in Pistoletto?

Jean-François Chevrier: Simply the persistence, even the conservation of preindustrial rites.

Benjamin Buchloh: And you stress that as positive?

Jean-François Chevrier: Of course it would bother me if it covered up what Max Weber identified as the characteristic disenchantment of modernity. But nothing is hidden in Pistoletto, so we're dealing with ambiguity. There are two things: the recognition of the process of disenchantment, with the subversive desublimation that Andreas Huyssen and Marcuse describe, and then the integration—in the psychological sense—of traditional elements through processes of genealogical reproduction, which are very explicit and legible in Pistoletto, as explicit and legible as in Richter, because Pistoletto works with his father, inherits from his father in the psychological sense, collaborates with him. . .

been fixed by Bacon. In his mirroring pictures he combined photographic representation—the hieratic snapshot—and the contingency of the spectator-visitor's mobile image. He took a stand with things, but in time, and in a time that moves at different speeds, not just the perpetual present of reproduction. Then there is a second phase in Pistoletto's art, with the *Minus Objects*. In my view, the origins of arte povera lie in the *Minus Objects*, which are a response to pop seriality but also to minimal seriality in its ideological form (I'm not speaking of the artists, but of minimalism as an ideology). In Pistoletto one can precisely assess the extent to which the ambiguity plays on the unresolved conflict between the demands of modernity and the remanence of a traditional structure. Here, in the case of an Italian artist, the traditional structure is summed up both by the family structure, which resists modern disenchantment and retains traditional rituals in a living form, and by a model of civic culture which has been able to keep certain aristocratic-popular styles of life. In Richter, of course, it's another culture, it's more a bourgeois structure, the one described by Habermas.

BENJAMIN BUCHLOH Is "aristocratic-popular" something like "poetic document"?

JEAN-FRANÇOIS CHEVRIER No, it's a historical situation, not an oxymoron! If we look back over Europe in the late eighteenth century, it's obvious that the enlightenment was stronger in Germany, France, and Great Britain than in the Mediterranean countries such as Italy, or even more so, Spain. What was established in the late eighteenth century is bourgeois society, market society, with its ideology and ideal of the public sphere. It is a system for the integration/exclusion of the people founded on this new bourgeois norm. In Italy, on the other hand, you see the perpetuation of an ancient urban civil structure, bourgeois and aristocratic, which gives rise to another structure for the integration/exclusion of the people, one which is based on the urban entity. Instead of a strong central government authority, as in France, Germany, or Great Britain, there is a civil structure, in which the bourgeoisie remains much more dominated by a regional aristocracy.

Michelangelo Pistoletto, *Due donne nude che ballano* (Two naked women dancing), 1962-64

BENJAMIN BUCHLOH What other examples of ambiguity could you cite? Myth, national culture, national identity, history?

JEAN-FRANÇOIS CHEVRIER I'm speaking about ambiguity as a dimension of artistic activity, when it has a critical bearing. Catherine has identified the structural problem of managing the traces, the leftovers, of an art which emphasizes activity over the work. How are these leftovers presented in an institutional, museographic space? I think that after 1978 there can no longer be an art of activity which does not also integrate the work. There should not be a hypostasis of activity against the work, against the object. That's why Dan Graham's pavilions are as important a change as the first works by Jeff Wall, because at that point Graham realized that he had to reintegrate the dimension of the work into his artistic production.

BENJAMIN BUCHLOH Something Acconci did not succeed in doing . . .

JEAN-FRANÇOIS CHEVRIER That is Graham's flagrant superiority over Acconci. To do that Graham used the architectural model; 1978 is the year he published "Art in Relation to Architecture . . .," a very important text, which is a synthesis of Venturi and Aldo Rossi. In 1978 he elaborated his first pavilion. That's a clear break, a turning point in his path. He rethinks the permanence of the object, and even the monumental object, giving up his earlier practice of opposing moments to monuments, which you identified in a 1977 article. He had written about Oldenburg and antiobjectality, which also means antimonumentality; and the monument means memory. So for him, reclaiming the monument means reclaiming the depth of time, *durée*; it's a way of getting back to work on memory. What remains pertinent in the pavilions is the fact that they integrate this psychic work, they are psychosocial objects and historical objects. They exist in social space, they reveal a social-historical-political situation and they are also psychic objects.

BENJAMIN BUCHLOH I'm not sure I agree when you identify his work as monumental right away, instead of saying architectural, or urban, since it is inscribed in questions of architecture rather than monumentality. That all comes together in the end, but later.

JEAN-FRANÇOIS CHEVRIER You're right, at that point he didn't yet think in terms of monumentality. But nonetheless the key to Aldo

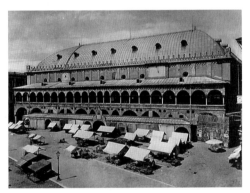

Padua, Palazzo della Ragione

Aldo Rossi, Modena, San Cataldo Graveyard, 1971

Rossi's thinking in *The Architecture of the City* is the monument. The idea of the city—of the *polis* in the Greek tradition, and not the urban realm—is focused for Aldo Rossi in the monument. But don't misunderstand, I'm not talking about an unequivocal return to the monument. Graham's thinking is a synthesis of Rossi and Venturi, of the monumental, historical city and the urban realm of circulation through signs; and in this sense he's exemplary of the ambiguity in modern art. It's worth recalling that Venturi had explicitly upheld the notion of ambiguity since 1966. But beyond this specific context, the ambiguity that enters critical, postconceptual American art results from the aporia of the criterion of autonomy upheld by modern art, as a continuation of the enlightenment ideal. This autonomy is subject to critique to the precise extent that the enlightenment ideal of individual emancipation is actually a bourgeois ideology, generating class exclusion. Thus there are two paradigms of modern art. The first is work-presentation-commentary, which can today be designated as traditional, but which in reality emerged around 1750, along with the modern public sphere and the initial affirmation of the autonomous subject. Then there is a second paradigm, which emerges in the twenties and then again in the sixties, and which links activity-information-debate. This second paradigm results from the will to overcome the contradictions of the criterion of autonomy. Since 1978 we know that if the second paradigm is isolated from the first it produces effects contrary to those it sought; therefore the first paradigm has to be integrated on the basis of the second. That's the ambiguity.

BENJAMIN BUCHLOH Richter does just that with the means of painting. Even the individual painting does not claim to be a singular, auratic object: it is already inscribed in an order of serialization. One large abstract painting, then another, then still another. The repetition and serialization in Richter's work is not the same as seeing a series of paintings by Barnett Newman, for which you have to maintain the original authenticity, the precarious moment.

Gerhard Richter, Untitled (green), 1971

With Richter the serialized order is already inscribed in the conception of the painting, even if he doesn't like to talk about it. That is what protects his paintings. He constantly moves between the figurative and the so-called abstract, and the same movement makes him slip between all the possibilities of representation, of photography and painting. This constant movement allows him to inscribe himself within the ambiguity you have just described, between the two positions. For Richter, painting is what guarantees the mediation between the two solutions, the one from 1750—because Richter is a profoundly bourgeois painter—and the later one, from 1950, which is postbourgeois, postrevolutionary. I think you are too quick to assimilate the vanguards of the twenties and those after the war. There are three positions: 1750; 1920, with the opening of a proletarian public space envisaged by surrealism and constructivism; and the moment around 1950, with the formation of a new postproletarian sphere, which is closed rather than public.

CATHERINE DAVID One nuance here: the first moment and the first paradigm have their place, even if it can be exceeded. This place is the museum. The second paradigm has no place.

BENJAMIN BUCHLOH The attack and critique of that place are exactly what define the project of 1920: abolish painting, abolish the frame, the subject, the museum.

CATHERINE DAVID The question concerning the second paradigm and its placelessness remains open.

BENJAMIN BUCHLOH That is why Broodthaers always refers to the place of the museum. He constantly refers to the absence of place when he explores the culture of the museum, or when he explores an avant-garde culture with reference to its place in bourgeois public space. It's not a nostalgia, but a retrospective reflection on the formation of bourgeois public space through the place of the museum. He explores the meaning of the practice of contemporary art outside or beyond this place.

JEAN-FRANÇOIS CHEVRIER But for Broodthaers, the colonial, exotic dimension is important. He displaces the consideration of the bourgeois ideal, because he qualifies it from the standpoint of exoticism, as Baudelaire did. Broodthaers works at what would today be called "decolonizing the subject," which implies that the process of colonization be taken into consideration in the transformation of bourgeois sovereignty. That's what Habermas completely misses: he doesn't account for the new element introduced by colonialism.

BENJAMIN BUCHLOH Is it colonialism that interests Broodthaers, or bourgeois capitalism in the imperialist phase?

JEAN-FRANÇOIS CHEVRIER You're quite right to put it that way; but that phase of capitalism presupposes colonialism . . . However, I think we should get back to the turning point of 1978, and to the shift between the two different series you edited.

BENJAMIN BUCHLOH I inherited a series of books created by Kaspar König, devoted to the history of the sixties, the minimalist and postminimalist years. Hans Haacke was the only European artist to have a book in this series—and some consider him an American in any case. Initially I seemed to continue in this direction: Dan Graham, Michael Asher. But at a certain moment in the exchange with the students at the college I realized that the question was increasingly that of a practice turned toward a local oppositional culture. We found it difficult to accept the application of a so-called avant-garde model from New York to a marginal, provincial situation like ours. It also became clear that the aspirations of conceptual art had come to an end with the counter-movement beginning in 1978. Therefore I sought out or accidentally encountered certain postconceptual artists who had integrated the conceptual heritage, but had developed new tools of political culture criticism. This is when I began working with Jenny Holzer, Dara Birnbaum, Martha Rosler, and Alan Sekula, with whom I did books from 1978 to 1981. With distance it now seems to me that it was a way of transforming the dead end of an academic conceptual art, while opposing the formation of a new visual culture on the basis of painting. Of course I now find this reversal too facile, because you can see it was also a matter of media: all these artists worked with language, photography, and television or video.

JEAN-FRANÇOIS CHEVRIER Can you precisely describe the difference between the four artists you have just mentioned and the earlier artists with whom you worked?

Heartfield and Rodchenko

BENJAMIN BUCHLOH The most transparent case is Jenny Holzer, who fascinated me from the beginning, in 1978. She had adically reversed the model of language used by the conceptual artists: the analytic proposal by Joseph Kosuth or the model of structural linguistics in Lawrence Weiner. Despite the choice of language in opposition to modernist visuality, the models of language inscribed in conceptual practice are paradoxically still self-reflexive models. Jenny Holzer immediately appeared closer to Althusser's model of language, because she defined language as an ideological practice. Each sentence in the book I did with her has a structure which parallels those of conceptual art; but at the same time they function on all levels with all sorts of slippages into what Althusser calls "interpellation." At that time I had begun to read Althusser through the English reception of his work, especially in *Screen* magazine; Dan Graham has always influenced me in my reading, and he was already familiar with a great deal of French post-structuralism and its English reception. This Althusserian perspective interested me in Holzer, because I thought she had really succeeded in abandoning the so-called neutrality of the conceptualist language model, and that she considered language as an integral ideological system. Perhaps I misunderstood. . .

The same argumentation holds for Dara Birnbaum, whom I met through Dan Graham. There I saw a radicality and intelligence similar to Graham's, but pushed to another level. In several works of the seventies Dan reads architecture as a semiotic and ideological system, but the popular-culture language of television remained outside his horizon. In Dara Birnbaum's work I saw a real effort to use the means of American pop art—structures of serialization and repetition informed by the heritage of Warhol and the formal heritage of minimalism—in order to construct a critical practice that confronts mass iconography and succeeds in rendering transparent the mechanisms at work in the ideological apparatus of television.

Jean-François Chevrier: Both of us are very interested in Heartfield, whose position I find ambiguous, because he is a dada artist who began from an anarchist position of revolt, but then signed up with the communist party—which isn't necessarily contradictory, at least not in Berlin at that time. Also because he referred to America by contrast to Prussia, and anglicized his name during the First World War. You have something similar with Grosz, but he crosses the Atlantic and ends up singing the praises of America, whereas Heartfield passes through London and finishes his life in East Germany. The exhibition on *Montage and Modern Life* in Boston, and at the same time, the little exhibition on worker's photography, made me understand that he had operated in the context of the propaganda effort headed by Münzenberg, and telecommanded from Moscow. It's the moment when the communist party tried to set up a structure of information production by the workers, and all kinds of publications appeared inciting workers to produce their own information. But Heartfield did photomontage, not documentary. He did the covers for the *Arbeiter Illustrierte Zeitung*, and the extraordinary thing, revealed by the exhibition in Hanover at the same time as documenta 9, was the way he worked the page of photomontage as a pictorial space, quite differently from documentary photography. When I saw the "originals," I was struck by the autonomy of the page used for the covers. There something quite different from the sequential, descriptive technique applied by the documentary photographers. Heartfield is at odds with a norm of documentary photography oriented to the sequential; in this he can be compared to Rodchenko. I think this ambiguity is necessary today, you need the pictorial unity of the *tableau*. One could critique Allan Sekula for never having worked on this unity of the image.

Benjamin Buchloh: Why are you so in favor of the *tableau* for contemporary practice? To replace the model of the page?

Jean-François Chevrier: I think you need to maintain pictorial unity inside a practice of sequential montage. The model of the *tableau* avoids the hypostasis of activity, of a radical alternative to the work, the illusion of a radically different public space which would not be bourgeois public space. That naiveté is the great downfall of the avant-garde.

Benjamin Buchloh: You think Jeff Wall avoids that naiveté?

Jean-François Chevrier: Yes, by reinstating the model of activity on the basis of the *tableau*, and playing on the ambiguity of the two models. He avoids the naiveté, which had been very productive in the seventies, but which no longer works . . .

Benjamin Buchloh: Isn't there a little contradiction when you explain that work like Wall's affirms the immutable validity of the institution or the space of the museum—whereas we've accepted that the museum space no longer exists? Photography transformed into pictorial convention by Jeff Wall presupposes the continuing validity of the museum space!

Jean-François Chevrier: It's true that Jeff Wall's light boxes presuppose the museum. But that's why Heartfield and Rodchenko are so important, because the pictorial unity is not necessarily the *tableau*, it can also be the page, and if it's the page it's not the museum. The Heartfield-Rodchenko model allows us to conceive a pictorial unity that works in a dialectical relation to the sequential model of montage.

Benjamin Buchloh: I think that's a good description of what Allan Sekula does. It's the model of the archive as a substitute for pictorial unity, using the sequence or, as Rodchenko called it, the photofile, which Rodchenko theorized as the sole way of escaping pictoriality. The sequence, the archive, gives access to the quantity necessary to construct relations between subject and object, subject and subject, and thus to construct the multitude of relations in the historical process itself. This is the famous 1926-28 debate on photography.

Jean-François Chevrier: What does Rodchenko say in that debate? He says that even a photographic image can stand at once as an autonomous picture, a *tableau*—and he knows the complexity and richness of the form of the easel painting, from which he isolated the pure form of the *tableau* with the exhibition of the three monochromes—and at the same time, the photographic image can be multiplied, reproduced, published on the page, used in a montage. He postulates an ambivalence, or a bivalence, of the photographic image—with, in the background, the refusal of what he calls fetishism. This position has never been precisely reactualized. It is important because in the debate, the proletarian ideologues reproach Rodchenko for being a bourgeois. He replies that you have to be both at once: you have to work for proletarian culture while conserving the progress made by the bourgeoisie.

Benjamin Buchloh: It's also worth mentioning that Rodchenko, when he's pressured by Kushner in that famous debate, responds that one should increasingly adopt a photographic aesthetic of the snapshot. That's quite to the opposite of the craft of photography or the conception of photography within a pictorial convention. The snapshot is what has recently been called the vernacular tradition, which continues all the way up to the sixties when Dan

The situation is somewhat different but still parallel in the books with Rosler and Sekula, who came from the West Coast and had been students of Marcuse when he was still at San Diego. They had worked with David Antin and Allan Kaprow, and had developed an unusual approach to artistic production, which appeared to be at odds with the standards of New York minimalism and conceptual art, and therefore was and remains difficult to read for some people. On the levels of theory and criticism, of the history of photography, but also in their own practice, they worked out what I again saw as a true development on the basis of conceptual art. Sekula attempts to deneutralize the use of language, and at the same time to politicize the iconography of pop art. With Rosler and Sekula in particular, I immediately shared an interest in the heritage of John Heartfield. The second aspect was that they had understood that pop art only dealt with the image of *consumption*, whereas they looked for popular strategies of image *production*, which they found in

David Berg: *Mutter Riba*, Deutsche Theater-Kammerspiele, Berlin, 1955, scenography by John Heartfield Typographic sketch for store display window with glued reproduction of a supermarket window

the so-called street photographer, Garry Winogrand, or the photographer of subcultures, Larry Clark, photographers who disseminated an image of everyday, popular, vernacular culture. They took these photographic practices as linguistic conventions which they analyzed and transformed in their work. I still find this an interesting position, above all if it is read not only in the context of the development of a critical history of photography, but also as an artistic practice inscribed in the moment of postconceptualism, in a reading of the forms of production and distribution of mass images. This generation of artists carries out a critical analysis of systems of representation, of culture in the sense of the production and consumption of everyday culture. And that's an enormous difference in comparison to the pure and simple affirmative gesture of pop art.

Graham, for example, asserts the possibility of taking photographs without any photographic skills. Rodchenko insists that the construction of a historical personality should be achieved by accumulating randomly taken snapshots arranged in a photofile; however, he doesn't say how the archive should be restructured to engender a reading. If you underline the bourgeois side of Rodchenko, which does exist, then you must also face the other dimension which is as opposed to the aesthetics of montage—which he abandons at that moment—as it is to the pictorial aesthetic.

Jean-François Chevrier: Maybe I could agree with you on the snapshot, but I'd like to draw out just one point. I don't see the archive as the solution. There are no solutions, there are just historical moments when an artist formulates a sufficiently developed complexity. The important thing is to locate an exemplary position reached by certain artists at a given moment in a progressive history, and to use that to identify a progressive practice today.

Benjamin Buchloh: In effect, I see the contrast between Sekula and Wall in just those terms: as an attempt to reclaim the dialectic of the twenties without any false nostalgia, and to reconcile it with the structures of contemporary art—because both Wall and Sekula are also engaged in a reflection on the history of the sixties and seventies, on pop, minimal, and conceptual art, and not just on photography in the twenties. That's still a necessary project, to identify the different uses of photography in conceptual art. The text by Wall in the recent Los Angeles catalogue didn't succeed in doing that.

Catherine David: There's a point to make here: at the time of Rodchenko and Heartfield, the strategies of the image were very subtle, negotiations between different registers of the image were possible, because there were different places for the practices.

Jean-François Chevrier: Couldn't we say that the difficulty facing artists today who want to inherit or reactualize these progressive practices is that they are not completely able to use the traditional site of the museum, but no longer have alternative sites, are longer able to invent a pertinent delocalization—which is all the more ironic given that the term delocalization designates part of the current structure of capitalism?

Benjamin Buchloh: This difficulty seems to me no greater than the fact that they don't realize that the return to the site of the museum is as precarious as the return to mass distribution systems which no longer function. It's an insoluble dilemma. How can we precisely describe the production and distribution apparatus of contemporary art today?

The last project I did even more clearly indicates the situation at the school: the publication of the archives of a vernacular photographer from the forties and fifties, which we found more or less accidentally in the coal-mining region of Cape Breton. It was a way of recognizing the local popular culture in its conflictive forms, and at the same time of getting away from a supposedly internationalist perspective which was in fact entirely dependent on New York. I once again engaged Alan Sekula for this last project. He hesitated but finally agreed, and wrote a very long text on the fact of discovering a local photographic archive in a hidden culture, and transforming the photographer into an *auteur*. After that I left the college in 1981 for Los Angeles, to teach the history of contemporary art at the California Institute of the Arts, which was also engaged in conceptual art, with a department called poststudio art. That's where I ended my activities as an editor, with the sole exception of the book on Marcel Broodthaers that I did for *October*.

JEAN-FRANÇOIS CHEVRIER In this period of the late seventies and early eighties, I have the impression that the huge wave of regressive practice that you described or denounced finally forced you, despite yourself, into a position of resistance. In this position of resistance you were led to make pacts with artists and intellectuals who do not, in my view, have the scope of your thinking.

BENJAMIN BUCHLOH It's true that in 1978 the new hegemony of painting put me in a position of opposition, of resistance, without any way to propose other tools. But what should I have done?

JEAN-FRANÇOIS CHEVRIER It's not a matter of saying you should have done this or that. Today, however, must ask the question of what can be done to revive progressive thinking. How, for exam-

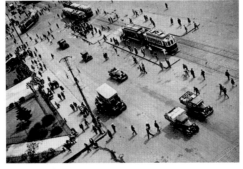

Rodchenko

Garry Winogrand, Radio City, 1961

Gerhard Richter, *Atlas*, Naples, 1986

ple, can we mount a documenta which is not just another spectacular event, but which is a moment of rearticulation for progressive thought?

BENJAMIN BUCHLOH That's obviously urgent.

CATHERINE DAVID In such a situation, we too face the problem of finding allies.

JEAN-FRANÇOIS CHEVRIER This is when you have to make pacts. So I can ask the question more provocatively: in the strategy of resistance to which you were condemned after 1978, what pacts did you make, and how did you make them?

BENJAMIN BUCHLOH After I left California, when I moved to New York in 1982, one of the first things I did was the special issue of *October* on Broodthaers. It was certainly motivated by my desire to reconnect with a historical project that had been forgotten or remained unknown in the U.S. at that time, and to develop a retrospective critique of conceptual art through Broodthaers' work.

JEAN-FRANÇOIS CHEVRIER What does *October* represent for you? You became a member of the editorial board.

BENJAMIN BUCHLOH I was initially invited to do a special issue, but only became a member of the editorial committee in 1992 or 1993. *October* has several aspects, in particular it's a space of resistance, which makes it a little dry sometimes. It tries to stay outside the institutional compromises made by other journals in this period of rapid industrialization of our sphere of the academic avant-garde. The price is a certain aridity, a degree of distance and obsolescence. But the journal is in danger every month and is constantly threatened with bankruptcy. First the private sponsors took away their support, then the state of New York said it was a privileged white journal which didn't take multicultural questions into account—even though it was the first in America to publish Homi Bhabha. Despite the stretched finances and certain internal debates, we believe it is necessary to maintain this space of resistance, which can print certain kinds of work and writing that otherwise might not be published. If *Artforum* was still what it was in the sixties, there would be no need for *October*. As for models of resistance, if one accepts that there is no way to conceive cultural practices outside a horizon of political expectations or a prospect of social or cultural transformation, if one accepts that all contemporary cultural production is part of the culture of the spectacle or of an ideological apparatus, then there is no social space which can guarantee the practices of negation as the space of the avant-garde traditionally did. What is to be done, if you accept what Warhol already said in the sixties? I have no answer, particularly not from the viewpoint of a critic or a historian. However, I do have some examples of certain contemporary artists who are interesting for the definition of what is contemporary, who have obviously abandoned the

Robert Rauschenberg
Feticci Personali (Personal Fetishes), ca. 1952
Pincio Garten, Rome, 1953

idea that cultural practice must be negative or subversive. They are well established in the apparatus of the culture industry without ceasing to be interesting: Richter, Jeff Wall, maybe Broodthaers, though I'm less sure . . . I'm willing to seriously ask myself the question about the demands that a critical historian should make of himself. I don't see how a historian can positively identify himself in the society of the spectacle. That may mean that we have no function in society. Professional functions often become obsolete . . .

JEAN-FRANÇOIS CHEVRIER Yet one can continue to carry out factual critique, and beyond that critique, one can propose norms. That's the solution of Habermas, with Arendt's position underlying it. It means articulating a demand for political action founded on public debate, in full awareness of the difficulties—and at the same time recognizing the gap between the political demand and

artistic practices as they have been produced and theorized since the sixties. The political demand is particularly necessary in the European context today, perhaps also in the American context.

CATHERINE DAVID Do you think that the multicultural practices in the United States are oppositional practices?

BENJAMIN BUCHLOH The famous American slogan "the personal is the political" is exactly the opposite of what I think, in so far as my definition of the political is essentially public. What is defined in contemporary American art as multicultural is often a generally acceptable and unthreatening practice, which lacks political critique. In fact it comes down to an extraordinary depoliticization of cultural practices, because the compensation offered by those practices permits the elimination of any real criticism of the economic order.

CATHERINE DAVID It would be necessary to reconsider Arendt's paradigms, and the fact that she didn't reflect on the conditions for applying her thought in the United States. In the current European situation these paradigms are not working too well either.

JEAN-FRANÇOIS CHEVRIER The reception and discussion of Arendt's work has been considerable in France; but there have been unfortunate appropriations, which accentuate the reference to tradition in a way that blocks any attempt to rethink politics in the heritage of the sixties vanguards. There is a real difficulty, because the aesthetic dimension, for Arendt, is entirely centered around the work, which she sees as permanence, by contrast to the reproduction of life through endless, repeated labor. This is how she stood apart from Marx. For us this is a problem, because this definition of aesthetics around the work is the exact opposite of what has happened in avant-garde practices since the sixties.

BENJAMIN BUCHLOH Warhol, again, is an artist who systematically denied the artwork as permanence, replacing it by the notion of production, of work as process.

JEAN-FRANÇOIS CHEVRIER That is where desublimation is necessary, because it is a matter of

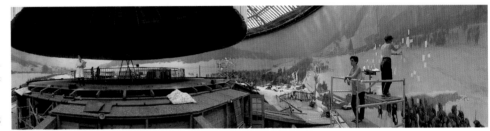

Jeff Wall, *Restoration*, 1993

overcoming the traditionalism that inheres to the veneration of the artwork as an atemporal permanence. The return to order is precisely that: restoring the ideal of the work as the permanence of the eternal. Arendt's stress on the work can obviously contribute to it, as you can see in France, where certain philosophers with a quite recent interest in art have used her concept of the work to denounce contemporary practice, gone "astray" since Duchamp. It is true that this notion of the work in its articulation with the political is very disturbing for those of us who have followed all the artistic experiments carried out in a logic of activity. The authority of the work as Arendt understands it seems irreconcilable with what you might call the political unrest of the avant-garde. But if politics is understood as the enduring organization of a human group, there can be no exigency of the political without the group being able somehow to think beyond the finitude of those who compose it, and even beyond its own history. Arendt refers to the model of the city in classical antiquity, and stresses the memorable action of the citizen, as it publicly endures in narrative. The work, in its distinction from the use object and even more, from the object of consumption (the product), takes on its importance in relation to this perennial memory. The work's distance from the consumer object is comparable to the distance between the memorable political action and the reproduction of life through labor, in all the senses of the word. The permanence of the work, as the creation whereby man apprehends the eternal, contributes to this separation of politics from pure social contingency. Now, I think we agree that this distinction of the political from the social is necessary, to keep politics from being reduced to a kind of bartering over purely private interests. But the difficulty for us, since we don't want to contribute to a return to order in art, is immense—especially because Arendt denounces one of the most prominent characteristics of art in the sixties: the process.

The only solution, then, is to displace the idea of permanence from the work to some other focus, to some facts or givens which can include artistic experimentation. These givens cannot be of an aesthetic nature, because the notion of the aesthetic, as inherited from the enlightenment, seems inevitably to cover up the shifts which have been introduced by contemporary art—even when you appeal to the sublime, as Lyotard does. Since we speak of activity, instead of the work with its theological con-

notations, I think we should look for permanences that can be transcultural, that can lead through the diversity of actual cultures; one could call them anthropological permanences, but with the clear understanding that I am not talking about universal forms or concepts. What orders of permanence are common to all contemporary cultures? I see only two: language and the urban. By language I mean the signifying function in the Lacanian sense, the symbolic as a constitutive activity, and not speech [*parole*] or the diversity of languages—and certainly not language as the basis of an exclusive group identity. By the urban I mean that which is not reducible to the city, its morphology, its historical particularities, but which might rather be defined, somewhat approximately, as a constructed relational space. I stress that these anthropological permanences are neither essences nor invariants, for one can only have access to them through specific cases. In other words, there is no linguistic community outside the diversity of languages, no urban reality outside specific urbanized territories. In both cases there is a permanence which cannot be fixed in an entity, even less in an artifact. It can only be experienced, specifically, and cannot even be reduced to a process. In other words, I propose that we locate permanence not in the contemplation of the immobile, the eternal, the transcendent, but instead in an experience of the continuity of immanence—the continuing activities through which language and urban relations take changing form.

BENJAMIN BUCHLOH This theme of permanence encounters one of my own concerns: why did postwar art immediately try to re-establish a neo-avant-gardist practice in the modernist tradition that disavows historical memory? This is an important question for me in the discussion of postwar culture. In German literature, for example, you have a discourse on the history of the Holocaust in the early fifties; and the same holds for cinema. On the contrary, there's nothing in the plastic arts, except Beuys' famous competition for the Auschwitz monument in 1953. The question is taken up again in Richter's *Atlas*, but in a subterranean way, and it only surfaces, very problematically, with Kiefer.

JEAN-FRANÇOIS CHEVRIER A filmmaker or writer begins with images and puts them into motion, inserts them in a narrative. A painter can't add anything to the image except matter, he's a prisoner of his pictorial cuisine, which appears completely obscene in relation to the force of the image.

BENJAMIN BUCHLOH Remember photomontage, if you are going to talk about pictorial cuisine. A long history of vanguard photographic practices could have been reconstructed after the war, but it was all covered up, repressed.

JEAN-FRANÇOIS CHEVRIER The movement of Subjektive Photographie in Germany produced a refusal, indeed a repression of the descriptive or documentary image, to the benefit of an idealized experimental image, distinct from functional practices.

BENJAMIN BUCHLOH What's interesting is that the plastic arts claim a greater precision, a phenomenological specificity in the analysis of the gaze—and they use that to justify their incapacity to represent history. But the art object is also a commodity, unlike film or literature, and it's impossible to understand the Holocaust in terms of commodities. That's one of the problems with the neo-avant-garde right after the war.

JEAN-FRANÇOIS CHEVRIER When you're confront-

James Coleman

Benjamin Buchloh: Visual cultural in the postwar period apparently fails before the necessity of representation, which is also an impossibility of representation. Adorno spoke notoriously of the impossibility of poetry after Auschwitz. In another text he speaks specifically of the impossibility of representing history: it's obscene to claim to represent it, he says, because history hasn't been made. History is the other which cannot yet represent itself. It's a modernist verdict on Adorno's part; for him, Heartfield isn't even worth talking about. But what interests me is to ask this question again in relation to work like Richter's, which succeeds in the contradictory practice of both maintaining a discourse of painting and disintegrating it. Or in the work of Jeff Wall: how does he place himself both within a historical narrative and outside it, in the integrated pictorial object and yet also in a critical position, inside and outside the museum?

Jean-François Chevrier: To throw back the same question, you see these articulations today in the work of James Coleman. Why did you become interested in him? Is this an evolution in your position of resistance? More generally, what are the new alliances you've made? How do you think it is possible to transform this position of resistance into a reactivation of progressive thinking?

Benjamin Buchloh: For three or four years now, all the

ed with a traumatic image that produces a fascination, you have to put yourself in motion again. Blanchot has a text in *The Space of Literature* about the work as a space of fascination. That was the problem in the postwar period: fascination before traumatic images, psychic arrest, the syndrome of the unrepresentable event, like the effect of the Medusa's head. Bacon brought a dramatic response to this unrepresentable event. It's significant that he used images of arrested movement, Muybridge for example, or stills from Eisenstein. He went through the filmic metaphor, because it is the metaphor of the image going into motion. The process of psychic integration, blocked by the traumatic image, had to start moving again. But we could draw parallels between that moment and what happens after 1978, with German neoexpressionism in particular. Or even the return to painting in France right now.

BENJAMIN BUCHLOH You had a first version of that in France in the late seventies, with Combas.

CATHERINE DAVID Yes, but that was less about painting than the articulation of a "youth culture." Whereas Barceló is really a return to the cuisine, to the traditional notion of embodiment. It's a way for people to continue fooling themselves, thinking that a medium, an ingredient, can replace meaning. It's a way of not understanding that painting's relations to metaphysics, to transcendence, to history, and to sensible space have all been deconstructed. They think that the little miracle of the gooey stuff can bring all that back together, in a ridiculous opposition to technology! Whereas Rossellini had already reintegrated the body after '45, in an operation of religious dimensions that you rarely find in contemporary painting.

JEAN-FRANÇOIS CHEVRIER And then there was Pasolini, with another, equally extraordinary vision of the body, and between the two you had Antonioni. Since Rossellini, Italian cinema has produced a history of the body in motion through a space inhabited by man: the body begins speaking again and is no longer fascinated. Today's new return to the pictorial *métier* wants to be a reincarnation, but it remains in the space of fascination.

approaches that formerly interested me have begun to seem insufficient. A kind of revision of my own methodology brought me to the problems of narrative as historical memory. The most dramatic thing was the change in my relation to minimalism, which was so important to my intellectual development and which suddenly became a primary problem—even if my fascination with minimalism continues. This was the point when I discovered the work of James Coleman. Dan Graham had already been suggesting for many years that I should look closer at his work, but my answer had always been that an art tending toward theater, narrativity, and literature was none of my concern. It's also because I had looked seriously at Broodthaers that I began wondering whether, at the final moment of the spectacularization of artistic practices and of the museum institution, it wouldn't be useful to analyze the conditions of the construction of a historical memory in opposition to the spectacle, as a reservoir of critical activity, of distance. How can one construct a mnemonic work of art, a practice of memory under the conditions of spectacularization, without falling into essentialism and the reconstitution of the fundamental myths of permanence, and without continuing to uphold the possibility of an avant-garde space outside the space of spectacle? All these questions are developed very persuasively in Coleman's work, because he succeeds in constructing very deep contradictions. Take his relation with Irish history for example: the question of an Irish identity is always pursued as a critique of the fundamentalist notion of identity; but at the same time he does not just deconstruct, he does not just get rid of the question. On the contrary, he analyses how one can enter into the dissolution or deconstruction of an identity and nonetheless maintain an artistic position whose definition of the subject is not complicit with the society of the spectacle.

Catherine David: We should recall that Coleman produces on budgets approaching those of cinema, and yet sells as art! He mixes different circuits, he isn't readable within the space he occupies. It's extraordinary, these production conditions which are not parallel to the conditions of reception.

Jean-François Chevrier: Could you describe the political subjectivization that interests you in Coleman as being a reprise or a displacement of what you remarked in Birnbaum's work?

Benjamin Buchloh: In my first text on Coleman I quoted that marvelous passage from Blanchot's *Michel Foucault As I Imagine Him*, where Blanchot says that the subject doesn't exactly disappear, but disperses. What you have in Coleman are the effects of dispersal. He is not a simplistic

poststructuralist, celebrating a facile deconstruction of the humanist subject as so many do in America. He explores the dispersal of subjectivity, with a central, ongoing reference to the theatrical tradition, but also to photography, painting, film, and television. This, I think, is the dialectic he constructs by presenting theatrical productions as complex as films, but which are in fact slide shows. His images also refer to painting, which is an important element in their construction. He revives the culture of the museum and the rhetorical conventions of the pictorial image in an allegorical discourse. He never claims access to a continuous tradition of painting; he is Benjaminian, he practices an allegorical model that constructs a discourse of the loss and inaccessibility of the historical. There I see a difference between Coleman and Jeff Wall: Wall insists that Manet can be transferred into the present with the means of photography. He constructs certain elements of continuity. Coleman problematizes them.

Catherine David: Wall is too confident in historical memory, too optimistic about the conditions of contemporary culture?

Benjamin Buchloh: Exactly. He presupposes a reading by the contemporary spectator which rests on privileged conditions of experience that are no longer available.

Jean-François Chevrier: I wouldn't put it exactly that way. He believes there is a history of modern art which is modernism—it's his framework of thinking, his mold. He's very conscious that there is a dogmatic dimension in this modernism, but he holds onto it like an armature. It's his subjective armature.

Catherine David: But his images are stronger when they involve a tension, something that breaks down between the content and the forms of the image.

Jean-François Chevrier: Absolutely. His confidence also allows him to crack the armature—and he often does! But Coleman, with his very dispersed subject, would seem to be to Foucault what Wall is to Habermas, because in Habermas there is a very strong subject, as in Wall. Could you develop this theme of dispersal? I think it is what defines these weak subjectivities—weak in Vatimo's sense—which we constantly encounter in the work of young artists today. Vatimo is often a reference for the critics supporting these artists. What differentiates Coleman from this weak subjectivity which effectively risks "weakening" the possibilities for criticism?

Benjamin Buchloh: I can't answer for the moment! I'm working on that right now. It is by considering past formations of subjectivity that the dispersed subject grows stronger, or constitutes itself. Here I see a distinct correspondence between Coleman, Richter, and Broodthaers.

All three share certain central questions. For example, Coleman is an artist of the museum, he explicitly takes his place in the traditions of figurative art, of narrativity, of the rhetoric of the pictorial image. He is manifestly a part of the great tradition of European painting. Invoking it, he destroys it. He does not invoke it as a presence, but as an inaccessible space of allegorical recollection.

Jean-François Chevrier: The weak thinking of Vatimo is articulated on the idea of de-foundation, *sfondamento*, the idea of deconstruction, effacing the foundation. The attitude you describe seems more complex.

Benjamin Buchloh: With respect to the notion of permanence, one can see how Coleman constructs that in a very contradictory way. There is nothing in his work like the *italianità* invoked by the Italian neoexpressionist painters—whether ironically, cynically, or naively, little matter. When Coleman inquires what an Irish culture or identity can be at the close of the twentieth century, it's a historical inquiry that explores identity with an intent to construct a moment of resistance on the basis of dispersal, rather than simply affirming either a traditional identity or the dispersal of identity. He positions himself between the two.

Jean-François Chevrier: Another ambiguity!

Benjamin Buchloh: This is where he constructs a work of considerable resistance. Because the fundamentalist discourse of identities can't resolve the crisis of the subject, and the terminal dissolution of the subject under the impact of the spectacle society can't offer sources of resistance or critique. Between the two, Coleman constitutes himself as an artist.

To conclude this answer to a very difficult question, I still find Adorno's strategy of double negativity to be valid in such a situation: a strategy that renounces, resists, and systematically destroys spectacularization by referring to history in ruins, to the dispersal of the subject. The subject's dispersal is also a resource of resistance. That's what happens with Coleman when he uses the theater as a system of representation, though I can't yet correctly say what theater is for him. To find out, I think it would be necessary to reconsider Benjamin's understanding of baroque or expressionist theater, developed before his aesthetics of reproduction. The dialectic between them is still, to my knowledge, unexplored. It's ultimately a question of the great dialectic between the authenticity of the body, of presence, in relation to the final stage of technical reproduction, which runs through all of Benjamin's thinking from the twenties onward. It continues in Coleman's work, with an extraordinary dialectic of reproduction, of the fragmentation of narrative, of the subject's dispersal.

CATHERINE DAVID It's a relation to painting that ignores the history of the avant-garde, such as Palermo's and Oiticica's work on spatialized pictoriality, which is inscribed in a more radical and demanding history. But it's true that this attention to mobility and contingency is much easier with vectors such as language or the urban than it is with the almost religious presence of an object. There again, our discourse and the way we do our exhibitions is necessarily unjust, because in a sense the museum just isn't the place for that mobility, for what has been called dematerialization . . . The object comes apart, disarticulates—and in the face of practices involving mobility and ubiquity, where meaning is constructed in relations more than in things, museum people don't know what to do.

BENJAMIN BUCHLOH Here I'd like to ask you both a question: what are the grounds for a political analysis of the museum today? Are the critical departure points of 1968—Buren, or Haacke's text on "Museums, Managers of Consciousness"—really no longer pertinent?

JEAN-FRANÇOIS CHEVRIER I'm not sure the highly analytic approach of those two artists is sufficient today. I wonder if analysis may not hide other possibilities, like the ones I propose: the reconstruction of permanences for which the museum is only one place among others. It remains to articulate these other places, which naturally implies working on the urban, to the extent that the urban is a relation of places. But we won't be able to do that in this exhibition, it would take three years for that. This is a transitional exhibition. We're simply indicating a critical goal, our critical position is one of demand. Catherine is not there to draw up a balance sheet on the present state of art; a critic can also formulate an expectation. Otherwise the critic becomes no more than a functionary of the culture industry.

CATHERINE DAVID Expectations are also what make observations possible. Otherwise you just rubber stamp.

JEAN-FRANÇOIS CHEVRIER You collect, you go shopping like an art lover. . . Would you agree that a book can be an ambiguous space, between the exhibition and the magazine page—a dream space that allows for the combination of the exhibition space and the space of the media?

BENJAMIN BUCHLOH Yes, but the traditional space of the book or the catalogue can be co-opted. *S,M,L,XL* by Rem Koolhaas interests me because of this moment of erosion in the traditional character of the book, which is turned over to the spectacle, to the space of the exhibition. Once again, that begins with Warhol's *Index Book*, where for the first time the traditional space of the book is devoted to the space of spectacularization. It's reminiscent of Benjamin's ideas about language verticalized in billboards: the letter can no longer remain embedded in its horizontal position in the book, it has been torn away to appear in the vertical space of the architectural façade. The space of the book is disappearing.

CATHERINE DAVID With its montage form, its capacity to accept mobility, Koolhaas's book can introduce much more complexity than an exhibition, whose forms are limited.

BENJAMIN BUCHLOH But at the same time, exhibitions can be more complex, because they can simultaneously introduce very diverse objects: you can show an auratic object from arte povera along with Dara Birnbaum's work, which is linked to television. An exhibition can give all the positions at once, which a book cannot.

CATHERINE DAVID But a book allows you to maintain distances. In a big exhibition the spectacular effect is such that distances are whittled away. . . Perhaps we need to shift this discussion to more recent horizons: in the debate over place and object, in-situ and ex-situ, one has to consider the development of virtual practices and what they imply in the imaginary, in people's way of projecting, seeing, living. This seems to me a very important element in the strengths and handicaps of the nineties. The relation to places could almost be an ideological stake: a location in a place more or less associated with a biography gives rise to a quite different attitude than a relation to the world conceived as perpetually in transit. We're in a triangle. James Coleman is certainly on the edge of it, but Wall and Richter fall short of the contemporary situation. The young artists now have a problem with the object that replays and yet goes beyond the questions of the sixties and the seventies. Beyond this relation to the object, you can see that the relation to a place is more or less contingent, except for those who articulate their practice with a certain use of the city. When you try to think this situation through, the works of Richter and Wall seem at once very powerful and not directly pertinent. They are in another space.

BENJAMIN BUCHLOH I think there is a key opposition within which we must work. On the one hand there is the model

Jean-Marie Straub
Nicht versöhnt **(Not Reconciled), 1965**

of the museum, which we still perceive as an institution of the democratic public sphere. It's tempting to say this place no longer works, no longer exists, but we agree that the history of its dissolution is more complex. Then there is another sphere whose development we've been aware of for some twenty years—I don't know if it can be called a public sphere, but now it's generally called the society of the spectacle, or the culture industry. This sphere replaces the museum, integrates it. An artist has to confront this situation, and precisely what interests me in Coleman is that he articulates that transition neither by totally abandoning or destroying the museum in a futurist way, nor by claiming to resuscitate it and producing traditional works made for the museum. How can one assert such a position without becoming reactionary or conservative? I see traps in all the notions we're discussing: narrative, figuration, the reconsideration of the fundamental procedures for the constitution of subjectivity. But at the same time I see no other possible procedure for the moment . . .

JEAN-FRANÇOIS CHEVRIER As I listen to you I can't help thinking that you push the need for critical vigilance to a kind of subjective limit, which risks straightjacketing your own subjectivity. I tend to think that it's possible to practice a vigilance somewhat removed from this norm of suspicion which has become too weighty and which hinders the experimental possibilities of subjectivization which a critic today should try to set into motion, no less than an artist. That's difficult! For that you must stay vigilant but lighten the burden of suspicion.

BENJAMIN BUCHLOH You wouldn't say that if you lived in the United States. Suspicion is more urgent than ever! Guarantees that still seemed certain just five years ago are disintegrating at a frightening speed. Under those circumstances, suspicion . . .

JEAN-FRANÇOIS CHEVRIER Is a minimum!

CATHERINE DAVID What are you referring to, social phenomena, cultural practices?

BENJAMIN BUCHLOH The only world I know, academics, art history, contemporary art, museums . . . When people in New York can propose a collaboration with David Bowie for the upcoming Damien Hirst exhibition—and it's serious, nobody laughs—then you know it's over! You've lost your territory! Someone like David Geffen, who made his money in music production, rock and rap and so on, can buy the contemporary art museum in Los Angeles for five million dollars and call it the David Geffen museum. There's nothing left to protect. There's not a single voice of resistance. At least not in America. So you see that the first part of my argument, which says that the museum still functions as a locus of self-reference and self-criticism for the formation of bourgeois consciousness, is already a dream, the nostalgia of an intellectual on the left! But fortunately the situation is still different in Europe.

JEAN-FRANÇOIS CHEVRIER That's where the stakes are considerable—and that's why I think that today, in this new context of globalization where the economic aspect is dominant, and under the conditions of the integral spectacle described by Debord, an imaginable response would be to reconstruct anthropological permanences without recourse to any precritical essentialism, and without any appeal to the universal. Because the universal has been used to create the situation of globalization in which we find ourselves today. The suspicion toward the universal should remain very high. It is urgent to conceive anthropological permanences on a global scale, as a strong alternative to the criterion of universality, which can be of no more help since it has contributed to economic globalization and the integral spectacle. That's why I'm skeptical about the positions of intellectuals who focus exclusively on a universalistic ideal of human rights, particularly in France, with its Francocentric notion of the universal. On the other hand I think we have an obligation to go beyond the radicality of suspicion, to reconstruct anthropological permanences that might give us the means for something a little stronger than just resistance.

BENJAMIN BUCHLOH That would be a nice ending, but I'd still like to add something! There's a difference between us. Again I ask myself, why anthropological permanences and why not a concrete, specific analysis of the means of globalization itself? That's also a practice which goes beyond pure resistance. I think the concrete analysis of the global universal, which is becoming completely mythical, is a fundamental cultural endeavor. And I don't think that's opposed to the anthropological givens; on the contrary, they are linked.

JEAN-FRANÇOIS CHEVRIER I propose a progressive perspective which cannot shirk the critical analysis of globalization. It's not a mat-

ter of proposing a new ideal, a new utopia, a universal in disguise . . . But an analysis of globalization, as pertinent and specific as it may be, even when it includes an autobiographical narrative, is necessary but not sufficient. We reached this conclusion by looking rather closely at the critical models of the sixties. Öyvind Fahlström, for example, is an extremely important artist for us today, although his analytic procedures are less rigorous than those of someone like Hans Haacke. The risk today is to block the processes of subjectivization by an overly analytic approach, that's why I come back to the surrealist unconscious, as well as the question of intimacy. The public/private dialectic is frozen, it hasn't been able to take new forms. If we want it recompose itself outside its bourgeois definition, on another terrain, then we have to reintroduce the thinking of subjectivity, all the way to the dimensions of the unconscious and of intimacy.

Peter Weiss, Die Ermittlung (The Inquest)
Freie Volksbühne Berlin, 1965, directed by Erwin Piscator

BENJAMIN BUCHLOH I'm wondering if you don't ask the impossible. You construct totalizing demands: the reintegration of subjectivity and the analysis of global transformation. You see that partially realized in Jeff Wall's work, and you admit the other dimension is missing, but you find that acceptable. But when there's an analysis without the subjective dimension, for you it's a failure. That may have already been a problem in the twenties, I'm not sure the two approaches have ever been reconciled. I wonder whether they shouldn't be conceived as two necessary urgencies, which remain separate. We don't have any novel, any literary practice which could show us the possibility of joining them.

JEAN-FRANÇOIS CHEVRIER I agree with you that it's better to keep things separate than to force them together in an authoritarian way.

BENJAMIN BUCHLOH Otherwise it becomes a Lukácsian perspective, a bourgeois realism that no longer exists . . .

JEAN-FRANÇOIS CHEVRIER But there's still a demand, which doesn't necessarily have to be satisfied by any given person. At this time there is a cultural and political need for the dimensions of subjectivization and of intimacy, which should be displaced from the subject to a territory of intersubjective relations. And here, artistic procedures have much to contribute. Whereas on the level of analysis, the position of the artist tends to align itself on that of the expert, either in an archaic, enlightenment-type mode as an expert in autonomy—the classically modern artist that a certain kind of reactionary criticism wants to return to now—or in an up-to-date way as an expert in spectacles, Warhol being the perfect example. I don't think that the artist can exercise his or her intellectual activity as an expert, using expert knowledge in either of these opposed but in a sense complementary ways. That is why we are not publishing any art critics in this book, except yourself, because we believe your activity has not been one of expertise. Our question is political: how can we now conceive an artistic activity without the people? To me the answer seems inconceivable. I have proposed two permanences, language and the urban, but this is no doubt another way to redefine something on the order of the people.

CATHERINE DAVID How can one conceive an expert public in a space which is *nolens volens* a space of cultural consumption? The public of an exhibition today enters a spectacularized space.

BENJAMIN BUCHLOH So you prefer an expert public to a public of spectacles?

JEAN-FRANÇOIS CHEVRIER What a horrible alternative! That's precisely what we want to break through!

BENJAMIN BUCHLOH It's a real alternative. The public visiting a Beuys installation in Germany today is not an expert public, it's the public of a national culture resuscitated under the sign of the spectacle . . . Your hypothesis seems to be that the great advantage of surrealism is to have allowed the experience of myth to become accessible to deep reflection—the myth in the form of mythology, and in the individual form of the unconscious and the dream. On the contrary, the internationalist culture of the Bauhaus and of constructivism no longer sought the presence and permanence of myth in experience. In the context of Weimar, and above all after Weimar, myth became the equivalent of fascist culture: this is an explanation why the access to surrealism is closed in all those cultures which underwent or came close to fascism or Stalinist totalitarianism in the twentieth century. After the war we increasingly realized that the terrain of the unconscious would be conquered and governed by the culture industry. Surrealism failed to

confront this question. This is why Weimar and Soviet constructivist internationalism, for me, are so important: they ask how an industrial culture can be created amid the culture industry. After rediscovering this question, one is confronted with new problems, which can be approached through the work of an artist like Coleman: how can one conceive the construction of a memory, or a cultural mnemonic practice, without raising the question of the national formation? And yet at the same time, and yet without affirming any idea of national foundation? Coleman's great contradiction is to work on the notion of identity, but without affirming the resurrection or recentralization of the model of the nation-state.

Robert Filiou, *Trois Jeux, Apollinaire, Rimbaud, Baudelaire* (Three Games: Apollinaire, Rimbaud, Baudelaire), 1961

JEAN-FRANÇOIS CHEVRIER I understand your profound interest in the internationalism of the modern movement—but I think it's finished since the seventies, and for reasons which have to do with a radical change in capitalism: the obsolescence of the Fordist model and the transition to the phase of flexible accumulation, which in my belief is the best definition of the postmodern phase, or the end of the modern project, not in the Habermasian but in the industrialist sense of the term. If there can be a project of social construction today, it is not international but local/global, it is more financial than industrial, and it implies subjective changes of such a degree that the Taylorized, Fordist, contractual subject which corresponds to the development of the nation-state in the twentieth century is no longer tenable. What we are seeing in art are processes of subjectivization which partake of minority logics, far from any national identity. In this context, the interest of the internationalist model no longer seems greater to me than that of the surrealist alternative. To oppose the internationalist model of the modern movement with an archaic, mythological surrealism would be to remain attached to a Benjaminian dialectic which is no longer contemporary.

BENJAMIN BUCHLOH You want to conceive the people outside of nation and class. I'm incapable of that.

JEAN-FRANÇOIS CHEVRIER In any case, "the people is what lacks"—to recall the phrase by Deleuze. I am trying to conceive the people on the basis of minorities, in order no longer to conceive it on the basis of a majority which imposes its norm. This is where we come back to an almost Brazilian model of heterogeneity. The two permanences of language and the urban are my way of thinking outside a schema that reduces the people to the identity of a nation-state, which in any case is untenable today. Of course it can be argued that a minority position is inapplicable to the most important group in any given European society, which is precisely the majority. But is that true in the current crisis? I think it is extremely interesting to look, for instance, at museums of technology and industrial history, which are where the questions of national identity are ruminated most deeply today. There is an incredible critical potential there. Citizens faced with the destructuring of the balances worked out in the past between capital and labor can find tools in those museums to help them in their struggles. This is why I have always been interested in the work of the Bechers, in the sense that their work has to do with the memory of the local variants of the industrial tradition, much more than with the cosmopolitan, minimalist aesthetic that was thrust upon them. There is a space of subjectivization when visitors are confronted with their own memory, their own history, in a confrontation of the local variant with the global project of industrialization, which is in a sense universal. And this confrontation itself is a permanent human activity. There may be a risk of historicization, here and in everything that involves anthropological permanences, but the risk is worth taking. In a period when the experience of the present is an experience of the actual versus the virtual, it's a matter of giving a broad public the feeling that the historical can be actualized. The actualization of the virtualities of history is an existential dimension. And there is another thing here that is quite interesting for us: these museums present not only documents and archives, but also artworks, and it is in these museums that the relation between the two is posed, not in contemporary art museums. We can use this as a model, a counter-model, for our work in museums. I think it is important today to reinvest the institution, to open up a truly political space within existing institutions. Not as a celebration of the institution, but neither as a purely critical practice that abandons it to others with much less respect for the political dimension.

BENJAMIN BUCHLOH The museum was already defined as an archive in the twenties, particularly by Russians like Stepanova and Lissitsky. But they never theorized the question of which public would be present in this museum.

Today we have the problem of a public of experts or a public of spectacles. You propose to reopen the question of the people. But is the people the right term? Can it be expressed in other ways: the common good, the universal? There is always a universal dimension in discussions of aesthetics. But you see it as having been excluded by expertise. What is the counter-model of expertise, for you?

JEAN-FRANÇOIS CHEVRIER There is a historical counter-model, which is the critical intellectual. Another historical counter-model is that of the intellectual organically linked to his class, as Gramsci explained. They are both models of the twenties and thirties, and it is precisely in order to invent another model that we have invited you here today. Foucault was the last European intellectual to have attempted to define a critical attitude, on the one hand as a displacement of disciplinary expertise, on the other as a process of subjectivization. He invented the notion of the specific intellectual, who puts his knowledge at the disposition of a minority which knows what it wants. The problem of representation, in the political sense of the word, is central to intellectual practice. For instance, it is quite possible that today an exhibition curator should not function as a manipulator, but as a catalyst, someone who sparks a certain type of process in others. And the exhibition could be the collage of these processes: no longer a universal space, but a space of collage-montage, containing situations elaborated in a relation of participation with the *monteur*-representative, that is, the curator. This is the way the most advanced postcolonial anthropologists describe their activity. The processes of the seventies remain processes of individual subjectivization, dreaming of the collective and yet not offering any real experiences of it, except in certain theatrical experiments. Today we can imagine processes which would be, if not collective, at least intersubjective.

CATHERINE DAVID I think that in the most complex—not say disordered—contemporary practices, what you describe is effectively in play. The notion of authorship is entirely reworked (although I never speak of the "death of the author," an expression which refers to the seventies, but unjustly, because Foucault never called for the death of the author). What is at stake is the redistribution of authorship, transactions between subjectivities.

BENJAMIN BUCHLOH What I liked in the recent Orozco exhibition in Zürich was the way it dealt neither with the object, nor with the process as defined in the sixties, but gave a new orientation to both. The *Tables*, which were the most interesting part for me, present themselves as an intimate repertory. These types of things constantly play between object, process, and sculpture, without ever becoming any one of the three. They place themselves in the interstices and stand fundamentally apart from the expertise of processes in the sixties.

Gabriel Orozco, *Recaptured Nature*, 1990

CATHERINE DAVID Many contemporary practices lay the accent on everything that has to do with movement, energy, dynamics, passages, more so than on real presence. Often these works can appear to be symptoms, and perhaps they are, to the extent that we have not understood them. Maybe it is not always necessary to understand. In the present juncture I tend to privilege untimely, disruptive attitudes, almost on the edge of confusion, rather than reinforcing any conformism. This brings us back to the case of Brazil, where the procedures of codification are extremely fluid. As one Brazilian said to me, "Here you decode or you die." If people are not capable of very rapidly articulating codes which are in perpetual dissolution, they die.

JEAN-FRANÇOIS CHEVRIER Without engaging in crass economic determinism, I'd like to point out that we are in a phase of flexible accumulation: things are constantly turned around, seen from a different point of view.

BENJAMIN BUCHLOH And that is not part of our usual theory of culture.

JEAN-FRANÇOIS CHEVRIER No, that's why there is an objective difficulty. Any culture which demands monumental symbols, any culture which feels the need to project itself into eternity, is necessarily in a state of peril, with all the regressive effects that sentiment can bring. We know this is a problem facing us in Europe today.

Jeff Wall

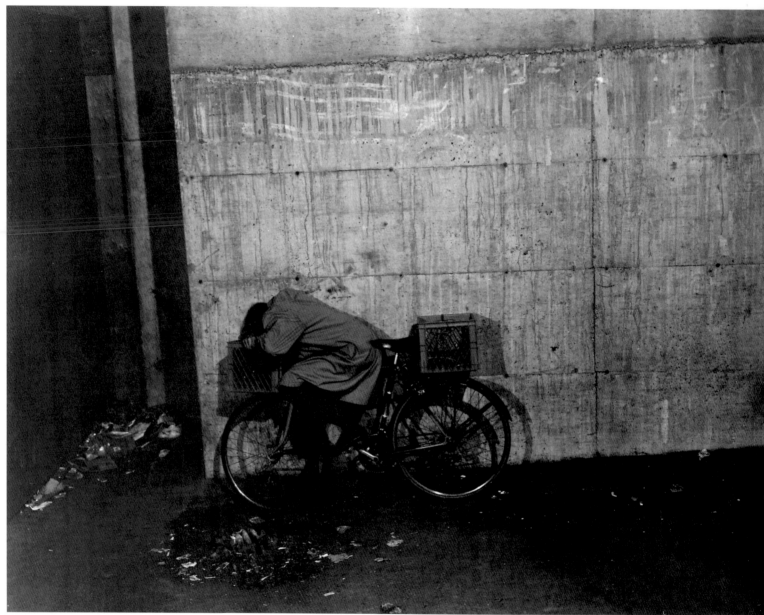

Cyclist, 1996

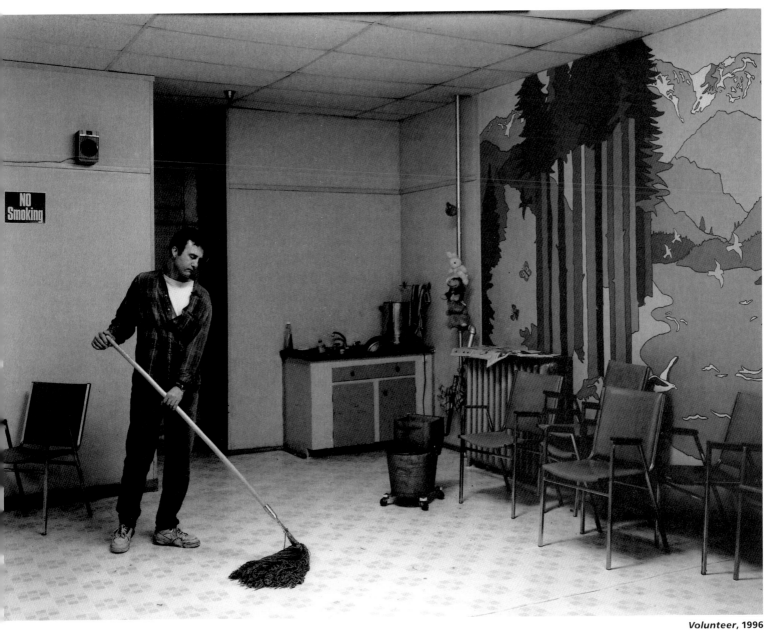

Volunteer, 1996

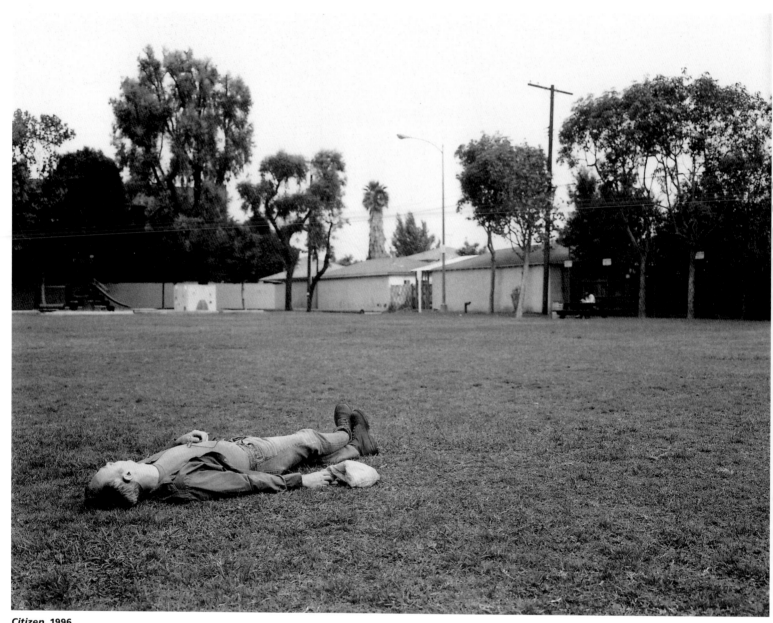

Citizen, 1996

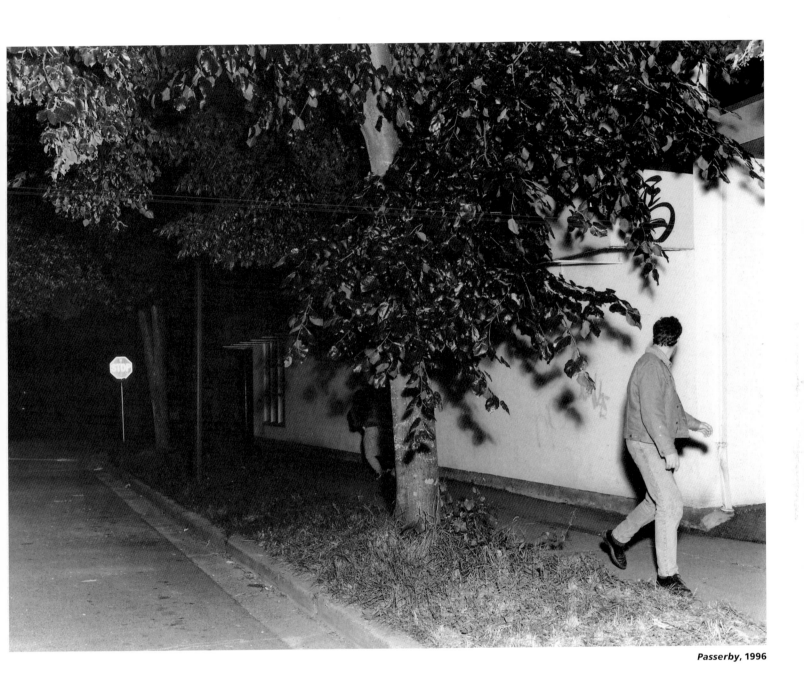

Passerby, **1996**

Hans-Joachim Ruckhäberle

Antigone

In 1991-92, Jean-Marie Straub and Danièle Huillet staged the *Antigone* of Sophocles-Hölderlin-Brecht for the theater—the Schaubühne in Berlin—and made a film in Sicily.

"The text we use is a filmscript consisting of 147 takes."

The starting point was "a place, a topography." In reality and in the film: "Segesta, a Greek theater, a hole between the hills, with a gap to the sea." In the theater: "The same setup. We have three screens arranged in exactly the same manner as the perspectives we will have for the filming."

Perception is the fundamental political and aesthetic category of this work. For the film, the camera was installed at one spot but at different heights. Thus it established a location, from within which spaces could be formed by the movement of the language and of the bodies. The "rigid" view determined the spaces. There are three: that of Antigone, that of Creon, that of the chorus. They involve the surroundings, nature, in different manners, they take possession of it in different ways: "Yet the whole thing belongs to no one. During the filming process there is one surface which no one is allowed to enter, and it is shown in its entirety at the end of the film" (Jean-Marie Straub, 1991).

For *Antigone* Straub and Huillet worked with location and space in a way previously undertaken, though in a different fashion, by Brecht and Neher. They emphasized the boundary between the spaces.

But the faculty of perception was directed towards yet another element: the language. The verses and caesuras of the text are clearly accentuated. The *Antigone Model 1948* commented on just that subject: "Question: How were the verses spoken?

"Answer: Above all, the deplorable custom was avoided according to which the actors, before beginning long verse passages, pump themselves full, so to speak, of an emotion approximately matching the passage as a whole. There should be no 'outflow of passion' before or after speech and agitation. The movement from verse to verse will be paced and each verse derived from the gesture of the figure.

"Question: What about the technical aspect?

"Answer: Wherever a line of verse ends, there is to be a caesura; alternatively, the beginning of the following verse is to be emphasized."

In the Straub/Huillet work the accentuation of the language found expression in what its opponents and advocates described as lay declamation, amateur theatricals. "The rhythmic hesitation, verse for verse, arises from the controlled excitement" (Peter Handke). Straub and Huillet thus come the closest to the "deathly factual" character of the drama's language by means of the technique of hesitation and suddenness. "The actions remain invisible, yet because they are referred to in such a variety of fashions—threatened by the tyrant Creon, recounted by the messengers, commented on by the chorus, prophesied by the blind seer Tiresias—the onlooker (myself) can see, with the aid of the rhythmic, the utterly and completely 'filmic' Straubian hesitation, sharply and deeply hallucinating. Through the words they perhaps imprint themselves much deeper on my mind than if I had indeed seen them as deeds: the deed, by merely speaking of it,

648

becomes invisible, and so it remains, all the more anticipatable, conceivable, imaginable" (Peter Handke, 1992). The supposed dilettantism of the amateur actors frequently cast by Straub and Huillet is one of the reasons why German theater criticism failed to do justice to *Antigone*. The standards applied were exclusively those of "professional" theater, nowhere regarded as part—at least a possible part—of an artistic process outside the theater. The investigation or function of perspective, the shifting of contents into structures of perception, the entire problem of the "spatialization" of art and its relationship to reality (in the film, the view of the highway overpass or the sound of traffic) elude the fixation on "professional" theater.

The question of the relationship to reality, or of its myth, included political commentary. Straub dedicated the Berlin theater production to the "murdered" (terrorist) Georg von Rauch and to the 100,000 Iraqis "whom we murdered." Thus both issues were touched upon—the rejection of "resistance" against the government and the "imperialism" of the new, reunified Germany. Borrowing from Brecht's characterization of Creon as the "Führer," Straub designated the American president as the "new Führer."

In the film credits Brecht is quoted with a statement made in 1952: "Mankind's memory of afflictions suffered is incredibly short. Its faculty to imagine coming afflictions is almost weaker . . ."

Handke assessed the political commentaries negatively as an expression of "explicit thought," contrasting them with the much different spirit of the film's images and language.

With Handke's very exact but very subjective description the circle is complete. His rejection of the "secondary," his longing to find directness, the elemental, leads back to George Steiner's history of the Antigones. Desiring to find origins, he falsely judges Hölderlin's and Brecht's "interventions" to be more or less insignificant. What he seeks and finds is the "elementary level of production and montage," film as "art." Handke removes the Straub/Huillet *Antigone* from its temporal context, from political commentary. "For me the Straub cinema and the classical Greek drama are nearly one and the same, identical in form; both stand, or stop short, at the beginning and remain there insistently, regardless of whether the beginning is in the cinema or the theater."

"I tell you that since Greek theater we have not had such a powerful means of expression as the cinema." Starting from this remark by Louis Delluc, Laurence considered *Antigone* in the light of Clint Eastwood's Western *Unforgiven*. He was concerned with origin, but not with a general myth of origin. Instead he explored the course of the boundary between the new and the old world, as depicted in film. What is the relationship between civilization and wilderness? Between law and violence? How is the city, i.e. society, formed? The concern is not so much with right and wrong as with the boundary on whose basis societies gain or lose credibility.

In contemporary art, this debate takes place as the discourse of the image in public space. The aesthetic and political issue is determined by the total loss of every form of utopia (François Furet); it can be seen as a reversion to the "strong" beginnings, to the Geschichts-Stätte or "place of history" (Heidegger), or in the political and aesthetic figure of "patriotic turnabout," "where the entire shape of things changes" (Hölderlin).

Hölderlin, 1823

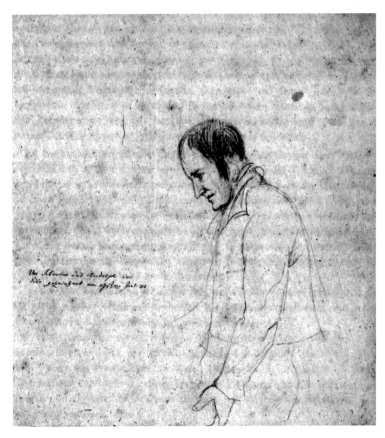

RICHARD SHUSTERMAN: A HOUSE DIVIDED

"A litter of pigs", writes Emerson (in his essay "Art"), "satisfies and is a reality not less than the frescoes of Angelo." The archaic fantasies of an American *inculte* who fails to recognize the essential distinction between Art and Reality? Pigs are surely real, and satisfy – in an impressive variety of culinary forms. But just as surely they cannot, in their real living presence, satisfy as art. Of course, one can make an artwork composed of pigs (or anything else), but then (according to established aesthetic theory) they are no longer simply real pigs but ontologically transfigured objects belonging to a separate artworld.

Pragmatist aesthetics, in the tradition I develop from Emerson and John Dewey, is devoted to challenging this crusty old dogma that firmly divides art from real life and praxis.[1] Not only a concretely embodied reality in itself, art can play a powerful role in changing other realities by changing our perceptions, attitudes, and consequent actions. The notion of art as a distinctive ideal realm was once extremely useful. Central to modernity's process of secularization, it provided a locus outside religion for our habits of sacralization and our need for spiritual expression. Religious sentiments were displaced toward art, whose works are now the closest things we have to sacred texts and relics. The idea of art's autonomy from real life

and praxis was also extremely useful in liberating art from exploitative control by its traditional conservative patrons, the aristocracy and Church.

By now, however, this idea has lost its usefulness, erecting a false barrier between art and action, that trivializes art and robs its power for positive praxis. For art's highest aim is not to make a few admirable objects in a world filled with misery, but to create a better world through the work such objects can generate. Art has won its autonomy by losing its purpose and consequently its public. Contrasting itself to the real, it can hardly claim to present or create truth. Disdaining concrete social aims as vulgar functionalism or propaganda, while likewise scorning the simple goal of pleasure as too base and utilitarian, art seems best appreciated when it is good for nothing. Its function, affirms Adorno, is "to have no function" and thus to protest our functionalist society.[2] Emptied of purpose, art displays its pure autonomy in the vacant frame of gallery space, a clean white box increasingly devoid of public. Boxed in this sacralized space of compartmentalized art, the artist is boxed out from the power to enlighten and move the multitudes toward the creation of a better world.[3]

1. See Richard Shusterman, *Pragmatist Aesthetics: Living Beauty, Rethinking Art* (Oxford: Blackwell, 1992); abbreviated French and German versions: *L'art à l'état vif* (Paris: Minuit, 1992) and *Kunst Leben* (Frankfurt/M: Fischer, 1994); and *Practicing Philosophy: Pragmatism and the Philosophical Life* (New York: Routledge, 1997).

2. T. W. Adorno, *Aesthetic Theory* (London: Routledge, 1984); 322

3. I developed this box metaphor for art in an essay, "Art in a Box" in Mark Rollins (ed.), *Danto and His Critics* (Oxford: Blackwell, 1993), 161- 74; and in an interview with Suzi Gablik, "Breaking Out of the White Cube", in her *Conversations before the end of time* (London: Thames and Hudson, 1995), 247-65.

4. See G. W. F. Hegel, *Die Vernunft in der Geschichte* (Hamburg: Felix Meiner, 1955), 202.

Carsten Höller and Rosemarie Trockel have constructed a monument that both exemplifies and protests art's boxed-in/boxed-out state. Evoking art's potential for real-world improvement, their *Haus für Schweine und Menschen* also embodies art's actual limits and impotence. A real concrete edifice where Documenta visitors can lie down to rest their weary legs and escape inclement weather, *Haus* obviously offers the practical function of shelter. It also offers a visual relief from the inanimate *objets d'art*, the sight of real "livestock". In all too human self-absorption, we forget a more crucial function: its being a haven for pigs in a society where they are brutally bred, systematically slaughtered, and greedily devoured by their human neighbors. Many of us have been introduced, as children, to the functional demands of the art of architecture through the old tale of "The Three Little Pigs". Should we see our culture, ourselves, as the viciously blood-thirsty wolf keen on destroying the pigs' refuge so as to devour them?

Höller and Trockel's *Haus* reminds us that our pork products are made from living creatures with whom we share a world, as we share this house. In *Haus*, we can literally see through the line dividing humans as bearers of "rights to life" from animals without such rights, though here exceptionally enjoying the best imaginable living conditions. But can we really see these fellow animals in the deeper sense of recognition? There can never be recognition's communicative meeting of the eyes, since the thick one-way glass allows only observation by the humans. The pigs are thus rendered mere visual objects (we can neither hear nor smell them, nor touch them, of course), and thus a deeper sense of identification is frustrated. Even when art strives to reveal a living reality worth engaging, it blocks real engagement by the limiting, one-directional, visual modality of its involvement. For real contact with the pigs, one must leave the boxed artwork and approach them from the back garden. Even when art tries to do something for pigs (as *Haus* implies), it is only doing it for a few lucky "art" pigs, and only for one brief charmed moment of the "Exhibition" or "Show".

There are also many human pigs in our social world: races and ethnicities that fail to gain our recognition because they are seen through the one-way glass of socio-cultural privilege. Very often such despised ethnicities are denigrated as pigs, though Hegel in denying the African's humanity, compared him not to a pig but a dog.[4] Like the division of *Haus*, the barriers that still divide the races of the world are clearly artificial and can easily be seen

through, but they remain nonetheless powerfully binding and blinding.

The partitioned house is not only a metaphor of ecological and social division, but an epistemological critique. Too rigidly we divide mind from body, privileging mind as the *human* observer that must police the base, slovenly flesh involved in its own piggish desires. Every intellectual hides a partitioned pig whose enjoyments cannot be affirmatively relished in full-bodied experience, but only seen through a thick barrier and at a distance implied by the visual. The same distanced visuality attenuates our experience of art, eviscerated by the aesthetic ideology of distanced, disinterested autonomy.

We return, then, to the divided *Haus* as a critical image of fine art's compartmentalization from life and forms of popular (piggish?) culture. We make and use this particular artwork together with the pigs. If we observers are the work's real agency, art seems an idle voyeurism cut-off from the real business and full sensorium of living. If, on the other hand, we view the pigs as the work's principal makers, the one-way glass provides a telling metaphor for the contemporary artist's inability to see the public who observes his work, thus making him revert in blindness to the mirror vision of self-absorption, to the Muppet model of Miss Piggy asserting "Moi!".

Haus is equally provocative with respect to aesthetic experience. If it remains for us a merely visual, distanced experience of autonomous art, is our enjoyment of this work as good as the pigs'? Is the art of living not better than the art of observing, and are not all conventional artworks best seen as promises or steps toward the highest art: that of living better in a world enobled by greater beauty and justice? This was Emerson's view. "There is higher work for Art than the arts… it is impatient with lame or tied hands, and of making cripples and monsters, such as all pictures and statues are. Nothing less than the creation of man and nature is its end."

Today's pragmatist aesthetics, as I construe it, remains consecrated to that supreme end, and remains impatient. But it insists on two further points: that valuing an end implies respecting the means needed to accomplish it; and that artworks can be provocative means to spur us toward noble ends not only by making them visible but by making it clear that art, in its compartmentalized form, is impotent to achieve them. Art should never rest complacent with this impotence that *Haus* succeeds in demonstrating. Mere aesthetic satisfaction with this success would be the worst of failures.

DETLEF B. LINKE: FROM ISOLATION TO IMPLOSION

Turning the pig into a work of art could provide a new reservoir for artistic creativity, while giving it a new refuge – something that could otherwise prove hard to find, following its demise as an intensively-bred farm animal. Art as an evolutionary niche in the wake of the ecological and vegetarian emancipation of homeless swine.

Even if existentialist demons do invade the pig, it's not about to jump into the Lake of Gerasa. But it could well take a dip in our own common gene pool, animal and human. UNESCO, too, sees a common thread between the genetic reserves of the Amazonian plant kingdom, works of art in the Louvre and the human genome – the organisation defines them all as the "heritage of mankind". This could be a metaphoric clue as to what the future holds in store: a market placing equal values on genes and works of art.

The constructivistic extension of evolution still can be reflected for a moment in the House of Trockel and Höller. The bicamerality of the House plays with the projective mechanisms of our psyche and demonstrates the one-way glass in the settings of the family therapist observer. Mutation and selection set together with the evolutionary principle of isolation – a short insight just before implosion, an opportunity for the reposing observer to visualize the distance between viewer and object, before the genes inexorably mix. On the other side of the glass we feel safe, protected by ethical principles on gene research and the safety barrier we have erected around the human genome. A zone difficult for animal genes to penetrate – actually, science now implants human genes into sheep to increase their performance. So the thought that this genetic conquest could be reversed, and victory still go to the other side must at least put a flicker of fear into our eyes – the experience of which Höller and Trockel have thoughtfully, with their one-way glass, kept at bay from the pigs.

Ein Haus für Schweine und Menschen entstand in Zusammenarbeit mit: Rolf Bandus (Architekturbüro, Mitarbeiter Miles Dutton), Christel Simantke (Beratung artgerechte Tierhaltung), Ottmar Holstein, Ulrich Rodewald (Landwirte), Winfried Waldeyer und Heinrich Schröder (Documenta)

Dominique Lecourt

The question I ask brings us straight to the heart of the great international multidisciplinary agitation around what are called "the cognitive sciences." I would like to demonstrate how a rather deliberate, even laborious, way of philosophizing—or, as they say, of "doing philosophy"—permits one to clarify the stakes of what seem to be quite technical debates, from which philosophers are too often absent, with a few notable exceptions such as John Searle (*Minds, Brains, and Science*). The "stakes" here involve not only the development of specific lines of research, particularly in biology, but also certain characteristic socioeconomic, ethical, and political traits of our modern world. The exacting language of these debates and their articulation with their immediate "objects"—the computer, the brain, language, evolution—cannot fail

Can Thinking Be Programmed?

Jordan Crandall, Blast

654

to capture the attention of students.[1] A philosophical education worthy of its name must not avoid this issue; but a peremptory appeal to the classic texts of philosophy (Descartes, Kant, Plato, Hegel) would leave the audience unsatisfied, and legitimately so. Wouldn't the students be right to reproach us for maintaining such a distance between the instrument of analysis and the object of intervention—especially if they observed that Descartes, to take just one example, was better informed than anyone of his time as to what he was facing, or rather, overcoming, when he took the automaton as the theme of his reflection, or when he tried with the materials at hand to produce an outline of the central nervous system?

Let us then consider the question as it stands. The word "program," detached from its almost exclusively theatrical past, was introduced into scientific language by the English mathematician Alan Turing in 1936, in his famous article "On Computable Numbers," whose explicit philosophical basis is the deterministic thinking of Laplace. Since then, the term has not ceased to prosper and proliferate: the intellectual discipline known as computer science has organized itself around the "Turing machine," conceived as an abstract, universal machine which could theoretically accomplish the task of any other machine. When concrete machines—computers—actually became feasible and industry took hold of them, then "programmers" appeared, at which point "programming languages" began to diversify and to reach increasing levels of sophistication. The "program" designates the set of instructions, drafted in a given language, that will be processed by the machine to carry out a specific task.

Turing asserted that everything a man could calculate could also be calculated by a machine, and he dreamt of building a device that would reproduce human mental activity. The dream was extended and amplified twenty years later with the appearance at Dartmouth College of so-called "artificial intelligence," a name born in the euphoria of the victory represented by the creation of the first program able to prove a few simple theorems of propositional logic. The computer revealed itself capable of manipulating symbols as well as numbers, giving a concrete basis to the idea that human intelligence might function like a computer, by processing symbolic representations . . . Searle sums up the immediate philosophical extension of this idea quite well with his definition of what he calls "strong AI": the mind is to the brain what the program is to computer hardware. The line of development seems perfectly continuous, marking the simple but momentous insistence of a dream. More or less distant precursors are evoked at will: from the English mechanic Charles Babbage, author in 1832 of the first work on factory economy, *On the Economy of Machinery and Manufactures* (quoted to great effect by Marx in the first volume of *Capital*), all the way to strophe 18 of the *Iliad*, where Hephaistos forges women of gold, instilled with reason, to help him in his tasks!

However, this continuity should not blind us to the intervention of a major scientific event between 1936 and 1956: the founding of molecular biology. Now, the interpretations that have been found for this event have conferred a spellbinding force on our little dream, giving it a powerful new twist. The vigilant examination of these interpretations is, I believe, the only way to clarify the curent debates over the above-mentioned "cognitive sciences."

The history of the "biological revolution" as it is endlessly recounted today is said to have begun with a sudden stroke of genius and an almost miraculous double coincidence. I recount the vulgate version first. The stroke of genius was that of the celebrated Austrian physicist Erwin Shrödinger who, from his Dublin exile in 1944, published a little volume entitled *What Is Life?* This veritable manifesto establishes a relationship, later to be termed premonitory, between atomic physics, statistical mechanics, and biological reality. Shrödinger took up the torch from Max Delbrück, who in 1935 had already attempted to link the formal laws of Mendel's genetics describing the transmission of hereditary characteristics to the physical nature of the components of the cell.

Schrödinger demonstrated that the molecular level represented the appropriate scale for the analysis of the organization of heredity. Better still: he hypothesized that the "atoms" of heredity were organized into an aperiodic crystalline structure. It was a hypothesis and a metaphor, but J. D. Watson in his book *The Double Helix* clearly shows how he and the physicist Francis Crick followed just that metaphorical path to the discovery of

the structure of DNA. Let's add that Schrödinger pushed his inquiry even further, asking how the organization of this structural support could be transformed into the activities of life (movement, reproduction, exchange of materials with the surrounding environment, etc.). He came to use the word "code" in a juridical sense, with a reference to the ideal of Laplace!

But, as Antoine Danchin explains, "the term 'code' is, of course, too narrow. The chromosomic structures simultaneously serve to carry out the very development they symbolize. They are both the legislative code and the executive power—or to use another analogy, they are at once the architect's blueprint and the artwork to be undertaken."

In short, the model according to which the organism will be constructed is itself manipulated by the rules it specifies. However, Schrödinger still lacked the linguistic metaphor that would later designate the material support of the gene as a linear sequence of four basic motifs whose order determines what the gene produces. Once the metaphor of the "code" was embedded in a linguistic context, it was not long before people began to speak of the "genetic program," in reference to Turing—who himself had taken a certain interest in codes…

In his major work on *The Growth of Biological Thought*, Ernst Mayr wrote a veritable hymn to genetics. According to him, genetics has unified biology on the basis of the idea that the "genetic program" represents the most important aspect of heredity.

Now we come to the coincidences. Number one: in the selfsame year of 1944 when Schrödinger published his little book, Oswald Theodore Avery (1877-1955), who had been working on the transformative principle of the bacteria that causes pneumonia, proved that DNA, which had long since been identified, was in fact the material support whose existence had been speculative-

Maria Lassnig, left to right:
Gehirnströme **(Brainstream), 1995**
Koordinatenvernetzung der
Gesichtsoberfläche
(Coordinetworking of Facial Surface), 1993

ly suggested by Schrödinger. This led to what Erwin Cha-graff retrospectively described as an "avalanche" of research on nucleic acids, which continued unchecked despite the explicit and persistent scepticism of a few great names such as Richard Goldschmidt.

This coincidence sanctified, if I dare say, the role of Schrödinger's speculative views, and contributed to inspire the idea of a historical continuity between the work of the physicists and that of the biologists in the early twentieth century, even though the research of Avery and his team obviously owed nothing to Schrödinger!

But there is another coincidence, fraught with weightier consequences. We still live today under the shadow of the confusion and memory lapses to which this one has given rise. The year 1937 marked the very beginning of what would become "information theory," with the publication of an article by Claude Shannon,

entitled "A Symbolic Analysis of Switches and Circuit Paths." This article established the link between binary mathematics, symbolic logic, and the functioning of electronic circuits. Shannon's perspective was "technological" in the strict sense of the term. He showed that propositional calculus could be used to describe the functioning of an electromechanical switch with two positions, open or closed: yes/no, open/closed, true/false, zero/one, the game was always the same. The idea of "information" as a measurable entity, manipulable at will, appeared here for the first time. It would blossom in England and the United States precisely during the 1940s, as an effect of the meeting between mathematicians (including Norbert Wiener and Johann von Neumann), physicists and technicians (including V. Bush and Bigelow), and physiologists (including MacCulloch and W. B. Cannon).

In his masterful book *Cybernetics and the Origin of Information*, written in 1954, Raymond Ruyer has clearly

„Aus dem, was ich bisher angemerkt habe", sagte Ellison, „werden Sie verstehen, daß ich die hier vorgetragene Ansicht von der Besinnung auf die ursprüngliche Schönheit des Landes ablehne. Die ursprüngliche Schönheit ist niemals so groß wie jene, welche noch hinzugefügt werden kann…" *Edgar Allan Poe, Der Park von Arnheim (1846)*
I am sealed in a cottage of glass that is completely airtight. Inside I breathe my exhalations. Yet the air is fresh, blown by fans. My urine and excrement are recycled by a system of ducts, pipes, wires, plants, and marsh-microbes, and redeemed into water and food which I can eat. Tasty food. Good water. Last night it snowed outside. Inside this experimental capsule it is warm, humid, and cozy. This morning the thick interior windows drip with heavy condensation… I am in a test module for living in space. My atmosphere is fully recycled by the plants and the soil they are rooted in, and by the labyrinth of noisy ductwork and pipes strung through the foliage. Neither the green plants alone nor the heavy machines alone are sufficient to keep me alive. Rather it is the *union* of sun-fed life and

oil-fed machinery that keeps me going. Within this shed the living and the manufactured have been unified into one robust system, whose purpose is to nurture further complexities – at the moment, me. What is clearly happening inside this glass capsule is happening less clearly at the great scale on Earth in the closing years of this millennium. The realm of the *born* – all that is nature – and the realm of the *made* – all that is humanly constructed – are becoming one. Machines are becoming biological and the biological is becoming engineered... This marriage between life and machines is one of convenience, because, in part, it has been forced by our current technical limitations. For the world of our own making has become so complicated that we must turn to the world of the born to under-stand how to manage it. That is, the more mechanical we make our fabricated environment, the more biological it will eventually have to be if it is to work at all. Our future is technological; but it will not be a world of gray steel. Rather our technological future is headed toward a neo-biological civilization. *Kevin Kelly, Out of Control (1994)*

shown that the idea, widespread at the time, of information as "the progress of an effective structural order" had the advantage of rendering Shannon's entity accessible to measurement. In effect, that idea designated the contrary of a "destruction," a diminution of order. But in physics since Clausius and above all since Boltzmann, a dimunition of order bears the name of "entropy." Information would thus be defined as the contrary of entropy, and would be measurable just as entropy is. Now, the aim of the cyberneticians' work was in no way speculative, it was above all technological: they sought to fabricate increasingly perfect automatons and information machines, at the incidental risk of awakening slumbering technophobic mythics, often dominated by the fear of seeing a mechanical logic metamorphose into a human fate. Since the early 1950s, the machines which have emerged from cybernetics—machines for which the Czech science fiction writer Karel Capek supplied the word "robot," meaning "forced labor"—have been visibly intended for important industrial uses: as feedback machines, they replace manual processes with automatic ones. It was said that they would realize the ideal of Bacon and Descartes: "Natural forces shall work on their own like artisans, and replace artisans."

As Ernst Mayr reservedly explains, "The breakthrough of molecular biology in the 1950s coincided with the birth of information science and some of the key words of that field . . . became available for molecular genetics." He immediately cites the word "program" as an example. This second borrowing combined with the first and inflected the course of further research, for in its transfer from computer science, the word "program" brought with it an essential aspect of the theoretical goals in whose service it had been forged: the attempt to conceive the functioning of a completed feedback machine. The fact that physiology had found much to learn from the work of the cyberneticians made this transfer all the more easy. In particular, the retroactive process of the machine rendered it possible to depict the feedback process of nerve connections. Thus, under the aegis of the notion of the program—here, "the genetic program"—the presuppositions behind a mechanical model of certain physiological processes succeeded in imposing themselves on biology as a whole, and at the same time made their first advances toward what would later be called "the neurosciences."

From this arose a veritable "dogma," which, as François Gros says in *The Civilization of the Gene*, led biology to a dead end in the mid-sixties: the idea that the entire organism is constructed around a genetic organization chart, that all its adult forms are inscribed, or rather coded, in the information contained in the genes of the initial cell, and that cybernetic-type mechanisms with various dampening or retroactive servocontrols are what effect the transfer of genetic information to the adult form, from the program to its realization. At this point the dogma becomes so powerful, so deeply seated, that embryologists are simply forgotten: the notion of program "deletes" the notion of development. It is a triumph of simplification: one need only trigger the program and everything unfolds from start to finish, just as it is written down. In short, Auguste Comte finally emerges the victor: progress is only an orderly process of unfolding, and this unfolding is determined strictly by the "initially given" order. Thus epigenesis—which is essential to embryological development, especially in the case of human beings—is reduced to nothing. Molecular genetics claims to explain the macrostructures of the adult with no help from any other discipline.

Better yet, it succeeds in grafting itself on to the neo-Darwinian theory of evolution, via statistical thermodynamics and information theory. Thus it can take

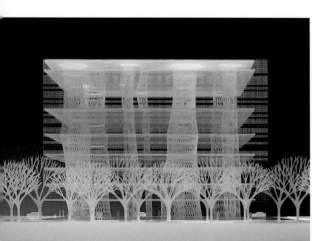

Toyo Ito, project for a mediathèque in Sendai

one step further and master the whole of life with a single explanatory principle, from DNA to the thought processes that comprehend DNA. Michel Serres has done a great deal in France to impose this grandiose vision, which today must be considered obsolete. Witness this singular introduction to the work of Jacques Monod: "Biochemistry is like any other branch of chemistry, at least in its methods and epistemology; chemistry is a science that works through physics, at least since Perrin; and the philosophy of physics is the theory of information. Thus when a biochemist announces that he is writing a natural philosophy, we can infer that he is applying the theory of information (the natural philosophy of 'natural philosophy') to his own discipline."

Here we see the new standing gained by the analogies that cyberneticians, since the famous article by MacCulloch in 1937, had so insistently observed between electronic circuits and the structures of the central nervous system (the neuronal networks in particular). First advanced with prudence, indeed scepticism, these analogies now appear to be founded in nature! And from here, with the development of the neurosciences, spring the two questions that press themselves upon us so virulently today: is the brain a sophisticated computer? Can computers think? Jean-Pierre Changeux brandishes the banner of a "strong materialism" in his recent texts, suggesting—in the long run—a positive response to question one. And by the same token, a great many specialists in artificial intelligence appeal to the shades of Turing and hold out the same positive response for question two.

Still, one must realize that the conjunction being carried out before our eyes, with all its "scientific totalitarianism" (in Ruyer's phrase), cannot succeed without the loyal services rendered by the psychologists. I will not retrace the fascinating but convoluted history of the idea of "scientific psychology" as it gradually developed over the course of the nineteenth century, after philosophy gave up that terrain. But it is worth noting how the flourishing behaviorism and gestalt theory of the postwar period lent a hand to cybernetic speculation with a basis in information theory: if understanding a message means reacting to it effectively, the same can be said of human beings as of machines. The critique of the notion of "mind" in Ryle's philosophy also played its role in this adventure.

It is this entire history which now must be rewritten. The neurobiologist Alain Prochiantz has begun to deliver a few essential pieces. There can be no question, he says, of denying the importance of the physicists' contributions to the life sciences, nor of underestimating the landmark date of the discovery of the double-helix structure of DNA. But the paradox is that after having struggled for a century against "mechanistic" physics, the physicists themselves have exported to the study of living things a mechanistic philosophy that has long nourished the dreams of technologists. This rapidly dominant philosophy has rewritten history, but in trompe-l'oeil. And thus a whole range of key questions in the life sciences has been shunted off into oblivion and pointedly neglected by researchers and institutions: all the questions bearing on the development of life forms. The notion of "program" was supposed to have provided the definitive answer. Thus a most sophisticated formalism has taken control of the life sciences and extended its sway over the entire field of culture (all the way to literature itself)—to the direct benefit of an unbridled empiricism in effective research. Yet if we reread the texts written by the biologists who had begun exploring evolution and heredity before the overwhelming entry of concepts borrowed from Shannon and Wiener, and even before Schrödinger's "stroke of genius," it appears clearly, in the work of Hugo de Vries in particular, that a double approach had gone into motion at the micro- and macroscopic levels, envisaging life as a dynamic creation of forms. The path toward an original mathematics of life, first broached by d'Arcy Thomson in his 1917 volume *On Growth and Form*, is no doubt to be discovered in this direction, and not in the use of statistics which, though necessary elsewhere, have no direct contact with the object of biology itself.

Before undertaking any formal and grossly approximate consideration of the brain as an information processing machine equipped with extraordinarily sophisticated electronic networks, it is worth realizing that the brain is a living reality, resulting from the evolution of the species and the development of the individual. It is also worth observing the unique aspects of the human brain, and relating them to evolution and development. These questions, which are today being asked by the "neurosciences," have recently raised a barrier against the for-

malism of the cyberneticians. They make clear the essential role played in human life by epigenesis, which, by selecting specific neuronal networks from among a practically infinite number of possible networks, inscribes individual history (on the levels of family, society, culture, etc.) into the development of the individual. Contingency—which can also take on the guise of the most coercive necessity—makes its entry here and disputes the empire of the "genetic" program. And because the nervous system is in no way isolated, much to the contrary, from the other major systems of the organism (as has been so spectacularly shown in the case of the immune system), the "basis" of thought cannot simply be confined to this one system. Certainly, there is no thought without the brain—but we also think with our feet, as Lacan used to say by way of provocation.

This recent research additionally makes apparent the need to cast off a "monadic" conception of individuality.

As Gilbert Simondon had already quite clearly perceived, human beings are subject to a continuous double process of biological individuation and cultural individualization, permanently making them a field of transindividual and preindividual tensions, where the "unconscious" finds both its place and its effectiveness. Thought, upheld by language, thus itself appears as a transindividual reality subtended by unconscious drives; indeed, the research done in recent years by specialists in human ethology has given this viewpoint a basis in guided observations. At the same time, this research casts doubt on the "computer science" notion that human thought could be programmed: that thought is human means that its free play can only be understood as the outbreak of contingency amid the realization of the program. This outbreak loosens up the program itself—so that it appears as the fruit of the evolution of the species.

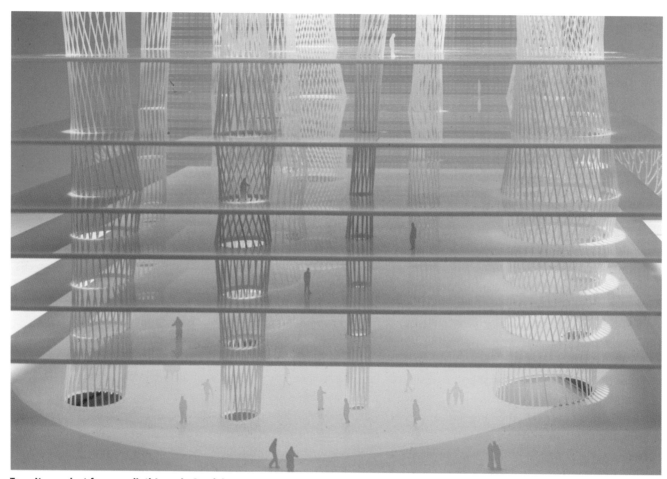

Toyo Ito, project for a mediathèque in Sendai

Why then does the ambition of applying the notion of "program" to thinking still persist, under the banner of the "cognitive sciences"? Apparently not because of simple philosophical naiveté. F. Varda is quite right to denounce the idea commonly accepted by these researchers that thought is a "representation of the world," but that denunciation is not enough. Nor does it suffice to revive the notion of intentionality for the occasion, as Searle and Dennett do in their different ways. A gamut of more pressing reasons comes to the fore, of which the most important from the philosophical viewpoint is stated outright in the famous text by Schrödinger, when he furnishes the juridical definition of the "code": the idea of the program contains an idea of order. It lends itself, under a very modern guise, to the support of an ideology of order, beginning with the ordering of thought. It corresponds to the technological vision of the world which has taken over from the scientific ideology of the last century, reviving the Saint-Simonian theme of organization, which it provides with a new metaphysical complement, a degraded equivalent of the idea of "absolute knowledge."

At the same time, the technological applications of the investigations carried out in the wake of this myth (all the work on form recognition, automatic translation, etc.) appear sufficiently promising in financial terms to stimulate massive investment. The organization of research does the rest: contracts follow contracts...

Faced with this situation, we philosophers have neither to get on the bandwagon nor to watch it pass by; at the very least it is our role to wonder aloud about its provenance and its destination.

Let me finish with a pair of quotes from one of the "classical" philosophers to whom all the specialists of artificial intelligence make ritual reference: Blaise Pascal. Everyone knows the opening lines of the short text written in 1618, *Of the Geometric Spirit and the Art of Persuasion*: "There are three principle aims in the study of truth. The first is to discover it when one is in search of it; the next is to prove it when one possesses it; the last is to discern it from falsehood when one examines it." Pascal shows that the second point contains the last: "For if one knows the method to prove the truth, one will also have that required to discern it, for when examining whether one's proof matches the familiar rules, one will know if it

has been exactly proven." It seems to me that from an epistemological viewpoint, "artificial intelligence" is supremely equipped to fulfill this program—a fact which no specialist can dismiss.

"But as to the art of discovering truth when one is in search of it," Pascal adds, "geometry has explained that: it is called analysis, of which it is useless to speak further after so many excellent works have been written." The allusion to Descartes barely veils the irony beneath the praise. "Art" is opposed to "method." The latter implies knowing the end of the itinerary in advance "to properly conduct one's reason" along the right path. Art designates a way of coming to grips with the unknown: it is an explication, unfolding and revealing itself on examples drawn from a practice that accepts the risk of the unforeseeable.

Thought cannot be programmed . . . And precisely there is its grandeur, if one is to believe Pascal: "Men are so necessarily mad that it would be mad by another twist of madness not to be mad." This is the truth whose play will always finally outwit the programs of those who resolutely seek to ignore it.

From: *A quoi sert donc la philosophie?*, Paris, 1993.

[1] Dominique Lecourt is among the rare philosophers to combine original research with a broad pedagogical practice: this talk was delivered to an audience of secondary school philosophy teachers at the Académie de Paris in 1991.

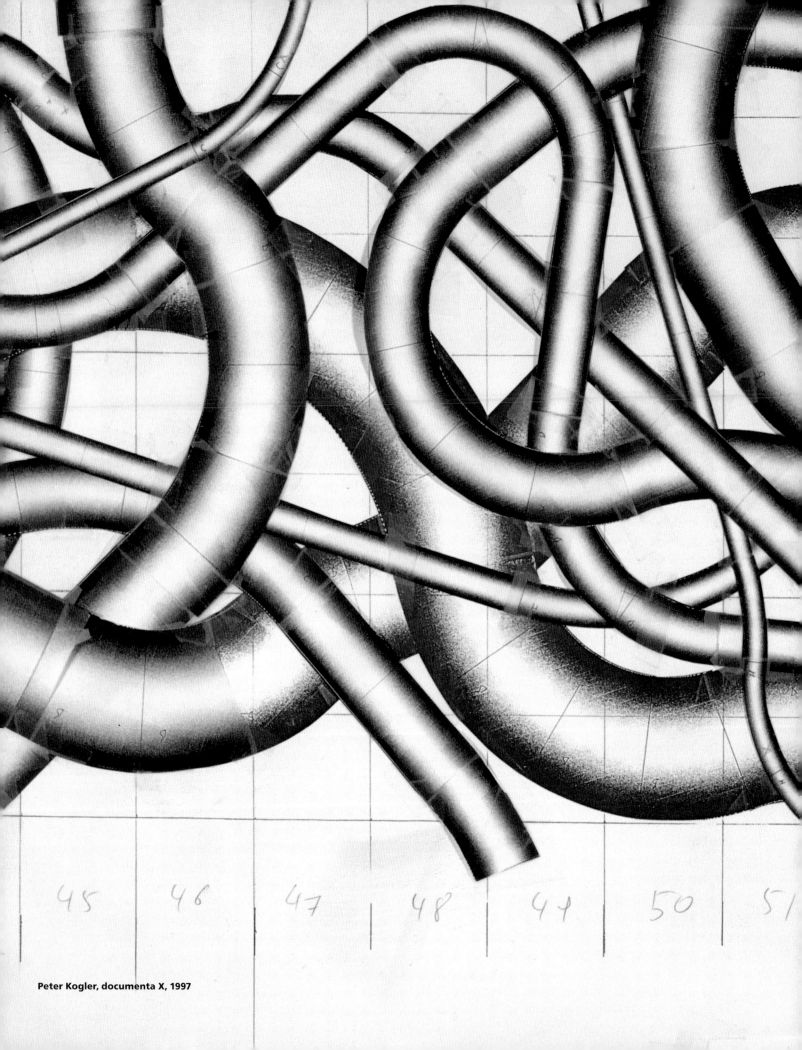

45 46 47 48 49 50 51

Peter Kogler, documenta X, 1997

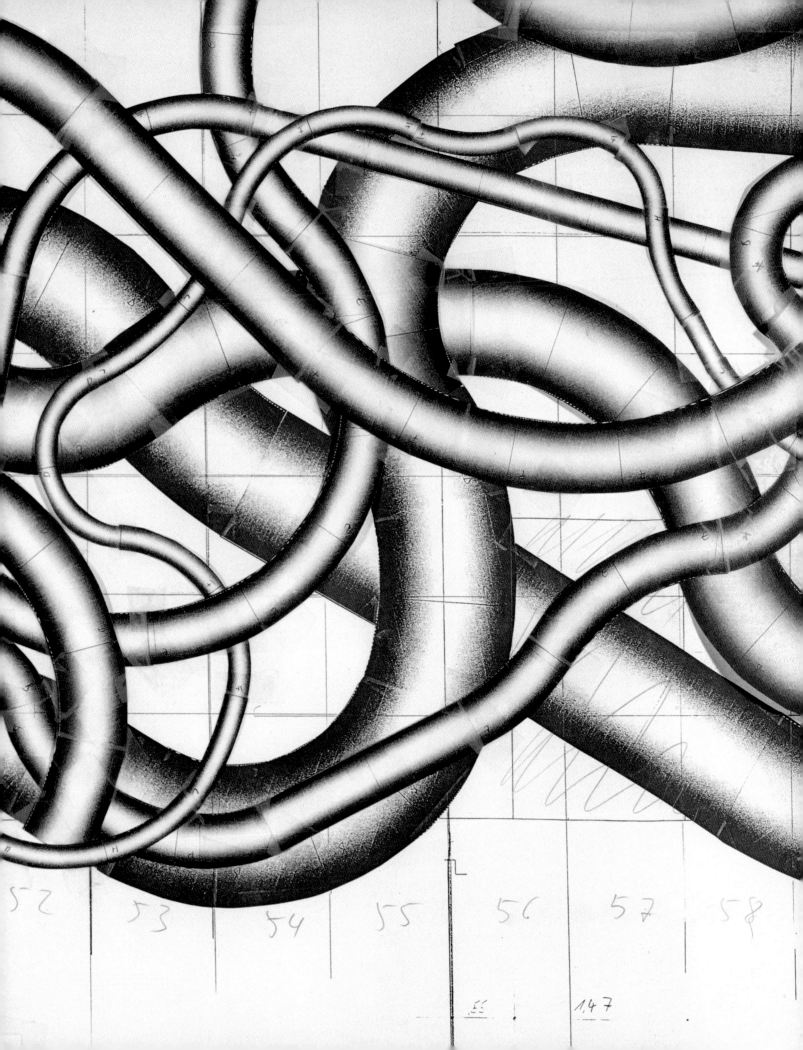

52 53 54 55 56 57 58

55 147

```
<body bgcolor="#000000" text="#00aa00">
<pre>IJ 0.0b1 initializing, wait...

get the routing warm...$?=0
checking permissions...VS?=0
opening ICMP ports...$?=0
scanning TCP/UDP ports...$?=0
done!

stay tuned while connecting to $* ...

x.
x.x.
x.x.x.
x.x.x.x.
x.x.x.x.x.
punt!
Sun Jan 26 17:44:52 UTC 1975
<PRE>

traceroute to XTAC-FTHUACHUCA.NIPR.mil (198.26.80.66), 30 hops
max
 1  RTRBONE.NET.CMU.EDU (128.2.1.2)  3 ms  2 ms  2 ms
 2  nss5.psc.edu (192.88.114.254)  3 ms  2 ms  2 ms
 3  border4-hssi1-0.WillowSprings.mci.net (204.70.108.5)  193
ms  204 ms  14 ms
```

To: equator@king.dom.de
Subject: Pre-Majordomo EMAIL for Comment VII

[Charset iso-8859-1 unsupported, filtering to ASCII...]

>Sampling and moving in a game-like, dramaturgical pattern through gateways and codings and then linked down to the spaces at lower altitude.

again Sam, just back from 10pht & really "Mudged" ... game-like... Mudge @ 10pht's heavy industries obviously decided to link himself down to the lower altitudes of 'nano-networks'. This guy's gateways... he's moving in system's memory like apes in trees.

authors:
>Judy Elkan
>Felix Stephan Huber
>Judith Mastai
>Udo Noll
>Philip Pocock
>Walter van der Cruijsen
>Otherselves
>Florian Wenz
>Norah Mary Wheating
>Florian Wuest
>John Zinsser

X-From_: wenz@arch.ethz.ch Sat Nov 9 12:48:13 1996 X-
Sender: wenz@grey.ethz.ch

its saturday morning, i just got out of bed and my brain
seems to be working at 150MHZ ... let me dump some
<core> on you

Leave the subject line blank, fill in the message body

<environment> address the core issues of networked
culture ... which is already HARDCORE reality. <scan>
<sample> and <display> do not invent fiction.

<header01> personal expression is individual perception
transformed to a communication signal, which goes from
analog (high res, diffuse) to digital (low res, discrete).

Date: Mon, 17 Feb 1997
From: jmastai@istar.ca
Subject: stuff

My constant travels on the airbus
have led me to a space in which
notions of the family have become
psychic
rather than geographic, so I've
come to think of the project as
the

<header02> a person is really not more than an online
database of <01> and its existence is directly related to
attributes, keywords, tags, indexes.

equators of my mind which
brings up moments of heat in
every sense - war, sex, fear

http://www.documenta.de/equator

63:12:11

A Description of the Equator and Some

OtherLands

Philip Pocock

Florian Wenz

Udo Noll

Felix Stephan Huber

> code is the current language of culture and the internet is
coded metacode.

Date: Thu, 30 Jan 1997 15:42:21 +0100
X-Sender: equator@mail.dom.de
To: zinsser@pw.cahners.com

<h1>The <author> goes home with the
audience.</h1>

<scenario01>

<01.1> supply them with technology to sample their brain
waves

hi John

<Mairead> How we talk shows
that we know.

It's turning out that the actual physical travel to the Equator is not so
important. I mean what we're doing right here on motherboard earth
is remapping or rewiring it the whole time. It's always 12 hours of
night and 12 hours of day on-line. And there are lots of bugs, topical
disease, etc.

<01.2> download these samples into the system

The <story line> ends in a fray.

So... *characters in search of an author* in a way. We use a sort of

Yes, then the <screen play> resumes.

neural net. We post a script on the Web http://www.documenta.de, one
that thinks in question/answer, action/reaction, bush-like forms of
SHOT DESCRIPTIONS, DIALOGUE, and some short lofi VIDEO and SOUND
LOOPS.

<01.3> index them into an database of signals

Read me in. EXTERIOR.AIRPORT NIGHT.

It goes like this, first, we seed the script. Then we respond selectively

Four or five disembark. FREEZE.

along with others out there. So a screen PLAY rather than a storyline
develops. When the difference is so blurred between author, audience
and even story, well is it a movie or a game? It's impossible, like
swimming and flying at the same time. © Geo. Lucas

<01.4> code a display that generates rules, feedback
among the actors

I mean if it moves, then its a movie, no? And words move me more

Display me.

than anything these days. Cinema is no longer architecture, it is the

"CUT OUT FRAMES of skipping,

USER.

EXCEPT when both feet are off the ground."

<01.5> dump this process to the visitors at the documenta ...

Here's how the neural-like net comes in. The system core monitors
responses, which authors get the most, and a screenplay develops

Print me out. "Turn off your computer.

accordingly and continuously. When a user gets lots of hits, he or she

Look out a window.

could the way its programmed crack the system and take over

Click here."

our eworld.

>preparing to connect to host

left

right

above

below

Alain Lipietz

Sustainable Development: History a

My preoccupation with what is now called "the environment" goes way back. In fact, it is my professional occupation. I am an engineer, a government functionary charged with land use, that is, with domesticating a certain environment for the needs and desires of human beings. When people speak of ecology today, one has the impression they only mean protecting the birds and the flowers against human activity. But things are a little more complicated. Is a landscape gardener someone who attacks or despoils nature? Is an architect someone who improves or degrades the urban environment? The oldest "ecological" journal in France was originally called *Revue des voies et chemins:* it was and still is a journal of public works engineers, a professional journal of land-use specialists, urbanists. It has just

once the product of the species' activity and the condition of its survival, the interdependence of the three factors is complete. A classical problem of ecology is typically one of hunting: how many square miles of hunting grounds are needed for the survival of ten foxes? And how densely populated with rabbits must these hunting grounds be, in order for the foxes to reproduce? Since the foxes are obviously going to eat the rabbits, their numbers will diminish; but as the population of the foxes diminishes in its turn, through starvation, the number of rabbits will rise again, and so on.

Now consider a *social* species. Social species are those which have a division of labor, such as ants, termites, beavers, etc. Under these conditions, the species itself forms part of each individual's environment, and ethology, or the interrelation of individuals of the same species, then becomes a decisive aspect of ecology. In the

Horizons

celebrated its one-hundred-fiftieth anniversary, under the new name of *Environment magazine.*

In short, the environment is a very old concern of public policy, and ecology is not only a matter of defending virgin nature against an evil humanity. What is the relation between political ecology and ecology as a natural science applied to the human species? How can we define the ideal that seems to be shared by scientific and political ecology, the ideal of sustainable development? These are the first questions I will attempt to answer. Then I will briefly examine the history of unsustainable human development, the crises it has provoked and their solutions, before evoking the great challenges on the horizon of the twenty-first century, when political ecology will no doubt come to embody the idea of progress itself.

Ecology, Politics, and Sustainable Development

Scientific ecology is the science of the triangular relation between a *species* (and the individuals of this species), its *activity*, and its *environment*. As the environment is at

case of the human species, ethology is called sociology or anthropology.

Consider further that the human species is political. Not only are humans genetically programmed to live in hordes, bands, tribes, and so on, but what is more, the horde, band or tribe organizes itself into a city where the individuals of the species define their behavior and activities by deliberation: together they judge what is good or ill. This makes them responsible for their own activity, for its effects on the territory, and thus for the way they ensure the possibility for succeeding generations to continue living on the same territory, with the same methods. In other words, the human species, the only species which is at once social and political, gives rise to a particular kind of ecology, which is called *political ecology*.

It might be objected that political ecology is just what results when people start using ecology to play politics. In fact, it all comes down to the same thing. As the saying went twenty-five years ago, "If you don't take care of politics, politics will take care of you." And if we don't take care of the politics of ecology today, we can be sure that the political ecology of reality will take care of us all. If urban policy, agricultural policy, labor policy,

and international policy do not concern themselves with ecological problems, that is, with problems involving the triple relation between the species, its activity, and its environment, then those policies will produce perverse effects that will render their perpetuation *unsustainable*, unbearable in the long run. And at the extreme, these unsustainable policies will even threaten the survival of the species. Thus we understand that one of the possible objectives of all politics is that of sustainable develop-ment. In fact, humans are by no means obliged to seek

sustainable development. The choice is always open, as Sophocles re-marked quite early in the game: "O wondrous subtlety of man, that draws to good or evil ways!" To make the choice of the life and survival of human beings is to make the choice

of sustainable development.

What exactly is the meaning of the adjective "sus-tainable"? The word has two dimensions: it is synchronic, directly regarding the present, because a development model is only sustainable if it is agreeable to everyone and can satisfy everyone's needs; but it is also diachronic, extending over a long span of time, because sustainable development must endure. In the postwar period, for example, the developed countries went through a mod-el of development in which buying power rose rapidly, at the same pace as productivity, thus guaranteeing full employment and the growth of "gross material happi-ness" for each individual. But that was an unsustainable model. Had we continued that way, had we extended that development model to the whole of humanity, we soon would have exhausted all terrestrial resources and rapidly saturated the atmosphere with carbon dioxide, to mention just one form of pollution.

The definition of sustainable development now adopted by all organs of the UN is the following: "a development model which allows the satisfaction of all the needs of a generation without compromising the possibility for successive generations to satisfy their needs." Clearly, the notion of "satisfying the needs of all human beings" is extremely ambiguous, because the rich and the poor do not demand the satisfaction of the same needs. Now, the contemporary world is wracked by frightful inequalities between human beings. Thus the

definition goes on to envisage an *order* of satisfaction, "beginning with the needs of the poorest." This is the cri-terion of minimal justice. It is not my criterion, but the one upheld by John Rawls in his *Theory of Justice*. The fundamental problem, from this point of view, is not that there are inequalities: some inequalities are acceptable, as long as they permit an improvement in the situation of those who are worst off. In other words, what counts in a comparison of two situations is the level of those who profit the least from each. This definition won unan-imous support in the UN, obviously because it could sat-isfy even the richest countries.

Such is the official definition of sustainable develop-ment, ranked among the rights of all human beings at the major international conferences that have punctuat-ed the last decade of our second millennium: Rio, Copen-hagen, Cairo, Beijing . . . As we have just seen, this defin-ition is a minimal compromise, extremely formalistic and abstract, representing a step back from the full implica-tions of what the pioneers of the 1970s called "ecodevel-opment."

The original idea of ecodevelopment began from the observation that the development model of the sev-enties entailed too much consumption of raw materials and produced too much waste. The first major United Nations Conference on the Environment, in Stockholm in 1972, endorsed an ecodevelopment model in which local communities were supposed to guard against these two errors. Thus the term "ecodevelopment" immediately conveyed a sharp critical connotation with respect to the dynamics of economic liberalism. But

this first conference had no ambition to dictate obligations. Then came the second major conference, in Rio in 1992, preceded long in advance by a series of preparatory meetings. This was the time to take firm deci-sions. One of the preparatory meetings was the United Nations Commission for the Environment, presided by Mrs. Brundtland, the social-democratic prime minister of Norway. The commission immediately ran up against the opposition of the United States, which refused any discussion of ecodevelopment. It was permitted to say that the needs of the present generation should be sat-isfied without compromising the possibilities of succes-

sive generations, and to call this demand "sustainability." But the term "ecodevelopment" was taboo, to the extent that it connoted the end of unbridled free trade, the prohibition of the exploitation of one territory by another, and so forth. In short, "sustainable development" became the politically correct euphemism for "ecodevelopment."

Call it the homage of vice to virtue: the hypocrisy of the euphemism at least allows us to pose the problem (sustainability), though without straying too far along the path of solutions (ecodevelopment). As I mentioned before, no one is obliged to seek sustainable development. In point of fact, the governing elites of many countries prefer unsustainable development—unsustainable for their own people, for other peoples, for future generations. Malaysia, for example, is a country that develops by massacring its indigenous peoples and destroying its forests, and what is more, it claims the right to go on doing so for the next one hundred and fifty years, taking the actions of Europe and the United States as precedents. Ultimately, sustainable development is not just one economic argument among others; it is a *categorical imperative* that is slowly asserting itself through the process of international public debate. But it is not yet accepted with the (admittedly relative) force of the Biblical imperative "thou shalt not kill."

For this reason, we can give a purely political or ideological definition of the political ecologists: those who struggle to promote sustainable development in the political arena. This position is a direct consequence of our initial definition. We began with the question of what ecology was for any species and we saw why a social and political species must seek sustainable development, if it reasons correctly from the viewpoint of its long-term interest as a species. In the field of politics, the political ecologists are those who struggle to obtain sustainable development. They struggle in the name of a certain conception of the general interest of humanity, against political and social forces who do not take that interest into account. Why were the Malaysian elites able to declare themselves resolutely against the imperatives of sustainable development at the Rio conference? For the same reasons that the old French nobility and Louis XVI could say: "After us, the deluge!"

George Bush, a de facto ally of Malaysia in the attempt to limit the scope of the Rio conference, displayed exactly the same attitude when he declared: "Our model of development is not negotiable."

Indeed, if human society remains as inegalitarian in the future as it is today, not all individuals will need to seek sustainable development—as long as they are on the right side of the dividing line. Today's generation does not need the satisfaction of all successive generations. But the majority of human beings, from generation to generation, do aspire to sustainable development. The conflicts exist because of the fact that in a social and political species, *social relations* develop: relations between the sexes, between social classes, between communities. Some of these social relations are contradictory: the interests of certain people are not the same as the interests of others. And although it can be maintained that all human groups have an interest in getting along with each other, the horizon of individual life being limited, once again the individual can conclude: "After me, the deluge." Consequently, human ecology is structurally informed by these social relations, which shape the way the species organizes its activity and determine how the species, organized in this way, will appropriate its environment (which itself is the product of past activity). In other words, ecological problems depend on social relations. The ecological crises of a given era are also the crises of social relations in that era.

A Short History of Ecological Crises

Consider the society that existed before the neolithic revolution. The neolithic is the process whereby, some twelve thousand years ago, human beings learned to plant, to raise animals, to write, and to build cities. Pre-neolithic societies are already societies, but societies whose members hunt and gather. In other words, human beings in those societies look on their environment as an exterior which contains their potential sustenance; they must fight to take from this natural environment what they need to feed and shelter themselves. In this respect they are not far from the situation of the foxes in relation to the rabbits. Their ecology obeys the same law of "predator-prey": it is an ecology that depends on the *carrying capacity* of the territory under consideration, that is,

on the quantity of human beings that can be nourished by a territory, given certain techniques of hunting and gathering. If they take too much, the carrying capacity of the territory is lowered and either they are compelled to migrate or they are decimated by hunger. The improvement of hunting techniques allows them to approach the ceiling of the carrying capacity of humanity on a territory, but at the risk of exceeding that ceiling, since the improved techniques do not increase the quantity of game. Hence the need for these people to be nomadic.

The example of preneolithic society shows in a very simple way how a particular kind of ecological crisis corresponds to a particular kind of social organization. In preneolithic society, famine is due to the fact that there is not enough game to be killed or fruit to be gathered, and migration in search of other territories is a solution. Like any human organization structured into social relations, this political ecology is regulated by *crises*, a crisis being a situation in which it is no longer possible to go on as before but in which one doesn't yet know what is to be done next. This is summed up in Gramsci's very beautiful phrase "the old dies away, the new cannot yet reach the light." Some of these regulating crises are relatively little ones in which the old dies away, but the shape of the new is more or less apparent, the way of overcoming the crisis is clear (in the case of nomadic hunters, it suffices to migrate). Others are major crises in which the new is completely unimaginable. The major crises are more devastating, but also much more interesting, since they can only be overcome by an *invention*.

The transition to the neolithic came about after a series of increasingly severe crises. Cultivating plants and raising domestic animals—the twin mainstays of the neolithic—meant shifting from the idea that it suffices to take from the environment to the idea that one must improve the environment so that it will become more productive in the future. Improving the animals so that they give more milk and bear their young within the protective circle of the herd. Improving the plants so that they become richer in sustenance. In this way, the carrying capacity of the territory itself could be increased.

Moreover, this revolution increased the capacity of human societies for differentiation and thus allowed the advent of the *city*, the appearance of subgroups within human communities, people devoting themselves to activities other than cultivating the earth: counting, commanding, carrying out sacrifices, etc. This social differentiation is distinct from the preneolithic hierarchy, in which the chief was simply the best hunter. Certain classes exonerated from productive activity begin living off the product of others' labor, in exchange for services which are often very real (the state appears because it renders services to society, distributing water, establishing land surveys, and so on) but which at the same time confer an often abusive right to the product of the community. Here a second type of ecological problem develops, no longer one that depends on the carrying capacity of a territory (which can be increased with new techniques), but one that stems from the growing portion taken from this capacity by people who do not produce.

The ecological crises then become more complex. A typical one is the "great bisecular fluctuation" in Europe, which began around 1340 and lasted for two centuries. This crisis broke out with the arrival of the Great Plague, precisely at the moment when Europe had reached the point where its carrying capacity was completely saturated, given the available agricultural techniques and the portion taken by nonproducers, in this case feudal lords who spent their time waging war. The Great Plague struck a peasantry weakened by the physical limits of its arable land and subjected to heavy tax levies by the lords. In a few years, Europe lost more than half of its population; it would require two centuries to regain the population level of 1340. This is an example of a crisis at once economic, ecological, social, and demographic. Given the relations of production (feudalism, with taxes in kind or in labor) and the techniques known at the time (the swing plow, fertilization by burning crop stubble), the carrying capacity of the land was outstripped, and finally collapsed beneath the effect of aggression from another species (the plague microbes). Death was an initial solution to the crisis, albeit a particularly horrid one: the population diminished until the point where the plague could no longer spread and the carrying capacity of the European territory became sufficient again.

This great crisis brought profound modifications to

the techniques of production and to social relations. Three-year rotation of fields and the association between multicrop cultivation and animal husbandry (with the animal waste serving as fertilizer for the wheat) marked a considerable progress, in the form of an improvement of the earth itself. With a share of the activity serving to better the environment, the labor/environment relation became more sustainable. But the development of these techniques, which constitute a kind of second degree of the neolithic revolution (labor expended to improve the earth), meant that the peasants had to be able to trust that the labor they furnished would come back to them in another form, that of a higher yield of products for consumption or for sale. This entailed a limitation of the portion taken by the lords. In fact, the new economy of the renaissance implied the transition from taxes in kind or labor to taxes in money, the shift from the metayage system to tenant farming. This is the phenomenon that triggered the process of constant progress all the way to the nineteenth century: the "agricultural revolution" of modern times.

But I have only presented the bright side of things: the revolution carried out against the lords, against the predators. It is often forgotten that this revolution was also carried out against the peasants themselves. For the peasantry of the feudal era worked two kinds of fields: the fields of the lords, and those of the village community (the *commons*). Now, it is clear that the peasants who accepted to furnish the effort required to improve the land were also going to demand that they be allowed to work the same land in years to come. And for that, the idea of common properties had to be done away with. The farmers who carried out the agricultural revolution of modern times were people who struggled to abolish the common properties, to "enclose" them. As to the others, at first they were able to work on the land of the rich peasants, thus forming an "agricultural proletariat." But the more the productivity of agricultural labor increased, the less farmers needed agricultural laborers to work their land. Thus there developed an urban proletariat alongside the agricultural proletariat. Traders and artisans began to hire "proletarians" who had nothing to sell but their muscular force: they had neither

land nor looms, but they were available to work. The resolution of the great bisecular fluctuation, the great ecological crisis, opened up a new destiny for Europe: the *capitalist revolution* in agriculture and in industry (at first, the textile and construction industries).

Capitalism is constituted of complex social relations. The entrepreneurs have money, with which they can hire proletarians. Thus they exchange money for work, and additionally take care of selling the products. The entrepreneur serves as the intermediary between the producer and the buyer. He takes the risk of selling or not selling, but in return he demands the right to fix salaries and organize the work. Capitalism is thus liable to much more rapid and spectacular changes than feudalism. Feudalism, as we have seen, went through several stages: taxes through forced labor, taxes in kind, taxes in money. But over two centuries, capitalism has gone through far more numerous and varied development models, depending on the period and the country.

Initially, the situation is always the same: the rich are surrounded by completely resourceless people who put themselves at their service. This is the first stage of primitive accumulation, where rich merchants or important artisans can shamelessly exploit wage-earning proletarians. As there is a seemingly infinite offer of available hands, or what Third-World economists call a "Lewisite" labor offer (after the theorist Arthur Lewis), the salary for which labor power can be purchased is negligible. The first type of ecological crisis met by the human species under primitive capitalism arose from the fact that salaries did not allow most workers to correctly reproduce. Indeed, the first ones in England to denounce capitalism were not the workers (they couldn't!) but the recruiting sergeants. They pointed out that in certain counties, the pressure of businesses on the labor market—to recall the carrying-capacity image of animal flocks subject to hunters—was such that at seventeen or eighteen years of age, the young men were unable to bear arms. In other words, capitalism undermined the possibility of recruiting an effective English army! Rapidly, over the first half of the nineteenth century, the recruiting sergeants were joined by doctors who demanded an end to overexploitation, particularly of

Political ecology, like the workers' movement of Marxist inspiration, draws on a critique, and therefore an analysis, a theorized knowledge, of the "existing order of things." More particularly, the Marxists and the Greens focus on a very precise sector of reality: the humanity/nature relation, and still more precisely, the relation between human beings in the face of nature, what Marx called "the productive forces." Of course, the two movements are radically opposed in their overall evaluation of this relation, which is positive for Marxists, negative for the Greens. This is an essential divergence, but one that must not be exaggerated. For Marxists as well, the productive forces are so overdetermined by the relations of production that his critique of the latter extends to the former. . . .

The Greens share the Marxists' conviction that they have come at the hour when Minerva's owl has taken flight, when a particular form of the order of things is leading us so close to catastrophe that the "great change" must come: revolution, paradigm shift, new era, etc. The form to be swept away is called "capitalism" by the workers' movement, "productivism" by political ecology. This dif-

Political Ecology and the Future of Marxism

ference is far from inconsequential; but who can fail to see that "productivism" plays exactly the same role for the Greens as "capitalism" for the Reds: the role of that which must be abolished to transform human existence? Whether productivism or capitalism, the form that has been identified is what brings the tension between human beings, and between human beings and nature, to its paroxysm. A "threshold" has been crossed: that is why the movement of political ecology is being born *today*, as the workers' movement was born in the past. . . .

On the whole, political ecology presents very strong similarities with Marxism. These two "models of hope" spring from a very similar mold: they are materialist (beginning with knowledge of reality), dialectical (supposing that this reality will engender its own material critique), historical ("now is the time!"), and progressive. In this respect the Greens run most of the same risks as the Reds, and already display their failings: the "fundamentalism" of the French and German Greens (the exact analog of "leftism") has often been denounced, and soon their "realism" will probably be deplored (like the old "opportunism"). The Greens have one great advantage over the Reds: they come after. The Green paradigm develops on its own base, but it includes the theoretical and practical critique of the Red paradigm. It is a principle of hope that develops from a similar mold, but not from the same mold. . . .

The Green paradigm is politically "progressive," but it is not "progress oriented," in the sense that its vision of history is not a history of progress. In fact, its vision of history is not oriented at all. At an extreme, it could consider history as being guided solely by the second principle of thermodynamics: a history of inexorable entropy, a history of degradation. Only self-critical consciousness can slow down or turn around this degradation. Political ecology can only define progress as a *direction*, oriented by a certain number of ethical or aesthetic values (solidarity, autonomy, responsibility, democracy, harmony, etc.)—without any material guarantee that the world will effectively take this direction (for instance, by the "socialization of the productive forces"). The historical and dialectical materialism of the Greens is nonteleological, and even rather pessimistic. . . .

children in the coal mines. In a sense these philanthropic doctors, or "hygienists," backed by the militants of the fledgling workers' movement, were the ecologists of the first industrial revolution. This is a very interesting point, which I frequently rediscover in the Third World today: very often, when the mayor of a city in Mexico, Peru, or Brazil is introduced to me as an "ecologist," I find he is a doctor, and that his municipal council is composed primarily of union organizers.

Thus when capitalism became the dominant mode of production it ran up against a very specific crisis, for it had failed to produce rules obliging the entrepreneur to pay his workers at least well enough so that they could reproduce themselves and their families. In the face of this crisis, society began to invent. It began by limiting the right to employ children, so that the entrepreneurs would be obliged to pay the parent adequately until the children had completed their growth. This was the struggle carried out by the most enlightened capitalists, those who sought the sustainability of capitalism, and by the most enlightened unionists, those who sought the sustainability of wage labor.

After the Second World War, these struggles would finally lead to a model of development known as "Fordism." This extraordinary case resulted from the struggles of the unionists and the reflection of the most intelligent of the capitalists, including both industrialists and bankers (Ford, Keynes, etc.). Society finally realized that according to the very logic of capitalism, its goal being to sell commodities, what must be created is the largest possible number of clients. As Henry Ford said, "The working class being the most populous class, it must become a wealthy class, to allow for the sale of our mass production." Ford's idea, broadly shared by the unionists of course, was that workers' salaries had to be systematically increased. And this systematic increase in the buying power of wage labor was what spurred the economic development of the postwar period.

The Ecological Crises of Our Time

To achieve that result, a great crisis had been necessary. Thanks to the alliance of the unionists and the hygienists, the physical sustainability of wage labor had been attained, with the prohibition of child labor and more generally the reduction of labor time, as well as the struggle against the insalubrity of workers' housing (these being the two major concerns of the workers' struggle in Europe from 1840 to 1920). The stakes of the years 1930-1950 were to guarantee the ability not only to survive but to live well, "living well" being reduced, however, to "consuming a lot." This version of the good life was also the bad life: it implied the destruction of the popular communities celebrated by the cinema of "poetic realism," the destruction of an entire workers' culture where people didn't live so miserably after all. But thanks to the "social progress" of the postwar years, the evenings at the riverside dance halls gave way to the evenings by the TV set. We became accustomed to measuring the happiness of life by increases in buying power. This new revolution allowed the resolution of one of capitalism's fundamental problems, the problem of the client, since capitalist production was now principally sold to the workers themselves.

But this revolution led to a new type of ecological crisis: the crisis of *overconsumption*, symbolized by the traffic jam and the destruction of the environment. The discourse of the environment is a new one, wielded by other forces than the unionists. In the early days of capitalism, the hygienist doctors and the unionists forged a natural alliance. As soon as the minimum was obtained (the prohibition of child labor, the eradication of workers' slums) and the decisions were increasingly between working less and earning more, taking less risks and obtaining "risk benefits," etc., what occurred was a dissociation between the doctor, the hygienist, or the ecologist, on the one hand, and a certain type of unionist, on the other. A "paycheck unionism" appeared, ready to accept a regression in the quality of life in exchange for heightened buying power. This is why around 1970, which marks the culminating moment of the Fordist period, political ecology developed independently of the workers' movement and often even in conflict with it. In the United States, Germany, France, and Italy, a major dif-

Contrary to Marx's analysis, capital no longer needs all the *proletariat* it has at its disposal (that is to say, all those who possess no means of production and cannot autonomously engage in commercial production). The idea that all proletarians are destined to become wage earners, that they form an "industrial reserve army," is only justified under an extensive regime of accumulation. When accumulation becomes intensive, without any redistribution of the gains from increased productivity, capitalist production has no reason to adjust its dynamics to the labor supply. The Fordist path to job creation by unlimited growth in mass consumption is blocked by the constraints of internationalization and the swollen organic composition of capital, as well as the ecological crisis. Finally, the current developments of wage labor render an increasingly larger segment of the proletariat structurally useless for lack of qualification, however low its wages may fall. Alongside the wage earner—but not necessarily "shoulder to shoulder"—appears the figure of the socially excluded individual.

In this "Lewisite" situation of unlimited excess in the labor offer, long familiar in the Third World but now on the rise in the advanced capitalist countries, the Keynesian argument that "fighting for wages is fighting for jobs" no longer holds. The wage earners and the excluded can no longer naturally consider themselves a unified force in confrontation with "them": the capitalists. The game is played by three (at least), and compromises between capital and qualified wage earners to the detriment of the excluded are perfectly imaginable. Hence the acuity of the debates

Political Ecology and the Future of Marxism

that the ecologists bring to bear over the "redistribution of working time," which implies struggles and compromises not only between "them" and "us" but even within what was formerly called "the proletariat." Now, the messianic role of the proletariat for Marx was founded on the fact that proletarians have "no particular interest to defend," that they "have nothing to lose but their chains" and "a world to win." Today, the world to which the excluded aspire is that of the wage earner, who himself has his wage to lose; and the very fact that certain people are excluded means they have no way to put any pressure on capital . . .

I have no intention of claiming that political ecology is necessarily the future of Marxism. Many are already convinced. To the rest, I will say only this: just as communism was Marx's answer to the limits of the French revolution, so political ecology seems called upon to become the answer to the tragedy of communism in the twentieth century; just as Marx's theory responded to the great problem of the nineteenth century, so ecological thinking and politics must respond to the great problems of the twentieth-first century. To paraphrase Marx's *Critique of Hegel's Philosophy of Right* and his polemic against Feuerbach, it is not enough to put the dialectic back on its feet, it has to be put back on the earth. Or again: Marxists transformed the world differently than the capitalists, but the important thing now is not to make any more big mistakes!. . . .

The basic problem is not simply the weakness of Marx's political thinking (beyond the fruitless debate over "reform or revolution"). Much has been written about this weakness, and we know that it is largely responsible for the criminal tendencies of a great deal of twentieth-century Marxism. But the same weakness crops up today in political ecology. We simply do not know how to conceive and above all how to deal with the relation between a critique of the existing order of things and an authentically humane and *therefore* ecological political practice capable of abolishing that existing order. We do not know how to bring together materialism, ethics, and politics. We didn't know how as Marxists, and we still don't know how as ecologists.

But what I have more particularly in mind is Marx's answer to the question of the link between materialism and politics: the *paradigm of production*. Let's go back to the celebrated letter to Wed-

ference developed between those fighting for a better salary and those fighting for better conditions, those fighting for more benefits and those fighting for less harm, those who demanded "a job, whatever the price" and those who refused a polluting factory.

This divergence is extremely interesting, because unlike the shared struggle of the unionists and the hygienists, it allows us to distinguish two aspects of "sustainability." People began to become conscious of the fact that a society which immediately and equitably satisfies the essential needs can in fact be dangerous, because it poisons the aquifers, because it renders urban growth uncontrollable, because over only a few generations it can make the survival of precious species impossible, because it worsens the lot of human beings living thousands of miles away. The effects of these ecological crises of overconsumption were initially local (traffic jams, air pollution, noise, etc.); indeed, political ecology as a social movement had mobilized itself against them already in the 1960s. Then, in the 1980s, we became conscious of the "global" crises, such as the erosion of the ozone layer, an aspect of the greenhouse effect. In these global crises, the "authors" of an unsustainable form of development can live in one time and place (the United States and Europe, at the end of the twentieth century) while the victims live in another time and place (Bangladesh, in the middle of the twenty-first century).

Indeed, this new consciousness of ecological problems led us to relativize the very success of the "social market economy" promised in postwar Europe by the Christian-democratic and the social-democratic parties. This development model, the European variant of Fordism, was considered a good capital-labor compromise, despite all the criticism that was addressed to it at its zenith. It only needed to be "improved." Today, however, we realize it was completely untenable. For example, the destruction of the ozone layer is taking place today, whereas for many years now it has been prohibited to release chlorofluorocarbons into the atmosphere; the problem is that the molecules of chlorine gas were emitted twenty years before, in the northern hemisphere for the most part. As to the greenhouse gases, principally carbon dioxide, they remain in the atmosphere for an average of one hundred and fifty years. All the carbon dioxide emitted since the industrial revolution is still there. The gases emitted between 1945 and

1975 will be in the atmosphere until the year 2100. Now, what counts is not the rate of emission, but the quantity of carbon dioxide in the atmosphere. A twofold increase in the amount of carbon dioxide will provoke an increase of two-and-a-half degrees centigrade in the mean temperature of the planet, and a rise in the sea level of thirty to sixty centimeters. At the current rate, these two changes will make life in Bangladesh impossible around 2050. Given that Bangladesh will then number around two hundred million inhabitants, one can imagine the dimensions of a Bengali evacuation to India. Not to mention the evacuation of the Egyptians and North Africans to Europe after the flooding of the Nile delta and the disappearance of the North African agricultural strip along the coast.

Thus the social and economic "conquests" of the years 1950-1970 have had serious ecological consequences. Today, the compromise of those years has entered a crisis, and throughout the world certain political and economic leaders are attempting to bring wage labor back to the situation of the 1930s, and indeed, to the situation of the nineteenth century. This regressive movement has been called the "hourglass society." Because of it, all the different types of ecological crises that emerged in succession since the beginnings of capitalism have been reactivated: global ecological crises (for more and more greenhouse gases continue to be produced), local ecological crises of overconsumption (for the upper classes, in Brazil no less than Europe, consume more and more), the dangerous working conditions of the early twentieth century, even the crises of early capitalism. Hunger has reappeared (in England, the life expectancy of the least well-established third of the population has begun to diminish) and diseases linked to unsanitary conditions are on the rise (for example, lead poisoning is again a problem in Paris . . .).

Are we then heading toward a new convergence of political ecology and movements of defense for wage earners and more generally for "the poor"? It is quite probable. But much still remains to be understood about the split that developed between the workers' movement and the ecology movement, after the former had obtained, over the course of the twentieth century, a minimum of laws allowing wage earners to survive and

ermeyer (March 5, 1852) which constitutes Marx's own definition of the overall logic of Marxism: "My truly new contributions are these: 1) the demonstration that the existence of classes is linked only to determinate historical phases of the development of production; 2) that the class struggle leads necessarily to the dictatorship of the proletariat; 3) that this dictatorship itself represents no more than a transition to the abolition of all classes and a classless society."

Today, of course, no one would dare maintain that Marx effectively "demonstrated" all that. Indeed, a Marxist researcher can be satisfied with the first phase of the program, which is purely

Political Ecology and the Future of Marxism

scientific and not eschatological: the analysis of the contradictions of each mode of production. The problem here is the program itself, its unifying principle: the central status of *production*, and production *as Marx understands it*, that is, as the activity of the transformation of nature by producers, organized by more or less alienating social relations. This principle is clearly structural, since it simultaneously allowed Marx to designate the enemy (capitalism), the revolutionary agent (the proletariat), and the aim of the political movement (communism).

Now, this tendentious reduction of the natural history of humankind to the transformative activity of man is exactly what places Marxism at odds with human ecology (whether theoretical, ethical, or political). Ted Benton has remarkably demonstrated how this divergence originated in the narrowness of the Marxian conception of the productive process (Benton says it is "a carpenter's conception," but Marx himself invites us to see it as an architect's conception—by contrast to that of a bee). As Benton shows, Marx sees history as a progressive artificialization of the world, freeing humanity of the external constraints imposed by its insufficient mastery of nature; a view which led him, and Marxism in his wake, to tendentiously neglect the irreducible character of these external, purely ecological constraints. From this point of view, Marx shares entirely in the Biblical-Cartesian ideology of the conquest of nature, brought to its paroxysm by the "triumph of the bourgeoisie" and then again by the sorcerer's apprentices of Siberia and the Kazakhstan steppes, in Stalin's day. . . .

I am not pleading for a radical version of "deep ecology." Long before the Great Chief Seattle, Blaise Pascal reminded us that the human species is just one stitch in the immense canvas of nature, but it is the only one which, through thought, understands nature. The human species is the only one on earth to be responsible for the earth, to be capable of transforming it for better and for worse. To return to the famous chorus of Sophocles' *Antigone*, humankind is the great telluric force of nature, but it can choose the path of good or evil. What I am saying is that the *a priori* positive accent placed by Marx on the demiurgical capacities of the human species, and the limitation of his critique to the existing order in the sole form of human relations and above all relations of production, opened the possibility of a split between Marxism and ethics, between Marxism and democratic politics, between Marxism and ecology. . . .

To reshape Marxism on such a central point, while still preserving its richness, is no easy task. As always in paradigm shifts, two paths open up before us. The first is that of cautious evolution: pruning away dead or diseased branches, loosening up over-hardy hypotheses, enriching an unaltered core with secondary amendments. The second is that of a radical change in paradigm: reconstructing materialism around another common trunk, with reusable elements drawn from the ruins of Marxism.

From: "L'écologie politique et l'avenir du marxisme," in *Congrès Marx International*, Paris, 1996.

even to profit from progress. It was then that a certain conception of "progressive politics" represented by communism and social democracy became rigidified, while political ecology developed into an autonomous movement.

Political Ecology, the "Progressive Movement" of the Twenty-First Century?

Because they share the same origin (resistance to the excesses of capitalism), the movements of political ecology and socialism bear a number of initial similarities. First, they both adopt a materialist discourse: "These are the current forces of production, these are the current relations between productive human beings, and this is the basis for our reflection." More precisely, this is a discourse of historical materialism: the Marxists, the most sophisticated theorists of the workers' movement, develop *a history of the modes of production* comparable to the broad picture of the history of humanity's relation to the environment which I have just sketched out. Second, both the Marxist and the ecologist discourses are "historicist": they hold that if today we can make a given judgment, it is because we have arrived at a particular point in history. Historicism is the excessive tendency to believe that Minerva's owl only takes flight after nightfall, as Hegel put it. Only when it is all over, when it is already too late, do we begin to understand what has

happened in history. Thus the workers' movement and political ecology meet in their alarmist, doom-saying proclamations. But third (and as a counterpoint to their historicism), both discourses are dialectical: they think in terms of *tensions* in a system, not in terms of places in that system. For example, the social tensions caused by the exploitation of proletarians result in workers' movements, thanks to which modes of regulation are set up which require capitalism to ensure the survival of wage earners. In the same way, the tensions raised by capitalist disrespect for the environment set off ecological movements which impose protective measures. Fourth, both are "progressive movements": they uphold progress

in solidarity and sustainability against those who say "After me, the deluge."

Let us pause over this last point. It is sometimes said that ecology is a concern of the rich; the phrase was pronounced at the Rio conference, for example. Ecology is thought of as a luxury, an indulgence after one has satisfied "all the rest." Now, the problem is that "all the rest" (that is, immediate needs) is already linked to ecological matters, though they are not designated as such. There is no way to distinguish between "environment" and "development" in the Sahel or in northeastern Brazil: for a very poor peasant, the improvement of the environment *is* development. The same is also true in a slum: is the installation of a sewer system and of drinking water urban ecology or "social development"? In reality, the same nongovernmental associations took part in the Rio conference (on the environment) and the Copenhagen conference (on social development). But in the already relatively rich countries, a large part of the middle classes will be opposed to ecology, considering it as a menace to the progress of its well-being, because respect for the environment seems to limit its buying power! In point of fact, ecology appeals today to the very poor and the very rich, it irritates the middle classes of the middle countries (including wage earners). As we have just seen, ecology and the social movements of the twentieth century began to split when unsustainable possibilities for a capital/labor compromise appeared within capitalism. But the differences run deeper.

The first difference is that ecological materialism is no longer teleological, whereas the principle theorists of socialism, the Marxists, begin with the presupposition that the development of the forces of production is the foundation of all social and even moral progress: because we are more and more able to appropriate nature, we will live better and better. To which moderate ecologists answer "That depends," and extreme ecologists retort: "On the contrary, the development of the forces of production only makes matters worse." For my own part, I am a moderate ecologist. The ecologists do not share this vision of history according to which the development of the forces of production, or in other words, the capacity to act upon nature, directly determines progress. There can be bifurcations or U-turns, progress on certain levels and regression on others, or progress at

a certain time which provokes regression at another time.

A second difference has to do with historicism. We can no longer believe that there is a moment when Minerva's owl takes flight. There is no decisive moment when past and future become clear. We now know that the very definition of "the good life" is the object of a permanent struggle which no doubt will never be resolved, not only because there will always be oppressed and oppressors, but also because the questions are complex and often undecidable. For example, relations between men and women were formerly considered natural, and consequently remained outside the field of political deliberation. The Greeks deliberated between men and never even dreamt of the possibility that women could be given the vote. Why did women obtain the right to vote long after wage earners had obtained the freedom to organize? The order in which social movements are able to achieve the recognition of their aspirations is highly chaotic and unpredictable.

What is more, nothing guarantees that humanity will one day attain a situation of total transparency to itself, when everyone will know what they want and it will be possible to find a solution which is acceptable to the entire community. It can even be shown that there will never be a procedure to bring all individuals, even reasonable individuals, into agreement. And psychoanalysis reminds us that a purely reasonable individual cannot exist. So is it good or bad to transform a thicket into a garden? There is no way to know: everything depends on your taste, on the quantity of thickets, jungles, or gardens around you, and so on. Aesthetics cannot be democratic. This is why there will never be a moment when history can be summed up and perfectly understood.

We know that every definition of "progress" entails the requirement of sustainability, which means that the imperative "thou shalt not kill" now becomes "you must not commit any action that risks causing the death of an individual, neither several generations later, nor at the other end of the world." But if we go one step further, if you are required "not to do to others what you would not have done to you"—Kant's way of secularizing the Christian imperative—then a highly complex situation emerges. Because what would the inhabitants of Bangladesh, two generations from now, not have me do to them today? If the definition of progress in the cen-

tury of the enlightenment was indeed a secularization of Judeo-Christian morality, then think of the image that the prophet Issiah gave of paradise: "The valleys will be filled and the mountains lowered." An ecologist defending his valley in the Pyrenees probably wouldn't accept that phrase as a definition of paradise!

Thus we no longer even know what will be considered "better" by future generations. This means we must define the changing content of progress democratically, through free deliberation. Are we completely disoriented? No, because a certain number of values seem certain, either because they have been reached through the prin- ciple of discussion, in Habermasian fashion, or because they spring from the respect that seizes us whenever we look the other straight in the eyes, as Levinas maintains. What are these values? The first is the value of autonomy: to reach a situation where each person can decide on his or her own fate, as far as possible. Progress then becomes the progress of a community where individuals tend increasingly to grasp and control the ends of their own actions. The second is the value of solidarity, which is one aspect of sustainability: no one must be left out in the cold, the satisfaction of human needs is to be measured by the satisfaction of those who are least well off. Finally, the other aspect of sustainability, the value of responsibility: what is good for us today must be preserved for tomorrow. Such are the values that can sustain a renewed idea of progress—precisely the idea the human race will need in order to face the perils of the twenty-first century.

Alain Lipietz delivered this lecture at the School of Fine Arts in Paris, November 18, 1996. It was transcribed by Valerie Picaudé and revised by the author.

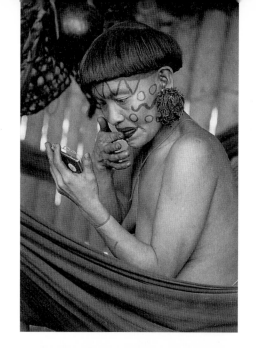

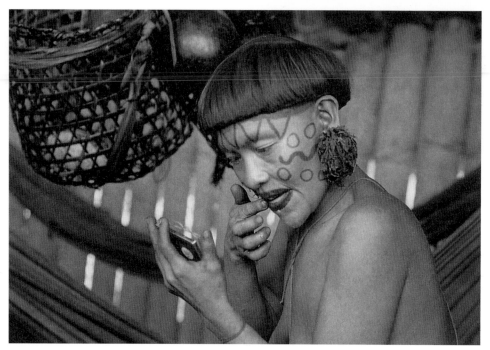

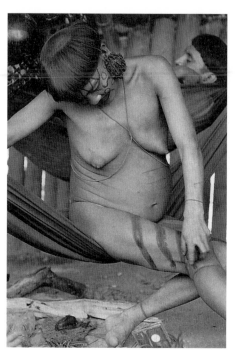

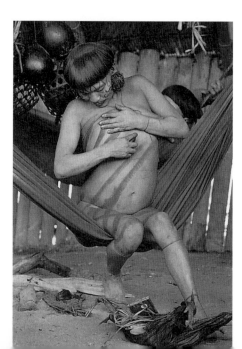

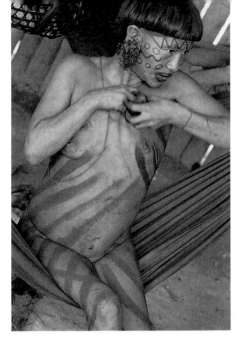

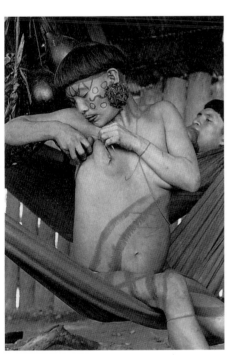

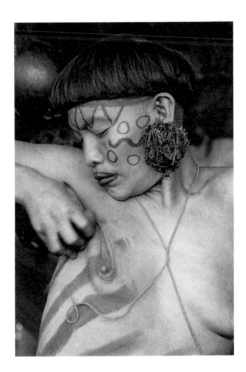

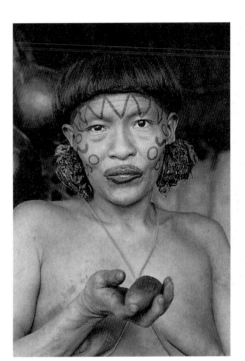

'ya onibraréma' – 'ich bemale mich'

Natoma aus Kashorawë-tʰeri
bemalt sich mit Nana rot Gesicht und Körper

'Wenn sie nicht allzeit bemalt ist,
wird sie schnell altern'

Yanomami, Alto Orinoco, Venezuela, 1978

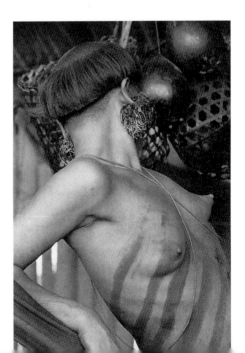

Max Welch Guerra

Berlin

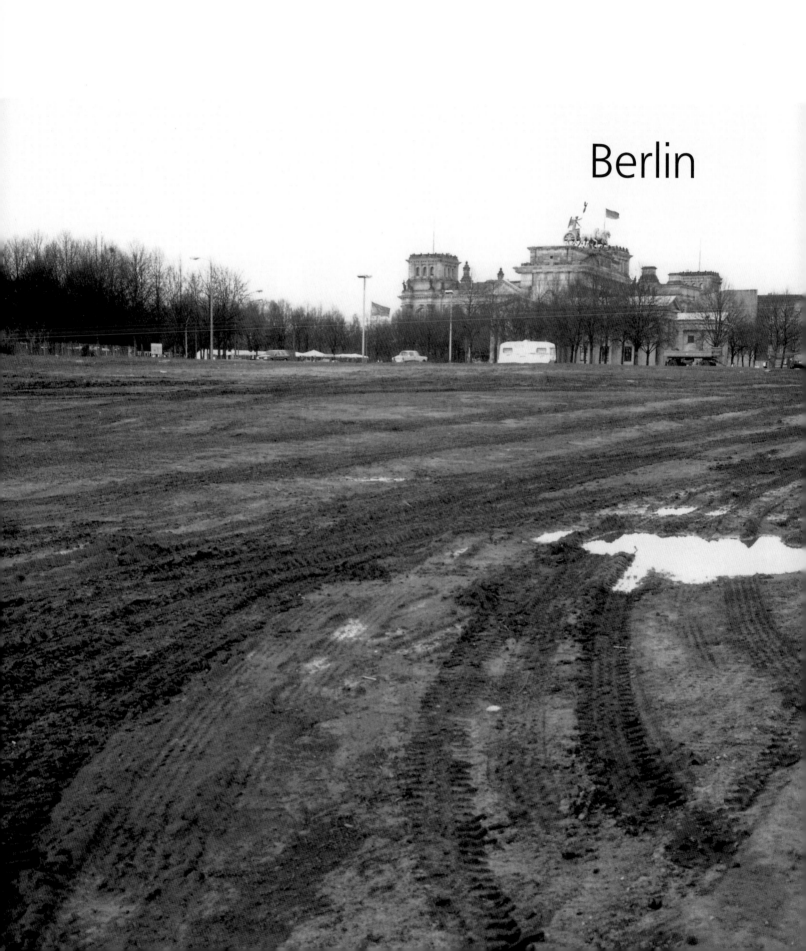

Moving In

The move from Bonn to Berlin places the Federal Republican state before a new task: the appropriate reoccupation of a city center full of urban spaces and structures reminiscent of the most delicate phases of Germany's past. In Bonn the parliament and government district spread itself out in a sparsely developed neighborhood of mansions outside the actual city. With regard to structural and spatial design, the zealous attempts to manifest cultural and political westward orientation relied upon new construction. A conscious confrontation with the architectural heritage of the ugly past would have been possible on the Rhine but was avoided to a large extent. In the Berlin of the 1990s, on the other hand, the "core of governmental functions" and the Bundestag are settling in a city permeated by evidence of its political history. As could be foreseen, on the river Spree the rearrangement of the old was not to be overshadowed by the shaping of the new.

At quite an early date—mid 1990—the municipal authorities of both East and West Berlin resolved to canvass for the government's removal to Berlin by furnishing proof of abundantly available buildings and surfaces in a representative location of the city, above all in the Spreebogen (the bend of the Spree) in the western Tiergarten district and in the vicinity of Spreeinsel (Spree island) in the eastern center. Back then it was natural that for the very reason of their historical associations these areas were viewed by many as an incentive for saying no to Berlin. But neither before nor after the June 1991 Bundestag resolution in favor of Berlin as the seat of government was a serious alternative anywhere on the Spree discussed.

How many of the symbolically laden structures and ensembles, originating primarily during the empire, the Nazi regime, and the GDR period, should be assumed by the federal German capital? To what extent was is permissible to reshape the center of Berlin? 1997 marks the seventh year of the urban planning of the capital, an opportune time to investigate the interim results.

The Desire for City and History

After initial attempts to spread out seamlessly over the old center, the federal government basically adopted the Berlin proposal to distribute the central governmental functions. Federal politicians on the higher and highest levels then began a series of debates on the symbolic acquisition of city and history. In 1990 Federal President von Weizsäcker laid claim to the Prinzesinnenpalais on Unter den Linden for his official residence—without considering the consequences of placing a function so bound to security requirements in the middle of the old center. In 1991 the Foreign Ministry fixed its eye upon the high-class address on Wilhelmstraße where its predecessors had once resided, without realizing of its own accord that two world wars had been initiated there and that to the ears of the rest of the world "Wilhelmstraße" did not sound like the good old days but rather like the German thirst for conquest.

Meanwhile, in 1992 the important ministries of foreign affairs (the interior, finance, and the economy) reached out for locations in the vicinity of Spreeinsel. Here was where Berlin had once been founded; here was where the House of Hohenzollern had its city palace until the GDR government, labeling it a symbol of militarism and imperialism, decided to tear it down. Until well into the 1970s the representative governmental district of the GDR was built up here; the ensemble included the buildings for the council of state (1962-64) and the foreign ministry (1963-66), the Palace of the Republic (1973-76) housing the People's Chamber (among other things), and the central committee of the SED (the ruling socialist party) in the building of the Reichsbank (1934-38) on the neighboring Friedrichswerder. The placement of four federal ministries—requiring some 200,000 m² of space—in this area would have meant to continue the nationalization of this part of the old city, a process begun by the GDR. What is more, because of the proximity to the Federal President a hardly permeable zone of high security requirements would have developed right in the middle of Berlin.

At the close of 1992 the federal government announced its intentions to tear down five of the most important existing government buildings: the council of state and foreign ministry buildings, the Palace of the Republic, the Reichsbank and Goering's Reich aviation ministry (1935-36) on Wilhelmstraße. Much criticism was voiced in Berlin, coupled with a demand for urban planning policies demonstrating greater historical awareness and better suitability to urban functions. In December of 1992 the federal government made its first retreat: the two Nazi-era buildings were to remain standing, the GDR buildings to be demolished.

The Spreebogen

In February 1993 the planning of the capital took a decisive step forward when the design by Axel Schultes and Charlotte Frank won the idea competition for the planning of government district on the Spreebogen. The task was not simple, dealing as it did with the location of two constitutional organs—the chancellor's office and the Bundestag—on historically complicated terrain. This is the site of the German government building

known best to the world, the Reichstag (1894), a unique symbol of German history: a monumental glorification of the German unification attained in 1871 and an architectural expression of parliamentarianism under Hohenzollern rule. In 1945 the building was seized by the Red Army as an embodiment of German fascism. After the removal of the damaged dome during the postwar period the building was gutted in the 1960s on commission of the Federal Republic and adapted to the stylistic language of the Bonn government under the supervision of Paul Baumgarten. The assignment of the role to be assumed by the Reichstag was one primary task spelled out in the competition advertisement of 1992, the other being the treatment of the Spreebogen and its planning history, particularly Albert Speer's colossal north-south axis, originally intended to render the Spreebogen the heart of Germania and capital of the German empire.

In the Schultes-Frank design, the Reichstag building forms a virtual anchor for the entire constellation. The major element of this design—and city-planning trademark of the new Federal Republican capital—is an elegant, ribbon-like row of buildings straight across the Spreebogen. The distinctive shape can be read as a conscious retort to the nationalist planning elements: in place of intimidation by a monumental north-south axis, an invitation to stroll along a corridor from east to west. The return to a place encumbered by its past is not designed as a linkup with former power and grandeur but as a symbolic new beginning. The figure can also be interpreted as an east-west connection, thus complying with the effort to construe Kohl's chancellorship as the "chancellor of German unification."

In June 1993 the Briton Sir Norman Foster was the winner of the simultaneous competition for the redesign of the Reichstag to house the German Bundestag. Now, following a number of modifications, the plans have been finalized and construction work is underway. The alterations of the 1960s are relentlessly being removed; a large public space will surround the plenum hall. The house of parliament is to be structurally transparent and accessible. Conservative politicians tried to implement the reconstruction of the old Reichstag dome, leading to a compromise resolved by the Bundestag in June 1994. A new dome is to be built, its design both a direct reference to the formal language of the Bonn era—trans-

Jean-Luc Moulène, *Berlin 1996-97*

parency as a symbol of democracy—as well as the establishment of a new symbol through the adoption of energy-saving lighting and ventilation functions: the young princess Ecology is being enthroned as a motif of national representation.

Decisions were made in favor of the designs submitted by Schultes and Frank to the 1994-95 architectural competition for the chancellor's office and by Stephan Braunfels to the Alsenblock competition (Bundestag offices north of the Reichstag building) of 1994, thus concretizing the east-west artery with a formal idiom attributable to late postwar modernism. The renunciation of classical demonstrations of power has been realized architecturally. The Spreebogen plans are not entirely free of fault: a low-traffic-volume zone is being created for the government at the expense of the rest of the city and the security measures are carried to an extreme—around the chancellor's office the elegant east-west corridor becomes an unfriendly prohibited area!

had not been first and foremost a governmental building but a large, open house of culture. The other group, of western origin and possessing professional and publicly effective working methods, fought for the reconstruction of the palace in its original form. With the support of large enterprises the latter group succeeded in putting up a spectacular palace facade on a scale of 1:1 in situ. Against this controversial background the Spreeinsel competition was advertised in August 1993. The primary requirement was now to rearrange the area to allow the installation of two ministries, the foreign ministry and the ministry of the interior.

The first prize was awarded to Bernd Niebuhr in May 1994. Niebuhr had used the ground plan of the prewar period as a guide and proposed a large-scale building for cultural purposes on the site of the old palace as the hub of his design. The jury decision triggered a great wave of protest. The chamber of architects, for example, criticized the fact that the winning design called for the razing of the council of state building, a protected monument. Niebuhr had adhered to the public promise of reward in letter and spirit, thus bringing to light what was indeed a remarkable constellation: whereas a building of the Nazi era, the Reichsbank, was to receive a new front section and become the seat of the foreign ministry, the structures of the GDR were to be torn down. As though the surprised winners of the cold war, still not quite confident of their victory, wanted to obliterate this most recently concluded phase of German history.

The survival of the council of state building is now assured. With a critical statement of June 1994, a group of experts initiated a turnabout leading to the acknowledgment of the building's political and architectural excellence. The structure has become an information center for urban planning of capitals and the seat of the organization in charge of the federal government's Bonn-Berlin move: it is the most public building of the new capital in Berlin. Furthermore it has been decided that the chancellor will occupy the building until the completion of his own offices on the Spreebogen.

The GDR foreign ministry, on the other hand, was torn down in the autumn of 1995, even though the reconstruction of the Bauakademie (1832-36) on that site still has not been determined with certainty and its use is also undecided. The Palace of the Republic is to be subjected to "cold demolition": the method to be applied for the removal of asbestos will leave only skeleton-like

Jean-Luc Moulène, *Berlin 1996-97*

The Spreeinsel Area

While the city planning competition for the Spreebogen led to enforceable solutions, the one for the Spreeinsel area came to a standstill. Even before the competition was advertised, two groups of the population had voiced their views on the island's formal future. The first group, consisting primarily of elderly former GDR citizens, organized a series of protests against the demolition plans for the Palace of the Republic, arguing that it

structures behind. A public consensus on its further fate is nowhere near being reached.

A federal resolution of early 1994 came to be of major significance for the events to follow: in its entirety, the cost of planning the capital may not exceed twenty billion DM. While in view of this directive new constructions have become the exception, the alteration of existing buildings has taken on greater importance. These circumstances paved the way for the reutilization of old structures in compliance with the requirements of monument protection and led to a wider scattering of ministries across the city.

The most recent status of the conflicts revolving around the structures of past power systems is illustrated by the alteration of the Reichsbank to make it the new seat of the foreign office. This building was the first major construction project of the Nazi era. Its interior is distinctly modern, its facade hermetic and serious, rendering the Reichsbank an example of the first phase of Nazi capital architecture. The central committee of the SED took over the centrally located structure in the late 1950s—it had hardly been damaged during the war and was easy to safeguard. In the course of time the layout of its nearly 1,000 offices was reorganized according to pragmatic considerations and the modern transparency of the interior spaces lost. The national socialist emblems were removed; in their place a large-scale SED badge was attached to the facade.

The Federal Republic has now decided to keep this building to accommodate one of the most important ministries—the foreign office. The new front section is to receive public-oriented functions and diminish the monumental effect of the original facade. In 1996 the design by Thomas Müller and Ivan Reimann—which had placed second in a realization competition—was chosen for construction. It organizes and shapes the building so as to radiate representativity with a sense of openness, and once again adheres stylistically to late postwar modernism. Also in 1996, the modifications of the old structure were entrusted with the office of architect Hans Kolhoff. His concept amounts to a retrieval of the modern features of the original design. In practice, this means the reversal of alterations made during the GDR era; only a few interior spaces of that period will be preserved as examples. Through its return to an earlier state, the facade will become more sinister, as the white transoms of the GDR will be exchanged for the brown ones of the Nazi era. The federal republican acquisition of the building will also be signaled in a virtually placard-like manner: large monochrome pictures by Gerhard Merz in the building's interiors are to emphasize the aspect of rupture signified by the new acquisition of these spaces.

Particularly in the first few years after its decision to move to Berlin, the federal government revealed itself as a sometimes shockingly helpless, even ignorant main character in the planning process for the capital city. The fact that the sites of central governmental functions are now scattered in a tolerable manner across Berlin's urban terrain and the city is not stifled by them, the fact that a confrontation with political history can be carried out in this urban space and is not only something to be looked up in picture books—we have above all public discussion to thank for this, although the discussion was a primarily Berlin event. As paradoxical as it may sound, the government's move from West to East, of all things, brought the capital of the Federal Republic closer to Western European models where the architectural witnesses and spatial relationships of the various past epochs of supremacy have been confidently incorporated into the present.

Christine Hill, *Volksboutique*, 1997

Rem Koolhaas

The jury for the recent Potsdamer/Leipziger Platz competition was disturbing for three reasons that, together, raise issues about the future of Berlin important enough to voice in public.

First, the blatant domination of the jury by Mr. Stimmann, Senats Baudirektor (condoned by jury chairman Thomas Sieverts from Bonn), turned the jury deliberations into a mockery. Extremely explicit, vocal and indiscreet, calling projects "stupid," "unreal," "childish" etc., his impact was the equivalent of deciding a court case with the prosecutor as part of the jury; independent judgment was flouted, all too often in the name of the "typical" or even "normal" Berliner. The fact that "literature" is, in his mouth, one of the strongest expressions of disapproval, makes it pathetically clear that someone is put in charge of the future Berlin who sees the building of a new center in the most narrow, even naïve, professional terms, oblivious to all other issues that, together, have to coalesce to generate the necessary density of a real city.

Secondary, partly as a result of the above situation, projects that contained intelligent and speculative potential, were from the beginning eliminated in favor of projects that were deemed to be "more normal."

The elimination of Hans Kollhoff's projects represents a crude attempt to bury the issue of highrise alive, to abort the investigation of the potential benefits of concentration, to avoid a discussion on the meaning of "density."

The project by Daniel Libeskind—when taken literally—represented an absolutely impressive attempt to reimagine the idea of center, in spite of all the forces that have eroded the very concept.

The project by Will Alsop—much more refined than apparent at first sight—bristled with new but realistic typologies and proposed the most convincing solution to a fiendishly

The place is not a building site, but an abyss. Once, the pillars of the Third Reich's administrative machinery—the Court of Justice, the Chancellery, the *Führerbunker*, the Air Ministry, the SS and Gestapo headquarters, the Reich Security Bureau—were scattered within a radius of only a few hundred meters around Berlin's devastated Potsdamer Platz and Leipziger Platz. After that, the area was caught for twenty-eight years in the middle of the "death strip" between East and West Berlin. Today, it is to become the hub of two fragmented worlds, showing the internationally acceptable face of Germany. The task of burying political history here while retaining the urbanistic heritage and setting a signal for change in Berlin calls for sorcerers rather than architects. The ideal planner for this place would have to possess a blend of French pride, Dutch understatement, and American assertiveness.
Michael Mönninger, in *Frankfurter Allgemeine Zeitung*, October 5, 1991.

Rem Koolhaas will not take part in the architectural competition for Potsdamer Platz, neither as an architect nor as a juror. This summer, the Dutch architect from Rotterdam sat on the jury of the Berlin Senate's urban planning competition for the heart of Berlin. . . . Koolhaas subsequently voiced vehement criticism of the jury's work. He spoke of a "massacre of ideas," claiming that important designs had been ignored. Berlin's architectural and construction world was appalled at Koolhaas' open criticism and called for him to be "drummed out of town." When Daimler-Benz, in collaboration with the Berlin Senate, chose the architects and jurors for the architectural competition at Potsdamer Platz, Koolhaas, one of the client's favorites and a highly respected international planner, had to be struck off the list of invitees at the express request of the Berlin building authority. Banned as juror and as designer, Koolhaas has now been drummed out of town twice over.
Report in *Frankfurter Allgemeine Zeitung*, April 2, 1992.

Aesthetics and reality are strange bedfellows. The economy of the metropolis—all the leaps and bounds of an anachronistic Berlin—has created a state of paralyzing confusion. Fear of change in the workplace is expressed in a desire to be housed in conventional architecture. The Senate's construction and housing department as well as its urban planning and environmental departments appeal to Josef Paul Kleihues' concept of "critical reconstruction" to justify their decisions. Originally intended as an exemplary concept that would revitalize the neglected Friedrichstadt district in the shadow of the Wall, its aim was to sensitively renew the baroque street plans and buildings destroyed in the war and the immediate postwar years, not to painstakingly reconstruct them. . . . In the fall of 1991, the Senate building department adopted the concept that had worked for Friedrichstadt, but rapidly vulgarized it as an instrument of municipal administration. Critical reconstruction lost its adjective. The *carré* became dogma, the block was no longer interpreted but codified. The "old-new" concept was not initially intended to stand in the way of architectural diversity, but since the summer of 1993 an architectonic equivalent to "critical reconstruction" has taken form. It is called the *Steinernes Haus* (stone house) and it seeks to uphold the tradition of Prussian neoclassicism—in a word, the school of Schinkel.
Rudolf Stegers in *Die Zeit*, March 11, 1994.

Insisting on the exclusive prerogative of pure modern architecture is a refusal of the basic right to an urban habitat. In the *Principle of Hope*, one of the manifestos of the modernist project, Ernst Bloch called for architecture reflecting the spirit of the age as an architectural foretaste of a future home. According to Bloch, the functionalist buildings that expressed the spirit of an era in flux looked for all the world like packed suitcases. Bloch predicted that this apodictic hesitation on the verge of departure would provoke an equally irrational counterblast, turning buildings into bunkers.
Berlin has such bunkers now. Most of them, however, are not oriented toward the Nazi style, but toward the architecture

Berlin: the Massacre of Ideas—An open letter to the jury of Potsdamer Platz

complex context, finding a way to connect Friedrichstadt to Kulturforum without compromise.

On the whole, the schemes that remained in the competition share the same weakness. In exploring solutions within a more or less classical (i.e. nineteenth century) morphology, based on the "normal" perimeter city block, they provoke/announce an obvious conflict between program and typology. To fit the program—in this case implying a hypercenter of enormous density and complexity—traditional blocks are extended beyond the breaking point—ten to twelve stories is not classical—or the programs have to undergo "procrustean" operations leading, for instance, to a Daimler headquarters extended over five blocks in conditions of absurd unpleasantness.

Finally, what the competition makes abundantly clear is a cruel paradox: Berlin has become a capital at the exact moment that politically, ideologically, and artistically it is least able to assume this responsibility. The fate that is announced through this result and the brutal manner of its selection is an idea of the city that is *bürgerlich*, dated, reactionary, unrealistic, banal, provincial, and, most of all, amateurish: a terrible waste of a potential enterprise unique in twentieth-century Europe. What could be the culmination is doomed to become anticlimax.

As someone who always has had a special feeling for the potential greatness of this city, participation in this luddite episode—the deliberate massacre of intelligence, imagination, realism—was the most painful experience of my professional life.

That such self-destructive prejudice needs the pretense of an international competition, with foreign observers and all, can only be understood as ultimate arrogance, if not shamelessness.

From: open letter published in the *Frankfurter Allgemeine Zeitung*, October 16, 1991.

of 1930s Chicago or New York. Their retrospective approach is accompanied by the continuing fever of reconstruction, evoking Schinkel's Berlin and adorning it with citations that provide contemporary variations on "Prussian neoclassicism."
Dieter Bartetzko in *Frankfurter Allgemeine Zeitung*, January 25, 1996.

There are obvious grounds for the imminent failure of the "critical reconstruction" that has been reduced to little more than a ban on highrises in southern Friedrichstadt. It began with the failure of a policy that rapidly dismantled the existing small-scale structures under pressure from investors. Whereas the much-cited European city has emerged in the course of the centuries through a confusion of unclear and piecemeal proprietorship, the very opposite applies to the wastelands of Berlin. Against all better judgment, the sites at the heart of the capital were sold off in large blocks. . . . In the end, howev-

er, it is the standardized taste of real-estate speculators and developers that dictates the architectural design. It is not for nothing that the architects involved in the Mercedes-Benz project at Potsdamer Platz are obliged to present the layout of each and every apartment for approval to the estate agents charged with renting them. The resulting architecture is nothing more than money turned to stone and glass on the drawing board.
Heinrich Wefing in *Frankfurter Allgemeine Zeitung*, September 23, 1996.

In many respects, the "Berlin city center project" represents a caesura. It is an attempt to form an entity out of the planning chaos of competition zones, construction plans, district development plans, and building projects. The centers of East and West Berlin have been developed together. In both East and West, the major traffic thoroughfares are to be replaced by city center traffic. The problem is that West Berlin still has its turn-of-the-century

structures, while in East Berlin the historic street plan has to be reconstructed. In both cases, it is a question of re-establishing a sense of urban density in inner city borderline areas. Moreover, there is a housing policy interest in reversing the increasing trend towards leaving the inner city. . . . The principles that apply here should be reconstruction instead of demolition, and compromising with historical structures rather than eliminating modernism.
Klaus Hartung in *Die Zeit*, November 29, 1996.

Town planners are not eager to look back on the scribbles they produced in the past. Plans are glibly sketched for the decades to come, even though all the designs of 1960 are long outdated now. Instead of working through patiently, street by street, their longing to create a *Gesamtkunstwerk* wins the day. With advice from the urban historian Dieter Hoffmann-Axthelm, secretary of state for urban de-

velopment Stimmann now proposes for all Berlin what he already attained at the IBA architecture exhibition and in Friedrichstadt—street blocks, closed gaps, narrower streets. In short, he wants to stitch together the urban fabric, adding to its warp and weft while retaining the traditional motif. Accordingly, the masterplan has no need for any major new layout. Instead, it pulls long-forgotten historical groundplans out of the top hat of architectural history, marshaling straight-line baroque against all other eras. On the blueprint there is scant trace of modernism, especially in the form of GDR urban planning.

Nowhere in Germany has architectural modernism so obviously lost the last vestiges of respect as in Berlin, the cradle of the modern movement. What began as a socially conscious battle against substandard living quarters in dark, dank backyard tenements and damp basements, culminated in the reality of prefabricated mass housing devoid of proportion and form, from Marzahn to the Märkisches district. The dream of a spacious, green urban landscape that inspired generations of architects has turned into the nightmare of the motorist-friendly housing project—and the voice of protest that railed so passionately against the inhumanity of Wilhelmine Berlin has grown uneasy in the inhospitable modern city.
Heinrich Wefing in *Frankfurter Allgemeine Zeitung*, December 18, 1996.

YANA MILEV

DIE GRENZE IST EIN IMPLANTAT EINE KÜNSTLICHE UNTERBRECHUNG DER SCHÖPFUNG

DIE GRENZE IST EINE ÖFFNUNG EINE SICH ENTFALTENDE AUSDEHNUNG DES ZWEIFELS

A.O.B.B.M.E.
RESEARCH <- URBAN -> INTERVENTION

Diskursive Verhältnisgleichung

EXPEDITIONEN - EXKURSIONEN, Berlin 1996/97

Projektionsforum mit Material aus -Kinetisches Archiv-

YANA MILEV

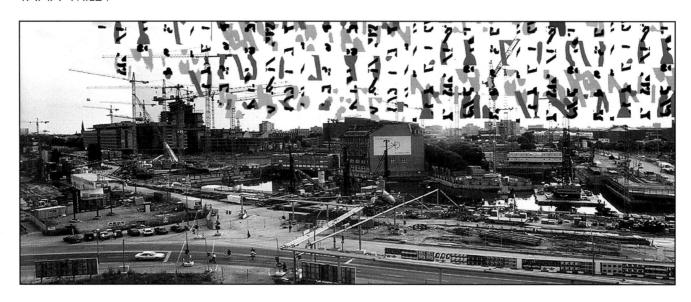

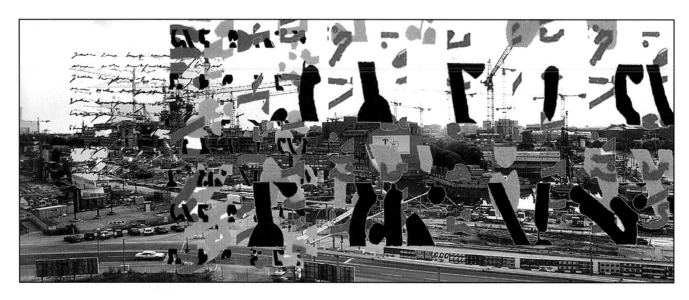

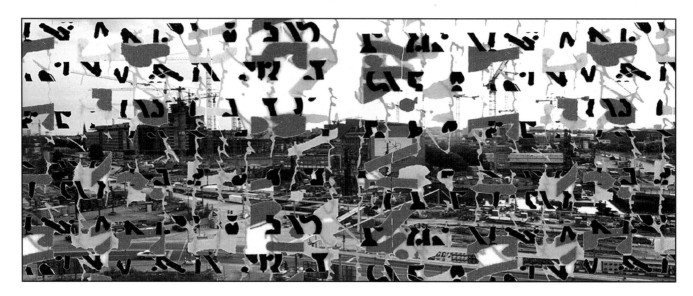

A.O.B.B.M.E.
RESEARCH <- URBAN -> INTERVENTION

Skulptur des Übergangs

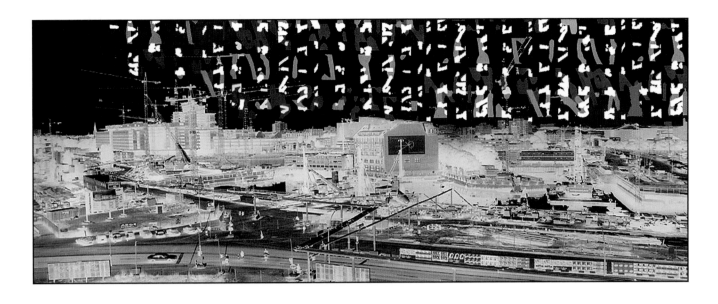

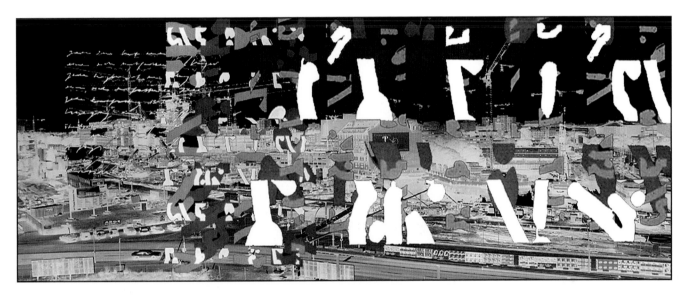

EXPEDITIONEN - EXKURSIONEN, Berlin 1996

Entwurf Potsdamer Platz

Stan Douglas

Contemporary, set for *Der Sandmann*, DOKFILM Studios, Potsdam, Babelsberg, 1994

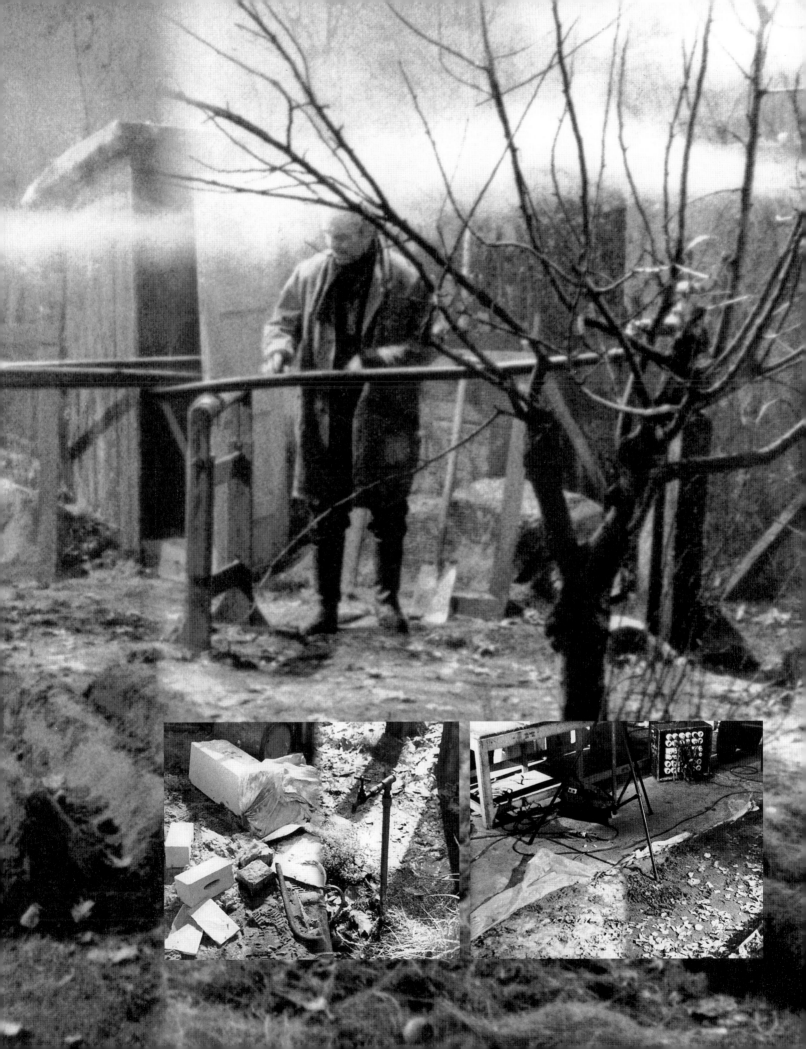

ISTANBUL

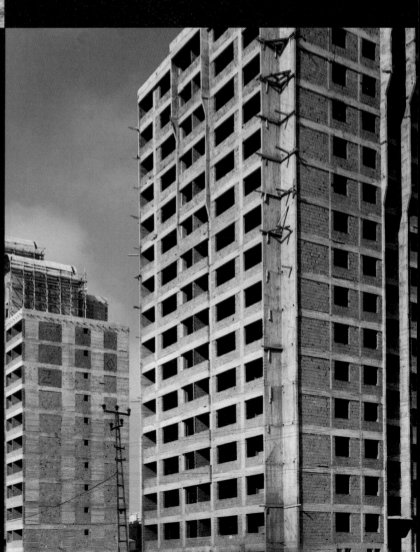

WIEN

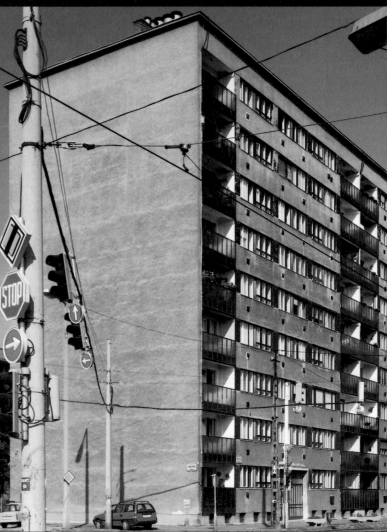

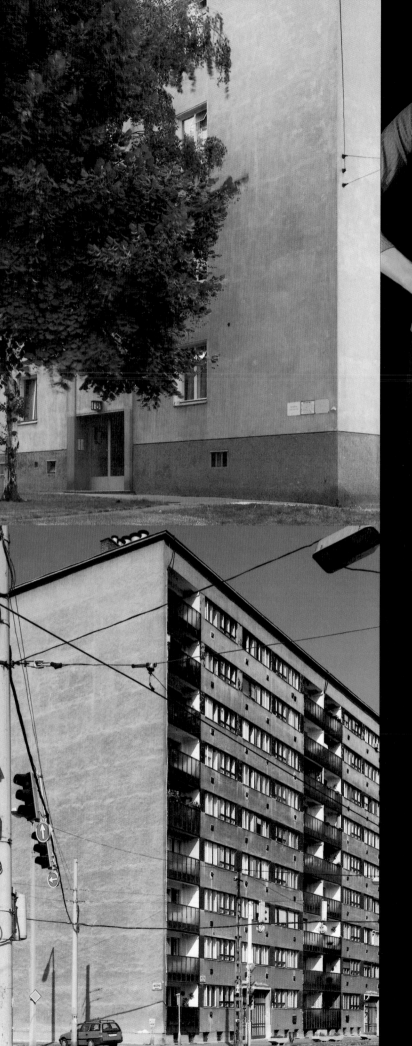

BUDAPEST

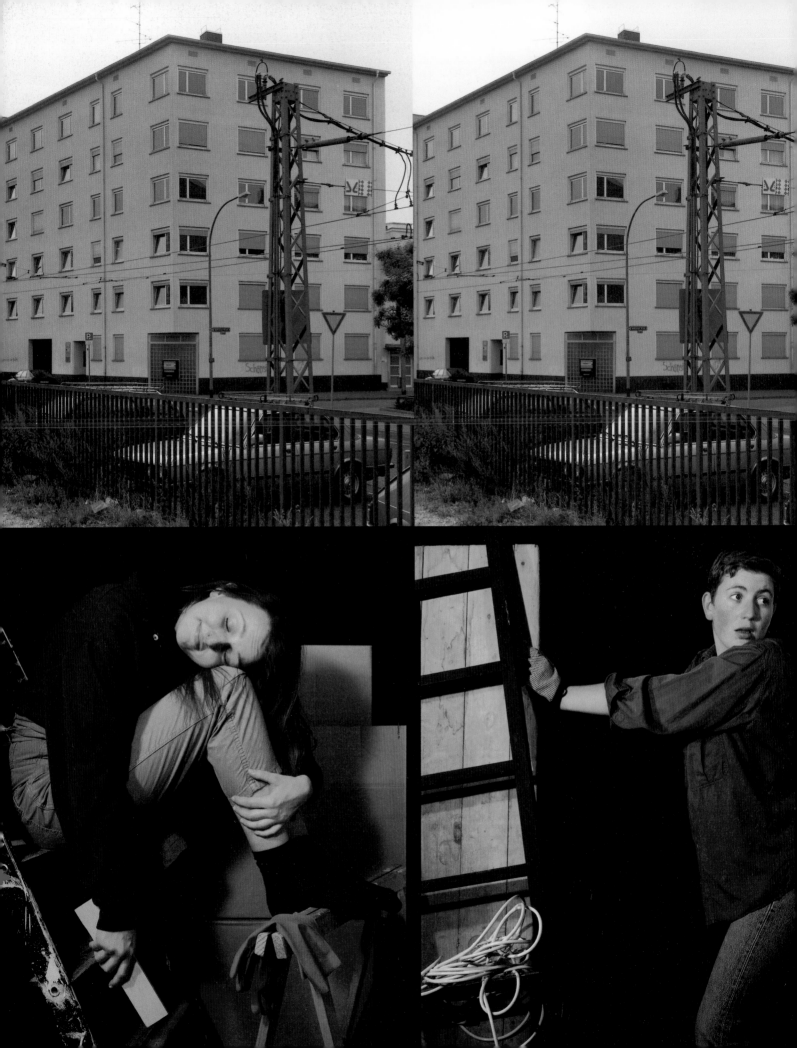

FRANKFURT

Peter Noller, Klaus Ronneberger

The economic and social reality of the metropolises is presently undergoing fundamental changes. Although the restructuring process is quite different from place to place, several common developments can be ascertained. On the one hand a network of global cities has evolved, from which worldwide production processes and capital circulation are directed and controlled. The requirements of the finance industry complex and the international business class now determine central areas of these cities. On the other hand, the metropolises of the highly industrialized countries no longer represent the centers of employment growth. On the contrary, the crisis of the industrial sector and the shift of production and service functions to the periphery has led to greater sociospatial polarization within the large cities.

The Headquarter Economy

The globalization of the economy not only contributes to a diffusion of economic activities but also intensifies the centralization tendencies of control and management functions and their concentration in the metropolises. The global networks of the transnational corporations and the banking consortia connect these cities with one another as though they had no borders. Global cities

Metropolis and Backcountry

function not only as the management centers of the world economy but also as marketplaces and production sites for the business-oriented finance and service trade (Sassen 1996). Individual cities exhibit differing concentrations of service enterprises, depending on their specific function within the international division of labor and the global or national markets. Thus the 1980s saw the development of a hierarchy of metropolises integrated in the international system in different ways. Presently at the peak are New York, London, and Tokyo. In Europe the next lower rung is occupied by Paris and Milan, followed by Amsterdam, Zurich, and Frankfurt with the Rhine-Main region (Noller and Ronneberger 1995). Frankfurt's skyline presents only one form of cen-

ing increasingly to the urban periphery where new, strategically placed crossroads of the headquarter economy and the high-tech industries are emerging. Whereas for example the global-city functions of New York are carried out primarily in the central business districts of the city center, Frankfurt-Rhine-Main exhibits a scattering of these functions over a wide region, which as a whole is structured as a "center" itself (Sassen 1995).

Intermetropolitan Competition

The position of each respective global city can be interpreted not only as an expression of functional division of

The Formation of the Rhine-Main Region in the 1990s

trality. The core city's growth spurts are triggering increased economic development in the peripheral communities. Contrary to the assumption that the service sector is concentrated in the city centers, the areas surrounding the large cities profited most of all from the tertiarization process of the 1980s. In metropolises like Frankfurt, the driving forces of the economy are spread-

Half-timbered house in a northern district of Frankfurt

~ice center in
~-Isenburg,
~h of Frankfurt

labor but also as the result of hierarchical power relationships. Transnational corporations place new kinds of demands on the sites they occupy, leading to increasing rivalry between the metropolises competing for growth potentials and the effects of prosperity. Key words of management philosophy such as "flexibilization" and "deregulation" now also determine local political activities. This applies not only to outwardly oriented site strategies but also to inwardly oriented reorganization. On the one hand, the cities are attempting to strengthen their positions with regard to the international division of labor by promoting high-tech industry. On the other hand, they are competing to provide sites for corporation headquarters and central offices of the financial industry as well as high-ranking governmental and administrative offices. And finally, the cities are anxious to improve their positions by attracting higher-income consumer groups. In the process the "urban lifestyle," represented by sumptuous shopping environments, has become an important object of capital investment. Competition for investment and buying power potential is leading municipal management to undertake costly projects to change existing spatial structures. Transportation and communication networks must be enhanced and the unrestrained expansion of office space guaranteed. These measures must be accompanied by the structural improvement of urban districts, the reutilization of space left barren by outmoded industries, and festivalization projects such as trade

shows or world fairs (Harvey 1985). At the same time, the economic policy activities of local administrations are accompanied by the reduction of public services and the promotion of market-oriented consumption patterns. In view of the massive decline of industrial employment, the decrease of trade taxes and growing social expenditures, these efforts are presently being accelerated.

Postmodern Image Strategies

Increased competition between cities is accompanied by the growing importance of image strategies. Large cities have always been favored objects of mythogenesis, constant sources of fictions and narratives. City planning, political concepts and popular depictions contribute to the characterization of urban space and the generation or enhancement of the local self-image. Pictures, stories, and visions constitute urbanity as an imaginary object, thus holding the fragmented space together. These ideologies or—to use the terminology of Roland Barthes—"myths of urbanity" present an image of the city as a coherent unit, synthesizing the diverse practices of the individuals and the collective, while at the same time forming them.

The myth of the "service metropolis" has fulfilled this function during the past decades. It unifies the upheaval of production and consumption forms in the image of the "post-industrial city." Many towns endeavor to present themselves as tertiary and consumer environments while playing down the importance of industrial production. The "white-collar economy" is regarded as a guarantor for prosperity and for the increase of well-trained, high-income employees. The decline of local industry and the expansion of the finance industry complex in the metropolises has coincided with the development of a "quartary" sector (Prigge 1995), combining services, new technologies, and cultural production—now a significant economic factor. The growth of the "symbolic economy" (Zukin 1995) in the areas of finance, the media, and entertainment leads urban management to invest in the expansion of cultural consumption and the culture-related industry. According to Christine Boyer (1995) the image strategy of postmodern urbanization operates above all through two seemingly contradictory elements: the emphasis on diversity (in comparison with other cities) and the guarantee of spatial homogeneity. The highly developed urban archipelagos—office high-rises, department stores, recreation centers, waterfronts—are intended to provide evidence of an unmistakable character and an attractive urban lifestyle. Yet at the same time these places are themselves becoming increasingly interchangeable, constructed as they are to correspond to ever-more-unified standards of luxury and recreation. The artificial space of these "self-enclosed places" (Christine Boyer) separates itself from its immediate surroundings, deriving its function from its respective position in the global economy and obtaining its symbolic value from its highly valued architectural design. The spaces between the archipelagos—such as the barren sites of formerly thriving industries or the residential districts of the subordinate classes—are neglected or left completely on their own. The "service city" provides urban space as an exclusive offer: individual products or shopping spaces vouch for the quality of the whole. The myth of postindustrialism is supposed to sprout from within the luxury consumption grounds and spread across the entire city. In contrast, according to Boyer, the myth of the industrial city was crystallized in the metaphor of the machine. The city was imagined as a well-functioning mechanical unit—like a factory with well-oiled machinery. Because the industrial infrastructure required the urban space in its entirety, the various disciplines of city planning strove to create a homogeneous space, unified in spite of functional divisions (working space, living space, traffic). With the flexibilization of the economy and the decentralizing effects of communications technology, this homogeneous space has increasingly become an obstacle to the fast-moving streams of capital and information. The new network of privileged centers spreads itself out over the old spatial structures of the industrial city, tearing up their large-scale spatial context (Banik-Schweitzer and Kohoutek 1996).

Sociospatial Heterogenization

In the large cities the development of the headquarter economy is leading to the dualization and segmentation of the labor market into a high-qualification sector and a low-wage area. The economic restructuring of these cities produces both an increase in the high-income class of professional service providers connected with control and management functions and—in a parallel development—poorly paid jobs in the lower levels of production

and services. The finance industry complex also requires maintenance mechanics, truck drivers, security services, cleaning crews, pizza sellers, etc. These developments cause growing "social polarization" or "dualization" with regard to property ownership and income within the urban population. It must be added that the present state of sociospatial polarization in the Federal Republic of Germany is in no way comparable to the social segregation in the USA. The German cities still have at their disposal a much more comprehensive state-controlled social security system; for several years, however, the dismantling of this system has been a major issue.

At the same time, the expansion of the headquarter economy intensifies the hierarchization of urban space. Banks, insurance funds, and transnational corporations put part of their surplus capital in globally scattered real estate and use property markets as pure investment opportunities (Ronneberger and Keil 1995). The value of this speculatively exploited real estate is measured more by global than by regional standards, leading in part to the characterization of the metropolitan centers by a monostructure of international store chains and boutiques. The city cores are made into consumer and cultural recreation spaces encompassing shopping opportunites, restaurants and museums, public art exhibitions, theater performances, and street festivals.

In the metropolises a new type of space is becoming common, described in Anglo-American terminology as "public-private liminal space." This term refers to places like malls or adventure parks where commercial and non-commercial activities overlap. These archipelagos of controlled adventure attempt to create the atmosphere and image of a traditional town square, generally equated with communication, the public sphere, and excitement. These sites bear witness to the dominance of the market over places and to a disavowal of the separation between private and public space.

At least in the USA, the classic public spaces—streets, squares, and parks—are being replaced by malls, shopping centers and theme parks. In reality these are "fortified cities," built primarily for middle-class suburbanites looking to escape the "dangers of the city." The theme parks and malls produce a kind of public sphere based on the myth of the ideal, intact small town: no violence, no homeless, no drugs (Ronneberger 1996).

Visual coherence, spatial control, and private management cause these theme parks and malls to appear as ideal expressions of a new type of public space, corresponding to the middle-class dream of a "clean adventure world." This urbanization model aims not only at a form of exclusion by means of money. Safe consumer

Service center in Neu-Isenburg, south of Frankfurt

archipelagos also function increasingly as models for urban development as a whole. The municipal authorities are ever more willing to organize public space in the manner typical of theme parks and malls. And because new urban poverty contradicts the idea of a relaxed consumption atmosphere, various sub-milieus are to be expelled from these spaces. The managers of department and chain stores in the city centers strive to adapt their environments to the suburban mall model whose success is based on the guarantee of safe consumption. The profitable utilization of real estate and the increase in merchandise turnover is now seen in direct relationship to safety and order. In this way central urban areas come under private economic control, which also encompasses supervision by private security services (Voß 1993).

Polarization Between the Core City and the Surrounding Countryside

Even if European cities have not yet undergone dualization to the extent experienced by American cityscapes, the relationships between the core cities and the sur-

rounding countryside are also becoming increasingly polarized. Present developments in the Rhine-Main region provide a good illustration of this process. Since the 1980s, Frankfurt has witnessed the supplanting of existing industrial and commercial sites through the sustained tertiarization process and the dominance of the globally oriented finance industry. The local labor market is polarizing appreciably, due both to the decline of production activity and to the specific requirements of the headquarter economy. In fact, Frankfurt is among the German cities with the greatest decline of low-skilled employment. According to the statistical average, employees living and working in Frankfurt earn below average, and are professionally less mobile and less qualified than the population of the surrounding communities, while bearing a higher labor market risk. The city registers the second highest unemployment rate in the region and, along with Offenbach and Wiesbaden, the largest proportion of welfare recipients (Bartelheimer 1995). The development of Frankfurt into an international finance and service metropolis and the downfall of the industrial sector has a particularly negative effect on the living conditions of the migrants. On the one hand, these groups of the population are hit particularly hard by the crisis in the industrial sector; on the other hand, they profit little from the expansion of the service economy. On the whole it can be maintained that the core city not only represents the most important employment market for the region but is also under pressure to achieve more than the surrounding countryside in terms of social integration.

The development of global-city functions creates a double peripherization process in the city center. As the middle classes and certain economic activities withdraw to the suburban periphery, the core city increasingly becomes "contested territory" (Sassen 1996, 165) for the people who do the dirty work within the service system and are therefore just as much a structural element of the citadel economy as the finance industry. Thus the terms "center" and "periphery" do not refer to geographical but to social circumstances, which are territorialized on the basis of the property market economy and the dominance of certain consumer groups. While "problem neighborhoods" emerge in certain inner-city areas, prosperous communities develop all around the periphery.

It should be added, however, that even the countryside surrounding Frankfurt is undergoing increased social polarization. Following the substantial increase of poverty within both the German and non-German population of Frankfurt during the 1980s, there is presently an acceleration of sociospatial polarization in the surrounding region. Today migration and poverty are growing at a faster rate in the rural counties than in the cities (Barthelheimer 1995).

Thus, in general, several simultaneous developments are discernible in the Rhine-Main area: punctual centralization of the region and peripherization of parts of the inner cities; increased social hierarchization within the core cities and polarization between the center and the periphery; growing marginalization of migrants; devaluation of the industrial labor culture; and finally, rapidly growing poverty in the communities of the surrounding countryside.

Regional Identity?

The dynamics of the present urbanization process also lead to the dissolution of the various contexts of everyday life. The perceptions and activities of agglomeration inhabitants have less and less to do with the traditional categories of urban space—"quarter" or "city." The process of sociocultural fragmentation is further reinforced by the patchwork of existing political-territorial structures. Expansive urban regions have come to encompass a large number of communities and even transcend interstate borders. This development provides a wide range of opportunities for territorial exclusion and formation strategies (Ronneberger and Schmid 1995). The administratively fragmented structure of the Rhine-Main market area is regarded by many economic and political entities to be a decisive obstacle in the competitive struggle with other European market areas. For this reason the issue of metropolization of the entire area is rapidly gaining significance.

The global restructuring of Frankfurt-Rhine-Main expresses itself above all as a discourse of regionalization. This discourse corresponds to the present urban development: the metropolization of the surrounding countryside, characterized by a reversal of the roles of center and periphery, i.e., the affluent outer ring on the one hand and the peripherization tendencies of the center on the other. Following a decade of concentration on

the global restructuring of Frankfurt's "urbanity," the current discourses of urban development are now addressing the problems of the city's absorption into the region.

In this context the creation of a regional consciousness is regarded as an important means of overcoming local particularism and thereby guaranteeing the further development of the market area. With the aid of symbolic acts, planning activities (e.g., the regional park) and a corporate identity policy, the Rhine-Main area is to be presented outwardly as a self-contained unit. Large-scale advertising campaigns repeatedly conjure up the image of the ever-more-coherent "people's region."

These endeavors are neutralized, however, by the region's polycentric structure. The diverse histories of the landscapes and cities, the lack of a common past—possessed, for example, by the Ruhr area with its specific industrial history—has hindered the development of an overall regional identity in the Rhine-Main area.

At the same time efforts have been undertaken to make strategic planning on the regional level more efficient. In the light of heightened global competition between regions, there is a tendency to link the necessary improvement of local cooperation with technocratic centralism and to dispose of small-scale decision-making structures (Ronneberger and Keil 1995). On the other hand, in view of diminishing resources many rural communities around Frankfurt insist upon the communal principle of independence and reject the comprehensive restructuring of the Rhine-Main region. Apparently the metropolization-oriented strategy of unification and the modernization of administrative structures raises doubts about the existing power balances and produces new conflicts. While the finely meshed economic network is familiar to all the parties involved, the attempt to tune the local population to a common regional identity quite obviously contradicts existing political and sociocultural realities. The postulate of a feeling of community, fabricated by the chambers of industry and trade, planners, etc. and projected onto the region, is therefore doomed to failure. The arguments of inefficiency and redundancy of offers are countered by the communities surrounding Frankfurt with the claim of polycentrism as the region's most fundamental strength. Indeed, the regionalization concepts can be understood as a campaign against the towns' communal autonomy.

Spatial Inequality

The discourse of economically advantageous location is linked with the cultural formation of regional identity. This position represents the "we" of the region—in competition with other European cities. To increase the attractiveness of the location the region must be unified. This is the focus of concepts for administrative reform originating in the jungle of party politics. Among the recurring topics of discussion are models for the structural reform of existing institutions as well as concepts for the foundation of new institutions to carry out regional planning and administration. Administration is to be rationalized and flexibilized in order to improve the coordination of planning, development, and the integration of resources in the economic, Frankfurt-based trend towards the "metropolization of the region."

The two positions—that of location and that of regional identity—are complementary and dominate the discourse of the region. They focus on the economic globalization and cultural unification of the market area: cen-

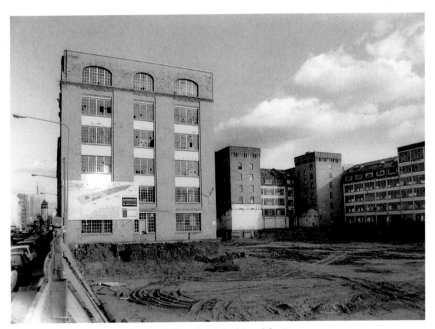

The former Adler factory in the Gallus district of Frankfurt

trality, effectivity, and identity are the points of departure for the regionalization of the urban development process. Within the framework of site-related competition, "the metropolis" becomes the spatial category with which the region is to be fabricated from above (Prigge and Ronneberger 1995).

These concepts are countered by the discourses of regional populism. They are locally oriented against the center—Frankfurt—according to the motto "not in my back yard." In the intraregional competition for the prosperity effects of globalization, they defend the communal principle of autonomy against the demand for regional regulation and Frankfurt's hegemonic position. The "suburbanites" exhibit little tolerance for the idea of cofinancing the core city, even though a share of the costs is brought about by the periphery's use of the center. With regard to communal financial adjustment to the benefit of Frankfurt, the primary response is, "No, thank you," based on the point of view that Frankfurt has been living beyond its means during the past years and now has to find its own solution for its own financial problems. "No, thank you" to drug users, the homeless, and welfare recipients, whom the municipal administration is trying to force out of Frankfurt. "No, thank you" to social housing developments, which Frankfurt would like to finance in communities outside city limits while reserving the right to place tenants there: for that would mean exporting the social "underclass," and would change the social composition of the respective communities.

A large proportion of the "suburbanites" profit professionally and materially from the economic power of the region's core city and have contributed a great deal to the urbanization of the "backcountry." Nevertheless, the periphery is where movements emerge which are critical of growth, particularly when the social and ecological problems of the metropolis threaten the local quality of life. These forms of protest can be understood primarily as expressions of the growing capacity of certain social milieus for self-organization. A wide spectrum of groups has learned to exert pressure in order to influence the distribution of resources or gain recognition for their specific lifestyles. Today, however, in contrast to the social movements of the 1970s, the focus is on securing one's own social status quo. In an interplay between territorial delimitation and the erosion of the idea of solidarity, a form of particularism has come to dominate, characterized by processes of exclusion and reinforcing the imbalances between the various areas. At the same time, resistance against the bureaucratic central government has evolved into a populist movement which attempts to satisfy the demands of individual social groups by creating disparities.

The globalization of Frankfurt exacts its sociospatial tribute, which is now to be regionalized. The populist discourses of the surrounding communities criticize the hegemony of the center: in the struggle for the prosperity of globalization, the growing self-confidence of the increasingly wealthy communities outside Frankfurt has come to express itself as socioeconomic localism. The big city is no longer draining the region. Instead, the surrounding communities which have the increasingly frequent relocation of various industries to thank for their affluence are trying to protect that affluence from the big city's problems.

In view of the polarizations in the regional discourse, regional compensation for socioeconomic problems appears largely improbable: the intertwinement of city and region finds no expression, regional solidarity no articulation.

Works Cited

Banik-Schweitzer, Renate and Kohoutek, Rudolf: *News Letter* 7, special issue "Öffentlicher Raum," Vienna, 1996.

Bartelheimer, Peter: *Frankfurter Sozialberichterstattung: Muster sozialräumlicher Polarisierung*, interim report, 1995. Frankfurt/Main.

Boyer, Christine: "The Great Frame-Up: Fantastic Appearances in Contemporary Spatial Politics," in *Spatial Practices*, ed. Helen Liggett and David C. Perry (London and New Delhi: Thousand Oaks, 1995).

Harvey, David: *The Urban Experience* (Baltimore, 1985).

Hoffmann-Axthelm, Dieter: *Anleitung zum Stadtumbau* (Frankfurt/Main and New York, 1996).

Noller, Peter and Ronneberger, Klaus: *Die neue Dienstleistungsstadt: Berufsmilieus in Frankfurt am Main* (Frankfurt and New York, 1995).

Prigge, Walter: "Urbi et orbi: Zur Epistemologie des Städtischen," in *Capitales Fatales*, ed. Hansruedi Hitz et al. (Zurich, 1995).

Prigge, Walter and Ronneberger, Klaus: "Globalisierung und Regionalisierung: Zur Auflösung Frankfurts in die Region," in *Stadt-Region*, ed. Detlef Ipsen (Frankfurt/Main, 1995).

Ronneberger, Klaus: "Die neue Stadt: Profitable Immobilienverwertung, Umsatzsteigerung, Sicherheit und Ordnung," in *Centrum: Jahrbuch Architektur und Stadt 1996*, ed. Peter Neitzke et al. (Braunschweig/Wiesbaden, 1996).

Ronneberger, Klaus and Keil, Roger: "Ausser Atem: Frankfurt nach der Postmoderne," in *Capitales Fatales*, ed. Hansruedi Hitz et al. (Zurich, 1995).

Ronneberger, Klaus and Schmid, Christian: "Globalisierung und Metropolenpolitik: Überlegungen zum Urbanisierungsprozeß der neunziger Jahre," ibid.

Sassen, Saskia: "Global City: Hierarchie, Massstab, Zentrum," ibid. —*Metropolen des Weltmarktes: Die neue Rolle der Global Cities*, (Frankfurt/New York, 1996).

Schmid, Christian: "Urbane Region und Territorialverhältnis: Zur Regulation des Urbanisierungsprozesses," in *Unternehmen Globus*, ed. Michael Bruch and Hans-Peter Krebs (Münster, 1996).

Voß, Michael: "Privatisierung öffentlicher Sicherheit," in *Strafrecht, soziale Kontrolle, soziale Disziplinierung*, ed. Detlev Frehsee et al. (Opladen, 1993).

Zukin, Sharon: *The Cultures of Cities* (Cambridge/Oxford, 1995).

The Messe Tower in Frankfurt

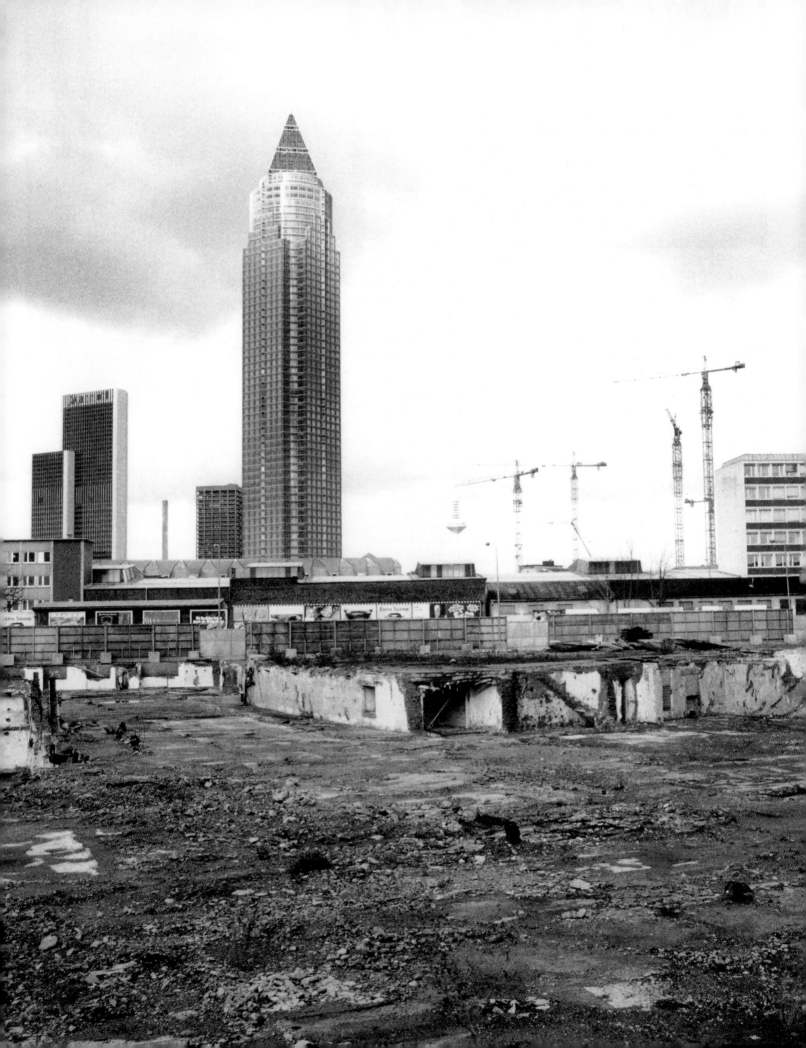

Installation, Prospekt 96, Schirn Kunsthalle Frankfurt 1996

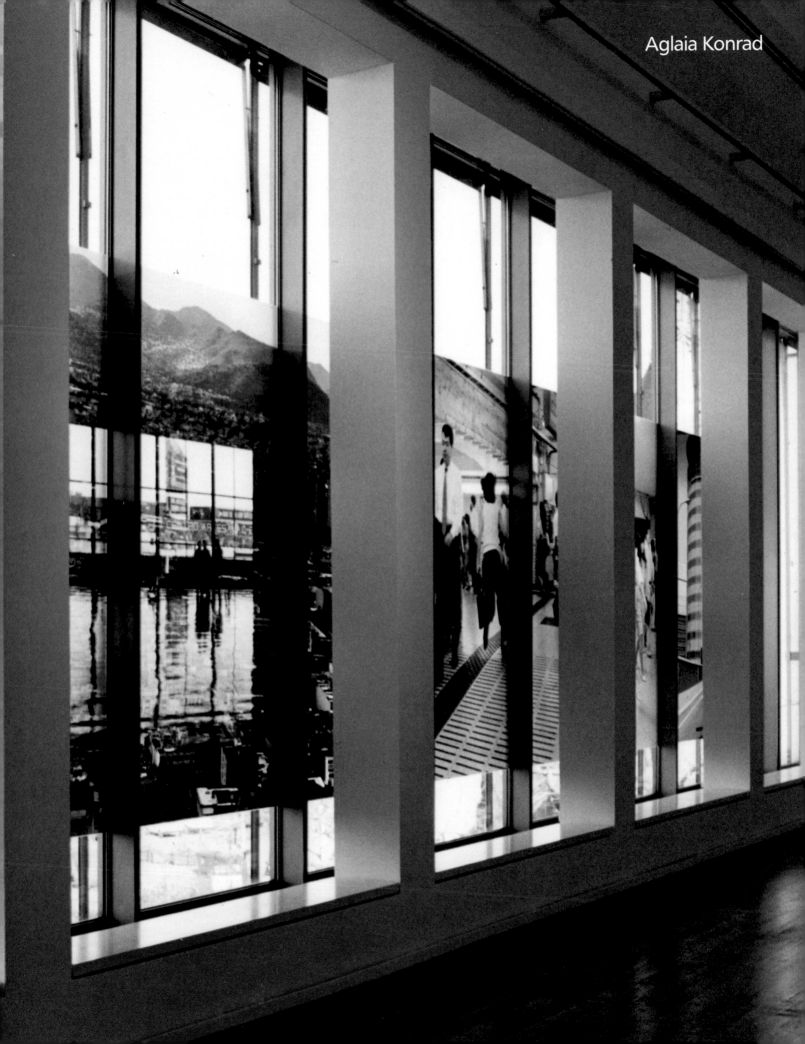

Aglaia Konrad

Projet du Grand Stade, Plaine Saint-Denis

In 1998 the World's Cup soccer match will be held in France. The "Grand Stade de France" is under construction in Saint-Denis at the north-eastern edge of the capital, amid a 7,000 hectare plain. The plain, a highly industrialized area from the beginning of this century (metallurgy, hydrocarbons), has lost its substance, the industries have fled along with the jobs. Only those who had no other choice remained. The landscape is dotted with the jobs. Only those who had no other choice remained. The landscape is dotted with industrial wastelands. On one of them , "Le Cornillon," where the stadium is being built, lived a small community of socalled homeless people. Some had been there for thirteen years. For almost all of them this was no temporary measure; they had settled in. A decision had been taken. Huts were constructed, life was organized alone or with others, a dignified life of one's own, every day. For over two years, from the official announcement of the construction of the stadium on November 3, 1993, to the final expulsion in May, 1995, through the cycle of the seasons, on the terrain, I undertook a patient photographic work in which I mingled my own intimacy with that of the territory and with the intimate life that had succeeded in constructing this precarious community.

Standortkultur, **1997**
(Corporate Culture)
Hans Haacke

Poster, 138 x 69 inch (350 x 175 cm)

At opening of documenta X, on poster columns of Deutsche Städte-Reklame (German agency administering outdoor advertising surfaces) in Berlin, Bonn, Bremen, Dresden, Düsseldorf, Frankfurt/Main, Hamburg, Hannover, Kassel, Leipzig, Vienna, Zurich; in Kassel also surfaces of Deutsche Bahn (German railroad).

Computer-assistance: Dennis Thomas

Translation of German poster texts:
Sponsoring Culture / tax-deductible

Sponsoring is used purposefully as part of image and good-will promotion.
Hans J. Baumgart (Daimler-Benz). „Daimler-Benz," *Corporate Collecting and Corporate Sponsoring.* Edited by Christoph Graf Douglas. Regensburg: Lindinger + Schmid 1994, p. 60.

It lends itself to reaching target groups which are resistant to traditional advertising.
Hagen Gmelin (Head office, Deutsche Bundespost/Telekom). Interview, *Kunstsponsoring: Situation und Perspektiven. Eine art Studie.* Hamburg: artDas Kunstmagazin, October 1994, p. 108.

We are not patrons. We want something for the money we spend. And we are getting it.
Peter Littmann, (President, Hugo Boss). "Warum lohnt es sich, Kunst zu sponsern, Herr Littmann?" Interview by Michael Freitag with Peter Littmann. *Frankfurter Allgemeine Zeitung / Magazin* (February 23, 1996), p. 51.

These programs build enough acceptance to allow us to get tough on substantive issues.
Raymond D'Argenio (Manager Public Relations, Mobil Oil) "Farewell to the Low Profile." Paper read at Eastern Annual Conference of the American Association of Advertising Agencies. New York. November 18, 1975. Typewritten manuscript, p. 3.

These can often provide a creative and cost effective answer to specific marketing objectives, particularly where international, governmental and consumer relations may be a fundamental concern.
Metropolitan Museum of Art, New York: *The Business of Art knows the Art of Good Business.* Leaflet. published in the mid-1980s.

It is a tool for the seduction of public opinion.
Alain-Dominique Perrin, (President, Cartier). "Le Mécénat français: La fin d'un préjugé." Interview by Sandra d'Aboville with Alain-Dominique Perrin. *Galeries Magazine,* Vol. 15, (October/November 1986). p. 74.

It's an inherent, insidious, hidden form of censorship.
Philippe de Montebello (Director, Metropolitan Museum, New York). "A Word from our Sponsor." *Newsweek* (November 25, 1985), p. 98.

Whoever pays controls.
Hilmar Kopper (President Deutsche Bank). "Die Kultur und das Kapital." *Süddeutsche Zeitung* (May 18, 1995), p. 13.

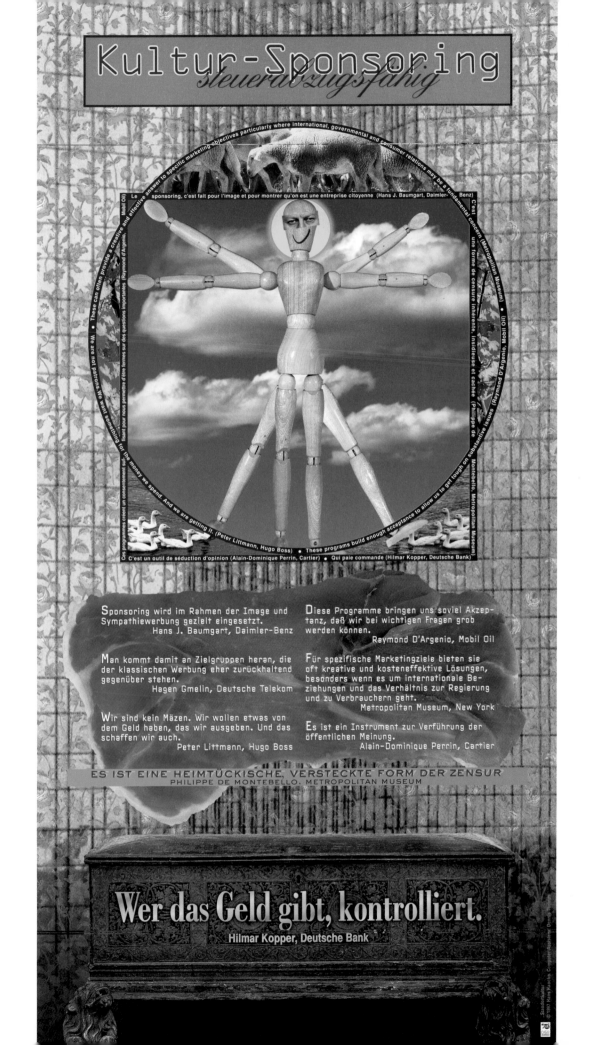

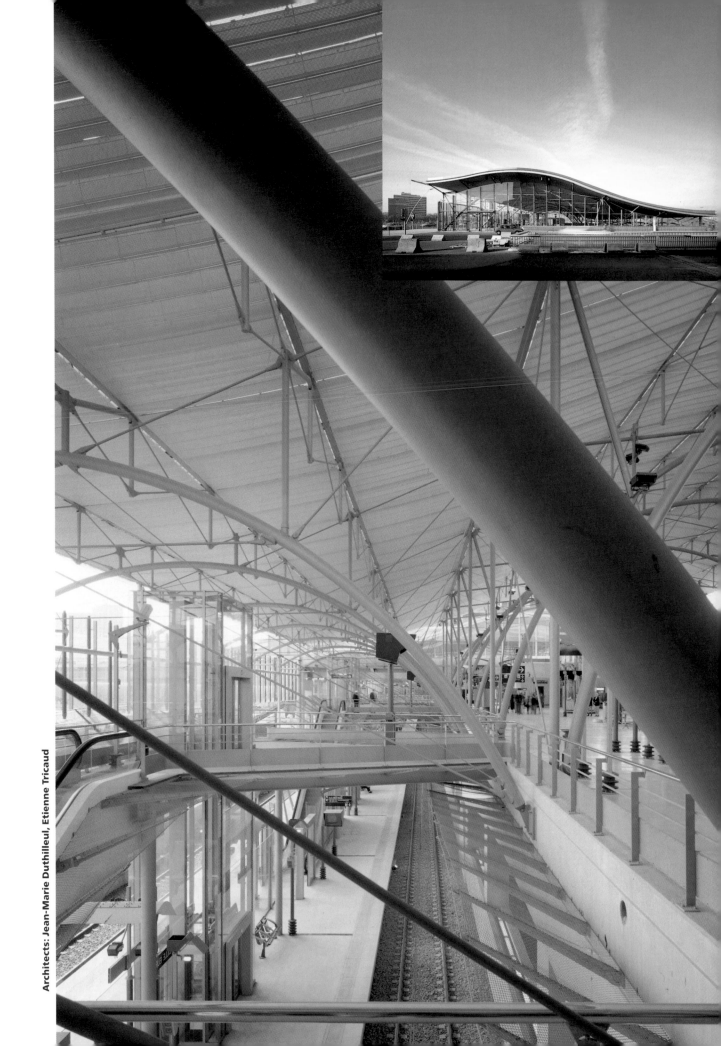

Architects: Jean-Marie Duthilleul, Etienne Tricaud

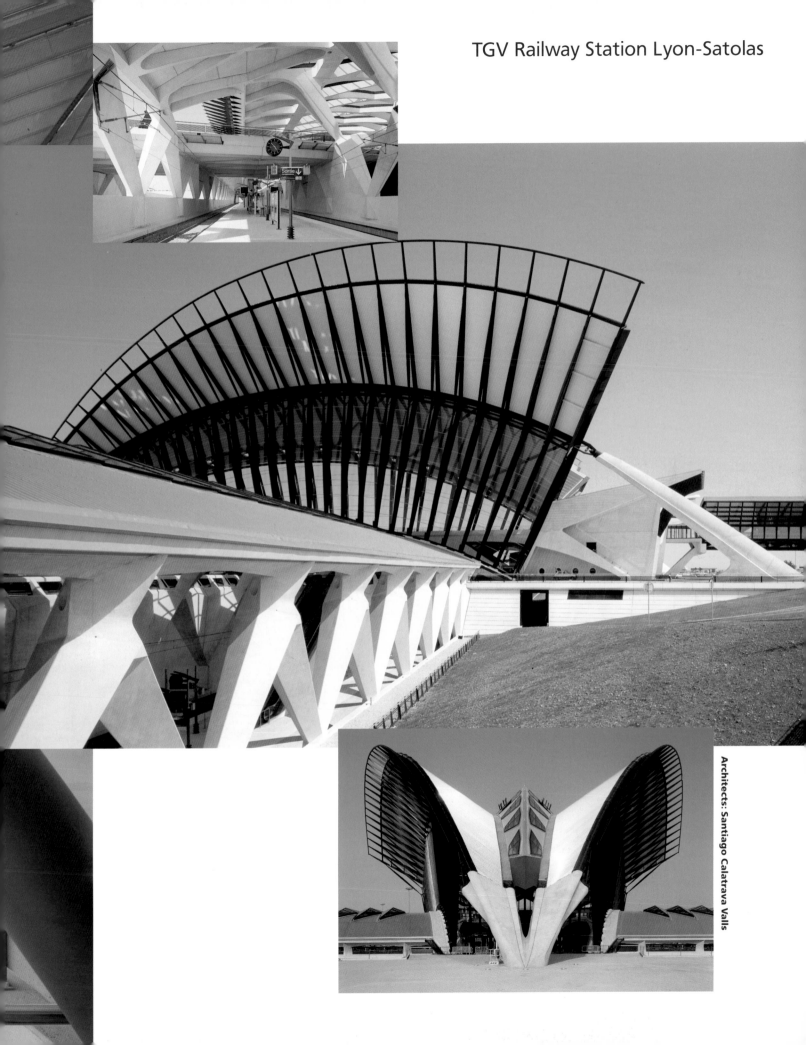

TGV Railway Station Lyon-Satolas

Architects: Santiago Calatrava Valls

Waterloo International Station London

Architect: Nicholas Grimshaw

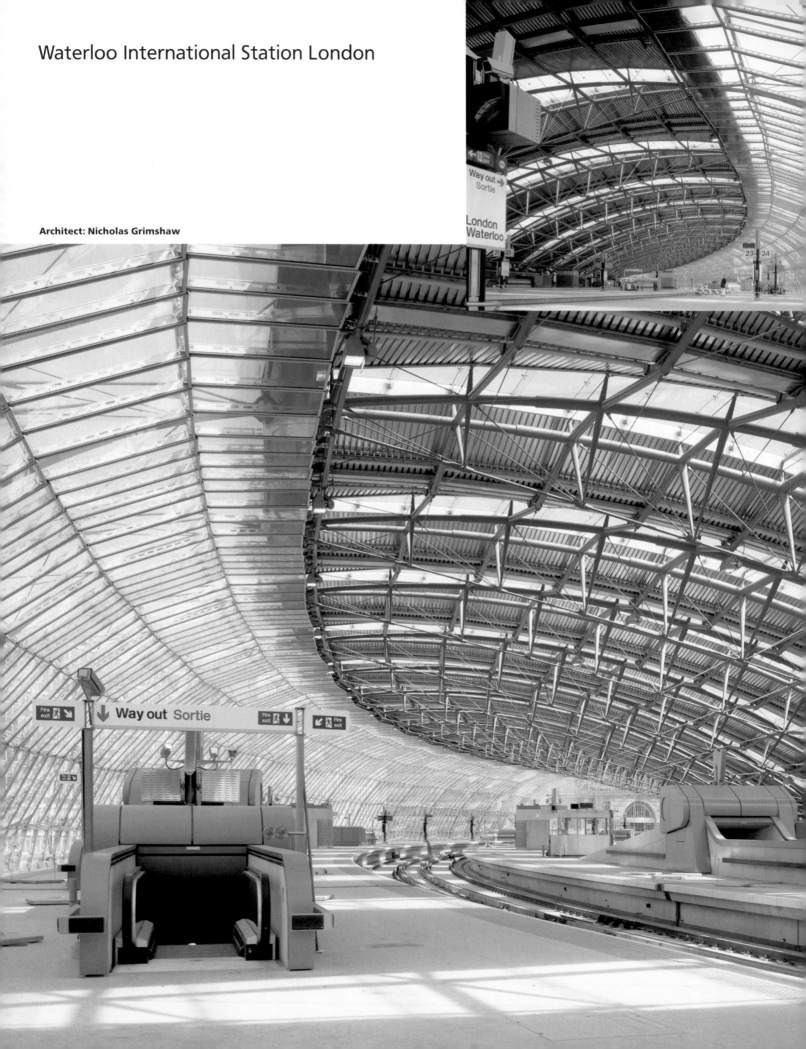

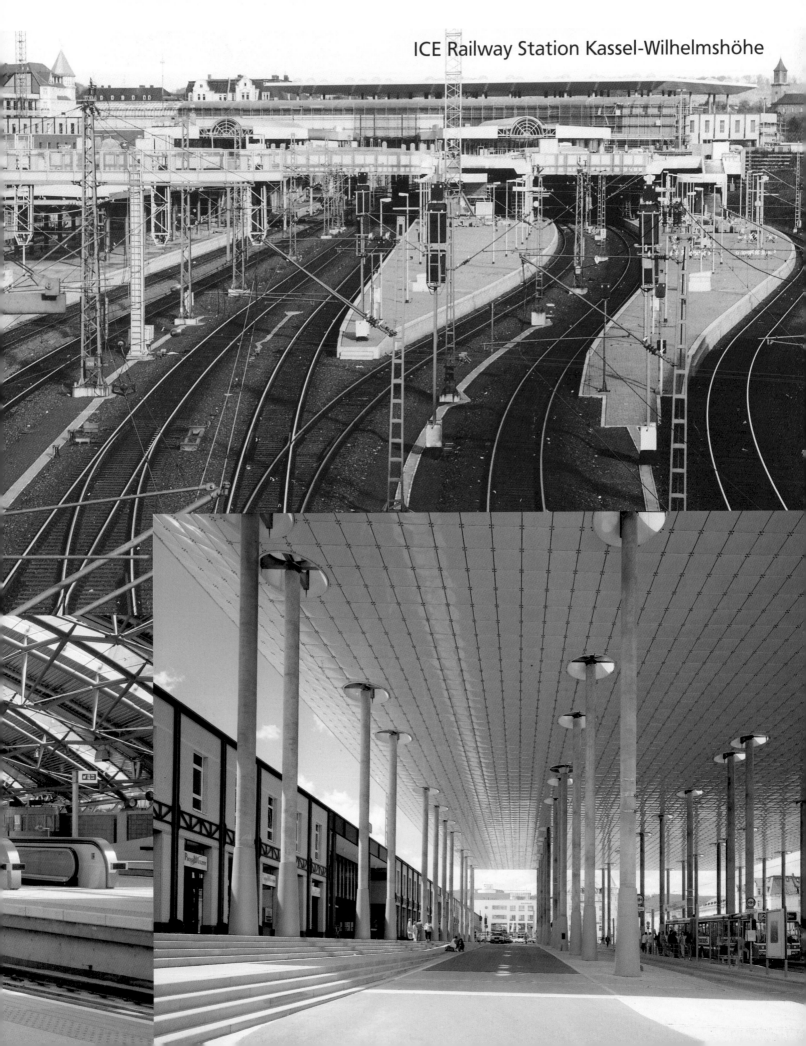

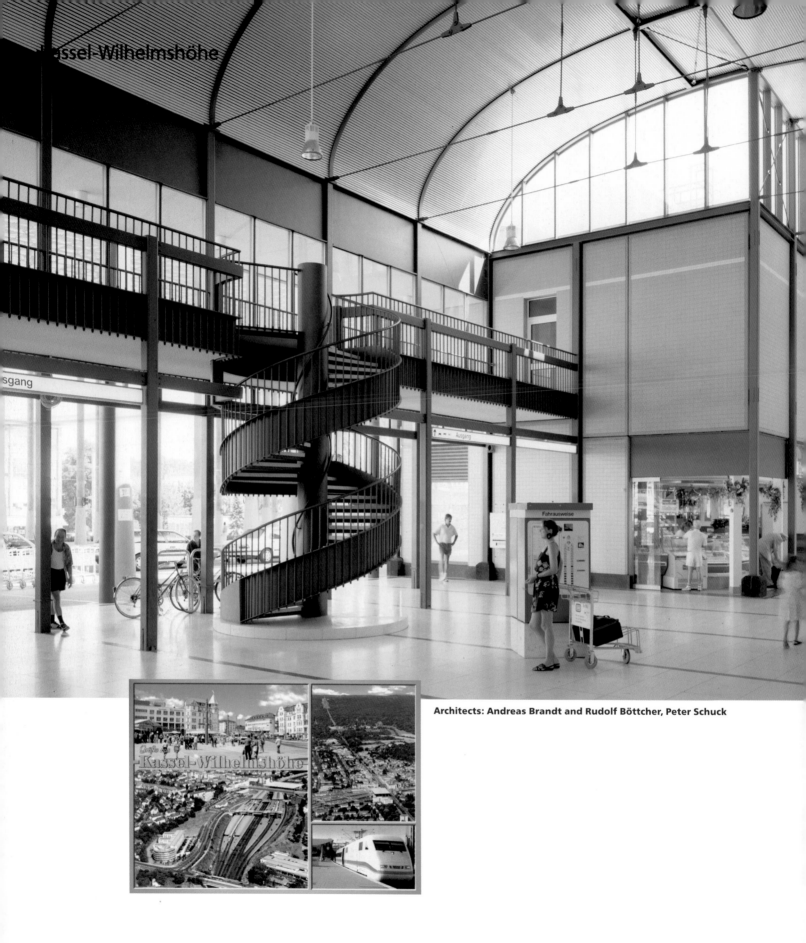

Architects: Andreas Brandt and Rudolf Böttcher, Peter Schuck

Kassel ['kasəl] F ab nach~! F file(z) *bzw.*
filons!; décampe(z) *bzw.* décampons!;
fiche(z) *bzw.* fichons le camp!; P bar-
re-toi *bzw.* barrez-vous *bzw.* barrons-
-nous!; ~er(in) I *m* ⟨~s; ~⟩ (*f*) ⟨~;
~nen⟩ habitant(e) *m* (*f*) de Kassel;
II ~er *adj.* ⟨inv.⟩ de Kassel; *cuis.* ~
Rippe(n)speer côtelette de porc salée
et fumée.

TRADUCTION :

BRUN de KASSEL [PRÈS de KASSEL]
(TERRE de KASSEL , BRUN VAN-DYK),
PIGMENT ORGANIQUE UTILISÉ PAR
LES PEINTRES , DE COULEUR SOMBRE.
BRUN PROFOND (TRÈS FONCÉ) :
UNE TERRE QUI PROVIENT DES COUCHES
DE CHARBON BRUN , FINEMENT BROYÉ
CONSTITUÉE DE MANGANÈSE et d'ACIDE
HUMIQUE.

Raymond Hains documentaliste (Cassettes pour Kassel)

Le Robert Noms propres p. 1668

Terre de Cassel ou terre de Cologne
sorte de lignite d'un brun noir existant
en dépôts considérables aux environs de
Cologne utilisé pour la préparation de
peintures brunes très solides.
Dictionnaire encyclopédique Quillet

729

KINO

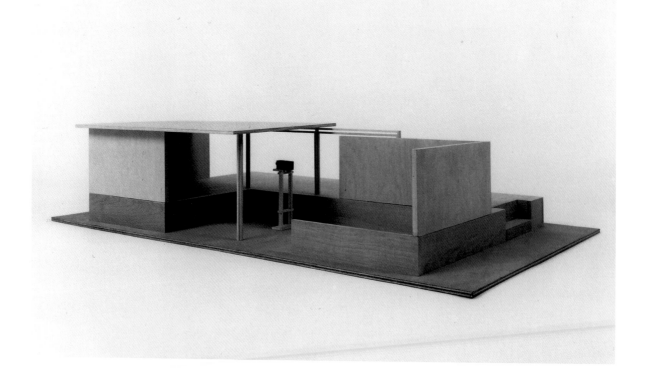

My work for documenta X in kassel is a model
Scale 1.2.
The actual full Scale pavilion is meant also to work
as one part model and part full Scale room.
The concept of the pavilion is so, that when viewed
from one side it appears to have the dimensions of
a huge model which seems to be resting on a plat-
form. This platform is actualy part of the pavilion.
when approached from the other side then the pavilion
opens into a full Scale room, which is possible to
enter, and which is bordered by the platform.
 This form is for me in one Sense a metaphor for
the exhibition.
 The concept for the pavilion derived from my interest
in the form and the history of the Treppen Straße in
kassel. A street designed and built by the Albert Speer
Architecture office during the 2nd world war.
 The pavilion evolved also as projection space around the
idea to make a film within certain premises along the Trepp
en Str and on the street itself.
This film projection corresponds to the fluctuating
scale of the pavilion.

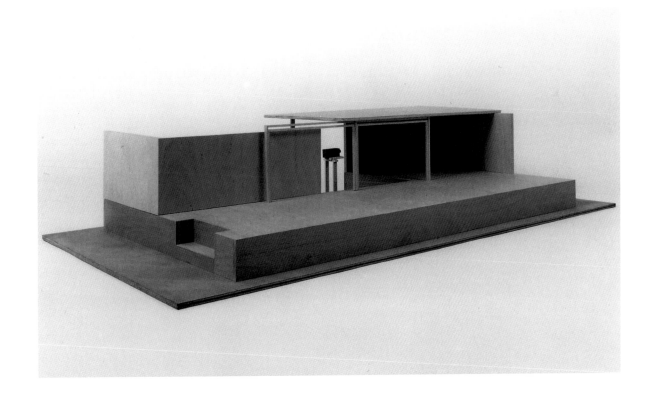

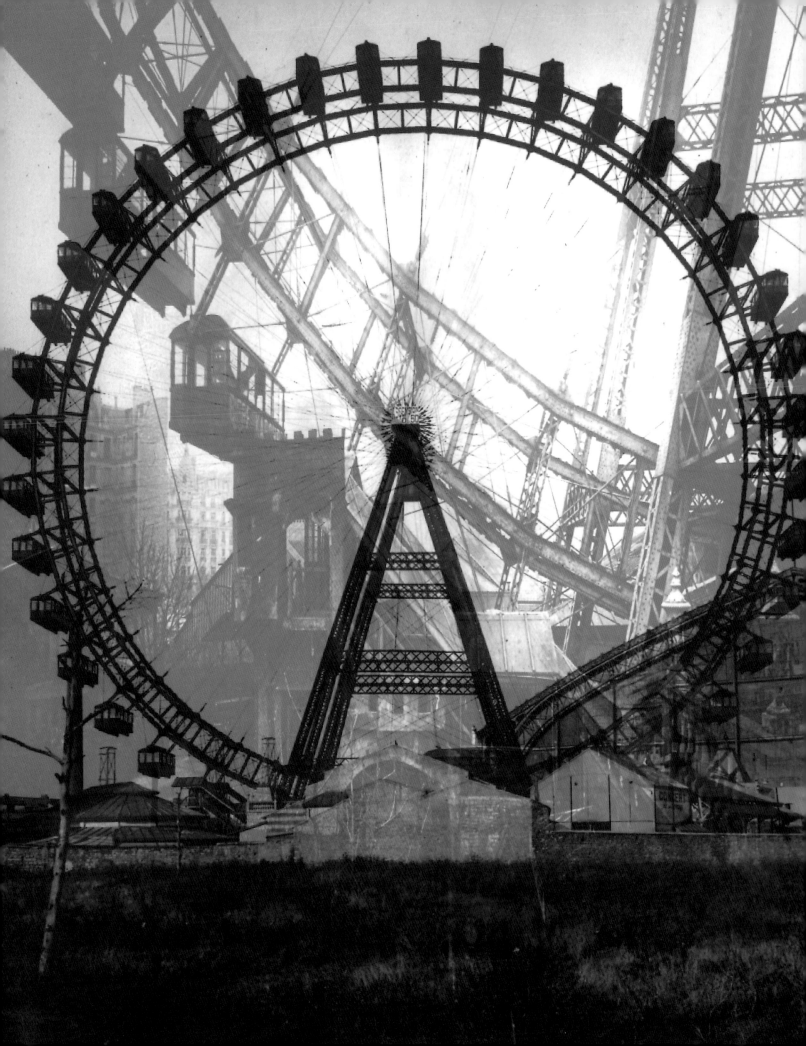

dans autre projet; tourner, pas d'utilité par avance , l'autonomie de quoi, pas de promenade initiatique ou intros-
ective - c'est tout de même bidimensionnel, panoramique et circulaire. Quelle est la différence entre Tintin et
Milou? Milou n'a pas de chien. Court-circuits de l'espace, machines sans frontières, les amusement parks ont clai-
ement une frontière - closed loop, looping ; a city machine. Est-ce que ça fait une chose pour en effectuer une
utre? Le cabinet du docteur Caligari a pour origine un fait divers violent dans un parc d'attractions - la proximité
e l'expérience simulée, comme l'exotisme. Les parcs à thèmes sont localisés; ils produisent et diffusent tant de
hoses sur leur propre réalité, qu'il n'est plus tout à fait nécessaire de les visiter pour les connaître; John Woo, Bruce
ee: réel et imaginaire dans les combats sont indissociables; la limite entre les effets spéciaux, la composition de la
mise en scène et la réalité est très floue. C'est la différence entre la mécanique et la dynamique. Le cours des évè-
ements; room in the city. N'importe quel état de faits constitue une image. Il n'y a aucune spécificité de l'image
'est dans la vie normale, dans la quotidienneté qu'il faut chercher la diabolicité. Nous produisons du temps. C' est
e qui nous engage. Le parc clos déborde, près de lui, loin de lui. Les parcs se dispersent; des éléments urbains son
ne de leurs structures, leurs éléments spécifiques se retrouvent, essaiment dans la ville. Il y a; il était - quel est le
commencement? il faut bien commencer - à l'entrée? dans ce qui est déjà dans la ville? dans les dessins animés
es comics, les mangas? Y a-t-il un point de départ à partir duquel on construit? un accident, une monstruosité à
intérieur de quelque chose qui aurait mal tourné; il faut commencer quelque part sans trop savoir où. Y a-t-il du
ciel, contempler du haut du ciel, aller vers la lune; est-ce-que c'est déjà vendre l'espace, comme vendre un espace

Saskia Sassen

The vast new economic topography that is being implemented through electronic space is one moment, one fragment, of an even vaster economic chain that is in good part embedded in non-electronic spaces. There is no fully virtualized firm and no fully digitalized industry. Even the most advanced information industries, such as finance, are installed only partly in electronic space. And so are industries that produce digital products, such as

the world economy; as key locations and marketplaces for the leading industries of this period (finance and specialized services for firms); and as sites for the production of innovations in those industries. The continued and often growing concentration and specialization of financial and corporate service functions in major cities in highly developed countries is, in good part, a strategic development. It is precisely because

The Topoi of E-Space:
Global Cities and Global Valu

software designers. The growing digitalization of economic activities has not eliminated the need for major international business and financial centers and all the material resources they concentrate, from state-of-the-art telematics infrastructure to brain talent.[1]

Nonetheless, telematics and globalization have emerged as fundamental forces reshaping the organization of economic space. This reshaping ranges from the spatial virtualization of a growing number of economic activities to the reconfiguration of the geography of the built environment *for* economic activity. Whether in electronic space or in the geography of the built environment, this reshaping involves organizational and structural changes. Telematics maximizes the potential for geographic dispersal and globalization entails an economic logic that maximizes the attractions/profitability of such dispersal.

One outcome of these transformations has been captured in images of geographic dispersal at the global scale and the neutralization of place and distance through telematics in a growing number of economic activities. Yet it is precisely the combination of the spatial dispersal of numerous economic activities and telematic global integration which has contributed to a strategic role for major cities in the current phase of the world economy. Beyond their sometimes long history as centers for world trade and banking, these cities now function as command points in the organization of

of the territorial dispersal facilitated by telecommunication advances that agglomeration of centralizing activities has expanded immensely.[2] This is not a mere continuation of old patterns of agglomeration but, one could posit, a new logic for agglomeration. It is a logic that operates mostly for strategic sectors; a majority of firms and economic activities do not inhabit these major centers.

Centrality, then, remains a key property of the economic system but the spatial correlates of centrality have been profoundly altered by the new technologies and by globalization. This engenders a whole new problematic around the definition of what constitutes centrality today in an economic system where i) a share of transactions occur through technologies that neutralize distance and place, and do so on a global scale; ii) centrality has historically been embodied in certain types of built environment and urban form. Economic globalization and the new information technologies have not only reconfigured centrality and its spatial correlates, they have also created new spaces *for* centrality.

As a political economist interested in the spatial organization of the economy and in the spatial correlates of economic power, it seems to me that a focus on place and infrastructure in the new global information economy creates a conceptual and practical opening for questions about the embeddedness of electronic

space. It allows us to elaborate that point where the materiality of place/infrastructure intersects with those technologies and organizational forms that neutralize place and materiality. And it entails an elaboration of electronic space, the fact that this space is not simply about transmission capacities but also a space where new structures for economic activity and for economic power are being constituted.

hains

A New Architecture of Centrality?

Architecture has played a central role in constituting the idea of centrality in physical terms: indeed a good part of architecture has been what I will refer to as an "architecture of centrality." The historical forms assumed by the architecture of centrality have to do with ceremony, politics, religion. Over the last two decades we have seen a displacement onto the economy of some of the central functions traditionally embedded in the realm of politics and religion. Architecture was instrumental in the 1980s to make visual the shift of many central functions from the political to the economic arena. The 1980s are emblematic of a new architecture of centrality representing and housing new forms of economic power: the hyperspace of international business, from corporate towers and corporate hotels to world class airports—a transterritorial space of centrality, a new geography of the built environment of centrality. But though transterritorial, it is a form of place. Place is fundamental to the process of elite formation; and place is where we can capture the new representations of power that used to be embedded in political institutions and have now been displaced onto the economic field.

But the hierarchy in the economic system which in the past assumed often rather transparent correlates in architecture and in urban form has been partly dematerialized through the spatial virtualization of key econom-ic activities. Economic globalization and the new information technologies have not only reconfigured centrality and its spatial correlates, they have also created new spaces for centrality. There are new forms of economic power being shaped in electronic space. Some of the new forms of centrality cannot be experienced as a lived centrality the way a city's central business district can give us that experience.[3] Furthermore, insofar as a good share of economic transactions has been displayed onto electronic spaces, it becomes more problematic to experience the density of economic activity as is the case with traditional commerce on the street. What is the architecture of these dematerialized forms of centrality?

The question becomes particularly interesting when we consider that there is no purely digital economic sector and there is no completely virtual firm: they are always partly embedded in actual material built environments. The digital constitutes one or more moments in organizational chains that keep coming back into actual built environments. What are the forms that capture the ongoing articulation of even the most virtualized economic activity to built environments? Something fundamental has changed, but it is not absolute virtualization as is often suggested in imagery about the global information economy. As I think of it, the concept of electrotecture could be expanded to include the structures for economic activity and centralization of control being "built" in economic space as is the case, for instance, with foreign currency markets or program trading in stock markets.

A focus on centrality in the economic system and the range of forms assumed by centrality today may contribute to a specification of some of the new economic contexts for architecture. I think of such an effort as providing a particular set of analytic pathways to these questions about architecture. These are pathways grounded in realms of practice other than architecture, and hence diverge from those provided by architecture per se.

[1] For more detailed accounts, see the following books by the author: *Losing Control? Sovereignty in an Age of Globalization* (New York: Columbia University Press, 1996); *Metropolen des Weltmarktes* (Frankfurt: Campus Verlag, 1996); *The Global City* (Princeton, NJ: Princeton University Press, 1991).

[2] It is becoming cheaper and easier for multinational firms to outsource the management of their communication networks. For example, J. P. Morgan, one of the largest US financial services firms, has contracted with British Telecom North America to handle its overseas, terminal to host networks. And BT North America has contracted with Gillette Co, to manage its telecom operations in 180 countries. AT&T provides the network linkages for General Electric in 16 countries. And so it goes. This expanding network of services has significantly raised the complexity and importance of central functions in all these major telecommunications firms.

[3] Though I find it rather amusing that the idea of the city is one of the preferred forms given to virtual spaces that concentrate services or options. There are now hundreds of Web sites that are "digital cities" of one kind or another.

New Forms of Centrality

Telematics and the growth of a global economy, both inextricably linked, have contributed to a new geography of centrality (and marginality). Simplifying an analysis made elsewhere (Sassen 1996), I identify four forms assumed by centrality today.

First, while there is no longer a simple straightforward relation between centrality and such geographic entities as the downtown, or the central business district as was the case in the past, the CBD remains a key form of centrality. But the CBD in major international business centers is one profoundly reconfigured by technological and economic change.

Second, the center can extend into a metropolitan area in the form of a grid of nodes of intense business activity. One might ask whether a spatial organization characterized by dense strategic nodes spread over a broader region does or does not constitute a new form of organizing the territory of the "center," rather than, as in the more conventional view, an instance of suburbanization or geographic dispersal. Insofar as these various nodes are articulated through cyber-routes or digital highways, they represent a new geographic correlate of the most advanced type of "center." The places that fall outside this new grid of digital highways, however, are peripheralized. This regional grid of nodes represents, in my analysis, a reconstitution of the concept of region. Far from neutralizing geography the regional grid is likely to be embedded in conventional forms of communications infrastructure, notably rapid rail and highways connecting to airports. Ironically perhaps, conventional infrastructure is likely to maximize the economic benefits derived from telematics. I think this is an important issue that has been lost somewhat in discussions about the neutralization of geography through telematics.

Third, we are seeing the formation of a transterritorial "center" constituted via telematics and intense economic transactions (Sassen 1991). The most powerful of these new geographies of centrality at the interurban level binds the major international financial and business centers: New York, London, Tokyo, Paris, Frankfurt, Zurich, Amsterdam, Los Angeles, Sydney, Hong Kong, among others. But this geography now also includes cities such as Sao Paulo and Mexico City. The intensity of transactions among these cities, particularly through the financial markets, trade in services, and investment has increased sharply, and so have the orders of magnitude involved.[4] At the same time, there has been a sharpening inequality in the concentration of strategic resources and activities between each of these cities and others in the same country.[5] For instance, Paris now concentrates a larger share of leading economic sectors and wealth in France than it did fifteen years ago, while Marseilles, once a major economic hub, has lost its share and is suffering severe decline.

Fourth, new forms of centrality are being constituted in electronically generated spaces. Electronic space is often read as a purely technological event and in that sense a space of innocence. But if we consider for instance that strategic components of the financial industry operate in such space we can see that these are spaces where profits are produced and power is thereby constituted. Insofar as these technologies strengthen the profit-making capability of finance and make possible the hypermobility of finance capital, they also contribute to the often devastating impacts of the ascendance of finance on other industries, on particular sectors of the population, and on whole economies. Cyberspace, like any other space, can be inscribed in a multiplicity of ways, some benevolent or enlightening; others, not. My argument is that structures for economic power are being built in electronic space and that their highly com-

[4] The pronounced orientation to the world markets evident in such cities raises questions about the articulation with their nation-states, their regions, and the larger economic and social structure in such cities. Cities have typically been deeply embedded in the economies of their region, indeed often reflecting the characteristics of the latter; and they still do. But cities that are strategic sites in the global economy tend, in part, to disconnect from their region. This conflicts with a key proposition in traditional scholarship about urban systems, namely, that these systems promote the territorial integration of regional and national economies.

[5] In the case of a complex landscape such as Europe's we see in fact several geographies of centrality, one global, others continental and regional. A central urban hierarchy connects major cities, many of which in turn play central roles in the wider global system of cities: Paris, London, Frankfurt, Amsterdam, Zurich. These cities are also part of a wider network of European financial/cultural/service capitals, some with only one, others with several of these functions, articulate the European region and are somewhat less oriented to the global economy than Paris, Frankfurt, or London. And then there are several geographies of marginality: the East-West divide and the North-South divide across Europe as well as newer divisions. In Eastern Europe, certain cities and regions, notably Budapest, are rather attractive for purposes of investment, both European and non-European, while others will increasingly fall behind, notably in Rumania, Yugoslavia, and Albania. We see a similar differentiation in the south of Europe: Madrid, Barcelona, and Milan are gaining in the new European hierarchy; Naples, Rome, and Marseilles are not.

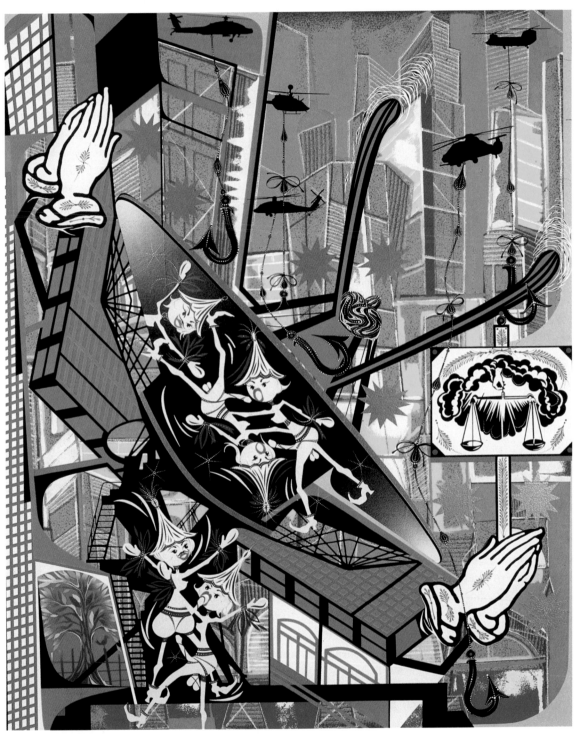

Lari Pittman, *Like you, hoping and wanting but not liking*, 1995

plex configurations contain points of coordination and centralization.

In the next sections I discuss various aspects of these four forms of centrality, focusing particularly on cities and on emergent forms of segmentation in electronic space as a way of showing the logic which produces centrality in a global information economy.

Agglomeration and Concentration in a Global Information Economy

One of the most well-defined forms of centrality is the continued and often growing concentration and specialization of financial and corporate service functions in major cities in highly developed countries. It is in many ways a paradox at a time when the development of telematics maximizes the potential for geographic dispersal. It also goes against the predictions of experts who posited the demise of cities as economic units.

It is precisely the combination of the spatial dispersal of numerous economic activities and telematic global integration which has contributed to a strategic role for major cities in the current phase of the world economy. Beyond their sometimes long history as centers for world trade and banking, these cities now function as command points in the organization of the world economy; as key locations and marketplaces for the leading industries of this period (finance and specialized services for firms); and as sites for the production of innovations in those industries. These cities have come to concentrate such vast resources and the leading industries have exercised such massive influence on the economic and social order of these cities that the possibility of a new type of city arises.

The formation and continuity of an economic center in the types of cities which I call global, rests on the intersection of two major processes: a) the growing service intensity in the organization of all industries, a much neglected aspect that I consider crucial and b) the globalization of economic activity. Both growing service intensity and globalization rely on and are shaped by the new information technologies and both have had and will continue to have pronounced impacts on urban space. The growing service intensity in economic organization generally and the specific conditions under which

information technologies are available combine to make cities once again a strategic "production" site, a role they had lost when large scale mass manufacturing became the dominant economic sector. It is through these information-based production processes that centrality is constituted.

One of the central concerns in my work has been to look at cities as production sites for the leading service industries of our time, and hence to recover the infrastructure of activities, firms and jobs that is necessary to run the advanced corporate economy. Specialized services are usually understood in terms of specialized outputs rather than the production process involved. A focus on the production process in these service industries allows us a) to capture some of their locational characteristics and b) to examine the proposition that there is a new dynamic for agglomeration in the advanced corporate services because they function as a production complex, a complex which serves corporate headquarters, yet has distinct locational and production characteristics. It is this producer services complex more so than headquarters of firms generally that benefits and often needs a city location.

We see this dynamic for agglomeration operating at different levels of the urban hierarchy, from the global to the regional. At the global level, some cities concentrate the infrastructure and the servicing that produce a capability for global control. The latter is essential if geographic dispersal of economic activity—whether factories, offices, or financial markets—is to take place under continued concentration of ownership and profit appropriation. This capability for global control cannot simply be subsumed under the structural aspects of the globalization of economic activity. It needs to be produced. It is insufficient to posit, or take for granted, the awesome power of large corporations or the existence of some "international economic system."

By focusing on the production of this capability, we add a neglected dimension to the familiar issue of the power of large corporations. The emphasis shifts to the *practice* of global control: the work of producing and reproducing the organization and management of a global production system and a global marketplace for finance, both under conditions of economic concentration. Power is essential in the organization of the world economy, but so is production—including the production

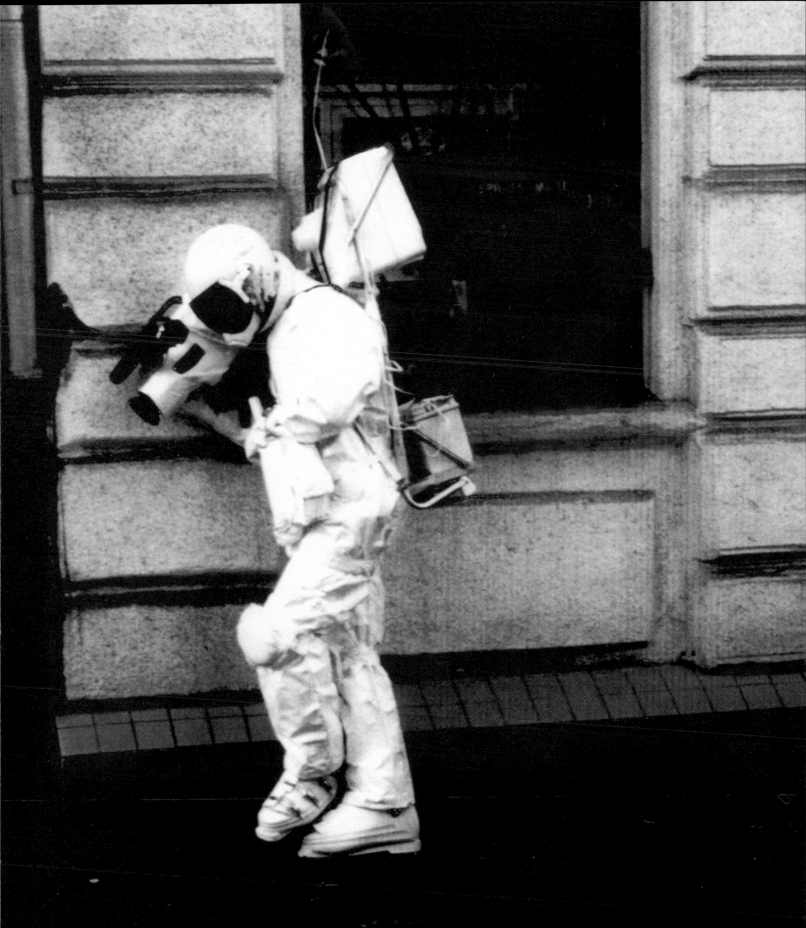

Kerry James Marshall

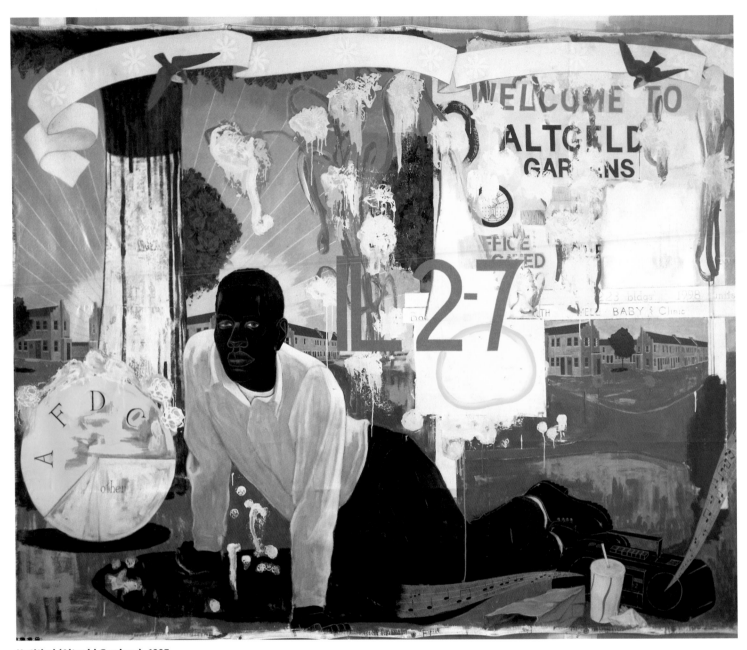

Untitled (Altgeld Gardens), 1995

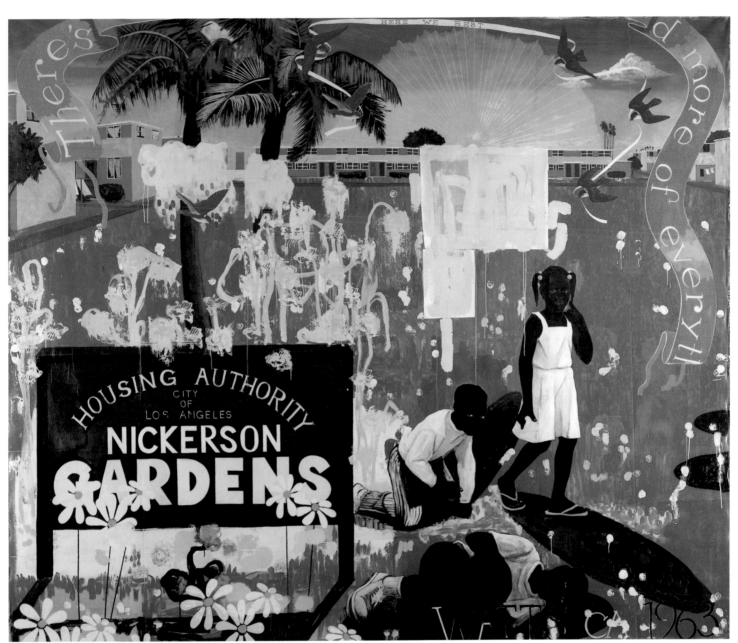

Watts 1963, 1995

of those inputs that constitute the capability for global control, and the infrastructure of jobs involved in this production. This allows us to focus on cities and on the urban social order associated with these activities.

The fundamental dynamic I posit is that the more globalized the economy becomes, the higher the agglomeration of central functions in global cities. The sharp increase in the 1980s in the density of office buildings evident in the business districts of these cities is the spatial expression of this logic. The widely accepted notion that agglomeration has become obsolete when global telecommunication advances should allow for maximum dispersal is only partly correct. It is, I argue, precisely because of the territorial dispersal facilitated by telecommunication advances that agglomeration of centralizing activities has expanded immensely. This is not a mere continuation of old patterns of agglomeration but, one could posit, a new logic for agglomeration. A key question is when telecommunication advances will be applied to these centralizing functions.

In brief, with the potential for global control capability, certain cities are becoming nodal points in a vast communications and market system. Advances in electronics and telecommunication have transformed geographically distant cities into centers for global communication and long-distance management. But centralized control and management over a geographically dispersed array of plants, offices, and service outlets does not come about inevitably as part of a "world system." It requires the development of a vast range of highly specialized services and of top level management and control functions.

Much analysis and general commentary on the global economy and the new growth sectors does not incorporate these multiple dimensions. Elsewhere I have argued that what we could think of as the dominant narrative or mainstream account of economic globalization is a *narrative of eviction* (Sassen 1996). Key concepts in the dominant account—globalization, information economy, and telematics—all suggest that place no longer matters and that the only type of worker that matters is the highly educated professional. This account privileges the capability for global transmission over the concentrations of built infrastructure that make transmission possible; information outputs over the workers producing those outputs, from specialists

to secretaries; and the new transnational corporate culture over the multiplicity of cultural environments, including reterritorialized immigrant cultures, within which many of the "other" jobs of the global information economy take place. In brief, the dominant narrative concerns itself with the upper circuits of capital, not the lower ones, and with the global capacities of major economic actors, not the infrastructure of facilities and jobs underlying those capacities. This narrow focus has the effect of evicting from the account the place-boundedness of significant components of the global information economy.

The Question of Centrality in Electronic Space

Do these tendencies towards centrality/concentration operate in electronic space? We tend to think of networked space as one that is characterized by distributed power, by the absence of hierarchy. The Internet is probably the best known and most noted. Its particular attributes have engendered the notion of distributed power: decentralization, openness, possibility of expansion, no hierarchy, no center, no conditions for authoritarian or monopoly control.

But we must recognize that the networks are also making possible other forms of power. The financial markets, operating largely through electronic networks, are a good instance of an alternative form of power. The three properties of electronic networks: speed, simultaneity, and interconnectivity, have produced orders of magnitude far surpassing anything we had ever seen in financial markets. The consequence has been that the global capital market now has the power to discipline national governments, as became evident with the Mexico "crisis" of December 1994. Further, these same properties of electronic networks have created elements of a crisis of control within the institutions of the financial industry itself. There are a number of instances that illustrate this: the stock market crash of 1987 brought on by program trading and the collapse of Barings Bank brought on by a young trader who managed to mobilize enormous amounts of capital in several markets over a period of 6 weeks.[6]

While the form of network power exemplified by international finance is potentially quite subversive in

that it destabilizes existing hierarchies of control (such as central banks or powerful institutions accustomed to far more control over the economy), it is very much a form of hierarchical power. It produces a vast concentration of power and of profits.

It also may be significant that although in some ways the power of these financial electronic networks rests on a kind of distributed power, i.e. millions of investors and their millions of decisions, it ends up as concentrated power. The trajectory followed by what begins as a form of distributed power may assume many forms, in this case, one radically different from that of the Internet.

It signals the possibility that networked power is not inherently distributive. Intervening mechanisms can re-shape its organization. To keep it as a form of distributed power requires that it be embedded in a particular kind of structure. In the case of the Internet, besides its feature as a network of networks and its openness—two crucial elements—it may well be the absence of commercialization that has allowed it to thrive the way it has.

There is no doubt that the Internet is a space of distributed power that limits the possibilities of authoritarian and monopoly control. But it is becoming evident over the last two years that it is also a space for contestation and segmentation.[7] When we think of the broader subject of the power of the networks we must recognize that there are about 40,000 networks today that are IP compatible and that the Internet is constituted by about 12,000. That leaves a lot of network power that may not necessarily have the properties/attributes of the Internet. Indeed, much of this is concentrated power and reproduces hierarchy rather than distributed power.

Conclusion: The Embeddedness of Electronic Space

Insofar as electronic space is embedded we cannot read it as a purely technological event and in terms of its pure technological capacities. It is inscribed by the structures and dynamics within which it is embedded: the Internet is a different type of space from the private networks of the financial industry; and the firewalled corporate sites on the Web are different from the public portion of the Web. Beyond this question of intentionality and use lies the question of infrastructure: electronic space is going to be far more present in highly industrialized countries than in the less developed world; and far more present for middle class households in rich countries than for poor households in those same countries.

[6] This in turn has produced conditions that cannot always be controlled by those who meant to profit the most from these new electronic capacities. We are seeing the elements of crisis in existing regulatory mechanisms which cannot cope with the properties of electronic markets. Precisely because they are deeply embedded in telematics, advanced information industries also shed light on questions of control in the global economy that not only go beyond the state but also beyond the notions of non-state centered systems of coordination prevalent in the literature on governance. These are questions of control that have to do with the orders of magnitude that can be achieved in the financial markets thanks to the speed in transactions made possible by the new technologies. The best example is probably the foreign currency markets which operate largely in electronic space and have achieved volumes that have left the central banks incapable of exercising the influence on exchange rates they are expected to have. For a full discussion of these issues, see S. Sassen *Losing control?* (New York: Columbia University Press, 1996).

[7] The net as a space of distributed power can thrive even against growing commercialization, but it may have to reinvent its self-representation as a universal space. It may continue to be a space for de-facto (i.e. not necessarily self-conscious) democratic practices. But it will be so partly as a form of resistance against overarching powers of the economy and of hierarchical power, rather than the space of unlimited freedom which is part of its self-representation today. It seems to me that there are enough changes in the last two years that the representation of the Internet needs to be subjected to critical examination. Perhaps the images we need to bring into this representation increasingly need to deal with contestation and resistance, rather than simply the romance of freedom and interconnectivity or the new frontier (though it needs to be said that the image of the frontier has been subjected to a critical reevaluation which frees it from the romance of freedom and escape from oppression and poverty). Further, one of the very important features of the Internet is that civil society has been an energetic user; but this also means that the full range of social forces will use it, from environmentalists to fundamentalist groups such as the Christian Coalition in the U.S. It becomes a democratic space for many opposing views and drives.

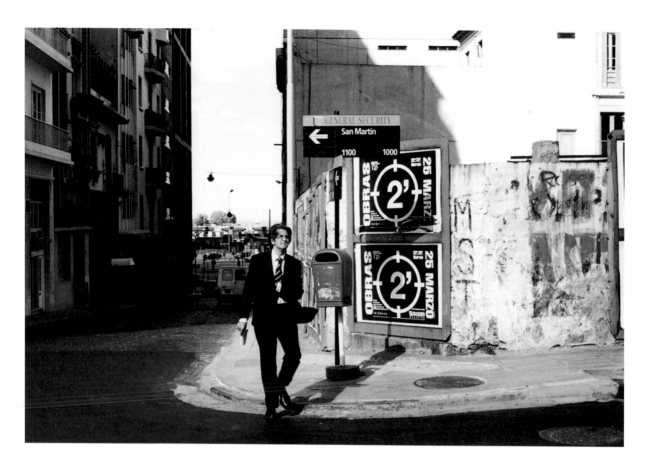

Amandes amères

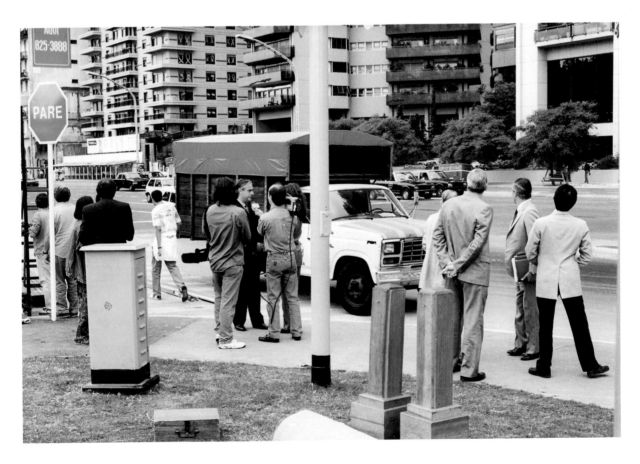

Jean-Marc Bustamante

1984

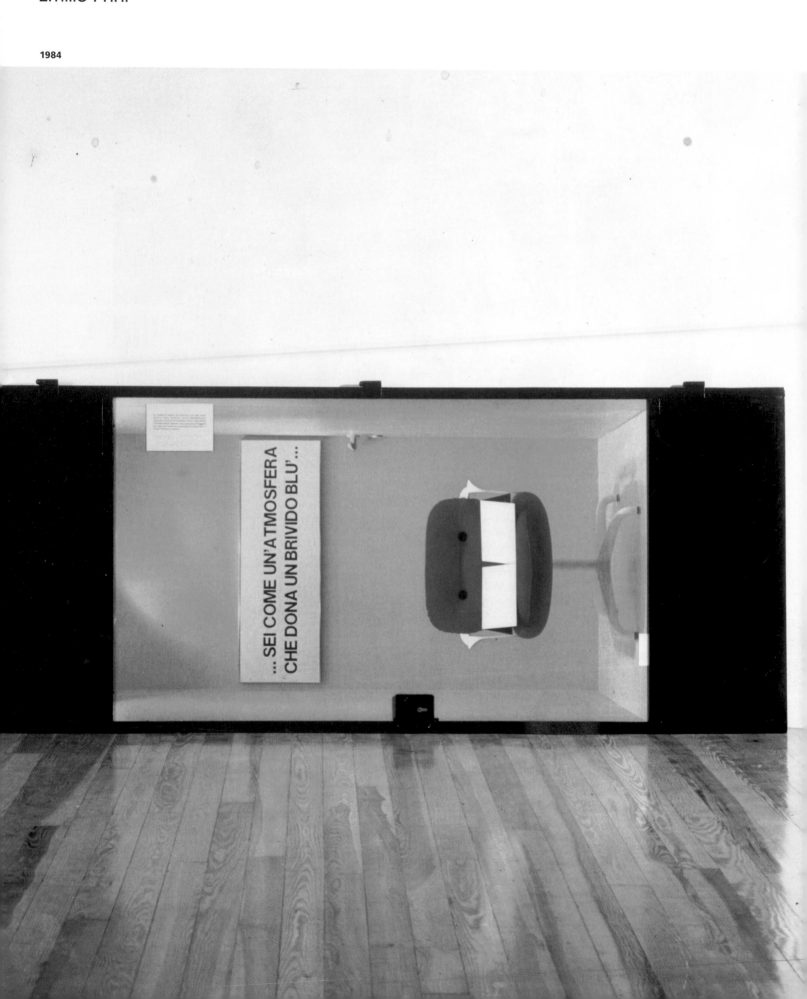

EMILIO PRINI LA INVITA AD ASSISTERE CON SGUARDI PARTECIPE

AI RIFLESSI DELL'AZIONE SULL'ENTE

THERE IT IS AGAIN

YOU KNOW

OVER AGAIN Y

REA

EXTERIOR CHARACTER

AN D AND EN

DESCRIPTION

DON'T W

REGISTRATION

ITITCOMESEGLOSERSAND ACLOSERSER

THE FEELING OVER AND

OU ARE WAITING , STARING ,

TO DO IT , YOU ARE

NVENTING A REASON ,, AND THEN

FORMER / SIMILAR APPEARANCE

N'S IT'SE OVER —

ACTION STORYLINE

— IT'S TOO LATE —

DON'T WAIT

IT'S A PERFEKT MOMENT

ELEMENTS

'S A PERFECT MOMENT

PROC. PLATE NO

COLLECTIVE

La ciutat de la gent (The City of the People)

Is a project by Valèria Bergallí, Josep Bonilla, Manuel J. Borja-Villel, Eduard Bru, Jean-François Chevrier, Miren Etxezarreta, Juan de la Haba, Craigie Horsfield, Juan José Lahuerta, Carles Martí, Lucas Martínez, Antonio Pizza, Maurici Pla, Albert Recio, Rosa Saíz, Isabel Sametier, Antonio Vargas i Lourdes Viladomiu.

La ciutat de la gent borrows its title from a well-known slogan used by the city of Barcelona, a city where in recent years consensus has been engineered to an extent unparalleled almost anywhere else, making it appear that no action can be taken. Although Barcelona is no different from many other cities in the industrially developed world, in the past fifteen years it has evolved so rapidly into a model of an outwardly focused city that it has somehow become a paradigm.

We all know that modernity has not brought demystification, a total enlightenment of the world. Modern society has instead taken new conditions and shaped a new mythology, casting a new spell over our relationships. On the pretext of rationalizing city planning, modern architects and city planners have produced a mythical architecture par excellence: the new labyrinth that is the city of today. In this context, art can be a source of regeneration whose objective is not so much to depict a collective dream as to liberate us from it.

The image depicted here is not the product of an individual: it is collective, an image that does not dissolve history in myth but instead places the myth in its historical perspective. Logically enough, this project is the outcome of close cooperation between representatives of the museum and a number of groups whose knowledge of, and research and actions in, the city include a variety of viewpoints: economic, social, anthropological and, of course, political. It is these groups which have helped us enter a particular human community, acting as our interpreters. Their subjective viewpoints, their own individual actions are, of course, also a part of our project.

La cituat de la gent was an exhibition and a book published as part of the Fundació Antoni Tàpies, Barcelona project of a collective. It was developed as a platform for dialogue and for the building of models that could be effective in this changed world, to speak about how we think and live within the public sphere and the private space, of what community may be and how we may conceive self: the individual and the social world. The project was developed over three years and is being continued in Rotterdam, Berlin, Kraków and Ghent.

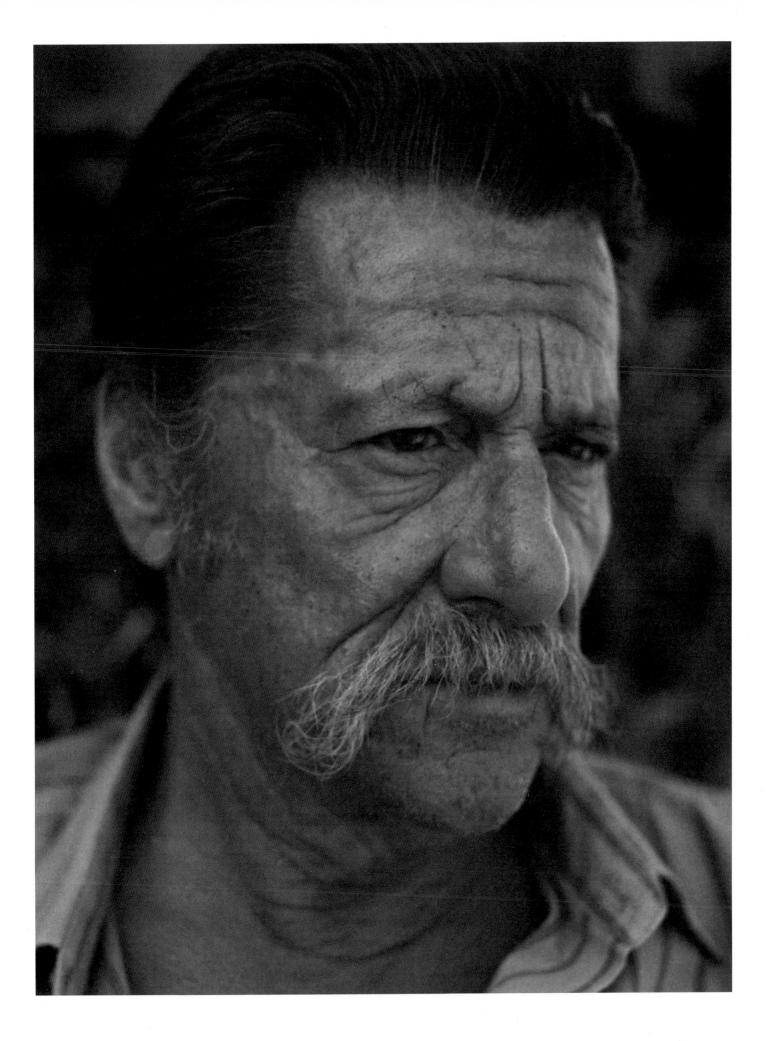

Verbindungen - Sie um
von der Natur nennen,
jene Konstruktionen,
welche die Grundweiten
die aus sich selbst
entwickelnden Möglich=
keiten der Natur ent,
stehen läßt, sind
ästhetisch, wenn
Kommt ein Netz
wechselt angewandten
Kultur den Verbindung
auffängt, wickelt sich
voneinander und. Die
Blüten der Wegwarte
öffnen sich etwa
um 6 Uhr früh
schließen sich gegen
Mittag hin.
So ist Natur, und
das natürliche
Leben, in ihnen
sicheren Entwachen
nicht Realisierten,
doch schon, was ihre
Inhaltheit im ver
gemeintes, sierliche
Stellen enthält,
nimmt sie an
Toten der Verbindung
und deren Gegenteil
ausdrückt in
Bleichen
96

Ulrike Grossarth

**Portikus
Frankfurt, 1996**

JEAN-FRANÇOIS CHEVRIER Identity, alterity, differences: these words haunt what is today called "postcolonial" discourse. We wanted to meet you to gain a better understanding of where you situate yourself in the labyrinth of this discourse, what your itinerary has been, and how it has led to your current position—knowing, of course, that every "position" is situated, contingent, and must be played out again in each speaking situation, at each turn of the labyrinth. Your publications make it clear that you are particularly alert to the institutional contexts in which you have been led to intervene, and thereby to exercise a kind of authority. This alertness seems to correspond to your experience of the gaps, the inequalities of status and recognition that are the stuff of daily life for a foreigner who has come from the "Third World," in your case the Indian subcontinent, to a hegemonic country like the United States. When we met in New York, you were in the process of obtaining a visa for Europe; you insisted on concretely showing me the existence of this gap or "split" between your status as an intellectual recognized by the university establishment and your status as an immigrant, a non-citizen, confronted with the everyday racism of the administrations that enforce population control. We also spoke of another split, this time between your activity as an intellectual teaching in an American uni-

Of Poetic

Gayatri Chakravorty Spivak, Jean-François Chevri

versity and your activity in the country of your birth, where you are helping to set up education networks for so-called "subaltern" groups. You distinguished these networks from what are commonly thought of as "schools," in order to mark the precarious conditions of this level of education in India and indeed of your collaborators themselves, who have no institutional training for their activity. I wanted to recall this background of our first meeting, as it will necessarily come up again here. We can begin by speaking of your own institutional background and the way you have displaced your initial object of study, literature. Do you see a connection between an interruption or suspension of the analyst's effort to intellectually master his or her material and a concern for the processes of subject formation or subjectivization which characterize what I would call "the literary," that is, an intimate yet also social experimentation with language outside the institutions of literature? I ask this as a way of getting at a question you have posed in your text, "Can the Subaltern Speak?"

GAYATRI SPIVAK Yes, I do see a connection. But one must not say "yes" too quickly, precisely because of the immense appropriated power of the literary establishment, its power to rewrite history. It is true that I have made an effort to be responsible to these so-called subaltern persons, by trying to learn how to call forth a response from them so that it becomes a kind of "answering for" and "answering to," etc. This task obviously has something to do with the literary. But the literary as we understand it has to acknowledge some kind of relationship to

"literature" in the narrow sense, to the institution of literature, if it is not to be a denegation. When we were talking in New York, you said that I used the word "aporia" too empirically. That's an opposition I would question. If you like, it's my friendship with Marx—the heterogeneous dialectic, knowing and doing, philosophy and the empirical. That relationship marks the place of the aporia. Of course one can understand the aporia as the ghost of the undecidable that inhabits every decision; but the second sense of aporia is where one can say that there are two determinate decisions, both "right," yet one canceling the other. This aporia must be crossed. So the aporia discloses itself in its own crossing. I think the relationship between the literary and the institution of literature is like that, because every time it is invoked, the aporia is crossed, in so far as the first is silenced.

JEAN-FRANÇOIS CHEVRIER Let's talk about Foucault, because he really tried to go beyond the institution of literature, and tried to do it in the most personal and yet also analytical way, when he worked with the Bastille archives and attempted to let the voices of the archives speak. I'm referring to the book *Le Désordre des familles*, published in 1982, which presents a selection of letters addressed by private people to the King, calling for the internment of spouses or

nd Politics

nd Françoise Joly

family members. These letters recount the everyday lives and "crimes" of ordinary people. Such an attempt to let the archives speak cannot be reduced to what Foucault said in the interview with Deleuze that you quote in your article on the subaltern; after all, Foucault is not Deleuze, and that was only an interview. Foucault tried to extract something from the archive which he could not simply comment on, given his experience of writing on madness—which is a real aporia. Now, I agree with you that the notion that the subaltern can simply speak is naive. But how do you see Foucault's position today?

GAYATRI SPIVAK When he talks about the subindividual arena of the *énoncé*, the place where the subject position is assigned, his words almost break down. But in America today, and certainly in India and sometimes in Britain—I don't know what the situation is in Europe—this very delicate notion of the subject position has been done into nothing but a little confessional. That's why I was saying, in "Can the Subaltern Speak?," that most of us, when we relate to the delicate philosophers, relate to them by travestying, so that Kant's public use of reason becomes the World Trade Organization, and so on. That's why I was trying to see what the philosophers say when they talk to each other, rather than when they are teaching or writing. You say Foucault is not Deleuze, but neither is he his hundreds of thousands of readers, and the conversations going on there are even more approximate than Foucault talking with Deleuze. We must bear the responsibility of what we say. That's what I meant. I think that what one has learned

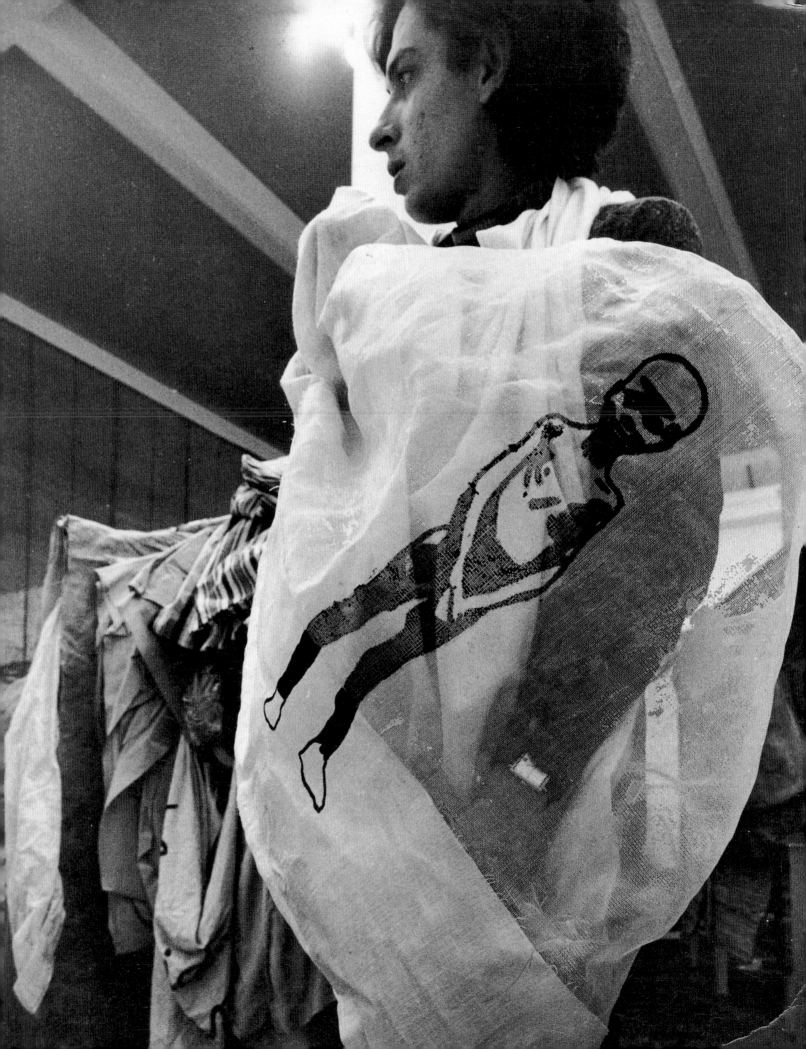

from Foucault's attempt at making the archives come forth is unbelievable. But look at the great US Foucaultians who have domesticated him for humanism. And this is also true of the subalternists, who work on governmentality, and so forth—they have reduced him to someone who comments on those issues.

JEAN-FRANÇOIS CHEVRIER Yes, I understand that very well. But there is a deeper attitude, an attitude of dialogicity in relationship to the material. I find it extremely interesting that when Foucault wanted to publish these archives he began to work with an historian, Arlette Farge, and she told him he had to comment on the texts, otherwise it would be fetishizing the archives. So in the end they published a double commentary, which created a space in between.

GAYATRI SPIVAK I agree with you. But I'm glad I wrote "Can the Subaltern Speak?" because looking back, those years between 1981 and 1984 were years when I was growing up, in a certain sense. I have undoubtedly been influenced by the disciplinary change that Said's *Orientalism* brought about, but not directly, because I started teaching in 1965; and I'm undoubtedly tremendously derivative of Derrida, but again, since I started teaching in '65 I never became part of the Yale school. In this situation I had become a homemade expert, and something in me made me want to stop being just a trained colonial subject, a first-class parrot, a mimic. And then suddenly, reading *Jane Eyre*, a book I had read many times, something ticked over in my head. So I wrote "Three Women's Texts and a Critique of Imperialism," giving the superficial idea that "everything is wrong with the British empire"—which is a silly attitude. But people still feel this way. Everyone wants to hear about white racism, that's the easiest thing. Then came "French Feminism in an International Frame" and my first translation of Mahasweta Devi—the same effort to get away from just being a well-trained monkey. But even those two were still not enough. In "Can the Subaltern Speak?" I had a huge writer's block, because I was taking this young woman who had killed herself in the family, and putting her as a text, over against these great grand philosophers. People in the family asked, "You're going to use her name?" I was cynical enough to know that nobody was going to pay any attention to her, and that's what happened. Nobody saw that what I had to say related to this one case. But for me it was a watershed experience. So I'm sure I was not just enough toward Foucault and Deleuze, because it was time to be unjust, so that I could break away from the balancing trick I had learned as the good monkey. And I must say one more thing: I write there about Sanskrit texts, but I'm not a Sanskritist. I can read Sanskrit texts of a certain kind, epics and so on. But what I did was extremely insolent toward the establishment of Sanskrit scholars. What right does this English honors B.A., this French, German, and English Ph.D., living in the United States and teaching in an English department, this Gayatri Spivak, what right does she have to write on Sanskrit texts? I am grateful to Bimal Krishna Matilal and to Peter Van der Veer that the two of them recognized there was something daring in doing that. Even the Indian feminists misunderstood that and they thought that I was only being *like* the British, that I was being a Brahmanical textualist. I am also very grateful to the historian Sumit Sarkar at Delhi University, who has recognized that this is the one piece where precolonial texts are talked about seriously as psychobiographically regulative; otherwise, everything else seems to start with colonialism. So I was taking on a lot in this essay, which was a kind of watershed for me. In fact, you have given me the image: this is where the split began to show.

FRANÇOISE JOLY I would like to approach this question of the subaltern with respect to women. A particularly reductive version of feminism has often identified its enemy as a monolithic masculine system extending throughout all historical and cultural contexts. This early formulation of feminism, which has left particularly strong echoes in Germany, was unable to recognize dif-

ferent conditions and modes of oppression and emancipation; it tended to appropriate cultural differences, and thus in a certain way to "recolonize" other women, in its struggle against a supposedly universal masculine imperialism. How does your work within feminist discourse seek to achieve a decolonization of *other* feminine subjects?

GAYATRI SPIVAK The times are not good for the decolonization of metropolitan feminists. In the wake of the Cold War, there is a mood of triumphalist Americanism in the United States. The "democratization" of state capitalisms and their colonies to tributary economies of rationalized global financialization carries with it the aura of the civilizing mission of earlier colonialisms. The rationalization of sexuality, the invasive restructuring of gender relations, poor women's credit-baiting without infrastructural involvement in the name of women's microenterprise, the revision of women-in-development (modernization) to gender-and-development (New World Order)—all this is seen as global sisterhood. An ecstatic metropolitan pregnant woman officer of Women's World Banking—who thanked the audience on behalf of her unborn son for being allowed to speak sitting down at a recent conference—quite unashamedly spoke of letting the commercial sector know there is a "huge untapped market" among rural poor women in the developing countries. It is scary to see how a subaltern will for the financialization of the globe is being created in the name of global feminism. And in the United States, at least, this phenomenon is kept strictly separate from issues of domestic justice: minority rights and citizenship. The success stories among minority women are welcomed into the agency of globalization. And "culture" is used to cement these alliances. If you dare to point this out you are treated like a bad smell, stonewalled, called a cultural conservative, a consensus-breaker, a nay-sayer. I am not a nay-sayer. I just say "yes yes" to women's constituencies that are invisible—even as needy or resistant—in the metropolis. I work in the hope that someone on these shores will be sufficiently moved to join her voice with mine.

JEAN-FRANÇOIS CHEVRIER In a 1989 interview published in *Polygraph* 2, and reprinted in *The Post-Colonial Critic*, you said this: "I like the word 'subaltern' for one reason: it is truly situational. Subaltern began as a description of a certain rank in the military. The word was used under censorship by Gramsci: he called Marxism a 'monism,' and was obliged to call the proletarian 'subaltern.' That word, used under duress, has been transformed into the description of everything that doesn't fall under a strict class analysis. I like that, because it has no theoretical rigor." I think that is the most precise thing I've ever read about the subaltern. The idea of the subaltern is post-Marxist, it is situational, but it is also a way to bring an indeterminacy into play. And this is my question, because I think your work is very much about indeterminacy.

GAYATRI SPIVAK But what kind of indeterminacy?

JEAN-FRANÇOIS CHEVRIER I think it has to do with the split we were talking about earlier. It is not a way of refuting determinations, but of introducing free play between elements which otherwise are always likely to fall into a new hierarchy.

GAYATRI SPIVAK For Gramsci, the censorship allowed an opening. In the essay on the Southern question, "subaltern" no longer remains an Aesopian word for proletarian. It has its own life. It is not post-Marxist, it is para-Marxist, and it is parasitic to Marxism. It is beside Marxism in another place. As we now understand (perhaps I didn't then), if you let the question of class go, you've had it. But if you make a mechanical split between cultural questions and class questions, you're not realizing that you must introduce indeterminacy and let it play in the very house of Marxist calculus, in the concept of class. The chapter on class at the end of *Capital*, volume three, doesn't end. Of course we know Marx didn't write it, Engels put it together. We've been saying since, "Karl, you never said the last word on class." But that's how it should

be. It's open-ended, it's a halfway house. Marx says the concept of class is completely useless if you take it out of the analytical grid, because then you would have to say a tailor class, a fisherman class—and he ends like that, with the fisherman! So to an extent, what the idea of subalternity allows us to do is to make indeterminate the concept of class and to transform it into a concept-metaphor, so that it works differently. In the first volume of the Subaltern Studies Group, the concept was taken as a name of the whole space of difference from the lines of access to the culture of colonialism. It was seen as a place where the lines were not set down. Today, of course, things have changed. Today, in the areas where I see the resistance, the people are in a space of cultural difference; in that sense they are subaltern. But they are not culturalists, for that very reason. In the areas I'm talking about, there is no culturalism. On the other hand, the needed infrastructure would in fact bring into consolidation some kind of cultural difference—and compromise it immediately, of course. So subalternity, as the name of difference, is forever moving, like living culture is always on the run. It's useful in that way too. But finally (my answers never end) I am also responsible for making this word lose rigor. First of all, because I didn't know enough about the historiography of India when I was asked to theorize the group's work. And secondly, because the *Selected Subaltern Studies*—which until recently is all that most people outside of South Asian history had read of the Subaltern Studies Group—was badly edited, by me. And thirdly, as a result of this book becoming viable in the West, especially the United States, that word was picked up to describe, to quote Frederic Jameson, "anyone who felt inferior." So, in the second volume of *Selected Subaltern Studies* which is coming out soon, I believe these problems have been gently corrected by the editor, Ranajit Guha. But I should say that not only do I like the term because it lacks rigor, but in the estimation of many people, I am guilty not only of having travestied and popularized and vulgarized deconstruction by writing the introduction to *Grammatology* so many years ago but also for having travestied, vulgarized, and de-rigorified, if I may make up that word, the concept of the subaltern, by daring to touch it. And I rather like that. I like to be the instrument of the de-rigorification of the rigor mortis of institutionally useful terms.

JEAN-FRANÇOIS CHEVRIER You said the word was used under censorship. I think that is a key point, because it brings us back to questions of subjectivity and power. As we know from a beautiful text by Coetzee, in *Doubling the Point,* censorship is not only about repression, it's also a way for a writer to shape his language, not only against the censor but also in response to the very existence of the censorship. Does the idea of the subaltern have to do with this structure of subjectivity and power?

GAYATRI SPIVAK These are two different things. A subaltern does not describe himself as such.

JEAN-FRANÇOIS CHEVRIER But he can do so.

GAYATRI SPIVAK There is no reason why not. But that's the crisis that allows for the recognition of the subaltern, that's what Subaltern Studies is all about.

JEAN-FRANÇOIS CHEVRIER What about yourself then—can you speak of censorship?

GAYATRI SPIVAK Because of the fact that I have not been a faithful follower, I don't know what it is to speak about myself. I'm not part of the Marxist establishment, I'm considered too elitist, too theoretical, too culturalist, I don't know what. I'm not part of the deconstructive establishment, for sure. I'm not rejected by either, but I'm not part of the Politburo, if you know what I mean. I'm not part of the feminist establishment. In all of these arenas you will hear some description of why I'm not to be trusted. Certainly I'm not to be trusted on Indian matters, and I'm not a part of the literary-critical establishment either; and slowly, my standing as a so-called theorist of postcoloniality is beginning to be shaken. And I feel good about this: it

is almost as though there were a certain kind of censorship, a taking away of the possibility of speaking for radical groups. This is something very interesting. With the activists too, I'm not one of them, and I'm very part time, I'm not identified with one area. You began with the notion of splits. I would say that I began with the notion of kaleidoscopic shifts of focus. It's not always planned, and sometimes I catch the last Spivak by the tail as it is escaping around the corner: I forget to be the one that is appropriate for this moment. As I'm growing older I think this is good. You know, it keeps one occupied! I must say, I would love to be an establishment radical. I'm profoundly envious of many of my friends who are solid establishment radicals. I'm only a kaleidoscope!

JEAN-FRANÇOIS CHEVRIER The situation you have just described reminds me very strongly of the writer's situation, once again. In fact, you mentioned your own name, something which, coming from someone who has read Lacan and Derrida, is not absolutely naive, I imagine. What interests me in *authors* like you, and I use the word by design, is a reinvention of the literary, which necessarily has a lot to do with a tradition of literature, but is not reducible to literature. I think this reinvention of the literary is politically very important today. It seems to me that the indeterminacy in situation you have just described, where your name is never adequate to a function, a role, where there is a gap between the name and the role, is exactly the literary. That disjunction between the name and the role defines the floating of the literary signifier.

GAYATRI SPIVAK It is in terms of this disjunction that we see what we call the literary escape. We see it escape!

JEAN-FRANÇOIS CHEVRIER Why only escape?

GAYATRI SPIVAK Because that is how it discloses itself. It discloses itself by escaping, but it has a specific fault in terms of which it discloses itself. I'm not being very original here—like you say, I've read my Derrida and Lacan. It is in terms of this disjunction that we watch the escape of that which, for want of a better word, we call the literary. This is where the idea of text comes in, the idea of the textualization of the random. But one must not think that textuality is the last word. Nor is the literary the last word. The literary is a *lieu tenant* [place holder] which allows us to look where we cannot see. It is a figure for the experience of the impossible. Now, if we come back to the name of Spivak, yes, of course it's true in that case—but it's simply a description of how everyone is. It's just how much of that, excuse me the very old-fashioned phrase, how much of that human condition becomes visible. When you began by saying that you linked the place of the other with Derrida and Foucault and so on, and that is why you were interviewing me, well this is what I also find. I'm amazed by it, that the place where these so-called theories can play is not here, and not in the universities, but in the places where, in a very battered way, and for historically bad reasons, some kind of inchoate critical theme of what, again, we can rapidly call the European enlightenment, is obliged to play itself out. It's not here. So from this point of view, I would say that what it makes visible is the way things are, alas. What my kaleidoscopic literariness makes visible is the way people are. It's not anything unique about me.

JEAN-FRANÇOIS CHEVRIER Now I have a very difficult question, one I'm not even sure I can formulate correctly. I have to tell a kind of story. When I met Masao Miyoshi in Los Angeles, he told me he hates novels. He doesn't want to read novels. Why does he say that? Miyoshi is someone from the humanities, but he would like to really understand social processes, economic processes, and so on. I can only relate his remark to his concern for realism, to put things simply. It's not a concern for effectiveness, because he claims that a university professor has no effectiveness—but maybe it's a concern for lucidity. At the time, I didn't ask the question. But

more recently I read a text called "Outside Architecture," published by MIT Press in the volume *Anywise* in 1996, where Miyoshi says that intellectuals and artists are ultimately employees of the culture industry, and that they all—or we all, and I don't think he excludes himself—claim an access to the little sphere of power to which, structurally, we don't have access. One of the ways of picking up the crumbs, of participating a little in the exercise of this power, is, among other things, the emphasis laid on what he calls "language games." So a great number of intellectuals become experts in certain kinds of language games, and are admitted, of course in a limited way, into the circles of power, because they are recognized as having this capacity. He says intellectuals make "gestures of surrender and homage to the dominant in the hope that culture employees might be granted a share of the corporate profits." My question is, if we are no longer in the era of Sartre, if we are no longer in the era of the intellectual as a real counter-power, and if language is in fact identified today, in the First World anyway, not only as a direct tool of power, but also, in an alternative way, as a space of expert games, then how can we transform this situation of expertise, without dreaming of a return to Sartre? Paradoxically, Miyoshi's suspicion turns around against him and makes me say that precisely because of this division where there is one language directly linked to power and another which is an alternative, but which nonetheless shares in power, the stakes of language are very serious indeed. These stakes can only be subjective, involving subjectivization. I wonder to what extent positing something on the order of the political today constantly implies, not language games in the strict sense, as arbitrarily composed, rule-governed sets, but rather a complex play with language? I can rapidly describe this kind of play by referring to a piece by Marcel Broodthaers, where he writes *Map of the Political World*, with the *li* crossed out and replaced by *e*: *Map of the Poetical World*. What we should understand, I think, is that when he crosses out the *li* it is not an erasure: the *l* and *i* always remain visible, you just have the *e* as a plus. Maybe poetic language is what allows us to make the political visible, to produce it. It became necessary, in the late sixties and early seventies, to somehow get around the univocal nature of the political imperative, to poeticize politics. In the new context that Miyoshi evokes, that remains a very current problem.

GAYATRI SPIVAK I'm not going to try to answer your question, because it would take a very long time. What I'm going to do is to tell you how I understand it. And I want to begin by talking about a very different Masao Miyoshi. I have no idea why he said that, obviously. But I think that he and I, very different as we are, nonetheless share a very broad structural similarity. You know, two Asians, straight—he's a bit older than I am—trying to teach English in an era when you had to be like the native speakers in order to make it. There was no multiculti when we were growing up, no feminism, etc. So, think about novels: it is possible that we cannot teach them anymore in the way that we were trained so well to teach them. It may not be just a desire for lucidity. It is also what we were talking about before, the appropriated power of the literary establishment.

JEAN-FRANÇOIS CHEVRIER This I understand very well. Excuse me, I took that for granted, and you do very well to point that out, because otherwise what I said could be ambiguous. But I took that for granted. I think when he said he didn't want to read novels, he was beyond that.

GAYATRI SPIVAK OK, forget it then. Now I would say, the way I understand your question is this, and here I'll just catch on to the end: I think that to an extent the political has always been a field of language. That's not necessarily a rupture. But what you're talking about, the political and the poetic, I would want to understand it precisely as the relationship between the calculus of rights and the mysterious, open terrain of learning to respond to the other in such a way

that one calls forth a response. The first is a calculus, the political is a calculus, and we must never forget that calculus. This is why class must remain. But one must make it play, and when one makes it play then the *e* comes in. That's when you loosen not just rights, but responsibility in this very peculiar sense: attending to the other in such a way that you call forth a response. To be able to do that is what I'm calling the poetic for the moment, because that brings in another impossible dimension, the necessary dimension of the political. That, for me today, is the most important thing. This is why I can talk about a suspension of the analytical—not a throwing away of the analytical, but another way of learning dialogue. Now I want to say three things here. One is a little example. When I talk to the teachers I work with in India, then I'm a very upper-class person, born into a high caste, living in the United States, etc. So when I make a suggestion, it is possible that these teachers will take it as an order, and that they will do what I say, simply because I have said it. But then nothing will have been achieved. Because I'm trying to share with them a way of teaching which I'm learning from sitting with the children

and them. Therefore if I succeed in simply making them follow what I have said as an order, everything will have failed. Now, who thinks about anything like this in the structural work of literacy that governments and NGOs perform? Nobody. So that's the difference between the calculus of the political and the open-ended nothingness of the poetic. Because there are no guarantees in what we are calling the poetic. The second thing is that I do not like culturalism as far as I am asked to perform it: as far as I am asked to anthropologize myself as speaking for some Indian stereotyped culturalism, I detest it. Therefore I will tell you the quick answer, of which one ought to be suspicious. In the Indic tradition, the word *kavi*—which is the common word for poets now, in the modern North Indian regions at least—is used for much more than "poet" in the narrow sense: it means a seer, a prophet, someone who knows how to give the codes of conduct, etc. In other words, a very large sense of the word for poet, like the way you are using "poetic." The quick culturalist answer would be to quote the Sanskrit tag: *ksurasya dhara nisita duratyaa durgama pathastad kavayo badanti*. Or in English: "The poet's path is as sharp as the razor's edge, it is hard to travel. So say the poets." This is a tag, like *ut pictura poesis*. But you don't know Sanskrit. If I didn't tell you this, you would have thought it was some kind of heavy-duty Sanskrit that I'm quoting from the bottom of my cultural expertise. If I had given you this answer, mysteriously couched in this banal piece of Sanskrit that everyone a little "gentlemanly" knows, and then talked to you about how Indians have always believed this (forgetting, of course, that it is just Hindu, etc.), well, that is how culturalism is played today, and that is how it must not be played. Finally, I want to end with the question of international art. To an extent it seems to me that the moment one says "international art," one has already become part of the problem. Because once you are in the First World space, there can be no migrant group

that does not want civil rights, whatever cultural rights they may want in addition. So that there is a certain kind of civil society taken for granted. I've written about this too: how, in a settler colony in Australia, the aboriginals were asked what kind of education they would like, and they said they would like mainstream information, but with cultural information, taught in the same way as European history is taught. So that since that culture is no longer a totalized performing technique—software—the children should have at least the ingredients so that it can be a second-level performance: museumization. Now that is a very fine lesson that the Warlpiri taught me. And it seems that when one asks the question of museumization of any sort, one has already assumed the disappearance of culture. So therefore, if I may risk this statement, we must acknowledge the power of censorship in Coetzee's sense. It is under the sign of that censor that we launch, again and again, projects of international art with the failure written in, because censorship is there for succeeding as well as failing.

Slaven Tolj, Untitled, 1997

This interview took place in Frankfurt in November 1996. Transcribed and edited by Brian Holmes.

Klaus Altstätter
Kurt Baluch
Thomas Baumgartner
Andi Brunner
Clemens Erlsbacher
Mario Gander
Dietmar Geppert
Andreas Hofmann
Christine Hohenbüchler
Irene Hohenbüchler
Rudi Ingruber
Andrea Mariacher
Sylvia Manfredaa
Georg Obkirchner
Maria Patterer
Hildegard Pranter
Veronika Pichler
Elfriede Skramovsky
Günther Steiner
Helmut Trojer
Ferdinand Wieser
Christian Wurnitsch

mu
lt
ip
le

au
TOR
en
sch
aft

KUNST WERKSTATT LIENZ

JEAN-FRANÇOIS CHEVRIER For a philosopher like yourself, coming from an essentially Franco-German tradition of Marxism, fully cognizant of the importance of the state, and convinced by the geopolitical and demographic analyses of Fernand Braudel, the question of citizenship is not exactly obvious. How did you arrive at it? You have proposed to dissociate citizenship from national identity, after having identified the racist component inherent to the nation-state.

ETIENNE BALIBAR Let me recall a theoretical and political-biographic fact: I was a member of the school of Althusser. Althusser is not the only one to have examined the fundamental articulations of Marxism, but the question was a powerful obsession for him. He told us: "Study the epistemology of Marxism as others have studied the epistemology of physics, of biology . . ." Such an epistemology proceeds like this: you take a given conceptual system and you ask, what is it capable of thinking, what is it incapable of thinking? Where are its intrinsic limits? In short, no improvising, no bricolage. It took some time to understand, against our own political interests, that the state, politics, citizenship, and the relation of citizenship to nationality were not future objects for Marxist theory but were inaccessible to that theory; they were not only momentary blind spots, but the absolute limits of any possible Marxist theorization. Not because of Marxism's much-decried economic reductionism, but because of its anarchist component.

Globalization

Etienne Balibar, Jean-François Chevrier, Catherine Dav

I am not an anarchist. On the contrary, I think Marx was far too much an anarchist, and that Marxists after him have paid dearly for their dream of the withering away of the state. Marx even considered himself more anarchist than Bakunin: where Bakunin toppled the state with words, crying "Down with the state!" Marx aimed to topple it in reality, using the class struggle. But everyone knows what happened: the discourse of the withering away of the state gave rise to a practice which supported an omnipotent state. I am now tempted to say that in fact, the state is not a social given but an institution, that it is the product—in the sense of a condensation, a crystallization, as Poulantzas explained[1]—of the combined action of heterogeneous factors: on the one hand, economic power; on the other hand, the symbolic and the imaginary, which Marxism sought to "catch" under the concept of ideology, although they are in no way the simple reflection of economic activity. What we have, as Freud put it, is "another stage," another causality that is just as powerful as the first. In history, we observe that each of these two causal chains produces effects on the stage of the other. The economic tendencies exert their pressure but never produce the effects that would be expected from a purely economic deduction; they only produce effects because ideological forces come into play. Conversely, the world is not run by ideas, ideological forces do not produce effects by themselves but because they are injected into certain junctures of the class struggle. A Marxism that reduces this causal complexity is necessarily mistaken, as is a Marxism that denies the economic causes. I realized that one had to look for subtle diagnostic procedures, rather than systematically operating by deduction.

In short, Marxism does not permit an understanding of citizenship because it does not understand the state. Citizenship has an "insurrectional" side and a "constitutional" side, just as it has individual and collective sides, which are indissociable. It is an always unstable balance between opposition to the state

(for example, civil disobedience) and democratization of the state, control of power by institutions. However, Marxism does understand the world-economy, through the work of Immanuel Wallerstein, a friend and interlocutor of Braudel. In fact, what was strongest in Marx himself was exactly that: the idea that the development of capitalism is a world process, which must be studied and formally described on the scale of the world. Today, of course, the term "globalization" is used everywhere, but this idea does not mark any radical break for Marxism. We who are between fifty and sixty years old today had the good fortune to complete our education at the time of the anti-imperialist movements, in solidarity with the movement for Algerian independence and with the Vietnamese struggle. And we learned long ago that the arena of world politics, insofar as politics is determined by capitalist and anti-capitalist forces, is the world-system.[2]

JEAN-FRANÇOIS CHEVRIER In its broadest dimensions, the question of citizenship responds to two phenomena which confront us today. On the one hand, we are witnessing an upsurge of racism in the old nation-states. This should not surprise us too much, since you yourself have identified the racist component of the nation-state; hence the urgency of the redefinition of citizenship that you have outlined. On the other hand, we see the hegemony of the Western European model gradually weakening, as its extension dissociates a norm of capitalist development from quite different principles of sociopolitical regulation. Marx knew capitalism and the national state, but he had not seen the entrepreneurial state. Today we are seeing this new figure of the state, which often functions in antidemocratic or predemocratic forms, apparently with the consent of the populations involved. I am thinking of the Asian dragons in particular. There, our European model seems very distant. But how did you come to rethink the question of citizenship?

ivilization 1

d Nadia Tazi

ETIENNE BALIBAR It is true that I didn't have much to say about citizenship before the early 1980s. I began to reflect on citizenship through the combination of two factors. The first owes nothing to my personal initiative: it was the movement of the young *beurs*, or French men and women of Arab origin, in 1983-84. The values to which these young people appealed and the terminology which they used were fundamentally the values and terminology of citizenship—a combination adapted to the conjuncture of liberty and equality, with liberty in this case taking the form of what was called "the right to difference." What struck me nonetheless was that this right to difference was never put forth in an exclusive and abstract way, but rather as a claim to recognition in public space. They were simply saying: "We exist." Which was anything but a way of saying: "We reject the republican political system. We want to close ourselves off in our own culture." Instead it was a matter of making this "culture" into an expression and an interpellation, an instrument of communication with others. A shortsighted Marxist could then say that all such declarations partake of a political illusion, an ideology. But I was convinced we had nothing to gain by trying to retranslate what was being expressed in the terms of citizenship into another, supposedly more accurate, more scientific language.

The second determining factor came from a reflection on communism and its historical role, not in the world in general but precisely in a country like France. I had the feeling that this reflection should include a redefinition of citizenship, taking up Machiavelli's notion of the "tribunal function"[3] and extending it, with certain provisos, to the entirety of the class struggle and the workers' movement. In point of fact, the workers' movement did play this role as a plebeian or popular tribunal, with a communist language influenced by the anarcho-syndicalist tradition in France, but also with a wholly different language in England. The idea is that under the pressure of the class struggle, the system creates a form of collective participation and political consciousness such that certain persons who are not members of the dominant class are nonetheless able to take part in the democratic institution of the

political—in something like the game of "loser wins." In that game, you maintain the discourse of revolution but you aim at reform: you force the recognition of a certain number of material interests (retirement, health care) along with the right to be considered as equals at a certain level. Marx scorned that discourse: he thought that making workers believe they were equal was a way of fooling them and buying them off. But he was wrong, because today we see that the absence of any such discourse culminates in a privation of rights and dignity, a reduction to collective powerlessness. Clearly, from that point, there was the temptation—and I felt it, that's why I wrote *Les frontières de la démocratie*[4]—to combine the theme of class struggle and the theme of liberty, without reducing one to the other, but rather by showing that the degree of citizenship that had been won or imposed at a certain historical juncture would never have been won or imposed outside of specific forms of class struggle; and that class struggle itself is a political and not only a social struggle. One can recall Engels' phrase "the workers are political by nature," which is modeled on the Aristotelian definition of the political, and signifies nothing other than "the workers are citizens by nature." Clearly, I have not ceased to think that citizenship is an important theme; but today I am no longer sure that it is the sole aspect of the problem of politics. Violence, identity conflicts, and above all the combination of the two, oblige us to reflect on other dimensions. Alongside the problem of social and political citizenship, I think there is also the problem of civility, even if the two are closely intertwined.

> **JEAN-FRANÇOIS CHEVRIER** Yes, precisely because the new relativism concerning the models of the nation-state and the new forms of the state induced by the world-economy lead us to pose the question of identities more radically.

>> **CATHERINE DAVID** One can then recall that the question of identity is modeled in roughly two ways. On one side is the Anglo-American tendency to conceive of identity as a package, with a collection of inherited items (color, social class, etc.). On the other side is the traditional, dialectical tendency, which considers identity as a process. There have also been attempts to reopen the question of identity on the basis of the subject in psychoanalysis, to show that the problem of minorities should be relocated in the intersubjective dimension. Here the preestablished markers are not necessarily the most constraining, nor the most active.

ETIENNE BALIBAR In any case, the question of identity is objectively difficult, because it cannot be solved with a discourse in favor of identity or with a discourse against it. The abstract dichotomy of culturalism or universalism, which is omnipresent today, is completely sterile. Even the works of Deleuze which I like to quote, and whose immense intelligence consists in working not with the word "identity" but with the terms "minority" and "becoming," are nonetheless haunted by the fantasy of the dissolution of identities, or at least their fluidity.[5] Indeed, the cultural or ethnocultural identities whose existing models you have recalled are not the only ones I have in mind. Religion as such is not exactly culture (neither in the sense of *Bildung* or in the sense of *Kultur*). Nationality isn't either. They are objective *and* subjective identities, closer to the symbolic, whereas culture largely has to do with the imaginary. That said, the question of why a given group prevails over all the others, and why it succeeds in domesticating them, is a historical question: one cannot give a deductive answer. I tend to think that first, the perceptions we have of these problems are constantly warped by ethnocentric biases. The assignation of identities is completely projective; in the immense majority of cases, identity is seen in the other but not in oneself, except after a transition to the phase where identity becomes a slogan of empowerment, in which case it turns aggressive, defensive, or both at once. The extreme form of that is self-racialization. So I quite agree with you when you speak of a process of identification, indeed, I think what we have are always phenomena of identification, but they are not limited to ethnic identifications.

> **NADIA TAZI** Don't you think that the very context of the crisis affects the way the question of identity is

posed? Isn't there an analogy between the question of identity and that of the body, in the sense that no one bothers trying to find out what health is as long as they are not ill . . .

ETIENNE BALIBAR Without playing at deconstruction, we would have to begin by asking what is meant by crisis. What is going wrong? When do we know it's going wrong? Of course, the suffering, the malaise, the disease are expressed either mutely or violently, and they are incontestable, undeniable. On the other hand, in the realm of social or collective life, and even in its cultural and aesthetic dimensions, one is nonetheless obliged to ask *who* expresses the malaise, in what language, for what reason, etc. And *for whom* these diagnoses are formulated.

What is certain is that "normality" cannot be separated from the hierarchization of identities. The great hegemonic, rational, political-philosophical mechanisms, which are precisely what fabricate normality, with the consent of the group concerned—for example, the universal religions, or democratic secularism— are not totalitarian mechanisms. If all domination is confused with totalitarianism, you end up at a loss before both. But it is true that when these mechanisms go into crisis, one of the things that destabilizes our view of history is an awareness that the cyclical succession of crises and organic phases, or phases of "normality," no longer fits the times. Globalization itself forces us to realize that religious universality is still in crisis (it hasn't ceased being so and may never cease being so). And yet at exactly the same time, secular universality—that is, a fundamentally political or juridicopolitical universality, whose principles are the nation-state and the formation of individuals by means of rights, science, education, and citizenship—is also in crisis. In short, one of the two crises is beginning, the other continues, and both of them overlap. Some people try to flee the one by denying the other: we see a return of the religious, to the very degree that the political collapses. Others, on the contrary, turn to a democratic fundamentalism, because there is a threat from the religious. But a major aspect of the problem of individual identity certainly resides in the fact that these mechanisms are above all mechanisms for the construction of collective identities. And at the risk of appearing conservative, I will say that absolute fluctuation, the anarchy of identities, is no more viable for the subjects concerned than totalitarianism or absolute coercion.

In my opinion, the mechanism of identification is always the same, the idealization of the national or quasi-national community always proceeds in the same fashion. And one mustn't think the bloodiest and most barbaric or most oppressive forms are bereft of the idealism that is usually associated with the term "patriotism." I don't want to amalgamate all the phenomena of patriotism, nationalism, ethnocentrism, and culturalism, as though they all produced the same effects everywhere. Nonetheless, it must be said that there does not exist a line of demarcation traced once and for all between the "good" and the "bad." Now, what's striking to see, above all among historians but also among political philosophers, is that they all practice the same essentialist reasoning: nationalism is one thing, patriotism another, and the two must not be confused—an idea that is particularly widespread in France, where patriotism is imbued with its own universalism, with its links to the "fatherland of human rights." But what furnishes the material for our political reflection right now is not the theoretical schemata, but the analysis of concrete circumstances. For they are what determine the hegemonic identities, they are what trace the demarcation between a liberating patriotism or nationalism and an oppressive patriotism or nationalism. "Everything depends on the conditions," as Althusser said.

In this sense, Wallerstein is quite right to adopt the immediately globalist Braudelian models, where the political form is not studied for itself in isolation, but insofar as it is the product of certain concrete conditions. The nation-state of the European type is a political form which was only able to impose itself under certain conditions in the dominated regions of the world-system, while remaining impossible elsewhere. It was structurally linked to "unequal development." Whereas the political dogma of colonialism and postcolonialism said that if it was possible in one place it was possible everywhere. Perhaps the situation today tends to reverse: the nation-state becomes "peripheral."

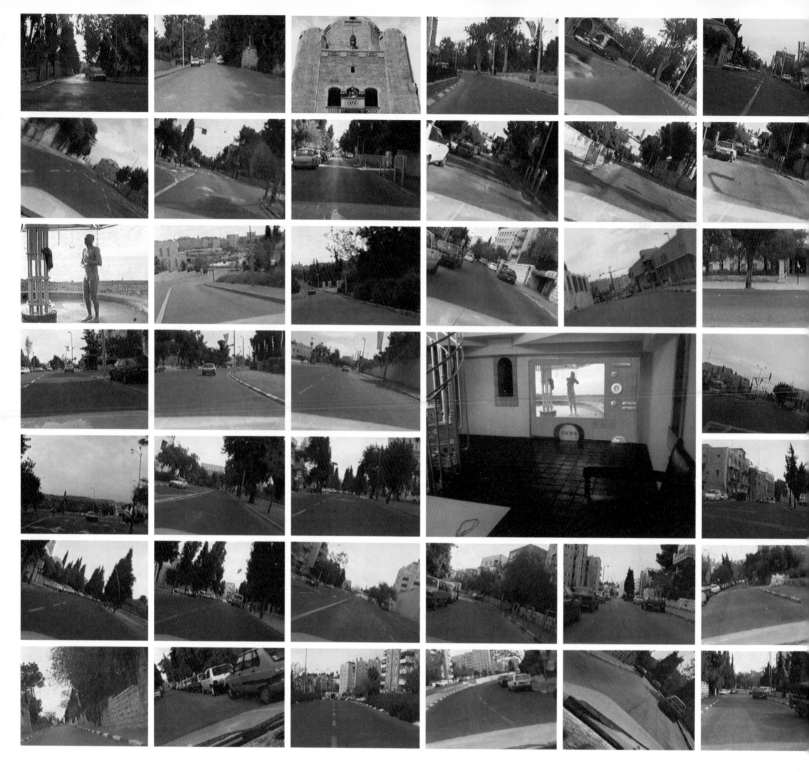

AYA & GAL MIDDLE EAST The naturalize / Local Observation Point

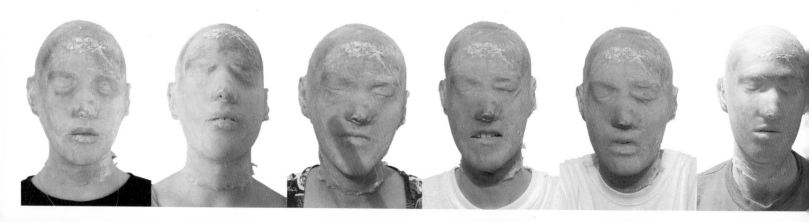

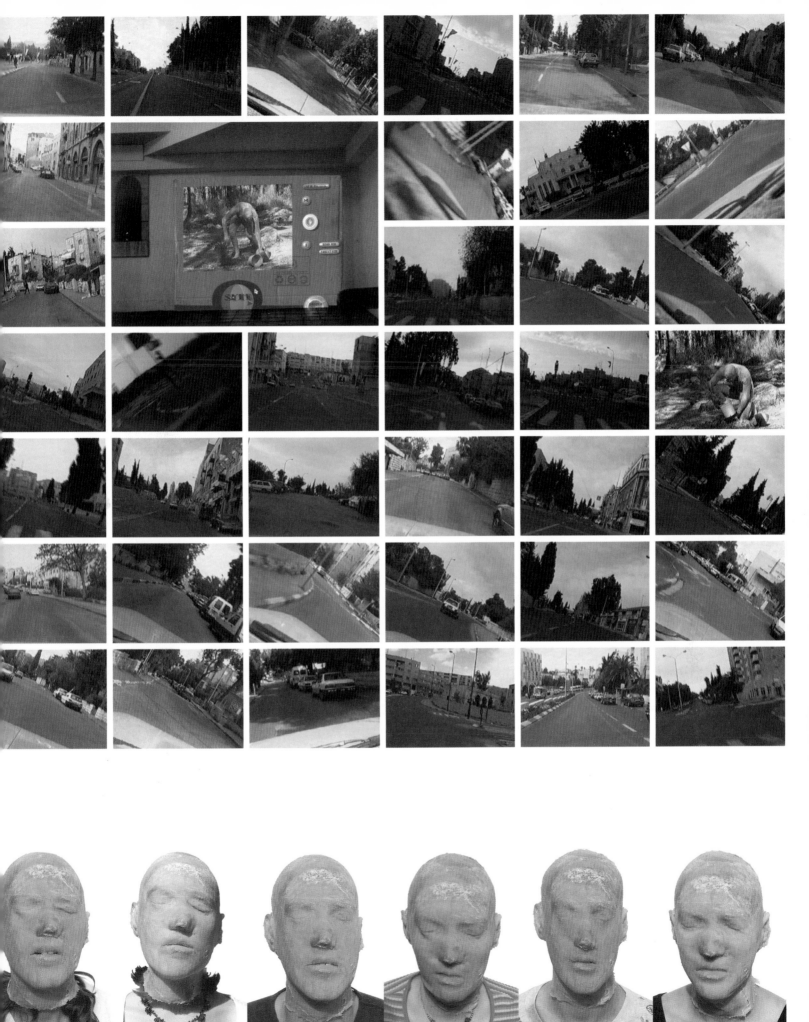

JEAN-FRANÇOIS CHEVRIER But in the context of globalization, the form of the nation-state tends to be relativized. We witness the return in force of city-states, regional phenomena. As the old forms unravel, all kinds of new entities are being woven together, new dimensions, which have greatly developed in Asian lands. Correlatively, the definition of the state undergoes an objective displacement such that the notion of the state pulls farther and farther away from that of the nation, yet without being reduced to nothingness—just look at Singapore, which is a veritable state. We could also take the example of Los Angeles, where a Chinese-"American" community which does not even aspire to any political participation in the American nation functions in an economic network with Hong Kong and Singapore as much as with other sites on the national territory. The identity of this community is American in the cultural sense of the term, at least if one considers American culture to develop through a process of hybridization. And in reality, this community does not at all constitute itself within the formal schema of the nation-state, but within a network of economic interests and cultural identifications. Isn't this a major shift in the question of identities, and do we still have the means to respond to it with the philosophical language that is ours in the West? Does the Western and primarily European model of the citizen, with its ideal of openness to the other, give us any purchase on this new reality?

ETIENNE BALIBAR The difficulty I have in answering you is that like all those who express their views on immigration and on the crisis of the nation-state, I can only judge from the tendency observable at present. But every tendency calls up "counter-tendencies." No single tendency is ever fully realized, and it could almost be said that this is a historical law which no "materialist" should ever neglect. I don't think I possess any privileged diagnostic or predictive tools in the matter; my work operates at the second degree, it is deconstructivist, almost "talmudic," it concerns the categories which our contemporaries are applying to such problems. At this point, what is striking for public opinion is that the Asian communities in California are already in the postnational era, in the sense that the space in which they are situated, which determines them and assigns them a function, is no longer the American national space, but a trans-Pacific space. This does not mean that their singular position foretells the world's future. But it is an index among many others of the fact that national identities are no longer hegemonic, they are no longer the only ones to "regulate" the system of community ties.

JEAN-FRANÇOIS CHEVRIER Whatever fundamental redistributions you choose to consider, there nonetheless subsists a European dimension where ethnopolitical identity is also at stake.

ETIENNE BALIBAR I recently took part in a debate with Franco-Arab sociologists and militants on the theme of the "new citizenship," meaning a citizenship that overflows the framework of the state and therefore also the purely national framework, running at once beneath and beyond it.[6] On the one hand, you have the idea of the *Bürgerinitiativen* translated into French terms, the terms of the associative movement and of civil society; on the other, you have European citizenship. For various reasons, I tried to theorize European citizenship: is it possible, on what conditions, where are its adversaries?[7] The adversary of European citizenship is the nationalism of each of the European countries, and I tried to show that if nationalism doesn't budge, if people remain satisfied with the status quo, first, the result will be apartheid on a European level, and second, the whole thing will veer toward failure. I'm still ready to write about immigrant voting rights as I did in the eighties, but it is true that I am not sure that the problem of the public or the political sphere on the European level is solely a problem of citizenship, even if one understands citizenship as something much broader than the question of the right to vote and the identity card. I would like to avoid falsely "Gramscian" platitudes which consist in adding the habitual supplement: saying that the problem is not only political, but also cultural.

In this case, the philosopher is a *bricoleur*. He tries to fit old concepts into a new configuration. Presently I'm trying to begin with the idea that the cultural and the economic don't necessarily go hand in hand. Let's return to the example we touched on above: the Californian-Asian communities living

together in a trans-Pacific space. Now, Asian civilization counts among the most powerful that world history has produced. It has proved capable of maintaining the symbols of a specific social tie; and what for the moment is a tool of resistance and of internal cohesion can later become a tool of adaptation and economic expansion. That remark holds for all sorts of communities throughout history. What was true for the Catholic Polish miner living in Lorraine in the thirties, in a certain European context and with certain objectives of class solidarity, is also true, or even truer, for Chinese migrating within the framework of the internationalization of commerce in the Pacific zone and thereby bursting open some of the closures of American space. But that makes it even more necessary to be clear about what we mean by "cultural."

Fundamentally, the word "cultural" is used to understand the close fit between a group's ways of living and the representations which are the mirror of its self-recognition. This is why we speak of "cultural distance," "cultural crisis," "cultural explosion," etc. Now, I tend to think that path leads nowhere, and for my theoretical bricolage I try instead to use a model inspired by Lacan's three functions: the real, the symbolic, and the imaginary. If the real is the economic, then there are some extremely violent processes for the restructuring of social and human groups. To be sure, the class struggle has not disappeared— but it may have moved relatively further into the background. The major phenomenon of the "real" today is globalization; there are more and more minorities; the collective interests of groups are no longer principally situated within states, but in larger spaces, and they are being powerfully restructured. There are those who adapt well to transnationalization, and others who do not; one can expect the latter to have extremely violent reactions.

On the other hand, there are so-called "cultural" phenomena, and that is where distinctions seem extremely important to me. When people speak of Americanization, for example, the strongest points of friction are not situated on the cultural level, because there is an American culture just as there is a European culture . . .

JEAN-FRANÇOIS CHEVRIER Do these points of friction involve what Americans call pop culture—not pop art, but the media, and a certain lifestyle determined by identification with media norms?

ETIENNE BALIBAR Yes, in my portable Lacan that's what I call the imaginary, the identifications. But the bloodiest things don't come from the imaginary, they come from the symbolic, that is, the fundamental benchmarks for the definition of a human subject, which always have universal pretensions and yet never exist in isolation. For example, I wrote a text on the "frontiers of Europe" at the time when a hotly debated trial in England had just ended with the sentencing of two children, six and seven years old, to lifetime imprisonment for the murder of a third child, younger still.[8] In the text I stressed how this trial was manifestly inscribed in a certain conception of human subjectivity and in fundamental questions such as What is a child? What is an adult? What does it mean to educate? What does it mean to punish?— questions over which the juridical tradition in Britain and the dominant tradition in France run the risk of absolute incomprehension. This is what I call, not a cultural difference, but a *symbolic difference* or a differential *trait of civilization*. I think there are other examples of the same type which ultimately make the idea of unifying the judicial systems unthinkable, particularly in the case of criminal law, with Anglo-American conceptions on the one side and Franco-German conceptions on the other. Despite the undeniable difficulties, it will always be possible to unify commercial law; on the contrary, conceiving what "crimes" and "punishments" are in two opposing moral traditions is far more difficult. There are splits at the very heart of the universal that have nothing to do with "cultural distance" in the sense the phrase can have in matters of immigration, mixed marriage, multiculturalism, etc., because from this viewpoint, one cannot get any "nearer" to one's "neighbors": this is the point where the conflicts are irreconcilable. So we need a second level of conceptualization. It is likely that the question of how relations between the sexes are defined, for example, is an absolutely crucial one. It is clear that although masculine dom-

ination is universally prevalent, there is not a single conception or univocal definition of sex in the world, nor even in Europe.

In short, if the problem of identities is among the most difficult of all, it is because it brings into play questions which are not situated at the same level. How does one fit into a sociopolitical hierarchy (the state, for example)? How should group cultural traditions be defined and understood? How does one consciously, but above all unconsciously, choose one's subjective position with respect to symbolic questions as crucial as knowing "what indignates," as Spinoza put it, or what is found cruel or judged worthy of sacrifice?

> **JEAN-FRANÇOIS CHEVRIER** Many observers amalgamate the two levels you distinguish, advancing the idea of a crisis of civilization, or, like Huntington, the idea of a conflict of civilizations: the West confronting its others, in particular its Asian others.[9]

ETIENNE BALIBAR Such things don't resonate the same way in all languages, even the closest languages. For example, I wrote a text on three political concepts: emancipation, transformation, and civility.[10] The use of the word "civility" rather than citizenship stressed that the concept was not to be immediately linked to the existence of the state or to particular forms of the state, but to a practice of politics that would be neither emancipation (the Declaration of the Rights of Man, the American Bill of Rights, and so on) nor transformation (the class struggle, in Marxian fashion, or the strategies of liberation for Foucault). I gave an excerpt of this text for translation into Italian. Now, in Italian *civiltà* translates both "civility" and "civilization." And indeed, the term *civiltà* is particularly interesting because it recalls a tradition from the renaissance in which the problem is both that of a balance between institutions and social forces and that of a certain use of art. An exercise of power and a practice of creation.

I would be tempted to say that what we most often understand in discussions on "culture" has nothing to do with the problems of *civiltà*, because culture is an idea that goes along with centralized education, with a hierarchy of the knowledgeable and the ignorant, with a direct or indirect system of state control over the formation of individual taste, and finally with the cultural market and therefore with the consumption of cultural goods. Of course there are distinct national traditions, there can be very violent clashes over the word "culture." Cultural difference and cultural uniformity are very powerful signs of recognition today in the field of political ideology. But in that domain it is neither a question of civilization nor of art (whether plastic art, literary art, or political art).

> **JEAN-FRANÇOIS CHEVRIER** Identity fixations search out symbolic and monumental representations. Nationalism has always produced ostentatious monuments. Since dada at least, the subversive dimension of avant-garde art has played with these symbols and fixations. But we could also speak of all the different plays on identity, whether social, sexual, or otherwise. Do you see any use in these models of a play on identity?

ETIENNE BALIBAR I'm still very Brechtian on that point, or rather, I would like to reintroduce the Brechtian schema, and in a double sense. First, the question of identification or distancing is not only a problem of theater, but of all the arts. Second, it is not only the problem of the spectacle and the spectator. Brecht, and Althusser's interpretations of Brecht, move away from the question of whether the actor's acting is such that the spectators must identify with the character he embodies.[11] Their idea is rather that the theatrical event as such—in the Western tradition in any case—simultaneously contains dissociation, the presentation of an image at a distance, and the shared implication of actor and spectator in a single scenario or "moment" of consciousness. The actor very clearly shows the fact that he or she is implicated; that the spectator should be equally implicated is what we might expect from a practice that no longer would be purely consumerist. Theorists have always explained that art as a mode of communication is a way of treating the problem of violence, or of anxiety, or of terror, and that the question is why such an activity is indispensable, in forms which persevere from highest antiquity but which must ceaselessly be

reinvented and revolutionized. The reason why is precisely because art is not culture, in the sense of a cultural supplement, a prosthetic for "the social tie."

JEAN-FRANÇOIS CHEVRIER What you're pointing to is not the artistic institution, the instituted artwork, but something like the outbreak of art, the artistic event, the invention of a thing that will be called art.

ETIENNE BALIBAR It's the artistic event, and at the same time, the fact that art as an object, or as a product, as a practice within an institution, still creates an event. It is the contradiction between the group and a new beginning, between community and discord or at least debate.

CATHERINE DAVID Where is this outbreak today, when the force of the cultural institution and the culture industry is so great?

JEAN-FRANÇOIS CHEVRIER It is significant that philosophers of the political like yourself should come to speak about art. Foucault already said that what interested him was not the artistic institution, but on the contrary, the processes of subjectivization.

ETIENNE BALIBAR There are many things that fascinate us in the production of art: the impossibility of a synthesis of the arts and the impossibility that each should be autonomous. For example, the fact that cinema and theater are so close and at the same time so opposed to each other in the ways they function, to the point where it can be said that each is the lack of the other. Over the space of a few years we moved from the thematics of alienation to the thematics of alterity; the sign has been reversed. It is no longer a question of alienating oneself or overcoming one's alienation, but instead of knowing what one makes of alterity. The entire post-Nietzschean tradition—and in particular I'm thinking of Deleuze's *Presentation of Sacher Masoch*—suggests that one should play with alterity; but the question then arises of who plays with alterity, how, and with what instruments. The instruments are necessarily, in the broad sense, those of representation.

[1] See Poulantzas, Nicos: *L'Etat, le pouvoir, le socialisme* (Paris: PUF, 1981).

[2] For an introduction, see Wallerstein, Immanuel: *Historical Capitalism* (London: Verso, 1983). For Wallerstein's full developments of this idea, see: *The Capitalist World-Economy* (Cambridge: Cambridge University Press, 1979); *The Politics of the World-Economy* (Cambridge: Cambridge University Press, 1984); *The Modern World-System*, vol. III: *The Second Era of Great Expansion of the Capitalist World-Economy*, 1730-1840s (New York: Academic Press, 1988).

[3] This idea is taken from the work by Lavau, Georges: *A quoi sert le parti communiste français?* (Paris: Fayard, 1981), which in turn refers to Machiavelli's *Discourse on Livy's First Decade*.

[4] Balibar, Etienne: *Les frontières de la démocratie* (Paris: La Découverte, 1992).

[5] See Deleuze, Gilles, and Guattari, Felix: *A Thousand Plateaus: Capitalism and Schizophrenia* (Minneapolis and London: University of Minnesota Press, 1988).

[6] Bouamama, Saïd; Coreiro, Albano; and Roux, Michel: *La citoyenneté dans tous ses états: de l'immigration à la nouvelle citoyenneté* (Paris: l'Harmattan, 1992).

[7] See the volume edited by Theret, Bruno: *L'Etat, la finance et le social: Souveraineté nationale et communauté européenne* (Paris: La Découverte, 1995).

[8] "Les frontières de l'Europe," 1995, reprinted in Balibar, Etienne: *La crainte des masses* (Paris: Galilée, 1997).

[9] Huntington, Samuel P.: *The Clash of Civilizations and the Remaking of the World Order* (New York: Simon and Schuster, 1996).

[10] Published in *Les Temps Modernes* 587, 1996; reprinted in *La crainte des masses*.

[11] Althusser, Louis: "The 'Piccolo Teatro': Bertolazzi and Brecht," in *For Marx* (New York: Vintage, 1970). Also see the essay by Denis Guenoun, *Le théâtre est-il nécessaire?* (forthcoming from Editions Circé).

SKYBOOKS

In the public squares laid out near the garden where the workers or (creators, as they had begun to ation, high while books opened against the dark sky. The squares were always full of crowds, and commune brought the latest news to the public by means of shadow printing on shadow books, p ow text by means of the projector's dazzling eye. Newsflashes about Planet Earth, the activities of th munes known as the United Encampments of Asia, poetry and the instantaneous inspirations of n ence, notifications for relatives and next of kin, directives from the soviets. Those who were inspire munications were able to go off for a moment, write down their own inspirations, and half an hou jected onto those walls in shadow letters by means of the light lens. In cloudy weather the clouds the the latest news projected directly onto them. Many people requested that news of their deaths be f

SCIENCE OF THE INDIVIDUAL - MAPPING OF LADOMIR

The redefinition of social and individual terms and the subsequent mate rialisation of their redefined status in new evolutionary conditions, demands appropriate physical, psychic and material preparation.

PROJEKT ATOL tries to enable the creative communication of individual forces to converge into a scientific/psychic entity, that would in its last stage result in the creation of an insulated/isolated environment - space/time. Insulation/isolation is understood as a vehicle to achieve independence from, and reflection of the actual entropic social conditions. The environment will serve as a development surface for the further formation of new creative social, spiritual and economic relations, based solely on integral individuality.

LADOMIR-ФАКТУРА is the first, training stage of the project pointing the way towards the achievement of final PROJEKT ATOL goals.
- Communication will be developed through technological representational (awareness of fiction/non fiction) and pedagogical systems.
- Insulation/isolation autonomy (a new category) will be achieved through energy/material and space/time autonomy and independence.
- The de-materialisation of logos will be replaced by the logoization of the material.
- Methods for the augmentation of maximum sensory awareness and sensory connection will be used throughout the work.

LADOMIR-ФАКТУРА is not only a work of art (with the limitations of that term) but progressive activity in time, based on the belief that ritualization of utopian conditions and forms and their projection in real space/time leads to concrete social evolution in the intermediate environment. This can then overcome the ever-actual discontinuity between

COMMUNICATION SUITE

Fly, human constellation
Ever farther into space
And pour the earth's dialects together
Into a single dialogue of mortals.
Where a blast of the heavens is like a swarm of stars,
Like the breast of the last Romanov,
A tramp of thought and friend of rakes
Forges the constellation anew.
This is the creatocracy marching
(Having substituted C for A)
The gatherhood of Ladomir

With the workingworld at the helm.
This is Razin's rebellionFlying into the sky over Nevsky,
It allures both the sketch
And the space of Lobachevsky.
Let Lobachevsky's level curves
Adorn the cities
Like an arc over the toiling neck
Of Worldwide labor.
And lightning will sob
That is scurries like a servant,
And there will be no one to sell
A tight sack of gold to.
Death's death will know
The hour of its return
And the earth's repetitious prophets
Will banish the redundant letter.

I discovered the pure Laws of Time in 1920 in Baku, the land of fires in a tall building that housed the naval dormitory where I was livin date was December seventeenth. I first resolved to search out the Laws of Time on the day after the battle of Tsushima, when news of t district where I was then living, in the village of Burnakino, at Kuznetsov's.

I wanted to discover the reason for all those deaths. The first truths about space sought the force of social law in the surveyor's art, in ord circular or triangular plots, or to make an equitable division among the inheritors of a piece of land. T points of support or the equitable demarcation of generations, and transfer the desire for equity and lav time. But in this case as well, the motivating force is that same old desire for equity, the division o Humanity, as a phenomenon caught up in the flow of time, was aware of the power of time's pure laws, strengthened by recurring and opposed dogmas, all attempting to depict the essence of time with the p

LIVING QUARTERS

ENERGY MODULE

HYGIENE SYSTEMS

STORAGE

OBSERVERS QUARTERS

vent for recre-
the creators'
ropriate shad-
workers' com-
roughs in sci-
ow-book com-
messages pro-
d as screens,
louds. **VH**

tegories of art and natural, social and spiritual sciences and in turn
rge in a wider definition, an optimal landscape of free creativity and
al individuality.

ork is being developed in three stages:

first stage consists of the engineering and projecting process
cture planning, construction of instruments and gears, construc-
planning, artistic material planning, historical research, program-
).

second stage is the particular materialisation of these processes
and taking advantage of different media, (performance, lectures,
entations, data media, publications, video) with the purpose of
lishing a dialogue with a wider context.

third stage is the materialisation of the LADOMIR-ФAKTYPA mod-
autonomous constructions and environments in nature, with open
munication lines and memorisation and reflection modules.

, the mapping of LADOMIR will begin in real space/time and the
vation and evolution of the science of the individual will take place.
)

MICRO-ECOSYSTEMS

TERRITORY MAPPING SYSTEM

SENSORS

TELEMETRY

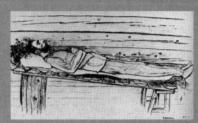

ky. The exact
the Yaroslavl

he taxes upon
out time seek
ension, that of
time-estates.
tionality were

CONTROL CONSOLE

* Grow edible microscopic organisms in lakes. Every lake will become a kettle of ready-made soup that only needs to be heated. Contented people will lie about on the shores, swimming and having dinner. The food of the future.
* Effect the exchange of labor and services by means of an exchange of heartbeats. Estimate every task in terms of heartbeats-the monetary unit of the future, in which all individuals are equally wealthy. Take 365 times 317 as the median number of heartbeats in any twenty-four-hour period.
* Use this same unit of exchange to compute international trade.
* Let air travel and wireless communication be the two legs humanity stands on. And let's see what the consequences will be.
* Devise the art of waking easily from dreams.
* Remembering that n with zero exponent is the sign for a point, n with exponent one the sign for straight line, n with exponent two and n with exponent three the signs for area and volume, find the space of the fractional powers: n with exponent one half, n with exponent two thirths, n with exponent one thirth. Where are they? Understand forces as the powers of space, proceeding from the fact that a force is the reason for the movement of a point, the movement of a point creates a straight line, the movement of a line creates area, and the conversion of point to line and line to area is accomplished by the increase of the power from zero to one and from one to two.
* Usher in everywhere, instead of the concept of space, the concept of time. For instance, wars on Planet Earth between generations, wars in the trenches of time.
* Reform of the housing laws and relations, the right to have a room of your own in any city whatsoever and the right to move where ever you want (the right to a domicile without restrictions in space). Humanity in the age of air travel cannot place limits on the right of its members to a private, personal space.
* Establish recognized classes of geagogues and superstates.
* Effect an innovation in land ownership, recognizing that the amount of land required for individual ownership cannot be less that the total surface of Planet Earth. Conflicts between governments will thus be resolved.
* Use heartbeats as the units of measurement for the rights and obligations of human labor. The heartbeat is the monetary unit of the future. Doctors are the paymasters of the future. Hunger and health are account books, and bright eyes and happiness are the receipts.
* Base a new system of measurement on these principles: the dimensions of Planet Earth in time, space, and energy to be recognized as the initial unit, with a chain of quantities diminished 365 times by the derivatives a, a divided by 365, a divided by 365 square. This method eliminates the stupidity of seconds and minutes, while preservng the solar day, divided now into 365 parts; each of these "day days" will equal 237 seconds ; the next smaller unit will be 0.65 seconds.
The unit of area will be 59 square centimeters, or K divided by 365 exponented with 7, where K equals the earth's surface.
The unit of length will be R divided by 365 exponented with 3, or 13 centimeters, where R equals the earth's radius. Similarly for weight and energy. What will happen is that many quantities will be expressed by the unit number.
* Arrange for the gradual transfer of power to the starry sky...
* Let the oriental carpet of names, and governments dissolve into the ray of humanity.
* The universe considered as a ray. You are a construct of space. We are a construct of time.**VH**

DOC21069974007RFP108109B111069ATMARKOPELJHAN

velimir hlebnikov ■ boštjan hvala ■ borja jelič ■ jurij krpan ■ brian springer
manakyan t.g. ■ valius s.v. ■ geta s.a. ■ sokolov a.k. ■ sivukha v.n. ■ utenkov d.m.
m. sterligova ■ projekt atol communication technologies ■ ljudmila ■ christian mass
paintings © mmk ■ english translation: paul schmidt ■ http://makrolab.ljudmila.org

Etienne Balibar

Globalization / Civilization

Part 2

ETIENNE BALIBAR To begin I'm going to list, in the order of their appearance, the three central theoretical, political, and philosophical problems that form the core of the previous interview, after the exchanges dealing with my intellectual biography. These three moments constitute a kind of progression: "Citizenship and Nationality," "Identity and Politics," "Art, Culture, and Civilization."

Citizenship and Nationality

What kinds of relations are knitted between these two notions? For some fifteen years now, one thing has appeared particularly clear in the French context, and more broadly, in Europe. Citizenship and nationality have a single, indissociable institutional base. They are organized as a function of each other within an ensemble of institutions, of rights and obligations, some operating on an everyday level, others more general and abstract. This tissue of obligations includes signs of recognition, symbols, places of memory like the Pantheon in Paris (which is a major symbol of citizenship and nationality, particularly characteristic of the French tradition). Now, the thing that appears so strikingly clear is the following: this tightly knit historical solidarity of citizenship and nationality has become problematic, such that each of our national intellectual traditions has been obliged to ask why and to what ends these two notions have been so closely identified. The question then arises as to how we might try to anticipate their future evolution. There are catastrophic visions resting on the postulate that the two notions cannot be separated, which means that the crisis of nationality is also a crisis of citizenship. There are more subtly differentiated visions which inquire first into politics and its possible evolution: what it has been and what it could be in the globalized world. Of course this question has to deal with basic principles, but above all it has to take

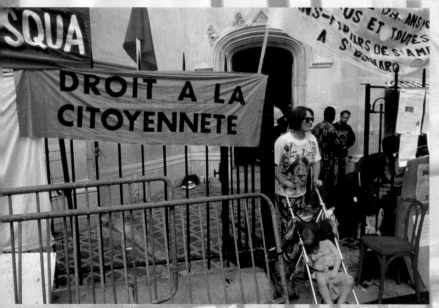

Demonstration for civil rights, Paris, August 1996

This presentation by Etienne Balibar and the discussion that follows took place in the context of Jean-François Chevrier's seminar at the School of Fine Arts in Paris on January 6, 1997, as a follow-up to the preceding interview (part 1). Both texts were transcribed by Valérie Picaudé and edited by Etienne Balibar.

stock of concrete objects in which specific things are at stake, things demanding that one take a stance, things that will no doubt provoke conflicts. Let's take the example of immigration. Does the question of the citizenship of immigrants, of foreigners, have a meaning, and if so, what is it? This is not a purely theoretical problem, but also a strategic and tactical one: the demand for a transnational, postnational, ultranational citizenship must be discussed and given a clearly defined content. This is the only way to provide a democratic answer to reactionary trends which are already moving toward violent racism, or are situated in that blurry and decisive transitional zone from nationalism to racism, as expressed in slogans like "national preference" [whereby the French National Front designates its policy of hiring only whites —Tr.]. That said, I do not believe that immigration is the only concrete problem that raises the question of a reorganization of relations between citizenship and nationality within the framework of globalization that we must analyze. Recently I, like a number of others, have come to think that the status of the *border* is one of the key questions. How is it experienced? What type of coercion does it impose? What is its institutional definition? What is its democratic or nondemocratic character? What kind of control can be exercised over the state's management of borders, over the way the states use borders to control populations? Of course this problem is not without its links to immigration, but it steers us toward other reflections. I remember the nice title of a review which made useful contributions to the debates on French society in the 1980s: *Sans Frontières*. The title reinvigorated a cosmopolitan tradition, more libertarian than internationalist; it also served as a slogan. While I don't think that we are headed toward a world without borders or some kind of "postnational" humanity, I am persuaded that the current status of borders is an untenable archaism; the whole question is in what direction the evolution of borders should proceed. The fact is that there is an intensification of the tensions between a police logic and a democratic logic. The fate of what was formerly called cosmopolitanism or internationalism is now being played out over the very concrete matters of family status and the right to political asylum.

This first set of core problems can be explored in a historical perspective. Where do the current forms come from? What are their causes, and into what are they like-

ly to evolve? What are the alternatives? On the other hand, how can we understand the violence that accompanies the various manifestations of these problems?

Identity and Politics

To what extent does the conflict of identities constitute a fundamental dimension of politics? Here our discussion takes two principal directions:

1. *Shall we speak of identities or processes of identification?* I note that the participants in the first discussion establish an implicit and perhaps overhasty accord on the idea that identities are not given, that they are not natural—not even in the sense of that pseudonature which is called "history." This accord stems from our desire to shake off the fetishism of identities whereby everyone tautologically identifies with their identities, or at least with some of their identities. Such fetishism can of course be criticized, both in the tradition of the critique of political economy elaborated by Marx and in the tradition of culture critique or the critique of accepted values, as received from Nietzsche. But we must explore the processes of identification insofar as they have at once an institutional side—for there is no identification outside of an institutional frame, identification being a matter of recognizing oneself in rites and beliefs, of associating and ultimately correlating an identity with the multiplicity of belongings, hence the "ambiguity of identities"—and a subjective side, for identification is always a subjectivization, a way for the subject to choose him or herself, to orient or construct herself, to accept or refuse himself.

2. *The question of hegemony.* This question concerns what Bourdieu calls symbolic capital, or what the German sociological tradition from Weber to Habermas calls rationality. This sociological tradition supposes that there are models of rationality, that is, models of conduct which at the same time are models for thinking, ways of collectively instituting communication, a representation of the world. For my part I use the term "hegemony," which I inherit from Gramsci but also from contemporary Anglo-American discussions of pluralism. I want to emphasize the strong tension stemming from the fact that the construction of identities is always violent, or in any case, coercive; it is the process of constructing an ideological hegemony. All the historical

societies in which there have existed states, civilizations, or cultural norms, are societies which present this kind of coercion. This does not mean that revolts or heresies disappear to the profit of an absolute uniformity. What we observe is the inverse: it is precisely because the educational constraint or the normalizing pressure of culture is so strong that revolts sometimes break out. But unlike Marcuse in his critique of bourgeois culture, I insist on the notion that hegemony is not the same as a totalitarian universe. The patriotism, or nationalism, without which nation-states would not hold together is a violently coercive "total" ideology, but as a general rule it is not totalitarian. The great universalistic religions, Christianity or Islam, were extremely coercive in the time of their hegemony, but they were not totalitarian in the strict sense of the term. The mechanism of hegemony is, instead, a way of accommodating pluralism, it is the construction of a universe where there is room for differences. In the interview as it stands, these questions culminate in the outlines of a reflection on crisis and normalcy. More precisely, my interlocutors ask me what happens when a hegemony enters a state of crisis; but I tend to shift the question from crisis to normalcy. The sense of crisis does not only emerge on the political and institutional levels, as a result of the fact that the hegemonies or "total ideologies" follow each other and transform each other, just as national secularism has replaced traditional religious hegemony; the sense of crisis also emerges from the fact that hegemony is always a system for the normalization of behavior and of the self. Unfortunately we did not discuss the problematic rapport of the political and the religious: is the return of the religious the symptom of a very old crisis, or on the contrary, the manifestation of a new crisis? Here arise the most enigmatic questions, and the ones which are most interesting for my interlocutors. Indeed, first there was the hegemony of the religious world, then that of the state (principally in its national form, even if alternative forms of the state existed and still exist); and now we have the hegemonic reign of the globalized market. Is this hegemony also a new normality, an institutional process of normalization, or is it a perpetuation of the crisis and the instability of identities? It could be that in this case, the sense of crisis paradoxically stems both from the way the all-powerful market dissolves the old hegemonies and from its own incapacity to institute a hegemonic culture, a totalization of "meaning."

Art, Culture, and Civilization

Here I am uncertain of the appropriate language. My feeling is that on this point, our research is essentially terminological. What I sketch out is a deconstruction of the notion of difference: not using difference as an instrument of deconstruction (that has been very common in philosophical debate for a number of years: wherever identity seemed to reign, the universality of difference is brought to the fore), but instead, criticizing the very notion of difference. Indeed, the problem is to know what a culture is, what we designate by that word. Let us begin with an initial, negative proposition on which we can try to achieve agreement: the economy is not everything, even if weighs tremendously heavy in the scales, for instance through the emergence of national or transnational forms of communication; more precisely, the economy only produces its effects on the express condition of its translation into propositions, inventions, etc., which are deployed on another stage. Now, what should we call this "other stage"? The magic word here seems to be "culture," which is why we speak of cultural homogenization or differentiation, cultural uniformity, cultural multiplicity. Is globalization a great process of cultural leveling, or on the contrary, an outburst of differences?

At bottom, this problematic leaves me unsatisfied, and that is why I question the operative notions themselves: "culture" and "difference." Maybe all these differences are not cultural, or maybe there are profound antitheses at the heart of all these so-called cultural differences. The political stakes are immediate, if only in the discourse of the "cultural distance" that is said to exist between ethnic or social groups (in fact, many groups are simultaneously characterized both as ethnic and social groups, as is particularly the case with "immigrant workers," for whom the Germans have invented that extraordinary euphemism, *Gastarbeiter*). I use a terminology of Lacanian origin to distinguish the *imaginary* from the *symbolic*. The imaginary is the projection of the self onto the other, in fascination and disgust. On this terrain there are indeed "distances," which are perceived as all the greater or more

conflictive insofar as they are constructed by more or less mythical and sometimes manipulated historical memories. For example, the image of the distance between West and East, between European and Arab, or between Frenchman and Algerian, is the product of all sorts of imaginary fabrications, as Edward Said showed in *Orientalism*. But the fact of considering only these kinds of differences covers up other differences which may be more difficult to overcome, for which I reserve the term of *symbolic differences or traits of civilization*. In my view, the differences do not always involve cultural traits, but sometimes have to do with traits of civilization. For example, the differences between the French judiciary system and the British judiciary system with respect to the ideal of humanity and of individual autonomy are much more irreconcilable than the cultural differences between the North African immigrants and the northern or southern French in matters of cooking, and more broadly of lifestyles. Here we touch on radical points of divergence between the way of conceiving wrongdoing, education, childhood (is the child always a victim or potentially responsible as well?). Every group treatment of these problems on both the political and intellectual levels must work through art and not through culture, in the sense that art is always irreducible to culture: art is an indigestible event, in rupture with all cultural and institutional tendencies. I'm thinking of *Antigone*, but theater has no absolute privilege in this respect. Rembrandt or Klee are equally indigestible. The important thing in art is to render the conflict dialectical, as held by a long tradition inherited from Hegel and extending to Brecht, and beyond, to Godard. Better yet: the important thing is to present or to represent that which is irreconcilable in the conflict (and perhaps that, at bottom, is what Marx called the "critical and revolutionary" side of the dialectic). However, the most decisive conflict to be rendered dialectical is not cultural conflict. That's why I don't see much importance in the films or plays that explain to us, in three acts, first the cultural conflicts that pit Arabs against French, then the meeting between the two, and finally their reconciliation in the discovery of their common humanity. Instead I look to the *Antigones* of our time, which try to approach the truly irreconcilable points in the representation of man or the human, the things that separate the civilizations one from the other while dividing them against themselves (though I don't necessarily claim that these civilizations must be identified with geographical zones or empires). Such works are indispensable and constitute a dimension of politics—a dimension which cannot be reduced to social politics, nor to economic politics, nor to the question of citizenship. What holds for the example of childhood also holds for the difference between the sexes. What holds for crime and punishment also holds for health and disease.

QUESTION Could you clarify the limit between what you call facts of culture and facts of civilization?

ETIENNE BALIBAR I have just admitted my disarray in the use of this terminology. I will not speak of facts of culture and facts of civilization, but of *traits* of culture and *traits* of civilization. Of course, the two kinds of traits are not perfectly separable from each other, as if they never coincided in practice. Simply, what I call a trait of culture designates the existence of community: it is that which makes individuals into a group and, subjectively, that which makes them identify to a greater or lesser degree with a sense of group belonging, through common stereotypes. But the raw material of this belonging is heterogeneous, built up of beliefs, interests, all the ways in which people represent a shared history: symbols, rituals, customs, popular arts and traditions. In general all these things are experienced as spontaneous, but in practice one realizes that to a large degree they are actually constructed and they evolve over time. I don't mean to claim that human groups could live without stereotypes, without shared cultural traits, but rather to stress the idea that such things are probably what evolve most rapidly. For example, French and British historians have worked very hard in recent years on what they call, in a voluntarily paradoxical way, *the invention of tradition*.[1] I think that the invention of tradition is at the heart of cultural difference. So you have all the traits considered characteristic of the regions in France, all the regional differences which make people identify themselves as French not only by abstract reference to national unity, but also through the intermediary of the province or the region, with their differences from Paris—which is a very important point in French national consciousness. These "authentic" things which supposedly come from a very deep past were, for the most part, fabricated or invented in the latter half of the nineteenth century. They are the group inventions of writers, of regionalist and sometimes even nationalist movements. We constantly

789

Anne-Marie Schneider, *Paris, Saint-Bernard, 23 août 1996*

observe transformations that are involved in cultural difference as understood in this sense, and I think it's worth discussing the idea that this is a field of projection for most of the discourses that bear on the incommunicable character of cultures, the perception of foreigners as impossible to assimilate, etc. But in fact, this is the area where the situations are the least frozen: they can be locally very conflictive, above all if they are overdetermined by class conflicts or instrumentalized by political and social interests. The "globalized" world is a world in which the capitalist mainlands of the "center" have slowly gotten used to experiencing what has never ceased going on elsewhere, particularly in the colonial societies, that is, the hybridization of cultures, the emergence of new cultural forms. That is the reason why the sociologists who have studied the *mestizo* societies of Latin

America—Bastide in Brazil, or Leiris in Martinique—or those who worked on religious syncretism in Africa, or on the origins of the rastafarian movement, are very interesting for us today. In principle, these are recreations of symbols of cultural belonging which are used to recognize oneself within a group, and to mark one's difference with respect to others. Ultimately, the global cities in which we live are the permanent seat of this phenomenon.

What about the trait of civilization, then? Here I'm very conscious that I'm walking a tightrope, because what I'm going to say risks feeding into certain exclusionary discourses on the incompatible character of major civilizations. One of the participants in the interview mentions the "war of civilizations" predicted by Huntington. I would like to refuse these globalizing visions, and at the same time suggest that there really are irreconcilable traits of civilization. But I do not say—not in the least—that these traits belong by their essence to certain *groups* of people. Rather I would be tempted to say that these traits are present everywhere. What are the stakes of these differences, which are comparable to what religions formerly called heresies (and indeed, it is striking that as religions have lost their hegemonic position, they have gradually renounced the use of the term)—what are the stakes of these differences which we are coming up against now and which we will always come up against again? They are metaphysical questions: the matter of believing in heaven or not, or deeper still, the manner of representing the difference between life and death, the way life is evaluated, with its influence on the major anthropological differences I mentioned a moment ago. It is clear that the so-called Western civilizations—and in this respect there is no difference between Christianity and Islam—do not have the same representation of the relations between life, thought, and nature, as the Eastern civilizations. Why did the idea of metempsychosis, of the great cycle of spirits entering and leaving nature, exist in the West for a time and finally disappear, to be replaced by the fundamental dualism of matter and soul? A certain number of technological transformations which we are undergoing today, linked to the possibility of using organs of human bodies after their death, and thus of transgressing the limit that separates one individual body from another, are no doubt of a nature to profoundly destabilize the representation that the West

Anne-Marie Schneider, Untitled, 1996

Anne-Marie Schneider, *Paris, Saint-Bernard, 23 août 1996*

has elaborated concerning life, death, and the individual. The difference of the sexes is another example. I would say that the question arises as to whether there are two sexes or more, whether the difference of sexes is indissociable from the difference of sexualities. Problems such as responsibility, guilt, the right to punish, the question whether the aim of punishment is to keep someone from doing further harm or, on the contrary, to reeducate the individual and even to save him from himself, constitute highly sensitive differences of civilization. Or again, the question whether there is a border line between health and disease, the "normal" and the "monstrous."

At the same time, I'd like to refute Huntington: there is no chance that fetishized differences of this type can serve as the banners around which world empires will

gather, that's a paranoid vision, it's a banal version of Orwell, and perverted too, because the three world empires Orwell discerned did not rest on distinct conceptions of the world, but were all constructions of power. Huntington, on the contrary, tells us that we are headed toward a war of civilizations which will set off the Christian West against Islam or the Far East, which is a pure political manipulation of cultural difference. And maybe a deliberate provocation.

On the other hand, the question of the status of women, and of the relation between sexual difference and religious belief, are at the heart of the problem of the Islamic veil and of the perceptions that the peoples of the northern and the southern Mediterranean have of each other; and these matters are not limited to questions of community belonging. One cannot skip over the underlying symbolic problem: what is a man, what is a woman? How has each great civilization worked out this difference, which is not "natural" (or just barely)? In such a case, one cannot do without art, whereas perhaps it is possible to account for cultural differences by way of education, politics, or social practice.

BRIAN HOLMES You suggested in the first interview that culture in the large sense, including the symbolic, is essentially unthinkable in economic terms, that culture is the "unthought" of the economy and vice-versa; and you went on to talk about diagnosing their relation. When the economy is conceived in purely liberal terms, as it is today, there is an increasing refusal to accept any kind of regulation based on other premises. It seems to me that the blind spot of economic thinking is indeed betrayed by this refusal of a regulation that is ultimately necessary even for the market to function. In Western civilization the notion of equality, with its double genealogy in a Christian sense of fraternity and justice on the one hand, and in a classical ideal of civic participation on the other, has no doubt become the most fundamental regulating force. Shouldn't we diagnose specific situations within the Western or Westernized world where the economic and the cultural clash, rather than always focusing on the clash of civilizations? Where do you diagnose this reciprocal inconceivability operating today?

ETIENNE BALIBAR Several languages blend together here without being unified, and their conflict is instructive, to the extent that it requires us to admit the limits of any functionalist discourse where economy and culture

791

Sigalit Landau

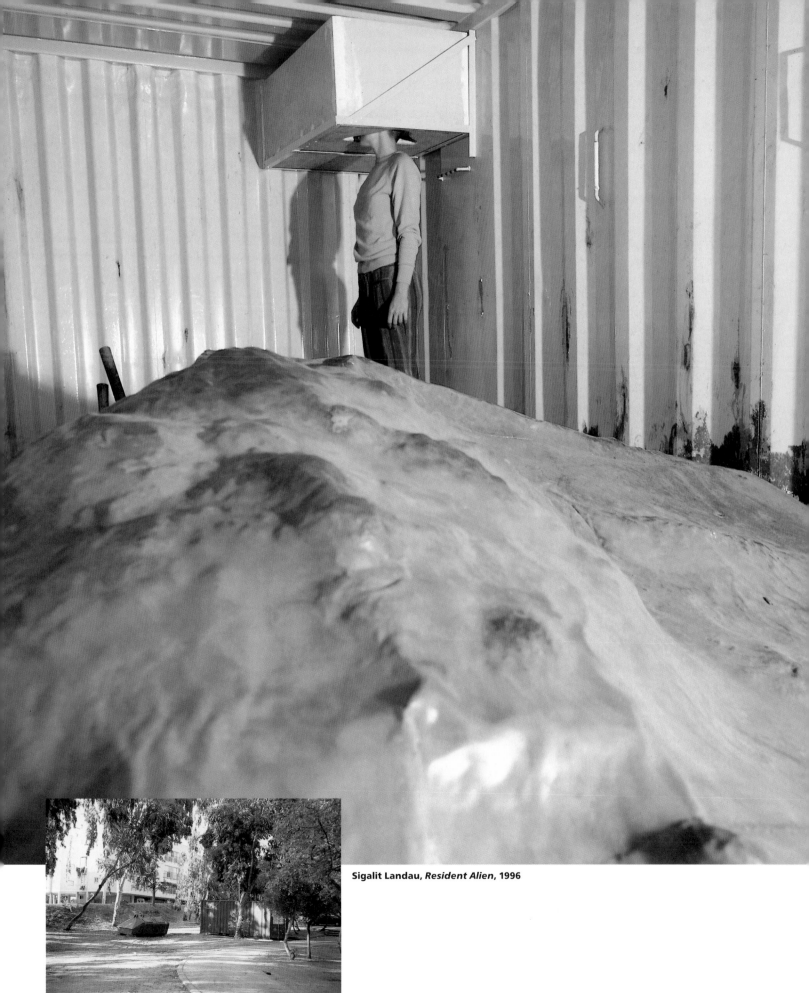

Sigalit Landau, *Resident Alien,* **1996**

directly "complement" each other, adapt to each other. On one side there is the expression of a violently reductionist language, which in many respects is salutary. I don't see any disadvantage, and quite to the contrary, in the fact that a certain "economism" should come into play here, and violently so. The violence is not in the theory, but in the facts—something which becomes particularly visible when one undertakes to explain that the whole system of what in French is called *différenciation ethnique*, and in English is called "race relations" and "race differences," is fundamentally *arbitrary*, historical, and rests only in a mythical way on any biological or even genealogical basis. In reality this is a way of coding differences of class and caste, differences of social status, at least when seen on a world scale. That is an extremely violent reductionism, since such a discourse ultimately comes down to explaining that colonialism is capitalism plus imperialism, and that the two of these invented and constructed the system for representing racial differences as a means to organize the differentiation of labor (and particularly the difference between "free" labor and "forced" labor, labor subjected to slavery or other kinds of bodily coercion, either in order to deport it elsewhere, or to stabilize it and enclose it locally). Everybody knows that the definition of a black man in the American South is different from the definition of a black man in the Antilles. That's the mainspring of Faulkner's astounding novel *Absalom, Absalom!* Wallerstein always quotes Genet's famous line in *Les Nègres*: "What is a black man, and first of all, what color is he?" In fact, the regimes of racial differentiation are always regimes of castes which have been constructed by capitalism and its expansion. That's a violently reductionist thesis, because when you look at the facts, the symbolic dimension of racial difference is completely instrumentalized.

Alongside that there are other stances, sometimes taken by the same authors, which consist in saying that throughout the world, the claim to cultural difference is the primary expression of resistance to the system. At its extremes this claim can take horrible forms, there are "slippages" (and I'm quite conscious of the obscene character of my words here). Ethnic cleansing, for instance, may be deplored as an abominable "slippage," but fundamentally, the claim to cultural identity is seen as a function of resistance against the hegemony of world capitalism. Even as he takes this tack, Wallerstein says something else which seems to go in exactly the opposite direction, namely that as the claims to identity proliferate in the context of globalization (but here one might better speak of the postcolonial world, which began to emerge some fifty years ago) and as such claims become the necessary channel for strategies of resistance or simply of autonomy, the differences become more and more superficial, until in reality they become indiscernible from each other. Local claims to specificity and "authentic" identity blossom everywhere against the great homogenizing systems, whether national or supranational: Indian identity in the United States, regional identities in France, the great world revolt against the institutions of uniformity (linguistic, artistic, etc.) . . . But in fact, the content is exactly the same everywhere: whatever distinguishes a claim to national or regional autonomy in the postcolonial context is absorbed back into a kind of antimodernity. Nothing has become more banal than the return to "traditions"—which, indeed, is something quite modern.

You say that the economy's inherent cultural foundation is unthinkable in economic terms . . . Yes, probably so, like everything which has to do with the "other stage." But here I think we must refer to specific institutions and historical facts. Where certain people spoke of the welfare state—a quintessentially apologetic notion, in which you are right to sense a Christian reference—others have more realistically spoken of a social state, and myself, I am among those who say that the social state is a national social state. I'm aware that the phrase is upsetting: I don't mean that the *national social* state is a *national socialist* state, but I do mean to suggest that we should examine together the two unequally viable and unequally acceptable forms that were taken by the political-economic development of the European societies in the mid-twentieth century, when it was time to set up what you call a regulation, at once economic and political. (I say two, but in fact with the "socialist" states, which as we know became more and more deeply nationalistic, there were at least three.) What I mean to say is that there never has been and never will be a pure liberal economy. What we are witnessing now is therefore surely not the return or the revenge of pure liberalism over the social state with its dimension of cultural integration. There is assuredly a liberal *discourse,* even a purist, fundamentalist liberal discourse, but this discourse should not be confused with

the *process* itself. Indeed, some economists are in fact interested in another thematic, that of institutions and conventions, other ways to designate what you call the cultural. These are all ways of saying that the economic does not stand on the mechanisms of exchange alone, but is an ensemble of social forces. The problem facing us today is that the national social state has been at once *dominant*, in the sense that it has built itself up in the region that has economically dominated the world, the "center" or the "North," and at the same time *exceptional,* not at all generalizable. Maybe the great myth of development proposed to the Third World, and accepted by the Third World itself for fifty years, rested on the idea that this form could be generalized, whereas in reality it was the product of particular local forces. I don't see any difficulty in ascribing these exceptional circumstances to imperialism, as long as one also realizes that the imperialist countries are exactly those where the social movements took place and the class struggle developed. The fearful thing is that the moment when we are becoming aware that these specific forms of regulation and social compromise are behind us may well coincide with a liquidation of the idea that there is no economy without society and social citizenship. The *reality* of the social state (or national social state) would then be replaced with the economic utopia of a "pure law of the market" in its most damaging form.

BRIAN HOLMES There has been a widespread critique of utopian modernity, for being overly abstract, technocratic, legalistic, productivist, uniformly individualizing, and so on. But utopia can serve much more progressive ends, particularly when it is conscious of itself as such. I'm tempted to say that the most modern modernity is now in revolt against economic and social regression. You said that Marxism and various strands of socialism themselves contributed to the emergence of the social state. Wasn't that a cultural demand which acted to counterbalance other forces, forces of concerted exploitation which do not even deserve to be called liberal? Isn't a utopian demand for equality still capable of producing real effects?

ETIENNE BALIBAR Let's take things from two different angles, leaving aside the possible developments of international capitalism, that is to say, the way the administrations and other organized powers at the state level may reorganize themselves, because I'm not competent to make any predictions there. I think nobody serious really believes that we are dealing with a linear development, in which the role of states would constantly diminish, to be replaced by the hegemony of a network of private multinational firms. There are different terminologies, depending on the authors: some speak of competition among capitals and competition among territories,[2] while others, more specialized in financial questions, explain that there has never been and consequently will never be a purely "private" capitalism.[3] The only thing that I would like to add, abstractly, is that these discussions are incomplete. You get the feeling that the problem is formulated solely in terms of a confrontation between private capital and state regulation, or in a Marxist terminology, between the bourgeoisie's two modes of domination. It is in fact important to be aware that the bourgeois class has never been organized around a single "center," but rather around two centers, the state and the economy. In reality there has always been a tension between the two, cooperation and rivalry, such that politics, among the bourgeoisie, has never purely and simply abandoned its terrain to economics. That's a point that gave Marx quite a bit of trouble and led to some manifestly erroneous predictions. The classical political theorists, since Machiavelli, are still pertinent, because political philosophy and science rest on the fact that there are several powers and that they are not automatically unified. Nonetheless, something essential is lacking in this presentation of things—whether you call it the people, the exploited class, the proletariat, or the dominated. When you read the economists and political scientists it sometimes seems as though the statistical "game" on which the distribution of powers and the configuration of institutions depends is a game played only at the top, among the "mighty," and that the only function of the mass of the people, the ordinary individuals who are administered, who work or are unemployed, is to be a *laboring mass*. This feeling is reinforced by cynical discourses like "the war of civilizations," or by the nostalgic discourses to which people like us are inclined, because we have the feeling that the political forces that allowed the demand for equality to be radically expressed have been swept away along with the old world which they opposed, and yet in which, for better or worse, they had found "their place."

That brings us to the other aspect of your question: the

place of equality in politics today. It is clear that the demand for equality played a decisive role in the political process from which the national social state emerged. I'd say that Marxism had its influence there, and did not play the same role as the cultural contribution of Christianity. It is not a question of sectarian allegiance; it is not a question of knowing whether our sympathies bend more to the CGT or the CFDT [two French unions, left and center-left—Tr.]. In reality everyone knows that things are much more complicated than that. Two things slowly rendered the social compromise possible. On the one hand, capital's proper comprehension of its own interest, playing on the local possibilities of a virtuous circle: augmenting the consumption rates, qualification levels, and productivity of the working class, at the price of recognizing a certain number of fundamental social rights which have become aspects of citizenship itself. On the other hand, a traditionally Christian reformism which for my part I would center around the question of *justice*. Today we are told that the crisis of this social compromise brings about phenomena of exclusion. Robert Castel is right to say that it is a very equivocal term,[4] but the concepts he proposes are more radical still: for him it is not a problem of "exclusion," a catch-all designation including very different situations, but rather a problem of *disaffiliation*, that is, the decomposition of the community ties that were rendered possible by the gradual institution of social rights and the incorporation of wage earning to citizenship itself. This is where it becomes interesting to ask why the language of *class struggle* is relatively powerless in the face of exclusion or disaffiliation, whereas the language of *justice*, including a dimension of recognition of the other which at the extreme can go as far as the idea of charity, is seemingly more well adapted. That said, I don't think that capital's proper comprehension of its own interest plus the Christian idea of justice would have sufficed to create what we have called the social state. A class struggle that spoke the language of antagonism was necessary, and it was organized not on the terrain of justice but of equality. Two antagonistic conceptions of equality confronted each other. That is what Marx said, and in this case there is no reason not to repeat his assertions. When Marx denounced the language of equality as the very language of the circulation of commodities, that is to say, the language of the bourgeoisie formalizing social relations as pure market rela-

tions, he pointed to the very foundation of the conflict. But the antagonism is not between those who speak the language of equality, the capitalists, and those who challenge it, the proletarians. On this point there is a famous passage by Engels in the *Anti-Dühring*, explaining that the demand for individual equality is opposed by the demand for social equality, understood as the abolition of class differences. It is therefore one conception and practice of equality versus another. The unthought of this confrontation, which has returned to the heart of contemporary political philosophy after a long eclipse, is the question of human rights. More precisely, the question of the rights of "man and the citizen," insofar as it is not only a matter of an ideal or a symbolic reference, but also of effective institutions and rights, and finally of politics, because the very notion of the rights of man is at play in this antagonism. Indeed, I am intimately persuaded that the reference to the "rights of man" as political rights, both individual and collective, after having long served to criticize the totalitarian excesses of socialism, is now once again changing sides.

JEAN-FRANÇOIS CHEVRIER You concluded your summary of the first interview with a reflection on the question of art. I can't help but think that philosophers often have recourse to the aesthetic as a solution. Isn't there a risk of returning to what Schiller develops in his "Second Letter on the Aesthetic Education of Man"? That is, the idea that the edification of true political freedom requires the aesthetic education of the citizens: "To solve the political problems of which I have spoken in the realm of experience, the path to take is to first consider the aesthetic problem: for it is by way of beauty that one reaches freedom."

ETIENNE BALIBAR What happened with Schiller is precisely the identification of the idea of art with the idea of culture, this time as *Bildung*. Clearly it was culture in the sense of a movement of collective education, a movement of collective emancipation working through education, and distinct from civilization.

JEAN-FRANÇOIS CHEVRIER At bottom, the entire critique of the Frankfurt school can be linked to the tradition initiated by Schiller. And today, countless philosophers grasp at the straws of aesthetics in situations of theoretical and above all political disarray. When one speaks of art in philosophical terms, precision is essential: exactly what are we speaking of? How can art be defined in relation

to culture and to aesthetics, or conceived in aesthetic categories? It is well known that since the eighteenth century, aesthetics has functioned as a highly problematic complement to the political.

ETIENNE BALIBAR Yes, but if you will pardon these elementary questions, are the terms of art and aesthetics entirely dissociable?

JEAN-FRANÇOIS CHEVRIER For me, yes, they are dissociable. But the dissociation must be carried out!

ETIENNE BALIBAR I must admit that everything I have advanced on this point is upheld by a Brechtian model whose questions, I feel, are taking on new pertinence. This is why I tried to link, though rather allusively, the artistic reference to the idea of a practice playing simultaneously on the idea of identification and distancing, or using identification to produce an effect of distancing. There is more here than mere wordplay, I think, to the extent that the problem of identities is at the heart of politics today. We must have something to learn from an artistic practice that explicitly asks the question of how one produces an effect of distancing, not only on the part of individuals with respect to their *conditions of existence*, but also with respect to their own *consciousness*. That said, this practice, which was only conceived by Brecht in relation to theater—a restricted context, but one that still constitutes the precondition of its effectiveness—was a practice of *action* rather than one of perception, consumption, or reception. In this sense, I believe, it distances itself from the category of the aesthetic.

JEAN-FRANÇOIS CHEVRIER To get back to your own life experience—one of the most interesting things in this interview being the fact that you speak in the first person—you were an Althusserian, and then you became critical towards the Althusserian model. I was struck by your praise of Deleuze. Twenty years ago you criticized him and found him unacceptable. It seems to me that your appeal to art, which comes at the end of a movement that successively examines the notions of citizenship and identity, and finally deconstructs the dichotomy of culture and civilization, brings us precisely back to your own philosophical biography. Identity is in question here, and this is also the identity of the speaker, an identity which emerges from a process of subjectivization, in a dialogic structure and also in a praxis. You recall Althusser's injunction: "Study the epistemology of Marxism as oth-ers have studied the epistemology of physics, of biology . . . no bricolage!" And then a few pages later you say: "The philosopher is a *bricoleur*." I think one could hardly be more clear . . . The subtitle of the work you published with Wallerstein is "Ambiguous Identities."[5] It seems to me that the key point here is the discovery of ambiguity. If we spoke of the history of art and of practical artistic activities, we would find the same situation. We would see that precisely what happened in the late 1970s is the discovery of ambiguity. In short, your philosophical development runs parallel to the evolution of avant-garde artistic practices since the late 1960s. These avant-garde practices expressed a radical social alternative, which in the domain of art was called "the great refusal." In the late 1970s, people discovered that such an approach did not work any more, for various reasons, notably because of the naiveté in the search for alternatives. Hence the acceptance in art of a politics of ambiguity. In this respect, I find your philosophical biography quite exemplary.

ETIENNE BALIBAR I'm not sure there has been such a sharp transition, or more precisely, I think that the earlier artists who produced the most interesting effects in the expression of struggle, social antagonism, or the irreconcilable nature of certain contradictions of our time, whether in theater or cinema, painting or music, are precisely those who in practice never ignored the dimension of ambiguity that you mention. It cannot be said that Godard ignored that dimension, nor that Antonioni ignored it (just look at the end of *La Notte*); nor can it be said that the best of the Brechtian tradition ignored it (just consider the *Life of Galileo*). Maybe what's fascinating for us today is that we can reread Brecht, or see his plays in the theater, with an inspiration from some of Deleuze's texts: we can see a function of the mask at work in Brecht's theater, a dimension of irony whereby the dis-identification is not only focused on the critical relation to the dominant ideology, but also on the way that the militant or the spectator—the militant-spectator—relates to his own social struggle. Thirty years ago, the idea that one could work conjointly with Brecht's analysis of "distancing" and Deleuze's analysis of "convention" would have seemed completely absurd, because these two analyses were two distinct alternatives. Today we can at least ask the question.

JEAN-FRANÇOIS CHEVRIER The end of those alternatives can

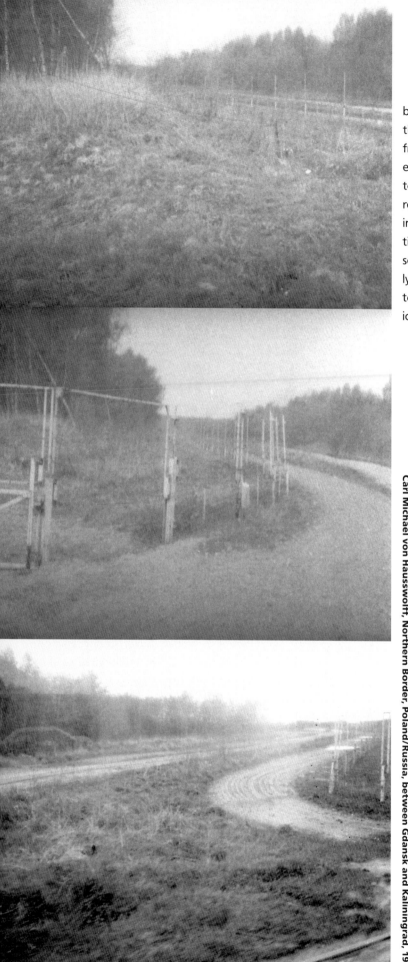

Carl Michael von Hausswolff, Northern Border, Poland/Russia, between Gdansk and Kaliningrad, 1996

be rather precisely dated at around 1978. You spoke of the invention of tradition; that invention dates exactly from 1978. The acceptance of ambiguity can be illustrated by the names of contemporary artists. It is also contemporary with a regressive movement that claims to return to a precritical pseudotradition, and thus partakes in an enterprise of restoration—which must be clearly distinguished from the critical invention of a tradition. It seems to me that your philosophical itinerary runs exactly parallel to all this. When you appeal to art, you appeal to a history of art which effectively converges with political history.

ETIENNE BALIBAR Personally I would not be capable of indicating or locating analogies or convergences between political-philosophical discourse and artistic practice, which always includes a political-philosophical dimension. As to Deleuze, it is only quite recently that I began exploring this kind of encounter. I simply apply the saying of Althusser, who attributed it to Napoleon: "You move ahead and then you see." It's useless to have a completed theory before proposing any formulations. The reverse is necessary: you try out formulations. It is certain that a line of reasoning has slowly built itself up in my mind, on the basis of the problem of identification, but above all on the basis of a simultaneous confrontation with the problem of identity and the problem of violence. It is the question of identity that leads to the idea of a democratic politics that is at once individual and collective, and is also a practice of dis-identification. This idea is not only mine: Jacques Rancière develops it in a recent work, though in a quite different language.[6] The question of how one escapes from the cycle of violence and counter-violence is what slowly led me to the region of *civility*, of civilization—including a critical rereading of Norbert Elias. I find him at once interesting and frustrating, because his normative perspective, despite the historicizing dimension, is extremely powerful. In him, one rediscovers the sociological postulate according to which a society must "function," meaning that individual behavior must be adapted to the needs of the society, even if individuals also contribute to its overall shape. It seemed to me that a dimension of political practice had to be evoked here, and not only a description of the tendencies of contemporary societies and of individual adaptations to the social norm. On one side, then, is social distancing, and on the other, civility. At the inter-

section of these two preoccupations there is necessarily a reflection on the institution. What is an institution? More radically, what does it mean to institute? The institution has very bad press in the Marxist tradition, fundamentally because that tradition is heir to the powerful naturalism of Marx himself, historicized and socialized as it may be. Productive forces, social relations, and social practice are determinant in that tradition, but not institutional practices. To put things otherwise, there is a powerful Rousseauism in the Marxist tradition, and therefore a great mistrust of everything on the order of artifice. This is the point where a rereading of Deleuze can come into play. I do not think that Deleuze is a simple, noncontradictory philosopher. I even have the feeling that he tries to hold together a number of philosophical orientations which are quite distant from each other: a powerful and imaginative pantheism and vitalism, and the thematic of the contract, of play, of becoming-minority, the whole continuation of Nietzsche which leads one to believe that because liberation tends toward the affirmation of singularities it is not the affirmation of one's own nature, it is not identity or authenticity, but artifice, mobility. It is clear that all this is not "dialectical," in the sense that in the Hegelian or Marxist dialectic there is always the idea of a process of education. The Germans say that with striking clarity: the dialectic is a *Lernprozess*. The class consciousness of the Marxists is typically a process of self-education, in a dimension that is at once individual and collective. It is true that quite recently I told myself that I had not yet thoroughly read Deleuze. His most original interpretations, the ones dealing with the history of philosophy, were very enigmatic for me; I'm thinking of his way of explaining that the contract can be something other than a juridical form. One would have to begin reading Deleuze anew with this question: how to produce a mixed language, fashioned at once of play and critique, of invention and revolution, with which we could at least begin to reflect on a politics of the civilization of violent identities.

Carl Michael von Hausswolf
Power Electric Controller, 1988–97

1. Hobsbawm, E. J., and Ranger, Terence, eds.: *The Invention of Tradition* (Cambridge: Cambridge University Press, 1983).

2. See Giraud, Pierre-Noël: *L'inégalité du monde* (Paris: Folio, 1996).

3. See Brunhoff, Suzanne de: *L'heure du marché: Critique du libéralisme* (Paris: PUF, 1986).

4. See Castel, Robert: *Les métamorphoses de la question sociale* (Paris: Fayard, 1995).

5. Wallerstein, Immanuel, and Balibar, Etienne: *Race, Nation, Class: Ambiguous Identities* (London: Verso, 1991).

6. Rancière, Jacques: *La mésentente* (Paris: Galilée, 1995). Also see his contribution to the journal *Lignes* 30 (special issue: "Algérie, France: regards croisés").

Jacques Rancière, Jean-François Chevrier, Sophie Wahnich

JEAN-FRANÇOIS CHEVRIER In your recent book, *La Mésentente*, you contrast democracy to police practice, by which you mean the reduction of the people to a population, much as Foucault described. One obtains a double system of oppositions: democracy/police, people/population.

JACQUES RANCIÈRE Yes, the same opposition is at work in both formulations. But Foucault understood the police essentially as an instance of control, whereas I use the term

The Political Form of Democracy

to designate a categorization of the common world such that there are only social groups, "objective" functions, and techniques for managing the balance between those groups and functions. Police practice is a way of dividing up perceptible reality without ever accounting for gaps or supplements. On the contrary, politics is the act that separates the real from itself, and brings into play what I call the share of the shareless, the part taken by those who stand apart. Politics is the count of the uncounted, the difference of the people as a political subject from the sum of all parts of the population. For the police there is never anything but the population, and the people is identical to the sum total of the population. Politics begins when the people, in the form of the Greek *demos* or the modern *peuple*, appears as that which splits the population from itself. That is why for me, democracy is not a particular political regime, or even less a social lifestyle. It is the very institution of the political. And those apart are not the poor or the unfortunate. Democracy is the count of the uncounted that shatters every perfect account, every seamless fit between the parts of society and political power structures.

JEAN-FRANÇOIS CHEVRIER You bring a dimension of the incalculable into a regime of social management based on calculation. But how do you distinguish those apart from the excluded?

JACQUES RANCIÈRE Those apart do not constitute a real group, but a symbolic function. The notion does not designate an underprivileged class, but refers to two antagonistic ways of structuring of the community. This is how the Greek *demos* was defined, as those who had no part in the government of the city, no title of authority such as nobility, knowledge, virtue, or wealth. The same is true for the proletarian of the nineteenth century: he was not the factory worker, but simply one who had been born into the world and who, in the traditional order, had nothing to do with the government of the city. Whereas the category of the socially excluded rests on a misunderstanding of the symbolic function of the uncounted, of those apart. It rests on the fiction of a well-policed society where everyone is supposed to be included, the fiction of a people constituted of an ensemble of groups with calculable interests and opinions whose balance is managed by the state. The excluded are, in a sense, the residue of this inclusion, the return in the form of naked otherness of a division which has been denied. The paradox of what is now called exclusion is precisely the impossibility to symbolize the barrier. The proletarian, for example, was a symbolization of the barrier: at that time, order was said to be founded on limits defining those who were

inside and those who were out. But this structuring barrier has been whisked away. The political part of those apart then becomes no more than the social suffering of the excluded, and social medicines are called upon to integrate the excluded. But only political struggle has the power to include the excluded. Where it disappears, this inclusion remains an irresolvable paradox.

SOPHIE WAHNICH If politics is defined as the intervention of a force of separation, doesn't that imply that politics is essentially discontinuous?

JACQUES RANCIÈRE Yes, politics is a strange accident that comes about in the course of human affairs. It is the advent of an extraordinary and always precarious exception to the logic of domination. The "normal" order of societies is to be governed by those who are entitled to govern, their entitlement being proven by the very fact that they do govern. With respect to this logical circle of domination, democracy is the exception or the paradox of a government founded on the very absence of any entitlement for domination. Normally, the practices of social management tend to suppress politics, because politics makes it difficult to govern well, to tranquilly manage a society. Now, power always exists. But politics does not always exist, in fact it's quite rare. For sequences of varying lengths, forms of political action come to impose their disagreement on the normal police order of societies. There are points of intersection between the police order and the political order, but these encounters are fundamentally discontinuous.

SOPHIE WAHNICH The detractors of the social movement of November and December 1995 in France blamed the strikers for identifying their cause with a real social body (a profession with a specific contractual status) and thereby forgetting the universal dimension that alone can carry a political project. Does your definition of politics that allow one to articulate a concrete situation with a horizon of universality, with an action of symbolic foundation? Doesn't the capacity to symbolize have to work through an anchor-point which can be described in reality?

JACQUES RANCIÈRE All political action involves a staging of universality by a subject who can be termed equivocal. When the German students demonstrated in Leipzig in 1989, saying "we are the people," nobody believed it and they didn't even believe it themselves, but it was a way of saying to the government: "What you are managing is not the people." Every political action works through these forms of subjectivization that make it possible to state polemical identities, in which the subject of the statement (*we*) and the subject stated (*the people, the workers, women. . .*) are disjointed. This relation of disjointed identity between the naming subject and the subject named constitutes a political subjectivization. It brings a universal singular into play. Thus, "proletarian" is defined not as a "universal victim" but as a subjectivization of a universality of wrong. There are two risks here. The first is that the two subjects can be unequivocally identified, which gives rise to an identity politics. The second risk is that no name whatsoever can be given to the universalizing subject. This is the case of the French social movement of 1995 or of the movement against the Debré anti-immigrant law, which began with protests by groups of filmmakers and writers. And yet it is incorrect to describe these movements as being the expression of a specific social body. The artists and writers in question did not represent their profession—among which

one could easily find just as many names to defend the anti-immigrant laws. Instead they represented sensibility groups, sharing a common history, a political tradition rooted in the student movements of the sixties and seventies. These sensibility groups are like fragments of a public opinion, capable of instituting a public stage of debate but not of producing a political subjectivity in the full sense of the term. What's lacking is the capacity to create a *we* that can provide the link between a massive strike for retirement benefits and a solidarity movement for immigrants without papers. Despite the dreams of a political alternative, no form has come to fill the gap left by the definitive bankruptcy of the supposedly democratic parties. At regular intervals, symbolic insurrections restage the equality that is the foundation of all politics. These tremors of insurrection run through individuals and groups who recognize themselves in them, yet without constituting a power for the universalization of a wrong.

JEAN-FRANÇOIS CHEVRIER Is the opposition to the Debré law on immigration the sign of a resistance to the formal reduction of democracy? The manifestation of a concrete redefinition of the democratic form?

JACQUES RANCIÈRE The forms of democracy, for me, are not the "juridical," constitutional forms, which the Marxist tradition contrasted to the real content of society. They are forms of the constitution of a polemical public space, modes of subjective enunciation and of the manifestation of disagreement. And the fundamental political disagreement bears directly on the counting of those who belong to the community. In this sense, the demonstrations in support of immigrants without papers, or in protest against anti-immigrant laws, are fundamentally democratic because they revolve around the division between those who are from here and those who are not, and they denounce the definition of the community as an identity, the identification of the people and the population, whose devastating effects they indicate. What's at the heart of the anti-immigrant laws is the legal constitution of a fictive subject, the "immigrant" subject. Whatever the difficulties that some may have with people of black or North African origin, whatever the security issues in suburbs or schools, all that doesn't add up to an immigrant problem. The immigrant cannot be constituted as a subject. There is an attempt to force the existence of a concept, and of an object of this impossible concept. This is something which is not only on the order of injustice but of madness, a kind of logical madness. The "enlightened governments" that claim to rationalize that madness do nothing but provide more arms for the extremists who wield the madness as pure madness.

JEAN-FRANÇOIS CHEVRIER In *La Mésentente* you pose the question of contemporary democracy in terms of postdemocracy. Why speak of "post" when this expression now appears so devoid of specific meaning?

JACQUES RANCIÈRE Postdemocracy is not a descriptive but a polemic term. It indicates a double distance: first with respect to the term of postmodernity, conceived as the end of the age of the modern "master narrative"; and second with respect to liberal democracy in its own self-conception, that is, as the end of the age of revolutions and divisions, the fulfillment of democracy as a political regime identical to a spontaneous mode of the regulation of society at a certain stage of development: the reign of opinion as the reign of the supermarket consumer. Postmodernist discourse and ordinary liberal discourse come together in equating consummate democracy with a state of social relations conceived as the end of the heroic age of wrong and conflict. Postmodernism is the disenchanted intellectual confirmation of a democracy which is said to have overcome the two great counts

against it: the alternative of a "real democracy," fallen with the Berlin wall, and the very concept of the people, revoked by the present state of social relations. However, the collapse of the Soviet system did not bring about any renewal of the ideal of democracy as a political form. The liberal state, on the contrary, took over the dogma of economic determinism and historical necessity. A kind of creeping Marxism of economic necessity, of the development of the productive forces, of democracy as a stage of development, has now become the official doctrine of the liberal state.

> JEAN-FRANÇOIS CHEVRIER You also say that the more a purely formal democracy triumphs, the less use people make of the institutional forms of that democracy. . .

> JACQUES RANCIÈRE Once again the question is one of the meaning of the form. Political forms are not constitutional forms. They are forms of activities carried on by subjects, modes of polemically structuring the common world. What I call postdemocracy is a pseudodemocracy that pretends it can do without a subject. It's the discourse telling us that "the people," "the proletarian," in short, all the polemical subjects, are phantoms of the past, and that democracy only functions well when it is emptied of any subject and is simply the autoregulation of a society at a certain stage of the development of the productive forces. This is the practice that reduces the people to the sum of all parts of the population, to easily namable interest and opinion groups whose balance can be guaranteed by the state, itself posed as the simple local representative of a kind of imaginary world government—in short, the total identification of democracy and capitalism.

> JEAN-FRANÇOIS CHEVRIER You associate politics and democracy on the one hand, and postdemocracy and consensus on the other. Postdemocracy is then the reduction of democracy to its consensual form. Yet for Gramsci, consensus is conflictive, it depends on a hegemony which itself emerges from a situation of violence. What is the status of Gramsci's concept of consensus in your thinking?

> JACQUES RANCIÈRE I lack enough knowledge of Gramsci to answer your question. But we must come to an understanding about what we understand by consensus. It can mean that one agrees with one's fellow combatants about the forms of combat. It can also mean that adversary parties agree on the fact that despite everything, they are playing a common game. But what is today called consensus is neither a reasoned agreement on a common terrain nor an acquiescence in cohabitation despite all the conflicts. Rather it is the suppression of *dissensus*, that is to say, of politics as the disruption of perceptible reality itself by that supplementary subject, "the people." Consensus is the hypothetical state where the people is identical to itself, identical to the sum of all parts of a society. It is the ontological thesis of a perfectly consistent, self-identical society. With that, I have not elaborated a concept of consensus. Rather, I have tried to analyze what is behind the theme of consensus as it functions today: a state of things where conflict is invisible, where the parties competing for power must recognize that the basic givens are the same, and the solutions fundamentally the same as well.

> JEAN-FRANÇOIS CHEVRIER There has been much reflection on the idea of productive conflict, for example, by Albert O. Hirschman. Do you think along the same lines?

> JACQUES RANCIÈRE I situate myself on a different level, which I call definitional. Conflict is not only productive, it is constitutive; politics only takes place by disagreement, even over what is "given." It was long considered a given that workers and women do not form part of the body politic. The affirmation of a community whose existence has been denied is constitutive of politics. But it is true that politics also has a sociological function, as a "civ-

ilizing" process. A great question in the nineteenth century was how to civilize the "barbarian" workers when they arrived from their distant countryside, barely speaking the national language. Education was held to be the key element of social integration, the way to constitute a common fabric. Yet the class struggle was just as important for social integration. The working class achieved integration to society not through the simple process of the domestication and education of the people, but through the development of a form of skill and intelligence in conflict and for conflict. Class conflict was civilizing because it was a symbolization of the forms of alterity. When that conflict is revoked, what appears in its place are forms of naked, unsymbolizable hatred of the other.

JEAN-FRANÇOIS CHEVRIER How do you understand what is now being tentatively identified as neofascism?

JACQUES RANCIÈRE What I see are racist, xenophobic resurgences, based on the claim to identity. I think they are the necessary consequence of the consensual definition of democracy, which postulates that the people and the population are identical. That is the effect of the total desymbolization of the field of politics. Democracy cannot do without the people. As soon as the democratic idea of the people is revoked, another people will spring up, a people defined in terms of identity and not division. The targets of the new racism or the new xenophobia are a part of the population which in a certain period would have been identified as working class or proletarian and who, having lost this form of political subjectivization, no longer have any more than a pure anthropological identity: the immigrant, the black, the North African, the naked other who is simply an object of hatred. Racism deals with the identities that remain when politics has disappeared. But the paradox is that the National Front in France also plays on the fact that it can claim to be the only force that is opposed to consensus, the only force that maintains the political tradition of conflict.

JEAN-FRANÇOIS CHEVRIER How do you situate your thinking with respect to Etienne Balibar, when he speaks of civility?

JACQUES RANCIÈRE What Etienne Balibar calls civility is politics itself insofar as it regulates the forms of identity and alterity that define the possibility of life in common. That seems to match what I am trying to articulate. Even the "non-political" forms of common life depend on a political determination of the same and the other. This idea of civility is opposed to the idea of a regulation of life in common by the forms of technical and economic development: for example, the idea that the commercial world of varied pleasures and standardized consumption, or the world of "communications," can generate a pacified social tie. This faith in a civility issuing from the commercial world is stupid. Civility is always the provisional effect of the relation between police and politics. One must have a political and not an anthropological conception of civility. The consequence of the suppression of the people as the political division of the community is the return of the stifled people in the savage forms of racism and xenophobia.

This interview took place on March 6, 1997. The text was transcribed and edited by Sophie Wahnich and revised by Jacques Rancière.

Exhibition Organizer

documenta and Museum Fridericianum Veranstaltungs-GmbH

Stockholders

Land Hessen, Stadt Kassel

Chief Executive

Bernd Leifeld

Confidential Clerk

Frank Petri

Advisory Board

Oberbürgermeister Georg Lewandowksi, Kassel, Vorsitzender

Dr. Christine Hohmann-Dennhardt, Staatsministerin, Wiesbaden, stellvertr. Vorsitzende

Prof. Dr. Hans Brinckmann, Präsident GhK, Kassel

Jürgen Fechner, Stadtverordneter, Kassel

Wilfried Gerke, Stadtverordneter, Kassel

Bertram Hilgen, Regierungspräsident, Kassel

Horst Kuhley, Stadtverordneter, Kassel

Dr. Harald Noack, Staatssekretär, Wiesbaden

Dr. Hans Ottomeyer, Ltd. Museumsdirektor, Kassel

Wolfgang Windfuhr, Stadtrat, Kassel

Major Sponsors

Deutsche Bahn AG

SONY Deutschland GmbH

Unternehmen der Sparkassen-Finanzgruppe

Sponsors

Binding-Brauerei AG

Deutsche Städte-Reklame GmbH

IBM Deutschland Informationssysteme GmbH

SBK Software + Systeme GmbH

Volkswagen

Media Partners

arte, Der Europäische Kulturkanal

bundmedia

Supporters

Arbeitsamt Kassel

Centre pour l'image contemporaine Saint-Gervais, Genf

Coutts Contemporary Art Foundation, Zürich

documenta-Foundation, Kassel

Forum Bahnhof, Geschäftsbereich Personenbahnhöfe der Deutschen Bahn AG

Francotyp-Postalia GmbH

Goethe-Institut

Hübner Gummi- und Kunststoff GmbH, Kassel

Koch Hightex GmbH, Rimsting

Mannesmann Arcor

Mövenpick Hotel Kassel

MVS Miete Vertrieb Service AG, Berlin

pro-bike, Kassel

Röhm Chemische Fabrik GmbH, Darmstadt

Stahlbau Simon GmbH, Kassel

Bernhard Starke GmbH, Kassel

Volkswagen Coaching GmbH Niederlassung Kassel

Zumtobel Licht GmbH, Usingen

for the Orangerie Project

Eberhard Mayntz, Berlin

Coproducers

Cantz Verlag, Ostfildern-Ruit

Edition Schellmann für documenta X, München - New York

Hebbel-Theater, Berlin

Hessischer Rundfunk, hr 2, Frankfurt

Theater am Turm, Frankfurt

National Subsidies

Gefördert durch die Kulturstiftung der Länder aus Mitteln des Bundesministers des Innern

Australia Council for the Arts, Sydney, Australia

Bundesamt für Kultur, Bern, Switzerland

Bundesministerium für Wissenschaft, Verkehr und Kunst, Vienna, Austria

Department of Foreign Affairs, Dublin, Ireland

Department of Foreign Affairs and International Trade of Canada, Ottawa, Canada

Embassy of the Republic of South Africa, Bonn

Foundation SPES, Belgium

Fundação Bienal de São Paulo, São Paulo, Brazil

Italienische Botschaft, Bonn

Kanadische Botschaft, Bonn

Mestna Obcina Ljubljana, Oddelek za Kulturo in Raziskovalno Dejavnost, Ljubljana, Slovenia

Ministère des Affaires étrangères, Paris, France;

AFAA - Association Française d'Action Artistique;

sous-direction de la politique du livre et des bibliothèques;

Service culturel de l'Ambassade de France, Bonn

Ministerium der Flämischen Gemeinschaft, Brussels, Belgium

Ministry of Education and Culture, Jerusalem, Israel

Ministrstvo za Kulturo, Ljubljana, Slovenia

Mondriaan Foundation, Amsterdam, Holland

National Arts Council, Singapore

Soros Center for Contemporary Arts - Warsaw, Poland

Soros Center for Contemporary Arts - Zagreb, Croatia

Stimuleringsfonds voor Architectuur, Rotterdam, Holland

The British Council, Cologne

The Fund for U.S. Artists at International Festivals and Exhibitions: United States Information Agency; National Endowment for the Arts; Rockefeller Foundation; Pew Charitable Trusts, with administrative support by Arts International, Institute of International Education

The International Programme of Moderna Museet, Stockholm, Sweden

The Henry Moore Foundation, Hertfordshire, Great Britain

United States Information Service, Embassy of the United States of America

Gefördert von der **K**ulturStiftung der Länder
aus Mitteln des
Bundesministeriums des Innern

Guide Service / Visitor Service
Matthias Arndt
Ulrike Kremeier
GhK Seminar
Ursula Panhans-Bühler
Michael Wetzel
Moderation
Christoph Tannert
Thanks for special help
Carlos Basualdo, Clémentine
Deliss, Ery Camara Thiam,
Paul Sztulman
Collaborators
Sonya Bouyakhf
Regina Caspers
Paul Galvez
Natalija Gavranovic
Mark Kiekheben
Tanja Möller
Guides
Marvin Altner, Jens Asthoff,
Seyhan Baris, Holger Birkholz,
Annette Brausch, Sabine Brox,
Jutta Buness, Simone Buuck,
Dominique Busch, Rika Colpaert,
Winnie Decroos, Berit Fischer,
Sabine Flach, Christine Fuchs,
Elke Grützmacher, Anja Helmbrecht,
Stefanie Heraeus, Carine Herring,
Katrin Jaquet, Benita Joswig,
Elisabeth Kenter, Anahita Krzyzanowski,
Holger Kube-Ventura, Karin Langsdorf,
Evelyn Lehmann, Vera Leuschner,
Iris Mahnke, Ulrike Massely,
Christiane Mennicke, Tabea Metzel,
Viola Michely, Carmen Mörsch,
Katrin Nölle, Barbara Otto,
Karin Rebbert, Petra Reichensperger,
Barbara Richardz-Riedl, Kalus Röhring,
Andreas Rollmann, Claudia Schmähl,
Ulrich Schötker, Iris Schröder,
Heike Schüppel, Stefanie Sembill,
Heike Sinning, Ursula Tax, Regina Thein,
Axel Tönnies, Eveline Valtink,
Hannie Verwoert, Tobias Vogt,
Stephan Waldorf, Hilke Wagner,
Tanja Wetzel, Ernst Wittekindt

ABC Buchladen, Kassel
A.C.P. Collection, Turin
äda'web, New York
Laura Agnesi, Triennale di Milano, Milan
Nelson Aguilar, Fundaçao Bienal de São
Paulo, São Paulo
Akademie Schloß Solitude, Stuttgart
Sandra Alvarez de Toledo, Paris
Ammann Verlag, Zürich
Andréhn-Schiptjenko Gallery, Stockholm
Paul Andriesse, Amsterdam
Antartica Artes com a Folha, São Paulo
Anthony d'Offay Gallery, London
Anthony Reynolds Gallery, London
Arche-Hof Rodewald, Hess. Lichtenau
Architektur- und Ingenieurbüro Reiser,
Engelhard, Frauenkron, Kassel
Archiv des Hessischen Rundfunks, Frankfurt
am Main
Archivio Contemporaneo del Gabinetto
Vieusseux, Florence
Argument Verlag, Hamburg
The Art Institute of Chicago, Chicago
Atria, Andrée Davanture, Annabel Thomas,
Paris
Marina Ballo-Charmet, Milan
Rolf Bandhus, Cologne
Edek Bartz, Vienna
Adam Baruch, Camera Obscura School
of Photography, Tel Aviv
Daniel Baumann, Genf
Bernd Behrens, Kassel
Dieter Beine, Kassel
Raymond Bellour, Paris
Luc Béranger, Cinésud, Paris
Beratung artgerechte Tierhaltung e.V.,
Harald Bürger, Christel Simantke,
Witzenhausen
Bereichsbibliothek Kunst + Gestaltung,
Regina Frindt, Kassel
Berliner Festspiele GmbH, Berlin
Beatrice von Bismarck, Lüneburg
Iwona Blazwick, Phaidon Press, London
Stefano Boeri, Milan
Jean-Louis Boissier, Paris
Manuel J. Borja-Villel,
Fundació Antoni Tàpies, Barcelona
Wieslaw Borowski, Galeria Foksal, Warsaw
Brandschutzamt Kassel
Sabine Breitwieser, E.A. Generali
Foundation, Vienna
Guy Brett, London
Buchhandlung am Bebelplatz, Kassel
Buchhandlung an der Hochschule Fischlein
KG, Kassel
Buchhandlung Habel, Kassel
Buchhandlung Vaternahm, Kassel
Die Bücherstube, Kassel

Christoph Buggert, Hessischer Rundfunk
Frankfurt am Main
Ery Camara Thiam, Mexico City
Campus Verlag, Frankfurt am Main
Corinne Castel, Musée national d'art
moderne, Centre Georges Pompidou, Paris
Centre National du Cinéma, Paris
Centro Studi e Archivio della
Communicazione, Parma
Carolyn Christov-Bagarkiev, Rome
Yan Ciret, Paris
City secretariat for culture and research,
Ljubljana
Noemí Cohen, Fundació Antoni Tàpies,
Barcelona
Collection Sharon Avery-Fahlström,
New York
Collection Lygia Neta Clark, Rio de Janeiro
Collection Andrea Rosen, New York
Collection Lia Rumma, Neapel
Collège International de Philosophie, Paris
Paolo Colombo, Centre d'Art
Contemporain, Genf
Jane Crawford, The Gordon Matta-Clark
Trust, Weston
Anne and Anthony d'Offay, London
Ildiko Dao, Genf
Gitty Darugar, Ruvigliana
Pascale Dauman, Paris
Karen Davidson, New York
Steef Davidson, Amsterdam
Monica S. de Carvalho, Fundaçao Bienal de
São Paulo, São Paulo
Hugues de Cointet, Paris
Jean-René de Fleurieu, Paris
Colin de Land, New York
Marco De Michelis, Venice
Dirk de Wit, Brussels
Cathy de Zegher, Kanaal Art Foundation,
Kortrijk
The Denver Art Museum, Denver
Kirsten Derwanz, Kassel
Deutsch-Französisches Institut,
Ludwigsburg
Deutsches Architektur-Museum, Frankfurt
am Main
Jean Digne, AFAA, Paris
dipa Verlag, Frankfurt am Main
Corinne Diserens, Musées de Marseille,
Marseille
DOCK 4, Axel Kolodziej, Ingrid Roberts,
Volker Sparr, Kassel
documenta-Archiv, Kassel
Martin Dörbaum, Berlin
Fa. Döring, Kassel
Na'illa Dollie, Johannesburg
Druckerei Schreckhase, Spangenberg
Heinz Dürr, Frankfurt am Main
Joel Edelstein, Rio de Janeiro

Thanks

Yongwoo Lee, Kwangju Biennale, Seoul
Leffers AG, Kassel
Rachel and Jean-Pierre Lehmann, Genf
Lehmann Maupin, New York
Michel Leiner, Stroemfeld Verlag,
Frankfurt am Main
Jean-Yves Leloup-Barbichon, Eric Pajot,
Radio Mentale
Janick Le Naour, Cinémathèque du
Ministère de la Coopération, Paris
Wolfgang Lepenies, Wissenschaftskolleg
zu Berlin
Franziska Lettner, Galerie Christine König &
Franziska Lettner, Vienna
Dalia Levin, Herzliya Museum of Art,
Herzliya
Yang Lian, London
Librairie Arthème Fayard, Paris
Dr. Alexander Link, Stadtmuseum Kassel
Werner Lippert, Projects, Düsseldorf
Karsten Lisker, Kassel
LJUDMILA, Ljubljana
LoGING d.o.o., Novo Mesto
Regina Lorenz, Sipa Press, Paris
Agnieszka Lulinska, Bonn
Svenrobert Lundquist, Konsthall, Göteborg
Judy Lybke, Galerie EIGEN + ART, Berlin /
Leipzig
Roland Mahle, Stuttgart
Maison de France, Berlin
MAK Center for Architecture, Los Angeles
Evelyne Massoutre, Paris
Eberhard Mayntz, Berlin
Carol McMichael Reese, MAK Center for
Art and Architecture, Los Angeles
Jean-Michel Meurice, Paris
Christian Milovanoff, Arles
Miuccia Prada, Milan
Robert Miniachi, Vancouver
Mobitel d.d., Ljubljana
Bruno Mocci, Botschaft der Republik
Italien, Bonn
Stefan Mosetter, Frankfurt am Main
Max Moulin, AFAA, Paris
Movimento Production, Christian Baute,
Pierre Hanau, Paris
Carrie Mullen, University of Minnesota
Press, Minneapolis
Musée d'art moderne, Saint-Etienne
Musée national d'art moderne, Centre
Georges Pompidou, Paris
Museu de Arte Moderna do Rio de Janeiro,
Rio de Janeiro
Museum Overholland, Nieuwersluis
MVS Miete Vertrieb Service AG, Kaufungen
Aymeric Nager
Manfred Neukirchen, Kassel
Peter Noever, Museum für Angewandte
Kunst, Vienna

Nordhessischer VerkehrsVerbund (NVV)
Götz Ohlendorf, Kassel
Claudio Oiticica, Miami
Willem Oorebeek, Brussels
OPAK, Frankfurt am Main
Alfred Pacquement, énsb-a, Paris
Peter Pakesch, Kunsthalle Basel, Basel
Enno Patalas, Munich
Patrick Painter Editions, Vancouver
Sylvain Pelly, Paris
Reinhard Penzel, SONY, Cologne
Giuliano und Anna Perezzani, Sanguinetto
Alan Phelan, Dublin
Jean-Michel Phéline, Institut français de
Cologne, Cologne
The Philadelphia Museum of Art,
Philadelphia
Mario Pieroni und Dora Stiefelmeier,
Zerynthia Associazione per l'Arte
Contemporanea, Rome
Albert Pinkvohs, Kassel
Marc Pottier, New York
Prentenkabinet Rijksuniversiteit, Leiden
pro nordhessen e. V., Renate Fricke, Kassel
Projeto Hélio Oiticica, Rio de Janeiro
Regen Projects, Los Angeles
Heitor Reis, Museu de Arte Moderna,
Salvador de Bahia
Judith Reuter, SONY, Cologne
Ulrich Rodewald, Hess. Lichtenau
Sabine Rollberg, arte, Strasbourg
Tim Rollins, New York
Shirley Ross Davis, San Francisco
Rotbuch Verlag, Hamburg
Anda Rottenberg, National Gallery of
Contemporary Art Zacheta, Warsaw
Jean-Christophe Royoux, Paris
Yves Roussel, Archives Michel Foucault,
Paris
Caroline Ruppert, SONY, Cologne
Doron Sabag, Tel Aviv
The Saint Louis Art Museum, St. Louis
Sammlung Generali Foundation, Vienna
Sammlung Hauser & Wirth, Zürich
Sandra Gering Gallery, New York
Savaprojekt d.d., Krško
Nicolaus Schafhausen, Stuttgart
Aurel Scheibler, Cologne
Manfred Schiedermair, Frankfurt am Main
Bärbel Schirrmacher, Kassel
Romana Schneider, Frankfurt am Main
Heinrich Schröder, Wildeck
Ulle Schröder, arte, Strasbourg
Martin Schüttpelz, Stuttgart
Schuhhaus Feist-Fashion, Kassel
Hans-Jürgen Schwarz, Kassel
Schwarze Risse, Buchladen- und Verlags
GmbH, Berlin
Dieter Schwerdtle, Kassel

Senatsverwaltung für Wissenschaft,
Forschung und Kultur, Berlin
Marie-Paule Serre, AFAA, Paris
Robert J. Shiffler Collection and Archive,
Greenville
Amos Shoken, Tel Aviv
Mark Sladen, Entwistle Gallery, London
Phil Smith, Vancouver
Dirk Snauwaert, Kunstverein Munich,
Munich
Juan-Carlos Soler, Paris
Spiel + Hobby Krüger, Kassel
Sporthaus Kajulä, Kassel
SRC Computers d.o.o., Ljubljana
St. Louis Art Museum, St. Louis
Michael Staab, Cologne
Stadt- und Kreisbildstelle, Kassel
Städtische Galerie im Lenbachhaus, Munich
Stahlbau Simon GmbH, Kassel
José Lebrero Stals, MACBA, Barcelona
Bernhard Starke, Kassel
Cecile Starr, New York
Steirischer Herbst, Christine Frisinghelli,
Sabine Reisner, Graz
Karin Stengel, documenta-Archiv, Kassel
Liliana Stepancic, Open Society Institute
Slovenia - SCCA, New York
Stiftung Deutsche Klassenlotterie, Berlin
Süddeutscher Rundfunk, Uwe Bork,
Stuttgart
Jean-François Taddei, FRAC des Pays de la
Loire, Nantes
David Tartakover, Tel Aviv
Gilane Tawadros, INIVA, London
Sophia Telles, São Paulo
The Thing, New York / Vienna
Dennis Thomas, New York
Pieter Tjabbes, Fundaçao Bienal de São
Paulo, São Paulo
Triennale di Milano, Milan
Jean-Pierre Tritz, Abder Bengmah,
Echap'Mode, Chapeaux, Paris
Andrea Überbacher, E.A. Generali
Foundation, Vienna
Siegfried Unseld, Suhrkamp Verlag,
Frankfurt am Main
Dean Valentine, Beverly Hills
Christine van Assche, Musée national d'art
moderne, Centre Georges Pompidou, Paris
Anneke van der Elsken, Warder
Peter van Vogelpoel, Amsterdam
Verlag Westfälisches Dampfboot, Münster
Verwaltung der staatlichen Schlößer und
Gärten, Michael Boßdorf, Nikolaus Backes,
Kassel
Giorgio Verzotti, Castello di Rivoli, Turin
VHT GmbH, Enger
Jean-Jacques Victor, Französische
Botschaft, Bonn

Klaus Voss, Mövenpick Hotel, Kassel
Robin Vousden, Anthony d'Offay Gallery,
London
Janka Vukmir, SCCA Zagreb, Zagreb
Kerstin Wahala, Galerie EIGEN + ART, Berlin
Peter Weibel, Steirischer Herbst, Graz
Olaf Weber, Kassel
Kurt Weidemann, Stuttgart
Heinz Weidner, Potsdam
Hans-Jochem Weikert, Kassel
Rainer Weiss, Suhrkamp Verlag,
Frankfurt am Main
Peter Wien, arte, Strasbourg
Wiener Secession, Vienna
Ulrich Wilmes, Städtische Galerie im
Lenbachhaus, Munich
Melanie Wilson, Anthony d'Offay Gallery,
London
Karl Winter, Kino Arsenal, Berlin
Witte de With Center for Contemporary
Art, Rotterdam
Johannes Wohnseifer, Cologne
Virginie Zabriskie, New York
ZDF / arte, Anne Even, Doris Hepp, Mainz
ZDF / Das Kleine Fernsehspiel, Eckart Stein,
Claudia Tronnler, Mainz
Beti Zerovc, Moderna Galerija Ljubljana,
Ljubljana
David Zwirner, David Zwirner Gallery,
New York

documenta X thanks all its sponsors

Deutsche Bahn **DB**

SONY

Finanzgruppe

Sparkasse Landesbank LBS SparkassenVersicherung

SEIT 1870

BINDING

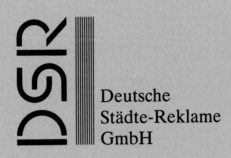

Deutsche
Städte-Reklame
GmbH

p. 304 Basilico Fine Arts, New York

p 305 Dorothee Golz; photo: August Lechner

p. 318 Courtesy Rhona Hoffman Gallery, Chicago; photo: David Reynolds

p. 324 Collection Ger C. Bout and Riitta Bout-Saari, VG Bild-Kunst, Bonn 1997

p. 326 Abisag Tüllmann Archiv, Frankfurt am Main

p. 330 Collection of the artist

pp. 334/335 Fraenkel Gallery, San Francisco

pp. 336-339 Collection of the artists; courtesy: Lisson Gallery, London

pp. 340/341 Collection of the artist

pp. 334/335 Courtesy of James Coleman and Marian Goodman Gallery, New York

pp. 342/343 Courtesy of James Coleman and Marian Goodman Gallery New York

p. 346 documenta Archiv, Kassel/Courtesy Gallery Durand-Dessert, Paris

p. 347 documenta-Archiv, Kassel

p. 348 Photo: Adam Rzepka

p. 349 Collection of the artist; photo: Adam Rzepka, Centre Georges Pompidou, Paris

pp. 350/351 Hans Haacke, VG Bild-Kunst, Bonn 1997

pp. 352/353 Rita Donagh, Northend

pp. 354/355 Collection of the artist

pp. 356/357 Helen Levitt. All rights reserved. Courtesy Laurence Miller Gallery, New York

pp. 358/359 Galerie Frank + Schulte, Berlin

pp. 360/361 Photos: Paolo Pellion

pp. 362/363 Städtische Galerie im Lenbachhaus, München, photo: Lenbachhaus, Jank/Koopmann

pp. 364/365 VG Bild-Kunst, Bonn 1997

p. 366 Collection National Gallery of Canada, Ottawa

p. 367 Courtesy Nova Gallery, Vancouver

p. 378 Film Bild Fundus Robert Fischer, München/Deutsches Theatermuseum, München, archives Willy Saeger

p. 386 Collection Grässlin, St. Georgen; photo: Hermann Haid

p. 387 Sipa-Press, Paris; photo: Alpay

p. 388 Maria Gilissen, Estate Marcel Broodthaers/Photo: Harald Szeemann

p. 396 Collection of the Whitney Museum of American Art, New York The Estate of Eva Hesse; courtesy: Robert Miller Gallery

p. 401 Marianne und Pierre Nahon, Galerie Beaubourg, Paris

p. 402 Groeningenmuseum, Bruges, Galerie Jos Jamar, Knocke

p. 403 Museum Moderner Kunst, Stiftung Ludwig, Vienna, former collection Hahn, Cologne; photo: Dr. Parisini

p. 407 Photo: Claude Gassian

p. 429 Collection of the artist

p. 432 Collection International Institute of Social History, Amsterdam/Collection S. Davidson; photo: Willem Jaarzon Morel (2)

p. 434 Collection International Institute of Social History, Amsterdam/Collection Steef Davidson; photos: Willem Jaarzon Morel

p. 435 Anneke van der Elsken

p. 436 Collection S. Davidson; photo: Willem Jaarzon Morel/Collection Landsberger, International Institute of Social History, Amsterdam

p. 437 Sipa Press, Paris; Photo: Huffschmitt (2)/Anneke van der Elsken

p. 444 Stedelijk Museum, Amsterdam

pp. 455-457 Photos: Marian Stefanowski

p. 472-474 Collection International Institute of Social History, Amsterdam

p. 475 Sipa Press, Paris

p. 476 Collection International Institute of Social History, Amsterdam

p. 477 Collection Landsberger, International Institute of Social History, Amsterdam

p. 480/481 Film Bild Fundus Robert Fischer, München

p. 483 Film Bild Fundus Robert Fischer, München

p. 486/487 Photos: Friedrich Rosenstiel

p. 489 Film Bild Fundus Robert Fischer, München

p. 488 Stiftung Archiv der Akademie der Künste; photos: Rambow

pp. 490-492 Photos: Masao Miyoshi

p. 506 Salzgeber & Co. Medien GmbH

pp. 522-535 Collection Aldo van Eyck, Amsterdam; Photo: Pieter Boersma (p. 523) ; photo: Violette Cornelius (p. 524)

p. 536 King Air Luftfoto, Biewer, Ahnatal/Photos: Albert Pinkvohs, Kassel (2)

p. 537 Photos: Herman Hertzberger; Ger van der Vlugt, I.A.P./Photography

p. 540 Collection of the artist

p. 542- 545 Collection of the artist

pp. 548/549 Photos: Nelson Kon

p. 550 Photo: Brian Gassel/Photo: Sexton/Matrix

pp. 552/553 Collection Generali Foundation; photos: Werner Kaligofsky

pp. 557–592 The China Group at the Graduate School of Design at Harvard University

p. 593 Filmmuseum München; photos: Gerhard Ullmann

p. 594 Sipa Press, Paris; photo: Delahaye

p. 595 Sipa Press, Paris; photo: Charlie Cole

p. 597 Sipa Press, Paris; photo: Marc Fallanda (2)/Sipa Press, Paris; photo: Malanca

pp. 600/601 Collection of the artist, Tel Aviv

pp. 602/603 Sipa Press, Paris; photos: Albert Facelly

pp. 605/606 Collection of the artist

p. 607 Anneke van der Elsken

pp. 606–608 Collection of the artist; courtesy Marian Goodman Gallery, N.Y.

p. 609 Sipa Press, Paris; photo: Lee Yong Ho

p. 625 Westfälisches Landesmuseum für Kunst und Kulturgeschichte Münster

p. 626 Photo: P. Mussat

p. 628 Beatrice Monti Collection, Milano; photo: A. Maranzano

p. 629 Bildarchiv Photo Marburg/Photo: Daniele de Lonti

p. 630 Gerhard Richter, Cologne

p. 632 John Heartfield Archiv, Berlin; photo: Roman März

p. 633 Fraenkel Gallery, San Francisco, and The Estate of Garry Winogrand

p. 634 Städtische Galerie im Lenbachhaus, München; photo: Lenbachhaus, Jank/Koopmann/Robert Rauschenberg; Courtesy PaceWildensteinMcGill, New York

p. 635 Kunstmuseum Luzern

p. 640 Film Bild Fundus Robert Fischer, München

p. 641 Archiv des Deutschen Theatermuseums München

p. 642 Neues Museum Weserburg Bremen, Collection Karl Gerstner; photo: Jörg Michaelis

p. 643 Courtesy Marian Goodman Gallery, New York

p. 644-647 Collection Jeff Wall, Vancouver; courtesy

Marian Goodman Gallery, New York and Galerie Johnen und Schöttle, Cologne

p. 656 Musée national d'art moderne, Centre Georges Pompidou,

p. 657 Collection of the artist; photo: Franz Schachinger

p. 670–685 Collection of the artists

p. 688 Collection of the artist

p. 691/692 Collection of the artist

p. 693 Collection of the artist, Copyright 1996/97 Artslut; photo: Jens Ziehe

pp. 700/701 Sammlung Hauser und Wirth, Zürich/David Zwirner, New York

pp. 702–707 Collection of the artist

pp. 708–715 Photo: SEHsternFilm, Reiner Krausz

pp. 718/719 Galerie Sylviane de Decker Heftler, Paris

pp. 720/721 Hans Haacke. VG Bild-Kunst, Bonn 1997

p. 722 Photos: Christian Richters

p. 723 Photos: Paola De Pietri

p. 724 Photo: Richard Bryant/Arcaid/Photo: John Edward Linden/Arcaid

p. 725 Photo: Monika Nikolic/Photo: Dieter Schwerdtle

p. 726 Photo: Monika Nikolic/King Air Luftfoto, Biewer, Ahnatal

p. 727 Photos: Erhard J. Scherpf

pp. 728/729 Photo: Joël Audebert/Photo: Ph.Gh. Duhot/ Photo: Joël Audebert/Photos: Thomas Mulcaire (4)

pp. 734/735 Roger Violler, Paris

p. 742 Coll. Johnson County Community College, Overland Park, Kansas; courtesy Jack Shainman Gallery, New York

p. 743 The Saint Louis Art Museum

p. 739 Collection of the artist; Regen Projects, Los Angeles

p. 741 Collection of the artist; Foksal Gallery

pp. 748/749 Photos: S. Licitra

pp. 756/757 Photos: Kathrin Schilling

p. 762 Projeto Hélio Oiticica, Rio de Janeiro; photo: John Goldblatt

pp. 768/769 Collection of the artist; photos: Ana Opalic (1+2)

p. 774 Sipa Press, Paris

p. 786 Sipa Press, Paris

pp. 792/793 Collection Sigalit Landau, Jerusalem/Courtesy: Contemporary Fine Art, Berlin

pp. 790/791 Collection of the artist

pp. 798/799 Courtesy: Andréhn-Schiptjenko, Stockholm

Sandra Alvarez de Toledo, art historian and photography specialist.

Etienne Balibar, professor of philosophy at Paris X University, author of works on Marxist epistemology in the 1970s (some in collaboration with Louis Althusser). Has more recently explored questions of citizenship and the limits of the nation-state.

Andrea Branzi, architect and designer from Milan, member of the architectural group Archizoom Associati from 1964 to 1974. His fields of activity are industrial design, experimental design, architecture, and city planning.

Benjamin Buchloh, professor of modern and contemporary art at Barnard College of Columbia University in New York. Author of numerous essays on contemporary art, member of the editorial board of the journal *October*.

Peter Bürger, professor of literature and aesthetic theory at the University of Bremen since 1971. Author of many books on literature and philosophy, including *Theory of the Avant-Garde* (1974).

Jean-Marie Chauvier, studied in Berlin and Moscow, journalist, specialist in Eastern Europe. Special correspondent in Moscow for *Le Monde diplomatique* and the Belgian TV channel RTBF. Author of numerous works on the Soviet Union.

Daniel Defert, professor of the sociology of medicine at Paris VIII University in Saint-Denis. Editor with François Ewald of the complete collection of Michel Foucault's articles and interviews. Founder of the international organization AIDES.

Werner Durth, architect and sociologist, professor of architecture at the University of Stuttgart. Author of numerous books and essays on urbanism.

Fabrizio Gallanti, studied architecture at the University of Genua, founder in 1993 of Gruppo A 12, which organized events in the field of architecture and city planning. After the completion of his studies in 1995 he was awarded the first prize at the Biennal of Young Artists from the Mediterranean region.

Serge Gruzinski, research director at the French Centre National de la Recherche Scientifique, professor at the Ecole de Hautes Etudes en Sciences Sociales in Paris. Specialist in pre- and postcolonial history and Mexican culture.

David Harvey, professor of geography at Johns Hopkins University in Baltimore (USA), labor organizer, Marxist philosopher. Author of numerous works dealing with spatial organization and social justice in the modern city.

Andreas Huyssen, professor of German and comparative literature at Columbia University in New York. A founding editor of the journal *New German Critique*, member of the editorial board of *October*, *Critical Studies*, and *Germanic Review*.

Benjamin Joly, student of German literature and philosophy at the Ecole Normale Supérieure in Paris.

Philippe Lacoue-Labarthe, professor of philosophy at the University of Strasbourg and visiting professor at the University of California in Berkeley. Author of books on German philosophy and literature.

Dominique Lecourt, professor of philosophy at Paris VII University. Author of numerous works, including studies in the philosophy of science.

Alain Lipietz, economist and research director at the Centre d'Etudes Prospectives d'Economie Mathématique Appliquées à la Planification (CEPREMAP) in Paris. Member of the French ecologist party, Les Verts; combines militant political activity with research as an economist.

Masao Miyoshi, professor of English, Japanese, and comparative literature at the University of California in San Diego. Author of numerous works of literary criticism and cultural studies.

Peter Noller, studies sociology and philosophy in Heidelberg, London, and Frankfurt. Since 1986 he has worked at the Institut für Sozialforschung in Frankfurt, publishing on the themes of urban and cultural sociology and lifestyle research.

Jacques Rancière, professor of aesthetics at Paris VIII University in Saint-Denis. His books explore politics, philosophy, and political aesthetics.

Klaus Ronneberger, studied cultural anthropology, sociology, and political science. Researcher at the Institut für Sozialforschung in Frankfurt. Author of numerous publications on urban sociology and the sociology of culture and technology.

Hans-Joachim Ruckhäberle, dramatist and director, drama professor at Berlin-Weißensee Kunsthochschule. Head dramatist and artistic director of the Munich Kammerspiel from 1983 to 1993.

Saskia Sassen, professor of city planning at Columbia University in New York. Author of articles and books on urbanism and the global economy.

Gayatri Chakravorty Spivak, professor of English and comparative literature at Columbia University in New York. Engaged in the deconstruction of neocolonial discourse, from a Marxist-feminist position.

Francis Strauven, professor of architectural history and theory at the College of Science and Arts in Brussels. Author of numerous publications on architecture, including a monograph on Aldo van Eyck.

Paul Sztulman, studied photography at the Ecole Nationale de la Photographie in Arles and art history in Paris.

Max Welch Guerra, studied political science at the Berlin Free University. Researcher since 1987 at the Institute for City and Regional Planning of the Berlin Technical University. Author of studies on Berlin, Moscow, Rome, Bonn, etc.

arte Medienpartner der documenta X

Colophon

Editor

documenta
and Museum Fridericianum
Veranstaltungs-GmbH

Idea and Conception

Catherine David
and Jean-François Chevrier

Coordinating Editor

Françoise Joly

Editor

Cornelia Barth

English Editor

Brian Holmes

Editorial Assistance

Jutta Buness

Design

Lothar Krauss

Design Collaboration

Charlotte Schröner

Layout

Klaus Chmielewski
Lothar Krauss
Saskia H. Rothfischer
Charlotte Schröner
and Julien Boitias, Paris

Translations

From the French

Brian Holmes
Charles Penwarden

From the German

Pauline Cumbers
Ishbel Flett
Stephen Locke
Judith Rosenthal

From the Italian

Brian Holmes

From the Swedish

Erikson Translation

Transcriptions

Carol Johnson, Valérie
Picaudé, Sophie Wahnich,

Film Research

Brigitte Kramer
Christian Milovanoff

Proofreading

Steve Holmes
Steve Torgoff

Production Coordination

Stefan Illing-Finné

Lithography

C+S Repro, Filderstadt

Typesetting

Michael Gahrtz
Christian Kramer-Kugelstadt

Printing

Werbedruck Schreckhase,
Spangenberg

Production

Dr. Cantz'sche Druckerei,
Ostfildern bei Stuttgart

Published by

Cantz Verlag
Senefelderstrasse 12
73760 Ostfildern-Ruit
T. (0)711 / 4405-0
F. (0)711 / 4405-255

ISBN 3-89322-911-6 (English trade edition)
ISBN 3-89322-909-4 (German trade edition)

Distribution in the USA
DAP, Distributed Art Publishers
155 Avenue of the Americas, Second Floor
New York, N.Y. 10013
T. (001) 212-6271999
F. (001) 212-6279484

Distribution in Great Britain
and British Commonwealth
30–34 Bloomsbury Street
London WC 1B3QP
T. (171) 6361695
F. (171) 6365488

Die Deutsche Bibliothek-CIP Einheitsaufnahme
Documenta <10, 1997, Kassel>: Documenta X –
the book : politics poetics / [Hrsg. Documenta-und-
Museum-Fridericianum-Veranstaltungs-GmbH. Idee
und Konzeption Catherine David und Jean-François
Chevrier]. – Ostfildern : Cantz-Verl., 1997
 Dt. Ausg. u. d. T.: Das Buch zur Documenta X
 ISBN 3-89322-911-6